DUTCH PAINTINGS
in The Metropolitan Museum of Art

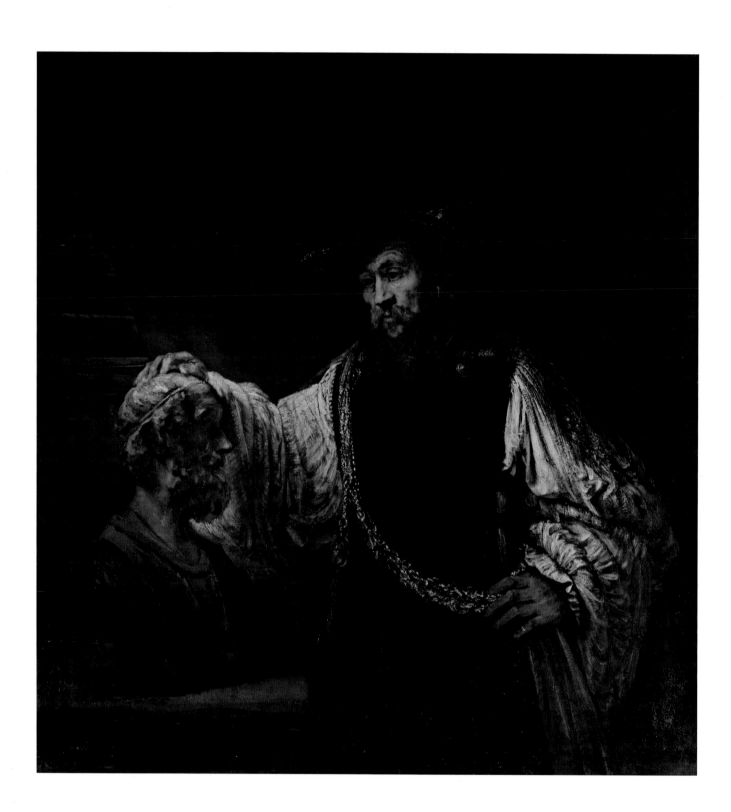

DUTCH PAINTINGS
in The Metropolitan Museum of Art

WALTER LIEDTKE

I

The Metropolitan Museum of Art, New York

Yale University Press, New Haven and London

This publication is made possible by Hata Stichting Foundation
and Mr. and Mrs. M.E. Zukerman.

Additional support is provided by the Kowitz Family Foundation
and The Christian Humann Foundation.

Published by The Metropolitan Museum of Art, New York
John P. O'Neill, Publisher and Editor in Chief
Gwen Roginsky, General Manager of Publications
Emily March Walter, Editor, with the assistance of Ellyn Childs Allison
Bruce Campbell, Designer
Christopher Zichello, Production Manager
Kathryn Ansite, Desktop Publishing Specialist
Jean Wagner, Bibliographic Editor

Photographs of paintings in The Metropolitan Museum of Art by
Juan Trujillo, The Photograph Studio, The Metropolitan Museum of Art.

Typeset in Galliard
Printed on Cartiere Burgo 130 gsm R-400
Color separations by Professional Graphics, Inc., Rockford, Illinois
Printed and bound by Mondadori Printing S.p.A., Verona, Italy

Slipcase illustrations:
Front: Rembrandt van Rijn (1606–1669), *Aristotle with a Bust of Homer*
(detail), 1653. Purchase, special contributions and funds given or bequeathed
by friends of the Museum, 1961 61.198 (Pl. 151)
Back: Johannes Vermeer (1632–1675), *Young Woman with a Water Pitcher*
(detail), ca. 1662. Marquand Collection, Gift of Henry G. Marquand, 1889
89.15.21 (Pl. 203)

Frontispiece: Rembrandt van Rijn, *Aristotle with a Bust of Homer* (Pl. 151)

Cataloging-in-Publication Data is available from the Library of Congress.
ISBN 978-1-58839-273-2 (hc: The Metropolitan Museum of Art)
ISBN 978-0-300-12028-8 (hc: Yale University Press)

CONTENTS

Volume I

Director's Foreword vii

Preface ix

Acknowledgments xv

Note to the Reader xviii

CATALOGUE

Backer, Jacob 3

Bailly, David 14

Beerstraten, Johannes 19

Berchem, Nicolaes 24

Berghe, Christoffel van den 28

Beyeren, Abraham van 31

Bisschop, Cornelis 35

Bloemaert, Abraham 40

Bol, Ferdinand 45

Bor, Paulus 53

Borch, Gerard ter 62

Borssom, Anthonie van 83

Bramer, Leonaert 87

Breenbergh, Bartholomeus 94

Brekelenkam, Quirijn van 101

Brugghen, Hendrick ter 108

Cappelle, Jan van de 119

Claesz, Pieter 126

Collier, Edwaert 130

Cuylenborch, Abraham van 133

Cuyp, Aelbert 136

Dou, Gerrit 153

Drost, Willem 167

Duck, Jacob 181

Eeckhout, Gerbrand van den 185

Ekels, Jan the Younger 193

Fabritius, Barent 197

Flinck, Govert 201

Gheyn, Jacques de, the Elder 211

Goyen, Jan van 224

Hals, Dirck 246

Hals, Frans 250

Hanneman, Adriaen 305

Haverman, Margareta 308

Heda, Willem Claesz 311

Heem, Jan Davidsz de 314

Helst, Bartholomeus van der 323

Heyden, Jan van der 332

Hobbema, Meyndert 341

Hondecoeter, Melchior d' 347

Hondius, Abraham 351

Hooch, Pieter de 354

Hoogstraten, Samuel van 372

Jongh, Ludolf de 377

Jonson van Ceulen, Cornelis the Elder 380

Jonson van Ceulen, Cornelis the Younger 384

Kalf, Willem 386

Keyser, Thomas de 393

Koninck, Philips 404

Lairesse, Gerard de 414

Leen, Willem van 422

Lingelbach, Johannes 425

Maes, Nicolaes 430

Marseus van Schrieck, Otto 450

Metsu, Gabriël 455

Miereveld, Michiel van 473

Mieris, Frans van, the Elder 480

Mijtens, Daniël the Elder 484

Molijn, Pieter de 489

Moreelse, Paulus 493

Murant, Emanuel 497

Naiveu, Matthijs	501	Pickenoy, Nicolaes Eliasz	527
Neer, Aert van der	505	Post, Frans	531
Neer, Eglon van der	512	Pynas, Jacob	535
Netscher, Caspar	517	Quast, Pieter	539
Ochtervelt, Jacob	521	Ravesteyn, Jan van	543
Ostade, Adriaen van	524		

Volume II

Rembrandt van Rijn	547	Vosmaer, Jacob	925
Style of Rembrandt	708	Vries, Abraham de	931
Ruisdael, Jacob van	786	Vries, Roelof van	934
Ruysdael, Salomon van	801	Weenix, Jan	937
Schalcken, Godfried	821	Willaerts, Adam	942
Slingelandt, Pieter van	825	Wit, Jacob de	946
Sorgh, Hendrick	830	Witte, Emanuel de	963
Steen, Jan	835	Wouwermans, Philips	971
Stom, Matthias	848	Wtewael, Joachim	975
Strij, Jacob van	852	Wtewael, Peter	987
Tieling, Lodewijk	858	Dutch Painters	992
Velde, Willem van de, the Younger	862		
Vermeer, Johannes	866		
Verspronck, Johannes	907	*Bibliography of Works Cited*	1005
Victors, Jan	910	*Index of Previous Owners*	1060
Vinckboons, David	913	*Index of Paintings by Accession Number*	1066
Vlieger, Simon de	917	*Index*	1070
Vliet, Hendrick van	921	*Photograph Credits*	1083

Director's Foreword

Among the many great collections in The Metropolitan Museum of Art, the more than 220 Dutch paintings of the seventeenth and eighteenth centuries may be regarded with particular pride and sympathy, for not only do they form the finest ensemble of their kind in the Western hemisphere, they also reflect the institution's growth from its earliest days to the present. One year after its incorporation in 1870, the Museum built upon the classical foundation of the sole object then in its collection, a Roman sarcophagus, by approving the purchase of 174 European paintings, of which only the largest part, Dutch pictures from the age of Rembrandt, could be said to offer an initial survey of a national school. To some extent, this was the consequence of what vice president William T. Blodgett encountered on the art market in Belgium and France. But his selection and the warm reception that the paintings received from Museum officials, the public, and critics in New York were also reliable indicators of American taste and reminders of the country's long-standing affinity for the Netherlands. The Museum's leading benefactors of the late nineteenth and early twentieth centuries—the Gilded Age and its legacy—appear to have confirmed the preferences expressed in the 1871 Purchase with their gifts and bequests, while at the same time raising the standard of the Dutch collection to that of only a few other cities in the world.

As the author notes in his preface, the present publication has been anticipated for many years. Realistically, the earliest moment at which a catalogue of the Dutch paintings in the Metropolitan Museum might have appeared was during the curatorship of W. R. Valentiner, from 1908 to 1914. Although he headed the Museum's new Department of Decorative Arts, Valentiner was the first true scholar of northern European paintings to work in America, and an almost compulsive cataloguer of private and public collections. World War I, however, sent Valentiner back to his native Germany (he had earned his stripes under Wilhelm von Bode, director general of the Kaiser-Friedrich-Museum in Berlin), and until well after World War II, none of the Museum's curators were primarily concerned with Dutch art. In earlier decades, the members of the small staffs of each curatorial department had wide-ranging responsibilities, and like Valentiner himself, were generalists. The key figures in the Department of European Paintings were the personable and perceptive Bryson Burroughs, who replaced the inflammatory Roger Fry in 1909 and served as curator until 1934; Harry B. Wehle, who joined the department in 1921 and was full curator from 1935 until 1948; Theodore (Ted) Rousseau, curator from 1947 until 1968 and curator in chief and vice director from 1968 to 1973; Margaretta Salinger, who rose from cataloguer in 1930 to curator in 1967, remaining as curator emerita until 1985; and Claus Virch, who quickly advanced through the curatorial ranks between 1957 and 1970. With John Walsh, curator from 1970 to 1975, the Museum gained a scholar completely at home in the literature of Dutch art, in the language, and in the international network of figures in the field. Egbert Haverkamp-Begemann, consultative curator for Dutch and Flemish painting from 1977 through 1979, gave valuable advice concerning the Museum's Dutch pictures (especially the Rembrandts) while working mainly on Rubens and Van Dyck.

Walter Liedtke became the Museum's curator of Dutch and Flemish paintings in 1980, after several years of teaching and one year of research at the Museum as an Andrew W. Mellon Fellow. His standard collection catalogue, *Flemish Paintings in The Metropolitan Museum of Art*, appeared in 1984. He catalogued many of the Dutch and Flemish paintings in the Museum's memorable exhibition "Liechtenstein: The Princely Collections" (1985–86), served as coordinator of "Zurbarán" (1987), and was co-author of "Masterworks from the Musée des Beaux-Arts, Lille" (1992–93) and (with conservator Hubert von Sonnenburg) the provocative exhibition "Rembrandt/Not Rembrandt in The Metropolitan Museum of Art" (1995–96). Steady work on the Dutch catalogue progressed from that point on, except during the two years leading up to the extraordinarily successful "Vermeer and the Delft School," of 2001.

A publication of this scale and significance would not have been possible without the generous support of a consortium of donors. We are deeply indebted to Hata Stichting Foundation for their sustained commitment to this project. We also thank Mr. and Mrs. M.E. Zukerman for their generosity in bringing this catalogue to fruition. Additional thanks go to the Kowitz Family Foundation and The Christian Humann Foundation for their support.

Not so long ago, collection catalogues like this one (although less ambitious) were entrusted to outside authorities. From about 1980 onward, Museum curators have been the sole or principal authors of exhibition and collection catalogues, and with appropriate exceptions this will undoubtedly remain the norm. Proud as we may be of our publications, however, they represent a comparatively small proportion of the knowledge gained and work accomplished in the Museum's curatorial, conservation, and education departments and in our libraries. The primary goal of the Museum is, of course, the preservation and effective display of works of art, so that specialists and laymen alike may study and appreciate them. What happens in that process cannot always be cast into words, as Aristotle — certainly as Rembrandt depicted him — appears to have understood.

Philippe de Montebello
Director
The Metropolitan Museum of Art

PREFACE

Dutch paintings of the Golden Age—the century of Frans Hals, Rembrandt van Rijn, and Johannes Vermeer—constitute one of the great collections in The Metropolitan Museum of Art, and may also be described (with only a touch of poetic license) as the Museum's first collection of any kind, going back to the founding purchase of 1871. As Henry James reported in his urbane essay "The Metropolitan Museum's '1871 Purchase'" (1872), the majority of the 174 paintings that had been acquired in Brussels and Paris by the new institution's vice president, William T. Blodgett, were either Dutch or Flemish, and most of the works from the southern, or Spanish, Netherlands treated themes "which we especially associate with the Dutch school—*genre* subjects, rustic groups, and landscapes." James deals brusquely with the few conspicuously Baroque compositions by or attributed to Peter Paul Rubens, Anthony van Dyck, and Jacob Jordaens. With a Yankee mistrust of courtly manners, he describes the treatment of a female portrait then ascribed to Van Dyck as "excessively, almost morbidly refined." By contrast, Hals's image of the cackling crone "Malle Babbe" (Pl. 69) is praised as "a masterpiece of inelegant vigour." Here, James may be more pleased with his aperçu than with the picture, for most displays of lively brushwork are regarded by him with suspicion (the Venetian view painter Francesco Guardi employs "mere artifice and manner"), while confidence is placed in examples of close observation and craftsmanship (a Dutchman such as Jan van der Heyden [see Pls. 78, 79] "feels that, unless he is faithful, he is nothing"). Addressing himself to a certain class of readers, James reminds them what it is like "to have turned with a sort of moral relief, in the galleries of Italy, to some small stray specimen of Dutch patience and conscience."[1]

The 1871 Purchase was not an instance of collecting in the usual sense but an expression of American taste embodied in a typically American gesture, the wholesale acquisition of what one ought to have—in this case, a public gallery of old master paintings. The wisdom of Blodgett's plan, in which Museum president John Taylor Johnston promptly became a partner, is underscored by the fact that very few European paintings of any kind were added to the collection between 1872 and 1889, apart from the Catherine Lorillard Wolff bequest, in 1887, of more than fifty works by then-fashionable Continental painters. However, the loyal trustee (and later Museum president) Henry G. Marquand must have had the Museum in mind when he added a few Italian and Spanish paintings and a good number of northern European pictures to his collection of Barbizon landscapes and predictable pieces of decorative art (Oriental porcelain, Renaissance ironwork, and so on). In 1889, Marquand donated thirty-seven paintings to the Museum, including America's first and most beloved Vermeer (Pl. 203) and works by Hals, Jacob van Ruisdael, Gerard ter Borch, and other Dutch artists.

Most of the works discussed in this catalogue came to the Museum through similar gifts and bequests made between 1900 and 1931. In addition to Marquand, the major benefactors included Collis P. Huntington and William K. Vanderbilt (all three were railroad entrepreneurs), the famous financier J. Pierpont Morgan, the sugar monopolist Henry H. Havemeyer, the retail potentate Benjamin Altman, and his business partner Michael Friedsam. It was not until after World War II that building—or rather, refining—the collections of Dutch and other paintings in the Metropolitan Museum became a matter of curatorial judgment rather than the acceptance of manna from one heaven or another. With particular regard to Dutch masters, the Museum's collection of European paintings reflects the wealth and taste of the Gilded Age, that period of (for some sectors of society) exceptional prosperity between the Civil War and World War I.[2]

As a result, the Dutch collection is comparatively extensive (229 paintings) and rich in works by "Rembrandt, Hals and Vermeer, the three prime immortals of their school" (as the conventional opinion was expressed in 1930).[3] Remarkably, paintings by those three artists represent about one-sixth of the entire collection: twenty (in my view) by Rembrandt, eleven by Hals, and five by

Vermeer. The remaining pictures are mostly by contemporaries of the same trio, whose careers span the six decades between about 1615 (Hals's *Merrymakers at Shrovetide* [Pl. 58], of about 1616–17, is one of the artist's earliest known works) and Vermeer's death in 1675. Only eight pictures in the collection date from the 1700s, and only two fall outside the period 1600–1800: a modern imitation of a Vermeer, dating from about 1925–27 (Pl. 207; included here as part of the history of collecting the Delft painter's work in America), and Abraham Bloemaert's early *Moses Striking the Rock,* of 1596 (Pl. 9). James would have judged that Mannerist composition as beyond the pale. But scholars now think otherwise, since the Golden Age of Dutch art is said to have begun about 1580 and Bloemaert was one of Utrecht's most respected artists until his death in 1651.

In addition to numerous masterpieces, the Museum's panorama of Dutch painting has exceptional breadth, and in certain areas—landscape, portraiture, and genre scenes especially—extraordinary depth. Landscapists represented by a few or several pictures include Aelbert Cuyp, Jan van Goyen, Meyndert Hobbema, Philips Koninck, Aert van der Neer, Jacob van Ruisdael, and Salomon van Ruysdael. And there are individual works by the pioneering Christoffel van den Berghe and Pieter de Molijn, a superb Brazilian vista by Frans Post, and characteristic landscapes by David Vinckboons, Johannes Beerstraten, and Philips Wouwermans. Among these views of farmland, forests, rivers, distant cities, occasional hills, and many dunes, a visitor to the Dutch landscape gallery will catch several glimpses of the sea (or, at least, large bodies of water) in pictures by Jan van de Cappelle, Van Ruysdael, Willem van de Velde the Younger, and Simon de Vlieger.

The great collectors of the Gilded Age were drawn instinctively to old master portraits, especially those from English country houses (as were many by Van Dyck) or stately homes in France. Businessmen such as Havemeyer evidently felt at their ease surrounded (as Havemeyer was in his library) by dignified Dutch individuals, who perhaps formed a society more polite than that of New York or implied prominent branches on the family tree. As a result, the Museum has a collection of Dutch portraits comparable with that of any European institution, except for the Rijksmuseum in Amsterdam, which is home to large group portraits of civic guard companies and other municipal organizations. Remarkably, there are a greater number of single and pendant portraits by Rembrandt in New York than in Amsterdam; the present catalogue includes thirteen, not counting the *Hendrickje Stoffels* (Pl. 154) as a proper portrait. There are also seven portraits by Hals, which, together with those by Rembrandt, a few of Rembrandt's followers, and twenty other artists, form a nearly complete picture of seventeenth-century portraiture in the Netherlands. Among the finest examples are a great equestrian portrait by Cuyp (Pl. 33), *The Van Moerkerken Family* by Ter Borch (Pl. 14), an ambitious self-portrait by Gerrit Dou (Pl. 37), three exceptional pictures by Thomas de Keyser (Pls. 98–100), Daniël Mijtens's full-length portrait of Charles I (Pl. 124), and works by leading figures from different cities, such as Michiel van Miereveld of Delft, David Bailly of Leiden, Adriaen Hanneman of The Hague, and Johannes Verspronck of Haarlem. Like several works in the style of Rembrandt, the two portraitlike pictures by Govert Flinck are actually *tronies,* or studies of imaginary characters based on live models.

Boasts give way to embarrassment (of the kind attributed to wealthy Dutchmen) when the plentitude of genre paintings is taken into account. Ter Borch, Gabriël Metsu, Jan Steen, and Vermeer are each represented by three genre scenes. There are two large and famous canvases (both given by Benjamin Altman) and a pair of lesser works by Hals, two sympathetic pictures of domestic life by Maes, no less than seven paintings by Pieter de Hooch, and typical works by most of the other key figures from Amsterdam, Haarlem, Leiden, The Hague, and Rotterdam. One of the pictures by Quirijn van Brekelenkam, the charming *Sentimental Conversation* (Pl. 24), is actually too Vermeer-like to be described as typical, and that term is inadequate also for the paintings by Cornelis Bisschop, Frans van Mieris, and Peter Wtewael.

The naughty picture by Wtewael (Pl. 225) and a small panel by Jacob Duck (Pl. 41) are the Museum's only good examples of genre painting from Utrecht. Like pictures of peasant life, those of carousing cavaliers and loose women by Utrecht artists such as Gerrit van Honthorst would have been frowned upon by the kind of collectors who in the first half of the twentieth century became Museum trustees. This predisposition was reinforced by lordly dealers such as Joseph Duveen. Compensation for the shortage of Caravaggesque works in the collection may be found in Hals's Honthorst-like *Boy with a Lute* (Pl. 61), Matthias Stom's *Old Woman Praying* (Pl. 198), and a hypnotic masterpiece of the Counter-Reformation in Utrecht, Hendrick ter Brugghen's *Crucifixion with the Virgin and*

Saint John (Pl. 25). In addition, *The Disillusioned Medea ("The Enchantress"),* by Paulus Bor (Pl. 12), is a bewitching concoction of the Utrecht style, from nearby Amersfoort.

As in the case of genre scenes, the history of taste accounts for the comparatively incomplete representation of Dutch still-life painting. In Duveen's day, these works were too inexpensive to be worth the trouble in the art trade, but now certain types—flower pieces, especially—bring spectacular prices. Curator Theodore Rousseau made a consistent effort to strengthen this part of the collection, for example, by purchasing the perfectly preserved vanitas still life by Pieter Claesz (Pl. 28) in 1949, then a year later one of Jan Weenix's finest "trophy" pictures of dead game birds and hunting gear (Pl. 216), and finally, in 1953, a classic *pronk* ("show") still life by Willem Kalf (Pl. 97) and a "forest-floor" study of plants, reptiles, and insects by Otto Marseus van Schrieck (Pl. 115). Marseus is a fascinating example of the Dutch artist as naturalist. As most accounts of his career are outdated or inadequate, the biography below is more thorough than might be expected.

The vanitas picture by Claesz is too early in style and too distinctive in subject matter to be considered typical of so-called monochrome still-life painting in Haarlem. Thus, the Markus bequest (2005) of an exquisite "monochrome breakfast piece" by Willem Claesz Heda (Pl. 73) was a significant addition to the collection. Still missing are works by the most distinguished members of the first generation of still-life painters, such as Ambrosius Bosschaert and Balthasar van der Ast. However, each collection has its own character, and the Museum's increasing harvest of seventeenth-century still-life painting (which includes works by Flemish, French, and German artists) is already remarkable for its inclusion of the earliest dated vanitas still life from the Netherlands, painted in 1603 by Jacques de Gheyn the Elder (Pl. 48), and a rarity from Delft, Jacob Vosmaer's *Vase with Flowers,* probably of 1613 (Pl. 213). Two early still lifes by Jan Davidsz de Heem, one very small and the other enormous (by Dutch standards), and fancy still lifes by Kalf and Abraham van Beyeren date from the middle years of the century. Life on country estates is evoked not only by the large Weenix but also by Melchior d'Hondecoeter's even grander and more animated *Peacocks,* of 1681 (Pl. 82). The canvas is a comparatively rare instance of a non-Italian gift to an American museum by Samuel H. Kress (in 1927). From the eighteenth century, the graceful bouquet painted by Margareta Haverman in 1716 (Pl. 72) is one of only two

works indisputably by this artist. Willem van Leen's *Flowers in a Blue Vase* (Pl. 105) shows the long floral tradition in Dutch painting adapted to interior decoration of the late 1700s.

In the first fifty years after the Museum was founded (in 1870), the American elite's lack of sympathy for the cultures, myths, and religions of foreign countries was even more pronounced than it is among conservative Americans today. The main exception was made possible by viewing the Netherlands as a Protestant republic of hardworking individuals with strong family values, a nation, in other words, that anticipated some of the perceived virtues of the United States. As a result, a relatively small proportion of Dutch pictures imported to America were history paintings, works representing mythological subjects, episodes of ancient history, and religious scenes. In recent decades, however, a more comprehensive view of Dutch painting—one allowing for Catholic and princely patrons, foreign and cosmopolitan collectors, and artists who favored international styles such as Mannerism and Classicism—has gradually formed in the Museum's collection, mainly through curatorial initiative. The most important example is the great Ter Brugghen *Crucifixion,* mentioned above (it was purchased in 1956). John Walsh was one of the first curators to take corrective measures, securing, for example, the Bloemaert in 1972. The same thinking went into the present writer's recommendations of Bartholomeus Breenbergh's *Preaching of John the Baptist,* the minor but popular *Annunciation of the Death of the Virgin,* by Samuel van Hoogstraten, and Joachim Wtewael's astonishing picture on copper, *The Golden Age,* of 1605 (Pls. 22, 91, 224; acquired in 1991, 1992, and 1993, respectively). The other history paintings by Dutch artists tend to follow the same pattern of acquisition: the works by Bor, Barent Fabritius, Abraham Hondius, Jacob Pynas, and Maes's earliest known dated work, *Abraham Dismissing Hagar and Ishmael,* of 1653 (Pl. 108), were all given in the early 1970s (surely with Walsh's encouragement), and Godfried Schalcken's *Cephalus and Procris* (Pl. 191) was purchased in 1974. The history paintings that came in earlier did so in most instances because they are or were thought to be by Rembrandt (Pls. 39, 147, 150, 168, 174, 175), or were at the time unappreciated pictures in search of a suitable home (Leonaert Bramer's *Judgment of Solomon* [Pl. 21], for example, given in 1911). The biggest coup of this kind was the gift in 1943 of Gerard de Lairesse's magnificent *Apollo and Aurora,* of 1671 (Pl. 104), which

went from the grand town house in Amsterdam for which it was made into three centuries of obscurity. Of course, the greatest Dutch painting in America, Rembrandt's *Aristotle with a Bust of Homer* (Pl. 151), happens to be a history picture, but that was a distinctly secondary consideration to the Museum officials who arranged for its purchase at auction in 1961.

The *Aristotle* is the only painting by Rembrandt or previously thought to be by Rembrandt that the Museum ever acquired by purchase rather than by gift or bequest. Similarly, none of the works by Ter Borch, Cuyp, Hals, Hobbema, De Hooch, Metsu, Ruisdael, or Vermeer were purchased, and the names of Van Goyen, Van Ruysdael, and several other important artists could be added to the list were it not for the pictures by them that were acquired in 1871. It should, however, be understood that the majority of gifts made to the Museum require considerably more initiative and diplomacy than does the average purchase. Trustees, directors, department chairmen, curators, and others all play leading roles, on some occasions with great success, at others without consequence. In the 1950s, Museum staff members consumed a fair amount of tea in Mrs. Erickson's library, where the *Aristotle* hung.

Normally, about a third of the Dutch paintings are on view in the galleries. An exhibition of the entire collection, "The Age of Rembrandt: Dutch Paintings in The Metropolitan Museum of Art" (September 18, 2007– January 6, 2008), which has been made possible by Accenture, coincides with the publication of this catalogue. The timing of the exhibition could be said to represent a compromise between two anniversaries, Rembrandt's four-hundredth birthday (he was born in 1606) and the centennial of the "Hudson-Fulton Celebration," held in 1909. The Museum took part in the citywide festivities by mounting a grand exhibition of Dutch and American art. The twin pretexts for the extravaganza were Henry Hudson's sail up the Hudson River in 1609 (the English captain served the Dutch merchant marine) and the same trip made by Robert Fulton's steamboat in 1807. The connection must have made as much sense to artists and collectors as it did to maritime historians, as seventeenth-century Dutch art had strongly influenced American painters since the early nineteenth century. But the main point of the exhibition was to demonstrate that New York was on the world map of cultural capitals (with steamships carrying collectors from one to another). The part of the exhibition that did so

was not the comparatively modest American section, but the galleries that displayed the 149 Dutch pictures, including (according to curator W. R. Valentiner) thirty-seven by Rembrandt. Some of the most important Dutch paintings now in America were in that exhibition — including Rembrandt's *Aristotle* (as *The Savant*).

When the present writer completed the collection catalogue *Flemish Paintings in The Metropolitan Museum of Art* (1984), it was intended that the Dutch counterpart would follow in a timely fashion. As the Director notes in the foreword, a variety of pleasant distractions were placed in the way, such as the Liechtenstein, Zurbarán, and Lille exhibitions of 1985–86, 1987, and 1992–93, and, in 1995–96, "Rembrandt/Not Rembrandt in The Metropolitan Museum of Art," which, in retrospect, was crucial preparation for the corresponding sections of the present catalogue. Another contributing factor, if in a less obvious way, has been the Museum's policy of allowing curators to flourish as scholars in their fields by (within reason) researching and writing about subjects that do not bear directly on the collections. "Vermeer and the Delft School" (2001), one of the Museum's most ambitious exhibitions of the past few decades, grew out of work that began with my own dissertation in the early 1970s and continued as a personal preoccupation.

The literature that has appeared in the past twenty-odd years — to think back again to the Flemish catalogue — allows some degree of gratitude that the Dutch catalogue was not completed sooner. Rembrandt studies, in particular (including the many of 2006), have been valuable to this publication, but so have articles and books devoted to much less familiar figures. This will be clear to readers who consult the endnotes and the References section in each entry, and the bibliography, which has expanded exponentially with the passing of years.

Like the size of the bibliography, the scale of the catalogue as a whole calls for some comment. Compilers of the past, ranging from Wilhelm von Bode to Neil MacLaren, managed to say everything they had in mind in much less space. But it is telling that when it appeared in 1960, MacLaren's *The Dutch School* was regarded as an overflowing font of knowledge about the subject in general, as well as a complete guide to the Dutch pictures in the National Gallery, London. Since that time, the literature of Dutch art has grown beyond all imagining, or rather, beyond what could have been expected in those innocent days before the arrival of the Rembrandt *Corpus,* Sumowski's

Gemälde der Rembrandt-Schüler (1983–[94]; approximately twenty-five hundred Rembrandt-school pictures presented in six volumes), monumental exhibition catalogues such as *Dawn of the Golden Age* (Rijksmuseum, Amsterdam, 1993), and monographs on Bloemaert, Van Goyen, Cornelis Cornelisz van Haarlem, Honthorst, Van der Neer, Netscher, Schalcken, Van de Velde, and others that tip the scales in prodigious competition with the standard volumes on Hals, Rembrandt, and Ruisdael (not to mention Michelangelo). Substantial books (at least in terms of shelf space) have been published on painters who would be sufficiently covered by short discussions in *Oud Holland*, although it is helpful — to auctioneers, collectors, dealers, and curators — to have a stockpile of photographs in one place (MacLaren's volume had none). Thus, the present catalogue betrays both vices and virtues that are common in the field. But it differs from similar publications in one respect that might mitigate criticism. At the end of each entry, under References, not only is every mention of the painting in print (with a few trivial exceptions) cited, but its essential content is summarized. This should save serious readers a great deal of time, if only by demonstrating that in some cases three or four references in a hundred need be further considered. The brisk chronological reviews of the literature also allow one to trace trends in taste, the rise and fall of misconceptions, and the gradual accrual of evidence or insight. Rather as in an archaeological dig, the profiles of opinion and scholarship offered in the References reveal long-term tendencies and sudden revelations. The fact, for instance, that a recent interpretation was advanced and rejected a century ago. Or that for fifty or a hundred years, almost nothing worth repeating was written about a great painting — as if the powerful image, like Medusa, had turned scholars and critics to stone.

The approach taken in the text of each catalogue entry, as in the References, exhibition histories, provenance sections (Ex Coll.), and condition notes reflects the assumption that the most likely readers — curators, collectors, teachers, graduate students, and laymen — are already conversant with some of the literature of Dutch art. As recently as ten or twenty years ago, it was fairly common for cataloguers to supply background information within a dense discussion of a specific work of art, as if the average reader would benefit from remedial interludes on such subjects as livestock, tulips, vanitas symbols, the prevalence of monochromatic palettes in the 1630s, and so on.

Addressing professionals and passersby in the same breath has proven ill-advised in several publications. Nevertheless, it should be recognized that not all readers will have at their fingertips important details of historical information, and that a catalogue of paintings might be consulted by someone whose main interests lie elsewhere, such as the history of dress, music, travel, or collecting. For some readers, the most important questions may be those of provenance, the history of ownership, and great care has been given to the ex-collection sections at the end of each entry, which for the most part represent the work of other members of the Department of European Paintings over many years.

It may seem inconsistent with remarks made above that the condition notes at the top of each entry, all of which were compiled by Museum conservator Dorothy Mahon, are no longer than they are. Recent catalogues of Dutch art have been less parsimonious in this regard, for example by advising the reader in nearly every entry that lead white is present in the paint layers or that the surface of a seventeenth-century canvas reveals small areas of abrasion. Only the absence of either (or the presence of something less expected) could possibly interest the specialist, who, like any reader, will be content with a brief description of a picture's state unless the case is unusual. Every one of the reports published here is based on close examination and, in many cases, conservation carried out in the past few years.

A similar effort has been made to convey the most essential information (for example, authorship and date) near the beginning of each entry, no matter how involved it becomes. And what of the ninety-nine biographies included in this catalogue, some of which are more substantial than the entries they precede? Many artists' biographies, especially in exhibition catalogues, appear to have been written by reviewing recent examples and composing slightly altered versions. As a result, factual errors are perpetuated, even in standard reference works such as the *Dictionary of Art* (1996). This is especially regrettable at a time when archival research is flourishing, and finding the latest information is facilitated by Internet and electronic communication. Because the present catalogue covers a fairly comprehensive group of Dutch artists, it was considered appropriate to offer the most reliable biographies possible or to state where they might be found and to offer only synopses here. After all the biographies in these two volumes were written, the new

catalogue of the Frans Halsmuseum made its appearance. In it, Irene van Thiel-Stroman sets a standard for completeness and documentation that cannot be maintained in these pages; nor would it be appropriate to do so (her subject is more specifically the lives of Haarlem artists, based on extensive archival work).[4] However, her findings have been absorbed, as have the contributions of most specialized publications through March 2007. Biographies were also greatly improved by consulting archival researchers such as Marten Jan Bok, S. A. C. Dudok van Heel, Jaap van der Veen, and the late J. Michael Montias. In one case, the search for better information (about Emanuel Murant) burst beyond the reasonable limits of this catalogue and landed where it belongs, in a volume dedicated to Montias's memory.[5]

Michael Montias is one of the many scholars who have made the past forty years a golden age in the study of Dutch art. The present writer was fortunate to work in that period, and moreover in an institution where the collection, resources, fellow staff members, and visitors — whether the general public or professional colleagues — were continual sources of inspiration. The people who in a spiritual or material way made this catalogue an aspiration and then a reality are recalled in the acknowledgments. What the paintings themselves have meant to the curator, who, for a moment in history, has had them in his nominal care (*cura*), is not an appropriate subject for a publication that presents them to others, but it is hoped that it will be sensed between the lines.

1. The quotes are from James's article in the *Atlantic Monthly,* June 1872, reprinted in James (1872) 1956, pp. 55, 58, 65. For a history and complete catalogue of the 1871 Purchase, see Baetjer 2004. Only one object, a Roman sarcophagus, was previously owned by the Museum.

2. The history of the Museum's collection of Dutch pictures is treated in the summer 2007 issue of the *Metropolitan Museum Bulletin*: see Quodbach 2007. For the more sweeping story of "Dutch Paintings in America: The Collectors and Their Ideals," see Liedtke 1990.

3. Cortissoz 1930, p. 259. The National Gallery of Art, Washington, D.C., now has approximately 115 Dutch paintings of the seventeenth century (92 are catalogued in Wheelock 1995a). Comparable European collections are generally older and larger. There are, for instance, about 440 Dutch pictures in the National Gallery, London, which was established in 1824.

4. The Haarlem catalogue is cited in the bibliography as Biesboer et al. 2006.

5. See Liedtke and Bakker 2006.

ACKNOWLEDGMENTS

This catalogue could not have been completed without the help of many colleagues in the Museum and in the international community of scholars, museum professionals, and others whose specific contributions will be acknowledged frequently in the following thousand pages. Nonetheless, work on a project of this kind requires in the first place solitude, which in this writer's case was made agreeable not only by dedication to the subject but also by a strong sense of moral support from the director of the Museum, Philippe de Montebello, and the chairman of the Department of European Paintings, Everett Fahy. In a broad view, significant publications are made possible by a vision of the Museum as an institution committed to scholarship, as well as to preservation, display, education, and other responsibilities. The great majority of the approximately one hundred curators in the Museum must share my impression of an environment sympathetic to their distinctive interests.

Study of the Dutch collection by members of the staff goes back at least to the curatorship of W. R. Valentiner (1908–14). Contributions made in the course of a century are cited in the notes, but they cannot adequately convey what has been accumulated in departmental files and Museum archives. Countless records of daily activity, such as conservation reports, correspondence about attributions, memoranda of conversations with specialists, drafts of old catalogue entries, and other material form a historical sediment in which occasional nuggets gleam: for example, letters from Benjamin Altman, Wilhelm von Bode, Abraham Bredius, or another name usually encountered on a wall plaque or a title page; certificates of authenticity from experts such as Cornelis Hofstede de Groot and (when he worked elsewhere) Valentiner; or notes painstakingly compiled by John Walsh during long afternoons at the Rijksbureau voor Kunsthistorische Documentatie in The Hague. Memos that Walsh and, before him, Bryson Burroughs, Harry Wehle, Theodore Rousseau, Margaretta Salinger, Claus Virch, and other curators in effect wrote to themselves were generally addressed "to the files," and thus to the future and to the grateful author of this catalogue.

During my decades of work on the Dutch pictures, a fair number of scholars have visited the Museum, often to see specific works. In addition to soliciting their opinions, it seemed wise to seek out the views of anyone who had demonstrated interest in a particular artist or area (for instance, the Rembrandt-school specialist Werner Sumowski kindly answered numerous inquiries). Myriad "oral opinions" and "personal communications" are cited in the notes to the entries (the References are restricted to remarks in print). Insufficiently reflected there are the benefits derived from frequent contact with colleagues such as Christopher Brown, Egbert Haverkamp-Begemann, Julius Held, Otto Naumann, Seymour Slive, Eric Jan Sluijter, and Ernst van de Wetering. Held made me feel connected (as he was) with Max Friedländer in Berlin and through him with Bode, although that frosty peak of the profession was far removed from Held in temperament. Slive's visits, in addition to redoubling enthusiasm for the paintings themselves, gradually revealed that great strides in scholarship actually consist of many small steps forward and several in reverse.

Within the Museum, my most helpful colleagues have often been conservators, in particular John Brealey, Hubert von Sonnenburg, Michael Gallagher, Charlotte Hale, Dorothy Mahon, George Bisacca, and Karen Thomas. All the condition notes in this catalogue were written by Dorothy Mahon after fresh examination of each painting. Many hours of conversation with Ms. Mahon have enhanced my understanding not only of condition questions but also those of technique, quality, and artistic intention. In the Department of European Paintings, my fellow curators Maryan Ainsworth, Keith Christiansen, Katharine Baetjer, and Andrea Bayer have all offered useful advice on matters such as iconography, patronage, and provenance. Keith Christiansen especially has enabled me to place certain Dutch pictures (for example, Ter Brugghen's *Crucifixion*) in a broader European context, and to share his amusement when they do not quite fit in. Extensive work on our computerized archives by Gretchen Wold and Jennifer Meagher made the references, exhibition

histories, and provenances at the end of each entry much easier to compile (the actual summaries of what authors have said are my own). That most precious commodity, time, was often donated to this catalogue, or to things that stood in its way, by Lisa Cain, Andrew Caputo, Josephine Dobkin, and Mary Sprinson de Jesús. Dorothy Kellett, my department's administrator, has been more like a guardian angel whenever assistants, funds, travel, or some other necessity suddenly arose. Most recently, she organized a large campaign of moving paintings for photography and condition reports at a time when gallery renovations and a busy schedule of loans already placed undue pressure on her and other members of the staff. I am also grateful to departmental technicians Gary Kopp, Theresa King-Dickinson, and John McKanna for innumerable favors, and for making every incursion into their domain a pleasant experience. Finally, no one in European Paintings has given more practical assistance to this project than Patrice Mattia. My quaint choice of computer program (Nota Bene) must surely have tried her patience, but this was never in evidence.

The Museum awards numerous fellowships and internships annually. Many research fellows, graduate interns, and curatorial assistants will be mentioned in the entries and are fondly remembered here, especially as good listeners, but also for their critical responses and discoveries. Their names are already familiar or will soon become known to historians of Dutch art, and include Ann Adams, Ronni Bear, Stephanie Dickey, Amy Golahny, Emilie Gordenker, Nancy Minty, Esmée Quodbach, Jo Saxton, Vanessa Schmid, Madeleine Viljoen, Els Vlieger, and Adriaan Waiboer. The fact that Dulce Roman and Lisa Duffy-Zeballos are scholars of Spanish art made them no less helpful to my research. The most recent and extensive contributions to this catalogue were made by Vanessa Schmid and Esmée Quodbach. Ms. Quodbach kindly accepted the challenge of critically reading all the biographies and entries. She proved to be not only the ideal reader as a scholar of Dutch art and the history of collecting but also, remarkably, as a gifted editor in English as well as in her native Dutch.

That the Museum has seventeen curatorial departments meant that solving problems outside my area of expertise was often a matter of making a brief telephone call. Arcane questions were answered immediately by Nadine Orenstein or Michiel Plomp in the Department of Drawings and Prints, and obscure queries the next day.

Assistance from further afield was generously offered by Stuart Pyhrr and Donald LaRocca (Arms and Armor); the staff of the Costume Institute; James Draper, Thomas Campbell, Daniëlle Grosheide, Jessie McNab, and Clare Vincent (European Sculpture and Decorative Arts); Carlos Picón (Greek and Roman Art); Laurence Kanter (Robert Lehman Collection); and Kenneth Moore (Musical Instruments). Barbara File, archivist, was a frequent and trusted source of information about donors, past members of the staff, and other aspects of Museum history. I am grateful also to Kenneth Soehner and the entire staff of the Watson Library, which, among its many areas of research, has extraordinary holdings for the study of Dutch art.

The actual production of these two volumes called for exceptional professionalism and taste. Working with the designer, Bruce Campbell, has always been such an effortless experience that it came as a pleasant surprise to discover that this is the fourth major publication we have done together (beginning with *Flemish Paintings in The Metropolitan Museum of Art*, 1984). New digital photography of nearly all the Museum's Dutch paintings was undertaken heroically by Juan Trujillo, to whom serious readers as well as the author owe a great debt of gratitude. Barbara Bridgers, general manager for imaging and photography, made the photographic campaign possible despite excessive demands on her department. Gwen Roginsky, general manager of publications, dealt with the peculiar challenge of Dutch palettes (before Vincent van Gogh) by repeatedly judging color proofs against the original paintings, and by once again foregoing the more romantic sights of Verona for the vigilant scrutiny of a printing press. Every other aspect of production was imperturbably supervised by Christopher Zichello. Jane Tai ordered most of the comparative photographs as they willfully proliferated, and compiled the appropriate credit lines.

My deepest thanks go to Emily Walter, senior editor, for devoting innumerable hours to these pages as if they were her own. The task of editing what amounts to 328 academic essays required considerable fortitude but was treated with finesse, adding nuance, grace, and tact to lines that may have attempted the same but were mired in detail or murky formulation. The editor loves literature as well as art, which made perusing her suggestions, and even the corrections, feel more like connoisseurship than surgery. For granting me this subtle and scrupulous muse and for the great interest and pride he has taken in the

entire enterprise, John P. O'Neill, publisher and editor in chief, deserves appreciation and praise. My thanks also to Margaret Chace, managing editor; to Ellyn Allison, who edited captions, exhibition histories, and provenances; to Kathryn Ansite, desktop publishing specialist; and especially to Jean Wagner, who transformed one of the most extensive (and constantly expanding) bibliographies of Dutch art into a remarkably reliable document. This process also involved editing all the short-form citations in the References, a monumental undertaking.

A few colleagues are cited so often in the notes that they should be mentioned here. Rudolf Ekkart, director of the Rijksbureau voor Kunsthistorische Documentatie, The Hague, spent two weeks studying the Museum's Dutch portraits in 1988 and submitted valuable notes on that large part of the collection. Edwin Buijsen, Charles Dumas, and Fred Meijer, also at the Rijksbureau, have repeatedly provided essential details that are easier to discover at that indispensable research institution than anywhere else. Jeroen Giltaij, at the Museum Boijmans Van Beuningen, Rotterdam, has been a faithful correspondent, usually about Rembrandt's *Aristotle with a Bust of Homer* but also about Rotterdam painters and other concerns. Pieter Biesboer, at the Frans Halsmuseum in Haarlem, has often been helpful for artists' biographies, Haarlem patrons, and archival questions. For the same in Amsterdam, I have turned frequently to S. A. C. Dudok van Heel, J. Michael Montias, and Jaap van der Veen, and in Utrecht to Marten Jan Bok. For years, previously unknown provenance information would arrive with explanatory notes from Burton Fredericksen, who recently has answered a number of urgent queries about collections and sales. The many other colleagues and friends who have facilitated research on this catalogue will, I trust, forgive me for remembering them only in the proper contexts below.

Certain of the writer's contemporaries have contributed in a spiritual way to this project, if that is the proper description for expressions of keen interest in its progress, and for sharing my passion for original works of art. In addition to Christopher Brown and Otto Naumann, mentioned above, art dealers such as Bob Haboldt and Charles Roelofsz, museum colleagues such as Frits Duparc, Emilie Gordenker, George Keyes, Daniëlle Lokin, Larry Nichols, Peter Sutton, Dennis Weller, and Arthur Wheelock,

and collectors such as George and Maida Abrams, Alfred and Isabel Bader, Jim and Donna Brooks, Arthur and Arlene Elkind, Gordon and Adele Gilbert, Frits and Rita Markus, Bernard and Louise Palitz, Henry and Jimmy Weldon, Martin and Ethel Wunsch, and Mo and Karen Zukerman cannot be forgotten. To thank even a few university colleagues would open a floodgate of names, most of which figure prominently in the bibliography.

Financial support has come from foundations and friends who are committed to the study and appreciation of European art, and in some cases of Dutch culture in particular. The Museum is especially grateful to Shinji Hata and Hata Stichting Foundation for substantial grants in support of this publication. Mo and Karen Zukerman have also been ardent supporters of this undertaking. It is a special pleasure to thank a curatorial forerunner, Claus Virch, as chairman and president of The Christian Humann Foundation, for that organization's support of technical and scholarly research on the collection of Dutch paintings. During years of study and travel related to the catalogue, Jaqui Beaucaire-Safra, Otto Naumann, and Martin and Ethel Wunsch have been especially supportive. David Kowitz and the Kowitz Family Foundation made it possible to improve this publication's appearance and usefulness, mainly by considerably increasing the number of comparative illustrations.

The reference to solitude in the first paragraph of these acknowledgments is more meaningful for the writer than it could be for anyone else—with one exception. A large part of this catalogue was written at home in Bedford, New York. My wife, Nancy, has sacrificed untold days of companionship, both out of love and with an understanding that the work was not work at all.

This kind of publication is meant to last for many years. And it represents the work of an institution as well as individuals. For these reasons, it would be quite exceptional to dedicate a standard collection catalogue to any one person, no matter how beloved, esteemed, or deserving. But American tradition, the history of The Metropolitan Museum of Art, and the author's sentiments encourage the offer of this catalogue as a gesture

IN HONOR OF THE NETHERLANDS.

Note to the Reader

Catalogue entries are arranged alphabetically by artist and then in chronological order. In the case of undated works, a few slight departures from this system have been made (for example, under Style of Rembrandt) in order to juxtapose paintings of similar type. Page numbers, plate numbers, and figure numbers run consecutively throughout the two volumes. The three indexes at the end of volume 2 cover both volumes and include a general index, an index of previous owners (including dealers), and an index of paintings listed by accession number. The last index may be used to identify pictures for which the attribution or title has changed, and it also reveals the order in which works entered the collection.

In the entries, the artist's name is given in the heading only when a modification such as "Attributed to" is required. (The artist's name is also given at the bottom of every page.) The number before a painting's title refers to its colorplate. Dimensions are given in inches and centimeters, with height preceding width. When a painting bears a signature, it is described either as "signed" or as "inscribed." The latter term, when applied to signatures and dates, implies that the inscription is not original or may not for some reason be reliable.

Credit lines and accession numbers are given both in the entry's heading and at the end of the entry, under "Ex Coll." This section follows two others, "References" and "Exhibited." The publications listed under References correspond to entries in the bibliography and are given in chronological order. Authors published in the same year are listed alphabetically unless their remarks call for a different sequence (e.g., "Brown 1975, reviewing White 1975, observes that . . ."). Under "Exhibited," names of institutions are those employed at the time. Under "Ex Coll.," names of dealers are given in brackets.

The following institutions appear in the text in abbreviated form:

Allen Memorial Art Museum, Oberlin College, Oberlin, Ohio

Alte Pinakothek, Bayerische Staatsgemäldesammlungen, Munich

Bodemuseum, Staatliche Museen zu Berlin

Busch-Reisinger Museum, Harvard University Art Museums, Cambridge, Massachusetts

Gemäldegalerie, Staatliche Museen zu Berlin

Gemäldegalerie Alte Meister, Staatliche Kunstsammlungen, Dresden

Gemäldegalerie Alte Meister, Staatliche Museen, Kassel

Koninklijk Kabinet van Schilderijen Mauritshuis, The Hague

Kunstmuseum, Öffentliche Kunstsammlungen, Basel

Kupferstich-Kabinett, Staatliche Kunstsammlungen, Dresden

Kupferstichkabinett, Staatliche Museen zu Berlin

Musée du Louvre, Paris

Museo Nacional del Prado, Madrid

Das Städel, Städelsches Kunstinstitut, und Städtische Galerie, Frankfurt am Main

The State Hermitage Museum, Saint Petersburg

Galleria degli Uffizi, Florence

Wallraf-Richartz-Museum & Fondation Corboud, Cologne

Westfälisches Landesmuseum für Kunst und Kulturgeschichte, Münster

CATALOGUE

JACOB BACKER

Harlingen 1608–1651 Amsterdam

Jacob Adriaensz Backer was one of the best figure painters and draftsmen in Amsterdam in the 1630s and 1640s, his gifts evidently acknowledged as early as 1633–34 by his commission—when he was only twenty-six and, as an artist, new to the city—for the group portrait *The Governesses of the Civic Orphanage of Amsterdam* (Amsterdams Historisch Museum, Amsterdam). Backer was born in the autumn of 1608 in Harlingen, an old port on the coast of Friesland, west of Leeuwarden. His parents were Hilk Folkertsdr and Adriaen Tjercksz, a baker and a Mennonite. In 1611, after the death of his mother, his father married Elsjen Roelofs, a widowed bakery owner from Amsterdam. The new family settled in that flourishing center of commerce and art, and, not surprisingly, adopted the surname Backer (*bakker*, meaning baker).

About 1626–27, the young artist went to study with Lambert Jacobsz (ca. 1598–1636), a painter of biblical subjects in Leeuwarden. This seeming return to the provinces was no such thing, since Jacobsz was the son of a prominent cloth merchant in Amsterdam and a product of the same Pre-Rembrandtist circle that, about 1624, set the Leiden artist on his own path as a history painter. In 1620, Jacobsz married a young woman from Leeuwarden (an event commemorated in a poem by Vondel) and soon became a preacher in that city's Mennonite community, as well as its most important painter and art dealer. In the latter capacity, he worked with Rembrandt's future art dealer in Amsterdam, the Mennonite Hendrick Uylenburgh (ca. 1584/89–1661). But for Backer's parents, as for Govert Flinck's (q.v.), it would have been Jacobsz's faith and character that encouraged them to send their son to Friesland.[1]

Backer moved back to Amsterdam by 1633 and set up shop as an independent history painter and portraitist. His large canvas *John the Baptist Rebuking Herod and Herodias*, signed and dated 1633 (Fries Museum, Leeuwarden), follows the grander of Jacobsz's two styles, which was inspired by artists in Utrecht and Antwerp. Backer emphasized the suavity of this manner, a direction that may have been encouraged somewhat by the Leeuwarden native Wybrand de Geest (1592–ca. 1662), who had traveled in France and Italy, and served as portraitist to the Protestant Nassaus and the Friesian nobility. Many of De Geest's formal portraits look like a synthesis of those by Paulus Moreelse (q.v.) and the Antwerp artist Cornelis de Vos (1583/84–1651). But what is sensed more strongly in Backer's biblical and mythological pictures of the 1630s (the latter including *Granida and Daifilo*; Hermitage, Saint Petersburg) and single-figure genre subjects (such as the painterly *Shepherd with Flute*, of about 1637; Mauritshuis, The Hague), is an interest in the Caravaggesque manner of Abraham Bloemaert (q.v.), who was De Geest's former teacher and a great success during the 1620s and 1630s, both in Utrecht and at the Dutch court in The Hague. Backer (like Rembrandt, Jan Lievens, and others in the same years) must have acquainted himself with recent painting in Utrecht, since the affinities extend to Gerrit van Honthorst (1592–1656), Jan van Bijlert (1597/98–1671), Moreelse, and his son Johannes (d. 1634). Also underscoring the Utrecht connection are Backer's many pastoral subjects and his appealing nudes (both exemplified by *Cimon and Iphigenia*; Herzog Anton Ulrich-Museum, Braunschweig), neither of which could have had much to do with Jacobsz. The nudes are based on studies from life, and form part of a wonderful oeuvre of figure drawings.[2]

Backer's debt to Rembrandt in the 1630s has been overestimated, and comes down essentially to his borrowing of some figure types (especially the "Noble Slav" variety; see Pl. 142) and a good dose of chiaroscuro. The latter is found in Backer's dignified *Portrait of a Boy in Gray*, dated 1634 (Mauritshuis, The Hague), where De Geest, De Vos, and Anthony Van Dyck seem more relevant than artists in Amsterdam. A Flemish flair is more obvious in Backer's *Portrait of Abraham Velters* (formerly with E. Speelman, London) and in his casual self-portrait drawing of 1638 (Albertina, Vienna). The artist clearly had the ability to modify his manner according to his sitters' tastes, as is seen in a comparison of his portraits of the Remonstrant preacher Johannes Uyttenbogaert (1638; Rijksmuseum, Amsterdam) or the lawyer François de Vroude (1643; Gemäldegalerie, Berlin) with his pendant oval portraits of the silversmith Jan Lutma and his wife (early 1640s; Rijksmuseum, Amsterdam) and with the presumed portraits of Bartholomeus Breenbergh (q.v.) and his spouse (1644; Amsterdams Historisch Museum, Amsterdam). Backer also painted large group portraits later in his career: *The Civic Guard Company of Captain Cornelis de*

Graeff and Lieutenant Hendrick Lauwrensz, of 1642 (which competed with Rembrandt's *Night Watch* and, on more even terms, with Bartholomeus van der Helst's *Company of Captain Roelof Bicker,* in the Kloveniersdoelen of Amsterdam), and *The Regents of the Nieuwezijds Institution for Relief of the Poor,* of about 1650 (all Rijksmuseum, Amsterdam). From works like the large *Venus and Adonis,* of about 1650 (Hessische Hausstiftung, Eichenzell, near Fulda), it appears that Backer would have been a worthy rival of Ferdinand Bol (q.v.) in the 1650s, but he died on August 27, 1651, not quite forty-three years old. He never married. Backer evidently returned a favor to Jacobsz by training his son, the talented Abraham van den Tempel (1622/23–1672), in Amsterdam.[3] It is likely that Backer's nephew Adriaen Backer (ca. 1635/36–1684) and Jan van Neck (1635–1714) were his apprentices.[4]

1. On Jacobsz and for further literature on his life and art, see Marijke van der Meij-Tolsma in *Dictionary of Art 1996,* vol. 16, p. 833, and on Backer, Ben Broos in ibid., vol. 3, pp. 22–23. For works by Jacobsz, see Sumowski 1983–[94], vol. 1, pp. 144–47, and The Hague 1992a, pp. 188–91 (under no. 23). For the business partnership of Jacobsz and Uylenburgh, see London–Amsterdam 2006, pp. 175–84.

2. For the paintings cited in this paragraph, see Sumowski 1983–[94], vol. 1, nos. 5–7, 36, and fig. 74, for the group portrait of 1634. On the Mauritshuis *Shepherd,* which was ascribed to Bloemaert in 1785, see also Broos in Broos and Van Suchtelen 2004, pp. 29–31, no. 2. Many of Backer's known drawings are reproduced in Sumowski 1979–95, vol. 1, pp. 15–175. The nude studies are considered an "effect of Rembrandt's lessons in Amsterdam" in The Hague 1992a, p. 89, where a quite misleading attempt is made to associate Backer with "Rembrandt's academy."

3. All the paintings cited here (except the portrait of Lutma's wife) are illustrated in Sumowski 1983–[94], vol. 1, as nos. 14, 52, 54, 62, 66–69, 75, 76. For the *Boy in Gray,* see Broos and Van Suchtelen 2004, pp. 26–28, no. 1. Backer's *Venus and Adonis* is discussed by Giltaij in Rotterdam–Frankfurt 1999–2000, pp. 160–63 (under no. 25); for Van den Tempel, ibid., pp. 254–63. For Backer's self-portrait drawing, see Liedtke 1995b, fig. 17, or Broos and Van Suchtelen 2004, p. 29, fig. 2b.

4. See London–Amsterdam 2006, pp. 224, 246–47, figs. 190, 191.

ATTRIBUTED TO JACOB BACKER

1. *Old Woman in an Armchair*

Oil on canvas, 50⅜ x 39⅛ in. (128 x 99.4 cm)
Inscribed (upper right): Rembrandt f./1635; (upper left)
AET.SVE 70./$\frac{24}{3}$

The painting is well preserved. There are several minor losses and abrasions in the background, two small losses in the skirt, and a series of small losses to the right of the head in the headdress and the collar.

Bequest of Benjamin Altman, 1913 14.40.603

Like a good number of former "Rembrandts," this large canvas in the Altman Collection was included in catalogues of the artist's work through Bauch's corpus of 1966 and then rejected by Gerson in 1968 and 1969 (see Refs.). In 1923, however, Van Dyke, no doubt responding to the frequent suggestion of Frans Hals's influence on the painting, assigned it to that master or to the "Hals school." Benesch, visiting the Museum in 1940, was the first to propose an attribution to Jacob Backer.[1] In 1984, De Bruyn Kops supported the Backer attribution, observing that the hands were characteristic (presumably the Rijksmuseum curator was recalling the hands in Backer's portrait of the eighty-year-old Johannes Uyttenbogaert, dated 1638, in the Rijksmuseum, Amsterdam). The Dutch portrait specialist Rudolf Ekkart more recently concluded that the painting is either by Backer or after a lost portrait by him.[2]

The brushwork in the face and hands is so fresh and purposeful that the notion of a copy may be dismissed.[3] Nor is there any sign in the irregular contours of the costume, the nervous behavior of the hands, the subtle description of the

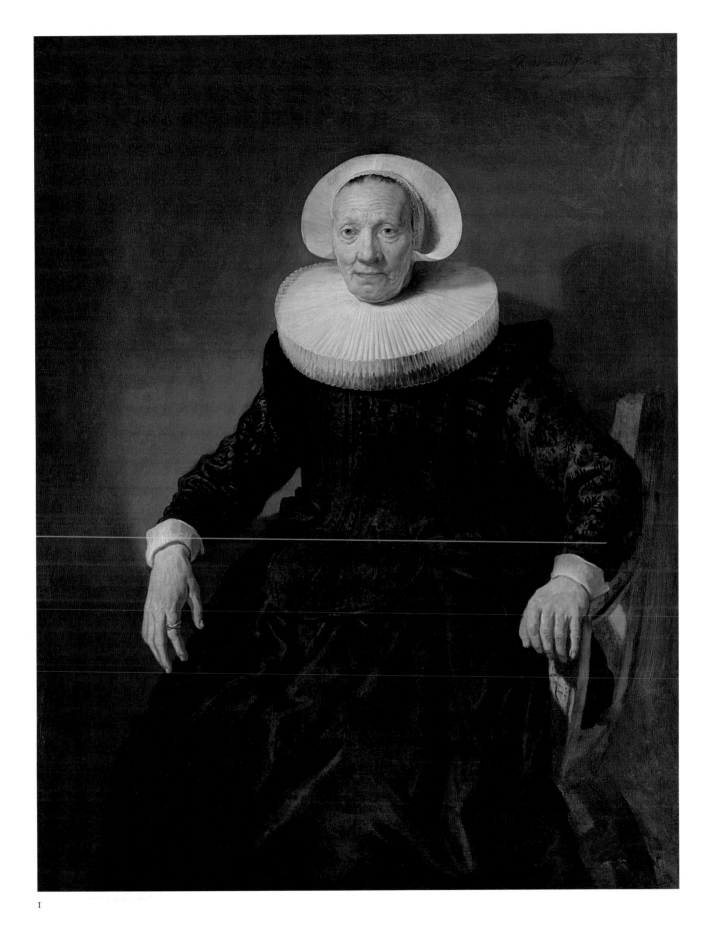

I

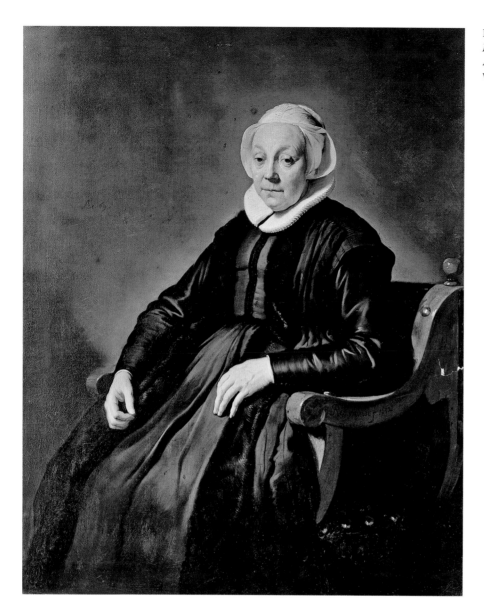

Figure 1. Jacob Backer, *Portrait of an Elderly Woman*, ca. 1638. Oil on canvas, 46¾ x 36⅜ in. (118.7 x 92.4 cm). The Wallace Collection, London

cap and ruff, the luxurious fabrics, or any other passage to suggest that the painter was reproducing another picture. As for the attribution to Backer, it is supported mainly by comparisons with portraits of middle-aged or elderly women that are dated between 1636 and the early 1640s in Bauch's monograph of 1926 and in Sumowski's 1983 survey of Backer's oeuvre.[4] Unfortunately, the ideal comparison would be with the lost *Portrait of an Old Woman* (see fig. 2), which happens to depict the same sitter as the Havemeyer *Portrait of an Old Woman* (Pl. 2), discussed below. In good photographs, however, it appears that the brushwork in the face (with long strokes describing highlights on folds of skin), the drawing, and the use of shadows are quite comparable to the execution in the Altman canvas. The costume and hands in the latter recall Backer's portrait of a younger woman (ca. 1640?) in the Statens Museum for Kunst, Copenhagen. The handling in the

so-called *Portrait of an Elderly Woman,* in the Wallace Collection, London (fig. 1), is also reminiscent of the Museum's picture, although the picture of a distinctly younger woman (which Sumowski dates to about 1638) is more typical of Backer in its softer and smoother application of paint overall.[5] The task of rendering dry and wrinkled skin in the Altman picture, its probably earlier date (ca. 1634?), and perhaps the inspiration of Rembrandt's treatment of similar faces, like that in his *Portrait of an Eighty-three-Year-Old Woman (Aechje Claesdr Pesser)*, dated 1634 (National Gallery, London), could account for the differences.[6]

In sales of 1760, 1769, and 1782, this picture was paired with the *Portrait of a Man*, now in the Corcoran Gallery of Art, Washington, D.C. Schmidt-Degener (1914; see Refs.) and later writers have convincingly discounted their connection as pendants. It has been noted that the crossed rings on the

woman's right index finger may indicate that she is a widow.[7] In any case, the painting, in its design, and the figure, in pose and expression (alert, with a slight smile), convey an impression of self-sufficiency.

The inscription to the left gives the sitter's age as seventy and the date 24/3 (March 24), presumably the date of her birth. No trace of a year (other than that following the spurious Rembrandt signature) can now be found on the canvas.

1. Otto Benesch, oral opinion, December 20, 1940. The same view was expressed by Daan Cevat on January 4, 1966. Frits Lugt, visiting in December 1941, did not trust the attribution to Rembrandt.

2. C. J. de Bruyn Kops's oral opinion was recorded by the present writer on January 10, 1984. Rudolf Ekkart's report to the Museum, written some months after he had studied the Dutch portraits for two weeks, is dated November 3, 1988. For Backer's portrait of Uyttenbogaert, see Sumowski 1983–[94], vol. 1, no. 62 (ill.).

3. See the color detail of the face in New York 1995–96, vol. 1, fig. 38.

4. See Sumowski 1983–[94], vol. 1, pp. 201, 262–67, nos. 59, 60, 63, 64 (paintings in Antwerp, Berlin, London, and Copenhagen, respectively), where references to Bauch's catalogue and other literature are provided. Also relevant, especially given the date of 1632, is the *Portrait of a Sixty-six-Year-Old Man* attributed to Backer in the Museum Bredius, The Hague (ibid., no. 51; Blankert 1991, pp. 42–43, no. 5).

5. See Sumowski 1983–[94], vol. 1, no. 63, for a large photograph, and Ingamells 1992a, pp. 20–22. The portrait is inscribed "Rembrandt f 1632" and "AEt.69."

6. Bruyn in *Corpus* 1982–89, vol. 3, p. 35, went so far as to say that "the basis for the remarkable, almost graphical [?] treatment of the wrinkled head [in the Altman portrait] is the forceful brushwork in pieces like the London *Portrait of an Eighty-three-Year-Old woman*" (the idea is repeated in ibid., p. 703). This apparent influence sufficed, evidently, for Bruyn's conviction that the New York canvas was painted in Rembrandt's studio, even though the same scholar and his colleagues thought that it revealed "so slight a resemblance to Rembrandt's portraits from the 1630s that it is surprising that no-one doubted its authenticity until Gerson termed the Rembrandt attribution 'not convincing,'" and notwithstanding their suggestion that the "workshop assistant trained elsewhere (Haarlem?)" (ibid., pp. 702, 704). On June 24, 1976, Bruyn suggested at the Museum that the picture was probably not by Backer, but possibly by a Haarlem painter.

7. See ibid., p. 704, for this observation, and on the different style of the Corcoran painting. In the curatorial files John Walsh recorded photographs at the Rijksbureau voor Kunsthistorische Dokumentatie, The Hague, that reproduce small oval bust-length copies of the figures in the New York and Washington pictures (both collection of Ian Hamilton, Melrose, Scotland; sold at Christie's, London, June 18, 1824, no. 76, as by Rembrandt).

REFERENCES: J. Smith 1829–42, vol. 7 (1836), p. 177, no. 554, lists the canvas under portraits of women by Rembrandt, "now in the collection of Mejufvrouwe Hoffman [*sic*], at Haarlem"; Lagrange 1863, p. 292, as a Rembrandt in the duc de Morny's collection, signed and dated 1635, "a magnificent portrait of a woman, some good old lady of the family, Rembrandt's mother perhaps"; Thoré 1867, p. 542, cites the work as one of the Rembrandts in the collection of Baron Seillière; Bode 1883, p. 617, describes a portrait of an old woman, evidently this picture, as in the collection of the "Herzog von Sagan" in Berlin, where it was wrongly attributed to Van der Helst; Dutuit 1885, p. 20, records the picture as in the de Morny sale of 1865, "passed on to the Seillières collection (?)"; Wurzbach 1886, text vol., no. 468; Monkhouse 1897, pp. 271–72 (ill.), as a Rembrandt in the collection of Arthur Sanderson, describes the subject and observes that the sitter is "said to be Rembrandt's mother, but bearing little resemblance to her well-known face"; Amsterdam 1898, no. 35, as "Portret eener oude dame, zittend," signed and dated "Rembrandt f. 1635" (lent by Arthur Sanderson, Edinburgh); Hofstede de Groot 1898, unpaged, no. 6 (in text section), and no. 35, pl. 6, offers a broad explanation of how this Rembrandt might have come to be influenced by Frans Hals; Bell 1899, p. 141, records the portrait as in the Sanderson collection; Hofstede de Groot in Bode 1897–1906, vol. 3 (1899), pp. 35–36, 192, 194, no. 224, pl. 224, observes that this Rembrandt portrait in the Sanderson collection "startles us by the stupendous truth and tenderness with which the ugly and, in some respects, vulgar features are rendered," and suggests that a portrait of an old man in an armchair in Lord Ashburton's collection (now Corcoran Gallery of Art, Washington, D.C.) is a pendant; A. Rosenberg 1904, pp. 87 (ill.), 257, as Rembrandt's "Portrait of an old lady" of 1635 in the Sanderson collection; A. Rosenberg 1906, pp. 145 (ill.), 397, without comment but, following the suggestion of Hofstede de Groot (1899), juxtaposes the picture with the portrait of a (younger) man in the Ashburton collection; A. Rosenberg 1909, pp. 209 (ill.), 555, as with Duveen Brothers, London; Bredius 1912b, pp. 339–41, pls. II–D, IV–H (details), uses this picture (assumed to be by Rembrandt) to help prove that the *Portrait of Elisabeth Bas* (Rijksmuseum, Amsterdam) is by Bol; Altman Collection 1914, pp. 10–11, no. 5 (ill.), as a Rembrandt of 1635, describes the sitter as "a plain old lady who would sit upright in her chair in the attitude of a peasant who poses for the village photographer," and opines of the picture that "from its tranquil and matter-of-fact appearance one would little suspect that its author was to show himself one of the most unaccountable among painters"; Schmidt-Degener 1914, pp. 1–2 (ill.), rejects the Corcoran portrait of a man as a possible pendant, noting its different format, composition, and style; Valentiner 1914b, pp. 352, 355, fig. 3, feels that the portrait "cannot but remind us of Hals," and that the sitter fights a dignified battle against the onslaught of old age; Altman Collection 1915, p. 83 (ill.), no comment; Hofstede de Groot 1907–27, vol. 6 (1916), pp. 347 (under no. 738), 398, no. 868, as in the MMA, lists provenance, and catalogues the Corcoran portrait as a pendant; A. Burroughs 1923, p. 272, remarks that the picture "might easily be Rembrandt's own work; but its hard, uncompromising surface defies one's feeling and leaves no illusion of insight"; Meldrum 1923, pp. 85, 140, 190, pl. CXI, states that the picture "anticipates the 'Rembrandt touch' of years later," and identifies the sitter as a Mennonite, dressed in the fashion of 1620; Monod 1923, p. 302, mentions the portrait of a "very sad, very ugly septua-

genarian" in a review of the Altman Collection; Van Dyke 1923, p. 167, pl. XLII, fig. 164, attributes the painting to Hals or the "Hals school"; Altman Collection 1928, pp. 74–75, no. 38 (ill.), inadvisedly reprints the remarks in Altman Collection 1914; Valentiner 1931, unpaged, no. 54, pl. 54, "shows the artist at a moment when he comes nearer to Frans Hals than at any other period of his life"; A. Burroughs 1932a, pp. 385, 390–91, figs. 3, 6 (X-radiograph detail), allows the painting to serve as a standard for Rembrandt portraits of the 1630s, in order to assign another picture to Flinck; Bredius 1935, pp. 9 (under no. 212), 15, no. 348, pl. 348, "perhaps" a pendant to the Corcoran portrait; Isarlov 1936, p. 16, reveals the influence of Hals on Rembrandt; A. Burroughs 1938, pp. 160, 161, cites the painting as a typical example of Rembrandt's brushwork, notwithstanding Hals's influence; J. Allen 1945, p. 73, cites the work as a "vigorous" Rembrandt; K. Bauch 1966, pp. 20 (under no. 382), 25, no. 491, pl. 491, as by Rembrandt, signed and dated 1635, possibly the pendant to the Corcoran portrait; Gerson 1968, pp. 297 (ill.), 495, no. 185, considers the painting to be not by Rembrandt but from his Amsterdam circle, and also rejects the Corcoran picture, which is "perhaps the companion portrait"; Gerson in Bredius 1969, pp. 273 (ill.), 565 (under no. 212), 577, no. 348, repeats Gerson 1968; Lecaldano 1969, p. 104, no. 171 (ill.), notes that the attribution is in doubt; Haskell 1970, fig. 10 (Altman gallery view); Van Eeghen 1977, p. 11, suggests that the Corcoran and MMA portraits may represent Willem van der Pluym, a wealthy Leiden plumber, and his wife, Jaapgen Carels, noting that Marten ten Hove (see Ex Coll.) was their great-great-grandson; Baetjer 1980, vol. 1, p. 150, as Style of Rembrandt, 17th century; Corpus 1982–89, vol. 3 (1989), pp. 35, 630, 679, 699–704, no. C112 (ill.), figs. 2–4 (details of face, left hand, signature, and X-radiograph of face), implausibly supposes that the work was painted in Rembrandt's studio, imagines that "the composition is taken partially from the 1634 full-length *Portrait of Maria Bockenolle* in Boston (no. A99),"[1] astonishingly proposes that the *Portrait of Antonie Coopal* (on loan to the Museum of Fine Arts, Boston) could be by the same painter, and rejects the Corcoran portrait as this picture's pendant; Liedtke 1990, fig. 37 (Altman gallery view); Lloyd Williams in Edinburgh 1992, p. 176, as with Arthur Sanderson until about 1906; Van Thiel 1992, pp. 40, 78, no. 35 (ill.), fig. 33 (gallery view), records the picture in the 1898 Amsterdam exhibition, and quotes the review by Jan Veth, for whom the painting was "een mooie Frans Hals"; Baetjer 1995, p. 321, as attributed to Jacob Backer; Liedtke in New York 1995–96, vol. 2, pp. 96–98, no. 24 (ill.), tentatively attributes the painting to Jacob Backer and discusses other opinions; Von Sonnenburg in ibid., vol. 1, pp. 43, 112, 114, figs. 38, 147 (details), and 39, 148 (X-radiograph details), 149, rejects an attribution to Backer and sees some similarity to (but also differences from) the technique employed in the face of the Altman *Portrait of a Woman* (Pl. 2); Schnackenburg 2001, pp. 117, 121 n. 127, sees the influence of the Kassel *Bust of an Old Man with a Golden Chain*, which the author considers (taking the minority view) to be by Rembrandt; Quodbach 2004, pp. 94 n. 13, 95, 97, 98 n. 42, cites the work among Baron Seillière's Rembrandts, notes the disappointing price it brought at the duc de Morny sale of 1865, and connects it

with a portrait mentioned by Bode (1883; see above) as in the collection of the "Herzog von Sagan" in Berlin; Scallen 2004, p. 375 n. 49, as doubted in A. Burroughs 1923; Secrest 2004, pp. 280, 476, cites the painting as a "Rembrandt" that "went through Duveen's hands"; Groen in *Corpus* 2005, p. 326, fig. 8, and pp. 662–63, reports that the first ground contains red earth, umber, and quartz, and the second ground lead white, yellow ocher, a little red ocher, and lampblack, resulting in a light yellowish gray color.

EXHIBITED: Amsterdam, Stedelijk Museum, "Schilderijen bijeengebracht ter gelegenheid van de inhuldiging van Hare Majesteit Koningin Wilhelmina," 1898, no. 35 (lent by Arthur Sanderson, Edinburgh); New York, MMA, "Rembrandt/Not Rembrandt in The Metropolitan Museum of Art," 1995–96, no. 24.

EX COLL.: J. A. Tourton or M. ten Hove (until 1760; their joint posthumous sale, Amsterdam, April 8ff., 1760, no. 2, for Fl 585, with pendant to Yver); sale, Cok, Amsterdam, May 8, 1769, no. 66, for Fl 650, with pendant to Fouquet; Pierre Fouquet, Amsterdam (from 1769); ?Sainte-Foix (his/her anonymous sale, Le Brun, Paris, April 22ff., 1782, no. 3, with pendant, for 2,399.19 livres to Donjeux; ?Donjeux (from 1782);[2] Mme Hoofman, Haarlem (in 1836);[3] Charles-Auguste-Louis-Joseph de Morny, duc de Morny, Paris (possibly by 1852, and certainly by 1863–d. 1865;[4] his estate sale, Palais de la Présidence du Corps Législatif, Paris, May 31, 1865, no. 69, for FFr 4,900); Baron Achille Seillière, Paris (in 1867); private collection (until 1888; sale, Christie's, London, July 14 and 16, 1888, no. 167, as property of a gentleman, for £1,155 to Lesser);[5] [L. Lesser, London, 1888–89]; Arthur Sanderson, Edinburgh (by 1897–until about 1906); [Duveen, London, until 1906; sold for $124,185 to Altman]; Benjamin Altman, New York (1906–d. 1913); Bequest of Benjamin Altman, 1913 14.40.603

1. The composition is entirely conventional for the period, as is clear from comparisons with works by Backer (see fig. 1), Hals, Paulus Lesire (see Sumowski 1983–[94], vol. 3, no. 1150), and others.
2. For the descriptions of this picture in the sale catalogues of 1760, 1769, and 1782, see *Corpus* 1982–89, vol. 3, p. 704 (under "Provenance").
3. According to J. Smith in 1836 (see Refs.).
4. According to Hofstede de Groot 1907–27, vol. 6 (1916), p. 398 (under no. 868), the painting was in the de Morny sale, Paris, May 24, 1852. Lagrange 1863 (see Refs.) places the work in de Morny's collection.
5. In Quodbach 2004, p. 98 n. 42, the painting is connected with a portrait of an old woman by Rembrandt owned by "a Sagan relative in Berlin," namely the "Herzog von Sagan" cited in Bode 1883, p. 617. Presumably this was Louis de Talleyrand-Périgord (Paris 1811–1898 Berlin), 5th Herzog zu Sagan (Sagan, where the family had a castle, is southeast of Berlin). The daughter of the previous owner, Achille Seillière (see Ex Coll.), was Jeanne Marguérite de Seillière (1839–1905), princesse de Sagan.

2. *Portrait of an Old Woman*

Oil on wood, 28 x 24 in. (71.1 x 61 cm)
Inscribed (lower right): Rembrandt/f. 1640; (upper left)
ÆT · SVÆ · 87 ·

The painting is well preserved. The grain of the oak panel runs in a horizontal direction.

H. O. Havemeyer Collection, Bequest of Mrs. H. O. Havemeyer, 1929 29.100.2

When this panel was in the Kann and Havemeyer collections, it was highly regarded as a Rembrandt, winning particular praise from Bode for the "extraordinarily loving care" with which it was painted (1895; see Refs.). The picture held its place in Rembrandt catalogues through Valentiner's unreliable corpus of 1931, after which the work was dropped from scholarly discussions for fifty years. Sumowski, in 1983, published the painting as by Backer, an attribution made more tentatively by Van Dyke in 1923 (see Refs.). Both critics draw attention to a canvas formerly in the Kaiser-Friedrich-Museum, Berlin (fig. 2), which depicts the same woman at about the same age, in the same or very similar attire, sitting in a chair with a small book and glasses in her hands. Her shoulders are at the same angle to the picture plane as in the Havemeyer portrait but her head is turned toward the viewer, and her expression is thoughtful and stern. Bauch knew the Berlin picture well and in his 1926 monograph on the artist included it as a work by Backer dating from about 1635–40.[1] Wilhelm Martin and Otto Benesch favored the same attribution for the present portrait when they saw it in 1938 and 1940, respectively.[2] A postwar predisposition to describe former "Rembrandts" as products of later periods was demonstrated by viewers of the painting such as Van Gelder, Gudlaugsson, and Stechow.[3] No specialist today would doubt that the portrait was painted in or near Amsterdam between about 1633 and 1640.

The current notion of Backer's work in the 1630s is based mainly on his stylish history and genre pictures (like those cited in the biography above) and his most admired portraits, such as the *Portrait of a Boy in Gray*, dated 1634 (Mauritshuis, The Hague). One gains a very different impression of Backer's manner from the *tronies* of old men he painted about 1633–35, such as *Old Man with a Mirror* (Gemäldegalerie, Berlin) and *Old Man in a Beret and Fur Coat* (Gemäldegalerie, Dresden), which are monogrammed "JB" and "JAB," respectively.[4] The latter picture and a few contemporary paintings by Backer

depict the same model as the one Rembrandt used for his great canvas of 1632, *Man in Oriental Costume ("The Noble Slav")* (Pl. 142).[5] Much as Rembrandt worked in a different manner in the *Bellona* of the following year (Pl. 147) and demonstrated a variety of techniques in portraits dating from 1632 (Pl. 141), 1633 (Pl. 146), and 1634 (for example, the *Portrait of an Eighty-three-Year-Old Woman [Aechje Claesdr Pesser]*, National Gallery, London),[6] Backer appears to have modified his style according to subject matter and figure type, especially about 1633–34, when he was in immediate contact with Rembrandt and their mutual dealer, Hendrick Uylenburgh (ca. 1584/89–1661).

Scholars for whom all this is familiar information—Bauch, Martin, Benesch, Sumowski, Ekkart, among others—agree that the Havemeyer portrait is in the style (or a style) of Jacob Backer. When Bauch catalogued the lost Berlin portrait as by Backer, he recalled "the same woman by Rembrandt (Backer?) in the Havemeyer Collection" (1926; see Refs.). As noted above, Sumowski (1983) considers both pictures to be by Backer. In 1988, Ekkart concluded that the Havemeyer panel is probably a contemporary copy after a portrait by Backer (and that the *Old Woman in an Armchair* [Pl. 1] is either by him or an early copy).[7] The present writer and Von Sonnenburg agreed with this opinion in the "Rembrandt/Not Rembrandt" catalogue of 1995–96 (see Refs.), and it remains the most plausible hypothesis.

However, there are reasons for uncertainty. Presumably, Backer's original would have been more fluently painted (even if he was working in the manner of his "Noble Slavs"), and yet the presumed copyist, in the present picture, chose to render flesh (if not fur and cloth) as if he were emulating Gerrit Dou (q.v.) or the other followers of Rembrandt who during the early 1630s turned topographical description of old faces into demonstrations of artistic skill. Often in those works (Dou's *Old Woman with a Fur Hat*, in the Gemäldegalerie, Berlin, is a good example) the dryness and detail of wrinkled skin are compared with painterly suggestions of soft fur and other contrasting materials.[8] The broadly stroked strips of fur in the Havemeyer portrait are reminiscent of Backer and at the same time seem atypical of a copy.[9] The delicacy with which thin skin and fine hair, veins, moisture in the eyes, transparency and highlights in the collar and cuffs, shadows to the right of the head, and other effects are described also speaks against the notion of a copy, as do the pentimenti at the shoulder to the left and at the top of the head.

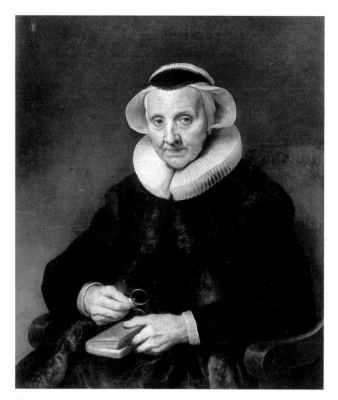

Figure 2. Jacob Backer, *Portrait of an Old Woman*, 1630s. Oil on canvas, 30⅜ x 25¼ in. (77.2 x 64.1 cm). Formerly Kaiser-Friedrich-Museum, Berlin (lost in 1940)

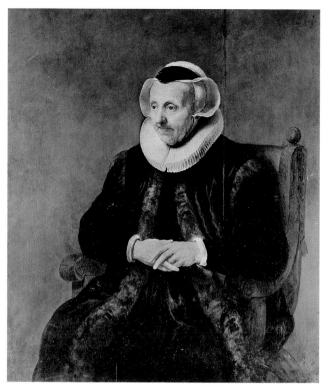

Figure 3. Attributed to Jacob Backer, *Portrait of an Old Woman*, 1630s. Oil on wood, 41 x 35 in. (104.1 x 88.9 cm). Formerly Yarborough and Ringling collections

Direct comparison with the *Old Woman in an Armchair* (Pl. 1) is necessary, given the supposition that these problematic portraits of similar sitters could be by the same hand. Their execution appears consistent, allowing for the fact that the Havemeyer painting is better preserved, is on wood not canvas, and represents a conscious effort to be even more specific in the description of an elderly woman's face and hands. The same surprisingly broad indication of shadows between the fingers is found, and a similar sureness, crispness, and impressive sense of volume are evident in the caps and collars. Both figures are adequately but not convincingly set in space against a nearly neutral wall. That two former "Rembrandts" of the same type may be found in the same collection is a coincidence but also a reflection of taste about 1900. The Havemeyer portrait was often mentioned in the same breath with the *Herman Doomer* (Pl. 148) and occasionally cited as a worthy companion in which the same sort of meticulous workmanship (then thought to be typical of Rembrandt about 1640) could be admired. When Altman bought the *Old Woman in an Armchair*, in 1906, it could have been said that he had acquired a "Rembrandt" portrait of the Havemeyer type.

Complicating the question of authorship in the case of the Havemeyer portrait is its relationship with a version formerly in the Yarborough and Ringling collections (fig. 3). To judge from photographs, the Yarborough painting, on a large panel, is inferior to the present picture and has suffered considerable wear. The face in the larger picture appears slightly younger and the expression comparatively vacuous. The hands are less well modeled, and the sitter's left shoulder and arm form weaker, less supportive angles than in the Havemeyer version. One has the unexpected impression that with a bit more age the old woman has gained strength, both in body and in character. The most likely conclusion would appear to be that the Yarborough picture records the format of the *principael* (first version) of the commissioned portrait, but that the Havemeyer painting gives a better idea of the missing work's quality. The grain of the wood in the smaller panel runs horizontally, suggesting that the artist chose a wide board so as to execute the painting on a single piece of wood of the equivalent height (cradling prevents inspection of the back). Thus, Valentiner's conclusion (1931; see Refs.) that the Havemeyer version was originally as large as the Yarborough panel is certainly mistaken.[10] Rather, it must be a reduced replica or perhaps a slightly different version (aging the sitter somewhat?) of an original knee-length portrait. In this connection, it is intriguing that Michel, in 1894 (see Refs.), when comparing the Yarborough and Havemeyer

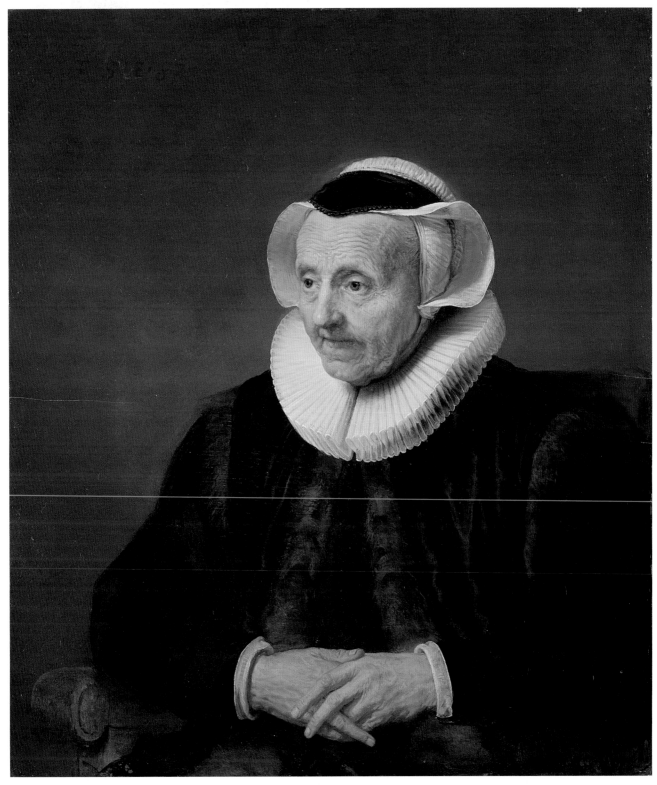

2

portraits, recalled that "another copy, probably by J. Backer, was sold by auction in London in March, 1889."

No firm conclusion can be drawn about the actual execution of the Havemeyer painting, given incomplete evidence and the present state of Backer scholarship. It would be hasty to catalogue the picture either as attributed to Backer or as a copy after a work by him. The designation Style of Backer in this case allows for either alternative, and for the possibility that the Havemeyer and Yarborough paintings and the lost Berlin portrait of the same sitter came from a different North Holland artist's studio.

1. See K. Bauch 1926, no. 195, pl. 26, and Sumowski 1983–[94], vol. 1, pp. 201, 263, no. 60.

2. Oral opinions, recorded in the curatorial files, in April 1938 and on December 20, 1940. Frederick Schmidt-Degener, on April 15, 1935, said, "Really Rembrandt."

3. Oral opinions recorded in the curatorial files include the following: J. G. van Gelder, February 1954, suggested an eighteenth-century copy; R.-A. d'Hulst and Wolfgang Stechow, together on December 14, 1954, agreed that the picture is a later copy "rather than a fake," and suggested a nineteenth-century origin; Sturla Gudlaugsson, April 6, 1956, thought the picture probably copied an original by Bol rather than Rembrandt, and proposed a late-eighteenth-century date; D. Cevat, January 4, 1966, pronounced the picture a nineteenth-century exercise using an old panel.

4. Sumowski 1983–[94], vol. 1, nos. 22, 30.

5. Ibid., nos. 17–19, 30 (K. Bauch 1926, nos. 27–30); see also *Corpus* 1982–89, vol. 2, p. 156, and London–Amsterdam 2006, pp. 129, 178 n. 175.

6. On the London portrait, see the text and note 6 of the preceding entry.

7. Rudolf Ekkart, report to the Museum dated November 3, 1988.

8. See Leiden 2005–6, no. 22, for the Dou in Berlin, and nos. 12, 18, 19, 36, 38, 41, 54, 66, and figs. 84, 149, for analogous works by Rembrandt, Dou, Jan Lievens, and others.

9. Ekkart (see note 7 above) stated that the painting "has all the characteristics of a copy," meaning that he found it harder and drier than such portraits by Backer as those in Antwerp and London (see New York 1995–96, vol. 2, p. 94). In 1994, Peter van den Brink, who at the time was planning a Backer exhibition, did not regard the present picture as a copy or as a work by Backer, although he did consider it an Amsterdam portrait of about 1635–38 (oral opinion, June 14, 1994). Von Sonnenburg in New York 1995–96, vol. 1, p. 114, cautions that "even copies produced in Backer's workshop [or in Uylenburgh's workshop?] very closely resemble his originals."

10. See Von Sonnenburg in New York 1995–96, vol. 1, p. 110, citing additional evidence that the Havemeyer panel has not been cut on the left.

REFERENCES: Vosmaer 1877, pp. 523–24, catalogues the work as by Rembrandt, signed and dated 1640 or 1646, and describes the "fine and spiritual head" and the hands and head as very detailed in execution; Lefort 1883, p. 221 (ill. opp. p. 218, etching by Ramus), praises the picture at length (partly following Vosmaer 1877) and lists the Muller through Demidoff sales; Dutuit 1885, p. 20, catalogues the picture as a Rembrandt in the Demidoff and Narischkine sales; Eudel 1885, pp. 404, 406, records the Beurnonville sale of 1884, in which this "Rembrandt" was "la pièce importante"; Eudel 1886, pp. 198–99, "merveilleux tableau daté 1646 ou 1640," records the sale to Kann in 1885; Wurzbach 1886, text vol., no. 307; "To Utilize the Loan Exhibit," *New York Times*, February 12, 1893, p. 4, calls this picture "a companion" to Rembrandt's "Gilder" (Pl. 148); É. Michel 1894, vol. 1, p. 268 n. 1, calls the painting a "replica" of the Yarborough "Rembrandt" (fig. 3 here), and remembers seeing the present picture in Paris: "It appeared to be an old copy, smaller and less frank in manner. Another copy, probably by J. Backer, was sold by auction in London in March, 1889"; Bode 1895, pp. 71, 74 (ill.), cites the picture as "das ausserordentlich liebevoll durchgeführte Bildnis der alten Frau vom Jahre 1640," which passed rapidly through Paris collections before Havemeyer's purchase of it, and records the Yarborough version as an excellent copy; Bell 1899, p. 184, lists it as a Rembrandt in Havemeyer's collection, signed and dated 1640 or 1646; Bode 1897–1906, vol. 4 (1900), pp. 31, 148, no. 278, pl. 278, catalogues the picture as by Rembrandt, signed and dated 1640, with complete provenance, and calls the Yarborough version an old copy "which has been repeatedly exhibited as an original of late"; A. Rosenberg 1904, pp. 114 (ill.), 258, as by Rembrandt in 1640; A. Rosenberg 1906, pp. 186 (ill.), 398, as by Rembrandt in 1640; A. Rosenberg 1909, pp. 256 (ill.), 557, as by Rembrandt in 1640; Stephenson 1909, p. 167, as in the Hudson-Fulton exhibition, "wonderfully warm and golden in coloring"; Valentiner in New York 1909, p. 90, no. 89 (ill. opp. p. 90), as by Rembrandt, signed and dated 1640, describes the sitter and lists collections; Breck 1910, p. 54, mentioned in passing as in the 1909 exhibition; Wurzbach 1906–11, vol. 2 (1910), p. 406, lists the painting as a Rembrandt in the Havemeyer Collection but calls the attribution "nicht ganz sicher"; Hofstede de Groot 1907–27, vol. 6 (1916), p. 399, no. 870, as by Rembrandt, dated 1640, records provenance, literature, and exhibitions, and describes the Yarborough version (fig. 3 here) as an old copy; Van Dyke 1923, pp. 45, 47, pl. VI, fig. 20, as by Jacob Backer, based on comparison with the portrait of the same woman in Berlin ("the work in both pictures is practically the same, and both were possibly done by Backer"); Downes 1923 (ill. opp. p. 665) quotes Van Dyke 1923 in the caption; Meldrum 1923, pp. 109 n. 1, 190, pl. CXXXI, listed as by Rembrandt, dated 1640; K. Bauch 1926, p. 96 (under no. 195, the portrait of the same sitter in Berlin), records the painting as "the same woman by Rembrandt (Backer?)" in the Havemeyer Collection"; Havemeyer Collection 1930, pp. 3 (ill.), 4, as by Rembrandt, "hard and detailed, but tremendously telling"; Mather 1930, p. 455, considers this "Rembrandt" to be by the painter of *Old Woman Reading the Bible* in the Frick Collection and "hence an excellent Van der Pluym"; Havemeyer Collection 1931, pp. 26–27 (ill.), as by Rembrandt, signed and dated 1640, lists collections; Valentiner 1931, unpaged, no. 70, pl. 70, as by Rembrandt, calls the Yarborough version (fig. 3 here) "now in the Ringling collection, Sarasota," a workshop copy of the Museum's picture, and concludes that its larger format "seems to prove that the original painting was larger and has been cut down at the bottom and possibly on the right side"; Havemeyer Collection 1958, p. 8, no. 29, catalogues the

picture as an 18th- or 19th-century copy after Rembrandt; Havemeyer 1961, p. 19, recalls the portrait "over the broad chimney place" in Havemeyer's library; Baetjer 1980, vol. 1, p. 150, as Style of Rembrandt, 17th century; Sumowski 1983–[94], vol. 1, pp. 201, 264 (ill.), no. 61, as by Backer about 1636–38, "im Stil des Berliner Porträts derselben Frau (Kat.-Nr. 60)," records the version formerly in the Yarborough collection as a copy; Weitzenhoffer 1986, pp. 64, 66, 68, 74 (photograph of Havemeyer's library), 224 (photograph of the picture hanging in the Knoedler exhibition of 1915), 254, pl. 20, records the purchase by Havemeyer and acknowledges that the painting is "now considered 'Style of Rembrandt'"; Liedtke 1990, p. 46, mentions Havemeyer's purchase and observes that the painting "would have been considered authentic by any scholar of the period"; Havemeyer 1993, pp. 19, 310 n. 37, repeats Havemeyer 1961 and adds, "now considered Style of Jacob Adriaensz. Backer"; Frelinghuysen in New York 1993, fig. 30, describes Havemeyer's library, in which this painting and other "Rembrandts" hung; Liedtke in ibid., p. 63, in a review of "the Havemeyer Rembrandts," describes the picture as "possibly an old copy or studio version of a portrait by Jacob Backer"; Rabinow in ibid., pp. 91, 95, fig. 10, cites the work in the exhibition of 1915; Stein in ibid., pp. 211, 214, 252, records Havemeyer's purchase of February 3, 1891, and the loan of the picture to the exhibitions of 1893 and 1909; Wold in ibid., p. 292, no. A11 (ill.), as Style of Jacob Adriaensz Backer, gives full provenance; Baetjer 1995, p. 321, as Style of Jacob Adriaensz Backer; Liedtke in New York 1995–96, vol. 2, pp. 93–95, no. 23 (ill.), reviews the history of the painting's connoisseurship and follows Ekkart in concluding that the work is an old copy after Backer; Von Sonnenburg in ibid., vol. 1, pp. 110, 111 (ill.), 114, no. 23, fig. 144 (detail), catalogues the picture as a "partial copy after Jacob Backer," describes the wood support (horizontal grain, evidently not cut down), and insists that "the diligent but blatantly labored paint application" evident here "bears no resemblance to Backer's fluent technique"; Broekhoff and Franken 1997, p. 76, notes that the work was cut from Rembrandt catalogues long ago "but continues to be involved in discussions about the work of Jacob Backer"; Quodbach 2004, p. 99, fig. 7, reproduces an old photograph of Henry Havemeyer's library (decorated 1890–92) in which this picture had a central place; Scallen 2004, p. 358 n. 14, notes the attribution made in New York 1995–96.

EXHIBITED: New York, MMA, "Loan Collection of Paintings," 1891, no. 12; New York, Union League Club, "Exhibition of Art Objects at the Union League," 1891; New York, American Fine Arts Society, "Loan Exhibition," 1893, no. 17 (lent by Mr. H. O. Havemeyer); New York, MMA, "The Hudson-Fulton Celebration," 1909, no. 89; New York, M. Knoedler & Co., "Loan Exhibition of Masterpieces by Old and Modern Painters," 1915, no. 8; New York, MMA, "The H. O. Havemeyer Collection," 1930, no. 96; Richmond, Va., Virginia Museum of Fine Arts, 1948; New York, MMA, "Splendid Legacy: The Havemeyer Collection," 1993, no. A11; New York, MMA, "Rembrandt/Not Rembrandt in The Metropolitan Museum of Art," 1995–96, no. 23.

EX COLL.: Gerrit Muller, Amsterdam (until 1827; his sale, at his residence, Heerengracht, Amsterdam, April 2, 1827, no. 57, as by Rembrandt, for Fl 2,005 to ?Lelie); Comte F. de Robiano, Brussels (until 1837; his sale, Hôtel du Défunt, Brussels, May 1, 1837, no. 543, for BFr 6,000 to Nieuwenhuys); [D. Nieuwenhuys, Brussels (from 1837; sold to Demidoff)]; Anatole Demidoff, Prince of San Donato, Florence, and Paris (until 1868; his sale, Hôtel Drouot, Paris, April 18, 1868, no. 11, for FFr 55,000 to Narischkine); B. Narischkine, Paris (1868–83; his sale, Galerie Georges Petit, Paris, April 5, 1883, no. 29, for FFr 51,000 to Beurnonville); Étienne Martin, baron de Beurnonville, Paris (1883–85; his sale, 3, rue Bayard, Paris, June 3, 1884, no. 291, for FFr 41,000, bought in; his anonymous sale, Hôtel Drouot, Paris, January 30–31, 1885, no. 68, for FFr 25,000 to Kann); Rodolphe Kann, Paris (from 1885); [Durand-Ruel, New York, 1890–91; sold to Havemeyer, February 3, 1891, for $50,000]; Mr. and Mrs. H. O. Havemeyer, New York (1891–his d. 1907); Mrs. H. O. Havemeyer, New York (1907–d. 1929); H. O. Havemeyer Collection, Bequest of Mrs. H. O. Havemeyer, 1929 29.100.2

DAVID BAILLY

Leiden 1584–1657 Leiden

A prominent portraitist and occasional still-life painter, Bailly was the son of a calligrapher and fencing master from Antwerp, Pieter Bailly. The young man studied with the local painter and doctor Adriaen Verburgh (d. 1602),[1] whose brother-in-law Jacques de Gheyn II (q.v.) clearly influenced Bailly's meticulous portrait drawings and his few known vanitas still lifes. De Gheyn served in turn as a model for Bailly's nephews and pupils (from 1628 until about 1635), Harmen Steenwyck (1612–1656 or later) and Pieter Steenwyck (ca. 1615?–after 1656).[2]

About 1602, Pieter Bailly and his family moved from Leiden to Amsterdam, where David continued his apprenticeship with the conservative portraitist Cornelis van der Voort (ca. 1576–1624). Van der Voort had an impressive collection of paintings by mostly Flemish masters, and Bailly (according to his contemporary biographer, Jan Orlers) spent much of his time copying them.[3] In the winter of 1608, the twenty-four-year-old artist departed for five years of foreign travel and residence. Orlers reports that Bailly spent a year in Hamburg, and then traveled through several German cities and the Tirol to Venice, "and from there through the most renowned Italian cities to Rome." In 1610, he returned to Venice, where he stayed five months, and then visited various German courts. According to Orlers, Heinrich Julius, duke of Braunschweig-Wölfenbüttel (d. 1613), offered Bailly a handsome yearly pension, "which he politely refused." Other German princes employed Bailly briefly, but virtually nothing about what he produced during his travels is known.[4]

Bailly's earliest known dated work is a portrait in pen and ink dated 1621, when he was thirty-seven years old.[5] About thirty of these finely finished portrait drawings (which were inspired by and admired by De Gheyn) have come to light, with dated examples ranging from 1621 to 1633.[6] Portrait paintings by Bailly also date from the 1620s, and in 1628 paintings by him were cited in two Leiden collections.[7] Bailly's success as a portraitist seems to have been somewhat delayed after he was convicted of assaulting an auctioneer in 1622, which earned him a large fine, nearly resulted in banishment from the city, and probably cost him the commission for six large group portraits of civic guard companies, in one of which he

served as ensign. The prestigious assignment was awarded to his principal rival in Leiden, Joris van Schooten (ca. 1587–1652).[8]

In a panel of about 1627 (private collection, Paris), Thomas de Keyser (q.v.) depicted Bailly seated in an interior at a table with a vanitas still life that was painted by the sitter himself.[9] The combination of portraiture and still life, which curiously has been considered Bailly's "most original contribution to 17th-century art,"[10] was repeated in the artist's masterwork, *Vanitas Still Life with a Portrait of a Young Painter*, of 1651 (Stedelijk Museum De Lakenhal, Leiden).[11]

Paintings by Bailly that are closely related to his pen drawings include a miniature oval portrait of a woman, on copper, dated 1626 (Rijksmuseum, Amsterdam), and the oval *Portrait of Duke Ulrich, Bishop of Schwerin*, on panel, dated 1627 (Hillerod Castle, Frederiksborg).[12] In the 1630s and 1640s, Bailly painted conventional portraits (usually on panel) that often depict Leiden professors or distinguished students, but also patrician sitters from Leiden and Amsterdam.[13] A pair of small portraits of the artist and his wife date from about 1642; the male pendant was engraved in 1649 and reproduced in De Bie's *Gulden Cabinet*, of 1661.[14]

These personal pictures were probably made to commemorate the aging bachelor's marriage, on May 3, 1642, to the apparently middle-aged Agneta van Swanenburgh. During the next six years, Bailly was a leading figure in the Leiden painters' "college," which in March 1648 achieved its goal of becoming the city's Guild of Saint Luke. The artist first served as *hoofdman* (headman), and in 1649 as dean.[15]

Bailly made out his will on April 18, 1657, and was buried on November 5 of that year.[16] In June 1657, he was awarded the lucrative post of steward to the Theological College of Holland and West Friesland, which his widow briefly took over.[17] She appears to have rented a house on the Rapenburg, Leiden's finest canal, in 1667, but at her death in 1670 she was insolvent as well as childless.[18]

1. On Verburgh and Bailly, see Van Regteren Altena 1983, vol. 1, pp. 28–29.
2. The basic article on Bailly's life and work remains Bruyn 1951. See also Ekkart 1992b, pp. 12–15, and J. Bruyn in *Dictionary of Art* 1996, vol. 3, pp. 77–78. On Bailly's still lifes, see Boström 1950

and Popper-Voskuil 1973. Koozin 1989 places the vanitas still lifes of Harmen Steenwyck in a broad context, with brief references to Bailly. On the Steenwyck brothers, see also New York–London 2001, pp. 93–95, 184–86, 347–48.

3. See Bruyn 1951, pp. 151–52, citing Orlers 1641, pp. 371–72.

4. See Bruyn 1951, pp. 152–53, and Bruyn in *Dictionary of Art* 1996, vol. 3, p. 77, suggesting that Bailly may have painted history pictures in the manner of the Pre-Rembrandtists in Amsterdam.

5. Amsterdam and other cities 1991–92, no. 16, which on the basis of an old inscription on the verso is thought to represent the Amsterdam painter Jan Pynas (1583/84–1631).

6. Orlers mentions De Gheyn's approval. See Bruyn 1951, pp. 158–60 (with a list of portrait drawings dating from the 1620s), and Plomp 1997, no. 23, for a double portrait of 1624 in the Teylers Museum, Haarlem. Portrait drawings of Johan Rutgers (n.d.) and of Daniel Heinsius (1630) are in the Morgan Library and Museum, New York. A portrait drawing of a young man, dated 1623, and a circular portrait drawing of a young woman, signed and dated 1629, were sold at Christie's, Amsterdam, November 18, 1985, nos. 28, 29, pls. 14, 15 (the sale catalogue, p. 12, refers to five more examples). See also Leiden 1976–77, pp. 40–42, and Lunsingh Scheurleer, Fock, and Van Dissel 1986–92, vol. 5B, p. 489, fig. 10, and vol. 6B, p. 634, fig. 13.

7. See Bruyn 1951, p. 159, fig. 5 (1627), and Lunsingh Scheurleer, Fock, and Van Dissel 1986–92, vol. 5A, pp. 4, 8 (see also p. 10, citing the Orlers inventory of 1640, and the tables on pp. 12, 16).

8. See Bruyn 1951, pp. 153–54, 162, fig. 7; Stedelijk Museum De Lakenhal 1983, nos. 386–91; Ekkart 1992b, pp. 12–13, fig. 7. Bailly evidently painted his own portrait in one of Van Schooten's group portraits, the *Civic Guard Company of Captain Harman van Brosterhuyzen*, of 1626 (Stedelijk Museum De Lakenhal, Leiden; see Stedelijk Museum De Lakenhal 1983, p. 305, no. 389).

9. Bruyn 1951, pp. 161–63, fig. 8.

10. Bruyn in *Dictionary of Art* 1996, vol. 3, p. 77; see Popper-Voskuil 1973 for the De Keyser and other antecedents, to which Aegidius Sadeler's well-known engraving after Bartholomeus Spranger's *Allegory on the Death of the Artist's Wife*, 1600, may be added (see Wurfbain 1969, and Sluijter 1998a, pp. 180–81, fig. 31).

11. In Bruyn in *Dictionary of Art* 1996, vol. 3, p. 78, and in Sluijter 1998a, pp. 187–89, it is suggested convincingly that the young painter is Bailly himself, as he appeared some forty years earlier. He holds a small *Self-Portrait* of about 1642 (see the text following). In Wurfbain 1988, the young man is imagined to be Frans van Mieris.

12. The Amsterdam portrait is catalogued in Van Thiel et al. 1976, p. 95, no. A16, as possibly a portrait of Hugo de Groot's wife. The same woman and her husband (who is younger and bears no resemblance to the famous jurist) are found in portraits by Bailly (panels, each 27⅛ x 19⅛ in. [68.9 x 48.5 cm]), dated 1628 and 1625, respectively, which were with the art dealer Daphne Alazaraki, New York, in 1994. See Bruyn 1951, pp. 154, 159–60, fig. 5, for the portrait of Ulrich, who was the son of Christian IV of Denmark.

13. See Bruyn 1951, pp. 154–55, figs. 9, 10, 13, 14.

14. First published in Bruyn 1953; sold at Christie's, New York, June 18, 1982, no. 71. A replica of the self-portrait, on a larger panel, is in the Muzeum Narodowe, Warsaw (cited with misleading references in Van Hall 1963, p. 10).

15. On Bailly's marriage and his role in the guild, see Bruyn 1951, pp. 155–56. In W. Martin 1901, p. 88, it is proposed unpersuasively that Bailly was also an art dealer, evidently because a few sales and purchases by him are cited in guild accounts (Obreen 1877–90, vol. 5, pp. 172–259; see the index under Bailly). The same source (p. 182) reveals that the painter had an unidentified pupil in 1645.

16. The relevant document was first published in De Baar 1973.

17. De Baar 1975.

18. See Bruyn 1951, p. 156, and Lunsingh Scheurleer, Fock, and Van Dissel 1986–92, vol. 3, pp. 716, 728.

ATTRIBUTED TO DAVID BAILLY

3. *Portrait of a Man, possibly a Botanist*

Oil on wood, 33 x 24½ in. (83.8 x 62.2 cm)
Dated and inscribed (center right): Ætatis 66/AN° 1641

The painting is well preserved, but throughout the background and in the black costume the paint surface is slightly abraded.

The Jack and Belle Linsky Collection, 1982 1982.60.29

This impressive portrait was once ascribed to Ferdinand Bol (q.v.), until Sturla Gudlaugsson more plausibly proposed Bailly.[1] The present writer supported this attribution in the Linsky Collection catalogue (1984) and still considers Bailly's authorship likely. Rudolf Ekkart stresses the difficulty of attributing conservative Dutch portraits like this one, and also notes the "rather great variety" found in Bailly's comparatively

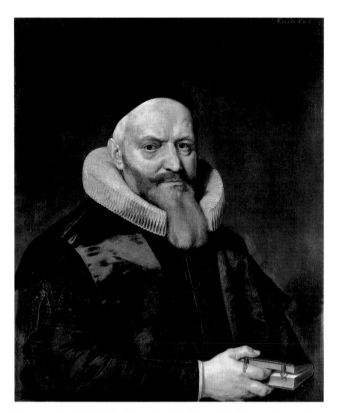

Figure 4. David Bailly, *Portrait of Anthony de Wale, Professor of Theology at the University of Leiden*, 1636. Oil on wood, 28 x 23⅝ in. (71 x 60 cm). Rijksmuseum, Amsterdam

small oeuvre.[2] Other scholars have observed similarities between the present picture and portraits by Jacob Gerritsz Cuyp (1594–1651/52), and more intriguingly have mentioned Michiel van Miereveld's (q.v.) sphere of influence in Delft, for example in portraits by his pupil Anthonie Palamedesz (1601–1673).[3] That Bailly and his Leiden colleague Joris van Schooten (see Bailly's biography above) were influenced by the leading South Holland portraitists is obvious and was to be expected, given the many artistic and social connections linking the university city with Delft and The Hague.

Nonetheless, the Linsky picture seems more typical of Leiden than of Delft in its execution and expression, and it is also consistent in type with numerous portraits of Leiden professors and clergymen. Bailly's portraits of the 1630s and 1640s recall Van Miereveld's manner but are less relieflike; a softer touch in the sitter's features contributes to the generally more atmospheric effect. The Leiden artist also seems more searching in his study of character than most portraitists active in the area of The Hague and Delft. As for Palamedesz, his portraits of the 1640s and later are even less reminiscent of Van Miereveld's style than are Bailly's portraits dating from about 1625–45.[4]

Gudlaugsson's attribution of the painting to Bailly on the basis of a photograph must have been informed by his knowledge of two works by the artist: the *Portrait of Anthony de Wale, Professor of Theology at the University of Leiden*, of 1636, in the Rijksmuseum, Amsterdam (fig. 4), and the *Portrait of an Unknown Professor or Pastor*, signed and dated 1642, in the Van Heeckeren van Wassenaer collection at Kasteel Twickel.[5] The three pictures are broadly similar in the presentation of the figure and in the emphatic gaze. The modeling of the hands and facial planes, in particular the creased brows, is comparable in the three portraits, as is the drawing of the ears and eyes (the latter circled by brownish shadow).[6] The descriptions of skin, hair, and fabrics naturally differ from sitter to sitter, but they are consistent in quality and in certain characteristics of handling, such as the tendency to reinforce the costume's contours with dark lines. The portraits in the Linsky Collection and in Kasteel Twickel are also similar in their use of furniture, which is in somewhat false perspective.

The identity of the sitter is not known. He could be a cleric or a professor (although his attire is not academic), an amateur of botany, a doctor, or an apothecary.[7] The book, which shows two views of a narcissus, cannot be identified and is probably the artist's invention.[8]

This type of "scholar portrait," which has sixteenth-century North Italian roots (as seen in works by Giovanni Battista Moroni), was popular in the Netherlands during the first half of the seventeenth century and was employed for amateurs as well as professionals. A well-known example is the portrait of the Haarlem shell collector Jan Govertsz van der Aer, by Hendrick Goltzius (1558–1617; P. and N. de Boer Foundation, Amsterdam, on loan to the Museum Boijmans Van Beuningen, Rotterdam), which was painted in 1603 and promptly praised by Karel van Mander (1604).[9]

1. The catalogue of the 1925 sale (see Ex Coll.) was compiled in part by Cornelis Hofstede de Groot, who had previously made a number of attributions to Bol and may have proposed this one. Blankert 1982, p. 180, no. R168, rejects the attribution to Bol and appears to support Gudlaugsson's suggestion, which was made as a marginal note to a photograph at the Rijksbureau voor Kunsthistorische Documentatie, The Hague.
2. Ekkart 1992b, p. 14. The painting is placed among the Museum's "puzzling portraits" in a letter from Rudolf Ekkart dated December 17, 1988. His remark about Bailly's variety could be illustrated by comparing the works reproduced in Bruyn 1951 with the *Portrait of a Scholar*, dated 1635, in Göttingen (Braunschweig 1983, no. 1).
3. In letters of 1983 (curatorial files), C. J. de Bruyn Kops and J. Bruyn mention J. G. Cuyp, but Bruyn also suggests looking to Delft, and cites Palamedesz while dismissing Jacob Willemsz

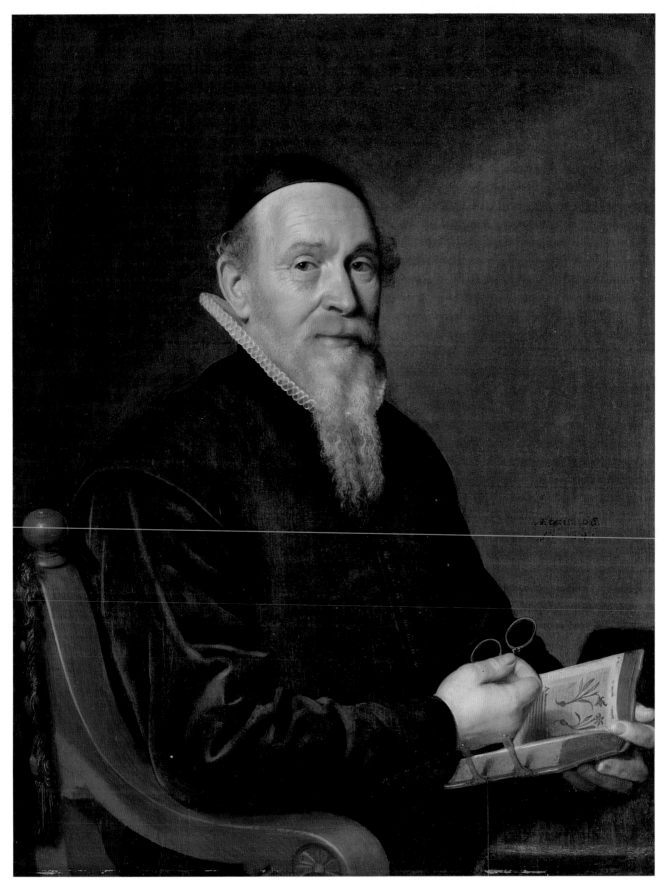

3

Delff II (1619–1661) and Hendrick van Vliet (q.v.) from consideration. Bruyn's "first reaction to Gudlaugsson's attribution was quite positive" (letter of August 19, 1983). On portraiture in Delft about 1600–1650, see New York–London 2001, pp. 43–54 (50–51 on Palamedesz).

4. Palamedesz's *Portrait of a Scholar Aged 72*, dated 1657 (Ader Picard Tajan, Paris, June 18, 1979, no. 110), may have brought the Delft painter's name into consideration, but the comparison is not encouraging.

5. Bruyn 1951, pp. 154, 163, 214, 216, 219, figs. 9, 13.

6. Similar ears are found in Bailly's drawings, for example the presumed portrait of Theodorus Schrevelius, of 1642, in the Museum voor Schone Kunsten, Brussels (ibid., fig. 4), and in the *Portrait of Johan Rutgers* (Morgan Library and Museum, New York).

7. As suggested by Rudolf Ekkart, whose opinion was communicated and endorsed by F. G. L. O. van Kretschmar, director of the Stichting Iconographisch Bureau at The Hague (letter of August 25, 1983). One visitor to the Museum has insisted that the sitter must be a rabbi, but no historical evidence supports this modern impression (see Gans 1971, Rubens 1973, and Katchen 1984).

8. This opinion was expressed in a letter from the botanist and still-life specialist Sam Segal (April 2, 1983). Compare the herbal (also probably invented) in Willem Moreelse's *Portrait of a Scholar*, of 1647 (Toledo Museum of Art).

9. Ekkart 1995, no. 18.

REFERENCES: Blankert 1982, p. 180, no. R168, rejects the attribution to Bol (see Ex Coll.) and suggests Bailly, following Sturla Gudlaugsson's undated note in the photographic files of the Rijksbureau voor Kunsthistorische Documentatie, The Hague; Liedtke in Linsky Collection 1984, pp. 84–86, no. 29 (ill.), supports the attribution to Bailly and describes the sitter; Baetjer 1995, p. 303, as by Bailly.

EX COLL.: Possibly T. H. Ward (until 1899; as "Man's Portrait," by Bol; sold to Agnew); [possibly Agnew, London, 1899; sold to Fischhof]; [possibly Eugène Fischhof, Paris, from 1899]; Achillito Chiesa, Milan (sale, American Art Association, New York, November 27, 1925, no. 18, as by Bol, for $2,900 to Bye); Dr. L. Bye (from 1925); Roland L. Taylor, Philadelphia (until d. 1943; his estate sale, Parke-Bernet, New York, April 5, 1944, no. 25, as by Bol, for $1,300); Mr. and Mrs. Jack Linsky, New York (1944–80); The Jack and Belle Linsky Foundation, New York (1980–82); The Jack and Belle Linsky Collection, 1982 1982.60.29

JOHANNES BEERSTRATEN

Amsterdam 1622–1666 Amsterdam

The artist signed his given name as Jan or Johannes, or with alternative spellings of the latter, and his surname as Beerstraten or Beerstraaten, and with versions of both. His father was probably Abraham Danielsz van Emden, a damask worker who on December 26, 1610, at the age of twenty-one, married Meynsjen Luytendr, age twenty-seven, in the Oude Kerk, Amsterdam. The baptisms of four children from this marriage are recorded: Daniel, in 1612; Annetje, in 1614; Jacob, in 1618; and Johannes, on March 1, 1622.[1] It has also been suggested that the painter's father may have been the cooper Abraham Jansz, whose son Jan was baptized in Amsterdam on May 31, 1622.[2] However, circumstantial evidence strongly supports Abraham Danielsz as the artist's father. For example, the names Daniel and Jacob frequently appear in Beerstraten's family. His own children, by his first marriage (in 1642) to Magdalena Teunisdr Bronckhorst (d. 1664), were named Abraham, Johannes, Jacobus, Magdalena, and Daniel (who were twenty-one, twelve, seven, five, and four years old in 1665).[3] Daniel became a carpenter and had sons named Johannes and Jacobus; the latter had a son named Daniel, whose own son was called Jacob.[4] It is also documented that on October 17, 1651, the artist became the guardian of the daughters (Meynsje, named for her grandmother, and Duyfje) of Daniel Abrahamsz Beerstraten; this would be his older brother, a barber (or barber-surgeon) who married in 1635 (with Abraham Danielsz, evidently his father, as witness) and died in the East Indies. Significantly, Daniel Abrahamsz's surname was recorded as Beerstraten on the occasion of his marriage (when Johannes Abrahamsz was only thirteen years old).[5]

Shortly after his first marriage, Beerstraten moved into a house by the Haarlemmerpoort (the Haarlem City Gate of Amsterdam). In 1651, he bought a house at the western end of the Rozengracht, and lived there for the rest of his life (Rembrandt's house, from about 1658 onward, was a few doors away).[6] The painter married his second wife, Albertje Egbertsdr Crale, on May 10, 1665, in the church at Sloterdijk,[7] a village very close to the Haarlemmerpoort.[8] Their life together was cut short a little over a year later: Beerstraten died in June 1666 and was buried in his neighborhood church, the Westerkerk, on July 1. Albertje died, probably in childbirth, within three

weeks of her husband; her burial is recorded as taking place on July 19, 1666, one day after the painter's posthumous daughter, Albertje, was baptized in the Westerkerk.[9]

It has been conjectured that the marine painter Claes Claesz Wou (1592–1665) was the artist's teacher. Beerstraten specialized in views of Dutch towns and noteworthy buildings, such as Gothic churches and medieval castles. Many of these pictures are winter scenes. He also painted imaginary views of Mediterranean seaports, in some instances with northern European churches incongruously set into the sunstruck terrain. The latter works inspired the Amsterdam artists Abraham Storck (1644–1708) and his less talented brother Jacobus (1641–ca. 1688).[10] A few paintings of sea battles are also known (for example, *The Battle of Terheide*; Rijksmuseum, Amsterdam).[11]

Several authors have attempted to distinguish the works of Johannes Abrahamsz Beerstraten from those of Abraham Beerstraten (possibly his son), a certain Anthonie Beerestraeten, and another Johannes.[12] In any event, Johannes Abrahamsz was certainly the most successful artist with the surname Beerstraten and the author of the painting discussed below.

1. Oldewelt 1938, p. 86, where the date of Johannes's baptism is given mistakenly as February 27, 1627. The error is corrected in Van Thiel 1968, p. 56 n. 7 (citing an obscure article by C. N. Fehrmann), and is noted in MacLaren/Brown 1991, p. 13, where MacLaren 1960, p. 13, is corrected.
2. See MacLaren/Brown 1991, p. 13, citing Havard 1879–81, vol. 3, pp. 9–14.
3. See Oldewelt 1938, pp. 81–82.
4. Ibid., p. 85.
5. Ibid., p. 85. On the same page it is noted, without remarking the coincidence, that one of the great-grandsons of Johannes Abrahamsz Beerstraten, Daniel (Jacob's son; d. 1762), was a ship's surgeon. As Oldewelt observes (ibid., p. 86), the many books and the barbershop sign listed in Johannes Beerstraten's estate were probably inherited from his brother Daniel.
6. Ibid., p. 81. For the locations of Beerstraten's and Rembrandt's residences, see Dudok van Heel 1991a, map on p. 63.
7. Oldewelt 1938, p. 84, citing a document dated September 11, 1666, that mentions this detail while recording the acceptance of the couple's daughter, "Albertje, age about seven weeks," into an Amsterdam orphanage.

8. See Bakker et al. 1998, p. 22, fig. 12 (a drawing of the bulwark of Sloterdijk and the Haarlemmerpoort, attributed to Gerbrand van den Eeckhout), and the maps on pp. 354, 362.

9. Oldewelt 1938, pp. 82–84.

10. See Schloss 1982, p. 28, and M. Russell in *Dictionary of Art* 1996, vol. 29, pp. 720–21.

11. See Bol 1973, p. 286, figs. 289, 290.

12. The most reliable remarks on the subject are found in MacLaren/ Brown 1991, p. 13. See also *Dictionary of Art* 1996, vol. 3, p. 493, and the slim book by Van der Most (2002, pp. 18–22).

4. *Skating at Sloten, near Amsterdam*

Oil on canvas, 36¼ x 51⅝ in. (92.1 x 131.1 cm)
Signed and inscribed (lower right, on stone wall): Slooten/ J·Beer-straaten/pingit

The overall abrasion to the paint surface is most extreme in the sky. Examination by infrared reflectography reveals that four individual and one pair of figures were painted out on the walkway next to the church that continues to the right over the bridge. Many changes were made by the artist to the positions and activities of the figures on the ice.

Rogers Fund, 1911 11.92

The village of Sloten, on the southwest edge of modern Amsterdam, was incorporated into the city in 1921. The Reformed Church (called the Petruskerk) was replaced in the 1860s.[1] Its structural problems ultimately dated back to 1572, when Spanish troops destroyed a much larger choir than the one seen here (which was built in the mid-1650s). Beerstraten's view in the Museum's painting and in a closely related canvas in the Rijksmuseum, Amsterdam (fig. 5), shows the church from the north. The church tower of Amstelveen, to the southeast of Sloten, is visible in the left background of the Amsterdam picture.[2]

The differences between the two versions of the composition are described in detail by Van Thiel (see Refs.). The church tower, the choir, the house behind the church, the bridge in front of it, the recession of the houses on the right, and many minor motifs are depicted differently. Van Thiel concludes that the church is more faithfully rendered in the signed painting in Amsterdam, which he feels is also more successful in its sense of space and in passages of naturalistic description. The latter point is supported by a comparison of areas like the bridge and the embankment on the right in the Rijksmuseum picture (where the light, surface textures, vegetation, and frozen canal are keenly observed) with the less specific handling of corresponding areas in the New York canvas.

However, it is not clear that the description in the Amsterdam painting coincides with a more reliable record of the church. Assuming that it does, Van Thiel suggests that the builder responsible for the modest new choir failed to strengthen its walls with buttresses (see fig. 5), and he goes so far as to associate this incautiousness with the choir's collapse in the late eighteenth century. But an engraving of approximately the same view published in "Descriptions" of Amsterdam in 1663 and in 1664 shows buttresses rising to the roofline all around the church and a tower more similar in shape to that in the Museum's picture.[3] It seems likely, then, that buttresses were arbitrarily omitted from the choir in the Rijksmuseum canvas, perhaps to allow the handsome house behind the church to stand out more prominently. In the New York painting, the somewhat different house in the same position is taller and plainer, and a few trees have been eliminated, so that the buttresses help effect a graceful transition between blocky forms.

Beerstraten probably departed from actual appearances to some extent in both paintings. In the New York picture, the village of Sloten serves in part as a backdrop for a lively panorama of people enjoying themselves on the frozen canal. The figures in the Amsterdam painting, by contrast, amount to little more than conventional staffage. This shift in emphasis from more exclusively topographical concerns to the theme of winter pleasures in the tradition of Hendrick Avercamp (1585–1634) and many younger Dutch artists (compare the Museum's winter scenes by Van den Berghe and Van Ruysdael; Pls. 6, 189) explains the variations in the handling of space and attention to detail far better than Van Thiel's hypothesis that the two canvases were painted by different members of the Beerstraten family.

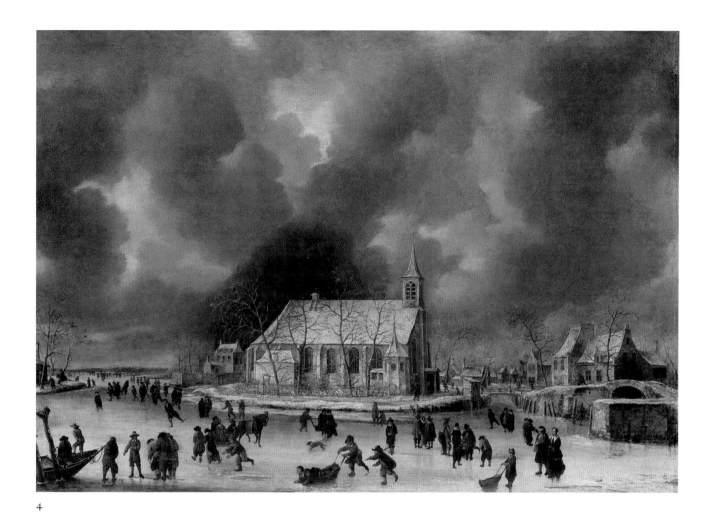

4

Figure 5. Johannes Beerstraten,
*View of the Church of Sloten in
Winter*, ca. 1660–64. Oil on can-
vas, 35⅜ x 50⅜ in. (90 x 128 cm).
Rijksmuseum, Amsterdam

This writer agrees with Brown (see Refs.) that the two paintings are sufficiently consistent in style with each other and with other works by Johannes Beerstraten to be both accepted as autograph. Van Thiel plausibly dates the Amsterdam picture to about 1658–59 on the basis of comparisons with Beerstraten's *The Castle of Muiden in Winter*, of 1658 (National Gallery, London), and with his so-called *View of Ouderkerk in Winter*, of 1659 (Amsterdams Historisch Museum, Amsterdam).[4] However, the two views of Sloten could just as well date from the early to mid-1660s. They are probably based on a single drawing of the village made at the site. The more straightforward treatment of the subject in the Rijksmuseum canvas suggests that it was most likely painted first.

Beerstraten drew and painted a fair number of views in Amsterdam and in nearby villages.[5] The paintings usually feature one prominent building in a snow-dusted landscape, with ice skaters and other figures on a frozen waterway in the foreground. In addition to Sloten and Muiden, which would have been day trips for the artist, he also recorded views of churches farther afield: in the South Holland villages of Delfshaven, Nieuwkoop, and Rijswijk; in the North Brabant city of 's Hertogenbosch and the town of St. Michielsgestel; in the Gelderland village of Zoelmond; and elsewhere.[6] Three paintings of Nieuwkoop are known, and two of them reveal changes in topographical details, staffage, the immediate foreground, and the overall impression of space, quite as in Beerstraten's views of Sloten.[7]

It is not known whether the artist's pictures of churches in various locations followed a program he set for himself or reflect the interests of individual patrons. The latter seems likely in the case of Sloten, although the village, like Amstelveen and Ouderkerk, was generally admired for being older than Amsterdam.[8] Schwartz recalls that the powerful Amsterdam burgomaster and art patron Cornelis de Graeff (1599–1664) was a major supporter of Sloten and its church during his tenure as the village lord of the manor, between 1650 and his death.[9] The same office was held by his father, the Amsterdam burgomaster Jacob de Graeff (1571–1638), and various members of the family were married in the church at Sloten.[10] Thus Beerstraten may have painted his views of Sloten for one of the De Graeffs, especially Cornelis. However, it is also possible that another patron was involved.

Of the various painters who in earlier years had recorded views of Sloten or the Sloterweg (the road leading to the village from the direction of Amsterdam)—for example, Claes Jansz Visscher (1587–1652), Roelant Roghman (1627–bur. Jan. 3, 1692), and an anonymous artist in 1639[11]—the most important for Beerstraten must have been Rembrandt, his neighbor on the Rozengracht in Amsterdam.[12] About 1645–50, Rembrandt made a number of sketches of cottages and other sights along the Sloterweg, of Sloten in the distance, and of the Sloten church and the ruins of its original choir.[13] It has been suggested either that Roghman's drawings and etchings of the church inspired Rembrandt's sketch of the same motif (Nasjonalgalleriet, Oslo) or that the master and the young man drew views of the picturesque site from slightly different vantage points on an outing together.[14] It seems likely that Beerstraten was aware of these precedents. He may also have been put in touch with the De Graeffs—to compound that hypothesis—by Rembrandt, who was well known to Cornelis and his brother Andries de Graeff (1611–1679) in the 1650s and 1660s.[15]

1. As noted in Bakker et al. 1998, p. 350.

2. Van Thiel 1968, pp. 54, 56 n. 4, briefly reviews the church's history and the evidence found in prints dating from about 1640 onward. See ibid., p. 51, for the identification of Amstelveen and the Osdorperweg leading out of the view to the right. The Rijksmuseum painting is discussed and reproduced in color in Perth–Adelaide–South Brisbane 1997–98, no. 22.

3. Dapper 1663, p. 34, and Von Zesen 1664, p. 139, cited in Van Thiel 1968, pp. 54, 56 n. 3, fig. 3. The tower in the Amsterdam painting resembles that seen in Geertruydt Roghman's etching of the church dating from about 1647 (ibid., fig. 4), which also shows the ruins of the former choir. (See also Roelant Roghman's etching of about 1645–48, *Old and New Church in Sloten*, which of course shows the church and the ruins of the old choir before the new choir was built; Bakker et al. 1998, pp. 352–53 nn. 11–13, fig. 4, for this print and other images of the church by Roelant and Geertruydt Roghman.) Plomp 1997, p. 58, notes that the similar tower in Beerstraten's drawing of the church at Rijswijk (see note 6 below) "does not correspond with reality."

4. Van Thiel 1968, pp. 55, 56 n. 6. For the London picture, see MacLaren/Brown 1991, pp. 14–16, pl. 13. The identification of the "Ouderkerk" view as such has been strongly doubted, for example in Blankert 1979, p. 36, no. 41, and in Copenhagen–Amsterdam 2001, pp. 47, 169 (under no. 44). The painting is catalogued as *View of Ouderkerk in Winter* in Van Thiel et al. 1976, p. 106, no. C94 (on loan from the City of Amsterdam).

5. An impressive group of Amsterdam views is in the Amsterdams Historisch Museum, Amsterdam (see Blankert 1979, pp. 32–35). The composition of *The Noorderkerk in Winter* (no. A644), with skaters on the Prinsengracht in the foreground, recalls the Sloten and Muiden views.

6. For Beerstraten's drawing of the church at Rijswijk, dated 1664, see Plomp 1997, p. 58, no. 26, where "five comparable drawings depicting church exteriors" in the Rijksprentenkabinet, Amsterdam, are cited by inventory number. There are actually six such drawings, two of identified churches and the others of the cathedral of 's Hertogenbosch and of the churches in Delfshaven, Zoelmond, and Saint Michielsgestel (kind communication of Marijn Schapelhouman in January 2004). On the last drawing, which

records a church destroyed in 1836, see Schapelhouman 1990, pp. 320–23.

7. Beerstraten's canvas *The Village of Nieuwkoop in Winter with a Child's Funeral Procession* (Szépművészeti Múzeum, Budapest) is inscribed "Nukoop naar leeven gedaen door J. Beerstraten" (see Czobor 1967, no. 48, where versions in Hamburg and Leeuwarden are cited). *The Church at Nieuwkoop*, in the Kunsthalle, Hamburg, is almost identically inscribed. There is no funeral procession, and the figures are entirely different. The churches in the Budapest and Hamburg pictures must depend upon a single drawing, but the houses and tower in the distance recede somewhat differently.

8. As noted in Bakker et al. 1998, p. 303.

9. G. Schwartz in Vancouver 1986, p. 329, noting that, according to the churchmaster Engelbertus Sloot, Cornelis de Graeff "showed exceptional favor to the village of Sloten" in the period 1652–55, "for example by buying a plot of land for the minister to put up a splendid house [the one behind the church's choir in Beerstraten's painting?], . . . all of this from means and income of the city of Amsterdam." There is some confusion in the literature about when the church was rebuilt. Schwartz (in ibid.) goes on to report that "in 1663–64 the church was completely rebuilt, once more with the help of de Graeff." But this is inconsistent with the documentary evidence cited in Bakker et al. 1998, p. 350 n. 7, which indicates that the church's "restoration was carried out in 1654." An engraving published in 1663 and 1664 (see text above and note 3) shows the church as completed, not as in the course of reconstruction. Apparently Schwartz, here and in Vancouver 1986, p. 61 (under no. 25), confused Sloten with Sloterdijk, the village on an inlet of the river IJ just west of Amsterdam (see the maps in Bakker et al. 1998, p. 305, location 5.9 for Sloten, and p. 354, location 6.2 for Sloterdijk). De Graeff's payment for the rebuilding and expansion of the church at Sloterdijk in the year 1664 was acknowledged by an inscription above the pulpit (Van der Aa 1852–76, vol. 5, p. 107). In May of the following year, Beerstraten's second marriage took place in the same church (see the biography above).

10. As recorded on several genealogical Web sites found through the search engine Google, using the keywords De Graeff and Sloten together.

11. See Bakker et al. 1998, p. 332, fig. 4 (anon.); p. 345, fig. 7 (Visscher); and p. 353, fig. 4 (Roghman).

12. See the biography above, note 6.

13. See Bakker et al. 1998, pp. 90, 141 (ill.); pp. 205, 304, 331, 337–48 (views near Sloten); and pp. 349–53 (views of and in Sloten).

14. Ibid., p. 352.

15. See G. Schwartz 1985, pp. 204, 223, 286, and 375–76 in the index under various De Graeffs. That Rembrandt's full-length portrait of a man dated 1639 (Gemäldegalerie Alte Meister, Kassel) represents Andries de Graeff, as S. A. C. Dudok van Heel proposed decades ago, is maintained forcefully by Jeroen Giltaij in Frankfurt 2003, pp. 134–37 (under no. 27).

REFERENCES: Van Thiel 1968, pp. 51, 54–55, 56 n. 2, fig. 2, describes the differences between the Museum's picture and the version in Amsterdam (fig. 5 here), and considers the former so much weaker in quality that he believes it must be by another painter, perhaps a relative (but not a son) who was also a J. or even a Jan Beerstraten and who was inclined to imitate the better-known artist's signature; G. Schwartz in Vancouver 1986, p. 61 (under no. 25, the Amsterdam version), reports that the New York picture "is believed to be a copy [*sic*] by Beerstraten's son," thus misreading Van Thiel while restating his conclusion; C. Brown in MacLaren/Brown 1991, p. 14 n. 11, rejects much of Van Thiel's argument, maintaining that "the discrepancies between the two paintings are not great enough to justify their attribution to two different hands"; Baetjer 1995, p. 328; Perth–Adelaide–South Brisbane 1997–98, p. 68 n. 1 (under no. 22), as "another version" of the Amsterdam picture; Van der Most 2002, p. 28, as "a slightly different version" of the Amsterdam painting.

EXHIBITED: Berkeley, Calif., University of California at Berkeley, University Art Museum, and Houston, Tex., Rice University, Institute for the Arts, "Dutch Masters from The Metropolitan Museum of Art," 1969–70, checklist no. 1.

EX COLL.: Sale, F. Muller & Co., Amsterdam, April 25, 1911, no. 5, for Fl 2,750 to "Johnson" (John G. Johnson, by wire, on behalf of the MMA); Rogers Fund, 1911 11.92

NICOLAES BERCHEM

Haarlem 1621/22–1683 Amsterdam

The son of Pieter Claesz (q.v.), Nicolaes (or Claes) Pietersz Berchem was born in Haarlem about 1621 or 1622.[1] Guild records indicate that he studied drawing with his father in 1634. Berchem took his surname from his father's birthplace, which is now known to have been the village of Berchem, near Antwerp.[2] Houbraken reports that the young artist's teachers were Jan van Goyen (q.v.), Claes Moeyaert (1591–1655), Pieter de Grebber (ca. 1600–1652/53), Johannes Wils (1603–1666), and Jan Baptist Weenix (1621–1660/61).[3] Weenix was actually Berchem's fellow student under Moeyaert in Amsterdam, and his collaborator on a painting of the 1650s, *The Calling of Matthew* (Mauritshuis, The Hague).[4]

Berchem registered as a master in the Haarlem painters' guild on May 6, 1642, and in the same year took on three pupils. He married in 1646.[5] About 1650, he traveled with his friend Jacob van Ruisdael (q.v.) to Westphalia, where both artists made sketches of the Castle of Bentheim, a motif they used in landscape paintings of the 1650s.[6] It is not certain that Berchem ever went to Italy, but likely that he did so in 1650–51.[7] The artist is documented in Haarlem in 1656 (when he bought a pleasure house and garden) and in 1657. He appears to have lived in Amsterdam throughout the 1660s. Berchem and his wife were again residents of Haarlem in 1670, and in 1674 he was still a member of the Haarlem painters' guild. At an unknown date the couple moved to the Lauriergracht in Amsterdam, where Berchem died on February 18, 1683. He was buried five days later in the Westerkerk.[8] His widow auctioned his collection of paintings (which brought 12,000 guilders on May 4, 1683) and his books and graphic works (December 7, 1683), which included many prints by the Florentine painter, engraver, and etcher Antonio Tempesta (1555–1630).

Berchem's early work is generally consistent with Haarlem landscape painting in the 1640s, although it also reveals the influence of Pieter van Laer (1599–?1642), a landscape painter and printmaker from Haarlem who was in Italy from about 1625 until the late 1630s.[9] After 1650, Berchem adopted a lighter palette and depicted panoramic vistas in an Italianate style inspired by Jan Both (ca. 1615/18–1652) and Jan Asselijn (ca. or after 1610–1652). During the 1660s, the work of Adam Pijnacker (ca. 1620–1673) also made an impression on him. In his mature work Berchem is so eclectic and versatile that his ideas seem to come from countless sources and at the same time to be all his own. In addition to idyllic landscapes, the artist painted some imaginary Mediterranean harbor scenes in which his suave figure style takes center stage (the most admired example is *A Moor Presenting a Parrot to a Lady*, of the 1660s; Wadsworth Atheneum, Hartford).[10] He also painted figures in landscapes by Van Ruisdael, Meyndert Hobbema (q.v.), and others. An accomplished draftsman and etcher,[11] Berchem made over fifty original prints representing Italianate landscapes and farm animals.

Berchem had many pupils and imitators. The former included Karel du Jardin (1626–1678), Abraham Begeyn (ca. 1635–1697), Willem Romeyn (ca. 1624–1694), Pieter de Hooch, and Jacob Ochtervelt (q.q.v.). Works by Berchem were greatly esteemed in the eighteenth century, particularly in France, and for most of the nineteenth century as well.

1. See the biography of Berchem by Irene van Thiel-Stroman in Biesboer et al. 2006, pp. 102–5. The artist is not identical with the Claes, son of Pieter Claess of Steinfurt, who was born in October 1620.
2. See Slive 2001, pp. 23, 27 n. 3, and the biography of Pieter Claesz below.
3. Houbraken 1718–21, vol. 2, p. 111.
4. The panel, which both artists signed, is discussed in Hoetink et al. 1985, pp. 132–33, no. 7. On the question of whether Berchem actually studied with the slightly younger Weenix, and for brief remarks on the other teachers named by Houbraken, see Jennifer Kilian's article on Berchem in *Dictionary of Art* 1996, vol. 3, p. 757.
5. On Berchem's wife (who was the stepdaughter of Johannes Wils) and the couple's children, see Van Thiel-Stroman in Rotterdam–Frankfurt 1999–2000, pp. 236, 242.
6. See Slive 2001, pp. 23–27, where Berchem's drawing of Bentheim dated 1650 and two landscape paintings of 1656 that include the castle are illustrated. For Berchem's *Westphalian Landscape with Castle Bentheim*, of 1656 (Gemäldegalerie Alte Meister, Dresden), see also Enschede 1980, no. 5. That Van Ruisdael was "een groot vrient van N. Berchem" is stated in the former's biography in Houbraken 1718–21, vol. 3, p. 66.
7. See Van Thiel-Stroman in Rotterdam–Frankfurt 1999–2000, p. 242, where the conclusions drawn in Jansen 1985 are refined.
8. On the evidence for Berchem's residence in Haarlem and Amsterdam between 1656 and his death, see Van Thiel-Stroman in Rotterdam–Frankfurt 1999–2000, p. 242.

9. On Van Laer and his influence, see Blankert 1968.

10. See London 2002, no. 32, listing several earlier exhibitions.

11. On his drawings, see Schatborn 1974 and Schatborn in Amsterdam 2001, pp. 187–95.

5. *Rest*

Oil on wood, 17 x 13½ in. (43.2 x 34.3 cm)
Signed and dated (lower left): cBerghem 1644 [cB in monogram]

The painting is well preserved but has suffered slight abrasion throughout. As the paint film and ground have become more transparent over time, the wooden support has begun to assert itself visually, appearing as darkened spots in the sky. Examination by infrared reflectography reveals that most of the composition is freely underdrawn; the dog at lower right, however, was not underdrawn.

Purchase, 1871 71.125

This is one of the earliest known works by Berchem, painted in 1644, when he was about twenty-two or twenty-three years old. In the past, the signature has been misread as "Berchem," and the date considered illegible or no longer discernible. However, the date read by Schatborn in 1974 (see Refs.) is visible to the naked eye and quite clear under magnification. The inscription has not been modified or reinforced.[1]

The work has its awkward moments, especially in the female figure and in the cow, with the horns seemingly perched atop its head. But the trees and sky are fluidly painted with considerable skill, and the figures, while lacking the artist's later flair, are (as Albert Blankert has noted) characteristic of his early work.[2] Most of the composition was prepared with underdrawing.[3] There are five white female goats and one dark male goat, shown nibbling a plant. The dog (which is not underdrawn) sniffs or licks the ground. Water may have been suggested in the lower right corner of the picture, but as in other areas of the ground this passage is now too thin to read closely.

Similar compositions are familiar from Berchem's oeuvre of the 1640s.[4] One of the most analogous designs is that of the *Italian Landscape*, dated 1645, in the Koninklijk Museum voor Schone Kunsten, Antwerp.[5] The same general arrangement of forms, with trees to the side, figures resting beneath them, and a deep recession over mostly flat landscape, dates back to the mid-1630s in the work of Jan van Goyen (q.v.), Pieter van Laer (1599–?1642), and other artists working in or associated with Haarlem.[6]

As Schatborn has shown, the figure of the standing man is based on a drawing by Berchem of about 1643–44 (fig. 6). The pose has been slightly modified, especially in the right leg. Although evidently sketched from life, the pose can be traced back to the Farnese Hercules.[7] A view of the Roman statue from the back was drawn by Hendrick Goltzius (1558–1617) in 1591 and engraved by the same artist about 1592. Goltzius's stepson Jacob Matham (1571–1631) also drew the rear of the sculpture a little later in the 1590s.[8] It seems likely that these images were occasionally copied, or used to pose models, by drawing students in Haarlem.

In 1926, Hofstede de Groot identified this picture with a painting in the sale of the collection of Nicolaas van Bremen, in Amsterdam (at the firm of De Winter and Yver), on December 15, 1766, where it sold with a pendant; and with no. 6 (which was offered without a pendant) in the 1846 Héris sale in Brussels (see Ex Coll.).[9] Nevertheless, it appears doubtful that it is identical with the one in the earlier sale. The two Berchems in the Van Bremen collection are described in the sale catalogue as "Een Veedrift in 't gebergte" (A cattle drive in the mountains), measuring one *voet* and four *duimen* high by one *voet* and eight *duimen* wide, and "Een weerga daar een Herder en Herderinne same legge te koute by veel Vee" (A pendant with a shepherd and a shepherdess lying together in conversation next to many cattle), measuring one *voet* and six *duimen* high by one *voet* and eleven and a half *duimen* wide.[10] The second painting is somewhat larger than the Museum's picture and appears to differ in several details. Moreover, the paintings in the Van Bremen sale are specifically described as broad, not tall-format pictures. Each work in that sale is

Figure 6. Nicolaes Berchem, *A Standing Shepherd*, ca. 1643–44. Black and white chalk on blue paper, 8½ x 4¼ in. (21.7 x 10.7 cm). Rijksprentenkabinet, Rijksmuseum, Amsterdam

6. Compare Van Goyen's *Shepherd and Shepherdess*, of 1636 (location unknown; Beck 1972–73, vol. 2, no. 167). On Van Laer and his influence, see Renckens 1954, Blankert 1968, and The Hague 1994–95, pp. 24–26, 64.

7. See Schatborn 1974, p. 6.

8. See Amsterdam–New York–Toledo 2003–4, no. 42, where Jan de Bisschop's etching after Matham's lost drawing (reversing the pose, as here) is illustrated as fig. 42c.

9. Hofstede de Groot 1907–28, vol. 9 (1926), p. 222, no. 618, where the painting is said to be the pendant of Hofstede de Groot's no. 628b.

10. Hoet 1752–70, vol. 2, p. 482.

REFERENCES: MMA 1871, pl. 3 (etching by Jules Jacquemart); Decamps 1872, p. 437, mentions this picture as in the MMA; James (1872) 1956, pp. 59, 63, considers it "a lovely Berghem"; Harck 1888, p. 76, as in the MMA; Hofstede de Groot 1907–28, vol. 9 (1926), pp. 222, 224, no. 618; Von Sick 1930, p. 17, fig. 6, considers the work, "of extraordinary quality," to be closely related to a painting dated 1647 (formerly Cook collection, Richmond); Schaar 1958, pp. 14, 25 n. 22, as dating from about 1647, and as closely related to the *Italian Landscape*, of 1645 (Koninklijk Museum voor Schone Kunsten, Antwerp), and to the *Milkmaids and Cattle by a Spinney*, dated 16[45?]; Ann Arbor 1964 (under no. 5) compares the *Resting Shepherds*, an early Berchem in the Allen Memorial Art Museum, Oberlin College, Oberlin, Ohio; Gerson 1964, p. 346, supports the comparison with the Oberlin picture; Stechow 1964, p. 15, fig. 10, observes that the New York and Oberlin paintings feature "the same combination of Italianate foreground and Dutch background"; Santifaller 1972, p. 486, fig. 3, describes the work as "Berchem's famous painting" and as the kind of peaceful landscape that inspired Tiepolo; Schatborn 1974, pp. 6–8, 15–16 n. 11, fig. 5, notes that Berchem's drawing of a standing shepherd in the Rijksprentenkabinet, Amsterdam, was used for the male figure in the Museum's picture, which the author considers to be dated, "most probably," 1644; Schatborn in Amsterdam–Washington 1981–82, p. 67, fig. 2, and p. 130 (under no. 11), repeats the comparison made in Schatborn 1974; White 1982, p. 22 (under no. 21), considers *A Shepherd and Shepherdess with Flocks*, in Windsor Castle, and the Museum's picture to belong to a group of Berchem paintings dating from the mid-1640s; Baetjer 1995, p. 326, as signed "Berchem," with no mention of the date; Baetjer 2004, pp. 170, 173, 197, 221–22, 245, appendix 1A, no. 159 (ill. p. 221), fig. 12, includes the Van Bremen sale of 1766 in the provenance (see Hofstede de Groot 1907–28).

EX COLL.: [Monsieur Héris, Brussels, until 1846; his sale, Schoeters and Étienne Le Roy, Brussels, June 19, 1846, no. 6, for BFr 650]; Marquise Théodule de Rodes, Brussels (until d. 1867; her estate sale, Hôtel des Commissaires-Priseurs, Paris, May 30, 1868, no. 2, for FFr 1,020 to Gauchez); [Léon Gauchez, Paris, with Alexis Febvre, Paris, 1868–70; sold to Blodgett]; William T. Blodgett, Paris (1870; sold half share to Johnston); William T. Blodgett, Paris, and John Taylor Johnston, New York (1870–71; sold to MMA); Purchase, 1871 71.125

described carefully in terms of height ("h.") and breadth ("br."), and the information throughout appears to be reliable. At present, then, this "lovely Berghem" (according to Henry James in his article on the 1871 Purchase) cannot be traced before it appeared in the large estate sale of the Belgian art dealer Héris in 1846.

1. Conservator Dorothy Mahon kindly assisted in studying the inscription, in October 2004. The 4s have angular tops (as here), not open.

2. Albert Blankert, letter to the writer dated May 9, 1996, firmly agrees with the several scholars who had earlier considered the work typical of the early Berchem, and suggests a date of about 1645. On visits to the Museum, Sturla Gudlaugsson (1956) and Horst Gerson (1964) described the picture as a good early work. Blankert held to this opinion when he reexamined the picture in 2003.

3. Noted by Dorothy Mahon (see note 1 above).

4. See White 1982, p. 22 (under no. 21). To his examples one might add *Landscape with a Nymph and a Satyr*, dated 1647 (J. Paul Getty Museum, Los Angeles).

5. The two pictures are reproduced together in Stechow 1964, figs. 9, 10.

5

CHRISTOFFEL VAN DEN BERGHE

Antwerp ca. 1590–1628 or later; active in Middelburg

The artist's family fled Flanders and settled in the Zeeland city of Middelburg. Very few relevant documents are known apart from those recording Van den Berghe in 1619 as a "leader" in the painters' guild of Middelburg, and in 1621 as the guild's dean.[1] In December 1621, he bought a house in Middelburg ("in de Corte Breestrate bij 't Begynhoff"), which he still owned in January 1628. The archives of Bergen op Zoom (in neighboring North Brabant) indicate that the artist intended to marry in May 1627, but a document of June 1628 reveals that the wedding bells never rang.[2]

Van den Berghe worked in two genres that flourished in Middelburg during the early seventeenth century, flower pictures and landscape painting. One of his few dated works is *Vase of Flowers in a Stone Niche*, signed "CV BERGHE 1617" (Philadelphia Museum of Art, John G. Johnson Collection).[3] The picture has been described as a synthesis of qualities found in flower still lifes by the Middelburg master Ambrosius Bosschaert the Elder (1573–1621), and by the Fleming Roelant Savery (1576–1639), who at the time lived in Amsterdam.[4] Van den Berghe's other known still lifes are mostly in the same vein, except for *Still Life with Dead Birds*, signed and dated "Cv berghe 1624" (J. Paul Getty Museum, Los Angeles),[5] and a vanitas picture with a skull, shell, and vase of flowers.[6]

The painter's landscapes are now as rare as his flower pictures. Key works for defining his oeuvre are the small pendants on copper in the Mauritshuis, The Hague, which are typically monogrammed "CVB" and date from about 1615–20.[7] These animated river views, representing the seasons of summer and winter, strongly recall landscapes by Adriaen van de Venne (1589–1662), who worked in Middelburg during the first quarter of the century (his earliest known paintings are from 1614, and include a pair of summer and winter scenes).[8] Landscape painting in Middelburg followed Flemish conventions, so that the earlier attribution of the Mauritshuis pictures to David Vinckboons (q.v.), and later to Paul Bril (ca. 1554–1626), is not surprising. Van den Berghe's small *Winter*

Landscape with Ice Skaters in the Museum Mayer van den Bergh, Antwerp, is contemporary with the paintings in The Hague.[9] The little *Landscape with Peasant Wagon* (art market, 1967), in the manner of Jan Brueghel the Elder (1568–1625), had its original monogram, "CVB," altered to read "JB."[10] Finally, the miniature *Wooded Landscape with a Gothic Palace* (private collection, Germany) shows a more imaginary side of Van den Berghe's work, and recalls forest scenes painted in Amsterdam by Vinckboons and by Gillis van Coninxloo (1544–1607).[11]

Van den Berghe appears to have painted the figures in all his landscape pictures, and they help to distinguish his works from those by other artists. The painting discussed below is an important addition to his known oeuvre.

1. Bredius in Obreen 1877–90, vol. 4, pp. 260–61, cited in Bol 1956, p. 185.
2. Bol 1956, p. 194, on the house and the betrothal. Van den Berghe is not documented after 1628. On evidence for a still life supposedly dated 1642, see note 5 below.
3. See Amsterdam–Cleveland 1999–2000, no. 7. Duparc 1980, p. 13, cites a winter landscape dated 1622 (art market, 1969), but the attribution is doubtful.
4. Segal in Amsterdam 1984, p. 76.
5. Jaffé 1997, p. 10 (ill.). As suggested in Meijer 1994, pp. 150, 156 n. 5, the still life said to be signed and dated "C. V. Berghe 1642" (presumably a misprint for 1624) in a Middelburg auction of 1779 is very probably identical with the Getty picture. Segal in Amsterdam 1984, p. 78, suggested that the canvas was actually painted by Gillis de Bergh (ca. 1600–1669), but this is not at all convincing.
6. Leiden 1970, no. 2; Amsterdam 1984, no. 33. For other still lifes by the artist, see Bol 1956, pp. 183–89; Bol 1982c, pp. 48–53, figs. 40–43; New York 1988, no. 3; Gemar-Koeltzsch 1995, vol. 2, pp. 83–84.
7. Duparc 1980, pp. 12–13 (ill. pp. 152–53). See also Bol 1982c, pp. 100–101, figs. 82, 83, and The Hague 2001–2, no. 11.
8. Bol 1989, pp. 17–18, figs. 3, 4 (Gemäldegalerie, Berlin). See also M. Royalton-Kisch in *Dictionary of Art* 1996, vol. 32, p. 230, and Baltimore 1999, no. 56.
9. Bernt 1979–80, vol. 1, no. 110.
10. Bol 1982b, p. 9, fig. 3.
11. Amsterdam 1979–84, pp. 100, 234–35, no. 59.

6. *A Winter Landscape with Ice Skaters and an Imaginary Castle*

Oil on wood, 10¾ in. x 17¾ in. (27.3 x 45 cm)

The condition of the painting is good; however, the castle, frozen water, ice skaters, and tree branches are abraded. The panel has been thinned to ⅛ in. (.32 cm) and laminated to a plywood panel support that has been cradled.

From the Collection of Frits and Rita Markus, Bequest of Rita Markus, 2005 2005.331.1

The earlier attribution of this picture to the pioneering painter of winter scenes Hendrick Avercamp (1585–1634) goes back to 1929, when the Dutch connoisseur Cornelis Hofstede de Groot (1863–1930) provided his expertise to a London art dealer. Clara Welcker, who published the standard monograph on Avercamp in 1933, generally deferred to Hofstede de Groot's opinions, and although she did raise the question of the panel's authorship, she allowed that it appeared to be one of Avercamp's earliest known works.[1] Her affirmative answer is explained partly by the fact that the painting was said to bear Avercamp's monogram (no inscription is visible now), and also because

landscapes by Christoffel van den Berghe were unknown at the time. For the past seventy-five years, the picture has evidently received almost no critical scrutiny.[2] The Markus bequest to the Museum will help to clarify the early development both of Avercamp and of the winter scene in Dutch art.

Comparison with pictures that were certainly painted by Avercamp early in his career, such as the *Winter Landscape* dated 1608 (Billedgalleri, Bergen), a simpler skating scene dated 1609 (private collection), *Ice Skating near a Village*, of about 1609–10 (Rijksmuseum, Amsterdam, on loan to the Mauritshuis, The Hague, since 1924), and *A Winter Scene with Skaters near a Castle*, of about 1609 (National Gallery, London), shows that the "Mute of Kampen" (Avercamp, a deaf-mute, was known by this sobriquet) employed similar compositions to the one found here, but that he had a very different sense of space, form, atmosphere, and coloring.[3] Avercamp's ground planes extend clearly and deeply toward the horizon, and his buildings, which look geometrically three-dimensional, assist the figures, trees, boats, and other forms in measuring prog-

ress from foreground to background, and even from side to side. He favors light tones overall with many local color accents, resulting in a crisp atmosphere well suited to his usual subject of a frozen river on a sunny day.

The present picture creates a very different impression. The artist seems more interested in filling the composition with curious shapes, delicately balanced, than in measuring distances (the sense of depth, compared with Avercamp's, appears rather rushed, and the ground plane slightly concave). Jagged silhouettes are exploited to artistic effect, but are softened by the thin application of paint and intimations of atmosphere. In these qualities the work is indeed "very 'Flemish,'" as noted by Blankert (see Refs.), for a Dutch landscape of this early period. (The costumes, as well as the style of the picture, suggest a date of about 1615–20.) And the painting is also less reminiscent of Avercamp or any artist working in North Holland (for example, David Vinckboons; q.v.) than of the winter landscapes that Adriaen van de Venne (1589–1662) painted in Middelburg during the same years. Both the figures and the setting in Van den Berghe's small *Winter Scene* of about 1615–20 (Mauritshuis, The Hague) strongly support an attribution of the Markus picture to that contemporary of Van de Venne's in Middelburg.

The painting's subject, the pleasures of wintertime, raises the question of whether the panel, like the Mauritshuis picture, might originally have had a pendant depicting summer.[4] The view is centered on a pink brick castle with a typical Flemish tower, a gate tower, and a drawbridge. A village, dominated by a church, closes the hazy view in the left background. Beyond the last houses receding on the right, a windmill on a hill is faintly visible through bare branches. A small farmhouse, a hayrick, and a larger building (possibly an inn) are framed by craggy trees on the left, where a snow-dusted boat is also frozen in the ice. Myriad figures stand, walk, talk, skate, sleigh, and play on the ice. In the right foreground, the group of five figures seen from the back—three men sporting swords and two women, one with a high lace collar and fur muff through which she grasps a gentleman's hand—represents the upper class. Nearby figures could be described as middle class, except for the boy defecating by the tree to the left, who is inconveniently

approached by a boy with a snowball. Crows perch in the trees and fly in the cloud-streaked sky.

The central motif of a castle occurs in many Dutch winter scenes of this period, both in paintings and in prints.[5] Castles with moats, and even in lakes, were common in the Netherlands, and offered a picturesque backdrop—and perhaps a perennial flavor—to winter scenes of people at play.

1. C. Welcker 1979, p. 88 (pp. xvi, 201, on the author's debt to Hofstede de Groot).
2. However, Otto Naumann (oral opinion, ca. 1996) mentioned the possibility of Van den Berghe's authorship at least a decade ago. Since then, the present writer has borne the picture in mind when examining the landscapes by Van den Berghe in The Hague and in Antwerp (see the biography above), and paintings by Avercamp and other possible candidates. Anthony Chrichton-Stuart, of Christie's, New York, also knew the Markus picture during the 1990s and independently came to the conclusion that it is probably by Van den Berghe.
3. See Amsterdam 1982, nos. 1, 2, 5, and MacLaren/Brown 1991, pp. 3–4, no. 1346, pl. 3, for good photographs of these pictures. For the Bergen panel of 1608, see also Stuttgart 2005–6, pp. 73–75, no. 18.
4. See Duparc 1980, pp. 12–13; Bol 1982a, pp. 100–101, figs. 82, 83; or The Hague 2001–2, no. 11 (fig. 1 for the pendant).
5. See, for example, Keyes in Amsterdam 1982, pp. 39–42, figs. 11–14, and pp. 150–51, no. 33.

REFERENCES: C. Welcker 1933, pp. 88, 204, no. s13, pl. 1, fig. XIII, cites the painting as an early work by Hendrick Avercamp, with the art dealer N. Beets in Amsterdam; C. Welcker 1979, pp. 88, 204, 237–38, nos. s13, s406, s415, pl. 1, fig. XIII, adds provenance of 1929; Blankert in Amsterdam 1982, p. 27, lists the picture (known only from Welcker's monograph) as one of the early, "very 'Flemish' pictures" by Avercamp, dating from about 1605–8.

EXHIBITED: Amsterdam, Kunsthandel J. Goudstikker, "Hollandsche winterlandschappen uit de 17de eeuw," 1932, no. 5.

EX COLL.: [Asscher and Welker, London, in 1929]; [P. de Boer, Amsterdam, and Ch. de Burlet, Berlin, in 1930]; [N. Beets, Amsterdam];[1] Frits and Rita Markus, New York; From the Collection of Frits and Rita Markus, Bequest of Rita Markus, 2005 2005.331.1

1. C. Welcker 1979 (see Refs.) lists the work as with Beets at or about the time of publication in 1933 (1st ed.).

ABRAHAM VAN BEYEREN

The Hague 1620/21–1690 Overschie

Van Beyeren is best known for his *pronkstillevens* (still lifes of luxurious objects),[1] like the one discussed below, but in the Netherlands especially he is also admired for his fish still lifes.[2] His father, Hendrick Gillisz van Beyeren, was a glazier in The Hague. In 1636, the painter was cited in guild records as a pupil of Tyman Cracht (ca. 1600–1645/46), who is known to have worked on the decorations of Honselaarsdijk Palace, the Stadholder's palace near The Hague, in 1638.[3] After a brief period in Leiden, where he married Emmerentia Stercke in 1639, Van Beyeren returned to The Hague and became a master in the painters' guild in 1640. At an unknown date, Van Beyeren's first wife died (leaving him a widower with three daughters). In 1647, the artist married Anna van den Queborn, a painter, and daughter of the engraver and portraitist Crispijn van den Queborn (1604–1652).[4] Anna's aunt Maria van den Queborn was married to a painter of fish still lifes, Pieter de Putter (ca. 1600–1659), who was probably Van Beyeren's main source of inspiration in pictures of this type dating from the 1640s.[5]

A large votive panel made by Van Beyeren and another artist in 1649 for the fishermen's guild in Maassluis displays his talent for depicting fish and marine views.[6] However, the average fish still life brought very little money, even in The Hague, where the genre flourished. Financial difficulties were probably the main reason that Van Beyeren moved from place to place. In 1657, he joined the painters' guild in Delft, but returned to The Hague in 1663. From 1669 to 1674, he lived in Amsterdam, and then moved farther north to Alkmaar, where he joined the guild in 1674. The next year, he and his wife returned to South Holland, living first in Gouda (1675–77)[7] and then near Rotterdam in Overschie, where the artist bought a house in 1678. He purchased another house in Overschie in 1680; Anna was said to be sick in bed when she made out a will in 1679, but the date of her death is unknown.[8] Van Beyeren remained in Overschie until he died in 1690.

The first known *pronk*, or fancy, still lifes by Van Beyeren date from the early 1650s.[9] They are quite elaborate banquet displays with expensive silver, porcelain, glassware, fruit, lobsters, and so on, which like the settings (silk-covered tables, large-scale architecture, and in some pictures curtains drawn aside)

suggest the influence of Jan de Heem (q.v.; see Pl. 75). The turn to this type of still life by Willem Kalf (q.v.) and others at about the same time, or somewhat earlier, must have encouraged Van Beyeren to produce costlier pictures, and to attract a more discerning clientele. Some of the luxurious objects in his banquet still lifes are rather closely described, but on the whole he retained and refined the broad technique and brown tonalities that he had earlier employed in fish still lifes. "Monochrome" banquet still lifes were a specialty of Pieter Claesz and Willem Claesz Heda (q.q.v.) in Haarlem, and Van Beyeren must have been familiar with their work as well.[10] The great majority of his fancy still lifes are tall in format and busy in design, with warm local color accents and numerous reflections (in this regard, Kalf's Paris-period luxury still lifes come to mind). Van Beyeren often worked on a larger scale than most of his Dutch colleagues, painting pictures about a meter high.

The artist also painted fish still lifes after 1650, as well as quiet pictures of wineglasses and fruit, a few flower pieces, and paintings of dead game birds.[11] The known dates tend to indicate that the most elaborate works were generally painted in The Hague or Amsterdam, which is what might be expected, but the many undated works by Van Beyeren make the issue of market demand difficult to judge.[12]

1. The term is explained in Segal 1989, where "sumptuous still life" is chosen as an ungainly English equivalent. The verb *pronken* means to show off, preen, or display ostentatiously.
2. On this subgenre, see Utrecht–Helsinki 2004, where Van Beyeren's contribution is discussed by Meijer on pp. 39–42, 251–59. On the artist's work in general, see Bergström 1956, chap. 6; Segal 1989, chap. 9; and Scott A. Sullivan's entry in *Dictionary of Art* 1996, vol. 3, pp. 900–901.
3. None of Cracht's works are known today. See The Hague 1998–99, p. 296, and p. 286 on Van Beyeren.
4. See ibid., p. 339.
5. On De Putter and Van Beyeren, see Meijer in Utrecht–Helsinki 2004, pp. 37–42, and pp. 247–49 for more on De Putter. He is incorrectly described by some authors as Van Beyeren's brother-in-law, for example in P. Sutton 1990a, p. 16.
6. See Bergström 1956, pp. 229–30, fig. 191, as by "P. Verbeek(?)" and Van Beyeren. On Verbeek, whom Bergström regards as "possibly active in The Hague," see ibid., pp. 235–36. A Pieter

Verbeeck the Younger was active in The Hague during the 1660s and 1670s (see The Hague 1998–99, p. 355).

7. See Helbers 1947, where the following documents are quoted: "Anna van Beyeren, living on the Turfmarkt, coming from Amsterdam," became a member of the Janskerk in Gouda (a Reformed Church) on September 29, 1675. The same register describes her on June 20, 1677, as "Anna van Beyeren, housewife of Abraham van Beyeren, having lived on the [Turf]markt, is departed to Overschie."

8. The relevant documents were published in Bredius 1915–22, part 7, pp. 13–14.

9. In Meijer 2003, p. 162 (under no. 9), it is suggested in a discussion of one of Van Beyeren's earliest still lifes of this type that he probably started painting them during the second half of the 1640s. The Ward collection of Netherlandish still lifes in the Ashmolean Museum, Oxford, has five examples by Van Beyeren (ibid., nos. 9–13), including a fish still life, probably of about 1655–60.

10. As noted in ibid., p. 163, where Cornelis Kruys (1619/20–1654) is also discussed. Some useful remarks on Van Beyeren's development, taking into consideration still lifes by Jacques de Claeuw (1623–1694 or later), are found in S. Sullivan 1974.

11. For examples of the last type, dated 1661 and 1675, see S. Sullivan 1984, figs. 97, 98.

12. According to Segal 1989, p. 173, no dated *pronkstillevens* are known from the period 1657–66, which includes the years Van Beyeren lived in Delft. However, some Delft artists worked for clients in The Hague.

7. *Still Life with Lobster and Fruit*

Oil on wood, 38 x 31 in. (96.5 x 78.7 cm)
Signed (left, on table): ·AVB· f [AVB in monogram]

Van Beyeren's palette was usually understated, but it is clear that this painting has lost some local color with age.

Anonymous Gift, 1971 1971.254

Probably dating from the early 1650s, this panel was painted quite thinly and freely, with an understated palette that has lost some color with age. Blue tones, in particular, have diminished; the table cover was most likely a stronger purple, and of course the Chinese cup was originally blue and white. Thinning of the paint with age (not abrasion) has caused some loss of form, and the impression of hovering highlights in the tall, silvergilt covered cup, a decorative or ceremonial piece known as a *Buckelpokal* (knobby goblet, in German; cups in this style were made mainly in Augsburg and Nuremberg).

The composition could be characterized as a simpler, quieter, more intimate version of a type of banquet, or *pronk*, still life (see Van Beyeren's biography above) that flourished in Antwerp during the 1640s, with artists such as Jan de Heem

Figure 7. Abraham van Beyeren, *Large Still Life with Lobster*, 1653. Oil on canvas, 49⅜ x 41⅜ (125.5 x 105.1 cm). Bayerische Kunstgemäldesammlungen, Alte Pinakothek, Munich

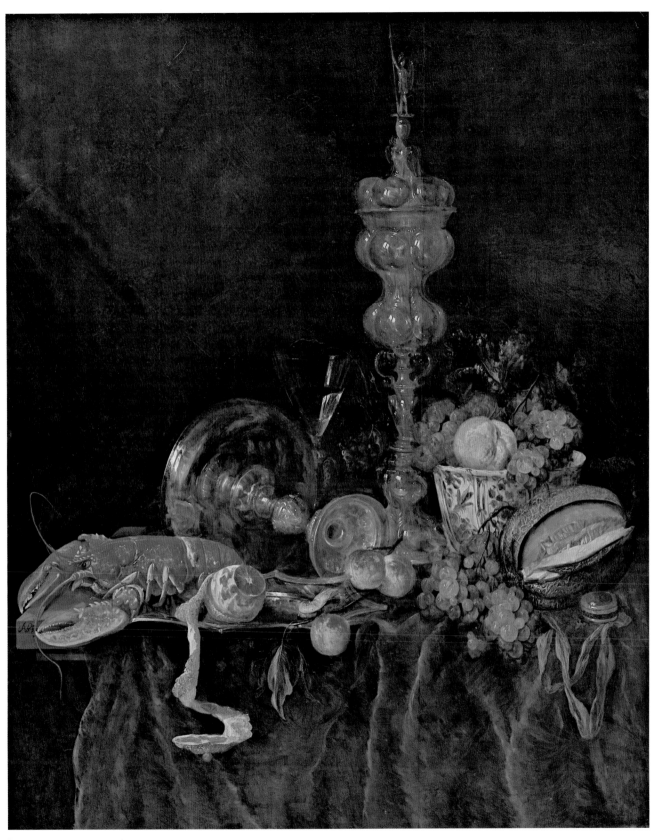

7

(q.v.), Alexander Adriaenssen (1587–1661), and Adriaen van Utrecht (1599–1652). In 1646, Van Utrecht contributed to the decorations of the Huis ten Bosch, near The Hague, and thus may have come to Van Beyeren's attention in the court city.[1]

The lobster, the tipped-over tazza, and the sliced melon were common motifs in works by De Heem and his circle well before Van Beyeren's earliest known use of them in a dated picture, the quite Flemish-looking *Large Still Life with Lobster*, of 1653 (fig. 7). In that canvas, a lobster is the centerpiece in a pile of luxurious tableware and cascading fruit, while in the New York picture the lobster, on a pointed silver platter with a peeled lemon (recalling Kalf; see Pl. 97) and a single shrimp, is placed to the side (where the lobster's claws point to the artist's monogram). A long stem allows one of three peaches to dangle over the near edge of the table, as do an unusual number of motifs (even for a still life of this kind). Green grapes surround the melon, and purple grapes set off a large peach in the Wanli bowl (actually a tall cup of a type known as a *kraalkop*, or crow cup, in Dutch).[2] Behind the tazza is a *façon de Venise* wineglass, half-full, and to the lower right is a pocket watch on a blue ribbon. The timepiece, like the dazzling reflections and the very freshness of the fruit, would have suggested to viewers of the period life's swift passage.[3] They might also have recognized the soldier crowning the covered cup as the "Christian Knight" (Miles Christianus), who through faith alone overcomes the Seven Deadly Sins.[4] In literary accounts, the hero is rarely concerned with avarice and gluttony, but he rises above those temptations here.

1. See Vienna–Essen 2002, nos. 4, 85, 86, 89, 90, for examples of the Antwerp type; and ibid., p. 374, on Van Utrecht's work for the Dutch court.
2. See Van der Pijl-Ketel 1982, p. 119. A crowlike bird is painted in the center of many Wanli cups of this shape, hence the name.
3. One of the most balanced treatments of this subject, in an entry on a painting by Van Beyeren that includes similar motifs, is by De Jongh in Auckland 1982, pp. 79–83 (under no. 7).
4. See Bergström 1983, pp. 440, 442–43, figs. 1, 4, 5 (cited in Ter Kuile 1985, p. 72 n. 2, with reference to a painting by Van Beyeren with a similar covered cup).

REFERENCES: Virch 1970, p. 3, gives basic catalogue information; Walsh 1974a, pp. 348–49, fig. 12, describes the picture as "a relatively sober work of the 1650s thinly and fluently painted," identifies the "tall silver-gilt covered cup, a type made in Nuremberg in the late-sixteenth and early-seventeenth centuries, the silver-gilt tazza of the same period and the Ming porcelain bowl," and suggests the influence of Willem Kalf; MMA 1975, p. 92 (ill.); P. Sutton 1986, p. 190, mentioned; Baetjer 1995, p. 327; Gemar-Koeltzsch 1995, vol. 2, p. 104, no. 28/38 (ill.); Meijer 2003, p. 165, notes the similar lobster, dish with pointed rim, melon, and other motifs in Van Beyeren's *Still Life with Lobster and Turkey* (Ashmolean Museum, Oxford), and suggests, indirectly, a dating to the early 1650s.

Ex COLL.: [Galerie Sanct Lucas, Vienna; sold to a private collection, Vienna];[1] private collection, Vienna, and later Greenwich, Conn. (by 1938–71; seized in Paris by the Nazis, held at Alt Aussee, Austria [1074/3], and at Munich collecting point [1275], returned to France, October 30, 1946; restituted; given by owner to MMA); Anonymous Gift, 1971 1971.254

1. According to a letter from the present owner of the gallery, dated June 20, 2000, the gallery has no records dating before 1938.

CORNELIS BISSCHOP

Dordrecht 1630–1674 Dordrecht

Houbraken, who like Bisschop was a native of Dordrecht, reports that the artist was born on February 12, 1630, and died in 1674 at the age of forty-four, leaving eleven children. These and other specific details, and the fact that the biographer devotes a paragraph to each of Bisschop's painter sons, Jacobus (1658–1697 or later) and Abraham (1670–1731), suggest that he obtained his information from a member of the immediate family.[1]

The artist's father, Jacob Dionysz Bisschop, was a tailor and the proprietor of an inn, De Pauw (The Peacock), on the Wijnstraat in Dordrecht. Jacob's wife, Anna van Beveren, came from Utrecht. Houbraken records that the young Cornelis studied with Ferdinand Bol (q.v.), who was also from Dordrecht. This must have been in Amsterdam, presumably during the second half of the 1640s. In this period, Bisschop may have become acquainted with, in addition to Bol, two other Rembrandt pupils from Dordrecht, Samuel van Hoogstraten (q.v.), who was with Rembrandt until about 1647, and Nicolaes Maes (q.v.), who was in the master's studio between about 1649–50 and 1652 or 1653. In any case, Bisschop was strongly influenced by Bol's work of the 1640s and by Van Hoogstraten and Maes during the 1650s and later. Affinities with Gerbrand van den Eeckhout and Willem Drost (q.q.v.) underscore Bisschop's early connection with the Rembrandt school.

On October 26, 1653, Bisschop and Geertruyt Botland, "both of Dordrecht," were married in that city.[2] The couple's first child, Anna, was baptized less than six months later, on April 10, 1654. Caterina was born in 1655, Maria in 1656, and then a child was born about every other year, altogether eight girls and four boys.[3] The parallel to Vermeer's life is intriguing: Vermeer, also an innkeeper's son, was born in 1632, died in 1675 at the age of forty-three, and left his wife with eleven children, seven or eight of them girls. There was also, as in Delft, art dealing in the Dordrecht family, according to Balthasar de Monconys (1611–1665), who visited the Bisschops in July 1663, a few weeks before his better-known visit to Vermeer. The learned French diplomat describes Bisschop's wife as a seller of paintings and sewing thread, and the artist himself as a painter who also decorated cabinets, chests, toiletry cases, and so on.[4] On April 6, 1669, another connoisseur

and diarist, Pieter Teding van Berkhout (1643–1713), traveled from the court city of The Hague to Bisschop's studio, and found him "a painter excellent for perspective." About five weeks later, on May 14, 1669, Teding van Berkhout paid his first visit to Vermeer; upon his second visit, on June 21, he noted that "the most extraordinary and the most curious aspect" of Vermeer's work "consists in the perspective."[5]

The best illustration of this "aspect" in Bisschop's oeuvre is *The Apple Peeler*, of 1667 (Rijksmuseum, Amsterdam), which may also be described as his most Vermeer-like work.[6] This and other scenes of middle-class life by Bisschop were inspired mainly by genre pictures painted in Dordrecht by Maes and Van Hoogstraten, although they also reflect broader developments in the region of South Holland.[7] In religious and mythological pictures of the 1650s and 1660s, and in a few paintings of old women reading Bibles, Bisschop is clearly a follower of Maes. As in that artist's work, a warm palette and rich effects of light and atmosphere recall Rembrandt and artists in his circle about midcentury.[8]

In the 1660s and 1670s, Bisschop was also quite active as a fashionable portraitist; Houbraken refers to the many artful examples that may be seen not only in the province of Holland but also in Zeeland, Brabant, and elsewhere. The most impressive portrait known today is Bisschop's painting of himself in 1668 (Dordrechts Museum, Dordrecht).[9] The dignified *Portrait of a Wine Merchant's Family*, dating from about 1670 (Gemäldegalerie Alte Meister, Kassel), is a large fragment.[10] In 1671, the artist was commissioned to paint his thirteen-figure portrait, *The Male and Female Regents of the Holy Sacrament Hospital* (Dordrechts Museum, Dordrecht).[11] This project and the request, in the last year of his life, that he become court painter to the king of Denmark (according to Houbraken) are among several signs of the considerable esteem that Bisschop earned during his twenty-year career, although he struggled to meet the needs of his growing family.[12] Another sideline, in addition to painted chests and boxes, was the fabrication of approximately life-size dummy-board figures, that is, illusionistic cutouts depicting people. Houbraken relates that one of these *chantourné* pictures, as they are sometimes called, was offered tips by unsuspecting houseguests.[13] It may

well have been this kind of work that attracted the attention of Christian V of Denmark, since his court artist Cornelis Gijsbrechts (ca. 1630–after 1675) painted illusionistic still lifes, including large cutout pictures like the *Trompe-l'oeil Easel with Fruit Piece*, of about 1670 (Statens Museum for Kunst, Copenhagen).[14]

1. Houbraken 1718–21, vol. 2, pp. 220–23, on the Bisschops. In a mostly helpful biography, Loughman in Dordrecht 1992–93, p. 85, states that Bisschop was baptized, as opposed to born, on February 12, 1630.
2. G. Veth 1887, p. 157.
3. The baptismal dates are listed in Dordrecht 1992–93, p. 85 n. 1. Houbraken (1718–21, vol. 2, p. 222) writes that of Bisschop's "three sons" (indicating that one had died), "two of them, and also three daughters," became artists. Anna Bisschop married the Dordrecht painter Abraham van Calraet (1642–1722) in 1680.
4. De Monconys 1665–66, vol. 2, p. 128, cited by Loughman in Dordrecht 1992–93, p. 85, where Bisschop's wife is mistakenly called Anna.
5. See New York–London 2001, pp. 14, 568 n. 56, on these visits by Teding van Berkhout, and p. 414 on his family and for another instance of enthusiasm for linear perspective.
6. See the entry by Wieseman in Dordrecht 1992–93, pp. 88–89, no. 5, and Liedtke 2000a, pp. 162–63, 253–54, fig. 309.
7. See Liedtke 2000a, chap. 4.
8. See the substantial section on Bisschop in the "Maes" pages of Sumowski 1983–[94], vol. 3, pp. 1961–62, 1964–66 nn. 61–93, and the plates on pp. 1977–99.
9. Dordrecht 1992–93, pp. 90–92, no. 6.
10. See Schnackenburg 1996, p. 62, pl. 212, supporting Sumowski's identification of a canvas depicting three children (location unknown) with most of the missing piece (Sumowski 1983–[94], vol. 3, pp. 1962, 1999 [ill.]).
11. Dordrecht 1992–93, pp. 42–43, fig. 7. Bisschop's portraits are discussed in the second part of Brière-Misme's five-part article on the artist (Brière-Misme 1950, pp. 104–16).
12. See Brière-Misme 1950, pp. 29–30, 40.
13. Houbraken 1718–21, vol. 2, p. 220. See Brusati in Dordrecht 1992–93, pp. 93–95, no. 7, which discusses a cutout panel depicting a sleeping child in a highchair (private collection), in my view correctly attributed to Bisschop. The painting was sold at Sotheby's, New York, January 25, 2007, no. 55, as by Bisschop.
14. See Copenhagen 1999, pp. 35–36, 176–78, no. 15, and London 2000, pp. 52–53, on *chantourné* pictures and the panel in Copenhagen. In 1664, De Monconys (see text above) met Gijsbrechts in Regensburg, and bought one of his letter-rack illusionistic still lifes (Koester in London 2000, pp. 12–13). Van Hoogstraten (q.v.), Bisschop's slightly older Dordrecht colleague, worked in Regensburg in 1653 and 1654.

8. *A Young Woman and a Cavalier*

Oil on canvas, 38½ x 34¾ in. (97.8 x 88.3 cm)

The paint surface has been flattened and abraded overall. The most serious alteration is the loss of form in the woman's red bodice where the modeling glazes have been disrupted.

The Jack and Belle Linsky Collection, 1982 1982.60.33

The painting was little known until it came to the Museum with the Linsky Collection in 1982. In a letter of 1954 to Jack Linsky, W. R. Valentiner proposed (or accepted) an attribution to Gabriël Metsu (q.v.), and noted the possible connection with a picture exhibited as by Metsu in 1868.[1] The present writer's conclusion, in 1984 (see Refs.), that the work was painted about the early 1660s in Dordrecht by Cornelis Bisschop has been consistently supported by specialists.

The paintings by Bisschop that are most comparable in style date from the late 1650s and the 1660s, and include the signed *Old Woman Seated in Thought* (Spencer Collection, Althorp);[2] *Joseph and Potiphar's Wife* (Kunstmuseum, Düsseldorf), which was formerly said to be signed and dated 1664;[3] and the large *Self-Portrait*, of 1668 (Dordrechts Museum, Dordrecht).[4] Bisschop followed Maes in his occasional rendering of domestic scenes on a large scale, with figures set against dark backgrounds (as in the Althorp canvas) and soft effects of light, shadow, and atmosphere. A warm palette, typical of Dordrecht, and a comparatively broad application of paint are found in works of this type, which include, according to Sumowski, *A Young Man and a Girl Playing Cards*, in the National Gallery, London.[5] The young man in that painting and, more obviously, the amorous visitor in the Linsky picture strongly

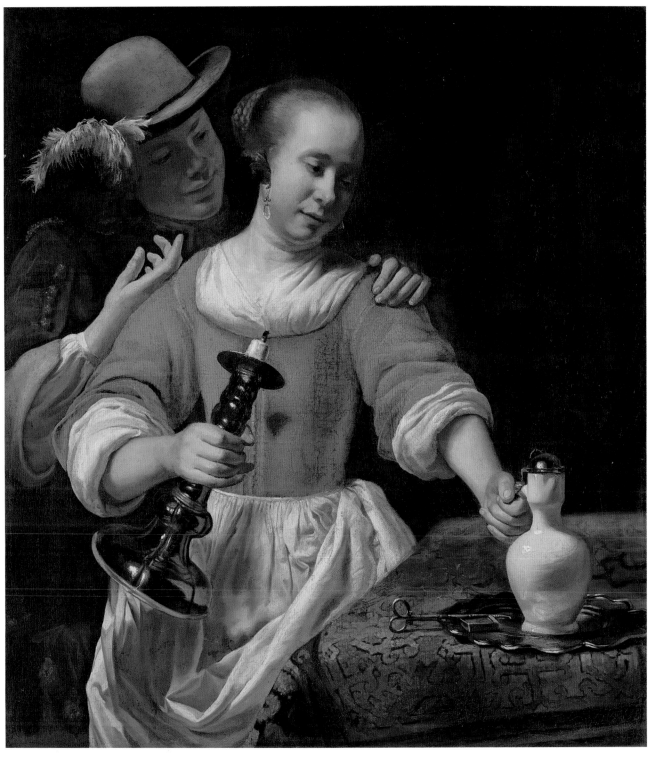

8

resemble Bisschop himself, to judge from the *Self-Portrait* of 1668 (which must follow the present work by five or six years). Furthermore, the woman in the New York canvas seems to be the same model Bisschop employed in a few pictures dating from the 1660s, such as *Joseph and Potiphar's Wife* (mentioned above) and *The Apple Peeler*, of 1667 (Rijksmuseum, Amsterdam). Brière-Misme concluded plausibly that she is Bisschop's wife, Geertruyt Botland.[6]

It was suggested in the Linsky Collection catalogue (see Refs.) that Bisschop's reputation for painting approximately life-size dummy-board figures (see the biography above) was relevant to the attribution of *A Young Woman and a Cavalier*. The scale and silhouetted effect of the figures in this canvas bring those illusionistic works to mind. Houbraken notes that Bisschop's cutout figures with candlesticks in their hands are painted in the manner of night pieces.[7] However, it should also be recalled that figure paintings, including genre scenes (like Vermeer's *Mistress and Maid*, of about 1666–67, in the Frick Collection, New York), were occasionally given very dark backgrounds in the early to mid-1660s, and were sometimes executed on a larger scale than usual.[8] For an artist already familiar with Maes's large-figure genre paintings of the 1650s, this fashion of the next decade must have had particular appeal.

The subject of Bisschop's painting brings to mind antecedents such as Gerrit van Honthorst's *Young Couple Lighting a Candle with a Hot Coal*, of about 1622 (Herzog Anton Ulrich-Museum, Braunschweig), and Rembrandt's *The Prodigal Son in the Tavern*, of about 1635 (Gemäldegalerie Alte Meister, Dresden).[9] In the latter, the painter and his wife served as models, and almost certainly were meant to be recognized.[10] Rembrandt's canvas has been placed in the context of a tradition (or common practice) in which artists depicted themselves as the Prodigal Son or *pictor vulgaris*, a type that wittily plays on the contemporaneous norm of presenting oneself as a gentleman, courtier, or learned individual (as in Dou's *Self-Portrait*; Pl. 37). Van Mander reports that Dürer gave his own features to the Prodigal Son in his engraving of 1498, and he also praises Hans von Aachen's portrait of himself carousing with a lute-playing courtesan (private collection), which probably dates from the 1590s and anticipates the arrangement of the figures in Bisschop's composition. Among the Dordrecht painter's contemporaries, Jan Steen (q.v.) routinely used his own well-known features, as well as those of family members, in ribald genre scenes (as in Pls. 196, 197), and Metsu more politely cast himself as a modern-day Prodigal Son in a tavern with his well-dressed wife, in a panel dated 1661 (Gemäldegalerie Alte Meister, Dresden).[11]

We do not know if Bisschop expected viewers to recognize the figures in the present painting as himself and his wife (if it is she), but this would hardly have been surprising in the rather small art world of Dordrecht. And the work may have hung in the artist's own home. However, its sympathetic treatment of romance seems in harmony with Dutch genre pictures of the 1660s—by Gerard ter Borch, Pieter de Hooch (q.q.v.), and others—in which no personal note is found. Furthermore, the young woman and her "cavalier" (the traditional term implies no more than gallant behavior) are not meant as models of decorum. To judge from his hat and sword belt (and perhaps the cloak hung on the wall to the right), the young man has just arrived on the scene; but the point of his visit appears to have been understood in advance. The woman picks up a wine jug and silver candlestick, on which the painter displays his ability to render reflections. The couple will no doubt retire to another room. For some viewers the extinguished wick of the candle, and perhaps the wick trimmer on the tray, may have been regarded as vanitas symbols, while other viewers may have remembered the saying "De kaers uyt, de schaemschoe uyt," meaning, "When the candle goes out, shame is extinguished too."[12] Of course, the candlestick is also an illusionistic motif, projecting forward from the bodice and apron, where its shadow falls. The object's distortion, implying a very close point of view, draws added attention to it, and is an artistic conceit employed frequently enough in the period for Bisschop's Dordrecht colleague Samuel van Hoogstraten to have complained about it.[13] Whether or not the candlestick and jug were also meant (as they would have been by Steen) as allusions to male and female anatomy is a question that, thankfully enough, must remain in the shadows of the past.

The painting's carved and gilded frame is remarkable, and possibly original to the picture. The canvas is unusually close to square in format, and neither it nor the frame has been cut down, suggesting that Bisschop himself may have put them together.[14] An expert on Dutch frames, C. J. de Bruyn Kops, considers the frame likely to have been made in the Netherlands during the 1660s.[15] A pair of frames in a very similar auricular style, but without the elephant heads and lion's muzzle at the top, are original to portraits of Jasper Schade and his wife, dated 1654, by Cornelis Jonson van Ceulen the Elder (q.v.; Rijksmuseum Twenthe, Enschede).[16] Another similar frame is seen in the background of Metsu's *A Man and Woman Seated by a Virginal*, of about 1663–65 (National Gallery, London).[17]

1. See Refs. and Exh. In a letter from W. R. Valentiner (in Los Angeles) to Jack Linsky, dated June 7, 1954, the scholar observes, "from the excellent color reproduction which you sent, it was not difficult to see that the painting is a fine work by Metsu," and he refers to Hofstede de Groot's no. 573 (see Refs.). A black-and-white photograph made in New York for Mr. Linsky (now in the curatorial files) bears on the back Valentiner's certificate, dated February 2, 1955, to the effect that the painting is by Metsu, and probably dates from about 1656–60.

2. Oil on canvas, 57⅛ x 39⅜ in. (145 x 100 cm), signed and dated "C. Bissch . . . 165[?]," according to Sumowski 1983–[94], vol. 3, pp. 1962, 1966 n. 86 (with earlier literature), and p. 1995 (ill.).

3. Ibid., pp. 1962, 1986 (ill.); Becker et al. 2002, pp. 16–17.

4. Dordrecht 1992–93, pp. 90–92, no. 6, where the colorplate is much too red. The present writer has examined the *Self-Portrait* in Dordrecht on several occasions and is convinced that the Linsky painting is by the same hand.

5. Sumowski 1983–[94], vol. 3, pp. 1962, 1966 (the proper note, n. 82, is not indicated, but begins in the twelfth line of n. 81), p. 1993 (ill.). In MacLaren/Brown 1991, pp. 371–72, no. 1247, pl. 299, the work is catalogued under Follower of Rembrandt, and Sumowski's attribution to Bisschop is considered "interesting" but "speculative" (see also Bomford et al. 2006, p. 209, where the attribution to Bisschop is doubted). Sumowski's comparison to the Althorp picture and his suggestion that the male figure in the London canvas strongly resembles Bisschop himself are not considered in MacLaren/Brown 1991.

6. Brière-Misme 1950, p. 188.

7. Houbraken 1718–21, vol. 2, p. 220.

8. See my discussion in New York–London 2001, p. 393, where Vermeer's large canvas in the Frick Collection is compared with Michiel Sweerts's *Clothing the Naked*, of about 1660–61 (MMA) and with works by Frans van Mieris (q.v.) and Karel du Jardin (1626–1678). In Bisschop's painting the woman's pose, the artful interplay of contours, and certain effects of light, like the indirect illumination of the man's face, are also typical of the period (compare Vermeer's *Young Woman with a Water Pitcher*; Pl. 203).

9. See Judson and Ekkart 1999, pp. 201–2, no. 262, pl. xv, and *Corpus* 1982–89, vol. 3, pp. 134–47, no. AIII (p. 146 on interpretations of the subject).

10. See Chapman 1990, pp. 114–20, where it is supposed that Rembrandt "made the picture for himself and not on commission" (p. 114).

11. Ibid., p. 118, cites these and other examples, and refers to Van Mander 1604, fol. 209v (on Dürer) and fol. 290r (Von Aachen). The painting by Von Aachen is illustrated in Kaufmann 1988, p. 72, fig. 51. A variant of that composition, *A Young Couple*, of about 1596 (Kunsthistorisches Museum, Vienna), shows Von Aachen and his wife, Regina di Lasso, in different poses; see Fucíková in Essen 1988, pp. 211–12, no. 92, pl. 13. On Metsu's self-portrait with his wife in a tavern, see also F. Robinson 1974, pp. 29, 32, fig. 34. Also relevant are the remarks in *Corpus* 2005, p. 142, about Frans van Mieris placing himself in genre pictures and modeling for *tronies*.

12. The saying is connected with a different Dordrecht picture in Brusati 1995, p. 204, following Broos (see ibid., p. 311 n. 46).

13. Van Hoogstraten 1678, p. 34. This question is treated at greater length in Linsky Collection 1984, pp. 95, 97, where Van Hoogstraten is quoted in n. 18.

14. Conservator George Bisacca observed that the frame has never been cut, and Conservator Dorothy Mahon confirmed that the canvas remains close to its original size.

15. C. J. de Bruyn Kops, on a visit to the Museum, January 10, 1984.

16. Van Thiel and De Bruyn Kops 1995, no. 34, where the influence of the silversmiths of the Vianen family and Johannes Lutma (1584?–1669) is discussed.

17. Ibid., fig. 9; MacLaren/Brown 1991, pp. 255–56, pl. 217.

REFERENCES: The painting is possibly that cited in Hofstede de Groot 1907–27, vol. 1 (1907), p. 308, no. 175f, as *A Woman Holding a Jug and a Man behind Her*, by Gabriël Metsu, with no mention of support, dimensions, or inscriptions, where the author notes that the work was "exhibited at Leeds, 1868, no. 573, [lent] by Baron de Ferrières"; Liedtke in Linsky Collection 1984, pp. 94–96, no. 33, attributes the work for the first time to Cornelis Bisschop, describes the subject as an amorous genre scene, and suggests that the artist used himself and possibly his wife as models; W. Liedtke in MMA, *Notable Acquisitions, 1983–1984* (New York, 1984), p. 56, summarizes the entry in Linsky Collection 1984; Chong and Wieseman in Dordrecht 1992–93, p. 28, fig. 25, cite the work as a typical genre scene by Bisschop, and as closely related to large-scale genre paintings by Nicolaes Maes; Baetjer 1995, p. 333; Liedtke in New York 1995–96, p. 151 (under no. 53), mentions the picture in connection with Maes's influence on Bisschop; Salomon 2004, p. 127 n. 26, places it within a broad tradition of images that associate "lust and drunkenness."

EXHIBITED: Possibly Leeds, Leeds City Museum, "National Exhibition of Works of Art, at Leeds, 1868," 1868, no. 573, as by Gabriël Metsu, *A Woman Holding a Jug and a Man behind Her* (lent by Baron de Ferrières).

EX COLL.: ?Baron de Ferrières (in 1868; as by Gabriël Metsu, "A Woman Holding a Jug and a Man behind Her"); Mr. and Mrs. Jack Linsky, New York (by 1954–80; as by Metsu);[1] The Jack and Belle Linsky Foundation, New York (1980–82); The Jack and Belle Linsky Collection, 1982 1982.60.33

1. Valentiner's letter of June 7, 1954, to Jack Linsky (see note 1 above) suggests that the collector had recently bought the picture in London or Paris. A photograph of the painting in the Rijksbureau voor Kunsthistorische Documentatie, The Hague, was obtained from P. Landry, Paris, in 1953.

ABRAHAM BLOEMAERT

Gorinchem 1566–1651 Utrecht

Bloemaert's life spanned the entire period of the Eighty Years' War, from the revolt of 1566 (he was born on December 24) to the Peace of Westphalia (1648) and beyond (he died at the age of eighty-four on January 13, 1651). Once Paulus Moreelse and Joachim Wtewael (q.q.v.) had died, both in 1638, Bloemaert stood alone as the grand old man among Utrecht artists, and remained very productive until the end of his life. He was an eminent teacher, and his students included Hendrick ter Brugghen (q.v.), Gerrit van Honthorst (1592–1656), Jan van Bijlert (1597/98–1671), Cornelis van Poelenburch (1594/95–1667), Jacob Gerritsz Cuyp (1594–1651/52), Jan Both (ca. 1615/18–1652), and Jan Weenix (q.v.).

Bloemaert's father, Cornelis Bloemaert (ca. 1540–1593), was a sculptor and architect from Dordrecht. In 1567, he worked in 's Hertogenbosch, repairing the damage done by iconoclastic rioters in the previous year. The family settled in Utrecht by 1576, where Abraham trained with his father, with a drunken dauber (according to Van Mander) named Gerrit Splinter, and with Joos de Beer (active 1575–d. 1591), a former pupil of the famous Antwerp painter Frans Floris (1519/20–1570). "Even though he [De Beer] was not one of the best painters himself, he had many handsome works by [the Floris disciple Anthonie] Blocklandt [1533/34–1583] and other clever masters in his house. Here Bloemaert copied in oil a piece by Dirck Barendsz [1534–1592], being a contemporary banquet [scene]."[1] This tuition ended because Bloemaert's father "felt that he had enough clever pieces of his own for copying," for example the Floris designs after which his son had made drawings earlier, and "a very clever kitchen piece by the elder Langen Pier," that is, Pieter Aertsen (1507/8–1575).[2]

Van Mander writes of the regret Bloemaert expressed to his pupils, saying that he never had the advantage of studying with a "good master."[3] However, the practice of copying designs by a variety of artists was not a bad beginning for such a precocious draftsman. In 1581 or 1582, when Bloemaert was about fifteen years old, he was sent to Paris to work for two and a half years with a certain Master Herry, and then briefly with Hieronymus Francken (ca. 1540–1610). The latter served the French court at Fontainebleau, where Bloemaert must have studied the decorations by Rosso Fiorentino, Niccolò dell'Abate, Primaticcio,

and others. Bloemaert's earliest known dated painting, the ambitious *Slaying of the Niobids*, of 1591 (Statens Museum for Kunst, Copenhagen), has been described as "unthinkable without the distant examples" of Rosso and Primaticcio, although its main debt is to Cornelis Cornelisz van Haarlem (1562–1638).[4]

Between about 1585 and 1590, Bloemaert evidently worked with his father in Utrecht. In 1591, they went to Amsterdam, along with Cornelis's former pupil the famous architect and sculptor Hendrick de Keyser (1565–1621). Cornelis worked for the city as an engineer, and Abraham finally established himself as an independent artist. He became a citizen of Amsterdam in October 1591, and for the next two years came to know some of the major artists of the day, including Van Mander, Jacques de Gheyn (q.v.), and the engravers Jacob Matham (1571–1631), Jan Muller (1571–1628), and Jan Saenredam (1565–1607). In the spring of 1592, Bloemaert married Judith van Schonenburch, a woman from a patrician family in Utrecht who was nearly twenty years his senior. After his father's death in the fall of 1593, Bloemaert settled in Utrecht. His wife died of the plague in 1599, and on October 12, 1600, the artist married a brewer's daughter, Gerarda de Roij. The couple had numerous children, four of whom became artists: Hendrick (1601/2–1672), a painter and poet; Cornelis (ca. 1603–1692), a painter and important printmaker; Adriaen (ca. 1609–1666), a painter; and Frederick (ca. 1616–1690), an engraver who worked mostly after his father's designs, including those for the *Konstryk tekenboek* (Artistic Drawing Book; Amsterdam, 1711).

Bloemaert flourished in the next three decades. With Paulus Moreelse (q.v.) as the driving force, he helped to establish a new painters' guild in 1611, and about a year later an academy for students of drawing. His style after 1600 turned in a more naturalistic direction, and his mythological and religious compositions, many of them set in thriving landscapes, became widely known through engravings by Matham, Saenredam, and several other printmakers. A devout Catholic, Bloemaert accepted a number of important commissions for altarpieces, among them the *Adoration of the Shepherds* (Louvre, Paris), which was painted in 1612 for the Convent of the Poor Clares in 's Hertogenbosch, where his sister Barbara was a nun.[5]

In 1617, Bloemaert and his family moved into a large house

on the Mariaplaats in the center of Utrecht, where he would spend the remaining thirty-four years of his life. He was appointed dean of the painters' guild in 1618, but later in the same year Prince Maurits replaced the city council, which led to the dismissal of Remonstrants and Catholics from public office (the trusty Protestant Moreelse took over again). Nonetheless, the 1620s were Bloemaert's most successful years. A sophisticated stylist, the master responded to the innovations of artists he had once taught, such as Ter Brugghen and Honthorst. His synthesis of Mannerist and Caravaggesque qualities is less eclectic than lyrical, a blend of naturalistic and idealized forms well suited to the poetic spirit of the Utrecht school in this period. It is not surprising that Bloemaert received commissions from Prince Frederick Hendrick, the Stadholder (from 1625 to 1647), among them *Theagenes Receiving the Palm of Honor from Chariclea*, dated 1626 (Mauritshuis, The Hague), and the *Wedding of Amarillis and Mirtillo*, of about 1635 (Jagdschloss Grunewald, Berlin).[6]

Bloemaert was still turning out technically accomplished paintings and drawings in his early eighties. He was a superb and prolific draftsman, by whom more than fifteen hundred figure drawings, preparatory studies for pictures, nature drawings, and sketches of rural life are known. Although he never went to Italy, he absorbed a great deal from the many Utrecht painters who did. And for all the travels and influence of his onetime disciple Honthorst, Bloemaert seems the more international figure, and the better artist.

A portrait of Bloemaert, dated 1609, was painted by Moreelse (Centraal Museum, Utrecht), and served as the model for prints by Matham and others.[7]

1. For these remarks in Van Mander's 1604 biography of the young Bloemaert, see Van Mander/Miedema 1994–99, vol. 1, p. 446 (fol. 297r), and the commentaries in vol. 6, pp. 84–91. No works by De Beer survive. As discussed in ibid., vol. 6, p. 88, De Beer's death was the subject of a letter by the Utrecht humanist Aernout van Buchell (mentioned here also in the biographies of Moreelse and Willaerts) in February 1591, so he did not die in 1599 as stated in C. J. A. Wansink's biography of Bloemaert in *Dictionary of Art* 1996, vol. 4, p. 150. On Barendsz, see Judson 1970.
2. Van Mander/Miedema 1994–99, vol. 1, p. 446.
3. Ibid., vol. 1, p. 449 (fol. 297v).
4. Roethlisberger 1993, p. 66 (under no. 14), and see pl. II. The most extensive biography of Bloemaert is that contributed by Marten Jan Bok in ibid., vol. 1, pp. 551–87, where, however, the stay in France receives almost no attention (pp. 556–57). Slightly more is offered in Van Mander/Miedema 1994–99, vol. 6, pp. 90–91. The most useful concise biography of Bloemaert is Bok's in Amsterdam 1993–94a, pp. 300–301, which does not mention any of the artist's works. Some major examples are cited by Wansink in *Dictionary of Art* 1996, vol. 4, pp. 150–53.
5. Roethlisberger 1993, no. 222, pl. 333. See Bok in ibid., pp. 567–70, on Bloemaert and the "Catholic elite" of Utrecht, to which he was allied by marriage.
6. Ibid., nos. 425, 513, pls. 595, 697. For the canvas of 1626, see also Broos 1993, pp. 65–71, no. 5.
7. Roethlisberger 1993, vol. 1, frontis., vol. 2, figs. 1–3 (prints); Helmus 1999, vol. B, pp. 1174–75, no. 450.

9. *Moses Striking the Rock*

Oil on canvas, 31⅜ x 42½ in. (79.7 x 108 cm)
Signed and dated (lower right): A·Blomaert·fe/a°·1596

The paint surface is flattened and blanched, and abrasion has exposed the crowns of the canvas weave.

Purchase, Gift of Mary V. T. Eberstadt, by exchange, 1972
1972.171

In Bloemaert's version of the Old Testament subject (Exod. 17:1–6), the children of Israel march out of Egypt either naked or provocatively dressed, and weighed down with earthenware pots, copper-lined cookware, and, in the arms of their least modest maiden, a silver-gilt ewer dating from the late sixteenth century (A.D.). The issue of drinking water had come up before, and despite Moses's performance of a miracle, and his injunction to "diligently hearken to the voice of the Lord thy God" (Exod. 15:22–27), complaints and disputes arose repeatedly. These were answered by bread raining down from heaven (Exod. 16:1–5), the striking of water out of solid rock (the Mountain of Horeb, meaning "dry," in the Sinai desert), and other solutions, culminating with the Ten Commandments (which, because of incidents surrounding the Golden Calf, required two drafts).

Bloemaert had employed largely nude ensembles in earlier mythological works, such as *The Wedding of Peleus and Thetis*, of about 1590–91 (Alte Pinakothek, Munich), and *The Judgment of Paris*, of about 1592 (private collection).[1] *The Flood* (Yale University Art Gallery, New Haven), a mostly male affair from the first half of the 1590s, brought the same sort of staging into the religious realm.[2] However, that academic study of strained anatomy hardly prepares one for the hysterical mood and frenzied eroticism of *Moses Striking the Rock*. Apart from a small number of marginal figures, a character comparable to the central one here does not occur again in biblical scenes by Bloemaert.

The graceful young woman's prominence led one scholar to suggest that the artist's subject is really *Aqua*, an allegory of water.[3] This is highly unlikely, given the absence of paintings by Bloemaert depicting the three other elements, and the fact that every motif in the composition, including the central figure, is consistent with the episode described in Exodus. Moses, in the left background, is shown just after having struck the rock, and his followers are in the first throes of responding to the miracle. People bend and stretch extravagantly in an effort to contain the lifesaving flow of water. Two men, to the lower left and right of Moses, raise their faces to

Heaven in thankful prayer. In the background, camels are brought forward to drink and small groups of figures reveal somewhat less excessive responses to the latest sign that the Lord is watching over them. The flourishing foliage on the outcrop of rock indicates that Moses combined basic survival skills with his unfailing faith.

The central figure has been compared with the heroine in Vasari's *Andromeda* and the man in the left foreground with bending bathers in Michelangelo's *Cascina* cartoon.[4] The Florentine roots of Dutch Mannerist figure types are well known. But more directly relevant to the Museum's picture is Bloemaert's knowledge of the decorations at Fontainebleau, especially Primaticcio's stucco caryatids (1541–44) in the Chambre de la Duchesse d'Étampes, whose gracefully raised arms, sinuous contrapposto, and the elegant ewer at one maiden's feet suggest that Bloemaert's memory of the palace, filtered through his more immediate experience of prints by and after Goltzius (who like Primaticcio emulated Parmigianino), informed the female figure types and poses in this design.[5] The extraordinary display of fancy fabric, however, is typical of Bloemaert himself. The male figures, especially the one to the left, bring to mind heftier nudes by Cornelisz van Haarlem.[6] The density of the composition, with its balletic interplay of poses and gestures, and its calculated placement of props and stage scenery, is somewhat more in the spirit of Joachim Wtewael (q.v.), Bloemaert's contemporary in Utrecht, than of their Haarlem associates. On the whole, Bloemaert's composition may be described as an original invention inspired by an eclectic survey of recent Dutch Mannerist forms. The intended viewer was an experienced connoisseur.[7]

As noted by several scholars (see Refs.), a drawing in the Musée du Louvre appears to be a copy of a preparatory drawing by Bloemaert for this composition.[8] The right half of the drawing, including the main figure, is largely in agreement with the painted design, but the two most prominent figures to the left are quite differently posed (although they play the same roles), and the cow has not yet arrived.

1. Roethlisberger 1993, nos. 12, 17, pls. 26, 40.
2. Ibid., no. 16, pl. 34.
3. Broos in The Hague–San Francisco 1990–91, p. 168 (under no. 8), where fig. 6 is an engraving after Goltzius, *Aqua*, dated 1586. The image is that of a nude female figure in the foreground with a large urn spilling water and, in the background, the Baptism of Christ.

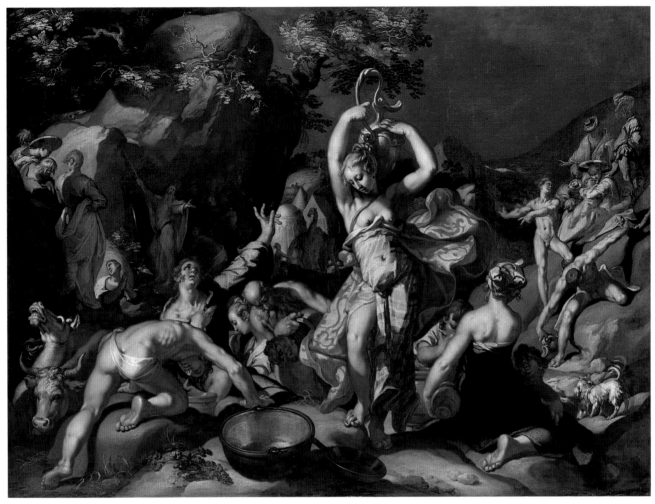

9

4. Roethlisberger 1993, vol. 1, p. 92; Seelig in San Francisco–Baltimore–London 1997–98, p. 134. Vasari's *Andromeda* is actually less similar to Bloemaert's figure than is the frontal Saint John in Jacopino del Conte's *Preaching of the Baptist*, of 1538 (Oratory of San Giovanni Decollato, Rome).

5. Among the relevant engravings by Goltzius are Strauss 1977, nos. 170 (*Andromeda*, 1583), 255 (various figures in the famous *Wedding of Cupid and Psyche*, 1587), and 315 and 337 (the female figure type in *Pygmalion and Galatea*, of 1593, and *Venus in Half-Length*, of 1596).

6. The best-known picture with such figures is Cornelisz's *Massacre of the Innocents*, of 1591 (Frans Halsmuseum, Haarlem); Van Thiel 1999, no. 42, pls. V, VI. See also ibid., pl. IV, and pls. 79, 80.

7. This point is stressed by Seelig in San Francisco–Baltimore–London 1997–98, p. 133, and it undercuts his claim that "the analogy with [Christian] salvation is obvious." As noted by Broos in The Hague–San Francisco 1990–91, p. 167, the Utrecht art lover Aernout van Buchell mentioned a Bloemaert painting (now lost) of Moses Striking the Rock in a diary entry of 1591. Broos associates the lost picture, which was evidently quite large, with Bloemaert's drawing of the subject in the Schlossmuseum,

Weimar (ibid., p. 167, fig. 3), but in Roethlisberger 1993, vol. 1, pp. 92–93, the drawing is convincingly dated to a later decade.

8. The most convenient reproduction is in The Hague–San Francisco 1990–91, p. 167, fig. 4.

REFERENCES: Frimmel 1892–1901, vol. 1 (1892), p. 120 n., reports recently seeing this previously unknown painting by Bloemaert at Miethke's, Vienna; Frimmel 1909, p. 67 n., recalls the painting as with Miethke about twenty years earlier, and states that it is probably the picture that was sold in a Posonyi auction, Vienna, December 1872; Delbanco 1928, pp. 24–25, 74, no. 8, fig. VIII, mentions the remote position of Moses; Lindeman 1928, p. 233, considers the Louvre drawing (see end of text above) a sketch for the composition, and describes how the central female figure in the painting is strongly set off from the rest of the painting by her light coloring; Lindeman 1929, pp. 120, 233, believes the Louvre drawing to be a sketch for the composition; Lugt 1929–33, vol. 1, p. 13 (under no. 86), considers the Louvre sketch a study for the painting, but "would not be astonished to discover elsewhere a better version of this drawing"; M. Lavin 1965, p. 125, compares a figure in the Museum's

picture with one in the monochrome *River Gods with Apollo and Daphne* (Busch-Reisinger Museum, Harvard University, Cambridge, Mass.); Roethlisberger 1967, pp. 20–21, cites the picture as an example of the growing importance of landscape in Bloemaert's work during the 1590s, and sees the artist as closely associated with Wtewael and Cornelisz van Haarlem at the time; Bennett and Mongan in Minneapolis and other cities 1968, unpaged (under no. 5), consider Bloemaert's *Ritual Washing of the Israelites*, a drawing of 1616, to recall earlier biblical narratives like this one; Hill in Poughkeepsie 1970, pp. 18–19, no. 3, pl. 38, "shows the influence of Spranger and Goltzius, and most especially that of Cornelis van Haarlem"; Slatkes 1970, p. 432 (under no. 3), suggests that the painting is "an autograph replica, perhaps with some studio participation, of a now lost prime version"; Lowenthal 1974b, pp. 127–28, 131, 133, fig. 5, relates the picture's style to that seen in Wtewael's oeuvre; Walsh 1974a, pp. 340–41, 349 nn. 1, 2, fig. 1, celebrates the work as the Museum's first Dutch Mannerist painting, rejects the estimate offered in Slatkes 1970, and compares a "possibly earlier" drawing of the same subject by Bloemaert, with the figures differently arranged (Schlossmuseum, Weimar); MMA 1975, p. 92 (ill.), superficially describes the picture's style; Hibbard 1980, pp. 276, 278, fig. 498, views the work as "an elaborate pantomime" and as "possibly an autograph replica of a lost painting"; Nichols 1980, pp. 5–6, fig. 1, considers the typically Mannerist composition and observes that the "seductive, seminude figure paradoxically symbolizes salvation through living water since the Old Testament story (Exod. 17:2–6) was understood as a prototype of New Testament baptism"; Lowenthal 1986, pp. 69–70, fig. 34, compares the painting as an example of Bloemaert's style with pictures by Wtewael; P. Sutton 1986, pp. 179–80, fig. 254, pens a turgid appreciation; Broos in The Hague–San Francisco 1990–91, pp. 165–68, no. 8 (ill. p. 164) and fig. 1 (detail), erroneously assumes that the painting was owned by Mary Eberstadt (see credit line below), compares the Louvre drawing (which is apparently a copy of Bloemaert's preliminary sketch for this composition), and suggests implausibly that the picture's subject is actually "*Aqua* rather than a story from the Old Testament"; P. Sutton in ibid., p. 104, observes that the canvas "came during John Walsh's curatorship"; W. Robinson in Amsterdam and other cities 1991–92, p. 20 n. 3 (under no. 1), compares the style of the Abrams drawing with that of the Museum's picture and other works; Liedtke in New York 1992–93, p. 95 (under no. 11), cites the painting as an instance of Bloemaert's shift in the mid-1590s away from convoluted surface effects, and toward more realistic anatomy and figure types; Roethlisberger 1993, vol. 1, pp. 22, 92–93, no. 46, vol. 2, figs. 81–85, pl. IV, considers the picture one of the foremost works of Bloemaert's Mannerist phase, describes the composition, and sees the agitated figures as embodying the agonies of thirst; Baetjer 1995, p. 296; C. J. A. Wansink in *Dictionary of Art* 1996, vol. 4, p. 150, notes the more evenly distributed figures,

compared with those in earlier works; C. Brown 1997, pp. 22–23, 70, fig. 6, frontis. (detail), describes the composition and some figures as "closely modelled on those of Cornelis van Haarlem"; Seelig in San Francisco–Baltimore–London 1997–98, pp. 132–35, 408, no. 1, and pp. 271, 272 (under no. 46), considers "the analogy with salvation" obvious in this pivotal work, reviews sources for the figures in Michelangelo, Cornelisz van Haarlem, and antique sculpture, and (in n. 11) rejects Broos's (1990–91) idea that the painting constitutes an allegorical representation of water; Spicer in ibid., p. 24, as a work that beautifully exemplifies a love of complexity; P. Sutton in Rotterdam–Frankfurt 1999–2000, p. 124, compares Pieter de Grebber's handling of the same subject in about 1630; Roethlisberger 2000, p. 160, fig. 11, dates the Weimar drawing (see Walsh 1974a above) later and relates it to Bloemart's painting of the subject, dated 1611, in Halle; Hardin in Saint Petersburg 2001, pp. 14, 38 (ill.), 53, 56, no. 3; Metzler in ibid., pp. 30–31, discusses the placement of the main figure (Moses) in the background as an example of contemporary taste; Roethlisberger in ibid., pp. 16–17, 19. Bolton 2007, vol. 1, pp. 29, 31 (under nos. 39, 44), discusses the Louvre drawing, which the author rejects.

EXHIBITED: Poughkeepsie, N.Y., Vassar College Art Gallery, "Dutch Mannerism: Apogee and Epilogue," 1970, no. 3 (lent by Bagley Reid, New York); New York, MMA, "Abraham Bloemaert, 1564–1651: Prints and Drawings," 1973, no. 1; New York, MMA, "Patterns of Collecting: Selected Acquisitions, 1965–1975," 1975–76, p. 32; The Hague, Mauritshuis, and San Francisco, Calif., The Fine Arts Museums of San Francisco, "Great Dutch Paintings from America," 1990–91, no. 8; San Francisco, Calif., The Fine Arts Museums of San Francisco, Baltimore, Md., The Walters Art Gallery, and London, The National Gallery, "Masters of Light: Dutch Painters in Utrecht during the Golden Age," 1997–98, no. 1; Saint Petersburg, Fla., Museum of Fine Arts, "Abraham Bloemaert (1566–1651) and His Time," 2001, no. 3.

EX COLL.: Possibly Jan Vincent Coster, Amsterdam, in 1622; John Andrews (his sale, Christie's, London, March 3, 1832, no. 65, "A. Bloemaert, 1596. Moses striking the rock"; sold to art dealer Tuck for £8.8); Isidor Sachs, ?Vienna (until d. 1871; posthumous sale, Posonyi, Vienna, December 17, 1872, no. 97); [H. O. Miethke, Vienna, about 1890]; Carl Franze, Tetschen (until 1916; his estate sale, Lepke's, Berlin, November 7, 1916, no. 63); Prof. Dr. Curt Glaser, Berlin (by 1928–33; sale, Internationales Kunsthaus, Berlin, May 9, 1933, no. 241, to Gurlitt); [Wolfgang Gurlitt, Munich, 1933–at least 1962]; [Adolphe Stein, Paris, until 1965; sold for $8,000 to Kleinberger]; [Kleinberger, New York, 1965–66; sold to Reid]; Bagley Reid, New York (1966–72; sold to MMA); Purchase, Gift of Mary V. T. Eberstadt, by exchange, 1972 1972.171

FERDINAND BOL

Dordrecht 1616–1680 Amsterdam

Bol was a highly successful artist in Amsterdam, but like several slightly later pupils and followers of Rembrandt he came from the South Holland city of Dordrecht. He was baptized there on June 24, 1616, in a Reformed Church. His father, Balthasar Bol (d. 1641), earned a comfortable living as a master surgeon, and Ferdinand's brother Jan entered the same profession. The artist's teacher is not named in documents. However, Jacob Gerritsz Cuyp (1594–1651/52), the father of Aelbert Cuyp (q.v.) and the most prominent painter in Dordrecht at the time, is a likely candidate.[1]

Bol probably went to study with Rembrandt in Amsterdam in about 1636, and he appears to have remained with that master until about 1641. The earliest signed and dated works by Bol are from 1642 (see the *Portrait of a Woman*, below), when he was already twenty-six. It has been plausibly suggested that Bol's role in Rembrandt's workshop evolved from that of a student to that of an assistant during the late 1630s,[2] but there is no evidence indicating that he collaborated with Rembrandt or with another pupil or assistant on any particular work.[3]

Like Rembrandt, Bol specialized in portraits and history pictures. His style in works of the 1640s is often strongly reminiscent of Rembrandt, as is especially evident in several self-portraits, in biblical paintings such as *The Holy Women at the Sepulchre*, of 1644 (Statens Museum for Kunst, Copenhagen), and *The Sacrifice of Isaac*, of 1646 (Mansi Collection, Lucca),[4] and in drawings and etchings of the same decade.[5] In commissioned portraits, particularly those of women (see Pl. 10), Bol moved more quickly away from his teacher, as did Govert Flinck (q.v.) and other former Rembrandt pupils during the mid- to late 1640s.

In 1653, Bol married Elisabeth (or Lysbeth) Dell (1628–1660), the daughter of Elbert Dell and Cornelia Dircksdr Spiegel. The latter's older brother, Elbert Spiegel, was receiver general of the Amsterdam Admiralty, in which Elbert Dell served as vendue master. In addition, Cornelia's eldest brother, Hendrick Spiegel, was an Amsterdam city councillor and burgomaster.[6] These connections brought Bol a number of important commissions, although he had already established a reputation in 1649 with his large canvas *Four Regents of the Amsterdam Lepers' House* (Amsterdams Historisch Museum, Amsterdam).[7] Nine years after Bol's first wife died, Bol married the wealthy widow

Anna van Erckel (1624–1680); the couple settled into a grand house on the Herengracht in Amsterdam, and the painter evidently retired (no work is known to date from the last decade of his life). In 1672, the Bols moved to a house on the Keizersgracht (the present no. 672).[8] The erstwhile artist survived his wife by three months; he was buried on July 24, 1680, in the Zuiderkerk.

Among Bol's most prestigious, if not attractive, pictures are the five-meter-high (more than 16 ft.) overmantel *Pyrrhus and Fabricius*, which he painted in 1656 for the burgomasters' chamber of the new Town Hall of Amsterdam (now the Royal Palace, where the work remains in situ),[9] and three canvases of the early 1660s depicting classical subjects suitable to the council chamber of the Admiralty.[10] Bol's portraits of public figures include several of the naval hero Adm. Michiel de Ruyter.[11] However, the most memorable works, after the last Rembrandtesque pictures (like the probable double portrait of 1649, *The String of Pearls*; Philips Electronics, Eindhoven),[12] are classicist mythologies such as the *Venus and Adonis*, of about 1660 (Rijksmuseum, Amsterdam).[13] In these paintings one might discover qualities reminiscent of Rembrandt and the Cuyps, but the impression of tender thoughtfulness is personal to Bol and found throughout his most distinctive works.

Over the past three centuries, Bol was often credited with paintings that could not be attributed to Rembrandt himself. Of the nearly five hundred pictures that were once ascribed to him, about 190 are accepted today.[14]

According to Houbraken, Cornelis Bisschop (q.v.) and Gottfried Kneller (1646–1723) were pupils of Bol.[15]

1. For these details, see Blankert 1982, p. 16, where J. G. Cuyp's apparent influence on the young Bol is discussed.
2. Ibid., pp. 18–19.
3. On this point, see Liedtke 1995b, pp. 23–24.
4. Blankert 1982, pls. 60–70 (self-portraits), and pls. 4 and 8, respectively. On Bol's *Self-Portrait* of about 1647, in the Museum of Fine Arts, Springfield, Mass., see also A. Davies 1993, p. 26, no. 2. Other self-portraits are discussed by Blankert in Melbourne–Canberra 1997–98, under nos. 45 and 46. The inadequate distinctions made in Blankert 1982 between portraits, *tronies*, and some other pictures are discerned in Bruyn 1983, pp. 209–10.
5. Drawings by Bol are expansively catalogued in Sumowski 1979–95, vol. 1, pp. 197–599. Bol made about sixteen etchings; four of

the 1640s are discussed by Orenstein and Dickey in New York 1995–96, vol. 2, pp. 233–39, nos. 101–4.

6. See Ekkart 2002, p. 25, correcting (in n. 33) Blankert 1982, p. 20, where Cornelia is said to be Hendrick's daughter.

7. As noted by Marijke van der Meij-Tolsma in *Dictionary of Art* 1996, vol. 4, pp. 249–50. See also Blankert 1982, pp. 20–21, pls. 189–92, 194, 195, for Bol's group portraits.

8. Blankert 1982, p. 24, fig. 12, citing additional literature.

9. Ibid., no. 52, pl. 26.

10. Ibid., nos. 56, 58, 59, pls. 50, 51, 53. Bol's public commissions are

discussed in Blankert 1975b.

11. Blankert 1982, nos. 76–86, pls. 84–94.

12. Ibid., no. 168, pl. 179. See also The Hague 1992a, pp. 104–7, no. 4, and Liedtke 1995b, p. 24, fig. 32.

13. Blankert 1982, no. 29, pl. 38 and frontis.

14. According to Blankert in Melbourne–Canberra 1997–98, p. 243.

15. Houbraken 1718–21, vol. 2, p. 220 (on Bisschop), and vol. 3, p. 234 (reporting that Kneller studied first with Rembrandt and then with Bol).

10. *Portrait of a Woman*

Oil on canvas, 34⅜ x 28 in. (87.3 x 71.1 cm)
Signed and dated (left center): f·Bol fecit/1642

The painting is well preserved, although the surface texture has been slightly flattened. There are several small flake losses distributed throughout the background and a few small losses in the sitter's hair, forehead, and hands.

Theodore M. Davis Collection, Bequest of Theodore M. Davis, 1915 30.95.269

The earliest known paintings by Bol to actually bear dates are three portraits of women dated 1642: the present work; a similar portrait of a woman, perhaps in her twenties, in the Baltimore Museum of Art; and a portrait of a middle-aged woman in the Gemäldegalerie, Berlin.[1] The date on the New York painting was read as 1643 in the past, but microscopic examination of the worn signature and date reveals an inscription almost identical to that on the Berlin canvas, ending in a tall script "16" and a tighter, angular "42."[2] The only known works by Bol bearing the date 1643 appear to be *David's Dying Charge to Solomon*, a painting in the National Gallery of Ireland, Dublin (mistakenly assigned by several scholars to Gerrit Willemsz Horst),[3] and an etching, *Holy Family in an Interior*.[4] A date of 1644 appears on a few large biblical pictures; on the introspective *Portrait of a Young Man* in the Städelsches Kunstinstitut, Frankfurt; and on the *Portrait of a Lady*, also in Dublin.[5]

It is likely that a number of male portraits by Bol dating from the early 1640s are now lost or unidentified, and a companion to the Museum's painting may probably be counted

among them. The emphasis given here to the sitter's beautiful dress, with its cascading layers of lace, and to her treasure trove of pearls and other jewelry would be typical of a Dutch portrait made to commemorate a betrothal or marriage. The ring on the left hand may be a betrothal ring, which was often worn on the little finger.[6] To be sure, apparently independent female portraits, like Rembrandt's lavish *Portrait of a Young Woman, probably Maria Trip*, of 1639 (Rijksmuseum, Amsterdam), feature similarly detailed displays of costume and jewelry.[7] But pair portraits were far more common in the seventeenth century (before many of them became separated) than were independent portraits of women.[8] And in Bol's picture the presentation of the sitter suggests the existence of a companion piece. The woman is modestly and perhaps deferentially posed,[9] turned a bit to the left (her right, where a pendant male portrait conventionally would have been placed),[10] and holds her closed fan in a position that invites the viewer's eye to move in the same direction.[11]

Rembrandt's example was obviously important for Bol's early efforts as a portraitist. In addition to the portrait of Maria Trip mentioned above, the present painting may be compared with Rembrandt's *Portrait of Agatha Bas*, of 1641 (Royal Collection, London).[12] But Bol's earliest dated portraits reveal a mastery of technique and composition and a gift for characterization that are quite his own.

1. Blankert 1982, nos. 117, 121, 122, pls. 126, 130, 131, where the date of the Museum's picture is given as 1643, following earlier

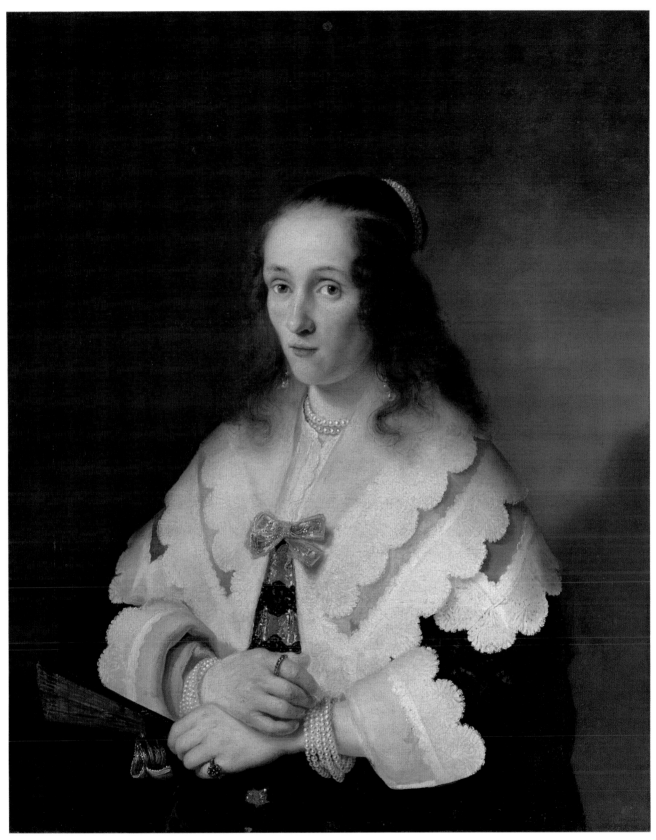

10

publications (see Refs.). The date on the *tronie* of a young woman in Potsdam has been read as 1643 in the past, but Blankert (ibid., p. 139 [under no. 126]) reads the inscription as "f.Bol f/1642." See also Hollstein 1949– , vol. 3, Bol nos. 6, 9, and 14, for etchings of male figures dated 1642.

2. See the facsimile of the Berlin portrait's inscription in Staatliche Museen zu Berlin 1931, p. 50 (under no. 809).

3. Blankert 1982, pp. 163–64, no. R16. That the Dublin painting is "a very fine early masterpiece by Bol" (Potterton 1986, p. 14 [under no. 47]; see fig. 225 for a photograph of the signature and date) was established in Richardson 1978 and in Bruyn 1983, pp. 211–13, figs. 1, 2.

4. Hollstein 1949– , vol. 3, Bol no. 4 (as dated 1645); see Dickey in New York 1995–96, vol. 2, p. 238 (under no. 104).

5. Blankert 1982, nos. 7, 16, 17, pls. 4–6 (biblical pictures), no. 98, pl. 107 (man), no. 118, pl. 127 ("lady"). For the Frankfurt painting, see also Sander and Brinkmann 1995, p. 20, pl. 3. For the Dublin portrait, see also Potterton 1986, pp. 14–15, no. 810, fig. 17, and fig. 226 for a photograph of the inscription, which closely resembles that on the New York canvas (except for the last digit).

6. See Kunz 1917, p. 224, on this usage, and Dalton 1912, p. xlviii, for various forms of betrothal and wedding rings.

7. *Corpus* 1982–89, vol. 3, pp. 312–20, no. A131; Edinburgh–London 2001, pp. 167–68, no. 85. Ernst van de Wetering has more recently conjectured that the portrait of Maria Trip may have a pendant in the *Portrait of a Man Standing in a Doorway*, formerly in the Thyssen-Bornemisza Collection (*Corpus* 1982–89, vol. 3, pp. 691–94, no. C110); see Hochfield 2004, pp. 88–89.

8. See D. Smith 1982a, p. 2, and chap. 3 ("Typology and Convention in Pair Portraiture").

9. Ibid., p. 43, mentions the similar crossing of hands at the waist, "a common gesture of feminine passivity," in Bol's *Portrait of Maria Rey*, dated 1650 (Rijksmuseum, Amsterdam; Blankert 1982, no. 146, pl. 157). The figure in the pendant *Portrait of Roelof Meulenaer* (also in the Rijksmuseum) is posed with Van Dyckian swagger.

10. See De Jongh in Haarlem 1986a, pp. 36–40. Exceptions were made in the case of betrothal portraits (ibid., pp. 66, 195 [under nos. 1 and 40, respectively]). The rigidity of the convention is questioned in Raupp 1986, p. 256, and in Hinz 1987, pp. 649–50.

11. Compare the similar position of the hands and fan in Frans Hals's pendant portraits in the Taft Museum, Cincinnati (see the present writer's entry in E. Sullivan et al. 1995, pp. 142–44, where D. Smith 1982a, pp. 111–12, figs. 44, 45, should be added to the literature).

12. *Corpus* 1982–89, vol. 3, pp. 424–39, no. A145 (companion to no. A144, the *Portrait of Nicolaes Bambeeck*, in the Musées Royaux des Beaux-Arts de Belgique, Brussels).

REFERENCES: *Boston Museum of Fine Arts Bulletin* 1 (1903), p. 31, notes the work as among the pictures lent to the museum by Theodore Davis; Valentiner in New York 1909, no. 3, as dated 1643, "the last figure nearly illegible"; Breck 1910, p. 56, considers the "golden tone" to reflect the "first style of Rembrandt"; B. Burroughs 1931b, pp. 15, 16, as "unusually delicate"; A. Burroughs 1932b, pp. 457–60, figs. 4, 8 (radiograph of face), suggests that "the portrait was begun and perhaps finished with more delicacy than it now seems to possess," and observes that "the hair originally covered part of the forehead at the sides, [and] that the outline of the cheek was more sensitive"; Isarlov 1936, p. 34 (under "Addendum I: Liste des tableaux signés et datés de Ferdinand Bol"), records the work as dated 1643; Baetjer 1980, vol. 1, p. 13, as signed and dated "f. Bol fecit/1642"; Blankert 1982, pp. 56, 138, no. 122, pl. 131, gives the date as 1643 but records the inscription as "f Bol f./16 . .," and describes the work as "executed with the same thoroughness" as the *Portrait of an Old Lady*, of 1642, in Berlin; Baetjer 1995, p. 323, as signed and dated "f. Bol fecit/1642"; Liedtke in E. Sullivan et al. 1995, p. 160, cites the picture in order to dismiss the Taft Museum's *Young Man in a Feathered Beret* as an early work by Bol; Liedtke in New York 1995–96, vol. 2, pp. 23, 141, no. 43, as one of Bol's earliest known independent works, dated 1642 not 1643, perhaps depicting a newlywed.

EXHIBITED: Worcester, Mass., Worcester Art Museum, "Winter Exhibition," 1898–99, no. 35 (lent by Theodore M. Davis); Boston, Mass., Museum of Fine Arts, 1903–4 (lent by Theodore M. Davis); New York, MMA, "The Hudson-Fulton Celebration," 1909, no. 3 (lent by Theodore Davis, Newport, R.I.); Berkeley, Calif., University of California at Berkeley, University Art Museum, and Houston, Tex., Rice University, Institute for the Arts, "Dutch Masters from The Metropolitan Museum of Art," 1969–70, checklist no. 2.

EX COLL.: Sale, "Property of a Lady of Rank," Christie's, London, February 25, 1893, no. 62, as "Portrait of a Lady, in black dress, lace collar and sleeves, holding a fan in her left hand," by F. Bol, signed and dated, for £346.10 to Colnaghi, London; [Wallis & Son, French Gallery, London, 1893; sold for £750 to Davis]; Theodore M. Davis, Newport, R.I. (1893–d. 1915); Theodore M. Davis Collection, Bequest of Theodore M. Davis, 1915 30.95.269

11. *Petronella Elias with a Basket of Fruit*

Oil on canvas, 31⅝ x 26 in. (80.3 x 66 cm)
Signed and dated (lower right): FBol/1657 [FB in monogram]

The painting is in good condition. There is a large area of restoration in the sky at top left, and the girl's cheeks have been enhanced with fine strokes of rosy red paint.

Purchase, George T. Delacorte Jr. Gift, 1957 57.68

The young girl in this portrait was identified recently by Ekkart (see Refs.) as the nine-year-old Petronella Elias (born in Amsterdam on August 17, 1648, and died there January 5, 1667). She was the daughter of the merchant Joost Pietersz Elias (1622–1694) and his first wife, Rebecca Spiegel (1625–1651), who was a first cousin of Bol's wife, Elisabeth Dell. On May 8, 1666, Petronella married her mother's cousin (and Bol's brother-in-law) Gerard Elbertsz Dell (1644–1688).[1] She died eight months later, at the age of eighteen.

As described in detail by Ekkart, the present painting is cited on a list of twenty-one seventeenth-century "Family portraits in the possession of Wigbold Slicher, President of the Court of Holland, Anno 1783."[2] The compiler of the list, and of a second list (also dated 1783) of twenty-four family portraits owned by another descendant,[3] was probably Slicher's son Raimond (1752–1807), an amateur artist. He made small pastel copies after several of the family portraits, including an oval composition repeating the head and shoulders of the figure in the Museum's picture.[4] Each of the surviving copies is extensively annotated on the back with information that proves to be reliable.

Although the sitter's father long outlived his daughter and her mother, the portrait descended in the latter's family. Ekkart suggests that the girl's maternal grandfather or her aunt—that is, Rebecca Spiegel's father, Elbert Spiegel (1600–1674), or the eldest of her four sisters, Elisabeth Spiegel (1628–1707)—ordered the portrait from Bol. Elbert Spiegel, the artist's uncle by marriage (see the biography above), started a tradition of commissioning family portraits. In 1638 and 1639, the Amsterdam portraitist Dirck Santvoort (ca. 1610–1680) painted a set of five panels representing the daughters of Elbert Spiegel and his wife Petronella Roeters (1599–1647)—our Petronella's grandmother—with attributes of the Five Senses. In her portrait (fig. 8), the twelve-year-old Rebecca Spiegel, Petronella's mother, holds fruit in her left hand and in her gathered skirt, thus assuming the role of Taste. Petronella's aunts Elisabeth (with a flute), Margriet (with a dog and mirror), Geertruyt (with a pecking bird), and yet another Petronella (with a wreath of flowers) represent Hearing, Sight, Touch, and Smell, respectively.[5]

In its composition the portrait by Bol recalls three of the portraits by Santvoort, but it comes closest to the portrait of the sitter's mother in design, costume, and, of course, the attribute of fruit. Ekkart concludes, "the fruit depicted there as a symbol of Taste has here [in the Museum's painting] lost that meaning and was evidently included only to supply a parallel with the earlier girl's portrait."[6]

This remark would seem to overstate the case, considering that the motif of children holding fruit or flowers is common in Dutch portraiture, quite apart from those rare cases in which the Five Senses are symbolized. Ekkart himself, in discussing Jacob Willemsz Delff's 1581 portrait of a two-year-old boy holding a basket of pears and cherries (Rijksmuseum, Amsterdam), has observed that "bowls and baskets of fruit often feature in sixteenth- and seventeenth-century art as allusions to fertility, which helps explain their regular appearance in paintings of children."[7] Other examples range from Jan Gossaert's *The Children of Christian II of Denmark*, dating from about 1526, to Jan de Bray's *Boy with a Basket of Fruit*, dated 1658,[8] and include Aelbert Cuyp's *Girl with Peaches* (Mauritshuis, The Hague); *Portrait of a Young Woman Holding a Basket of Fruit*, attributed to Jacob Fransz van der Merck (ca. 1610–1664);[9] Salomon de Bray's *Child with Cherries*, of ca. 1655;[10] and, most likely, Santvoort's portrait of Rebecca Spiegel, where the reference to the sense of taste need not exclude other meanings.[11] In these examples, the motif of fruit suggests that the child is the product of a fruitful marriage, and in some instances of a careful upbringing, like fruit that must be cultivated.[12] Flowers, like the garland in Petronella's hair, usually suggest the innocence of youth.[13] The almost celebratory manner in which the fruit is presented in Bol's portrait of Petronella Elias is understandable, given that in 1657 she was the only (and, as it happened, last) child of Joost Elias and Rebecca Spiegel, whose son, Pieter, had died in 1653 at the age of two.[14]

The silver-gilt basket reappears, filled with flowers, in Bol's large portrait of Jan and Catharina van der Voort, dated 1661 (fig. 9).[15]

1. Ekkart 2002, p. 35 (under no. S16).
2. Ibid., p. 32, where the document's title is given in the original Dutch and in English. Ekkart (ibid., pp. 32–36) publishes the list of twenty-one portraits as Appendix I, "The Slicher inventory, 1783."
3. Ibid., pp. 36–41 (Appendix II), "The Testart inventory, 1783."

Figure 8. Dirck Santvoort, *Portrait of Rebecca Spiegel as the Sense of Taste*, ca. 1638–39. Oil on wood, 24 x 19¼ in. (61 x 49 cm). Private collection

This document lists twenty-four seventeenth-century portraits of members of the Slicher family and their relatives. The paintings were in the possession of Cornelis Anthony Testart (1743–1820), town clerk of Haarlem, whose grandmother was a first cousin of Wigbold Slicher's father.

4. Ibid., pp. 16 (on Raimond Slicher and his pastel copies, six of which are known today), 26, fig. 16.

5. Ekkart 1990b, figs. 1–5; also in Ekkart 2002, figs. 7–11.

6. Ekkart 2002, p. 26. Perhaps the wreath of flowers in the girl's hair (see also the text below) was inspired by the one held by her aunt Petronella, who died at the age of twenty-six in 1656. She was married to Barend Elias (1621–1695), the slightly older brother of our Petronella's father.

7. Haarlem–Antwerp 2000–2001, p. 102 (under no. 8), citing the chapter "Fruit and Fertility: Fruit Symbolism in Netherlandish Portraiture of the Sixteenth and Seventeenth Centuries," in Bedaux 1990, pp. 71–108 (see especially p. 89). The chapter is a reprint, with a few minor changes, of Bedaux 1987. For portraits of girls holding a basket of cherries, see also Haarlem–Antwerp 2000–2001, nos. 7, 11.

8. Haarlem–Antwerp 2000–2001, nos. 3 (known from seven versions), 65 (Museum of Fine Arts, Boston).

9. Museum of Fine Arts, Boston. See Haarlem 1986a, p. 187, fig. 37e, as by Van der Merck or Jacob Gerritsz Cuyp.

10. Memorial Art Gallery of the University of Rochester, Rochester, N.Y.; Albany 2002, no. 14.

11. Santvoort may have intended double readings in each of the five portraits of the Spiegel children, since all the attributes they hold, with the exception of the mirror (*spiegel*, in Dutch), are found in Dutch portraits of children where there is no reference to the Five Senses. The flute could refer to family harmony (see Haarlem 1986a, pp. 40–45), the dog and the finch (both on leashes) to proper training (see Haarlem–Antwerp 2000–2001, pp. 19–21, 148), the fruit to fertility and "cultivation" (see note 12 below), and the flowers to youth and innocence (see note 13 below). A similar case of attributes referring to family virtues and the Five Senses at the same time is evidently found in Hendrick van Vliet's contemporary (1640) portrait of Michiel van der Dussen, his wife, and their five children (Stedelijk Museum Het Prinsenhof, Delft); see the present writer's discussion in New York–London 2001, p. 408 (under no. 80).

12. See Haarlem–Antwerp 2000–2001, p. 19, for Jacob Cats's proverb about the upbringing of children, "Tucht baert vrucht" (Discipline bears fruit), and similar thoughts.

13. See ibid., pp. 24–25, and p. 206 (under no. 52, Jan Baptist Weenix's *Girl as Shepherdess*, of ca. 1650), where Ripa's allegorical figure of Innocence is cited. See also the discussions of Paulus Moreelse's *Portrait of Two Children in Pastoral Clothing* (1622) and Bernard Zwaerdecroon's painting of the same title (ca. 1645), in Utrecht–Frankfurt–Luxembourg 1993–94, nos. 40, 59.

14. As noted in Ekkart 2002, p. 26 n. 39.

15. As noted in Blankert 1982, p. 153 (under no. 173).

REFERENCES: A. Cunningham 1834, vol. 1, pp. 65–70, mentions the painting as in the collection of Robert Ludgate, with a reproductive engraving by Edward Smith; Wurzbach 1906–11, vol. 1 (1906), p. 128, as a portrait of a young woman holding fruit, in the collection of R. Ludgate, 1835, and vol. 3, p. 32, no. 30, as a half-length picture of a young woman holding a basket of flowers, in the collection of Robert Ludgate, 1834; "Mrs. Joseph Heine Sale: French Art Starred," *Art News* 43, no. 15 (November 15–30, 1944), p. 30 (ill.), as in the forthcoming Heine sale of November 24–25, 1944, at Parke-Bernet; "Purchases," *MMA Bulletin*, n.s., 16 (October 1957), p. 63, as purchased with funds donated by George T. Delacorte Jr.; Toledo Museum of Art 1976, p. 25, compares the picture with Bol's *The Huntsman* as a portrait set outdoors; Blankert 1982, pp. 143–44, no. 142, pl. 153, and p. 153 (under no. 173), notes the repetition of the "metal dish" in a double portrait of 1661; Sumowski 1983–[94], vol. 1, pp. 304 (under no. 131), 313, 411 (ill.), no. 172, states that the meaning of the basket of fruit has not yet been explained; Baetjer 1995, p. 323; Liedtke in New York 1995–96, vol. 2, p. 141 (under no. 43), notes that no trace of Rembrandt's style remains; Ekkart 2002, pp. 24, 26–27, fig. 17, and p. 35, no. S16 (not no. S15, as indicated on p. 26), identifies the sitter for the first time, and considers the basket of fruit a reference to Dirck Santvoort's portrait of the sitter's mother (fig. 8 here).

II

Figure 9. Ferdinand Bol, *Jan and Catharina van der Voort*, 1661. Oil on canvas, 68⅛ x 82¼ in. (173 x 209 cm). Koninklijk Museum voor Schone Kunsten, Antwerp

1. The preceding is based on the provenance information and family tree published in Ekkart 1990b, and the provenance information published in Ekkart 2002, pp. 16–17.
2. See Ekkart 2002, pp. 23–24, on the dispersal of the portrait gallery owned by Wigbold Slicher (d. 1790).

PAULUS BOR

Amersfoort ca. 1601–1669 Amersfoort

Bor came from a wealthy Catholic family in Amersfoort, which is about ten miles east-northeast of Utrecht. His grandfather Bor Jansz was one of the most prominent citizens in Amersfoort, and his father, also named Paulus Bor, was a successful cloth merchant there. All three generations of the family served as regents in church and charitable organizations.

Nothing is known of Bor's youth or training as a painter, although he was clearly acquainted with contemporary works by the major artists of Utrecht, in particular Abraham Bloemaert (q.v.) and Jan van Bijlert (1597/98–1671). In 1623, Bor was living in the parish of San Andrea delle Fratte in Rome, in a house with three minor Netherlandish artists, and in 1624 he lived in the Piazza di Spagna with two of the same northerners and the Roman painter of low-life subjects Michelangelo Cerquozzi (1602–1660). The young Dutchman was a founding member of the Schildersbent, the fellowship of Netherlandish artists in Rome, along with the Utrecht painters Dirck van Baburen (ca. 1594/95–1624), Cornelis van Poelenburch (1594/95–1667), and (most likely) Van Bijlert, and other Dutch artists such as Leonaert Bramer and Bartholomeus Breenbergh (q.q.v.). Bor was given the "Bent" nickname of Orlando, presumably in reference to Ariosto's *Orlando Furioso*. He returned to Amersfoort and joined the painters' guild there about 1626.[1]

In 1632, Bor married Aleijda van Crachtwijck, who came from a patrician family in his hometown. The bride and groom together had assets worth 10,000 guilders, which is about what a prosperous middle-class couple would spend in ten or twelve years. With rental and investment incomes, Bor certainly did not have to paint for a living. These circumstances may shed light on the artist's work: a small oeuvre (about two dozen paintings are known) revealing an eclectic style, some amateurish qualities, and the occasional highbrow subject. However, other artists in Bor's circle touched upon learned themes, and wealth did not always prove a deterrent to talent and industry (see, for example, the biography of Joachim Wtewael below).

One of Bor's earliest known works is a broad, sober, thirteen-figure group portrait dated 1628, *The Van Vanevelt Family Saying Grace* (Saint Pieters-en-Blokland Gasthuis, Amersfoort).[2] In the early 1630s the artist formulated his mature manner, which derives mainly from the "Haarlem Classicists" Salomon de Bray (1597–1664), Jacob van Campen (1595–1657), and Pieter de Grebber (ca. 1600–1652/53). Van Campen was a decisive figure for Bor's career. In 1626, the Haarlem artist and classicist architect inherited his mother's family estate, Randenbroek, near Amersfoort. Bor's connection with the new "Lord of Randenbroek" (for whom he acted as a witness in 1628) served as his entree into the most prestigious cultural milieu in the country, that of Constantijn Huygens, secretary and artistic adviser to the Stadholder, Prince Frederick Hendrick.[3]

Some of Bor's paintings are close enough in style to Van Campen's to have been attributed to that artist in the past.[4] In 1637, Bor and De Grebber worked for Van Campen on the Surrounding Gallery in the Great Hall of Honselaarsdijk, the prince's country house outside The Hague. The decorations featured musicians, servants, and revelers on an illusionistic balcony extending around the coved vaulting of the room.[5] A canvas by Bor, evidently *The Finding of Moses*, of about 1635–37, in the Rijksmuseum, Amsterdam, hung in Huygens's new house in The Hague. The landscapes in this picture and in *The Flower Sellers*, of about 1640 (Nationalmuseum, Stockholm), are generally considered to be by the Haarlem specialist Cornelis Vroom (1590/91–1661).[6] Six paintings by Bor were listed in the inventory of Van Campen's estate, and the latter's debt of 1,000 guilders was noted in Bor's legacy twelve years later.[7]

Bor presented a few of his paintings to charitable institutions. In 1631, he gave a "bust-length picture of a devout woman" to the Saint Jobs Gasthuis (Hospital) in Utrecht.[8] His *Descent from the Cross*, of the 1630s (Centraal Museum, Utrecht), is possibly identical with the painting of that subject cited (without giving the artist's name) in the 1641 inventory of the Saint Elisabeths Gasthuis in Amersfoort, of which Bor's mother-in-law, Everarda van Dorsten, was the "mother general."[9] In 1656, Bor became a regent of the local Catholic almshouse De Armen de Poth (The Poor of the Pot) and painted two canvases for the Regents' Chamber (they remain in the Stichting De Poth, Amersfoort). The larger of the two, a chimneypiece, depicts the Holy Ghost framed by a flight of chubby cherubs bearing bread and a garland of vegetables.

Bor died on August 10, 1669. He left a large estate to his wife, which at her death in 1687 was divided between their two daughters, the unwed Judith Christina and the well-married Anna Maria.[10]

1. Leonard Slatkes, in his useful biography of Bor in *Dictionary of Art* 1996, vol. 4, p. 377, states that Bor joined the guild in 1630, which is actually the date that the guild was recognized as such by the city magistrates; see Bok in Utrecht–Braunschweig 1986–87, p. 224. The latter biography, which cites documentation and earlier literature, is acknowledged as the main source of information in the unpublished *doctoraalscriptie* (master's thesis) by Ad Bercht (1991), pp. 7–13, from which some details are adopted here.

2. See Haarlem 1986a, no. 74.

3. See Huisken, Ottenheym, and Schwartz 1995, p. 38 (Bor serves as a witness on Van Campen's behalf, in 1628), and pp. 38–43, 45, on Randenbroek as a country retreat, hunting lodge, and center of culture, where Constantijn Huygens and Count Johan Maurits visited in 1636. In 1655, Van Campen's neighbor Everard Meyster named Bor among a number of hunting enthusiasts in his poem "Goden-landspel om Amersfoort" (ibid., p. 49, on Meyster; Bercht 1991, p. 8, where it is asked whether Meyster meant "our painter").

4. See Buvelot in Huisken, Ottenheym, and Schwartz 1995, pp. 59–60, where it is implausibly suggested that Bor was Van Campen's pupil, and Rotterdam–Frankfurt 1999–2000, pp. 23–24, 144.

5. See Huisken, Ottenheym, and Schwartz 1995, pp. 125–28; The Hague 1997–98a, pp. 43–44, fig. 12; New York–London 2001, pp. 10–11, fig. 12.

6. Discussed in Bercht 1991, pp. 22–25; see also Buvelot in Huisken, Ottenheym, and Schwartz 1995, p. 59, fig. 31.

7. See Bok in Utrecht–Braunschweig 1986–87, pp. 224–25 nn. 19, 20.

8. Ibid., pp. 224–25 n. 13, citing the source of 1778. The gift is discussed at greater length in Bercht 1991, pp. 10, 16, 25–26, 93, no. 21. The painting was presumably similar to *The Magdalen* by Bor in the Walker Art Gallery, Liverpool.

9. Noted in Bercht 1991, p. 20, where it is also observed that no such painting is found in an inventory of the hospital dating from 1628. Bercht cites Van Beurden 1924, pp. 81–83.

10. For more details and the relevant documents, see Bok in Utrecht–Braunschweig 1986–87, pp. 224–25 nn. 25–30.

12. *The Disillusioned Medea ("The Enchantress")*

Oil on canvas, 61¼ x 44¼ in. (155.6 x 112.4 cm)
The painting is well preserved.
Gift of Ben Heller, 1972 1972.261

This poetic painting, one of Bor's finest works, dates from about 1640. Its subject and its relationship to a similar picture in the Rijksmuseum, Amsterdam (fig. 10), have been debated, but it is concluded here that the two canvases were indeed painted as a pair and depict the (in Bor's treatment) complementary stories of the disillusioned Medea and Cydippe with Acontius's apple, as told in Ovid's *Heroides* (letters 12 and 20–21, respectively).

In the New York canvas, a woman holding a wooden wand sits below a statue of Diana, goddess of the hunt, identified by the crescent moon above her brow (only barely discernible in the reproduction), a bow and quiver of arrows, and a hunting dog at her side (his head is visible just above the melancholy heroine's head). The graven image is draped with garlands of flowers, and is honored also by incense burning in the large urn at the center of the picture and in the elaborately carved torchère. The arrangement of temple props leading back to the right requires some explanation, since—as often in Bor's work—motifs are assembled with an eye to surface design rather than clarity of spatial disposition. The smoking urn, supported by a curved buttress crowned with a carved goat's skull, is meant to be right behind the seated figure. This form is festooned with flowers, which carry the eye from the woman's silhouette (enhanced by an elongated arm) and the flowing folds of her drapery to the ascending torchère, where climbing putti balance the form of the skull. The broad base of the torchère is ornately sculpted with two heads, apparently male and female. Behind the torchère is a second, larger urn, bowl-shaped and embellished by a winged sphinx in relief. The lower left corner of the composition is filled by a tasseled red velvet pillow and a plinth on which the faint trace of two heads in profile (over-

lapping, as on antique cameos) are visible under strong light. The woman in the foreground is set off from the olive tones of the somber background by bright light (looking very much like daylight rather than the torchlight one might expect), and by her white blouse and the shiny fabrics of her blue skirt and gold brocaded mantle (used by the artist in other pictures; see Refs.). There are hints of Dutch reality in the woman's reddish face and hands, as compared with her white torso, and in her plain prettiness, of a type Odysseus would surely never have encountered in his Mediterranean wanderings.

That the lady is Medea was first suggested by Mazur-Contamine in 1981 (see Refs.). The modern image of Medea is perhaps typified by Delacroix's large canvas *Medea About to Murder Her Children*, of 1838 (Musée des Beaux-Arts, Lille).[1] Although the Romantic painter is thought to have been inspired by Corneille's play *Médée*, of 1635, his picture hardly prepares one for the different treatments that date from the seventeenth century.[2]

It would be helpful to review the myth before considering Bor's interpretation. Jason, a youth of Iolkos, is ordered by the king to fetch the Golden Fleece, which is in the possession of King Aeëtes of Colchis and guarded by a dragon that never sleeps. Accordingly, Jason gathers together the finest men of Greece and sets sail on his ship, the *Argo*. After many adventures Jason and his band of Argonauts arrive in Colchis, where Jason approaches the king. Aeëtes promises to give up the Golden Fleece if Jason will yoke together two bronze-footed bulls, plow the grove of Ares, sow the earth with the teeth of the watchful dragon, and slay the warriors who will have sprung up from the ground. The king has a daughter, Medea, who is a sorceress. Medea falls in love with Jason and offers to assist him if he will marry her and take her with him to Greece. This Jason agrees to do, and with Medea's protection he accomplishes his tasks. But the king reneges on his promise. So Jason absconds with the Golden Fleece, and with Medea embarks on the *Argo*, pursued by the king and his henchmen. After many horrific encounters the couple arrives at Corinth, where they live happily with their two sons for ten years. But Jason wearies of Medea and, with an eye to the future, divorces her and takes another wife, Creusa (or Glauce), daughter of the king of Corinth. Medea, enraged, sends a poisoned gown and diadem to her rival. When Creusa puts on the garment, she is consumed by fire. Medea, in a passion of revenge against Jason, goes on to murder their sons.

The story of Medea is described variously by Hesiod, Pindar, Apollonius, Euripides, and other ancient authors. In the seventeenth century, Netherlandish artists who depicted Jason, his companions, or Medea usually drew upon Ovid's *Metamorphoses* (7:1–425). However, less familiar sources were also consulted, and modern versions composed. Thus Rembrandt's large etching of 1648, *Medea, or the Marriage of Jason and Creusa* (fig. 11), was made as a frontispiece to a version of *Medea* written and published that year by his patron Jan Six. It is interesting for Bor's painting that Rembrandt's print does not correspond with any line or scene in Six's play. Jason and Creusa never make it to the altar, to say nothing of a royal wedding in an Amsterdam church. Nor is the explanatory verse below Rembrandt's image drawn from any couplet in the play.[3] The lines (composed by Six?) were added by a professional engraver in the fourth state of the plate. Earlier impressions, on Japanese paper, were intended as independent works of art for a small circle of cognoscenti. It was apparently concluded that some explanation of the image would be needed by viewers who acquired the etching together with the play. The inscription reads:

Creus' en Iason hier elckandren Trouw beloven:
Medea Iasons vrouw, onwaerdighlijk verschoven,
Werdt opgehitst van spijt, de wraecksucht voert haer aen.
Helaes! Ontrouwigheydt, wat komt ghij dier te staen!

(Creus and Jason here pledge their troth to each other.
Medea, Jason's wife, unjustly shoved aside,
Was inflamed by spite, [and] vengeance drove her on.
Alas! Infidelity, how dear your cost!)[4]

Without this verse or the context of the printed play, it is doubtful that many viewers of the 1640s would have recognized Medea in Rembrandt's print, or the marriage of Jason and Creusa (which does not occur in classical versions of the story). The subject might be taken for a biblical scene, unless one realizes that the figure in the foreground holds a dagger and a container of poison in her hands, and that above her is a statue of Juno, whom Rembrandt introduces (it has been suggested) as a patron saint of deceived wives.[5] Of course, Rembrandt and Six could have identified the subject for collectors who received the print directly from them. In the case of Bor's paintings of Medea and Cydippe, the explanation almost certainly went in the other direction, from patron to artist. These large pictures are probably the finest works Bor ever painted, which, together with the comparatively obscure subject matter, implies that they were commissioned by someone who made quite specific demands.

The story of Cydippe requires a temple of Diana, and yet the statue in the Rijksmuseum canvas (which has not been

12

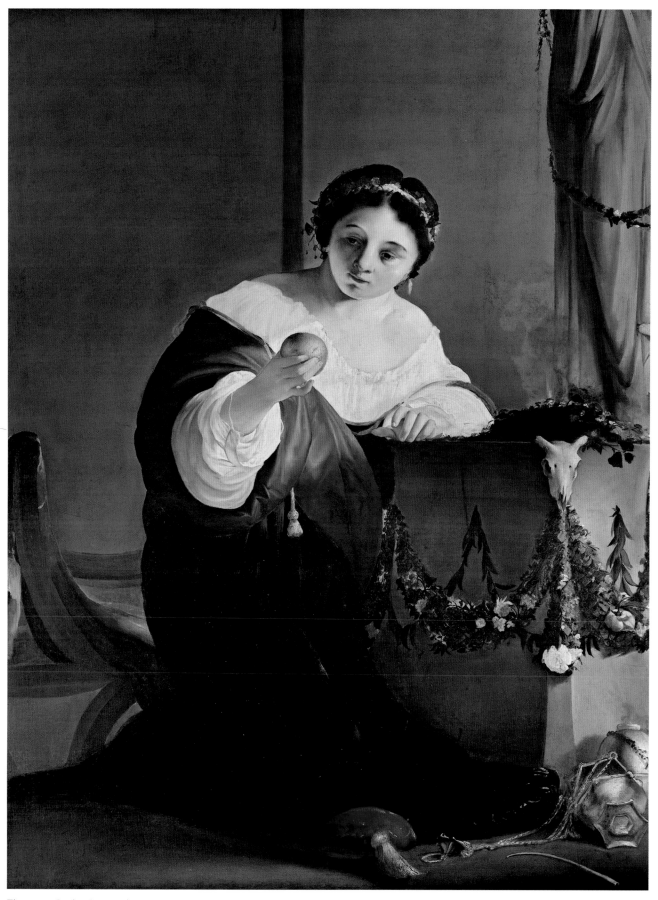

Figure 10. Paulus Bor, *Cydippe with Acontius's Apple*, ca. 1640. Oil on canvas, 59½ x 44⅞ in. (151 x 114 cm). Rijksmuseum, Amsterdam

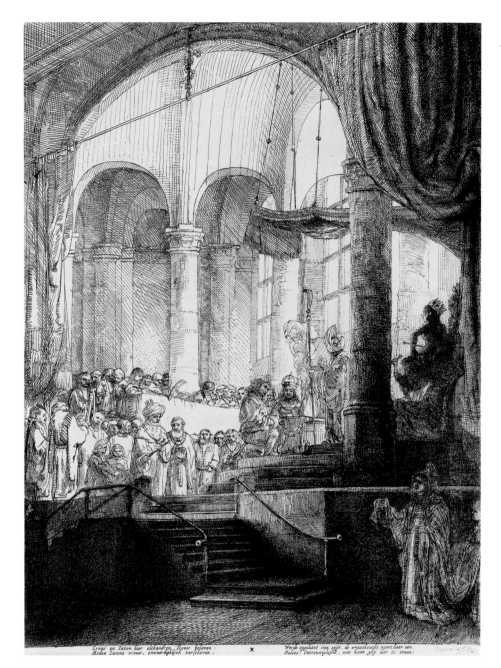

Figure 11. Rembrandt, *Medea, or the Marriage of Jason and Creusa*, 1648. Etching and drypoint, 9⅜ x 7 in. (23.9 x 17.8 cm). The Morgan Library & Museum, New York, RvR 178

significantly trimmed) has no identifying attributes. The analogous scene in the story of Jason and Medea can be staged with or without reference to Diana, but Ovid's *Heroides* and, to a lesser extent, other classical sources provide ample reason for including her. Thus the two pictures clarify each other: Medea broods by the altar of Diana, where Jason had vowed fidelity, and Cydippe kneels at the same location, staring at the object that will bind her to her own object of desire.

For those not familiar with the story, Bor's patron could have seized the opportunity to enlighten them: Acontius had fallen in love with Cydippe, whose family was of higher social standing than his. One day, when she was worshiping at the temple of Diana at Delos, he tossed an apple (or an orange) in front of her. She picked it up and, noticing that the fruit was inscribed, read the words aloud: "I swear before Diana that I will wed Acontius." Cydippe's parents presented her with more suitable prospects, but whenever a marriage was arranged, Cydippe would become ill. Eventually, an oracle revealed the reason, and Cydippe was permitted to marry her intended. The story had been adapted by Ovid (43 B.C.–A.D. 17) from the *Aetia* (Causes), by the Hellenistic poet Callimachus (ca. 305–ca. 240 B.C.), but in the seventeenth century only Ovid's *Heroides* provided more than a passing reference to Cydippe and Acontius. Bor would have used the Dutch translation by Cornelis van Ghistele, which was published in Antwerp in 1559.[6]

As noted above, the story of Medea was more widely available.

Diana's name, however, is rarely invoked. The goddess is mentioned only once by Euripides, when Medea exclaims, "O mighty Themis [guardian of oaths] and my lady Artemis [Diana], do you see what I suffer, I who have bound my accursed husband with mighty oaths?" (*Medea*, lines 160–63).[7] Diana has even less to do with Medea in Ovid's *Metamorphoses*, where Medea is portrayed as a witch and murderess too preoccupied to pause for reflection. Bor's Medea comes from a very different text by Ovid. As one classics scholar has observed, "The few hints of Medea's dreadful powers in *Heroides* 12 do little to detract from her self-representation as an unjustly injured wife and lover, the victim of an ungrateful Jason."[8]

In Medea's letter to Jason, as imagined in *Heroides* 12, she remembers where their story began.

> There is a wood . . . in [which] there is—or certainly there was—a shrine to Diana; The golden goddess stands there, made by a barbaric hand. Do you know the place? Or have places disappeared from your mind, along with me? We came there. You began to speak first, with unfaithful lips.

Jason begs Medea, "by the three-fold face and hidden rites of Diana," to save him and his men. If she does, "then my soul will vanish into thin air before any woman, but you will be a bride in my chamber. Our accomplice will be Juno, ruler of sacred marriage, and the goddess in whose marble temple we are."[9] Jason's faulty iconography appears not to have influenced Dutch poets and painters (although his remark is interesting for Rembrandt's print). In Six's *Medea* (line 36), for instance, Jason himself remembers that he promised to marry Medea "before the altar of Diana."

That Bor based *Cydippe with Acontius's Apple* on Ovid's *Heroides* is beyond doubt, and the same text is by far the most likely source for the New York picture. In her letter to Jason, Medea describes how she beat her breast and tore the wreath from her hair (12.153–57), and in the painting, though she can hardly be described as overwrought, her hair does fall and flowers dangle behind the upraised hand that cradles her head in the conventional pose of melancholy. Elsewhere in the *Heroides* (15.113–22) a different heroine relates, "After my grief had found itself, I felt no shame to beat my breast, and rend my hair," and explains, "Modesty and love are not at one. There was no one did not see me; yet I rent my robe and laid bare my breast."[10]

Obviously the artist conveys these ideas in the most understated manner, which is rather what one expects of Bor (there is almost no action in his entire oeuvre), and what best suits the comparison with his figure of Cydippe. Both women are lost in contemplation, Cydippe of her uncertain but probably happy future, Medea of a past and a future that are all too clear (the two infants, carved on the torchère, hint of her grotesque resolve). The one woman is innocent, a maiden, the other experienced with men. Observations such as these could go on late into an evening; the paired stories offer more than the sum of their parts. There is the irony, for example, that both Cydippe and Creusa become too ill to marry, but with very different consequences. Cydippe finds love with a man of lesser station; Medea, a princess, is betrayed by one.

If Bor's Medea is unusual, there are obvious reasons why. First, the comparison with Cydippe, which was almost certainly assigned to Bor, perhaps by a patron who wished to treat with classical erudition the familiar Dutch theme of the contented marriage.[11] It has also been observed that the *Heroides* was a difficult source for artists, since the main elements of each story have to be pieced together from often indirect references.[12] But as painters treat subjects freely (so Six explains in his preface to *Medea*), according to their temperaments, so may poets too take liberties.[13]

The Amsterdam and New York paintings serve as pendants in formal as well as iconographic terms. *The Disillusioned Medea* was almost certainly meant to be seen on the viewer's left, with Cydippe on the right, so that the statues of Diana close the space to either side. Medea slumps to the left, Cydippe leans to the right, and the various forms on the floor recede from the outside corners of the compositions. It would be expected in a Dutch interior of the time that the two works would have been installed at either side of an architectural element such as a fireplace. The open spaces and rhythms that flow between the two compositions would have suited such an arrangement; the smoking urns may have flanked an actual hearth. Significantly, both scenes are illuminated from the right, the Amsterdam picture more brightly, an unusual approach that implies a real source of light to the right of the two canvases. Several motifs—the garlands, the goats' skulls, the red pillows—link the pictures together; they are also consistent in color scheme. It has been noted that the figures differ in scale,[14] but the difference is not great (one might imagine Medea on her knees, like Cydippe), and the observation expects of Bor a consistent handling of proportions not found elsewhere in his oeuvre.[15] In any case, whatever shortcomings the pictures may have, they are slight considerations compared with their conceptual novelty and the quality of their execution.

1. See Griswold's discussion in New York 1992–93, p. 161, no. 37. A smaller version, dated 1862, is in the Louvre.

2. In addition to illustrated editions of Ovid's *Metamorphoses* and Rembrandt's etching of 1648 (fig. 11 here), see Rubens's early drawing *The Flight of Medea* (Museum Boijmans Van Beuningen, Rotterdam; Meij 2001, no. 5), which is based on an ancient sarcophagus, and Castiglione's *Sorceress (Medea)*, of the 1650s (Wadsworth Atheneum, Hartford; see Percy 1970).

3. Except for the occasional "Helaes!" The entire play, *Medea. Treurspel* (Amsterdam, 1648), which runs to 1,158 lines, was obtained from www.let.leidenuniv.nl/dutch/ceneton/SixMedea1648.html. Six confines himself to the events that take place in Corinth.

4. For the history of this print, and for a slightly different translation of the inscription, see Rassieur in Boston–Chicago 2003–4, pp. 209–10 (under no. 138).

5. Ibid., pp. 210, 211 n. 3, credits this observation to Clifford Ackley. However, Juno is described differently in Ovid's *Heroides* 12 (see text below).

6. See Mazur-Contamine 1981, pp. 6, 7–8 nn. 2–5. The author notes that the famous Dutch poet Joost van den Vondel (1623–1680) was acquainted with the letters of Acontius and Cydippe in the *Heroides*, but he translated only small fragments of them (*Brieven der Heilighe Maeghden*, 1642). After Van Ghistele's translation of 1559 (Ovidius Naso, *Der Griecxser Princersen en de Jonckvrouwen clachtige Sandtbrieven . . .* [Antwerp, 1559]), the next treatment in Dutch was by Jonas Cabeljau (1623–1680), a lawyer at the Court of Holland in The Hague (*Treurbrieven der blakende Vorstinnen en Minnebrieven der Vorsten en Vorstinnen, van P. Ovidius en Aulus Sabinus, op gelijk getal Nederd. vaerzen overgeset* [Rotterdam, 1657]).

7. Euripides 1994, p. 311.

8. Newlands 1997, p. 179.

9. The quotes are from a translation by James M. Hunter, who has placed "An Ongoing Translation of Ovid's *Heroides*" on the Internet. The same lines, from the Dutch translation of 1559, are quoted in Bercht 1991, p. 35.

10. See Ovid 1914, p. 155, in letter 12 (Medea to Jason), and p. 189, in letter 15 (Sappho to Phaon). These sources are noted in Mazur-Contamine 1981, p. 7.

11. Franits 1993a, chap. 2 (on the bride and wife in Dutch culture), offers a good introduction to the subject. Ovid's *Amores*, in loose translations, sometimes served as a literary guide to courtship (ibid., p. 37).

12. Mazur-Contamine 1981, p. 6.

13. From the "Voorreden" of Six's *Medea* (see note 3 above): "gelijck de schilders plegen, wanneer sy een saeck, elck nae eygen sinlijckheydt, op bysondere wijse uytbeelden."

14. Walsh 1974a, p. 349 n. 17.

15. Compare, for example, the relative scale of the figures in Bor's pendant pictures *Bacchus* and *Ariadne*, in the Muzeum Narodowe, Poznań.

REFERENCES: Morgan 1824, vol. 2, p. 373, cites the painting as *A Sorceress* by Salvator Rosa, in the "Ghigi Palace," Rome; Longhi 1943, p. 29, pl. 66, as a masterpiece by Bor, dating from 1620–30 and recalling Gentileschi; V. Bloch 1949, pp. 106–8, figs. 3, 4, describes the figure as "so very Dutch, so exquisitely phlegmatic . . . the offspring of a distinctively flavoured and agreeable provincialism," and calls the canvas now in the Rijksmuseum "the pendant" (without further explanation); Van Regteren Altena 1949, pp. 108–9, wonders whether the work is really by Bor and not Jacob de Gheyn III; V. Bloch 1952, p. 19, describes the work as "la singolare 'Sibilla' domestica," and dates it from about 1641; Hoogewerff 1952, p. 151, pl. 13, as "an exceptional masterpiece" by Bor; Longhi 1952, p. 57, regrets that he could not study the picture in good light "at Amersfoort" (meaning Utrecht) in order to consider its dating more closely; Nicolson 1952, p. 252, as *The Enchantress*, dating from just before 1641, and as having "a companion piece in a private collection in Basle" (the Rijksmuseum painting, fig. 10 here); Utrecht–Antwerp 1952, no. 17, pl. 12, dates the picture to the 1620s; D. Sutton in London 1955, pp. 11–12, no. 9 (ill.), on the basis of her attributes, concludes that "this rather lost and dumpy girl might thus be a Circe," and speculates whether the work dates from the artist's Roman years; D. Sutton 1955, p. 25, describes the nature of Caravaggio's influence; Waterhouse 1955, p. 222, calls the work "Bor's fantastic *Après-midi d'une sorcière*"; Bandmann 1960, p. 76, fig. 29, mentions the painting among pictures of enchantresses holding wands; J. Rosenberg, Slive, and Ter Kuile (1966) 1972, p. 298, fig. 237, as dating from "c. 1640(?)," describes it as typical of Bor's style, which is supposed to have been influenced by Caravaggio, Orazio Gentileschi, and Rembrandt; Muzeum Narodowe w Poznaniu 1972, p. 10 (under no. 6), notes that this work and the *Ariadne* in Poznań are similar in composition and format; Walsh 1974a, pp. 346, 348, 349 nn. 14–17, fig. 11 and cover, believes that Bor may have intended the figure "as a nameless member of the species enchantress, traditionally melancholic," and concludes that this canvas and the one in the Rijksmuseum are probably not pendants, but may have been from a series of similar works; Anthony M. Clark in MMA 1975, p. 93 (ill.), describes the work as "Italianate, earthy, enigmatic, and amusing," and as possibly "an allegory of sloth, melancholy, and magic"; Von Moltke 1977, pp. 150–52, 157, 159, no. 9, fig. 102, considers the painting a pendant of the "so-called *Pomona* in Amsterdam," describes the two pictures in detail but finds their meaning unclear, and notes that the same brocaded material is seen in Bor's *Magdalen* (Walker Art Gallery, Liverpool) and *Jesus in the Temple* (Centraal Museum, Utrecht); Nicolson 1979, p. 24, lists the painting under works by Bor as *Sorceress (?Circe)*; Mazur-Contamine 1981, pp. 5–7, 8 nn. 7, 10, fig. 2, dates the work to about 1640, identifies its subject as "the disillusioned Medea," and considers the painting to have been intended as a pendant to the canvas of about the same size in the Rijksmuseum, Amsterdam, which is said to depict another subject drawn from Ovid's *Heroides*, Cydippe with Acontius's Apple; P. Sutton 1986, p. 180, observes that the figure here, with her "oddly disaffected expression," is sometimes identified as Circe, but is yet to be satisfactorily explained; Moiso-Diekamp 1987, pp. 307–8 (under no. B1), summarizes opinions whether this painting and the similar picture in the Rijksmuseum were intended as pendants, and agrees with Mazur-Contamine that they probably were; Nicolson 1989, vol. 1, p. 66, and vol. 3, pl. 1639, as *Sorceress (?Circe)*, and as possibly a pendant to the Rijksmuseum's *Mythological Figure (?Pomona)*; Bercht 1991, pp. 27, 29, 31–33, 35–40, no. 12, fig. 16, repeats Von Moltke's remark about the brocaded material, considers the female type characteristic of Bor, and discusses the subject, attributes, and possible sources in literature; Van den Brink in Utrecht–Frankfurt–Luxembourg 1993–94, pp. 132, 133–34 n. 7, fig. 16.1, considers the subject to be "the disillusioned Medea," agrees

with Mazur-Contamine's dating to about 1640, and compares Bor's painting *A Scene from "The Spanish Gypsy" (Pretiose, Don Juan, and the Gypsy Woman Maiombe)*, of 1641 (Centraal Museum, Utrecht); Baetjer 1995, p. 308, as *The Enchantress*; Buvelot in Huisken, Ottenheym, and Schwartz 1995, p. 252 n. 47, as *The Disillusioned Medea*, notes J. G. van Gelder's unpublished attribution of the picture to Jacob van Campen; Slive 1995a, p. 230, fig. 310, repeats the remarks in J. Rosenberg, Slive, and Ter Kuile 1966; Weller in Raleigh–Milwaukee–Dayton 1998–99, pp. 90–92, no. 9 (ill.), dates the picture about 1638–40 and reviews Mazur-Contamine's argument, but concludes with little explanation that the identification of the figure as Medea cannot be supported and therefore neither can "the theory of pendants"; Giltaij in Rotterdam–Frankfurt 1999–2000, pp. 144, 146–47 (under no. 20), fig. 20b, considers the subject of "the disillusioned Medea" to be a plausible identification, but doubts that this painting and the *Cydippe* in the Rijksmuseum were intended as pendants, given their slightly different sizes and seemingly unrelated compositions; Sotheby's, Amsterdam, *Old Master Paintings*, sale cat., May 14, 2002, p. 70 (under no. 48, *The Annunciation* by Bor), observes the same candlestick in that painting (now in Ottawa; see Dolphin 2007 below) and in the Museum's picture, where Medea "seems to be a contemplative paraphrase of the Virgin Annunciate"; Cavalli-Björkman 2005, p. 101, fig. 2, compares the central woman in Bor's *The Flower Seller* (Nationalmuseum, Stockholm) with the female type in the Museum's picture; Liedtke in Martigny 2006, pp. 76–80, no. 12, publishes an abbreviated version of the present entry; Liedtke in Barcelona 2006–7, pp. 46–49, no. 9, repeats the entry in Martigny 2006; Rosenberg 2006, pp. 102, 103 (ill.), as "Medea Betrayed," of about 1640, perceives in this picture realism and poetry combined; Bikker in Bikker et al. 2007 (under no. 25), a catalogue entry on the Rijksmuseum picture (fig. 10 here), considers it to be a pendant of the New York painting and independently comes to essentially the same conclusions as those described in the text above,

except that a date of about 1650 is considered possible; Dolphin 2007, pp. 92, 93 n. 4, fig. 26, as *The Enchantress*, compares *The Annunciation of the Death of the Virgin* by Bor (National Gallery of Canada, Ottawa).

EXHIBITED: Utrecht, Centraal Museum, and Antwerp, Koninklijk Museum voor Schone Kunsten, "Caravaggio en de Nederlanden," 1952, no. 17, as *Sibylle* (lent by Andrea Busiri Vici, Rome); Milan, Palazzo Reale, and Rome, Palazzo delle Esposizioni, "Mostra di Pittura Olandese del Seicento," 1954, no. 13 (no. 15 in Rome), as *La sibilla* (lent by Andrea Busiri Vici, Rome); New York, MMA, Toledo, Ohio, The Toledo Museum of Art, and Toronto, Art Gallery of Ontario, "Dutch Painting, The Golden Age," 1954–55, ill. p. 10; London, Wildenstein Gallery, "Artists in 17th Century Rome," 1955, no. 9 (lent by Andrea Busiri Vici, Rome); Raleigh, N.C., North Carolina Museum of Art, Milwaukee, Wis., Milwaukee Art Museum, and Dayton, Ohio, The Dayton Art Institute, "Sinners and Saints, Darkness and Light: Caravaggio and His Dutch and Flemish Followers," 1998–99, no. 9; Berlin, Neue Nationalgalerie, "Melancholie: Genie und Wahnsinn in der Kunst," 2006, hors cat.; Martigny, Switzerland, Fondation Pierre Gianadda, "The Metropolitan Museum of Art, New York: Chefs-d'oeuvre de la peinture européenne," 2006, no. 12; Barcelona, Museu Nacional d'Art de Catalunya, "Grandes maestros do la pintura europeo de The Metropolitan Museum of Art, Nueva York: De El Greco a Cézanne," 2006–7, no. 9.

EX COLL.: The Princes Chigi, Castelfusano, Rome (by 1824–1941; as by Salvator Rosa; sold through Cecconi to Busiri Vici [according to the latter and Federico Zeri]); Andrea Busiri Vici, Rome (1941–at least 1955); Ben Heller, New York (until 1972); Gift of Ben Heller, 1972 1972.261

GERARD TER BORCH

Zwolle 1617–1681 Deventer

Ter Borch was trained by his father, Gerard ter Borch the Elder (1582/83–1662), in the small city of Zwolle, in the eastern Dutch province of Overijssel.[1] His mother, Anna Bufkens, died in 1621, and his father married Geesken van Voerst (d. 1628) the same year. In 1634, the precocious draftsman, who had already visited Amsterdam and probably Haarlem, went to study with the Haarlem landscapist Pieter de Molijn (q.v.). He returned to Zwolle in the spring of 1635 and left shortly thereafter for London, where he entered the studio of his uncle by marriage Robert van Voerst (1597–1636). As court engraver to Charles I, Van Voerst (who had trained in Utrecht under the prolific printmaker Crispijn de Passe the Elder [1564–1637]) reproduced portraits by Anthony van Dyck (1599–1641), Gerrit van Honthorst (1592–1656), Michiel van Miereveld, and Daniël Mijtens (q.q.v.). Thus, Ter Borch in his late teens became familiar with the work of several of the most successful court portraitists in Europe, and was exposed to life in a great foreign capital. However, he was back in Zwolle by April 1636, escaping the plague to which Van Voerst succumbed.

Between the winter of 1636–37 and about 1639, Ter Borch traveled to Italy and probably to Spain. He must have visited Rome, where his father had flourished (about 1605–11), and where he presumably painted the *Procession of Flagellants* (Museum Boijmans Van Beuningen, Rotterdam), which records a Roman custom but also resembles nocturnes by De Molijn.[2]

In the early 1640s Ter Borch appears to have resided mostly in Amsterdam. He painted small portraits that recall works by Thomas de Keyser (q.v.), Hendrick Pot (1580–1657), and Govert Flinck (q.v.), and guardroom scenes of the type that Pieter Codde (1599–1678), Willem Duyster (1598/99–1635), and Pieter Quast (q.v.) produced in the 1630s. He was in Münster during the peace negotiations of late 1645 to May 1648, where he joined the entourage of Adriaen Pauw (delegate for the Province of Holland and West Friesland) and painted portraits of Dutch and Spanish dignitaries. A multifigure portrait, *The Swearing of the Oath of Ratification of the Treaty of Münster, May 15, 1648* (National Gallery, London), immortalizes the moment when the Netherlands was finally recognized as an independent country.[3]

From 1648 until 1654, Ter Borch was evidently based in Amsterdam, but he was also in The Hague (1649 and later; see *The Van Moerkerken Family*, below) and must have visited Zwolle occasionally. His half sister Gesina (1631–1690), an amateur draftsman and watercolorist, served as a model for some of his genre scenes dating from about 1648 onward, and her own work of the time reveals his influence.[4] It was probably in connection with a trip to The Hague that Ter Borch visited Delft, where in April 1653 he witnessed a deposition together with the twenty-year-old Johannes Vermeer (q.v.).[5]

On February 14, 1654, Ter Borch married his father's third wife's younger sister Geertruyt Matthijs in Deventer, where he became a citizen the following year. (Deventer is south of Zwolle in Overijssel, not far from Münster in neighboring Westphalia.) During the next two decades in Deventer the painter was somewhat removed from the main centers of Dutch art, but the superb genre scenes for which he is most remembered (such as *Curiosity*; Pl. 17) and his portraits of important patrons in Overijssel and Amsterdam demonstrate that he continued to move in cosmopolitan circles.[6] Caspar Netscher (q.v.) was his pupil from about 1655 until about 1658, a period during which Ter Borch painted a number of his finest works.

In 1672, Deventer was occupied by troops of the Archbishop of Cologne and the Bishop of Münster, who were allies of Louis XIV. Ter Borch retreated to Amsterdam (his wife had died the same year or earlier) and returned to Deventer in the summer of 1674. He spent his remaining years there, although he was also active in The Hague and Haarlem for brief periods. He died in December 1681, and was buried in the family grave in Zwolle.

Ter Borch was one of the most accomplished Dutch genre painters of the period. His habit of drawing from life (which began at about the age of eight) and his searching approach to portraiture may have contributed to his treatment of genre figures as distinctive characters. Ter Borch's scenes of contemporary life are at once sophisticated and remarkably naturalistic, with psychological shadings as subtle as his descriptions of satin and silk.[7]

A full-length *Self-Portrait* of about 1668 is in the Mauritshuis, The Hague.[8]

1. On Ter Borch's life and family, see Gudlaugsson 1959–60, vol. 1, chaps. 2–4. His travels and artistic development are also discussed by Wheelock in Washington–Detroit 2004–5, pp. 1–17. For biographies of and drawings by Gerard Sr., Gerard Jr., his half sister Gesina, and his half brothers Harmen and Moses, see Kettering 1988, and A. M. Kettering's entry on the Ter Borchs in *Dictionary of Art* 1996, vol. 4, pp. 379–84. On art and culture in seventeenth-century Zwolle, see Zwolle 1997.

2. See Gudlaugsson 1959–60, no. 7.

3. See MacLaren/Brown 1991, pp. 34–39, and The Hague 1998.

4. See Kettering 1988, vol. 1, p. 87.

5. Montias 1977, pp. 280–81, no. 46a; Montias 1989, p. 308, no. 251.

6. On his portraits of the "Deventer elite," see Kettering 1999.

7. On Ter Borch's description of fabrics, see Kettering 1993, and Wallert's essay in Washington–Detroit 2004–5, pp. 31–41. In the same catalogue, Alison Kettering discusses Ter Borch's subjects and "the modern manner."

8. See Broos and Van Suchtelen 2004, pp. 47–50 (under no. 6), where two less impressive self-portraits are also discussed and illustrated. The Mauritshuis painting is also discussed in Washington–Detroit 2004–5, pp. 165–67, no. 45.

13. *A Young Woman at Her Toilet with a Maid*

Oil on wood, 18¾ x 13⅝ in. (47.5 x 34.5 cm)

The original high finish of the entire paint surface has suffered from abrasion.

Gift of J. Pierpont Morgan, 1917 17.190.10

This small panel of about 1650–51 seems, in retrospect, to introduce several of the most admired qualities of Ter Borch's mature style (as found, for example, in *Curiosity*; Pl. 17). His extraordinary ability to describe surface textures, especially of fabrics, is already evident here in the maid's modest, deep green dress, in the young woman's yellow blouse and pink-coral satin skirt, in the claret-colored velvet on the chair, and in the rusty tones of the tablecloth and bed hangings. The play of light on the crinkled skirt looks entirely different from that on the oversize silver pitcher and basin, or on less reflective surfaces such as the lady's blond tresses and the turned-wood chair supports. These effects are rendered with the artist's typical reserve. The brush, comb, and expensive boxes, like the fancy borders on the satin skirt and the chair's upholstery, are imbued with overall effects of light and atmosphere, allowing such motifs as the pitcher and the mirror's ebony frame to quietly play their more significant parts.

The picture has been cited as one of the earliest Dutch genre paintings of its kind, described variously as a "high-life interior," a "high genre scene," and other cumbersome formulations.[1] The claim is hardly indisputable,[2] but the painting is the first known example by Ter Borch that presents full-length figures in a well-appointed domestic interior, thereby anticipating many compositions by him and by artists such as Frans van Mieris, Gabriël Metsu, and Johannes Vermeer (q.q.v.) in which the same or a similar theme is addressed.[3]

The specific subject of a woman admiring or adorning herself in front of a mirror may be traced back in Netherlandish art at least two centuries, for instance to the scene labeled "Superbia" (Pride) in Hieronymus Bosch's *Tabletop with the Seven Deadly Sins*, of 1485 (Prado, Madrid). The theme flourished in sixteenth-century art and literature,[4] and became one of the most common vanitas images in Dutch and Flemish art of the 1600s. Two examples that might be mentioned in connection with the present picture are an engraving by Jacques de Gheyn II (q.v.) in which a woman is shown preening before a mirror[5] and a panel of about 1645–50 by Erasmus Quellinus the Younger (1607–1678) in which the woman's gesture and the general arrangement of figures and objects are similar (fig. 12).[6]

Ter Borch treated the subject of a young woman before a mirror in at least two earlier but quite different compositions: a small circular panel of about 1648–49 for which the artist's half sister Gesina served as model (formerly in a private collection, Paris);[7] and a painting of about the same date, known only from copies, that includes a maid combing her mistress's hair while a page holds the mirror.[8] The first picture reveals how effectively Ter Borch could combine artistic sources with direct observation. Gesina was also the model for the patrician young woman in the Museum's painting, and here again she is

shown looking downward and revealing the long line of her back and neck. The artist's study of feminine activity "from life" may have inspired this figure of a young woman preoccupied with a ribbon or other decoration (the detail is no longer legible), and perhaps also the idea of letting a maid observe the woman's self-absorption by glancing in a mirror. Thus the most meaningful motifs in the picture, the mirror as a symbol of vanity and the basin and pitcher as a symbol of purity,[9] are linked by the actions of the maid. However, she simply assists the young lady, and shares her pleasure in prettiness. The perception of vanity is left to the viewer, of whom the two figures seem charmingly unaware.

Later interpretations of the subject differ considerably from this one, and even Ter Borch's may be considered conventional by comparison.[10]

1. See, for example, P. Sutton in Philadelphia–Berlin–London 1984, p. xxxii, on "the rise of the high-life interior."

2. On this point, see Naumann in ibid., p. 239, and, for a broader perspective, Liedtke 1988.

3. The interest of this picture for Vermeer is stressed in Liedtke 2000a and by Liedtke in New York–London 2001 (see Refs.).

4. See Goodman-Soellner 1983.

5. See Amsterdam 1976, p. 192, where a similar image in Roemer Visscher's *Sinnepoppen* (Amsterdam, 1614) is also discussed. Variations on this theme include Abraham Janssen van Nuyssen's *Lascivia* in the Musées Royaux des Beaux-Arts de Belgique, Brussels, and Jan Miense Molenaer's *Woman at Her Toilet (Lady World)*, of 1633, in the Toledo Museum of Art, Toledo, Ohio (see Philadelphia–Berlin–London 1984, no. 78, and Raleigh–Columbus–Manchester 2002–3, no. 12, with additional literature). See also Nicolas Régnier's *Vanitas* in the Musée des Beaux-Arts, Lyons (Caen–Paris 1990–91, no. F.39), and Paulus Moreelse's *Young Woman with a Mirror*, of 1627, in the Fitzwilliam Museum, Cambridge (ibid., no. F.41; Amsterdam 1976, no. 47). Franits 1993a, pp. 127, 231 n. 66, discusses the mirror "as a metaphor for the necessity of self-examination," and on p. 126 considers the comb as a symbol of self-purification. On the comb in Ter Borch's oeuvre, see also The Hague–Münster 1974, no. 24.

6. Gudlaugsson 1959–60, vol. 2, pp. 98–99, refers to this Flemish painting, which the author believes is by Christoffel van der Lamen (ca. 1606–1651/52). De Bruyn 1988, no. 78, must be right to accept the earlier attribution to Erasmus Quellinus the Younger. The painting is said to be signed (lower left): "E. Quellinus." It was formerly in the collection of Joseph Fiévez (sale, Brussels, April 30, 1947, no. 47). The work is compared with Vermeer's *Woman with a Pearl Necklace* (Gemäldegalerie, Berlin) in Liedtke 1988, p. 103, and in Liedtke 2000a, pp. 237–38.

7. Gudlaugsson 1959–60, no. 77; The Hague–Münster 1974, no. 19; Washington–Detroit 2004–5, p. 84, fig. 1.

8. Gudlaugsson 1959–60, no. 76. Compare the figures in Molenaer's so-called *Lady World* (see note 5 above).

9. On hand washing as a traditional symbol of purity or innocence, see Gudlaugsson 1959–60, vol. 2, p. 123, and Amsterdam 1976, p. 195, both of which cite contemporary emblem books. Snoep-Reitsma 1973 discusses the basin and pitcher as a symbol of purity or innocence in Dutch art. Compare Style of Rembrandt, *Pilate Washing His Hands* (Pl. 175), and Vermeer's *Young Woman with a Water Pitcher* (Pl. 203). In an article that usefully reviews the theme of a woman at her toilet, Sluijter (1988, p. 161 n. 25) doubts that such a pitcher and basin would have suggested purity to a contemporary viewer, as opposed to vanity (as in Roemer Visscher's *Sinnepoppen* [Amsterdam, 1614], no. LIII). However, no persuasive argument is offered, and the proper reading of such a motif would appear to vary with the pictorial context.

10. See Gudlaugsson 1959–60, nos. 83, 113, 127. The same basin and pitcher appear in Ter Borch's Dresden panel of about 1655 (ibid., no. 113; Madrid 2003, no. 4). On the latter and a similar composition by Quirijn van Brekelenkam (q.v.), see Stockholm 1992–93, no. 107.

REFERENCES: J. Smith 1829–42, vol. 4 (1833), p. 124, no. 19, refers to the painting as "The Toilet," mistakenly including the Dulac sale of 1778 in the provenance; Blanc 1857–58, vol. 1, p. 404, as in the Blondel de Gagny sale (sold for FFr 3,000), vol. 2, pp. 289, 531, records the Villers sale of 1812 and the Patureau sale of 1857; Bode 1900, no. 17 (ill.); Glück 1900, p. 91, as "one of [the artist's] delightful small pictures with full-length figures"; Bode 1907, vol. 1, pp. VII, 87, no. 86; Nicolle 1908, p. 197, as a perfect example of Ter Borch's "suprême distinction"; Hellens 1911, pp. 66–68, 125 (ill. opp. p. 72);

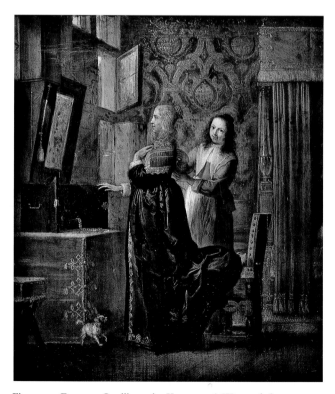

Figure 12. Erasmus Quellinus the Younger, *A Woman before a Mirror, with Her Maid*, ca. 1645–50. Oil on wood, 15⅛ x 12¾ in. (38.5 x 32.5 cm). Formerly collection of Joseph Fiévez

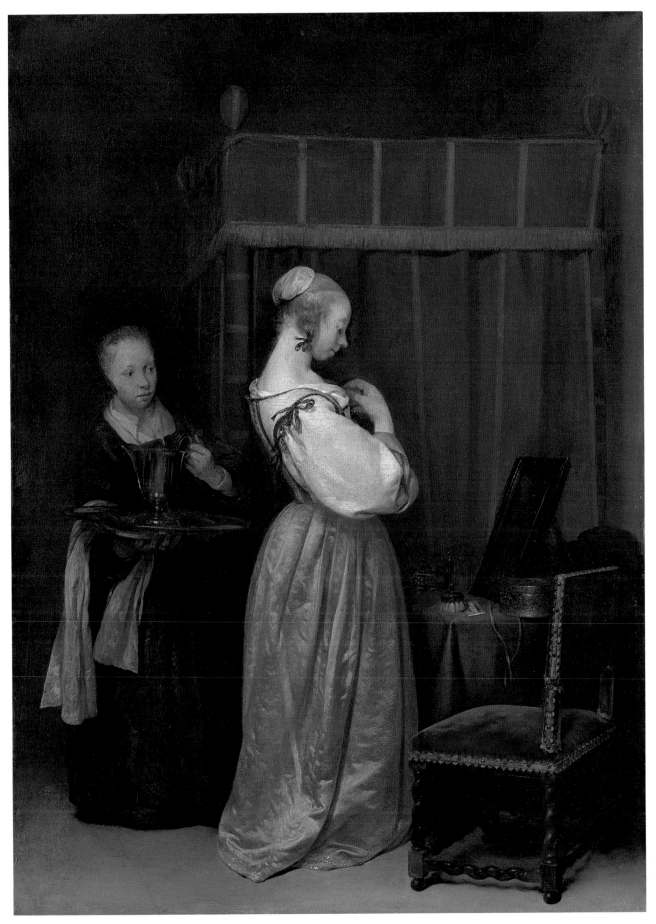

13

Hofstede de Groot 1907–27, vol. 5 (1913), p. 23, no. 50, as with Duveen, and gives a full description and provenance; B. Burroughs 1931a, p. 353; Plietzsch 1944, p. 51 (under no. 73), mentions the panel in connection with the painting of a similar subject in Dresden; Gudlaugsson 1959–60, vol. 1, pl. 80, and vol. 2, p. 23 n. 7, and pp. 98–99, no. 80, suggests a date of about 1650 or shortly thereafter, observes the repetition of a few motifs in other pictures by Ter Borch, briefly discusses the theme, notes the influence of the main figure in a painting by Jan Steen, and considers it possible that the latter's father-in-law, Jan van Goyen, owned the present panel or sold it on Ter Borch's behalf; Westers 1961, pp. 94–95, fig. 13, discusses the silver pitcher and basin in this and another painting by Ter Borch; Haverkamp-Begemann 1965, p. 39, fig. 6, describes the work as the first in which the artist "chose a patrician interior as a setting"; Naumann 1981, vol. 1, p. 68, fig. 89, considers a painting by Van Mieris to be "basically derived" from this one; P. Sutton 1982–83, p. 12, repeats Gudlaugsson's observation that the main figure appears to have been borrowed by Jan Steen; P. Sutton and Naumann in Philadelphia–Berlin–London 1984, p. 151 n. 1, and p. 239, follow Haverkamp-Begemann's observation; P. Sutton 1986, p. 187, fig. 266, considers the picture "one of the earliest works to display the elegance that would pervade genre painting in the second half of the century"; Kettering 1993, pp. 117 n. 14, 121 n. 62, notes that a "lady in light-coloured satin" occurs similarly in other paintings by Ter Borch; Baetjer 1995, p. 323; A. M. Kettering in Dictionary of Art 1996, vol. 4, p. 382, as Ter Borch's most innovative picture of about 1650, "often considered the earliest example of a new type of genre painting . . . the high-life interior"; Westermann 1997, pp. 213–14, fig. 120, as the kind of Ter Borch from which Steen adopted figures; Strouse 1999, p. 568, mentions Morgan's acquisition of the picture; Liedtke 2000a, pp. 104, 118, 237–38, fig. 292, compares works by Vermeer and by Erasmus Quellinus the Younger; Strouse 2000, p. 31, fig. 33 and detail on p. 3, as one of the old master paintings that J. Pierpont Morgan purchased in 1907 from the Kann estate (through Duveen); Franits in Franits et al. 2001, pp. 2–3, fig. 1, describes the refined style of the painting; Liedtke in New York–London 2001, pp. 17–18, 151, 161, 163, 384, fig. 17, compares works by Vermeer; Vergara in Madrid 2003, pp. 96, 235, no. 1, notes the influence of this type of painting by Ter Borch on Van Mieris and Vermeer; P. Sutton in Dublin–Greenwich 2003–4, p. 164, fig. 1, compares Steen's *Bathsheba with King David's Letter*, of about 1659–60 (private collection); Franits 2004, pp. 99–100, fig. 88, cites the painting as an early example of this compositional type and praises its descriptive qualities; Washington–Detroit 2004–5, pp. 27, 33, 81, 84–86 no. 17, 138, 141, 200 (notes to no. 17), 202 n. 6 (under no. 21), identifies the model as Gesina ter Borch, describes the theme, analyzes the artist's technique in painting satin, and offers other observations, based partly on a draft of the present entry; Yapou 2005, p. 81, mentioned; Van der Ploeg in The Hague–Washington 2005–6, p. 157, fig. 31b, cites this picture in support of the erroneous claim that Ter Borch "was the first to paint a scene of a young woman from the affluent classes while she made her toilet."

EXHIBITED: Madrid, Museo Nacional del Prado, "Vermeer y el interior holandés," 2003, no. 1; Washington, D.C., National Gallery of Art, and Detroit, Mich., The Detroit Institute of Arts, "Gerard ter Borch," 2004–5, no. 17; Amsterdam, Rijksmuseum, "Schitterend Satijn—Het beste van Gerard ter Borch," 2005, no. 17.

EX COLL.: Blondel de Gagny, Paris (until 1776; his sale, Paris, December 10–24, 1776, no. 73, together with a painting of the same dimensions by Dominicus van Tol, for FFr 3,000); [Le Brun, Paris (until 1778; his sale, Paris, January 19, 1778, for FFr 1,900)]; the architect Villers (until 1812; his sale, Le Brun, Paris, March 30, 1812, no. 44, for FFr 2,400 to Bernardeau); Monsieur L. Lapeyrière (by 1817–25; his sale, Paris, April 14ff., 1817, no. 60, for FFr 2,490 to Vas [bought in?]; his sale, Paris, April 19ff., 1825, no. 164, for FFr 4,000); Théodore Patureau (until 1857; his sale, Paris, April 20–21, 1857, no. 40, for FFr 7,800 to the auctioneer E. Leroy); Vicomte Bernard du Bus de Gisignies, Brussels (until 1882; his estate sale, Brussels, May 9–10, 1882, no. 78, for BFr 26,000 to Thibaudeau); Léopold Goldschmidt, Paris (in 1898); Rodolphe Kann, Paris (by 1900–d. 1905; his estate, 1905–7; sold to Duveen); [Duveen, London and New York, 1907; sold for £12,500 to Morgan]; J. Pierpont Morgan, New York (1907–d. 1913; his estate, 1913–17); Gift of J. Pierpont Morgan, 1917 17.190.10

14. *The Van Moerkerken Family*

Oil on wood, 16¼ x 14 in. (41.3 x 35.6 cm)
Inscribed (upper left, on ribbon): V:MOERKERKEN
NYKERKEN

The painting is well preserved, although the man's garment is abraded. Pentimenti associated with the hand that holds a watch indicate that the artist made changes in this area.

The Jack and Belle Linsky Collection, 1982 1982.60.30

This charming portrait of the artist's cousin Hartogh van Moerkerken (1622–1694), his first wife, Sibilla Nijkerken (1625–1665), and their son Philippus (1652–1688) is generally dated to 1653–54 on stylistic grounds, and more specifically on the basis of the boy's apparent age (he was born January 8, 1652, and seems here to be about two years old). The slightly eccentric composition has not been modified and is consistent with the designs of several group portraits and genre scenes painted by Ter Borch in the early 1650s.[1] The low placement of the figures in the picture field sets them apart from the family crests and suggests space and intimacy with characteristically limited means.

Hartogh van Moerkerken was the son of Gerard ter Borch the Elder's sister Maria, who in 1610 married the Delft goldsmith Justinus (or Joost) Jansz van Moerkerken.[2] The younger Van Moerkerkens also settled in the area of Delft and The Hague, in the village of Monster. Ter Borch was probably in or in the vicinity of The Hague more often during the early 1650s than is known from documents, one of which records him as a witness, together with Johannes Vermeer (q.v.), in Delft on April 22, 1653.[3] According to that deposition, Johan van den Bosch, a captain in service to the States General, had guaranteed payment to a young woman of 1,000 guilders due to her from the estate of the late Lord of Treslong, former governor of Den Briel. Ter Borch had other contacts with gentlemen in service to the national government at The Hague. The man in the Museum's picture was States General representative to the district of Den Bosch ('s Hertogenbosch), and the paterfamilias in Ter Borch's similar family portrait of about 1654, *The De Liedekercke Family* (fig. 13), was a captain of the States General fleet who at the time resided in Delft (or who had just moved from there to Leiden).[4] The artist's involvement with government figures went back to his years in Münster (late 1645 to May 1648), when he served the powerful delegate of the Province of Holland and West Friesland, Adriaen Pauw (see the biography above). Ter Borch also appears to have been on good terms with Jan van Goyen (q.v.), who lived in The Hague, owned or dealt in paintings

by Ter Borch during the early 1650s, and in about 1653 sat for a small portrait by him (Collection of the Princes of Liechtenstein).[5]

The watch in the Linsky painting has been variously interpreted. It has been suggested that the watches here and in *The De Liedekercke Family* are vanitas symbols, and that in the latter portrait the timepiece probably also refers to the young man's death in or about 1655.[6] However, the proud look of his parents speaks against this idea, which together with the three heraldic crests at the top of the panel suggests that the mother's gesture—she appears to pass the watch to her son—perhaps refers to his eventual succession as head of the family.[7] This would account for the emphasis given in both pictures not only to the watch, which certainly may be described as an heirloom, but also to the female figure. Ter Borch departs from the usual convention in Dutch portraiture by placing both wives in positions of honor, to their husbands' right. This arrangement may have been intended to acknowledge the woman's essential role in providing the family with a male heir. The different displays of a watch in Ter Borch's two family portraits would appear to support rather than discourage this interpretation. The teenaged son of the De Liedekerckes, an older couple, had just entered the University of Leiden and thus was beginning to stand on his own. In the Van Moerkerken portrait, by contrast, the husband seems to express to his lovely young wife his contentment that he now has a proper successor, whose small hand she protectively holds. The boy's placement between his parents is echoed in the configuration of the family crests, with the son's hanging like a pendant below those of his parents. That both the mother and son predeceased the father may have given the watch its more usual significance as a memento mori for Hartogh van Moerkerken in his late years, but this was probably not the object's principal meaning when the portrait was painted.

Symbols in Dutch art are occasionally multivalent, depending on the context. The interpretation suggested above does not exclude the watch's more familiar function as a vanitas motif (a reminder of mortality) or as a symbol of temperance.[8] Ter Borch referred to the latter concept by featuring a watch in a number of genre pictures, including two in the Museum's collection (Pls. 15, 17). A conspicuous watch key might underscore the idea of moderation or temperance (the connection between the Latin *temperare*, "to moderate," and *tempus*, "time," would have been understood by a person of Van Moerkerken's standing).[9] The importance of temperate behavior was complexly related to the production of progeny through Dutch

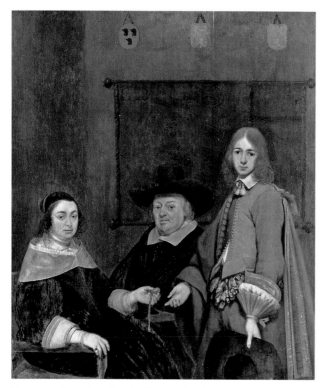

Figure 13. Gerard ter Borch, *The De Liedekercke Family (Anthonie Charles de Liedekercke, Willemina van Braeckel, and Their Son Samuel)*, ca. 1654. Oil on wood, 17⅜ x 15⅜ in. (44 x 39 cm). Frans Hals-museum, Haarlem

from the Van Moerkerken family to the De Fremery family of 's Gravesande and, later, California.

1. Compare Gudlaugsson 1959–60, vol. 1, pls. 76, 90, 91, 97, and 101 (the last is reproduced as fig. 13 here).
2. See ibid., vol. 2, p. 46, for the elder Ter Borch's family tree.
3. Montias 1989, p. 308, no. 251.
4. On this painting, see Gudlaugsson 1959–60, no. 101, and Haarlem 1986a, no. 53.
5. See Gudlaugsson 1959–60, vol. 2, pp. 23 n. 7, 104–5, no. 93.
6. Haarlem 1986a, p. 238; repeated in Yamaguchi and other cities 1994–95 (under no. 47, *The De Liedekercke Family*).
7. This reading, first proposed by the present writer in Linsky Collection 1984, p. 87, is supported in Gaskell 1990, p. 129. As De Jongh in Haarlem 1986a, p. 238 n. 8, observes, clocks and watches could also suggest impartial public service, usually on the part of judges and magistrates. This could be relevant in the case of Hartogh van Moerkerken, but the manner in which the watch is displayed in the Linsky pictures does not support its identification as a professional attribute.
8. The sitter in Rubens's early *Portrait of a Man, possibly an Architect or Geographer*, which is also in the Linsky Collection (see Liedtke 1984a, pp. 187–91), holds a watch immediately in front of a dividers and square. The latter objects have always been interpreted as professional attributes but may (or may also) symbolize temperance, since only a bridle occurs more frequently as a symbol of that virtue.
9. The hypothesis that in some Dutch portraits (and perhaps still lifes and genre scenes) a watch key was intended to emphasize the idea of moderation deserves further consideration. The watch itself keeps proper measure only when it is wound, and could thus suggest the judicious regulation of one's allotted time. This might explain the apparent focus on the watch key in the present picture and others, for example Pieter van Slingelandt's *Portrait of a Man with a Watch*, of 1688, in the Rijksmuseum, Amsterdam (Leiden 1988, no. 67). In Pieter Nason's *Portrait of a Man*, of 1664 (Tambov Picture Gallery, Tambov, Russia), the sitter displays a watch and is about to wind it with a key.
10. We are grateful to Marieke de Winkel for this information and for references to documents dating from the 1630s to the 1680s (personal communication, April 12, 2006).
11. Ekkart 1995, no. 58.
12. Gudlaugsson 1959–60, vol. 2, pp. 287–88, nos. 3–8. The portraits of the twins are dated 1659. The portrait of Maria is reproduced in Haarlem–Antwerp 2000–2001, p. 70, fig. 35.

views on marriage, procreation, and mortality. Healthy children were considered gifts of God, and in this culture it was commonly felt that people should not just count but also earn their blessings.

The little boy wears a flat beret called a bonnet in both Dutch and English. They were usually made of velvet or silk, and are cited in seventeenth-century inventories as well as depicted in Dutch portraits of boys. Feathers, jewels, and fancy ribbons often decorated a bonnet. It was usually worn over a tight cap called a *begijntje* and a *flep*, or "cross-cloth" of linen, which gave added protection to the head and also pinned the ears flat.[10]

Several years before this picture was painted, in 1645, the Hague painter and engraver Crispijn van den Queborn (1604–1652) made a half-length portrait of Hartogh van Moerkerken (Museum Boijmans Van Beuningen, Rotterdam).[11] And in the mid- to late 1650s, Ter Borch's half brother Harmen (1638–before September 1677) painted single-figure portraits of Hartogh van Moerkerken, Sibilla Nijkerken, and their young children Maria, Cornelis, and the twins Justinus and Harmen. (A portrait of Philippus may have been painted by Harmen ter Borch but none is recorded.)[12] In the nineteenth century these five pictures, together with the Museum's painting, descended

REFERENCES: Moes 1897–1905, vol. 2 (1905), p. 108, nos. 5094, 5096, and p. 151, no. 5477, records the sitters; Hellens 1911, pp. 99–100 (ill. opp. p. 32), describes the composition; Hofstede de Groot 1907–27, vol. 5 (1913), pp. 84–85, no. 248, p. 92 (under no. 282), and p. 142, describes the figures and their costumes, dates the picture to 1653–54 on the basis of the boy's apparent age, and considers it "not very happily composed"; Plietzsch 1944, pp. 16–17, 44–45, no. 45, pl. 45, dates the painting to about 1654–55 on the basis of the boy's apparent age, describes the composition, and compares it with other

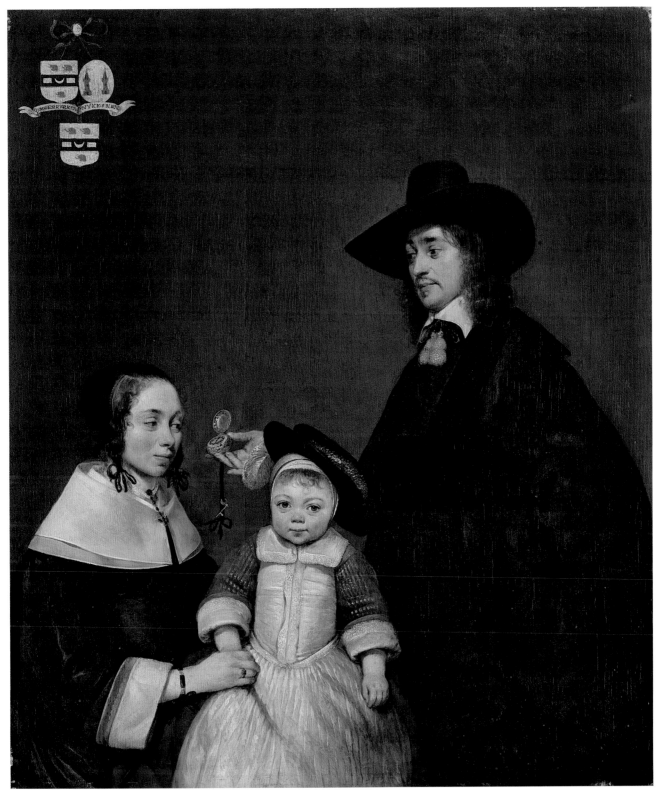

14

family portraits by the artist; Chapuis 1954, p. 72, fig. 99; Gudlaugsson 1959–60, vol. 1, pp. 93, 261 (pl. 102), 420, and vol. 2, pp. 40, 43, 46, 112–13, 287, no. 102, identifies the sitters, dates the painting to about 1653–54, and compares it with *The De Liedekercke Family* (fig. 13 here); The Hague–Münster 1974, p. 118, mentioned; Sarasota 1980–81 (under no. 9), cites the picture in connection with a miniature portrait by Ter Borch that bears an inscription referring to the Van Moerkerken family; Auckland 1982, p. 159, fig. 29a, considers the watch a symbol of transience; Liedtke in Linsky Collection 1984, pp. 86–88, no. 30, discusses the sitters, the watch, and the composition, and records the literature through 1982; W. Liedtke in MMA, *Notable Acquisitions 1983–84* (New York, 1984), p. 54 (ill.), describes the watch as "an heirloom signifying that, in time, the son will become head of the family"; De Jongh in Haarlem 1986a, pp. 236, 238, fig. 53a, claims that "in such a case the watch unquestionably serves as a *memento mori*"; P. Sutton 1986, p. 184, supports Liedtke's reading of the watch; Gaskell 1990, p. 129, notes that the watch may indicate succession from father to son; P. Sutton in The Hague–San Francisco 1990–91, p. 105, mentioned; De Jongh in Yamaguchi and other cities 1994–95, p. 137, fig. 47b, and pp. 62–63 in the English Supplement, repeats De Jongh in Haarlem 1986a; Baetjer 1995, p. 323; Ekkart 1995, p. 172, compares the picture with Van den Queborn's earlier portrait of Hartogh van Moerkerken (see text above).

EXHIBITED: Utrecht, Gebouw voor Kunsten en Wetenschappen, "Tentoonstelling van oude schilderkunst te Utrecht," 1894, no. 266 (lent by James de Fremery); The Hague, Mauritshuis, 1895–1904 (lent by James de Fremery).

EX COLL.: Hartogh van Moerkerken, Monster, the Netherlands (until d. 1694); by descent to James de Fremery, 's Gravesande, the Netherlands, and later Oakland, Calif. (by 1894–at least 1913); Paul de Fremery, San Francisco, Calif. (until 1942; his sale, Waldorf-Astoria, New York, December 16, 1942, no. 26, to Koetser for Linsky); Mr. and Mrs. Jack Linsky, New York (1942–80); The Jack and Belle Linsky Foundation, New York (1980–82); The Jack and Belle Linsky Collection, 1982 1982.60.30

15. *A Woman Playing the Theorbo-Lute and a Cavalier*

Oil on wood, 14½ x 12¾ in. (36.8 x 32.4 cm)

The painting is well preserved, although there is slight abrasion in the thinly painted shadows in the figure of the soldier, his hat, and the top right background along the right edge. Examination by infrared reflectography reveals some finely drawn lines in the head of the woman that loosely outline the top of the head, the hairline, and the curls that fall to the shoulders, the chin, the left side of the neck, the necklace, and the top of both shoulders. Examination by X-radiography reveals that the woman's head was originally placed higher and that changes were made in the position of the music book and the left hand of the soldier, which initially just touched the edge of the music book.

Bequest of Benjamin Altman, 1913 14.40.617

The small Ter Borch in the Altman Collection has been dated convincingly to about 1658. It depicts a young woman playing a theorbo-lute and singing with a young man.[1] He wears a sword and holds a hat, indicating that this is a brief social call. The lady is stylishly dressed and coiffed for the occasion. With her right hand, she strums the instrument's strings: she is playing chords not melody. The songbook in front of her does not show lute tablature and must contain vocal music, although the couple appears to know the present tune by heart. In this scene of genteel courtship, the duet resonates to the heartstrings, which, however, may quiver only so long as music is in the air. The watch on the table quietly recommends temperance.[2]

Ter Borch's intimate view of a domestic interior is so naturalistically conceived that one might be surprised to discover that the composition is closely related to other works by the artist. He had already used the same fireplace, seen from a low angle and to the upper left, in *Carousing Soldiers*, of about 1656–57 (private collection, Paris).[3] Like the curtained bed in that painting, an illegible map in the present picture helps to define the rear wall, and to set off the figure in profile. The careful dovetailing of shapes between the man and the woman reminds one of Vermeer's approach to design at about the same time, but Ter Borch's style differs strongly in most respects. Ter Borch dwells upon tactile sensations, and delights in reflections—on metalwork, silk, satin, and wood. The table carpet artfully serves as a foil for the shiny surfaces of the woman's costume and the man's sleeve, while his fingertips encourage the viewer to imagine the carpet's touch.

By the late 1650s, Ter Borch had been arranging three-quarter-

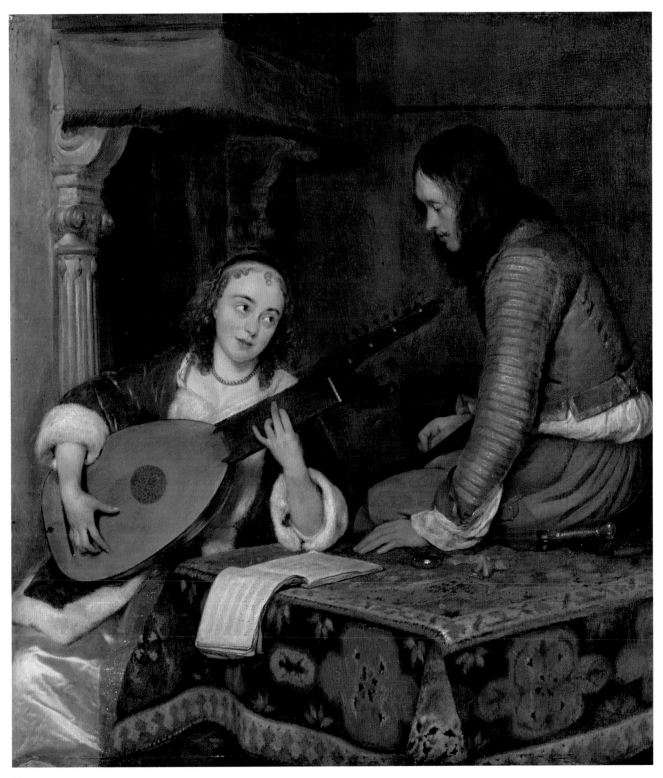

15

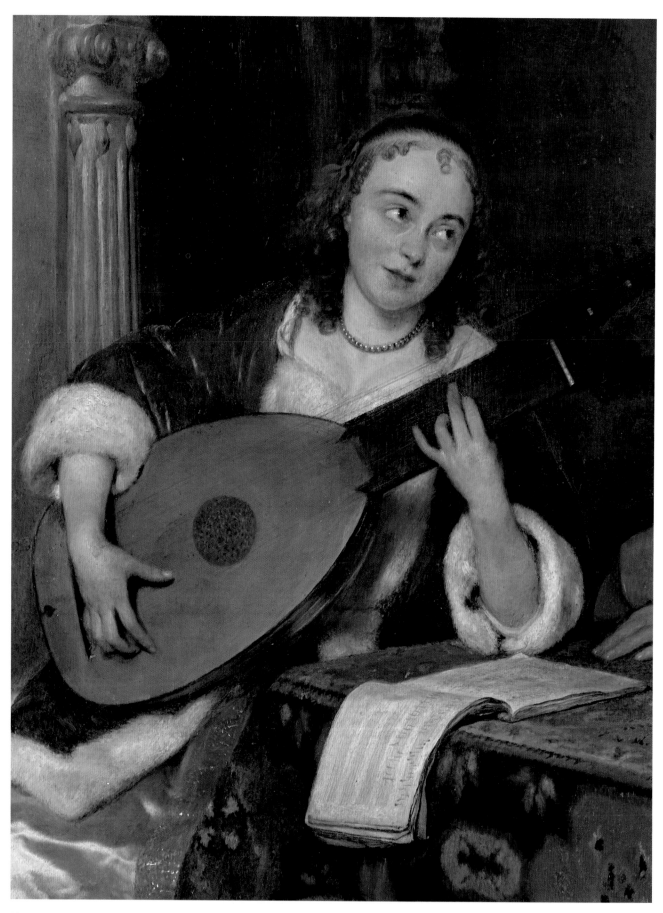

Figure 14. Detail of Ter Borch's *A Woman Playing the Theorbo-Lute and a Cavalier* (Pl. 15)

length figures around tables, in compositions of similar format, for about ten years. The poses and gazes of the couple in the Altman painting unexpectedly resemble those of two male figures in the small, moody *Inn Scene*, of about 1648 (formerly Wetzlar collection, Amsterdam).[4] Similarly, the table set at an angle very close to the picture plane, or some analogous element (like the bench in the *Boy Fleecing a Dog*, of about 1655, in the Alte Pinakothek, Munich), was a device that the artist employed especially in the mid-1650s, for example in the *Musicmaking Woman with a Page*, of about 1657 (Louvre, Paris), and in the contemporaneous *Lute Player with a Young Man* (Koninklijk Museum voor Schone Kunsten, Antwerp).[5] As Gudlaugsson noted, the figure of the theorbo player in the Museum's painting recalls the young woman in blue who plays alone at a table in *The Suitor's Visit*, of about 1658 (National Gallery, Washington, D.C.).[6] Her features, however, resemble those of another model, and her jacket reappears in yet another work.[7] Of course, it was common practice to recycle compositional schemes, studio props, and models. What is remarkable in Ter Borch's pictures, especially those of the 1650s, is his ability to make these motifs and conventions appear freshly observed each time.

A somewhat later drawing after the painting is in the British Museum, London,[8] and a pastiche in the Gemäldegalerie Alte Meister, Dresden, copies the left side of the composition, adopting a figure from the artist's *An Officer Dictating a Letter while a Trumpeter Waits* (National Gallery of Art, Washington, D.C.).[9] Ter Borch would later return to the same theme in, for example, *A Young Woman Playing a Theorbo to Two Men*, of about 1667–68 (National Gallery, London), where, however, the woman's spirits are not uplifted by song.[10]

Formerly titled by the Museum *A Woman Playing the Theorbo for a Cavalier*.

1. Laurence Libin, research curator, Department of Musical Instruments, has noted on several occasions that the instrument is a theorbo-lute, a somewhat smaller instrument than a theorbo. He also observes that the woman is strumming, not playing a melody, and that therefore the Museum's former title, *A Woman Playing the Theorbo for a Cavalier*, is inaccurate. The term "cavalier" is poetic license; the young man is probably in the army but not necessarily in the cavalry.
2. See Gudlaugsson 1959–60, vol. 2, p. 149, on "Emblematik," and The Hague–Münster 1974, no. 39. Music and love are discussed below in the entries on Metsu's *A Musical Party* (Pl. 116) and Vermeer's *Woman with a Lute* (Pl. 204).
3. Gudlaugsson 1959–60, no. 123; see also the different fireplace in no. 96 (Rotterdam), and the same one in nos. 115, 141.
4. Ibid., no. 69.

5. The Munich, Paris, and Antwerp pictures are ibid., nos. 116, 126, 128. On the Antwerp painting, see also The Hague–Münster 1974, no. 39, and Madrid 2003, no. 5.
6. Gudlaugsson 1959–60, vol. 2, p. 149, referring to his no. 139 (on which, see Wheelock 1995a, pp. 26–30).
7. See Gudlaugsson 1959–60, vol. 2, p. 149.
8. See ibid., no. 140, copy a. Curator Martin Royalton-Kisch considers the drawing to be "perhaps by a good eighteenth-century hand" (letter dated July 8, 1997).
9. Gudlaugsson 1959–60, vol. 2, p. 149 (under no. 140b), implicates Caspar Netscher (q.v.), who served as model for the man. Wieseman 2002, p. 352, no. C71, catalogues a canvas in Baroda, India, as a "variant after" the Museum's picture, with the clothing and setting altered to "Italianizing taste," and describes the Dresden painting as "another pastiche copy."
10. Gudlaugsson 1959–60, no. 220; MacLaren/Brown 1991, pp. 32–34.

REFERENCES: J. Smith 1829–42, vol. 4 (1833), pp. 125–26, no. 25, lists the painting, with provenance; Altman Bequest 1913, p. 236, listed; Hofstede de Groot 1907–27, vol. 5 (1913), p. 50, no. 135, as in Altman's collection; Monod 1923, p. 310, considers the picture a late work; Altman Collection 1928, no. 45; Plietzsch 1944, pp. 23–24, 53, fig. 87, compares other works by Ter Borch; Gudlaugsson 1948–49, pp. 248 n. 1, 263, no. 87, as not a late work, but about 1658; Gudlaugsson 1959–60, vol. 1, pp. 113, 297, pl. 140, vol. 2, pp. 148–50, no. 140, dates the picture to about 1658, gives provenance, compares other paintings by Ter Borch, and lists works derived from this one; B. Scott 1973, pp. 28, 30, fig. 6, as owned by Marigny and later by Calonne; Walsh 1973, fig. 34, claims that the artist "paints objects in consistently sharp focus"; C. Brown 1984, pp. 120 (ill.), 137, describes the amorous situation; P. Sutton 1986, pp. 187–88, "suggests something of [Metsu's] debt"; Liedtke 1990, pp. 48–49, mentioned; MacLaren/Brown 1991, p. 42, notes that the fireplace is similar to the one in the London picture (see text above); Jäkel-Scheglmann 1994, p. 99, fig. 102, describes the subject; Baetjer 1995, p. 324; Düchting 1996, pp. 57, 58 (ill.), paraphrases C. Brown (1984); Wieseman 2002, p. 352, no. C71, catalogues a "pastiche copy" of the painting in Baroda, India; Waiboer in Rotterdam–Frankfurt 2004–5, p. 216, fig. 1, considers the picture to have been influenced by a painting by Metsu in Kassel; Washington–Detroit 2004–5, pp. 122, 174, 176, 212 n. 4 (under no. 48), compares the setting to that found in Ter Borch's *Three Soldiers Making Merry*, of about 1656 (private collection), and the subject to that of *The Music Party*, of about 1668–70 (Cincinnati Art Museum).

EXHIBITED: London, British Institution, 1829, no. 37 (lent by William Wells); London, British Institution, 1832, no. 73 (lent by William Wells); London, Royal Academy, 1876, no. 81 (lent by William Wells).

EX COLL.: Willem Lormier, The Hague (by 1752; sold to L. Lormier for Fl 160); his sister L. Lormier, Rotterdam (by 1754; sale, The Hague, July 4, 1763, no. 285, for Fl 420 to Cocq); Abel-François Poisson, marquis de Ménars et de Marigny, Paris (until d. 1781; sale, Paris, March 18–April 6, 1782, no. 108, for FFr 1,900 to Le Brun); [Le Brun, Paris, from 1782]; Charles d'Arverley, Paris (bequeathed to Calonne); Charles-Alexandre de Calonne, Paris (by

1788–95; sale, Paris, April 21–30, 1788, no. 74, bought in; sale, London, March 23–28, 1795, no. 32); William Wells, Redleaf, Kent (by 1829–at least 1876); Adolphe de Rothschild, London (in 1884); Francis Denzil Edward Baring, 5th Baron Ashburton, London and The Grange, Alresford, Hampshire (until 1907; sold to Agnew);

[Agnew, London, 1907]; [D. S. Hess & Co., New York, 1907–8; sold to Altman on January 23, 1908, for $29,331.56]; Benjamin Altman, New York (1908–d. 1913); Bequest of Benjamin Altman, 1913 14.40.617

16. *Portrait of a Seated Man*

Oil on wood, 14⅛ x 12 in. (35.9 x 30.5 cm)

The paint surface is abraded, and a 1 in. (2.5 cm) diagonal scratch on the sitter's face extends from the left cheek to just below the lips. The oak panel is beveled and retains its original thickness.

Marquand Collection, Gift of Henry G. Marquand, 1889
89.15.15

The first of seven paintings by Ter Borch to enter the Museum's collection, this anonymous portrait probably dates from the late 1650s or early 1660s.[1] The blond gentleman sits in front of a small table covered by a deep red cloth, which is complemented (as often in Ter Borch's portraits) by an olive green background. The chair is completely obscured by the figure's conical presentation, which finds an echo in the shape of the hat. The sitter's right arm is supported fashionably in the folds of his cloak, which flows voluminously over his lap. His knees are well separated, and barely discernible to the lower right is his left calf, stockinged and beribboned.

The patron was presumably one of Ter Borch's numerous clients in and around Deventer.[2] A good number of single male portraits by the artist are known, many, like this one, that include a hat resting on a table. To judge from the present figure's placement in the picture field, as compared with

that of men in Ter Borch's pendant portraits,[3] the Marquand painting never had a mate.

1. Gudlaugsson 1959–60, no. 152, suggests a date in the late 1650s, without explanation. On the basis of style or costume one could just as well assign the portrait to the early 1660s. The man's collar, cuffs, tall hat (with a relatively narrow brim), and hairstyle should be considered: compare ibid., vol. 1, pls. 150, 151, 158, 185, etc., and works by other portraitists of the period. The charts of hats and collars published in Meyer 1986, pp. 83–85, 95–97, are remarkably unhelpful.
2. On this "elite," see Kettering 1999.
3. See, for example, Gudlaugsson 1959–60, vol. 1, pls. 240–45.

REFERENCES: Caffin 1902, p. 274, observes that the portrait's "quiet directness and subdued color give it an unmistakable dignity"; Hofstede de Groot 1907–27, vol. 5 (1913), p. 100, no. 317, records that the picture was purchased by Marquand in 1888 in London, and describes the sitter as standing; Gudlaugsson 1959–60, vol. 1, pl. 152, vol. 2, p. 164, no. 152, dates the portrait to the late 1650s; Liedtke 1990, p. 36, mentions it among Marquand pictures; Baetjer 1995, p. 323.

EXHIBITED: New York, MMA, "Exhibition of 1888–89" [Marquand Collection], 1888–89.

EX COLL.: Purchased by Marquand in 1888 in London (according to Hofstede de Groot; see Refs.); Henry G. Marquand, New York (1888–89); Marquand Collection, Gift of Henry G. Marquand, 1889 89.15.15

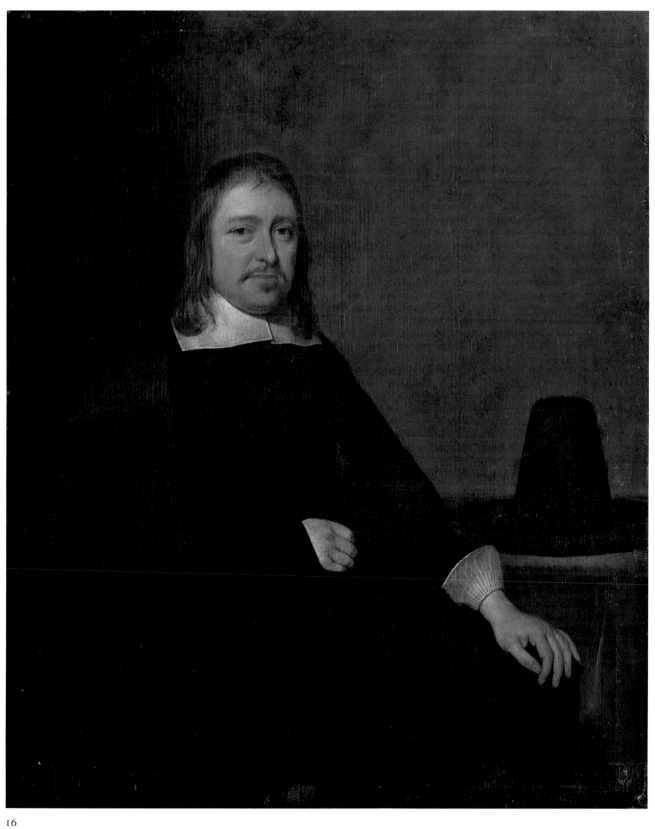

16

17. *Curiosity*

Oil on canvas, 30 x 24½ in. (76.3 x 62.3 cm)

The condition of the painting is good, although some areas of the surface are abraded. The original finish is disrupted on the pink bodice of the woman at left, the headdress of the woman writing, the figure of the woman looking over her shoulder, and the objects on the table.

The Jules Bache Collection, 1949 49.7.38

The subject and quality of this picture, one of the key works of Ter Borch's maturity, have attracted many writers and a succession of discerning collectors.[1] The painting probably dates from about 1660–62, when the artist lived in Deventer, but the luxurious interior and the casual elegance of the *juffertjes* ("young ladies," as the picture itself might have been titled in the seventeenth century) evoke the cosmopolitan milieu of Amsterdam (compare Pl. 118).

The traditional title, *Curiosity*, may be traced back as far as Smith's catalogue (1833) and pays homage to the pert beauty on the right.[2] The woman on the left, however, is the main protagonist, her dreamy expression betraying her pleasure at the arrival of the unsealed letter on the table. With her bare shoulders, sumptuous dress (to which Ter Borch devoted virtuoso attention), and string of pearls, the young lady could be described as the Venus in a modern-day Judgment of Paris, with the male viewer cast in the title role. The artist awards her with shimmering fabrics and the strongest light. Although she appears capable of composing an appropriate reply to the letter, the woman is assisted by a slightly older companion, perhaps her sister, whose attire suggests that her own courting days are over and that she now lives a comfortably settled life.[3]

As has often been noted, letter writing flourished in the Netherlands in the 1650s and 1660s as a refined form of social discourse. Painters such as Ter Borch, Metsu, Van Mieris, and Vermeer treated the theme in a variety of invented situations.[4] Manuals by Dutch and French authors (for example, Jean Puget de La Serre's *Le secrétaire à la mode*, 1630; Dutch ed., 1651) offered advice and models, with formulaic exchanges such as: "*Madam*, I should not take the Libertie to let you know [how] extreamlie I honour you, if the absolute power of your beauty did not force me to it"; and, "*Sir*, I am much obliged . . . but I have no other liberty left me, except to give you thanks, as I do very humbly."[5]

These lines could easily serve as captions to paintings by Metsu and by many of his contemporaries,[6] but they fail to do justice to Ter Borch's dozen or more paintings concerned with

private correspondence.[7] In the present picture especially, the painter's close connection with his half sisters, in particular the amateur poet and artist Gesina (1631–1690), surely contributed to his affectionate sensitivity to how young women might behave on such an occasion.[8] Another half sister, Jenneken (1640–1675), has been proposed as a model for the figure on the left,[9] while the curious young woman resembles Gesina as she appears in pictures dating from several years earlier.[10] The letter writer may be another version of Gesina, much as Rubens's wife, Helena, served not only as a model but also as a favorite type.

The candlestick and watch on the table are most likely conventional vanitas motifs.[11] The watch's winding key, which hangs on a chain over the edge of the table, perhaps conveyed to contemporary viewers the idea of self-regulation, that is, temperance. Symbolic motifs in Ter Borch's oeuvre are usually unobtrusive, and quite secondary to the artist's interest in human behavior and emotions. A painting like this one would have been considered a *conversatiestuk* (conversation piece), in which various nuances of meaning and observation might be discussed and appreciated.[12]

Details of costume and interior decoration, as well as the little spaniel on the velvet-upholstered stool, reappear in other paintings by the artist.[13] The somewhat similar composition and nearly identical dimensions of his *Lady at Her Toilet*, of about 1660 (Detroit Institute of Arts), led Gudlaugsson to conclude that it was painted as a pendant to the present picture.[14] It seems more likely, however, that the two works are independent representations of the same theme, that of a woman's world in which a man is the main concern.

1. Esmée Quodbach (in conversation, 2006) has drawn attention to the popularity of Ter Borch's paintings in eighteenth- and nineteenth-century France, reflected in the present picture's provenance, as well as that of other works by Ter Borch in the Museum's collection.
2. J. Smith 1829–42, vol. 4 (1833), p. 118, no. 6, and vol. 9 (1842), pp. 529–30, no. 3, as "The Letter, or female curiosity." The idea of curiosity is not mentioned in the sale catalogues of 1762, 1777, and 1801 (see Ex Coll.) or in an eighteenth-century print. P. Sutton in Philadelphia–Berlin–London 1984, p. 149, refers to "the eighteenth century's anecdotalizing title *Curiosity*," but it seems likely that Smith is the inventor, as with similar titles printed in roman type in his catalogue. The preceding entry in Smith (vol. 4, p. 118, no. 5) is *Le Magister Hollandois*, and the author notes, "engraved by Basan, under the above title."
3. Kettering 1993, p. 108, discusses the presumed suitor and, on p. 122 n. 69, describes the woman on the left as "the main love

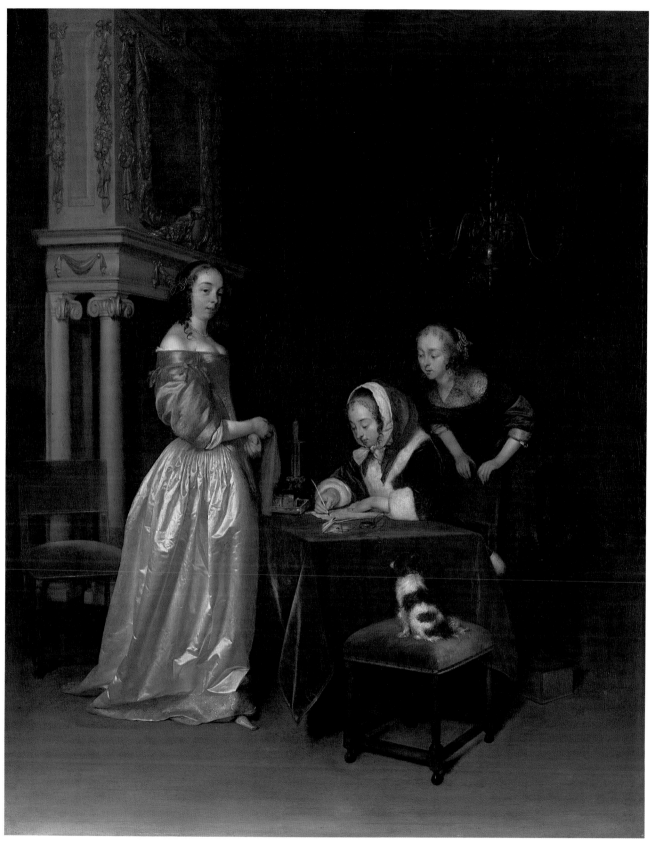

17

interest." See also pp. 99–101 on bright satin and the task of painting it, and p. 105 on posture and movement as prescribed in conduct books of the period.

4. See Naumann 1981, vol. 1, pp. 111–12; P. Sutton 1990a, pp. 28–29, and the sources cited in n. 12; Wheelock 1995a, pp. 377–81; and especially Dublin–Greenwich 2003–4.

5. Naumann 1981, vol. 1, p. 112, quoting from the 1654 English edition of La Serre.

6. See F. Robinson 1974, figs. 74–76, 118, 145, 146.

7. See Gudlaugsson 1959–60, vol. 1, pls. 111, 114, 124, 129, 130, 142–44, 164, 168, 169, 188, 190.

8. Kettering (1993, p. 101) observes that Gesina, who never married, had courtship in mind about 1660 and wrote amorous songs "saturated with Petrarchan diction and content."

9. Gudlaugsson 1959–60, vol. 2, p. 168.

10. Kettering 1993, p. 121 n. 62, sees Gesina as the model for "all (but one) of Ter Borch's earliest toilet scenes," for example Gudlaugsson 1959–60, nos. 77, 80 (Pl. 13), 83, 113. The pose of the figure leaning over the back of a chair recalls that of a maid in a scene of letter reading, Ludolf de Jongh's *The Message*, of 1657 (Landesmuseum, Mainz); see Fleischer 1989, fig. 83, or Stukenbrock 1997, pp. 259–60.

11. See P. Sutton in Philadelphia–Berlin–London 1984, p. 150 n. 3, citing Gudlaugsson 1959–60, vol. 2, p. 168, and The Hague–Münster 1974, no. 44. Gudlaugsson (p. 169) relates the dog to an Italian proverb published by Jacob Cats: "A woman is like a lapdog," or, more loosely, "The lady is a tramp." In my view, the dog is effective enough as a compositional element (which helps to focus attention on the opened letter and watch).

12. See Guépin's essay, "De rug zonder ommezijde," in The Hague–Münster 1974, pp. 31–41, and Westermann 1996, p. 57, on ambiguity. Ter Borch more than most of his contemporaries looks forward to Fragonard, whose vivacious young women recall the figure on the right.

13. See Gudlaugsson 1959–60, vol. 2, p. 168, and Philadelphia–Berlin–London 1984, p. 150. The partial copy of *Curiosity* in the Museum of Art, Carnegie Institute, Pittsburgh (Gudlaugsson 1959–60, no. 164a; Carnegie Institute 1973, pp. 124–25, no. 64.11.20 as by Caspar Netscher), appears to be of the period but not by Ter Borch or Netscher (in Wieseman 2002, p. 341, no. c22, the panel is described as "a much later copy").

14. Gudlaugsson 1959–60, vol. 1, p. 124, and less cautiously in vol. 2, nos. 164, 165; overruled in Moiso-Diekamp 1987 (see Refs.). See also P. Sutton in Philadelphia–Berlin–London 1984, p. 151. As discussed in Bruyn 1979, Dutch artists often obtained stretched canvases in standardized sizes.

REFERENCES: Buchanan 1824, vol. 2, p. 67, no. 45; J. Smith 1829–42, vol. 4 (1833), p. 118, no. 6, cites the painting as "Curiosity," in the collection of the duchesse de Berry, and incorrectly as in the Live de Jully sale of 1769, and vol. 9 (1842), pp. 529–30, no. 3, observing that "this capital production is of the highest excellence"; Blanc 1857–58, vol. 1, pp. 110, 354, vol. 2, pp. 195, 421, lists sales; Blanc 1861, vol. 1, p. 16 of the section on Ter Borch; Galichon 1868, p. 406, as from the "Galerie de San Donato"; G. Reid 1872, pl. 13; Hofstede de Groot 1907–27, vol. 5 (1913), p. 62, no. 169, describes the picture, mistakenly refers to the figure on the right as a "maid-servant," and gives provenance; W. Gibson 1928–29 (ill. opp. p. 322); A. Alexandre 1929, pp. 119 (ill.), 122; Bache Collection 1929, unpaged (ill.); Heil 1929, pp. 4, 16 (ill.), mentioned; Wilenski 1929, p. 239, pl. 105, listed as with Duveen; Hendy 1931, p. 352, considers the picture "a triumph of meticulous manipulation"; W. Martin 1936, pp. 240, 512 n. 337, as a work of about the 1670s; Bache Collection 1937, no. 39; *Duveen Pictures* 1941, no. 207, as from 1660–65; Bache Collection 1943, unpaged, no. 38 (ill.); Heil 1943, pp. 19 (ill.), 24, mentioned; Wehle 1943, p. 288, "an exceptionally brilliant work"; Plietzsch 1944, pp. 21, 47, no. 56, dates the picture to about 1657–58; Wilenski 1945, p. 161, pl. 105; Gudlaugsson 1959–60, vol. 1, pp. 124, 314 (ill.), vol. 2, p. 168, no. 164, dates the painting to about 1660 or shortly thereafter, identifies the model for the woman on the left as Ter Borch's half sister Jenneken, and compares motifs in other pictures by him; Haverkamp-Begemann 1965, p. 40, fig. 4, mentions a mantel similar to the one depicted here in the Town Hall of Deventer; Von Sonnenburg 1973, figs. 86 (detail) and 92 (X-radiograph detail), caption to fig. 92, observes that the X-radiograph "shows a much-reworked image"; Walsh 1973, fig. 57, as about 1660; The Hague–Münster 1974, p. 156, no. 44, admires the image's courtly elegance and detects symbolic motifs, including the foot warmer; F. Robinson 1974, p. 64; Kirschenbaum 1977, pp. 40, 58 n. 47, misnames the picture "The Curious Servant"; Hibbard 1980, pp. 342–44, fig. 620, considers it typical of "Ter Borch's elegant, discreetly anecdotal paintings"; Naumann 1981, vol. 1, pp. 57–58 n. 42, 111 n. 143, mentioned as an example of the theme; Liedtke 1984b, p. 62 (ill.); P. Sutton in Philadelphia–Berlin–London 1984, pp. 149–51, no. 12, pl. 71, supports Gudlaugsson's dating and discusses the picture's influence on Metsu; P. Sutton in Hoetink et al. 1985, pp. 45–46, fig. 7, considers Metsu's *Young Woman Composing Music*, in the Mauritshuis, The Hague, to be "freely based" on this composition; Paris 1986, pp. 266, 268–69 n. 6, fig. 2, repeats the preceding observation; P. Sutton 1986, p. 187, "even the dog seems to take an interest"; Moiso-Diekamp 1987, pp. 483–84, no. D7, rejects Gudlaugsson's suggestion that Ter Borch's *Lady at Her Toilet* (Detroit Institute of Arts) may have been intended as a pendant to the present picture; Kettering 1988, vol. 1, p. 148 (under no. GJr88), compares the composition of a drawing by Ter Borch in which the fireplace and two women at a table are similar; Leiden 1988, p. 137 n. 7, suggests that the curious young woman arouses the viewer's curiosity; Liedtke 1990, p. 52, mentions the canvas as a Bache acquisition of 1927; Ingamells 1992a, p. 201, suggests that the subject of Metsu's *The Letter Writer Surprised* in the Wallace Collection, London, may derive from this picture; Kettering 1993, pp. 95, 108, 110, 113, 122 n. 69, fig. 53, imagines the seventeenth-century male viewer's voyeuristic response and discusses the woman on the left and the possible significance of her handkerchief; Todorov 1993, p. 127, fig. 78, misinterprets the subject, considering the figure on the left simply "content to be there"; Werche in Frankfurt 1993–94, pp. 144, 146, fig. 8.2, compares other paintings of letter writers by Ter Borch; Jäkel-Scheglmann 1994, p. 86, fig. 77, describes the subject; Baetjer 1995, p. 324; A. M. Kettering in *Dictionary of Art* 1996, vol. 4, p. 382, cites the picture as an example of the letter-writing theme reaching a culmination in Ter Borch's oeuvre; Westermann 1997, p. 246 n. 55, compares a painting by Steen; Wieseman 2002, p. 341, no. c22, records a partial copy in the Carnegie Museum of Art, Pittsburgh; P. Sutton

in Dublin–Greenwich 2003–4, pp. 20, 38, 63, fig. 11, describes the behavior of the figures; Franits 2004, pp. 104–6, 185, fig. 93, describes the subject, the setting, and the contemporary viewer's likely response, and mistakenly considers the figure on the right to be a maid; Kettering, Wallert, and Wheelock in Washington–Detroit 2004–5, pp. 36, 137, 138–40, no. 35, pp. 141, 207 (notes to no. 35), and large detail on title page, describes precisely how the satin in this picture was painted, compares the subject and setting in *A Lady at Her Toilet*, of about 1660 (Detroit Institute of Arts), discusses the theme and related works by Ter Borch, and repeats Haverkamp-Begemann's remark about the fireplace resembling one in the Deventer Town Hall; Waiboer in Rotterdam–Frankfurt 2004–5, p. 219, fig. 2, considers Metsu to have based his figure of a man in *Young Woman Composing Music* (Mauritshuis, The Hague) on the curious woman in this painting.

EXHIBITED: Paris, Galerie Georges Petit, "Exposition de peinture: Cent chefs-d'oeuvre des collections Parisiennes," 1883, no. 126 (lent by the princesse de Sagan); London, Royal Academy, "Exhibition of Dutch Art, 1450–1900," 1929, no. 231 (lent by Jules Bache); New York, New York World's Fair, "Masterpieces of Art," 1939, no. 367; New York, Duveen Galleries, "Paintings by the Great Dutch Masters of the Seventeenth Century," 1942, no. 63 (lent by the Bache Collection, New York); New York, MMA, "The Bache Collection," 1943, no. 38; Boston, Mass., Museum of Fine Arts, "Masterpieces of Painting in The Metropolitan Museum of Art," 1970; New York, MMA, "Masterpieces of Fifty Centuries," 1970, no. 281; The Hague, Mauritshuis, and Münster, Landesmuseum für Kunst und Kulturgeschichte, "Gerard ter Borch," 1974, no. 44; Philadelphia, Pa., Philadelphia Museum of Art, Berlin, Gemäldegalerie, Staatliche Museen Preussischer Kulturbesitz, and London, Royal Academy of Arts, "Masters of Seventeenth-Century Dutch Genre Painting," 1984, no. 12; Athens, National Gallery and Alexandros Soutzos Museum, "From El Greco to Cézanne: Masterpieces of European Painting from the National Gallery of Art, Washington, and The Metropolitan Museum of Art, New York," 1992–93, no. 16; Washington, D.C., National Gallery of Art, and Detroit, Mich., The Detroit Institute of Arts, "Gerard ter Borch," 2004–5, no. 35; Amsterdam, Rijksmuseum, "Schitterend Satijn—Het beste van Gerard ter Borch," 2005, no. 35.

EX COLL.: Gaillard de Gagny, Paris (sale, Paris, March 29, 1762, no. 15, to Randon de Boisset for FFr 3,600); Randon de Boisset, Paris (sale, Paris, February 27–March 25, 1777, no. 52, to Le Brun for FFr 10,000); [Le Brun, Paris]; Robit (sale, Paris, May 11, 1801, no. 151, to Bonnemaison for FFr 9,000); [Bonnemaison, Paris]; Duchesse de Berry, Paris (by 1833; sale, Paris, April 4–6, 1837, no. 2, to Demidoff for FFr 15,200); Anatole Nikolaevich Demidoff, Prince of San Donato, Florence (from 1837; sale, Paris, April 18, 1868, no. 19, for FFr 71,000 to Seillière); Baron Achille de Seillière, Paris (from 1868); his daughter Princesse Jeanne Marguérite de Sagan, later duchesse de Tallyrand-Périgord, Paris (by 1883); Baroness Mathilde von Rothschild, Grünburg, near Frankfurt-am-Main (by 1912–d. 1924); Baron Goldschmidt von Rothschild, Frankfurt-am-Main (from 1924); [Duveen Bros., London and New York, by 1927; sold to Bache on October 16, 1927, for $175,000]; Jules S. Bache, New York (1927–44); The Jules Bache Foundation, New York (1944–49); The Jules Bache Collection, 1949 49.7.38

18. *Burgomaster Jan van Duren*

Oil on canvas, 32⅛ x 26⅛ in. (81.5 x 65.5 cm)
Signed (center left): GTB [monogram]
Robert Lehman Collection, 1975 1975.1.141

19. *Margaretha van Haexbergen, Wife of Jan van Duren*

Oil on canvas, 32 x 25⅝ in. (81.3 x 65.1 cm)
Robert Lehman Collection, 1975 1975.1.142

Dutch paintings in the Robert Lehman Collection are catalogued by Egbert Haverkamp-Begemann in *The Robert Lehman Collection II* (Sterling et al. 1998).

These full-length portraits of the Deventer burgomaster Jan van Duren (1613–1687) and his wife, Margaretha van Haexbergen (1614–1676), are in several respects (for example, type, scale, and date) ideal complements to the other five paintings by Ter Borch presently in the Museum's collections. As Haverkamp-Begemann explains, the pictures were painted in Deventer about 1666.[1] In that year, the artist himself became a *Gemeensman* (representative) of one of Deventer's eight wards, which placed him in regular contact with the city council. Many of Ter Borch's sitters of the 1660s and 1670s were members of Deventer's political elite.[2]

After he married and moved to Deventer in 1654, Ter Borch specialized in portraits that have been described as "small-scale, full-length, stately in appearance, remarkably spare in setting"—a type that was comparatively rare outside the

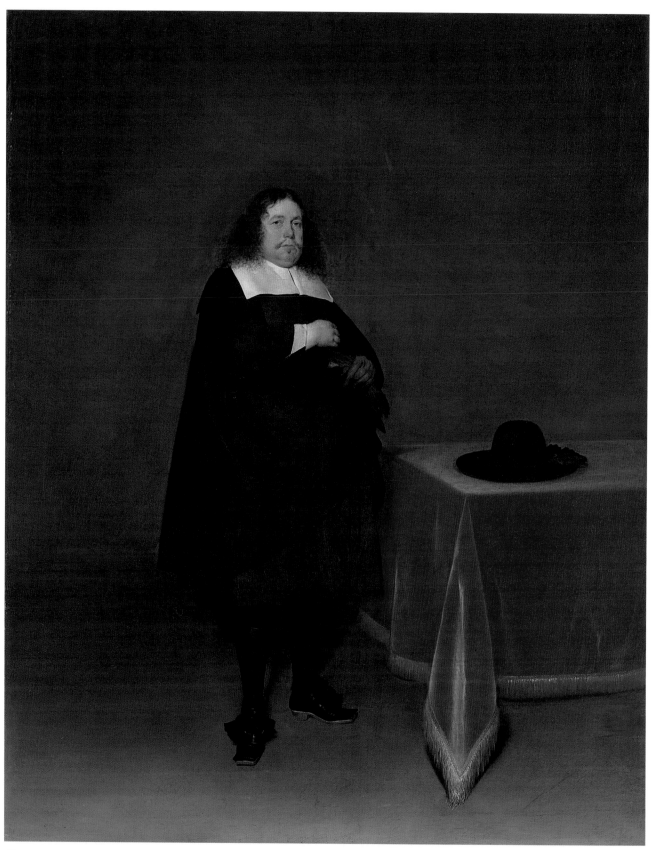

18

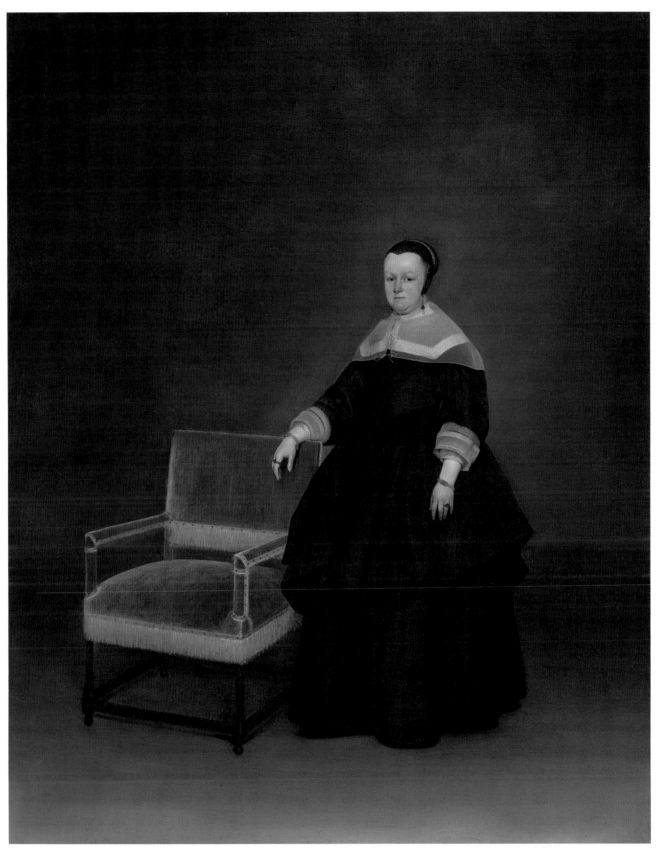

19

eastern Dutch province of Overijssel.[3] Most of these pictures are considerably smaller than those in the Lehman Collection.[4] The pendants make a magnificent impression in their size, condition, and dignified reserve. The last quality owes something to Spanish court portraiture, about which Ter Borch was better informed than most of his Dutch contemporaries.

1. Haverkamp-Begemann in Sterling et al. 1998, p. 158.
2. As noted in Kettering 1999, p. 48.
3. The quote is from ibid., p. 46, where the point about rarity is somewhat exaggerated.
4. See the plates in Gudlaugsson 1959–60, vol. 1, where dimensions and dates are given. About fourteen portraits (ibid., pls. 184–86, 206, 207, 211–13, 252, 254–57, 259) are approximately as large as the Lehman pair.

REFERENCES (additional to those given by Haverkamp-Begemann in Sterling et al. 1998, pp. 153–58, nos. 33, 34 [ill.]): Kettering 1999, pp. 46–48, 57–58, figs. 1, 2, dates the paintings to about 1667, and cites them as prime examples of "Ter Borch's portraits for the Deventer elite"; Kettering in Washington–Detroit 2004–5, pp. 158–59, 209–10, nos. 42, 43, dates the paintings to about 1666–67, discusses Van Duren and his wife as patrons, describes their dress, and suggests that like similar works by Ter Borch the pictures were probably given elaborately carved wooden frames.

EXHIBITED (after 1998): Washington, D.C., National Gallery of Art, and Detroit, Mich., The Detroit Institute of Arts, "Gerard ter Borch," 2004–5, nos. 42, 43.

EX COLL.: See Sterling et al. 1998, p. 153.

ANTHONIE VAN BORSSOM

Amsterdam 1630/31–1677 Amsterdam

Anthonie van Borssom (or Van Borssum) was baptized in Amsterdam on January 2, 1631. His father, Cornelis van Borssom, was a mirror maker from Emden, the German seaport on the northeastern Dutch border. The artist married a woman from Emden, Anna Crimpings, on October 24, 1670.[1] At the time, Van Borssom shared a house with his father on the Rozengracht in Amsterdam, but by September 9, 1671, the date he drew up a will, he was living on the Prinsengracht. A more modest address was recorded on March 19, 1677, when he was buried in the Westerkerk.

The influence of Rembrandt's landscape etchings on drawings by Van Borssom has led scholars to suppose that he was the master's pupil about 1645–50, but the assumption remains unsupported by documents.[2] During the first half of the 1650s, the young draftsman recorded views in the area of Emmerich and Cleves.[3] In his approximately two dozen known paintings and in his numerous drawings, Van Borssom proves himself to have been an eclectic artist whose ideas came from a considerable variety of contemporary Dutch painters and draftsmen. Some works of the 1650s recall the young Jacob van Ruisdael (q.v.);[4] several of the 1660s were inspired by Philips Koninck (q.v.);[5] and other pictures derive from landscapes by Jan Wijnants (1632–1684) or Aert van der Neer (q.v.),[6] park views with birds by Melchior d'Hondecoeter (q.v.),[7] church interiors by Hendrick van Vliet (q.v.),[8] or still lifes by Otto Marseus van Schrieck (q.v.).[9] A number of paintings by Van Borssom are plainly dependent upon cattle pictures by Paulus Potter (1625–1654) and in a few cases borrow bovines from Potter's prints.[10]

Van Borssom may be counted among the fair number of Dutch artists who were much better draftsmen than painters (the closest comparison would be with the Rembrandt pupil Lambert Doomer [1624–1700]).[11] His pen drawings, while occasionally derivative, are mostly records or convincing evocations of rural landscape, farm buildings, ruins, and scenes of everyday life. Van Borssom's sketching style was imitated in the eighteenth century by Jacob van Strij (q.v.) and others, while his manner of painting became confused with that of Albert Klomp (ca. 1618–?1688) or, optimistically, with the far more sophisticated technique of Potter.

1. A. D. de Vries 1885, p. 69, for this and the following details. The record describes the bride as thirty years old, "parents dead," and as living with her sister on the Herengracht in Amsterdam.

2. As noted by Ben Broos in *Dictionary of Art* 1996, vol. 4, p. 439. Compare Sumowski 1979–95, vol. 2, p. 617, and Sumowski 1983–[94], vol. 1, p. 426.

3. See Sumowski 1979–95, vol. 2, nos. 289 (datable before 1656) and 365 (dating from the fall of 1651 at the earliest). See also Dattenberg 1967, pp. 50–53, and P. Sutton 1990a, pp. 31–33.

4. See Sumowski 1983–[94], vol. 1, nos. 187–89. On Van Borssom, Jan van Kessel, and other landscapists in Van Ruisdael's circle, see A. Davies 1992, pp. 102–4.

5. See Sumowski 1983–[94], vol. 1, nos. 191–93, citing the Museum's Koninck of 1649 (Pl. 102) under no. 191, Van Borssom's panoramic landscape of 1666 (Kunstmuseum, Düsseldorf); and Chong in Amsterdam–Boston–Philadelphia 1987–88, p. 274.

6. On Van Borssom's relationship to Van der Neer, see Schulz 2002, pp. 42–44.

7. See Sumowski 1983–[94], vol. 1, no. 196.

8. See Liedtke 1982a, p. 129, no. 121, fig. 121.

9. See the signed canvas in the Rijksmuseum, Amsterdam (Sumowski 1983–[94], vol. 1, no. 211).

10. See the examples cited in Sumowski 1983–[94], vol. 1, nos. 199–204, which include the picture discussed below.

11. See Schulz 1974 and Schulz 1978; Sumowski 1979–95, vol. 2, pp. 783–1125; and Sumowski 1983–[94], vol. 1, pp. 463–95.

20. *Barnyard Scene*

Oil on canvas, 20 x 27 in. (50.8 x 68.6 cm)

As a result of abrasion and the increasing transparency of the paint over time, the darker passages have lost definition. The cow at center and the two pigs at lower right, all of which were painted with more opaque mixtures, are well preserved. In the sky are numerous points of abrasion along the crowns of the weave. The cross on the top of the tower is not original. Examination by infrared reflectography reveals underdrawing that outlines the cow at center and a few lines that describe the shed and tower.

The Friedsam Collection, Bequest of Michael Friedsam, 1931
32.100.12

A dilapidated barn borders the property of a country house with a slender tower. A busy dovecote crowns the barn doorway; another birdhouse and a number of earthenware jugs invite small birds to nest on the château's tower and gable.[1] Three cows (one being milked), two pigs, and a quartet of chickens (two of them now nearly invisible) animate the barnyard, which is sparsely strewn with plants, rocks, and a few mussel shells (the only inedible part of someone's leftovers). A line of trees recedes diagonally to a view of improbable hills and a man and dog herding a flock of sheep.

The painting evidently acquired a Paulus Potter signature between its sale in 1872 as a work by Albert Klomp (ca. 1618–?1688) and its sale from the Kums collection in 1898.[2] The artist was listed as unknown in the 1910 catalogue of the Yerkes collection, but no reservations about Potter's authorship were expressed by Hofstede de Groot in 1912 or in the Duveen sale of 1915.[3] In 1932, Burroughs and Wehle published the picture as a fine example of Potter's work, although the signature had come off in cleaning a few months earlier.[4] The attribution was changed to Klomp in 1940 and was maintained for fifty years, despite the fact that Niemeijer, in 1962, convincingly assigned the painting to Anthonie van Borssom.[5]

The country house in the background occurs in slightly different form in two drawings by Van Borssom, one of which is signed.[6] The unsigned drawing (Museum Fodor, Amsterdam) shows a formal garden next to the house, while the signed and stronger drawing (fig. 15) includes the more plausible setting of a fenced-in yard and trees. The subject of the signed drawing has been described since the eighteenth century as a view in the village of Soest, near Utrecht,[7] but Broos and Luykx have shown that the house is almost certainly the *jacht-slot* (hunting castle, or small country house) Toutenburg in the

village of Maartensdijk, near Utrecht.[8] Parts of the house survived until the late eighteenth century.

The drawing cited above and other signed sheets (one of which represents a barn like the one seen here) strongly support an attribution of the Museum's picture to Van Borssom.[9] Comparisons with a few signed paintings of similar subjects leave no doubt.[10] Van Borssom recalls Pieter de Hooch (q.v.) in that his figures and animals are usually less well described than their environments. The cattle in particular look patched into the present composition, with little regard for the overall impression of space, light, and atmosphere. Nearly the same three cows are depicted in a canvas by Van Borssom (art market, 1998), although they are juxtaposed differently.[11] Sumowski noticed that the recumbent cow was derived from an engraving by Potter;[12] the other cows may also have been borrowed from Potter prints.[13] The spiky plants in the foreground (which set off the scene like a row of footlights) are modeled on still lifes by Otto Marseus van Schrieck (see Pl. 115), whom Van Borssom imitated in his own paintings of plants and forest animals.[14]

This scene is probably an early work by Van Borssom, dating from about 1650–55, to judge from comparable paintings by the artist and their relationship to Potter. Van Borssom's Potter- and Klomp-like pictures are more naïve exercises in landscape painting than are those recalling the dune landscapes of Jacob van Ruisdael, the panoramas of Philips Koninck, or the valley views of Cornelis Vroom (1590/91–1661).[15] These painters appear to have revealed to Van Borssom the virtues of broader pictorial effects such as atmosphere and a natural flow of space, qualities that are not conspicuous in the present work.

No other view of a farmyard by Van Borssom features a fine country house. Nonetheless, the juxtaposition of disparate structures in the Museum's painting has no particular significance beyond that of picturesque effect, and the Dutch conviction, here maintained more or less unconsciously, that the cow was a prime mover of the country's prosperity.[16]

Previously attributed by the Museum to Albert Klomp.

1. The faint cross atop the tower was introduced by a restorer at an unknown date (kindly noted by conservator Dorothy Mahon in July 2006).
2. See Ex. Coll. The illustrated entry in the 1898 sale catalogue is remarkably flattering to the picture, as is Max Rooses in the catalogue's preface, p. XIII. Potter was very popular throughout the

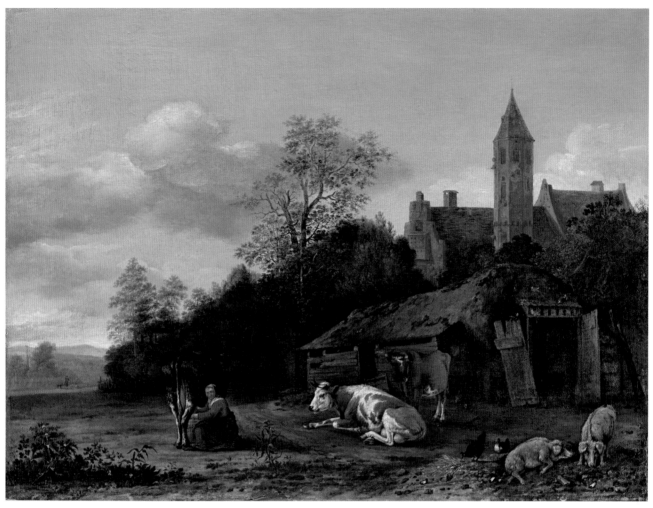

20

Figure 15. Anthonie van Borssom, *Castle Toutenburg, Maartensdijk, near Utrecht*, early 1650s? Pen, brown ink, and water-color, 8¾ x 13½ in. (22.2 x 34.2 cm). The Morgan Library & Museum, New York, Purchased as a Gift of Mrs. Charles W. Engelhard

nineteenth century. In 1801, when the Society of Fine Arts in New York sent John Vanderlyn to Paris to obtain copies after masterpieces by Raphael, Correggio, Titian, and other famous painters, Vanderlyn himself added Potter to the list (see Liedtke 1990, p. 27).

3. See Refs. and Ex Coll. With regard to the Duveen sale in New York and Friedsam's purchase of the picture, it is worth recalling that Potter, along with Van Ruisdael, Hobbema, and Cuyp, was considered one of the most desirable Dutch landscape painters during the Gilded Age in America. See Liedtke 1990, pp. 27, 31, 34, 37, 41, and 42 (on an implausible "Potter" in Peter Widener's collection).

4. See Refs. A record of the cleaning, dated August 1, 1932, is in the curatorial files.

5. See Refs. John Walsh favored Niemeijer's attribution, which Horst Gerson also proposed (undated note in files). See also Chicago–Minneapolis–Detroit 1969–70, Broos 1981, and Sumowski 1983–[94] under Refs. below. The change to Klomp in 1940 was probably influenced by Wilhelm Martin's oral opinion (1938) that the painting is not by Potter, and it was certainly encouraged, according to Louise Burrough's note in the curatorial files, by the exhibition of a painting assigned to Klomp but falsely signed "Potter," in Burlington Fine Arts Club, *Catalogue of a Collection of Counterfeits, Imitations and Copies of Works of Art* (London, 1924), p. 49, no. 26 (lent by the Earl of Crawford).

6. Niemeijer 1962, figs. 1, 2; Meischke 1978, p. 96, fig. 8 (the Amsterdam drawing); Sumowski 1979–95, vol. 2, nos. 307, 343.

7. Niemeijer 1962, p. 62.

8. Broos 1981, p. 106, citing P. J. E. Luykx's oral identification, which Broos supports with comparative material. A map of 1641 (ibid., p. 107) shows the sixteenth-century structure surrounded by trees. Van Borssom's signed drawing (fig. 15) and two eighteenth-century views (ibid., figs. b, c) show roads and a canal close by the house, which may account for the straight line of trees in the present painting.

9. Sumowski 1979–95, vol. 2, no. 301; also, a drawing exhibited at Colnaghi's, London, 1967, no. 23.

10. Sumowski 1983–[94], vol. 1, nos. 199–204, and a canvas on the art market in 1970 (see note 11 below).

11. Christie's, Amsterdam, November 9, 1998, no. 113 (ill.). The painting, inscribed "Paulus Potter.F," was attributed to Van Borssom by Buijsen in The Hague 1994–95, p. 78 n. 2. Compare also the landscape painting signed by Van Borssom that was sold at Sotheby's, London, November 4, 1970, no. 10 (ill.), and the barnyard scene in the Fitzwilliam Museum, Cambridge (Sumowski 1983–[94], vol. 1, no. 202).

12. Sumowski 1983–[94], vol. 1, p. 429, citing the print recorded by Hollstein 1949– , vol. 17, p. 213, no. 3. As Buijsen notes in The Hague 1994–95, p. 78 n. 2, the cow also occurs in Potter's painting *Two Cows and a Bull*, of 1647 (private collection, on loan to the York City Art Gallery, York, England).

13. Compare the cow being milked in the background of Hollstein 1949– , vol. 17, p. 212, no. 1 (dated 1650), and the standing cow in no. 8 (p. 216); also the standing cow in the painting cited in

the previous note (York; The Hague 1994–95, no. 8A). Common sources in Potter probably explain the similarity between the cows in the Museum's picture and those found in paintings and drawings by Cornelis Saftleven (1607–1681) dating from the 1650s to at least 1670 (see Amsterdam 1993, no. 81).

14. A signed example is in the Rijksmuseum, Amsterdam (Sumowski 1983–[94], vol. 1, no. 211).

15. See ibid., nos. 187–95.

16. See Spicer 1983, and Alan Chong's essay, "In 't Verbeelden van Slachtdieren," in Dordrecht–Leeuwarden 1988–89, pp. 56–86.

REFERENCES: Kums 1891, p. 21, no. 130, cites the work as by Paulus Potter; Yerkes Collection 1910, no. 100, as by an unknown artist; Hofstede de Groot 1907–27, vol. 4 (1912), pp. 627–28, no. 91, as a late Potter, "Cows in a Meadow," featuring "a building with a tower similar to the castle of Binkhorst near The Hague"; Pène du Bois 1917, p. 402 (ill. p. 401 [hanging on wall]); Valentiner 1928a, p. 17, as a signed work by Potter; B. Burroughs and Wehle 1932, p. 49, no. 86, as *Barnyard Scene* by Potter, "departing widely from the conventional subject matter of his Italianate contemporaries"; New York 1934, p. 17, no. 25, as by Potter; Niemeijer 1962, pp. 63, 74, fig. 3, as *Landhuis te Soest* by Van Borssom, on the basis of comparisons with two drawings by the artist that show the same house (see fig. 15 here); Chicago–Minneapolis–Detroit 1969–70, p. 185 (under no. 159, the Fodor drawing), restates Niemeijer's conclusions; Bénézit 1976, vol. 8, p. 450, records the price in the Kums sale of 1898; Sumowski 1979–95, vol. 2 (1979), p. 730, follows Niemeijer 1962; Baetjer 1980, vol. 1, p. 101, as by Klomp; Broos 1981, p. 109, as one of the few paintings that can be attributed to Van Borssom, with the country house Toutenburg in Maartensdijk, near Utrecht, as "filling-in"; Boerner 1982, p. 38 (under no. 28, the Morgan drawing); Sumowski 1983–[94], vol. 1, pp. 429, 445, no. 200 (ill.), as *Landscape with Milkmaid* by Van Borssom, noting that a cow was adopted from an engraving by Potter; Felice Stampfle in Ryskamp 1984, pp. 224–25, supports the attribution to Van Borssom; Baetjer 1995, p. 333, as by Van Borssom; Schulz 2002, p. 43, as *Landscape with Castle-Soest*, and as an example of Van Borssom imitating other artists.

EXHIBITED: New York, MMA, "Landscape Paintings," 1934, no. 25, as by Potter; American Federation of Arts, traveled 1954–57.

EX COLL.: Prince Wenzel Anton von Kaunitz (1711–1794), Vienna [according to the Hochschild sale cat., 1858]; Baron de Hochschild, London (his estate sale, Christie's, London, March 1–6, 1858, no. 1442, as by Potter, for £53 11s. to "Rippe"); the duc de Persigny, Paris [?] (sale, April 4, 1872, no. 12, as by Klomp, sold for FFr 750 to Tourguéneff [?]); Édouard Kums, Antwerp (by 1891; sale, Antwerp, May 17–18, 1898, no. 124, as by Potter, sold for BFr 26,000 to Montaignac); Charles T. Yerkes, Chicago (sale, New York, April 5–8, 1910, no. 100, as "Landscape" by an unknown artist); [Dowdeswell, London]; [Duveen Bros., New York; public sale, April 29, 1915, no. 8, as by Potter]; Michael Friedsam, New York (1915–31); The Friedsam Collection, Bequest of Michael Friedsam, 1931 32.100.12

LEONAERT BRAMER

Delft 1596–1674 Delft

The long-lived Leonaert Bramer, who in his heyday was the most esteemed artist in Delft, was born there on Christmas Eve in 1596.[1] Almost nothing is known about his family,[2] and his teacher is not identified in any contemporary source.[3] De Bie's biography of 1661 reports that Bramer set off for Rome at the age of eighteen, stopping at Arras, Amiens, Paris, Genoa, and Livorno en route.[4] On February 15, 1616, in Aix-en-Provence, Bramer contributed a drawing of figures in a landscape and a dedicatory poem to the *album amicorum* of Wybrand de Geest (1592–ca. 1662), a painter from Leeuwarden who had trained with Abraham Bloemaert (q.v.).[5] Bramer is recorded at various addresses in Rome between 1616 and 1627; in the early 1620s he shared living quarters with Wouter Crabbeth (ca. 1594–1644), the painter from Gouda.[6] The two artists, along with Dirck van Baburen (ca. 1594/95–1624), Paulus Bor (q.v.), Bartholomeus Breenbergh (q.v.), and Cornelis van Poelenburch (1594/95–1667), were founding members of the Schildersbent in Rome, a fellowship of Dutch and Flemish artists.[7]

This was an exciting time for a Netherlandish painter to be living in Rome, in the neighborhood of Santa Maria del Popolo and other churches where large canvases by Caravaggio could be studied. Two of the leading Caravaggesque painters from Utrecht, Baburen and Gerrit van Honthorst (1592–1656), painted altarpieces and other major works in Rome between about 1615 and 1620. The most important Italian and French representatives of the Caravaggesque manner, Bartolomeo Manfredi (1582–1622) and Valentin de Boulogne (1591–1632), were active in the same milieu.[8] Bramer's response to these artists was complemented by his enthusiasm for the small dramatic figure paintings of Adam Elsheimer (1578–1610), an interest he shared with Rubens, Rembrandt, and the latter's teacher Pieter Lastman (1583–1633) and more immediately with Elsheimer's compatriot in Rome, Goffredo Wals (ca. 1599/1600–1638/40). It has been suggested plausibly that Bramer, like Wals, may have worked for the illusionistic muralist Agostino Tassi (1578–1644), from whom he may have acquired his unexpected expertise in fresco painting. Some small pictures painted by Bramer in Italy, in particular stormy seascapes, are so similar to works by Tassi that their attributions have gone back and forth.[9] Bramer also had in common with Wals the support of Gaspar Roomer (d. 1674), a Fleming who lived in Naples and collected contemporary pictures by the hundreds. His inventory of 1634 refers to sixty small landscapes by Wals and "forty small paintings" by Bramer.[10] In Rome, where the painter was nicknamed Leonardo delle Notti, he also enjoyed the patronage of Mario Farnese and of the Dominican cardinal Desiderio Scaglia (elected in 1621).[11] Very few works certainly dating from Bramer's Italian years are known, although it has been assumed that his paintings on slate date mostly from that period.[12] Domenico Fetti (1588/89–1623) is one of several Italian artists who appear to have influenced the theatrical *notti* (night scenes) of the 1620s.[13]

In October 1627, Tassi's famous pupil Claude Lorrain intervened in a knife fight between two Italians and Bramer, thereby getting wounded and possibly saving the Dutchman's life. By early December, Bramer was back in Delft. He joined the painters' guild on April 30, 1629, and by 1637 was a member of the Knightly Brotherhood, an exclusive civic guard company.[14] The artist flourished during the 1630s and 1640s, to judge from the houses he bought,[15] and the frequent mention of paintings by him in the possession of prominent citizens. Collectors of his works included wealthy merchants and manufacturers in Delft, burgomasters, aldermen, solicitors, and so on. Bramer's prices were not high, but his mostly small paintings were produced quickly and are cited more frequently than pictures by any other artist in Delft inventories of the 1630s through the 1670s, except for works by Hans Jordaens.[16]

According to the inscription beneath an engraved portrait of Bramer in Jean Meyssens's *Images de divers hommes desprit sublime* (Antwerp, 1649), the artist worked not only for "Farneso" and "Scalie" in Italy but also "painted several works at Rijswijk for His Highness the Prince of Orange Frederick Hendrick and for his Excellency Count [Johan] Maurits of Nassau, and other princes."[17] Meyssens treats Bramer as if he were Delft's answer to Rubens, but it is true that two large mythological paintings by him were installed in the Stadholder's new country house at Rijswijk, and an allegorical picture of Fortune Distributing Treasures hung in Honselaarsdijk, Frederick Hendrick's other château near The Hague.[18]

Perhaps this experience with palace decoration stirred Bramer's memories of mural painting in Italy. In February 1653, he signed a contract to paint frescoes on the walls of a passageway that ran between his own house and that of Anthonie van Bronchorst, who would give him 300 guilders and a silver pitcher worth 50 guilders.[19] The artist was paid substantially less in 1657 when he painted a fresco in a garden house behind the Gemeenlandshuis (Communal Land House) in Delft.[20] In 1660, Bramer received 100 guilders as a first payment for his work on a much larger decorative project, the Painted Room in the Nieuwe Doelen (New Civic Guard House). The Delft historian Dirck van Bleyswijck records that the meeting hall was "most attractive, having all the walls painted in the Italian manner in fresco or damp plaster by the famous Leonard Bramer, all befitting and suiting the purpose of the place."[21] Like Bramer's other frescoes, the Doelen decorations did not last long in the Dutch climate. In 1667, he was paid for repairs, and in the same year he started work on a set of large mural paintings—this time on canvas—for the Grote Zaal (Great Hall) in the Prinsenhof of Delft. The main scene (to judge from a drawing dated 1742) told the story of the Romans and the Sabines, while classical or biblical banquet scenes were placed over the fireplaces on the end walls. To the sides musicians on a balcony and other figures placed within illusionistic architectural settings recall Veronese's frescoes in the Villa Barbaro at Maser. A few drawings and one large canvas of about 1665–70 provide further evidence of Bramer's approach to wall and ceiling decoration, which may be traced back to Renaissance Italy through the works of Netherlandish court painters such as Hans Vredeman de Vries (1526–1609) and Van Honthorst.[22]

Weyerman, in 1729, described Bramer as "a talented and diligent draughtsman, as evidenced by thousands of drawings in the hands of collectors."[23] In addition to studies for murals, ceilings, and what appears to have been a perspective box,[24] Bramer made suites of drawings devoted to biblical, classical, and literary themes as finished products for collectors. Typical examples are the 140 drawings dating from the 1650s illustrating Virgil's *Aeneid* and the 72 scenes from *The Life of Lazarillo of Tormes*, which Bramer presented to the wealthy artist and art dealer Abraham de Cooge in 1646. The known series of drawings are mostly devoted to ancient history, but the 65 "Street Scenes" (*Straatwerken*), of about 1659, represent all kinds of professions and derive from popular prints.[25] In his graphic oeuvre and in his paintings of occasionally obscure subject matter, Bramer allowed himself to appear as the learned artist and virtuoso inventor.[26] The variety and sheer abundance of his works, which he dashed off on wood, canvas, copper, slate, paper, and wet plaster, imply a concept of artistic creativity somewhat out of proportion to the average painting by him (like the one discussed below), and to his mastery of technique.

Bramer was a respected member of the Delft painters' guild, which appointed him *hoofdman* (headman) in 1644–45, 1660, and 1664–65. He was evidently Catholic, and a lifelong bachelor. No pupils are recorded, although a few minor figures may have received instruction from him.[27] In his late years the elderly artist appears to have had trouble supporting himself. He was buried in the Nieuwe Kerk of Delft on February 10, 1674.[28]

1. According to Van Bleyswijck 1667–[80], vol. 2, p. 859. See Huys Janssen in Delft 1994, p. 13, where it is suggested that "Bramer, still alive in 1667, could actually have told this [the date of Bramer's birth] to Van Bleyswijck." Perhaps, but the information is found in volume 2, of 1680.

2. In Delft 1994, p. 13, Paul Huys Janssen identifies the artist's father as Henricus Bramer, who was "possibly . . . the same as the painter of equestrian pieces" (meaning cavalry skirmishes, like those depicted in Delft by Palamedes Palamedesz [1607–1638]), but then observes that "Henricus may have been Leonaert's brother or cousin." In Plomp 1986, p. 104, it is more clearly explained that Bramer's father was named Henricus, but that the artist after whom Leonaert Bramer made a drawn copy of a painting, "Henricus Bramer" (according to an inscription on the sheet), was more likely Leonaert's brother and a "Sunday painter." Bramer's father was probably not a painter, since his son paid six, not three, guilders (the fee for a master's son) when he joined the Guild of Saint Luke in Delft (as noted by Wichmann 1923, pp. 3–4, and Plomp 1986, p. 104 n. 4). It is also unlikely that the son of a minor artist (if not a wealthy dilettante) would have been able to afford the journey to Italy (see Montias 1982, p. 46, on this point). Bramer's mother, Christyntge Jans, died in May 1638 (Delft 1994, p. 18).

3. Wichmann (1923, p. 70) implies that Bramer's teacher may have been Adriaen van de Venne (1589–1662), a hypothesis that is considered "very attractive" in C. Brown 1995, p. 46. However, Van de Venne, although a native of Delft, lived in Leiden before his Middelburg period of 1614 to 1624. In New York–London 2001, p. 66, the present writer mentions Hans Jordaens the Elder (1555/60–1630) as a more plausible candidate, considering that he was an esteemed master in Delft, a specialist in history pictures with small figures, and, like Bramer, a painter of peasants, soldiers, nocturnes, fires, and other "clever things" (Van Mander/Miedema 1994–99, vol. 1, p. 290, fol. 258r).

4. De Bie 1661, p. 252. The passage is reprinted in Delft 1994, p. 27. Bramer probably passed through Antwerp on the way to Arras.

5. As noted by J. W. Noldus in the entry on Bramer in *Dictionary of Art* 1996, vol. 4, p. 656, who fails to cite (even in his bibliography) Delft 1994, where (pp. 14–15, fig. 2) Bramer's calligraphic lines are reproduced. The date is fifty-two days after Bramer's nineteenth birthday, which tends to support De Bie's information

that Bramer was eighteen when he began his overland journey to Italy.

6. See Delft 1994, pp. 14–16.

7. See David A. Levine in *Dictionary of Art* 1996, vol. 28, pp. 92–93, on the Schildersbent, or "painters' clique."

8. On this point, see Slatkes in Milwaukee 1992–93, p. 14.

9. On Tassi and Bramer, see the essay by Plomp and Ten Brink Goldsmith in Delft 1994, pp. 52–53, figs. 6, 7 (shipwreck scenes by Tassi and Bramer), and no. 14.

10. See Delft 1994, p. 53, and Repp 1985 on Wals.

11. On Farnese and Scaglia, see Delft 1994, p. 53; C. Brown 1995; and New York–London 2001, p. 67, where it is said that Farnese lived mostly in Parma. This is corrected by Noldus in *Dictionary of Art* 1996, vol. 4, p. 656, where it is noted that Farnese lived in Rome as general of the papal army.

12. Noldus in *Dictionary of Art* 1996, vol. 4, p. 656, claims that there are no dated works from Bramer's Italian period, but the *Soldiers Resting*, in the Museum Bredius, The Hague, is signed and dated "LvB 1626" (Blankert 1991, no. 24; Delft 1994, no. 9). On the assumption that Bramer's works on slate all date from the Italian period (e.g., in Milwaukee 1992–93, pp. 50–51 [under nos. 3, 4]), see my remarks in New York–London 2001, pp. 67–68.

13. See New York–London 2001, p. 67.

14. For these details, see Delft 1994, pp. 16–17.

15. See ibid., pp. 18–19 (buys a house on the Korenmarkt in 1643, for 2,500 guilders; buys an investment property in 1648). Montias 1982, p. 125, remarks on the high property tax paid by Bramer.

16. On Bramer's patrons and clients in Delft, see Montias in Delft 1994, pp. 35–45.

17. See Delft 1994, pp. 19–21, fig. 5. The information was borrowed by Filippo Baldinucci in 1681 (Baldinucci 1845–47, vol. 4, p. 527).

18. See Delft 1994, p. 21.

19. See ibid., pp. 22, 63, 200, and my comments in New York–London 2001, pp. 122, 579 n. 95.

20. See Delft 1994, pp. 23, 63 (misstating the payment, which was apparently 52, not 12, guilders), 200, 245 n. 4.

21. Van Bleyswijck 1667–[80], p. 566. See also Delft 1994, pp. 24–25, for the original text and a looser translation; Plomp and Ten Brink Goldsmith's discussion in ibid., pp. 64–65; and my own, in New York–London 2001, pp. 122–23, figs. 132, 133 (Bramer's small model for the room).

22. On the Prinsenhof murals and Bramer's work in a similar vein, see my discussion of lost mural paintings by Bramer and Carel Fabritius in New York–London 2001, pp. 120–24 (fig. 136 for Augustinus Terwesten's drawing of the Grote Zaal in the Prinsenhof), and pp. 232–34, no. 11 (Bramer's *Musicians on a Terrace*, a canvas mural owned by Richard L. Feigen and Co., New York). Bramer is also connected with Vredeman de Vries in Liedtke 2004c.

23. Weyerman 1729–69, vol. 1, pp. 392–93, as quoted in translation by Plomp in Delft 1994, p. 184.

24. On the latter, see Liedtke in New York–London 2001, p. 127, and Plomp in ibid., pp. 458–61, nos. 108, 109.

25. See my brief remarks in New York–London 2001, pp. 70–71, where further literature is cited, and Plomp in ibid., pp. 174–77, 452–54, 456–57, 462–65, nos. 103, 104, 106, 107, 110, 111. Michiel Plomp devoted an essay to Bramer as a draftsman and catalogued forty-six examples in Delft 1994, pp. 183–208.

26. Bramer's choice of unusual subjects and aspects of his style in the 1640s have been connected with the Utrecht painter Nicolaes Knupfer (1603 or ca. 1609–1655), most recently in Saxton 2005, p. 38. However, this inclination is also found in the work of other Dutch painters (see the entry for Paulus Bor in this catalogue), and must reflect the intellectual tastes of patrons.

27. The hypothesis that Bramer was Vermeer's teacher is considered unlikely and unhelpful in New York–London 2001, p. 147. Adriaen Verdoel, Pieter Volmarijn, and Pieter Vromans have also been proposed as Bramer pupils (see Delft 1994, pp. 30, 37).

28. See Delft 1994, pp. 28–29, for documents suggesting financial difficulties, and p. 31 for the record of Bramer's burial.

21. *The Judgment of Solomon*

Oil on wood, 31⅛ x 40½ in. (79.1 x 102.9 cm)

The painting is in poor condition. It is severely abraded, and as the thinly applied oil paint has grown more transparent over time, the effect of the medium brown ground preparation has increased. Consequently, there is an overall loss of detail in the dark passages and an enhancement of the contrast between the light and dark passages. The oak panel is composed of four horizontal boards. There is paint loss along the three horizontal panel joins and at the edges of the multiple horizontal splits in the bottom board.

Gift of National Surety Company, 1911 11.73

This painting of the 1640s is one of a few known works by Bramer that treat the Old Testament subject of the Judgment of Solomon (1 Kings 3:5–28). In a dream the Lord appeared to Solomon, who was the son of David and Bathsheba and David's successor as king of Israel. The youthful monarch beseeched God for "an understanding heart to judge thy people," and the Lord answered that his request would be granted, because he had not asked for wealth, a long life, or the lives of his enemies. "Lo, I have given thee a wise and an understanding heart; so that there was none like thee before thee, neither after thee shall any arise like unto thee." Furthermore, Solomon would be blessed with riches, honor, and longevity, providing that he kept God's commandments. Upon waking, Solomon burnt offerings before the ark of the covenant "and made a feast to all his servants." Then two women, harlots who shared a house, came to the king with conflicting stories about their newborn children, for each woman had recently given birth to a boy. One of the infants had died in the night, and was supposedly switched with the living child by the unfortunate mother. But the woman with the surviving son pleaded that she had done no such thing. In the first act of Solomonic wisdom, the king ordered that the living child be cut in two, so that each woman would have half. The true mother cried out for the baby's life, conceding the child to the other woman, who at the same time expressed her assent to Solomon's decision. Whereupon he gave the child to its actual mother, and all of Israel came to respect their new king, "for they saw that the wisdom of God was in him."

In Bramer's picture, Solomon sits on a high throne flanked by the usual figure of a lion. Older men behind the throne and in the crowd underscore the king's youth. A carpet cascades from his feet to the lifeless baby on the ground. The center of interest, and the one passage of impressive painting,

consists of the duplicitous mother and a swordsman dangling the live baby by one foot (fig. 17). The executioner's pose recalls that of *The Dioscuri*, or Horse Tamers, one of the most admired ancient sculptural groups in Rome.[1] Behind the good mother, with her hands raised in protest, a man on a horse and a host of male figures suggest recession in space (although the onlookers gathered against the low walls to the left could not in reality stand on the same ground plane as the horse and the rest of the crowd). The ambiguity of the entire background is such that one might suspect drastic revisions by the artist, with overpainted passages now showing through. But the haphazard space is as typical of Bramer as is the mishmash of architecture, which features a monumental column to the right, an arched window in the center background, and in the left distance something like the wall or wing of a Renaissance villa surmounted by classical statues and set against trees and an evening sky. That this backdrop fails to suggest the earliest days of Jerusalem is a moot point in the case of an artist who freely mixed ancient, medieval, and modern buildings in, for example, his illustrations to Livy's *History of Rome (Ab urbe condita)*.[2]

Bramer's figures are thinly dashed on a dark layer of paint, with flashy white and yellow highlights used to pick out the key protagonists in the overall tonality of golden brown. This bold but superficial technique may be traced back to the artist's earliest pictures on slate, copper, and wood, as may the broad outlines of this picture's Baroque design. However, Bramer was also inspired by Rubens's *Judgment of Solomon*, of about 1615–17, which was known from several versions, and from Boetius à Bolswert's engraving (fig. 16). (Christiaen van Couwenbergh, Bramer's colleague in Delft, also appears to have referred to Rubens's invention in a painting of about 1640.)[3] The original painting by Rubens was made for the Town Hall of Brussels, and burned in 1695. A pupil's version of the Brussels painting is in the Statens Museum for Kunst, Copenhagen, and another version was in Bramer's own city of Delft by the late seventeenth century, and possibly earlier.[4] Responses to Rubens are found in Bramer's king and in the two thoughtful figures on the near side of the throne, and especially in the gesturing mother (who in the Rubens is the real one) and in the suspended child. Another treatment of the subject by Bramer, dated 1643 (location unknown),[5] resembles Rubens's arrangement in that the false mother is standing and faces Solomon from the far side. The true mother, on her knees in the foreground, is a more desperate version of the false mother in the Museum's painting. In other respects, the

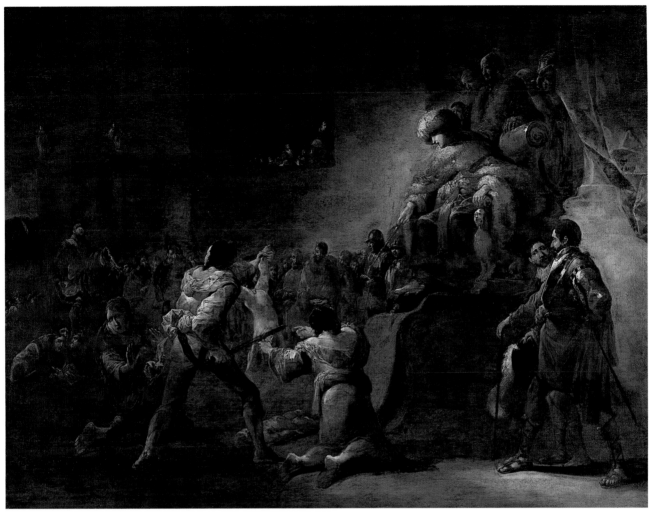

21

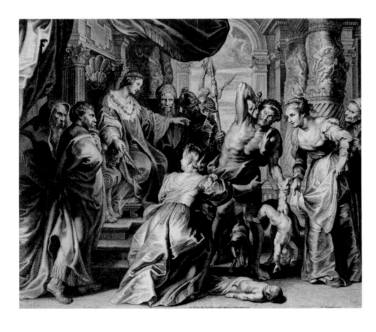

Figure 16. Boetius à Bolswert after Rubens, *The Judgment of Solomon*, ca. 1630–32. Engraving, 17½ x 20⅛ in. (44 x 51 cm). The Metropolitan Museum of Art 51.501.7016

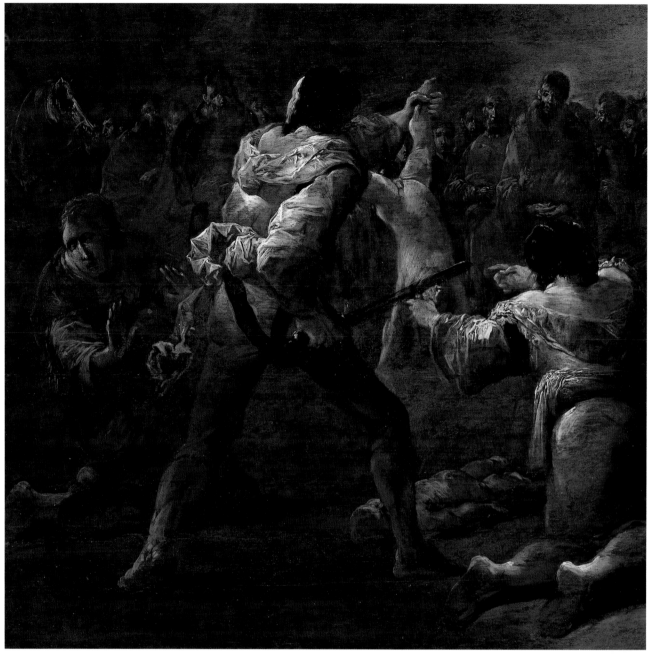

Figure 17. Detail of Bramer's *The Judgment of Solomon* (Pl. 21)

panel of 1643 has little in common with Rubens's composition or with the present picture, apart from Bramer's usual nocturnal staging and theatrical light.

A taller *Judgment of Solomon* by Bramer, with fewer figures, a deep foreground, and a spare, stagelike setting, is in the Saint Annen-Museum, Lübeck, and probably dates from the late 1640s or early 1650s.[6] The artist employed somewhat similar compositions in paintings of the Queen of Sheba before Solomon, for example in a tall panel in a private collection, Milwaukee, and in a broad panel in Jagdschloss Grunewald, Berlin, both of which probably date from between 1645 and 1655.[7] Other images, such as a drawing of Joseph Interpreting Pharaoh's Dreams, dating from about 1655–60 (National Gallery of Canada, Ottawa), are also reminiscent of the present picture in their designs.[8]

During the seventeenth century, courtrooms and similar

chambers in the town halls of the Netherlands were usually decorated with images of justice. The most common subject was the Judgment of Solomon, although themes drawn from ancient history, such as the Judgment of Cambyses or the Judgment of King Zaleucus, were also portrayed.[9] In Delft itself, Pieter van Bronckhorst (1588–1661) painted a large *Judgment of Solomon*, dated 1622, for the *vierschaar* (tribunal) of the newly built Town Hall.[10] However, Bramer's comparatively small paintings of the Judgment of Solomon, and even the large version of Rubens's composition that was in seventeenth-century Delft, were intended for private collectors.[11] A large *Judgment of Solomon* by Bramer was recorded in a Delft collection in 1666,[12] and a painting of the same subject by his presumed pupil, Pieter Vromans, together with "a large painting of Diogenes by Bramer," was in the collection of Dirck van Brantwijck (d. 1646), who owned a sawmill in Delft.[13] In 1665, paintings of the Judgment of Solomon and of the Justice of Willem III, by unnamed artists, were recorded with landscapes and still lifes in one of the rooms of Hendrick Schaeff's house in Amsterdam.[14] Schaeff was a notary, and it may be supposed that the private owners of pictures depicting the Judgment of Solomon and similar themes were often people whose professions involved the administration of justice or scrupulous behavior. It may be worth noting in this regard that the present picture was given to the Museum by the National Surety Company.

1. See Liedtke 1989b, pp. 148–49, pl. 11, noting that the ensemble (which dates from about A.D. 272) was often drawn by artists from Raphael and Maarten van Heemskerck onward.

2. See Delft 1994, nos. 34, 35. Bramer's visions of ancient architecture must owe something to Wals (see the biography above, and Repp 1985).

3. See Refs. under Plomp 1986 and Maier-Pruesker 1991. The painting of a historical subject (possibly Semiramis condemning her husband to death) is known from a drawing after it by Bramer of about 1652–53 (also discussed in New York–London 2001, p. 60, fig. 62). In the present writer's opinion, Bramer's painting probably dates from somewhat later than Van Couwenbergh's. If Bramer borrowed anything from the Delft artist's design, as opposed to Rubens's, it was the arrangement of the high throne to the right and the approximate pose of the ruler.

4. See D'Hulst and Vandenven 1989, pp. 146–50 (under no. 46). On the Delft picture, which is now in the Stedelijk Museum Het Prinsenhof, Delft, see Lokin 2004. Rubens may have noticed the small vignette of the same subject in the border of Goltzius's engraving *The Schoolroom*, one of the twelve *Allegories of Faith* first published by Philips Galle in Antwerp about 1578 (see Strauss 1977, vol. 1, p. 127, no. 55).

5. Tomkiewicz 1950, no. 122 (ill.), as taken from the collection of Benedykt Tyszkiewicz, Warsaw.

6. As suggested in Delft 1994, p. 172 (under no. 48). A *Judgment of Solomon* by Bramer, said to be dated 1630, was in the collection of General Roudzewitch in Saint Petersburg, according to a note in Semenov Collection 1906, p. XXXII n. 2 (see also Wichmann 1923, p. 97, no. 21).

7. See Delft 1994, no. 44, for the Milwaukee picture, and Börsch-Supan 1964, p. 32, no. 31.

8. Ottawa–Cambridge–Fredericton 2003–5, no. 47.

9. See Brenninkmeyer-de Rooij in Washington–Detroit–Amsterdam 1980–81, pp. 66–67, and no. 63 (Zaleucus) in the same catalogue; Liedtke 1984a, pp. 233–34 (Cambyses); Van Gent in Amsterdam–Jerusalem 1991–92, p. 95, where it is implausibly stated that the Judgment of Solomon was less frequently depicted by Dutch artists on a small scale for private buyers than on a large scale for public buildings; and Huiskamp in ibid., pp. 134–55, on Old Testament scenes in town halls and other public buildings in the Netherlands.

10. See Huiskamp in Amsterdam–Jerusalem 1991–92, p. 150, fig. 98, and Liedtke in New York–London 2001, p. 81, fig. 94.

11. As explained in Lokin 2004, p. 81, Ewout van Bleijswijck, who gave the Rubensian picture to the city of Delft in 1703, had inherited it from his father, the former burgomaster Heijndrick van Bleijswijck.

12. Wichmann 1923, p. 97, no. 22.

13. See Montias in Delft 1994, p. 37.

14. Loughman and Montias 2000, p. 90.

REFERENCES: Blankert 1975b, pp. 12–13, 15, fig. 3, cites the painting as an example of Bramer's work in Delft; Bader in Milwaukee 1976, p. 102, fig. 23, comparing Bramer's *Queen of Sheba before Solomon* (private collection, U.S.A.), notes that Bramer was "singularly fond of subjects with King Solomon"; Blankert 1978b, pp. 11–12, fig. 4, repeats Blankert 1975b; Montias 1982, p. 147, fig. 6, dates the painting to the 1630s; Blankert in Aillaud, Blankert, and Montias 1986, pp. 71–72, fig. 48, repeats Blankert 1975b; Plomp 1986, p. 110 n. 5, compares the composition of this picture with that of Christiaen van Couwenbergh's *Historical Subject (Semiramis Commanding Her Husband's Death)*, of about 1640; P. Sutton 1986, p. 180, considers the work "especially attractive"; Maier-Preusker 1991, p. 189, accepts Montias's dating to the 1630s and suggests that Van Couwenbergh referred to this composition when designing his lost painting of a historical subject (see Plomp 1986); Delft 1994, p. 172 (under no. 48), fig. 48a, compares Bramer's different treatment of the subject in his painting in Lübeck; Baetjer 1995, p. 307; Liedtke in New York–London 2001, pp. 64–65, fig. 68, compares the picture with the Van Couwenbergh painting mentioned above (see Plomp 1986) and concludes that "the two painters were working along parallel lines about 1640."

EXHIBITED: Palm Beach, Fla., Society of the Four Arts, "Portraits, Figures and Landscapes," 1951, no. 5; Minneapolis, Minn., University Art Museum, University of Minnesota, "Space in Painting," 1952.

EX COLL.: Gift of National Surety Company, 1911 11.73

BARTHOLOMEUS BREENBERGH

Deventer 1598–1657 Amsterdam

Breenbergh was the son of Jan Bredenbergh (or Breenbergh), the town apothecary in Deventer, and Anna Becker, who came from one of the most prosperous families in the Overijssel capital. Bartholomeus, the second youngest of at least eight children, was baptized on November 13, 1598. After his father's death in 1607, the family moved from Deventer, probably to Hoorn, just north of Amsterdam. Opportunities to train as a painter in Hoorn were limited, and it is usually assumed that Breenbergh began an apprenticeship in Amsterdam when he was about fourteen years old. His early works, and also those dating from the 1630s (like the one discussed below), are closely linked with the Pre-Rembrandtists, the Amsterdam circle of Pieter Lastman (1583–1633), Jacob Pynas (q.v.), and others.

Breenbergh was described as a painter when he testified in Amsterdam in October 1619. By the end of that year, he was living in Rome and listed in the census (perhaps inaccurately) as a Catholic. In 1623, Breenbergh became a founding member of the Schildersbent, the fellowship of Netherlandish artists in Rome, which brought him into contact with the Italianate landscapist from Utrecht with whom he is often associated, Cornelis van Poelenburch (1594/95–1667). Paintings by Breenbergh dating from 1622 to about 1630 have been confused with Van Poelenburch's in the past. Another artist who influenced Breenbergh in Rome was the much older Flemish landscapist Paul Bril (ca. 1554–1626), with whom Breenbergh "spent more than seven years," according to his own recollection in 1653.[1]

Of the approximately two hundred drawings by Breenbergh that are known, all but about thirty-five date from between 1624 and 1629. These early drawings are highly accomplished, much more so than the artist's contemporary paintings, and were intended as independent works of art. Using a pen and brown ink and on most sheets a brown wash, Breenbergh drew ancient ruins in Rome and the Campagna, as well as a series of rocky landscape views near Bomarzo and Bracciano. The latter drawings were evidently made for Paolo Giordano Orsini II, duke of Bracciano.[2]

It is not known when Breenbergh returned to the Netherlands, but it was probably about 1629–30. In September 1633, he married the Protestant Rebecca Schellingwou (after 1604–1667), daughter of a prominent cloth merchant. The couple lived in Amsterdam in the Dijkstraat and, from 1648, at various addresses on the Lauriersgracht, the Prinsengracht, and the Herengracht. They had two sons, Pieter and Hendrik, neither of whom went into their father's profession. Breenbergh was buried on October 5, 1657, in the Oude Kerk.

The artist flourished during the 1630s, when he treated biblical subjects (especially Old Testament scenes) and mythological themes. Although Breenbergh incorporated motifs he had drawn in Italy, his compositions, palette, and demonstrative figures recall Lastman and other history painters working in Amsterdam. A few portraits by Breenbergh are known. Portraits presumed to be of Breenbergh and his wife, painted by Jacob Backer (q.v.) in 1644, are in the Amsterdams Historisch Museum.[3]

Breenbergh had no known pupils and did not exercise much influence on the art of his time. It is possible that Amsterdam was not the best market for his work; most of the Dutch painters who were successful in a similar vein—even some whose work was influenced by Breenbergh—lived in Utrecht or in the area of The Hague. His drawings were especially important for Jan de Bisschop (1628–1671), the lawyer and gifted amateur draftsman who moved from Amsterdam to The Hague.[4]

1. Most of these biographical details are adopted from Roethlisberger 1981, pp. 2–4. See also Nicolette Sluijter-Seiffert in *Dictionary of Art* 1996, vol. 4, p. 733, especially on Breenbergh's connection with Van Poelenburch; on that with Bril, see also Schatborn in Amsterdam 2001, p. 66.
2. See Schatborn in Amsterdam 2001, p. 67.
3. Roethlisberger in Amsterdam 1981, p. 4, figs. 218a,b.
4. On Breenbergh's influence, see ibid., pp. 19–21, and Ger Luijten on Jan de Bisschop in *Dictionary of Art* 1996, vol. 4, p. 96. Breenbergh's importance for De Bisschop is also stressed in Amsterdam 1992b, pp. 13–14.

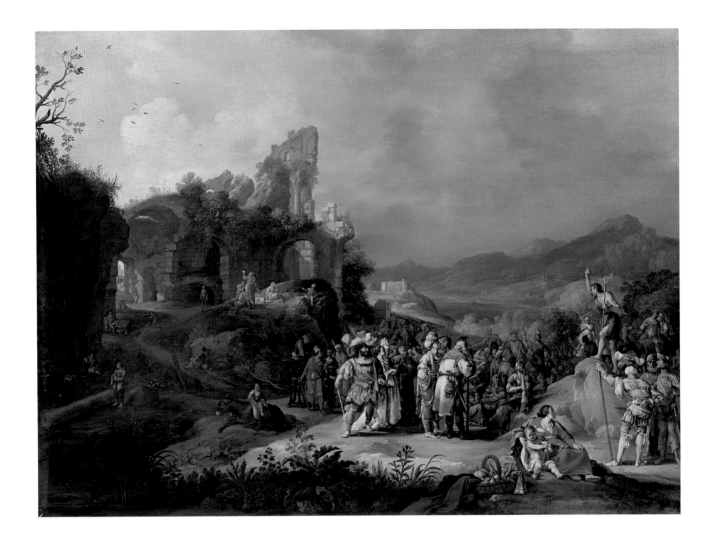

22. *The Preaching of John the Baptist*

Oil on wood, 21½ x 29⅝ in. (54.6 x 75.2 cm)
Signed and dated (lower right): B.B.f. A 1634

The painting is very well preserved.

Purchase, The Annenberg Foundation Gift, 1991 1991.305

This well-preserved panel of 1634 has long been recognized as one of Breenbergh's finest works. The artist had recently settled in Amsterdam, and the most highly regarded history painter in the city, Pieter Lastman (1583–1633), had just died. It is possible that Breenbergh intended the picture as a special demonstration of his abilities. The dramatic distribution of Roman ruins, castles, and hill towns in a panoramic Italian landscape, the remarkably diversified survey of curious types in the crowd around John the Baptist, the choice of a biblical subject that had

particular resonance in the Netherlands, and the care devoted to *bywerck* (as embellishments or accessories were called in contemporary descriptions of paintings), like the repoussoir of plants and still-life elements in the foreground, suggest that after a decade's residence in Rome the artist intended, by producing masterworks like this one, to make a name for himself in his native country.

The Baptist, holding a cross-shaped staff on a hillock to the right, points upward and commands his listeners, "Repent ye: for the kingdom of heaven is at hand" (Matt. 3:2). Each of the Gospels tells the story of John preaching in the wilderness of Judaea, but for Breenbergh's composition the most interesting account is that of the patron saint of painters, Saint Luke.

And he came into all the country about Jordan, preaching

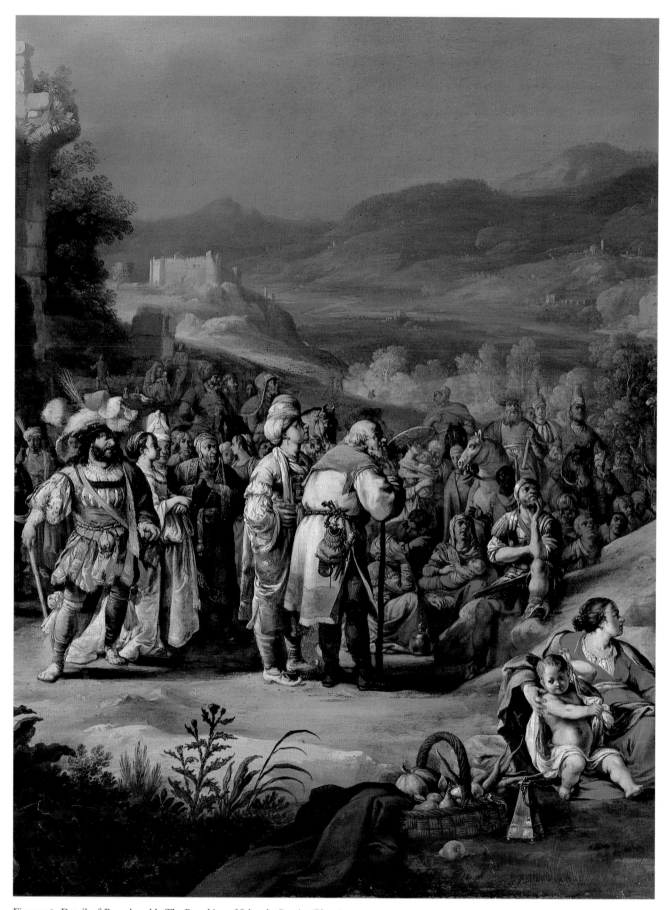

Figure 18. Detail of Breenbergh's *The Preaching of John the Baptist* (Pl. 22)

the baptism of repentance for the remission of sins; As it is written in the book of the words of Esaias the prophet, saying, The voice of one crying in the wilderness, Prepare ye the way of the Lord, make his paths straight. Every valley shall be filled, and every mountain and hill shall be brought low; and the crooked shall be made straight, and the rough ways shall be made smooth; And all flesh shall see the Salvation of God. (Luke 3:3–6)

John then enjoins the people to acts of charity, urging them to live within their means. To the publicans he says, "Exact no more than that which is appointed you," and to the soldiers, "Do violence to no man, neither accuse any falsely; and be content with your wages" (Luke 3:12–14).[1]

Rather as some figures in the crowd attend less to the preacher than to people nearby, the viewer's glance is drawn to secondary figures, especially the spectacularly plumed soldier in the center of the painting. The figure's extravagant chapeau, colorful silk costume, and cocky contrapposto are typical of the mercenary soldiers known as *Landsknechten* (lansquenets), a favorite subject of sixteenth-century German printmakers.[2] Abraham Bloemaert (q.v.), Cornelis Cornelisz van Haarlem (1562–1638), Rembrandt, and other Dutch painters adopted the type when they depicted soldiers of the past, mythological warriors, and imaginary mercenaries of their own time.[3] The inclusion of exotically dressed characters in outdoor preaching scenes was common from at least the time of Pieter Brueghel the Elder (ca. 1525–1569), whose *Sermon of Saint John the Baptist* (Szépmüvészeti Múzeum, Budapest), dated 1566, was known through many versions by his sons Pieter Brueghel the Younger (1564/65–1637/38) and Jan Brueghel the Elder (1568–1625), and by artists in their circle.[4]

A different preaching scene, Jacques Callot's etching *The Sermon of Saint Amandus*, of about 1622, was the source for Breenbergh's *Landsknecht* and for the Roman soldiers in the right foreground of the Museum's picture. The old man—a publican?—with a walking stick and keys attached to his belt could have been adopted from the same print.[5] However, the most prominent figures in the center of the composition also bring to mind Rembrandt's recent introduction of conspicuous witnesses to biblical events, such as the turbaned figure of Joseph of Arimathea in the foreground of *The Descent from the Cross*, of about 1632–33 (Alte Pinakothek, Munich), and in his etching of the same subject (1633).[6]

Only a firsthand inspection of Breenbergh's painting allows one to appreciate the variety of intriguing individuals who surround John the Baptist (fig. 18). Figures mounted on camels, horses, and donkeys represent different social stations; women range from apparent princesses to impoverished peasants. A noteworthy figure is the pensive soldier seated at the foot of the preacher's mound. In the central group, a priestly, comic character presses his hands together and smiles in adulation. The more distant areas in the left background are occupied by travelers resting in the shadows of the ruins and by figures at a well. An archway flooded by sunlight yields a distant view. The Roman ruins, derived from Breenbergh's own drawings of the Colosseum, and the fallen column to the left may be meant to suggest the decline of an empire as a different kingdom comes.[7] Accordingly, it may be wondered whether the mother and child in the foreground were intended as anachronistic reminders of the Virgin and Child (with whom John the Baptist often appears as an infant), and whether the child's playful pose, with one arm vigorously raised, is a conscious reference to Christ at the Last Judgment, as seen in Michelangelo's fresco in the Sistine Chapel.

The Preaching of John the Baptist had been a popular subject in Netherlandish art since the time of Joachim Patinir (ca. 1480–1524) and Herri met de Bles (ca. 1510–after ca. 1550). Scholars have debated whether Bruegel's painting of 1566 (mentioned above) was intended to refer to the Spanish suppression of Protestant worship and the Calvinist response of *hagepreken* (hedge preaching) to large crowds in the fields surrounding Antwerp, Breda, and 's Hertogenbosch.[8] The practice spread to Holland in July 1566, when mass sermons were held outside Hoorn (where Breenbergh probably grew up), and then near Amsterdam and Haarlem, followed by Utrecht, Leeuwarden, and elsewhere.[9] The power of the evangelical movement and the fact that Bruegel filled most of his composition with a close view of the crowd surrounding John the Baptist suggest that the painting did have political significance. More relevant to Breenbergh's picture is the fact that a considerable number of Dutch artists treated the same subject between the 1590s and the 1630s. They include Bloemaert (in as many as a dozen examples),[10] Cornelisz van Haarlem (in the large canvas of 1602 in the National Gallery, London),[11] Lastman (in a lost painting of 1611),[12] Joachim Wtewael (in a panel dated 1618; Statens Museum for Kunst, Copenhagen),[13] Claes Moeyaert (in a panel of 1631; Nationalmuseum, Stockholm),[14] and Rembrandt (in the grisaille painting, of about 1634–35, in the Gemäldegalerie, Berlin).[15] Rembrandt's composition is thought to have been made in preparation for an etching.

Of course, not all these works would have been understood by contemporary viewers as referring to Protestant worship, to the Dutch struggle for liberation from Spain (which was ongoing in the 1630s), or to both these closely related concerns.[16] But

the Preaching of Saint John was a favorite subject of Protestant collectors,[17] and the Protestant mode of worship—preaching the word of God in the vernacular from a pulpit surrounded by a congregation—was a frequent subject in Dutch literature and art (for example, the "Sermons," as the pictures were sometimes called in contemporary inventories, that painters such as Pieter Saenredam (1597–1665) and Emanuel de Witte (q.v.) set in the interiors of actual Dutch churches).[18]

Furthermore, several biblical and mythological subjects, as well as historical subjects set in ancient times, were interpreted as analogous to, or even prefigurations of, the Dutch war of independence.[19] One of the keenest chroniclers of the new nation's history and mythology, the preacher and historian Willem Baudart (1565–1640), in his 1616 account of the so-called Nassau Wars against Spain, explicitly compared John the Baptist preaching in the wilderness with the Netherlandish hedge preachers of 1566.[20] Breenbergh's painting, if it was meant to evoke nationalistic sentiment, would have recalled not only the rebellion of the 1560s and the contemporary wars of religion (in which mercenaries played a large part) but also the currently popular stories of the Batavian nation, the ancient Dutch people who rose as the Roman Empire fell.[21]

The picture was in particularly distinguished collections between the 1770s and the 1840s. Johan van der Marck, who bought it at auction in 1768, was a four-time burgomaster of Leiden and a director of the West Indies Company in Amsterdam. In the catalogue of his own collection, he praised the present work as being "as handsome in its drawing and Imagination of the Passions, variety of clothing, and elaborateness of Painting, as is to be seen by this master." At the sale of Van der Marck's estate in 1773, the painting was bought by the dealer Pieter Fouquet, who acted for or sold it to Pierre-Louis-Paul Randon de Boisset, the receiver general of France. At his estate sale of 1777, the work went to the great collector Joseph-François, comte de Vaudreuil, who in 1784 sent it with his other non-French pictures to auction.[22] In about 1802, the painting was sold by a Parisian dealer to Pieter van Winter, a wealthy merchant in Amsterdam, who in the preceding thirty years had formed one of the greatest private collections in the Netherlands. At Van Winter's death in 1807, "Mr. van Winter's collection," which many connoisseurs visited in the family home on the Keizersgracht, was inherited by his daughters, Lucretia van Winter and her younger sister Annewies. During the next fifteen years, Lucretia added fifty-three old masters to the collection (her own Vermeer, *The Milkmaid*, joined her father's Vermeer, *The Little Street*; both are now in the Rijksmuseum, Amsterdam). In 1822, Lucretia married Hendrik Six van Hillegom, and her share of the Van Winter pictures was added to the works of art owned by that famous family of collectors. Their two sons (see Ex Coll.) gradually sold off the Six van Hillegom–Van Winter collection during the second half of the nineteenth century.[23] The Breenbergh was one of the first pictures to go, sold in 1851 to the well-known Brussels art dealer Charles J. Nieuwenhuys. The painting's later history in England, Czechoslovakia, and America has been discussed elsewhere.[24]

1. For an interesting commentary on John the Baptist's message and the broad audience for which it was intended, see Walter Wink in Metzger and Coogan 1993, pp. 371–73.

2. Broos in The Hague–San Francisco 1990–91, p. 202, fig. 5, compares Breenbergh's central figure with a woodcut after Hans Schäufelein, *The Ensign Bearer*, of 1521. On the *Landsknecht* type, see Moxey 1989, chap. 4, especially figs. 4.4, 4.6, 4.21. Two sixteenth-century German bronzes representing *Landsknechten* are in the Linsky Collection (Linsky Collection 1984, p. 165, nos. 82, 83). See De Winkel 2006, pp. 236–37, on the use of early sixteenth-century military dress in biblical scenes.

3. See Roethlisberger 1993, nos. 18–20, pls. 43–45; Van Thiel 1999, no. 183, pls. XXIV and 189 (*Venus and Mars*, 1604; the male costume is described on p. 123); ibid., no. 43, pls. 177, 178 (soldiers in Cornelisz van Haarlem's *Preaching of John the Baptist*, of 1602, National Gallery, London); and Melbourne–Canberra 1997–98, p. 84 (under no. 1), where Hans Holbein the Younger's drawing *Two Lansquenets* is compared with Rembrandt's *Bust of a Man in Gorget and Cap*, of about 1626–27 (private collection).

4. See Marlier 1969, pp. 47–59, and Ertz 1979, pp. 429–32.

5. See Broos in The Hague–San Francisco 1990–91, p. 202, fig. 4.

6. *Corpus* 1982–89, vol. 3, pp. 276–88, no. A65, fig. 5 (the print reproduced in reverse).

7. The third chapter of Luke begins with a sonorous reminder of Roman authority: "Now in the fifteenth year of the reign of Tiberius Caesar, Pontius Pilate being governor of Judaea, and Herod being tetrarch of Galilee, and his brother Philip tetrarch of Itruraea and of the region of Trachonitis, and Lysanias the tetrarch of Abilene, Annas and Caiaphas being the high priests, the word of God came unto John the son of Zacharias in the wilderness." Broos in The Hague–San Francisco 1990–91, p. 201, fig. 3, illustrates one of Breenbergh's drawings of the Colosseum. Similar ruins occur in a number of Breenbergh's earlier paintings.

8. Bruegel's reference to contemporary events was evidently first suggested in Glück 1932, pp. 73–74 (under no. 27). The question is reviewed in Katona 1963.

9. See Crew 1978, chap. 6, especially pp. 161–73, and Israel 1995, pp. 146–48.

10. See Roethlisberger 1993, p. 22, and nos. 18–20, 53, 381, 382, 392 (engraving), 445–47, 490, 491, and 563.

11. MacLaren/Brown 1991, pp. 85–86, no. 6443, pl. 72; Van Thiel 1999, no. 43, pls. 177, 178.

12. See C. Tümpel 1993, pp. 157 (ill.), 159.

13. Lowenthal 1986, pp. 144–45, no. A-79, pls. 110, XXI.

14. A. Tümpel 1974, pp. 257–58, no. 94, fig. 238 (see also nos. 95–97); Stockholm 1992–93, no. 42.

15. *Corpus* 1982–89, vol. 3, pp. 70–88, no. A106; Berlin–Amsterdam–London 1991–92a, no. 20.

16. Roethlisberger (1993, p. 70) considers the detection of a "Calvinist undertone" in paintings of the Baptist preaching to be "certainly inappropriate in the case of Bloemaert," who was Catholic. But this confuses supply (or self-expression) with demand (or "reception"). As is well known, Protestant artists painted subjects favored by Catholic collectors in the Netherlands, and vice versa.

17. See Montias 1991, p. 340, and Loughman in Dordrecht 1992–93, p. 57.

18. See, for example, G. Schwartz and Bok 1990, figs. 100, 103, and Liedtke in New York–London 2001, no. 92. See also G. Schwartz 1966–67 and Liedtke 1976.

19. For some introductory words on the subject, see Westermann 1996, pp. 99–103. On the contemporary relevance of Cornelisz van Haarlem's paintings of the Massacre of the Innocents and other biblical subjects, see McGee 1991, pp. 187–88. See also Schama 1987a, pp. 106–22.

20. Baudartius 1616, fol. 9, cited by McGrath 1975, p. 194 n. 51, and kindly brought to the present writer's attention by Todd Magreta (personal communication, September 2, 2004). A brief characterization of Baudart is given in Schama 1987a, pp. 82–83, 629 n. 67. For a later (1659) instance of hedge preachers being remembered by the Dutch in the seventeenth century, see Plomp 2006a, p. 186, figs. 32, 33.

21. See Schama 1987a, chap. 2 ("Patriotic Scripture"), especially pp. 77–82.

22. The three collectors mentioned here are discussed by Broos in The Hague–San Francisco 1990–91, p. 199.

23. On the Van Winter collection, see Priem 1997.

24. See Broos in The Hague–San Francisco 1990–91, pp. 199–201.

REFERENCES: Possibly Hoet 1752–70, vol. 1, p. 125, no. 12, as "een kapitael stuk van Bartholomeus Breenberg, zeer heerlyk geschildert," records such a picture's sale in Amsterdam on September 12, 1708; Hoet 1752–70, vol. 1, p. 132, no. 9, as "St. Jans Predicatie, kapitael, van B. Breenberg. 150 – 0," would appear to record this painting's sale in Amsterdam on May 7 and 8, 1709; and p. 135, no. 15, as "Sint Jans Predicatie, vol Beelden, in een Landschap, zynde een kapitaal Stuk van Bartholomeus Breenberg. zeer heerlyk geschildert. 430 – 0," appears to record the picture's sale in Amsterdam on July 17, 1709, and possibly p. 240, no. 2, as "Johannes de Dooper in de Woestyn, van B. Breenberg. 310 – 0," records such a picture's sale in Amsterdam on March 22, 1720; Joullain 1783, p. 26, records the picture's sale from the Randon de Boisset collection in 1777; Wurzbach 1906–11, vol. 1, p. 179, listed as in the Randon de Boisset collection and (erroneously) as in the collection of Gerrit Braamcamp; Feinblatt 1949, pp. 268, 271, describes the composition as an example of Breenbergh's "standardization of the ruin landscape for the background of any historical epoch"; Bille 1961, vol. 2, pp. 90–91, clarifies that the present picture was not the one in the collection of Gerrit Braamcamp; "Notable Works of Art Now on the Market," *Burlington Magazine* 91 (1969), p. 416, pl. XXIX, lists the painting as with the Schweitzer Gallery, New York, and (erroneously) as from the collections of Peter Paul Rubens and Gerrit Braamcamp; Foucart in Paris 1970–71, p. 29 (under no. 28), compares the painting with

Christ Healing the Sick, dated 163[?], in the Louvre; Fuchs 1973b, pp. 80–81, fig. 33, compares it with Rembrandt's oil sketch of the same subject in Berlin, maintaining that the landscape by Breenbergh is more stagelike and Italianate; Bénézit 1976, vol. 2, p. 292, as in the Vaudreuil sale (see Ex Coll.); Salerno 1977–80, vol. 1, pp. 239–40, 256, fig. 41.22, and vol. 3, p. 1000 n. 25, notes the adaptation of figures from German prints or perhaps from Filippo Napoletano; Roethlisberger 1981, pp. 17, 68, no. 165, pls. 165 and 165 detail, notes that the painting was called a masterpiece in the sale catalogue of 1802 (see Ex Coll.), that the ruins are (as in earlier paintings by Breenbergh) inspired by the Colosseum, and that the figure of the soldier in the right foreground was borrowed from an etching by Callot (see text above); Haak 1984, p. 144, fig. 298, "whereabouts unknown," offers an unhelpful comparison with Van Poelenburch's approach to composition; Vergara 1985, p. 405, sees the painting as "in a vastly different style — or 'styles,'" than Breenbergh's work of the Italian years; A. Adams in New York 1988, pp. 24–25 (ill.), 39, no. 7, suggests that the artist "dignifies and heroicizes the scene" by "setting the painting [*sic*] in a distant and ancient location"; Broos in The Hague–San Francisco 1990–91, pp. 197–203, no. 14, offers a long and partly erroneous account of the picture's provenance (with interesting biographical details), and repeats a few of Roethlisberger's observations; Roethlisberger in New York 1991, pp. 32–35, no. 12, sees the painting as a "masterful example of the huge strides" Breenbergh made shortly after returning to Amsterdam, where he had "renewed contact with Pieter Lastman," and draws attention to the distinguished collectors who owned the work in the second half of the eighteenth century; W. Liedtke in "Recent Acquisitions," *MMA Bulletin* 50, no. 2 (Fall 1992), p. 31 (ill.); Baetjer 1995, p. 307; Priem 1997, pp. 121, 123, 188, fig. 31, and p. 218, no. 28, for the first time records the painting in the collection of Pieter van Winter and of his daughter Lucretia van Winter (see Ex Coll.); Westermann 2000, pp. 118, 120, fig. 73, "painted while Rembrandt was working on his version"; Kuretsky in Poughkeepsie–Sarasota–Louisville 2005–6, pp. 214–16, no. 53, describes the subject and the artist's treatment of it, suggests that a distinction is made between figures in light and figures in areas of darkness, compares Rembrandt's grisaille painting in Berlin, and mentions hedge preachers in the Netherlands.

EXHIBITED: Hartford, Conn., Wadsworth Atheneum, "The Life of Christ," 1948, no. 54, as "Sermon on the Mount" (lent by Paul Drey, New York); Coral Gables, Fla., University of Miami Art Gallery, "Old Dutch Masters II," 1951, no. 11 (lent by Walter P. Chrysler Jr.); Birmingham, Ala., The Birmingham Museum of Art, Washington, D.C., George Washington University, Atlanta, Ga., Atlanta Art Association and High Museum, Columbus, Ohio, The Columbus Gallery of Fine Arts, Dallas, Tex., The Dallas Museum of Fine Arts, Columbus, Ga., The Columbus Museum of Arts and Crafts, New Orleans, La., The Isaac Delgado Museum of Art, West Palm Beach, Fla., The Norton Gallery of Art, Columbia, S.C., The Columbia Museum of Art, and Chattanooga, Tenn., The George T. Hunter Gallery, "Dutch, Flemish and German Paintings from the Collection of Walter P. Chrysler, Jr.," 1957–58, entry p. 9; New York, MMA, 1970–73 (long-term loan from Christian Humann, New York); New York, Richard L. Feigen & Co., "Landscape Painting in Rome, 1595–1675," 1985, no. 11 (lent from a private collection); New York, National Academy of Design, "Dutch and Flemish Paintings from

New York Private Collections," 1988, no. 7 (lent by Richard L. Feigen, New York); Montreal, The Montreal Museum of Fine Arts, "Italian Recollections: Dutch Painters of the Golden Age," 1990, no. 23 (lent by Richard L. Feigen, New York); The Hague, Mauritshuis, and San Francisco, Calif., The Fine Arts Museums of San Francisco, "Great Dutch Paintings from America," 1990–91, no. 14 (lent by Richard L. Feigen, New York); New York, Richard L. Feigen & Company, "Bartholomeus Breenbergh," 1991, no. 12; Amsterdam, Rijksmuseum, "The Glory of the Golden Age," 2000, no. 91; Poughkeepsie, N.Y., Vassar College, Frances Lehman Loeb Art Center, and Sarasota, Fla., John and Mable Ringling Museum of Art, Louisville, Ky., The Speed Art Museum, "Time and Transformation in Seventeenth-Century Dutch Art," 2005–6, no. 53.

Ex Coll.: ?Sale, Amsterdam, September 12, 1708, no. 12, for Fl 450; ?sale, Amsterdam, May 7–8, 1709, no. 9, for Fl 150; ?sale, Amsterdam, July 17, 1709, no. 15, for Fl 430; ?sale, Amsterdam, March 22, 1720, no. 2, for Fl 310;[1] Theodore Boendermaker and his wife, Jacoba Elisabeth ten Grootenhuys, Amsterdam (until 1768; her estate sale, Amsterdam, March 30, 1768, no. 2, for Fl 510 to Van der Marck); Johan van der Marck, Leiden (1768–73; his estate sale, Amsterdam, August 25, 1773, no. 30, for Fl 800 to Fouquet); Pierre-Louis-Paul Randon de Boisset, Paris (until 1777; his estate sale, Rémy and Julliot, Paris, February 27ff., 1777, no. 96, for 5,019.19 livres); Joseph-François, comte de Vaudreuil, Paris (1777–84; his sale, Paris, November 24–25, 1784, no. 49, for 4,990 livres to Lenglier); sale, Paillet and Delaroche, Paris, July 19–29, 1802, no. 13, for 1,581 livres to Paillet; [Alexandre Paillet, Paris, 1802; probably sold to Van Winter in or shortly after 1802]; Pieter Nicolaas Simonsz van Winter, Amsterdam (in or shortly after 1802–d. 1807); his daughter Lucretia Johanna van Winter, Amsterdam (1807–22); Lucretia Johanna van Winter and her husband, Hendrik Six van Hillegom (1822–her d. 1845; his d. 1847); their sons, Jan Pieter Six van Hillegom and Pieter Hendrik Six van Vromade, Amsterdam (1847–51; [their] anonymous sale, November 25, 1851, no. 7, for Fl 250 to Nieuwenhuys); [Nieuwenhuys, Brussels and London, from 1851]; Charles Scarisbrick, Scarisbrick Hall or Wrightington Hall, Lancashire (until 1861; his estate sale, Christie's, London, May 10–25, 1861, no. 675, for £28 10s. to Bohn); Henry George Bohn, North End House, Twickenham (1861–85; his estate sale, London, March 20, 1885, no. 200); J. Passmore Edwards, London (until 1902; sale, Christie's, London, April 7, 1902, no. 60, for £19 19s. to Schroeder); Baron Karl Kuffner de Dioszegh, Castle Dioszegh, near Bratislava (until 1940); his son, Baron Raoul Kuffner de Dioszegh and Baroness de Dioszegh [the painter Tamara de Lempicka], New York (1940–48; sale, Parke-Bernet, New York, November 18, 1948, no. 29, for $475); [Paul Drey, New York, 1948–?51]; [Julius Weitzner, New York, in 1951; sold to Chrysler]; Walter P. Chrysler Jr., New York (1951–at least 1958); [M. R. Schweitzer, New York, by 1969; sold to Humann on May 5, 1969, for $24,000]; Christian Humann, New York [?], 1969–73 (lent to MMA 1970–73; sold to Feigen on December 18, 1973, for $90,000);[2] Richard L. Feigen, New York (1974–91; sold to MMA); Purchase, The Annenberg Foundation Gift, 1991 1991.305

1. This and the above lots must refer either to the Museum's painting or to Breenbergh's larger picture of the same subject, Roethlisberger 1981, no. 203 (collection of Richard Feigen, New York).
2. Documentation and information on Humann's purchase and sale of the picture were kindly sent to the present writer by Claus Virch of The Christian Humann Foundation, in a letter dated October 7, 2003.

QUIRIJN VAN BREKELENKAM

Zwammerdam? after 1622–ca. 1669 Leiden

Quirijn Gerritsz van Brekelenkam, a Leiden painter of humble household scenes, craftsmen and shop-keepers, hermits, and occasionally more stylish figures, was probably born shortly after 1622 in Zwammerdam, a village on the Oude Rijn river just north of Gouda, halfway between Leiden and Utrecht. He and his three sisters were the children of Gerrit Adriaensz de Plutter and Magdalena Crijnendr. The artist adopted the name Brekelenkam, which may refer to a small place (*kam* is short for *kamp*, or camp). Most likely, he trained in Leiden, where he joined the painters' guild on March 18, 1648. A few weeks later, on April 11, he married Marie Jansdr Carle (or Scharle) in the Catholic church at Rijnswaterswoude, a village northeast of Leiden. During the next seven years, four girls and two boys were born to the couple. In August 1655, Marie died. Van Brekelenkam remar-ried a year later, in September 1656.[1] With his second wife, the widow Elisabeth van Beaumont, he had three children, a daughter and two sons. All the painter's children were bap-tized Catholic in Leiden. Van Brekelenkam was still living in May 1668, when he paid dues to the guild; a work dated 1669 is attributed to him. He probably died in 1669, perhaps of the plague that spread in Leiden during that year, claiming thou-sands of lives in 1669 and 1670.[2]

The artist appears to have struggled financially. Various debts are recorded, for rather small amounts.[3] Another sign of ill fortune is the inconsistent quality of the painter's produc-tion. An anonymous writer of the eighteenth century made the same observation, reporting that Van Brekelenkam was "a little man, [who] had many children and domestic cares and very little means, which is the reason for his having done many bad pieces, which he tossed off quickly in order to get some money in his pocket." In the same account, it is said that the painter's colleagues "often sought his company, as he was very witty and funny, having as well the gift of being able to imitate everyone's speech and mannerisms."[4]

The two pictures in the Museum's collection convey reli-able impressions of Van Brekelenkam's work at the lower level (but by no means the bottom) of his qualitative range (Pl. 23) and of his abilities when making a special effort (Pl. 24). The paintings also suggest the scope of his subject matter, from working people in modest dwellings to the much less frequent scenes of fashionable figures in comfortable interiors. The lat-ter works date from the 1660s and bring Delft painters to mind, though Van Brekelenkam's sources of inspiration may be found right in Leiden, with Gabriël Metsu (q.v.) and fol-lowers of Gerrit Dou (q.v.) such as Adriaen van Gaesbeeck (1621–1650).[5]

Many works by Van Brekelenkam depict diligent craftsmen and shopkeepers — cobblers, tailors, spinners, fishmongers, and vegetable sellers.[6] One of the finest examples of this genre is *Interior of a Tailor's Shop*, dated 1653 (Worcester Art Museum).[7] Van Brekelenkam's domestic subjects include kitchen maids, lacemakers, and young women going to market (most remin-iscent of Nicolaes Maes; q.v.), and old women preparing a meal. Scenes of child care are not uncommon. Occasionally the artist employed the nichelike window favored by Dou and Metsu (for example, in *The Gold Weigher*, of 1668, in the Alte Pinakothek, Munich); other pictures (again, of the 1660s) reveal an admiration of Gerard ter Borch (q.v.). A few paint-ings of hermit monks might be thought to reflect the sympa-thy of a poor Catholic painter. What is more certain is that Van Brekelenkam's variety of themes, all of them well tested in the marketplace, betray not only imagination and industry but also the persistent need to turn out a popular product. The artist did have at least one important patron, however, Hendrik Bugge van Ring (d. 1669). Of the 237 paintings owned by the Catholic collector in 1667, eighteen were by Van Brekelenkam, including, interestingly, several of saints.[8]

1. The date is given as September 5, 1656, in Lasius 1992, p. 8, but as September 24, 1656, in Leiden 1988, p. 80, citing the same docu-ment. The later date is correct (kind communication of André van Noort, Archivist, Regionaal Archief Leiden, July 21, 2006).

2. See Leiden 1988, p. 80, which offers a bit more information than Lasius 1992, p. 9.

3. See Lasius 1992, p. 9, where two debts are described. The author dismisses the claim made in many short biographies of Van Brekelenkam that he obtained a license to sell beer and brandy.

4. Ibid., p. 11, for the Dutch and this translation. The anonymous author wrote an unpublished commentary on Hoet 1752–70. The phenomenon of large output and poor quality is found in the oeuvres of a number of contemporary painters, for example Aert van der Neer (q.v.).

5. See Liedtke 2000a, pp. 156–59, for a discussion of these Leiden painters within the context of a South Holland tradition that encompasses painters in Delft and Rotterdam, among other cities.
6. The oeuvre catalogue in Lasius 1992 is organized by subject, and also has a list of dated paintings (1648–68), which in effect gives an overview of the artist's themes. The 78 plates are useful (the painting in pl. 76 is dated 1663, not 1660).
7. Philadelphia–Berlin–London 1984, no. 18.
8. See Fock 1990, p. 10, and Westermann 1997, p. 64.

23. *The Spinner*

Oil on wood, 19 x 25¼ in. (48.3 x 64.1 cm)
Signed and dated (on base of spinning wheel): Q V B · 1653

The painting is well preserved. Examination by infrared reflectography reveals that a round platter beneath the black cast-iron pot at lower right was painted out by the artist.

Purchase, 1871 71.110

This panel, acquired in the 1871 Purchase, is a typical work by Van Brekelenkam, signed with his initials and dated 1653. While hardly the equal of contemporary works such as the *Interior of a Tailor's Shop*, also dated 1653 (Worcester Art Museum), the painting is entirely consistent in execution with such pictures as *Man Spinning and Woman Scraping Carrots*, of about 1653–54, in the John G. Johnson Collection, Philadelphia Museum of Art.[1]

As in the Philadelphia painting, the subject here is an elderly couple seen together in the main room of a very modest home. The woman spins yarn while the man sits with his hands folded over a walking stick. Not surprisingly, he wears a coat and fur hat in this interior scene, with its feeble fire in the hearth to the right, and a spiral staircase where heat would rise faster than the occupants could. The artist has framed the view with a silhouetted water pump and wooden bucket to the left, and cookware by a rough bench to the right. Red-glazed earthenware pots, one turned over on a damaged platter, flank an iron cooking pot with a wooden lid. The arrangement suggests not so much disorder as recent washing up. A pewter tankard stands on the bench, stitching foreground and background together. The still-life elements, with their glints of light, textures, and function as repoussoirs, recall similar interiors (with L-shaped floor plans, as here) by the Antwerp artist David Teniers the Younger (1610–1690), and by the Rotterdam painters Pieter de Bloot (1601–1658), Herman (1609–1684) and Cornelis Saftleven (1607–1681), and Hendrick Sorgh (q.v.).[2]

On the rear wall, above the small doorway (which may lead into a storeroom), an old map bearing the inscription "MARE GERM[ANICUM]" (as the North Sea was usually labeled) peels off the wall. Like the map of South America in the Philadelphia picture, the large sheet of parchment is meant merely as cheap decoration, like a faded poster in modern times. The small cupboard, topped by a plate or colander and a Bible, holds some meat (smoked ham?) on a plate, a wedge of cheese in a bowl, and a loaf of bread. The large leather bag hanging on the pillar must be the old man's.

Most of the motifs in the composition—an elderly couple with a spinning wheel, a pump in shadow to the left, the door, cupboard, and spiral staircase—are found in an earlier painting attributed to Gerrit Dou (formerly with P. de Boer, Amsterdam),[3] though Van Brekelenkam's figures have different features and clothing, the objects are not the same, and the earlier work lacks the view to the fireplace and motifs in the right foreground. Perhaps an even closer prototype was known to Van Brekelenkam. Like other types of interiors introduced or made familiar by Dou, this one had a long life in Leiden. All of Van Brekelenkam's interiors are invented, using the local pictorial dialect. "The same interior," as one scholar loosely describes it, occurs not only in the Philadelphia painting but also in the cluttered *Kitchen Interior*, dated 1659 (Musée d'Art et d'Histoire, Geneva), and in a number of other works.[4]

In Leiden, one of the leading centers of the Dutch cloth trade, spinning was a widespread cottage industry, with both men and women doing piecework at home, supplying yarn to factory looms.[5] The act of using a spinning wheel, which in Maerten van Heemskerck's portraits of a well-to-do couple (1529; Rijksmuseum, Amsterdam) is a sign of virtue on the distaff side,[6] in Van Brekelenkam's work reflects a hard reality, people working more than twelve hours a day for pennies. Of

23

course, the Dutch painter was no Courbet; his picture offers praise for hard work and humility rather than social commentary. The Bible placed on top of the cupboard serves as a reminder of the couple's prayer before each meal (itself a frequent subject in the artist's oeuvre). The elderly were considered exemplary in their contentment with little, their diligence and spirituality. These points were made by Johan de Brune in his book *Emblemata of zinne-werck* (Amsterdam, 1624), beneath the engraved illustration of an old woman who spins while her husband whittles by the fire.[7]

1. Philadelphia–Berlin–London 1984, nos. 18, 19. The reservations of Lasius (see Refs.) can in good part be explained by his never having viewed the work. The fine quality of certain passages such as the old man's face and the bench to the right cannot be appreciated in photographs.

2. On the approach to space in the work of Rotterdam genre painters and their relationship to Antwerp, see Liedtke 2000a, pp. 159–60.

3. Sumowski 1983–[94], vol. 1, no. 247, as by Dou between 1630 and 1635. The Dou specialist Ronni Baer has not seen the picture but considers it doubtful as an autograph work.

4. P. Sutton in Philadelphia–Berlin–London 1984, pp. 160, 161 n. 7 (listing similar interiors). For the Geneva picture, see Oberlin and other cities 1989–90, no. 8, or Lasius 1992, no. 138, fig. 37.

5. P. Sutton in Philadelphia–Berlin–London 1984, pp. 160, 161 n. 4, comments further on the textile industry, and cites social historians. Labor was extremely cheap in good part because of the flood of immigrants from the Spanish Netherlands. In England, where there was also a cottage industry of spinners, the earliest known use of the term "homespun" dates from 1591 (according to lexicographers). See also Haak 1984, pp. 222–23.

6. See Franits 1993a, pp. 30, 71–76, 206 n. 46, and Madrid 2003, no. 2, for similar examples from Van Brekelenkam's own time.

7. See Franits 1993a, pp. 186–89, fig. 168. The emblem is also mentioned by P. Sutton in Philadelphia–Berlin–London 1984, p. 160,

and by other authors. Elderly people in Dutch genre paintings are also discussed in Franits 1993c. On the subject of spinning as a virtuous activity, see also Dresden–Leiden 2000–2001, pp. 49–51, and Stukenbrock in Mai et al. 1993, pp. 94–96, no. 36.

REFERENCES: Harck 1888, p. 75, cites the picture as an excellent example of the artist's work, now in the MMA; Wurzbach 1906–11, vol. 1, p. 181, listed; Philadelphia–Berlin–London 1984, pp. 160–61, fig. 2, considers this work the closest in conception of Van Brekelenkam's pictures to his *Man Spinning and Woman Scraping Carrots*, in the John G. Johnson Collection, Philadelphia Museum of Art; P. Sutton 1986, p. 187, mentioned; Lasius 1992, pp. 30, 153–54, no. B30, in the absence of firsthand examination, catalogues the painting as an uncertain attribution; Baetjer 1995, p. 327; Baetjer 2004, pp. 170, 205, no. 79 (ill.), gives a full account of the known provenance.

EX COLL.: Cropley Ashley Cooper, 6th Earl of Shaftesbury, Saint Giles's House, Wimborne, Dorset (until d. 1851; his estate sale, Christie's, London, May 15, 1852, no. 18, for £5 10s.); Baron de Heusch, Château de l'Andweck (until 1870; his estate sale, Étienne and Victor Le Roy, Brussels, May 9–10, 1870, no. 4, for BFr 300 to Le Roy); [Étienne Le Roy, Brussels, through Léon Gauchez, Paris, 1870; sold to Blodgett]; William T. Blodgett, Paris and New York (1870–71; sold half share to Johnston); William T. Blodgett, New York, and John Taylor Johnston, New York (1871; sold to MMA); Purchase, 1871 71.110

24. *Sentimental Conversation*

Oil on wood, 16¼ x 13⅞ in. (41.3 x 35.2 cm)
Signed (lower right, on table stretcher): QB (in monogram)

The painting is generally well preserved, except for paint layers in the ash gray cloth draped over the table to the lower right. This passage appears disrupted and blanched, possibly due to the discoloration of a smalt pigment. The panel retains its original thickness, with bevels intact. There is a tight cluster of three microscopic pinpoints near the center of the composition, coincident with the lower left corner of the landscape on the wall and toward which all the orthogonals of the perspective scheme recede. Infrared reflectography reveals that the upper sleeve of the woman's velvet jacket was painted over a wide band of brocade.

The Friedsam Collection, Bequest of Michael Friedsam, 1931
32.100.19

This painting in the Friedsam Collection, one of Van Brekelenkam's finest works, dates from the early 1660s. In 1913, Bode described it as "a chef-d'oeuvre," and as signed with the artist's monogram. There appears no reason to doubt the authenticity of the QB in monogram (B inside a large Q) to the lower right, on the stretcher of the table.

The popular subject is presented as if it were based on direct observation, which the figures may well have been. A gentleman in fashionable clothing and a crisp linen collar has come calling on a young lady in a handsome house. The woman is also richly attired, in an ermine-trimmed, garnet-colored velvet jacket, which like her skirt and cap reveals chic good taste. Her posture and the way she holds a wineglass are exactly *comme il faut*. She takes pleasure in the anecdote or comment she conveys, gesturing unconsciously with her left hand. Van Brekelenkam was surely less aware than present-day viewers that the woman's prettiness is of a common Dutch type, but he is almost as sensitive as Gerard ter Borch (q.v.) in tracing her profile and the curls gracing her temples and her long neck.

The young man has mastered the art of appearing absorbed in conversation while his eyes are as attentive as his ears. In the way he holds his hat, rests his right hand, and assumes a casual contrapposto on his chair, he could win Castiglione's approval as a potential courtier. The figures sit quite close together, which seems consistent with their body language and looks of absorption and implies that they are fairly well acquainted and far from indifferent to each other's charms.

Like Vermeer's *Cavalier and Young Woman*, of about 1657 (Frick Collection, New York), where two similarly posed and juxtaposed figures are seen, the present picture employs familiar conventions of depicting courtship. The couple have played or will play a duet, he on the violin, she on the lute that lies on the table. Draped over the table is the visitor's sword belt, elaborately fringed and lined in scarlet. The hilt of the sword, an impressive piece of sculpted silver, is poised above a leather volume on the table, in a brief encounter of contemplative and active, indoor and outdoor lives. The book, which appears to be neither a Bible nor a collection of songs, is there to suggest (perhaps to the suitor) that the lady was reading as she waited

24

Figure 19. Quirijn van Brekelenkam, *A Couple in Conversation, with a Sleeping Man and a Maid Nearby*. Oil on wood, 14⅛ x 18¾ in. (36 x 47.5 cm). Art market, 1930s

for the man to arrive. A stoneware pitcher provides a point of focus for the seemingly random arrangement of objects on the table, and adds at least two more textures to those that are surveyed in the still life.

Many pictures of polite company, especially those painted during the 1650s and 1660s in Leiden and Delft, show a similar corner of space, with a receding wall and windows on the left, a beamed ceiling overhead, and two or three figures grouped around or next to a table. While it could be said that no other painting by Van Brekelenkam is so reminiscent of De Hooch and Vermeer, the similarity reflects a complex regional development rather than direct influence between particular works.[1] Even the closing of the nearest shutter over the window is found often in works of similar composition, and here lends the scene a slightly stronger sense of privacy. To the right of the upper windows, the shadowy form of a birdcage floats in front of the window moldings. This routine reference to virginity (lost, endangered, or closely guarded) was sensibly taken out by

overpainting, which has become transparent with time. The rocky landscape, very much in the style of Allart van Everdingen (1621–1675),[2] remains the only symbolic reference to the progress of love, which can resemble a rocky road. But here, the wayfarer on a steep path, seen to the right between the heads of the courting couple, intimates that they have chosen the more difficult path of virtue, like Hercules—and for that matter like the vast majority of Dutch men and women who were interested in finding a mate. It is true that many foreigners were surprised at the freedoms afforded to young couples in the Netherlands, where meeting without chaperones was commonplace.[3] But Dutch courtship was regulated by firm convictions as well as by various rules. One of the more appealing aspects of this painting is the way in which natural feelings, or at least gestures and expressions, emerge in a situation where proper behavior is precisely prescribed.

The painter depicted a similarly posed young woman a number of times, although never so successfully as here. The

closest resemblance to both figures is that found in a picture last seen on the art market in the 1930s (fig. 19).[4] Women with different features but approximately the same pose, and seen from the same angle are found in paintings in the Herzog Anton Ulrich-Museum, Braunschweig, and elsewhere.[5] Two of these pictures are dated 1662 and support a comparable date for the Museum's picture, where the composition is also typical of about 1661–62. The superior quality and stronger individualization found in the present painting suggest that it precedes the other works. A similar landscape occurs in *The Suitor's Application*, in the Suermondt-Ludwig-Museum, Aachen, and in the *Cardplayers*, formerly in Vaduz.[6]

1. These stylistic conventions, typical of the South Holland region, are described in Liedtke 2000a, chap. 4.
2. See, for example, A. Davies 2001, pls. 65, 154, V, VIII. Stechow's remark (see Refs.) that the landscape is "Flemish-looking" is a surprising slip.
3. See Franits 1993a, pp. 60, 211 n. 127.
4. Lasius 1992, no. B40. The back of the old photograph of this picture in the curatorial files is inscribed "36 x 47½ cm./bois" and "GK Paris/GK New York." This must stand for the Galerie Kleinberger of Paris and New York, which left a photographic archive to the Museum. A version of this composition, with a maid cooking oysters to the left and a child standing next to her, was formerly in the collection of P. A. B. Widener, Philadelphia (ibid., no. B39).
5. Klessmann 1983, pp. 37–38, no. 312, and Lasius 1992, no. 231 (*Couple Playing Cards*, dated 1662). See also *Two Women and an Old Man Drinking Wine* (art market, 1968; Lasius 1992, no. 221); *Couple Drinking Wine* (art market, 1982; ibid., no. 222, pl. 74); and *Man Playing a Lute and a Woman with a Parrot*, dated 1662 (art market, 1986; ibid., no. B42).
6. As noted by Stechow (see Refs.) and Lasius 1992, no. 215, pl. 71 (Aachen), and no. 230 (Vaduz).

REFERENCES: Bode 1913, preface (unpaged), p. 46, no. 27, pl. 27, describes the painting as "A young Couple, taking wine together," signed with a monogram, and considers the picture "one of the very best" known works by the artist, and close to Metsu; Valentiner 1928a, p. 16, as "The Entertaining Suitor," signed in monogram; Stechow 1960, p. 177 n. 27, finds the landscape painting on the wall in other pictures by Van Brekelenkam, with slight variations, here being "more Flemish-looking"; Vey 1966, p. 234, no. 188 (ill.), as in the collection of Johann Peter Weyer, Cologne, in 1852, as by Metsu; Liedtke 1990, p. 52, mentioned as in the Friedsam Collection and as exceptional in the artist's oeuvre; Lasius 1992, pp. 47, 64, 144, no. 223, pl. XI, dates the work to about 1663, notes similar figures in other paintings by the artist, describes the suitor (incorrectly) as a young officer, and the violin (ditto) as a sign of "moral laxity"; Liedtke 1992a, p. 104 n. 12, compares the pose of the man with that of the male figure in Vermeer's *Cavalier and Young Woman*; Baetjer 1995, p. 327, with no mention of the monogram; Liedtke 2001, p. 189 n. 12 (reprint of Liedtke 1992d); Franits 2004, pp. 132–34, fig. 119, sees the influence of Ter Borch, and places the painting in its social context; Fusenig 2006, p. 50, notes the similar landscape paintings in the backgrounds of the Aachen and New York genre scenes.

EXHIBITED: Leeds, Leeds City Museum, "National Exhibition of Works of Art," 1868, no. 574, as "A Conversation Piece" (lent by E. A. Leatham); New York, F. Kleinberger Galleries, "The Collection of Pictures of the Late Herr A. de Ridder," 1913, no. 27, as "A Young Couple, Taking Wine Together"; Kansas City, Mo., The Nelson Gallery of Art and Atkins Museum, "Paintings of 17th Century Dutch Interiors," 1967–68, no. 2.

EX COLL.: Probably Johann Peter Weyer, Cologne (in 1852);[1] Lady Wantage, Lockinge, London; E. A. Leatham, Miserden Park, Cirencester, Gloucestershire (in 1868); Sir George Donaldson, London; August de Ridder, Schönberg, near Kronberg im Taunus, Germany (d. 1911; his estate, 1911–24; his estate sale, Galerie Georges Petit, Paris, June 2, 1924, no. 7, for FFr 205,000 to Kleinberger;[2] [Kleinberger, Paris and New York, 1924; sold to Friedsam]; Michael Friedsam, New York (1924–d. 1931); The Friedsam Collection, Bequest of Michael Friedsam, 1931 32.100.19

1. See Vey 1966, p. 234, no. 188, *Der Besuch*, by Metsu. The painting is listed in the 1852 catalogue of Weyer's collection (no. 248) but not in the 1859 and 1862 catalogues.
2. For a brief account of the collection of August de Ridder, a Flemish industrialist who lived in Frankfurt, see Broos in The Hague–San Francisco 1990–91, pp. 326–28.

HENDRICK TER BRUGGHEN

The Hague? 1588–1629 Utrecht

Ter Brugghen was, with Gerrit van Honthorst (1592–1656) and Dirck van Baburen (ca. 1594/95–1624), one of the most important Dutch painters to work in a Caravaggesque manner during the early decades of the seventeenth century. Honthorst, during his long career, was much more influential in the Netherlands, while the short-lived Baburen's career was made mostly in Rome, except for the last two or three years of his life, when he was back in Utrecht. Ter Brugghen was certainly the finest painter of the three, with regard to both describing appearances (especially qualities of light) and stylistic refinements. He was highly esteemed by his contemporaries, including Constantijn Huygens, secretary and artistic adviser to the Dutch princes, and evidently by Rubens, who visited Utrecht in 1627 and may also have encountered Ter Brugghen twenty years earlier in Rome. Although the artist died three years before Johannes Vermeer (q.v.) was born, he appears to have made a brief but profound impression on the Delft painter's early work.[1]

The artist's father, Jan Egbertsz ter Brugghen (or ter Brugge, ca. 1561–?1626), probably came from the province of Overijssel, but was in Utrecht by June 1581, when he was appointed secretary to the Court of Utrecht. He had recently married Sophia (Feysgen) Dircx, a widow. About 1585, Ter Brugghen became bailiff of the Provincial Council of Holland in The Hague, where his son Hendrick was probably born, in 1588.[2] The future painter may have received his first drawing lessons in the court city, but from about 1602 onward (when his father was intermittently in Utrecht) he was almost certainly, as Joachim von Sandrart claimed, a pupil of the great Utrecht master Abraham Bloemaert (q.v.). Ter Brugghen may be identical with a cadet of his name, who in the spring of 1607 was serving in the army of Ernst Casimir of Nassau-Dietz. If so, he must have begun his long stay in Italy during that year, rather than in 1605 or 1606.[3] In any case, he was the only Dutch Caravaggesque painter to have been in Rome during Caravaggio's lifetime. It is possible that he made a second trip to Italy between 1619 and 1621.[4]

Ter Brugghen was in Milan during the summer of 1614 and then traveled home through Switzerland, together with three minor Dutch artists. He is listed as a member of the Utrecht painters' guild in the accounts for the year 1616–17. On October 15, 1616, he married Jacomijna (or Jacoba) Verbeeck, who was his elder brother Jan's stepdaughter. By 1624, the couple had four children: Sophia, Elizabeth, Huberta, and Richard. In January 1625, their fifth child, Johannes, was baptized, and another daughter, Commertgen, was baptized in January 1627. In March 1628, one of the two youngest children died, but another, Aert, was baptized in October 1628. The artist died during a plague on November 1, 1629, at the age of forty or forty-one. A daughter, named Henrickgen in his honor, was born in March 1630. Ter Brugghen's three youngest children died between 1631 and 1633; his wife died in January 1634.[5]

By 1626, the artist and his family lived in a narrow street in the center of Utrecht called the Snippevlucht. They rented a large house from Johan Wtewael, brother of the painter Joachim Wtewael (q.v.). Honthorst lived on the same street.[6] Ter Brugghen was closely associated with Baburen between about 1622 and the latter's death in 1624.

Until 1985, it was assumed that Ter Brugghen was Catholic, based on a genealogical error and the artist's sympathetic treatment of some explicitly Catholic subjects. However, he was married in a Reformed Church, and the four baptisms of his children that are recorded also took place in Reformed Churches. Bok suggests that Ter Brugghen, who apparently did not become a member of a particular congregation, was Protestant but did not hold orthodox Calvinist views. Sandrart, who knew Ter Brugghen at the end of his life, refers to his "profound but melancholy thoughts."[7]

No works from the Italian period have been identified so far, but it is clear that Ter Brugghen was influenced not only by Caravaggio but also by his follower Bartolomeo Manfredi (1582–1622) and by other Roman painters such as Orazio Gentileschi (1563–1639) and Carlo Saraceni (ca. 1579–1620). The earliest known dated paintings by Ter Brugghen are *The Supper at Emmaus*, of 1616 (Toledo Museum of Art), and *The Adoration of the Magi*, of 1619 (Rijksmuseum, Amsterdam).[8] Among his most admired pictures are *The Calling of Matthew*, of 1621 (Centraal Museum, Utrecht), the pendant paintings of flute players, of 1621 (Gemäldegalerie Alte Meister, Kassel), *Saint*

Sebastian Tended by Irene, of 1625 (Allen Memorial Art Museum, Oberlin, Ohio), and the painting discussed below.[9]

The *Saint Sebastian* and earlier pictures such as *Christ Crowned with Thorns*, of 1620 (Statens Museum for Kunst, Copenhagen), reveal a distinctive use of physiognomic types, poses, restless hands, and compositional devices derived from sixteenth-century and occasionally older Netherlandish sources. Ter Brugghen also retained more of the Late Mannerist qualities that flourished in Utrecht than did his Caravaggesque colleagues; his beautifully peculiar color harmonies might be described as something like Bloemaert's palette done over from nature. Concerning other aspects of the artist's style and expressive qualities, the reader should turn elsewhere, especially since Ter Brugghen's oeuvre was a preoccupation of the two leading scholars of Caravaggism in Northern Europe, Benedict Nicolson and Leonard Slatkes.[10]

1. See New York–London 2001, pp. 363–65, and sources cited. Comparisons of Ter Brugghen and Vermeer effectively began with the perceptive observations of Benedict Nicolson (1958a, pp. 24–25). The present biography is based mostly upon Bok and Kobayashi 1985; Bok in San Francisco–Baltimore–London 1997–98, pp. 379–80; and L. J. Slatkes in *Dictionary of Art* 1996, vol. 5, pp. 1–6. On Huygens's and Rubens's opinions of Ter Brugghen, see Nicolson 1958a, pp. 26–28.

2. Whether Ter Brugghen was born in The Hague or Utrecht has been answered differently. Bok in San Francisco–Baltimore–London 1997–98, p. 379, overrules his own view of what "would seem more likely" (Bok and Kobayashi 1985, p. 9), maintaining that the artist was probably born in The Hague. Slatkes in *Dictionary of Art* 1996, vol. 5, p. 1, strongly favors this conclusion.

3. Compare the remarks of Bok in San Francisco–Baltimore–London 1997–98, p. 379, with those of Slatkes in *Dictionary of Art* 1996, vol. 5, p. 1.

4. See Schuckman 1986. Slatkes in *Dictionary of Art* 1996, vol. 5, p. 3, argues against the hypothesis.

5. See Bok and Kobayashi 1985, pp. 10–13, for all the details in this paragraph, with references to the documents published at the end of the same article. A family tree is provided in ibid., pp. 16–17.

6. See the city plan in San Francisco–Baltimore–London 1997–98, pp. 88–89, nos. 17, 22.

7. Sandrart 1675–79, vol. 2, p. 308, quoted by Bok in San Francisco–Baltimore–London 1997–98, p. 380. On the artist's religion, see ibid., p. 379, and Bok and Kobayashi 1985, pp. 13–14.

8. Utrecht–Braunschweig 1986–87, nos. 1, 2.

9. Ibid., nos. 5, 10, 11, 20, 21.

10. Slatkes's survey of Ter Brugghen's work in *Dictionary of Art* 1996, vol. 5, pp. 2–6, is the best short introduction. Wayne Franits is currently editing the late Leonard Slatkes's monograph on Ter Brugghen.

25. *The Crucifixion with the Virgin and Saint John*

Oil on canvas, 61 x 40¼ in. (154.9 x 102.2 cm)
Signed, dated, and inscribed: (lower center) HTB [monogram] fecit/162[]; (on cross) IN RI

The painting is well preserved. The gray color of Mary's cloak and the gray-green cast of the night sky suggest that these passages may contain a discolored smalt pigment.

Funds from various donors, 1956 56.228

Ter Brugghen's *Crucifixion*, one of the great treasures of the Museum's Dutch collection, was painted about 1624–25 in Utrecht, most likely for a Catholic *schuilkerk*, a clandestine or "hidden" church.[1] The picture's style strongly recalls religious paintings and prints dating from the previous century, and has inspired comparisons (see Refs.) with works by Albrecht Dürer

(1471–1528), Matthias Grünewald (ca. 1475/80–1528), and Utrecht's own Jan van Scorel (1495–1562). As discussed below, some scholars have suggested that the painting may have been made to replace—and even to resemble—an earlier altarpiece. However, the artist also emulated his Northern European predecessors in other religious pictures, where, as here, older forms are combined with everyday figure types and passages of naturalistic description.[2] Ter Brugghen's apparent goal in scenes of Christ's Passion and similar subjects was to recapture the expressive power of Late Gothic and Early Renaissance *Andachtsbilder*, or devotional images, which are often remarkable for their tragic character.

In discussing the picture's "archaic" qualities, most writers refer to its "iconic structure" and to the figure of Christ.[3] Christ's

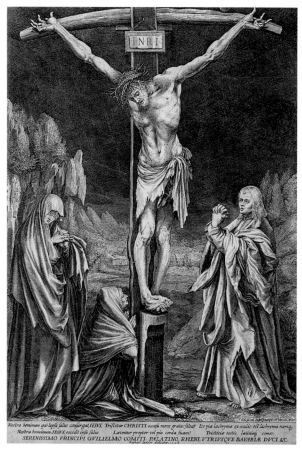

Figure 20. Raphael Sadeler the Elder after Matthias Grünewald, *The Crucifixion*, 1605. Engraving, 12 x 8 in. (30.4 x 20.4 cm). National Gallery of Art, Washington, D.C. Gift of the Samuel H. Kress Foundation

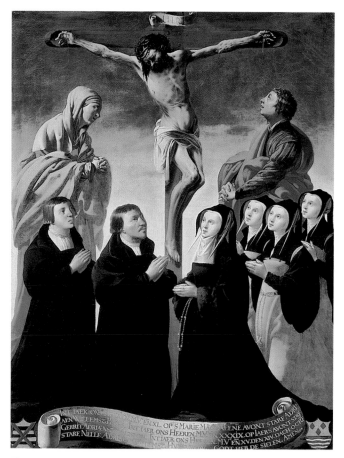

Figure 21. Dutch painter, *Epitaph for the Family of Adriaen Willemsz Ploos*, ca. 1624–34. Oil on canvas, 41¾ x 31⅛ in. (106 x 80.3 cm). Centraal Museum, Utrecht

bony, angular, greenish gray body, with its pinched torso, sinewy arms, and tortured hands, has reminded many viewers of Grünewald's Crucifixion scenes, but the pose of Ter Brugghen's Savior is almost graceful compared with Grünewald's grim figures of Christ, and his skin is smooth rather than excoriated. Comparison of Grünewald's *Small Crucifixion*, of about 1511/20 (National Gallery of Art, Washington, D.C.), with the engraving made after it by Raphael Sadeler the Elder in 1605 (fig. 20) reveals similar adjustments to contemporary taste and style (the drapery, for example, has taken on volume, rhythm, and more elaborate folds). Sadeler's print was commissioned specifically as a reproduction, and it helps to clarify how Ter Brugghen's figure of Christ (which in its pose follows current conventions) represents a Baroque emulation of earlier art, not the untempered imitation of an older model.[4] Similarly, John's slashed doublet, and perhaps Mary's head covering, remind one of sixteenth-century dress, but their faces seem studied from models discovered in a country church, where openmouthed wonder as well as pure religious feeling might have been found.

With regard to style rather than type, the figures of Mary and John are sophisticated, and entirely of their time. Light streaming from the left creates a strong sense of volume in their garments, which exhibit the artist's characteristic attention to balanced masses and rhythmic lines. The light and the transparent shadows that fall over the figure of Christ are consistent with the illumination throughout, but in tonality they suggest the strange aura of an eclipse. The face of Christ, as Nicolson noted, is very similar to the naturalistic face of Christ in Ter Brugghen's *Incredulity of Thomas* (Rijksmuseum, Amsterdam), which he dates slightly earlier.[5] It appears likely that the head crowned by thorns is a somewhat simplified repetition of the head in the Amsterdam painting, which may have been based on a live model.

As for the iconic nature of the composition, Ter Brugghen repeats a traditional arrangement that is found in Netherlandish prints and paintings dating back to the fifteenth century.[6] In examples from that period, the Virgin and Saint John the Evangelist stand, as here, in nearly the same shallow zone

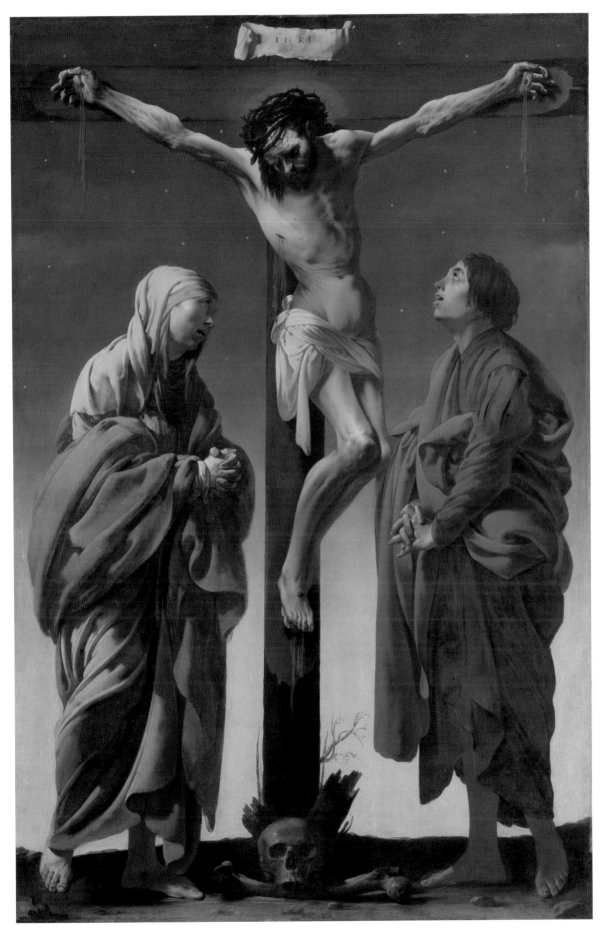

of space as Christ (his knees, in the Museum's picture, overlap John's robe). The cross is often stunted, so that the figures of Mary and John nearly fill the areas to either side. In some Late Medieval images, a slight concession to receding space is made not only on the simple ground plane but also by making the figure of Christ somewhat smaller in scale (Ter Brugghen's Christ, in a standing position, would be about twenty percent smaller than Mary and John). Versions of this iconic design continued through the sixteenth century and into the Baroque period, as seen in a triptych with the Crucifixion, dated 1626, by the Haarlem Catholic Willem Claesz Heda (q.v.; art market, 2001).[7] The arrangement is also common in small sculptural groups of the period.[8] (The waxy, wooden, or "alabaster-like" quality of John's intertwined fingers may indicate that Ter Brugghen intended some resemblance to the kind of sculptures that were found in major Dutch churches before the iconoclastic revolt.)[9] More commonly, of course, contemporaries of Ter Brugghen, such as Hendrick Goltzius (1558–1617), in his engraving of 1585,[10] Pieter Lastman (1583–1633), in his various Crucifixion scenes,[11] and Abraham Bloemaert (q.v.), in his monumental Crucifixion of 1629 (Museum Catharijneconvent, Utrecht), with its "antiquated" type of Christ,[12] departed from older pictorial patterns in favor of tall crosses, deep recessions, figures in action, and full descriptions of the setting. Ter Brugghen adjusts to modern times in the qualities of light, space, and volume, mentioned above, and also in the very low viewpoint, an approach recalling that of recent altarpieces painted in Rome. The low horizon makes for a sobering encounter with the skull and bone, which (with the battered wedges used to erect the cross) forms an emblem of death not unlike Jacques de Gheyn's (Pl. 48), as well as one of Bloemaert's (which Jan Saenredam engraved about 1600).[13]

The starry sky, indicating "darkness over all the land" (Matt. 27:45), is treated abstractly in works of the early fifteenth century,[14] more naturalistically as a night sky by Grünewald, and so naturalistically by Ter Brugghen that (his olive tone notwithstanding) one writer relates the effect to an actual eclipse which the artist could have seen.[15] But this ignores the arbitrarily dramatic device of silhouetting the standing figures against brilliant light (as if the sun of the "sixth hour," meaning noon, had slipped below the horizon) and setting the Savior's illuminated body against the darkened sky. Indeed, when one compares the late afternoon sky in Ter Brugghen's approximately contemporary *Saint Sebastian Tended by Irene* (Allen Memorial Art Museum, Oberlin, Ohio), his miraculous vision of angels in the *Annunciation* of 1629 (Stedelijk Museum, Diest), and even his more luminous genre scenes, the

Crucifixion's transformation of observation into artistic effect is not surprising.[16]

The question of the painter's distinctive coloring need not be considered here, but it is worth noting that some scholars have related the present work's palette to paintings by contemporary artists, such as Ter Brugghen's teacher Bloemaert and to Guido Reni (1575–1642).[17] Similarly, Slatkes, although he supports the theory that the New York canvas was commissioned as a "pseudo-family heirloom," compares its "deliberately archaic" quality with Goltzius's virtuoso imitation, in *The Circumcision*, of 1594, of Dürer's engraving technique and figure types.[18] This seems to imply that Ter Brugghen, perhaps with Sadeler's engraving after Grünewald in mind, took up the modern "game of imitation and emulation" that Goltzius played in his six Masterpiece prints.[19] The one in the style of Dürer almost winks at the connoisseur by including a self-portrait, and by setting the old-fashioned figures in a faithfully described corner of Haarlem's familiar church.

A more plausible context in which *The Crucifixion* may be placed is that of the Counter-Reformation in Utrecht, which emphasized the Passion of Christ and the sacrament of the Eucharist. Before the painting itself, one is struck by its conspicuous cascades of blood, which hang like lengths of rope from Christ's hands, feet, and the wound in his side. There is nothing naturalistic about the flow of blood, especially when one compares contemporary pictures like Gerrit van Honthorst's *Saint Sebastian*, of about 1623 (National Gallery, London), or Ter Brugghen's own painting in Oberlin of the same saint pierced by arrows. Indeed, it could be said that the most archaic feature of *The Crucifixion* is not its hieratic composition, type of Christ, or starry sky, but its rendering of blood, in equal measure from four wounds, as if it were streaking down the surface of the altarpiece (this is sensed especially in the blood descending from Christ's side).

Thus, what might have been (as in Grünewald) a visceral stimulus to empathy is treated by Ter Brugghen as an unmistakable symbol of the Eucharist. There was no more important point of doctrine for the Catholic church in the northern Netherlands during the early decades of the seventeenth century, and it is known that specifically in the many clandestine Catholic churches of Utrecht, "devotion to the Eucharist played a central role."[20] This would appear to explain the Virgin's stare, in this picture, at the wound in Christ's side, and her folding of hands, as if she were not the Mother of God but a devout worshiper witnessing a miraculous event. In other words, Mary serves as intercessor for the faithful. Similarly, John draws the viewer's attention to Christ's bloody brow.[21]

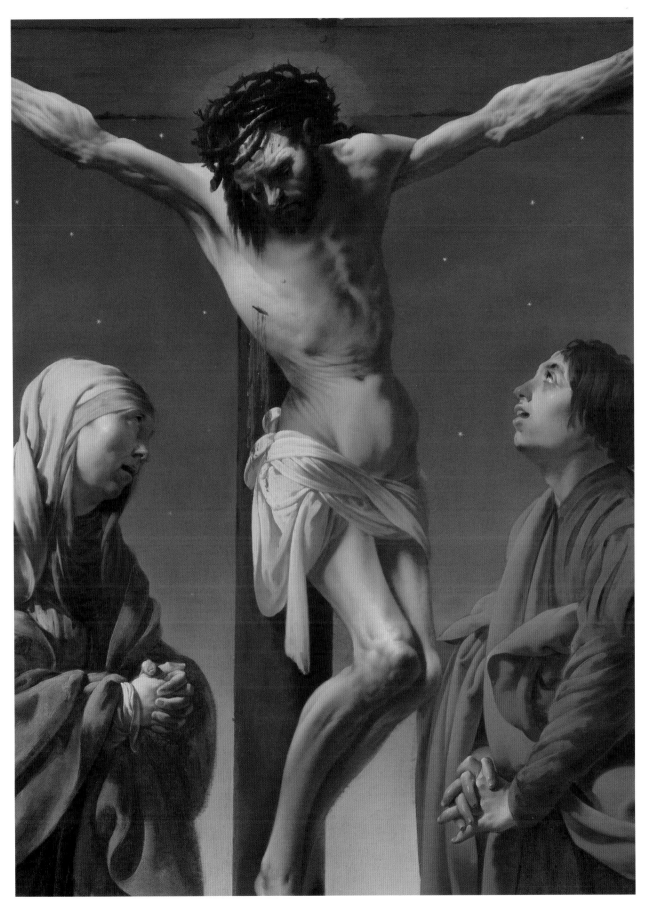

Figure 22. Detail of Ter Brugghen's *The Crucifixion with the Virgin and Saint John* (Pl. 25)

In Utrecht, where perhaps a third of the population (and most of the nobility) was Catholic, the practice of Catholicism was tolerated, but public displays of the religion were prohibited.[22] In this climate, even within the sanctuary of a hidden church, the more aggressive themes of the Counter-Reformation were avoided, and basic tenets—redemption through Christ's sacrifice, the Virgin as intercessor, the inspirational role of the saints—were underscored.[23] It was consistent with this conservative approach to content that (in contrast to the Flemish Rubens) Dutch painters working for Catholic clients often adopted traditional forms, thereby emphasizing continuity with the old Catholic church and suggesting the reformist spirit of the resurgent faith. Ter Brugghen, although he was firmly Protestant, was evidently recognized for his ability to convey an impression of venerability in Catholic images. He was probably well connected with Catholics, in part through his teacher Bloemaert, but also because he was an artist esteemed by patrician collectors (and reportedly by Rubens as well). In any case, his work for Catholic churches was not unusual for a Protestant artist in Utrecht or elsewhere in the Netherlands.[24]

It is understandable that scholars of Dutch art have been less attuned to the effects of the Counter-Reformation on pictorial conventions than have their colleagues in the fields of Flemish, French, Spanish, and especially Italian painting.[25] Aurigemma's comparison (1993; see Refs.) of The Crucifixion's "neo-medieval" character with qualities one finds in paintings by Ludovico Carracci (1555–1619), Lavinia Fontana (1552–1614), and other Italian artists is, by contrast, an entirely expected insight coming from that writer's academic community. A parallel to Ter Brugghen's altarpiece is found in Carracci's Annunciation, of about 1583–84 (Pinacoteca Nazionale, Bologna), "with its drastically simplified, 'neo-quattrocentesque' style, unprecedented in Bologna," but to be followed by numerous examples painted in Bologna, Rome, and elsewhere in Italy, under the influence of Counter-Reformation thought.[26] Orazio Gentileschi, for example, painted his Madonna and Child with Saints Sebastian and Francis, of about 1597–1600 (private collection), in Rome with an "insistently isocephalic composition [that] seems distinctly archaic," and this has been connected with the antiquarian interests of one of the Vatican's most influential figures, Cardinal Cesare Baronio (1538–1607).[27] Sassoferrato (1609–1685) is well known for his emulation of sixteenth-century religious pictures, by Raphael especially (as in the Virgin of the Rosary, in Santa Sabina, Rome), but also by Dürer.[28] One could draw many other parallels to Ter Brugghen's archaizing manner in The Crucifixion, from works as modest as the woodcut Man of Sorrows by Giuseppe Scolari (act. 1592–1607)[29] to the majestic and austere Christ on the Cross (Art Institute of Chicago) that Francisco de Zurbarán (1598–1664) painted in 1627 for a monastery in Seville.[30] If anything, Rubens's response to the Counter-Reformation has obscured its importance for Catholic art in the Dutch provinces, although the revival of the triptych represents an attempt to recapture the authority of Late Medieval religious art in the Netherlands.[31] A closer Flemish analogy to Ter Brugghen's conservatism in The Crucifixion may perhaps be found in Abraham Janssens van Nuyssen's The Dead Christ in the Tomb, with Two Angels, of about 1610 (MMA), which revives (through a print after Goltzius) a type of "angel pietà" common in northern Italy during the sixteenth century.[32]

About 1624, or perhaps slightly later, an unidentified artist copied the upper half of The Crucifixion as part of a new composition, which features a donor's family kneeling in prayer (fig. 21). The inscription on the banderole names "Adriaen Willemsz Plois" (Ploos) as dying in 1540, his son (d. 1539), and his wife (d. 1515). The canvas (not panel) purports to be a copy of a grave board, or "memorial tablet," said to have been in a church in Loosdrecht, but this is completely implausible, first as a Dutch design of the 1540s,[33] and second because it is partially derived from a picture that is recognizably from the early seventeenth century. The raison d'être for this copy of an old painting that actually never existed is found in the lower left corner, namely the crest of the Van Amstel van Mijnden family. This detail was crucial to the campaign of an Utrecht lawyer, politician, and ally of the Stadholder, Prince Maurits, namely Adriaen Willemsz Ploos (1585–1639), who wanted to prove himself descended from a noble line and to style himself (as his descendants still do) "Ploos van Amstel." Ploos was one of the twenty-four judges who, as a favor to the prince (and themselves), sentenced the famous statesman Johan van Oldenbarnevelt (1547–1619) to death for alleged treason. Ironically, Oldenbarnevelt himself had used the same ploy in an attempt to elevate himself socially, using an old triptych with donors and a long inscription dated 1444. The wood of which the central panel is composed is from a tree felled in 1616 at the earliest.[34]

Ploos enlisted the Utrecht humanist and genealogist Aernout van Buchell (1565–1641) in his campaign.[35] According to a document written in his hand and dated February 19, 1624, Van Buchell had been shown "a copy of a memorial tablet that had hung in the church there [Loosdrecht] of those [people] from whom he [Ploos] is supposed to descend."[36] From this, Bok concludes that in 1624 the original memorial tablet was "no longer" (or never) in Loosdrecht; that the copy

may have been a different one from the canvas in the Centraal Museum (fig. 21); and that Van Buchell was, if not suspicious, at least reserving judgment.[37] It is of slight interest for the Ploos affair, and of greater interest for Ter Brugghen, that Van Buchell was well connected with the major Utrecht artists of the day (see the biographies of Bloemaert, Paulus Moreelse, and Joachim Wtewael), and was something of a specialist (as print collector and connoisseur) in Dutch artists of Lucas van Leyden's generation and in the "Dürer Renaissance."[38]

A somewhat different idea of (or for) the Loosdrecht tablet is found in a watercolor drawing that is preserved in a voluminous file of transcripts and documents used in January 1642 by Ploos's son Gerard Ploos van Amstel in his application for admission into the Utrecht Ridderschap (Knightage). In the drawing, the six family members of about 1540 are spread out wide on a grassy ground plane and are joined by two unfinished figures of knights (their helmets replace Ter Brugghen's skull at the foot of the cross), all of them kneeling below a version of Ter Brugghen's Christ on the cross, and with Mary and John now placed well to each side, as if they were the Ploos parents' patron saints. The drawing is absurd as a reconstruction of a sixteenth-century composition, and no knight of the Ploos family ever existed. Van Buchell would have known this or would have easily found it out. The "copy" he saw in 1624 was either the canvas in the Centraal Museum or yet another version. His testament of 1630 on behalf of Adriaen Ploos mentions seeing a copy of an old tablet with some different details: for example, the coats of arms were painted on the frame, and the inscription was on the "foot" of the "panel," which suggests some sort of predella or base.[39]

In 1993, Schillemans came to the unexpected conclusion that a Ploos memorial tablet of about 1540 actually existed and was more or less faithfully copied in the Centraal Museum canvas, which in turn (according to his hypothesis) inspired the design and figure types of Ter Brugghen's *Crucifixion*. Schillemans also suggests that Adriaen Ploos may have "had something to do" with the commission, despite the fact that he also accepts an enlarged version of *The Crucifixion* (private collection, Turin) as an autograph work of the artist's Italian period.[40] In the present writer's opinion, the most positive observation one might make about Ploos's connection with the Museum's picture is that he (or the copyist who worked for him) recognized the archaic qualities of Ter Brugghen's composition and realized that it might be useful for his own ends.

The painting in Turin is certainly later than the New York canvas and by another hand. It is curious that it shows only slightly more of Mary and John at the bottom of the canvas than is seen in the Centraal Museum's "copy" of the memorial tablet. But this may be a coincidence, if the Turin canvas has been cut down (the upper corners are cropped laterally and at the top to Christ's hands). Although the Turin picture repeats only about two-thirds of *The Crucifixion*, it is considerably larger (74 x 68⅛ in. [188 x 173 cm]). Having not seen the painting in Italy, the present writer prefers not to speculate about its national origin.

Another copy, evidently by a minor Dutch artist, is in the Saint Clemenskerk at Nes, in Friesland.[41]

It is possible but improbable that the "Christ on the Cross by van der Brugghe" in the estate of the Amsterdam art dealer Johannes de Renialme (1657) is identical with the present picture. The most likely owner of the painting in the preceding decades was not a private party but a hidden church in Utrecht, which probably would not have disposed of such a powerful work by one of the city's most celebrated masters.[42]

1. On hidden Catholic churches and their paintings, see Schillemans 1992, Van Eck 1993–94, and Van Eck 1999. Utrecht's *schuilkerken* are discussed by Kaplan in San Francisco–Baltimore–London 1997–98, pp. 65–66.

2. On some of Ter Brugghen's borrowings from prints by Dürer and Lucas van Leyden, see Van Kooij 1987. The painter's references to earlier northern artists are discussed in almost every relevant catalogue entry, which, it might be stressed, are those for religious pictures, in particular those depicting Passion scenes or martyrdoms. See also Leeflang in Amsterdam–New York–Toledo 2003–4, pp. 224–25, where Hendrick Goltzius's emulation of Passion series by Dürer and Lucas van Leyden is discussed, and it is noted that Goltzius's example was "used by Karel van Mander, Jacques de Gheyn II and Nicolaes de Bruyn as the starting point for similarly archaizing *Passion* series."

3. Slatkes in San Francisco–Baltimore–London 1997–98, p. 151.

4. On Sadeler's print, see Aschaffenburg 2002–3, pp. 301–2, no. 185, where the taste for Dürer and his contemporaries at the courts of Rudolf II in Prague and Wilhelm V in Munich is also discussed, and Joachim von Sandrart's admiration of Grünewald's *Small Crucifixion* (in Munich, about 1650) is mentioned.

5. See Nicolson 1958a, p. 45 (under no. A2), pls. 52, 53, for a direct comparison of the two heads.

6. See Slatkes in Dayton–Baltimore 1965–66, p. 30, and Slatkes in San Francisco–Baltimore–London 1997–98, pp. 153–54, fig. 1 (woodcut of about 1495 by the Master of the Virgin among Virgins). Slatkes's reference to a painted *Crucifixion* fresco in the Cathedral of Utrecht (Chapel of Guy d'Avesnes) has been repeated by scholars who cannot have made the comparison themselves (e.g., C. Brown in Washington–Detroit–Amsterdam 1980–81, p. 104), since there is little resemblance.

7. Sotheby's, Amsterdam, May 8, 2001, no. 44. The type of Christ, with a fluttering loincloth, the figures in general, and of course the triptych form, are inspired by Early Netherlandish examples. For a sixteenth-century variation with a spectacular sky, see the

panel attributed to the Flemish painter Michiel Coxie in a sale at Drouot Richelieu, Paris, June 24, 1998, no. 2. Compare also Jacques de Gheyn's triptych dated 1618 (Xhos Castle, Namur), with the Crucifixion in the center and the patrons and their patron saints on the wings (Van Regteren Altena 1983, vol. 2, pp. 12–13, no. IIP3, and vol. 3, pl. 11). This work, made for a Catholic count (seen here in armor), is deliberately archaic in style and in some respects anticipates Ter Brugghen's design.

8. There are many examples, for instance the bronze *Christ on the Cross with Mary and John*, of about 1613–17, by Leonhard Kern (Museum für Kunst und Gewerbe, Hamburg).

9. The quote is from Slatkes in San Francisco–Baltimore–London 1997–98, p. 153. The herringbone pattern of John's fingers is probably the artist's invention, and a variation on the remarkable examples of clasped and gesturing hands that are found earlier in his oeuvre.

10. Strauss 1977, vol. 1, no. 221.

11. See Amsterdam 1991–92, nos. 8 (1615), 9 (1616), and Van Schooten and Wüstefeld 2003, no. 43 (1625).

12. Roethlisberger 1993, no. 458, fig. 635. Roethlisberger (ibid., vol. 1, p. 28) considers the design traditional and "the type of Christ antiquated," but the "stirring grandeur," the palette, and so on are Baroque.

13. Ibid., no. 55, fig. 101. The broad use of the term "emblem" here stresses the heraldic look of Ter Brugghen's skull, which of course identifies Calvary (place of the skull).

14. For example, in the Roermond Passion scenes (Rijksmuseum, Amsterdam, no. A1491), painted in Gelderland about 1435, which is mentioned by Slatkes in San Francisco–Baltimore–London 1997–98, p. 153. See Van Thiel et al. 1976, p. 674.

15. Nickel 2007.

16. For the Oberlin and Diest pictures, and Ter Brugghen's *Flute Player* in Kassel, see San Francisco–Baltimore–London 1997–98, nos. 10, 15, 41.

17. See Refs., under Kitson 1987 and C. Brown 1988.

18. Slatkes in San Francisco–Baltimore–London 1997–98, p. 153. On the previous page, Slatkes contrasts the "self-consciously old-fashioned" approach taken in *The Crucifixion* with Ter Brugghen's "earlier applications of sixteenth-century Netherlandish artistic motifs [which] were apparently utilized to make the new Italian Caravaggesque elements acceptable to more conservative Utrecht tastes." This seems an implausible hypothesis to apply to the city of Bloemaert and Wtewael, and overlooks the ready reception of Caravaggesque pictures by Gerrit van Honthorst, Dirck van Baburen, and others during the 1620s in the same place.

19. The quote is from Leeflang's discussion of the Masterpiece engravings by Goltzius in Amsterdam–New York–Toledo 2003–4, p. 212 (under no. 75).

20. Kaplan in San Francisco–Baltimore–London 1997–98, p. 66. As is well known, the emphasis on the Eucharist and Holy Communion was a response to the Protestant attack on the doctrine of transubstantiation. But it was also central to the reform movement within the Catholic church, which especially in the Dutch provinces stressed the basic doctrines of the faith.

21. Compare Rubens's handling of Eucharistic motifs in *The Descent from the Cross* in the Musée des Beaux-Arts, Lille (discussed by the present writer in New York 1992–93, pp. 60–61 [under no. 1]).

22. Kaplan in San Francisco–Baltimore–London 1997–98, pp. 68–70, closely examines the complicated question of how many Catholics could be counted in Utrecht during the seventeenth century, and suggests that perhaps thirty-five percent of the population was Catholic about 1650. Despite his praise of Kaplan's essay, Paul Huys Janssen, in his review of the relevant exhibition catalogue in *Simiolus* 27 (1999), p. 102, simply repeats the common misconception that in Utrecht "the majority of the population remained Catholic."

23. As noted by Spicer in San Francisco–Baltimore–London 1997–98, pp. 18–21.

24. In stressing this point, Kaplan, in ibid., p. 71, notes that the Protestant painter Jan van Bijlert (1597/98–1671) "produced a large number of works for Catholic *schuilkerken*, including altarpieces."

25. An exception is provided by Spicer in ibid., who briefly discusses Ter Brugghen's *Crucifixion* in a section of her essay called "Body and Spirit: The Impact of the Counter-Reformation" (pp. 17–24, p. 20 on Ter Brugghen's picture), and who placed the painting and seventeen others in a section of the catalogue bearing the same title (pp. 132–85, nos. 1–18). Nonetheless, the entry on *The Crucifixion*, by Slatkes, does not refer to any religious interests in Utrecht, but (like literature going back to 1958) treats the work as a stylistic curiosity, explained by Ter Brugghen's admiration of earlier art and perhaps by a private patron's desire to create the impression that his family tree had "Early Netherlandish" roots.

26. The quote is from Gail Feigenbaum's entry on the painting in Bologna–Fort Worth 1993–94, p. 12. The present writer is grateful to Keith Christiansen for this and other references.

27. Christiansen in Rome–New York–Saint Louis 2001–2, p. 48. He refers also to a frescoed "icon" of three saints in Santa Susanna, Rome, by Baldassare Croce (1558–1623). On Baronio, see De Maio et al. 1985. See also Glen 1977, p. 15, on the use of a composition derived from Gerard David (ca. 1460–1523) in the fresco decorations of Il Gesù in Rome.

28. See Sassoferrato 1990, nos. 16 (a *Virgin* in the style of Dürer), 54 (*Virgin of the Rosary*), 62 (*The Annunciation*), and see also p. 22, no. VI, *Christ on the Cross with the Virgin and Saint John*, dated 1598, by Simone De Magistris.

29. See Feliciano Benvenuti in *Dictionary of Art* 1996, vol. 28, pp. 214–15 (ill.), where the influence of Hans Baldung Grien (1484/85–1545) and Rhenish printmakers is mentioned.

30. See New York–Paris 1987–88, no. 2, where the "exegetes of the Counter-Reformation" are discussed (p. 76).

31. As noted in Glen 1977, p. 23.

32. As discussed in Liedtke 1984a, pp. 109–11, pl. 49.

33. My colleague Maryan Ainsworth, curator of European Paintings, confirmed this impression.

34. See Bok 1996 on Oldenbarnevelt, Ploos, and a third case of false claims to nobility based on "old" pictures.

35. See Pollmann 1999, p. 188: "As an expert on genealogy and heraldry, Buchelius [Van Buchell's Latinized name] was repeatedly called as an expert witness in disputed claims of nobility. Although he actively co-operated in the attempts of Adriaen Ploos, the Stadholder's power-broker in Utrecht, to defend his dubious rights to the extension 'Van Amstel', he was also truly appalled by the many people in Utrecht with aristocratic pretensions."

36. The document is transcribed in Ploos van Amstel 1990, col. 283, *bijlage* (addendum) no. XIX. The Utrecht archivist and art historian Marten Jan Bok, who discussed the same subject in Bok 1996, kindly checked the original document on the present writer's behalf and commented extensively on its contents (personal communication dated August 10, 2005, in the curatorial files).

37. Personal communication (see previous note).

38. As discussed in Vignau-Wilberg 1994, p. 241.

39. Schillemans 1993, pp. 146–47. This document, too, was discussed in Bok's communication (see note 36 above).

40. Schillemans 1993, pp. 147–48 (quote from p. 147). The copy in Turin is discussed in Turin 1987. Slatkes in San Francisco–Baltimore–London 1997–98, pp. 153–54, generally subscribes to Schillemans's scenario.

41. Schillemans 1993, pp. 139–40, fig. 3, where it is improbably suggested that the canvas (70⅛ x 50 in. [178 x 127 cm]) is from the studio of Ter Brugghen. It was previously attributed to Gerardus Wigmana (1673–1741).

42. By contrast, Slatkes in San Francisco–Baltimore–London 1997–98, p. 151, simply lists under "provenance" Adriaen Ploos and De Renialme. For "Een Christus aen het Cruys van der Brugge" in the inventory of De Renialme's estate, see Bredius 1915–22, part 1, p. 237, no. 137.

REFERENCES: *The London Times*, November 29, 1956, p. 12, notes the picture's sale and compares its painter with Mantegna and Grünewald; *Illustrated London News*, December 8, 1956, p. 974 (ill.), records the sale ("a record price"), and reports erroneously (see Ex Coll., note 2 below) that the painting was originally acquired from a furniture shop for an amount equal to less than $100; *Die Weltkunst* 36, no. 24 (December 15, 1956), p. 19 (ill.), gives the price as £15,000; Easby and Rorimer 1957, pp. 38, 40, 43 (ill.), mentions the work as an outstanding acquisition; Gerson 1957 (ill.), cites the picture as evidence of Ter Brugghen's "reassessment"; Nicolson 1958a, pp. 6, 8, 22, 41, 45, 79–82, no. A49, pls. 53, 54, 55c, 56, 57, describes the painting's style and (quite subjectively) its expressive qualities, compares the head of Christ in the *Incredulity of Saint Thomas* (Rijksmuseum, Amsterdam), considers this picture probably the one cited in the Amsterdam art dealer Johannes de Renialme's estate inventory of 1657 as "Christ on the Cross by van der Brugge," discusses at length the partial copy with added donors (see text above), dates the Museum's picture about 1624–26 on the basis of comparisons with other paintings by the artist, and regards the influence of Grünewald as of "little doubt"; Nicolson 1958b, pp. 88, 90, fig. 4 (detail of skull), dates the painting to about 1623–26 and compares it with the newly discovered *Saint Jerome*; Virch 1958, reports the picture's rediscovery and its purchase by the MMA, describes the composition, coloring, and figure types ("these saints are but unpretending Dutch peasants"), and reviews earlier northern examples of the subject; Frankfurter 1959, p. 62 (ill.), on the price and "new mode" on the art market for Ter Brugghen; Gerson 1959, p. 317, proposes a date of about 1625 for the picture, which "has no parallel in Dutch painting of this time"; Maison 1960, p. 215, fig. 61, notes a source in Dürer; Nicolson 1960, p. 470 n. 22, approves of the Grünewald comparison made in Virch 1958; Plietzsch 1960, pp. 143, 145, comments on the picture's expressive power, and on the price it brought at auction; Judson 1961, p. 347, suggests that the canvas served as an altarpiece in a private chapel or hidden church, cites earlier uses of stars in the skies of Crucifixion pictures, and suggests searching for a source in fifteenth-century German or Dutch panel painting; H. Gerson, "Hendrick ter Brugghen," in *Kindlers* 1964–71, vol. 1 (1964), pp. 563–64, sees the picture as a high point of the artist's religious painting; Slatkes 1965, pp. 52–53 n. 27, 91, considers the interlaced fingers of Saint John likely to have been derived from Baburen, with an awareness of the same expressive device in sixteenth-century northern prints, and on p. 91, mentions "A. Ploos, who may have commissioned a copy of Terbrugghen's *Crucifixion*"; Stechow 1965, pp. 49–50, fig. 1, detects a debt to Grünewald, but not for the colors or for the "haggard and weightless" figure of Christ; Slatkes in Dayton–Baltimore 1965–66, pp. 28–30, no. 9 (ill.), gives provenance, full literature to date, and details about the partial copy with donors, finds the deliberate use of archaizing elements difficult to explain unless (as Judson suggested) the work was painted to replace an earlier picture, cites some possible Dutch prototypes, and approves Nicolson's dating to about 1624–26; Stechow in ibid., pp. 7–9, suggests the possible influence of a Gothic sculpture, and praises the picture's formal qualities; Boston 1970, p. 38 (ill.), finds "something beyond realism here . . . the impression of an almost unbearable supernatural event"; Van Thiel 1971, p. 109, finds the work "Gothic," but the usual comparison with Grünewald too specific; Nash 1972, fig. 23, compares a Rembrandt *Christ on the Cross*; Spear 1976, p. 106, contrasts the picture's "Gothic" expressiveness with the "mundane reality" of a contemporary work by Ter Brugghen; Bernt 1979–80, vol. 3, no. 1249 (ill.); Hibbard 1980, p. 299, fig. 537, "Grünewaldian"; De Jongh in Utrecht 1980, pp. 10, 31 n. 52, considers the painting probably the one cited in De Renialme's estate inventory of 1657; C. Brown in Washington–Detroit–Amsterdam 1980–81, pp. 15, 104–5, no. 11 (ill.), notes that the subject and deliberate archaism are unusual, suggesting "a particular commission, perhaps a replacement for a fifteenth- or sixteenth-century altarpiece"; Kitson 1981, p. 444, fig. 70, finds "elements of German renaissance art and a baroque light effect" in this "hauntingly beautiful work"; Hecht 1981–82, p. 185, a "first-rate" work, "very peculiar, Germanically severe"; Hecht and Luijten 1986, p. 194 (ill.), refers to the Museum's acquisition of the painting in a review of the artist's critical reception, which flourished in the 1950s; P. Sutton 1986, p. 180 (ill.), describes "this remarkably hieratic image" as having qualities more Gothic than Baroque, and as "one of the most monumental and powerful Dutch paintings in the collection"; Slatkes in Utrecht–Braunschweig 1986–87, pp. 129–30, 133–36, no. 21 (ill.), suggests that the archaic qualities may indicate that the painting replaced an earlier one, compares the coloring and low horizon in the artist's *Saint Sebastian Tended by Irene*, of 1625, suggests a dating close to that work's, and repeats the comparisons to earlier Dutch images made in Dayton–Baltimore 1965–66; Kitson 1987, p. 137, finds the coloring reminiscent of earlier works by Bloemaert; De Meyere 1987, p. 350, fig. 16, mentions the possibility of De Renialme's ownership; Schnackenburg 1987, p. 172, cites the painting as an example of Ter Brugghen's remarkable range and is convinced by the suggestion that the work was intended as an altarpiece; Turin 1987, p. 42 (ill. on foldout opp. p. 42), dating the painting incorrectly to 1620, discusses its relationship to the version in a private collection, Turin, which is claimed to be earlier (see text above); "Un Ter

Bruggen [sic] Romano," *Il giornale dell'arte*, no. 50 (November 1987), p. 61, repeats the information found in Turin 1987; C. Brown 1988, pp. 93–94, 97 nn. 19, 23, fig. 124, discusses similarities, especially of color, in a "Crucifixion" by Guido Reni, and reports (based on examination by Joyce Plesters) that the colors in the New York painting, including those in the sky, have not changed significantly; W. Kloek 1988, p. 51, compares a Dutch altarpiece of about 1400; Nicolson 1989, vol. 1, p. 190, listed, with basic information; Liedtke 1990, p. 55, mentioned as a postwar purchase; Schillemans 1992, p. 42, described as outside the author's topic of discussion because it cannot be traced back to a specific church; Aurigemma 1993, pp. 50–52, fig. 8, refers to the work's neomedieval or archaic quality as something one finds also in works by Lavinia Fontana, Ludovico Carracci, and other Italian artists; Schillemans 1993, pp. 137–42, 147–49, fig. 1, supports Slatkes's conclusion that the picture must have been based on a sixteenth-century composition, compares the copy in Nes and the version in Turin (accepting the owner's idea that the latter is autograph and dates back to about 1612–13, when Ter Brugghen was in Italy), and relates the painting to the Ploos epitaph (fig. 21 here), which is considered as a reliable copy of an earlier work; Baetjer 1995, p. 304; Albert Blankert in *Saur AKL* 1992– , vol. 14 (1996), pp. 504–5, as certainly dating from about 1625; Bok 1996, pp. 210, 212, fig. 4, summarizes the conclusions of Schillemans 1993, and links the painting to several archaistic (or "fake") works of art that were employed to suggest noble lineage; Slatkes 1996, pp. 217–18, compares the figure of Mary in "ter Brugghen's 1625 New York *Crucifixion*" with the artist's newly discovered painting of a religious woman holding a candle to establish that the latter represents the Death of the Virgin; C. Brown 1997, p. 33, discusses the painting's "strikingly archaic" style; Olde Meierink and Bakker in San Francisco–Baltimore–London 1997–98, p. 79, comments on the connection with the Ploos epitaph; Slatkes in ibid., pp. 151–55, 411, no. 8 (ill.), considers this work's "self-consciously old-fashioned" qualities exceptional, notwithstanding the artist's "earlier exercises in the use of archaizing elements," dates the work to about 1625 (largely on the basis of similarities with *Saint Sebastian Tended by Irene*), reviews possible Dutch prototypes dating from the 1400s, and discusses the Ploos epitaph (fig. 21); Spicer in ibid., pp. 20, 394 n. 20, describes the approach here and in an earlier religious painting by Ter Brugghen as a homage to "early Netherlandish traditions"; Wheelock

1998, p. 52, reports the circumstances of the picture's commission, as given in the catalogue; Raleigh–Milwaukee–Dayton 1998–99, p. 213, no. 3 (ill.), includes the work in a checklist of Caravaggesque paintings in America; Blankert 2004, pp. 101–3, fig. 85, mentioned as in the exhibition of 1980–81. Seaman 2006, chap. 4, discusses the blood at length, dismisses the Ploos epitaph, and assumes that this picture is the version owned by de Renialme.

EXHIBITED: Dayton, Ohio, The Dayton Art Institute, and Baltimore, Md., The Baltimore Museum of Art, "Hendrick Terbrugghen in America," 1965–66, no. 9; Boston, Mass., Museum of Fine Arts, "Masterpieces of Painting from The Metropolitan Museum of Art," 1970; Washington, D.C., National Gallery of Art, Detroit, Mich., The Detroit Institute of Arts, and Amsterdam, Rijksmuseum, "Gods, Saints and Heroes: Dutch Painting in the Age of Rembrandt," 1980–81, no. 11; Utrecht, Centraal Museum, and Braunschweig, Herzog Anton Ulrich-Museum, "Nieuw Licht op de Gouden Eeuw: Hendrick ter Brugghen en tijdgenoten," 1986–87, no. 21; San Francisco, Calif., M. H. de Young Memorial Museum, Baltimore, Md., Walters Art Gallery, and London, The National Gallery, "Masters of Light: Dutch Painters in Utrecht during the Golden Age," 1997–98, no. 8.

EX COLL.: ?[Johannes de Renialme, Amsterdam (d. 1657)];[1] Christ Church, South Hackney, London (ca. 1878?–1956); [Nigel Foxell, Oxford (1956; sale, Sotheby's, London, November 28, 1956, no. 115];[2] Funds from various donors, 1956 56.228

1. De Renialme's ownership of the picture is doubted in the last paragraph of the text above.
2. According to Nigel Foxell (personal communication, January 2, 2007), the painting served as the altarpiece of a side chapel in Christ Church, South Hackney, London, until shortly before that building was demolished in 1956. The canvas was transferred to Saint John's in the same parish, from which Mr. Foxell purchased the picture for £75. He placed the picture in the Sotheby's sale, and gave the net proceeds, less ten percent, to the Diocese of London. The Museum is grateful to Mr. Foxell for this new information, and to Jonathan Lopez (New York) in facilitating the contact.

JAN VAN DE CAPPELLE

Amsterdam 1626–1679 Amsterdam

"One of the greatest painters of water and shipping, and above all . . . one of the greatest painters of the Dutch school," according to Hofstede de Groot, Van de Cappelle is indisputably one of the two or three most admired marine painters of the seventeenth century.[1] He was not a professional artist in the narrow sense, but a wealthy amateur who was keenly active as a painter, draftsman, and collector. His father, Franchoys van de Cappelle (1592–1674), ran a successful dye business which the painter inherited late in life. The woman he married (before 1653), Anna Grootingh, also came from a prosperous family. In 1653, her mother left the couple three houses in Amsterdam, but they lived in yet another on the Keizersgracht. About 1663, they moved to the Koestraat, near the Zuiderkerk.[2] At his death in December 1679, Van de Cappelle, by then a widower, left his four sons and three daughters the dye works, six houses and other properties in Amsterdam, a country house on the river Vecht, a pleasure yacht, "44 bags of ducats" and bonds altogether valued at 92,720 guilders, and about two hundred paintings and six thousand drawings. The collection was remarkably concentrated, suggesting that in a few cases the artist bought large lots at estate sales. He owned 883 drawings by or after Hendrick Avercamp (1585–1634),[3] nine paintings and over thirteen hundred drawings by Simon de Vlieger (q.v.), six paintings and about five hundred drawings said to be by Rembrandt (q.v.), ten paintings and more than four hundred drawings by Jan van Goyen (q.v.), sixteen pictures by the pioneering seascape painter Jan Porcellis (before 1584–1632), five paintings by Hercules Segers (1589/90–1633/38), and a variety of works by Flemish, German, Italian, and French artists.[4]

The artist was self-taught, according to a verse by Gerbrand van den Eeckhout (q.v.) that accompanies a drawing by Van de Cappelle in the *album amicorum* of the humanist Jacob Heyblocq (1654).[5] His paintings dating from the late 1640s and early 1650s are mostly indebted to De Vlieger. From designs and motifs that Van de Cappelle shares with Hendrick Dubbels (1620/21–?1676) and Willem van de Velde the Younger (q.v.), Kelch concludes that, about 1650 the three artists may have worked in Weesp, the old town on the Vecht near Amsterdam where De Vlieger lived between 1649 and his death in 1653.[6]

During the 1650s, Van de Cappelle's style evolved from close description and a palette of silvery tones to a more painterly manner and warmer coloring. There are no immature works to speak of: even comparatively early pictures like the *State Barge Saluted by the Home Fleet*, of 1650 (Rijksmuseum, Amsterdam), are remarkable for their variety of diverting light effects, and for the skill with which ships are arranged in perspective on the nearly undisturbed surface of a bay or sea.[7] The artist dwells on rippled reflections in the water and sunlight shining through clouds, which wonderfully foil the maritime forest of ships at anchor. In later works, such as *The Disembarkation of the Fleet*, of about 1660 (fig. 23), and the seascape discussed below, beige and reddish brown sails tend to blend together, here like coulisses framing a stage, there like sheets or veils thrown over furniture.[8] In these rich effects, there is some resemblance to contemporary works in other genres, such as Abraham van Beyeren's more muted still lifes (see Pl. 7) and Emanuel de Witte's moodier architectural views.

Van de Cappelle's oeuvre has been described as small, considering that fewer than 150 paintings are known.[9] But this number, which compares closely with the known oeuvres of artists such as Gabriël Metsu and Frans Post (q.q.v.), is impressive for an amateur who evidently painted for less than twenty years. Assuming a normal rate of survival of his paintings, it seems likely that Van de Cappelle turned out at least one painting a month and a number of drawings (the majority of which are lost). Most of the known drawings are winter scenes, a subject the artist also treated in a small number of paintings (Russell counts fewer than twenty) and in one of his two signed etchings.[10]

In November 1666, Van de Cappelle was described as a dyer, which may indicate that he had taken over his elderly father's business.[11] No pictures dating from after the mid-1660s appear to be known.[12]

Portraits of Van de Cappelle by Rembrandt, Hals, and Van den Eeckhout are listed in the inventory of his estate but are now unknown.[13]

1. Margarita Russell, whose 1975 monograph on Van de Cappelle is based on Hofstede de Groot's catalogue, claims that the artist is

"now considered the outstanding marine painter of 17th-century Holland," and that "more than any other artist of his time, with the exception only of Rembrandt, van de Cappelle was a painter of light" (M. Russell in *Dictionary of Art* 1996, vol. 5, pp. 679, 681). However, the names of Willem van de Velde the Younger and Johannes Vermeer (q.q.v.) have also been advanced. Keyes in Minneapolis–Toledo–Los Angeles 1990–91 calls Van de Velde "the greatest Dutch marine painter of the seventeenth century." The posthumous competitors probably would have awarded first place to their mentor, Simon de Vlieger (q.v.).

2. Breen 1913b, p. 112, on Van de Cappelle's purchase of the house on the Koestraat, for 2,300 guilders, on May 21, 1661.

3. See C. Welcker 1979, p. 94.

4. Most of these details are adopted from the excellent biography by Kelch in Rotterdam–Berlin 1996–97, pp. 287–88. The inventory of Van de Cappelle's estate was first published in Bredius 1892, pp. 133–36, and is translated into English in Russell 1975, pp. 49–57. The paintings by Segers may have come from Rembrandt's collection (he owned eight in 1656), considering how many of Rembrandt's own works were acquired by Van de Cappelle.

5. See Russell 1975, pp. 10, 34, 48–49, fig. 40, and Thomassen and Gruys 1998, pp. 174–75, nos. 194, 195. Kelch in Rotterdam–Berlin 1996–97, pp. 287–88, infers from a list of the album's contributors that "Van de Cappelle moved in circles of a high artistic and intellectual standard," which is quite a compliment to Emanuel Murant (q.v.) and the other minor artists who were Heyblocq's friends.

6. Rotterdam–Berlin 1996–97, p. 288. On Dubbels, see Middendorf 1989.

7. See Russell 1975, fig. 6, or *Dictionary of Art* 1996, vol. 5, p. 680, fig. 1.

8. For the Rotterdam canvas, see Rotterdam–Berlin 1996–97, no. 65.

9. Russell in *Dictionary of Art* 1996, vol. 5, p. 682.

10. Ibid., where the locations of some drawn and painted winter scenes are cited, and where other etchings attributed to Van de Cappelle are dismissed. See also Russell 1975, pp. 30–32, figs. 22–30, 40–42, 44, 45, 47. A drawing of a winter landscape (Teylers Museum, Haarlem) is discussed in Cambridge–Montreal 1988, p. 83 (under no. 18), and in Plomp 1997, pp. 113–14 (under no. 94).

11. This could have been the reason the artist moved from the Keizersgracht to the Koestraat in about 1663. From there it was a very short walk down the Kloveniersburgwal (toward the Muntplein) to the Raamsgracht, where the dye works was located. In the seventeenth century the small Raamsgracht, south of the Zuiderkerk, was called the Verwers Graft, after the Dutch word for dyer (*verwer*). In a letter of April 28, 2004, J. E. A. Boomgaard, director of the Gemeentearchief (Municipal Archives), Amsterdam, kindly clarified these details, reviewed the values of houses on the Koestraat and larger adjoining canals, and concluded that Van de Cappelle's "move to the Koestraat seems to be somewhat surprising indeed. A house along the main canals meant much more social status."

12. However, Russell (1975, p. 19) notes that an easel was still set up in the artist's studio at his death, and that an unfinished painting was found there.

13. See ibid., pp. 50, 52, nos. 31, 32, 102.

26. *A State Yacht and Other Craft in Calm Water*

Oil on wood, 27½ x 36⅜ in. (69.9 x 92.4 cm)
Signed (lower right): Cappelle

The boats and the water are well preserved but the thinly painted sky has become more transparent over time.

Francis L. Leland Fund, 1912 12.31

This signed and authentic work of about 1660 has been the subject of several misconceptions: that Van de Cappelle is not the author;[1] that the picture bears a date of "167(1 or 5)" (there is no trace of any date);[2] that its condition is unsatisfactory; and that it represents "the mouth of the Scheldt."

Before 1979, the picture's appearance was affected by discol-ored varnish (mostly a Vinylite varnish applied in 1947), and the work was rarely on view. In its cleaned state, the painting, although thinner in the sky and drier in touch, appears similar in style and execution to such works as *The Disembarkation of the Fleet,* of about 1660, in Rotterdam (fig. 23).[3] The Rotterdam picture is on canvas, is more elaborate in composition, and is on the whole a finer and more ambitious work. But there can be little doubt that the New York panel was painted by the same hand, using a comparable palette and employing a few similar motifs, in particular the two most prominent boats in the center of the middle ground (although they are closer to the viewer in the Museum's painting) and the nearest sailboat in the right background. Russell also compares a canvas

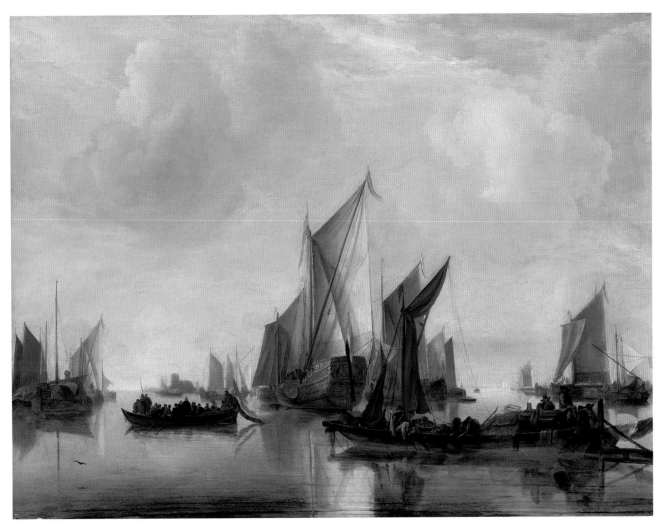

26

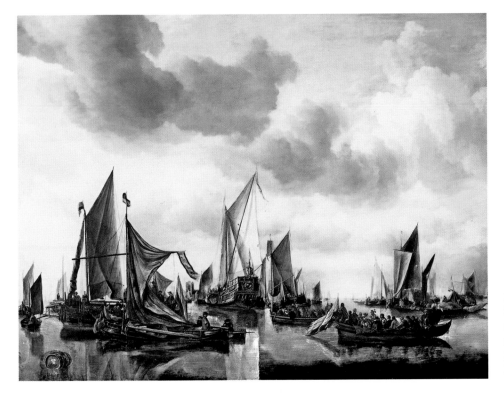

Figure 23. Jan van de Cappelle, *The Disembarkation of the Fleet*, ca. 1660. Oil on canvas, 43¾ x 56¾ in. (111 x 144 cm). Museum Boijmans Van Beuningen, Rotterdam

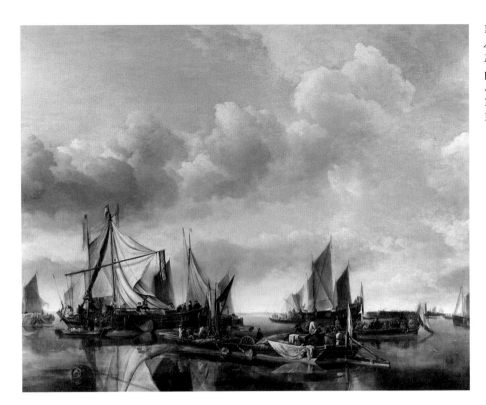

Figure 24. Jan van de Cappelle,
*A River Scene with a Large Ferry and
Numerous Dutch Vessels at Anchor*,
probably mid-1660s. Oil on canvas,
48 x 60¾ in. (122 x 154.5 cm). The
National Gallery, London, Wynn Ellis
Bequest, 1876

of the 1660s in the National Gallery, London (fig. 24).[4] Especially impressive in the present work are such characteristic passages as the reflections in the foreground, the impasto strokes in the clouds and in the sunlit central sail, the silhouetting effects throughout the composition, and the luminous recession on the right.

As Kelch has observed in connection with the painting in Rotterdam, this type of subject in the oeuvres of Van de Cappelle, Hendrick Dubbels (1620/21–?1676), Willem van de Velde the Younger (q.v.), and other masters active in the 1650s and 1660s derives from a group of "naval parades" by Simon de Vlieger (q.v.), and above all from his panel of 1649, *The Disembarkation of Prince Frederick Hendrick of Orange on the Merwede at Dordrecht*, in the Kunsthistorisches Museum, Vienna. De Vlieger himself, in works of about 1649–50, and Van de Cappelle in his *State Yacht with Inland Craft in a Calm*, of 1649 (J. Paul Getty Museum, Los Angeles), almost immediately adopted a practice of "dehistorification" in response to the Vienna prototype, so that "all that remained of the event was its event-like quality."[5] In the New York panel, as in the Rotterdam canvas, a church reminiscent of the Grote Kerk in Dordrecht is visible in the background, and a dignified figure, wearing a medal on a ribbon, sits in the back of the crowded sloop (or, more properly, a state barge) trawling the Dutch flag.[6] A crest decorates the stern of the yacht, which flies the same tricolors, and a crown is emblazoned on the

Dutch flag at the back of the supply barge in the foreground (which includes a cannon in its pile of freight). But there would be no point in attempting to identify the historical occasion depicted here or in any of the pictures by Van de Cappelle that represent essentially the same subject, the anchorage of a small fleet and disembarkation of a distinguished person in a calm river or bay. In a broad view, the theme of these paintings, which flourished right after the Treaty of Münster (1648), is peace in the Netherlands after many years of war.[7]

Previously titled by the Museum *The Mouth of the Scheldt*.

1. See Refs. A fair number of oral opinions are recorded in the curatorial files. F. Schmidt-Degener (April 15, 1935) told H. B. Wehle that the work was an eighteenth-century copy. Jakob Rosenberg (June 8, 1936) "considers this very good." A. B. de Vries (Winter 1951–52) thought the painting might be a late eighteenth-century copy. J. G. van Gelder (February 24, 1954) stated that the subject is not the mouth of the Scheldt, but may be that of the Maas. Wolfgang Stechow (December 14, 1954) thought the painting "could be a copy" (but see note 2 below); R. A. d'Hulst (on the same day) noted that it had "something English" about it. Sturla Gudlaugsson (April 6, 1956) believed it to be a "later copy—paint not seventeenth century." Daan Cevat (January 4, 1966) described it as "a good example," noting that Van de Cappelle was a friend of Rembrandt's and was responsible for Rembrandt's going twice to England. J. S. Held (March 1971), as "possibly dubious as Cappelle." Cevat again (February 5, 1973), as "genuine but weak." Jan Kelch (November 8, 1979), as not by Van de Cappelle, but

resembling the work of Hendrick Dubbels. Margarita Russell (February 11, 1986) considers the painting to be certainly by Van de Cappelle (the figures and all the rest characteristic), but suggests that it was overcleaned in the past. Kelch (July 24, 2004), based on firsthand examination of the painting, considers it to be typical of Van de Cappelle about 1660. His earlier doubts were based on the information given in Russell 1975 (see Refs.) to the effect that the picture bears a signature and a date of 1671 or 1675.

2. Wolfgang Stechow, in a letter dated July 29, 1962, noted that in the Museum's 1954 catalogue the picture is said to be dated 1671, but that there is no mention of a date in the catalogue of 1924 or in Valentiner's article (1941, p. 283). "It would be by far the latest date we have on any of his pictures, and it is therefore very important to me to find out what the facts are." Curator Claus Virch answered in a letter dated August 6, 1962, that examination with a microscope and with raking light revealed "no trace of a date whatsoever. Where a date should appear—if there had been one—the picture is somewhat worn, but the same is the case with the signature which is still visible." Virch also writes that Schmidt-Degener and De Vries "considered the picture a later copy or imitation" (see note 1 above), but that he personally was "convinced that it is by Cappelle."

3. See Jan Kelch's entry in Rotterdam–Berlin 1996–97, no. 65, where a date of about 1660 is maintained on the grounds of style, coloring, and the form of signature—"I V Cappelle," as opposed to "I V Capel" or "I V Capelle," was used from 1652 onward. (In the case of the present picture, the artist appears to have inscribed his name without initials.)

4. Russell 1975, p. 27, referring to no. 967 (MacLaren/Brown 1991, pp. 76–77, pl. 63). See also Russell's remarks cited at the end of note 1 above.

5. Kelch in Rotterdam–Berlin 1996–97, p. 298 (under no. 65, the Van de Cappelle in Rotterdam); see also pp. 198–99 (under no. 37, the De Vlieger in Vienna) on "dehistorification" and p. 196, fig. 1 (the Van de Cappelle in the Getty Museum), and pp. 260–61, no. 54, where "the impression of a pseudo-event" is created by Dubbels.

6. On the state barge ("used for ferrying dignitaries from one vessel to another or from land to a ship") and state—or admiralty—yacht (called a *prinsejacht* when used by the Stadholder), see Leo Akveld's "Glossary of 17th-Century Dutch Ships" in Rotterdam–Berlin 1996–97, p. 31.

7. Other paintings of this type by Van de Cappelle include the panel dated 1650 in the National Gallery, London (see MacLaren/Brown 1991, p. 75 [under no. 965], where a previous attempt to place Frederick Hendrick in the sloop is rightly questioned), a canvas of about 1650 in the same museum (ibid., p. 78, no. 4456), and a painting of about the same date in the Koninklijk Museum voor Schone Kunsten, Antwerp (no. 767). For similar works by Dubbels, see Middendorf 1989, nos. 5, 14, 19, 20, 27 (other works may be relevant, but poor illustrations do not allow judgment). For analogous works by Willem van de Velde the Younger, see M. Robinson 1990, vol. 1, pp. 303–72 (sec. 3.2, "Dutch Yachts").

REFERENCES: B. Burroughs 1912, p. 76 (ill. p. 79), describes the work as a new acquisition and as "a marvel of skilful painting and luminosity"; B. Burroughs 1914 (and subsequent editions), as signed "J V Cappel-(le?)"; Hofstede de Groot 1907–27, vol. 7 (1923), p. 170, no. 45, as "A River Scene—Said to be the mouth of the Schelde," and as "in the collection of E. H. Griffith, London, 1910"; Valentiner 1941, pp. 281–82, 283, fig. 8, compares the composition favorably with the De Vlieger in Vienna (see text above); J. Allen and Gardner 1954, p. 16, as signed and dated "J V Cappelle [16]7[1]"; Russell 1975, pp. 27, 67, no. 45, and p. 89 (under no. 9), repeats Hofstede de Groot's entry but adds that the painting is "signed lower right: J V Cappelle 167(1 or 5)," and records another version known only from a photograph in the Frick Art Reference Library; D. Sutton 1979, p. 393, records that Robert Langton Douglas recommended the "large and brilliant" painting to John G. Johnson, who in turn recommended it to the MMA, and p. 423, fig. 19, as sold by Douglas to the Museum "at the suggestion of J. P. Morgan and J. G. Johnson," and as previously in the collection of Mrs. E. V. Stanley, and in that of "the liberal politician, Henry Labouchère, first Lord Taunton," which Douglas catalogued in 1909–10; Baetjer 1980, vol. 1, p. 23, as signed "J.V. Cappelle" with no mention of a date; P. Sutton 1986, p. 191, mentioned as one of the Museum's "lovely marines"; Baetjer 1995, p. 329, as signed "J.V. Cappelle" with no mention of a date; Kelch in Rotterdam–Berlin 1996–97, p. 300 n. 3, as "purported to date from 167(1 or 5)" and as "probably not authentic" (see note 1 above on Kelch's retraction of this opinion).

EXHIBITED: London, Royal Academy, "Winter Exhibition," 1910, no. 73 (lent by Major E. H. Griffith); New York, MMA, "Landscape Paintings," 1934, no. 26; Palm Beach, Fla., Society of the Four Arts, "Portraits, Figures and Landscapes," 1951, no. 6; Paris, Petit Palais, "Trois millénaires d'art et de marine," 1965, no. 59, as "L'Estuaire de l'Escaut (1671?)."

EX COLL.: Henry Labouchère, Lord Taunton, Taunton, Somerset (d. 1869); probably by descent to his eldest daughter, Mary Dorothy Labouchère (Mrs. Edward James Stanley) (1869–?ca. 1907);[1] Major E. H. Griffith, London (in 1910); [Robert Langton Douglas in partnership with Colnaghi, London?];[2] Francis L. Leland Fund, 1912 12.31

1. The statesman Henry Labouchère (1798–1869) held many offices, including Lord of the Admiralty (1832–34). His wife died in 1850, and he had no sons. In 1872, the eldest of his three daughters, Mary Dorothy (d. 1920), married Edward James Stanley (1826–1907). His death may have occasioned the sale of the present painting, if indeed his widow owned it. Presumably, the "Mrs. E. V. Stanley" mentioned in D. Sutton 1979 (see Refs.) is a transcription error for Mrs. E. J. Stanley.

2. D. Sutton 1979, p. 423, reports, "As Douglas was unable to handle the Labouchere-Stanley collection on his own account, he went into some form of partnership with Colnaghi's."

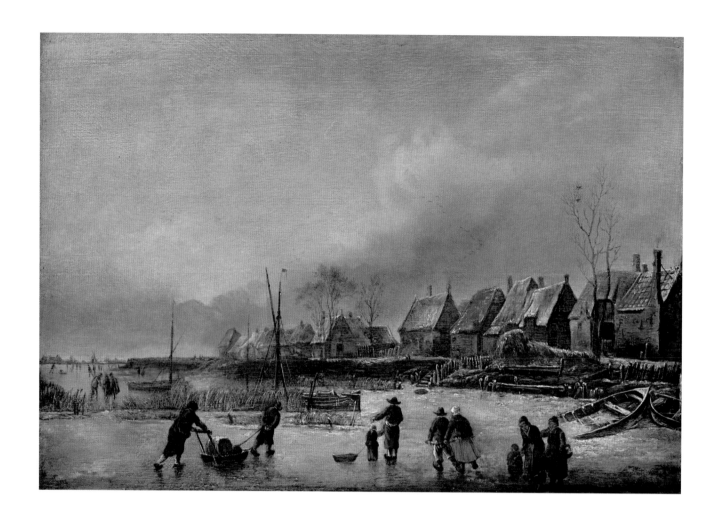

STYLE OF JAN VAN DE CAPPELLE
(18TH OR 19TH CENTURY)

27. *Winter Scene*

Oil on wood, 13⅜ x 19½ in. (34 x 49.5 cm)
Inscribed (lower right): J.V DE CAPPELLE

The paint surface has a soft and artificially distressed appearance. The oak panel—⅜ in. (.95 cm) thick—is composed of two boards joined with the grain running horizontally. On the reverse, there are very evenly beveled edges along the sides and bottom but not at the top, which suggests that the support was cut from a larger panel.

The Friedsam Collection, Bequest of Michael Friedsam, 1931
32.100.16

Van de Cappelle's authorship of this awkward picture has been consistently doubted by the few scholars who have considered the question in recent decades.[1] That the picture must be a later imitation was suggested independently by the collector Daan Cevat (oral opinion, 1966), by Museum conservator Dorothy Mahon (2004), and by Horst Gerson when he stated that the painting might be by Andries Vermeulen (1763–1814).[2]

Examination of the wood support also suggests a later date. The oak panel is beveled on three sides but is cut at the top, where the wood is thickest. Wood supports of the seventeenth century were beveled to reduce thickness at the edges so that the panel would fit into the shallow rabbet of a frame. Thus, it appears that the present panel was originally larger, and cut down for reuse. X-radiography reveals no other image below the paint surface, which makes it seem likely that the wood was borrowed from an old cabinet or piece of furniture.[3]

It is impossible to say whether the now obscure signature dates from the same period as the painting. At different times in his career, Van de Cappelle signed his pictures "I V Capel,"

"I V Capelle," and "I V Cappelle,"[4] but the form "De Cappelle" is not found on authentic works. As Russell notes in her monograph, "both copies and imitations of pictures by Van de Cappelle and his circle were produced throughout the eighteenth and well into the nineteenth century."[5] No other version of the composition is known, and its design, with its wedge of ice and cottages aligned like carriages on a toy train, does not encourage the idea of a lost original. Comparison with winter scenes certainly by Van de Cappelle underscores their much subtler conception and execution, and also confirms that the imitator had this artist in mind rather than Aert van der Neer (q.v.) or another seventeenth-century painter of similar subjects.[6]

Gerson's mention of Vermeulen brings one closer to a likely date for the Museum's picture and to its level of quality, although that artist's least impressive paintings are superior to this one. Original works strongly reminiscent of seventeenth-century winter landscapes date from throughout the next two hundred years; in addition to Vermeulen, painters such as Andries Schelfhout (1787–1870), Barend Cornelis Koekkoek (1803–1862), and Johann Bernard Klombeck (1815–1893) are among the many representatives. Within this long tradition the present painting seems most at home among works dating from the early to mid-nineteenth century.

1. See Refs. and note 1 under Ex Coll.
2. See Refs. under Russell 1975 and note 1 below.
3. Conservator Dorothy Mahon was the first to suggest that the wood panel was recycled from some older context (in conversation with the writer, May 2004).

4. See Russell 1975, p. 20.
5. Ibid., p. 47.
6. Compare ibid., figs. 22–30, 93, 96.

REFERENCES: Woermann 1907, pp. 232–33, no. 288, cites the painting as by Van de Cappelle, with a facsimile of the signature reading approximately "J NT DE CAPPELLE," and as purchased from "Dr. P. Mersch (Sedelmeyer) aus Paris" in 1904; Hofstede de Groot 1907–28, vol. 7 (1918), p. 229, no. 179, as by Van de Cappelle, with a descriptive text borrowed from Woermann, "fully signed lower right"; Hofstede de Groot 1907–27, vol. 7 (1923), p. 208, no. 179, as "signed in full to the left [sic] at foot," and as in the Weber sale of 1912, no. 288, sold for 5,400 marks to Kleinberger; Valentiner 1928a, p. 24, as by Van de Cappelle, signed "J.v.Capelle," and as very likely dating from the mid-1650s; Russell 1975, p. 90, no. 21, fig. 94, as by an unknown follower of Van de Cappelle, with a rubbed and almost illegible inscription reading "J. v. CAPPELLE," and noting that "according to the Museum records the attribution has been doubted before, e.g. by J. S. Held [1971] and by Gerson [1976] who suggested Vermeulen as the artist";[1] Baetjer 1995, p. 329, as by Jan van de Cappelle.

EX COLL.: Paul Mersch, Paris (until 1904; sold through Sedelmeyer[?] to Weber); Éduard F. Weber, Hamburg (1904–d. 1907; his sale, Berlin, February 20–22, 1912, no. 288, to Kleinberger for 5,400 marks); [F. Kleinberger Galleries, Paris and New York, 1912; sold for $4,000 to Friedsam]; Michael Friedsam (1912–d. 1931); The Friedsam Collection, Bequest of Michael Friedsam, 1931 32.100.16

1. Notes recording the opinions of Held and Gerson remain in the curatorial files, as does a memo of 1972 written by curator John Walsh: "I am still dubious about this, as the quality of execution seems markedly below Cappelle's average."

PIETER CLAESZ

Berchem? 1596/97–1660 Haarlem

Little is known of Claesz's early life, and until recently he was confused with a Pieter Claesz from Steinfurt or Burgsteinfurt, Westphalia, who died in Haarlem by the spring of 1639. The artist, "Pieter Claessen van Berghem schilder," was so described on January 3, 1661, two days after his burial (which would mean that he died in the last days of 1660). On that occasion, his daughters, "Lucia and Catharina Pieters who are twins aged twelve years born in Haarlem," were placed in an orphanage. Their mother, Trijntien Lourensdr, from Flanders, became Pieter Claesz's second wife in Haarlem on August 8, 1635; the civil ceremony suggests that they were Catholic. Also cited in the document of 1661 is the twins' half brother, "Claes Pieters van Berghem schilder," namely Nicolaes Berchem (q.v.). Two married half sisters are also named. The village of Berchem, from which Claesz and, more conspicuously, his son Nicolaes adopted their surnames, is near Antwerp.[1]

The date of Claesz's first marriage (about 1620?) and the date of his entry into the Haarlem painters' guild are not known, but a Pieter Claesz is listed as a member of the guild in 1634. It is thought that he trained in Antwerp, where he probably came into contact with Flemish still-life specialists such as Osias Beert (ca. 1580–1624).

Dated paintings by Claesz are known from almost every year of his career, beginning with a work of 1621 and ending with a few of 1660.[2] The early *Still Life with Smoking Implements, Brandy Jug, Beer Glass, and Playing Cards* (private collection) is signed and dated "Pieter Claessen/ANNO 1622,"[3] but nearly all the other known works are monogrammed PC, with a capital C speared by the long stem of a capital P.[4] These initials and stylistic similarities have led to some confusion between still lifes by Claesz and those by the Fleming Clara Peters (1589?–after 1657).

Claesz was a key figure in the development of still-life painting in Haarlem, especially with regard to the "monochrome" manner that he employed during the second half of the 1620s and in the 1630s. As in the picture discussed below, he would often group together a small number of objects on a tabletop, dwelling upon their different surfaces and responses to light. The effects of candlelight as well as daylight intrigued the painter, with a glass usually playing a prominent role. Some early works, such as the *Sumptuous Tabletop Still Life with Turkey*, of 1627 (Rijksmuseum, Amsterdam), and a greater number of later pictures, like the large canvas of 1644 (Szépművészeti Múzeum, Budapest), which Claesz painted in collaboration with Roelof Koets (1592?–1655), are much more elaborate than the subtle compositions of the 1630s.[5] Claesz would have been inspired to paint more ambitious arrangements and luxurious motifs by the Haarlem specialist Willem Claesz Heda (q.v.) and other artists who, like Jan de Heem (q.v.), reflected broader trends in Dutch and Flemish still-life painting. In his last decade especially, Claesz developed a painterly technique and a warmer palette. His work appears to have been highly regarded by local collectors, to judge from the 121 pictures by him that are listed in Haarlem estate inventories of the seventeenth century, many of which record the possessions of prominent citizens.[6]

1. See Slive 2001, p. 27 n. 2, citing Irene van Thiel-Stroman's transcription of the 1661 document; Biesboer in Haarlem–Zürich–Washington 2004–5, pp. 16, 25, 136–37 nn. 18–21, 41; and Van Thiel-Stroman in Biesboer et al. 2006, pp. 124–26. The known documents concerning his life and family are also reviewed in Brunner-Bulst 2004, pp. 134–35. On September 29, 1640, Claesz was described in a notarized deposition as being about forty-three years old.

2. See Brunner-Bulst 2004, pp. 206–351, where 243 pictures by Claesz are catalogued. The author of that monograph refers to Claesz's "last work, a still life with fish," as a work of 1656 in Haarlem–Zürich–Washington 2004–5, p. 58, presumably the last work mentioned in her essay and included in the exhibition.

3. Brunner-Bulst 2004, pp. 207–8, no. 4; Haarlem–Zürich–Washington 2004–5, pp. 16–18, 42, 87, 114, no. 2.

4. See the monograms reproduced in Brunner-Bulst 2004, pp. 352–55.

5. For these two paintings, see Haarlem–Zürich–Washington 2004–5, nos. 13, 40 (ill. pp. 40, 94, respectively).

6. See Biesboer in ibid., pp. 25–26. Anne Lowenthal in *Dictionary of Art* 1996, vol. 7, p. 370, concludes that "the porcelain, glassware, metalwork and foods he depicted were of the sort found in homes of the Dutch middle class, who in turn purchased Claesz's paintings." This statement would appear to underestimate the value of many of the objects that Claesz represented, and the social level of his known patrons.

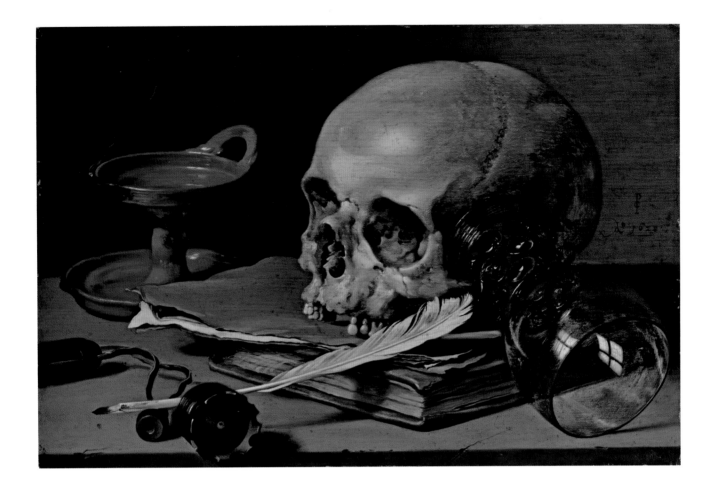

28. *Still Life with a Skull and Writing Quill*

Oil on wood, 9½ x 14⅛ in. (24.1 x 35.9 cm)
Signed and dated (to right of skull): PC [in monogram]
/A° 1628·

The painting is well preserved.

Rogers Fund, 1949 49.107

This superb early work by Claesz, in pristine condition, was long considered to date from 1623 until the question was revisited, in 1982, at the request of Martina Brunner-Bulst, whose monograph of 2004 and the Claesz exhibition of 2004–5 (see Refs.) now make clear that in style and subject matter the painting is typical of the late 1620s. Technical examination of the date inscribed on the painting confirms that it is intact and can be read only as 1628.[1]

The picture represents, with haunting verisimilitude, a skull resting on a folder of papers and a leather-bound book, both of which have the curled, worn look of long use. A *roemer*, or

drinking glass, is propped against the side of the skull, with the rim balanced on the stone tabletop. In the left foreground, a small inkwell lies on its side and extends over the chipped edge of the table and a quill pen is suspended between the book and the wooden toggle of a leather pen case. The wick glows with its last spark of life in the earthenware oil lamp, emitting a faint trail of smoke.

The clarity of light, its suggestion of textures, casting of shadows, and creation of substance and space testify to Claesz's exceptional powers of observation. Rubbed areas on the oil lamp (the handle of which is unglazed), the shiny teeth in the skull, and the frayed corners of the book give a vivid sense of a life lived in the recent past. The artist must have studied these or very similar motifs in the studio, and perhaps arranged them approximately as they are presented here. One reason for the extraordinary success of his illusionistic approach (in addition to the immediately noticed qualities) is the painter's precise rendering of difficult shapes and volumes, which falters

Figure 25. Pieter Claesz, *Vanitas Still Life with Violin and Glass Ball*, ca. 1628. Oil on wood, 14⅛ x 23¼ in. (36 x 59 cm). Germanisches Nationalmuseum, Nuremberg

slightly only in the base of the lamp, perhaps an artistic choice. The composition is strong and subtle, with crossing diagonals and oval shapes corresponding across carefully constructed voids. The shadows of the pen, the rim of the glass, and the strap of the pen case greatly enhance the impression of three-dimensional space in the foreground. The fall of light in general—and, of course, the window reflected in the glass— suggests the larger space of a room, and implies that our roving eyes have come to rest on something too disturbing or too significant to be ignored. The position of absolute authority given to the skull is more compelling in this painting than in the emblematic arrangement by Jacques de Gheyn painted twenty-five years earlier (Pl. 48); here the effect is more realistic, as though the force of nature has taken its course beyond human control.

The simplicity and directness achieved in this work were gradually distilled by Claesz over a period of several years, in which he could be said to have reached a moment of early maturity. The *Vanitas Still Life with Brass Candlestick, Writing Materials, Letter, Pocket Watch, and Anemone*, of 1625 (Frans Halsmuseum, Haarlem), continues the additive distribution of motifs found in earlier works, but reduces their number, focusing on two objects, the candlestick and the skull.[2] The *Vanitas Still Life with Violin and Glass Ball*, of about 1628, in the Germanisches Nationalmuseum, Nuremberg (fig. 25), is more complex and repeats the motifs and to some extent the placement of the lamp, pen, pen holder, inkwell, *roemer*, book, and folders of papers that are found in the New York composition.[3] Of known works by Claesz, it is not a vanitas picture

with a skull but the *Still Life with Books and Burning Candle*, of 1627 (Mauritshuis, The Hague), that anticipates the present work in its concentration, but the impression is of a small world of reflections and shadows, rather than that of a stark encounter with death in the light of day.[4]

The subject might be interpreted as one of many variations on the theme of worldly accomplishments—writing, learning, dabbling in the arts—that ultimately come to nothing: all is vanity. Claesz's more encyclopedic *Vanitas Still Life*, of 1628 (Rijksmuseum, Amsterdam), with musical instruments, armor, and objects representing the fine arts and scholarship, certainly has this meaning.[5] In the Museum's painting, however, the book and folder of papers are closed, the glass is overturned, the lamp and pen have been put aside. In such a setting the skull is not merely an intrusion into a world of human activity, but the familiar attribute of a scholar or philosopher.[6] For the original owner of a work of art such as this one, the image probably expressed not only the vanity of knowledge but also the knowledge of vanity, much as a contemporary portrait of a person holding a skull conveyed the sitter's belief in a spiritual life after death.[7]

The wisp of smoke in the lamp and the reflections in the glass are signs of fleeting existence too common in Dutch pictures to be discussed here (see under discussion of De Gheyn, Pl. 48). The familiar motif of the tipped-over glass is given an explanation in a still life by an anonymous contemporary of Claesz's of a skull, books, a watch, a glass, and an extinguished candle (private collection). Carved into the side of the chipped stone tabletop is the inscription:

Het glas is leegh. De tyd is om.
De keers is uyt. Den mensch is stom.

(The glass is empty. Time is up.
The candle is out. Man is silent.)[8]

1. Correspondence from Martina Brunner, dated August 24, 1982, explains in some detail how the numbers 3 and 8 can be confused in Claesz's inscriptions. Examination under magnification in 1982 confirmed her reading of 1628 (see Brunner-Bulst 2004, p. 352 (ill. "Kat. 37," a detail photograph taken by the Department of Paintings Conservation at the Museum).
2. Brunner-Bulst 2004, no. 18 (ill. p. 29); Haarlem–Zürich–Washington 2004–5, no. 9 (ill. p. 30).
3. Brunner-Bulst 2004, no. 36 (ill. p. 39); Haarlem–Zürich–Washington 2004–5, no. 17 (ill. p. 49).
4. Brunner-Bulst 2004, no. 31; Haarlem–Zürich–Washington 2004–5, no. 15 (ill. p. 45).
5. Brunner-Bulst 2004, no. 38.
6. Dürer's engraving *Saint Jerome in His Study*, which includes a skull on the windowsill, is a special case (the scholar saint) within this tradition. Another is Shakespeare's *Hamlet* ("Alas, poor Yorick!"). See also Samuel van Hoogstraten's *Young Man Reading*, of 1644 (Museum Boijmans Van Beuningen, Rotterdam; Brusati 1995, pp. 44–45, fig. 32), and the lost family portrait by Carel Fabritius, in which a young scholar sits at a desk with books and a skull (The Hague–Schwerin 2004–5, p. 46, figs. 37, 38, for the surviving visual evidence). For other examples, see Caen–Paris 1990–91, p. 66, fig. 18 (the captions of figs. 18 and 19 are switched), and pp. 200–201, no. F.53; also compare Jan de Heem's vanitas still life of a skull and books, ibid., pp. 254–55, no. O.18. Wurfbain, in his brief essay in Leiden 1970 (unpaged), offers a few observations concerning humanist scholars and the vanitas theme.
7. See the portraits of people with skulls catalogued in Caen–Paris 1990–91, pp. 180–91, nos. F.44–49. A portrait of a couple attributed to Dirck Jacobsz (ca. 1497–1567) and the same painter's *Portrait of Pompejus Occo*, both featuring skulls, is discussed by De Jongh in Haarlem 1986a, pp. 98–101 (under no. 11). In Frans Hals's *Portrait of a Man Holding a Skull*, of about 1611 (Barber Institute of Fine Arts, Birmingham, U.K.), the sitter points to the skull in his hand as, in a sense, a portrait of himself in the future (see Slive 1970–74, vol. 3, pl. 2; also Washington–London–Haarlem 1989–90, no. 2). Some sixteenth-century Netherlandish portraits feature illusionistic paintings of skulls on the back of the panel; see Bergström 1956, p. 15, fig. 13.
8. See Basel 1987, no. 29, where the painting is catalogued as by Claesz (it is not accepted in Brunner-Bulst 2004). Bergström in Leiden 1970 (unpaged) first drew attention to the picture and its inscription. See also Welu 1982, p. 34, where the inscription is connected with the Museum's picture and it is noted that the meaning of the Latin word *vanitas* is "empty."

REFERENCES: A. Bredius in *Kunstchronik* 20, no. 11, (December 25, 1884), col. 197, records De Stuers's purchase of the painting at the Amsterdam auction of October 14, 1884 (see Ex Coll.), referring to it as "einer der schönsten, frühen Pieter Claesz, eine 'Vanitas' mit herrlich gemaltem Schädel, Büchern, Römer, Uhr [*sic*] u. von 1623"; Wurzbach 1906–11, vol. 1 (1906), p. 285, listed as the first among dated works by Claesz, "Eine Vanitas. 1623," in the Muller sale, Amsterdam, 1884; E. W. Moes, "Pieter Claesz," in Thieme and Becker 1907–50, vol. 7 (1912), p. 38, as the artist's earliest known dated picture, of 1623, in the collection of Alphonse de Stuers, Paris; Baetjer 1980, vol. 1, p. 28, as dated 1623; Hibbard 1980, p. 333, fig. 577, as dated 1623; Welu 1982, p. 34, as dated 1623, describes the composition and its meaning, with particular attention to the overturned glass as a vanitas symbol; P. Sutton 1986, p. 190, as dated 1623; Liedtke 1990, p. 55, as "early and extraordinary"; Segal in Utrecht–Braunschweig 1991, pp. 23, 52 n. 28, and p. 132 (under no. 4), as dated 1628, discerns the influence of this kind of vanitas still life by Claesz in works by W. C. Heda (1628) and by Jan de Heem (1628 and 1629); Roethlisberger 1993, vol. 1, p. 102 (under no. 55), mentions the picture among early vanitas still lifes that are "more narrative" than the Museum's painting by De Gheyn (Pl. 48); M. Brunner-Bulst in *Saur AKL* 1992– , vol. 19 (1998), p. 354, listed; Chong and W. Kloek in Amsterdam–Cleveland 1999–2000, pp. 140–42, no. 15, as dated 1628, describe the subject and composition, compare the Museum's painting by De Gheyn, and claim that "the specific vanitas meaning of the painting is open-ended"; Brunner-Bulst 2004, pp. 133, 170, 185, 225–26, no. 37, and p. 352 (detail of inscription), notes the close relationship between this composition and the right half of W. C. Heda's *Vanitas*, of 1628, in the Museum Bredius, The Hague, places the work among other "pure *vanitas* still lifes" that Claesz painted, and reports on the rereading of the date in 1982; Haarlem–Zürich–Washington 2004–5, pp. 46, 120, no. 18 (ill. pp. 50, 89 [detail]), as dated 1628, and as revealing "tremendous concentration."

EXHIBITED: Amsterdam, Rijksmuseum, and Cleveland, Ohio, The Cleveland Museum of Art, "Still-Life Paintings from the Netherlands, 1550–1720," 1999–2000, no. 15; Haarlem, Frans Halsmuseum, Zürich, Kunsthaus Zürich, and Washington, D.C., National Gallery of Art, "Pieter Claesz. Master of Haarlem Still Life," 2004–5, no. 18.

EX COLL.: Graeff van Polsbroek, Amsterdam (by 1877–84; sale, Van Pappelendam and Schouten, Amsterdam, May 16, 1877, no. 28, bought in for Fl 200; sale, Muller and Van Pappelendam, Amsterdam, October 14, 1884, no. 20, for Fl 450); Chevalier Alphonse de Stuers, Madrid and Paris (1884–at least 1912); by descent to Chevalier H. de Stuers, Château La Tourangelle, Gland (until 1947; sale, Fischer, Lucerne, October 21–25, 1947, no. 2975); [N. Katz, Dieren, until 1949; exchanged with Kleinberger]; Kleinberger, New York, 1949; sold to MMA; Rogers Fund, 1949 49.107

EDWAERT COLLIER

Breda ca. 1640?–after 1707 London or Leiden

The still-life painter Edwaert Collier (also spelled Colyer and Kollier) may have trained in Haarlem, since a number of his early paintings recall monochrome still lifes in the manner of Pieter Claesz and Willem Claesz Heda (q.q.v.), and works by younger Haarlem natives such as Jan Jansz van de Velde III (1620–1662) and Vincent van der Vinne (1628/29–1702). Between 1667 and 1691, Collier is documented in Leiden. He married Maria Franchoys, a widow, in 1670. As a widower, he was betrothed to another woman in May 1674, but that union was prevented by a promise made previously by the intended bride. In 1677, Collier married Cornelia Tielman in Leiden, and, again as a widower, in 1681 he wed Anna du Bois.[1] In 1693, he went to London, where he evidently worked until about 1702. On still lifes dating from between that year and 1706, the artist often added "Leyden" or "tot Leyden" (in Leiden) to his signature, as on a letter-rack still life (Stedelijk Museum De Lakenhal, Leiden) that includes a speech given by Queen Anne in 1703. (Another trompe l'oeil picture of the same type, signed "E. Collier, 1703," features Dutch texts and a portrait print of Erasmus.)[2] As of now, the earliest known dated work by Collier appears to be a Claesz-like composition dated 1661 (formerly private collection, Wassenaar), and the latest a still life dated 1707 and inscribed "fecit London."[3]

In subject and style, Collier's vanitas still lifes follow a Leiden tradition that dates back to the late 1620s with works by Jan Lievens, Jan de Heem, and Gerrit Dou, and continues with David Bailly, his pupils Harmen Steenwyck and Pieter Steenwyck, De Heem's pupil Pieter de Ring, and others.[4] Haarlem artists such as Claesz, Van der Vinne, and Jan Vermeulen have also been associated with Collier's vanitas compositions.[5] His letter-rack still lifes must have been inspired by examples painted in the 1650s and 1660s by Samuel van Hoogstraten (q.v.) and Wallerant Vaillant, and by the similar trompe l'oeil still lifes that Cornelis Brisé painted as early as 1656 in Amsterdam.[6] Letter-rack and other illusionistic pictures were popularized in London during the 1660s by Van Hoogstraten, and at the Danish court between 1668 and 1672 by Cornelis Gijsbrechts.[7] Collier's contribution to this international fashion

was made mainly during his years in London, where his topical pictures of documents, newspapers, letters, portrait miniatures and medals (often of Charles I), quill pens, and other items seemingly stuck behind ribbons tacked to boards were sufficiently appreciated to be copied and imitated by English artists.[8]

1. Compare the accounts of M. Wurfbain in *Dictionary of Art* 1996, vol. 7, p. 568, and of F. Meijer in *Saur AKL* 1992– , vol. 20 (1998), p. 299. According to Wurfbain, Collier was separated from his wife in April 1682. A vanitas still life by Collier dated 1684 (formerly private collection, Recklinghausen) includes a painter with a palette, displaying in his right hand a portrait drawing of a woman; see Bergström 1956, fig. 155, or Vroom 1980, vol. 1, fig. 180. The male figure is plausibly (given the nature of the still life and the inscription "Leyden") assumed to be a self-portrait, and one would presume that the woman is his wife.

2. Private collection; see Grimm 1988, p. 178, fig. 122.

3. The former is cited in Vroom 1980, vol. 1, pp. 136–37, fig. 179, vol. 2, p. 43, no. 189, and the latter (art market, 1980) is noted by Meijer (see note 1 above). Other authors cite different works and dates, which appear to be less reliable.

4. See Amsterdam–Cleveland 1999–2000, nos. 18, 27, 28, 34, 38, for vanitas still lifes by Lievens, De Heem, Dou, and Bailly; Stedelijk Museum De Lakenhal 1983, pp. 319–21, and New York–London 2001, pp. 93–95, 347–48, on the Steenwycks; Gemar-Koeltzsch 1995, vol. 3, pp. 818–21, for examples by De Ring (especially no. 330/2, the canvas of 1650 in Berlin). Jacques de Claeuw (1623–1694 or later) painted vanitas still lifes in Leiden during the 1650s and early 1660s; see Meijer 2003, pp. 194–95.

5. See Bol 1982c, pp. 335–40, and Gemar-Koeltzsch 1995, vol. 3, pp. 1041–43, for Vermeulen.

6. For this type of still life by Van Hoogstraten, see Brusati 1995, pp. 95–96, 162–68, figs. 56, 111, 112, and Amsterdam–Cleveland 1999–2000, pp. 61–63 (where C. Brusati also discusses Vaillant and Cornelis Gijsbrechts), 224–28, nos. 53, 54. Vaillant's letter-rack still life dated 1658 (Gemäldegalerie Alte Meister, Dresden) is reproduced in Gemar-Koeltzsch 1995, vol. 3, p. 1000, no. 391/1. For works by Brisé, see ibid., vol. 2, pp. 197–99, and Amsterdam–Cleveland 1999–2000, pp. 23–24, fig. 22 (1658), and pp. 228–30, no. 55 (*Account Ledgers of the City Treasury of Amsterdam*, which was painted in 1655 to serve as an overdoor in the Town Hall of Amsterdam and won considerable acclaim).

7. On Gijsbrechts, see the biography of Cornelis Bisschop above, note 14.

8. See Meijer 2003, pp. 30–31, figs. 14, 15.

29. *Vanitas Still Life*

Oil on wood, 37 x 44⅛ in. (94 x 112.1 cm)
Signed and dated (left, on book): ·EC· [in monogram]/1662
Inscribed: (left, on ring) E·K; (left, on book) Almanach . . . ;
(center, on bookmark) VANITAS; (center, on print) IACOB.CATZ
RIDDER RAED/PENSION. VAN H.M.HEEREN/STATEN.VAN.
HOLLANT.CVRAT. (Jacob Cats, Grand Pensionary of Their
Majesties the Lords of the States of Holland); (on left page of
book) Sermoon X (Sermon 10); (on right page of book) DE
DERDE ENDE/VIERDE DECAS DER SER./MOONEN HENRCHI
BVLLINGE . . . /DAT TWEEDE DEEL/JESVS./DESE·IS MYN
LIEVE SONE/in den welcken mijn ziele/te/vrede is. Hoort
hem.Mat (The Third and Fourth Decades of the Sermons of
Heinrich Bullinger . . . Volume Two. Jesus. This is my beloved
Son, in whom I am well pleased; hear ye him. Mat[thew 17:5])

The condition of the painting is poor. It has suffered abra-
sion throughout, and in the background at upper left a large
area of paint has been completely lost.

Purchase, 1871 71.19

Collier put his initials in two places on this early work: "EC"
in monogram, above the date 1662 on the almanac (where the
quill pen could suggest the freshness of the inscription); and
"E·K" on the gold ring (Kollier was a common alternative
spelling, often used by the artist himself). The painting is a
fairly conventional, but well-conceived and well-composed, vani-
tas picture. The focus of the design in the area of the tipped-
over silver tazza and green-glass *roemer* (which with the watch
recall still lifes by Willem Claesz Heda; q.v.) and the organiza-
tion overall, with various X-patterns countering the impression
of disarray, indicate that in his early twenties Collier had
already mastered the syntax of a visual language in which earlier
masters, including Pieter Claesz and Jan de Heem (q.q.v.), had
expressed themselves. The actual execution is another matter:
Collier has a dry, rather petty touch, which he overcomes some-
what in the elaborate decorations of the tazza and other

reflective surfaces. Even allowing for condition problems, however, the pearls (on a red ribbon), the moneybag, the oil lamp (with a faintly smoking wick), and the books look nearly as wooden as the violin and the shawm. Later works cannot be described as great advances beyond this point.

Heda also comes to mind in connection with the fancy glass pitcher in the left background, and with the "monochrome" tonality throughout. Except for isolated patches of local color, the palette is quite restrained, perhaps in deference to the sober tenor of the subject. Some loss of color is the result of age, but the hints of burgundy in the table cover and the red in the flag were always subordinate to browns.

The flag must refer to military or, more specifically, civic guard service, and is thus a sign of worldly honor (compare Rembrandt's *The Standard-Bearer (Floris Soop)*; Pl. 152). In general, the objects refer to wealth and individual accomplishment, with (as often in Leiden still lifes) the vanity of learning given particular emphasis. Literature, secular music (unidentified), and hobbies such as astronomy (indicated by the crude version of a Blaeu celestial globe; see Pl. 136) will all pass away like whiffs of smoke, days marked by an almanac, hours ticked off by a watch, a tune played on the shawm, and measures of music.[1] A string on the violin has conspicuously snapped. In this familiar context one hardly needs the skull, the hourglass, and the inscription in the center, "VANITAS." But then pedantry, too, is a Leiden tradition.[2]

Collier often included books and prints in his vanitas pictures. In some cases they represent mundane diversions, but usually the books and the person portrayed in a print (for example, Erasmus or Admiral Tromp) are meant for the viewer's edification. The portrait print of the popular writer Jacob Cats (1577–1660) in the Museum's painting was engraved by Michael Natalis after Pieter Dubordieu, and was published in *Alle de wercken van Jacob Cats* (1655). Collier raised and enlarged the first line of the inscription, which is below the image in the actual print, and set it off on a plaque. Cats had recently died, and he serves here as an exemplary figure, remembered for public service and moral advice. The large book is one volume of a Dutch edition of *The Decades, or Fifty Sermons Divided into Five Decades*, by the Swiss reformer Johann Heinrich Bullinger (1504–1575). Each "decade" consists of ten sermons. The third decade opens with sermons on material possessions, wealth, theft, and so on.

The earliest known dated painting by Collier is evidently a less ambitious vanitas still life of 1661, in which some similar motifs are found.[3] Several still lifes by Collier are dated 1662, including a canvas in the Rijksmuseum, Amsterdam; a canvas on the art market in 1999;[4] and another sold in 2001.[5] Comparable pictures date from the succeeding years.

1. Celestial globes in other works by Collier have been interpreted as references to eternal life, especially when juxtaposed with a terrestrial globe (see Auckland 1982, p. 201, and New York 1988, p. 45). Such a reading here would appear insupportable.
2. For a brief synopsis of the "musical *vanitas*" in Dutch painting, see Liedtke 2000a, pp. 69–70. In that passage the present writer mentions the following lines from Jan van der Veen's *Zinne-Beelden oft Adams Appel* (Amsterdam, 1659), emblem no. 32: "DE VEDEL of FIOOL die wert God betert, meer Gebruyckt tot ydelheyt, als tot Godts lof en eer" (The Fiddle or Violin which would better serve God is used more for vanity than for God's praise and honor).
3. Sold by The Fine Arts Museums of San Francisco, Christie's, New York, June 15, 1985, no. 33.
4. Christie's, New York, May 25, 1999, no. 10; ibid., April 6, 2006, no. 72; and Christie's, London, December 7, 2006, no. 28.
5. Christie's, London, July 11, 2001, no. 32.

REFERENCES: Decamps 1872, p. 437, cites the work as "une remarquable *Vanitas*" by Cesar van Everdingen; MMA 1872, no. 65, as by Cesar van Everdingen (based on the monogram); Harck 1888, pp. 76–77, notes that the picture is called a Van Everdingen but the monogram is Collier's, as is the painting; E. W. Moes, in Thieme and Becker 1907–50, vol. 7 (1912), p. 263, as the earliest known dated work by Collier; Vorenkamp 1933, p. 108, as the artist's earliest known work, dated 1662; Bol 1982c, p. 354, as the earliest known dated work by Collier; De Jongh in Auckland 1982, p. 201 (under no. 40), dates a vanitas still life in the Stedelijk Museum De Lakenhal, Leiden, to Collier's early period, based on comparison with the Museum's picture and others; A. Adams in New York 1988, p. 45 (under no. 13), refers to the Museum's picture in order to date a painting by Collier in a private collection; Baetjer 1995, p. 341; Gemar-Koeltzsch 1995, vol. 2, p. 256, no. 80/2 (ill.); Maarten Wurfbain in *Dictionary of Art* 1996, vol. 7, p. 568, mentioned; F. G. Meijer in *Saur AKL* 1992– , vol. 20 (1998), p. 300, listed; Baetjer 2004, pp. 203, 245, no. 65 (ill.), clarifies provenance.

EXHIBITED: Hartford, Conn., Wadsworth Atheneum, "The Painters of Still Life," 1938, no. 12.

EX COLL.: ?By descent to Martin, comte Cornet de Ways Ruart, Brussels (until d. 1870); [Étienne Le Roy, Brussels, through Léon Gauchez, Paris, until 1870, as by Caesar van Everdingen; sold to Blodgett]; William T. Blodgett, Paris and New York (1870–71; sold half share to Johnston); William T. Blodgett, New York, and John Taylor Johnston, New York (1871; sold to MMA); Purchase, 1871 71.19

ABRAHAM VAN CUYLENBORCH

Utrecht ca. 1620–1658 Utrecht

The artist is not well documented. It is assumed he was born in Utrecht about 1620, since he joined the painters' guild there in 1639. He has been described as possibly a pupil of Cornelis van Poelenburch (1594/95–1667), who, however, was in England between 1637 and 1641, when Van Cuylenborch might have been studying with him.[1] In any case, he was very much influenced by that artist and must have been impressed by his success in court circles (The Hague and London), and also by that of Van Poelenburch's probable pupil Dirck van der Lisse (1607–1669). Unlike those artists, Van Cuylenborch appears to have worked only in Utrecht. He was married there on May 23, 1641. Most of his known paintings date from the 1640s. He died in November 1658.

Van Cuylenborch specialized in arcadian landscapes with mythological and occasionally biblical figures, and in somewhat melodramatic grotto scenes. The latter, which are enlivened by mythological or contemporary figures, were derived from early works by Van Poelenburch and also from paintings by Carel de Hooch (d. 1638), who was active in Utrecht during the 1630s.[2] The ruins and catacombs of Rome and both natural and artificial grottoes in Italy (for example, the nymphaeum of Hadrian's Villa at Tivoli) caught the imagination of Netherlandish artists as early as the 1530s, when Marten van Heemskerck (1498–1574) and Herman Posthumus (active by 1536–d. after 1542) explored the Domus Aurea of Nero.[3]

Van Cuylenborch was a talented figure painter (he occasionally contributed staffage to works by other artists), although not nearly as refined as Van Poelenburch.[4] His landscapes (apart from the grotto views) are comparatively naturalistic, in a style generally resembling that of Jan Both (ca. 1615/18–1652). The Van Poelenburch manner continued with younger artists such as Jan van Haensbergen (1642–1705).

1. On Van Poelenburch, see Sluijter-Seijffert 1984. A contemporary collector, Aert Teggers of Dordrecht, described Van Cuylenborch as Van Poelenburch's pupil; see Loughman 1991, pp. 534, 536, and Sluijter-Seijffert 2006, pp. 444, 450.
2. Van Cuylenborch's relationship to Van Poelenburch and De Hooch is concisely discussed in Salzburg–Vienna 1986, pp. 81–82 (under no. 26, Van Cuylenborch's *Nymphs Bathing in a Grotto*, of 1646, in the Tiroler Landesmuseum Ferdinandeum, Innsbruck). Contemporary figures appear in the artist's *Landscape with Antique Ruins*, of 1643 (Städelsches Kunstinstitut, Frankfurt; Sander and Brinkmann 1995, p. 26, fig. 26).
3. See Guy Bauman's discussion of Posthumus's *Fantastic Landscape with Roman Ruins*, of 1536, in New York 1985, no. 158. On grottoes, see Barbara Rietzsch in *Dictionary of Art* 1996, vol. 13, pp. 702–5.
4. For a collaboration with the landscapist Willem de Heusch (1625–1692), see San Francisco–Baltimore–London 1997–98, p. 306, fig. 2 (a panel dated 1643 in the Musée des Beaux-Arts, Nîmes, to which Nicolaus Knupfer also contributed). A different sort of collaboration, with Jacob Duck (q.v.), is discussed in Rosen 2004.

30. *Bacchus and Nymphs in a Landscape*

Oil on wood, 22⅞ x 28⅜ in. (58.1 x 72.1 cm)
Signed (lower left): AvC· f [AvC in monogram]

The painting is in good condition. The oak panel has been thinned to a thickness of ⅛ inch (.32 cm), attached to an oak panel support ¼ inch (.64 cm) thick, and cradled. There is paint loss along a horizontal split just above the main figural group that extends the width of the panel, and abrasions along the left and lower edges. The wood grain has grown more visible in the sky as the paint film has aged. The darkened pores of the grain are also visible in the more thinly painted and slightly abraded group of figures at lower right.

Bequest of Collis P. Huntington, 1900 25.110.37

This lighthearted mythological picture is a typical Van Cuylenborch, probably from the 1640s. It was given to the Museum as a "Landscape" by Cornelis van Poelenburch (1594/95–1667), and the monogram was misread as "CP." Curator Harry Wehle corrected these errors in 1948.

Apart from Bacchus, who enjoys a flute of red wine, none of the figures appear to be intended as a specific mythological personality. The naked nymphs in the foreground receive fruits and vegetables from two heavily laden putti, one posing like a little Atlas with a basket on his head (fig. 26). Five putti cavort overhead, pulling vine tendrils from the trees. In the right background, a nymph and satyr dance, another nymph with drapery around her hips plays a flute or some other instrument, and a satyr on his knees appears to hold a large jug (details are unclear due to abrasion). The dark green area of the foreground is attractively embellished by twigs and leaves.

The graceful woman seated on a rock occurs variously in the

Figure 26. Detail of Van Cuylenborch's *Bacchus and Nymphs in a Landscape* (Pl. 30)

30

artist's work. In this case, she comes closer than usual to one of Raphael's Three Graces in the Sala di Psiche of the Villa Farnesina, Rome, which was widely known through engravings. However, there are many similar figures in Dutch art, as seen in the work of Joachim Wtewael (q.v.), Cornelis Cornelisz van Haarlem (1562–1638), Van Poelenburch, and others.[1] There may be some Renaissance source for Bacchus as well, but Van Cuylenborch perused earlier material for useful ideas rather than familiar quotations. The chubby-cheeked type holding a modern glass is very much a Batavian Bacchus, like the one in the title print of Dirck Pers's book on the use and misuse of wine, *Bacchus Wonder-wercken* (Amsterdam, 1628).[2]

1. Compare, for example, Cornelisz van Haarlem's small copper, *Venus, Cupid, Bacchus, and Ceres*, dated 1624, in the Musée des Beaux-Arts, Lille (New York 1992–93, no. 12; Van Thiel 1999, no. 174, pl. 285).

2. See Roodenburg 2000, p. 76 (ill.).

REFERENCES: Baetjer 1995, p. 324.

EX COLL.: Collis P. Huntington, New York (until d. 1900; life interest to his widow, Arabella D. Huntington, later [from 1913] Mrs. Henry E. Huntington, 1900–d. 1924; life interest to their son, Archer Milton Huntington, 1924–terminated in 1925); Bequest of Collis P. Huntington, 1900 25.110.37

AELBERT CUYP

Dordrecht 1620–1691 Dordrecht

Cuyp came from a family of artists in Dordrecht, where he spent his entire artistic career. He was the only child of the painter Jacob Gerritsz Cuyp (1594–1651/52), whose diverse oeuvre includes various kinds of portraits as well as history pictures, genre paintings, and still lifes. J. G. Cuyp and his two half brothers, the painter Benjamin Gerritsz Cuyp (1612–1652) and the glass painter Gerrit Gerritsz the Younger (1603–1651), were the sons of the glass painter Gerrit Gerritsz (ca. 1565–1644), who moved from Venlo (east of Eindhoven) to Dordrecht about 1585. Jacob Gerritsz adopted the surname Cuyp by 1617 and, in 1618, married Aertken van Cooten, from Utrecht. He was a prominent figure in the Dordrecht painters' guild and the teacher of Benjamin and Aelbert, and most likely also of Paulus Lesire (1612–after 1654/56) and Ferdinand Bol (q.v.).[1]

Unlike Bol, Cornelis Bisschop, Samuel van Hoogstraten, Nicolaes Maes, Godfried Schalcken (q.q.v.), and even his own father, Aelbert Cuyp was almost unknown outside Dordrecht during the seventeenth century. His reputation in the late eighteenth century, especially in England, and in the nineteenth and twentieth centuries was almost equal to that of Jacob van Ruisdael and of Meyndert Hobbema (q.q.v.). He is routinely numbered among the Italianate landscapists of his generation and was known in the past as "the Dutch Claude," but it appears certain that he never went to Italy.[2]

Cuyp was baptized in the Reformed Church of Dordrecht during the later days of October 1620. By the time he was nineteen, he was active as an independent artist and also as his father's collaborator: three landscapes of 1639 are his earliest known works, while he also painted landscape backgrounds in family portraits by his father that date from 1640, 1641, and 1645.[3] Cuyp's early style and motifs have been associated with the work of the Gorcum painter Herman Saftleven (1609–1685) and others, especially Jan van Goyen (q.v.), who lived in The Hague from 1632 onward and was an influential figure throughout the southern part of the Province of Holland. Collectors and artists in the court city and in nearby centers such as Delft, Rotterdam, and Dordrecht also were traditionally attentive to developments in Utrecht (J. G. Cuyp was no exception), so that Cuyp's apparent interest in the Italianate

landscapes of Cornelis van Poelenburch (1594/95–1667) in the early 1640s and, from 1645 onward, those of the newly returned Jan Both (ca. 1615/18–1652) is not unexpected. However, the degree to which Cuyp responded to Both was exceptional, and becomes even more conspicuous in works of the 1650s (see *Landscape with the Flight into Egypt*; Pl. 32). Also important for the formation of Cuyp's style were his sketching tours in the provinces of Holland and Utrecht about 1642, and in the Rhine Valley in 1651 or 1652.

The death of Jacob Gerritsz Cuyp (by 1652) apparently improved his son's prospects as a portraitist in Dordrecht; the equestrian portrait of the young Pompe van Meerdervoort brothers (Pl. 33), discussed below, is an early example of his work for the city's leading families. In July 1658, Cuyp himself moved up in society when he married the slightly older Cornelia Boschman (1617–1689), who was the widow of a wealthy regent, Johan van den Corput. Cuyp and his wife had only one child, Arendina (1659–1702), although Cornelia had three children from her first marriage. The artist became a man of property and responsibility. In 1660, he was made a deacon of the Reformed Church, and an elder in 1672. The following year, he was named regent of the Dordrecht hospital and was also placed on a list of one hundred candidates for municipal office who were loyal to the new Stadholder, Willem III. In 1679, he was named a member of the High Court of South Holland. From 1663, Cuyp lived with his family in a large house in the Wijnstraat, and he and his wife also acquired large tracts of land outside the city. The artist's net worth was 42,000 guilders in 1689, the year of his wife's death. There is no evidence that he continued to paint after about 1660.[4]

Cuyp's mature works date from the late 1640s to the late 1650s. In addition to many works in which groups of cows are set in meadows and along riverbanks (see Pl. 34), Cuyp painted superb views of the river Maas at Dordrecht (some with anchored fleets), of the river Waal at Nijmegen, and of cliffs along the Rhine; a number of equestrian pictures (not all of them with portraits); and stall interiors, religious subjects set in landscapes, and conventional portraits.[5]

Drawings made out of doors were an important part of

Cuyp's creative process,[6] but the paintings are very much studio products, even when their wonderful light effects are convincingly observed. A remarkable aspect of the artist's typical pictures is the way they transform Netherlandish landscape into something like the Roman campagna in the late afternoon on a spring or summer day. As in paintings of pastoral subjects and picturesque countryside by contemporaries such as Paulus Potter (1625–1654) and Nicolaes Berchem (q.v.), this image of a Dutch Arcadia was made for an urban clientele.[7]

1. On J. G. Cuyp, see Dordrecht 1992–93, pp. 144–55; A. Chong in *Dictionary of Art* 1996, vol. 8, pp. 291–92; and Dordrecht 2002. See also Dordrecht 1977–78 on the Cuyp family of painters.
2. On Cuyp's reputation after 1700, see Chong in Washington–London–Amsterdam 2001–2, pp. 42–48 (p. 43, for "the Dutch Claude").
3. For two examples of collaboration dated 1641, see Reiss 1975, nos. 16, 17, and nos. 1 and 4 for landscapes by Aelbert dated 1639. See also Chong 1991 on Aelbert Cuyp's early work. His development will be further clarified in Chong's forthcoming monograph. Chong's claim (1991, p. 608) that some of Aelbert's earliest works "directly recall" the Antwerp landscapist Josse de Momper II (1564–1635) seems somewhat simplistic, considering the Fleming's popularity in Holland and the emulators who were active in the southern part of that province during the 1630s. On this point, see New York–London 2001, pp. 83–86, 187, 264.
4. These details are adopted from the biographies of Cuyp by Chong in Amsterdam–Boston–Philadelphia 1987–88, p. 290, and in *Dictionary of Art* 1996, vol. 8, p. 293. As noted by Chong in Washington–London–Amsterdam 2001–2, pp. 40–41, Cuyp's wife was the granddaughter of Franciscus Gomarus, the founder of the Counter-Remonstrants, who were strong supporters of the House of Orange.
5. See the illustrations in Reiss 1975, the discussion by Chong in *Dictionary of Art* 1996, vol. 8, pp. 294–97, and the paintings section of Washington–London–Amsterdam 2001–2, pp. 88–185.
6. See Haverkamp-Begemann's essay on Cuyp as a landscape draftsman in Washington–London–Amsterdam 2001–2, pp. 75–85, and the drawings section of that catalogue, pp. 214–77.
7. See Chong's essay on Cuyp's patrons and collectors in Washington–London–Amsterdam 2001–2, pp. 35–51, especially pp. 40–41. Cuyp's most important patron was the Dordrecht tax collector Aert Teggers (see Loughman 1991).

31. *Piping Shepherds*

Oil on canvas, 35¾ x 47 in. (90.8 x 119.4 cm)
Signed (lower right): A. cuÿp. F.

The artist's monochrome palette as well as abrasion of the surface contribute to the picture's generally impoverished appearance.

Bequest of Collis P. Huntington, 1900 25.110.15

The Huntington picture is a signed early work by Cuyp, probably painted about 1643–44.[1] Although larger than most works painted by the artist when he was in his early to mid-twenties, the painting shares with them a fluid touch and a palette reminiscent of Jan van Goyen (q.v.); pale browns and yellows blend together in the landscape, tans and grays in the costumes, and blues in the sky. The color of the light and the fall of the shadows suggest that the time is late afternoon, which is consistent with the alignment of Dordrecht Cathedral on the horizon to the far left. A mood of quiet contentment prevails: the boy plays a flute, the man a bagpipe, and a younger boy lies on the ground, while attentive cows and smiling sheep seem to assemble for the music or for the walk back home. The playful dog, by contrast, appears to eye the viewer.

Reiss (see Refs.) seems somewhat uncertain of the attribution, and implies that the figures and animals may be by Aelbert's father, Jacob Gerritsz Cuyp (1594–1651/52).[2] The question is raised by the general resemblance of the figures to types painted by the elder Cuyp, and by known examples of collaboration between father and son in the early 1640s.[3] The execution, however, reveals no indications of more than one hand, and is entirely consistent with Aelbert's undisputed works of the early 1640s, such as *Sunset near Dordrecht* (Museum Boijmans Van Beuningen, Rotterdam)[4] and *Orpheus Charming the Animals* (private collection, Boston).[5]

As several authors have noted (see Refs.), the landscape in the left background, with its distant view of Dordrecht Cathedral (the Grote Kerk), corresponds with a drawing, *Dordrecht from the East* (Rijksprentenkabinet, Rijksmuseum,

Amsterdam), made from nature by Cuyp about 1641–43. Cuyp used the same study for the backgrounds of *The Kicking Horse* (John G. Johnson Collection, Philadelphia Museum of Art)[6] and *Landscape near Dordrecht with Shepherds Teasing a Goat* (private collection, the Netherlands).[7] The latter is also similar to the Museum's picture in its grouping of trees and animals at the right, and in the scale of the shepherds (who differ, but wear the same hats).

The boy lying on the ground is an early instance of a common motif in Cuyp's work.[8] The sheep probably derive from examples by his father.[9] The entrance of cows and other animals from offstage is a common occurrence in the elder Cuyp's oeuvre, where a model for the dog is also found.[10] To judge from their facial types, the musical shepherds may also have immediate antecedents in the work of Cuyp's father, but none is presently known.

A copy of two-thirds of the composition, cropping the left side and replacing the dog with a copper jug, was on the art market in 1990.[11]

1. As concluded by Alan Chong in his dissertation on Cuyp (Institute of Fine Arts, New York University, 1992, unpaged; entry kindly provided to the Museum). Chong dismisses Reiss's reservations (see Refs.), and considers the foliage and figures typical of Cuyp in the early 1640s.

2. In letters to the Museum dating from 1951 and 1952, Reiss suggests that the picture (which he had not seen) is probably by J. G. Cuyp. In Reiss 1975, p. 75 (under no. 42), the author acknowledges mistakenly attributing an early work by Aelbert Cuyp to J. G. Cuyp in Reiss 1953.

3. For example, Dordrecht 2002, nos. 26, 27, 30; Washington–London–Amsterdam 2001–2, no. 3.

4. Reiss 1975, no. 62; Dordrecht 1977–78, no. 23.

5. Washington–London–Amsterdam 2001–2, no. 1.

6. Reiss 1975, no. 61, where a detail of the drawing is reproduced.

7. Yapou 1981, revising Reiss 1975, no. 52.

8. Compare the drawing *Three Studies of a Young Shepherd* (Rijksprentenkabinet, Rijksmuseum, Amsterdam), from which one of the figures was adopted in a painting of the 1650s (see Amsterdam–Washington 1981–82, pp. 120–21, fig. 2; MacLaren/Brown 1991, p. 89, no. 822, fig. 24, pl. 75). Similar figures occur in the work of Jan Both (see Amsterdam–Washington 1981–82, pp. 64–65, fig. 1).

9. Compare the sheep in Dordrecht 2002, nos. 7, 18, 27, 30.

10. See ibid., no. 18 (the same dog, in a portrait of 1638), and no. 26 (the cow).

11. Christie's, New York, April 4, 1990, no. 203 (ill.).

REFERENCES: J. Smith 1829–42, vol. 5 (1834), p. 306, no. 76, records the painting as in the Bessborough sale of February 1801; Hofstede de Groot 1907–27, vol. 2 (1909), p. 78, no. 238a, as in the Bessborough sale of February 1801, and p. 102, no. 331, as in the collection of Mrs. C. P. Huntington, New York, and describes the composition; Valentiner in New York 1909, pp. xxxiv, 8, no. 7 (ill.), as "early work, about 1640–50"; Breck 1910, p. 61, mentioned; B. Burroughs 1925a, pp. 142, 146 (ill.), 180, as "the well-known *Piping Shepherds* by Aelbert Cuyp," with a vision of "uncommon simplicity and objectivity"; J. Holmes 1930, p. 182, listed; Barnouw 1944, pl. 23; Reiss 1975, pp. 9, 86, 87, 207, no. 51, as by the "Cuyp studio 1640–45," closely related to J. G. Cuyp's work, the background based on a drawing in the Rijksmuseum (see the following ref.); J. G. van Gelder in Dordrecht 1977–78, p. 128 n. 1 (under no. 48), notes the use of a landscape drawing by Aelbert Cuyp, *Dordrecht from the East*, of about 1641–43 (Rijksprentenkabinet, Rijksmuseum, Amsterdam), as the basis for the left background in this picture; Yapou 1981, pp. 160, 163 n. 15, repeats Giltay's ([*sic*], i.e., Van Gelder in Dordrecht 1977–78) observation in connection with the background of another painting by Cuyp (Reiss 1975, no. 52); P. Sutton 1986, p. 191, as an early work by Aelbert Cuyp "which is sometimes thought to be a collaboration between Aelbert and his father"; Duparc in Cambridge–Montreal 1988, p. 88, fig. 1 (under no. 21), repeats the information about the Rijksmuseum drawing; Liedtke 1990, p. 37, mentioned as part of Collis Huntington's bequest; Baetjer 1995, p. 326.

EXHIBITED: New York, MMA, "The Hudson-Fulton Celebration," 1909, no. 7 (lent by Mrs. Collis P. Huntington).

EX COLL.: Earls of Bessborough, Roehampton (by 1801–92; their sale, Christie's, London, February 5–7, 1801, no. 60, as "A Landscape and Cattle, a View from Nature, in Holland," bought in for £409 10s.; their sale, Christie's, London, April 7, 1801, no. 60, as "A Landscape and Cattle, a View from Nature in Holland," bought in for £189; their sale, April 1, 1848, no. 87, bought in for Gn 340; their sale, March 14, 1891, no. 148, as "A Sunny River Scene," bought in for Gn 200; sale, June 11, 1892, no. 66, for Gn 200, to Colnaghi, London); [Martin Colnaghi, London, from 1892]; [Sedelmeyer, Paris, in 1894]; Collis P. Huntington, New York (until d. 1900; life interest to his widow, Arabella D. Huntington, later [from 1913] Mrs. Henry E. Huntington, 1900–d. 1924; life interest to their son, Archer Milton Huntington, New York, 1924–terminated in 1925); Bequest of Collis P. Huntington, 1900 25.110.15

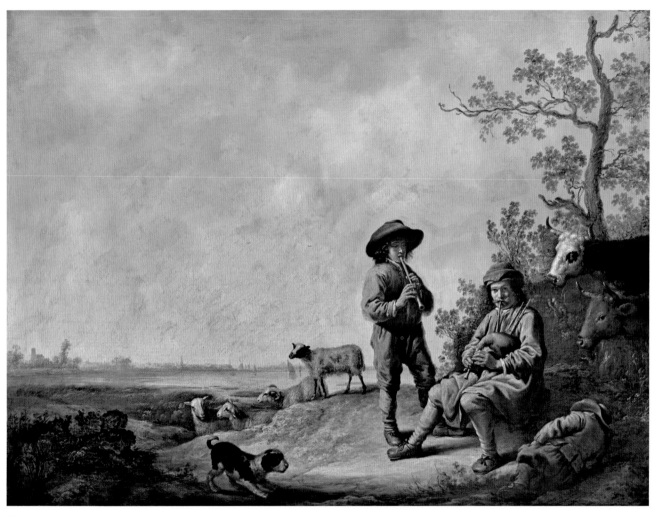

31

32. *Landscape with the Flight into Egypt*

Oil on wood, 18 x 22⅞ in. (45.7 x 58.1 cm)
Signed (lower left): A:C

The painting is well preserved. The final glazes are disrupted in the passages of foreground vegetation that appear blanched. Microscopic examination reveals an admixture of fine brass particles in the dark, transparent final glazes in the trees and other vegetation at lower right.

Bequest of Josephine Bieber, in memory of her husband, Siegfried Bieber, 1970 1973.155.2

One of the clearest examples of Cuyp's response to the Italianate landscapes of Jan Both (see the biography of Cuyp above), this panel of about 1650 shows the Holy Family on the left, traveling on a path in the light of a radiant sunset. The way to Egypt appears to have taken Mary and Joseph down the Rhine and along the coast of Liguria, although the view behind them seems an evocation of distant memories of those places rather than signs of recent experience. As is well known, Cuyp never went to Italy himself, but he borrowed the Claudian light, cisalpine motifs, and compositional ideas that Both employed in his prints and paintings. For example, Both's etching *The Ferry* (fig. 27) is very similar in composition to the present picture and includes analogous details, such as wayfarers with donkeys, herders with cows, distant towers, and a few light clouds colored by the descending sun. Some of Both's paintings of about 1645–50 are strikingly similar to this picture in tonality as well as design, and in their idyllic mood.

About two dozen landscapes by Cuyp are enlivened by religious figures,[1] and at least three of them by the Holy Family on their way to Egypt. A large canvas in the care of the Instituut Collectie Nederland (Netherlands Institute for Cultural Heritage), Amsterdam, probably painted about 1645–48, shows the Holy Family with their donkey in a river valley, passing a bagpiper quite like the one in the Museum's *Piping Shepherds* (Pl. 31).[2] The beautiful *Flight into Egypt* from the Carter Collection (Los Angeles County Museum) could be described as a larger and more elaborate version of the present work.[3] And while the two paintings date from about the same time, one would imagine that the Carter picture is the slightly later.[4]

The placement of religious figures in extensive landscapes went back to the beginning of the genre in the Netherlands and continued through the seventeenth century (see Pls. 22, DV1), though by about 1650 the practice was more common in some regions (South Holland and Utrecht, for example) than

in others. The story of the Flight into Egypt (Matt. 2:13–14) was especially popular, perhaps because many Netherlanders had fled persecution themselves, but more broadly because the subject allowed for spectacular scenery. In this regard, the whole tradition could be said to head downhill from Pieter Brueghel the Elder's painting of 1563 (Samuel Courtauld Trust, Courtauld Institute of Art Gallery, London), where the Holy Family treks from an alpine meadow into all God's creation. Some of the most impressive examples of the next generation are by Paul Bril, in the frescoes of the Palazzo Pallavicini-Rospigliosi in Rome and in a small, superb painting on copper of about 1595 (private collection);[5] by Jan Brueghel the Elder, in panels of 1600 (private collection) and 1607 (Hermitage, Saint Petersburg);[6] and by Adam Elsheimer, whose painting on copper of 1609 (Alte Pinakothek, Munich) was engraved by Hendrick Goudt in 1613. Through either a copy or the print, Elsheimer's composition inspired Rembrandt in his nocturnal landscape of 1647, *The Rest on the Flight into Egypt* (National Gallery of Ireland, Dublin).[7] Rubens's treatment of the subject, in a small panel of 1614 (Gemäldegalerie Alte Meister, Kassel), is atypical, since the figures nearly fill the moonlit space.[8]

Cuyp's approach follows not only that of Both but also that of the Dutch Italianate landscapists in general. Cornelis van Poelenburch's *Landscape with the Flight into Egypt*, of 1625 (Centraal Museum, Utrecht), was evidently the first of nine pictures he devoted to the subject.[9] Bartholomeus Breenbergh (q.v.) depicts The Rest on the Flight into Egypt in a panel of

Figure 27. Jan Both, *The Ferry (View of the Tiber in the Campagna)*, ca. 1645–50. Etching, sheet 7⅞ x 11⅛ in. (19.8 x 28.1 cm). The Metropolitan Museum of Art, The Elisha Whittelsey Collection, The Elisha Whittelsey Fund, 1960 60.621.47

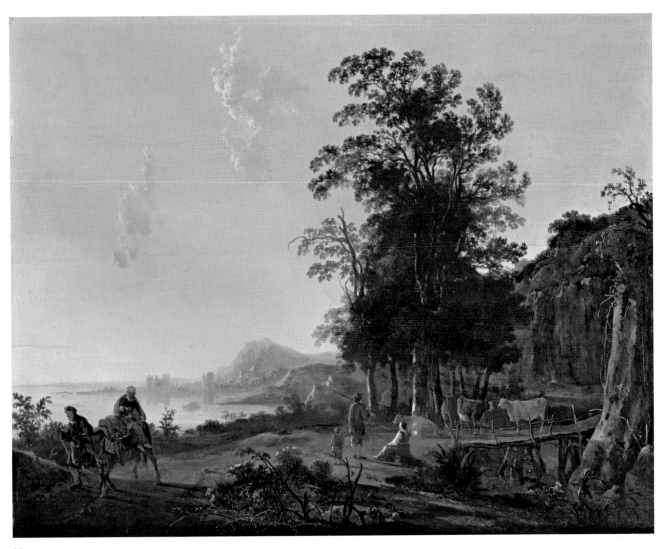

32

Figure 28. Herman van Swanevelt, *The Flight into Egypt*, ca. 1645–50. Oil on copper, 8¼ x 10⅝ in. (21 x 27 cm). Private collection

1634 (Alte Pinakothek, Munich).[10] Not surprisingly, one of Both's landscape etchings of the 1640s centers on the Holy Family and two donkeys on a winding road.[11] Paulus Potter's *Flight into Egypt*, of 1644 (formerly Newhouse Galleries, New York), has been mentioned in connection with Cuyp's pictures,[12] but one of the closest parallels, in date and in its sympathy with Both, is a small painting on copper of about 1645–50 by Herman van Swanevelt (ca. 1600–1655; fig. 28), who worked in Rome from the late 1620s until 1644, when he moved to Paris.

1. Hofstede de Groot 1907–27, vol. 2, pp. 8–13, nos. 1–19. See Dordrecht 1992–93, pp. 126–27, no. 19, for two paintings of the Baptism of the Eunuch by Cuyp and one by Both.

2. Los Angeles–Boston–New York 1981–82, p. 43, fig. 3 (incorrectly as on panel); Rijksdienst Beeldende Kunst 1992, p. 77, no. 522 (ill.), as on canvas, 41⅝ x 60⅝ in. (105.5 x 154 cm).

3. Los Angeles–Boston–New York 1981–82, pp. 40–45, no. 10, pl. in front.

4. Wheelock in Washington–London–Amsterdam 2001–2, pp. 176, 208 (under no. 41), places the Carter picture in the mid- to late 1650s, with no mention of the painting in New York.

5. For the painting on copper, see London 2002, no. 1.

6. Ertz 1979, nos. 62, 154, figs. 239, 251. The Flemish tradition of imaginary forest landscapes is followed in Jacob van Geel's *Rest on the Flight into Egypt*, of 1633, in the Niedersächsisches Landesmuseum, Hannover (Wegener 2000, pp. 182–83, no. 76 [ill.]).

7. See Kelch in Berlin–Amsterdam–London 1991–92a, pp. 238–41 (under no. 38). For Elsheimer's painting in Munich, see Frankfurt–Edinburgh–London 2006, no. 36.

8. Schnackenburg 1996, vol. 1, p. 261, no. GK87, pl. p. 274.

9. This work has been extensively exhibited, for example in Amsterdam–Boston–Philadelphia 1987–88, no. 69 (see also no. 70), and in London 2002, no. 4.

10. As noted by Chong in Amsterdam–Boston–Philadelphia 1987–88, p. 407, fig. 2, in connection with the Poelenburch of 1625.

11. See Chong in ibid., pp. 198–99, fig. 2, and p. 408.

12. Los Angeles–Boston–New York 1981–82, pp. 43–44, fig. 5.

REFERENCES: W. Roberts 1897, vol. 1, p. 300, notes the sale of 1878; Bode 1900, pp. XIV–XV, pl. 28, describes the subject and style ("affinities with Jan Both"), and places the work at "the end of his first period"; É. Michel 1901, p. 398, praises the picture as a youthful work, recalling Potter; Bode 1907, vol. 1, pp. ix, 36, no. 34 (ill.), repeats Bode 1900; Nicolle 1908, p. 198, notes the picture as one of four Cuyps in the Kann collection; Hofstede de Groot 1907–27, vol. 2 (1909), p. 135, no. 442, describes the composition and gives provenance through Duveen in 1907; J. Holmes 1930, p. 167, fig. 5, mentions the work as formerly in the Kann collection, compares it with a similar picture then in the Fisher collection, Detroit (now Los Angeles County Museum); Walsh 1974a, p. 349, fig. 13, records the bequest to the MMA and observes that in its composition and golden sunlight the picture "reflects more clearly than most Cuyps the inventions of Jan Both"; Los Angeles–Boston–New York 1981–82, pp. 43–44, fig. 4, compares the painting with the larger panel in the Carter collection, which is very similar in composition and also includes the *Flight into Egypt*; P. Sutton 1986, p. 191, cites the work as a "golden Both-like landscape probably painted by Cuyp in the early 1650s"; Gaskell 1990, pp. 446–47, fig. 2, compares the composition of Cuyp's *Evening Landscape* in the Thyssen collection; Chong 1991, p. 610 n. 32, mentions the work among others with bright Italianate light; Baetjer 1995, p. 327.

EXHIBITED: Lucerne, Kunstmuseum Luzern (date unknown).[1]

EX COLL.: Mrs. Edward Romilly, London (until d. 1878; posthumous sale, Christie's, London, March 23, 1878, no. 128, for Gn 290 or £304 10s. to Colnaghi); [Colnaghi, London, from 1878]; Étienne Martin, baron de Beurnonville, Paris (until d. 1881; his estate sale, Pillet, Paris, May 9–16, 1881, no. 247, as "Paysage, soleil couchant," for FFr 10,050 to Sedelmeyer); [Sedelmeyer, Paris, from 1881; sold to Kann]; Rodolphe Kann, Paris (by 1900–d. 1905; his estate 1905–7; sold to Duveen); [Duveen, London and New York, 1907–15; sale, American Art Association, New York, April 29 (or 19), 1915, no. 9, for $4,000 to Knoedler]; [Knoedler, New York, 1915–27; sale, Christie's, London, July 8, 1927, no. 114, for £441 to Duits]; [Duits, London, from 1927]; [A. S. Drey, Munich, in 1931]; Mrs. Siegfried (Josephine) Bieber, Berlin and New York (until d. 1970);[2] Bequest of Josephine Bieber, in memory of her husband, Siegfried Bieber, 1970 1973.155.2

1. A stamped sticker on the back of the panel reads "Kunstmuseum Luzern KH 215." The Kunstmuseum was unable to identify the exhibition (letter from curator Cornelia Dietschi, dated December 12, 2000). However, a date in the early 1930s is likely, considering that the probable owner, Siegfried Bieber, emigrated to the United States in 1934.

2. Siegfried Bieber (1873–1960), a Berlin banker, moved to the United States in 1934. Various efforts have been made to determine whether he owned the painting in Germany, but so far these have proved unsuccessful.

33. *Equestrian Portrait of Cornelis and Michiel Pompe van Meerdervoort with Their Tutor and Coachman ("Starting for the Hunt")*

Oil on canvas, 43¼ x 61½ in. (109.9 x 156.2 cm)
Signed (lower left): A. cuyp. fecit.

The painting is very well preserved. A pentimento is visible just above the horizon line over the head of the running figure at left. Examination with infrared reflectography reveals that the building now behind the portrait group was first painted in the middle ground at left.

The Friedsam Collection, Bequest of Michael Friedsam, 1931
32.100.20

This exceptionally fine picture in the Friedsam Collection represents two young members of a distinguished Dordrecht family: on the left, Cornelis Pompe van Meerdervoort (1639–1680), and, in the center, his slightly older brother Michiel (1638–1653), who died not long after Cuyp completed the portrait. The sitters are identified in the 1749 inventory of the estate of Cornelis's descendant Johan Diederik Pompe van Meerdervoort: "Een stuk, zijnde een schoorsteenstuk, verbeeldende de heer Michiel en Cornelis Pompe van Meerdervoort op de jagt gaande met haar praeceptor, knegts etc. door A. Kuyp" (A piece, being a chimneypiece, depicting the Messrs. Michiel and Cornelis Pompe van Meerdervoort going to hunt with their instructor, servants etc. by A. Kuyp).[1] In a much earlier inventory, one made of the contents of the Huis te Meerdervoort (the family castle at Zwijndrecht, near Dordrecht) shortly after Cornelis Pompe van Meerdervoort's death in 1680, the items "in the children's room" included a painting depicting "d'heer Caulier te peert met 2 Jonckhers en Willem de koetsier, voor de schoorsteen" (Mr. Caulier on horseback with 2 milords and Willem the coachman, over the mantelpiece).[2]

When Cuyp made this portrait, there were only three living members of this particular branch of the Pompe van Meerdervoort family, Adriana van Beveren (1618–1678) and her two sons, Michiel and Cornelis. Her husband (also named Michiel) died in 1639, just two years after the couple's marriage and before the birth of their second son. With the latter's death in 1653, the thirty-five-year-old widow was left alone with her fourteen-year-old son, Cornelis, who was to outlive her by two years. In the 1670s, he had his portrait painted by Samuel van Hoogstraten (q.v.; the canvas is in a Dutch private collection), and although at least twenty years had passed since his features were recorded by Cuyp, the resemblance to the boy on the left in the Museum's picture is unmistakable.[3]

Cornelis was more fortunate than his mother with respect to the longevity of his spouse and children. In 1662, he married Alida van Beveren (1640–1680; daughter of Jacob van Beveren and Johanna de Witt). They both died in 1680, leaving fourteen children, who included Jacob (1666–1720) and Michiel (1668–1721). In 1723, Jacob's son Johan Diederik (1697–1749; mentioned above) married his first cousin, Michiel's daughter Johanna Alida (1691–1749). They too died the same year, leaving three daughters aged about twenty-six, twenty-one, and twenty (two sons had died in infancy). None of these women ever married. It appears likely that at some time after two of the sisters, Adriana and Maria Christina, died in 1778 and 1781, respectively, their sister and heir, Christina Elisabeth (1729–1801), sold the painting by Cuyp.[4] This family history allows us to complete the provenance of the picture (see Ex Coll.), which passed from one generation to another with ownership of the Huis te Meerdervoort.

Adriana van Beveren was almost certainly the first owner of Cuyp's painting, and she is one of three parties who may have commissioned it. As discussed below, such a picturesque portrait of two boys on horseback made a very different impression on contemporary Dutch society than it does on the average viewer today. The young gentlemen represent the male line of a distiguished Dordrecht family with extensive land holdings in the area of Dordrecht and in the province of Gelderland. The Huis te Meerdervoort itself (fig. 29) was purchased by the boys' paternal grandfather (and the older son's namesake), Michiel Pompe van Meerdervoort (1578–1625). Their maternal grandfather, Cornelis van Beveren (1591–1663; Lord of Strevelshoek, West-IJsselmonde, and De Lindt), was one of the wealthiest and most influential citizens of Dordrecht. He held numerous high public offices, including burgomaster of Dordrecht (repeatedly), receiver general of South Holland, representative to the States of Holland and to the States General, and was ambassador to Denmark, Hamburg, England, and France (Louis XIII knighted him in 1635).[5] This heritage rests on the shoulders of the young horsemen in Cuyp's painting, and then within a year or two the older one died. Ironically, Mr. Caulier's gesture, meant simply as a command to the retainer Willem, became one that in later years could have been read as an act of pointing to the immediate family's sole heir and, in still later years, to their patriarch.

It is possible that Van Beveren himself commissioned the

portrait, or that the boys' uncle Matthijs Pompe van Slinge-landt (1621–1679) was the patron or the person who suggested having this type of portrait painted, and by whom. It was for Matthijs Pompe, "Lord of Slingelandt" and other estates, that the artist's father, Jacob Gerritsz Cuyp (1594–1651/52), painted a full-length portrait of the patron's six-year-old son, Michiel Pompe van Slingelandt, in 1649 (Instituut Collectie Nederland, on loan to the Dordrechts Museum, Dordrecht). The boy is shown briskly walking in the countryside, with a falcon on his arm and a dog just in front of him, tracking a scent.[6] The young hunter wears a Turkish tunic of red velvet, antique sandals, a sixteenth-century bonnet, the same kind of saber that his cousins wear in the present picture, and other elements of fancy dress.[7] The portrait thus signifies that the boy is a member (and, as it happens, the male heir) of a family with large estates, hunting privileges, and certain similarities to their social superiors at the court of The Hague.

The Meerdervoort estate was located across the Oude Maas from Dordrecht, just south of the village of Zwijndrecht.[8] As seen in Cuyp's slightly earlier canvas *The Avenue at Meerdervoort* (fig. 30), the castle and its surroundings (to the left) were separated from the river by a road on a dike and by a canal (to the right). The Grote Kerk of Dordrecht is visible to the northeast (right background). A young groom stands on the avenue, holding the reins of two saddled ponies. A man on a horse approaches from the direction of the house, and farther down the avenue stand two boys and a woman, who are surely meant to be identified as Adriana van Beveren and her sons.

The setting in the Museum's picture does not derive from the same neighborhood. The partly ruined castle in the background is imaginary (similar walls and towers occur elsewhere in Cuyp's work), and was probably intended to suggest a seigneurial past.[9] As has often been noted, the view in the left background is based on *The Rhine near Elten* (Fondation Custodia, Institut Néerlandais, Paris), one of the drawings Cuyp made in the area of Nijmegen about 1651–52.[10] The church and cloister of Hoog-Elten are seen on the hill below Cornelis's akimbo arm. To the far left, on the near side of the river, are the church and village of Rindern, while the town and church of Laag-Elten appear beyond the sailboats on the Rhine. No specific connection between the area of Elten and the Pompe van Meerdervoort family is known (although they owned land elsewhere in Gelderland). Cuyp used the same drawing for a picturesque landscape painting with riders and sheep, *Cavaliers Halted, One Sketching* (Collection of the Duke of Bedford), which also dates from the early 1650s.[11]

The Friedsam canvas is among the earliest examples in the

Netherlands, or anywhere in Europe, of sitters from outside court circles depicted in an equestrian portrait. The type had previously been, and indeed remained in other countries, a prerogative of royalty and high nobility.[12] To some extent, the Dutch development during the 1650s may have been related to the collapse of the House of Orange as a political power and the rise of a burgher from Dordrecht, Johan de Witt (1625–1672), as the effective leader of the United Provinces.[13] During the same "stadholderless period," wealthy middle-class patrons of the arts, encouraged by a generally flourishing economy, favored forms of interior decoration, dress, and social behavior that were associated with the aristocracy. The purchase of country estates, and with them lordly titles and hunting rights, was one of the most conspicuous signs of gentrification, and this rise in stature was often underscored by pictures of country houses (for example, by Jan van der Heyden; q.v.), of dead game (see Pl. 216),[14] and of fashionable gentlemen or couples riding to hunt (as in landscapes of the 1650s by Ludolf de Jongh and Philips Wouwermans; q.q.v.).[15] Artists such as Bartholomeus van der Helst (q.v.) in Amsterdam, Jan Mijtens (ca. 1614–1670) in The Hague, and Anthonie Palamedesz (1601–1673) in Delft painted portraits of male figures, married couples, and families with dead game, hounds, and hunting equipment.[16]

In Dordrecht, Cuyp and his father were leaders in this genre; as early as 1641 they collaborated on a canvas, *Family Group in a Landscape* (Israel Museum, Jerusalem), in which successful hunters are featured prominently among nine figures in a rural landscape.[17] Aelbert Cuyp's several equestrian portraits of the early to mid-1650s are all pictures of wealthy burghers (most

Figure 29. Roelant Roghman, *Huis te Meerdervoort, near Dordrecht*, 1647. Black chalk and gray wash, 13⅝ x 19⅞ in. (34.5 x 50.5 cm). The Metropolitan Museum of Art, Frits and Rita Markus Fund, 2001 2001.636

33

likely from Dordrecht) hunting with hounds, and the reference to this aristocratic pastime is the reason that horses are featured in the first place.[18] It appears likely that Cornelis van Beveren encouraged the artist's turn to equestrian portraiture, whether or not he commissioned this picture.[19] With his experience of foreign courts, he would have realized that Cuyp's equestrian portraits represented a new form of Dutch liberty, since even people like the Pompe van Meerdervoorts would not have enjoyed hunting privileges in other countries, including the Spanish Netherlands not far to the south.[20]

The dogs in this painting are greyhounds and foxhounds. The animal leading the pack at the left edge of the composition appears to be Cuyp's awkward attempt to render a running hare. The costumes are not normal hunting attire, but exotic outfits modeled on Hungarian dress. As Gordenker has explained, the two boys and their riding instructor wear tight-fitting velvet coats, or *dolmans*, over elaborate shirts. The coachman to the right wears a looser and heavier coat called a *mente*. The hats are more European, but fanciful. Cornelis's cap resembles a Turkish turban, Michiel's bonnet is modishly outdated and trimmed with a chain, and the other hats are Dutch ideas of eastern European headgear. The swords are probably based on a European saber of Orientalizing design. Since Cuyp used the same or similar motifs in contemporary pictures, they were probably based on studio props.[21] Like the castle and the overdressed servants, the theatrical costumes worn by the Pompe van Meerdervoort brothers create the romantic aura of a noble family that extends over borders and back in time. It may seem fitting that the painter did not quite succeed in placing the heads of Cornelis and especially Michiel in the picture, so that it would resemble life itself.

Figure 30. Aelbert Cuyp, *The Avenue at Meerdervoort*, ca. 1651. Oil on canvas, 27½ x 39 in. (69.8 x 99 cm). The Wallace Collection, London

1. G. Veth 1884, p. 260.

2. The Hague 1933, no. 938.

3. See Sumowski 1983–[94], vol. 2, no. 872 (ill. p. 1355), for Van Hoogstraten's painting, and Brusati 1995, pp. 134, 298 n. 150, on the artist's acquaintance with "Sir Cornelis Pompe van Meerdervoort, Knight and Chief Sheriff of the city of Dordrecht" (as he is styled in Houbraken 1718–21, vol. 2, p. 162).

4. It is also possible that the painting was sold by the Pompe van Meerdervoort sisters at some earlier moment after their parents died. By 1781, when the surviving sister was fifty-two years old, it was clear that her line of the Pompe van Meerdervoort family would die out with her and the Huis te Meerdervoort would pass to another line of the family. Genealogical tables of the Pompe van Meerdervoort and Van Beveren families, with particular attention to the ownership of the Huis te Meerdervoort, are provided in Van der Leer 1994, pp. 92–96. See ibid., p. 60, fig. 20, for Nicolaas Verkolje's portrait of Johan Diederik Pompe van Meerdervoort with his wife and their first daughter, dated 1724.

5. Van Beveren was an important figure for cultural and especially literary life in Dordrecht: see Van Vliet and De Niet 1995.

6. See Haarlem–Antwerp 2000–2001, and Dordrecht 2002, no. 35.

7. As described by Gordenker in Washington–London–Amsterdam 2001–2, pp. 55–56, fig. 5.

8. See the map of about 1676 in Van der Leer 1994, p. 52, fig. 12.

9. For similar towers and walls in various arrangements, see Washington–London–Amsterdam 2001–2, nos. 16, 30, 33, 34, 40.

10. Brussels and other cities 1968–69, no. 32; Dordrecht 1977–78, no. 71. See also Refs. below, especially under Reiss 1975.

11. Reiss 1975, no. 120.

12. See Liedtke 1989b, chap. 2, on "symbolic themes" in equestrian portraiture, and pp. 79–83 on the Dutch development. Paulus Potter's *Dirck Tulp on Horseback*, of 1653 (Six Collection, Amsterdam; ibid., pl. 179), is a contemporary example remarkable for its princely scale and design. For a nearly complete catalogue of Dutch equestrian portraits, see Leeuwarden–'s Hertogenbosch–Assen 1979–80.

13. See Israel 1995, chap. 29. Of course, there was no causal relationship between politics and the rise of the bourgeois equestrian portrait in the Dutch Republic, but rather a mental climate in which the emulation of aristocratic forms must have seemed less inappropriate than before.

14. This kind of still life is surveyed in S. Sullivan 1984.

15. See Fleischer 1989, pp. 45–57.

16. See S. Sullivan 1984, pp. 44–45, pls. 72–74; Haarlem 1986a, nos. 52, 63; P. Sutton 1990a, p. 118; Ingamells 1992a, pp. 142–44 (on Van der Helst's *Family Group*, of 1654); Ekkart 1995, nos. 53, 69. About 1655, Mijtens portrayed Matthijs Pompe van Slingelandt (mentioned in the text above) as a hunter with hounds in a landscape together with his second wife and his daughter from his first marriage, Christina Pompe. On this painting in the Nationalmuseum, Stockholm, see Chong in Washington–London–Amsterdam 2001–2, p. 37, fig. 2, and Ekkart in Stockholm 2001–2, p. 55, no. 164.

17. S. Sullivan 1984, p. 44, pl. 75; Dordrecht 1977–78, no. 17; Dordrecht 2002, pp. 34–35, fig. 34.

18. This point is missed in Wheelock 1995a, p. 51, where hunting is said to have become "a popular pastime for the aristocracy in the second half of the seventeenth century" (it had been for centuries, in their case), and that "in this instance [Cuyp's *Lady and Gentleman on Horseback*, in the National Gallery of Art, Washington, D.C.] the hunt theme merely served as a pretext for the unusual [i.e., equestrian] portraits."

19. Reiss maintains that Van Beveren's three sons (all in their twenties) appear in Cuyp's large canvas *Huntsman Halted* (Barber

Institute of Fine Arts, Birmingham, U.K.); that one of Van Beveren's sons is the horseman in *The Negro Page* (Royal Collection, London); and that he may have commissioned *The Avenue at Meerdervoort* (fig. 30 here) and the present portrait of his grandsons (Reiss 1975, pp. 9, 154, 159, 161, 162, pls. 113, 119, 121–22). See also White 1982, pp. 33–34, no. 37, pl. 33, on *The Negro Page*. However, Alan Chong in his dissertation (Chong 1992) rejects the conjectural identifications of Van Beveren's sons.

20. As discussed in Koslow 1996.

21. On the costumes and swords, see Gordenker in Washington–London–Amsterdam 2001–2, pp. 53–57.

REFERENCES: J. Smith 1829–42, vol. 5 (1834), p. 326, no. 150, cites the painting as "A Gentleman with his two sons" in the Sanderson collection, with provenance from 1825; Waagen 1838, vol. 2, p. 400, as in the Sanderson collection, with Smith's title, "executed with unusual care in all parts"; Jervis 1854, p. 326; Waagen 1854, vol. 2, p. 289, as in the Sanderson collection; G. Veth 1884, pp. 260–61, mentions the description of this painting in the 1749 inventory of Johan Diederik Pompe van Meerdervoort's estate (see Ex Coll.), where the sitters are named, identifies their parents, and (n. 69) notes that the picture was not sold at auction in 1749 but remained in the family and was sold privately later on (location unknown to Veth); Sedelmeyer Gallery 1895, p. 6, no. 3 (ill. p. 7), as "The Prince of Orange with his sons," and as brought to England by M. Delahante; W. Roberts 1897, vol. 2, pp. 248–49, records the results of the 1848 and 1895 sales of the painting; Moes 1897–1905, vol. 2 (1905), p. 223, entry no. 6005 (Cornelis Pompe van Meerdervoort), no. 1, records the information given in G. Veth 1884; Gillet 1909, p. 369, praises the work in the most flowery terms; Hofstede de Groot 1907–27, vol. 2 (1909), p. 33, no. 85, records the information given in G. Veth 1884, but does not connect it with his: p. 183, no. 617, "A Cavalier and His Two Sons Starting for the Hunt," describes the subject, suggests that "the landscape resembles the neighbourhood of Hoch and Nieder Elten on the Rhine," and records the provenance from 1829 onward; Marguillier 1909, p. 24, describes the work (then in the Kann estate) as a family portrait on horseback, the father in a long tunic of black velvet, the boys in red and blue, the valet in brown; Bode 1911, p. 23, as a portrait of a father and his sons on horseback; "Die Versteigerung der Sammlung Maurice Kann," *Der Cicerone* 3 (1911), p. 519 (under no. 12), sold for FFr 160,000 to Fischhof; Mourey 1913, pp. 4, 6 (ill.), "une oeuvre absolument magistrale"; Valentiner 1928a, p. 22, as painted about 1655–60; J. Holmes 1930, pp. 168, 185, no. 38, as "The Gentleman with two Sons before the Departure for the Chase," in the Friedsam Collection, an example of Cuyp's late style;[1] Staring in The Hague 1933, no. 938, as in the Fischhof sale of 1913, identifies the sitters, based on the 1680 and 1749 inventories (see Ex Coll.), which were earlier in the possession of a family descendant, the late Jacob Stoop, of Zwijndrecht; Reiss 1953, pp. 45, 46, fig. 15, observes that the painting cannot date from later than 1653 because Michiel Pompe van Meerdervoort died in November of that year; Staring 1953, pp. 117–18, credits the identification of the sitters made in Reiss 1953, adding that this had already been accomplished in The Hague 1933 (by Staring himself); Dattenberg 1967, p. 72, no. 78, reports that a view of Hochelten is found in the background (compare Hofstede de Groot 1907–27 above); Brussels and other cities 1968–69, vol. 1, p. 35 (under no. 32), notes that the background derives from Cuyp's drawing *The Rhine near Elten* (Fondation Custodia, Institut Néerlandais, Paris); Paris 1970–71, p. 50 (under no. 55), cites the "discovery" made by Staring (1953); Broos 1974, p. 198 n. 9, includes the painting in a list of equestrian portraits by Cuyp; Reiss 1975, pp. 9, 161, 205, 210, no. 121 (ill.), as painted 1652–53, identifies the figures, and notes that the same landscape occurs in Cuyp's *Cavaliers Halted, One Sketching*, in the Duke of Bedford's collection (ibid., no. 120); Dordrecht 1977–78, p. 174 n. 2 (under no. 71), restates the observation that the background depends on Cuyp's drawing *The Rhine near Elten*; C. Brown 1979, p. 7, repeats the information that the background depends on Cuyp's drawing; Leeuwarden–'s Hertogenbosch–Assen 1979–80, pp. 102–3, no. 65 (ill.), included in a list of Dutch equestrian portraits; Duparc 1980, p. 24, sees the relationship between horses and riders in the painting as "distinctly unhappy" (evidently meaning in formal terms); Burn 1984, p. 58 (ill.), finds "traces of Persian influence" in the costumes; Broos in Paris 1986, p. 186, fig. 4, observes that the position of the rider on the left occurs again, in reverse, in Cuyp's drawing of a man on horseback in the Fitzwilliam Museum, Cambridge; P. Sutton 1986, p. 184, mentioned among Dutch portraits in the MMA; Chong in Amsterdam–Boston–Philadelphia 1987–88, p. 111, fig. 8, and p. 304 n. 4, cites the painting as an instance of the artist's patronage in Dordrecht, and notes that the castle is invented although Cuyp did include the Huis te Meerdervoort in another picture; Schama in ibid., p. 81; Herbert 1988, pp. 163, 168, fig. 165, compares the recession of space in Degas's horse-racing pictures; Liedtke 1989b, pp. 83, 134, 301, fig. 68, no. 184 (ill.), pl. 28, praises the painting for its setting of mounted figures in landscape "to create the impression of an everyday event," and as an "anticipation of a common kind of 'conversation piece' painted by French and especially English artists of the next century"; Franits 1990, p. 219, remarks that the motif of a child with a horse refers in this case to hunting and social status, not training; Liedtke 1990, p. 52, listed as one of Friedsam's bequests to the MMA; Chong 1991, p. 611 n. 35, notes that the portrait may be dated by the death of one of the sitters; Ingamells 1992a, p. 72, mentions the painting in connection with Cuyp's *The Avenue at Meerdervoort* (fig. 30 here), where the brothers evidently appear at a younger age; Chong in Dordrecht 1992–93, p. 125, fig. 1 (under no. 18), and p. 126 (under no. 19), uses the approximate date of the picture to date Cuyp's *Riders in a Landscape* (private collection); Loughman in ibid., p. 154, cites the work in relation to J. G. Cuyp's *Portrait of Michiel Pompe van Slingelandt*; Franits 1993a, p. 239 n. 169, allows that the picture does not convey pedagogical notions, as do some Dutch portraits of children with horses; Van der Leer 1994, pp. 52–53, fig. 13, describes the figures in connection with the history of Meerdervoort castle; Baetjer 1995, p. 326, records that the painting was installed over a fireplace in the Meerdervoort house, for which it was painted; Wheelock 1995a, p. 48, sees Eltenberg in the background, and pp. 52, 54, 55, 55 n. 10, compares aspects of Cuyp's *Lady and Gentleman on Horseback*, of about 1655 (National Gallery of Art, Washington, D.C.); Sluijter in Dordrecht–Enschede 2000, p. 105, fig. 145, describes a copy (with variations) of this painting, by Jacob van Strij (q.v.); Fenton 2001, p. 83, "a glossy presentation of social aspirations"; Chong in Washington–London–Amsterdam 2001–2, pp. 35–36, 39, 150–51, 200, no. 29 (detail ill. on

p. 34), identifies the figures in the painting and its original location, citing documents, notes the status symbols (including servants), dates the work to about 1652–53, describes the setting, and discusses the significance of hunting in the Netherlands; Gordenker in ibid., pp. 53–54, 56–57, fully describes the unusual costumes and their origins; Wheelock in ibid., pp. 22, 168, 172, admires the avoidance here of anecdotal incident, and relates the painting to other equestrian pictures by Cuyp; Cornelis 2002, p. 244, "perfectly illustrates that Cuyp's patrons belonged to the upper classes of Dordrecht society who liked to show off their land-owning status and hunting privileges"; Van Noortwijk in Dordrecht 2002, p. 152, fig. 35a (under no. 35), compares the portrait with that of the sitter's cousin by J. G. Cuyp; Paarlberg in Athens 2002, p. 116, fig. 1 (under no. 23), refers to Jacob van Strij's copy of this "famous painting"; L. de Vries 2002, p. 209, reviews the virtues of the picture and approves Gordenker's analysis of the costume but questions the suggestion that Hungarian style implied Protestant sympathies; Broos and Van Suchtelen 2004, p. 75, compares the picture with the *Equestrian Portrait of Pieter de Roovere ("Salmon Fishing")*, of about 1650, in the Mauritshuis, The Hague (fig. 246 here);[2] Liedtke 2005a, p. 192, cites the picture in a review of Dutch paintings made for specific locations; Neumeister 2005, p. 212, mentioned in connection with an equestrian portrait of a man painted in the style of Thomas de Keyser.

EXHIBITED: Santa Barbara, Calif., Santa Barbara Museum of Art, San Francisco, Calif., California Palace of the Legion of Honor, and Kansas City, Mo., William Rockhill Nelson Gallery of Art, "The Horse in Art: Paintings—17th to 20th Century," 1954, no. 5; Dordrecht, Dordrechts Museum, "Aelbert Cuyp, 1620–1691," 1991–92, no. 31 (in informational pamphlet); Washington, D.C., National Gallery of Art, London, The National Gallery, and Amsterdam, Rijksmuseum, "Aelbert Cuyp," 2001–2, no. 29.

EX COLL.: Adriana van Beveren and her son Cornelis Pompe van Meerdervoort, Zwijndrecht (ca. 1652/53–d. 1680; 1680 inventory of his estate, Huis te Meerdervoort, Zwijndrecht, as "in the children's room: Mr. Caulier on horseback with 2 milords [Jonckhers] and Willem the coachman, over the mantelpiece" [see text above]); his son Jacob Pompe van Meerdervoort (1680–d. 1720); his son Johan Diederik Pompe van Meerdervoort, Zwijndrecht (1720–d. 1749; 1749 inventory of his estate, as "A piece, being a chimneypiece, depicting the Messrs. Michiel and Cornelis Pompe van Meerdervoort going to hunt with their instructor, servants etc. by A. Kuyp" [see text above]); Maria Christina (1723–1781), Adriana (1728–1778), and Christina Elisabeth (1729–1801) Pompe van Meerdervoort (1749–before 1803); [Alexis Quatresols de la Hante, Paris and London]; Walsh Porter (until 1803; sale, Christie's, London, March 22, 1803, no. 28, as "Prince of Orange on Horseback, and attendants going out to the Chace [*sic*], finely treated," sold for £145); Monsieur L[apeyrière], Paris (until 1825; sale, Galerie Le Brun, Paris, April 19ff., 1825, no. 103, as "La Partie de Chasse," for FFr 17,900 to Emmerson); Thomas Emmerson, London (1825–29; his sale, Phillips, London, May 2, 1829, no. 165, as "La Partie de Chasse du Prince d'Orange," sold for £1,102 10s.); Richard Sanderson, London (by 1834–48; sale, Christie's, London, June 17, 1848, no. 25, as "Prince of Orange on a grey horse," for £556 10s. to Norton); [Norton, London, from 1848]; Mrs. Lyne Stephens, Lynford Hall, Norfolk (until d. 1895; her estate sale, Christie's, London, May 11, 1895, no. 331, as "'The Prince of Orange with his sons prepared to depart for the chase,' brought to this country by Mons. Delahaute [*sic*]," for £2,010 to Wertheimer); [Charles J. Wertheimer, London, and Sedelmeyer, Paris, 1895; sold to Kann]; Maurice Kann, Paris (1895–d. 1906; his estate, 1906–11; his sale, Galerie Georges Petit, Paris, June 9, 1911, no. 12, as "Départ pour la chasse," for FFr 160,000 or 170,000 to Kleinberger and Fischhof); [Kleinberger and Eugène Fischhof, Paris, 1911–13; sale, Galerie Georges Petit, Paris, June 14, 1913, no. 50, for FFr 145,000 to Kleinberger]; Monsieur Magin, Paris (until 1922; sale of his sequestered property, Galerie Georges Petit, Paris, June 23, 1922, no. 12, for FFr 62,000 to Kleinberger); [Kleinberger, Paris, 1922; sold to Friedsam]; Michael Friedsam, New York (1922–d. 1931); The Friedsam Collection, Bequest of Michael Friedsam, 1931 32.100.20

1. As late as April 1962, Holmes wrote letters to the Department of European Paintings, asking to see the painting in storage, and complaining that his late dating "was attacked publicly" by Reiss (1953) and by Staring (1953).
2. The two drawings of riders in the Fitzwilliam Museum, Cambridge, that Broos considers studies for the Museum's picture (Broos and Van Suchtelen 2004, p. 75) are described by Chong in his 1992 dissertation as "late 18th-century, perhaps by Jacob van Strij."

34. *Young Herdsmen with Cows*

Oil on canvas, 44⅛ x 52⅛ in. (112.1 x 132.4 cm)
Signed (bottom left): A : cuÿp.

The landscape portion of this painting, the cows, and the human figures are very well preserved; there are, however, large losses and significant abrasions throughout the sky.

Bequest of Benjamin Altman, 1913 14.40.616

The Altman Cuyp, which like the artist's *Landscape with the Flight into Egypt* (Pl. 32) was also in the collection of Rodolphe Kann in Paris, is a classic work dating from the later years of his activity, about 1655–60. As a large and typical picture by Cuyp, the canvas could hardly have been better chosen to complete the trio — with Altman's Hobbema and Ruisdael (Pls. 80, 182) — of Dutch landscapists one ought to have represented in a great

collection of old masters, according to the art dealers and critics of America's Gilded Age.[1]

In proposing a comparatively late date for this painting, Alan Chong refers in particular to the handling of the clouds, which have a crispness and "Italianate sheen" not found in works of the early 1650s.[2] The overall composition varies a scheme that the artist had employed for about a decade,[3] but with an assurance that belies the impression of inventing a scene in the studio. Cuyp's familiar idea of aligning parallel cows so that they overlap and gently lead the eye into depth is lent rhythm and grace by the arrangement of the resting animals, which continue the curve of the hill. The foursome serves as a foil to the crowning motif, a standing black cow silhouetted against the bright sky and facing in the opposite

direction.[4] This carries the view into the rolling landscape on the other side of the river, which is also crossed by the bent branches to the lower left. The display of plants on the right ascends (assisted by some manure) toward the synchronized row of cows, so that no part of the landscape lacks flowing lines and attractive passages. Between the vertical elements of the standing cow and the pointing shepherd, the horned head turned toward the viewer is perfectly placed.

These aesthetic refinements are suited to Cuyp's subject, which has been described as a "Dordrecht Arcadia."[5] In other contexts, the cow could serve as a national emblem, or as a sign of Dutch prosperity.[6] In Cuyp's hometown, it is possible that such a painting would have evoked personal associations, since a number of his patrons owned farms in the area.[7] However, the hilly terrain, Claudian light, and stately composition convey a sense of well-being unfettered to any time or place, other than Europe since the age of Horace and Virgil.[8]

Comparisons with Cuyp's drawings of cattle show how important these studies were for his paintings, and also how the artist tended to idealize the animals in the final work.[9] In addition to landscape and animals, Cuyp also drew studies of plants like those to the lower right, the largest of which may be butterbur.[10]

A copy of the present picture was on the art market in 1985.[11]

1. A parallel provenance is found in the case of Cuyp's *Equestrian Portrait of Cornelis and Michiel Pompe van Meerdervoort* (Pl. 33), which went from the collection of Maurice Kann (Rodolphe's brother) through Paris dealers to Altman's successor, Michael Friedsam. An important link between the Kanns and Gilded Age collectors in America was Wilhelm von Bode, in his role as adviser (kindly mentioned in conversation by Esmée Quodbach, 2006). As noted in Liedtke 1990, p. 39, there were eleven landscapes by Jacob van Ruisdael, seven by Hobbema, and eleven pictures by or said to be by Cuyp in the 1909 Hudson-Fulton exhibition at the Metropolitan Museum. Apart from his examples by these artists, Altman owned no other landscape paintings dating from before the nineteenth century. He had earlier followed the fashion of buying "pictures of the Barbizon school" (as Mary Berenson, wife of Bernard, disdainfully observed; see Samuels 1987, p. 76).

2. Chong 1992, unpaged, in the entry for this painting. Compare the clouds in Washington–London–Amsterdam 2001–2, nos. 42–45, all dated to the late 1650s or about 1660.

3. Compare Washington–London–Amsterdam 2001–2, nos. 19, 25, which are dated in the years about 1650. As Chong notes in his dissertation (see previous note), the two adult figures (there is also a boy) recall the staffage in *Five Cows with Herdsmen*, of the late 1640s (Earl of Harrowby collection; Reiss 1975, no. 73).

4. As noted in Wheelock 1995a, p. 34, and repeated by Wheelock in Washington–London–Amsterdam 2001–2, p. 130, Cuyp would often stretch his cows' heads forward, "in a way that suggests a

degree of alertness and even intelligence not normally associated with this species."

5. See Wheelock in Washington–London–Amsterdam 2001–2, p. 22, citing Lambert van den Bos's publication of 1662, *Dordrechtsche arcadia*.

6. See Spicer 1983, where Jacob Cats's praise of Dutch cows (1656) is quoted on p. 256.

7. As noted by Chong in Dordrecht–Leeuwarden 1988–89, pp. 77–78.

8. See Liedtke 2003 on the rise of the bucolic tradition in Dutch landscape painting, and for references to most of the specialized literature.

9. On this point, see Rüger in Washington–London–Amsterdam 2001–2, p. 132, and Chong in ibid., p. 134, noting that Cuyp would "manipulate the color of his cattle to achieve picturesque effect." The drawing of a cow in the Hofstede de Groot Collection (Groninger Museum, Groningen) appears to have served as a study (in reverse) for the nearest cow in the Museum's picture, as noted by Bolten in Groningen 1967, p. 56 (under no. 17). The same drawing is catalogued in Groningen 2005–6, p. 126, no. 21.

10. See Washington–London–Amsterdam 2001–2, nos. 94–96 (plant studies), 97–103 (cows and horses).

11. Sotheby's, Amsterdam, April 29, 1985, no. 273 (canvas, 42½ x 50⅜ in. [108 x 128 cm]), as after Cuyp.

REFERENCES: Bode 1900, p. xv, pl. 30, describes the painting as a stately, masterful Cuyp in the Kann collection, one of two "aus England stammende Bilder"; Friedländer 1901 (ill. p. 153); É. Michel 1901, p. 399 (ill.), as one of the most accomplished pictures of Cuyp's maturity; Marguillier 1903, p. 28 (ill. p. 26), notes the admirable rendition of atmospheric effects; Bode 1907, vol. 1, pp. IX, 34 (pl. 32, opp. p. 34), praises the picture as "excellent" in its rendering of the animals and the landscape; *Connoisseur* 19 (September–December 1907), frontispiece, as with Duveen Brothers; Nicolle 1908, p. 198, mentioned; Hofstede de Groot 1907–27, vol. 2 (1909), p. 72, no. 217, as in Altman's collection, with a description of the subject; Monod 1923, p. 310, "c'est le *nec plus ultra* de ses symphonies de sérénité"; Altman Collection 1928, pp. 86–87, no. 47, as from the Kann collection and "cited by various authorities"; J. Holmes 1930, p. 182, no. 19, listed; B. Burroughs 1931a, p. 80, no. C99-3; J. Rosenberg, Slive, and Ter Kuile 1966, p. 154, pl. 131 (rev. ed., 1972, pp. 263–64, fig. 210), as dating from about 1665, and showing "classical elements" and a "power of expressive organization [that] is as remarkable as the depth of feeling before nature and the pictorial beauty"; Bolten in Groningen 1967, p. 56 (under no. 17), lists the work as one of the pictures for which a drawing of a cow by Cuyp in the Hofstede de Groot Collection (Groninger Museum, Groningen) served as a study; Hibbard 1980, pp. 348–50, fig. 629, as "a bucolic paradise of herds and herdsmen"; P. Sutton 1986, p. 191, mentioned as "an excellent mature example of Cuyp's art"; M. Scott 1987, p. 47, mistakenly cites the work as an example of about 1650; Liedtke 1990, pp. 48–49, fig. 36, identified in a view of Altman's art gallery in his Fifth Avenue house; Baetjer 1995, p. 327; Slive 1995a, pp. 195–96, fig. 268, repeats the remarks in J. Rosenberg, Slive, and Ter Kuile 1966, p. 154, but revises the dating to about 1655–60; L. Miller, "Benjamin Altman," in *Dictionary of Art* 1996, vol. 1, p. 731, mentioned.

EX COLL.: ?Private collection, England (see Bode 1900 under Refs.); Rodolphe Kann, Paris (until d. 1905; his estate, 1905–7; sold to Duveen); [Duveen, London and New York, 1907–8; sold to Altman on February 1, 1908, for $124,185]; Benjamin Altman, New York (1908–d. 1913); Bequest of Benjamin Altman, 1913 14.40.616

ATTRIBUTED TO AELBERT CUYP

35. *Children and a Cow*

Oil on wood, 17¼ x 21½ in. (43.8 x 54.6 cm)
Inscribed (lower right): A cuyp.

The painting is in good condition, but the paint film has grown thin with age and suffered slight overall abrasion. There is minor paint loss along the horizontal panel join running through the cow's legs, the waists of the two boys, and the girl's head. Examination by infrared reflectography reveals that the head of the girl and that of the boy at left were underdrawn. The small child between them was painted on top of the fully completed landscape.

Bequest of Mariana Griswold Van Rensselaer, in memory of her father, George Griswold, 1934 34.83.1

As might be expected of a work that is close in style to the teenaged Aelbert Cuyp, and also to that of his father and teacher, Jacob Gerritsz Cuyp (1594–1651/52), this painting has elicited differing opinions. F. Schmidt-Degener and W. R. Valentiner (oral opinions, both in April 1935) accepted the picture as by the young Aelbert Cuyp. Horst Gerson (1960s?) was uncertain, and wondered whether J. G. Cuyp might have painted the work. Albert Blankert believed that the younger Cuyp was probably responsible, based on firsthand examination of the picture in 2003. Alan Chong, however, in his 1992 dissertation on Cuyp, thought that another, anonymous pupil

35

of J. G. Cuyp might be the artist.[1] Nevertheless, it must be admitted that such a disciple of the elder Cuyp, working in a manner very close to the young Aelbert's, is a hypothetical figure. Furthermore, the inconspicuous signature on the panel appears to be genuine.

The painting is rather hard to judge from reproductions, where the landscape, the cow, and indeed all the forms look flatter than they do in the work itself. Thinning of the paint layers and the visible wood grain contribute to this effect. Originally the landscape must have receded convincingly from the vegetation in the left foreground, which is sketched with some skill. The trees and bushes in the right background appear consistent with similar passages in the young Aelbert's work. The body of the cow is thin and in the lower half worn; the head suggests that some modeling and textures have been lost. Of course, one rarely encounters a smiling cow in nature, but happy cows (and sheep) are not uncommon in works by Jacob Gerritsz and by Aelbert Cuyp from the 1630s, for example, the *Shepherd and Shepherdess in a Landscape*, which they painted together in about 1639–40 (Musée Ingres, Montauban).[2] The same dog and very similar sheep are found in paintings by both the young Aelbert Cuyp, including the Museum's own *Piping Shepherds* (Pl. 31), and his father.[3]

The girl in the Museum's picture, including her costume and hat, is (with the exception of the hands) quite well painted, with attractive highlights in the skirt, and sufficient modeling. The male figures are also successful, though worn. The three shepherd crooks are finely rendered and, like the straw hat, require explanation if the painting is dismissed as a minor pupil's work. However modest, the picture might be employed to illustrate two basic principles of connoisseurship: that a work must be seen in the original; and that its strongest passages, as well as its weaknesses, must be explained. Accordingly, the present writer feels that the picture may be ascribed to Aelbert Cuyp in the second half of the 1630s, with the understanding that this is a tentative attribution, and that our knowledge of the artist's earliest efforts is limited.

The faces of the figures have a family resemblance but are not standard types. The Cuyps painted a good number of portraits of actual children in pastoral settings.[4] Lambs are commonly included as symbols of innocence, and several pictures by Jacob Gerritsz show a girl feeding flowers to one of her fleecy companions.[5] A dog, cows (usually in the background), and shepherd crooks suggest responsibility, or good upbringing, a virtue that reflects upon the parents who commissioned the portrait. In a broad view, the pastoral theme suggests an ideal age of innocence, when humankind had not yet been exposed to misfortune and selfish desires, and animals lived in harmony with people (as these domesticated animals clearly do).[6]

Previously catalogued by the Museum as by Aelbert Cuyp, and (from 1990) as Style of Aelbert Cuyp.

1. Chong 1992, unpaged. After reviewing the Museum's Cuyps with Alan Chong in 1990, the present writer requested that *Children and a Cow* be recatalogued as Style of Aelbert Cuyp (the work had previously been catalogued as autograph).
2. Dordrecht 2002, no. 26.
3. See ibid., p. 33, figs. 31, 32, nos. 18, 30.
4. J. G. Cuyp's pioneering role in this specialty is discussed in ibid., pp. 32–35.
5. Ibid., p. 33, figs. 31, 32. In both paintings by J. G. Cuyp (locations unknown), a lamb is shown actually eating the flowers; the girl in fig. 31 (a panel dated 1639) is in precisely the same pose as the girl in the Museum's picture. See also ibid., p. 34, fig. 33, a drawing by J. G. Cuyp in which two girls feed flowers to sheep in front of their watchful parents; and p. 37, fig. 39, and pp. 142–43, no. 30.
6. See the discussion under Joachim Wtewael's *The Golden Age* (Pl. 224).

REFERENCES: Baetjer 1980, vol. 1, p. 39, as by Cuyp; Baetjer 1995, p. 327, as Style of Aelbert Cuyp, 17th century.

EXHIBITED: Nashville, Tenn., Fisk University, Atlanta, Ga., Atlanta University, and New Orleans, La., Dillard University, 1951–52, no cat.

EX COLL.: George Griswold (from 1865; said to have been purchased by him in the Netherlands); Mariana Griswold Van Rensselaer (until d. 1934); Bequest of Mariana Griswold Van Rensselaer, in memory of her father, George Griswold, 1934 34.83.1

GERRIT DOU

Leiden 1613–1675 Leiden

Gerrit (or Gerard) Dou was one of the most successful and influential Dutch artists of the seventeenth century. It could be said, broadly, that he modernized the descriptive tradition of Early Netherlandish painting, in good part by adopting the young Rembrandt's observational preferences and some of his stylistic devices, specifically the use of light and shadow for illusionistic and dramatic purposes.[1] Dou was Rembrandt's first student and would become the master's most independent former pupil. Once Rembrandt had left Leiden, Dou was the city's leading painter.[2]

Dou's parents, Douwe Jansz de Vries van Arentsveld (ca. 1584–1656) and the widow Maria (Marijtgen) Jansdr van Rosenburg (ca. 1585–1651), married on November 6, 1609.[3] Maria's first husband had a glassmaking business, and Douwe Jansz took it over. Only one other shop in Leiden, that of Pieter Couwenhorn (ca. 1599–1654), was more important in producing painted glass windows for churches.

Gerrit, born April 7, 1613, began his artistic career by studying drawing with the engraver Bartholomeus Dolendo (ca. 1560–1626), about 1622–23. He then trained as a glass painter with Couwenhorn for two and a half years, and entered the glassmakers' guild in 1625. Dou and his brother Jan, who joined the guild during the same year, worked in their father's shop. It is not known whether his personal inclination or practical business considerations led Gerrit to give up his father's profession for easel painting,[4] but on February 14, 1628, he signed on with Rembrandt, who was twenty-one years old and beginning to attract the attention of connoisseurs. Dou stayed with Rembrandt for three years and, according to Jan Orlers, in 1641 emerged as "an excellent master."[5]

In his early paintings, Dou adopted a number of subjects from Rembrandt, including the theme of a painter in his studio, studies of old people as hermits or biblical figures, and *tronien* of interesting characters (see the discussion of *tronien* under Rembrandt's *Man in Oriental Costume*; Pl. 142). Some portraits and still lifes also date from the 1630s.[6] The figures set in interiors and the *tronien* of old people are especially reminiscent of Rembrandt's contemporaneous work. It has been suggested that the meticulous nature of glass painting helped to determine Dou's fine technique and even his preference for working on a small scale,[7] but the hypothesis has been put forward somewhat to the neglect of the many Dutch artists who painted small, precisely described figures, including portrait miniaturists (for example, David Bailly [q.v.] in Leiden),[8] and history painters such as Bartholomeus Breenbergh (see Pl. 22), Cornelis Cornelisz van Haarlem (1562–1638), Joachim Wtewael (see Pl. 224), the German Adam Elsheimer (1578–1610),[9] and, in Leiden, Rembrandt himself and his colleague Jan Lievens (1607–1674). That Dou studied initially with an engraver (and that Rembrandt worked in the medium as well) probably attracted him to miniature miracles of observation by printmakers ranging from Lucas van Leyden (ca. 1494–1533) and his German contemporaries to Hendrick Goltzius (1558–1617) and other Netherlandish engravers of his and the next generation.

In the 1640s, Dou appears to have painted fewer portraits, and he diversified his repertoire of genre subjects beyond those he had depicted earlier—a world of artists, musicians, and scholars surrounded by appropriate paraphernalia (for example, *An Interior with a Young Violinist*, dated 1637, in the National Gallery of Scotland, Edinburgh)—to include domestic and related themes, as in *The Spinner Saying Grace*, of about 1645 (Alte Pinakothek, Munich), and *The Village Grocer*, of 1647 (Louvre, Paris).[10] The latter picture shows four figures in the rapidly receding space of a shop interior, which is framed by an arched stone window. This so-called niche format was previously used in portraiture, and in flower still lifes by Ambrosius Bosschaert the Elder (1573–1621) and his followers. It also recalls the framing devices used by fifteenth-century Netherlandish painters in portraits, portable altarpieces, and manuscript illumination; the last art form had been especially important in Leiden and nearby Delft during the preceding two centuries. Dou made the niche device (seen in his *Self-Portrait* and in Gabriël Metsu's *A Woman Seated at a Window*; Pls. 37, 117) into a trompe l'oeil window, which the viewer identifies with the picture plane. Space projects strongly in both directions, into the background, and around and in front of the frame and sill. Subtleties of light and shadow, and some atmospheric effects (achieved in good part through gradations

of coloring), complement Dou's painstaking description of physical qualities—textures of stone, fabrics, hair, and so on—and of showpiece motifs like tapestries, metal vessels, worn books, and pristine bottles of wine, water, and more unsavory fluids. The description of light reflections in Dou's pictures was especially praised by contemporaries such as Philips Angel, in his celebratory address "In Praise of the Art of Painting," delivered on Saint Luke's Day in 1641 and published the following year.[11]

Dou's most impressive pictures include those that variously demonstrate the power of art to deceive and delight the eye, and the ability of painting to triumph over sculpture.[12] However, his microcosmic surveys of interior space are occasionally claustrophobic, their suggestion of volume dependent on the presence of figures and a clutter of props. There is less sense in Dou's work than in Rembrandt's that he was interested in observation per se, as opposed to the creation of illusionistic effects.[13] Except for his paintings of hermits in prayer and a few other works, Dou's pictures often give the impression of great skill and learning invested in qualities of interest solely to art lovers.

In the 1650s and 1660s, the lifelong bachelor often depicted pretty young women, young mothers, cooks, and maids, in some cases with erotic symbols.[14] In other works, and even in those with hints of romance, the artist's main theme is domestic virtue.[15] The modern idea that Dou's subjects were of less interest to his patrons than his virtuoso execution has some truth to it, but it is also contradicted by the promptness with which Dou adopted newly fashionable subject matter, and the care with which he selected motifs, designed compositions, and conceived iconographic programs.[16] Contemporary accounts, however, dwell upon Dou's obsessively patient technique: stories of several days devoted to a single motif (a broom, for example) accompany descriptions of hourly rates (six guilders, according to Joachim von Sandrart) and pictures selling for six hundred to over a thousand guilders (the price of a small house).[17]

Dou's patrons were people of considerable means. His well-known connection with the Swedish court was made by Pieter Spiering, who through his father François Spiering's tapestry firm in Delft became familiar with Queen Christina's father, King Gustaf II Adolf (1594–1632).[18] Notwithstanding the (total of?) eleven paintings that went through Spiering to Stockholm (and back to him in 1652), and Cosimo III de' Medici's visit to Dou's studio in 1669 and later acquisition of a self-portrait (the panel of 1658 in the Uffizi, Florence), Dou's most important patrons appear to have been residents of Leiden and other cities in the Province of Holland.[19] The leading enthusiast in Leiden was Johan de Bije (or de Bye), a Remonstrant (like Vermeer's contemporary patron Pieter van Ruijven), who owned twenty-seven works by Dou and arranged to have them exhibited for a year in 1665–66.[20] Another collector of the artist's work was the Leiden professor of medicine François de le Boe Silvius, who at his death in 1673 owned 185 paintings, ten of which were by Dou.[21] It is also noteworthy that the States General, when presenting Charles II with the "Dutch Gift" of artworks upon his restoration in 1660, included three paintings purchased directly from Dou. These and a canvas by Titian were given special mention by the king in his words of appreciation delivered to the Dutch ambassadors.[22]

Dou was one of the founding members of the Leiden painters' guild in 1648. He influenced many local artists, and taught a good number of them, including Frans van Mieris the Elder, Godfried Schalcken, Pieter van Slingelandt, and Matthijs Naiveu (q.q.v.), as well as lesser-known figures.[23] The *fijnschilder* ("fine painter") tradition that Dou established in Leiden extended well into the eighteenth century with the Van Mieris family and other artists, and into the nineteenth century with Dutch and German imitators. His reputation among critics and collectors has soared and dipped with the winds of taste, but his importance for the history of Dutch art is beyond doubt.[24]

Dou was buried on February 9, 1675, in the Pieterskerk, Leiden.

1. On Dou's use of light and shadow and its debt to Rembrandt, see Sluijter 2000b, chap. 6 ("In Praise of the Art of Painting: On Paintings by Gerrit Dou and a Treatise by Philips Angel of 1642"), pp. 233–39. References below to Sluijter 2000b are to the same essay.

2. On Leiden as an art center, see Dick de Boer's article on Leiden and Eric Jan Sluijter's article on the Leiden "Fine" painters, in *Dictionary of Art* 1996, vol. 19, pp. 99–102, 102–3, respectively, with additional literature.

3. Orlers 1641, p. 377. A number of relevant documents preserved in the city archives of Leiden are cited by Sluijter in Leiden 1988, p. 96. Maria's first husband was Vechter Vechtersz Cuyper, with whom she had a son and a daughter.

4. See Ronni Baer, "The Life and Art of Gerrit Dou," in Washington–London–The Hague 2000–2001, pp. 28, 44 n. 23, on this point. Gerrit's brother Jan was probably seen as the eventual heir to his father's business. His date of birth is unknown, but he was surely the first son, since he was given his paternal grandfather's name. (Gerrit's patronymic, Dou, is short for Douweszoon, "Douwe's son"). Douwe Jansz and his son Jan were still registered in the glassmakers' guild in 1628, when Gerrit's name was dropped (ibid., p. 44 n. 22).

5. Orlers 1641, p. 380. See the remarks in Sluijter 2000b, pp. 204–5.

6. See Sumowski 1983–[94], vol. 1, pp. 498–99, and the plates cited (not all of which reproduce works accepted as Dous by other

scholars), and Washington–London–The Hague 2000–2001, nos. 1–10. W. Martin 1902 is valuable for reproductions, if not connoisseurship.

7. Baer in Washington–London–The Hague 2000–2001, p. 30.

8. See ibid., pp. 34–35, fig. 9.

9. On the connection between Elsheimer and the Amsterdam circle of Rembrandt's teacher, Pieter Lastman (1583–1633), see the biography of Jacob Pynas below.

10. See Sumowski 1983–[94], vol. 1, no. 273, for the Munich picture. Ronni Baer in *Dictionary of Art* 1996, vol. 9, pp. 192–93, fig. 1, considers *The Village Grocer* to mark a change in Dou's work.

11. See Sluijter 2000b, chap. 6 (pp. 239–44 on the reflection of light).

12. On the *paragone* with sculpture in Dou's work, see ibid., pp. 210–13.

13. This complicated issue is touched upon frequently in ibid., chap. 6.

14. See the discussion in Franits 2004, pp. 118–19.

15. See, for example, *The Young Mother* (Mauritshuis, The Hague), which is discussed in Franits 1993a, pp. 16, 84, fig. 5.

16. This question is briefly considered by Baer in Washington–London–The Hague 2000–2001, pp. 30, 44 n. 41. Noted there is Pierre Lebrun's advice to would-be connoisseurs (learn to talk about style rather than subject), which has essentially nothing to do with the real connoisseurs who bought Dou's work.

17. Baer in Washington–London–The Hague 2000–2001, p. 31, citing the fuller discussion of Dou's prices in Leiden 1988, p. 26. At a rate of six guilders an hour, a typical painting by Dou (costing Fl 600) would require as much as a hundred hours of work, which is plausible. Dou's technique is discussed by Boersma in Washington–London–The Hague 2000–2001, pp. 54–63, and more fully in Wadum 2002. On Jan Orlers's description of Dou's technique in 1641, see Sluijter 2000b, pp. 204–5.

18. See Sluijter in Leiden 1988, p. 26, and Baer in Washington–London–The Hague 2000–2001, p. 31. On Pieter Spiering "Silvercroon," see also New York–London 2001, pp. 12, 512, 520. Spiering was Sweden's ambassador to his own country, the Netherlands, between 1637 and 1651. It is not always made clear in biographies of Dou that Christina was only six years old when her father died in 1632 and she became queen. The paintings that Dou sold to the Swedish crown through Spiering must have actually been acquired by the chancellor, Axel Oxenstierna, who served as regent from 1632 until Christina's majority in 1644, and also as the United Provinces' crucial ally in the Thirty Years' War. From 1644 until 1652, Christina opposed many of Oxenstierna's policies. She suffered a nervous collapse in 1652 and abdicated in 1654. In Gaskell 1982, p. 15, Spiering's purchase of paintings by Dou for "his" queen is associated with Christina's "attempting to improve the intellectual and artistic tenor of her court," an ambitious program for a preteen. Similarly, in Washington–London–The Hague 2000–2001, p. 30, Baer remarks that Christina's "own taste ran to the Italianate, so much so that in 1652 the queen returned to Spiering eleven of Dou's paintings." She probably had nothing to do with their purchase in the first place.

19. See Sluijter in Leiden 1988, pp. 38–39, on what is known of Dou's domestic and foreign patrons. The author notes that some major collectors in Leiden itself had no works by Dou, or only one or two.

20. See Lunsingh Scheurleer, Fock, and Van Dissel 1986–92, vol. 3B, pp. 444–45, 462–63 ("1655" on p. 462 is an error), 486 (appendix 1), and vol. 5A, p. 11; and Baer in Washington–London–The Hague 2000–2001, pp. 30, 45 n. 43, 49 n. 111.

21. See Lunsingh Scheurleer, Fock, and Van Dissel 1986–92, vol. 3A, pp. 278ff. (on Rapenburg 31), especially p. 285. The patron also supported Dou's pupil Frans van Mieris (q.v.).

22. See Baer in Washington–London–The Hague 2000–2001, pp. 31–32.

23. See ibid., pp. 30, 32, 45 n. 45. On contemporary copies after works by Dou, see Sluijter in Leiden 1988, pp. 34–35.

24. On Dou's critical reception and posthumous reputation, see Baer in *Dictionary of Art* 1996, vol. 9, pp. 194–95, and Wheelock in Washington–London–The Hague 2000–2001, pp. 12–24.

Oil on wood, arched top, 10 x 9 in. (25.4 x 22.9 cm)

The old man, young girl, open book, candles, and hand of the figure at right who reaches to light a candle are very well preserved. An extensive network of wide cracks that appeared as the paint dried disfigures the balance of the composition, including the two boys and the entire background. There are minor losses along the central panel join. The dark maroon-brown curtain that borders the composition along the top is not original. Absent in a photograph published in 1913, this feature was added sometime before the painting was acquired by the Museum. The irregular edges and lopsided shape of the arched top suggest that either the panel has been pared down along the top or that this is not the original format. The slightly chipped paint around all edges indicates that the panel was trimmed on all sides before the cradle was attached.

Bequest of Lillian M. Ellis, 1940 40.64

This small picture was probably painted by Dou about 1655–57 (as suggested by Baer; see Refs.), or within the next couple of years. It thus appears to anticipate the artist's best-known pictures of a teacher and his young students working by candlelight, *The Night School* (Uffizi, Florence), which is thought to date from about 1660, and a panel that goes by the same title (Rijksmuseum, Amsterdam), which probably was painted a few years later.[1] These works are considerably larger overall, 18⅛ x 14⅜ in. and 20⅞ x 15⅞ in. (45.9 x 36.4 cm and 53 x 40.3 cm), respectively, although the scale of the figures is not much different. An earlier painting of a similar subject, dated 1645, is *The Schoolmaster* (Fitzwilliam Museum, Cambridge). The panel is about the same size as the New York picture (which, however, may have been cut down; see condition note above), and the composition is similar in reverse, except for the absence of a figure in the foreground. All the pupils are boys, and their teacher looks like a stern taskmaster about to impose discipline.[2]

In the present painting, by contrast, a sympathetic old pedagogue sharpens the point of his quill pen, while two quiet boys and an earnest girl are intent upon their studies. The girl leans over her book, following the text with her finger, and the seated boy practices writing with careful concentration. The standing boy must have just arrived, as suggested by the hat in his hand and by the maid (or some member of the teacher's household), who carries a lantern. The boy lights another candle, which will certainly be needed when he settles down to work.

Dou painted a good number of night scenes in the 1650s and 1660s. Here the candlelight allows the artist to demonstrate his skill in handling highlights and shadows (the maid's face, illuminated from below, is noteworthy), and to contrast the features of the old man and the young girl. The candle standing like a beacon in the midst of the scholars is surely also intended as a metaphor for knowledge, a common notion in antiquity and in the seventeenth century. Cesare Ripa's figure of Cognitione (Understanding) is a young woman who follows the text of a book with one hand and holds a flaming torch in the other.[3] It is possible that Dou meant the lighting of the second candle to convey the idea of learning passed on from teacher to pupil.

As discussed by several writers, the act of sharpening a pen (an independent subject in Dutch art) signified the notion of practice, which is suggested more literally by the boy who is diligently writing. About 1660, Dou painted an unusual triptych (lost, but known from Willem Joseph Laquy's copy of the late eighteenth century, in the Rijksmuseum, Amsterdam) illustrating Aristotle's maxim (repeated by his compatriot Plutarch) that "three things are needed to achieve learning: nature, teaching, and practice; but all will be fruitless unless practice follows nature and teaching." The phrasing here is not that of the ancient author but Arnold Houbraken's in 1721, in a learned aside (citing Aristotle) in his discussion of the eclectic training that the Rotterdam painter Michiel van Musscher (1645–1705) received.[4] These words of wisdom must have come up occasionally in the studios of Leiden artists, and in the classrooms of the city's venerable university. Dou's own pupils (see the biography above) clearly grasped the idea.

1. The Uffizi picture is catalogued in Chiarini 1989, pp. 105–7 (ill.). For the Rijksmuseum panel, see Sumowski 1983–[94], vol. 1, no. 289; Leiden 1988, no. 14; or Washington–London–The Hague 2000–2001, no. 28. The pictures are reproduced side by side in W. Martin 1913, pp. 170–71.
2. W. Martin 1913, p. 68 (ill.). A slightly better reproduction may be found in Gerson, Goodison, and Sutton 1960, pl. 16.
3. See the discussion of Dou's *The Night School* (Rijksmuseum, Amsterdam) by Baer in Washington–London–The Hague 2000–2001, p. 120 (fig. 1 for Cognitione in Ripa 1644a).
4. Houbraken 1718–21, vol. 3, p. 166 (p. 211 in 1753 ed.). The meaning of Dou's lost triptych was first explained convincingly in Emmens 1963, and in Emmens 1969. A synopsis and amplification are found in Amsterdam 1976, pp. 91–93 (under no. 17). A brief summary is offered by Baer in Washington–London–The Hague 2000–2001, pp. 17–18, fig. 4. For Plutarch's influence on Dutch educational theories, see Bedaux in Haarlem–Antwerp 2000–2001, pp. 19–22.

36

REFERENCES: Dodsley 1761, vol. 1, p. 322, lists "A Schoolmaster" by Dou, 14 x 11 in. (35.6 x 27.9 cm), in the collection of Sir Gregory Page, possibly this picture; Hofstede de Groot 1907–27, vol. 1 (1907), p. 416, no. 208, records the picture as in the Paris sale of 1786; W. Martin 1913, pp. 174 (ill.), 195, as in the Yerkes sale, 1909 [*sic*], and as dating from about 1660–65; H. W. W[illiams] Jr., in *MMA Bulletin* 35, no. 10 (October 1940), p. 206, notes the bequest of the picture to the Museum, and compares the paintings of similar subjects in the Rijksmuseum, Amsterdam, and in the Uffizi, Florence; Werner 1969, p. 53, considers the work to demonstrate that Dou "learned in his master's studio how to light up an interior"; Durantini 1983, p. 154, fig. 78, in a discussion of "the child and formal education," describes the subject, observing that "in this instance all the figures are engaged in useful practice"; Sumowski 1983–[94], vol. 1, p. 534 (under no. 289), cites the work in connection with *The Night School* in the Rijksmuseum, Amsterdam; P. Sutton 1986, p. 187, mentions the painting as "a very good example"; Chiarini 1989, p. 107, notes its relation to *The Night School* in the Uffizi, Florence; Baer 1990, no. 68, dates the picture to about 1655–57, and discusses the subject; Baetjer 1995, p. 322; Liedtke in New York 1995–96, vol. 2, p. 142, no. 44, describes the painting's style as ultimately dependent upon Rembrandt's example, explains the subject, and proposes a dating of about 1655–60. Baer 2004, p. 21, fig. 3, compares the composition of the *Old Woman Cutting Bread*, of about 1655 (acquired in 2003 by the Museum of Fine Arts, Boston).

EXHIBITED: Montreal, The Montreal Museum of Fine Arts, and Toronto, Art Gallery of Ontario, "Rembrandt and His Pupils," 1969, no. 37; New York, MMA, "The Painter's Light," 1971, no. 9; New York, MMA, "Rembrandt/Not Rembrandt in The Metropolitan Museum of Art," 1995–96, no. 44.

EX COLL.: ?Sir Gregory Page, Wricklemarsh, Blackheath, near London (by 1761–d. 1775; his estate, from 1775); private collection [Berthels?] (bought from Page's estate; until 1786; sale, Paillet, Paris, March 27–28, 1786, no. 9, with a "pendant" by Schalcken, sold for [FFr?] 280 [for the pair?]);[1] Charles T. Yerkes, Chicago and New York (until d. 1905; his estate sale, American Art Association, New York, April 5–8, 1910, no. 91, sold for $2,500 to Ellis); Lillian M. Ellis, New York (1910–d. 1940); Bequest of Lillian M. Ellis, 1940 40.64

1. Kindly brought to the Museum's attention by Ronni Baer, in a letter dated April 11, 1995.

37. *Self-Portrait*

Oil on wood, 19¼ x 15⅜ in. (48.9 x 39.1 cm)
Signed (left, on ledge): GDO[U] [GD in monogram]
Inscribed (in book, upside down): Gdov

The painting is very well preserved. The blue color of the plant leaves at left suggests the use of a fugitive yellow lake pigment.

Bequest of Benjamin Altman, 1913 14.40.607

Dou's self-portrait in the Altman Collection is one of his latest, dating from about 1665 when the artist was approximately fifty-two years old. It is difficult to estimate how many self-portraits were painted by Dou in the course of some forty years, perhaps about a dozen, or several more.[1] Nine autograph self-portraits, including the present one, are listed below in approximate chronological order, with another example (no. 5) that is known from copies.

1. *Self-Portrait*; said to date ca. 1635–38, but perhaps from about 1640. Cheltenham Art Gallery and Museums, Cheltenham, England (fig. 31). Oil on wood, arched top, 7¼ x 5½ in. (18.3 x 14 cm). The painter is seated in the foreground, in conventional attire except for his beret. He holds a palette and brushes, and rests his right hand on a plaster cast of a head, which perhaps refers to proper training (drawing after sculpture) as well as to imitation. An apselike section of classical architecture in the left background frames the artist's head and shoulders, and an easel is seen in the right background. Baer 1990, no. 20; Washington–London–The Hague 2000–2001, no. 7; London–Sydney 2005–6, no. 13.

2. *Self-Portrait*, ca. 1645–48. Kremer collection, Spain (fig. 32). Oil on wood, 4⅞ x 3¼ in. (12.4 x 8.3 cm). In this very small, half-length portrait, the artist presents himself as a dignified young gentleman in conventional attire, wearing a hat and holding gloves. In the right background, at some distance, is an easel supporting a history picture, with props suggestive of learning (a lute, globe, and old armor). Melbourne–Canberra 1997–98, no. 40; Washington–London–The Hague 2000–2001, no. 14.[2]

37

Figure 31. *Self-Portrait*, ca. 1635–40. Cheltenham Art Gallery and Museums, Cheltenham, England

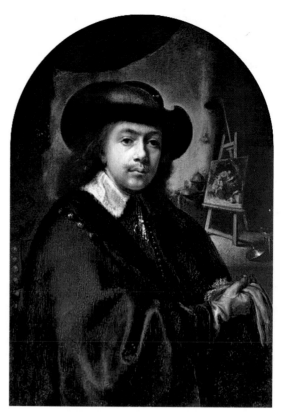

Figure 32. *Self-Portrait*, ca. 1645–48. Kremer collection, Spain

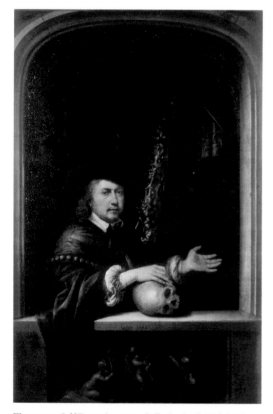

Figure 35. *Self-Portrait*, 1658. Galleria degli Uffizi, Florence

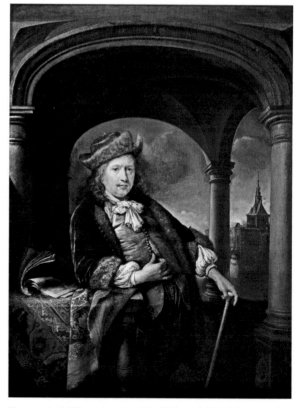

Figure 36. *Self-Portrait*, 1663. The Nelson-Atkins Museum of Art, Kansas City, Purchase: Nelson Trust, 32-77

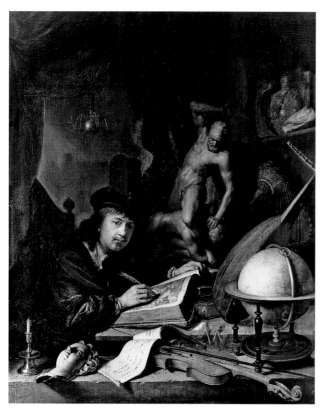

Figure 33. *Self-Portrait*, 1647. Gemäldegalerie Alte Meister, Staatliche Kunstsammlungen, Dresden

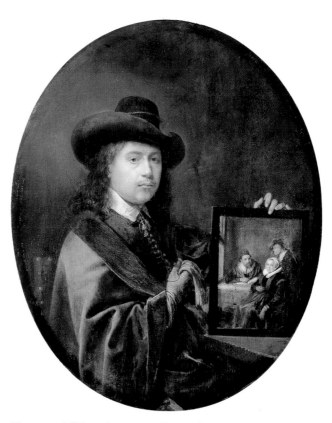

Figure 34. *Self-Portrait*, ca. 1650. Herzog Anton Ulrich-Museum, Braunschweig

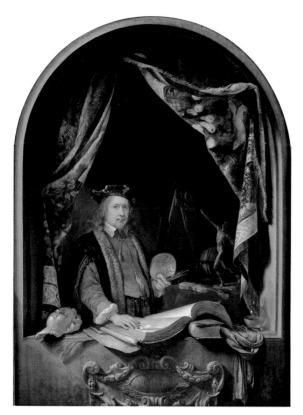

Figure 37. *Self-Portrait*, ca. 1665. Private collection, Naples, Florida

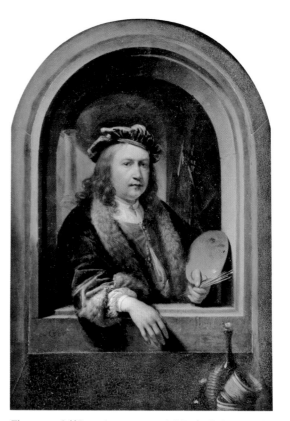

Figure 38. *Self-Portrait*, ca. 1665–67? Musée du Louvre, Paris

3. *Self-Portrait*, dated 1647. Gemäldegalerie Alte Meister, Staatliche Kunstsammlungen, Dresden (fig. 33). Oil on wood, 17⅛ x 13⅝ in. (43.5 x 34.7 cm). In a composition resembling one of Dou's more complicated genre scenes, he shows himself seated (in about one-fifth of the picture field), and surrounded by attributes of the arts and learning. A beret and a fancy Japanese-style robe worn over ordinary clothing create an artistic impression. The painter draws in a large folio, flanked by appropriate models, such as the plaster head (the same as in no. 1) on the sill in the foreground, and the large sculpture of Hercules and Cacus in the background. A globe, violin, lute, music score, and books attest to various accomplishments. There is no easel, but the Oriental parasol used to protect fresh paintings from dust, seen in no. 2 and other self-portraits, is prominently featured here, probably as a personal signature. W. Martin 1913, p. 17; Baer 1990, no. 46; Dresden–Leiden 2000–2001, pp. 27–29; Washington–London–The Hague 2000–2001, p. 35, fig. 10; London–Sydney 2005–6, no. 13.

4. *Self-Portrait*, ca. 1650. Herzog Anton Ulrich-Museum, Braunschweig (fig. 34). Oil on wood, oval, 10⅝ x 9 in. (27 x 23 cm). In this unusual self-portrait, the artist presents himself as a proper gentleman (with hat and gloves) seated at a table on which he displays a small painting of three figures in an interior. They have been identified as Dou's parents and his brother Jan (d. 1649).[3] W. Martin 1913, p. 18, right; Braunschweig 1980, no. 4; Baer 1990, no. 56.

[A self-portrait appears in the background of Dou's elaborate genre painting *The Quack*, of 1652, Museum Boijmans Van Beuningen, Rotterdam (not illustrated). The artist is shown leaning out of a window, holding a palette. Baer 1990, no. 58; Washington–London–The Hague 2000–2001, p. 19.]

5. *Self-Portrait*, 1650s. Residenzgalerie, Salzburg; formerly Czernin collection (not illustrated). Oil on wood, 9 x 6¾ in. (23 x 17 cm). Not accepted as autograph by Baer and other scholars. Looking at the viewer, the painter is seen in half-length, leaning on the sill of an arched stone window, palette in hand. The interior behind him shows, under a parasol, a painting on an easel, next to a table and globe. A trompe l'oeil piece of paper on the exterior of the windowsill, between the artist's hands, bears his name and a partially legible date. W. Martin 1913, p. 18 (left); Baer 1990, no. C3; illustrated and discussed in Melbourne–Canberra 1997–98, p. 232, and in London–The Hague 1999–2000, p. 238, in each case in an entry for no. 2 above.

6. *Self-Portrait*, dated 1658. Galleria degli Uffizi, Florence (fig. 35). Oil on wood, 19⅜ x 13⅜ in. (49.2 x 33.9 cm). The painter appears half-length in an arched stone window, resting one hand on a skull, and gesturing toward an hourglass with the other. He wears the dignified attire of a gentleman, and has a sober expression. A large, obscure painting in an elaborately carved and gilded frame stands behind him. Below the windowsill, the wall is decorated with the well-known Duquesnoy relief of playful putti (as in the Museum's picture, but less covered by other motifs). The picture celebrates illusionism and at the same time suggests that all visible things are fleeting illusions, vain and transient. W. Martin 1913, p. 19 (left); Chiarini 1989, pp. 110–11; Baer 1990, no. 75; Sluijter 2000b, p. 220, fig. 167; Washington–London–The Hague 2000–2001, p. 31, fig. 5.

7. *Self-Portrait*, dated 1663. The Nelson-Atkins Museum of Art, Kansas City (fig. 36). Oil on wood, 21½ x 15½ in. (54.7 x 39.4 cm). The artist, seen in three-quarter-length, stands with one elbow leaning on a carpet-covered table (where a book is set down momentarily), and with his left hand on a walking stick. He wears a fur-lined velvet robe and a fur hat. The setting is a portico with columns; in the background, across water, is the Blauwpoort of Leiden, where a chamber of rhetoric met. Dou added this view to the painting in 1667 or somewhat later, which required shortening the balustrade across the foreground (it became the table) and lengthening the figure from a half-length presentation at a window (as in the New York painting). The portrait is inscribed "age 50," and shows Dou as a literate and prosperous citizen of his native Leiden. W. Martin 1913, p. 20; Baer 1990, no. 88; Washington–London –The Hague 2000–2001, no. 27.

8. *Self-Portrait*, ca. 1665. Private collection, Naples, Florida (fig. 37). Oil on wood, arched top, 23¼ x 17⅛ in. (59 x 43.5 cm). The artist is seen in slightly more than half-length standing behind the low sill of an arched stone window. He rests his right hand on a large book open on the sill, where a plaster head (as in nos. 1 and 3), another book, a silken sash, and a flask of amber liquid also appear. He holds a palette and brushes, and wears a fur-lined cloak, or *tabbaard*,[4] and a fancy beret. A tapestry hangs inside the window, pulled to both sides. In the background are an easel and, on a table, a violin, a globe, and an écorché figure of an athletic male. Below the windowsill is an elaborate cartouche in high relief, within which "Gdov" is inscribed. As in no. 7, Dou appears as a prosperous and learned gentleman, but here also as an artist in

his studio, surrounded by objects that demonstrate the illusionistic powers of painting. W. Martin 1913, p. 19 (right); Washington–London–The Hague 2000–2001, no. 29.

9. *Self-Portrait*, ca. 1665. The Metropolitan Museum of Art (Pl. 37). Oil on wood, 19¼ x 15⅜ in. (48.9 x 39.1 cm). Dou is seen in half-length with one elbow resting on the sill of an arched stone window, holding between his fingers one leaf of a large and well-used book. A palette and a sheaf of brushes are displayed in his other hand. The artist wears an elegant, "historical" cloak (similar to that in no. 8), in dark green with detailed trimming, and a blue beret with red and gold piping. A red curtain, edged in gold, is gathered up inside the window, and an easel protected by a parasol appears in the shadowy interior. An empty birdcage, receding in perspective like a small demonstration piece, is mounted in the window frame to the right. Below the sill, the Duquesnoy relief (see below) is partly obscured by a long, colorfully striped silk sash and a creeping vine that casts a shadow on the sculpture and ascends the wall to the right. In the left foreground, a cracked terracotta flowerpot stands on a plinth, permitting marigolds (?) to bask in sunlight. In the figure and in other respects, the Museum's picture is similar to no. 8, but no other self-portrait by Dou illusionistically extends forms in front of the window (the apparent picture plane) to such a degree.

10. *Self-Portrait*, ca. 1665–67?. Musée du Louvre, Paris (fig. 38). Oil on wood, arched top, 12⅜ x 8¼ in. (31.5 x 21 cm); original paint surface, 8⅞ x 6¼ in. (22.5 x 16 cm). The half-length figure of the artist nearly fills an arched window. His right hand hangs over the sill, and in his left hand he holds a palette and brushes. He wears a fur-lined robe and a beret. In the background, a spare interior with a column is seen in raking window light. At some later date, another painter expanded the window frame and placed a still life with a bottle in the foreground. The work recalls Dou's earliest self-portraits in its small scale and comparative simplicity. W. Martin 1913, p. 21 (right); Paris 1988–89, pp. 20–22; Baer 1990, no. 79, as ca. 1660.

It should be noted that Dou's paintings of pipe smokers in the Rijksmuseum, Amsterdam, and in the National Gallery, London, are no longer considered self-portraits, and the identity of the sitter in the so-called *Self-Portrait* of about 1640 (private collection, Scotland) is also uncertain.[5]

Rembrandt, with his much more complex program of painting, drawing, and etching self-portraits throughout his career, exercised some influence on Dou's self-portraits through the early 1650s, but from the Uffizi painting (fig. 35) of 1658 onward, the impression made by the master is more obvious. The famous *Self-Portrait* of 1640 (National Gallery, London) was, as for other Rembrandt pupils, former pupils, and followers, the most important model for Dou, who probably knew some of the Rembrandt school derivations as well. Despite its slight swagger, the figure in the Kansas City self-portrait of 1663 (fig. 36) is the most reminiscent of Rembrandt's self-portrait dated 1640, whereas the more upright figure in the Naples picture of about 1665 (fig. 37) has taken on something of the authoritative (as opposed to refined) poses one finds in Rembrandt's *Self-Portrait* of 1658 (Frick Collection, New York) and in the self-portrait with a palette, brushes, and a maulstick of about 1661–62 (Iveagh Bequest, Kenwood House, London).

The figure in the Museum's self-portrait could be said to blend elements of the figures in the Kansas City and Naples self-portraits, thereby showing a learned gentleman at his ease (perusing a book for inspiration or for a reliable source), and at the same time depicting a working painter whose intellect and skill allow him to capture any appearance, and a moment in time. Thus art triumphs over mortality. This familiar topos — *ars longa, vita brevis* (which Seneca attributes to Hippocrates) — must have had special significance for an artist like Dou, who worked slowly and in some cases for hundreds of hours on a single painting, creating something that would long outlast him, and that would carry his image (like portraits of artists from the past) into the future and into an imaginary pantheon of important painters. The concepts of the learned artist and of painting's superiority to poetry or sculpture were pressing issues when linked with the prospect of achieving immortality through art. One did not hear of routine works by average painters in connection with the idea, but rather of great artists who through grand or sophisticated projects, and through extraordinary technique or virtuosity, contributed something memorable to the profession. Ultimately, the artist's identity consisted of the works he or she left behind, a point that was consciously demonstrated in ambitious self-portraits such as this one. Late self-portraits must have been regarded as especially significant, since they adduced the evidence of fortune, fame, skill, and experience (perhaps even wisdom) gained in the course of a career. A youthful self-portrait was like a trial masterpiece produced upon entrance into the painters' guild, but a late self-portrait was a masterwork submitted for judgment by posterity.

Two characteristics of Dou's self-portraits are quite unlike self-portraits by Rembrandt, and they reflect fundamental differences between the two artists. First, Dou made liberal use

of symbolic or otherwise meaningful motifs and second, he insisted on illusionism as the standard by which artistic virtuosity was to be measured. It has been shown that Dou's aesthetic was in line with current art criticism, particularly that of his Leiden colleague Philips Angel.[6] However, it may also be allowed that Dou's idea (as revealed in his self-portraits) of what constituted excellence in an artist and in works of art was plainly tailored to the style he settled upon in his youth, and to his usual subject matter. One need only refer to Nicolas Poussin's contemporaneous work, including his celebrated *Self-Portrait* of 1650 (Louvre, Paris), or to Rembrandt's *Aristotle with a Bust of Homer* (Pl. 151, which, like the present picture, touches upon the *paragone* of painting and sculpture) and his mature self-portraits (see Pl. 157), to place Dou's manner of presenting himself in a national and international context, where he appears as the chief exponent of a local or regional style (despite sales to a few foreign courts).

In the Altman panel and in the Uffizi *Self-Portrait* of about seven years earlier (fig. 35), Dou includes a relief below the window that repeats the composition of a marble sculpture (Galleria Doria Pamphilj, Rome) carved in 1626 by François Duquesnoy (1597–1643).[7] After training in his native Brussels, Duquesnoy established himself in Rome, where, under the influence of antiquity, Titian, and Poussin, he became a leading representative of the classicist style. Painters as different as Dou and Rubens would have named Duquesnoy one of the great sculptors of their time, and would have been proud that he came from the Netherlands. The putti relief, now known as *Children with a Goat* or *Bacchanale of Children*, was familiar from casts that circulated in northern Europe from about the late 1640s onward.[8] Dou appears to have depicted the relief for the first time in *The Violinist*, of 1653 (Princely Collections, Vaduz Castle, Liechtenstein), and he included it in several other genre paintings over the next twenty years.[9]

With reference to those pictures, and even in discussions of Dou's self-portraits, the relief's significance has been variously interpreted, sometimes with little regard for the pictorial context.[10] Here, however, its meaning seems to be fairly straightforward. The mask held by the putto to the left stands for deception, the ability to fool the eye, which will be tested on the resistant goat. In addition to a palette, a mask is one of the main attributes of Pictura, the Art of Painting, as seen in Ripa's illustration of the allegorical figure, and in the exquisite little painting of Pictura, dated 1661 (J. Paul Getty Museum, Los Angeles), by the prince of Dou's pupils (according to Houbraken), Frans van Mieris (q.v.).[11] Because the mask itself is artifice, used here to deceive an animal, art could be said to

triumph over nature, meaning that it fools a living creature into mistaking art for life. Dou's apologist Angel, in his *Lof der Schilder-Konst* (In Praise of the Art of Painting), of 1642, retells Pliny's shopworn tale of the contest between two great painters of antiquity, Zeuxis and Parrhasios: Zeuxis depicted grapes so realistically that birds tried to peck at them, but Parrhasios painted a veil over the still life to such lifelike effect that Zeuxis later tried to pull it aside. Indeed, Dou was dubbed "the Dutch Parrhasios" in a laudatory verse by the Leiden poet Dirk Traudenius in 1662; the artist himself probably encouraged the comparison.[12] It therefore seems likely that, in the self-portrait, the birdcage, the small bunch of grapes next to it, the vine, the curtain hanging inside the window, and perhaps the sash dangling over the relief are intended as allusions to the story of Zeuxis and Parrhasios. The reference may seem oblique, but Dou's patron (evidently his greatest supporter, Johan de Bije; see Ex Coll.) could simply have had the meaning explained.[13]

Duquesnoy's relief does double duty in this picture (and others by Dou), for in content it concerns imitation, and in form it represents sculpture in the *paragone* with painting, the Renaissance debate about which art was superior. In his *Lof der Schilder-Konst*, Angel offers some clever, if not concise, remarks on the subject, among them the observation that only painting can distinguish colors, textures, and insubstantial things such as light (including reflections, shadows, and atmosphere and, of course, the illusion of space — and all of this on a flat plane rather than in three dimensions.[14] Dou's painting includes a laudatory reference to convincing illusion of sculptural relief (on the flowerpot as well), but in fact the great Duquesnoy's work of art is cast into the shade by Dou's virtuoso description of the vine and the sash in front of it.[15] A little more salt could be poured into the wound, at least in conversation, if Dou had known (as he might have, from Joachim von Sandrart) that Duquesnoy's putti reliefs were in good part inspired by the works of Titian, such as the putti-strewn *Worship of Venus* (Prado, Madrid), which was then in the Aldobrandini collection in Rome.[16]

The cracked flowerpot, and the flowers themselves, probably symbolize transience, quite as in floral still lifes of the period (see the discussion of Jacob Vosmaer's *A Vase with Flowers*; Pl. 213). Fahy (1982; see Refs.) identifies the flowers depicted by Dou as marigold or calendula, noting that the latter may bloom all year long and thus "def[y] the rules of nature." It is possible that Dou was aware of this, since his city was home to eminent botanists. If so, and if the flowers are calendula, they might be meant as an analogy to the enduring nature of Dou's

art. However, the blooming plant more likely conveys the usual idea of mortality, as in biblical passages that describe the life of humankind, for example, "He cometh forth like a flower, and is cut down" (Job 14:1–2). Whatever the reading, Dou's self-portraits would tend to suggest that the motif, like the painter's general demeanor in the present work, is an expression of erudition rather than humility.

A few copies of the Museum's painting are known.[17]

1. Moes 1897–1905, vol. 1, pp. 241–42, lists twenty-eight self-portraits by Dou or records of the same, but some entries are redundant (different records of the same object), and others refer to works that are either not self-portraits, or are no longer accepted as by Dou (for example, nos. 3, 4, 9–17, 21, 24).

2. Also catalogued in Van der Ploeg, Runia, and Van Suchtelen 2002, no. 10.

3. On the subject and date of the Braunschweig portrait, see Sluijter 1998a, p. 190, fig. 38.

4. On the *tabbaard*, see De Winkel 1995.

5. For the Amsterdam and London pictures, see Washington–London–The Hague 2000–2001, nos. 15, 16. The panel in Scotland is considered a self-portrait in Baer 1990, no. 30, and by Lloyd Williams in Edinburgh 1992, p. 80 (under no. 17). The figure is presented in half-length, with no attributes other than a beret.

6. See especially Sluijter 2000b, chap. 6, pp. 208–24.

7. See Šafařík and Torselli 1982, p. 33, pl. 37; Boudon-Machuel 2005, no. OE.64b, fig. 34.

8. See Hecht 2002, p. 194, and the literature cited there.

9. As noted in ibid., p. 186, citing *The Grocer's Shop*, of 1672 (Royal Collection, London). On *The Violinist*, see also Washington–London–The Hague 2000–2001, no. 20, where in a note to the entry (p. 140 n. 5) several of these pictures are listed, and the title of the relief is confused with that of another sculpture by Duquesnoy in the Galleria Doria Pamphilj, *Sacred and Profane Love* (Hecht 2002, fig. 8).

10. Baer in Washington–London–The Hague 2000–2001 concludes that the relief "simply signals Dou's painterly abilities and *Pictura*'s deceptive qualities." See also Dresden–Leiden 2000–2001, p. 41, and Franits 2004, pp. 116–18. In Hecht 2002, p. 191, the author criticizes Josua Bruyn for finding erotic content in the relief, asking whether Dou's "own or somebody else's libido" would have been an issue "in the self-portrait that was sold to [implying, "intended for"] the Grand Duke of Tuscany." This is a good point made poorly, since the painting was acquired by Cosimo III de' Medici in 1676, a year after Dou's death.

11. See Amsterdam 1989–90, no. 14, and an illustration of Ripa's Pictura (which Dou would have known from the Dutch translation, Ripa 1644a). For Houbraken's remark about Van Mieris, see the latter's biography below.

12. See Sluijter 2000b, pp. 209–10. Pliny's account is connected with other Dutch painters, as well as with Dou, by Hecht in Amsterdam 1989–90, pp. 42–44, and by Liedtke in New York–London 2001, pp. 262–63 (especially n. 13), 438.

13. For De Bije, see Dou's biography above, note 20. On the col-lecting of self-portraits by contemporary Dutch art lovers, see *Corpus* 2005, pp. 136–39, with references to Dou and De Bije, and criticism of Ronni Baer's idea that Dou's self-portraits were a form of self-expression or autobiography.

14. See Sluijter 2000b, pp. 210–13.

15. L. Hadermann-Misguich in *Dictionary of Art* 1996, vol. 9, p. 409, describes the relief by Duquesnoy as "one of his most pictorial marbles, in which he exploited to the full the possibilities of all gradations of relief to create a scene full of atmosphere and animation."

16. See Hecht 2002, pp. 193–94 (n. 21 on Sandrart's visit to Dou's studio, and on the German artist's study, with Duquesnoy, Poussin, and others, of one of Titian's Bacchanals in the Aldobrandini collection).

17. The one listed in Hofstede de Groot 1907–27, vol. 1, p. 438, no. 282a, may be identical with the old copy (wood, 13¾ x 10¼ in. [35 x 26 cm]) sold at Galerie Fischer, Lucerne, December 2, 1993, no. 2050. A copy (wood, 14½ x 10½ in. [36.8 x 26.7 cm]) that omits the vine and rusticates the wall around the window was sold at Parke-Bernet, New York, May 16, 1951, no. 33 (ill.). A later, cropped version of the composition, omitting the vine and the flowerpot on a plinth and with a different relief (seven putti misbehaving), was in a private collection, Buenos Aires, during the 1980s.

REFERENCES: Descamps 1753–54, vol. 2, p. 225, remarks, "Chez M. le Marquis de Voyer, le Portrait de Gerard Douw";[1] J. Smith 1829–42, vol. 1 (1829), pp. 34–35, no. 101, as purchased by Erard in 1825 for FFr 25,000, erroneously dates the picture to when Dou was about forty years old, and fully describes the composition, and vol. 9 (1842), p. 19, no. 60, "now in the Collection of M. Kalkbrenner, at Paris"; Nagler 1835–52, vol. 18 (1848), p. 115, no. 26, engraved by Pierre Alexandre Tardieu; Pavilliez 1860, p. 138, prints the remarks of Paul d'Ivoy on the Piérard sale, who gives the buyer's name as M. Baring, and who finds the work dreadful (despite its fame) because of its finish, anatomy, and color; Moes 1897–1905, vol. 1 (1897), p. 242, no. 22 (under subject no. 2096), portraits of Dou, listed as in the Kalkbrenner collection; Hofstede de Groot 1907–27, vol. 1 (1907), pp. 438–39, no. 283, reviews the motifs, including "the well-known relief by Duquesnoy" and "a pot of marigolds," and adds the 1860 sale to the provenance; W. Martin 1911a, p. 172, no. 57, listed as in the Altman Collection, with provenance; W. Martin 1913, p. 179, frontis. (dated "about 1660–1665" in the caption), describes the picture as untraced between the 1860 sale and its acquisition by A. Schloss "about 1905"; Altman Collection 1914, pp. 27–28, no. 18, reports that the picture "passed through the collections of Mr. Kalkbrenner and Mr. Say, and so to its late owner"; Monod 1923, p. 309, compares the Louvre *Self-Portrait*; (NB: There is no published reference for forty years, except for Altman Collection 1928, pp. 81–82, no. 43, which repeats Altman Collection 1914); Van Hall 1963, pp. 82–83, no. 35, listed; Walsh in New York 1972, p. 11, no. 9, compares the artist's serious expression with that in Rembrandt's self-portrait of 1660 (Pl. 157 here), and observes that "by the time Dou painted this self-portrait he was famous and rich, but not of a mind to show himself simply as a human being"; Hibbard 1980, p. 336, fig. 607, parrots Walsh's remarks found in New York 1972; Naumann 1981, p. 71, fig. 98, observes the "references to book-

learning and artistic heritage"; Fahy 1982, p. 7 (ill. on p. 6), relates that the study of plants reached a high point at the time, as can be seen in Dou's self-portrait "as a prosperous artist-gentleman," and mentions the grapevine and the urn holding "a pot marigold or calendula," adding that the latter can bloom all year long, and is thus "one of the few plants that defies the rules of nature"; Hunnewell 1983, vol. 1, pp. 226–27, 232–43, 245–46, 249, 256 nn. 17, 18, 257 n. 19, 260 n. 32, 262 n. 52, and vol. 2, figs. 175, 177 (details), dates the painting to 1660–65, discusses the symbolism in detail, and sees the work as a visual commentary on the epigram *Ars longa, vita brevis*; P. Sutton 1986, p. 184, remarks the "elegant costume" and "a large volume, probably an allusion to the scholarship required of a successful artist"; Chrétien in Leiden 1988, p. 210 n. 1, compares the pose with one employed in a portrait by Pieter van Slingelandt; Foucart in Paris 1988–89, pp. 20, 22, compares the self-portrait in Paris, which is possibly the last known; Baer 1990, no. 112, suggests a date of about 1665, and describes the work as "the only extant self-portrait by the artist to include a flowerpot; hence, it is probably the painting listed as no. 22 in the contract between De Bye and Johannes Hannot"; Liedtke 1990, p. 48, mentions the work among Altman's pictures; P. Sutton 1992, p. 61, cites this and other self-portraits by Dou to demonstrate that the *Portrait of a Young Man* in the Samuel collection is not one; Baetjer 1995, p. 322; Liedtke in New York 1995–96, vol. 2, p. 142, no. 45, dates the picture to about 1665, notes that Dou presents himself as a learned painter, and that the cracked flowerpot is probably meant as a symbol of transience; Westermann 1997, p. 230, fig. 136, briefly notes the picture's contribution to the *paragone* of painting and sculpture; Baer in Washington–London–The Hague 2000–2001, p. 48 n. 98, cites the painting in connection with the motto *Ars longa, vita brevis*, and notes that "the emphasis on the artist's tools, the dignified costly dress, and the steady serious regard" recalls sixteenth-century portrait prints of artists that function as "a *memoria*, an image intended to transcend death," p. 140 n. 5, mentions the picture in a list of works by Dou that depict the Duquesnoy relief, p. 142 n. 1 (under no. 27), excludes this work as the self-portrait seen in 1662 by the Danish scholar Ole Borch, when he visited Dou's studio, and p. 142 n. 1 (under no. 29), lists the picture as one of the self-portraits by Dou that have the character of a personal manifesto; Schölzel in Dresden–Leiden 2000–2001, p. 20, in a discussion of Dou's technique, describes the paints visible on the artist's palette, noting "six or seven colours set out round the edge of his palette and four mixtures in the middle"; Liedtke in New York–London 2001, p. 439 n. 10, mentions this and another self-portrait by Dou of about 1665 (fig. 37 here) in connection with a work by Emanuel de Witte that contrasts the illusionistic limits of painting and sculpture; Hecht 2002, p. 196, fig. 15, discusses Dou's "somewhat obsessive" use of the Duquesnoy relief here and in other pictures; M. Hollander 2002, pp. 65–67, 68, 70, fig. 29, considers this work Dou's "most direct, even blatant, praise of painting and, in particular, his own skill," and discusses the significance of various motifs in the picture.

EXHIBITED: New York, MMA, "Portrait of the Artist," 1972, no. 9; New York, MMA, "Rembrandt/Not Rembrandt in The Metropolitan Museum of Art," 1995–96, no. 45.

EX COLL.: ?Johan de Bije (or de Bye), Leiden (in 1665);[2] Voyer d'Argenson (in 1754); Chevalier Sébastien Erard, Château de la Muette, Passy (1825–d. 1831; bought for FFr 25,000; his estate sale, Paris, April 23–August 7, 1832, no. 76, for FFr 19,250, bought in; his estate sale, Christie's, London, June 22, 1833, no. 40, for £603 15s.); [Étienne Le Roy, Brussels]; Kalkbrenner, Paris (in 1842); M. Piérard, Valenciennes (until 1860; his estate sale, Hôtel des Commissaires-Priseurs, Paris, March 20–21, 1860, no. 17, for FFr 37,000 to Baring); A. Schloss, Paris (from about 1905); ?Henry Say, Paris; [Scott & Fowles, New York, until 1907; sold for $45,000 to Altman]; Benjamin Altman, New York (1907–d. 1913); Bequest of Benjamin Altman, 1913 14.40.607

1. As noted in Baer 1990, no. 112, n. 2.
2. For a list of the twenty-seven paintings by Dou in De Bije's collection, see Lunsingh Scheurleer, Fock, and Van Dissel 1986–92, vol. 3B, p. 486 (appendix I). De Bije owned three self-portraits by Dou, described as (no. 11) "Gerrit Douw his portrait in small"; (no. 15) "Douw himself with father and mother"; and (no. 22) "Douw himself with a flowerpot, [seen] from outside, with one candlelight." The last term could simply mean a dimly lit interior, rather than a visible candle. Baer 1990, no. 112, considers the Museum's picture to be De Bije's.

WILLEM DROST

Amsterdam 1633–1659 Venice

One of Rembrandt's most gifted pupils, Willem Jansz Drost was also one of the most short-lived, dying before his twenty-sixth birthday. He was baptized in the Nieuwe Kerk, Amsterdam, on April 19, 1633, and buried in Venice, after having worked there some three years, on February 25, 1659.[1] Documentary evidence for both dates has only recently been discovered, and has assisted in a plausible sketch of Drost's career. When basic information about his life was unknown, including the approximate dates of his training with Rembrandt and of his departure for Italy, Drost's hypothetical oeuvre often served as a receptacle for works previously thought to have been painted by Rembrandt as early as about 1645 and as late as the 1660s.[2]

Drost's father, Jan Barentsz (ca. 1587–1639), was a bookbinder from Antwerp. On November 19, 1614, he married Mary (or Marritje) Claesdr (b. ca. 1591) in the Nieuwe Kerk of her native city, Amsterdam. The couple had eight children, according to surviving baptismal records. When their son the future ebony worker Claes Jansz Drost (1622–1689) was baptized, Jan Barentsz was described as a bookseller, but in 1627 he was recorded as a schoolteacher.[3] At his death in 1639, he left his widow with four children. The eldest, Barent Jansz Drost (b. 1615), appears to have supported the family as a barber surgeon. He married in 1653 and moved to Zaandam. Drost's only surviving sister, Engeltje (1624–1665), married a furnituremaker in 1646.

Houbraken (1721) identifies Drost as a history painter, "a pupil of Rembrandt," and a colleague of the German painter Johann Carl Loth ("Carlotto"; 1632–1698) in Rome.[4] "Guglielmo Drost of Amsterdam" is also said to be "of the school of Rembrandt" in an inventory dated 1655, which records the possessions (including a lost painting by Drost) of the brothers Agostino and Giovan Donato Correggio in Venice.[5]

Bikker suggests that Drost may have been drawn into Rembrandt's circle through an association with the ebony worker Herman Doomer (see Pl. 148) and his son, the painter and draftsman Lambert Doomer (1624–1700), who was (at the least) a Rembrandt follower.[6] Drost's tenure with Rembrandt is usually dated between about 1648 and about 1650–52. It has also been suggested that Drost studied earlier (before he turned fifteen) with Rembrandt's pupil Samuel van Hoogstraten (q.v.).[7]

This would have been about 1646–47. However, it is also possible that Van Hoogstraten, who was nearly six years older than Drost, may have simply made a strong impression on the novice painter. Attributions of Rembrandtesque pictures dating from the second half of the 1640s have gone back and forth between Van Hoogstraten and Drost, and it is clear that the teenager admired pictures that the Dordrecht artist painted during his early years in Amsterdam.

The listing of a picture by Drost in a Venetian inventory of 1655 suggests that he arrived in Italy by that year. Houbraken was probably misinformed about Drost's living for any length of time in Rome, considering that no works by him are cited in seventeenth-century Roman inventories; but a fair number are recorded in Venice. In any case, at the age of twenty-two Drost was working in Italy, and no evidence suggests that he ever returned to the Netherlands during the remaining few years of his life. At the time of his death in early 1659, he was said to have been ill for four months and to have been living in the house of a certain Cornelio van Baerle in Venice. This patron was probably a merchant, originally (like the famous humanist Caspar van Baerle, or Barlaeus; 1584–1648) from the Spanish Netherlands. His brother Giovanni Giacomo (presumably, Johannes Jacobsz) was living in Venice by 1639, and is cited in a later document as a merchant of Genoa. In 1651, Giovanni witnessed an affidavit together with Agostino Correggio (mentioned above).[8]

The earliest known dated work by Drost is a very small etching, inscribed "w DROST/1652," which shows the artist in half-length, smiling at the viewer (fig. 41).[9] The Museum's *Portrait of a Man (Self-Portrait?)* (Pl. 38) and its probable pendant, *Portrait of a Woman (the Painter's Fiancée?)* (fig. 39), are most likely both from 1653. *Bathsheba with King David's Letter* (fig. 43) is dated 1654. The last is clearly an Amsterdam picture, as is *The Sibyl* (Pl. 39), of about the same date. A formal portrait of a Dutch woman with a fan (private collection) is also dated 1654.[10] Pictures of this brief Dutch period reveal an ability to work in both a painterly and a polished manner, the latter being expected in portraiture but also found in figures like the bare-breasted model who appears as Bathsheba in the Louvre picture.

In Italy, Drost adopted a tenebrist style that had roots in Caravaggism and the work of Jusepe de Ribera (1591–1652).

The *tenebroso* manner was practiced in Venice by Giovanni Battista Langetti (1635–1676), Antonio Zanchi (1631–1678), Loth, and Drost. Among the pictures that Drost painted in Italy are two self-portraits, one in the guise of John the Evangelist (art market, 2005) and the other the moody image in the Uffizi, Florence.[11] The relationship between Loth and Drost has been a matter of conjecture. In 1685, Cosimo III de' Medici's agent in Venice, Matteo del Teglia, wrote to the Grand Duke with respect to the Uffizi self-portrait that Drost "was an esteemed artist in his time, and was the master of S. Carlo Loth, who is still alive, and saw him execute it while he [Loth] was studying."[12] Although a few scholars considered Loth to have influenced Drost, Ewald (1965) and Bikker (2005) maintain convincingly that the slightly younger Drost had more experience and took the lead in adopting a tenebrist style.[13] He thus transformed Rembrandt's approach into a romantic manner, for which the master himself was arbitrarily admired in Venice during the eighteenth century.[14]

1. Bikker 2005, pp. 7, 193, docs. 1, 2. Drost's year of birth was published in Dudok van Heel 1992, p. 18, but missed in a number of later publications (e.g., Melbourne–Canberra 1997–98, p. 296).
2. The most indiscriminate use of Drost's name is found in Bruyn 1984, pp. 153–58.
3. See Bikker 2005, pp. 8, 174 nn. 17, 18, citing the baptismal record of a Willem Jansz who died before the painter of the same name was born. In his text, Bikker (ibid., p. 9) mistakenly gives Claes Jansz's birth date as 1621, which is when a Claes who died in infancy was born (ibid., p. 174 n. 16).
4. Houbraken 1718–21, vol. 3, p. 61.
5. Bikker 2005, pp. 39, 163 (under no. L2).
6. Ibid., pp. 7, 9–10.
7. Ibid., p. 11.
8. On the Van Baerles, see ibid., pp. 39–40.
9. See Liedtke 1995b, p. 29, and Bikker 2005, p. 11.
10. See Bikker 2005, nos. 2, 10, 18, 19, 22, for these paintings.
11. Ibid., nos. 26, 38.
12. See ibid., p. 193, docs. 3, 5.
13. See ibid., pp. 44–45, where Ewald 1965 is quoted.
14. On Rembrandt's influence in eighteenth-century Venice, see F. Robinson 1967.

38. *Portrait of a Man (Self-Portrait?)*

Oil on canvas, 34⅛ x 28½ in. (86.7 x 72.4 cm)
Signed and inscribed (lower left): Wilhelm[.?] Drost. f/A [??] / Am[ster]dam.

The entire paint surface is severely abraded. There are several small losses in the sitter's coat and a few in the right background, large areas of loss in the top left corner, and another on the crown of the hat.

Given in memory of Felix M. Warburg by his wife and children, 1941 41.116.2

This portrait has long been accepted as the pendant to Drost's *Portrait of a Woman (the Painter's Fiancée?)* (fig. 39), which is signed and dated "Drost f. —/1653." (see Refs.). The two canvases first became known in a London sale of 1884; they were separated in the art market after they appeared in a London sale of 1903.[1] When the paintings were exhibited side by side in 1992, it was obvious that they are consistent in execution (although the Bredius picture is better preserved) and work well as a pair, providing that the woman's portrait is placed to the viewer's left. This departure from the conventional placement of the man to the left—that is, on the woman's right-hand side (or "heraldic right")—usually indicates that the sitters were betrothed rather than married.[2]

The form of the signature on the male portrait and whether there is any evidence of a date have been variously reported (see Refs.). As revealed by Abraham Bredius in 1912–3 and 1929, the *cartellino* bearing Drost's signature and a date of 1653 or 1655 had been covered over by someone in the art trade in order to sell the painting as a Rembrandt. Removing the overpaint must have caused damage to the inscription. There is enough space for the "Wilhelmus" (the Latin form of Willem) read by Hofstede de Groot before 1913, but only a

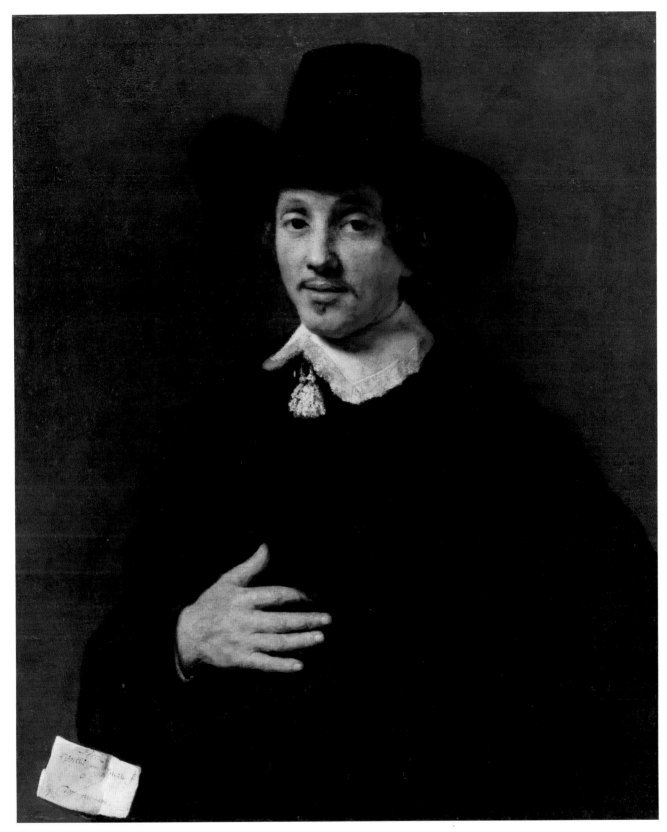

38

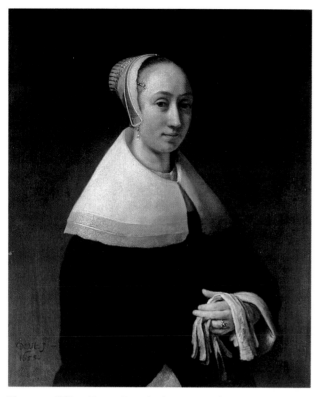

Figure 39. Willem Drost, *Portrait of a Woman (the Painter's Fiancée?)*, 1653. Oil on canvas, 34¼ x 28 in. (87 x 71 cm). Museum Bredius, The Hague

Figure 40. Drost's *Portrait of a Man (Self-Portrait?)* (Pl. 38)

possible period can now be discerned following the much abraded "Wilhelm." Above the artist's name is a decorative flourish that may have been read in the past as a date, but this is doubtful. In the center of the *cartellino*, which is now nearly void, are the remains of a capital *A* followed by slight traces of other painted marks. Presumably, "Ao 16??" was once in this area, but disappeared a long time ago. The remains of "Amsterdam.," with flourishes, are at bottom center.

Bredius, who owned the pendant portrait, proposed in 1929 that the New York painting is a self-portrait by Drost. This identification has fallen out of favor in recent literature, but it deserves to be more closely considered.

First, the young man resembles Drost as he appears in his etched *Self-Portrait* of the previous year (fig. 41), which could have been made as little as a month or as much as about twenty-three months earlier. The wide-spaced eyes, the arching eyebrows, and the shapes of the nose, mouth, and chin are similar. The hair looks the same, but is cut shorter in the painting, where there is also a small amount of facial hair.

Second, the importance of the *cartellino* bearing Drost's inscription has been underestimated. The motif is not comparable (as

Figure 41. Willem Drost, *Self-Portrait*, 1652. Etching, 2½ x 2 in. (6.4 x 5.2 cm). Rijksprentenkabinet, Rijksmuseum, Amsterdam

has been claimed) with Rembrandt's monogram on the letter held by Marten Looten in the portrait of 1632 (Los Angeles County Museum of Art), where the sitter's name is far more prominent, nor with the signature placed on a paper in the

background of another Rembrandt portrait of 1632.[3] The notion of an almost unknown artist making such a conspicuous display of his signature on the formal portrait (or, more unexpectedly, the betrothal portrait) of a person other than himself is implausible, without some special explanation.[4] By contrast, the illusion of a sheet of paper stuck between the surface of the painting and the frame is precisely the sort of device, or demonstration piece, that Netherlandish artists (following their Italian colleagues) employed to draw attention to their skill and their name at the same time.[5] Examples are found in a variety of genres, including still life (by Edwaert Collier [q.v.] and others), marine painting (Jan Porcellis's *Stormy Sea*, of 1629, in the Alte Pinakothek, Munich), and portraiture.[6] The fact that Drost, on this one occasion, signed with his full name and added the place, probably the date, and calligraphic flourishes strongly suggests that the painting is indeed a self-portrait. It should also be noted that the placement of the hand on the chest, while found in portraits of diverse gentlemen (for example, Rembrandt's *Marten Looten*), is especially common in Dutch and Flemish self-portraits and portraits of fellow artists.[7] The gesture is often meant as a reference to artistic temperament, and has origins mainly in sixteenth-century Venetian painting.[8]

Third, the young woman in the pendant portrait bears a strong resemblance to the model in Drost's *Bathsheba with King David's Letter*, of 1654 (fig. 43), and in his *Young Woman in a Brocade Gown* (fig. 42), of about the same date.[9] The long, thin, slightly upturned nose, the high brow, the slim ovoid face, and other features are quite similar. This is not a matter of the artist's having a standard female type, from which he did not vary, even when attempting to capture an individual's appearance. The most likely explanation is that Drost, like Rembrandt, employed his young wife (or companion, in Rembrandt's contemporary pictures) as a convenient model in paintings of Bathsheba and other erotically charged characters.

At present, Drost's possible engagement in 1653 and his marriage in 1653, 1654, or at any other time are not indicated by known documents. It may well be that an Amsterdam record (like that of Drost's baptism) has long been overlooked, or that the painter's presumed fiancée was from another city or town and the marriage took place there (where records may or may not survive). If Drost was married before he went to Italy, his wife probably would have stayed at home; a number of cases are known in which married painters made the expensive and potentially risky trip on their own. For example, about 1642 Jan Baptist Weenix (1621–1660/61) went to Rome, leaving behind his wife and fourteen-month-old son, Jan Weenix

(q.v.), to whom he did not return until about four years later.

It is also possible that Drost's wife died, or that he was never betrothed, in which case the Museum's picture would have to be considered as a portrait of an unidentified gentleman.

1. See Ex Coll. below, and Blankert 1991, p. 74, where the year of the 1884 auction is mistakenly given as 1883.
2. As in Maes's portraits of Jacob Binkes and his fiancée, Ingena Rotterdam (Pls. 113, 114), discussed below. See also Haarlem 1986a, p. 195 (under no. 40).
3. For these comparisons, see Bikker 2005, pp. 97–99, where the reference should be to *Corpus* 1982–89, vol. 2, nos. A52, A54.
4. For example, that the sitter is his brother or best friend. But the present writer is unable to cite an example in support of this hypothesis. The proper comparison would be with pendant portraits by Rembrandt (for example, Pls. 143, 144, 146, 148), where the famous master's signature is inconspicuous.
5. See, for example, the Museum's *Christ Crowned with Thorns*, by Antonello da Messina (ca. 1430–1479), where the creased *cartellino* reads "Antonellus messane/[us]/me pin[x]it" (Baetjer 1995, pp. 69–70). Bernaert van Orley's *Holy Family*, of 1522 (Prado, Madrid), has a *cartellino* projecting into the viewer's space, with the artist's signature and the date. The device was especially common in northern Italy during the 1500s. One of the cleverest versions of the motif is found in Ribera's *Drunken Silenus*, of 1626 (Museo e Gallerie Nazionale di Capodimonte, Naples), where the *cartellino* (with Latinized signature and reference to the academy in Rome) is being torn by a snake.
6. The device is common in formal portraiture, for example, Samuel Hoffmann's full-length *Portrait of Elisabeth Schmid-Blarer von Wartensee*, dated 1629 (Landgut zur Schipf, Herrliberg, Switzerland; Schlégl 1980, no. 18). A less conventional example is David Bailly's *Vanitas Still Life with a Portrait of a Young Painter*, dated 1651 (Stedelijk Museum De Lakenhal, Leiden), where the young man is probably Bailly himself (as suggested by J. Bruyn in *Dictionary of Art* 1996, vol. 1, p. 78, and in Sluijter 1998a, pp. 187–89).
7. See Raupp 1984, figs. 42, 46–49, 52, 66, 74, 76, 120, 129. The gesture as a sign of sincerity is mentioned above in connection with Frans Hals's *Portrait of a Bearded Man with a Ruff* (Pl. 62). However, the examples given in ibid. support the more specific reading in the case of an artist. Van Dyck used the gesture repeatedly in portraits of artists: see Barnes et al. 2004, nos. II.48, III.91, III.116, III.117, III.149, III.155, III.161, III.168, III.A21, III.A23.
8. Raupp 1984, pp. 107–15.
9. See Sumowski 1983–[94], vol. 1, nos. 319, 333, or Bikker 2005, nos. 2, 8.

REFERENCES: Bredius 1913c, col. 275, reports that when the picture was with Lesser in London, it was signed and dated "*Wilhem Drost 1655*," but now that it is with the art dealer Ehrich in New York, the *cartellino* bearing the signature and date has been removed or overpainted in order to pass the picture off as a Rembrandt; C. Hofstede de Groot in Thieme and Becker 1907–50, vol. 9 (1913), pp. 576, 577, describes the canvas as signed and dated "Wilhelmus

Drost f 1655" and considers the portrait of a woman in the Bredius collection a pendant; Bredius 1915–22, part 3 (1917), pp. 887, 890, no. 2, suggests that portraits "of the deceased and the widow" by Drost in the 1655 Leiden estate inventory of Jacob Gerritsz van Velsen are the Museum's painting (described as signed and dated "Wilhelm Drost f 1653") and the female pendant signed "Drost f 1653" in the author's own collection; Van Dyke 1923, pp. 60, 61, 62, 63, pl. X, fig. 35, considers this work "alone sufficient to indicate his [Drost's] singularity" and "an excellent portrait than which there are few better in the Rembrandt *oeuvre*"; Bredius 1929, pp. 96, 98 (ill. p. 97), gives a personal account of seeing this "very Rembrandtesque" painting on the New York art market, which he mentioned to Warburg (who bought it immediately), records the inscription as "Wilhelm Drost f. 1655" ("or 1653"; n. 1), and considers the sitter to be Drost himself and the woman in the pendant portrait (owned by Bredius) to be the artist's wife; Hofstede de Groot 1929, p. 36, mentions the work as a Drost formerly in the "MacCormick" collection; Valentiner 1939, pp. 300, 303, 325 n. 4, fig. 4, describes the work as "clearly signed Wilhelm Drost," considers the spelling of the first name to indicate that the artist was German, reads the date as 1655, sees the portrait and its pendant in the Bredius collection to be close in style to Rembrandt's work, and identifies the picture with one sold in Amsterdam on December 17, 1850 (with a pendant); Pach in New York 1940, p. 74, no. 99, as *Self-Portrait*, reads the "date" as 1655; Wehle 1942, pp. 160–61 (ill.), describes the portrait "of a young Dutch burgher" by Drost, and considers it to dismiss *The Sibyl* (see next entry) from Drost's oeuvre and to place it back in Rembrandt's; Valentiner in Raleigh 1956, p. 116, no. 21, surprisingly sees the sitter as "a middle-aged man (Jacob Gerritsz van Velsen?)," and the canvas as dated 1655; MacLaren 1960, pp. 107, 108, as dated 1653 not 1655, supports an attribution to Drost of a woman's portrait in the National Gallery, London; Plietzsch 1960, p. 181, cites the picture as one of Drost's few certain works; Ewald 1965, pp. 36, 36–37 n. 3, refers to the painting in an attempted outline of Drost's activity; Bruyn in Montreal–Toronto 1969, pp. 79, 80, suggests that the signature confirms a German origin; Haak 1969, p. 223, fig. 371, as dated 1653; Rifkin 1969c, p. 33, commends the picture's inclusion in the exhibition of 1969; Sumowski 1969, pp. 376, 383 n. 23, in an unreliable sketch of Drost's career, mentions the work as a portrait of Jacob Gerritsz van Velsen, dated 1655; Cunningham in Chicago–Minneapolis–Detroit 1969–70, p. 19, considers the painting of only "moderate help" in establishing Drost's oeuvre; Judson in ibid., pp. 53, 54–55, no. 40, as *Self-Portrait?*, the date read variously as 1653, 1655, 1656, or 1666, maintains that the signature reads "Wilhelmus," the Latinized form of Willem, and that this is probably a self-portrait by Drost, and the Bredius picture a portrait of Drost's wife; Bernt 1970, vol. 1, no. 331 (ill.), as *Portrait of a Gentleman*, 1655; Blankert 1978a, pp. 51–52 (under no. 49), 168 (ill.), considers both the painting and its pendant in the Museum Bredius as from 1653, but does not believe they represent Drost and his wife, or Van Velsen and his wife, but possibly members of the Valkenburg family (based on the supposed presence of the pictures in an auction of 1850); Baetjer 1980, vol. 1, p. 48, as not dated; Sumowski 1983–[94], vol. 1, pp. 610, 617, 664, no. 335, considers it as signed "Wilhelmus Drost" and dated 1653, pendant to the Bredius picture, but rejects all previous identifications of the sitter; Haak 1984, p. 369, repeats the discredited idea that the signature indicates a German origin; Van

Velzen in New York and other cities 1985–87, p. 50 (under no. 10), as more likely depicting a member of the Valkenburg family than Drost himself; M. Scott 1987, p. 51, observes that the inscription confirms that Drost worked in Amsterdam; Foucart in Paris 1988–89, p. 95, cites the work in support of an attribution to Drost of the *Portrait of a Young Scholar* in the Louvre; Blankert 1991, p. 74, fig. 49A, repeats Blankert 1978a; MacLaren/Brown 1991, pp. 113–14, as signed "Wilhelmus Drost," follows MacLaren (1960) in considering the painting to support an attribution to Drost of a woman's portrait in the National Gallery, London; Huys Janssen in The Hague 1992a, pp. 110–11, 113–14 (under nos. 5, 6), as possibly a portrait of a member of the Valkenburg family, and the Bredius painting as depicting the sitter's wife (the pictures are reproduced as facing plates, with the woman on the left); Ingamells 1992a, p. 87, repeats the idea of the German name; Baetjer 1995, p. 337; Liedtke in New York 1995–96, vol. 2, pp. 28, 29, 106, 108, 119, 144, no. 46, as dated 1653; Von Sonnenburg in ibid., vol. 1, p. 24, observes that the canvas was given a double-layer ground; Ben Broos in *Dictionary of Art* 1996, vol. 9, p. 300, as one of Drost's earliest dated works, the form of the signature implying "German descent"; White 1999a, p. 33, as dated 1653; Hamburg 2000–2001, pp. 32, 40 n. 145, as dated 1652; Ekkart in Utrecht 2002, pp. 70, 72, 120 n. 6 (under no. 11), follows Bikker's dissertation (2001) in doubting the pendant relationship with the *Portrait of a Woman* in The Hague; Bikker 2005, pp. 7, 17, 33, 67, 74, 92, 95, 96–99, no. 22, and pp. 101, 102, 106, 163, 184 (notes to no. 22), as *Portrait of a Man*, agrees with MacLaren that the visible "date" is merely an ornamental flourish, argues at length against all previous identifications of the sitter, and accepts the pendant relationship with the *Portrait of a Woman* in the Museum Bredius, but notes that the usual convention of placing the man on the woman's right is reversed.

EXHIBITED: New York, New York World's Fair, "Masterpieces of Art," 1940, no. 99, as a self-portrait by Drost, dated 1655 (lent by Mrs. Felix M. Warburg, New York); Madison, Wis., Memorial Union Gallery, University of Wisconsin, and Colorado Springs, Colo., Colorado Springs Fine Arts Center, "Old Masters from the Metropolitan," 1949; Raleigh, N.C., North Carolina Museum of Art, "Rembrandt and His Pupils," 1956, no. 21 in pupils' section; Montreal, The Montreal Museum of Fine Arts, and Toronto, Art Gallery of Ontario, "Rembrandt and His Pupils," 1969, no. 39; Chicago, Ill., The Art Institute of Chicago, Minneapolis, Minn., The Minneapolis Institute of Arts, and Detroit, Mich., The Detroit Institute of Arts, "Rembrandt after Three Hundred Years," 1969–70, no. 40, as "Self-Portrait?"; The Hague, "Rembrandt's Academy," 1992, no. 5; New York, MMA, "Rembrandt/Not Rembrandt in The Metropolitan Museum of Art," 1995–96, no. 46.

EX COLL.:[1] Albert Levy, London (until 1884; posthumous sale, Christie's, London, May 3, 1884, no. 24, for £54 12s. to Lesser); [Lesser, London, from 1884]; James MacAndrew (or McAndrew), Belmont, Mill Hill (until 1903; his estate sale, Christie's, London, February 14, 1903, no. 128, as "Portrait of the Artist," for £462); [Lesser, London]; [Ehrich, New York, by 1913–at least 1915]; Felix M. Warburg, New York (ca. 1915–d. 1937); Mrs. Felix M. Warburg (1937–41); Given in memory of Felix M. Warburg by his wife and children, 1941 41.116.2

1. Blankert 1991, p. 74, identifies this painting and the presumed pendant in the Museum Bredius with two portraits in an Amsterdam auction (Roos), December 17, 1850, no. 30, catalogued as "J. Drost, Twee stuks deftige Mans- en Vrouwen-Portretten," on panel, 32¼ x 27⅛ in. (82 x 69 cm), sold to Roos for Fl 30. If identical with the pictures in New York and The Hague, the canvases may have been backed with wood, or incorrectly described in the sale catalogue. However, Bikker (2005, p. 99) offers a number of convincing reasons why the portraits are not those by "J. Drost" in the 1850 sale.

39. *The Sibyl*

Oil on canvas, 38½ x 30¾ in. (97.8 x 78.1 cm)

X-radiography reveals that *The Sibyl* was painted over a composition turned upside down. The surface is extremely worn, and the impasto was somewhat flattened when the painting was lined at some earlier time. The red lake glazing in the background and dark passages of drapery painted over the light reddish brown priming that the artist used to cover the composition underneath are seriously abraded. Much of the red lake and orange-colored ochre glazing that finished the thickly applied highlights in the turban and the pastose drapery covering the shoulder has been lost. Damage to the face and hands reveals patches of the dark underlayers that interrupt the once softly blended ochreous scumbles used to model these features.

Theodore M. Davis Collection, Bequest of Theodore M. Davis, 1915 30.95.268

Drost's authorship of this picture has been supported by most specialists since 1923 (see Refs.), and may be considered as beyond reasonable doubt. Comparisons with other works by the young artist suggest a date of about 1654, when he was still in Amsterdam and very much under the influence of Rembrandt.

The painter's technique was greatly clarified by conservation carried out in 1995 by Hubert von Sonnenburg, in preparation for the exhibition "Rembrandt/Not Rembrandt in The Metropolitan Museum of Art." As he reported in the catalogue, the present composition was painted over another one (evidently with a similar figure) by turning the canvas upside down, applying a light reddish brown priming, and then laying in extensive areas of shadow. More opaque paints were scumbled over this dark but translucent layer to describe drapery and other forms. The face was rather softly modeled in warm ocherous tones, and thick impasto was used in the drapery on the shoulder and in highlights on the turban and along the neckline. In the past, the assertiveness of these highlights and of the impasto cloak was considered as typical of the late

Rembrandt, as alien to Drost, or as suggestive of later intervention, but technical examination reveals that these effects were toned down considerably by scumbling and glazes when the artist completed the picture. The apparent inconsistencies of execution, and the soft or painterly touch that some critics have seen as differing from Drost's style of about 1654, are largely the result of the artist's working in a more superficial manner than usual because of the preexisting design, and of later abrasion and other damage.[1] Before 1995, the effects of past cleanings and old restorations played an inscrutable part in the responses of connoisseurs.[2]

Despite these considerations, the manner of execution found in the Museum's picture has often reminded scholars of other paintings by or attributed to Drost, in particular the *Young Woman in a Brocade Gown*, of about 1654 (fig. 42).[3] Furthermore, the facial type in that painting, in *The Sibyl*, and in the original (Dresden) version of the *Young Woman with a Pearl Necklace* (see fig. 44) could be described as idealizations or variations of the features seen in the Bredius *Portrait of a Woman (the Painter's Fiancée?)*, dated 1653 (see fig. 39), and in the *Bathsheba with King David's Letter*, dated 1654 (fig. 43). Whether or not that model is the artist's fiancée or wife (see the discussion in the preceding entry), the transformations of the figure type are comparable to those found in the favorite female types of Rubens, Rembrandt, and other artists of the period.

The picture has been known as *The Sibyl* since its earliest trace. Presumably, the title was chosen on analogy with the similarly posed and comparably dressed figure in Domenichino's celebrated *Cumaean Sibyl*, of about 1616–17 (Galleria Borghese, Rome).[4] It has been plausibly suggested that one of the many painted copies of that picture (which was not engraved until the eighteenth century) was seen by Drost in the Netherlands.[5] The possibility of another Italian source cannot be excluded, since

Figure 42. Willem Drost, *Young Woman in a Brocade Gown*, ca. 1654. Oil on canvas, 24⅝ x 19⅝ in. (62.5 x 49.8 cm). The Wallace Collection, London

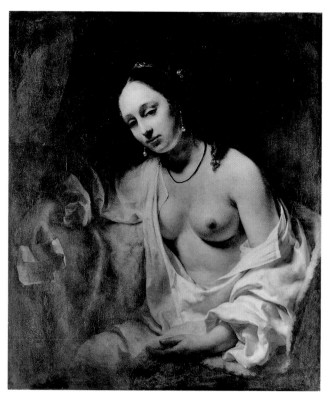

Figure 43. Willem Drost, *Bathsheba with King David's Letter*, 1654. Oil on canvas, 39¾ x 33⅞ in. (101 x 86 cm). Musée du Louvre, Paris

Orazio Gentileschi, Guercino, and other cisalpine painters treated the subject.[6] Netherlandish precedents include Jan van Eyck's Cumaean Sibyl, on the exterior of the Ghent Altarpiece, and Maarten van Heemskerck's *Erythraean Sibyl* (Rijksmuseum, Amsterdam), which was painted in 1564 on the wing of a private triptych. Ten full-length sibyls (each with a book), engraved by Philips Galle after Anthonie Blocklandt, were published in Antwerp in 1575, and are inscribed with verses by Philip II's librarian, Benito Arias Montano (1527–1598).[7]

In contrast to these earlier northern examples, where each sibyl's foretelling of the coming of Christ is either obvious from the pictorial context or conveyed by an inscription, Drost appears to have chosen the subject (as in his erotic *Bathsheba*) as a mere pretext for the image of an exotic creature. Without the apparent source in Domenichino's picture or a similar Italian composition, and without the book (which is hard to explain otherwise), the figure would not be any more readily identified with a classical or religious subject than Drost's contemporary *Young Woman in a Brocade Gown* has been, which is to say, not at all. Similar observations might be made in regard to Rembrandt's *Hendrickje Stoffels* (Pl. 154) and

his *Woman at an Open Door* (see fig. 181),[8] both of which date from about the mid-1650s, and other works produced in Rembrandt's circle in Utrecht, Haarlem, and elsewhere in the Netherlands.[9] The general type goes back to pictures of courtesans by Venetian painters such as Titian and Palma Vecchio. The tenor of those works already resonates in the paintings of sibyls by Gentileschi and Domenichino, and is more plainly adopted in a seventeenth-century Roman artist's series of twelve canvases depicting sibyls, who wear mostly modern dress, have no books, and appear to have nothing on their minds.[10] Were it not for the painted labels, one would probably identify the series as a typical gallery of beauties the artist hypothetically encountered at European or Middle Eastern courts. Not only Drost's femme fatale, who foresees little more than a memorable evening (for the male viewer, at any rate), but also the painter's smoldering palette and impetuous brushwork may be regarded as tributes to Venetian art. *The Sibyl*, as a painting, could be taken (admittedly, with the advantage of hindsight) as a prediction that a pilgrimage to Venice was to come.

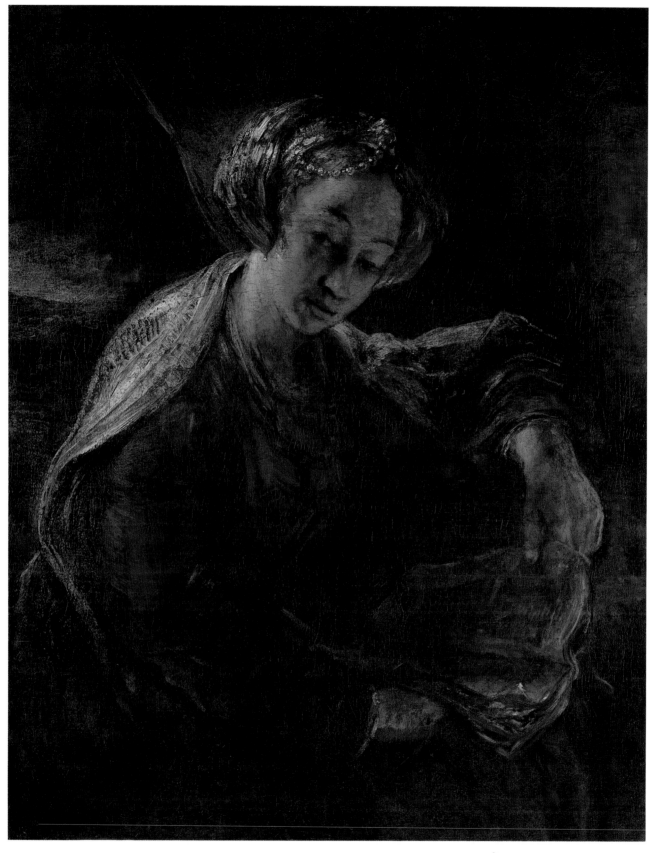

39

1. See Von Sonnenburg in New York 1995–96, vol. 1, pp. 66–67, figs. 84–86.

2. The suggestion that the impasto cloak was added at a later date, advanced in Van Regteren Altena 1967, p. 70, was echoed by some visitors to the Museum. Seymour Slive (1986), for example, agreed with the attribution to Drost, as did the following (oral opinions recorded in the curatorial files, unless otherwise stated): Frederick Schmidt-Degener, 1935; Wilhelm Martin, 1938; W. R. Valentiner (letters dated July 1, 1942, and April 12, 1946, objected to the Museum's change of attribution from Drost back to Rembrandt); Wolfgang Stechow, 1954 (considered the face as by Drost); Horst Gerson, 1960s; Bob Haak, 1971. Different opinions were offered by other scholarly visitors: Otto Benesch, 1940 (rejected Rembrandt, and was unsure of Drost because of the heavily painted cloak); Jakob Rosenberg, 1942 and 1947 (rejected Rembrandt; the painting could date from 1660s); A. B. de Vries, 1952 (doubted seventeenth-century origin); Ellis Waterhouse, 1952 (Dutch, and not by Reynolds); J. G. van Gelder, 1954 (not Rembrandt; perhaps from the period but repainted in the eighteenth century); Sturla Gudlaugsson, 1956 (not Rembrandt, "roughly done"; mentions B. Fabritius, but without conviction); D. Cevat, 1966 (by a very good painter, perhaps a pupil from Rembrandt's late period); E. Speelman, 1982 (by Horst).

3. See especially Liedtke in New York 1995–96, vol. 2, p. 108, and Bikker 2005, pp. 74–75 (under no. 10). The latter suggests that "misinterpretation of the painting's condition" may have led the present writer to "date the painting so late," namely, to about 1654–60 (at the time, Drost's date of death was unknown, and his development was much less well understood than it is today). Bikker himself dates the picture to about 1654. The remark is perplexing, considering that my co-author, Hubert von Sonnenburg, made the painting's condition clear for the first time in print. A detailed report of John Brealey's technical examination of the painting, signed by this writer and dated July 14, 1986, is in the curatorial files.

4. J. Veth 1915 (see Refs.) compared the two works for the first time in print.

5. Bikker 2005, pp. 75, 182 n. 14. As noted there, sixteen painted copies of the Borghese canvas are listed in Spear 1982, vol. 1, p. 191 (under no. 51).

6. Michelangelo's monumental Sibyls on the Sistine ceiling will be recalled, but have nothing to do with Drost. Sibyls by Andrea del Castagno, Raphael (engraved by Agostino Musi), and other earlier Italian artists are known. Guercino was commissioned in 1651 to paint *The Cumaean Sibyl with a Putto* (National Gallery, London, on loan from Sir Dennis Mahon since 1992; Salerno 1988, no. 281, pl. 28). Gentileschi's *Sibyl* (Museum of Fine Arts, Houston), which is usually dated to the early 1620s, is closer than the Domenichino to Drost's picture in the curving arrangement of the arms and the glance at the viewer (see Raleigh and other cities 1994–95, no. 14). The same Gentileschi has been cited in association with Jan van Bijlert's *Girl with a Lute*, of about 1630–35 (Herzog Anton Ulrich-Museum, Braunschweig; see Huys Janssen 1998, pp. 142–43, no. 115, pl. 68, fig. 57).

7. Hollstein 1993– , vol. 10, part 2, pp. 168–77, nos. 239–48.

8. On the Berlin picture, see Kelch in Berlin–Amsterdam–London 1991–92a, pp. 267–71 (under no. 45), where Drost's presumed response to Palma Vecchio is brought into consideration.

9. See, for example, F. Lammertse's discussion of Salomon de Bray's *Young Woman in an Imaginary Costume*, dated 1652 (Frans Halsmuseum, Haarlem), in Rotterdam–Frankfurt 1999–2000, pp. 100–103 (under no. 9).

10. Christie's, London, October 27, 2004, no. 86 (all reproduced).

REFERENCES: Eudel 1885, p. 405, records the price of "Une Sibylle" by Rembrandt in the sale of 1884; Eudel 1886, p. 199, records the price in the sale of 1885, and considers the general tonality too dark; Bode 1897–1906, vol. 7 (1902), pp. 17–18, 118, no. 528, pl. 528, publishes "The Sibyl" in Mr. T. J. Blakeslee's Collection, New York, as a "hitherto unknown" Rembrandt of about 1667, one of his "few summarily executed pictures"; Sedelmeyer Gallery 1902, no. 31; "The Sibyl, by Rembrandt . . . ," *[Boston] Museum of Fine Arts Bulletin* 3 (1905), p. 45, reports the loan from Davis's collection, and quotes Bode at length; R[oger] E. F[ry], "Rembrandt's Sybil," *MMA Bulletin* 1, no. 13 (December 1906), pp. 162–63, notes the loan to the MMA, and heaps praise upon the picture, which "shows Rembrandt's increased power of synthetic construction," and much more; A. Rosenberg 1909, pp. 386 (ill.), 561, rejects Bode's dating for one in the mid-1650s, close to the *Hendrickje* in the Mendelssohn collection, Berlin; Valentiner in New York 1909, p. 102, no. 101, as by Rembrandt, "painted about 1656"; J. Veth 1915, pp. 13–14, fig. 39, sees this painting, "which has not yet been given enough thought," as Rembrandt's response to *The Cumaean Sibyl* by Domenichino (Galleria Borghese, Rome), which he may have known through a copy or variant; Hofstede de Groot 1907–27, vol. 6 (1916), pp. 141–42, no. 214, as painted by Rembrandt about 1667, although the sale catalogue of 1884 (see Ex Coll.) records a signature and date of 1654, "no longer to be found"; Valentiner 1921b, p. 126, note to p. 386, considers the author's earlier dating to about 1656 to be supported by the 1884 sale catalogue's record of a date, 1654, on the canvas; Meldrum 1923, p. 204, pl. CCCCXLVIII, fig. 2, listed as a Rembrandt of "c. 1667(?)"; Van Dyke 1923, p. 64, pl. X, fig. 38, attributes the painting to Willem Drost for the first time, based on comparisons with the style and type of figure found in that artist's *Young Woman in a Brocade Gown* (fig. 42 here), and with the figure type in the *Bathsheba* of 1654 (fig. 43 here); Downes 1923, p. 666, in a sensible review of Van Dyke 1923, notes that catalogue's attribution of *The Sibyl* to Drost; Weisbach 1926, pp. 234, 571, as an artful late work by Rembrandt; B. Burroughs 1931b, pp. 15, 16, listed as by "Drost (?)," and described as "the famous Sibyl" that Valentiner and others now attribute to Drost; Bredius 1935, p. 18, pl. 438, as by Rembrandt with no comment; Chicago 1935–36, p. 21, no. 11, as by Drost, citing Van Dyke, Valentiner, and F. Schmidt-Degener (1935 oral opinion) in support; Worcester 1936, p. 27, no. 12, repeats entry published in Chicago 1935–36; Valentiner 1939, pp. 308, 311, fig. 15, in a monographic article on Drost, attributes the work to that artist, notes that the cleaning was revealing, and considers the date of 1654 (recorded when the painting was auctioned in 1884) to represent "exactly the period when we believe Drost must have been in closest relations with Rembrandt"; Borenius 1942, p. 10, fig. 9, as a Rembrandt of about 1667 (with no mention of contrary opinions), compares Domenichino's *Cumaean Sibyl*, revealing how the Dutch

master was indebted to Italian art for important design qualities; Ivins 1942a, pp. 3, 9 (ill.), as by Rembrandt about 1660; Ivins 1942b, pls. 23, 24, as by Rembrandt about 1660; Wehle 1942, p. 161, observes that the painting "was recently for a few years labeled Drost," but now that one may compare Drost's *Portrait of a Man* (Pl. 38) given to the Museum by Mrs. Warburg and her children, it becomes clear that both pictures cannot be by the same artist and therefore "the Museum takes this occasion in all modesty to reattribute its Sibyl to Rembrandt himself"; J. Allen 1945, p. 74, as "probably by Rembrandt"; J. Rosenberg 1948, vol. 1, pp. 204, 234 n. 15, vol. 2, fig. 270 (detail of head), maintains that "here we have a pupil — Valentiner suggested Drost — imitating Rembrandt's late, bold impasto technique, yet his rather loose splashes of paint fail to suggest any substantial form"; Valentiner in Raleigh 1956, p. 38, mentions as a work by Drost; Plietzsch 1960, p. 182, defends Valentiner's attribution to Drost; J. Rosenberg 1964, pp. 326–27, fig. 270 (detail), reprints J. Rosenberg 1948; Kühn 1965, p. 199, lists the work as a Rembrandt in a table giving ground colors (yellowish white); K. Bauch 1966, p. 49 (under Bredius no. 438), lists the picture as an impressive work by Drost; Van Regteren Altena 1967, p. 70, considers the female type characteristic of Drost, but not the broadly painted mantle, which could have been added at a later date; Gerson in Bredius 1969, p. 589, is "not so sure about the attribution to Drost, but cannot see any trace of Rembrandt's own brushwork in the picture" either; Rifkin 1969c, p. 33, cites the work in support of another attribution to Drost; Wegner 1970, p. 33, considers the execution "softer" than in typical Drosts; Arpino and Lecaldano 1978, p. 131 (ill.), included among dubious attributions to Rembrandt; Baetjer 1980, vol. 1, p. 150, as Style of Rembrandt; Sumowski 1983–[94], vol. 5, pp. 3089, 3166, no. 2035, as by Drost about 1654, close in execution and figure type to the Wallace Collection's painting, the subject probably (as in Domenichino) a sibyl; Jeromack 1988a, p. 108 (ill.), mentioned as long attributed to Drost; Baetjer 1995, p. 320, as Style of Rembrandt; Liedtke in New York 1995–96, vol. 2, pp. 106, 108–10, 112, 114–15, 119, no. 29, as attributed to Drost ca. 1654–56, suggests (incorrectly) that it was painted in Italy (considering the apparent connection with Domenichino), and cautions that pictures such as this one are often painted in a different manner than the formal portraits by the same artist; Von Sonnenburg in ibid., vol. 1, pp. 66–67, 69, figs. 84 (detail), 85 (X-radiograph), 86 (X-radiograph detail), describes the picture as extremely worn (mostly because it was painted over a discarded composition), considers the impasto passages autograph,

and explains that the striking highlights and the "yellow in the pastose drapery covering the shoulder" would have been considerably toned down by scumbling with an orange-colored ocher tone; Binstock 1999, p. 147 n. 40, cited as by Drost; Scallen 2004, pp. 297, 375 n. 52, as first attributed to Drost in Van Dyke 1923; Bikker 2005, pp. 27, 30, 59, 68, 73 (under no. 9), 73–75, no. 10, and p. 182 (notes to no. 10), with numerous references, maintains that the picture was painted by Drost about 1654 (based on comparisons with works by Drost in the Museum Bredius, the Wallace Collection, and the Louvre), and considers the question of whether Drost intended to paint a sibyl or not as uncertain; Groen in *Corpus* 2005, pp. 666–67, 672–73, reports that the first ground contains quartz, clay minerals, a little brown earth, and chalk, resulting in a light yellowish brown color.

EXHIBITED: New York, MMA, "The Hudson-Fulton Celebration," 1909, no. 101, as by Rembrandt (lent by Theo. M. Davis, Newport, R.I.); Chicago, Ill., The Art Institute of Chicago, "Loan Exhibition of Paintings, Drawings, and Etchings by Rembrandt and His Circle," 1935–36, no. 11, as by Willem Drost; Worcester, Mass., Worcester Art Museum, "Rembrandt and His Circle," 1936, no. 12, as by Drost; New York, MMA, "The Art of Rembrandt," 1942; Toronto, Art Gallery of Ontario, and New York, MMA, "The Classical Contribution to Western Civilization," 1948–49, hors cat.; Cedar Rapids, Iowa, Coe College, 1952; Decatur, Ga., Agnes Scott College, 1954; Athens, Ga., Georgia Museum of Art, 1954; Columbus, Ohio, Columbus Gallery of Fine Arts, 1956; New York, MMA, "Rembrandt/Not Rembrandt in The Metropolitan Museum of Art," 1995–96, no. 29.

EX COLL.: Richard Clemson Barnett, London (until 1881; his sale, Christie's, London, January 22, 1881, no. 90, for £273 to Lesser); [Lesser, London, as by Rembrandt, from 1881]; Baron Étienne de Beurnonville, Paris (by 1884; his sale, Hôtel Drouot, Paris, June 3ff., 1884, no. 293, as by Rembrandt, "signé à droite et daté 1654," bought in at FFr 18,100; his sale, Hôtel Drouot, Paris, January 30–31, 1885, no. 69, as "Une Sibylle," by Rembrandt, for FFr 6,500); [Sedelmeyer, Paris, in 1902]; [T. J. Blakeslee, New York, in 1902]; [Lawrie & Co., London, by 1902–5; their sale, Christie's, London, January 28, 1905, no. 102, for £3,360, bought in]; [Trotti, Paris, 1905; sold for £6,000 to Davis]; Theodore M. Davis, Newport, R.I. (1905–d. 1915); Theodore M. Davis Collection, Bequest of Theodore M. Davis, 1915 30.95.268

40. *Young Woman with a Pearl Necklace*

Oil on canvas, 33⅛ x 24½ in. (84.1 x 62.2 cm)
Inscribed (lower right): [illegible]

The painting is well preserved except where damage from lining and harsh cleaning in the past has destroyed many glazes in the flesh tones.

Bequest of Benjamin Altman, 1913 14.40.629

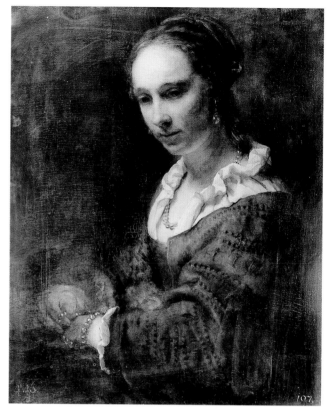

Figure 44. Willem Drost, *Young Woman with a Pearl Necklace*, ca. 1654. Oil on canvas mounted on wood, 30¾ x 24⅛ in. (78 x 62.5 cm). Gemäldegalerie Alte Meister, Staatliche Kunstsammlungen, Dresden

The painting in the Altman Collection is an anonymous copy of Drost's *Young Woman with a Pearl Necklace*, of about 1654, in the Gemäldegalerie, Dresden (fig. 44).[1] Its age is difficult to determine, but a date in the late seventeenth or early eighteenth century would appear likely. Compared with the original, the modeling of the face is schematic and descriptive qualities are simplified throughout, so that the precise nature of the cap, jacket, and fur wrap (draped over the woman's right arm) is unclear. The collar of the white blouse is especially conspicuous in its failure to resemble the counterpart in Dresden—or, for that matter, any kind of cloth (something like white-glazed earthenware comes to mind). The woman's expression, which in Dresden is reflective and evocative, is here rather vapid.

Few Dutch pictures in the Museum's collection have fallen so far from grace as this one has. In 1909, Hofstede de Groot (see Refs.) published the "very important painting" as Rembrandt's apparent portrait of Hendrickje Stoffels (compare Pl. 154), known previously only through a "copy" in Dresden attributed to Barent Fabritius (q.v.). At the time, the painting was with the art dealer Lesser in London, but it soon became a "Duveen." On February 2, 1910, Hofstede de Groot's erstwhile collaborator, and more senior colleague in Berlin, Wilhelm Bode, wrote to Duveen Brothers in London (which had asked for his opinion), "I not only believe it that it is a true picture by Rembrandt but I have no doubt that it is a very fine one of his best period and of marvelous preservation." More praise follows in the letter, along with an identification of the figure as undoubtedly "Rembrandt's second wife Hendrikje" and a dating to about 1656. In a postscript, Bode adds, "Indeed, I think so highly of the picture that I shall certainly include a reference to it in the forthcoming supplement to my Work on Rembrandt" (which never appeared). In a letter dated February 12, 1910, Bode adds: "Dear Mr. Duveen, I have to thank you for the pleasure of showing me the Hendrikje by Rembrandt since you had it cleaned from London dust. It looks splendid in his marvelous colour, masterly broadness of pencilwork and splendid preservation. I was much interested to see now the full signature just as I thought to discover it when you showed me the picture first before washing it. The date is, as much as I can see, 1656. That corresponds exactly with the age of Hendrikje. Believe me/Yours very truly/W Bode."[2]

In an article on "the Rembrandts of the Altman Collection," published in 1914, the expansive Valentiner (see Refs.) praised "the portrait of Hendrickje of 1656," with its "thickly applied pigment [that] flows over the surface in a broad stream. . . . Nothing is carefully shaded or carried out in detail." And although "this portrait of Hendrickje reveals the comfortable kindliness and gentleness of her nature, it lacks the charm of some others—for example, of the one in the Museum at Berlin. Hendrickje, it should be remembered, was merely a girl of the people."

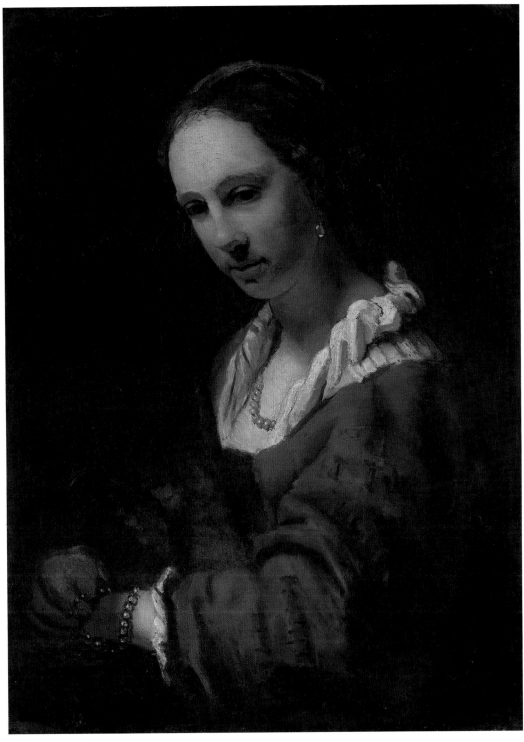

40

Actually, the model for the original version of this fancy picture, or *tronie*, may have been Drost's companion, not Rembrandt's, although the resemblance between the young woman in the Dresden painting and the figure in Drost's *Portrait of a Woman (the Painter's Fiancée?)* (see fig. 39) is less striking than in other paintings of about 1654 (see the discussion above, under Drost's *Portrait of a Man (Self-Portrait?)*; Pl. 38). The first author to reject the painting as a Rembrandt was the iconoclastic John Van Dyke, who in 1923 (see Refs.) considered it "probably by Bernaert Fabritius," noting that the Dresden version was attributed to him, and "supposed" to be a copy after the Museum's "Rembrandt." By 1939, Valentiner, citing

earlier doubts (see Refs., 1931 and 1939), had come around to a similar opinion, arguing at some length that "the Altman picture is a copy after that in Dresden," as was evident to him from its less original conception, more superficial execution, and absence of certain details. Valentiner detected a close relationship between Fabritius and Drost, and was inclined to see the present painting as Fabritius's copy after Drost, to whom the author assigned the Dresden canvas, citing similarities with that painter's *Bathsheba with King David's Letter*, of 1654 (see fig. 43), and *The Sibyl* (Pl. 39). Like Van Dyke, who saw a distinctive "Fabritius red" in the Altman canvas, Valentiner found "in the reddish brown of the coat something of the color of Barend Fabritius." But comparisons with works of the 1650s by that artist serve rather to dismiss than to support the attribution. In retrospect, one must applaud Valentiner's insight, even though he ends with the observation that "the girl is again most likely Hendrickje, whose character Drost represents this time [in the Dresden painting] with great charm and not without that mystery which must have been an expression of her fine feminine instinct."

On Valentiner's advice (and against Schmidt-Degener's), curator Harry Wehle changed the Museum's attribution of the Altman picture from Rembrandt to Fabritius in December 1937.[3] In 1991, at the present writer's tardy instigation, the Museum's designation was changed from "Attributed to Barent Fabritius" to "Copy after Willem Drost."

1. For the Dresden picture, see Sumowski 1983–[94], vol. 1, pp. 616, 641, no. 332, and Bikker 2005, no. 7.
2. Bode's original letters are in the Museum's curatorial files. On February 22, 1910, the London office of Duveen Brothers sent the New York branch ("Duplicate Mailed Paris") a letter headed "Lesser Rembrandt" (referring to the London art dealer Lesser), in which Bode's original letter of February 2 was enclosed, along with the news that Dr. Hofstede de Groot had posted his letter "this morning." Hofstede de Groot's certificate dated May 9, 1910, is also in the curatorial files, and declares the picture "an unquestionable Rembrandt [underlined] of his best period." A copy of the Duveen letter of February 22 is annotated (evidently by Altman), "4/8/10 Never rec'd this letter from Duveen but have copy of it in Stoffels book."
3. Record on the curatorial catalogue cards, noting that F. Schmidt-Degener (April 15, 1935) "considers this not even [Barent] Fabritius, suggests that it is only a repetition of Fabritius in Dresden."

REFERENCES: Hofstede de Groot 1909a, p. 181, fig. 7, publishes the "very important" picture as a Rembrandt "from his ripest time,"

apparently depicting Hendrickje Stoffels, and close to Rembrandt's *Woman at an Open Door,* in the Gemäldegalerie, Berlin (fig. 181 here); Hofstede de Groot 1909b, pp. 167–68, fig. 7, repeats the previous publication's information in translation; Altman Collection 1914, pp. 21–22, no. 13, as *Hendrickje Stoffels,* by Rembrandt, noting that the sitter "rose to a position of intimacy with her master," although in this picture she "has no great claim to good looks, and a shadow on the upper lip does not add to her charms"; Valentiner 1914b, pp. 358, 361, discusses the work extensively as Rembrandt's portrait of Hendrickje Stoffels of 1656 (see text above); Hofstede de Groot 1907–27, vol. 6 (1916), p. 339, no. 719, as *Hendrickje Stoffels* by Rembrandt, "painted about 1658," copy in the Dresden Gallery, 1908 cat. no. 1591, as by Barent Fabritius; Bredius 1921, p. 151 (under S[eite] 87), as certainly not by Rembrandt, but by "a pupil, e.g. Barent Fabritius?," the only one of Altman's dozen "Rembrandts" that is wrong, and he never liked it (according to the executors of his estate); Valentiner 1921b, p. XXIII, no. 87, pl. 87, as Rembrandt's *Hendrickje* of about 1658, the "old copy" in Dresden incorrectly ascribed to B. Fabritius; A. Burroughs 1923, p. 272, as "the so-called *Portrait of Hendrickje Stoffels,* a weak study identical with one by B. Fabritius in the Dresden Gallery, and probably painted by a fellow pupil"; Monod 1923, p. 302, as perhaps by Maes; Van Dyke 1923, pp. 77–78, pl. XIV, fig. 52, as "probably by Bernaert Fabritius"; Altman Collection 1928, pp. 64–65, as by Rembrandt, *Hendrickje Stoffels*; Valentiner 1931, no. 136, pl. 136, as Rembrandt's *Hendrickje* of about 1658, but the attribution "is not quite certain. The painting is very much in the style of Barend Fabritius, whose similar although somewhat weaker painting is preserved in the Dresden Gallery"; Valentiner 1939, pp. 318, 321, fig. 24, as probably by Barent Fabritius, after Drost's *Hendrickje* in Dresden; Pont 1958, p. 133, has not seen the painting and therefore declines to offer an opinion about Fabritius's possible authorship; Ewald 1965, pp. 36–37 n. 3; Rifkin 1969a, p. 27, as a copy by B. Fabritius after the Dresden Drost; Sumowski 1969, p. 382 n. 13 (under no. 3), as a copy after Drost; Baetjer 1980, vol. 1, p. 55, as attributed to Barent Fabritius; Sumowski 1983–[94], vol. 1, p. 616 (under no. 332), as "copy with changes in the clothing after the Dresden Drost; Baetjer 1995, p. 337, as a copy after Drost's painting in Dresden; Liedtke in New York 1995–96, vol. 2, pp. 108, 110–11, 119, no. 30, as a copy after Drost's painting in Dresden; Scallen 2004, pp. 296, 375 n. 49, as rejected in A. Burroughs 1923; Bikker 2005, p. 67, fig. 7a (under no. 7), as a copy of the Dresden Drost; Groen in *Corpus* 2005, pp. 666–67, reports that the first ground contains red earth, and the second ground lead white and a little brown ochre, resulting in a yellowish color.

EXHIBITED: New York, MMA, "Rembrandt/Not Rembrandt in The Metropolitan Museum of Art," 1995–96, no. 30.

EX COLL.: J. Osmaston, Hawkhurst Court, Billinghurst, Sussex; [Lesser, London, in 1909]; [Duveen, London, in 1910; sold to Altman on March 22, 1910, for $136,360]; Benjamin Altman, New York (1910–d. 1913); Bequest of Benjamin Altman, 1913 14.40.629

JACOB DUCK

Utrecht ca. 1598/1600–1667 Utrecht

The Utrecht genre painter Jacob Jansz Duck was the second son of Jan Jansz Duck, from the village of Vleuten (just west of Utrecht), and Maria Bool. His parents married on January 10, 1596, which suggests that their first son, Johan, may have been born in that year or the next, and Jacob between about 1598 and 1600. Entering into this calculation is the fact that he was apprenticed to a goldsmith in 1611, became a master in the goldsmiths' guild in 1619, and married on April 29, 1620. His father's profession is not known, but his mother sold cloth from the family home on the Donkere Gaard in the heart of Utrecht.[1]

In 1621, Duck was listed as a drawing student of the Utrecht painter Joost Cornelisz Droochsloot (1586–1666) and other masters, and in the same year he was recorded as an apprentice portraitist. Duck was still a member of the goldsmiths' guild in 1642, but it is clear that by the late 1620s, and probably earlier, he was working mainly as a painter. He donated a picture of a musical company to the Saint Job's Hospice of Utrecht in 1629.

The gift is one of several indications that Duck was Catholic. His marriage to Rijckgen Croock was a civil not a church ceremony (the former often indicates that the couple was Catholic), and two of Duck's brothers, Johan and Cornelis, were priests. Jacob and his wife had at least eight children, but their names and dates of birth are mostly unknown.[2]

Like Duck's mother, his wife and father-in-law were linen merchants; his wife took over her father's business in 1643. Five years later she died, by which date the couple was living in a rented house on the Nieuwegracht near the Magdalenabrug (Magdalene's Bridge). Duck continued to live there with his six unmarried daughters. He appears not to have prospered. After his death in January 1667, his daughters declined their inheritance, since the artist's debts were expected to exceed the value of his assets.

It was supposed in the past that Duck spent time in Haarlem, since pictures by him were offered in a lottery there in 1636.[3] However, charitable lotteries in Dutch cities often included paintings by artists from other towns, and Duck is documented in Utrecht during the same period.[4] In 1660, he was living in The Hague, where he joined the painters' confra-

ternity Pictura at an unknown date.[5] Pictures by Duck are recorded in collections at The Hague.[6] He returned to Utrecht in 1661.

Duck's parents were friendly with Abraham Bloemaert (q.v.), who witnessed their will in 1638.[7] Connections with other artists can only be deduced from Duck's oeuvre. He was obviously aware of the Amsterdam guardroom painters Pieter Codde (1599–1678) and Willem Duyster (1598/99–1635), and in the 1650s he adopted compositional and other ideas from painters active in Leiden and Rotterdam (Ludolf de Jongh [q.v.] is recalled by Duck's *Guardroom Scene*, dated 1655 [location unknown]).[8] Apart from his rather stark lighting and theatrical gestures, Duck has comparatively little in common with the Caravaggesque painters of Utrecht. He was an eclectic artist, a very good painter of figures and still-life motifs, with a frequently peculiar approach to pictorial space (broad, deep, and disconnected) in those compositions where the scheme is not clearly derived from someone else's example. It is something of a tribute to Duck's inventive interpretations of guardroom, tavern, and bordello scenes that writing on his work tends to deal almost exclusively with iconographic questions.[9] A more surprising aspect of the literature on Duck is that his relationship with the Utrecht painter Nicolaes Knupfer (1603 or ca. 1609–1655) remains to be explored.[10]

1. See no. 20 on the plan of Utrecht in San Francisco–Baltimore–London 1997–98, pp. 88–89, and pp. 381–82, 438, for M. J. Bok's biography of Duck, from which most of these details are taken. Agnes Groot's entry in *Dictionary of Art* 1996, vol. 9, p. 364, offers the familiar reminder that Duck was long confused with Jan le Ducq (1629/30–1676; on this artist of The Hague, see The Hague 1998–99, pp. 301–2). Additional biographical information is given in Salomon 1998a, pp. 16–18, for example, the fact that the artist gave his age as about sixty in July 1660 (p. 16 n. 2, citing Obreen 1877–90, vol. 5, p. 291).

2. As Bok explains in San Francisco–Baltimore–London 1997–98, pp. 381–82, records of Catholic baptisms in Utrecht during this period have been lost.

3. For example, in Philadelphia–Berlin–London 1984, p. 189, and in San Francisco–Baltimore–London 1997–98, p. 193.

4. As noted in Salomon 1998a, p. 17.

5. Ibid., p. 17; The Hague 1998–99, p. 301.

6. See Salomon 1998a, p. 18, where it is mentioned that a guard-

room scene by Duck was listed in the collection of Archduke Leopold Wilhelm in 1659. The picture could have been acquired through an agent in the court city of The Hague.

7. See Bok in San Francisco–Baltimore–London 1997–98, p. 382.

8. See Liedtke 2000a, p. 172, fig. 232. The painting (Salomon 1998a, p. 156, no. 66, fig. 2, with earlier sales) was sold at Christie's, Amsterdam, November 8, 1999, no. 95.

9. As in Salomon 1998a.

10. On Knupfer, see San Francisco–Baltimore–London 1997–98, pp. 265–69, no. 45, and pp. 383–84 (biography by Bok), and Saxton 2005, where the question is not considered. However, Saxton agrees that Knupfer and Duck share qualities of style and expression, and that Duck is the more likely debtor (personal communication, February 23, 2005).

41. *A Couple in an Interior with a Gypsy Fortune-Teller*

Oil on wood, oval, 9⅞ x 13 in. (25.1 x 33 cm)
Signed (lower right, beside fireplace): JDVCK [JD in monogram]

The painting is in very good condition, although the highlights on the women's faces have been reinforced and the paint is chipped along the slightly irregular border. The oak panel retains its original thickness, with bevels intact. Examination by infrared reflectography reveals that the chair at left was underdrawn.

Gift of Dr. and Mrs. Richard W. Levy, 1971 1971.102

This small oval panel was painted by Duck about 1632–33, to judge from other pictures by the artist, the painting's composition and coloring (works by Dirck Hals [q.v.] as well as by Pieter Codde and Willem Duyster should be compared),[1] and the style of the woman's clothing (see, for example, Rembrandt's *Portrait of a Woman*, dated 1632; Pl. 144). Curator John Walsh, who in the later 1970s titled the picture *The Procuress*, suggested on stylistic grounds that it must be earlier than one of Duck's very few dated works, *Merry Company*, of 1635 (private collection).[2] This is consistent with the conclusions of other scholars (see Refs.).

The subject, however, has nothing to do with prostitution, although the arrangement of the three figures superficially recalls Utrecht paintings like Dirck van Baburen's *The Procuress*, of about 1622 (Museum of Fine Arts, Boston).[3] In Duck's picture, by contrast, a woman in very proper attire responds skeptically to the words of an old fortune-teller. The latter's boldly striped mantle, her appearance in general, and her "profession" make it clear that she is a gypsy.[4] The lady's companion, who has placed his cloak and sword on the empty chair, wears an extravagantly feathered cap and an impatient expression. The setting must be a tavern, considering its plain décor, the glass of red wine to the far left, and the smoking requisites dropped onto the floor (a clay pipe, a metal tobacco box, and tobacco in a paper wrapper). The fireplace offers heat and nothing else; such a hearth in the kitchen of a Dutch house would be provided with cooking implements. A sure sign that the room is not part of a private home is that the gypsy has been admitted to it.

Salomon considers the painting as the earliest of several paintings by Duck featuring gypsy fortune-tellers.[5] A fine excursus on the theme of gypsies in Netherlandish art is offered by Sutton in his discussion of Jan Steen's scene set in front of a country inn, *The Fortune-Teller*, of about 1650 (Philadelphia Museum of Art).[6] In addition to examples by Jacques de Gheyn, Dirck Hals, Leonaert Bramer (q.q.v.), and several other artists, Sutton refers to Jacob Cats's popular poem "Het Spaens Heydinnetje" (The Spanish Gypsy Girl), of 1637, and the actual circumstances of gypsies in Holland during the seventeenth century.[7] As Salomon observes, Dutch literature and theater employed gypsies to assist the progress of romantic situations, usually by palm reading (which was given a physiological explanation at the time).[8] Duck, however, in a departure from the lighthearted norm in Utrecht and elsewhere, shows a fortune-teller ill received by people who look incapable of having a good time.[9]

In a painting probably dating from about five years later (private collection, Bern), Duck shows an elegantly dressed young woman in an inn declining to have her fortune read by an elderly gypsy woman, despite the encouragement of her handsome suitor. The figure of the gypsy recalls the one in the Museum's picture but comes much closer to the study of an old gypsy woman in a drawing by Duck (Museen für Kunst und Kulturgeschichte, Lübeck).[10] The man in the present painting

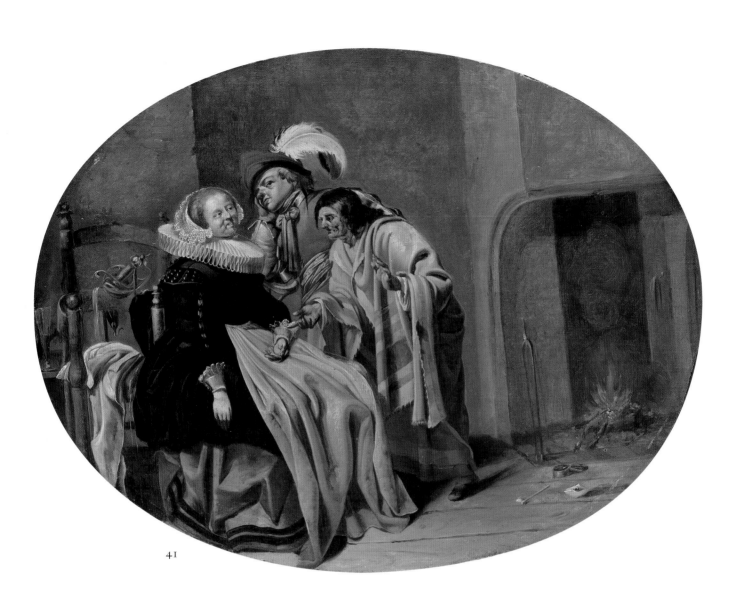

41

is repeated as a full-length figure leaning on a large sword in a somewhat later panel by Duck, *Tavern Scene* (formerly in a Swedish collection).[11] That he painted the figure in half- and full-length versions suggests that he made a full-length drawing of the figure before he painted either panel.

The use of a broad oval format, which is common in works by Duyster, also is found in Duck's *Bordello Scene*, of the 1630s (art market, 1975).[12] The oak support of the New York painting is beveled on all sides and (despite some slight shaving around the edges) retains its original shape. When the picture was in the Jaucourt collection, it was engraved by Jean Augustin Pâtour, who reversed and altered the composition to a rectangular format and added over the fireplace the motif of a drawing of a peasant's head in profile.[13]

Previously titled by the Museum *The Procuress*.

1. See the biography of Duck above.
2. Undated note in curatorial files. The panel (Salomon 1998a, p. 154, no. 58, fig. 99) was with the dealer Salomon Lilian, Amsterdam, in 1993. Another Duck dated 1635, *Interior with Lady and Cavalier*, is published in Norwich 1988, no. 110.
3. The suggestion in Walsh 1974a, p. 344, that the gypsy woman "may be a procuress" was encouraged by his reading of the fire tongs as a symbol of sexual excitement (ibid., p. 346). The theme is easier to find in literature of Dutch art dating from the 1970s than in this picture.
4. Compare the costume, physical type, and behavior of the gypsy woman in *Fisherman and Gypsies on a Beach* by Arent Arentsz Cabel (ca. 1585/86–1631), in the Museo Thyssen-Bornemisza, Madrid (Gaskell 1990, pp. 310–11, no. 68).
5. Salomon 1998a, pp. 128–31, figs. 118, 121, 122, 124, 125.
6. P. Sutton 1990a, p. 315.
7. On the latter, see also Rotterdam–Washington 1985–86, p. 68, no. 63 (De Gheyn's drawing, *The Fortune-Teller*), and Gaskell 1990, pp. 310–11.
8. Salomon 1998a, pp. 127–28. The connection with contemporary literature is also touched upon in Dresden–Leiden 2000–2001, p. 88, in a discussion of Willem van Mieris's panel *The Soothsayer*, dated 1706 (Gemäldegalerie Alte Meister, Dresden).
9. Compare Jan van Bijlert's *Fortune-Teller with a Young Couple* (Gemäldegalerie Berlin) and *The Fortune-Teller* (Musée

Françisque Mandet, Riom), which are dated 1625–35 in Huys Janssen 1998, p. 150, nos. 135, 136, pls. 80, 83. See also the Delft artist Jacob van Velsen's small painting on copper, *The Fortune-Teller*, dated 1631 (Louvre, Paris; New York–London 2001, pp. 75–76, fig. 87).
10. See Salomon 1998a, p. 129, figs. 119, 121.
11. Lund 1953, pp. 18–19, no. 19, pl. 13. A detail of the figures is reproduced in Béguin 1952, p. 115, fig. 3.
12. Salomon 1998a, pp. 82–83, 147, no. 24, fig. 72.
13. The Museum owns an impression (53.1000.2553) that bears an inscription naming the artist ("Durc"), the collector, and the engraver.

REFERENCES: Béguin 1952, pp. 114, 115 n. 18, compares the picture with paintings by Duck dating from about 1630–35; Lund 1953, p. 18, no. 18, gives the apparently mistaken information that the painting was purchased on November 18, 1933 (1934?), from Galerie Sanct Lucas, Vienna; Walsh 1974a, pp. 344, 346, 349 n. 11, fig. 8, as *Couple with a Gypsy Woman*, dates the picture ("a kind of miniature Baburen") to the early 1630s, describes the subject and the "peculiar composition," interprets the fireplace as a reference to enflamed passions, and compares the Lübeck drawing of a gypsy woman by Duck; P. Sutton 1986, pp. 186–87, fig. 265, questions the former title, *The Procuress*; Kisluk-Grosheide 1988, pp. 201–2, 207 n. 7, figs. 2, 3, notes the open tobacco box, clay pipe, and folded paper containing tobacco on the floor to the lower right; Baetjer 1995, p. 308; Salomon 1998a, pp. 128–29, 147, no. 27, fig. 118, pl. VII, as *Gypsy Fortune Teller (The Procuress)*, discusses the work as Duck's earliest known representation of a gypsy fortune-teller, dating from the early 1630s, in which the strong contrast of physiognomic types is reminiscent of the Utrecht Caravaggisti.

EXHIBITED: Lund, Sweden, Skånska Konstmuseum, "Gamla Holländare I Skånska Hem," 1953, no. 18 (lent by E. Lundström).

EX COLL.: Louis, chevalier de Jaucourt, Paris (until d. 1779; as by Durc, "Le Petit Menteur"; [D. A. Hoogendijk, Amsterdam, in 1932, as by Johan le Ducq]; R. H. Ward, London (until 1934; sale, Frederik Muller, Amsterdam, May 15–17, 1934, no. 119, as by J. Duck); [Galerie Sanct Lucas, Vienna, 1934; sold to Lundström]; Edna Lundström, Malmö, Sweden (1934–69; sale, Winkel & Magnussen, Copenhagen, May 7–21, 1969, no. 483); [Brian Koetser, London, in 1970; sold to Feigen]; [Richard L. Feigen, New York, until 1971]; Dr. and Mrs. Richard W. Levy, New Orleans (1971); Gift of Dr. and Mrs. Richard W. Levy, 1971 1971.102

GERBRAND VAN DEN EECKHOUT

Amsterdam 1621–1674 Amsterdam

This versatile and prolific painter and draftsman was born in Amsterdam on August 19, 1621, the eighth child of Jan Pietersz van den Eeckhout (1584–1652) and Grietje Claesdr Lydecker. His father and his brother were goldsmiths, and in the 1650s Gerbrand drew a series of "Various artful inventions to be made in gold, silver, wood and stone."[1] In 1633, Jan Pietersz, who had been widowed two years earlier, married Cornelia Dedel (1594–1660), the daughter of a wealthy director of the East India Company (VOC) in Delft, which considerably lifted the family's fortunes and social standing.[2]

Houbraken records that Van den Eeckhout was a pupil of Rembrandt's.[3] This was probably between about 1635 and 1639.[4] In the 1640s, he painted numerous religious pictures strongly influenced by Rembrandt and by the master's teacher, Pieter Lastman (1583–1633). The older artist's example is reflected in the palette of pictures such as *Isaac Blessing Jacob* (Pl. 42), discussed below, and in body language that is often legible to a fault. In a broad view, Van den Eeckhout's religious, mythological, and history pictures—he favored edifying scenes from antiquity—reveal a development similar to that of Ferdinand Bol and Govert Flinck (q.q.v.). But Van den Eeckhout was much more eclectic, employing both detailed and broad techniques, and turning also to guardroom and stylish genre scenes (see, for example, Pl. 43), as well as to landscapes (especially drawings) and *portraits historiés*.[5] In 1657, with the help of his brother Jan (who was head of the wine rackers' guild), Van den Eeckhout received the commission for an important group portrait, *Four Officers of the Amsterdam Coopers' and Wine Rackers' Guild* (National Gallery, London). He would paint the same guild's officers in 1673 (Amsterdams Historisch Museum).[6] Single portraits date from throughout the artist's career, but portraiture was not Van den Eeckhout's main interest. Special emphasis must be placed upon his drawings which, even allowing for many misattributions, are extraordinary for their number and for their technical and thematic range.[7]

The painter and draftsman was also an etcher, an amateur poet, a collector, and an adviser on art (he was often asked to appraise pictures). He never married, although in his last years (he died at the age of fifty-three) he shared a fine house on the Herengracht with the widow of his brother Jan (d. 1669). Van den Eeckhout was buried in the Oudezijds Kapel in Amsterdam on September 29, 1674. His appearance is known from a drawn self-portrait, dated 1647 (Collection Frits Lugt, Fondation Custodia, Institut Néerlandais, Paris), and from an engraved image in Houbraken's *Groote Schouburgh*.[8]

1. See Sumowski 1979–95, vol. 3, p. 1374, on this and other series of designs by or partly by Van den Eeckhout.
2. For more on the Mennonite family of Jan Pietersz, see Volker Manuth in Berlin–Amsterdam–London 1991–92a, p. 344, and in *Saur AKL* 1992– , vol. 32 (2002), p. 233. Manuth is preparing a monograph on the artist. For Van den Eeckhout's portraits of his father and stepmother, each dated 1644, see Sumowski 1983–[94], vol. 2, pp. 749, 883–84, nos. 520–21, and Leiden 2005–6, pp. 73–74, figs. 69, 70.
3. Houbraken 1718–21, vol. 2, p. 100. The frequently quoted remark by Houbraken that Van den Eeckhout was Rembrandt's "great friend" is found in ibid., vol. 1, p. 174. However, the meaning of the sentence is not entirely clear: "He [the landscapist Roelant Roghman (1627–1692)] was in his time, with Gerbrant van den Eekhout, a great friend of Rembrant van Ryn." That Roghman and Van den Eeckhout were friends is known independently.
4. On this point, see Liedtke 1995b, p. 22, and Liedtke 2004b, p. 68. Manuth (see note 2 above) keeps the artist with Rembrandt until 1640/41.
5. For an overview of Van den Eeckhout's subjects and styles, see Ben Broos in *Dictionary of Art* 1996, vol. 9, pp. 741–44. His landscapes are discussed by P. Sutton in Amsterdam–Boston–Philadelphia 1987–88, pp. 304–6; see also Sumowski 1979–95, vol. 3, nos. 670–95, and Sumowski 1983–[94], vol. 2, nos. 544–46. Rhine views dating from 1663 were drawn on a trip made together with Jacob Esselens and Jan Lievens.
6. Sumowski 1983–[94], vol. 2, nos. 905, 906; MacLaren/Brown 1991, pp. 128–30, pl. 111, for the canvas of 1657.
7. Most of Sumowski 1979–95, vol. 3, is devoted to Van den Eeckhout (nos. 601–819).
8. Ibid., no. 613; Houbraken 1718–21, vol. 2, pl. E opp. p. 102, fig. 1.

42. *Isaac Blessing Jacob*

Oil on canvas, 39⅝ x 50½ in. (100.6 x 128.3 cm)
Signed and dated (lower center): G V eeckhout/A° 1642

The painting is generally in good condition, although the headboard and the curtain above it have been severely abraded.

Bequest of Collis P. Huntington, 1900 25.110.16

This is an early work by Van den Eeckhout, painted in 1642, when he was about twenty-one years old and had been out of Rembrandt's studio for two or three years. Earlier paintings by the artist include another *Isaac Blessing Jacob*, dated 1641 (art market, London, ca. 1914),[1] and *The Presentation of Christ in the Temple*, of 1641 (not 1671; Szémüvészeti Múzeum, Budapest).[2] Several biblical pictures of the early 1640s are known, including *Gideon's Sacrifice* (location unknown), *The Dismissal of Hagar* (formerly Edzard collection, Munich), and *Jacob's Dream* (Muzeum Narodowe, Warsaw), each of which is dated 1642, and *Joseph Telling His Dreams*, dated 1643 (Bob Jones University, Greenville, South Carolina).[3] The majority of these subjects were especially popular in Rembrandt's circle. Other artists who represented Isaac Blessing Jacob (Gen. 27:21–23) include Jan Lievens (1607–1674), in a painting known through an engraving by Jan Joris van Vliet;[4] Govert Flinck (q.v.), in his well-known canvas of 1638 (fig. 45);[5] Gerrit Horst (ca. 1612–1652), in a painting dated 1638 (Dulwich Picture Gallery, London) and in contemporary works;[6] and Jan Victors (q.v.), in a painting probably of about 1645–50 (Louvre, Paris).[7] It has been suggested in the past that Van den Eeckhout (in the present picture), Flinck, and others were influenced by an earlier drawing of the subject by Rembrandt, but the two examples usually cited are no longer accepted as autograph works.[8]

Like most of his colleagues, Van den Eeckhout shows Isaac's son Jacob kneeling for the blind patriarch's blessing, as contrived by Isaac's wife, Rebekah. The firstborn, Esau, had been sent out by his father to hunt for venison, which was to be enjoyed by Isaac before he conveyed his legacy. Rebekah then instructed Jacob, who was her favorite son, to fetch "two good kids of the goats," one of which is seen served on the table together with salt in a silver cellar, bread, a knife and napkin, and an extravagant vessel for wine. Jacob wears his brother's "goodly raiment" and quiver, and the kids' hair upon his hands, so that he would feel like the rougher Esau to his father's touch. Esau enters in the background, and will soon discover how he has been cheated out of his blessing, as well as his birthright (Gen. 25:29–34).

Unfortunately, none of this is effectively staged by Van den Eeckhout, who makes Isaac look slow-witted rather than trusting, Rebekah didactic rather than duplicitous, and the sons mere props, with Jacob's face turned away from the viewer. A comparison with Flinck's painting of 1638 shows how much the young artist might have achieved had he been concerned more with the figures' emotions than with their household goods. The arrangement of the exotic bed, with its fancy head- and footboard, the canopy above, the table, and the platform seems to have been inspired by Rembrandt's famous *Danaë*, of 1636 (Hermitage, Saint Petersburg), which is thought to have been reworked by Rembrandt himself in the early 1640s. A painting plausibly attributed to Ferdinand Bol (q.v.) and dated to about 1640–41, *Isaac and Esau* (private collection), and the same artist's canvas dated 1643, *David's Dying Charge to Solomon* (National Gallery of Ireland, Dublin), appear to be contemporaneous responses by a former fellow pupil to the same Rembrandt prototype.[9]

The silver ewer stands for the riches that Jacob will inherit, and reproduces one of the first masterpieces of the auricular style in the Netherlands (fig. 46), Adam van Vianen's covered ewer made in 1614 for the Amsterdam guild of silversmiths (of which Van den Eeckhout's father was a member). The piece was commissioned in memory of Van Vianen's brother Paulus, who had died the year before in Prague.[10] Adam van Vianen was highly esteemed by artists and collectors, and this particu-

Figure 45. Govert Flinck, *Isaac Blessing Jacob*, 1638. Oil on canvas, 46⅛ x 55½ in. (117 x 141 cm). Rijksmuseum, Amsterdam

42

lar example of his work captured the imagination of numerous painters, no doubt in part because its bizarre form allowed it to pass as an object from an ancient and foreign land.[11] Pieter Lastman (1583–1633) included the ewer in at least seven pictures dating from between 1615 and 1630.[12] Other Dutch artists who incorporated the ewer in one or more paintings include Adriaen van Nieulandt (1587–1658), in a large kitchen still life dated 1616 (Herzog Anton Ulrich-Museum, Braunschweig);[13] Thomas de Keyser (q.v.), in a group portrait of the Amsterdam silversmiths' guild, dated 1627 (formerly Musée des Beaux-Arts, Strasbourg; destroyed in World War II);[14] Jacob Backer (q.v.), in *David and Bathsheba*, of 1640 (art market, 1996);[15] Salomon Koninck (1609–1656), in *King Solomon's*

Idolatry, of 1644 (Rijksmuseum, Amsterdam), and at least five other paintings;[16] and Flinck (q.v.), in *Marcus Curtius Dentatus Refusing the Gifts of the Samnites*, dated 1656 (Royal Palace, Amsterdam).[17] Van den Eeckhout himself passed the object on from Isaac's house to King David's palace (1646; Národni Galerie, Prague), and to scenes of Scipio's continence (ca. 1652; Instituut Collectie Nederland, Amsterdam) and Joseph returned to his brothers (ca. 1668; Skokloster Castle, Sweden).[18]

1. With Lesser, London, according to R. Bangel in Thieme and Becker 1907–50, vol. 10 (1914), p. 335. Bangel describes the "blond, bright Rembrandtesque tonalism" of the painting, suggesting that its palette differs from that of the Museum's picture. He does not give measurements. The painting may be the same as the one in the following sales. In both catalogues the dimen-

Figure 46. Adam van Vianen, Ewer, 1614. Silver gilt, height 10⅛ in. (25.5 cm). Rijksmuseum, Amsterdam, purchased with funds from the Prins Bernhard Fonds, the Vereniging Rembrandt and the Commissie voor Fotoverkoop

Figure 47. Detail of Van den Eeckhout's *Isaac Blessing Jacob* (Pl. 42)

sions (39½ x 49½ in. [100.3 x 125.7 cm]) are given, but there is no mention of a signature or date: Christie's, London, March 4, 1921 (property of Mary, Lady Carbery, and other sources), no. 11, sold to Peacock; Christie's, London, April 27, 1925, no. 70, sold to Spiller. Another painting dated 1641, *Moses and Aaron*, is untraced since 1893 (see Sumowski 1983–[94], vol. 2, p. 725 [under no. 392]).

2. Sumowski 1983–[94], vol. 2, pp. 742, 893, no. 476 (as 1671); Ember in Cologne–Utrecht 1987, pp. 72–73, no. 14 (as 1641).

3. See Sumowski 1983–[94], vol. 2, nos. 392, 393, 395, 398.

4. Ibid., vol. 3, no. 1182.

5. Von Moltke 1965, no. 8; Sumowski 1983–[94], vol. 2, no. 614 (see also no. 613); Hamburg 1983–84, no. 235.

6. Sumowski 1983–[94], vol. 2, nos. 907, 908 (Dulwich), 909. See also Stockholm 1992–93, no. 92.

7. See Washington–Detroit–Amsterdam 1980–81, no. 35; Paris 1988–89, pp. 82–86.

8. See Refs., under Judson in Chicago–Minneapolis–Detroit 1969–70, and under Haussherr 1976. The two drawings in question are catalogued in Benesch 1954–57, vol. 3, as no. 507, fig. 667 (formerly Van Diemen collection, Berlin), and no. 509, fig. 669 (formerly Bondi collection, Vienna). Martin Royalton-Kisch, at the British Museum, considers Benesch no. 507 to be by or close to Nicolaes Maes, as others have suggested before. Benesch no. 509, and to a lesser extent nos. 508 and 510 (also catalogued by Benesch as Rembrandt drawings of Isaac Blessing Jacob), he considers "close to the [Carel] 'Fabritius Group,' which needs further work to know whether these really belong" (personal communication, February 18, 2005).

9. See *Corpus* 1982–89, vol. 3, p. 29, fig. 18, and pp. 215–16, figs. 6, 8. The empty chair facing the dramatis personae is also a Rembrandt device, found, for example, in his large etching *The Death of the Virgin*, dated 1639 (B99).

10. As noted by T. Schroder in *Dictionary of Art* 1996, vol. 32, p. 401 (ill. p. 400). Klessmann 1981 discusses the negative meaning of the ewer in several Dutch paintings, relating it to an emblem in Visscher 1614, which explains that such objects are useless for daily life and serve instead to foster conflict, discord, and so on.

11. See Ter Molen 1979 on Van Vianen's fame and on the representation of his silver ewer in various Dutch paintings. A more detailed account of the object's appearance in pictures is given in Duyvené de Wit-Klinkhamer 1966, pp. 86–96. The use of contemporary silver to decorate ancient tables was not unusual; compare the Museum's painting by Rubens and Jan Breughel the Elder, *The Feast of Acheloüs*, of about 1614–15 (Liedtke 1984a, pp. 194–98, pl. XIV).

12. According to Broos 1993, p. 170, where Van den Eeckhout and four other painters are also named. See also Amsterdam 1991–92, nos. 8, 11, and Van Schooten and Wüstefeld 2003, no. 43, for Lastman's use of the ewer in paintings of 1615, 1617, and 1625.

13. Klessmann 1983, pp. 152–53, no. 212 (ill.).

14. Duyvené de Wit-Klinkhamer 1966, pp. 95–97, fig. 14. See also the discussion of De Keyser's *Portrait of a Silversmith*, dated 1630, in the sale catalogue *Pictures and Watercolours from Longleat*, Christie's, London, June 14, 2002, no. 593, where the group portrait is reproduced.

15. The painting survives as a fragment; Christie's, London, July 3, 1996, no. 338.

16. Sumowski 1983–[94], vol. 3, nos. 1084–86, 1097, 1101, 1102.

17. Von Moltke 1965, no. 113, pl. 22.

18. Sumowski 1983–[94], vol. 2, nos. 403, 411, 467.

REFERENCES: B. Burroughs 1925a, p. 142 (ill. p. 146), mentions the painting as part of the Huntington bequest; Chicago 1935–36, p. 24 (under no. 16), cites the picture in the entry for Flinck's painting of the subject, dated 1638; Isarlov 1936, p. 34, listed ("où?") among paintings signed and dated by Van den Eeckhout; Ivins 1942a, p. 3, listed as one of the approximately sixteen works by Rembrandt pupils on view in the Museum's galleries; Brion and Heimann 1956, p. 212, fig. 55; Sumowski 1957–58, pp. 239, 278, fig. 127, compares the picture with the Rembrandt school *Christ Washing the Feet of the Disciples*, in the Art Institute of Chicago; Sumowski 1962, pp. 11–12, includes it among early paintings by Van den Eeckhout that reveal the influence of Pieter Lastman; Duyvené de Wit-Klinkhamer 1966, pp. 91, 93, fig. 13 (detail), cites the work among pictures that include Adam van Vianen's silver ewer of 1614; Haak 1969, p. 183, fig. 294, shows "a strong dependence on Rembrandt" and depicts Van Vianen's ewer; Judson in Chicago–Minneapolis–Detroit 1969–70, pp. 57–58, no. 45 (ill. p. 129), compares the picture's composition with that of a drawing by Rembrandt [?], and with Flinck's painting of the subject dated 1638; R. Roy 1972, pp. 7–9, 212, no. 11; Pigler 1974, vol. 1, p. 60, listed; Bader in Milwaukee 1976, pp. 36–37, no. 13 (ill.), compares Rembrandt and Lastman, and offers original remarks on the interpretation of the subject; Haussherr 1976, pp. 27–28, fig. 19, agrees with Judson (in Chicago–Minneapolis–Detroit 1969–70) that Van den Eeckhout appears to have referred to a drawing by Rembrandt; Sumowski 1979–95, vol. 3 (1980), p. 1320 (under no. 605), compares the composition to that of a drawing by Van den Eeckhout, *David's Promise*

to *Bathsheba*, of about 1642–43 (MMA); Foucart in Washington–Detroit–Amsterdam 1980–81, p. 163, mentions the work among interpretations of the subject by Rembrandt pupils; Broos 1981, p. 110, refers to the silver ewer; Sumowski 1983–[94], vol. 2, pp. 720, 726, 760, no. 397 (ill.), describes the picture as an early work influenced by Lastman and by Rembrandt's approach to composition, coloring, and chiaroscuro, and vol. 6, p. 3600, listed among Rembrandt school pictures of this subject; P. Sutton 1986, p. 183, relates the painting to Rembrandt; Foucart in Paris 1988–89, p. 85, cites the work in a list of paintings of this subject by Rembrandt disciples; Liedtke 1990, p. 37, noted as part of the Huntington bequest; P. Sutton 1990a, pp. 82, 83 n. 17, mentions the inclusion of the silver ewer; Broos in The Hague–San Francisco 1990–91, pp. 224–28, no. 19 (ill.), discusses the subject, dwells at length on the silver ewer, and confuses the picture's provenance; Sumowski in The Hague 1992a, pp. 59–60, fig. 20, claims that Lastman influenced the composition and coloring; Baetjer 1995, p. 328; Liedtke in New York 1995–96, vol. 2, pp. 20, 22, 145, no. 47, discusses Rembrandt's influence, compares the work unfavorably with Flinck's painting of the subject dated 1638, and mentions interpretations by other Rembrandt pupils; Logan in ibid., p. 197 (under no. 83), observes that the composition is similar to that employed in the Museum's drawing by Van den Eeckhout, *David's Promise to Bathsheba*; Ben Broos in *Dictionary of Art* 1996, vol. 9, p. 742, fig. 1, describes the painting's style as a combination of "Lastman's palette and Rembrandt's lighting and formal language," and notes the inclusion of the ewer by Van Vianen; T. Schroder in ibid., vol. 32, p. 401, cites the painting as one of the many to illustrate Van Vianen's famous ewer; Gaillemin 1997, pp. 96–97 (detail ill.), uses the painting to illustrate the ewer; V. Manuth in *Saur AKL* 1992– , vol. 32 (2002), p. 236, listed.

EXHIBITED: New York, MMA, "The Art of Rembrandt," 1942; Hempstead, N.Y., Hofstra College, "Metropolitan Museum Masterpieces," 1952, no. 14; New York, The Jewish Museum, "The Hebrew Bible in Christian, Jewish, and Muslim Art," 1963, no. 46; Little Rock, Ark., Arkansas Art Center, "Five Centuries of European Painting," 1963 (p. 26); Chicago, Ill., The Art Institute of Chicago, Minneapolis, Minn., The Minneapolis Institute of Arts, and Detroit, Mich., The Detroit Institute of Arts, "Rembrandt after Three Hundred Years," 1969–70, no. 45; Milwaukee, Wis., Milwaukee Art Center, "The Bible through Dutch Eyes," 1976, no. 13; Boston, Mass., Museum of Fine Arts, "Dutch Silver, 1580–1830," 1980, hors cat.; The Hague, Mauritshuis, and San Francisco, Calif., The Fine Arts Museums of San Francisco, "Great Dutch Paintings from America," 1990–91, no. 19; New York, MMA, "Rembrandt/Not Rembrandt in The Metropolitan Museum of Art," no. 47.

EX COLL.: ?Elisabeth Hooft, widow of Wouter Valckenier (until d. 1796; her estate sale, C. Blasius et al., Amsterdam, August 31–September 1, 1796, no. 10, for Fl 630);[1] ?Pieter Nicolaas Simonsz van Winter, Amsterdam (until d. 1807);[2] ?his daughter Annewies (Anna Louisa Agatha) van Winter, Amsterdam (1807–15); Annewies van Winter and her husband, Willem van Loon (1815–his d. 1847; her d. 1877); possibly sold to Alphonse, Gustave, and Edmund de Rothschild, Paris;[3] Collis P. Huntington, New York (until d. 1900;[4] life interest to his widow, Arabella D. Huntington, later [from 1913] Mrs. Henry E. Huntington, 1900–d. 1924; life interest to their son, Archer Milton Huntington, 1924–terminated in 1925); Bequest of Collis P. Huntington, 1900 25.110.16

1. See Broos in The Hague–San Francisco 1990–91, pp. 225–26. The possibility that the painting was in Pieter van Winter's collection adds some weight to the identification of the Museum's picture with the Van den Eeckhout of this subject described in the 1796 sale catalogue. Broos (ibid., p. 226) concludes that the Museum's picture was also in a sale held at The Hague on April 24, 1737 (see Hoet 1752–70, vol. 3, p. 13, no. 34), but this is too conjectural for inclusion under Ex Coll. here.
2. See Priem 1997, p. 219, no. 58.
3. In a letter dated March 9, 2000, Michael Hall, curator to Edmund de Rothschild, describes his study of a manuscript inventory and valuation prepared by Frederic Reiset, director of the Louvre, for the Rothschild family with a view to the purchase *en bloc* of the Van Winter–Van Loon collection in 1877 (see also Priem 1997, p. 104). "The widow Van Loon died in 1877 and her children sold most of the pictures to a consortium of Rothschilds. . . . Some pictures were refused and sold in Amsterdam in the following year. Some pictures were sold by the Rothschilds after they had been divided. I believe your Gerbrand van den Eeckhout to be no. 28 in Lot 3 of Rieset's valuation, destined for a French Rothschild, as yet unidentified." The Van Loon sale in Amsterdam was held on February 26, 1878, and did not include the painting by Van den Eeckhout (kindly checked by Edwin Buijsen at the Rijksbureau voor Kunsthistorische Documentatie, The Hague).
4. Broos in The Hague–San Francisco 1990–91, pp. 225, 226, 228 nn. 5, 8, invents a scenario according to which another painting by Van den Eeckhout, sold in London in 1921 and 1925 (see text note 1 above), might be the Museum's picture. The latter painting was in the collection of Collis P. Huntington when he died in 1900, leaving his paintings to the Museum. Cited by artist and title, it was listed as in the hallway of Collis P. Huntington's house at 2 East 57th Street, New York, in an appraisal of the collection dated October 21, 1902 (kindly brought to the present writer's attention by Barbara File, Museum archivist, on February 24, 2005).

43. *A Musical Party*

Oil on canvas, 20 x 24¼ in. (50.8 x 64.5 cm)

The painting is in a poor state. Its surface is severely abraded from past cleaning. The increasing exposure of the medium-brown ground, which has contributed to the overall darkening of the painting, is the result partially of natural aging and partially but more significantly to restoration treatments that have physically and optically thinned the paint layers. X-radiography reveals large losses of paint and ground along the perimeter, especially at the bottom and left side. Raking light reveals the rough texture of later filling and retouching, which extends 1–4 in. (2.5–10.2 cm) into the paint. A thin strip of golden metallic paint has been applied to the edges all around. Small modern nails set at intervals of 1¼ in. (3.2 cm) have been driven into the face of the painting along all borders.

Bequest of Annie C. Kane, 1926 26.260.8

Although entirely typical of Van den Eeckhout in the early 1650s, this painting was given to the Museum as a work by the Amsterdam genre painter Barent Graat (1628–1709), and was earlier considered to be by Pieter de Hooch (q.v.). Both artists set similar figures on terraces, Graat as early as 1652, and De Hooch not until the 1660s.[1] Van den Eeckhout has long been a familiar figure as a Rembrandtesque history painter (see Pl. 42), but his important contribution to scenes of modern society was generally overlooked until the 1960s.[2] Valentiner must have known the artist's *A Party on a Terrace*, of 1652 (fig. 48; sold by the dealer R. Langton Douglas to the Worcester Art Museum in 1922), or with a similar work when he suggested in 1930 that the New York picture was actually by Van den Eeckhout.[3]

The painting shows five stylish young people socializing on the garden terrace of an impressive country house, to judge from the scale of the columns and the extent of the trees. A servant stands to the left, looking in the direction of the couple singing from a songbook (the woman keeps time with her hand).[4] Another songbook lies open on the table (compare those in *A Musical Party* by Gabriël Metsu; Pl. 116). The man in the background gestures to his heart, to which his lovely companion seems to be respond somewhat stiffly (she holds a fan, which can indicate a cool reception).[5] Van den Eeckhout made just such an encounter the main motif of the painting in Worcester (fig. 48), where couples in the background appear to be further along in their courtships. The main figure here probably feels that he has much to offer a young woman, given his especially chic attire and the fashionable attribute of a greyhound (which implies hunting; see Pl. 33). The empty chair to

the right, although quite an elegant piece of furniture, offers little hope of pleasure to a dandy cast in the role of fifth wheel. The young man's body language is both natural and symbolic, the pose of someone spending too much time watching other people enjoy themselves and of figures in art (going back at least to Dürer's famous engraving of the subject) that stand for melancholia.[6]

It has often been observed that the pictures of *buitenpartijen* (alfresco parties) and *gezelschapjes* (Merry Companies) painted by Van den Eeckhout, Jacob van Loo (1614–1670), and other Dutch artists in the 1650s and 1660s brought an earlier type of composition up-to-date, namely, the scenes of wining, dining, making music, and musing about making love that were often set on palatial terraces and on the grounds of grand estates by such painters as David Vinckboons (q.v.), Esaias van de Velde (1587–1630), and Willem Buytewech (1591/92–1624).[7] Like Gerard ter Borch (q.v.), if not so consistently, Van den Eeckhout brought to this genre an eye for how people hold themselves and behave in social situations. He also modernized his Rembrandtesque style (compare Pl. 42), so that the play of light and shadow not only brings out the key protagonists but also suggests mood and other qualities, in this case a physical intimacy similar to that found in his contemporaneous pictures of courtship set indoors (in particular, the *Musical Company*, of 1653, in the Gemeentemuseum, The Hague, and the *Interior with a Singing Couple and a Listener*, of 1655, in the Statens Museum for Kunst, Copenhagen).[8] The composition is also very much of the 1650s, with its triangular grouping of figures, vertical elements, and nearly parallel arms and legs. Unfortunately, the appeal of the picture has been much diminished by darkening with age and abrasion (see condition note above).

1. See Graat's paintings of modern-day prodigal sons dated 1652 and 1661 in the Rijksmuseum, Amsterdam (Van Thiel et al. 1976, p. 247).
2. In Plietzsch 1960 the chapter on painters of genre interiors and Merry Companies in Amsterdam and elsewhere after 1650 includes numerous secondary figures and also Jacob van Loo (1614–1670), who is now usually cited in the same breath with Van den Eeckhout as a key figure for Dutch genre painting in the 1650s (see, for example, Naumann in Philadelphia–Berlin–London 1984, pp. 238–39 [under no. 64]). Van den Eeckhout is not mentioned at all. In 1956, Valentiner gave him his due, albeit in the curious context of "Rembrandt and his pupils" (see Exhibited), and in J. Rosenberg, Slive, and Ter Kuile 1966, p. 94, it is acknowledged that "around 1650 he depicted genre scenes which anticipate Pieter de Hooch." The Worcester *Party on a*

43

Figure 48. Gerbrand van den Eeckhout,
A Party on a Terrace, 1652. Oil on canvas,
20¼ x 24½ in. (51.4 x 62.2 cm). Worcester
Art Museum, Worcester, Massachusetts

Terrace (fig. 48 here) was included in the exhibition "Rembrandt after Three Hundred Years," 1969–70 (see Chicago–Minneapolis–Detroit 1969–70, no. 50). Nonetheless, Rainer Roy's Viennese dissertation of 1972, "Studien zu Gerbrand van den Eeckhout," was for genre painting specialists of the time a source of seemingly secret knowledge.

3. Oral opinion, recorded in the curatorial files. According to other memos, the attribution to Graat was proposed by Colin Agnew; curators Bryson Burroughs and H. B. Wehle went along with it "partly on the basis of comparison with the superior Eeckhout in the museum at Worcester." F. Schmidt-Degener, in a letter to Wehle dated November 16, 1931, tentatively assigned the painting to Van den Eeckhout on the basis of a photograph, but told Wehle in 1935 that it might be by Graat. Frits Lugt and Sturla Gudlaugsson (orally, 1943 and ca. 1952–53, respectively) favored Van den Eeckhout. "Your painting is certainly by him and not by Barend Graat," W. R. Valentiner observes in a letter to Margaretta Salinger dated March 13, 1957. "I have had several students here [in Raleigh, where the work had just been exhibited] who agreed with me; also, Dr. [J. G.] van Gelder wrote to me about it." In 1971, curator John Walsh pursued the matter at the Rijksbureau voor Kunsthistorische Documentatie, The Hague, concluding that "this is a typical work by Eeckhout of the 1650s."

4. On keeping time with a raised hand, see Franits 1993a, p. 208 n. 89, and Liedtke 2000a, p. 246, fig. 304, on the same gesture in *The Concert*, of about 1665–67, by Vermeer (Isabella Stewart Gardner Museum, Boston). As noted there, the act of measuring musical time might be taken as a reference to the virtue of temperance, depending on the context (see also Salomon 1998a, p. 124). Such a meaning is more likely intended in the painting by Vermeer (where a brothel scene hangs on the wall behind the singing woman) than in the Van den Eeckhout.

5. See Franits 1993a, pp. 43–44, 208 n. 86.

6. As noted in ibid., pp. 44, 208–9 n. 90.

7. See Sumowski 1979–95, vol. 3, p. 1370 (under no. 630), Van den Eeckhout's drawing *Party on a Terrace* (Fondation Custodia, Institut Néerlandais, Paris), citing earlier literature; P. Sutton in Philadelphia–Berlin–London 1984, pp. xxix–xxx, nos. 25, 43, 64, 112, 113, 121, 122, pls. 1–5, 87, 88; Pittsburgh 1986; Franits 1993a, pp. 37–46; Haarlem–Hamburg 2003–4, nos. 1, 2, 4; and Franits 2004, pp. 18–33. Prints were important for this tradition, as is evident from several that are discussed in Amsterdam 1997a, for example, nos. 8, 12, 19, 28, 33, 34.

8. Sumowski 1983–[94], vol. 2, nos. 503, 509. The subject of the Copenhagen picture bears comparison with that of the New York painting, which probably dates from two or three years earlier.

REFERENCES: Valentiner in Raleigh 1956, p. 117, no. 26, as by Van den Eeckhout, "formerly attributed to Barent Graat," compares the painting of 1652 now in the Worcester Art Museum (fig. 48 here); R. Roy 1972, p. 232, no. 141, as probably dating from the mid-1650s; F. Robinson in Saint Petersburg–Atlanta 1975, pp. 34–35, no. 21 (ill.), dates the work to the early 1650s and compares similar genre paintings by the artist; Sumowski 1979–95, vol. 4 (1981), p. 1796, relates the costume of the figure in the foreground to that of the Prodigal Son in a drawing by Barent Fabritius; Sumowski 1983–[94], vol. 2, pp. 747, 870, no. 507 (ill.), suggests a date of about 1652–55 on the basis of similar works by the artist that bear dates; P. Sutton in Philadelphia–Berlin–London 1984, p. 201, fig. 2, compares the painting with the artist's *A Party on a Terrace*, of 1652 (fig. 48 here); Franits 1993a, pp. 44–45, fig. 29, and p. 208 n. 89, compares the Worcester painting and describes the behavior of the figures, in particular that of the man in the foreground with "his head resting on his hand, the time-honored gesture of melancholia," which identifies him as "the classic spurned suitor"; Baetjer 1995, p. 328; Liedtke in New York 1995–96, vol. 2, pp. 22, 145; V. Manuth in *Saur AKL* 1992– , vol. 32 (2002), pp. 234, 236, listed, and cites the work as representing an important step in the development of Dutch genre painting during the 1650s; Franits 2004, pp. 179, 289 n. 23, fig. 163, describes the subject in detail, and notes that the spurned suitor's laments are like those commonly voiced in amatory poetry and songs of the period.

EXHIBITED: Amsterdam, Frederik Muller & Co., "Maîtres hollandais du XVIIe siècle," 1906, no. 65, as by Pieter de Hooch; Pensacola, Fla., Pensacola Art Center, "Opening Exhibition," 1955; Jacksonville, Fla., Jacksonville Art Museum, and Raleigh, N.C., North Carolina Museum of Art, "Rembrandt and His Pupils," 1955–56, no. 26; Westport, Conn., Westport Community Art Association, "Music in Art," 1963; Saint Petersburg, Fla., Museum of Fine Arts, and Atlanta, Ga., High Museum of Art, "Dutch Life in the Golden Age," 1975, no. 21.

EX COLL.: Probably William C. Schermerhorn (d. 1903), New York, father of the following; Annie Cottenet Schermerhorn Kane, New York (by 1923–d. 1926); Bequest of Annie C. Kane, 1926 26.260.8

JAN EKELS THE YOUNGER

Amsterdam 1759–1793 Amsterdam

Ekels was born in Amsterdam on June 28, 1759.[1] He died there (reportedly after a stroke) on June 4, 1793, shortly before his thirty-fourth birthday.[2] He was trained by his father, Jan Ekels the Elder (1724–1781), a cityscape painter in the tradition of Jan van der Heyden (q.v.). The elder Ekels's father owned a dye factory, and the family was prosperous. Jan the Younger did not pursue painting and drawing in order to support himself.

Ekels was enrolled in the Amsterdam Tekenacademie (Drawing Academy) on October 5, 1774, and in 1776 won third prize. Still a teenager, he spent the next two years studying art in Paris, and between 1779 and 1781 he was again at the Amsterdam academy. In 1783, with two artist friends, Daniel Dupré (1752–1808) and Jacques Kuyper (1761–1808), Ekels traveled up the Rhine, visiting places such as the picture galleries in Düsseldorf and Mannheim. Upon his return to Amsterdam, he became active in the recently formed Felix Meritis Society, a "Temple of Enlightenment" on the Keizersgracht, which was (and remains) devoted to the pursuit of the arts, sciences, and learning in general. In his will, he left 1,000 guilders to the organization.

Ekels is best known for "conversation pieces" like the one discussed below. One of his most admired works is the *Writer Sharpening His Pen,* of 1784 (Rijksmuseum, Amsterdam), which is at once very much of its time and an homage to earlier Dutch masters such as Gabriël Metsu and Johannes Vermeer (q.q.v.).[3] A full-length portrait of an officer, dated 1787, and an undated portrait of the landscapist Egbert van Drielst (1745–

1818) give some idea of the artist's range as a portraitist.[4] An impressive group portrait of two couples playing music dates from 1785.[5] Two small genre pictures, one of a smoker, dated 1787, the other of a young draftsman seated by a window (n.d.), are in the Städelsches Kunstinstitut, Frankfurt.[6]

Fewer than two dozen paintings by Ekels may be located today. However, works now unknown are cited in a number of old sale catalogues and estate inventories. An obituary published in the *Algemene Konst- en Letterbode* of June 13, 1793, refers to the artist's widespread fame, especially as a draftsman. In addition, "many of his paintings are preserved in the Cabinets of the foremost and most knowledgeable amateurs, and are most highly esteemed."[7]

1. See Knoef 1928, p. 55 n. 1. Ekels was baptized "Joannes Hermannus" in a Catholic ceremony. His mother's name was Sebilla Angenent.
2. Ibid., p. 58. Ekels was buried in the Nieuwezijds Kapel on June 6, 1793.
3. See Loos, Jansen, and Kloek 1995, no. 32. See also the drawing of three men playing cards (1784) discussed in Haarlem 1989, p. 218 (under no. 245). Like other works by Ekels, the drawing (which was made in preparation for a painting now lost) represents modern figures but adopts the composition of a seventeenth-century genre scene.
4. For the portrait of an officer, see Van Thiel et al. 1976, p. 216, and Blankert 1979, pp. 101–2, no. 136. On the portrait of Van Drielst, see De Bruyn Kops 1968.
5. Sold at Phillips, London, December 7, 1993, no. 24.
6. Sander and Brinkmann 1995, p. 29, figs. 27, 28. The picture of a humble smoker brings Adriaen van Ostade (q.v.) up-to-date.
7. Quoted in Knoef 1928, p. 49.

44. *Conversation Piece (The Sense of Smell)*

Oil on canvas, 25⅞ x 23½ in. (65.7 x 59.7 cm)
Signed and dated (lower right, on dado): I.EKELS. F/A°
17[?][1?] —

The paint surface is abraded throughout along the crowns of the canvas weave.

Gift of Mr. and Mrs. Bertram L. Podell, 1981 1981.239

This characteristic work by Ekels was probably painted in 1791, as the now fragmentary date was read in the past (see Refs.). The picture almost certainly comes from a series of five canvases depicting the Five Senses, of which four paintings are presently known. *The Sense of Hearing* (fig. 49) was in collections together with the Museum's picture until 1964, and reappeared on the

Figure 49. Jan Ekels the Younger, *The Sense of Hearing*, 1791. Oil on canvas, 25¾ x 23⅜ in. (65.5 x 59.5 cm). Location unknown

Figure 50. Jan Ekels the Younger, *The Sense of Taste ("The Wine Tasters")*, 1791. Oil on canvas, 26 x 24 in. (66 x 61 cm). Stedelijk Museum De Lakenhal, Leiden

English art market in 1994.[1] *The Sense of Taste ("The Wine Tasters")*, signed and dated 1791, is in Leiden (fig. 50). It depicts a standing gentleman draining the last drop from a wineglass, while a maid offers a glass of wine to a seated man holding a clay pipe. The fourth canvas (fig. 51), has confounded critics, since it too appears to represent Taste.[2] Two men sit casually at a table, one holding a glass of wine, the other a pipe. A young woman stands behind the table, resting her arm on the back of a chair. The man with the wineglass points to it and speaks while glancing upward thoughtfully, as if extolling the virtues of the wine. His two companions listen, smile, and seem to stare at the glass. Within the narrow parameters defined by the series as a whole, it is reasonable to assume that the picture represents Sight.

When the New York painting was sold in 1964, it was entitled *Taste,* and it was correctly noted that a man takes snuff, another man smokes (he lights his clay pipe in a metal brazier), and a woman dips a biscuit in a glass of wine. However, Knoef (see Refs.) was surely correct in calling the painting *Smell.* In each of the four known pictures, the figure on the left appears to define the subject: a man drinks, a man sniffs, a woman listens demonstratively (her seated companion does not), and a man points to his glass as if drawing attention to the wine's color. It is conceivable, of course, that the London

painting stood for Taste in another series of pictures, but none of its figures is tasting anything, and biscuits (present in Leiden and New York) have not been provided. No other known painting by Ekels qualifies as a representation of one of the senses.[3]

The four paintings are all on canvas, with the same dimensions. Each one shows two men and a woman in a room, which is furnished with a colorful rug, a covered table with the same kind of chairs, and in three of the pictures a foot warmer. The backgrounds all feature a bare wall with a curtain pulled to one side and a door to the left or right, with an overdoor painting depicting a classical relief (in the present picture, maidens worship a Bacchic herm). Indications that at least one of the men is visiting occur throughout: a coat tossed over a chair, a hat set down on the floor, and in the Museum's picture a walking stick.

The idea of painting a series of pictures devoted to the Five Senses is one of the many notions Ekels derived from seventeenth-century Dutch art. However, the treatment of the theme in a suite of gentrified genre scenes was his own idea. This allowed him to indulge in a none too searching survey of modern manners, and a closer study of various poses, gestures, and expressions. The latter interest, when observed in the series as a whole, creates the impression of an artist who had spent a good deal of time in a drawing academy.

44

Figure 51. Jan Ekels the Younger, *The Sense of Sight* (?), 1791. Oil on canvas, 25½ x 23½ in. (64.8 x 59.7 cm), National Theatre, London

p. 114, as "German, 18th C."). A drawing teacher speaks about a piece of sculpture, and a seated female student stares at it. However, this smaller canvas (22⅛ x 17¾ in. [57.5 x 45 cm]) with two figures cannot belong to the same series as the paintings under discussion.

REFERENCES: Knoef 1928, p. 51, fig. 1 (opp. p. 49), cites the painting as with the art dealer Dr. Benedict & Co., Berlin, considers the work to represent Smell within a series of paintings depicting the Five Senses, and states that the picture dates from 1791; Knoef 1943, pp. 25–26 (ill. p. 22), as *Smell*, dated 1791, repeats the author's remarks of 1928, including praise for the painting's quality, notwithstanding the "impersonal formalism" of the woman's face; Mander and Mitchenson 1955, pp. 269–71, fig. 2, as *Smell*, relates the painting and that representing Hearing to Ekels's canvas in the National Theatre, London (called *Taste*; see text above), and notes that both *The Sense of Smell* and *The Sense of Hearing* were in the Waltfried sale of 1928 (see Ex Coll.); De Bruyn Kops 1968, pp. 63, 66 n. 10, describes the canvas as one of four known pictures representing the Five Senses; Stedelijk Museum De Lakenhal 1983, p. 129 (under no. 88), relates the picture to *The Sense of Taste ("The Wine Tasters")*, dated 1791, in Leiden (see text above); Baetjer 1995, p. 343, as *Conversation Piece*.

EX COLL.: [Dr. Benedict & Co., Berlin, until 1928]; C. Waltfried (1928; his sale, Jacob Hecht, Berlin, November 13, 1928, no. 386a, with no. 386, *Hearing*); ?private collection, Brumfield, Nottingham; sale, Christie's, London, July 17, 1964, no. 209 [as *Taste*, followed by no. 210, *The Sense of Hearing*], for Gn 280 to Houthakker; [Bernard Houthakker, Amsterdam, between 1964 and 1968];[1] Mr. and Mrs. Bertram L. Podell, New York (until 1981); Gift of Mr. and Mrs. Bertram L. Podell, 1981 1981.239

1. Phillips, London, April 19, 1994, no. 103. No inscription on this painting is recorded in any sale catalogue.
2. See Mander and Mitchenson 1955, pp. 268–71, where all four paintings are illustrated, and Stedelijk Museum De Lakenhal 1983, p. 129 (under no. 88).
3. The anonymous author of the entry in Stedelijk Museum De Lakenhal 1983, p. 129, cites a painting that is probably by Ekels, and suggests that it may depict Sight (ill. in *Weltkunst* 39 [1969],

1. De Bruyn Kops in 1968 (see Refs.) described the painting as passing from the 1964 auction to the Amsterdam art market and then to a private collection. A Houthakker sticker is on the stretcher.

BARENT FABRITIUS
Middenbeemster 1624–1673 Amsterdam

arent Fabritius and his celebrated brother, Carel (1622–1654), were the oldest of at least eleven children born to the schoolteacher and minor painter Pieter Carelsz (ca. 1598–1653) and his wife, Barbertje Barentsdr van der Maes (1601–1667).[1] The family lived in Middenbeemster, a village in the Beemster polder about nineteen miles north of Amsterdam. The brothers must have learned the rudiments of painting from their father. In May 1641, when Barent was sixteen (he was baptized on November 16, 1624), he and Carel were confirmed as members of the Beemster's Reformed Church. In September of the same year, Carel married the girl next door and shortly after moved to Amsterdam, where he became one of Rembrandt's most gifted pupils. The family's adoption of the Latinized surname Fabritius has been much discussed.[2] Barent was preceded in using it by his father and older brother.

By the fall of 1643, Carel's wife and two infants had died and he had returned to Middenbeemster. He remained there until 1650, when he married a woman in Delft and was said to be living there. It seems likely that Carel's proximity was important for Barent, who so far as is known never studied with an artist outside his immediate family. His earliest known works, which date from about 1650 onward, reveal the influence of Carel's paintings of the 1640s, and of Rembrandt in a more general way.[3] Barent's best pictures date from the mid-1650s and are even more indebted to his brother's recent work. They include the *Portrait of a Man as a Shepherd,* of about 1655 (Gemäldegalerie der Akademie der Bildenden Künste, Vienna), which is probably a self-portrait.[4]

On August 18, 1652, "Barent Pietersz. Fabricius, bachelor from Beemster, living in Amsterdam, and Catharina Mussers, bachelorette from Breda, living in Delft," were married in Middenbeemster. The couple's sons, Pieter and Valentijn, were baptized in the same town on April 7, 1653, and April 25, 1655, respectively.[5] A portrait by Barent of the municipal architect of Leiden, Willem van der Helm, and his wife and son (Rijksmuseum, Amsterdam) is dated September 30, 1656, and suggests that he may have moved there by that time. On January 22, 1657, the artist signed a contract to rent a house in Leiden for three years, beginning on May 1 of the same year. He joined the Leiden painters' guild on May 14, 1658, and paid his annual dues on October 9, but next to that entry in the account book it is noted (possibly at a later date) that he had left the city.[6]

Between August and December 1661, Fabritius was paid for his work on five large canvases depicting biblical parables, which were installed on the front of the balcony below the organ in the Lutheran Church of Leiden.[7] Three of the paintings survive and are in the Rijksmuseum, Amsterdam. He is recorded as a resident of Middenbeemster, and as a member of the Reformed Church there, in the register for the year 1665–66. Fabritius was living in Amsterdam in the year of his death. He was buried there on October 20, 1673, in the Leidse Kerkhof, leaving his wife and six children.[8]

Fabritius painted religious pictures intended mostly for private clients, and some mythological works and genre pictures. He could have made a career as a portraitist, but evidently failed or declined to do so. His works of the 1660s are generally inferior to those of the previous decade, which may reflect financial realities (hasty production often went with hard times), and, for this artist, an unfortunate shift in contemporary taste. The looser, smoother, more elegant manner that Fabritius developed in his later years is found in other Dutch painters of the time—Gerbrand van den Eeckhout (q.v.) seems the closest parallel and may have been a model—but the turn away from descriptive qualities in favor of a suaver style led the artist into territory he was unprepared to explore.

1. See the family tree in The Hague–Schwerin 2004–5, p. 12, and F. Duparc's essay, pp. 14–16. Another Barent, born in 1623, died before the painter Barent was born, and at least one other child died in infancy.
2. See ibid., pp. 15–17. Some scholars connect the name with carpentry, others with its earlier use by humanist scholars.
3. This is all the more apparent now that a few pictures of the 1640s have been added to Carel Fabritius's known oeuvre: see The Hague–Schwerin 2004–5, nos. 2, 3, 5, 6, and compare Barent's *Expulsion of Hagar and Ishmael,* of about 1650 (Fine Arts Museums of San Francisco; see Pont 1958, no. 3, fig. 3; Sumowski 1983–[94], vol. 2, no. 547; and Berlin–Amsterdam–London 1991–92a, no. 81).
4. Trnek 1992, pp. 131–35, no. 46; Melbourne–Canberra 1997–98, no. 58. Compare the *Self-Portrait,* dated 1650, in the Städelsches Kunstinstitut, Frankfurt (Pont 1958, no. 31, fig. 4).

5. See Pont 1958, p. 139, for these documents.
6. Ibid.
7. First published in Liedtke 1977, p. 319.

8. Pont 1958, p. 140. In *Dictionary of Art* 1996, vol. 10, p. 732, Irene Haberland misreads the Dutch, so that Barent is buried in a churchyard in Leiden that for some reason was reserved for poor residents of Amsterdam.

45. *Abraham Dismissing Hagar and Ishmael*

Oil on wood, 19½ x 14 in. (49.5 x 35.6 cm)
Signed and dated (bottom center): ßFabritius/1658

The painting is well preserved, although the tree branches painted over the sky at upper right are slightly abraded. The oak panel retains its original thickness, and the bevels are intact around all the edges.

Bequest of Harry G. Sperling, 1971 1976.100.23

The signature and date on this well-preserved picture are almost invisible under normal viewing conditions, but there is no doubt about the reading given above. In 1658, Fabritius was thirty-four years old and living in Leiden with his family. He had probably been painting since his mid-teens, but no works dating from before about 1650 are known. One of the earliest, a canvas in the Fine Arts Museums of San Francisco, depicts the same subject as this one, which was exceedingly popular in Rembrandt's circle and with Protestant collectors. The theme and its prominence in Dutch art are discussed below in the entry for Nicolaes Maes's painting *Abraham Dismissing Hagar and Ishmael* (Pl. 108), which dates from five years earlier.

In his previous treatment of the scene (Gen. 21:14), Fabritius was influenced by Rembrandt but more obviously based his composition on a painting of 1612 by Rembrandt's teacher, Pieter Lastman (1583–1633; the panel is in the Kunsthalle, Hamburg).[1] In several works that date or may be dated between the San Francisco canvas, of about 1650, and the present work, Fabritius clearly benefited from the influence of his brother Carel (1622–1654), adding effects of texture, daylight, and shadow to domestic settings.[2] In the Museum's painting, by contrast, the artist appears to have returned to a manner more exclusively of the Rembrandt school in the 1650s, which is not unexpected for an artist working in Leiden and no doubt looking to Amsterdam for inspiration, as he had before. Carel Fabritius's example resulted in a Delft-like interlude in his

brother's work, during which he painted several of his best pictures. Two or three years after Carel's death, however, Barent's style became more similar to that of Maes, Gerbrand van den Eeckhout (q.q.v.), and other Rembrandt pupils who first flourished in the 1640s or early 1650s (see Pls. 42, 108).

Although the painting is a comparatively minor work by Fabritius, it should be said that reproductions do not do it justice. In the brown tones that dominate in the wooded landscape and in the garments, the fall of light and the use of local color concentrate the dramatic moment. The bold red of Abraham's jacket below his tan cloak is echoed in the clothing of his son. Hagar is heavily dressed in muted greens and whites, with a brick red coat circling her waist. A straw hat is tied at the back, and is awkwardly juxtaposed with a farmhouse in the distance. The trees and green hill in the background suggest that Hagar and Ishmael are being banished to Westphalia rather than to a wilderness in the Middle East.

Comparison with other biblical pictures by the artist assures one that this rather sentimental staging of the subject is entirely sincere.[3] Abraham, at the age of one hundred, still has the physical and emotional strength to give his concubine a gentle shove and to point out her path. The manner in which Hagar slumps in despair on his shoulder, with hands clasped together, is affecting and (to the writer's knowledge) original. Ishmael's expression seems inconsistent with the mood of his parents and no match for what the young Maes achieved. It seems likely that Fabritius meant to suggest bravery and trust. In his right hand the boy holds onto the cord of Hagar's gourd filled with water (shoes and a knife also hang from her waist). His bow and quiver of arrows, conspicuously displayed, remind us that the future founder of the Ishmaelites would grow strong hunting in the wild.

Previously titled by the Museum *Hagar and Ishmael*.

45

1. See Volker Manuth's discussion of the San Francisco picture and its sources in Berlin–Amsterdam–London 1991–92a, pp. 380–83, no. 81. The painting is reproduced next to the Museum's in New York 1995–96, vol. 2, p. 146. In the mid-1660s, Fabritius painted a very different interpretation of the subject, in a large canvas in the Ferens Art Gallery, Kingston upon Hull (Pont 1958, no. 5, fig. 27; Sumowski 1983–[94], vol. 2, no. 572).
2. For example, *The Satyr and the Peasant,* of about 1652 (Wadsworth Atheneum, Hartford), *Tobit and Anna with the Kid,* of the mid-1650s (Museum Ferdinandeum, Innsbruck), and *Elkanah with His Wives Penninah and Hannah* (Galleria Sabauda, Turin). See Sumowski 1983–[94], vol. 2, nos. 549, 555, 556.
3. A remarkable proportion of Fabritius's oeuvre of the 1650s is devoted to biblical stories involving husbands and fathers. See Sumowski 1983–[94], vol. 2, nos. 547, 550–58.

REFERENCES: Pont 1958, pp. 47–48, 103–4, no. 4, fig. 17, describes the painting as signed and dated 1658,[1] from the collection of Sir Joshua Reynolds, "the situation outstandingly thought through"; Sumowski 1959, p. 288, suggests that the figure of Abraham depends on a drawing by Rembrandt;[2] Baetjer 1980, vol. 1, p. 55, omits any reference to the signature and date; Sumowski 1983–[94], vol. 2, pp. 912, 915 (under no. 547), 918, 920 (under no. 572), 937, no. 557 (ill.), considers the work a solid achievement, despite weaknesses in drawing and technique, describes the sympathetic characterizations of Abraham and Hagar, and notes the artist's two other known treatments of the subject; P. Sutton 1986, p. 183, listed; Broun 1987, p. 14, no. A1, suggests that Reynolds never actually owned the work, but purchased it for his friend George Chambers; Baetjer 1995, p. 329, omits any reference to the signature and date; Liedtke in New York 1995–96, vol. 2, pp. 19, 145–46, no. 48 (ill.), 149 (under no. 52), gives the proper reading of the signature and date, and notes that the painting depicts one of the biblical themes that Rembrandt evidently assigned to pupils; Irene Haberland in *Dictionary of Art* 1996, vol. 10, p. 733, mentions the Museum's picture and paintings in Hull and San Francisco as representations of the same subject by Fabritius.

EXHIBITED: Montreal, The Montreal Museum of Fine Arts, and Toronto, Art Gallery of Ontario, "Rembrandt and His Pupils," 1969, no. 51 (lent by F. Kleinberger & Co., New York); New York, MMA, "Rembrandt/Not Rembrandt in The Metropolitan Museum of Art," 1995–96, no. 48.

EX COLL.: ?Sir Joshua Reynolds, London (possibly acting as agent for Chambers); ?Sir William Chambers, London, Hampton Court, and Whitton Place, near Hounslow (d. 1796); by descent to George Chambers; Chambers family; Miss E. M. Chambers (until 1957; sold to Leger); [Leger, London, 1957; sold to Kleinberger]; [Kleinberger, New York, 1957–75; bequeathed by Harry G. Sperling, last surviving partner of the firm, to MMA]; Bequest of Harry G. Sperling, 1971 1976.100.23

1. Daniël Pont was made aware of the painting, its inscription, and provenance through a letter sent to him from Harry Sperling (November 18, 1957).
2. Benesch 1973, pp. 139–40, no. 504, fig. 665. There is a slight similarity.

GOVERT FLINCK
Cleve 1615–1660 Amsterdam

According to Arnold Houbraken, who knew Flinck's son, the artist was born in the "winter month" (December) of 1616.[1] However, his birth occurred nearly two years earlier, in January 1615.[2] His father was a Mennonite cloth merchant in Cleve, which is southeast of Arnhem and was at the time (as now) a German city.[3] Houbraken tells the tale that Flinck's father strongly opposed his son's desire to be an artist, until the Mennonite preacher, painter, and art dealer Lambert Jacobsz (ca. 1598–1636), gave a sermon in Cleve, met the Flincks, and "changed their minds completely." About 1629, when he was approximately fourteen years old, Flinck went to study with Jacobsz in Leeuwarden (Friesland). Jacobsz himself was the son of a wealthy cloth merchant in Amsterdam, but after his marriage in 1620 he settled in Leeuwarden, his wife's native city. His work is closely related with the Pre-Rembrandtist circle in Amsterdam and to some extent also with the Caravaggesque movement, the same influences that Rembrandt experienced, however differently, in the 1620s.[4] Jacobsz's art-dealing business was connected with that of Rembrandt's dealer in Amsterdam, the Mennonite Hendrick Uylenburgh (ca. 1584/89–1661).[5]

Houbraken also reports that Flinck, in Leeuwarden, became the roommate and "companion in art" of Jacob Backer (q.v.). It must have been helpful to the teenage Flinck that at least for a few years, he had a gifted colleague who was about seven years older (Backer became an independent painter in his native Amsterdam by 1633). On behalf of Jacobsz and Uylenburgh, Flinck was probably copying and imitating paintings by Rembrandt before they ever met. When Flinck became a pupil or apprentice of Rembrandt is a matter of debate. Von Moltke has Flinck in Rembrandt's Amsterdam studio from 1633 until 1636,[6] and other scholars have found this convenient for their reattribution of works by Rembrandt (or simply in his style) to Flinck during that period.[7] But Houbraken explicitly says that Flinck was with Rembrandt for one year, and "in that short time" he became so adept at painting in Rembrandt's manner that pictures by Flinck were sold as works by the master's own hand.[8] It is quite possible that Flinck remained in Leeuwarden until 1635 or even 1636, so that his association with Rembrandt would have taken place in 1635–36 or during most of the latter year.[9] Flinck's earliest known independent works date from 1636, for example, the small full-length portrait of his Mennonite cousin Dirck Leeuw (which still belongs to the Amsterdam Mennonite community).[10]

In the later 1630s, Flinck established himself as a successful artist in Amsterdam. Paintings such as *Isaac Blessing Jacob,* of about 1638 (see fig. 45), are Rembrandtesque but distinctive, not a small achievement for someone who had just emerged from under Rembrandt's wing.[11] In 1642, when Rembrandt finished *The Night Watch,* Flinck also painted a large group portrait for an Amsterdam civic guard company, and did so again in 1645 and 1648 (all three canvases, as well as Rembrandt's, are in the Rijksmuseum, Amsterdam).[12] During the 1640s, Flinck flourished as a history painter and as a fashionable portraitist, his style in the latter specialty adhering to or departing from Rembrandt's according to the patron's taste. His ability to charm is obvious in portraits of children, pictures of sleeping cupids, and paintings of half-naked goddesses.

In May 1644, Flinck bought two houses on the Lauriersgracht (now Nos. 76 and 78) for 10,000 guilders. The top floors served as his studio and gallery for the remaining sixteen years of his life. Houbraken describes a Rembrandt-like array of exotic costumes, armor, weapons, embroidered hangings, and bolts of old velvet, in addition to fine casts of ancient sculpture and other studio props. The same writer relates that burgomasters such as Cornelis and Andries de Graeff would drop in on Flinck, and he would visit the homes of amateurs such as Jan Six and the tax collector Johannes Wtenbogaert. The information comes from Flinck's son, Nicolaes Anthonis Flinck (1646–1723), who became a distinguished collector and director of the East India Company (VOC) in Rotterdam. His mother, Ingeltje Thoveling (1619–1651), the daughter of a VOC director in Rotterdam, had married Flinck in June 1645; she died six years later. Flinck remarried in 1656. His bride, Sophia van der Houve, was the daughter of another VOC director in Rotterdam. The wedding was commemorated in a poem by Joost van den Vondel, who also provided panegyrics for a number of Flinck's public paintings.[13]

The 1650s brought the artist a string of prestigious commissions, including portraits of the Elector of Brandenburg (1652)

and of Johan Maurits, count of Nassau-Siegen (1658), and the *Allegory on the Memory of Frederick Hendrick, Prince of Orange,* which Flinck painted in 1654 for the widowed princess Amalia van Solms.[14] When the great Town Hall of Amsterdam was nearing completion in 1655, the painter's international Baroque style (of a very Dutch sort) and his good connections won him the commission for the nearly 16½ x 13 foot (5 x 4 m) canvas *Marcus Curtius Dentatus Refusing the Gifts of the Samnites,* dated 1656 (still in situ). In 1658, he produced the equally large and more agitated picture *Solomon's Prayer for Wisdom* (Council Chamber, or "Moses Room," in the former Town Hall, now the Royal Palace, Amsterdam).[15] These successes led to the contract, in late 1659, for twelve large canvases to decorate the Great Gallery of the Town Hall. However, Flinck died on February 2 of the following year, at the age of forty-five. He was buried five days later in the Westerkerk.

According to a witness in 1649, Flinck's workshop was occupied by a number of students and assistants at that time.[16] His only known pupil, however, is the Düsseldorf painter Johannes Spilberg (1619–1690), who spent several years with Flinck in the 1640s.[17]

1. Houbraken 1718–21, vol. 2, p. 18. Most of Houbraken's life of Flinck is translated into English in G. Schwartz 1985, p. 282.
2. In Von Moltke 1965, p. 9, and in many later sources, Flinck's date of birth (baptism?) is given as January 25, 1615, but no document is cited.
3. Cleve in North Rhine-Westphalia. In 1647, the Elector of Brandenburg appointed Johan Maurits, count of Nassau-Siegen, stadholder of Cleve. Flinck's success with both noblemen is described in Houbraken 1718–21, vol. 2, p. 22. The Mennonites were a conservative branch of the Anabaptists. They emphasized the study and personal interpretation of scripture, and individual responsibility for one's own salvation.
4. For Jacobsz's biography and an example of his work, see The Hague 1992a, pp. 187–91.
5. On Uylenburgh's business, see London–Amsterdam 2006 (pp. 160–69 on Flinck's collaboration with Uylenburgh about 1635–38).
6. J. W. von Moltke in *Dictionary of Art* 1996, vol. 11, p. 169. The article is remarkably slight, given the artist's stature and the writer's experience. Compare Van der Veen in London–Amsterdam 2006, p. 160, where it is suggested that in the absence of further evidence Flinck's arrival in Amsterdam "can perhaps better be placed 'around 1635.'"
7. For example, Kelch in Berlin–Amsterdam–London 1991–92a, pp. 314–17 (biography of Flinck and reattribution of Rembrandt's *Self-Portrait* in Berlin to Flinck, at the implausibly early date of about 1633). See also Bruyn in ibid., p. 73 (Flinck "entered the workshop probably in 1633 and stayed for only one year").
8. Houbraken 1718–21, vol. 2, pp. 20–21.
9. See Liedtke 1995b, p. 17, and Liedtke 2004b, pp. 52, 68, 70 n. 34.
10. The portrait of Leeuw is mistitled in Sumowski 1983–[94], vol. 2, no. 265, following Von Moltke 1965, no. 211, pl. 39.
11. On this picture, see Sumowski 1983–[94], vol. 2, no. 614; Amsterdam–Jerusalem 1991–92, no. 11; and Liedtke 1995b, p. 20, fig. 25.
12. Von Moltke 1965, nos. 475–77, pls. 53–57.
13. On Flinck's house and studio, see Dudok van Heel 1982. A good short biography of Nicolaes Flinck is provided by J. S. Turner in *Dictionary of Art* 1996, vol. 11, pp. 170–71. Flinck's two marriages and the poem by Vondel are mentioned in Von Moltke 1965, pp. 10–11.
14. Von Moltke 1965, nos. 198, 214, 118; for the *Allegory* (Rijksmuseum, Amsterdam), see Washington–Detroit–Amsterdam 1980–81, no. 36.
15. For these two commissions, see Von Moltke 1965, p. 41, nos. 30, 113, pls. 12, 22. An autograph replica of *Solomon's Prayer for Wisdom* (Bob Jones University Collection, Greenville, S.C.) is discussed by Wheelock in Washington–Detroit–Amsterdam 1980–81, p. 166 (under no. 37).
16. See Liedtke 2004b, p. 53.
17. See The Hague 1992a, pp. 287–92.

46. A Young Woman as a Shepherdess ("Saskia as Flora")

Oil on canvas, oval, 26¼ x 19⅞ in. (66.7 x 50.5 cm)
Inscribed (lower right): Rembrandt·f/1633

The painting has been transferred from wood to canvas. An inscription on the stretcher records that this was done in Paris in 1765. Microscopic fragments of the original oak panel remain along the vertical line just right of center that marks the position of the former panel join. There are numerous small losses in the background, along a vertical split at left, and just above the left corner of the mouth. The Rembrandt signature and the date were applied on top of the original paint layer, but they predate the transfer.

Bequest of Lillian S. Timken, 1959 60.71.15

The painting was transferred from a wood panel to a canvas support in 1765, and its surface suffered in the process. In 1732, the work was listed in the estate inventory of Charles Jean Baptiste Fleuriau, comte de Morville (d. February 3, 1732), as one of "deux têtes de Rembrandt." Evidently the picture had been arbitrarily paired with a painting of a young woman by Rembrandt, probably his celebrated canvas, *A Girl at a Window,* of 1645 (Dulwich Picture Gallery, London). De Morville had been French ambassador at The Hague from 1718 until 1720 and was familiar with other important collectors of the day, including Valerius Röver in Delft and the Polish count Charles Henry d'Hoym in Paris. D'Hoym, a distinguished bibliophile as well as an amateur of paintings, apparently purchased the present picture from de Morville's estate.[1]

Rembrandt's name and the (for him) plausible date of 1633 swim in a suspicious pool of paint to the lower right.[2] Until the picture was cleaned in 1995, the inscription, heavy overpainting, and varnish lent the work a surface and tonality that were considered typical of the master by nineteenth- and early-twentieth-century connoisseurs. However, Wilhelm Martin, in 1921, cited the work as an example of "genuinely signed Rembrandts among which non-autograph pictures may be found."[3] Scholars such as Bredius, Valentiner, and Bauch (see Refs.) maintained the attribution to Rembrandt, but Gerson, in 1969, referred to the picture's problematic condition and concluded that "even on the strength of what can be seen of the original paint, an attribution to Rembrandt is unjustified. Perhaps a work by G. Flinck."[4]

The attribution to Flinck is so convincing and so widely accepted that it is reasonable to catalogue the work under his name rather than under "Style of Rembrandt." Sumowski, in assigning the *Shepherdess* (his title) to Flinck, compares the *Saskia as Shepherdess,* formerly in the Harrach collection, Vienna, which has long been recognized as a Flinck painted in the manner of Rembrandt during the late 1630s, and the *Young Shepherdess in a Window* (Louvre, Paris), which is signed by Flinck and dated 1641.[5] The Harrach painting, Flinck's *Woman with a Turban and Veil,* of about 1636 (Devonshire Collection, Chatsworth), his *Woman with Feathered Hat and Veil* (formerly Galerie Fischer, Lucerne), and the Museum's picture are similar not only in execution and in exotic figure types but also in their derivation from Rembrandt, the most obvious known model being his *Bust of a Young Woman ("Saskia"),* of about 1633 (fig. 52), which depicts a veiled and bejeweled beauty with a straight nose, level lips, dark brows, and a direct gaze.[6] At least two other Rembrandtesque Flincks should be compared with the New York painting, the *Girl in Arcadian Dress with a Dog* (Fuji Art Museum, Tokyo) and the *Shepherdess,* in the Herzog Anton Ulrich-Museum, Braunschweig, which is signed and dated 1636 and a pendant to the signed *Rembrandt (?) as a Shepherd,* in the Rijksmuseum, Amsterdam.[7] Finally, another onetime "Rembrandt" and former "Saskia," the oval *Young Shepherdess as Flora* (Louvre, Paris), is convincingly ascribed to Flinck by Foucart and is strongly reminiscent of the present "Saskia as Flora."[8]

In all these pictures, it is not only the execution but also the palette, the drawing of the faces, and the way shadows are used to model features such as the nose (especially the underside) and lips that may be considered typical of Flinck in the second half of the 1630s. Even when a figure by Rembrandt served as model, Flinck introduced his own peculiar type of physiognomy: heads in the shape of elongated ovals with flattened sides, slight, sloping shoulders, and a short, curving, almost amphibious forearm and hand. He is also fond of fussy flowers, and fabrics that make up for their lack of substance with a display of shimmering detail.

The title employed for a century (see Refs.), "Saskia as Flora," is doubly mistaken. Any resemblance to Rembrandt's wife derives from the influence on this work of paintings by Rembrandt that depict an idealized type somewhat reminiscent of Saskia (much as Rubens's second wife, Helena Fourment, is recalled by his Venuses and other female figures of the 1630s).[9] It is true that the figure here, crowned with a wreath of flowers, is similar to the goddess in Rembrandt's *Flora* of 1634 (Hermitage, Saint Petersburg), but the attribute of a shepherd's crook

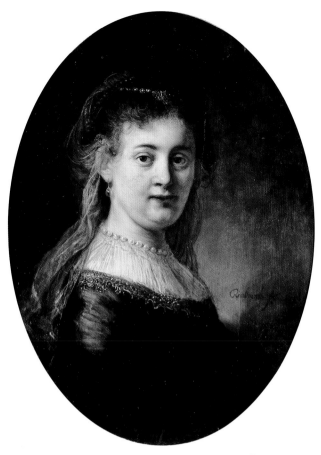

Figure 52. Rembrandt, *Bust of a Young Woman ("Saskia")*, ca. 1633. Oil on wood, 25⅞ x 19½ in. (65.6 x 49.5 cm). Rijksmuseum, Amsterdam

qualifies Flinck's young woman for a place in Arcadia not a seat on Mount Olympus. Her fashion sense also points to pastoral occupations, of the kind practiced by ladies of the Dutch court. As noted by Louttit (1973; see Refs.), exotic veils and striped silks, despite their look of Oriental opulence rather than rustic simplicity, were part of the pastoral mode in the 1630s. The genre flourished not only in painting and prints but also in the theater, poetry, and other forms of literature. It has occasionally been suggested that the popularity in Rembrandt's circle of this type of *tronie* and of closely related types (Flinck's *Woman with a Turban and Veil* at Chatsworth, for example, is some sort of Persian princess) initially had to do with the marketing talents of Saskia's cousin Hendrick Uylenburgh. But the prevalence of the pastoral theme in Utrecht (which depended partly on court patronage) and in countries other than the Netherlands makes it clear that Rembrandt's street in Amsterdam served as an avenue to a larger artistic world.[10]

Roscam Abbing (1999; see Refs.) reconstructed the painting's eighteenth-century provenance. It follows from this valuable information and from Gersaint's description of the picture in

1747 (see Refs.) that the original support must have been a rectangular panel.[11] Thus, the composition would have more closely resembled that of Rembrandt's *Bust of a Young Woman ("Saskia")*, which appears originally to have been rectangular.[12]

1. Roscam Abbing 1999, pp. 167–70. See also note 2 under Ex Coll. below.

2. As explained by Von Sonnenburg in New York 1995–96, vol. 1, p. 65, the Rembrandt signature and the date of 1633 were painted in a light gray layer that was still wet at the time, and that was applied on top of the original paint surface. The false signature must predate the transfer of 1765. Compare the doubtful inscription on Rembrandt's *Bust of a Young Woman ("Saskia"),* of about 1633 (Rijksmuseum, Amsterdam; *Corpus* 1982–89, vol. 2, p. 359, fig. 4 [under no. A75]).

3. W. Martin 1921, p. 30 ("Aber sogar unten den echt bezeichneten Rembrandts dürften sich nicht eigenhändige Bilder befinden"). The hypothesis that Rembrandt signed works executed by students or assistants and the reference to his Leiden pupil Isaack Jouderville (1612/13–1645/48) in the same paragraph anticipate arguments in *Corpus* 1982–89, vol. 2.

4. Gerson in Bredius 1969, p. 555 (under no. 98).

5. Sumowski 1983–[94], vol. 5, p. 3099 (under no. 2081), comparing his nos. 665 and 673 (see vol. 2, pp. 1032, 1034), which are also catalogued in the standard monograph on Flinck: Von Moltke 1965, nos. 139, 141.

6. On the Rijksmuseum painting (commonly but erroneously said to represent Saskia), see *Corpus* 1982–89, vol. 2, pp. 355–60, no. A75. It is cited as a source for Flinck in Sumowski 1983–[94], vol. 2, pp. 1031–32 (under nos. 659 [Chatsworth] and 665 [Harrach]). The ex-Lucerne Flinck (ibid., no. 661; Von Moltke 1965, no. 366) was helpfully available for study prior to its sale at Sotheby's, New York, May 18, 2006, no. 17.

7. The Tokyo painting (Sumowski 1983–[94], vol. 6, no. 2279) is the best version of several by or after Flinck, which include a canvas in the Kunsthalle, Hamburg (ibid., vol. 2, no. 662, as by Flinck; Ketelsen 2001, pp. 94–95, no. 292, as from Flinck's workshop). For the Braunschweig and Amsterdam pendants, see Von Moltke 1965, nos. 130, 140, pls. 26, 27; Sumowski 1983–[94], vol. 2, nos. 655, 656; and J. Kelch in Berlin–Amsterdam–London 1991–92a, p. 318, no. 61.

8. A. Rosenberg 1904, p. 94, as Rembrandt's *Flora*; Bode 1913, p. 4, pl. 2, as Rembrandt's *Saskia*; Foucart in Paris 1988–89, pp. 55–57, as by Flinck about 1635 (inv. no. RF 1961–69).

9. See G. Martin 1970, pp. 156, 159 n. 29.

10. Louttit 1973 remains fundamentally important for this subject, notwithstanding its brusque treatment in Kettering 1983, p. 113, and its inaccurate reading in *Corpus* 1982–89, vol. 2, pp. 500–501 (under A93, the *Flora* in the Hermitage). The article centers on Rembrandt's *Flora* of 1635 (National Gallery, London; *Corpus* 1982–89, vol. 3, pp. 148–60, no. A112, under that title), which is called *Saskia van Uylenburgh in Arcadian Costume* in MacLaren/ Brown 1991, pp. 353–58 (where Louttit 1973 is properly credited). Kieser 1941–42 (see Refs.) deserves special mention for insisting that the Museum's picture represents not Flora but a shepherdess, a point hastily overlooked by the present writer in New York

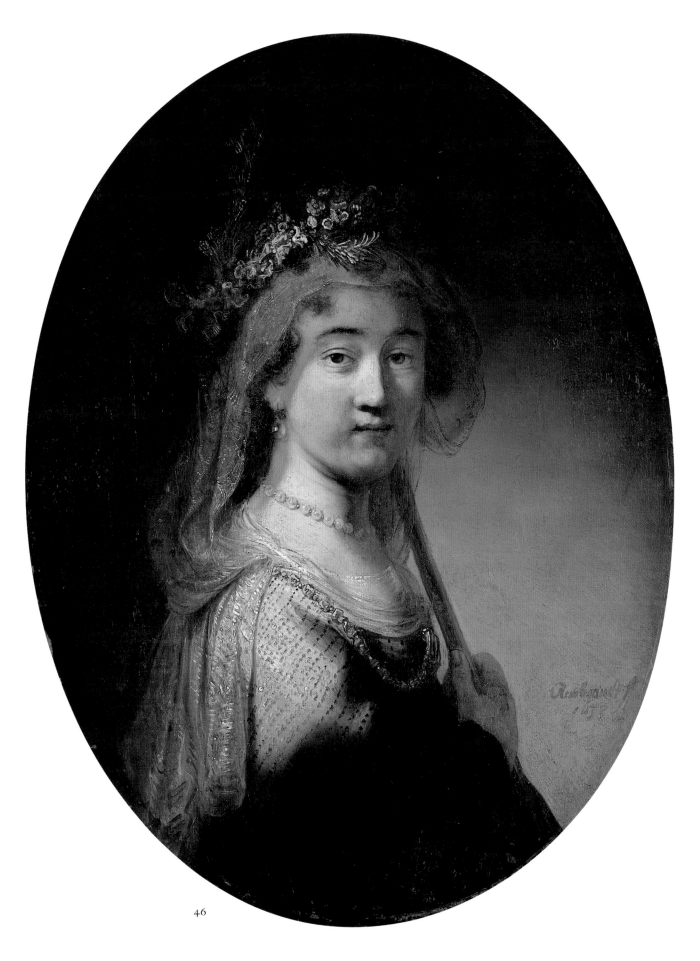

46

1995–96, vol. 2, pp. 91–93 (under no. 22). Ibid., pp. 16–17, 91, 93, describes *tronies* by Flinck as Uylenburgh stock.

11. The Museum's picture is described in Gersaint 1747 (catalogue of the Fonspertuis sale in 1747–48), pp. 197–98 (under no. 434), as on wood, 30 *pouces* (about 31⅞ in. [81 cm]) high by 23¾ *pouces* (about 25¼ in. [64.1 cm]) wide, as rounded above ("sa forme est ceintrée par le haut"; p. 198), and as serving as a pendant to the following lot (no. 435), having been enlarged to this end ("ayant même été agrandi à cet effet"; presumably the top of the panel was shaped at the same time). The pendant in question is almost certainly Rembrandt's *Girl at a Window,* of 1645 (Dulwich Picture Gallery, London), which is described as "Une autre Portrait de même forme & de même grandeur aur le précédent" (the Dulwich painting is on canvas, 32⅛ x 26 in. [81.6 x 66 cm], with rounded corners at top). White in Washington–Los Angeles 1985–86, p. 102 (under no. 26), cautions that no. 435 in the Fonspertuis sale may have been Rembrandt's *Kitchen Maid* (Nationalmuseum, Stockholm) or the Rembrandt school *Girl at a Dutch Door,* in Woburn Abbey (Sumowski 1983–[94], vol. 6, no. 2298a, attributed to Van Hoogstraten), rather than the Dulwich picture, but these candidates are conclusively dismissed in Roscam Abbing 1999, pp. 107, 108, 159, figs. 28, 41. In the Blondel de Gagny sale of 1776 no. 70, "La servante de Rembrandt, connue sous le nom de la Crasseuse" (the Dulwich picture), is "painted on a canvas rounded at top," 30 x 23¾ *pouces,* and no. 71, "Une jeune & jolie femme à micorps, grande comme nature, couronnée de fleurs," is described (without specifying the support) as "de même forme & grandeur que le précédent." This suggests that when the painting was transferred from wood to canvas in 1765 it remained rectangular (but with rounded corners at top). In the Destouches sale of 1794, no. 15, "Une belle figure de jeune fille . . . couronne de fleurs" has been reduced to 24 x 18 *pouces* (25½ x 19⅛ in. [64.8 x 48.6 cm]; very close to its present dimensions) and is described as painted on canvas "de forme ovale." For complete transcripts of these sale catalogue entries, see Roscam Abbing 1999, pp. 229, 237–38, and 238–39.

12. See *Corpus* 1982–89, vol. 2, pp. 355 (under "support"), 360 (under "copies"). The painting is also discussed by Lloyd Williams in Edinburgh–London 2001, p. 98 (under no. 98), where it is observed that "the balance of the picture is convincing as it stands and the oval may, after all, be original." But the remark is meaningless in the absence of technical evidence.

REFERENCES: Gersaint 1747, pp. 197–98, no. 434, catalogues the painting in the Fonspertuis sale of 1747–48 as "Un Joli Portrait de femme couronnée de fleurs," by Rembrandt, "connu parmi les Curieux, sous le nom de la belle Jardinière," on wood, rounded on top ("sa forme est ceintrée par le haut"), 30 x 23¾ *pouces* (31⅞ x 25¼ in. [81 x 64.1 cm]), and states that the picture was enlarged to serve as a pendant to no. 435 in the same sale, Rembrandt's "Portrait de sa Servante" (see note 11 above); J. Smith 1829–42, vol. 7 (1836), p. 168, no. 522, catalogues a portrait of "A Young Lady" by Rembrandt from the Destouches collection, evidently this picture, and refers to no. 508; Pichon 1880, vol. 2, pp. 80, 86, as by Rembrandt, listed in the 1732 and 1737 inventories of the collection of Charles Henry d'Hoym (as nos. 421 and 82, respectively); Bode 1906b, pp. 8–10

(ill.), as "Saskia als Flora," by Rembrandt, in the collection of Meyer von Stadelhofen, notes that the painting has suffered from transfer to canvas, compares a portrait of Saskia in Lord Elgin's collection (now Rijksmuseum, Amsterdam; fig. 52 here), dates both works to 1633, and considers the manner of execution close to that of a "Flora" in the Galerie Schloss, Paris (now Louvre, Paris, inv. no. 1961–69, as by Flinck); A. Rosenberg 1909, pp. 138 (ill.), 553, 571, dates the picture to about 1634; Hofstede de Groot 1907–27, vol. 6 (1916), pp. 136, 138, no. 204, as with the dealer Krämer in Paris, describes the subject as Flora "with the features of Saskia," suggests a date of about 1635, states that the painting was transferred from canvas to panel (actually vice versa) in 1765, and (under no. 206a) tentatively identifies it with the picture in the Destouches sale of 1794; W. Martin 1921, p. 30, rejects the work from Rembrandt's oeuvre; Hofstede de Groot 1922, p. 16, disagrees with Martin (1921), defending the attribution to Rembrandt; Valentiner 1930b (ill. following p. 4), as "Portrait of Saskia as 'Flora,'" by Rembrandt, in the collection of William R. Timken, New York; Valentiner 1931, unpaged, no. 32, pl. 32, "Saskia as Flora" by Rembrandt, dates the picture to about 1633–34, based on related works and "the pale greyish tone"; Benesch 1935b, p. 14, calls this the earliest "Flora" by Rembrandt, and close to the 1633 "Saskia" in the Rijksmuseum, Amsterdam (fig. 52 here); Bredius 1935, p. 6, no. 98, pl. 98, "Saskia as Flora," by Rembrandt, no date proposed; Kieser 1941–42, p. 155, perceptively questions the identification of the figure here (and in Rembrandt's paintings in London and Saint Petersburg) as Flora, as opposed to a shepherdess; K. Bauch 1966, p. 14, no. 256, pl. 256, as "Flora" by Rembrandt, about 1632–33, Saskia serving as model; Gerson in Bredius 1969, pp. 86 (ill.), 555, no. 98, "Saskia as Flora (?)," a work that has suffered considerably, states that an attribution to Rembrandt is unjustified, and concludes, "perhaps a work by G. Flinck"; Lecaldano 1969, p. 131 (ill.), "Ritratto di Saskia incoronata," included among doubtful attributions; Louttit 1973, p. 325 n. 38, mentions the gauzy veil covering the head as an exotic exception to the usual simplicity of Arcadian dress; Bolten and Bolten-Rempt 1977, p. 180, no. 167 (ill.), as by Rembrandt; Kettering 1977, p. 19 n. 3, pp. 22–24, fig. 5, as "Saskia as a Shepherdess," attributed to Rembrandt, notes that his authorship has been questioned, makes an effort (p. 24 n. 14) to preserve the picture as at least Rembrandt's invention in 1633, and observes that if by Flinck the picture would have to date from 1636 or later; Baetjer 1980, vol. 1, p. 151, as "Style of Rembrandt," of uncertain date; Jansen in Amsterdam–Groningen 1983, p. 156 (under no. 33), considers the painting a possible Flinck of about 1636 or later, based on the argument in Kettering 1977; Kettering 1983, pp. 47, 61, 78, 79, 148 n. 95, fig. 41, "Saskia as a Shepherdess" attributed to Rembrandt, dated 1633, repeats Kettering 1977, and calls this picture (despite its discussion as a possible Flinck of 1636 or later; p. 148 n. 95) the "first of the shepherdess portrayals outside Utrecht and the first of Rembrandt's pastoral compositions"; Foucart in Paris 1988–89, p. 57, observes that the provenance (Paris sales of 1748 and 1777) assigned by Hofstede de Groot 1907–27 (vol. 6, no. 203) to Flinck's oval *Young Shepherdess as Flora* (Louvre, Paris) is actually that of the Museum's picture, which is another oval "ex-Rembrandt"; Sumowski 1983–[94], vol. 5, pp. 3099, 3212 (ill.), no. 2081, as "Shepherdess," attributes the painting to Flinck about 1637–40, and adopts the provenance information recorded by Foucart in Paris 1988–89; Baetjer 1995, p. 318, "Saskia as Flora," by a follower of

Rembrandt; Bruyn 1995, pp. 108–9, calls the picture a pastiche of uncertain date;[1] Liedtke in New York 1995–96, vol. 2, pp. 15, 17, 70, 91–93, no. 22 (ill.), as "Flora," attributed to Govert Flinck and dating from about 1636–38, compares similar works by Flinck, and briefly discusses the subject and Amsterdam market for inexpensive paintings of Flora; Von Sonnenburg in ibid., vol. 1, pp. 28, 61, 63, 65, fig. 83 (cleaned state), as attributed to Flinck, notes the "rather early" transfer of the painting from wood to canvas; Roscam Abbing 1999, pp. 167–70, 174, 226 (under Rembrandts owned by Charles Henry d'Hoym), 227 (under the 1732 estate inventory of de Morville), 229 (under the sale of 1748), 239 (under the sale of 1794), 244, fig. 45, as "Flora," now attributed to Flinck, provides important new provenance information (see note 11 above); Ketelsen in Hamburg 2000–2001, pp. 54, 56 (under nos. 7, 8), describes the picture as a "Flora" attributed to Flinck, which depends directly on Rembrandt, and suggests that Flinck painted this and similar pictures for the art dealer Hendrick Uylenburgh; Ketelsen 2001, p. 95 n. 6, repeats the point made in Hamburg 2000–2001; Dickey 2002, pp. 27, 38, fig. 16, and p. 214 n. 57, as by Flinck about 1636–38, compares the "shimmer of patterned oriental silk" found in this painting with the richness of fabrics in Dutch court portraits of women in fancy dress, and suggests that "a feminine type based on [Saskia's] likeness may well have become a trademark motif" of Rembrandt's studio; Bøgh Rønberg in Copenhagen 2006, pp. 197, 293 n. 8 (under no. 38), notes that the picture is now considered to be by Flinck; Krog in ibid., p. 291 n. 3 (under no. 34), as by Flinck.

EXHIBITED: Leiden, Stedelijk Museum De Lakenhal, "Fêtes de Rembrandt à Leyde," 1906, no. 53, as "Saskia comme bergère," by Rembrandt (lent by Meyer von Stadelhofen, Château d'Hermance, near Geneva); Detroit, Mich., The Detroit Institute of Arts, "Thirteenth Loan Exhibition of Old Masters: Paintings by Rembrandt," 1930, no. 25 (lent by Mr. and Mrs. William R. Timken, New York); New York, MMA, "Rembrandt/Not Rembrandt in The Metropolitan Museum of Art," 1995–96, no. 22.

EX COLL.: Charles Jean Baptiste Fleuriau, comte de Morville, Paris (until d. 1732; his inventory, dated March 3, 1732, one of "deux têtes de Rembrandt," probably sold privately shortly afterward for 800 livres);[2] Charles Henry, comte d'Hoym, Paris (1732?–d. 1736; 1732 inv., p. 31, nos. 420 and 421, "Deux tableaux représentant l'un la Crasseuse de Rembrandt avec son pendant"; d'Hoym's 1737 inv., nos. 82 and 83, "Une Flore, une Crasseuse, sur bois avec bordure, 400 l[ivres]");[3] Angran, vicomte de Fonspertuis (his sale, Paris, Ger-

saint, March 4, 1748, no. 434, with "pendant" no. 435, for FFr 2,001 to Blondel de Gagny); Augustin Blondel de Gagny (until d. 1776; his sale, Rémy, Paris, December 10–24, 1776, and January 8–22, 1777, no. 71, sold for FFr 680 to Destouches);[4] Destouches, Paris (until 1794; his sale, Le Brun jeune & Julliot, Paris, March 21, 1794, no. 15, as "Une belle figure" by Rembrandt, for FFr 451 to Le Brun);[5] [J.-B. P. Le Brun, Paris, in 1794]; J. H. Meyer von Stadelhofen, Château d'Hermance, Switzerland (in 1906); [Kraemer, Paris, in 1916]; [Wildenstein, New York]; Mr. and Mrs. William R. Timken, New York (by 1930–his d. 1949); Lillian S. Timken, New York (1949–d. 1959); Bequest of Lillian S. Timken, 1959 60.71.15

1. The present writer strongly disagrees with Bruyn's negative assessment of Sumowski's (1983–[94]) work on Flinck. Here (Bruyn 1995) and elsewhere, the Dutch critic reveals an eccentric view of the artist.

2. Identified in Roscam Abbing 1999, pp. 101–9, 167–70, 227, as Rembrandt's famous canvas *A Girl at a Window*, of 1645 (Dulwich Picture Gallery, London). See note 11 above.

3. See Roscam Abbing 1999, p. 167. Charles Henry d'Hoym (1694–1736) was ambassador from Saxony-Poland to France between 1720 and 1729. According to Pichon 1899, p. 91, and Roscam Abbing 1999, p. 156, d'Hoym left Paris for Dresden on March 3, 1729, and never saw his Parisian collections again (he was imprisoned in Castle Königstein and hanged himself in his cell on April 21, 1736). However, he purchased paintings in absentia through his secretary, Isaac Milsonneau (Roscam Abbing 1999, pp. 167, 168). A sale or auction of d'Hoym's 161 or more paintings is not recorded but must have taken place.

4. There are three annotated copies of this sale catalogue in the Rijksbureau voor Kunsthistorische Documentatie, The Hague (copies were kindly sent by M. de Voogd). Two of them record the buyer as Destouches. One of them gives the price as FFr 680, and the other two as FFr 679 and 19 sols (there were 20 to the franc). The Paris sales of 1748 and 1776–77 (Lugt 1938–64, vol. 1, nos. 682 and 2616) were thought by Hofstede de Groot (see 1907–27, vol. 6, p. 136, no. 203) to have included a similar painting by Flinck (now in the Louvre, Paris), but Foucart in Paris 1988–89, p. 57, suggests that the entries in the sale catalogues actually refer to the New York not the Paris picture. Sumowski (1983–[94], vol. 5, p. 3099, under no. 2081) adopts Foucart's information, but misprints the date of 1777 as 1771. The provenance is clarified in Roscam Abbing 1999 (see Refs.).

5. Lugt 1938–64, vol. 1, no. 5171.

47. *Bearded Man with a Velvet Cap*

Oil on wood, 23¾ x 20⅝ in. (60.3 x 52.4 cm)
Signed and dated (left center): G. flinck f·1645

The picture was painted over a portrait of a woman. There is some abrasion in the cloak and the lower part of the beard, revealing points of impasto from the first composition, and paint loss along a split in the panel at the top left corner. The oak panel was trimmed at the top corners and then triangular pieces of wood were attached, returning the panel to its present rectangular shape. The last digit of the date is indistinct, but can be read with magnification.

Bequest of Collis P. Huntington, 1900 25.110.27

This *tronie,* an imaginary portrait probably based on a live model (see the discussion under Rembrandt's *Man in Oriental Costume;* Pl. 142), would be recognized as typical of Flinck in the 1640s even if the panel were not signed and dated. X-radiographs (fig. 53) show that Flinck painted his dashing if no longer youthful character over a female portrait, which itself seems consistent with the artist's work in the early to mid-1640s.[1]

The man wears a red velvet beret trimmed with a gold chain and a black, fur-lined cloak over a medium-green jacket. Originally these colors were set off against a deep olive background, but this has darkened almost to black with age. The gold pendant is a type often employed by Rembrandt and artists in his circle to suggest antiquity or the exotic Middle East.

Perhaps the most striking aspect of the picture is the wispy white beard, which was something of a signature motif for Flinck, especially in the 1640s. Even in more carefully descriptive pictures such as *The Apostle Paul,* of about 1636 (Kunsthistorisches Museum, Vienna), Flinck lends a rhythmic flair to flowing facial hair.[2] Here, however, the effect is much more artificial, a calligraphic display that might just as well describe an eddy of water or tall grass buffeted by wind. Sumowski's critique of the picture (see Refs.) was anticipated by curator Harry Wehle: "Photos [of other works by Flinck] all bear out authenticity of MMA example in vacuity of expression and emptiness of handling."[3] Empty or not, the manner of execution is a clear instance of how far Flinck had distanced himself

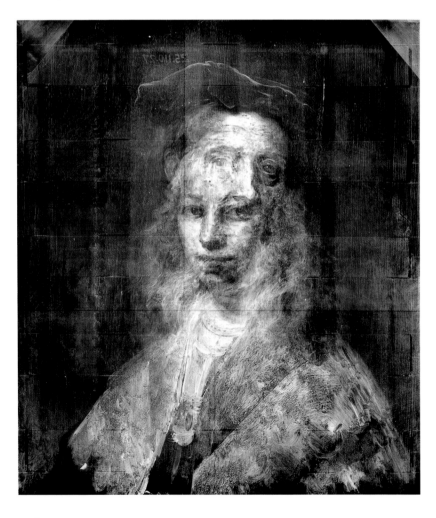

Figure 53. X-radiograph of Flinck's *Bearded Man with a Velvet Cap* (Pl. 47)

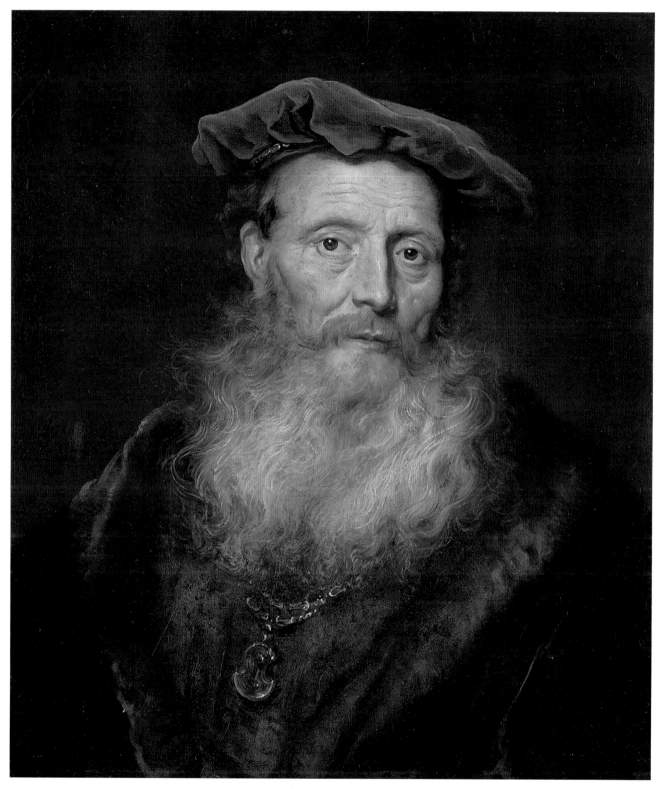

47

from Rembrandt by the time he was thirty and had been out of the master's studio for about eight years.

The most similar works by Flinck in type and style include the *Bearded Old Man with Beret and Gold Chain* (National Gallery of Ireland, Dublin) and the so-called *Portrait of a Rabbi* (formerly Guterman collection, New York), both of about 1642.[4] A good number of similar figures were depicted in a generally comparable style by the Amsterdam artist Salomon Koninck (1609–1656) during the 1640s.[5]

1. The young woman does not appear elsewhere in Flinck's oeuvre, so far as is known. Compare the style of his *Portrait of a Woman*, in a Swedish private collection (Von Moltke 1965, no. 435, pl. 49), which dates from about 1643–45 and has been thought to possibly represent the painter's fiancée or wife (see Sumowski 1983–[94], vol. 2, p. 1035 [under no. 681]).

2. For a large detail of Saint Paul's head, see Von Moltke 1965, pl. 7.

3. Memo dated 1939 in the curatorial files, comparing Flinck's *Self-Portrait* of 1639, in the National Gallery, London. In reproductions of the Museum's painting, the face usually appears smoother and harder than it really is, and the beard softer.

4. Von Moltke 1965, nos. 177, 178; see also nos. 269, 271, which date from several years later. See also Sumowski 1983–[94], vol. 2, nos. 676 (the Dublin painting in color) and 678 (the Guterman panel, which was sold from that collection at Sotheby's, New York, January 14, 1988, no. 15).

5. See Sumowski 1983–[94], vol. 3, nos. 1104, 1108 (dated 1643), 1111, 1113, 1126, 1129. One of the most similar works by Koninck,

signed and dated 1642, was with the Alfred Brod Gallery, London, in 1957 (a clipping from what appears to be their catalogue is in the curatorial files).

REFERENCES: Von Moltke 1965, p. 117, no. 249 (ill.), records that the top corners of the panel were added later, and claims that "the same model appears" in Flinck's painting *Marcus Curtius Dentatus*, of 1656, in the Town Hall of Amsterdam (where there are three or four similar types); Sumowski 1983–[94], vol. 2, pp. 1003, 1035, 1114, no. 682, considers the picture to be of "negligent" quality, a "straggler" compared with the excellent *tronies* of old men that precede it; Liedtke 1990, p. 37, mentioned as part of the Huntington bequest; Baetjer 1995, p. 322; Liedtke in New York 1995–96, vol. 2, pp. 60, 100, 147, no. 49 (ill.), compares the quality of Rembrandt's *Herman Doomer* and the style of *Man with a Steel Gorget*, by a follower of Rembrandt (Pls. 148, 166), and describes the work as a typical *tronie* by Flinck, who first painted such imaginary portraits under Rembrandt's influence; Von Sonnenburg in ibid., vol. 1, pp. 114, 117, figs. 154, 155, employs an X-radiograph of the painting (fig. 53 here) in an attempt to attribute *Man with a Steel Gorget* (Pl. 166) to Flinck.

EXHIBITED: New York, MMA, "Rembrandt/Not Rembrandt in The Metropolitan Museum of Art," 1995–96, no. 49.

EX COLL.: Collis P. Huntington, New York (until d. 1900; life interest to his widow, Arabella D. Huntington, later [from 1913] Mrs. Henry E. Huntington, 1900–d. 1924; life interest to their son, Archer Milton Huntington, 1924–terminated in 1925); Bequest of Collis P. Huntington, 1900 25.110.27

JACQUES DE GHEYN THE ELDER

Antwerp 1565–1629 The Hague

Jacques or Jacob de Gheyn II is often called "the Elder" to distinguish him from his son Jacques de Gheyn III (1596?–1641), who drew and etched in a manner that generally resembles his father's. Jacques II was the son of Jacques (Jacob Jansz) de Gheyn I (1537/38–1581/82), a now obscure draftsman, engraver, and glass painter. Karel van Mander, who had known Jacques II for at least fifteen years when the *Schilder-Boeck* was published in 1604, writes that the artist's parents were from Utrecht and "were descended from a distinguished and honourable lineage there."[1] Only the first name (Cornelia) of Jacques I's wife is known, which was mentioned when their son Isaac was baptized in Antwerp in 1567. Jacques II's baptism is not documented, but Van Mander states that he was born in Antwerp in 1565. Jacques I joined the Antwerp guild in 1558, at the age of about twenty (in an Antwerp document of 1564 his age is given as twenty-six). It is not surprising that a Dutch designer and painter of stained glass went to work in the artistic and commercial capital of the Spanish Netherlands. Utrecht artists of the 1500s often looked to Antwerp for training or inspiration, one of the most important being Anthonis Mor (1516/20–?1576).

It is not known whether the De Gheyn family, with three boys and a girl, had already moved to the northern Netherlands by the time Jacques I died in 1581 or 1582, although Van Mander records that he had heard of a stained-glass window by the artist in the Oude Kerk of Amsterdam.[2] The date of the elder De Gheyn's death is estimated on the basis of Jacques II's remark to the biographer that he was seventeen years old when his father died. Reportedly, the son completed Jacques I's unfinished glass paintings, and started his own career by engraving and painting in gouache. This would have been in Utrecht. About 1585, Jacques II, then twenty years old, entered the workshop of Hendrick Goltzius (1558–1617) in Haarlem, where he made great progress as a draftsman and engraver. Whether De Gheyn was Goltzius's pupil for two years and then his assistant or set up his own shop in Haarlem is uncertain.[3] Goltzius departed for Italy in October 1590, and by 1591 De Gheyn moved to Amsterdam,[4] where he made engravings after his own designs and those of other artists, including Abraham Bloemaert (q.v.). It was probably about 1590–91 that

the gifted engraver Jan Saenredam (1565–1607) studied with De Gheyn.

In 1593, the artist was entrusted by the City and Admiralty of Amsterdam with the commission for an engraving on two sheets, *The Siege of Geertruidenberg*, which celebrates one of Prince Maurits's victories. Although De Gheyn, to his later regret, sowed some wild oats in his first years in Amsterdam, he was well established as a draftsman and engraver by 1595, and ready to settle down. In the spring of 1595, he married Eva Stalpaert van der Wiele, a wealthy and well-bred young woman from The Hague, where her father had been a burgomaster in 1584–85. The couple's only son, Jacques III (or the Younger), was probably born in 1596. The marriage brought De Gheyn into aristocratic circles in the South Holland region and made him financially independent. He became increasingly inclined to draw and, from about 1600 onward, to paint subjects of his own choosing, and (like Goltzius) appears to have given up engraving with the dawn of the new century. The four hundred thirty prints known to have been executed by De Gheyn seem more remarkable in number than the approximately fifteen hundred drawings that have been catalogued, given the laborious nature of engraving and the fact that he was a printmaker for little more than fifteen years.[5]

From 1596 until 1601 or 1602, De Gheyn and his wife lived in Leiden. He became acquainted there with a child prodigy from Delft, Hugo de Groot or Grotius (1583–1645), the future law scholar. Grotius's first words in print were Latin verses appended to engravings by De Gheyn and signed *H. Grotius aet. 12* (age 12).[6] The relationship lasted for years and drew De Gheyn into a learned world of humanists, mathematicians, and scientists. He remained extremely productive as an engraver, working both after his own designs and after drawings by Van Mander (*The Prodigal Son*, for example, a multifigure outdoor party scene dated 1596). In 1598 and 1599, De Gheyn engraved a series of twenty-two prints, *The Riding School, or Exercise of Cavalry*, which was probably commissioned by Count Jan VII van Nassau-Siegen, a cousin of Prince Maurits. This was followed by the *Exercise of Arms*, a drill manual showing foot soldiers with weapons in a variety of approved positions. Publication was deliberately delayed for (in modern terms)

reasons of national security, and the first edition did not appear until 1607–8. De Gheyn's incisive drawings for the *Exercise of Arms* are widely dispersed (although a good number are in the National Maritime Museum, Greenwich), and are prized by collectors. The prints served as patterns for Delft tile painters and other artisans until fairly recent times.[7]

Around 1600, De Gheyn started making faithful drawings of flowers and insects, inspired partly by his association with the famous Leiden botanist Carolus Clusius (for whose book of 1601, *Rariorum plantarum historia,* the artist designed a title page and a portrait in an emblematic frame), and probably also by seeing some miniatures of naturalia by Joris Hoefnagel (1542–1601). From 1591 until his death, Hoefnagel was court artist to Emperor Rudolf II, but his work was known in The Hague because his sister Susanna was married to Christiaan Huygens, secretary to Prince Maurits. (The couple's son Constantijn Huygens became secretary to Prince Frederick Hendrick and an eminent patron of the arts.) An album of watercolor miniatures on parchment by Jacques II, described by Van Mander (1604) as in Rudolf II's collection, is now in the Fondation Custodia, Institut Néerlandais, Paris.[8]

De Gheyn worked for the States of Holland and for the court at The Hague from 1597 onward. He therefore joined the Guild of Saint Luke in The Hague (by 1598 at the latest) as a painter and engraver; in 1615, he was listed solely as a painter. In 1603 (the date of the painting discussed below), he painted a life-size portrait of a prize Spanish horse captured at the Battle of Nieuwpoort (July 2, 1600) and presented to Prince Maurits, who awarded the commission for the now worn canvas (Rijksmuseum, Amsterdam). In the same period, De Gheyn painted his first flower still lifes, which recall those of Roelant Savery (1576–1639).[9] One of these was (according to Van Mander) purchased by Rudolf II, and in 1606 the States General commissioned a flower painting from De Gheyn (untraced) for presentation to Maria de' Medici. Van Mander mentions a *Sleeping Venus* (with a Cupid and two satyrs) as painted "in this year, 1604." The work is not preserved but its Mannerist style may be inferred from De Gheyn's *Seated Venus with Cupid* (Rijksmuseum, Amsterdam) and *Neptune, Amphitrite, and Cupid* (Wallraf-Richartz-Museum, Cologne), both of which date from about 1605 or slightly later.[10] These paintings and the others that survive (at least twenty-one are known) or that are recorded by documents or sale catalogues suggest that De Gheyn deliberately took on a variety of subjects, as well as works in different media and sizes. The ability to work on a miniature or monumental scale was one of several signs of virtuosity that he could have claimed.

Exactly when De Gheyn and his family moved to The Hague is not known, but it must have been in 1601 or 1602. They lived first on the Lange Voorhout (the finest avenue near the court) and from 1623 on the Lange Houtstraat, where Constantijn Huygens was their neighbor. In 1627, the artist's assets were valued at 40,000 guilders, making him one of the wealthier residents of a city that was known for its idle rich. But De Gheyn was active through the 1610s and 1620s, painting superb flower pieces and some less impressive devotional pictures. His own religious convictions are not clear, but they appear to have shifted gradually from Catholic beginnings to Calvinism.

The extraordinary range of De Gheyn's interests is evident from his prints and paintings, to say nothing of the garden with grottoes that he designed for Prince Maurits.[11] However, his prolific output of drawings must be studied to understand the artist's many sides. As objects of close observation there are insects, rodents, flowers, plants, trees, native landscapes, townscapes, domestic scenes, portraits and studies of anonymous people, animals, and candid nudes. But the same artist rivaled Bosch and Bruegel by inventing impossible mountains and monsters, the latter more frightful for being informed by studies "from life" of dead birds, fish, frogs, rats, and other creatures. De Gheyn's figure studies include drawings of young men and women in various poses and kinds of dress, and older people whose features are freakish enough for adaptation (along with his biological specimens) in his scenes of sorcery.[12] There are also allegorical compositions, including several on vanitas themes, and sketches of contemporary people on their deathbeds, one of whom is probably Karel van Mander in 1606.[13] De Gheyn died on March 29, 1629, at the age of sixty-three or sixty-four.

1. Van Mander/Miedema 1994–99, vol. 1, p. 434, fol. 294r. As noted in Van Regteren Altena 1983, vol. 1, pp. 2–3, Van Mander's remark suggests that Jacques de Gheyn I and his wife were cousins or otherwise related.

2. On this point, see Van Regteren Altena 1983, vol. 1, p. 13, where it is maintained (not altogether convincingly) that Jacques I probably died in Antwerp.

3. The latter alternative is favored by Van Regteren Altena (ibid., p. 27), but E. K. J. Reznicek in *Dictionary of Art* 1996, vol. 12, p. 529, after reading all the literature, states simply that De Gheyn "remained for five years" in Goltzius's workshop.

4. The first known document placing De Gheyn in Amsterdam is an entry in the diary of the Utrecht humanist Arnold Buchelius (Aernout van Buchell, 1565–1641), who met the artist on April 4, 1591. See Van Regteren Altena 1983, vol. 1, p. 27.

5. For a discussion and complete catalogue of De Gheyn's prints, see Filedt Kok 1990a and 1990b.

6. See Van Regteren Altena 1983, vol. 1, p. 43, where the account

makes a somewhat different impression than Reznicek's statement in *Dictionary of Art* 1996, vol. 12, p. 529, that after arriving in Leiden De Gheyn "began collaborating with the famous law scholar Hugo de Groot." The boy's father was a governor of Leiden University, where his uncle Cornelis was rector.

7. See Van Regteren Altena 1983, vol. 1, pp. 54–55, vol. 2, pp. 64–78, nos. 342–64, and vol. 3, pls. 85–155. The author refers to Jan II of Nassau, meaning "de Middelste" (the middle one), who is identical with Jan VII (1561–1623).

8. Ibid., vol. 1, pp. 66–70, vol. 2, pp. 141–43, nos. 909–30, vol. 3, pls. 172–93. See also Van Mander/Miedema 1994–99, vol. 6, p. 48 (under 294v21), fig. 39.

9. De Gheyn's beginning in the genre of still-life painting is described in Van Mander/Miedema 1994–99, vol. 1, p. 437 (fol. 294v).

10. Van Regteren Altena 1983, vol. 1, pp. 109–10, vol. 2, pp. 13–14, nos. 5, 6, vol. 3, pls. 4, 5.

11. See Sellers 2001, pp. 102, 104, 238, 259.

12. See, for example, Swan 2005, pp. 163–64, fig. 63.

13. Van Regteren Altena 1983, vol. 2, p. 113, no. 693, vol. 3, pl. 318. In addition to the catalogue and illustrations of drawings in Van Regteren Altena 1983, see Judson 1973 and Rotterdam–Washington 1985–86.

48. *Vanitas Still Life*

Oil on wood (single piece), 32½ x 21¼ in. (82.6 x 54 cm)
Signed and dated (on sill, below skull): JDGHEYN FE AN°
1603 [now largely illegible]; Inscribed: (on keystone of arch) HVMANA/VANA (human vanity); (lower left, on obverse of coin) IOANA.ET.KAROLVS.REGES. [ARA]GONVM. TRVNFATORES.ET.KATHOLICIS/C A (Joanna and Charles triumphant and Catholic regents of Aragón); (lower right, on reverse of coin) IOANA.ET.KAROLVS. [EIVS.FI]LIVS. PRIMO.GENITVS.DEI.GRA[CI]A. R[E]X/ARAGON[VM]/L S (Joanna and Charles her firstborn son by the grace of God king of Aragón) [from a coin struck in 1528]

The paint film is abraded, rendering many of the significant iconographic details difficult to discern. In addition, areas of minute cracks that appeared as the paint dried surround the skull and bubble, further marring the image. An overall warm brown imprimatura can be seen where the paint layers are thin. Passages painted with more opaque paint—for example, the coins and the figure of the philosopher at top left—are better preserved. The oak panel is made from one large piece of wood and retains the original bevel on the reverse.

Charles B. Curtis, Marquand, Victor Wilbour Memorial, and The Alfred N. Punnett Endowment Funds, 1974 1974.1

This panel, dated 1603, is generally regarded as the earliest known vanitas still life to have been painted in the Netherlands. The genre flourished from the 1620s onward, as is seen, for example, in Pieter Claesz's *Still Life with a Skull and Writing Quill*, of 1628 (Pl. 28). The influence of De Gheyn's composition should not be overstated, since it may not have been widely known, and it differs in character from later vanitas still lifes, which find deeper meanings in plausible realities (that is, objects one might actually encounter in everyday life). Here the artist paints a more purely conceptual image, comparable to didactic prints and title pages. (The latter, in this period, were often embellished by architectural frameworks, figures, and symbolic elements.) Nonetheless, the painting was a remarkably original work when it was made. This may reflect not only the special qualities of De Gheyn's imagination, but also his independence from the art market (as noted in the biography above). Furthermore, the possibility that the painting was intended expressly for a particular patron, such as the "Reynier Antonissen" in Amsterdam who owned a "Death's Head" by De Gheyn in 1604 (according to Karel van Mander's *Schilder-Boeck* of that year), would help to explain its exceptional character.[1]

The dominant motifs in the picture are a human skull and, floating above it, a transparent sphere or bubble. These forms occupy a stone niche with a slightly pointed arch, the keystone of which is inscribed HVMANA VANA (Human Vanity). The spandrels flanking the arch are filled with sculptural figures of philosophers with books at their feet: to the left, Democritus,

Figure 54. Jacques de Gheyn the Elder, *Allegory of Transience*, 1599. Engraving (after De Gheyn's drawing in the British Museum, London), 18 x 13⅞ in. (45.7 x 35.2 cm). Rijksmuseum, Amsterdam

who gestures toward the globe and laughs; and, to the right, Heraclitus, who points to the sphere and weeps. The sphere purposefully resembles a soap bubble, the familiar vanitas motif that suggests the emptiness and transience of human life ("Homo Bulla," as inscribed above a child making bubbles in an engraving by De Gheyn, of 1599; fig. 54).[2] However, the two philosophers and the images reflected in the sphere identify it as the world, meaning mundane experience.[3] Seneca, Juvenal, and other ancient authors contrasted Democritus (ca. 460–ca. 370 B.C.) with the earlier Heraclitus (ca. 540–ca. 475 B.C.), calling them the laughing and weeping philosophers because of the former's mocking and the latter's melancholic responses to the world of mankind. The theme was eagerly adopted by Renaissance writers, and often depicted from the fifteenth century onward (as in Bramante's fresco of 1477, in the Pinacoteca di Brera, Milan). The subject was especially common in Dutch art of the seventeenth century.[4]

One of the most important antecedents of De Gheyn's composition is an engraving of 1557 by the Haarlem humanist Dirk Volkertsz Coornhert (1522–1590), after Maerten van Heemskerck (1498–1574). In the print (fig. 55), the two philosophers stand in a "world landscape" with, between them, a translucent orb draped with a foolscap. At top center, flanked by putti holding hourglasses and resting on skulls, a plaque bears the legend REMPUS RIDENDI TEMPUS FLENDI (A time to

Figure 55. Dirk Volkertsz Coornhert after Maerten van Heemskerck, *Democritus and Heraclitus*, 1557. Engraving. Fitzwilliam Museum, University of Cambridge, Cambridge, England

laugh and a time to weep).[5] De Gheyn probably also knew the figures of Democritus and Heraclitus (with a globe) that were painted by Cornelis Ketel (1548–1616) on the exterior of his house in Amsterdam, reportedly in 1602.[6]

In De Gheyn's picture, two common vanitas symbols, cut flowers and smoke, rise from urns at either side of the niche. More elaborate versions of the same motifs occupy the lower corners of his engraving dated 1599 (fig. 54). The painted flowers are a red-and-yellow flamed tulip (a luxury item) and a field rose, one petal of which has fallen onto the sill (where chips and cracks also suggest the ravages of time). Contemporary viewers would have recalled biblical passages comparing mortal life with flowers and smoke: for example, "Man that is born of a woman is of few days, and full of trouble. He cometh forth like a flower, and is cut down: he fleeth also as a shadow, and continueth not" (Job 14:1–2); and, "Hear my prayer, O Lord . . . in the day when I call answer me speedily. For my days are consumed like smoke, and my bones are burned as an hearth" (Psalms 102:1–3). Similarly, the straw beneath the skull in the painting perhaps makes reference to the words in the same Psalm, "My heart is smitten, and withered like grass" (102:4) and, "My days are like a shadow that declineth; and I am withered like grass" (102:11). Similar thoughts are found in Isaiah, in verses on the greatness of God and man's insignificance: "All flesh is grass, and all the godliness thereof is as the flower of the field: The grass withereth, the flower fadeth: because the spirit of the Lord bloweth upon it: surely the people is grass" (Isa. 40:6–7).[7]

Ingvar Bergström, in his essential article on the painting, was inclined to see "the ears of corn [?] and the few fallen grains lying around the skull" as an expression of the idea "that Man when dead and buried will be resurrected through the sacrifice of Christ—the grain of corn falls into the earth and a new plant grows."[8] De Gheyn had employed the concept earlier (as in fig. 54),[9] but the clarity with which he referred to resurrection in other images suggests that Bergström's discovery of a "rather concealed" allusion to the same notion in this picture, together with his claim that Democritus and Heraclitus have, like sibyls, undergone a "Christianizing process," amounts to grasping at straws. All vanitas pictures of the seventeenth century may be considered as calls to a spiritual life and thus salvation, usually without any overt reference to Christ. It seems unlikely that one was intended here.

Bergström also published a diagram of the small images that float in the sphere, describing them as "symbols of worldly vanity and of Man's frailty and infirmity."[10] His reading of these motifs evidently took place shortly after the owner of the picture had

it cleaned, which probably reduced the definition of forms in an area that had been very thinly painted in the first place and that later became more transparent and ambiguous by natural aging and the use of solvents. Bergström's imagination may also have been stimulated to some extent by the fact that he identified some symbols on the basis of comparison with motifs depicted in the border of the engraving after Van Heemskerck (fig. 55).[11]

At present, the images on and in the sphere (fig. 56) may be described as follows. On top of the sphere, there are wavy, ambiguous forms, with at least one ball-like (or bell-like) object dangling from an appendage. This small, vague motif (not mentioned by Bergström) recalls the foolscap on the globe in the engraving, but it is now unclear. In the upper center of the sphere, just to the right of the reflected window, is an imperial crown (which is too large in Bergström's diagram), with traces of swords at top left and right.[12] Bergström was probably correct in describing this arrangement as a trophy comprising a crown with one pair (in his reading, two pairs) of swords, as there is some resemblance to the trophy of a crown and weapons in the border of Van Heemskerck's design. The lower swords and plumelike shapes to either side of the crown in Bergström's diagram are now almost invisible. The lance below the crown in his rendering remains faintly visible under magnification. Bergström's identification of an "upturned money-bag with coins streaming out through a broken heart," in the area above the crown, cannot, because of its poor condition, be supported (or rejected) by examination of the paint layer.[13]

The reflected window to the upper left coincides with a grayish heart, apparently stuck through with a blade or an arrow, with a flame at the top.[14] A cascade of much less visible forms, sketched in grays and browns, descends along the highlighted left side of the sphere. They are, from top to bottom: probably a caduceus, now very faint; probably a bellows; two or three drinking vessels; to their left, a few small rectangular forms, plausibly called playing cards by Bergström; and, to the lower left, a backgammon board, with Bergström's "dice" being quite uncertain. On the right side of the sphere, a wagon wheel, mounted on a shaft or pole, and three flasklike shapes float in a large rectangular highlight. Bergström read one of the smaller forms as a *Lazarusklep* (Lazarus clapper, an attribute of lepers), which is merely a possibility.[15]

This tedious inventory of symbols that may or may not be discernible in De Gheyn's transparent sphere is, fortunately, not difficult to interpret. All is vanity: earthly possessions, authority, pleasures, desires. The crown with swords signifies power and glory. The caduceus, if there, probably refers to

Figure 56. Detail of De Gheyn's *Vanitas Still Life* (Pl. 48)

commerce, the bellows to success or good fortune (like having wind in one's sails).[16] Playing cards, a backgammon board, and drinking glasses would be expected attributes of pleasure and idleness. The flaming heart must symbolize earthly love, as Bergström supposed, and his reading of the wheel on the pole as the familiar Flemish instrument of torture and execution (as in the background of Pieter Bruegel the Elder's *Triumph of Death*; Madrid) is convincing.[17] The proximity of a *Lazarusklep* to a gibbet wheel would not be surprising, since leprosy was considered to result from sinful behavior.

Turning now to "the root of all evil" (1 Tim. 6:10), the money depicted by De Gheyn at the bottom of the composi-

tion, all the coins shown—except for the largest example—were used as currency in the Netherlands about 1600. The exception is the hundred-ducat goldpiece minted in Zaragoza (capital of the kingdom of Aragón) in 1528, illustrated both in obverse (lower left corner) and in reverse (lower right corner). The coin, weighing 350 grams, must have been rare even in De Gheyn's lifetime; very few examples are known today, and why it was made remains a matter of speculation. The reverse bears the crowned crest of Aragón, and the obverse displays bust-length portraits of Joanna the Mad (who nominally ruled Aragón from 1516 until her death in 1555) and her son, Charles I, king of Spain (and, from 1530, Emperor Charles V), who ruled

Figure 57. Obverse (left) and reverse of the medal commemorating the capture of the Portuguese galleon *Santiago* by two Zeeland ships off Saint Helena on March 16, 1602. Silver, diameter 2 in. (5.2 cm). Koninklijk Penningkabinet, Leiden

Figure 58. Detail of the Zeeland medal of 1602 in De Gheyn's *Vanitas Still Life* (Pl. 48)

on his mother's behalf.[18] De Gheyn faithfully reproduces the Latin inscriptions on both sides of the coin, though he improves the modeling of the portraits.[19]

On the sill between the vases, the following coins may be identified (from left to right): a silver taler with an image of Charles's younger brother, Ferdinand I (1503–1564; king of Hungary and Bohemia from 1526); a pile of five coins, of which the first three or four (all silver) are German talers and the gold coin to the right is an 8-real silverpiece of Philip II (minted ca. 1590); next, a gold noble (worth 6 shillings, 8 pence) of Edward IV, king of England (r. 1461–83); below, four small gold coins, of which the one to the left is a Spanish escudo; in the middle, below the skull, a Zeeland silver medal of 1602, bearing a galloping horse and a rampant lion (discussed below); beneath the medal, an unidentified silver coin with a charging boar; on top of four silver pieces, an unidentified silver medal or coin bearing a crowned shield between rampant lions; a bronze (?) pseudoantique coin, probably from the 1500s, with a head in profile; a coin with a seated antique figure, perhaps the reverse of a coin like the preceding one; below the last two coins, two others, unidentified, one showing a dog in profile.[20]

The silver medal dated 1602 (fig. 57) commemorates the capture of a Portuguese galleon by two Zeeland merchant ships earlier that year, off Saint Helena in the South Atlantic. This was a victory in the Dutch war of independence, since their enemy, Philip III, king of Spain, ruled Portugal as Philip II, treating the kingdom as a Spanish province. The Zeeland ships and their prize sailed into Middelburg on July 7, 1602. The galleon and its precious cargo (such vanities as porcelain, spices, gold, silver, and pearls) were sold off for 1.5 million guilders, which was divided among numerous entitled parties: the Zeeland chamber of the East India Company (VOC), the

States of Zeeland, the Stadholder, Prince Maurits (who received 100,000 guilders), merchants who had invested in the ships, the crew, and so on. The directors of the Zeeland VOC had the medal minted in Middelburg; silver and, reportedly, gold examples (none have been identified) were handed out to members, investors, and friends.

The reverse of the medal, not seen in De Gheyn's picture, shows the three ships sailing together (an illustration of having one's "ship come in"), with a border inscribed: POSSVNT QVAE POSSE VIDENTVR.16 MARTY.1602 (They can because they believe they can. 16 March 1602). The quote is from the fifth book of Virgil's *Aeneid,* in which Aeneas holds funeral rites and athletic games in honor of his deceased father. Four Trojan ships compete with one another, and the victorious sailors, who "would sell life for renown," triumph by the slimmest of margins, "because they believe they can" (5.231).

The obverse of the medal shows the Zeeland lion (in water, as on the province's crest) chasing a horse on a globe, with the inscriptions: NON SVFFICIT ORBIS (The world is not enough) and QVO SALTAS INSEQVAR (Where you go, I will follow). These inscriptions are clearly legible in the painting just below De Gheyn's signature and the skull. "Non sufficit orbis" was a personal device of Philip II, and went back, in Spanish history, to the Treaty of Tordesillas (1494), when the pope declared the world beyond Europe to be the property of Spain and Portugal.[21] The horse must also refer to Philip II and Philip III, since their name, "Philippus" (from the Greek *philipos*), means "horse lover," an etymology to which the Spanish court frequently drew attention.[22] Thus the medal of 1602 shows the Dutch Republic (or rather, one Dutch province) chasing Spain and Portugal around the globe, which they had the hubris—or vanity—to imagine as all their own.[23]

In De Gheyn's hands the medal takes on additional currency, since he surely knew (from his own reading, his Latinist circle in Leiden, or one of his learned friends) that "non sufficit orbis" is a quote from Juvenal's *Satires,* specifically no. 10, on the vanity of human desire. In this Stoic essay concerning the ability "to distinguish true blessings from their opposites" (10.3), kings, rich men, and ordinary people praying for longevity, beauty, and so on, pass by in pitiful review, unaware that virtue, "the woes and hard labors of Hercules," rather than the luxuries of Sardanapalus, paves "the one and only road to a life of peace" (10.360–64). "The foremost of all petitions —the one best known to every temple—is for riches and their increase, that our money-chest may be the biggest" (10.23–25). But poison comes "in a golden bowl," and therefore, "will you not commend the two wise men, one of whom would laugh while the opposite sage would weep every time he set foot outside the door?" (10.28–30). Some twenty lines follow on the merits of Democritus, after which Juvenal turns to the great men of history and their downfall. "Few indeed are the kings who go down to Ceres' son-in-law [Pluto] save by sword and slaughter—few the tyrants that perish by a bloodless death!" (10.110–12). Hannibal, for instance, "for whom Africa was all too small . . . [so that] Spain is added to his dominions: he overleaps the Pyrenees . . . and now Italy is in his grasp" (10.146ff.), lives his last days in exile and poisons himself. Similarly, "one globe is all too little ["non sufficit orbis"] for the youth of Pella [Alexander the Great]; he chafes uneasily within the narrow limits of the world," but, in the end, "a sarcophagus will suffice him" (10.168–72).[24]

It has been suggested that De Gheyn gave the Zeeland medal a prominent place in the painting because he may have been its designer, quite as, two years earlier, he had designed a medal commemorating the victory of Prince Maurits over Spanish troops at the Battle of Nieuwpoort.[25] Scholars of De Gheyn's oeuvre reject this idea, and historians of numismatics have proposed more plausible candidates.[26] Nonetheless, De Gheyn was keenly interested in coins and medals, and he was the brother-in-law of Caspar Wyntgens, mintmaster of West Friesland, whose brother Melchior Wyntgens, as mintmaster of Zeeland at Middelburg (from 1601 until 1612), supervised the production of the 1602 medal.[27] Melchior Wyntgens was also a well-known collector of paintings (Van Mander refers to his many works by Cornelis Cornelisz van Haarlem), and a resident of Delft before his appointment in Middelburg.[28]

The most likely scenario, therefore, is that De Gheyn and his patron (if the picture was commissioned) were quite familiar with the Zeeland medal, knew the source of Philip II's

device in Juvenal, and saw that this connection invited the invention of a vanitas allegory comparable to that in the *Allegory of Transience,* dated 1599 (fig. 54), but more strongly focused, with (as in Juvenal) the laughing and weeping philosophers featured, mundane desires condemned, and particular attention given to the vanities of money and imperial power. Philip II, at this point in Dutch history, was unlikely to be identified with such venerable megalomaniacs as Hannibal and Alexander, or with a generic emperor like the one holding a crystal orb in the vanitas print (fig. 54), but rather with the Habsburg dynasty and the Spanish kings who oppressed the Netherlandish provinces.[29] Thus the painting is at once topical and a meditation on the nature of all mankind, with motifs bringing to mind complementary quotations from classical authors and the Bible. The medal and coins, while symbolizing the vanities of wealth and fame, also lend a sharp political edge to the picture, with Philip II's own motto turned against him, revealed on the medal as an idle boast, and on the painting as words by which to live—and by which to die: the world does not suffice.

Van Mander's mention of a "death's head" by De Gheyn in the collection of one Reynier Antonissen in Amsterdam has generally been connected with the present picture (see Refs.), but has also been thought to refer to a less complex composition, in part because a probably much simpler vanitas painting by Abraham Bloemaert, in the collection of Jacques Razet in Amsterdam, was described by Van Mander as "a death's head with other additional things, very well executed and colored."[30] It has also been suggested that De Gheyn might have painted the picture for the Middelburg mintmaster Melchior Wyntgens, which is plausible, although Van Mander, as a friend of Wyntgens, might have known that he owned the work in time to cite it in the *Schilder-Boeck* of 1604.[31]

If De Gheyn made this unusual work for a particular patron, which seems likely, then a strong candidate would be Prince Maurits. The artist was a member of the Stadholder's social circle in The Hague, and in the same year, 1603, was commissioned by him to paint a life-size portrait of the Spanish horse that was captured at the Battle of Nieuwpoort (Rijksmuseum, Amsterdam).[32] Trophies of war, such as captured flags, ships, and so on, were always of keen interest to the prince. De Gheyn's design for a medal commemorating Maurits's victory at the Battle of Nieuwpoort (1600) was mentioned above. The horse picture has also been compared with the artist's work on two suites of engravings, *The Riding School, or Exercise of Cavalry* (1598–99) and the *Exercise of Arms* (published in 1607–8; see the biography above), "all of them connected with the victorious army."[33] The sweetest victories were

those that brought a large windfall of funds, since finances were a constant problem during the struggle for independence, and taking silver, gold, or salable goods directly from the enemy (who also found the war expensive) was like doubling the advantage.[34]

It may be assumed that Prince Maurits received one of the Zeeland medals, or a number of them, in addition to his 100,000-guilder share of the booty seized in 1602. In addition to the Nieuwpoort medal of 1600, there were many others: in the 1590s and early 1600s, medals were minted nearly every year to celebrate army and navy victories over Spain, a number of them showing Maurits's portrait or his figure in action.[35] Unfortunately, not all the circumstantial evidence in favor of Maurits as the first owner of the vanitas still life can be supported or overruled by contemporaneous documents or accounts. At the prince's death in 1625, there was no need for an inventory of his household goods, since his half brother, Prince Frederick Hendrick, was his sole heir.[36] Frederick Hendrick was a major patron and a man of very different tastes, so that it is possible that a painting owned by his deceased predecessor could have left the princely collections without leaving a trace. However, there are many other possibilities. In De Gheyn's circle during the early 1600s, and in the Dutch art world as a whole, meditations on the fragility of life and the certainty of death were commonplace, in reflection of the times.

No copies of this painting are known. At least two drawings by De Gheyn relate to the composition. One depicts three flowers, dated 1601, from which the tulip is repeated here, and the other (of about 1603?) represents Democritus and Heraclitus seated to either side of a small sphere.[37] In the latter, the gestures are quite like those in the painting and the poses are similar, but the figures do not lean on a support and the facial types differ.

1. According to Miedema in Van Mander/Miedema 1994–99, vol. 6, p. 49, the painting cited by Van Mander is the one in New York, and "Reynier Antonissen" was "possibly the book-seller Reyer Anthonisz., who in 1605 made a declaration relating to two small paintings by Jacques Savery."

2. The print reproduces a drawing by De Gheyn, *Allegory of Transience,* signed and dated 1599 (British Museum, London). De Gheyn is traditionally assumed to have engraved his own design. See Van Regteren Altena 1983, vol. 2, pp. 52–53, no. 204. In the print, the standing figures of a peasant and an emperor reappear as corpses in the foreground, showing that all stations of mankind come to the same end. Another interesting case of the "Homo Bulla" motif is the painting of a naked child blowing a soap bubble on the back of Cornelis Ketel's round *Portrait of a Man,* dated 1574 (Rijksmuseum, Amsterdam). See Haak 1967, pp. 26,

30, fig. 8, and Van Thiel et al. 1976, p. 315.

3. On the transparent sphere as a symbol of the world, see Tervarent 1958–59, cols. 362–63, and Bergström 1970a, p. 153 n. 30 (with additional literature); as a vanitas symbol, see Möller 1952. Haak 1967, pp. 28–30, fig. 6, discusses Maerten van Heemskerck's *Portrait of a Man,* of about 1645 (Museum Boijmans Van Beuningen, Rotterdam), in which the sitter points to a transparent sphere that he holds in his other hand. In the sphere are images of the seasons, which, as the inscription in a cartouche suggests, fly by like light and dark, meaning day and night.

4. As discussed at length in Blankert 1967, and Lurie 1979. See also Weisbach 1928. Martin Luther, in his letter to Nicolas Armsdoff, published as an appendix to *De Servo Arbitrio* (The Bondage of the Will), 1525, condemns Erasmus as "a plain Democritus or Epicurus, a crafty derider of Christ."

5. See Bergström 1970a, pp. 151–52, fig. 11. Compare the engraving by Crispijn van de Passe, catalogued in Blankert 1967, pp. 115–16, no. 87, fig. 42.

6. Van Mander's account (see Van Mander/Miedema 1994–99, vol. 1, p. 373 [fol. 278v]) is connected with De Gheyn's painting in Van Regteren Altena 1983, vol. 2, p. 15 (under no. 11).

7. These quotations expand upon those offered in Walsh 1974a, pp. 341–42.

8. Bergström 1970a, p. 154. See also Koozin 1989, p. 28, where the "ideas of resurrection and redemption" are said to "appear metaphorically as the fallen grains underneath the skull."

9. See Bergström 1970a, p. 154, figs. 8, 13. The first is fig. 54 here, the second De Gheyn's drawing of about 1595, *Vanitas Allegory* (Rijksprentenkabinet, Rijksmuseum, Amsterdam; Van Regteren Altena 1983, vol. 2, p. 53, no. 205), in which a naked child sits with a mirror and a cut flower surrounded by a skull, a smoking urn, and a cornstalk dropping seeds on the ground.

10. Bergström 1970a, p. 154, fig. 5.

11. Ibid., p. 152, compares objects in De Gheyn's sphere with those in the engraving after Van Heemskerck, and p. 153, on objects in the sphere "which do not occur in the 1557 engraving."

12. The swords point toward the top of the crown, like minute hands pointing to the numbers 11 and 1 on a clock. The hilts differ, the one on the left having a crossbar ("guard") not indicated in Bergström 1970a, fig. 5. Of the two lower, crossed swords he detected, the only remaining trace is a faint line at ten o'clock, perhaps the point of a sword.

13. There is a small, heart-shaped blob of lead white, nearly effaced by craquelure, directly above the crown. According to Bergström (ibid., p. 152), De Gheyn repeated the motifs of moneybag and crown from the lower right corner of the engraving after Van Heemskerck.

14. In Van Regteren Altena 1983, vol. 2, p. 15 (under no. 11), the "flaming heart pierced by an arrow" is considered "to belong to a category of reality different from all the other images shown inside the glass," evidently because it is (according to the writer), like the window, a reflection of something outside the sphere. Without much explanation, the heart is called a sign of Christian redemption. Bergström (1970a, p. 153) understood the burning heart as "an image of earthly love, of luxury," meaning desire, and observes that in De Gheyn's painting of a provocative Venus and an aggressive Cupid, perhaps of about 1604–5 (Rijksmuseum,

Amsterdam), Venus holds up a flaming heart (see Van Regteren Altena 1983, vol. 2, p. 14, no. 6, and vol. 3, pl. 4).

15. Bergström 1970a, p. 152. On this noisemaker, see the discussion of Jan Steen's *The Dissolute Household* (Pl. 196), below. Conservator Dorothy Mahon was extremely helpful in tracing the evidence of motifs in the sphere.

16. See Bergström 1970a, p. 153, and Tervarent 1958–59, col. 358.

17. On the heart, see note 14 above. In Bergström 1970a, p. 152 n. 24, De Gheyn's engraving *Three Drunken Men at a Table* is mentioned because there is such a gibbet in the background. There is also an hourglass in the foreground. The point is that drinking soon leads to a bad end.

18. Van der Meer 2004, pp. 18–19, 27 n. 6.

19. The obverse is illustrated in Bernhart 1919, p. 92, no. 230, fig. 22 (example in Vienna). The inscriptions on both sides are transcribed. In Van der Meer 2004, p. 27 n. 6, it is said, on another scholar's authority, that the only known example of the coin is in the Cabinet des Médailles, Bibliothèque Nationale, Paris, but this must be mistaken. In the same note, it is said that De Gheyn corrected a fault in the inscription on the reverse, but the present writer finds no difference from the transcription given in Bernhart 1919, p. 92, no. 230, fig. 22.

20. See Bergström 1970a, pp. 143–44, nn. 3, 4, and Van der Meer 2004, pp. 19, 26. Bergström mistakenly refers to a 10-ducat rather than a 100-ducat goldpiece, and Van der Meer describes the 8 real coin incorrectly as silver rather than gold. Dutch imitations of the English noble were common. The coin shows a primitive image of Edward IV (r. 1461–83), with a shield, in a small ship. Bergström (ibid.) was indebted for his identification of coins and medals to a letter dated February 14, 1969, from H. Enno van Gelder, director of the Koninklijk Kabinet van Munten, Penningen en Gesneden Stenen, The Hague. Van der Meer (see 2004, p. 27 n. 9) referred to a copy of the same letter, as did the present writer (copies in Leiden, and in the Museum files). In a letter to the writer dated September 9, 2003, Van der Meer described all of the late Dr. Enno van Gelder's identifications as "still valid," and added that De Gheyn was evidently "not aiming at absolute accuracy," especially in the inscriptions.

21. This observation was made by the eighteenth-century Dutch historian Gerard van Loon, in reference to the Zeeland medal of 1602: Van Loon 1723–31, vol. 1, pp. 563–64 (cited in Van der Meer 2004, pp. 19, 24, 28 n. 12).

22. For example, the authority on equitation, Bernardo de Vargas Machuca (1557–1622), in the introduction to his *Teoria y exercicios de la jineta* (Madrid, 1619), observes that "great princes of all nations have treasured the name of Philip as a friend of the horse."

23. Presumably, this pursuit is promised by the motto "Quo saltas insequar," which the writer has not found in a classical source. It recalls Ruth 1:16, in which the widow Ruth expresses loyalty to her widowed mother-in-law, Naomi: "for where thou goest, I will go" (kindly brought to my attention by Frima Hofrichter). However, the use of the motto as an expression of loyalty to Zeeland or the United Provinces is not known.

24. These quotes are from Juvenal and Persius 1918, pp. 193ff. Juvenal refers specifically to Alexander's death in Babylon, after pushing his army to geographical extremes.

25. This was H. Enno van Gelder's personal suggestion to Bergström,

acknowledged in Bergström 1970a, p. 143 n. 3. On De Gheyn's design of the Nieuwpoort medal, which was commissioned by the States General late in 1600, see Van Regteren Altena 1983, vol. 1, pp. 63–64, fig. 50 (the medal itself, which features the triumphant prince on horseback), vol. 2, p. 40, no. 149, vol. 3, pl. 157, and Amsterdam 2000–2001, pp. 218–20, no. 63.

26. As noted in Van der Meer 2004, pp. 24–25, 29 n. 34.

27. See Van Regteren Altena 1983, vol. 1, p. 64, and Van der Meer 2004, pp. 25, 29 n. 35.

28. See Van Mander/Miedema 1994–99, vol. 2, p. 75, and Van Thiel 1999, pp. 297–98.

29. For the historical circumstances, see Israel 1995, chaps. 7–12. A brief sketch of the relationship between the Netherlands and the Spanish kings is found in New York–London 2001, pp. 25–26. Left unexplained here, and by earlier authors, is the inclusion of the gold noble of Edward IV. The fifteenth-century king had no special connection with the Netherlands. Perhaps, in this case, money is merely money, or a tribute to England, allies of the Dutch. Imitations of English nobles, including this one, were made by the Dutch through the early 1600s, with inscriptions clarifying their places of origin (Van der Meer 2004, p. 27 n. 8, citing more specialized literature). It should be noted that Edward IV is shown with a shield sailing in a ship, thus suggesting a naval victory (like that of the Zeeland ships in 1602, or of the English navy over the Spanish Armada in 1588).

30. See Van Mander/Miedema 1994–99, vol. 1, p. 449 (fol. 297v), which offers a slightly different translation. M. L. Wurfbain, in a letter to the present writer dated March 27, 2002, and in correspondence with Gay van der Meer (see Van der Meer 2004, p. 26), has argued against the identification of the Museum's picture with that in the collection of Reynier Antonissen, mainly because Van Mander describes the simpler painting by Bloemaert in more detail. On Bloemaert's painting (presumed lost) and Van Mander's description, see Roethlisberger 1991, pp. 21–22, and Roethlisberger 1993, vol. 1, pp. 101–3, no. 55.

31. See Van der Meer 2004, p. 26, crediting M. L. Wurfbain with this suggestion, and relating it to the legal claims of the Italian merchant Francesco Carletti, who had consigned valuable cargo to the seized Portuguese ship. Wurfbain also discusses the possibility of Wyntgens's patronage in letters to the present writer dated May 10 and October 22, 2002.

32. Van Regteren Altena 1983, vol. 1, pp. 74–76, vol. 2, p. 17, no. 15; Amsterdam 2000–2001, pp. 234–35, no. 81. In the latter publication, pp. 144, 298, it is suggested that De Gheyn's *Seated Venus with Cupid,* of about 1603–4 (Rijksmuseum, Amsterdam), was also owned by Maurits.

33. Van Regteren Altena 1983, vol. 2, p. 17 (under no. 15, *The White Stallion*). Van Mander 1604, fol. 294v, cites the horse painting commissioned by Maurits, but not a vanitas still life made for him. However, his information was almost always incomplete and what he chose to include selective, and the panel (no matter where it was) may have been painted too late in 1603 for mention in a publication of the following year.

34. The most famous case is Admiral Piet Hein's capture of a Spanish treasure fleet off Cuba in 1628. This brought in 11 million guilders, and was a tremendous blow to the Spanish crown. Large Spanish flags hung over Hein's tomb in Delft, as seen in

paintings of the 1650s. See New York–London 2001, pp. 24, 204, 412–14, no. 82, fig. 117.

35. See Amsterdam 2000–2001, pp. 214–21, nos. 49–67. A few of these medals are of special interest here: the silver-gilt medal of 1588 commemorating English and Dutch collaboration in defeating the Spanish Armada (ibid., no. 49); the silver medal of 1597 in remembrance of the Battle of Turnhout (no. 59), with an inscription noting that thirty-nine Spanish flags had been captured (and hung in the Great Hall, or Knight's Hall, of the court buildings at The Hague); the Canary Islands' gold medal of 1599 (no. 61), showing Maurits as General Admiral of the Fleet, with a figure of Fortune on the reverse (a thousand Dutch were lost); De Gheyn's Nieuwpoort medal of 1600, with an equestrian portrait of Maurits (no. 63); the 1602 medal commissioned by the States General to mark three victories of that year (no. 64), at Grave, at Tongeren (more flags captured), and at sea (six Spanish ships sunk or captured); the medal marking the defeat of Spinola's ships in 1603 (no. 65).

36. On this point, see ibid., pp. 142–43.

37. Van Regteren Altena 1983, vol. 2, pp. 38, 142, nos. 136, 914, vol. 3, pls. 177, 264.

REFERENCES: Van Mander 1604, fol. 294v, refers to a painting (possibly this one) as "eene doots cop die t'Amsterdam by Reynier Antonissen te sien is" (a death's head which is to be seen in Amsterdam with Reynier Antonissen); Van Mander 1618, p. 108 (repeats Van Mander 1604); Greve 1903, p. 225, records the reference in Van Mander 1604; Van Regteren Altena 1935, p. 24, cites the reference in Van Mander 1604; Bergström 1956, p. 161, mentions the reference in Van Mander 1604; Merrill 1960, p. 9, notes the reference in Van Mander 1604; Bergström in Stockholm 1967, pp. 47–48, no. 53 (ill. p. 50), describes the composition and mentions Van Mander's reference to such a picture in 1604; Bergström 1970a, passim, recalls the circumstances (in 1966–67) of discovering that the work is by De Gheyn, describes the composition, identifies the symbolic motifs and several of the coins, relates earlier prints and drawings by De Gheyn, considers the painting to be the earliest dated independent picture of its kind, and notes the apparent reference to it in Van Mander 1604; Bergström 1970b, pp. 12–13, 15, fig. 3, describes the work as one of the most interesting paintings in the Leiden "Vanitas" exhibition of 1970; Bergström in Leiden 1970, unpaged (first and third pages of his essay), refers to the tulip in the picture, and in the catalogue section, pp. 10–11, no. 12, summarizes the remarks made in Bergström 1970a; Wurfbain in ibid., unpaged (first and second pages of his essay), briefly discusses whether this is the painting cited by Van Mander in 1604; Fischer 1972a, p. 63, mentions the work in a discussion of vanitas imagery; Judson 1973, pp. 18, 38, 42 n. 17, relates the painting to De Gheyn's drawing of Democritus and Heraclitus (see text above), and doubts that this is the picture described by Van Mander which "must have been executed prior to 1603–1604"; Popper-Voskuil 1973, p. 68, suggests that a painting by David Bailly may have been inspired by this work; Walsh 1974a, pp. 341–42, 349 n. 3, fig. 3, announces the picture's purchase by the MMA, describes it as "the earliest developed Vanitas painting," compares the niche in Titian's Entombment, identifies the "straw" (Bergström) below the skull as "The grass [that] withereth" (Isa.

40:6–7), cites two other biblical sources, and in other respects follows Bergström 1970a in explaining the composition; MMA 1975, p. 95 (ill.), as "perhaps the earliest Vanitas still life"; Voskuil-Popper 1976, p. 74 n. 28, refers to the images of Democritus and Heraclitus in the picture as standing for the motto "A time to laugh and a time to weep," sees the responses of the philosophers to the world as reflected in the division of the composition into a brighter side and a darker side, with a flower on one side and smoke on the other, and discusses the coins; Bergström et al. 1977, p. 31, refers to a print inspired by the iconography of the painting; Chastel 1978, p. 26, fig. 8, reflects on man's mortality and illustrates a quote from Malraux with this picture; Heezen-Stoll 1979, pp. 243–44, 250 (in English summary), fig. 16, sees De Gheyn (not David Bailly) as the originator of vanitas painting in Leiden, on the evidence of this work; Becker in Münster–Baden-Baden 1979–80, pp. 455, 458, mistakenly describes the painting as by De Gheyn's father, and compares a later work by Pieter van Roestraeten; Klemm in ibid., pp. 194–96, 199 (ill.), 202–6, summarizes the symbolism and compares the later use of a "soap bubble or glass sphere" by Jan de Heem; Veca in Bergamo 1981, pp. 64–65, fig. 75, cites the panel as the first vanitas painting, and compares images of skulls on the backs of earlier Flemish portraits; Bergström 1982, p. 175, mentions the tulip as a symbol of transience; De Jongh in Auckland 1982, p. 206, fig. 41d, mistakenly as in "Stockholm, private collection"; Segal in Amsterdam–'s Hertogenbosch 1982, p. 31, imagines that Jan Brueghel "took the idea" of coins from this painting; Welu 1982, pp. 32–34, fig. 9, discusses the picture's meaning; Van Regteren Altena 1983, vol. 1, pp. 84–85, 177 n. 14, describes the painting's style and iconography, and considers it the one cited in Van Mander 1604, and vol. 2, pp. 15 no. 11, 38 (under no. 136), 130 (under no. 815), 142 (under no. 914), and vol. 3, p. 15, pl. 3, slightly refines the iconographic reading advanced in Bergström 1970a, and considers three drawings by De Gheyn, one of Heraclitus and Democritus, one of three flowers, and one of a skull, to have been adopted in the painting; Haak 1984, pp. 118, 126–28, fig. 218, cites the tulip as "a favorite emblem of human mortality," and the picture as possibly that cited in Van Mander 1604; Ter Kuile 1985, pp. 32–33, 35, fig. 11, as "the earliest known Vanitas," reviews the symbolic motifs, and cites the work as a likely influence on David Bailly and other vanitas still-life painters in Leiden; Rotterdam–Washington 1985–86, p. 55 (under no. 38), catalogues the drawing of Democritus and Heraclitus used for the figures in the painting; Segal in Cologne–Utrecht 1985–86, pp. 57, 64 n. 13, compares a painting by Roelant Savery dated 1603; P. Sutton 1986, p. 190, cites the picture, "the earliest vanitas in existence," as "one of the most important if not best-preserved still lifes in the [Museum's] collection"; Briels 1987, pp. 260–62, fig. 328, interprets the image as presenting a choice between material and spiritual values; Kuretsky 1987, pp. 85–86, fig. 3, notes the vase with a striped tulip and a rose as a symbol of mortality; Koozin 1989, pp. 28, 30, fig. 8, interprets the figures of philosophers, the bubble, and the straw beneath the skull; Segal 1989, pp. 19–20, 65, considers the work as "the basis of a great tradition," and inexplicably considers the "coins with portraits of the Roman Catholic couple Charles and Johanna of Aragon" to be evidence of De Gheyn's direct contact with Antwerp; Liedtke 1990, p. 55, cites the work as a postwar acquisition; Olbrich and Möbius 1990, p. 246, pl. XXIII, begins a brief discussion of Dutch vanitas still lifes with this work; Bergström in Caen–Paris 1990–91, pp. 50–

52, fig. 6, describes the composition, diagrams the symbols in the bubble, and compares the symmetry of the image with that found in allegorical prints; Foucart in ibid., p. 56, fig. 1, in a passage rife with superficial aperçus and exclamation points, considers the picture to represent a "vanitas-type of the years 1600–30"; Tapié in ibid., p. 242, mistakes De Heem for De Gheyn as the painting's author; P. Sutton in The Hague–San Francisco 1990–91, p. 104, notes the purchase; S. Alexandre 1991, pp. 54, 59 n. 23, fig. 3, describes the iconography and raises the question of whether this picture can really be described as a still life; Leistra in The Hague 1991, p. 106, fig. 1 (under no. 25), cited as the earliest independent vanitas painting; Roethlisberger 1991, pp. 22, 26 n. 14, mentions the picture as close in time to a vanitas painting by Abraham Bloemaert; Walford 1991, p. 215 n. 21, considers the meaning of the wheel seen in the sphere; Kortenhorst-von Bogendorf Rupprath in Haarlem–Worcester 1993, p. 216, mentions the tulip as a symbol of human mortality; Roethlisberger 1993, vol. 1, p. 102 (under no. 55), cites the painting in connection with Bloemaert's painting of a "skull with other motifs," which was cited by Van Mander in 1604; Amsterdam 1994, pp. 15, 17, fig. 10, suggests that the coins symbolize the material world of mankind and worldly power; Van Mander/Miedema 1994–99, vol. 1 (1994), pp. 436–37, fol. 294v, reproduces Van Mander's text of 1604 and gives an English translation; Baetjer 1995, p. 296; Cavalli-Björkman in Stockholm 1995, pp. 140, 230, "usually referred to as the earliest free-standing Vanitas composition"; Gemar-Koeltzsch 1995, vol. 2, pp. 376–77, no. 135/1 (ill.), gives basic catalogue information; Hans J. van Miegroet, "Vanitas," in *Dictionary of Art* 1996, vol. 31, pp. 881–82, fig. 1, cites the work as one of the earliest independent vanitas still-life paintings and describes the composition; E. K. J. Reznicek in *Dictionary of Art* 1996, vol. 12, p. 532, mentioned, as *Allegory of Mortality*; Van Mander/Miedema 1994–99, vol. 6 (1999), p. 49, fig. 41, identifies the painting called "eene doots cop"

by Van Mander with the Museum's picture, describes the composition, and compares a painting of a "skull with other subsidiary elements" ("een dootshooft met ander byvoeghselen") by Abraham Bloemaert, which was then (1604) with the Amsterdam collector Jacques Razet (probably the composition recorded in an engraving by Jan Saenredam); Schama 1999a, p. 709 n. 15, refers to the tulip in the painting as "an emblem of both mortality and remembrance"; Amsterdam–Cleveland 1999–2000, pp. 140–41, fig. 15a, compares the work with the Museum's own vanitas still life by Pieter Claesz (Pl. 28); Van der Meer 2004, pp. 17–19, 25–27, fig. 1, identifies the coins and a medal of 1602 in the painting, considers their possibly topical significance, and reviews the question of patronage in this light; Klemm in Haarlem–Zürich–Washington 2004–5, pp. 79–80, fig. 4, places the painting in a historical context, comparing works by Abraham Bloemaert and Cornelis Ketel, and summarizes the picture as "both a step forwards, towards standardizing the level of reality depicted, and a step backwards, with the whole image being presented as an emblematic theater piece instead of as a possible reality."

EXHIBITED: Stockholm, Nationalmuseum, "Holländska Mästare i Svensk ägo," 1967, no. 53; Leiden, Stedelijk Museum De Lakenhal, "Ijdelheid der Ijdelheid: Hollandse Vanitas-voorstellingen uit de zeventiende eeuw," 1970, no. 12.

EX COLL.: Possibly Reynier Antonissen, Amsterdam (according to Karel van Mander in 1604, this collector owned a painting of a "death's head" by De Gheyn); J. H. Prince, London (until 1939; sale, Christie's, London, April 21, 1939, no. 159, as "J Heyn . . . 1607," to Manenti); [Harrison, London, until 1966/67; sold to Larson]; Rolf Larson, Stockholm (1966/67–74; sold to MMA); Charles B. Curtis, Marquand, Victor Wilbour Memorial, and The Alfred N. Punnett Endowment Funds, 1974 1974.1

JAN VAN GOYEN

Leiden 1596–1656 The Hague

Born in Leiden on January 13, 1596, Jan Josephsz van Goyen was the son of a Catholic shoemaker who took an interest in painting and drawing. According to Jan Orlers's *Beschrijvinge der stadt Leydens* (Description of Leiden; 1641), Van Goyen studied with four minor painters in Leiden and then for about two years with the obscure Willem Gerritsz (Gerrit Willemsz?) in Hoorn.[1] Orlers is also the only source for the information that Van Goyen returned to Leiden (about 1614?), traveled in France for a year, and then went to Haarlem, where about 1617 he entered the studio of Esaias van de Velde (1587–1630).[2] This influential landscape painter, draftsman, and etcher was Van Goyen's only significant teacher. In the late 1610s and 1620s, Van de Velde made chalk drawings and painted compositions that clearly influenced Van Goyen's first subjects and his early style.[3] The tonal manner adopted by Van Goyen and Pieter de Molijn (q.v.) about 1626–27, and by Salomon van Ruysdael (q.v.) shortly thereafter, may also have been influenced by the technique's recent introduction in seascapes by Jan Porcellis (before 1584–1632).[4]

On August 8, 1618, Van Goyen married Annetje Willemsdr van Raelst in Leiden, where he bought a house in 1625 (which was sold to Porcellis in 1629), and where he was often cited in documents dating from 1627 to 1632.[5] About 1630, Constantijn Huygens, secretary to the Prince of Orange and a well-known connoisseur, mentioned Van Goyen as one of a few landscape painters with exceptional reputations.[6] Perhaps the prospect of support from patrons like Huygens encouraged Van Goyen's move to The Hague in the spring or summer of 1632.[7]

Except for sketching trips, Van Goyen remained in the court city for the rest of his life. He became a citizen of The Hague in 1634, and was *hoofdman* (headman) of the painters' guild in 1638 and in 1640. The purchase of a house on the Veerkade in 1635 and the construction of two houses on the Dunne Bierkade in 1636 (Paulus Potter lived in one of them from 1649 to 1652) indicate that, as in Leiden, Van Goyen invested in property. Nevertheless, at his death on April 27, 1656, he was heavily in debt. He famously lost money in the tulipomania of the 1630s. One of Van Goyen's more successful ventures, at least financially, was the very large view of The Hague that he painted in 1650–51 for the Burgomasters' Chamber of the Town Hall.[8]

Van Goyen traveled widely in the Netherlands, sketching views of places as distant as Cleve and Emmerich (early 1640s) as well as Antwerp and Brussels (1648), and as familiar as Haarlem, Leiden, and Delft.[9] In August 1634, he was fined by the painters' guild of Haarlem for producing pictures locally, in the house of Isaack van Ruysdael (the brother of Salomon van Ruysdael and father of Jacob van Ruisdael); works by Van Goyen were sold at auction in Haarlem in 1634 and 1636.[10] Paintings of the 1630s by Salomon van Ruysdael and by Van Goyen reveal many similarities, suggesting that the latter, who is often considered a Haarlem painter, maintained close contacts with landscapists there.[11]

Van Goyen had three daughters, one of whom married Jan Steen (q.v.) and another Jacques de Claeuw (1623–1694 or later), a still-life painter from Dordrecht. About 1661–63, Steen may have portrayed Van Goyen and members of his family in a fancy interior (Nelson-Atkins Museum of Art, Kansas City).[12] Gerard ter Borch (q.v.) painted a small portrait of Van Goyen around 1653 (Collections of the Princes of Liechtenstein, Vaduz), which was engraved about 1680 by Carel de Moor.[13]

Van Goyen was an extremely prolific artist; approximately twelve hundred paintings and more than one thousand drawings by him are known.[14] Nicolaes Berchem (q.v.) was his pupil, but his influence is more obvious in the work of some forty followers.[15]

1. Orlers 1641, pp. 373–74. See Renckens 1951 on the question of Willem Gerritsz in Hoorn or Gerrit Willemsz in nearby Enkhuizen, and Ekkart in Enkhuizen 1990–91, p. 15, on painters named Willemsz in Enkhuizen, one of whom married in Leiden in 1615. Van Goyen's teachers in Leiden and extensive literature on the artist are cited by P. Sutton in Amsterdam–Boston–Philadelphia 1987–88, pp. 317–18. For a discussion of the artist's life and reputation, a family tree, and documents, see Beck 1972–73, vol. 1, pp. 15–38. See also H.-U. Beck in *Dictionary of Art* 1996, vol. 13, pp. 255–58, and in Leiden 1996–97.

2. Keyes 1984, p. 14, quotes part of the passage from Orlers in English and Dutch.

3. See ibid., pp. 35, 73, on chalk drawings, and pp. 32, 43, 56, 67, 74, on subjects and compositional patterns adopted by Van Goyen from Van de Velde. Wurfbain 1981, pp. 16–18, considers it possible that the landscapist Coenraet van Schilperoort, Van Goyen's first teacher, also made an impression on him.

4. See Gudlaugsson 1965, p. 729; Gifford's essay, "Jan van Goyen en de techniek van het naturalistische landschap," in Leiden 1996–97, pp. 70–79; Sluijter in ibid., p. 45; and Vogelaar in ibid., p. 18. On Porcellis, see Walsh 1974b. Other marine painters are brought into consideration by Margarita Russell, in London 1986a, pp. 63–71. For literature on the question of whether market forces influenced the use of a comparatively economical technique, see Liedtke 2003, p. 29 n. 12.

5. See Beck 1972–73, vol. 1, pp. 16–17. A number of documents dating from this period reveal that Van Goyen speculated in real estate.

6. Huygens 1971, p. 73. On Huygens's list of landscapists, see Keyes 1984, p. 13, where J. A. Worp's dated translation from the Latin diary is used.

7. Huygens thought highly of Esaias van de Velde, who became a resident of The Hague in 1618, and died there in November 1630. Beck 1972–73, vol. 1, p. 17, repeats Vorenkamp's implausible idea that Van Goyen may have gone to The Hague in search of religious tolerance.

8. See Beck 1972–73, vol. 2, no. 332, and Sluijter in Leiden 1996–97, p. 44, fig. 37, on this canvas (66⅞ x 172½ in. [170 x 438 cm]) in the Haags Historisch Museum, The Hague.

9. See Beck 1972–73, vol. 1, pp. 17–18 (pp. 67–72 for a topographical register), and Buijsen 1993 on the sketchbook of 1644.

10. See Miedema 1980, pp. 158–59, 195.

11. Van Goyen is treated as a central figure in London 1986a, which is devoted to landscape painting in Haarlem and Amsterdam in 1590–1650.

12. Beck 1972–73, vol. 1, p. 18, dates the canvas to about 1650, which is impossible for several reasons. Two of the women may be Van Goyen's daughters; his third daughter appears to have died in 1632 (see ibid., p. 25, no. 22, on Elsgen van Goyen, and p. 30, doc. 11, for the record of a daughter being buried at The Hague). The painting's subject is discussed by Broos in The Hague–San Francisco 1990–91, no. 58, and in Westermann 1997, pp. 268–70. The latter suggests that the late Van Goyen and his wife (who would be the seated woman) are both shown in the prime of their lives, a convention known from other Dutch portraits. However, Dudok van Heel 2006, pp. 312–13 n. 112, maintains that Steen shows himself and four of his children with a patron, Gerrit Schouten.

13. Gudlaugsson 1959–60, no. 93.

14. According to Beck 1972–73 and Beck 1987.

15. See Beck 1991.

49. *Sandy Road with a Farmhouse*

Oil on wood, 12⅛ x 16¼ in. (30.8 x 41.3 cm)
Signed and dated (lower left corner): I V GOIEN 1627

The landscape portion of the painting is well preserved. However, the area of the sky has suffered many small flake losses throughout, and there is a series of paint losses along a scratch that extends vertically next to the trees at left, a 1½ in. (3.8 cm) vertical loss above the cottage, and a 1½ in. diagonal scratch in the lower part of the trees at left. The oak panel retains its original thickness, with bevels intact.

Bequest of Myra Mortimer Pinter, 1972 1972.25

This small panel was painted in Leiden in 1627, a year in which Van Goyen produced an impressive number of paintings and drawings, including a sketchbook.[1] Both the subject and the compositional type, with its diagonal road and wedge-shaped repoussoir, are found frequently in the artist's oeuvre from the late 1620s to about 1640. Works by Van Goyen like the present picture influenced his contemporary Pieter de Molijn (q.v.; see

Pl. 125), the slightly younger Salomon van Ruysdael (q.v.), and other landscapists in the area of Haarlem and Amsterdam.[2]

The rugged oak on the left is one of the painter's standard motifs; similar survivors from the windswept dunes near the Dutch coast are placed prominently in paintings dating from his earliest years. An almost leafless tree trunk is set slightly deeper in space, framing a distant church tower. The recession through the middle ground is clarified by the comparative scale of the two resting figures and that of the man in the distance walking with a dog, while weathered farm buildings stand out in the late-afternoon sun. The dark clouds passing through the blue sky recall an observation made by Max Friedländer that a view by Van Goyen usually promises rain, whereas in scenes by Van Ruysdael the clouds have retreated, driven off by a fresh breeze.[3]

The Museum's picture dates from about the time that Van Goyen first employed a tonal palette and Baroque compositional designs, as is evident from comparisons with his more

Figure 59. Esaias van de Velde, *Farm on a Rise to the Right of a Country Road*, ca. 1616. Pen, brown ink, brown and gray washes, 6¼ x 7⅝ in. (16 x 19.4 cm). The Morgan Library & Museum, New York, I, 117a

colorful but less theatrically staged works of about 1624–26. Paintings dating from 1628 through the early 1630s reveal many of the same devices, especially the division of terrain into contrasting areas. But the pattern used here was promptly transformed into subtler arrangements, usually in broader vistas with more diffused effects of light and atmosphere.

The care with which Van Goyen composed works of this type is also clear from his sketchbook of 1627, which comprises about fifty ideas for paintings (not sketches) recorded "from life."[4] For this type of design, the artist was indebted to his teacher Esaias van de Velde (1587–1630), who anticipates the present picture in a drawing of about 1616 (fig. 59).[5] However, Van Goyen eschews his master's fondness for graceful motifs in favor of more rugged forms. Their tactile qualities are emphasized to both descriptive and artistic effect, as in the sunlit grass that flows like seaweed over the sandy ground.

Although rich in observations made out of doors, landscapes like this one are very much products of the studio. The subject of bucolic cottages flourished in Holland during the early seventeenth century and was encouraged by literature celebrating the supposed pleasures of a simple life lived on the land. While contemporary poets such as G. A. Bredero and P. C. Hooft looked back to Horace and Virgil, painters and printmakers continued a tradition that effectively began in Antwerp

with artists like the Master of the Small Landscapes, whose series of fourteen landscape engravings published in 1559 is described on the title print as images of "Many and very attractive locations of various country cottages, farmsteads, fields, roads, and the like." The Amsterdam draftsman, engraver, and publisher Claes Jansz Visscher (1587–1652) brought out an edition of the *Small Landscapes* in 1612, and numerous other series of landscape prints (after drawings by Visscher, Jan van de Velde, Abraham Bloemaert, and other Dutch artists) were published during the 1610s and 1620s. The contemporary appreciation of these many works of art is a complicated subject, but it is certain that pictures like *Sandy Road with a Farmhouse* were extremely popular in their own time and more evocative in meaning than most later viewers would imagine.[6]

1. Beck 1987, p. 284, lists twenty-two paintings by Van Goyen bearing the date 1627. Other pictures painted in that year may be lost or not dated. Drawings dating from 1627 include those catalogued in Beck 1972–73, vol. 1, as nos. 63–88, and in Beck 1987 as nos. 62A–88.

2. See Liedtke 2003, and the extensive literature cited there in the notes.

3. Friedländer 1963, p. 95 (kindly brought to my attention by Seymour Slive, who quoted the line in J. Rosenberg, Slive, and Ter Kuile 1966, p. 151).

4. See Beck 1957 and Beck 1972–73, vol. 1, p. 27 of the catalogue. Nearly all the artist's known drawings of the 1620s appear to be compositional studies. Compare the drawings (including numerous cottage views) in the Albertina and London sketchbooks of the early 1630s and about 1627–35, respectively (Beck 1972–73, vol. 1, pp. 255–64, nos. 843, 844).

5. Keyes 1984, no. D172, fig. 71, which the author considers a "companion piece" to D171, dated 1616.

6. The literature on this subject is surveyed in Liedtke 2003. Among the most important contributions are Spickernagel 1979, Freedberg 1980, Leeflang 1998, and W. S. Gibson 2000.

REFERENCES: Anon., "Recent Museum Acquisitions," *Burlington Magazine* 115 (1973), p. 537, fig. 79, describes the picture; Walsh 1974, pp. 344, 349 n. 9, fig. 7, discusses the painting as a "remarkably advanced" early work; Hibbard 1980, p. 332, fig. 601; Beck 1987, p. 265, no. 1054A (ill.); Baetjer 1995, p. 306; Liedtke 2003, pp. 23, 24, 29 n. 18, fig. 2, discusses the picture's style, technique, and subject.

EX COLL.: Myra Mortimer Pinter, New York (d. 1972); Bequest of Myra Mortimer Pinter, 1972 1972.25

49

50. *View of Haarlem and the Haarlemmer Meer*

Oil on wood, 13⅝ x 19⅞ in. (34.6 x 50.5 cm)
Signed and dated (lower left): VG 1646

The painting is well preserved. The sky is thinly painted, and with age the dark horizontal grain of the oak panel has become more prominent. The foreground, which is more thickly built up, has not suffered to the same degree.

Purchase, 1871 71.62

Van Goyen's sweeping view of the Haarlemmer Meer is one of the finest paintings acquired in the 1871 Purchase and remains among the most admired Dutch pictures in the Museum, not least by visitors from the Netherlands. Tributes have ranged from academic recognition of the work's place in the development of panoramic landscape painting to the patriotic verse ("my land lay still and wide") of a famous Dutch aviator who lived in New York during World War II.[1]

The Haarlemmer Meer (Haarlem Sea) was an inland body of fresh water (reclaimed in the nineteenth century) that extended from near Haarlem east to below Amsterdam; south to Warmond, near Leiden; and north to the inlet IJ, which led to the Zuiderzee and the North Sea.[2]

On the horizon is the unmistakable profile of Saint Bavo's, the Grote Kerk of Haarlem. This familiar motif would lead one to assume that the view is to the north, and that the billowing clouds are blowing in from the coast beyond the trees in the left background. Such a panorama might have been recorded from the towers of Heemstede Castle, although the viewpoint seems even more elevated here.

In fact, Van Goyen based the composition on two of seven sheets in the Bredius sketchbook of 1644 that record panoramic views from a vantage point high in the bell tower of Saint Bavo's.[3] Page 20 of the sketchbook (fig. 60) corresponds very approximately to the left two-thirds of the Museum's picture, which Van Goyen presumably painted in The Hague about two years later. In the drawing, the view is to the south and slightly southeast, just the opposite of what one might think when viewing the final work. Heemstede Castle with its two towers is visible, in the sketch, in the right background, and, in the painting, near the sailboat at right center. Like a signpost for the general area, Saint Bavo's was arbitrarily placed on the horizon (as was the church tower farther to the right).

The waterway that meanders back through the middle ground is the river Spaarne, which grew considerably wider as it flowed southward to the Haarlemmer Meer. The Meer itself appears in the background of the sketch, and more ambiguously in the painting, where the large body of water begins at the beacon breaking the horizon in the center of the view.

The entire foreground of the painting is invented. This area, which would have encompassed many houses on the south side of Haarlem, was left blank in the sketch. The windmills and smoking limekiln in the painting appear to have been inspired by similar motifs found in another drawing in

Figure 60. Jan van Goyen, *Bird's-eye View of the Environs of Haarlem* (page 20 of the Bredius sketchbook), 1644. Private collection, on loan to the Museum Bredius, The Hague

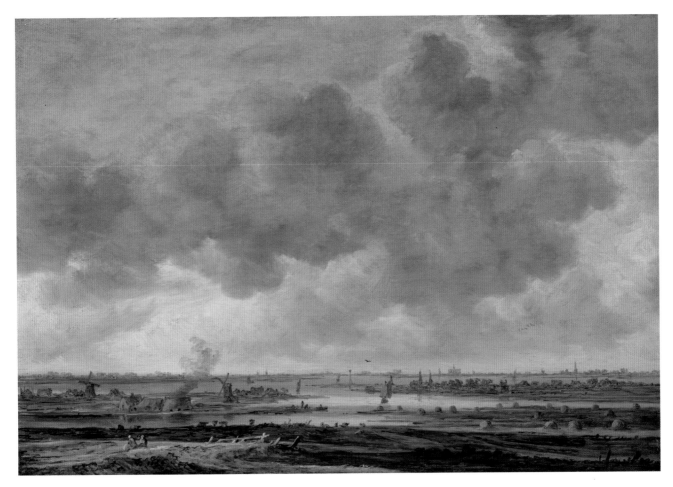

50

Figure 61. Jan van Goyen, *Two Bird's-eye
Views of the Environs of Haarlem* (page 21
of the Bredius sketchbook), 1644. Private
collection, on loan to the Museum Bredius,
The Hague

the Bredius sketchbook, namely, that on the bottom half of the following page (fig. 61). In that sketch, the Spaarne recedes westward to the right edge of the composition, and then bends back toward the southeast and the distant Haarlemmer Meer.[4]

As in so many pictures with more or less recognizable topography, it was the overall impression or spirit of the place that appealed to Van Goyen. Reproductions cannot convey the pleasure of viewing the painting itself, where one's enjoyment of the scenery is greatly enhanced by the imaginary foreground. A couple sits by the winding road, beyond which the land flows down to cattle and haystacks and to the water, where a few fishermen and a number of boats invite one to wander along Holland's countless waterways. The overwhelming sensation on such a journey is the experience of endless sky, to which Van Goyen devotes nearly four-fifths of the picture, despite the originally downward point of view.

Study of the Bredius sketchbook helps one appreciate the present painting's relationship to earlier panoramic views, for the full-page compositions in particular (for example, fig. 60) bear a remarkable resemblance to such pioneering works as Hendrick Goltzius's well-known drawings of 1603, which represent dune landscapes near Haarlem.[5] While the panoramic pictures of the 1640s cannot be connected directly with more distant antecedents like those by Hans Bol (see his small painting dated 1578 in the Los Angeles County Museum of Art), Van Goyen was clearly aware of many examples produced in and around Haarlem. The relevant material includes drawings and prints by artists such as Goltzius, Willem Buytewech, Esaias van de Velde, and Jan van de Velde; marine paintings by Hendrick Vroom;[6] and panoramic landscape paintings and drawings made during the 1630s by Vroom's son Cornelis.[7] Thus Van Goyen's panoramic landscapes (which date mostly from about 1638–47) were derived not only from his own sketches made from life but also from numerous precedents in Haarlem, where a number of closely associated artists gradually transposed innovations made in drawings and prints to the generally more conservative medium of painting.

A review of Van Goyen's panoramic landscape paintings dating from the late 1630s onward reveals that the naturalistic impression made by the Museum's picture was achieved through artistic experience. In his most comparable landscapes and ice-skating scenes the artist either minimized or emphasized elements in the foreground, depending upon which aspect of the topography he wished to stress.[8] With respect to composition the most instructive comparisons with the present work include those found in an ice-skating scene dated 1641 (Hermitage, Saint Petersburg); two panoramic landscapes of the same year (Staatliche Museum, Schwerin, and Rijksmuseum, Amsterdam); a dune landscape dated 1642 (Museum der Bildenden Künste, Leipzig); and panoramic landscapes dating from 1644 (Amsterdam), 1646 (Leipzig), and 1647 (Smith College Museum of Art, Northampton).[9]

Several painters active in the area of Haarlem and Amsterdam must have been influenced by Van Goyen's panoramic landscape paintings. The most obvious example is Philips Koninck, whose earliest panoramic views date from two or three years later than this one (see Pls. 101, 102).[10] Van Goyen's *View of Haarlem* also looks forward to Jacob van Ruisdael's celebrated landscapes with the city in the distance beneath majestic clouds.[11]

1. The untitled poem by Adriaan Viruly (1905–1986) is published in his collection *De zee en de overkant* (Amsterdam, 1954), p. 203. Viruly's work was brought to the Museum's attention by Dr. H. Wernik of Nijmegen, who also clarified aspects of the view depicted by Van Goyen (letters of October 28, 1993, and June 15, 1994, in the curatorial files). While the panel is generally considered one of the artist's finest pictures, W. R. Valentiner suggested that it was painted by the young Aelbert Cuyp (oral opinion, June 19, 1931).

2. See the maps in Beck 1972–73, vol. 1, pp. 254, 265, and especially Jacob Colom's map of 1639, reproduced in Van der Wyck 1990, vol. 1, pp. 254–55. The saltwater Zuyder Zee (or Zuiderzee) corresponds to the modern IJsselmeer. The IJ is saltwater but was separated from the freshwater Spaarne River by the lock at Spaarndam, a village north of Haarlem.

3. See Buijsen 1993, pp. 39–44, where the sketch on page 20 (fig. 60 here) is mistakenly said to have served for the "right half of the panel" (p. 44).

4. Buijsen (ibid., p. 44) cites another picture (Beck 1987, no. 973A) in which part of the middle ground corresponds to the lower half of page 21 in the Bredius sketchbook; the last digit of the date, read as 1642, may have been retouched. Contemporary maps of Haarlem (for example, Balthasar Floris van Berckenrode's of 1643) confirm that there were mills and limekilns on the east bank of the Spaarne south of Haarlem (called the Zuider Buiten Spaarne, or "South Outer Spaarne," in this stretch of the river). As noted by Wernik (see note 1 above), the mill seen to the right of the smoking limekiln in the Museum's painting corresponds approximately in form and location to Het Tuchthuis, an oilseed-crushing mill that was replaced by a different kind of mill around 1700. The mill in the left background may be De Kat; a limekiln was situated more or less in front of the mills (up the Spaarne) when viewed from Haarlem: see B. C. Sliggers, ed., *De Loop van het Spaarne: De geschiedenis van een rivier* (Haarlem, 1987), pp. 104–5, figs. 67 (map of 1643), 68 (print of Het Tuchthuis). However, distances appear compressed and features simplified in Van Goyen's painting, as they are in his sketches.

5. See Russell in London 1986a, p. 63, fig. 1, and Duparc in Cambridge–Montreal 1988, no. 34, with references to earlier literature. For two of the Goltzius drawings, see Amsterdam–

New York–Toledo 2003, nos. 74.1, 74.2. Stechow 1966, pp. 33–49, remains the fullest survey of the panoramic landscape in Dutch art.

6. See Russell's remarks in London 1986a, pp. 64–67.

7. See Amsterdam–Boston–Philadelphia 1987–88, no. 115 (Cornelis Vroom's *Estuary Viewed through a Screen of Trees,* of about 1638, in a private collection), and p. 519, figs. 1, 3.

8. See Beck 1972–73, vol. 2, pp. 435–43, and pp. 28–32, 40, within the section on views of frozen waterways. A few more panoramas of the 1640s are illustrated in Beck 1987, pp. 256–57. P. Sutton 1992, p. 68, briefly reviews Van Goyen's "panoramic winter scenes" (which also date from 1638 onward) in relation to the *Winter Landscape* in the Harold Samuel collection, London. See also Peter Sutton's observations in Amsterdam–Boston–Philadelphia 1987–88, pp. 37–38, where the present picture is seen as a culmination of the development.

9. Beck 1972–73, vol. 2, nos. 56, 971, 972, 976, 979, 981, 983, respectively.

10. On Van Goyen's importance for Koninck, see Gerson 1936, p. 19.

11. See The Hague–Cambridge 1981–82, nos. 44–46, for Van Ruisdael's view of Amsterdam, its harbor, and the IJ as seen from the tower of the new Town Hall. See also Walford 1991, pp. 128–29, and, on Van Ruisdael's distant view of Naarden, of 1647, in the Thyssen collection, Gaskell 1990, no. 86.

REFERENCES: Decamps 1872, p. 436, mentions the picture, as "une symphonie vert tendre"; MMA 1872, no. 116, reports that the painting "belonged to the Burger collection. From the Macklenburg collection"; Harck 1888, p. 76, describes it as a "splendid picture in gray-green tones, excellent condition"; Hofstede de Groot 1907–27, vol. 8 (1927), p. 146, no. 579, describes the composition, which he entitles *View of a Broad Flat Landscape,* and notes a "church reminiscent of the Groote Kerk at Haarlem"; Beck 1966, p. 14 n. 18, notes that pages 20 and 21 in the Bredius sketchbook (figs. 60 and 61 here) were drawn "from a similar viewpoint," but that Saint Bavo's appears on the horizon; Dobrzycka 1966, pp. 44 n. 17, 112, no. 169, fig. 117; Beck 1972–73, vol. 2, pp. 441–42, no. 980 (ill.), describes the composition and observes "a large church (Haarlem?)" on the horizon; P. Sutton 1986, p. 191, observes that the painting "still recalls Hercules Segher's [*sic*] art"; P. Sutton in Amsterdam–Boston–Philadelphia 1987–88, p. 37, fig. 52, contrasts "Segers's earlier panoramas"; Baetjer 1995, p. 306; Liedtke 1995a, pp. 156–57 n. 35, fig. 7, discusses the picture's relation to the site and to the Bredius sketchbook of 1644; Liedtke in Timken Museum 1996, p. 102, notes that Saint Bavo's is arbitrarily inserted on the horizon and compares Van Ruisdael's approach; Jowell 2003, pp. 93–94, n. 215, fig. 63, considers it highly likely that the painting was owned by Thoré-Bürger; Baetjer 2004, p. 211, no. 116, gives provenance; Wiemann in Stuttgart 2005–6, pp. 136–38, no. 49, offers general remarks on the picture's subject and execution.

EXHIBITED: New York, New York World's Fair, "Masterpieces of Art," 1940, no. 92; Amsterdam, Rijksmuseum, "The Glory of the Golden Age," 2000, no. 83; Stuttgart, Staatsgalerie Stuttgart, "Die Entdeckung der Landschaft: Meisterwerke der niederländische Kunst des 16. & 17. Jahrhunderts," 2005–6, no. 49.

EX COLL.: Possibly Paris sale, April 16, 1811, no. 69 (FFr 102 to Este); ?Baron Henry de Mecklembourg (d. 1861; not in his estate sale, Hôtel Drouot, Paris, March 12, 1870); probably Étienne-Joseph-Théophile Thoré (W. Bürger; sold ca. 1867?; d. 1869, Paris). [Léon Gauchez, Paris, with Alexis Febvre, Paris, until 1870; sold to Blodgett]; William T. Blodgett, Paris and New York (1870–71; sold half share to Johnston); William T. Blodgett, New York, and John Taylor Johnston, New York (1871; sold to MMA); Purchase, 1871 71.62

51. *The Pelkus Gate near Utrecht*

Oil on wood, 14½ x 22½ in. (36.8 x 57.2 cm)
Signed and dated (lower right, on boat): vG 1646

The painting is well preserved. In the sky, the grain of the oak panel has become more prominent with age. There are a few flake losses in the water and along the bottom edge.

Gift of Francis Neilson, 1945 45.146.3

Pale yellows set off the tower and model the cumulus clouds in this blue and green river view, one of perhaps a dozen paintings by Van Goyen that feature some form of the once familiar Pelkus Gate near Utrecht. The surroundings and the other structures vary greatly in this group of pictures, suggesting that (as in literally hundreds of river views with imaginary architectural elements) the artist freely invented all but the main motif in each composition.[1]

The Pelkus Gate, or Pellekussenpoort (erected 1371), was a freestanding tower on the towpath of the river Vecht between Utrecht and Muiden on the Zuiderzee. The villages of Zuilen and Weert were nearby. According to the text of Abraham Rademaker's *Kabinet van Nederlandsche en Kleefsche Outheden* (Cabinet of Antique Monuments in the Netherlands and Cleve; 1732), the gate "belonged in former times to the old Pellekussen family, so that this gate is now commonly called the Pelkuspoort . . . of which nothing remains today."[2] In Van Goyen's

time the Vecht was already what it is now, a meandering, canal-size waterway celebrated for picturesque views of old castles, country houses, and villages.

A recently published drawing by Van Goyen (fig. 62) shows the site of the Pelkus Gate from approximately the same direction as in the Museum's painting, where the building itself has been arbitrarily turned clockwise ninety degrees.[3] The actual alignment of the gate tower is seen in Rademaker's prints and in an anonymous drawing of about 1580–1600 (fig. 63).[4] The latter and Van Goyen's drawing, however different in style, were both evidently recorded from life, from different angles across the Vecht.[5] In the present picture, Van Goyen has slimmed and simplified the gate tower, and added vertical accents to the step gable. It should be emphasized that the entire site bears little resemblance to the actual Vecht, which was narrow and lined with low buildings on both sides. Apart from a couple of houses at the water's edge (which correspond approximately to structures on the right in fig. 62), the other buildings are common types set down on sloping land (which is actually flat) where no such structures existed. The invented motifs include the farm building to the left, the church, the manor house with flying flags, and a second gate tower on the riverbank.

The earliest known paintings that show buildings based on

Figure 62. Jan van Goyen, *The Pelkus Gate*, ca. 1645–50. Black chalk and gray wash, 4⅛ x 6½ in. (10.6 x 16.5 cm). Private collection

Figure 63. Unidentified artist, *The Pelkus Gate*, ca. 1580–1600. Pen and brown ink, 9¼ x 6⅞ in. (23.4 x 17.4 cm). Gemeentearchief, Utrecht

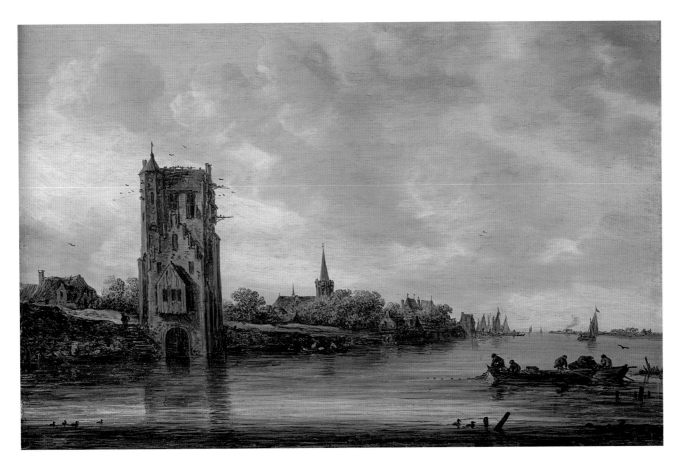

51

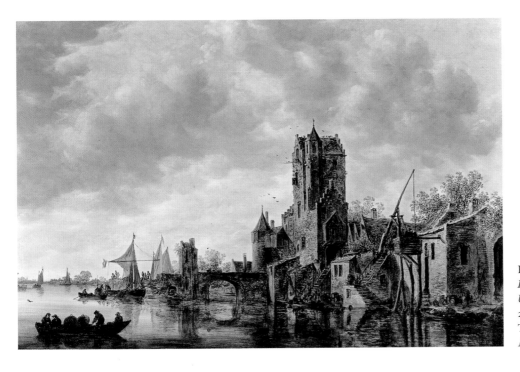

Figure 64. Jan van Goyen, *River Landscape ("Pellekussenpoort near Utrecht")*, 1648. Oil on wood, 25½ x 37 in. (64.8 x 94 cm). The Minneapolis Institute of Arts, Gift of Bruce B. Dayton

the Pelkus Gate are two panels by Van Goyen dated 1640.[6] These inventions may have depended upon some other artist's rendering.[7] The newly published drawing by Van Goyen (fig. 62) has been dated to about 1650 but could just as well date from about 1645, when other motifs found in the area of Utrecht begin to appear in the artist's work. In four paintings dating from 1645, the Pelkus Gate is treated with comparative fidelity (as in fig. 65),[8] but in two panels of 1648, in Schwerin and Minneapolis (fig. 64), and in two of the mid-1650s Van Goyen's fancy is given freer rein.[9] Altogether, the evidence, while undoubtedly incomplete, is consistent with the painter's other views of well-known buildings in the vicinities of Arnhem, Dordrecht, Nijmegen, Rhenen, and Utrecht.[10] His interest in medieval architecture flourished in the 1640s and was more romantic than archaeological.

It has been suggested that Van Goyen's views of the Pelkus Gate and other "monuments of the Medieval past" were expressions of national pride during the 1640s, and that "it is no coincidence" that the Minneapolis picture was painted in 1648 when Dutch independence was recognized by Spain.[11] Patriotic ideas would appear to be more relevant to printed views of Dutch castles dating from earlier in the century, and perhaps to some of Van Goyen's views of more significant medieval monuments. The artist made such free use of the Pelkus Gate that its specific identity seems unimportant, and was probably insignificant to most of his fellow citizens in The Hague.[12] Van Goyen's small castles and towers, which he depicted by the hundreds (see Pls. 52, 53), reveal such an eye for picturesque detail that the attraction to him of the Pelkus Gate must have been principally its patchwork design and, to judge from the present painting, its suitability as a haven for birds (compare *The Pigeon House*, by Roelof van Vries; Pl. 215).[13]

A copy of the Museum's picture, attributed to the eighteenth-century Dordrecht painter Abraham van Strij (1753–1826), was on the art market in 1982.[14]

1. About 1642, Aelbert Cuyp (q.v.) drew a faithful view of the Pelkus Gate and the river Vecht from nearly the same vantage point as Van Goyen's in the present picture; see Washington–London–Amsterdam 2001–2, no. 49. A pictorial map of the actual site, dating from about 1630, is reproduced by Broos in The Hague–San Francisco 1990–91, p. 251, fig. 5. On Van Goyen's similar approach in views of Nijmegen, see Pantus 1994.

2. The original Dutch text by Isaac Le Long is quoted in Stechow 1938a, p. 204. More information on the Pelkus Gate is provided by Broos in The Hague–San Francisco 1990–91, pp. 251–52 (under no. 24), and by Kuretsky in Poughkeepsie–Sarasota–Louisville 2005–6, pp. 130–31 (under no. 10). In the latter catalogue entry, two drawings by Herman Saftleven are reproduced, showing the

gradual destruction of the gate in the mid-1670s.

3. The drawing in a Dutch private collection (fig. 62 here) was published in Von Oven 1991, and earlier in the privately printed catalogue: Bolten and Folmer-von Oven 1989, no. 73. Von Oven reports that Beck accepts the drawing, which he did not know before his last catalogue of Van Goyen's work (Beck 1987) was published. Broos in The Hague–San Francisco 1990–91, p. 249, fig. 1, attributes a drawing of the Pelkus Gate in the Rijksprentenkabinet, Rijksmuseum, Amsterdam (inv. no. A2947, under the name Anthonie Waterloo) to Van Goyen, but Peter Schatborn and others at the Rijksprentenkabinet do not consider Van Goyen or Waterloo responsible (letter from Schatborn dated June 14, 1994). In any case, it offers an "accurate notion" of the gate tower, as observed in Keyes 1991, p. 58, fig. 14.

4. The drawing of about 1600 was published by Broos in The Hague–San Francisco 1990–91, p. 251, fig. 3.

5. The map reproduced in ibid., fig. 5, makes it clear how such different views of either side of the gate tower would result. The Vecht bends about twenty-five degrees right at this point.

6. Beck 1972–73, vol. 2, nos. 639, 640, both last seen on the art market in the 1950s.

7. But not upon the drawings of 1620 and 1622 that are reproduced by Rademaker's etchings: see Stechow 1938a, figs. 2, 3, and Keyes 1991, figs. 15, 16.

8. Beck 1972–73, vol. 2, nos. 74 (Lille), 721 (formerly Hermitage, Saint Petersburg), 760 (Genf), 762 (art market, 1932).

9. Beck 1972–73, vol. 2, nos. 690 (Schwerin), 693 (Minneapolis), 711 (private collection), 788 (Bordeaux). The Schwerin picture is reproduced in Grosse 1925, pl. 51, and in Yokohama 1988, pp. 180–81, no. 14 (ill. pp. 56–57). On the painting in Minneapolis, see The Hague–San Francisco 1990–91, no. 24; Keyes 1991; and Kuretsky in Poughkeepsie–Sarasota–Louisville 2005–6, no. 10. The Bordeaux picture is thoroughly discussed in Le Bihan 1990, no. 29. Seven paintings of the Pelkus Gate by Van Goyen and one by Salomon van Ruysdael are illustrated in De Meyere 1988, pp. 87–95, but his text has been criticized (see The Hague–San Francisco 1990–91, p. 252 nn. 8, 14).

10. See the chart listing numbers of paintings by decade in Keyes 1991, p. 58.

11. Ibid., pp. 62, 64. Compare Schama 1987b, p. 76.

12. Keyes 1991, p. 64, stresses the building's "original function, which was to regulate the flow of traffic along one of the main rivers of the northern Netherlands." The Vecht was hardly a strategic artery, and if the tower protected anything it was most likely the toll rights of the Pellekussen estate.

13. See also the drawings of Dutch castles made in 1646 and 1647 by Roelant Roghman, which are often quite as picturesque but which systematically survey "Noble Houses, Castles &c. located in Holland, Utrecht, Gelderland &c." (Broos 1981, no. 51; Cambridge–Montreal 1988, no. 76; Van der Wyck 1990).

14. Monte Carlo, auction in the Sporting d'hiver, December 11 and 12, 1982, no. 155, on wood, 11⅞ x 15⅜ in. (30 x 39 cm); noted in Beck 1987, p. 233 (under no. 765).

REFERENCES: Probably Hofstede de Groot 1907–27, vol. 8 (1927), p. 200, no. 789, repeating information from the 1889 Leipzig exhibi-

tion catalogue (see below); Dobrzycka 1966, fig. 67 (not mentioned in text); Stechow 1966, p. 56, fig. 103, describes the composition of the "enchanting picture" and emphasizes that the date is 1646 not 1643; Beck 1972–73, vol. 2, p. 344, no. 765 (ill.), describes the subject; Beck 1987, p. 233, no. 765, records the copy sold in 1982 (see text above and note 14); De Meyere 1988, pp. 93, 95, fig. 33, mentions the painting among other views of the Pelkus Gate by Van Goyen; Le Bihan 1990, pp. 120–21, n. 7 (ill. [under no. 29]), compares the composition of the 1656 panel in Bordeaux; Baetjer 1995, p. 306; Liedtke 1995a, pp. 156–57 n. 31, fig. 6, places the picture in the context of other views of the Pelkus Gate by Van Goyen, and relates them to his one known drawing made at the site.

EXHIBITED: Probably Leipzig, Museum der Bildenden Künste, "Ältere Meister aus sächsischem Privatbesitz," 1889, no. 87 (same composition, support, dimensions, signature, and date), as lent by Count Luckner of Altfranken; Chicago, Ill., The Art Institute of Chicago, 1924 and 1926 (lent by Mr. and Mrs. Francis Neilson); Richmond, Va., Virginia Museum of Fine Arts, 1947–51; Sarasota, Fla., John and Mable Ringling Museum of Art, and Louisville, Ky., The Speed Art Museum, 2005–6, "Time and Transformation in Seventeenth-Century Dutch Art," hors cat.[1]

EX COLL.: Probably Count Luckner of Altfranken (in 1889, according to the 1889 exhibition catalogue cited above); private collection, Berlin (according to Wilhelm von Bode, who recommended the picture to Francis Neilson); [Van Diemen Gallery, Berlin, in 1921 (according to Francis Neilson in 1946)]; Francis Neilson, Chicago, Ill., 1921–45; Gift of Francis Neilson, 1945 45.146.3

1. The painting was lent in substitution for Van Goyen's panel of 1648 in Minneapolis (fig. 64 here; Poughkeepsie–Sarasota–Louisville 2005–6, no. 10), which was unexpectedly withdrawn from the exhibition after the first venue in Poughkeepsie, N.Y.

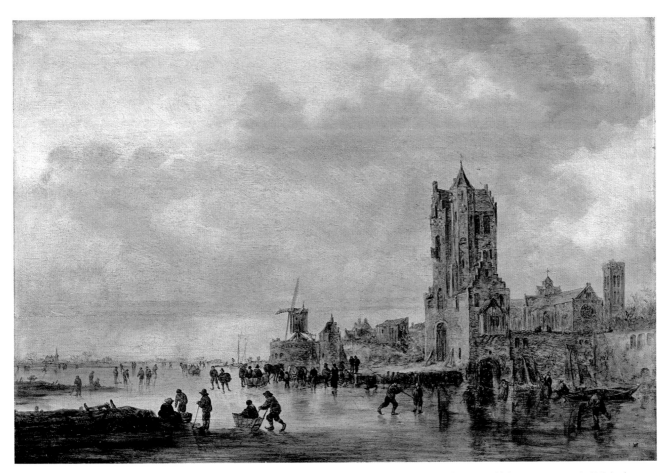

Figure 65. Jan van Goyen, *Ice Skating before the Tower and Walls of a City, 1645.* Oil on wood, 26 x 38¼ in. (66 x 97 cm). Palais des Beaux-Arts, Lille

52. *Country House near the Water*

Oil on wood, 14⅜ x 13 in. (36.5 x 33 cm)
Signed and dated (on boat): VG 1646

The painting is well preserved. There are a few minute flake losses and some slight thinning of the paint along the wood grain in the sky. The oak panel, which has a vertical grain, retains its original thickness and beveled edges. The irregular edges of the left side and top suggest that the panel has been slightly trimmed.

The Friedsam Collection, Bequest of Michael Friedsam, 1931
32.100.6

There are three paintings by Van Goyen dated 1646 in the Museum's collection, and three demonstrating the artist's interest in picturesque medieval architecture (see Pls. 51, 53). The present example is well preserved, which allows one to appreciate such impressive passages as the cloudy sky and the surface of the water, where the castle, the boat, and the four figures are reflected. The twisting patches of grass, the dappled leaves on the tree to the right, and the impressionistic forms in the distance are reminiscent of the chalk drawings in Van Goyen's sketchbooks of motifs found on Holland's country roads and waterways.

The house is the kind of small "castle" that might have appealed to the imaginations of busy burghers in The Hague, although they would certainly have preferred something less rustic and isolated, like Constantijn Huygens's small country house, Hofwijck.[1] The building here was called the Castle Van der Boos near Dordrecht when Friedsam owned the painting, but any attempt to identify the structure is discouraged by a brief review of similar pictures by Van Goyen and of Late Medieval Dutch châteaux.[2] The general form is plausible, as is seen in Anthonie van Borssom's drawing of Castle Toutenburg (see fig. 15), but the proportions are peculiar, the adjoining façades are unexpected, and the wooden addition to the second floor (compare the one on the Pelkus Gate; Pl. 51) could not function in any but an artistic way (in part because of the chimney above it). The tower is generic, as a comparison with Toutenburg or with the many Dutch castles drawn by Roelant Roghman will reveal (see fig. 29).[3]

Similar compositions depicting yet more fanciful castles were painted by Van Goyen between the early 1640s and about 1650.[4] Nonetheless, Wilhelm Martin, director of the Mauritshuis at The Hague, on a visit to the Museum in 1938, persuaded an earlier curator that the present composition resulted when a broader panel by Van Goyen was sawn in half.[5] The left side of the panel has in fact been slightly trimmed, but at least half the original bevel remains, and the grain of the wood runs vertically. It is true that a few contemporary pictures by Van Goyen would, if cut in half, yield a composition like this one and a rather vacant pendant.[6] But the proportions and structure of this design are entirely characteristic of Van Goyen in the mid- to late 1640s, as many of his immediate followers— Anthony van der Croos, Frans de Hulst, Adriaen van der Kabel, Willem Koll, and others[7]—and also later artists such as Roelof van Vries (see Pl. 215) would have known without turning the panel over.

1. For Hofwijck, see Kuyper 1980, pp. 153–54, fig. 314. On castles as scenery to be experienced on country outings, and as images of country life, see Van der Wyck 1990, vol. 2, pp. 49–50, 71–73, with references to Van Goyen.
2. This applies not only to Van Goyen (as is clarified by the identifications of subjects in Beck 1972–73 and Beck 1987), but also to the artist's many followers who depicted imaginary medieval architecture (see Beck 1991). "Van der Boos" is perhaps an error for "Van den Bos," but the name sounds invented in any case.
3. See the plates in Van der Wyck 1990, vol. 1, for example no. 13 (Castle Altena near Delft).
4. Beck 1972–73, vol. 2, nos. 171 (see Beck 1987, p. 162, for later provenance), 174–76, 182, 213.
5. According to unsigned notes in the curatorial file.
6. For example, Beck 1972–73, vol. 2, no. 665.
7. See Beck 1991, nos. 171, 510, 535a, 594, 706, etc.

REFERENCES: Pène du Bois 1917, p. 402, mentions the picture; Valentiner 1928a, p. 20, considers it a good example of Van Goyen's later period; Beck 1972–73, vol. 2, p. 88, no. 179; Haverkamp-Begemann 1978, p. 146 (under no. 60), compares the composition of *Dutch River Scene*, of 1645, in the Wadsworth Atheneum, Hartford; Beck 1987, p. 162, no. 179 (ill.); Baetjer 1995, p. 306.

EXHIBITED: New York, MMA, "Landscape Paintings," 1934, no. 18; San Francisco, Calif., Palace of Fine Arts, "Golden Gate International Exposition," 1940, no. 187; Dayton, Ohio, The Dayton Art Institute, "The City by the River and the Sea: Five Centuries of Skylines," 1951, no. 28; Hempstead, N.Y., Hofstra College, "Metropolitan Museum Masterpieces," 1952, no. 16; Colorado Springs, Colo., Colorado Springs Fine Arts Center, 1955.

EX COLL.: Said to have come from the collection of Leopold II, king of Belgium (d. 1909); [Galerie F. Kleinberger, Paris, before 1917]; Michael Friedsam, New York (by 1917); The Friedsam Collection, Bequest of Michael Friedsam, 1931 32.100.6

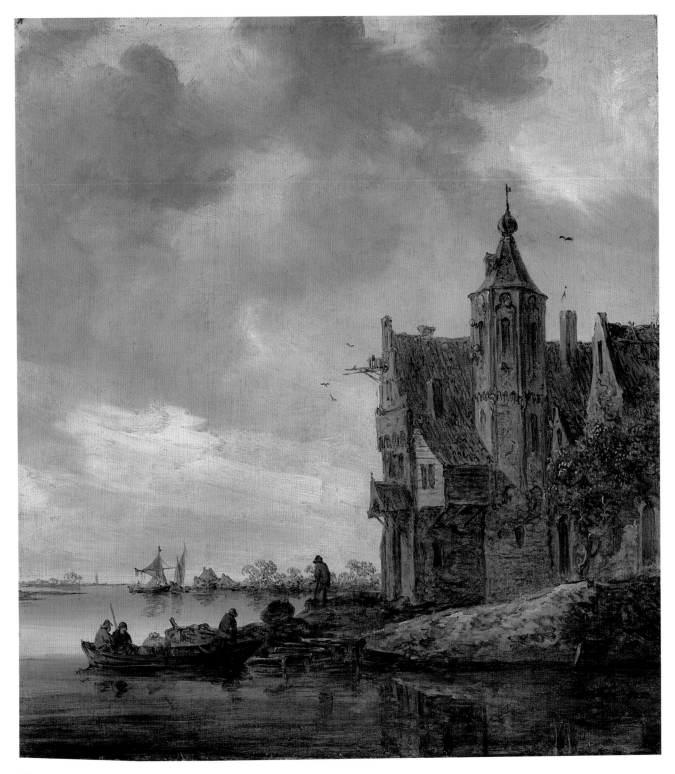

52

53. *Castle by a River*

Oil on wood, 26 x 38¼ in. (66 x 97 cm)
Signed and dated (lower left, on boat): VGOYEN 1 6 4 7

The painting is remarkably well preserved, although there are passages in the thinly painted sky where the wood grain has become more prominent with age. The oak panel, constructed of three horizontal boards, retains its original thickness.

Anonymous Gift, 1964 64.65.1

In this splendidly preserved picture Van Goyen fully exploited the hardwood surface to set off the rich textures of his paint strokes, touches, and dabs. The shadowy, overgrown wall to the right, for example, is one of the most attractive areas of the painting despite its peripheral part in the composition. The work is remarkable for the warmth of its brown and yellow tones, with rose and salmon colors throughout the cloudy sky.

The subject and composition recall Van Goyen's many views of Nijmegen, which date from 1633 to the late 1640s,[1] but the fort here, with its Romanesque bell tower, improbable portals, and asymmetrical façade, is surely imaginary.[2] Three figures peer over the ramparts, like tourists at Saint-Malo, looking at the fishing boats below. In the boat to the far left, two men pay out a net before a glistening sheet of water, which recedes to a pale green profile of distant farms, trees, and sailboats on the opposite shore.

Comparison with a smaller panel of the same date in Bordeaux (fig. 66) reveals the ease with which Van Goyen modified architectural motifs.[3] In the Bordeaux picture, the tall tower and (curiously) the other tower and the roofs within the fort recall the Oude Kerk in Delft, as seen in a drawing by Van Goyen of about 1640–45 (Kupferstichkabinett, Berlin).[4]

The Museum's picture was engraved by the amateur artist and director of the Koninklijk Museum (later Rijksmuseum) in Amsterdam, Cornelis Apostool, in his series of aquatints, *Beauties of the Dutch School, Selected from Interesting Pictures of Admired Landscape Painters,* London, 1792–93.

1. See Beck 1972–73, vol. 2, nos. 342–67; Beck 1987, nos. 342–72; and Pantus 1994. Compare also the compositions of the unsigned drawing in Brussels (Beck 1972–73, vol. 1, no. 24) and of paintings dated 1642 and 1647 (ibid., vol. 2, no. 685; Beck 1987, no. 647a).

2. The Romanesque tower inevitably recalls that of the much admired Mariakerk in Utrecht, which Van Goyen drew around 1645–50 (Beck 1972–73, vol. 1, nos. 665, 746; see also the more imaginary treatment in a drawing dated 1651, Beck no. 229). Van Goyen used the Mariakerk as a point of departure for paintings dated 1642, 164(9?), and 16(5?)3 (Beck 1972–73, vol. 2, nos. 742, 784, 210, respectively; see no. 742 also in Beck 1987). However, the tower of the Abbey Church at Egmond, which is seen in an undated drawing by Van Goyen (Beck 1987, no. 727B), and other Romanesque towers in the Netherlands (see Vermeulen 1928–41, part 1, pls. 12, 13, 15, etc.) are equally similar to the one depicted here. The round tower at the far corner of the fort resembles that found in paintings of 1638, 1642, 1643, etc. (see Beck 1972–73, vol. 2, nos. 638, 743, 751).

3. The Bordeaux picture is catalogued in Beck 1972–73, vol. 2, no. 685, and in Le Bihan 1990, no. 30.

4. Beck 1972–73, vol. 1, no. 583; Beck 1987, p. 100 (ill.); New York–London 2001, p. 473, fig. 314.

REFERENCES: Apostool 1792–93 illustrates the painting in reverse (aquatint); Virch 1970, p. 8, gives provenance; Beck 1972–73, vol. 2, p. 314, no. 687 (ill.); Beck 1987, p. 226, no. 687, notes that a very similar composition by Salomon van Ruysdael was sold at auction in 1978; Le Bihan 1990, pp. 122–23 (ill. [under no. 30]), compares the painting in Bordeaux (fig. 66 here); P. Sutton in The Hague–San Francisco 1990–91, p. 105, mentions the picture as part of an anonymous gift made to the Museum in 1964; Baetjer 1995, p. 306.

EX COLL.: ?Private collection, England (in 1792); [possibly Christie's, London, April 26, 1912, no. 102, called *The Castle and Town of Nimeguen,* a panel, 25¼ x 37½ in. (64.1 x 95.3 cm), signed and dated 1647, £1,050 to Pawsey & Payne; before 1965, the Museum's picture was called *River Scene Nymwegen*]; Sir Samuel Hoare, London (in 1934; sale, Sotheby's, London, November 21, 1934, no. 99, for £610 to Collings); [Galerie Sanct Lucas, Vienna, 1935–before 1938]; Mr. and Mrs. Charles Neuman de Végvár, Vienna and later Greenwich, Conn. (1938–1964); Anonymous Gift, 1964 64.65.1

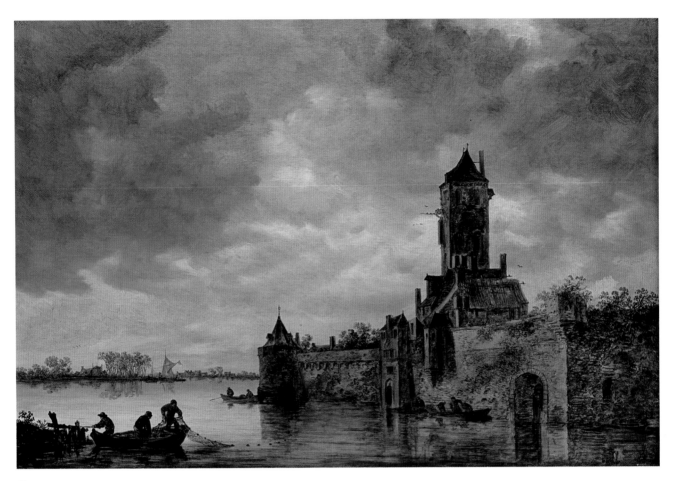

53

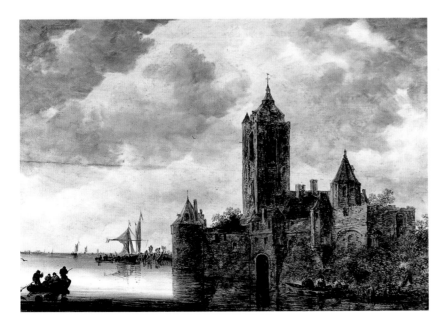

Figure 66. Jan van Goyen, *A Castle at the Water's Edge*, 1647. Oil on wood, 19¼ x 27⅛ in. (49 x 69 cm). Musée des Beaux-Arts, Bordeaux

54. *View of The Hague from the Northwest*

Oil on wood, 26 x 37⅞ in. (66 x 96.2 cm)
Signed and dated (at bottom, center right): VGOYEN 1647
[VG in monogram]

The painting is not well preserved. The sky is severely abraded, and paint has been lost along the two horizontal panel joins. There is slight abrasion throughout the landscape, a 2 in. (5.1 cm) vertical scratch at lower left, and a 3 in. (7.6 cm) vertical scratch at lower right.

From the Collection of Rita and Frits Markus, Bequest of Rita Markus, 2005 2005.331.3

In the center of the view is the Late Gothic Grote Kerk (Great Church) of The Hague, also known as the Jacobskerk (Church of Saint James). Its familiar profile, with the choir rising well above the nave, could be recognized from considerable distances. The same may be said for the two churches of Delft, which appear in the right background just to the right of four windmills. The taller tower on the horizon is that of the Nieuwe Kerk, close to which is the small tower of the Town Hall. The Oude Kerk is visible slightly farther to the west. The tower near the right edge of the panel is that of the Reformed Church in the village of Wateringen.[1]

To the far left (above the dog following a man in the foreground), the Kloosterkerk (Cloister Church), with a small spire, appears closer than, and to the left of, the large Ridderzaal (Knights' Hall), which is in the courtyard, or Binnenhof (Inner Court), of the court complex. Immediately to the right of the Ridderzaal's twin-towered façade, one sees the slightly closer Hofkapel (Court Chapel), with a small central spire. The tall, blocky form a little farther to the right is the Mauritstoren (Tower of Prince Maurits), which stands at the corner of the Stadholder's Quarters (remodeled in the early 1620s).[2] The next large structure to the right, seen midway between the Mauritstoren and the Grote Kerk, is the Oude Hof (Old Court, later called Paleis Noordeinde). The faintly indicated building to the left rear of the Oude Hof may be Van Goyen's anticipation of the Nieuwe Kerk, which was planned in 1646 but not erected until 1649–56.[3] Below this building one can make out the sails of the Beekmolen (Brook Mill), erected in 1621. Just to the right of the Oude Hof, one sees the modest tower of the Engelse Kerk (English Church) on the Noordeinde, and then the Oude Stadhuis (Old Town Hall), with its tall tower of the 1560s.

The short, square tower to the right of the Grote Kerk's tower (and above the coach in the middle ground) is the Huis van Assendelft, a fine town house on the Westeinde.[4] The dis-

tant church seen to the latter's right is the Oude Kerk in Rijswijk, a village halfway between The Hague and Delft.

Van Goyen moved from Leiden to The Hague in 1632. His first known view of the court city dates from 1637,[5] but views of other cities, with compositions quite like that of the present picture, date back to at least 1633, when he painted the earliest of his several known views of Arnhem.[6] Van Goyen's views of Rhenen date from as early as 1636,[7] and from the next year until at least 1653 he occasionally painted views of The Hague (at least nine are known), including a very large canvas executed in 1650–51 for the Burgomasters' Chamber of the Town Hall (Haags Historisch Museum, The Hague).[8] He also painted comparable views of Dordrecht (especially in the 1640s), Brussels and Antwerp (1648), Delft (1654), and less well known places.[9] Altogether about one hundred fifty views of cities, usually seen from a fair distance, as here, are known in Van Goyen's oeuvre, which amounts to an eighth of his approximately twelve hundred surviving paintings. However, cityscapes that are similar to the present work in their attention to actual buildings number between about seventy-five and a hundred. As the panoramic *View of Haarlem and the Haarlemmer Meer* (Pl. 50) demonstrates, Van Goyen's interest in actual topography was not limited to views like the present one.

A view of The Hague from approximately the same vantage point occurs in the background of a drawing by Van Goyen dated 1651 (Louvre, Paris).[10] The sheet appears to be a study for another painting, rather than a sketch from life. It may depend on the present picture or related material.

1. The church at Wateringen and the four windmills were identified by Charles Dumas (author of Dumas 1991), who in 2005 helped the present writer identify every building in the picture. He describes the four mills standing together as the Westermolens (western mills) next to the West Singel (West Canal). From left to right, they are: the Haanmolen (Cock Mill), destroyed by fire in 1679, rebuilt immediately, and demolished in 1919; the Valkmolen (Falcon Mill), replaced in 1697, demolished in 1865; the Heremolen (Gentleman's Mill), built before 1554, replaced in 1712, demolished in the 1860s; the Westmolen (Western Mill), built before 1554, replaced in the late 1600s, demolished in the 1860s. The closer windmill, seen to the left of the row of four windmills, is the Gortmolen (Grits Mill), which stood by the West Singel.
2. See Dumas 1991, pp. 555–59 (under no. 47).
3. C. Dumas, personal communication of October 9, 2005. See Dumas 1991, pp. 95–100 (under no. 1).
4. See Dumas 1991, p. 141 (under no. 7), and p. 701 on the house.
5. Beck 1972–73, vol. 2, no. 324 (private collection).

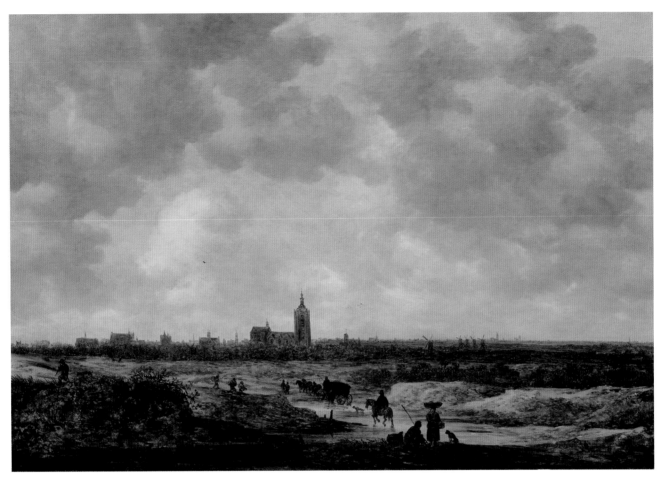

54

6. Ibid., no. 272. Views of Dordrecht also date from 1633 onward (ibid., no. 290), but as one would expect in the case of that city on the Maas, these pictures are more river views than cityscapes. It is not surprising that the artist's interest in city views appears to have developed during a trip to a comparatively distant Dutch city. There are many precedents (see Amsterdam–Toronto 1977 for a survey of the genre). A well-known example is the *View of Zierikzee,* dated 1618, by Van Goyen's teacher, Esaias van de Velde (Gemäldegalerie, Berlin). See also New York–London 2001, nos. 89, 90, for Hendrick Vroom's two profile views of Delft, dated 1615 (Stedelijk Museum Het Prinsenhof, Delft). Views of The Hague are discussed in the introductory essay of Dumas 1991.

7. Beck 1972–73, vol. 2, nos. 374–400a.

8. Ibid., vol. 2, nos. 324–32. For the large canvas of 1650–51 (Beck no. 332), see also Dumas 1991, pp. 508–17, no. 41.

9. Beck 1972–73, vol. 2, nos. 290–322a, 401a–20. The *View of Delft* (Beck no. 420) is now in the Stedelijk Museum Het Prinsenhof, Delft. See Kersten 1992.

10. Beck 1972–73, vol. 1, p. 80, no. 223; Dumas 1991, p. 21, fig. 12.

REFERENCES: A. B. de Vries et al. 1968, pp. 48–51 (ill., with large detail of church on p. 51), describes the painting incorrectly as on canvas, mentions other views of The Hague by Van Goyen, and quotes two poems by Constantijn Huygens; Beck 1972–73, vol. 2, p. 161, no. 328 (ill.), with provenance to 1968; Beck 1987, p. 181, no. 328, adds provenance and exhibition details (to 1982).

EXHIBITED: The Hague, Mauritshuis, "Terugzien in bewondering: A Collectors' Choice," 1982, no. 37.

EX COLL.: [Matthiesen, London, in 1953]; Knoedler & Co., London and New York, in 1955]; [E. Speelman, London, in 1963]; [J. R. Bier, Haarlem, in 1966]; Sydney J. van den Bergh, Wassenaar (by 1968); [G. Cramer, The Hague]; private collection (by 1982); Frits and Rita Markus, New York; From the Collection of Rita and Frits Markus, Bequest of Rita Markus, 2005 2005.331.3

55. *A Beach with Fishing Boats*

Oil on wood, 11 x 17 in. (28 x 43.2 cm)
Signed and dated (lower left, on skiff): vG 165(3?) [vG in monogram]

The painting is well preserved. The oak panel, which retains its original thickness and bevels, has been reduced in height about ½ in. (1.27 cm).

From the Collection of Rita and Frits Markus, Bequest of Rita Markus, 2005 2005.331.2

This beach scene of the early 1650s is deftly sketched almost entirely in tones of brown, with glimpses of blue sky above the windswept clouds. The forms and movements of the clouds are described by broad and very thin brushwork, making the virtuoso execution of the sky a major part of this painterly exercise.

At seaside villages, the beach was something akin to the market square. Here, small fishing boats return from a long day on the water, and villagers gather to greet them, see the catch, buy fish, or talk among themselves. To the far left, low waves define the shoreline, which a lone boat approaches with the wind. In the right background, a church stands among houses; a windmill is close by. Below the mill, a man and his dog trudge behind a peasant cart. The figures, skiff, and barrels in the foreground are conjured by Van Goyen with minimal means, the tip of the brush used as if it were chalk or pencil. Farther back, detail gives way to dissolution in atmosphere. The figures to the left of the central boat, for example, and, farther to the left, the approaching rider with hat in hand are seen as if from a distant dune, with eyes squinting in the damp, salty air.

The scene was one witnessed almost every day near the coastal towns of seventeenth-century Holland. It was recorded in many paintings by Van Goyen and others (see, for example, Salomon van Ruysdael's *Market by the Seashore*; Pl. 184), and in dozens of drawings by Van Goyen dating from his early years onward.[1] Van Goyen's painted beach scenes date back to at least 1632. The artist returned to the subject many times during the 1630s and 1640s; he appears to have abandoned it about 1653.[2] The date on the present picture (one of two Van Goyens from the Markus Bequest) has been read as 1651 (see Refs.) but appears to be 1653. Circumstantial support for this reading comes from the fact that Van Goyen drew many beach views in 1652 and especially in 1653, and because his last known paintings of beaches include works from 1649 and 1653

but none from between these dates.[3] Furthermore, the Markus panel was paired in the past with a river view (with fishing boats) of exactly the same size that is dated 1653 (private collection).[4] The pictures were separated in the art trade shortly after they left the collection at Kellie Castle in 1929.[5] Artists and dealers in Van Goyen's day are known to have offered paintings, and particularly landscapes, in pairs, although pictures painted as, so to speak, optional pendants were also sold separately. In any case, the two paintings once at Kellie Castle work equally well as a pair and independently.

1. For example, Beck 1972–73, vol. 1, nos. 59 (1626), 131, 159, 160, 193, 199–203, 284–89 (beach sketches of 1652, some at Scheveningen), 358–72 (all dated 1653), etc.
2. Ibid., vol. 2, nos. 923–63.
3. Ibid., nos. 959, 960?, 961–63.
4. Ibid., no. 875, vol. 3, no. 875; Leiden 1996–97, no. 50. Beck records the pictures as pendants, but the connection is not mentioned in the Leiden exhibition catalogue of 1996–97.
5. Curiously, Beck no. 875 was later in the collection of Sydney van den Bergh (see A. B. de Vries et al. 1968, pp. 56–57), with whom Markus had a close relationship.

REFERENCES: Anon., "Old Master Paintings at the Terry-Engell Gallery," *Connoisseur* 151, no. 609 (November 1962), p. 181 (ill.), cites the painting as dated 1651; anon., "Notable Works of Art Now on the Market," *Burlington Magazine* 104 (1962), unpaged (after p. 568 in December issue), pl. XIV, as dated 1651, offers extreme praise; Beck 1972–73, vol. 2, pp. 432–33, no. 962 (ill.), considers the painting a pendant to Van Goyen's river view dated 1653, which was also in Kellie Castle before 1929 (see Ex Coll.); Amsterdam 1981, p. 136, simply repeats (in translation) the brief description found in Beck 1972–73, again mistaking the windmill for a watchtower; Beck 1987, p. 255, no. 962, records the work as with Cramer, The Hague.

EXHIBITED: Worthing (West Sussex), Worthing Art Gallery, "Dutch and Flemish Paintings from the Collection of Mrs. Geoffrey Hart," 1952, no. 25, as *Coast Scene* (the date misread as 1648); Amsterdam, Waterman Gallery, "Jan van Goyen 1596–1656: Conquest of Space," 1981, pp. 136–37 (lent from a private collection).

EX COLL.: Earl of Mar and Kellie, Kellie Castle, Scotland (before 1929); [Asscher & Welker, London, in 1929]; Mr. and Mrs. Geoffrey Hart, London; Mrs. Geoffrey Hart (in 1952); [E. Speelman, London, about 1958]; [Sotheby's, London, June 27, 1962, no. 26 (ill.), sold to Terry-Engell for £6,000]; [H. Terry-Engell, London, in 1962]; [Douwes, Amsterdam, in 1964]; [Hans M. Cramer, The Hague, in 1981]; Frits and Rita Markus, New York; From the Collection of Rita and Frits Markus, Bequest of Rita Markus, 2005 2005.331.2

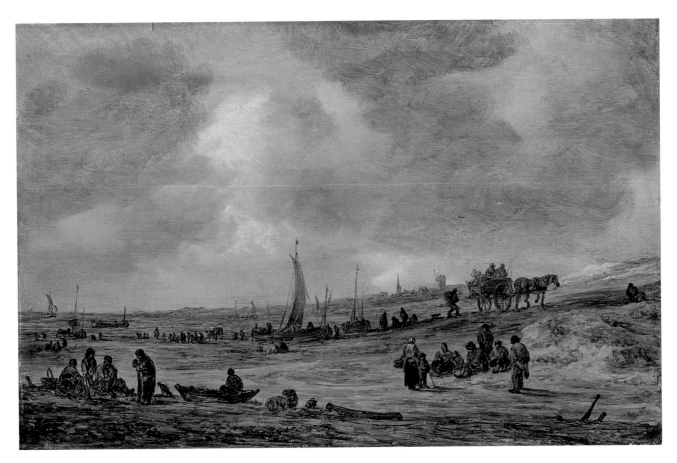

55

Figure 67. Detail of Van Goyen's
A Beach with Fishing Boats (Pl. 55)

56. *River View with a Village Church*

Oil on canvas, 25½ x 38½ in. (64.8 x 97.8 cm)

The painting is in good state, although the paint surface has been slightly flattened during lining. There is some abrasion in the trees and rooftops where these overlap the sky, and in the more thinly painted reflections in the water.

Bequest of Adele L. Lehman, in memory of Arthur Lehman, 1965 65.181.11

When this painting was in the Lehman Collection it was thought to be a view of Overschie by Van Goyen, monogrammed and dated 1637.[1] The inscription came off with cleaning in 1967,[2] one year after a visiting connoisseur dismissed the little-known canvas from the landscapist's oeuvre.[3] Shortly thereafter, Beck placed the picture among five "varying copies" after a lost painting by Van Goyen.[4] At least two of these copies (one of them especially close to the Museum's picture) and other versions have been attributed in auction sales to Salomon van Ruysdael (q.v.), although Stechow in 1938 rejected that artist's or Van Goyen's responsibility for four examples of the composition.[5] Van Goyen sketched out the main lines of the composition as early as 1631.[6] Similar works by Van Ruysdael date from about 1632 onward.[7] The formula was so successful that the two painters returned to it frequently over the course of twenty years,[8] and imitators produced paintings of this type well into the second half of the century.

The pictures by Van Goyen that most resemble this one date from 1645 onward. They include a panel dated 1645 in the National Gallery, London;[9] another panel of 1645 that was on the London art market in 1923;[10] a version of 1648 formerly in the Argenti collection, London;[11] and a panel dated 1651 in the Corcoran Gallery of Art, Washington, D.C.[12] In these versions the church steeple is central in the composition, there are more trees and some undeveloped land to the left, and a strip of land, occupied by cows and/or fishermen, fills most of the immediate foreground. Beck is probably right to consider the Museum's canvas and versions of it to have derived from another painting by Van Goyen that is now lost or unknown.[13]

This does not suggest that the five examples listed by Beck are all from Van Goyen's studio. Aspects of the present picture, such as the execution of the building at the water's edge and some passages of foliage, recall works by Frans de Hulst (1605/7–1661) more than the related paintings by Van Goyen.[14] Nonetheless, the sheer number of Van Goyen's known followers

makes any attribution to an individual artist inappropriate, especially in the case of a work most likely copied after Van Goyen himself.

The earlier identification of the church in this canvas, in the painting of 1645 in the National Gallery, London, and in similar compositions derives from the inscription "Oudeschie" in a later hand on a sketch in Van Goyen's Bredius sketchbook of 1644.[15] Brown, following Beck, rightly rejected the identification with Ouderschie, Ouwerschie, or Overschie (all the same place, a village on the Schie between Delft and Rotterdam) because an engraving of the church published in 1680 shows a bulbous cupola on the spire.[16] Van Goyen appears to have depicted the church at Overschie in three other paintings, dating from 1645, 1647, and 1651.[17] More recently, Buijsen identified the drawing inscribed "Oudeschie" in the Bredius sketchbook as a view of Ouderkerk aan de Amstel, and this is confirmed by his comparisons with several images, including two paintings by Van Goyen (dating from 1650 and 1651), a drawing by Jacob van Ruisdael (q.v.), and an engraving in Abraham Rademaker's *Kabinet van Nederlandsche Outheden en Gezichten* (Amsterdam, 1725).[18]

It does not follow that the Museum's picture and related paintings show the church at Ouderkerk aan de Amstel, since that structure differs in almost every detail (including its alignment with the river), except for the similar, but slimmer, spire, and the arcade on the tower. With Van Goyen's architectural subjects, one repeatedly reaches the same conclusion: Occasionally his depictions of buildings are more or less faithful to life, but generally he allowed topographical material to serve his artistic whims.

1. Virch 1965, p. 46.
2. The monogram and date, formerly on the boat, bottom center, were found to be "in between layers of the last varnish" (condition report dated October 1967).
3. Daan Cevat, January 4, 1966.
4. Beck 1972–73, vol. 2, p. 285, no. 628b; Beck 1987, p. 218, adds more recent provenance details for his copies III and IV.
5. Stechow (1938) 1975, pp. 44–45, n. 32, "als kleine Apokryphenprobe." Beck 1972–73, vol. 2, no. 628b, copy III (which he notes is very similar to copy V, the Museum's picture) was offered at Christie's, London, April 1, 1960 (Van Aalst sale), no. 41, as signed by Salomon van Ruysdael and dated 1640; and at Sotheby's, London, December 10, 1986, no. 152, as attributed to Van Ruysdael.
6. See Beck 1987, no. 441A, recording a panel sold at Sotheby's, London, March 9, 1983, no. 71.

56

7. See Stechow (1938) 1975, figs. 11, 15, etc., and Amsterdam–Boston–Philadelphia 1987–88, p. 472 (under no. 93).

8. See Stechow (1938) 1975, pp. 19–24, 43–45; Beck 1972–73, vol. 2, pp. 220–61; and Beck 1987, pp. 194–209.

9. Beck 1972–73, vol. 2, no. 509 (ill. in Beck 1987, p. 203); see MacLaren/Brown 1991, pp. 144–45, where versions are cited.

10. Beck 1972–73, vol. 2, no. 507 (ill.).

11. Ibid., no. 534 (ill.).

12. Ibid., no. 552 (ill. in Beck 1987, p. 207). A very similar panel in the National Gallery, Prague, is said to be dated 1635 (see Tokyo–Kyoto 1990, no. 49 (ill. p. 109), as *A View of Overschie*), but it is not included in any of Beck's catalogues. The work appears to have suffered, and its attribution and date are uncertain.

13. See note 4 above.

14. See Beck 1991, pp. 185ff.

15. Buijsen 1993, no. 55.

16. MacLaren/Brown 1991, p. 144, referring to the print in Van Bleyswijck 1667–[80], and to a history of Overschie. The church was destroyed by fire in 1899. See also Rademaker's print of 1725 (Buijsen 1993, fig. 18).

17. As noted by C. Brown in MacLaren/Brown 1991, p. 144. All three pictures are illustrated in Beck 1972–73, vol. 2, nos. 505, 529, 263, respectively. See also Buijsen 1993, p. 76.

18. Buijsen 1993, pp. 76–79.

REFERENCES: Hofstede de Groot 1907–27, vol. 8 (1927), p. 194, no. 765, as by Van Goyen, monogrammed and dated 1637, and with the dealer J. Schnell, Paris, in 1913; Virch 1965, p. 46, as by Van Goyen, with provenance; Beck 1972–73, vol. 2, pp. 285–86, no. 628b, copy V (ill.), as a copy after a lost painting by Van Goyen; Morris and Hopkinson 1977, vol. 1, p. 85 (under no. 613), n. 1, compares the similar picture by a follower of Van Goyen in Liverpool; Baetjer 1995, p. 306.

EXHIBITED: Columbia, S.C., Columbia Museum of Art, "Landscape in Art: Origin and Development," 1967, no. 27, as by Van Goyen.

EX COLL.: Robert Hutcheson, Glasgow (until 1851; sale, Christie's, London, April 4, 1851, no. 58, for £7 15s.); John Bell, North Park, Glasgow (until 1881; sale, Christie's, London, June 24, 1881, no. 623, for £90 6s.); Sir Christopher Beckett Denison, London (from 1881); ?Lady C. Beckett Denison; Lord Faber (until 1913; sale, Christie's, London, June 20, 1913, no. 66); [J. Schnell, Paris]; Adolph Lewisohn, New York (until 1938); Mr. Samuel A. Lewisohn, New York (in 1938; gift to Adele Lewisohn [Mrs. Arthur Lehman]); Mrs. Arthur Lehman, New York (1938–65); Bequest of Adele L. Lehman, in memory of Arthur Lehman, 1965 65.181.11

DIRCK HALS

Haarlem 1591–1656 Haarlem

About eight years younger than his brother Frans (q.v.), Dirck Hals was baptized in a Protestant ceremony in Haarlem on March 19, 1591. By that date, his parents had probably been in Holland for nearly five years (see the biography of Frans Hals below). It has been assumed that Dirck studied with his brother, and perhaps with Willem Buytewech (1591/92–1624).[1] Frans and Dirck Hals were both members of the Haarlem chamber of rhetoric De Wijngaardranken (The Vine Tendrils) and the Saint George civic guard company (Dirck from 1618 until 1624).

Both brothers appear to have been late bloomers in the field of art. Dirck was thirty-six when he joined the Guild of Saint Luke in 1627, by which time he had been married for six or seven years (the date of the ceremony is unknown) to a woman named Agneta Jansdr. Six daughters and one son are known to have been baptized between 1621 and 1635. (Anthonie, the firstborn, became a genre painter and portraitist in Amsterdam.) A document of 1624 refers to Hals being owed 24 guilders in wages by a Haarlem engraver, which suggests that he worked for other artists before he became a master in the guild.[2]

A number of documents concerning the painter are known, but only a few are illuminating, such as the mention of "several copies after Dirck Hals" in a Haarlem auction of 1631, and references to lotteries of paintings he co-organized in 1634 and 1635 (submitting several of his own pictures).[3] The fact that Hals's work was copied fairly early on, and that he is praised together with the far more famous Frans in Ampzing's "Description of Haarlem" published in 1628, suggests that he was well regarded in the 1620s and early 1630s.[4] This is reflected also in his collaboration with the architectural painter Dirck van Delen (1604/5–1671) in several paintings dating from the late 1620s.[5] Hals was esteemed as a specialist in painting and drawing small figures, which is easy to understand when one examines his small panel *A Young Couple,* of 1624 (Collections of the Princes of Liechtenstein, Vaduz),[6] or figure studies like those of seated gentlemen in the Rijksprentenkabinet, Rijksmuseum, Amsterdam, and the Frits Lugt Collection, Paris.[7]

Hals and his family appear to have lived mostly in Leiden during the 1640s. He rented a house there on February 22, 1641, but his possessions were seized in June 1642 and he was told to vacate because of payments outstanding. He found himself in similar circumstances in Leiden at the end of 1649, although it is not certain that he had been living there continuously since the early 1640s. He died in Haarlem in May 1656, and was buried in the Begijnhof church.

In his colorful and painterly technique, Dirck owed a debt to Frans Hals, especially in his early oil sketches on paper.[8] As a painter of Merry Companies, he continued the tradition of Buytewech, Esaias van de Velde (1587–1630), and David Vinckboons (q.v.). The Rotterdamer Buytewech and the Amsterdamer Van de Velde both joined the Haarlem painters' guild in 1612 and remained in the city for several years. The importance for Dirck Hals of their stylish figures socializing in living rooms, on terraces, and in the gardens of fine estates has often been considered.[9] Hals's more monochromatic and atmospheric genre scenes of the 1630s, such as *Woman Tearing a Letter,* of 1631 (Mittelrheinisches Landesmuseum, Mainz), are remarkable for their simplicity and naturalism, an innovation comparable to that in Haarlem still-life or landscape painting during the same or slightly earlier years.[10] The quality of the artist's pictures dating from after 1640 is quite uneven, and their ideas repetitive, which must be the consequence of difficult financial circumstances and a competitive market. The lives of lesser talents, such as Pieter Quast (q.v.), were a constant struggle during the same period.

1. On Buytewech as Dirck Hals's possible teacher, see Kolfin 2005, pp. 105–6.
2. See Van Thiel-Stroman in Haarlem–Worcester 1993, p. 256 (and the same author's biography of Hals in Biesboer et al. 2006, pp. 176–77). Her thorough biography of Dirck Hals offers numerous details about his immediate family, business affairs, debts, and so on. Similar information, with references to many documents, is found in Nehlsen-Marten 2003, pp. 93–97.
3. Van Thiel-Stroman in Haarlem–Worcester 1993, pp. 256–57. The copies after Hals are mentioned by Giltaij in Rotterdam–Frankfurt 2004–5, p. 51, based on archival information published by Bredius.

4. The verse in Ampzing 1628, p. 371, is translated into English in Rotterdam–Frankfurt 2004–5, p. 51.
5. See Philadelphia–Berlin–London 1984, no. 45; Potterton 1986, pp. 32–33, no. 119; Trnek 1992, no. 57; and Nehlsen-Marten 2003, pp. 311–13, nos. 354–57, figs. 195, 197–99.
6. New York 1985–86, no. 168.
7. For both, see Amsterdam–Washington 1981–82, pp. 74–75.
8. On Dirck Hals's oil sketches, see ibid., and Schatborn 1973.
9. See, for example, Franits 2004, pp. 27–34, and Kolfin 2005, pp. 105–10.
10. Franits 2004, pp. 32–33, fig. 23; Nehlsen-Marten 2003, no. 361, fig. 207.

57. *A Banquet*

Oil on wood, 16 x 26 in. (40.6 x 66 cm)
Signed and dated (bottom center): Dirck hals/1628

The painting is generally abraded. The wood grain, which has become more prominent, can be seen throughout the thinned paint layers and is most disfiguring in the light passages.

Purchase, 1871 71.108

Hals usually signed his paintings DH in monogram, DHALS in block letters, or not at all (many accepted works are not signed).[1] This picture, however, is fully signed in an elegant script and dated 1628. Examination with a microscope reveals clearly that the signature is in the original paint layer, that the third digit of the date (transcribed in the past as a 3) is certainly a 2, and that the last digit is a "lazy 8," tilted with the top forward so that it nearly parallels the long diagonal tail of the "h" in the signature.[2]

The painting is typical of Hals in execution, and may be described as a routine effort derived in good part from a much better work by the artist. All the figures seated at the table, with the exception of the man in a dark hat to the right, and also the wine cooler and the young servant with a pewter pitcher, are adopted from the more multifigure *A Garden Party*, dated 1627, in Amsterdam (figs. 68, 69). Some figures are essentially the same, but a few (like the third from the left) have been altered. The Amsterdam panel is one of Hals's finest works, made in the year of his entry into the Haarlem painters' guild. It is not surprising that he would repeat part of the figure group in another setting. Similar examples of recycling, and also borrowing from other artists' compositions, are fairly common in his oeuvre.[3]

Figure 68. Dirck Hals, *A Garden Party*, 1627. Oil on wood, 30¾ x 54 in. (78 x 137 cm). Rijksmuseum, Amsterdam

To give the figures a different stage from that employed in the Amsterdam panel, Hals turned to his familiar shoe-box design, with light- and dark-gray tiles on the floor, a curtained bed to the left, an entrance wall to the right, a fireplace flanked by a generic seascape and landscape, and a bench. Large bottles of red and white wine stand in the wine cooler, placed, like the chairs, somewhat uncertainly on the floor. Hals was exceptional among Haarlem and Amsterdam genre painters of his generation for the frequency with which he defined interior spaces with the help of tiled floors (which were almost unknown at this date in Dutch houses). This practice may have been encouraged to some extent by his association with Dirck van Delen (see the biography of Hals above), but examples of tiled floors and boxy rooms in Hals's oeuvre predate his collaboration with the architectural painter, and a similar approach is found occasionally in the work of North Holland contemporaries (for example, Isack Elyas's *Merry Company,* of 1620, in the Rijksmuseum, Amsterdam).

The women to the left hold apples, while four of the men raise wineglasses, one to his lips. A large cooked fowl sits on a pewter platter in front of the smiling woman in a yellow dress. The four figures seated on this side of the table are quite well painted, with special attention paid to the vivid colors and the highlights on their clothes. (X-radiographs show how deftly Hals sketched the figures in paint, with little or no drawing beforehand.)[4] The two women in the foreground are dressed in deep green, the man turned from the viewer in dark gray (the coat draped over his left shoulder and the enormous hat keep the rhythm of the group flowing), and the dapper gentleman to the right in brown with a mauve shirt and stockings. One could describe the scene as "A Banquet," to repeat the title that the work was given more than a century ago, but the subject is really a drinking party with much less food than in Frans Hals's comparably composed portrait of the officers of the Saint George civic guard company (1616; Frans Halsmuseum, Haarlem), to which the Hals brothers belonged.

The painting may have been owned by Théophile Thoré (the celebrated "discoverer" of Vermeer) just before it was acquired by dealers in Paris and passed on to the Museum's first vice president, William T. Blodgett (see Ex Coll.).

A simplified version of the composition, apparently by another hand, has been on the art market.[5]

1. See the catalogue section of Nehlsen-Marten 2003.
2. Conservator Dorothy Mahon and assistant conservator Isabelle Duvernois kindly brought the inscription to my attention (April 2006), with particular attention to the reading of the date in the past as "163[]" (as in Baetjer 1995, p. 305).
3. As discussed in Kolfin 2005, pp. 145–48.
4. As noted by Dorothy Mahon and Isabelle Duvernois (see note 2 above). On Hals's use of a painted sketch and undermodeling on the primed support, see Kolfin 2005, pp. 150–51.
5. Christie's, London, July 9, 1999, no. 5; accepted in Nehlsen-Marten 2003, no. 81, fig. 187, with no reference to the New York or Amsterdam pictures.

REFERENCES: Thoré 1868b, p. 394, refers to the picture as "mon *Intérieur de maison galante,*" and compares the painting of 1628 by Dirck Hals and Dirck van Delen in the Gemäldegalerie der Akademie der Bildenden Künste, Vienna; MMA 1872, p. 44, no. 109, as from the collection of W. Bürger, the date read as 1625; Harck 1888, p. 75, describes the work as extremely well preserved; P. Sutton 1986, p. 187, as "a routine Dirck Hals dated 163[?]"; Baetjer 1995, p. 305, as signed and dated "163[]"; Jowell 2003, pp. 92–94 n. 212, fig. 61, as probably owned by Théophile Thoré; p. 306, no. 323, as signed and dated 1636(?), and as "last" in the MMA, 1931;[1] Haarlem–Hamburg 2003–4, p. 96 n. 8, mentions the picture in connection with the Rijksmuseum panel (fig. 68 here); Baetjer 2004, p. 209, no. 109 (ill.), catalogues the work as part of the 1871 Purchase.

EX COLL.: Probably Étienne-Joseph-Théophile Thoré (W. Bürger) (d. 1869); [Léon Gauchez, Paris, with Alexis Febvre, Paris, until 1870; sold to Blodgett]; William T. Blodgett, Paris and New York (1870–71; sold half share to Johnston); William T. Blodgett, New York, and John Taylor Johnston, New York (1871; sold to MMA); Purchase, 1871 71.108

1. As noted in Nehlsen-Marten 2003, p. 261, the author based her catalogue (which fails to meet professional standards) on the photograph files of the Rijksbureau voor Kunsthistorische Documentatie, The Hague, and in this case did not check any published source (to say nothing of writing the Museum a letter).

57

Figure 69. Detail of Hals's
A Garden Party (fig. 68)

FRANS HALS

Antwerp 1582/83–1666 Haarlem

Like many less famous Dutch painters, Hals was actually from the Spanish Netherlands. His father, Franchoys Hals, was a clothworker from Mechelen (Malines) who moved to Antwerp, where his first child, Frans, was born, probably in 1582 or 1583. Hals's mother was Adriana van Geertenryck. Both parents had lost their first spouse before the end of 1581.[1] A second son, Joost, was born in Antwerp in 1584 or 1585, but Frans's younger brother Dirck Hals (q.v.) was baptized in Haarlem in March 1591. How much earlier the family had left Antwerp for the northern Netherlands is not known, but it appears likely that they had done so by July 1586. Franchoys Hals was marked down as a Catholic in an Antwerp civic guard company, on a list intended to exclude Protestants from membership. However, his son Dirck was baptized as a Protestant. It appears likely that the family left Antwerp for both religious and economic reasons.[2]

Frans Hals joined the painters' guild in Haarlem in 1610, and in the same year (or in early 1611) he married Anneke (or Annetgen) Harmensdr (1590–1615). Their son, the painter Harmen Hals (1611–1669), was baptized on September 2, 1611; two small children from this brief marriage—Anneke died in 1615—were buried in 1613 and 1616. Hals's earliest known work, a fragmentary portrait of the Catholic clergyman Jacobus Zaffius (Frans Halsmuseum, Haarlem), is dated 1611. At the time, Hals was already about twenty-nine years old. According to the anonymous biography of Karel van Mander (1548–1606) in the second edition of his *Schilder-Boeck* (1618), the Haarlem Mannerist counted among his many pupils "Frans Hals, portrait painter of Haarlem." Such an apprenticeship could have continued until 1603 at the latest, when Van Mander left town.[3]

From 1612 to 1615, Hals was a musketeer in a new company of the Saint George civic guard in Haarlem, and from 1615 until 1624 he served in another company of the same civic guard. From 1616 until 1624, he was a "friend" or "second member" of a Haarlem chamber of rhetoric, De Wijngaardranken (The Vine Tendrils). Documents concerning a debt in Haarlem reveal that Hals was in Antwerp between some date before August 6 and the second week of November 1616.[4] The fact that the artist spent more than three months in Antwerp at an ideal moment

to survey in that city the work of Rubens and the styles of other Flemish painters, such as the young Jacob Jordaens (1593–1678), is of considerable interest for early pictures like *Merrymakers at Shrovetide* (Pl. 58), discussed below.

On January 15, 1617, "Frans Hals, widower from Antwerp" and Lysbeth Reyniersdr of Haarlem had their marriage banns announced. They married in Spaarndam on February 12, 1617, nine days before their daughter Sara was baptized. The names of ten other children from this marriage are known, and include four sons (in addition to Harmen, mentioned above) who became painters: Frans the Younger (1618–1669), Reynier (1627–1672), Nicolaes (1628–1686), and Jan (ca. 1620–1654).

In 1616, Hals completed the first of his large "shooting pieces," or group portraits of civic guard companies, the *Banquet of the Officers of the Saint George Civic Guard* (Frans Halsmuseum, Haarlem).[5] The others date from about 1627, 1633, 1634–37, and 1639. Despite these prestigious commissions, Hals had financial troubles at various times throughout his career. This is not surprising, given the large size of his family and the fact that very few Dutch portraitists were well paid. Hals supplemented his income as a portraitist by painting genre pictures, especially in the 1620s and 1630s; by occasional dealing in works by other artists; and by taking on a number of pupils, who included (in addition to his brother Dirck) Adriaen Brouwer (1605/6–1638), Adriaen van Ostade (q.v.), and Philips Wouwermans (q.v.). In his lifetime, Hals's reputation was mostly restricted to his own city, where his patrons were "a cut or two below Haarlem's élite": merchants, scholars, clergymen, artists, and so on.[6] More than half his sitters remain unidentified. The majority of Hals's portraits are half-length or three-quarter-length compositions. Apart from the full-length figures that appear in *The Company of Captain Reynier Reael and Lieutenant Cornelis Michielsz Blaeuw, Amsterdam ("The Meagre Company")* (Rijksmuseum, Amsterdam), which was commissioned from Hals in 1633 but finished by Pieter Codde (1599–1678) in 1637, Hals is known to have painted only one full-length portrait, that of the wealthy Haarlem textile merchant Willem van Heythuysen, which dates from about 1625 (Alte Pinakothek, Munich).[7] About two hundred autograph works are known,[8] which is not a large number given the

nature of Hals's technique and a career that lasted more than half a century. Two late group portraits, depicting the male and female regents of the old men's almshouse in Haarlem (both in the Frans Halsmuseum, Haarlem), date from about 1664, when the artist was about eighty-two years old.[9]

Hals was exceedingly adept in the use of Baroque design ideas, so that his borrowings of compositional devices from earlier Haarlem artists, Flemish painters, the Utrecht Caravaggisti, and other portraitists tend to go unnoticed or unappreciated. The animation of his figures' poses, expressions, and gestures is complemented by Hals's famous brushwork, which consistently suggests three-dimensional form and convincing effects of light and atmosphere (in this regard, the frequent description of Hals's technique as "very fast" is less careful than he was).[10] In the 1630s and especially the 1640s, Hals's approach to portraiture was toned down in more than one sense, with darker palettes and restrained poses responding to current taste. Even at their most reserved, however, his sitters appear accessible, and the suggestion of individuality compelling, in contrast to the uniformly engaging examples of Johannes Verspronck (q.v.).

Hals's style fell out of favor in the eighteenth century, but gained great esteem from the mid-nineteenth century onward, not least with European painters such as Courbet, Manet, and Van Gogh, and American artists such as John Singer Sargent, James McNeill Whistler, and William Merritt Chase.[11] Apart from group portraits, Hals's work is strongly represented in American collections, especially those of New York and Washington. This is a legacy of the Gilded Age (ca. 1870–ca. 1915), when candid portraits of prosperous but unassuming Dutchmen struck sympathetic chords in homes that bore little resemblance to those for which they were painted.[12]

1. For much more on the families of Hals's parents, see Van Thiel-Stroman on "The Frans Hals Documents," in Washington–London–Haarlem 1989–90, p. 372. See also Van Thiel-Stroman in Biesboer et al. 2006, pp. 178–84.
2. On this point, see ibid., p. 373 (under doc. 2).
3. See ibid., p. 375 (under doc. 9), and p. 379, doc. 25 (quoting from the unpaginated biography of 1618).
4. Documents relating to the details in this paragraph are given in ibid., pp. 375–78.
5. Slive 1970–74, vol. 2, pls. 15–22, vol. 3, pp. 5–7, no. 7.
6. Slive in Washington–London–Haarlem 1989–90, p. 6. This observation contrasts with the surprising remark made by Ingeborg Worm in Dictionary of Art 1996, vol. 14, p. 94, that "Hals's clients were the wealthiest and most influential people in the city of Haarlem." The author claims on the same page that Hals "had little ambition to extend his clientèle beyond Haarlem" but then observes that "members of the Amsterdam banking family of Coymans were among his faithful customers." On Hals's clientele, see Biesboer in Washington–London–Haarlem 1989–90, pp. 23–44.
7. Slive 1970–74, vol. 3, nos. 31, 80. For the Heythuysen portrait, see also Washington–London–Haarlem 1989–90, no. 17.
8. Slive 1970–74 counts about 220, of which only 168 are accepted in Grimm 1972.
9. Washington–London–Haarlem 1989–90, nos. 85, 86.
10. For example, by Worm in Dictionary of Art 1996, vol. 14, p. 93.
11. On the "rediscovery" of Frans Hals in the nineteenth century, see Jowell in Washington–London–Haarlem 1989–90, pp. 61–86.
12. On the Gilded Age in America and the taste for Hals and other Dutch painters, see Liedtke 1990, pp. 31–54.

58. *Merrymakers at Shrovetide*

Oil on canvas, 51¾ x 39¼ in. (131.4 x 99.7 cm)
Signed or inscribed (on flagon): fh

The painting is in good condition, although the impasto has been slightly flattened during lining in the past.

Bequest of Benjamin Altman, 1913 14.40.605

Of the two famous paintings by Frans Hals in the Altman Collection (see Pl. 59 for the other), this one, against stiff competition on all counts, is the more audacious in its coloring and brushwork, the more salacious in its subject matter, and the more important for the history of Dutch genre painting in what was then its main center of activity, the flourishing city of Haarlem.[1] The picture was probably painted about 1616–17, and is thus one of the artist's earliest surviving works.

Figure 70. Frans Hals, *The Rommel Pot Player*, ca. 1616–18. Oil on canvas, 41¾ x 31⅛ in. (106 x 80.3 cm). Kimbell Art Museum, Fort Worth, Texas

Among other paintings by Hals that date from the same decade, the most similar in execution are *Pieter Cornelisz van der Morsch*, dated 1616 (Carnegie Museum of Art, Pittsburgh), *The Rommel Pot Player*, of about 1616–18 (fig. 70), and *Catharina Hooft with Her Nurse*, of about 1618–20 (Gemäldegalerie, Berlin).[2] The genre painting in Fort Worth is comparable in its packed composition as well as in its painterly handling. The crowding of faces and hands around a central figure (or couple, in the Museum's picture) and the very sketchy handling of the peripheral heads are quite consistent in the two large canvases. There is also some resemblance in type between the central and right-hand figures in the Kimbell picture and the two most mature (so to speak) men in the Altman painting, and a much stronger similarity in the way their faces, hands, and hats are painted. In the Berlin portrait, costume details offer the closest analogies, although the maid's hand (with fingers like fresh éclairs) and the child's fist find mates in the Merry Company, to employ the term by which many pictorial descendants of the Museum's painting are known.

The picture's style requires careful consideration, since it falls somewhat out of the mainstream in Hals's oeuvre, and

has occasionally been misunderstood.[3] Many of Hals's genre scenes are more loosely painted than his portraits, and apart from *The Rommel Pot Player* (which has been doubted in the past), only a few works from the same period are suitable for comparison. That Hals had visited his native Antwerp between August and November 1616 also suggests that the Altman painting's seemingly Flemish qualities—the ruddy palette, broad brushwork, and impulsive rhythms over the entire surface—may have been inspired partly by contemporaneous pictures by Jacob Jordaens (1593–1678) and other Antwerp artists. The way every available pocket of space is filled with a face, a hand, a conspicuous object, or a costume detail is reminiscent of compositions by Jordaens dating from about 1615–17, to a degree rarely found in Dutch art of the same period.[4] However, a similar approach to grouping figures is found in some earlier and contemporary works by Haarlem artists,[5] and there are older Dutch precedents as well.[6] Slightly later compositions by Willem Buytewech (1591/92–1624) and Dirck Hals (q.v.)—not only those derived from this design—show that such a dense clustering of figures was a decorative principle of the time.[7] Of course, the goal in Hals's painting is to suggest a carnival atmosphere, and to amuse the viewer with funny physiognomies.

Most of these observations do not preclude Grimm's opinion (see Refs.) that the picture is an old copy of a lost work by Hals. However, its manner of execution and level of quality are entirely consistent with autograph works by the artist, and reveal none of the characteristics that normally indicate replication. Close study of the strongest passages, such as the bearded man's face, shows the artist's distinctive technique, with brushstrokes that admirably model forms at the same time that they capture fleeting effects of light and shadow. Shapes and contours are invented or discovered in virtuoso bursts of activity. The deft handling of hair and lace (both visible in fig. 71) surpasses the known abilities of artists from the circle of Hals, including Dirck Hals and Buytewech.

The subject has often been described but deserves further explication. The British reference to Shrovetide, the period of three days preceding Lent, corresponds with seventeenth- and eighteenth-century Dutch descriptions of the subject as Vastenavond (Eve of Lent, or Shrove Tuesday).[8] Known elsewhere as Mardi Gras, the occasion is celebrated with a carnival devoted to foolish behavior and popular foods such as pancakes and sausages. Slive mentions the colophon of Sebastian Brant's *Ship of Fools* (Basel, 1494), which states that the book was published "at the Shrovetide, which one calls the Fool's Festival." Also cited by Slive is the inscription on an engraving of a rommel-pot player by Jan van de Velde (1593–1641),

58

which observes that on Vastenavond many fools make pennies by playing the raucous instrument.[9] Like the "musician" in the Kimbell painting (fig. 70), the man in the print wears on his hat a foxtail, symbol of foolishness.[10] The bearded man in the Altman painting holds a foxtail in his right hand, while with the left he paws the shoulder of the young blonde.

Slive's suggestion that the girl is no lady but a young man in drag is supported by the hairstyle, which looks peculiar for a woman of the time.[11] She—or he—appears to sit in her middle-aged admirer's lap.[12] It seems likely that, with his laurel wreath, the youth has been crowned "queen" for the day and dressed as a Flemish floozy, a city girl with more fashion sense than any other kind.[13] Her attire is extravagant by Dutch standards of the period, but the lace collar and abundance of embroidered silk barely go beyond costumes that could have been seen in Antwerp or at the Brussels court. However, it may be that the fancy dress is simply traditional in carnival celebrations, as is suggested by prints by Jacques de Gheyn (q.v.) and others.[14]

The central figure is flanked by two familiar characters of the comic stage: on the left, Pekelharing (Pickled Herring), and, on the right, Hans Worst (John Sausage, which has the same ring as Simple Simon). As Slive and others have explained, these names (given here with modern spellings) were assigned to stock figures in satirical comedies, and were much less standardized in the Netherlands than were their counterparts in the commedia dell'arte of Italy.[15] Farces (as well as more civilized plays) were performed by chambers of rhetoricians, or *rederijkers*, usually in private rooms, but occasionally in public competitions.[16] The organizations were exclusively male, and the humor often coarse. Hals himself was a "second member" or "friend" of a Haarlem chamber of rhetoric, De Wijngaardranken (The Vine Tendrils), from 1616 to 1624.[17] And his sitter in a portrait dated 1616, Pieter van der Morsch (1543–1629; mentioned above), played Piero the buffoon in performances staged by a Leiden chamber of rhetoric, De Witte Accoleijen (The White Columbines).[18] Hals's painting in New York must have been inspired by his familiarity with rhetoricians, and was perhaps intended for a chamber of rhetoric, an individual *rederijker*, or an enthusiast of bawdy plays.

In any case, the subject and symbols were too lewd for the average Haarlem household. The table is strewn with a variety of "male" and "female" forms, the most phallic of which are the bagpipe and the many sausages.[19] The bagpipe and open tankard had been used in combination before, for example in Pieter Huys's naughty pictures of a bagpiper and his "wife" (according to the conventional title). The latest of them, dated 1571 (Gemäldegalerie, Berlin), is inscribed with the bagpiper's

declaration that his purse has been emptied, and his "pipe is all piped out."[20] Pekelharing wears a garland of Shrovetide appetizers, of which the fish (salted herring) and the mussel are also symbols of male and female private parts.[21] Eggs were a sign of masculine prowess, thanks to their resemblance to testicles, but when ruptured (as here) they implied diminished capacity, especially in older men. Farmers bringing their eggs to market were a popular theme on the stage, as in "A Boor with Eggs," written in sixty-nine lines of verse by a member of Hals's own chamber of rhetoric.[22] The artist's follower (and possibly pupil) Jan Miense Molenaer (1610/11–1668) treated the subject in a painting of about 1630, *The Drunken Egg Seller* (art market, New York), in which a gray-bearded boor is shown losing his eggs in a crowd that finds his predicament much funnier than might be expected by the modern viewer.[23] Eggs also suggested foolishness, since the word *door* (or *dooier*) meant both "yoke" and "yokel," or simpleton.[24] Peas (in a pod) may have had a similar meaning (as in "pea-brain"), but this is uncertain.[25] A pig's foot (or trotter) usually referred to gluttony.[26] All the food in the picture is peasant fare, and most of it was abundant at carnivals. Bax cites a seventeenth-century French print in which the fat figure of Carnival wears a chain of sausages draped over the shoulders, as here.[27]

As a physical type, Hans Worst often resembles the man Hals presents here as Pekelharing.[28] But in this picture (and in Jan Steen's *Merry Company on a Terrace*; Pl. 197), Hans is identified by sausages dangling from his cap. His obscene gesture (again anticipating Steen; see Pl. 196) was once painted out.[29] Slive correctly notes "the equally vulgar gesture" made by the man with a spoon stuck in his cap, which he calls "a familiar allusion to prodigality."[30] Given the spoon's size, it probably does imply immoderate consumption, perhaps of drink as well as of food.[31] Pekelharing's pipe, which is lit, may also stand for overindulgence, as does the jug and (it seems) the voices raised by the sottish types in the background. But pipes were also phallic: *pijp* was slang for penis, and the verb *pijpen* meant (besides "to pipe," as on a bagpipe) to copulate.[32] In this context, the pot of hot coals (next to which another clay pipe and the bagpipe have been placed) may refer to female heat.[33]

It has been pointed out frequently that Buytewech, Dirck Hals, and other artists borrowed the main figures or the whole of this composition for use in a number of works.[34] A version of the entire design (adding more space at the sides and above) in the Frits Lugt Collection, Paris, is signed "DHALS 1637," and although remarkably mediocre is generally accepted as a work by Frans Hals's younger brother.[35] A picture of similar quality and composition was formerly in the

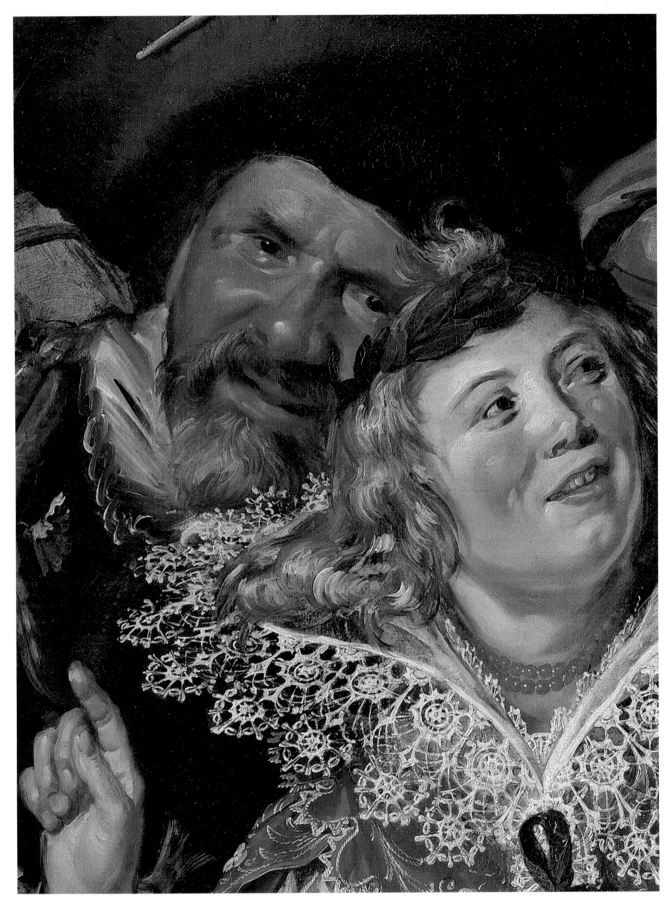

Figure 71. Detail of Pekelharing in Hals's *Merrymakers at Shrovetide* (Pl. 58)

Metzger collection, New York.[36] Another amplification, with the central figure transformed and other liberties taken, is now in the care of the Instituut Collectie Nederland.[37] None of these pictures may be taken as evidence that the Altman painting was cut down. Rather, they are adjustments to a slightly later period's concept of pictorial space.

In Dirck Hals's *Banquet in the Garden* (Louvre, Paris), the three main figures in the Museum's picture appear in the midst of several others, except that Hans Worst has become an attentive violinist.[38] The same painter's panel of about the same time, *Merry Company* (Städelsches Kunstinstitut, Frankfurt), sets the threesome in reverse among a greater number of banqueters, one of whom has stolen Pekelharing's attention away from the "girl" (who now reacts with a knowing sneer to Hans Worst's unseemly gesture).[39] Dirck Hals also employed the Pekelharing type in his collaboration with Dirck van Delen (1604/5–1671), *Elegant Company in a Renaissance Hall*, of 1628 (Gemäldegalerie der Akademie der Bildenden Künste, Vienna).[40] Pekelharing appears more conspicuously in the background of Dirck Hals's *Musical Party*, in the Michaelis Collection, Cape Town.[41]

Buytewech did bust-length drawings of both Pekelharing and Hans Worst, based loosely on those figures in the present picture. Since Buytewech moved from Haarlem to Rotterdam by August 1617, it appears likely that Hals completed the painting before that date.[42]

1. On genre painting in Haarlem, see Franits 2004, chap. 2.
2. See Slive in Washington–London–Haarlem 1989–90, nos. 4, 8, 9. In ibid., p. 148, the authenticity of the Kimbell picture (which was conserved in 1988) is convincingly defended, but the date proposed, about 1618–22, is insufficiently supported on the basis of the composition's design. The three paintings cited here in the text were examined by the present writer in 2002 or later, and on several earlier occasions. The Pittsburgh painting was flattened by its transfer from wood to canvas.
3. Most recently, by Grimm (1972, 1989). Grimm's methodology, which consists in good part of comparing isolated details of paintings against perceived norms of execution, has also led him to reject as works by Hals the Museum's *Young Man and Woman in an Inn* (Pl. 59), *Boy with a Lute* (Pl. 61), and the portraits of Petrus Scriverius and his wife (Pls. 63, 64), as well as well-known paintings by Hals in other collections.
4. The best example may be Jordaens's *Adoration of the Shepherds*, of about 1617 (Koninklijk Museum voor Schone Kunsten, Antwerp; D'Hulst 1982, fig. 40), but there are many other works by him that might be compared. See also Abraham Janssen van Nuyssen's *Vertumnus and Pomona*, of about 1613–14 (Kaiser-Friedrich-Museum, Berlin; missing since 1945).
5. Compare, for instance, the heads (likewise caricatures) filling spaces between the main figures in Hendrick Goltzius's "master-

piece" engraving *The Circumcision*, of 1594 (Strauss 1977, vol. 2, no. 322; Amsterdam–New York–Toledo 2003–4, no. 75.4), and the piling up of heads in Cornelis Cornelisz van Haarlem's celebrated altarpiece *The Massacre of the Innocents*, of 1591 (Frans Halsmuseum, Haarlem; Van Thiel 1999, no. 42, pl. vi; see also pls. 2, 64a, 216, 218). These examples could be described as Mannerist elaborations of an Early Netherlandish scheme, as seen in Hieronymus Bosch's *Christ Mocked*, of about 1490–1500 (National Gallery, London), and Quentin Massys's *Adoration of the Magi*, of 1526 (MMA).
6. One of the most similar compositions is that of Lucas van Leyden's *Fortune-Teller* (Louvre, Paris), where a variety of colorful figures are arranged around a young woman seated at a table.
7. See, for example, Buytewech's drawing *Interior with Dancing Couples and Musicians* (Fondation Custodia, Institut Néerlandais, Paris; Haverkamp-Begemann 1959, no. 45, fig. 112), and the Museum's own painting by Dirck Hals (Pl. 57).
8. See Slive 1970–74, vol. 1, p. 34, fig. 15, vol. 3, p. 3 (under no. 5), concerning the inscription, "Vastavonts-gasten," on the verso of a drawing by Mathys van den Bergh (ca. 1617–1687), which is dated 1660 and copies Hals's composition. The 1765 sale catalogue that apparently refers to this picture also employs the term (see Ex Coll.). In July 1972, curator John Walsh changed the title of the Museum's painting from *The Merry Company* to *Merrymakers at Shrovetide*, presumably in response to the discussion in Slive's monograph.
9. Ibid., vol. 1, pp. 34, 37, fig. 19.
10. See also the figure wearing a foxtail on his hat in Hendrick Pot's *Merry Company* of about 1630 (Museum Boijmans Van Beuningen, Rotterdam; Haarlem–Hamburg 2003–4, no. 42).
11. As noted by Nicole LaBouff, Department of Costume and Textiles, Los Angeles County Museum of Art (personal communication, February 28, 2005), who is studying carnival traditions and a group of miniatures (Netherlandish, ca. 1650?) that include images of women cross-dressed, for example as ecclesiastics, and perhaps vice versa. The corresponding figure in Dirck Hals's *Merry Company* in Frankfurt (Neumeister 2005, pp. 135–43) looks even more male, but in a follower's version of the Altman composition formerly with the dealer D. Katz in Dieren (Slive 1970–74, vol. 1, p. 34, fig. 16, vol. 3, p. 4, no. 3; Rijksdienst Beeldende Kunst 1992, p. 129, no. 1042), the figure has become a young woman, with a more plausible costume and coiffure.
12. The couple recalls the comic theme of unequal or ill-matched lovers that flourished in Netherlandish art and literature from the sixteenth to the eighteenth century. See Stewart 1977; Braunschweig 1978, no. 22; Renger 1985; and Amsterdam 1997a, no. 9.
13. A drawing inscribed "Juffrouw Braet-Haringh" (Mistress Grilled Herring), by Jan van Bouckhorst (1587/88–1631), is another example of a male actor playing a stock female part (Amsterdam and other cities 1991–92, no. 15). The present writer has not discovered whether being crowned with a laurel wreath was common in carnival celebrations or in *rederijker* performances. But it would hardly be surprising. On fancy female Flemish (and Spanish) dress, see Stanton-Hirst 1982, pp. 221–22, fig. 13 (a drawing of comedians by Pieter Quast [q.v.] in which an overdressed young woman is rudely offered an enormous sausage by a fool).
14. See the examples reproduced in Haarlem–Worcester 1993, p. 152,

figs. 5b, 5c. As noted in Kolfin 2005, p. 99, colorful clothing was considered an affectation of young adults.

15. Slive 1970–74, vol. I, pp. 34–35. Compare Hans Worst's costume to that of Pekelharing in two other paintings by Hals: Washington–London–Haarlem 1989–90, nos. 31, 32 (canvases in the Gemäldegalerie Alte Meister, Kassel, and the Museum der Bildenden Künste, Leipzig).

16. See Westermann 1997, pp. 138–42. The author refers her reader to Brandt and Hogendoorn 1992 and to Smits-Veldt 1991, but omits Schotel 1871. Also of interest are Van Duyse 1900–1902; Gudlaugsson 1945; and Dekker 1997 (or Dekker 2001). For additional literature on *rederijkers,* see P. Sutton 1982–83, p. 27 n. 5.

17. See Washington–London–Haarlem 1989–90, p. 377, doc. 16.

18. See Slive 1970–74, vol. 3, p. 5, no. 6, and Slive in Washington–London–Haarlem 1989–90, p. 138 (under no. 4). The portrait's meaning was first explained in Van Thiel 1961.

19. The straws by the bagpipe go with the pot of coals, and were used for lighting pipes. On sausages, see Bax 1979, p. 229. The author quotes the following lines, which refer to young maids, from a fifteenth-century play: "They blush where sausages are displayed, for they with breasts bared do not parade" (Bax's translation is altered here). The bagpipe was considered a peasant instrument (see Winternitz 1943 and Rotterdam–New York 2001, no. 99).

20. See Salomon 1998a, p. 77, fig. 64. Jan Massys used the same two motifs with a bit more variety, but the same sexual symbolism, for example in Merry Companies of 1557 (private collection) and 1564 (Kunsthistorisches Museum, Vienna): see Renger 1985, pp. 38–40, figs. 4, 5 (where the Berlin picture by Huys is also discussed).

21. For literature on fish as phallic symbols, see Westermann 1997, pp. 126 n. 29, 130 n. 66. "Fishing" as a metaphor for intercourse is discussed in Amsterdam 1997a, pp. 86–87. Herrings could also suggest impotence: see Renger 1985, p. 39. On mussels, which were eaten during both carnival and Lent, see Bax 1979, pp. 259–60. The author observes with regard to mussels, "this combination, in one and the same symbol, of Carnival food, erotic significance, and sustenance during Lent, we find also in the egg and the fish" (p. 260).

22. As described by Bostoen in Haarlem–Hamburg 2003–4, pp. 46–48. See also Bax 1979, p. 193.

23. Haarlem–Hamburg 2003–4, no. 31. See Bax 1979, pp. 150–53, where it is suggested plausibly that drink plays a role in Pekelharing's problem. On his love of drinking ("because his throat is always brackish"), see also Middelkoop and van Grevestein 1989, p. 36 (under c).

24. Bax 1979, pp. 192–93.

25. See ibid., p. 193.

26. Ibid., pp. 230–32. Two more pig's feet are in the plate of sausages.

27. Ibid., p. 229. The nature of one item worn by Pekelharing in Hals's picture is unclear: the brown object hanging from his belt (just above the pot of hot coals). It may be a leather case for eating utensils. In any event, its form is less innocent than its function.

28. As noted in Slive 1970–74, vol. I, p. 34, fig. 17, with reference to the lost *Merry Trio,* said to have been monogrammed and dated 1616 (formerly Kaiser-Friedrich-Museum, Berlin; see also ibid., vol. 3, pp. 115–16, no. L2).

29. As decribed in ibid., vol. 3, p. 3 (under no. 5). A jester makes the same sign next to an amorous couple, in a Merry Company signed and dated "LIVIN da . . ./pix 1596" (Sotheby's, New York, April 11, 1991, no. 22 [ill.]).

30. Slive 1970–74, vol. I, p. 36, for both remarks. This figure, like Hans Worst, wears a costume appropriate for carnival.

31. On spoons, see Bax 1979, p. 31, where *lepelaar,* or "spooner," is translated as "boozer," and the long digression on pp. 300–301 n. 87. A large wooden spoon (or ladle) is similarly attached to the rucksack of "The Wayfarer" in Bosch's tondo (also called *The Peddler* or *The Prodigal Son*) in the Museum Boijmans Van Beuningen, Rotterdam. See Zupnick 1973, p. 135, where (following Bax) the spoon is called "a popular symbol of self-indulgence."

32. As noted by P. Sutton in Philadelphia–Berlin–London 1984, p. 173, and in Royalton-Kisch 1988, p. 105. See also Salomon 1998a, pp. 56, 77.

33. See Braunschweig 1978, no. 15, and Judson and Ekkart 1999, pp. 201–2 (under no. 262), in both cases discussing Gerrit van Honthorst's painting of an amorous couple, in the Herzog Anton Ulrich-Museum, Braunschweig.

34. See Slive 1970–74, vol. 3, pp. 3–4, listing three "painted variants," and discussing other adaptations; also P. Sutton in Stockholm 1992–93, p. 86 n. 5.

35. See Nihom-Nijstad in Paris 1983, pp. 57–58, no. 34, pl. 72, as by D. Hals. Stijn Alsteens, formerly curator at the Institut Néerlandais, Paris, and now curator of Dutch drawings at the MMA, supported the attribution in a personal communication dated August 1, 2006.

36. See Slive 1970–74, vol. 3, p. 3, variant no. 2 (under no. 5).

37. Ibid., vol. I, pp. 34, 36, fig. 16, vol. 3, p. 4, variant no. 3 (under no. 5). This is the canvas formerly with the dealer Katz in Dieren (see note 11 above).

38. Ibid., vol. 3, p. 4, fig. 3; Nehlsen-Marten 2003, p. 268, no. 37, with inconclusive remarks on the likely date.

39. Sander and Brinkmann 1995, p. 33, pl. 62; Nehlsen-Marten 2003, no. 19; Haarlem–Hamburg 2003–4, no. 9; Neumeister 2005, pp. 135–43.

40. Trnek 1992, pp. 166–70, no. 57.

41. Bax 1981, no. 27 (ill.).

42. As noted in Slive 1970–74, vol. 3, p. 4, figs. 4, 5. For the two drawings by Buytewech (both in the Fondation Custodia, Institut Néerlandais, Paris), see Haverkamp-Begemann 1959, pp. 96–99, nos. 27, 28, figs. 28, 29, and Rotterdam–Paris 1974–75, pp. 25–27, nos. 26, 27, pls. 44, 45.

REFERENCES: Hoet 1752–70, vol. 3 (1770), p. 457, no. 51, records what appears to be this painting in an Amsterdam sale of June 5, 1765 (see Ex Coll.); Bode 1883, pp. 49–50, 85, no. 75, considers the work to be by Hals and to date from several years before 1616; Erasmus 1909, pp. 51–54, considers the picture a pastiche after the central group in Dirck Hals's painting in the Louvre; Bode 1909b, pp. 128–30 (ill.), rejects the argument in Erasmus 1909a; Erasmus 1909b, pp. 325–27, repeats and amplifies the argument of Erasmus 1909a; Moes 1909, pp. 25–26, 109, no. 208 (ill. opp. p. 18), as "Scène de moeurs," reports Schmidt-Degener's opinion that the work dates from about 1625, and that one of the male figures is "le seigneur

Ramp"; Valentiner in New York 1909, p. 146, no. 22A (ill. opp. p. 146), dates the picture to about 1615 and notes Dirck Hals's adoption of figures from it in his painting in the Louvre; Cox 1909–10, p. 245, considers the painting to represent "Hals at his most irresponsible . . . an intentional caricature rather than a serious picture, but it is prodigiously, almost impudently, skilful"; Hofstede de Groot 1907–27, vol. 3 (1910), probably pp. 40–41, no. 137h, and p. 42, no. 141, as in B. Altman's collection, describes the subject in detail, and notes Dirck Hals's borrowing of figures for his painting in the Louvre ("it was not copied from Dirck"); Waldmann 1910, pp. 77–78, defends Hals's authorship; Altman Collection 1914, pp. 30–32, no. 21, and pp. 34, 35 (under no. 23 [ill. opp. p. 30]), shows the artist "in his most jovial and rollicking mood"; Binder in Bode and Binder 1914b, vol. 1, pp. 19–20, 25, no. 1, pl. 1, dates the painting to the early 1620s, claims that the man at right also appears in two portraits by Hals, and suggests identifying him as Dirck Hals; Kronig 1918, p. 83, sees Hendrick Pot's "Temptresses" in Rotterdam as a worthy counterpart to this picture; Valentiner 1920a, pp. 355 (ill.), 356, mentioned as one of three Halses owned by Altman; Valentiner 1921a, pp. 11 (ill.), 306, dates the picture to about 1616–20, identifies it with the canvas sold in 1765 (see Ex Coll.), states that the composition originally had six heads in the background (overpainted, but recorded in copies), and agrees with Binder's identification of the man at right with sitters in portraits by Hals but suggests that he may be the artist himself; Monod 1923, pp. 300–302, describes the man to the left as "un vieux paillard à la Jordaens," and feels that the painting does not merit its reputation; Valentiner 1923, pp. 12 (ill.), 306, repeats Valentiner 1921a; W. Martin 1925, pp. 50–51, fig. 4, considers the picture to date from before 1616 and to have been influenced by a lost Musical Company by Willem Buytewech (known from an old copy); Valentiner 1925, pp. 152–53, 154, repeats the argument that the man at right is a self-portrait and also appears in other pictures; Poensgen 1926, p. 96, dates the painting about 1616–17, along with two drawings by Buytewech after the heads of the main male figures; Altman Collection 1928, pp. 63 (under no. 29), 89–92, no. 50 (ill. opp. p. 90), repeats Altman Collection 1914; Hofstede de Groot 1928, p. 45, says the author recently saw in Ireland a "smaller, sketchier version" of this composition, which includes a row of heads in the background, and observes that in the Altman picture heads in the background have been painted over; Valentiner 1928b, p. 237, calls the work mentioned in Hofstede de Groot 1928 a sketch for this painting; London 1929, p. 33 (under no. 48), finds "the same person" as one of the figures here in Hals's Portrait of a Man Standing, in the collection of the Duke of Devonshire; Borenius 1930, p. 572, considers the version mentioned in Hofstede de Groot 1928 as "of particular interest in showing us the master's own conception of the group in its entirety"; Dülberg 1930, pp. 48, 52, 54, fig. 13, dates the picture about 1615–20, states that the female figure also appears in Young Man and Woman in an Inn (Pl. 59), in The Merry Trio formerly in the Kaiser-Friedrich-Museum, Berlin, and possibly in the Marriage Portrait in the Rijksmuseum, Amsterdam; H. Kauffmann 1931, p. 228, considers this work a later version of the painting published in Hofstede de Groot 1928, based on the altered style of the woman's dress; W. Martin 1935, pp. 352, 449 n. 477, fig. 204, dates the picture about 1617, sees the "life-size" figures as coming straight out of Hals's work as a portraitist, and is reminded of Manet; Valentiner 1935, pp. 90, 95–96, again finds a self-portrait in

the man to the right, and in other paintings where there is no such thing; Valentiner 1936, p. 9, no. 3 (ill.), suggests a date of about 1616–17, sees a self-portrait to the right, and mentions overpainted figures above (as indicated by old copies and adaptations); Plietzsch 1940, pp. 7, 14 (ill. p. 20), dates the work about 1617, and observes Dirck Hals's borrowings; Trivas 1941, p. 26 (under no. 9, the Devonshire Portrait of a Man), declares that the Museum's picture "is not included in this catalogue"; Haverkamp-Begemann 1959, pp. 22, 58, 62, 96–97 (under no. 27), 98, 99 (under no. 28), fig. 26, discusses the stock figures, which are copied in two drawings by Buytewech; Van Hall 1963, p. 125, no. 1 (under Frans Hals), cites the man at right as a self-portrait; Slive 1963, p. 436, describes the subject as the celebration of Shrovetide, a holiday "traditionally dedicated to fools and foolishness," and observes that old copies suggest that the canvas has been cut down on all sides; Van Regteren Altena 1965, p. 238, draws attention to two figures in a kitchen scene attributed to Frans Snyders and Jan van den Bergh that ultimately derive from the Museum's picture and therefore suggest that it was painted before 1620 (the latest date at which Van den Bergh could have moved from Haarlem to Antwerp); J. Rosenberg, Slive, and Ter Kuile 1966, pp. 31, 36, pl. 10B, dates the picture about 1615–17, observing that "the cramped composition and the over-exuberance of the details, as well as the loud, gay colours, indicate a comparatively youthful work"; Descargues 1968, p. 18, claims that this is "the only one of Hals's pictures that might have influenced" his pupil Adriaen Brouwer; Haskell 1970, pp. 264–65, fig. 10 (Altman gallery view), reports that Altman made a special effort to ensure that this painting and other Dutch pictures were sent back from Europe in time to be included in the 1909 exhibition at the MMA; Slive 1970–74, vol. 1, pp. 7, 33–36, 37, 58, 67, 80, 94, 96, 152, identifies the man at left as "Peeckelhaering" and the one at right as "Hans Wurst," stock figures in contemporary Dutch farces, suggests that the central figure may be a young male actor dressed as a woman, and discusses the symbolism of the food and other objects, vol. 2, pls. 7–11, suggests a date of about 1615 (caption to pl. 8), and vol. 3, pp. 3–4 no. 5, 15 (under no. 21), 116 (under no. L2), 116, 117 (under no. L3), fig. 53 (monogram), tentatively connects the picture with the sale of 1765 (see Ex Coll.), discusses a variety of related works, and rejects the identifications of portraits in the painting; Grimm 1972, pp. 29, 41, 50–52, 199, no. A4, considers the work a copy after Hals; Plietzsch 1972, pp. 23, 26, remarks on the picture's considerable influence, especially in the work of Dirck Hals; Grimm and Montagni 1974, p. 87 (under no. 10), fig. 10a, as a copy after Hals; De Mazia 1974, p. 12, pl. 24, considers the work an example of Hals being "content to treat the means as ends in themselves, for the sake of an ostentatious, dashy technique"; Rotterdam–Paris 1974–75, pp. 27, 28 (under no. 26), 28, 29 n. 1 (under no. 27), discusses Buytewech's drawn copies after the male figures to the left and right; Hochfield 1976, p. 27 (ill. [before and after cleaning of 1951]), calls for the removal of "the dulled synthetic varnish"; Wiesner 1976, p. 6, feels the painting "may lack the final touches," especially in the background figures; Bax 1979, pp. 191, 192–93 n. 35, 193, 229, 230, 301, notes the sausages, eggs, beans, and pig's trotter worn by the "gadabout"; Baard 1981, p. 72, figs. 54, 55 (details), pl. 5, dates the picture about 1615, and superficially describes the subject; Stanton-Hirst 1982, pp. 223, 225, identifies Hans Worst here and in a drawing by Pieter Quast; Nihom-Nijstad in Paris 1983, pp. 57–58, discusses the copy inscribed

"DHALS 1637" in the Lugt Collection, Paris, and mentions other derivations; P. Sutton in Philadelphia–Berlin–London 1984, p. XXXIV, fig. 36, as dating from about 1615, and as a prime example of this type of genre picture (large half-length compositions); P. Sutton 1986, pp. 185–86, pl. 6, describes the subject and considers the picture to illustrate "Frans Hals's role in the history of Dutch genre"; Grimm 1989, pp. 50–51, 56, 117, 220–21, 236, 284–85, no. KI, pls. 73, 74a, fig. 124b, as a copy of a lost Hals, revealing Flemish influence; Middelkoop and Van Grevestein 1989, p. 17, fig. d, suggests that the "atmosphere" of *rederijker* performances in Haarlem is reflected here; Slive in Washington–London–Haarlem 1989–90, pp. 1, 148, 151 n. 3, 166, 216, pl. II, remarks that the painting is missing from the 1989–90 exhibition because of the "ironclad terms" of its bequest, and compares the work with three of the exhibited pictures; Grimm 1990, repeats Grimm 1989 in translation; Liedtke 1990, p. 48, fig. 37 (Altman gallery view), describes the work as one of "two famous early genre pictures that stand quite apart from the Halses bought by Frick, Morgan, Widener, Huntington, and the Tafts"; P. Sutton 1990b, pp. 67, 70, compares the Fort Worth picture (fig. 70 here) unfavorably with this one; P. Sutton in Stockholm 1992–93, p. 86 n. 5, lists several of Dirck Hals's borrowings from the composition; Kortenhorst-von Bogendorf Rupprath in Haarlem–Worcester 1993, p. 152 (under no. 5), fig. 5d, p. 265 n. 13, sees the possible influence of this painting by Hals on Judith Leyster's *Merry Company,* of about 1630 (private collection); Stukenbrock 1993, p. 153, describes the removal of overpaint in 1951; Bruyn in Amsterdam 1993–94a, p. 118, fig. 9, imagines that the subject may be described as "A Young Woman Prefers an Old Drunk to a Youthful Lover"; Baetjer 1995, p. 299; Slive 1995a, pp. 28–29, 37, fig. 27, dates the work to about 1615, discusses the subject and style, and compares the color scheme with that of "the so-called *Yonker Ramp*"; De Jongh in Amsterdam 1997a, pp. 363–64, fig. 6, in a review of sexual hand signals, describes "a whole range of ambiguous [?] gestures" in this picture; Westermann 1997, p. 248 n. 88, compares a gesture in a work by Steen; Klessmann 1999, pp. 26, 28, fig. 6, compares a work by Liss with this composition, and incorrectly reports that "its attribution is not generally accepted"; De Jongh 2001, p. 22, fig. 34, in an essay on symbolic hand gestures, asks what two fingers raised to the left temple might mean (seen here to upper left); Schnackenburg in Kassel–Amsterdam 2001–2, pp. 101, 119 n. 53, fig. 8, calls the painting "a brilliant early work by Frans Hals," which may have influenced the young Rembrandt and Jan Lievens; Runia in Van der Ploeg, Runia, and Van Suchtelen 2002, p. 27 (under no. 3), compares a work by Abraham Bloemaert; Weller in Raleigh–Columbus–Manchester 2002–3, p. 11, fig. 3, cites the painting as the kind of work by Hals that influenced Jan Miense Molenaer; Korthals Altes

2003, p. 67 n. 42, notes that a painting by Hals, *De Vastenavondzotten,* purchased by Willem Lormier 1739, is not this one; Nehlsen-Marten 2003, pp. 107–8, 268 (under no. 37), fig. 85, dates the picture to about 1617, describes it incorrectly as on wood, and reviews Dirck Hals's responses to the composition; Vergara in Madrid 2003, pp. 23, 203, fig. 13, as by Hals about 1615, sees the same vivacity and loose handling that are found in the master's portraits, while the subject anticipates Steen; Biesboer in Haarlem–Hamburg 2003–4, pp. 180, 184, compares the figure of "Peeckelhaeringh" in two pictures by Hendrick Pot; Von Bogendorf Rupprath in ibid., pp. 78, 88, 153 n. 11, pl. 31, fig. 9.1, notes the adaptation of the man to the left for a figure in Buytewech's *Merry Company,* of about 1616–17 (Museum Boijmans Van Beuningen, Rotterdam), and of the three main figures in Dirck Hals's *Merry Company* of about 1620 (Städelsches Kunstinstitut, Frankfurt), and observes that broken eggs were a symbol of impotence; Sitt in ibid., p. 102, sees the man to the left as a model for the servant in Dirck Hals and Dirck van Delen's *Merry Company in a Palace Interior,* of 1628 (private collection); Franits 2004, p. 263 n. 24, recalls that "among Hals's earliest genre paintings is his famed *Shrovetide Revellers* of about 1615"; Giltaij in Rotterdam–Frankfurt 2004–5, pp. 14, 47 (ill.), compares the figure festooned with sausages in Buytewech's canvas in Rotterdam; Neumeister in ibid., p. 52, fig. 1, discusses Dirck Hals's repetition of the three main figures in his painting in Frankfurt; Kolfin 2005, pp. 147, fig. 126, notes Dirck Hals's borrowing; Neumeister 2005, p. 141, fig. 120, repeats the observation made in Rotterdam–Frankfurt 2004–5.

EXHIBITED: Paris, Palais de la Présidence du Corps Législatif, "Ouvrages de la peinture exposés au profit de la colonisation de l'Algérie par les Alsaciens-Lorrains," 1874, no. 844, as "Scène de kermesse," by Frans Hals (lent by M. Cocret); New York, MMA, "The Hudson-Fulton Celebration," 1909, no. 22A, as "The Merry Company" (lent by B. Altman, New York).

EX COLL.: ?Sale, Amsterdam, June 5, 1765, no. 51, for Fl 35, "een ryke Ordinantie van veel Beelden halver Lyf te zien, verbeeldende een Vasten-Avond vreugd, zeer kragtig op doek, door Frans Hals: hoog 36, breet 49 duimen" (A rich composition of many figures seen in half-length, representing a pre-Lenten feast, very vigorous on canvas, by Frans Hals: height, 36, breadth 49 inches [presumably inverting height and width]); Monsieur Cocret, Paris (by 1874–at least 1883); [Kleinberger, Paris and New York, until 1907]; [D. S. Hess and Company, New York, 1907; sold for $89,102 to Altman]; Benjamin Altman, New York (1907–d. 1913); Bequest of Benjamin Altman, 1913 14.40.605

59. *Young Man and Woman in an Inn* (*"Yonker Ramp and His Sweetheart"*)

Oil on canvas, 41½ x 31¼ in. (105.4 x 79.4 cm)
Signed and dated (right, above fireplace): FHALS 1623
[FH in monogram]

The condition of the painting is fairly good, although the canvas weave has been emphasized and the impasto slightly flattened during lining in the past. The crowns of the canvas weave are abraded, most severely in the area of the young man's broad-brimmed hat and in the halftones of his face and that of the young woman.

Bequest of Benjamin Altman, 1913 14.40.602

From the eighteenth century until as recently as fifty years ago, this famous genre painting by Frans Hals was known as *Yonker Ramp and His Sweetheart,* with the motto, "Long Live Fidelity!" added in the 1880s for clarification.[1] These titles were rather off the mark for a picture of a young man and woman who have just met and probably would not have exchanged names, or at least not their real ones. As discussed below, the subject is a brief encounter in a tavern or bordello, and not even "Fido" to the lower right could be counted on for feelings of fidelity.

"Yonker" is an English rendering of *Jonker,* or *Jonkheer,* which means "Young Gentleman," and may be translated as "master," "squire," or "milord." Quite as the artist himself and his brother Dirck were once identified with the figure to the

right in *Merrymakers at Shrovetide* (Pl. 58), the young man in the present picture was considered to resemble Pieter Ramp, the ensign in the right background of Frans Hals's *Banquet of the Officers of the Saint Hadrian Civic Guard Company,* of about 1627 (Frans Halsmuseum, Haarlem). Wilhelm von Bode, in 1909 (see Refs.), was evidently the first scholar to connect the painting with the story of the Prodigal Son (Luke 15:11–32), and also to emphasize (as historians do now) that the main figure in the present picture would have been understood by Hals's contemporaries as a modern-day type, similar to but not identical with the biblical wastrel. Nonetheless, it is quite possible that this is the painting cited simply as *Een verloren soon van Frans Hals* (A Prodigal Son by Frans Hals) when it was traded between two Amsterdam merchants, Martin van de Broecke and Andries Ackersloot, as recorded in a document dated March 28, 1647.[2]

No other genre painting by Hals is dated,[3] but this one is signed and dated 1623 on the mantel of the fireplace. In recent decades, only one critic has doubted Hals's authorship (and that of the other two genre paintings by Hals in the Altman Collection).[4] For all other writers, and for the great majority of specialists who have not expressed themselves in print, the canvas is one of Hals's most important contributions to the theme of "everyday life," meaning conventionalized descriptions of modern manners and mores.

Figure 72. Gillis van Breen after Karel van Mander, *Inn Scene with Prostitutes,* 1597. Engraving, 5¼ x 7⅝ in. (13.3 x 19.4 cm). Prentenkabinet, Universiteit, Leiden

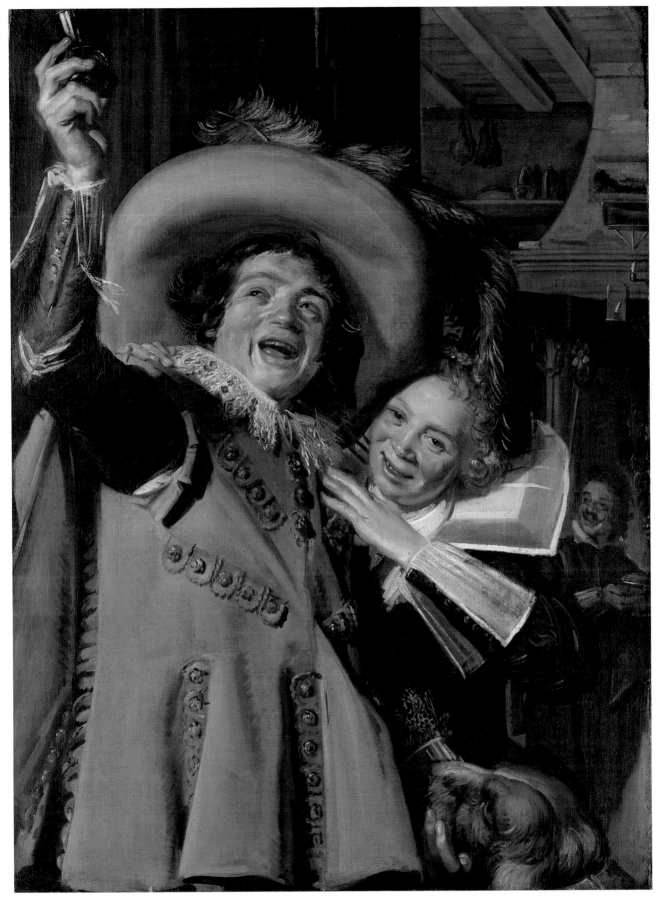

59

In its presentation of figures in space, and in its modeling, muted colors, and light effects, the painting is considerably more naturalistic than the *Merrymakers at Shrovetide* (Pl. 58), of six or seven years earlier. Nonetheless, the later picture still belongs to a formative phase of Haarlem genre painting, and of Hals's work in that field. In terms of style, this is evident in the way the artist combines an Early Baroque figural arrangement (reminiscent of works by Gerrit van Honthorst, such as *Merry Violinist with a Wineglass,* also of 1623; Rijksmuseum, Amsterdam) with a setting that recalls Mannerist schemes, as found, for example, in one of Joachim Wtewael's kitchen scenes (see fig. 282).[5] The result is at once striking in its immediacy and slightly contrived. In reproductions especially, some critics may discover signs of calculation in the composition, for instance the diagonal recession from the upraised glass, through the young man and his companion, to the innkeeper. The languid blue feather in the oversize hat answers the embrace of the unbashful blonde, and smooths the transition between parts of the background. The same blue occurs in the raised arm, so that the sleeve and the feather echo each other, like brackets framing the pair of smiling faces. These devices lend order and focus to the dynamic design. However, before the canvas itself (where its scale is a sizable factor), the use of a standard compositional pattern is barely noticed. On the contrary, compared with similar works by Honthorst, Hals's staging seems much more alive. The low viewpoint and placement of figures in the picture field create the impression that the viewer is extremely close to the couple, perhaps at a table or by an open door.[6] Loose brushwork gives a sense of movement, strong shadows the impression of brilliant light, and blended tones a feeling of atmosphere, which shifts from freshness in the foreground to the haziness of the tavern interior.

In its iconography, too, the painting seems to represent an early moment in the development of Dutch genre subjects, with their entertaining descriptions of contemporary life. Scholarly debates about whether Hals depicts the Prodigal Son himself or the sort of Haarlem youth who should read the story reflect the fact that most earlier bordello pictures are clearly inspired by (or illustrate) the parable, while the pedigree is largely lost in later examples.[7] Honthorst's *Merry Company,* of 1622 (Alte Pinakothek, Munich), was catalogued as *The Prodigal Son* in 1719, but Giulio Mancini (1558–1630) in the 1620s described a very similar picture by Honthorst as *Cena di Buffonarie* (Supper of Buffoons, or Merry Company), and scholars today do not consider any Utrecht painting of this type to represent the passage in Luke.[8] Rembrandt's large canvas *The Prodigal Son in the Tavern,* of about 1635 (Gemäldegalerie

Figure 73. Title page of Willem Dircksz Hooft's play *Heden-daeghsche Verlooren Soon* (Amsterdam, 1630). Koninklijke Bibliotheek, The Hague

Alte Meister, Dresden), is not an exception, since it is also a portrait of the artist and his wife.[9] It does, however, demonstrate how Dutch painters would transform the traditional story into a witty reflection of their own world.

Two prints have often been compared with the Museum's picture for the light they shed on its subject matter. An engraving dated 1597 after a composition by Hals's presumed teacher, Karel van Mander, shows a dapper gentleman embraced by two prostitutes at an inn (fig. 72). Behind them is a curtain, suggesting a bed or some private space. Two dogs lick at a morsel in the man's outstretched hand. An innkeeper and a serving boy bring food out of the kitchen in the background. Hals reduces this image to its essential elements, adding only the commonplace gesture of an upraised glass to clarify the young man's character. The print bears a legend in Italian and Dutch, which reads (to quote the catchier version) "Carezza de cani, Amor de Puttani, et invitti d'hosti: Non se po far che non vi costi" (The nuzzle of dogs, the love of whores, the hospitality of innkeepers: None of it comes without cost).[10]

The seventeenth-century viewer would not have needed to know this saying to recognize a dolled-up young woman in a tavern for what she was, or even to understand the dog as a symbol of her profession, and of libidinous behavior in general.[11] The hound in Hals's painting was evidently borrowed from an engraving by Jan Saenredam after Hendrick Goltzius (*The Sense of Smell,* showing a romantic couple with a basket of flowers), but dogs routinely appear in earlier Netherlandish brothel scenes.[12] The other print (in addition to the one after Van Mander) that has been connected with the present painting serves as an illustration on the title page of Willem Dircksz Hooft's play entitled *Heden-daeghsche Verlooren Soon* (Present-day Prodigal Son), which was performed in Amsterdam on February 3, 1630, and published the same year (fig. 73). Slive observes that "Hooft's play was moralistic in intent and if Hals's picture was meant to illustrate an episode from scripture it was so too."[13] What the play actually demonstrates is that the story of a modern young man who simply resembles the Prodigal Son was rich in moral content, and familiar enough to find its way onto the popular stage.[14] This does not mean that moral instruction was the main point of Hooft's play (which was apparently an occasional piece performed around Shrovetide), or of Hals's picture. Rather, "the viewer's knowledge of the moral was the basis of the joke"—namely, the humor found in a young man behaving foolishly, as young men have since biblical times.[15]

1. See Ex Coll. According to Slive 1970–74, vol. 3, p. 13 (under no. 20), "the earliest known reference to the traditional title" appears in the description of an eighteenth-century drawing, no. 54 in the sale of Johannes Enschedé's collection, held in Haarlem on May 30, 1786. But the painting itself, no. 87 in the Enschedé sale, is described in the catalogue in the same way (as quoted here under Ex Coll.).

2. See Van Thiel-Stroman in Washington–London–Haarlem 1989–90, p. 400, doc. 119. As noted in Slive 1970–74, vol. 3, p. 115 (under no. LI), another picture possibly identical with the one called *Een verloren soon van Frans Hals* in 1647 is the *Banquet in a Park* formerly in the Kaiser-Friedrich-Museum, Berlin (lost in World War II). As Slive notes, however, the painting cited in 1647 is probably identical with one described as large in 1646 (according to Hofstede de Groot 1907–27, vol. 3, p. 9, no. 1; see also Washington–London–Haarlem 1989–90, p. 399, doc. no. 115), which would be more expected of the Altman picture. Furthermore, the Berlin painting's attribution to Hals and its representation of the Prodigal Son (among many carousing figures) are both quite uncertain.

3. As noted in Slive 1970–74, vol. 1, p. 75.

4. See Grimm 1972 and Grimm 1989 under Refs. below. The author's opinion was anticipated by Van Dantzig (1937) and

Trivas (1941). Grimm (1989) accepts Hals's authorship of the main figure in *The Smoker* (Pl. 60), which can hardly be considered superior to the main figures in the present painting.

5. Lowenthal 1986, pp. 148–49, no. A-84, pl. 119. See the discussion below of Pieter Wtewael's *Kitchen Scene* (Pl. 225). In Grimm 1972, p. 52, the scale of Hals's "waiter" (as the innkeeper is described) and the disjunction between foreground and background space are criticized as if these qualities put the attribution in question. The same sort of extrapolation backward from mature works would cast doubt upon Vermeer's *A Maid Asleep* (Pl. 202).

6. The background behind the main figure is evidently meant as a curtain rather than an open door. In Dirck Hals's *Merry Company,* of about 1625–28 (Gemäldegalerie, Berlin; Nehlsen-Marten 2003, no. 70, fig. 127), five figures sit at a table in a tavern, and in the left background the space drops back abruptly into a kitchen, where an innkeeper very similar to the one in the Altman picture carries a pie past the fireplace.

7. See Kolfin 2005, pp. 20–22, 58–60, on how the theme of the Prodigal Son in Dutch art "dissolved, as it were, into the profane merry company" during the period about 1590 to 1610 (quote from p. 59). The same point is made by Von Bogendorf Rupprath in Haarlem–Hamburg 2003–4, p. 70 (under no. 4, Buytewech's *Merry Company in the Open Air,* of about 1616–17, in the Gemäldegalerie, Berlin). Of course, this applies only to the Prodigal Son in a tavern, not to his departure or return. On "Early Netherlandish Bordeeltjes and the Construction of Social 'Realities,'" see Salomon 2004, chap. 7.

8. Mancini and the cataloguer of 1719 are compared in Judson and Ekkart 1999, p. 220 (under no. 283, the Munich picture, reproduced as pl. 168). See also ibid., p. 221 (under no. 284, another former *Prodigal Son*).

9. See the discussion in *Corpus* 1982–89, vol. 3, pp. 142–46.

10. The engraving, evidently by Gillis van Breen, is connected with earlier inn scenes in Renger 1970, p. 130, fig. 85, and with the Museum's picture in Grimm 1972, p. 197, and in Haeger 1986, pp. 143–44. See also Kolfin 2005, pp. 54, 263 n. 154. The print's Dutch inscription, which is quoted often in the Hals literature, reads: "Honden gonst hoeren lieft weerden gastrien/Sonder cost gheniett ghy niet een van drien."

11. See Renger 1970, p. 130, and Kolfin 2005, p. 50, on the dog as a symbol of libido, or Luxuria (lust). On actual tavern-cum-bordellos just outside Haarlem and Amsterdam, and their mention in popular literature of the period, see Van Deursen 1991, p. 98.

12. The comparison with Saenredam's print and the observation about dogs are both made in Slive 1970–74, vol. 1, p. 73 (fig. 55 for the series of prints by Saenredam).

13. Ibid., vol. 1, pp. 73–74.

14. Slive's "if" is criticized in Haeger 1986, pp. 141–43, where it is emphasized that secular inn scenes are "as likely to admonish the viewer as the biblical." On the musical aspect of Hooft's title plate, see Liedtke 2000a, pp. 67–68.

15. The quote is from Kolfin 2005, p. 52, in a discussion of "foolish young lords" as a type in Dutch genre painting about 1580–1610. See ibid., pp. 54, 263–64 n. 155, on Hooft's play.

REFERENCES: Gonnet 1880, pp. 78–79, describes the picture's sale in 1880, its provenance, the composition, and various members of "the very distinguished Catholic family Ramp"; Baignières 1883 (ill. opp. p. 122 [etching by H. Guérard]), p. 557, as "Vive la fidélité!"; Bode 1883, pp. 49–51, 81, no. 13, as "Junker Ramp mit seiner Liebsten," mentioned among other early works; Paris 1883, p. 112, no. 90 (ill. opp. p. 88, etching), as "Leve de Trouw! (Vive la Fidélité!)"; Bode 1909b, p. 129, describes the subject as a bordello scene adhering to the Prodigal Son theme "so beloved" in the Netherlands during the 16th and 17th centuries, mentions similar motifs in works by Hendrick Pot, Jan Steen, and Dirck Hals, and praises the execution as typical of the early Hals; Erasmus 1909a, p. 51, listed as one of Hals's rare early works with several figures; Moes 1909, pp. 25, 109, no. 209, observes that "ce sire Ramp était probablement un type populaire des tréteaux" (a popular stage type); possibly the picture cited in Hofstede de Groot 1907–27, vol. 3 (1910), p. 9, no. 1, as used by Cornelia van Lemens to pay rent on March 24, 1646, and valued at Fl 48, possibly the picture cited in ibid., no. 2, as part of a transaction between the Amsterdam merchants Martin van de Broecke and Andries Ackersloot, as recorded on March 28, 1647, and ibid., pp. 41–42, no. 139, and (under no. 140), as "Junker Ramp and His Girl," owned by B. Altman, cites a "repetition" in the collection of J. P. Heseltine, London; Mireur 1911–12, vol. 3, p. 406, gives the purchase price at the Copes van Hasselt sale as FFr 37,800; Altman Collection 1914, pp. 31–32 (under no. 21), 34–35, no. 23 (ill. opp. p. 34), as a picture "of similar type to the Merry Company," suggests that Ramp "must have been a famous roisterer of Haarlem in his time," and observes that despite the "bewildering" speed of execution "the brush strokes are dashed on the canvas with perfect sureness"; Bode and Binder 1914b, vol. 1, p. 25, no. 2, pl. 2A, as "Junker Ramp and His Beloved"; Altman Collection 1915, p. 79 (ill.), cited as one of Altman's first Old Masters; Valentiner 1921a, pp. 23 (ill.), 307, notes that the title, "Jonker Ramp and His Sweetheart," goes back to the 1786 sale but cannot be original since Hals's sitter, Pieter Ramp, bears no resemblance, and suggests that the picture may be identical with a large painting of the Prodigal Son that was owned by Cornelia Lemens in 1646 and by Martin van de Broecke in 1647; Monod 1923, pp. 300–301, praises the execution, connects the subject with the rederijkers of Haarlem, and calls the smaller version mentioned in Hofstede de Groot 1907–27 a copy by an artist in Hals's circle; Valentiner 1923, pp. 23 (ill.), 307, repeats Valentiner 1921a; Poensgen 1926, p. 99 n. 3, compares the hat in a painting by Buytewech; Altman Collection 1928, pp. 62–64 no. 29 (ill. opp. p. 62), 90–91 (under no. 50), repeats Altman Collection 1914; Hofstede de Groot 1928, p. 45, concludes that names such as Jonker Ramp "serve to show that even the contemporaries of Hals perceived the strongly individual element in the single figure genre pictures, and tried to attach individual names to them"; Dülberg 1930, pp. 52, 54–56, 57, pl. 14, praises the composition and execution, sees the same woman in Merrymakers at Shrovetide (Pl. 58) and the man to the left in a variety of other pictures, and suggests that perhaps this Merry Company in the "Hauptmuseum Nordamerikas" was originally called "The Prodigal Son" (citing the 1646 inventory mentioned in Valentiner 1921a); B. Burroughs 1931a, describes the composition; Valentiner 1936, p. 9, no. 4 (ill.) (and under nos. 5 and 20), titled "A Cavalier and His Sweetheart," considers the painting close in composition and execution to The Rommel Pot Player (fig. 70 here) and The

Smoker (Pl. 60), and again cites the "large representation of the Prodigal Son" in Amsterdam collections in 1646 and 1647; Van Dantzig 1937, pp. 49 (ill.), 64, no. 46, gives various reasons for believing that the picture is a later copy; Trivas 1941, p. 61, no. App. 2, and (under no. App. 4), pl. 153, considers none of the versions to be by Hals, and erroneously states that the picture was not in the 1786 sale (confusing it with an eighteenth-century drawing after the picture, no. 54 in the same sale); New York 1952–53, p. 229, no. 120, pl. 120, offers a superficial description of the painting's subject and style; d'Otrange-Mastai 1956, pp. 114–15 (ill. [overall and detail]), considers the smaller version (formerly in London) to have been painted first by Hals, who then did the Museum's picture; MMA 1959, unpaged, no. 37 (ill.), repeats some of the meaningless remarks first published in Altman Collection 1914; Plietzsch 1960, pp. 23, 26, cites the work for its handling of interior space, incorrectly giving its date as 1625; J. Rosenberg, Slive, and Ter Kuile 1966, pp. 36–37, pl. 12A, finds it difficult to decide whether the painting represents the story of the Prodigal Son or is a "pure" genre scene, and compares Rembrandt's Prodigal Son in the Tavern in Dresden; Haskell 1970, p. 262, cites the picture as one of Altman's first Dutch acquisitions, of 1905; Slive 1970–74, vol. 1, pp. 72–74, 75, 76, 80, 100, 141, 226, calls the picture an outstanding example of Hals as a genre painter, supports the identification with the "Prodigal Son" cited in 1646 and 1647, relates the subject to W. D. Hooft's play of 1630, The Modern-Day Prodigal Son, compares the composition of The Smoker (Pl. 60), and finds a source for the dog in an engraving after Goltzius, vol. 2, pl. 42, vol. 3, pp. 13–14, no. 20, pp. 15 (under no. 21), 115 (under no. L1), defends the attribution, discusses the picture or pictures recorded in 1646 and 1647 as possibly the same as this one, credits Valentiner with properly dismissing the old title, and considers the smaller version formerly in the Heseltine collection to be a copy by another hand; Grimm 1972, pp. 29, 49, 50, 52–55, 56, 62, 63, 64, 66, 197, 200, no. A5, fig. 25, describes various supposed faults of the painting and claims that it gives only a limited idea of a lost original by Hals, compares The Laughing Cavalier and other portraits, and relates the subject to an engraving after Karel van Mander (fig. 72 here) with an inscription about the favors of whores, dogs, and innkeepers (quoted in the text above); Plietzsch 1972, pp. 23, 26, as "The Prodigal Son," mistakenly gives the date as 1625; Grimm and Montagni 1974, p. 89 (under no. 24), fig. 24a, says that the composition is known above all from the New York canvas, which is a copy according to Trivas and Grimm, although it is included in various catalogues of Hals's work; Wiesner 1976, p. 6, pl. 10, reveals "the development of [Hals's] individual style"; Blankert in Washington–Detroit–Amsterdam 1980–81, p. 189 n. 8, agrees that the picture is possibly the "Prodigal Son" cited in 1646 and 1647; Baard 1981, fig. 58, as by Hals; Naumann 1981, vol. 1, p. 21 n. 7, notes the source for Hals's dog in an engraving after Goltzius (see text above); Hofrichter in New Brunswick 1983, p. 41, fig. 16, "conveys all that we associate with the energy of Haarlem"; Haeger 1986, pp. 141–48, fig. 1, discusses the earlier literature (except Bode 1909b) at some length, and interprets the subject not as the biblical Prodigal Son but as "a moral exemplum," and as an illustration of the saying that the attentions of dogs, whores, and innkeepers come at a cost; P. Sutton 1986, p. 185, fig. 262, remarkably, considers it "unclear whether the figures are portraits" or otherwise; Foucart 1987, p. 80 (ill. p. 79), compares the male figure with that in Hals's Lute Player

in the Louvre (ex-Rothschild collection); Liedtke 1988, p. 100, considers the picture remarkable for its observed qualities and suggestion of space perceived from a close vantage point, even if the setting remains a "clever backdrop"; Grimm 1989, pp. 51–52, 56, 224, 237, no. K4, figs. 74b, 75, 78b (overall and details), rejects the picture as by Hals, and finds the same model in Hals's *Lute Player*; Slive in Washington–London–Haarlem 1989–90, pp. 1, 129, 197, 224, pl. III, remarks that the painting is missing from the 1989–90 exhibition because of the "ironclad terms" of its bequest, notes that this is Hals's only known genre picture to bear a date, and states that the work "can be classified with a group of Netherlandish depictions of the Prodigal Son in a contemporary setting, wasting his substance with loose women"; Van Thiel-Stroman in ibid., pp. 399 doc. 115, 400 doc. 119, lists the document of 1646 (not yet located in the Amsterdam archives) and the document of 1647 (which survives), both of which may refer to this painting; Grimm 1990, pp. 51–52, 56, 223–24, 237, 291–92, no. C4, figs. 74b, 75, 78b (overall and details), repeats Grimm 1989 in translation; Liedtke 1990, p. 48, describes the work as one of "two famous early genre pictures that stand quite apart from the Halses bought by Frick, Morgan, Widener, Huntington, and the Tafts"; P. Sutton 1990b, pp. 67, 70, compares the Fort Worth picture (fig. 70 here) unfavorably with this one; P. Sutton 1992, pp. 74, 76 n. 1, fig. 1, notes the motif of the raised glass here and in Hals's *Merry Lute Player* in the Samuel collection; Kortenhorst-Von Bogendorf Rupprath in Haarlem–Worcester 1993, pp. 135 n. 12, 155 n. 14, 203 n. 2, 246, fig. 21a, compares the composition to that of *The Smoker* (Pl. 60), and (less convincingly) to works by Leyster and Molenaer; Stukenbrock 1993, p. 140, fig. 39, compares other genre pictures by Hals, noting that Moes in 1909 had already described the male figure as a popular type rather than the Prodigal Son; Baetjer 1995, pp. 300–301; Slive 1995a, pp. 36–37, 43, fig. 34, considers the picture not a portrait "and probably not a genre scene *pur* but a representation of the Prodigal Son," compares W. D. Hooft's title page (which would lead to a different conclusion), and discusses the raised glass and the dog; I. Worm in *Dictionary of Art* 1996, vol. 14, p. 91, uses the old title and calls the painting a portrait; Klessmann 1999, p. 26, fig. 7, compares the composition of Liss's lost painting, *Courting Couple with Cherries*; Franits 2004, pp. 24–25, 263 n. 23, fig. 10, describes the picture's stylistic innovations and considers whether its meaning is moralistic.

EXHIBITED: Paris, Galerie Georges Petit, "Cent chefs-d'oeuvre des collections parisiennes," 1883, no. 90, as "Leve de Trouw! (Vive la Fidélité!)" (lent by M. le comte Edmond de Pourtalès); New York, MMA, "Art Treasures of the Metropolitan," 1952–53, no. 120, as "Yonker Ramp and His Sweetheart."

EX COLL.: Possibly Cornelia Lemens, Amsterdam, in 1646; possibly Martin van de Broecke, Amsterdam, in 1647; possibly Andries Ackersloot, Amsterdam, in 1647;[1] Johannes Enschedé, Haarlem (until d. 1780; his estate sale, Haarlem, May 30, 1786, no. 87, as "Jonker *Ramp* en zyn Matres; konstig door FRANS HALS" [Jonker Ramp and His Sweetheart; artful by Frans Hals], for Fl 21.10 to Van Gent);[2] Johan Adriaen Versijden van Varick, Leiden (until 1791; his estate sale, Leiden, October 29, 1791, no. 103, for Fl 130 to Delfos); B. C. de Lange van Wijngaarden, Haarlem;[3] his sister, C. E. A. Copes van Hasselt (née De Lange), Haarlem and Amsterdam (d. 1879; sale, Amsterdam, April 20, 1880, no. 1, as "Hals [Leve de Trouw]: Le Chevalier Ramp et sa Maîtresse" [Long Live Fidelity: Milord Ramp and His Sweetheart]; Comte Edmond de Pourtalès, Paris (in 1883); [Gimpel & Wildenstein, Paris and New York, until 1905; sold for $155,840 to Altman]; Benjamin Altman, New York (1905–d. 1913); Bequest of Benjamin Altman, 1913 14.40.602

1. For Lemens, Van de Broecke, and Ackersloot, see Washington–London–Haarlem 1989–90, pp. 399–400, docs. 115, 119. See also Montias 2002b, pp. 132, 230 n. 15.
2. In Van Sterkenburg 1981, p. 137, "matres" is given in modern Dutch as "geliefde, liefde, beminde." Johannes Enschedé (1708–1780) is described on the title page of the 1786 sale catalogue as a book printer in Haarlem, and his "excellent collection" as consisting of "artful and pleasant paintings, exceptionally fine drawings, very attractive and rare prints, and fine and well-preserved bound works, as well as fine rarities." The collection was sold by Tako Jelgersma and Vincent van der Vinne, in the Prinsenhof, Haarlem. Enschedé was the author of *Proef van letteren, welke gegooten worden in de nieuwe Haerlemsche Lettergieterij* (Haarlem, 1768). His sale is cited as provenance in the 1880 Copes van Hasselt sale.
3. The painting's ownership by B. C. de Lange van Wijngaarden (secretary of the city of Haarlem) and its inheritance by his sister are reported by C. J. Gonnet (director of the Museum van Moderne Kunst, Haarlem) in Gonnet 1880.

60. *The Smoker*

Oil on wood, octagonal, 18⅜ x 19½ in. (46.7 x 49.5 cm)

The painting is well preserved, but the face of the smoker has been more harshly cleaned in the past than the rest of the composition. The color of the background curtain, a dull grayish green, has faded, as is evident from passages along the edge where the original blue has been protected from the light. Analysis of a paint sample by Raman spectroscopy confirms that the fading can be attributed to the painter's use of indigo, a light-sensitive pigment. The octagonal oak panel is composed of one piece of wood with the grain oriented horizontally. It retains its original thickness and bevels on the back.

Marquand Collection, Gift of Henry G. Marquand, 1889
89.15.34

This genre picture of the 1620s, which retains its original shape, has been described by scholars as a workshop replica of a slightly different composition (on a round panel) formerly in the Museum Stadt Königsberg (Kaliningrad) and, alternatively, as an original painting by Hals. Slive (see Refs.) accepts the picture as autograph while acknowledging that the execution of the background is "slack," but also noting that the backgrounds of the two major paintings by Hals in the Altman Collection (Pls. 58, 59) are analogous. Grimm (see Refs.), having rejected this work—and the Altman pictures—in 1972, revised his opinion in a monograph of 1989. He defends Hals's responsibility for the main figure in *The Smoker*, observing that the facial features are "executed with an aplomb typical only of Hals," and that "the laughing girl . . . must be the work of one of Hals's students."[1] An earlier Hals specialist, Valentiner (1936; see Refs.), likewise overruled himself, at a time when the issue turned (as it had since 1910) on opinions of the painting in Königsberg. That work, even if judged solely from photographs, is obviously so inferior in execution to the Museum's picture, and so dissimilar in some respects (the faces, through no deliberate effort, seem based on different models), that it may be considered irrelevant to the question of authorship considered here.

Direct juxtaposition with *Young Man and Woman in an Inn* (Pl. 59) strongly supports the view that the two paintings are by the same artist. This is especially evident in the deft descriptions of hair and lace, and in the modeling of the female faces (which conform to a single type). *The Smoker* was probably painted more quickly, as an inexpensive work for the open market. The wood support accounts in good part for the slicker appearance of the loose brushwork, an effect the painter

exploits especially in the young man's slashed doublet and in the play of light on his face.[2] With regard to quality, only willful effort, based on the perusal of inadequate photographs, could lead critics to consider the face, hair, and distinctive hands of the smoker's companion to be less accomplished in execution than the corresponding passages in the Altman canvas. A virtuoso suggestion of movement, of excitement, and of an abrupt shift in focus from the couple in the foreground to the blurred figure of a serving girl in the background may be appreciated from a normal viewing distance, where the eye is attuned not to supposed inconsistencies in execution but to the intended effect of the composition as a whole. Grimm's opinion, in 1989, that two hands are responsible for the picture seems to the present writer less rational than his earlier rejection of the work, which itself was clearly mistaken.

Among the most similar works by Hals are three circular panels from the same period, the delightful *Laughing Boy*, in the Mauritshuis, The Hague, and the two tondos in the Staatliches Museum, Schwerin, *Drinking Boy (Taste)* and *Boy Holding a Flute (Hearing)*. Slive dates the Mauritshuis picture broadly, to about 1620–25, and the Schwerin paintings to about 1626–28.[3] Comparison with these pictures led Biesboer and Von Bogendorf Rupprath to date *The Smoker* to 1625 at the earliest.[4] A date of about 1625 is plausible. The panel was certainly painted after *Young Man and Woman in an Inn*, from which the design of *The Smoker* to some extent derives.

In the 1620s, smoking and drinking were regarded as similar weaknesses, with the former having the added detraction of being a new fad. Prints of the period, including one of the early 1620s after Dirck Hals (q.v.), often show smokers in a tavern or bordello, and the two women in the present picture represent those businesses. The moralizing inscription on the engraving after Dirck Hals associates smoking with "indecent lovemaking," both of which are bad for the soul, but only the former is said (in this print) to damage the body.[5] Prints, especially with inscriptions, functioned differently from paintings in Dutch collections of the time. This panel was intended not as a small step toward the improvement of mankind but as a comic glance at his nature, and as a brisk demonstration of what a modern painter could do.

1. The quote is from the English edition of Grimm 1989: Grimm 1990, p. 238.
2. See the large color detail of the man's face in Grimm 1989 or 1990, fig. 76a. Druesedow (1990; see Refs.) discusses the style of the doublet.

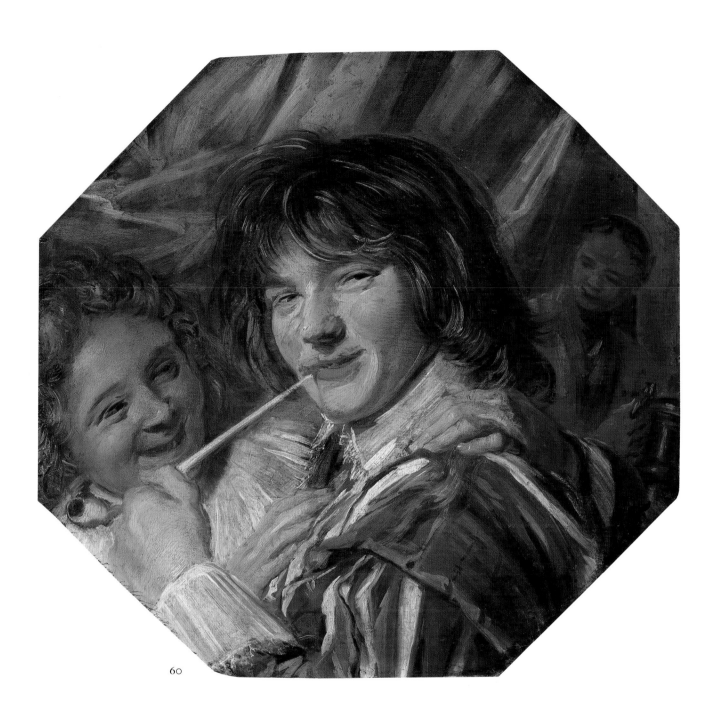

60

3. Slive in Washington–London–Haarlem 1989–90, nos. 16, 27, 28. Large color details of the Schwerin panels are reproduced in ibid., pls. VI, VII, on pp. 12–13. An overscaled detail of the boy's face in the Mauritshuis picture is reproduced in Grimm 1989 (and 1990), fig. 81.

4. In Haarlem–Worcester 1993, pp. 80, 246.

5. The subject of smoking is discussed exhaustively by C. Kortenhorst-von Bogendorf Rupprath in connection with *The Smoker* in ibid., pp. 246–51 (under no. 21). See ibid., pp. 248–29, fig. 21d, for the engraving after Dirck Hals and a complete translation of its Dutch and Latin verses. See also Gaskell 1987 and De Jongh 2003. In Slive 1970–74, vol. 1, pp. 77, 79, condemnations of smoking are discussed (one of the prominent critics was Petrus Scriverius, Hals's sitter in Pl. 63), and it is suggested that the New York painting "can also be viewed as a secularized [?] representation of the sense of taste." Series of pictures depicting the Five Senses, for example by Dirck Hals (Mauritshuis, The Hague), are reproduced by Slive. But the complete absence of evidence for other octagonal paintings by Hals depicting one of the senses suggests that the Museum's picture was made as an independent work.

REFERENCES: MMA 1905, no. 234; Moes 1909, p. 109, no. 212, describes the picture as "Un fumeur avec deux femmes (Réplique)"; Valentiner in New York 1909, p. 23, no. 22 (ill. opp. p. 23), as by Frans Hals, describes the subject; Cox 1909–10, p. 178, noted as "in the catalogue [New York 1909] but not in the exhibition"; Breck 1910, pp. 49 (ill.), 51, mentioned as in the Hudson-Fulton exhibition; Haendcke 1910, p. 301, in a brief article (reacting to Valentiner 1910 and Waldmann 1910) on the version of this composition in Königsberg, considers that picture superior to the New York panel, although the author knows the latter only from reproductions; Hofstede de Groot 1907–27, vol. 3 (1910), p. 37 (under no. 133), calls the picture a replica of the circular panel in the Königsberg museum, noting that the main figure is worthy of Hals but the other two are inferior; Valentiner 1910, p. 6, dates the picture to about 1625, and supports Hofstede de Groot's qualified attribution to Hals (see above); Waldmann 1910 (ill. p. 73), as by Hals; Altman Collection 1914, p. 29 (under no. 19), "partakes of the nature of a subject- or character-picture as well as of portraiture"; Bode and Binder 1914b, vol. 1, p. 25, no. 6, pl. 4B, as "The Smoker and His Girl," by Hals, reproduces the picture next to the Königsberg version; Valentiner 1921a, p. 307 (note to p. 27), describes the painting as probably a workshop version of the original in Königsberg; Monod 1923, p. 302, considers the "original" to be in Königsberg; Valentiner 1923, p. 307 (note to p. 27), repeats Valentiner 1921a; Altman Collection 1928, p. 62 (under no. 28), repeats Altman Collection 1914; B. Burroughs 1931a, p. 149, no. H16-1, notes that Moes (1909) calls it a replica of the Königsberg version; Königsberg [1934], p. 33 (under no. 57), agrees with Haendcke 1910 that the Königsberg version is the original;

Valentiner 1936, unpaged, no. 5 (ill.), as "A Boy Smoking and a Laughing Girl," dates the painting to about 1623, considers both the New York and Königsberg pictures to be autograph, and finds the execution similar to that of *Young Man and Woman in an Inn* (Pl. 59); [n.b.: no literature for thirty-four years]; Slive 1970–74, vol. 1, pp. 76–77, 79–80, considers the painting to be by Hals about 1623–25, compares *Young Man and Woman in an Inn*, and discusses the meaning of the work, suggesting that it could be a moralizing genre picture, or represent the sense of taste in a series of the Five Senses, vol. 2, pl. 41, vol. 3, pp. 14–15, no. 21, notes another instance of the octagonal format in Hals's work, reviews opinions about this work and the version in Königsberg, agrees with Valentiner (1936) that the New York painting is autograph, concedes that the figure to the far right is weak but observes that "such slack passages are found in the backgrounds of other paintings by the artist [Pls. 58, 59] and in my view should not serve as the basis for excluding the work from his *oeuvre*"; Grimm 1972, pp. 63, 92 n. 100, 200, no. A7, calls the work a copy after a lost original, dating from 1624–26 (p. 63) or 1624–25 (p. 200); Grimm and Montagni 1974, pp. 89–90 (under no. 25), fig. 25a, reviews scholarly opinions, and notes "various *gaucheries* typical of followers" in the work; Grimm 1989, pp. 178, 237, 272, 284, no. 17, pls. 76a, 76b (details), revises the opinion expressed in Grimm 1972, now attributing the painting to Hals about 1623, but noting that the head of the girl is inferior in execution and must be the work of a student; Jean L. Druesedow in "Recent Acquisitions," *MMA Bulletin* 48, no. 2 (Fall 1990), p. 56, compares the doublet worn by the figure to an actual doublet of about 1625 acquired by the Museum; Grimm 1990, pp. 178, 204, 237–38, 273, 291, no. 17 (ill. p. 273), pls. 76a, 76b (details), repeats Grimm 1989 in translation; Liedtke 1990, p. 36, mentions the picture as part of the Marquand bequest; Biesboer in Haarlem–Worcester 1993, p. 80, dates the painting to 1625–30; Kortenhorst-von Bogendorf Rupprath in ibid., pp. 246–51, no. 21 (ill.), in a long entry, suggests a date of slightly later than 1623–25 (based on the costume and composition), compares the execution with that of Hals's *Boy Holding a Flute* in Schwerin, and offers an excursus on the reputation of smoking in the 1620s; Baetjer 1995, p. 299; Weller in Raleigh–Columbus–Manchester 2002–3, pp. 67, 68 n. 2, fig. 2, sees this type of painting by Hals as influential for Jan Miense Molenaer, and acknowledges that the painting's authorship has been debated.

EXHIBITED: London, Royal Academy of Arts, "Winter Exhibition," 1887, no. 95, as "Three Heads," by Frank [*sic*] Hals (lent by R. G. Wilberforce); New York, MMA, "Exhibition of 1888–89" [Marquand Collection], 1888–89; New York, Hunter College, 1953; Worcester, Mass., Worcester Art Museum, "Judith Leyster: A Dutch Master and Her World," 1993, no. 21.

EX COLL.: R. G. Wilberforce, London (in 1887); Henry G. Marquand, New York (until 1889); Marquand Collection, Gift of Henry G. Marquand, 1889 89.15.34

61. *Boy with a Lute*

Oil on canvas, 28⅜ x 23¼ in. (72.1 x 59.1 cm)

The paint surface is worn and the impasto has been slightly flattened during past lining. The stippled decoration on the collar and the lute strings over the proper left thumb are not original. There is a pentimento in the right background: a feather extending from the beret to the wineglass was painted out by the artist. Microscopic examination of a sample mounted in cross section revealed that the lute was planned from the start. The fruit was painted after the tablecloth was fully finished.

Bequest of Benjamin Altman, 1913 14.40.604

The Altman *Boy with a Lute* was probably painted by Hals about 1625. His authorship has occasionally been doubted (see Refs.), but condition problems and clumsy restorations would appear to largely explain the picture's shortcomings (see the condition note above). The strongest passages are consistent in handling with contemporary genre paintings by Hals. The hair, the drapery folds, the highlights on the sleeve, the modeling of the face and hands, the use of stark shadows (which have been exaggerated by retouching in the hand holding the glass), and the description of the open mouth may be compared with motifs in works by Hals such as *Singing Boy with a Flute* (Gemäldegalerie, Berlin) and *The Merry Lute Player* (Harold Samuel Collection, Mansion House, London), both of about 1625–27.[1]

A large, light-colored feather originally hung from the right side of the beret and curved down to the wineglass. A similar motif is found in the Berlin picture and in Hals's *Young Man Holding a Skull*, of about 1626–27 (National Gallery, London).[2] Technical examination, including a cross section of the paint layers in this area, suggests that the artist blocked out the lute in approximately its present position, and then painted it out with a brownish black layer of paint. The feather was then painted in. Although the lead white present in the feather would have dried quickly, it was not completely dry when the neck of the lute was painted in its present position.[3] The decision to insert a curtain in the background may have come at this stage. Most genre pictures by Hals have neutral backgrounds, but a curtain was sketched into the background of *The Smoker* (Pl. 60), and a similar curtain is draped behind the figure in Hals's full-length portrait *Willem van Heythuyzen*, of about 1625 (Alte Pinakothek, Munich).[4] The orange was probably introduced at a late stage to balance the composition and to create an impression of receding space to the lower left. All

this suggests that Hals had decided upon the boy's head and the arrangement of his hands and the glass from the start, but that other parts of the picture were revised in the course of work.

The Altman painting is probably identical with a canvas by Hals that was sold in Rotterdam in 1825, and was described in the auction catalogue as representing "a youth in a merry pose who lets the last drop from a glass fall on his fingernail, beautiful in coloring and execution" (see Ex Coll.). In his 1909 monograph, Moes introduced the title "Le rubis sur l'ongle" (The Ruby on the Fingernail). The Altman catalogue of 1914 observes that the young man pours "the last drops of the wine on the left thumb, indicating thereby, no doubt, that the glass is empty and that he wants it refilled." Moes's title is cited, and explained as "some slang phrase of the time."[5] The expression was indeed current in the seventeenth century and remains familiar today. The "ruby" is a drop of red wine spilled onto the drinker's thumbnail (which, presumably, would then go into his mouth).[6] The same subject is found in an engraving (fig. 74) by the Haarlem printmaker Theodoor Matham (1605/6–1676), after an unnamed artist (possibly Gerrit van Honthorst; Matham engraved similar images by Honthorst in 1626 and 1627).[7] The inscription compares actual rubies to "delicious drops," which remind mankind of life's brevity.[8] The print is signed "Theod. Matham fec a Paris," and bears the name of the Parisian publisher Charles David (Matham is thought to have worked in Paris about 1629–30). About the 1680s in Paris, the print was copied in reverse in the background of an engraving after Andries Both (1612/13–1641), *The Poor Painter in His Studio*, and there it is labeled "La Rubie."[9] The saying is also illustrated in a painting of 1639, *Rubis sur l'ongle*, by the Mechelen artist Pierre Franchoys (1606–1654; Musées Royeaux des Beaux-Arts de Belgique, Brussels).[10] Similarly, a painting attributed to Michiel Sweerts (1618–1664) depicts a young man in modest attire pouring the last drops from a small wineglass onto his thumbnail.[11] Thus in a scene of mindless merriment Hals reminds viewers that all too soon the music stops: "The glass is empty. Time is up."[12]

1. Slive 1970–74, vol. 3, nos. 25, 26. For the Berlin painting, see also Philadelphia–Berlin–London 1984, no. 47; for the Samuel picture, P. Sutton 1992, pp. 73–78, no. 24. The attribution to Judith Leyster (1609–1660), proposed by Wilhelm Martin in 1938 (oral opinion), in Frima Hofrichter's dissertation on the artist (Rutgers University, 1979) and in Hofrichter 1989 (see Refs.) was provisionally adopted by the Museum in 1986. Scholars of

*Tous ces Rubis que nous mettons
Au rang des pierres precieuses,
Quest-ce : si nous les comparons*

*A ces gouttes delicieuses :
Qui peuuent, comme dons deuins,
Rappeller des mors les humains.*

Figure 74. Theodoor Matham (after Gerrit van Honthorst?), *Merry Toper ("Le rubis sur l'ongle")*, ca. 1629–30. Engraving, 8½ x 6¾ in. (21.6 x 17 cm). Albertina, Vienna

Hals and his circle have not found the attribution convincing, and the present writer now considers it implausible.

2. For the London canvas, see Slive 1970–74, vol. 3, no. 61, and MacLaren/Brown 1991, pp. 160–61, pl. 142.

3. This analysis summarizes that of Ella Hendriks, head of Paintings Conservation at the Frans Halsmuseum, Haarlem, as detailed in a letter to the present writer, dated December 4, 1993.

4. See Slive 1970–74, vol. 2, pl. 56.

5. Altman Collection 1914, p. 29, referring to Moes 1909, p. 109, no. 210.

6. Details are given on numerous Web sites. One says either "boire" or "faire rubis sur l'ongle." Similarly, "payer rubis sur l'ongle" means to pay the last cent for something, implying complete (and usually prompt) payment.

7. See Judson and Ekkart 1999, nos. 226, 240, pls. 121, 127, and Amsterdam 1997a, p. 315, fig. 3.

8. Both the original French and the English translation are botched in Amsterdam 1997a, pp. 266, 267 n 14. The French reads, "Tous ces Rubis que nous mettons/Au rang des pierres pretieuses,/Quest-ce: si nous comparons/A ces gouttes delicieuses: Qui peuvent, comme dons devins,/Rappeller des mor[t]s les humains." This may be freely translated: "These rubies, precious stones, what are they? Like these precious drops, gifts divine, they remind us of human mortality."

9. See ibid., pp. 250–51, fig. 10. The Matham print, as it appears in the engraving after Both, bears the lines after the large title, "La Rubie": "Ausy tost que jay bu/Je voudrois encoreboir" (All that I have had to drink/I want to drink again). Martin Royalton-Kisch kindly recorded the inscription on the British Museum's engraving after Both, which was published by Pierre Landry in Paris about 1680–90 (personal communication, February 27, 2006).

10. See Brussels 1965, p. 83, no. 84, where the discussion cites the use of the expression in a French play of 1704.

11. Not in Kultzen 1996. Sold at Christie's, London, December 8, 1995, no. 34, where the Museum's painting by Hals is compared, and where Malcolm Waddingham and Lindsey Shaw-Miller are thanked for "confirming the attribution." Waddingham proposes a date of about 1648–50, when Sweerts was in Rome. This appears consistent with the figure's working-class attire, which includes a head scarf with an embroidered border.

12. For the quote, see the entry on Pieter Claesz's *Still Life with a Skull and Writing Quill* (Pl. 28), page 129 and note 8. On the lute as a vanitas symbol, see Liedtke 2000a, pp. 69–70.

REFERENCES: Cust 1907, p. 3 (ill. opp. p. 3), cites the painting as "Young Man with Mandoline," by Frans Hals, states that it was sold for Gn 3,800 in Dublin in the autumn of 1906, and subsequently changed hands three times (see Ex Coll.); Moes 1909, p. 109, no. 210, as "Le Rubis sur l'ongle" (The Ruby on the Fingernail); Hofstede de Groot 1907–27, vol. 3 (1910), pp. 20, 24, no. 86, as "The Finger-Nail Test (or, The Mandoline-Player with a Wine-Glass)," describes the subject and lists provenance; Altman Collection 1914, pp. 28–29 no. 19, 31–32 (under no. 21), as "A Youth with a Mandolin," states that the picture "partakes of the nature of a subject- or character-picture as well as of portraiture," and concludes that the title given in Moes 1909 "must be some slang phrase of the time"; Bode and Binder 1914b, vol. 1, p. 32, no. 57, pl. 24, listed, as "A Youth with a Mandolin: The 'Finger-Nail Test'"; Valentiner 1921a, pp. 56 (ill.), 310, dates the painting to about 1627, and finds the same model in *The Merry Lute Player* (Harold Samuel Collection, Mansion House, London); Monod 1923, pp. 300–301 (ill.), as "Rubis sur l'ongle," suggests that the motif of the upturned wineglass is borrowed from one of Hals's civic guard portraits; Valentiner 1923, pp. 59 (ill.), 310, repeats Valentiner 1921a; Altman Collection 1928, pp. 61–62 no. 28, 90–91 (under no. 50), as "A Youth with a Lute," repeats the text from Altman Collection 1914; Dülberg 1930, p. 78, as "Nagelprobe," describes the composition, and repeats the idea that the gesture is borrowed from one of Hals's civic guard company portraits; B. Burroughs 1931a, p. 150, no. H16-6, as "A Youth with a Lute," explains that the picture is "also known as Le Rubis sur l'ongle (The Ruby [last drop of wine] on the Finger Nail)"; Valentiner 1936, p. 9, no. 21 (ill.), believes the model to be one of the artist's children, and the painting to be "a sort of companion piece" to *The Merry Lute Player*; Slive 1970–74, vol. 1, p. 88, sees the type as adopted from Ter Brugghen but treated quite differently, vol. 2, pl. 47, vol. 3, pp. 16–17, no. 24, as painted by Hals in about 1623–25, suggests that the work may be identical with one in the Kamermans sale, Rotterdam, October 3, 1825, no. 47 (despite the larger size recorded there);[1] Grimm and Montagni 1974, pp. 116 (ill.), 118, no. 310, reports that Valentiner, Slive, and other scholars have accepted the

61

work as by Hals, but Trivas (by excluding it from his monograph) and Grimm reject it as a work from the artist's circle; Baetjer 1980, vol. 1, p. 83, as by Hals; P. Sutton 1986, p. 186, as by Hals, describes the "popular gesture"; Grimm 1989, p. 284, as from the circle of Hals; Hofrichter 1989, pp. 26, 57–58, no. 32, pl. 32, attributes the picture to Judith Leyster, dates it to about 1633–35, and interprets the theme as intemperance, with the lute a vanitas motif and the orange a symbol of luxury; Grimm 1990, p. 291, as from the circle of Hals; Liedtke 1990, fig. 36 (Altman gallery view); P. Sutton 1992, pp. 75, 78 n. 13, describes the painting as a work by Hals that is similar to *The Merry Lute Player*, but rejects Valentiner's idea (1936) that the two pictures were intended as companion pieces; Stukenbrock 1993, p. 248, listed as a work by Hals; Baetjer 1995, p. 303, as "Attributed to Frans Hals."

EXHIBITED: Dublin, Dublin Exhibition Buildings, Earlsford Terrace, "Dublin Exhibition of Arts, Industries, and Manufactures, and Loan Museum of Works of Art," 1872, no. 104, as "Boy with Glass," by Franck Hals (lent by J. L. Naper).

EX COLL.: Probably J. Kamermans (his sale, Rotterdam, auctioneer A. Lamme, October 3, 1825, no. 47, as by F. Hals, "Een Jongeling in eene vrolijke houding den laasten droppel uit een glas op zijnen nagel latende lopen, fraai van coloriet en behandeling, h.84d.b.64d. D[oek]" (A Youth in a merry pose who lets the last drop from a glass fall on his fingernail, beautiful in coloring and execution, h[eight] 84 *d[uim]* b[readth] 64 *d[uim]* C[anvas]);[2] James Lenox William Naper (1791–1868), Lough Crew (or Loughcrew), near Oldcastle, County Meath, Ireland; Most Rev. James Bennett Keene (1849–1919), bishop of Meath, Dublin (until 1906; sale, Dublin, April 6, 1906, for £3,990 to Sulley); [Sulley and Co., London, in 1906]; [Dowdeswell & Dowdeswell, London]; Charles J. Wertheimer, London; [Gimpel & Wildenstein, Paris and New York, until 1907; sold for $77,920 to Altman]; Benjamin Altman, New York (1907–d. 1913); Bequest of Benjamin Altman, 1913 14.40.604

1. See the following note on the painting's size in the Kamermans sale.
2. The metric system was adopted in the Netherlands between 1793 and 1835. There were many local variations, but in general, as of 1820, the *duim* (thumb), previously equivalent to the English inch, became the term employed for a centimeter. Thus the measurements given in the 1825 Rotterdam sale catalogue are approximately 84 x 64 centimeters, about 12 x 5 centimeters larger than the painting's present dimensions. Radiographic examination reveals substantial cusping on all sides, indicating that the canvas has not been cut down at all. It appears likely that the dimensions given in 1825 were slightly inaccurate, or that some framing element was included in the measurements. Alternatively, the canvas recorded in 1825 could have been another version of the composition, or a very similar picture by Hals.

62. *Portrait of a Bearded Man with a Ruff*

Oil on canvas, 30 x 25 in. (76.2 x 63.5 cm)
Dated and inscribed (right): AETAT 36/AN° 1625

The impasto has been slightly flattened during lining, and the paint surface is abraded. There is significant paint loss in the lower portion of the figure and in the oval surround, particularly at the corners.

The Jules Bache Collection, 1949 49.7.34

As the original inscription indicates, the unidentified sitter was thirty-six years old when Hals painted his likeness, in 1625. The portrait's immediacy is enhanced by vivid brushwork, the strong modeling of the head, the glance and gesture (which respond to the viewer), and the oval framing device. Hals used a similar fictive frame in his *Portrait of a Man Holding a Medallion*, of about 1615 (Brooklyn Museum), where the sitter's hand extends through the frame, but the present picture appears more illusionistic, mainly because of the emphatic contrasts of light and shadow. Another example of a painted oval frame is found in Hals's *Portrait of a Man*, dated 1622 (Duke of Devonshire and the Chatsworth House Trust, Chatsworth), which like the Brooklyn portrait is on a canvas of conventional size.[1] Hals's use of the oval format, which is closely related to portrait engravings by Dutch artists, is discussed in the following entry.

The feathery touch with which Hals painted the lace ruff is one of the portrait's most attractive features. The comparatively flat treatment of the shadowy part of the ruff is typical of Hals, who took bold steps to suggest receding space as perceived from a normal viewing distance. Another instance of an effect meant to be seen from feet—not inches—away is the shadow to the side of the nose. The man's ring, with a gray stone, draws attention to the hand, which has convincing volume and a sense of movement created by blurred contours and by the loose strokes defining the cuff of the sleeve. If Van

der Helst's *Portrait of a Man* (Pl. 76) is, in the words of Henry James, "The perfect prose of portraiture" (see p. 324), then Hals's portrait is neither that nor poetry, but a brief character sketch meant to delight the patron's family and friends.

The man's gesture, placing his hand on his heart, suggests sincerity, as explained by John Bulwer in 1644.[2]

1. For the Brooklyn and Chatsworth pictures, see Slive 1970–74, vol. 2, pls. 14, 39, vol. 3, pp. 3, 12–13, nos. 4, 18.
2. Bulwer 1644, pp. 88–89 (under the motto *Conscienter affirmo*); quoted and connected plausibly with Rembrandt's *Portrait of Johannes Wtenbogaert* (1633; Rijksmuseum, Amsterdam), in *Corpus* 1982–89, vol. 2, p. 397.

REFERENCES: Valentiner 1923, p. ix, mentions the picture in the foreword as a newly discovered male portrait by Hals, dated 1625, with Buttery, London; Valentiner 1928b, p. 247, fig. 1, as in the Bache collection; Detroit 1935, unpaged, no. 3 (ill.); Valentiner 1935, p. 101, listed, as in the Bache collection; Valentiner 1936, pp. 8–9, no. 13 (ill.), sees the influence of Rubens, and notes the same position of the hand in other portraits by Hals; Bache Collection 1937, no. 35 (ill.), describes the composition and compares a few contemporary works; Trivas 1941, p. 30, no. 17, pl. 29, lists literature; Bache Collection 1943, no. 34 (ill.); Slive 1970–74, vol. 2, pls. 66, 70, vol. 3, p. 22, no. 34, adds Carl Thomson, about 1923, to the provenance (possibly David Croal Thomson of Barbizon House; see Ex Coll.); Grimm 1972, pp. 20–21, 87, 202, no. 55, dates the picture about 1628–32, finding evidence of overpainting and later additions, including the oval framing device and the inscription; Grimm and Montagni 1974, pp. 90 (ill.), 91, no. 37, notes that the date has been verified as original by recent conservation treatment; Grimm 1989, pp. 18, 178, 272, 284, no. 20, fig. 7, accepts the date of 1625, and reports that conservation in 1973–74 revealed the presence of Hals's hand in the execution of the head, collar, and hand; Groen and Hendriks in Washington–London–Haarlem 1989–90, pp. 117, 124, report that the hand is underpainted in a light red tone, and describe the ground color; Grimm 1990, pp. 18, 178, 273, 291, no. 20, fig. 7, repeats Grimm 1989 in translation; Baetjer 1995, p. 301.

EXHIBITED: Detroit, Mich., The Detroit Institute of Arts, "Fifty Paintings by Frans Hals," 1935, no. 3 (lent by Jules S. Bache, New York); New York, MMA, "The Bache Collection," 1943, no. 34.

EX COLL.: Julia, Countess of Dartrey, London; [A. H. Buttery, London, in 1923]; [Barbizon House, London, until 1925]; [Julius Böhler, Munich, 1925; sold half share to Kleinberger]; [Julius Böhler, Munich, and Kleinberger, Paris and New York, 1925–26; sold to Lucerne Fine Art]; [Lucerne Fine Art Co., Ltd., in 1926]; [Gaston Neumans, Brussels; sold to Bache on August 30, 1926, for $121,176.25];[1] Jules S. Bache, New York (1926–d. 1944; his estate, 1944–49); The Jules Bache Collection, 1949 49.7.34

1. According to L. Levy n.d., p. 9.

63. *Petrus Scriverius*

Oil on wood, 8¾ x 6½ in. (22.2 x 16.5 cm)
Signed, dated, and inscribed (lower border of painted frame): FHF 1626 [FH in monogram]; (right center): A° ÆTAT.50

The painting is very well preserved. There is a small amount of paint loss along a vertical split that extends the length of the panel at center to the right of the sitter's left eye. A small hole at top center, now repaired, may have been caused by a hanging device.

H. O. Havemeyer Collection, Bequest of Mrs. H. O. Havemeyer, 1929 29.100.8

This small portrait and its pendant, *Anna van der Aar* (Pl. 64), are certainly by Hals and are each monogrammed and dated 1626. The sitters were a couple who lived in Leiden, though Hals would have painted the pictures in Haarlem, where they both had close ties (see the biographical section below).

Hals's first picture of this type may have been a portrait of the Counter-Remonstrant preacher Johannes Bogaert, who died in 1614. The painting is lost but recorded by Jan van de Velde's engraving dated 1628, which is inscribed "F. Hals pinxit." The sitter in that painting is presented half-length in an oval frame, and holds an upraised book (perhaps his *Schrifterlijke Fondamenten*, of 1603, a critique of Catholic teaching).[1] A more direct precedent is found in the artist's small oval portrait on copper (5¾ x 4¾ in. [14.5 x 12 cm]; Frans Halsmuseum, Haarlem) of Theodorus Schrevelius (1572–1649), inscribed, on the scholar's book, AET. 44/1617. The image is reversed in an engraving by Jacob Matham (1571–1631), which is inscribed "Fra. Hals pinxit." and dated 1618.[2] As discussed below, this example of academic portraiture would not have escaped Scriverius's attention.

THE SITTERS AND THEIR HAARLEM TIES

Pieter Schrijver (1576–1660), who is better known by his Latinized name, Petrus Scriverius, was born on January 12, 1576, in Haarlem.[3] He was the eldest son of Hendrik Schrijver, an Amsterdam merchant, and of Cornelia Soop, who came from a wealthy family in Haarlem. The couple settled in the bride's hometown, but business concerns obliged Hendrik Schrijver to move the family back to Amsterdam. Pieter, however, was left in the care of his mother's sister, who was married to a Haarlem burgomaster, Barthoud van der Nijenburg. The boy attended the Latin School in Haarlem, which was then flourishing under its distinguished rector, Cornelius Schonaeus (1540–1611).[4] Scriverius's thorough education and love of Latin poetry were debts to Schonaeus warmly acknowledged in later years.

At the age of nineteen, Scriverius transferred to the University of Leiden. Six years later, on May 22, 1599, he married Anna van der Aar, daughter of the City Councilman and sheriff, Willem Govertsz van der Aar (see the following entry). The young couple moved into a house next to that of Anna's parents, on the Nieuwe Rijn in the heart of the city. Scriverius never sought a university position or public office, but spent the rest of his life in Leiden studying classical literature and the history of the Netherlands from ancient to modern times. As a Remonstrant, Scriverius would have found many doors closed to him, especially in Leiden and Haarlem.[5] Nevertheless, he was closely associated with leading scholars of the day, including Johannes Woverius, Daniel Heinsius, Janus Dousa, and the esteemed French humanist and Leiden professor Joseph Justus Scaliger (whose poems he edited). The Dutch members of this Neo-Latinist circle were great apologists for their own language, a cause advanced by Scriverius's influential preface to Heinsius's *Nederduytsche poemata* (1616). Scriverius also published Dutch poems of his own composition, as well as an edition of Seneca's tragedies (1621) and commentaries on other classical authors. He is best remembered, however, for his histories of the Netherlands and of particular provinces, including *Batavia illustrata* (1609), *Beschryving van Oud Batavien* (1612), and *Principes Hollandiae, Zelandiae et Frisiae* (1650). His more popular efforts include an attack in 1616 on Dutch *rederijkers* (rhetoricians), which depicts them in terms not far from those of Frans Hals (Pl. 58), and a tract against the use of tobacco (1628).[6]

Scriverius must have been well acquainted with the slightly older Theodorus Schrevelius, the subject of Hals's small portrait of 1617 and Matham's engraving of the following year. Schrevelius was co-rector of the Latin School in Haarlem,

under Schonaeus, whom he succeeded as rector in 1609. After sixteen years in that position, he moved to Leiden, where he served as rector of the Latin School (1625–42) and pursued his interests in Latin and Dutch poetry and the history of Dutch cities (his *Harlemias,* of 1648, extolls Hals's portraits, which "seem to live and breathe").[7]

In May 1628, when the Utrecht art lover Aernout van Buchell (or Buchelius) visited Schrevelius in Leiden, he was shown a portrait of his host by Hals, and was given an impression of Van de Velde's print (1626; fig. 75) after Hals's portrait of Scriverius.[8] The latter very likely turned to Hals in Haarlem, rather than a Leiden portraitist such as David Bailly (q.v.),[9] because he knew the artist's portrait of Schrevelius and the engraving after it. The six lines of Latin verse at the bottom of the print were composed by Scriverius himself. He praises the schoolmaster's control of "wayward youths [through] the force of his eloquence and his Palladian discipline," and describes Matham's copperplate as the teacher's proper reward and as a remembrance, "so that if perchance envious time should blot out his name and hide the man, his likeness may speak for him."[10]

The actual circumstances that brought Hals and Scriverius together were undoubtedly more complex. Both of Scriverius's parents died in Haarlem in July 1626, which would have taken him back to his native city to settle their estate. Scriverius was also helping Samuel Ampzing with his history of Haarlem (*Beschryvinge ende lof der stad Haerlem in Holland,* 1628) by contributing scholarly information, a treatise on Haarlem's supposed inventor of movable type (Laurens Coster), and inscriptions for engraved plates, such as Jan van de Velde's print after Pieter Saenredam's drawing of a modern printing press. Most of the illustrations in the book, including a number of oval portraits, were engraved by Van de Velde.[11]

In providing learned (or simply literate) inscriptions for prints, Scriverius was following the example of Schonaeus, Schrevelius, and other humanists.[12] Scholars of the time worked closely with publishers of books and prints. Schonaeus and Schrevelius were especially involved with Haarlem's most famous artist, Hendrick Goltzius (1558–1617), and with the engravers who (like Goltzius's stepson Jacob Matham) worked directly for him. Some of the most coveted prints of the time are embellished with verses written by Scriverius's scholarly predecessors. Schonaeus, for example, composed the inscriptions for Jan Saenredam's series of three engravings after Goltzius, *The Worship of Bacchus, Venus and Ceres* (1596), and for a dozen other prints after Goltzius by Matham and Saenredam, all dating from the second half of the 1590s.[13] Schrevelius provided the Latin text for Matham's engraving,

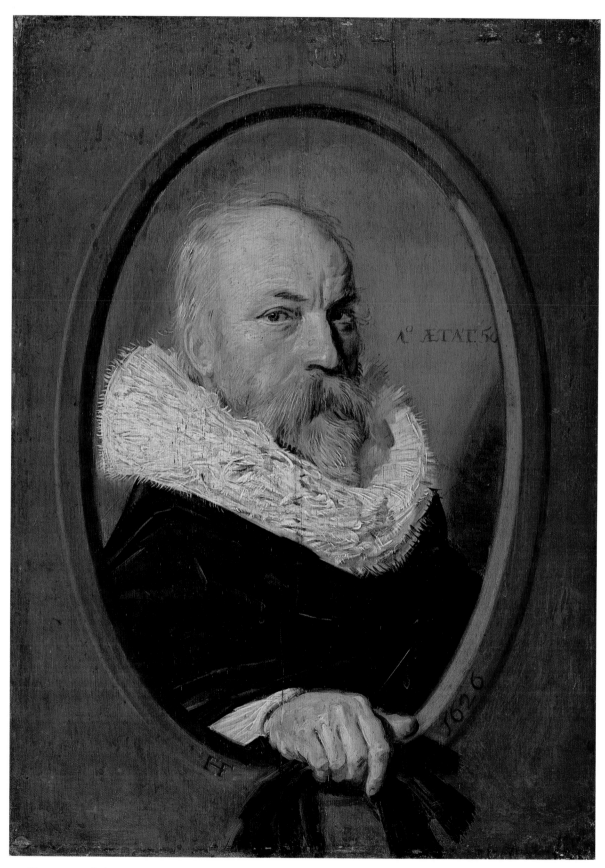

63. Shown actual size

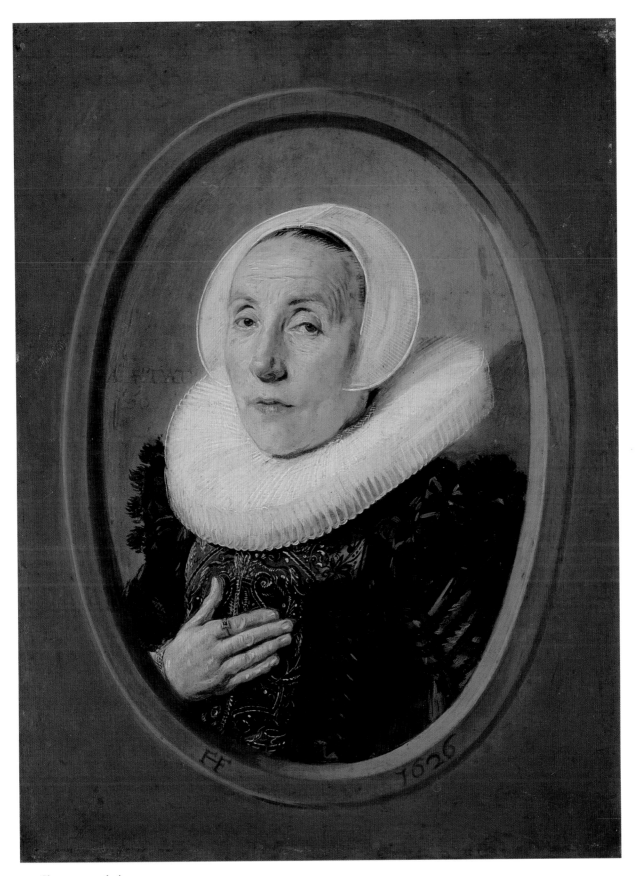

64. Shown actual size

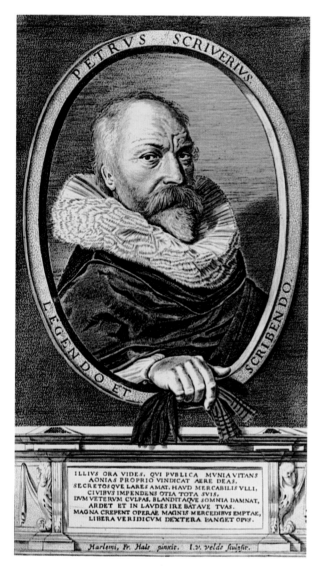

Figure 75. Jan van de Velde II after Frans Hals, *Petrus Scriverius*, 1626. Engraving, 10½ x 6⅛ in. (26.6 x 15.5 cm). The Metropolitan Museum of Art, Gift of Carl J. Ulmann, 1924 24.57.27

dated 1598, after Goltzius's well-known drawing *The Beached Whale near Berkhey* (the print also bears a long Dutch description by Karel van Mander),[14] and composed inscriptions for other engravings after Goltzius.[15]

These Latin School contacts with Goltzius might explain how Scriverius, when he was only twenty-one years old and living in Leiden, came to compose the inscription on one of the Haarlem master's most personal prints, his original portrait engraving, dated 1597, of Frederik de Vries.[16] Scriverius also penned a Latin poem of praise for Van Mander's *Schilder-Boeck* of 1604.[17] The connection with Van Mander may have been made by Scriverius's uncle by marriage Jan Govertsz van der Aar (1544/45–1612), who was one of Haarlem's most important patrons of the pictorial arts. He is presented as a shell collec-

tor in Goltzius's portrait, dated 1603 (P. and N. de Boer Foundation, Amsterdam, on loan to the Museum Boijmans Van Beuningen, Rotterdam),[18] a boldly naturalistic picture which Van Mander, in the *Schilder-Boeck*, describes as a work that the artist painted for his own pleasure.[19] Van der Aar appears in no less than eight other works by Goltzius, in a drawing and an engraving by Matham, and in two paintings by Cornelis Cornelisz van Haarlem (1562–1638), which suggests that he was familiar with all the leading Mannerist artists in Haarlem (who, of course, included Van Mander).[20] Cornelisz van Haarlem shows the collector as himself in a large canvas, *Allegory of the Arts and Sciences ("Image of Peace"),* dated 1607 (Lord Sackville collection, Knole, Kent), and Goltzius cast Van der Aar in the role of Saint Luke (patron saint of painters) in a posthumous portrait drawing (dated 1614), and in another drawing, known from a print by Matham.[21] In addition to collecting shells and pictures, Van der Aar was a merchant and a substantial investor in the East India Company (VOC). Several documents suggest that the businessman was, in effect, the Haarlem branch of the textile business that was owned in Leiden by Scriverius's father-in-law, Willem Govertsz van der Aar, and his brothers.[22] Thus, Scriverius had considerable knowledge of the art world in Haarlem—painters, engravers, printers, patrons, critics, and scholarly associates—well before his portrait was painted by Hals.

THE PORTRAITS AND THEIR PURPOSE

Slive raises the question of whether any of Hals's small painted portraits were "done expressly as *modelli* for engravers," and answers, "probably some were."[23] In the case of pendant portraits of a public figure and his wife, it was normal that (as in this case) only the male portrait would be engraved. Hals's portrait of Scriverius's wife, Anna van der Aar (Pl. 64), thus indicates that the scholar's portrait was not made solely as a *modello* for a print, but also as a personal keepsake. The scale and design of the two portraits, however, were certainly determined by the intention of having Scriverius's image immortalized in an engraving. The fact that Van de Velde's print (fig. 75) does not (despite its several lines of information) bear the name of a publisher implies that it was intended mainly for private distribution, a gesture common in the academic community. Examples are found right in our sitter's milieu. One of the inducements employed by the governors of the University of Leiden to bring Scaliger from the south of France to Holland was to have Goltzius engrave his and his father's portraits, and to send him numerous impressions of both (which were also dispatched as gifts to universities throughout Europe).[24]

Matham's print after Hals's portrait of Schrevelius, with its inscription by Scriverius, lacks a publisher's name and was surely intended for circulation among colleagues and institutions. That the engraving of Scriverius would have served the same purpose is underscored by its "anonymous" inscription:

Here you see the face of he who, shunning public office,
Makes the Muses his own at personal expense.
He loves the privacy of his home, sells himself to
 no one, [and]
Devotes all his leisure time to fellow citizens . . .[25]

Formal precedents for Hals's composition were plentiful. Slive cites a portrait of the famous composer Jan Pietersz Sweelinck (Gemeentemuseum, The Hague), which was painted in 1606 by the sitter's brother (and Haarlem printmaker), Gerrit Pietersz (1566–before ca. 1612). The approximately life-size figure rests his right forearm on an oval frame, and through it gestures rhetorically with his left hand.[26] In Hals's *Portrait of a Man Holding a Medallion*, of about 1615 (Brooklyn Museum), the sitter presents a miniature portrait of his beloved (presumably), extending his hand through the oval frame.[27] These paintings of conventional size penetrate the plane of the framing device in a manner adopted from Mannerist prints and drawings, including portraits by Goltzius. In examples of the 1580s, including a tiny oval portrait of the artist's wife, Goltzius places the body of the bust-length figure in front of the lower part of the frame, while the head is centered within it.[28] A closer precedent for Hals's portrait of Scriverius, with respect to the hand resting on the frame, is found in Goltzius's half-length portrait print of the art collector Jan Nicquet, dated 1595.[29] The figure, framed simply in a rectangular field, holds gloves (the sign of a gentleman) in his left hand, while his strongly modeled right hand casts a shadow on the lower border of the engraving (which is inscribed with a Dutch and Latin text in elaborate calligraphy).

Of course, such an artistic conceit in portraiture represents a special case within a broader trend of illusionism, which was celebrated by Van Mander in connection with Hans Vredeman de Vries and other artists.[30] In murals of the 1580s and 1590s, Vredeman de Vries (1526–1609) depicted (like Veronese before him) figures behind balustrades, over which they extend their hands, arms, and glances.[31] Because these motifs constitute displays of artistic virtuosity, it seems appropriate that a maulstick extends beyond the picture field (itself a riot of spatial effects) in Aegidius Sadeler's engraving after Bartholomeus Spranger's design, *Memorial to the Artist's Wife*, of 1600.[32] The staff recalls the scythe that, together with a bare foot, thrusts beyond the

lower border of Pieter van der Heyden's print *Summer,* after Pieter Bruegel the Elder's drawing of 1568. The invention has been said to illustrate a Dutch expression, "over de schreef gaan" (to go beyond bounds).[33] Scriverius would have appreciated that these Netherlandish notions had roots in classical texts, quite as Van Mander had Pliny in mind when he praised artists for deceiving viewers.[34] The patron would also have recognized that the illusion of actual existence before the beholder's eyes was particularly appropriate in portraiture, where a loved or admired person was (as Scriverius wrote of Frederik de Vries on the engraving by Goltzius) "brought to life in copper with a skillful hand, like that of Phidias."[35]

Or that of Hals. The painter went well beyond the limits of engraving (as is obvious in Van de Velde's print after this picture) through color and brushwork, suggesting textures, shifting highlights, a space filled not only by the figure but also with atmosphere, and a sense of movement conveyed by broken contours, busy surfaces, strands of hair, and points of lace. The different temperaments of Scriverius and his wife can be sensed from their expressions and poses, and even from the play, or comparative stillness, of light and shadow on their faces and hands. In these vivid effects, Hals may have been inspired once again by Goltzius, whose colored portrait drawings of the 1590s and slightly later seem the most immediate antecedents of Hals's small painted portraits, despite their distance in date.[36]

CONNECTIONS WITH REMBRANDT

Van de Velde's engraving after Hals's portrait of Scriverius (fig. 75), or the painting itself, has been said to have served as a model for one of Rembrandt's most memorable portrait prints, that of the deceased preacher Jan Cornelisz Sylvius (1563/64–1638).[37] The etching of 1646 makes Sylvius look very much alive, in part by having him lean and gesture through an oval frame (his hand and face cast strong shadows on the surface of the sheet). Some influence is plausible, in part because Scriverius, beneath the illusionistic image, added two lines to the long Latin inscription by Caspar Barlaeus. However, Hals's small portrait on panel of the Haarlem theologian Johannes Acronius, of 1627 (Gemäldegalerie, Berlin), which was engraved by Van de Velde, and especially his small *Portrait of a Man,* on copper, which probably dates from 1627 as well (and is also in Berlin), develop the motif of the extended hand much further than in the Scriverius portrait of the preceding year, and come closer to Rembrandt's gesture of 1646 (and of 1642, in *The Night Watch*).[38]

In addition to his relationships with Haarlem artists, Scriverius has been identified as a likely patron of Rembrandt

in Leiden during the mid-1620s. It is thought that two large panel paintings by the artist, *The Stoning of Saint Stephen*, dated 1625 (Musée des Beaux-Arts, Lyons), and the so-called *History Painting (Palamedes Protesting his Innocence?)*, of 1626 (Stedelijk Museum De Lakenhal, Leiden), are probably identical with "Twee braave groote stukken van Rembrant" ("Two fine large pieces by Rembrandt") listed as lot 3 in the auction catalogue of Scriverius's estate, dated August 8, 1663.[39] Late in life, Scriverius also became the owner of another large painting by Rembrandt, *The Standard Bearer (Floris Soop)*, of 1654 (Pl. 152). The canvas depicts the scholar's nephew, who died in 1657.[40] As the bachelor's sole heir, Scriverius inherited the portrait, but he never saw it, having gone blind about four years before it was painted.

1. The engraving is illustrated and briefly discussed in Slive 1970–74, vol. 1, p. 28, fig. 10. Of course, it is possible that Van de Velde based the print on a conventional portrait by Hals.

2. See ibid., vol. 1, pp. 28–29, vol. 2, pl. 23, vol. 3, p. 7, no. 8. The Schrevelius portrait is also catalogued by Slive in Washington–London–Haarlem 1989–90, pp. 141–43, no. 5 (then in a private collection), where Matham's print is reproduced (fig. 5a). As noted in Bijl 2005, pp. 52–54, Matham traced over Hals's portrait of Schrevelius, probably before the painting was varnished.

3. On the question of whether Scriverius was born in Haarlem or Amsterdam, see Dudok van Heel 2006, p. 50 n. 124.

4. On Schonaeus and the Latin School in Haarlem, see Van de Venne 2001.

5. On the religious and political conflicts of the time (especially the 1620s), see Israel 1995, chap. 21.

6. On Scriverius, see Langereis 2001. Van der Aa 1852–76, vol. 10, pp. 182–85, is still valuable, especially for its bibliography of Scriverius's publications. "Dutch late humanism" is briefly reviewed in Israel 1995, pp. 575–81 (where Scriverius's dates are erroneously given as 1580–1655 on p. 576). The importance of Scriverius's preface to Heinsius's volume of Dutch poetry is mentioned in Schenkeveld 1991, p. 17. Scriverius's *Oudt Batavien*, of 1606, is credited with adopting "examples of common diction and vulgar usage" in Melion 1991, p. 18. The humanist's assault on the *rederijkers*, and their actual merits, are considered in Smits-Veldt 2001. Scriverius's wife, her parents, and their houses on the Nieuwe Rijn in Leiden are discussed in Nichols 1988, pp. 243–45, where Tuynman 1977, Wolleswinkel 1977, and other articles on Scriverius and his relatives are cited.

7. Slive 1970–74, vol. 1, p. 8. On Schrevelius, see Van der Aa 1852–76, vol. 10, pp. 155–56, and (as rector of the Latin School in Leiden), Coebergh van den Braak 1988, pp. 43–47.

8. Slive 1970–74, vol. 1, p. 59, vol. 3, p. 7 (under no. 8), erroneously reports that Van Buchell saw a (painted) portrait of Scriverius. For Van Buchell's account, see Van Thiel-Strohman in Washington–London–Haarlem 1989–90, p. 383, doc. 42, where the date is given as January 10, 1628. However, Marten Jan Bok, basing his conclusion on firsthand examination of Van Buchell's manuscript (ms. 1781) in the library of Utrecht University, con-

cludes that the passage dates from May 1628 (personal communication, February 28, 2006); the same conclusion was reached independently in Tuynman 2006, p. 219. Slive's identification of two small paintings by Hals (each dated 1628) as portraits of Schrevelius (Slive 1970–74, vol. 2, pls. 74, 75, vol. 3, pp. 31–32, nos. 49, 50) is clearly mistaken, as noted by Van Thiel-Stroman in Washington–London–Haarlem 1989–90, p. 383, doc. 42.

9. Bailly was producing portrait drawings and paintings of the same type in the 1620s, for example the small oval portrait on a rectangular copper support (7¼ x 5½ in. [18.5 x 14 cm]), *Portrait of a Woman, Thought to be Maria van Reigersbergh, Wife of Hugo de Groot*, dated 1626 (Rijksmuseum, Amsterdam). See also Leiden 1976–77, pp. 40–41, nos. T1–T3.

10. Quoted from Slive in Washington–London–Haarlem 1989–90, p. 141 (under no. 5).

11. On Scriverius's work with Ampzing, see G. Schwartz and Bok 1990, pp. 39, 43, 50, 288, 292, no. 188. See also G. Schwartz 1985, p. 25, caption to fig. 5, citing Van de Velde's engraved portraits (after Hals and other artists) of notable Haarlem figures, and G. Schwartz and Bok 1990, pp. 46–48, figs. 43–48. In 1629, Saenredam drew a view of the Grote Markt, Haarlem, in Scriverius's *album amicorum* (ibid., pp. 45, 266, no. 90, fig. 42). Hals's small portrait on copper of Samuel Ampzing dates from 1630 (see Washington–London–Haarlem 1989–90, no. 40). In 1632, it was engraved by Van de Velde, with eight lines of Latin verse by Scriverius (G. Schwartz and Bok 1990, fig. 48). The extent of Scriverius's involvement with Haarlem printmakers and publishers remains to be explored. A broader review of inscriptions on reproductive engravings by Matham, Van de Velde, and others would be of interest. In Judson and Ekkart 1999, pp. 180 no. 226, 189–90 no. 240, pls. 119, 121, 127, it is noted that Scriverius provided the light Latin inscriptions for Matham's engraving of 1626 after Honthorst's *Young Woman (Phyllis) Playing the Violin*, and for Matham's engraving of 1627 after Honthorst's *Merry Violinist Holding a Wineglass*. The author of the entry goes so far as to wonder "whether or not these gay, outgoing and boisterous types represented by Honthorst did not come to Hals's attention through Scriverius." On this point, see the discussion of Hals's *Boy with a Lute* (Pl. 61). Scriverius also composed captions for the Leiden engraver Willem van Swanenburg (1580–1612; see G. Schwartz 1985, p. 45) and other printmakers.

12. As noted above, in the biography of Jacques de Gheyn, the Leiden scholar Hugo de Groot [Grotius; 1583–1645] started composing inscriptions for engravings when he was twelve years old.

13. See Reznicek 1961, p. 190 (on the friendship of Schonaeus and Goltzius), and nos. 10, 12, 15, 25, 106, 122, 130, 137, 143, 155, 193–94.

14. Amsterdam–New York–Toledo 2003–4, pp. 182–84, no. 65 (drawing and print). Note that the anonymous etching of 1594, after a different drawing of a beached whale by Goltzius (ibid., p. 182, fig. 65a), bears an inscription by Schonaeus.

15. See Reznicek 1961, p. 316 (under no. 195), nos. 207 and 227 (both of 1617), and Amsterdam–New York–Toledo 2003–4, pp. 30–31, fig. 7b (Matham's engraving after Goltzius, *Portrait of Hendrick Goltzius*, 1617). Schrevelius was also familiar enough with Goltzius's former pupil Jacques de Gheyn (q.v.) and with Goltzius's engravers, Matham and Saenredam, to characterize their relationships

with the master, in *Harlemias* (the book of 1648 mentioned above). See Amsterdam–New York–Toledo 2003–4, pp. 20, 205, 310 n. 63, 321 nn. 12, 13.

16. Amsterdam–New York–Toledo 2003–4, pp. 165–66, no. 57. De Vries was a friend's son who lived with Goltzius's family. In this wonderfully naturalistic portrait, he is seen with the artist's spaniel.

17. Van Mander 1604, p. 6; Van Mander/Miedema 1973, p. 47. The present writer is grateful to Marten Jan Bok for a transciption of the poem, which is mentioned in G. Schwartz 1985, p. 25, under "Scriverius and Art and/or Propaganda."

18. Amsterdam–New York–Toledo 2003–4, no. 104. The sitter was identified for the first time and his family discussed in Nichols 1988.

19. Van Mander/Miedema 1994–99, vol. 1, p. 402 (fol. 286r).

20. See Reznicek 1983, where it is suggested that Van der Aar "must have had a *kunstkamer*" (p. 212); Amsterdam 1993–94a, pp. 584–85 (under no. 256); and Van Thiel 1999, pp. 43, 125, 136, 318 (under no. 63), 372–73 (under no. 203), pls. 194, 242.

21. For Goltzius's drawing of 1614 and Matham's print, see Amsterdam–New York–Toledo 2003–4, p. 261, no. 95, fig. 95a (p. 286, fig. 104a, for Cornelisz van Haarlem's allegorical painting of 1607). As noted in Van Thiel 1999, pp. 43, 160, 473, a "head of friend [or old man] Goverts" was listed in the 1639 inventory of Cornelisz van Haarlem's estate.

22. See Nichols 1988, pp. 246–47, on the evidence of Jan Govertsz van der Aar's activity as a cloth merchant and his investment in the VOC. He appears to have carried on trade with English merchants. Jan Govertsz is first recorded in Haarlem in May 1602 ("merchant residing here about sixty years old"; see Nichols 1988, p. 246), but he could have settled there some years earlier. Van Thiel (1999, p. 43) mistakenly writes that Van der Aar "settled in Haarlem in 1602."

23. Slive in Washington–London–Haarlem 1989–90, p. 185.

24. See Strauss 1977, vol. 2, nos. 309, 310; Orenstein et al. in Amsterdam 1993–94a, p. 182 (where the date is incorrectly given as 1595); and Schapelhouman in Amsterdam–New York–Toledo 2003–4, pp. 147–48, fig. 63.

25. For all eight lines, and a slightly different translation, see Washington–London–Haarlem 1989–90, p. 185. From the sentiment and syntax it would appear that Scriverius is describing himself. It will be recalled that an impression of this print was given to Van Buchell by Schrevelius.

26. Slive 1970–74, vol. 1, p. 27, fig. 9, vol. 3, p. 3 (under no. 4, the male portrait in Brooklyn, cited in the text following). For two etchings by Pietersz, both of 1593, see Boston–Saint Louis 1980–81, nos. 9, 10.

27. Slive 1970–74, vol. 2, pl. 14; Washington–London–Haarlem 1989–90, p. 185, fig. 20b.

28. See Amsterdam–New York–Toledo 2003–4, no. 15 (*Grietgen Jansdr,* 1580); also p. 60, fig. 35 (*Portrait of Erasmus Pleiobius,* 1584).

29. Ibid., no. 55.

30. See Van Mander/Miedema 1994–99, vol. 1, pp. 322, 325; Brusati 1995, pp. 10–12; Liedtke 2004c, pp. 19, 23–24.

31. See Lemgo–Antwerp 2002, nos. 144, 162.

32. The print is widely reproduced, for example in Alpers 1983, fig. 58.

33. Plomp in Rotterdam–New York 2001, p. 243 (under no. 110).

Esmée Quodbach observes that the expression originated in printer's jargon.

34. As noted in Van Mander/Miedema 1994–99, vol. 5, p. 8 (commentary at fol. 262r30).

35. Amsterdam–New York–Toledo 2003–4, p. 165 (under no. 57).

36. For superb examples by Goltzius, see ibid., nos. 2, 3, 48–50, 53.

37. See, for example, G. Schwartz 1985, p. 235, where it is stated simply that "Rembrandt took as his model the portrait of Scriverius by Frans Hals." Slive in Washington–London–Haarlem 1989–90, p. 185, fig. 20c, and Welzel in Berlin–Amsterdam–London 1991–92b, pp. 228–30, make the connection in a more moderate way. See also Dickey 2004, p. 64.

38. The interest of Hals's portraits of 1627 for the Sylvius print is noted by Ackley in Boston–Saint Louis 1980–81, p. 150 n. 1, and at greater length in Dickey 2004, p. 64, figs. 43 (print of Acronius), 68 (Sylvius).

39. Strauss and Van der Meulen 1979, p. 526, doc. 1663/7. See Wurfbain in Leiden 1976–77, p. 68 (under no. s26); G. Schwartz 1985, pp. 25, 35–38; Westermann in Boston 2000–2001, p. 40; and especially Dudok van Heel 2006, pp. 191–92. Also relevant, if not helpful, are Van den Boogert in Kassel–Amsterdam 2001–2, p. 147 (under no. 7), and Van Straten 2005, p. 48. Another suggestion concerning the subject of the Leiden *History Painting,* that it represents the Clemency of Claudius Civilis, has been made by Benjamin Binstock, as reported in Schama 1999a, pp. 226–27.

40. Van Eeghen 1971b; Van Thiel-Stroman in Washington–London–Haarlem 1989–90, p. 410 (under doc. 166). As explained by Van Thiel-Stroman, Floris Soop's father (and Scriverius's brother), Jan Hendricksz Schrijver (1578–1638), adopted the surname of his maternal grandfather, Jan Soop. In a personal communication (March 2006), S. A. C. Dudok van Heel kindly explained that the portrait of Floris Soop could not have been one of the "twee braave groote stukken" sold in 1663, since such a description would never have been employed for portraits in a seventeenth-century Dutch sale catalogue or inventory.

REFERENCES: Tardieu 1873, p. 219, describes the composition and reproduces the signature, date, and inscription; Eudel 1882, p. 72, mistakenly lists the Kaiser-Friedrich Museum, Berlin, as the buyer at the Wilson sale, and gives the purchase price as FFr 80,000 for the pair; Bode 1883, pp. 55, 84, no. 65, mentions the picture and its pendant as in the Secrétan collection; D. Franken and Van der Kellen 1883, p. 37 (under no. 33), lists three states of the engraving by Jan van de Velde after this portrait; possibly Van Ryn 1887, p. 151, publishes Van Buchell's supposed reference to a portrait of Scriverius (actually a print) in the collection of Theodorus Schrevelius in Leiden; Moes 1897–1905, vol. 2 (1905), p. 370, no. 7130-2, lists the painting and its pendant as in the Wilson and Secrétan sales, and as previously in the collection of M. J. Caan van Maurik at Oudewater, and identifies the picture with a portrait of Scriverius said to have been mentioned by Aernout van Buchell in 1628 as in the collection of Theodorus Schrevelius in Leiden; Hofstede de Groot 1906a, pp. 9–10 (under no. 14), identifies the picture with the portrait of Scriverius mentioned by Aernout van Buchell in 1628; Moes 1909, pp. 32, 103, no. 72, records the Havemeyer purchase at the Secrétan sale of 1889, where the pair sold for the "enormous sum of 91,000

francs"; Hofstede de Groot 1907–27, vol. 3 (1910), pp. 67–68, no. 224, as in the Havemeyer collection, describes the composition and reviews provenance; Mireur 1911–12, vol. 3, pp. 405, 406, records the Wilson and Secrétan sales; Péladan 1912 (ill. opp. p. 50), as "Un homme"; Bode and Binder 1914b, vol. 1, p. 39, no. 106, pl. 57A, as *Petrus Scriverius*, owned by Mrs. H. O. Havemeyer, New York; Valentiner 1923, pp. 306, 309 (ill. p. 50), states that the two portraits were obviously made as models for engravings, but none of the female pendant is known; Mather 1930, p. 462, praises "the largeness of stroke . . . that must be arrested within a fraction of an inch" in these "rather large miniatures"; Wehle 1930, p. 60, refers to these "small and early but brilliant portraits of Petrus Scriverius and his wife by Hals" as in the exhibition of the Havemeyer collection; Havemeyer 1931, pp. 16–17 (ill.), adds Le Roy to provenance; Valentiner in Detroit 1935, unpaged, no. 6 (ill.), notes that this portrait and its pendant are "perhaps the earliest pictures by Frans Hals to come to America"; Valentiner 1936, pp. 8–9, no. 17 (ill.), admires the "lightning-like technique" and illusionistic effect of the painted frame; K. Bauch 1960, pp. 40–41, fig. 26, suggests that Scriverius may have requested this format for his portrait, since he would have known the similar miniature portrait drawings by David Bailly, but Hals follows a pattern employed in portrait engravings, for example Jacob Matham's *Portrait of Hendrick Goltzius,* of 1617; Havemeyer 1961, p. 20, describes the hanging in the Havemeyer home; J. Rosenberg, Slive, and Ter Kuile 1966, p. 42, cites the work as an example of the miniature portraits that Hals painted "as modellos for engravers"; Slive 1970–74, vol. 1, pp. 58, 59, 77, describes the spatial effect, and questions whether this is the portrait mentioned by Van Buchell, vol. 2, pl. 60, vol. 3, pp. 22–23, 35, no. 36, calls the painting a *modello* for a print, and states that this portrait and its pendant were possibly in the collection of Theodorus Schrevelius in Leiden in 1628 (see Moes 1897–1905 above); Grimm 1972, pp. 29, 63, 200, no. A9, considers this painting and its pendant to be copies;[1] Grimm and Montagni 1974, p. 92 (under no. 45), fig. 45a, records that various scholars consider this picture and its pendant as autograph works by Hals, but Trivas (by excluding them from his monograph) and Grimm view them as copies; Ekkart in Leiden 1976–77, pp. 35, 39 n. 1, fig. a, notes that the Leiden scholar turned to a Haarlem artist; Wurfbain 1977, p. 111, cites the painting in connection with a supposed portrait of Scriverius by Bartholomeus van der Helst; Strauss and van der Meulen 1979, p. 61 (under doc. 1628/1), mentions the work in connection with the Buchelius account (in which the young Rembrandt is also mentioned, but not by name); G. Schwartz 1985, pp. 25, 45, reproduces Jan van de Velde's print after the painting, translates the inscription, and relates circumstances that might have brought Scriverius to Haarlem in 1626; P. Sutton 1986, pp. 183–84, mentioned; Weitzenhoffer 1986, pp. 58, 77, 158, 254 (ill. p. 74 [photograph in the Havemeyer house]), records the Havemeyer purchase "for $9,000 each"; Nichols 1988, pp. 245, 252 n. 23, mentions the portraits in connection with Anna van der Aar's uncle Jan Govertsz van der Aar (Goltzius's sitter, in 1603); Grimm 1989, pp. 34, 53, 234, 284–85, no. K7, figs. 49a, 123a (detail), pl. 97 (detail), as a copy after Hals; Groen and Hendriks in Washington–London–Haarlem 1989–90, pp. 111, 115, 120, 124, report the color of the ground layer and the main pigments present in the paint layers, and note that the panels come from differing cuts of trees, one radial, one (Scriverius) tangential and close to the bark, resulting in splits; Slive in ibid., pp.

142, 185, 189, 202 (ill. p. 186), discusses the different wood supports, a few of the sitter's connections to Haarlem, Hals's illusionistic treatment of a "porthole" framing device (also found in his large *Portrait of a Man,* of 1622, at Chatsworth), Van de Velde's engraving (the entire inscription is quoted in translation), and the question of whether the painting was made expressly as a *modello* for the print; Van Thiel-Stroman in ibid., pp. 383 doc. 42, 409 (under doc. 166), mentions the portrait in connection with the print after it which Schrevelius gave to Van Buchell in 1628, and cites the picture and its pendant in connection with the estate inventory of Scriverius's son, Willem Schrijver (1608–1661); Grimm 1990, pp. 34, 53, 234, 291–92, no. C7, figs. 49a, 123a, pl. 97, as a copy after Hals; Liedtke 1990, p. 46, mentions the portraits as part of the Havemeyer bequest; P. Sutton 1990b, p. 68, commends the findings of Groen and Hendriks (published in Washington–London–Haarlem 1989–90) that this picture and its pendant were painted on differing wood supports; De Baar and Moerman in Leiden 1991–92, p. 25, cite the picture while noting that Jan Lievens also painted a portrait of Scriverius; Welzel in Berlin–Amsterdam–London 1991–92b, pp. 228, 230 n. 12, compares Rembrandt's etching of Sylvius (1646); Frelinghuysen in New York 1993, fig. 30 (photograph of the Havemeyers' Rembrandt room, where the Hals portraits hung); Liedtke in ibid., p. 65, pl. 64, suggests that these pictures and the Rembrandts in Harry Havemeyer's study "established an air of propriety that somehow became the collector's own"; Stein in ibid., p. 209, describes the acquisition in Paris; Wold in ibid., pp. 348–49, no. A320 (ill.); Havemeyer 1993, pp. 20, 310 n. 38, describes the hanging in the Havemeyer home (details of the purchase in Paris are given in the footnote); Baetjer 1995, p. 301; Kleinmann 1996, p. 73 n. 262, fig. 31, remarks on the adaptation of the framing device from portrait engravings; G. Schwartz in *Dictionary of Art* 1996, vol. 28, p. 309, mentioned; Carasso 1998, fig. 17, reproduces the painting as an (oddly chosen) example of Hals's work in general; Judson and Ekkart 1999, p. 189 (under no. 240), mentions the portrait in connection with Scriverius's inscription on an engraving by Matham (1627) after a genre picture by Honthorst; Schama 1999a, p. 714 n. 2, mistakenly dates the picture to 1625; Royalton-Kisch in Amsterdam–London 2000–2001, p. 227 n. 6, compares Rembrandt's etching of Sylvius; Van de Wetering in Kassel–Amsterdam 2001–2, p. 29, fig. 9 (detail), mentions the portrait in connection with the hypothesis that Scriverius bought paintings of 1625–26 by Rembrandt; Wheelock in Washington 2002–3, p. 79, fig. 2, cites the work as an example of Dutch illusionisim; Nichols in Amsterdam–New York–Toledo 2003–4, p. 330 n. 114, mentions the Hals portraits in connection with Anna van der Aar's uncle Jan Govertsz van der Aar (Goltzius's sitter, in 1603); Dickey 2004, pp. 64, 182 n. 195, compares Rembrandt's 1646 portrait etching of Sylvius; Quodbach 2004, p. 99, fig. 7, identifies the picture in a photograph of Havemeyer's library; Dudok van Heel 2006, pp. 30–31, fig. 15, p. 263 (ill. in genealogical outline), reproduces the portrait in connection with an account of Scriverius's involvement in Remonstrant politics; G. Schwartz 2006, pp. 144, 145, mentions the portrait of Scriverius in a discussion of the scholar as a Rembrandt patron. Tuynman 2006, pp. 223–24, figs. 15c, 15d, suggests unconvincingly (based on a reading of Van Buchell's account) that both this portrait and its pendant may have been engraved by Van de Velde.

EXHIBITED: Brussels, Cercle Artistique et Littéraire, "Collection de M. John W. Wilson," 1873; Paris, Palais de la Présidence du Corps Législatif, "Ouvrages de la peinture exposés au profit de la colonisation de l'Algérie par les Alsaciens-Lorrains," 1874, no. 231 (lent by Wilson); New York, MMA, "The H. O. Havemeyer Collection," 1930, no. 69; Detroit, Mich., The Detroit Institute of Arts, "Fifty Paintings by Frans Hals," 1935, no. 6; Richmond, Va., Virginia Museum of Fine Arts, 1947; Palm Beach, Fla., Society of the Four Arts, "European Masters of the XVII and XVIII Centuries," 1950, no. 3; Des Moines, Iowa, Des Moines Art Center, "Masterpieces of Portrait and Figure Painting," 1952–53; Pensacola, Fla., Pensacola Art Center, "Opening Exhibition," 1955; Jacksonville, Fla., Jacksonville Art Museum, 1955–56; New York, MMA, "Dutch Couples: Pair Portraits by Rembrandt and His Contemporaries," 1973, no. 4 (with pendant); New York, MMA, "Splendid Legacy: The Havemeyer Collection," 1993, no. A320.

EX COLL.: Petrus Scriverius, Leiden and Oudewater (1626–d. 1660); probably his son, Willem Schrijver (1660–d. 1661), Oudewater; Van Hoogstraten family, Willeskop (in the mid-1800s); [by descent to?] M[arie] J. Caan van Maurik, Oudewater and/or The Hague; [Étienne Le Roy, Brussels]; John Waterloo Wilson, Brussels and Paris (by 1873–81; his sale, at his hôtel, 3, Avenue Hoche, Paris, March 14–16, 1881, no. 56, for FFr 80,000 with pendant, to Petit); [Galerie Georges Petit, Paris, from 1881]; E. Secrétan, Paris (by 1883–89; his sale, Galerie Charles Sedelmeyer, Paris, July 1–7, 1889, no. 124, for FFr 91,000 with pendant, to Durand-Ruel for Havemeyer); Mr. and Mrs. H. O. Havemeyer, New York (1889–his d. 1907); Mrs. H. O. Havemeyer, New York (1907–d. 1929); H. O. Havemeyer Collection, Bequest of Mrs. H. O. Havemeyer, 1929 29.100.8

1. In Grimm 1972, all twenty-five of the small portraits by Hals (which are accepted in Slive 1970–74) are considered as copies after lost originals. The absurdity of this hypothesis is concisely explained in Bijl 2005, pp. 47–48, where Hals's authorship of the Schrevelius portrait (Frans Halsmuseum, Haarlem) is proven by technical evidence (pp. 52–54).

64. *Anna van der Aar*

Oil on wood, 8¾ x 6½ in. (22.2 x 16.5 cm)
Signed, dated, and inscribed (lower border of painted frame): FHF 1626 [FH in monogram]; (left center): A⁰ ÆTAT/50

The painting is very well preserved. A small hole at top center, now repaired, may have been caused by a hanging device.

H. O. Havemeyer Collection, Bequest of Mrs. H. O. Havemeyer, 1929 29.100.9

Anna van der Aar was born in Leiden in 1576 or 1577, and died there on September 9, 1656. Her parents were Willem Govertsz van der Aar (1540/41–1617), the City Councilman and sheriff, and his first wife, Alijt Claesdr den Hartogh (1542–1579). Anna was raised by Geertje Huijgensdr Duyck (d. 1604), who married Willem van der Aar in July 1579, four months after his first wife died. On May 22, 1599, Anna married the poet and historian Petrus Scriverius (see the preceding entry).

Anna's father, Willem, three of his brothers, and his brother-in-law, Albrecht Gerritsz van Hoogeveen, were active in Leiden's flourishing textile industry and in civic affairs. Another of Willem's brothers, Jan Govertsz van der Aar (1544/45–1612), was evidently also a cloth merchant. He moved to Haarlem by March 1602 (possibly years earlier), and in 1603 was depicted as a shell collector in a well-known canvas by Hendrick Goltzius (P. and N. de Boer Foundation, Amsterdam,

on loan to the Museum Boijmans Van Beuningen, Rotterdam).[1] The role of Anna van der Aar's uncle Jan Govertsz in the art world of Haarlem is also discussed above, in connection with Scriverius.

A possible portrait of the same woman, at the age of eighteen (1595), was painted by Isaac van Swanenburg (1537–1614).[2] Van Swanenburg was the next-door neighbor of Anna's parents. Scriverius wrote a long poem in memory of the artist's son in Jan Orlers's *Beschrijvinge der Stad Leyden* (Description of the City of Leiden), of 1614.[3]

In the year of her death, 1656, Anna van der Aar's eightieth birthday was celebrated by an album of poetry presented by friends.[4]

1. See Amsterdam–New York–Toledo 2003–4, pp. 286–88, no. 104. The preceding biographical information on all the Van der Aars is adopted from Nichols 1988, pp. 244–45 (with family tree).
2. See Ekkart 1998, pp. 76, 157, no. 20, fig. 68, where it is allowed that the sitter could also be a cousin of Anna van der Aar. However, there is a resemblance to the woman Hals painted about thirty-one years later.
3. Ibid., p. 10.
4. Wolleswinkel 1977, p. 109, cited by Slive in Washington–London–Haarlem 1989–90, p. 185.

REFERENCES: Tardieu 1873, p. 219, describes the composition and reproduces the signature, date, and inscription; Eudel 1882, p. 72, mistakenly lists the Kaiser-Friedrich-Museum, Berlin, as the buyer at the Wilson sale and gives the purchase price as FFr 80,000 for the pair; Bode 1883, pp. 55, 84, no. 66, mentioned as in the Secrétan collection; Moes 1897–1905, vol. 1, p. 2, no. 7, listed as in the Wilson and Secrétan sales, and previously in the collection of M. J. Caan van Maurik, The Hague; Moes 1909, pp. 32, 103, no. 73, records the Havemeyer purchase at the Secrétan sale (1889) of both portraits for the "enormous sum of 91,000 francs"; Hofstede de Groot 1907–27, vol. 3 (1910), p. 68, no. 225, as in the Havemeyer Collection, describes the composition and reviews provenance; Mireur 1911–12, vol. 3, pp. 405, 406, records the Wilson and Secrétan sales; Péladan 1912 (ill. opp. p. 52), as "Une dame"; Bode and Binder 1914b, vol. 1, p. 39, no. 107, pl. 57B, as *Anna van der Aar, the Wife of Petrus Scriverius*, owned by Mrs. H. O. Havemeyer, New York; Valentiner 1923, p. 309 (ill. p. 50), notes that Scriverius was a celebrated historian and poet in Leiden; Mather 1930, p. 462, praises "the largeness of stroke . . . that must be arrested within a fraction of an inch" in these "rather large miniatures"; Havemeyer Collection 1931, pp. 16–17 (ill.), adds Le Roy to provenance; Valentiner in Detroit 1935, unpaged, no. 7 (ill.), notes that this portrait and its pendant are "perhaps the earliest pictures by Frans Hals to come to America"; Valentiner 1936, pp. 8–9, no. 18 (ill.), admires the "lightning-like technique" and illusionistic effect of the painted frame; Havemeyer 1961, p. 20, describes the hanging in the Havemeyer home; Slive 1970–74, vol. 1, pp. 58, 59, describes the spatial effect, vol. 2, pl. 61, vol. 3, pp. 22–23, no. 37, states that this portrait and its pendant were pos-

sibly in the collection of Theodorus Schrevelius in Leiden in 1628 (see Moes 1897–1905 above); Grimm 1972, pp. 29, 63, 200, no. A10, considers this painting and its pendant to be copies; Grimm and Montagni 1974, p. 92 (under no. 46), fig. 46a, records that various scholars consider this picture and its pendant as autograph works by Hals, but Trivas (by excluding them from his monograph) and Grimm view them as copies; Ekkart in Leiden 1976–77, pp. 35, 39 n. 1, fig. a, notes that the couple turned to a Haarlem artist; P. Sutton 1986, pp. 183–84, mentioned; Weitzenhoffer 1986, pp. 58, 77, 158, 254 (ill. p. 74 [photograph in the Havemeyer house]); Nichols 1988, pp. 245, 252 n. 23, refers to the portraits in connection with Anna van der Aar's uncle Jan Govertsz van der Aar; Grimm 1989, pp. 34, 53, 284–85, no. K8, fig. 49b, as a copy after Hals; Groen and Hendriks in Washington–London–Haarlem 1989–90, pp. 111, 115, 120, 124, report the color of the ground layer and the main pigments present in the paint layers; Slive in ibid., pp. 142, 154, 185, 189, 202, no. 20 (ill. p. 187), explains why this portrait and not its pendant (which has a split in the panel) was included in the exhibition of 1989–90, and devotes most of the discussion to the male portrait; Van Thiel-Stroman in ibid., p. 409, doc. 166, mentions this portrait and its pendant in connection with the estate inventory of Scriverius's son, Willem Schrijver (1608–1661); Grimm 1990, pp. 34, 53, 291–92, no. C8, fig. 49b, as a copy after Hals; Liedtke 1990, p. 46, mentions the portraits as part of the Havemeyer bequest; P. Sutton 1990b, p. 68, commends the findings of Groen and Hendriks (published in Washington–London–Haarlem 1989–90) that this picture and its pendant were painted on differing wood supports; Frelinghuysen in New York 1993, fig. 30 (photograph of the Havemeyers' Rembrandt room, where the Hals portraits hung); Liedtke in ibid., p. 65, pl. 65, refers to these pictures as hanging with Rembrandt portraits in Harry Havemeyer's study; Stein in ibid., p. 209, describes the acquisition in Paris; Wold in ibid., pp. 348–49, no. A319 (ill.); Havemeyer 1993, pp. 20, 310 n. 38, describes the hanging in the Havemeyer home (details of the purchase in Paris are given in the footnote); Baetjer 1995, p. 301; Kleinmann 1996, p. 73 n. 262, remarks on the adaptation of the framing device from portrait engravings; Nichols in Amsterdam–New York–Toledo 2003–4, p. 330 n. 114, mentions the Hals portraits in connection with Anna van der Aar's uncle Jan Govertsz van der Aar; Quodbach 2004, p. 99, fig. 7, identifies the picture in a photograph of Havemeyer's library; Dudok van Heel 2006, pp. 30–31, fig. 16, p. 263 (ill. in genealogical outline), illustrates the portrait and its pendant in connection with Scriverius's politics.

EXHIBITED: Brussels, Cercle Artistique et Littéraire, "Collection de M. John W. Wilson," 1873; Paris, Palais de la Présidence du Corps Législatif, "Ouvrages de la peinture exposés au profit de la colonisation de l'Algérie par les Alsaciens-Lorrains," 1874, no. 232 (lent by Wilson); New York, MMA, "The H. O. Havemeyer Collection," 1930, no. 70; Detroit, Mich., The Detroit Institute of Arts, "Fifty Paintings by Frans Hals," 1935, no. 7; Richmond, Va., Virginia Museum of Fine Arts, 1947; Palm Beach, Fla., Society of the Four Arts, "European Masters of the XVII and XVIII Centuries," 1950, no. 4; Des Moines, Iowa, Des Moines Art Center, "Masterpieces of Portrait and Figure Painting," 1952–53; Pensacola, Fla., Pensacola Art Center, "Opening Exhibition," 1955; Jacksonville, Fla., Jacksonville Art Museum, 1955–56; New York, MMA, "Dutch Couples: Pair Portraits

by Rembrandt and His Contemporaries," 1973, no. 4 (with pendant); Washington, D.C., National Gallery of Art, "Frans Hals," 1989, no. 20; New York, MMA, "Splendid Legacy: The Havemeyer Collection," 1993, no. A319.

EX COLL.: The painting has the same history of ownership as its pendant; see Ex Coll. for *Petrus Scriverius* (Pl. 63); H. O. Havemeyer Collection, Bequest of Mrs. H. O. Havemeyer, 1929 29.100.9

65. *Portrait of a Man, possibly Nicolaes Pietersz Duyst van Voorhout*

Oil on canvas, 31¾ x 26 in. (80.6 x 66 cm)

The painting is in good condition, although the impasto is slightly flattened. The area of the hair has suffered abrasion, and there is one large area of paint loss in the hair at left. The paint surface in the background to the left of the head and the deep shadows in the costume are also abraded. Two large areas and one small area of paint loss along the brim of the hat that extend into the background.

The Jules Bache Collection, 1949 49.7.33

This brilliantly painted portrait must date from about 1636–38, to judge from the style of the costume, in particular the very broad lace collar that extends over the shoulders. Hals's description of blurred reflections on the satiny surface of the pewter-toned jacket is especially masterful.

The sitter's identity was written on the back of a panel to which the original canvas was attached until 1927.[1] In 1920, Collins Baker (see Refs.) transcribed the Dutch inscription as "Claas Duyst van Voorhout brouwer in des Brouwerij het Zwaanschel?" (Claas Duyst van Voorhout brewer in the brewery Het Zwaanschel?). The Petworth catalogue of 1856 (see Refs.) misquotes the same inscription.

A Nicolaes (Claes) Pietersz Duyst van Voorhout owned a Haarlem brewery called Het Swaenshals (The Swan's Neck) in 1629, when he gave his age as twenty-nine (born ca. 1600).[2] He was the son of the brewer Pieter Claesz Duyst van Voorhout (ca. 1569–1624) and his wife, Maria (or Maritge) Quirijnsdr Aecker (d. 1646). A portrait of the elder Duyst by an anonymous Haarlem artist (Frans Halsmuseum, Haarlem) is dated 1625, gives the sitter's age as fifty-six, and bears a crest with the necks (and heads) of three swans.[3]

Hals's sitter could certainly be a man in his mid- to late thirties. But how reliable is the old inscription? It was evidently followed by a question mark, and it probably dates from decades after the painting itself, when the canvas needed additional support. For all we know, the inscription came with the wood panel and does not refer to the portrait at all. However, an inventory of Nicolaes Duyst (or Duijst) van Voorhout's estate, dated November 7, 1650, indicates that he was an enthusiastic collector of paintings by Haarlem and other artists, and that he owned one or two independent portraits of himself (it appears that the patron never married) and pendant portraits of his parents and of his grandparents.[4] Hals's name is not mentioned in the inventory, but none of the nine portraits in the inventory is attributed, evidently because the notary, Nicolaes van Bosvelt, or Duyst van Voorhout's heirs were more concerned with the identity of the sitters. Of the forty-seven paintings listed in the inventory, twenty-six are ascribed to specific artists, including Rubens, Hendrick Goltzius, Jan van Goyen, Pieter Claesz, and a number of well-known marine and still-life painters.[5]

The identification of Hals's subject as Nicolaes Pietersz Duyst van Voorhout (ca. 1600–1650) may be cautiously maintained, based on the circumstantial evidence. Slive, following Waagen's Victorian assessment of one hundred twenty years earlier, discovers in the sitter's features a fondness for alcohol, and states that Waagen's "estimate of the model's drinking habits was virtually substantiated when it was discovered that the man portrayed [was the owner of a brewery]."[6] There is nothing in the sitter's pose or serious expression (except, perhaps, for his somewhat ruddy complexion) that justifies this subjective interpretation. Furthermore, the owners of breweries in Haarlem, Delft, and other Dutch cities were often prominent citizens, a number of whom held government

offices. For example, the Delft brewer Aper Frans van der Houve was a wealthy collector of art and naturalia who was praised by Karel van Mander and sought out by the Utrecht humanist Aernout van Buchell (Buchelius).[7] The widow of the Haarlem brewer Pieter Quirijnsz Aker (our presumed sitter's uncle), Belitge Ewoutsdr Schilperoorts, was the most senior regent of the Saint Elizabeth Hospital in Haarlem, as Johannes Verspronck (q.v.) makes clear in his sober group portrait of the institution's administrators, dated 1641 (Frans Halsmuseum, Haarlem).[8]

1. A memo from Duveen Brothers, London, to the same firm in New York, dated October 18, 1927, reports that "the Frans Hals, you remember, was painted on canvas stuck on to wood, and the panel was badly split. We are having it transferred on to canvas which will take at least three weeks. Then, we shall have to restore the picture and frame it" (photocopy in curatorial files).

2. As noted by Slive in Washington–London–Haarlem 1989–90, p. 280, citing a letter dated May 30, 1975, from Josine E. de Bruyn Kops, curator at the Frans Halsmuseum, to research assistant Donald Rosenthal in the Department of European Paintings, MMA. The letter cites the will, dated July 23, 1629, of "Nicolaes Duyst Pietersz." (notary Jacob Schoudt; Gemeentearchief, Haarlem, Reg. 128, fol. 211), in which the testator's mother, "Maria Quirynsdr. Aker," is named as sole beneficiary. The same man, described as "Nicolaes Duyst van Voorhout," appeared before the same notary on April 3, 1626 (ibid., Reg. 127, fol. 39v), and on that occasion (which involved granting power of attorney) was called "brewer in the Swaenshals." His father, "Pieter Duyst," testified about a delivery of wheat on January 27, 1614 (notary Egbert van Bosvelt; ibid., Reg. 56, fol. 141), and in that document is called "brewer in the Swaenshals." In the same letter of 1975, De Bruyn Kops dismisses from consideration two other Claes Duyst van Voorhouts from consideration, one born about 1611 (son of Augustijn Duyst van Voorhout and Tanneke Vogel), and one born in 1618 (son of Joost Duyst van Voorhout and Geertruyd Jansdr van Napels).

3. The date is not 1623, as recorded in old catalogues. Pieter Biesboer, curator at the Frans Halsmuseum (personal communication, March 28, 2006), kindly brought the earlier misreading of the date to my attention.

4. Biesboer 2001, pp. 123–25, inventory no. 29. Duyst van Voorhout died on April 16, 1650. The family portraits are recorded as nos. 18 and 35 (the deceased), no. 6 (his parents; "Crijns" = Quirijns), and no. 44 (his grandparents). Biesboer (ibid., p. 123) mistakenly records that Nicolaes Pietersz was married to Guertgen Augusteynsdr Steyns, who was his grandmother (kindly acknowledged by the author; see note 3 above). No evidence of a spouse is known.

5. Ibid., pp. 123–25. Of the forty-seven entries, six refer to maps or prints, but nos. 6, 29, and 44 each refer to two paintings, and no. 42 to four, which adds up to six additional paintings.

6. Slive 1970–74, vol. 3, p. 64 (under no. 119); repeated almost verbatim in Washington–London–Haarlem 1989–90, p. 280.

7. See Liedtke and Bok in New York–London 2001, pp. 39, 90, 206–7.

8. Haarlem 1979, pp. 83–84, 156 (ill.), no. 29; cited in Biesboer 2001, p. 123.

REFERENCES: Waagen 1854, vol. 3, p. 36, records this portrait as in the collection of Colonel Wyndham at Petworth House, is "inclined to attribute" the picture ("of great breadth, and spiritedly treated") to Hals, and observes that the man's eyes and cheeks reveal "many a sacrifice to Bacchus"; *Catalogue of Pictures in Petworth House, Sussex* (London, 1856), p. 41, no. 383, as "Portrait of 'Van Voorhout,'" by Frans Hals, gives an inaccurate reading of the inscription on the back; Bode 1883, p. 92, no. 153, as a portrait of a middle-aged gentleman by Hals, dating from about 1630; Moes 1909, p. 101, no. 33, identifies the sitter as Claes Duyst van Voorhout; Hofstede de Groot 1907–27, vol. 3 (1910), p. 55, no. 176, as *Claas Duyst van Voorhout*, in the collection of Lord Leconfield, Petworth; Bode and Binder 1914b, vol. 1, p. 40, no. 114, pl. 62, as by Hals, *Claas Duyst van Voorhout, The 'De Zwaan' Brewer*, erroneously as on panel; Collins Baker 1920, p. 53, no. 383 (ill. opp. p. 52), as "a latish example of fine quality," records the identification of the sitter inscribed on the back of the panel to which the canvas was mounted; Valentiner 1921a, pp. 145 (ill.), 316, dates the painting to about 1636; Valentiner 1923, pp. 154 (ill.), 316, dates the painting to about 1636; Hussey 1925–26, pp. 901 (ill., with incorrect caption), 902, describes the picture as a late work by Hals, identifies the subject (citing Bode), perceives "the complexion one expects to find on a brewer," and observes that "where another artist might have made Voorhout merely a sodden boor, there is a fine braggartry about this portrait which makes the subject, with all his beerishness, the equal of the 'Laughing Cavalier' as representative of the glories and weaknesses of seventeenth century Dutchmen"; Hussey 1926, pp. 38 (ill.), 39, reprints Hussey 1925–26; Valentiner 1928b, p. 248, describes the picture as "one of the finest portraits painted by Hals in the middle thirties"; A. Alexandre 1929, pp. 117 (ill.), 130, "one of the greatest and liveliest" of Hals's portraits; Bache Collection 1929, unpaged (ill.), identifies the sitter as "the proprietor of the Zwaan Brewery at Leyden"; Heil 1929, pp. 4, 27 (ill.), as "painted in 1636," compares a portrait by Van Dyck; Witt 1929, pl. II, with no comment; Cortissoz 1930, p. 259, compares Rembrandt, and admires Hals's "technical fireworks"; Dülberg 1930, p. 144, as in the Bache collection, subjectively interprets the sitter's expression; Valentiner in Detroit 1935, unpaged, no. 33 (ill. in introductory text), relates the sitter in this "brilliant, pompous" portrait to Shakespeare's comedic figures; Valentiner 1936, pp. 11–12, no. 59 (ill.), compares Hals's portrait of Willem Heythuysen and another male portrait; Bache Collection 1937, no. 34 (ill.), as dating from about 1636, gives provenance and lists of exhibitions and references; Van Dantzig 1937, p. 47, no. 19, as by Hals in 1636; Siple 1937, p. 93, mentioned as in the 1937 Haarlem exhibition; *Duveen Pictures* 1941, unpaged, no. 192 (ill.), praises the picture; Trivas 1941, pp. 45–46, no. 62, pls. 84, 85, as from about 1636, inaccurately reports that "the name of the model [is] inscribed on the reverse side of the canvas"; Bache Collection 1943, no. 33 (ill.), repeats Bache Collection 1937; Slive 1970–74, vol. 1, pp. 86–88, 122–23, suggests a date of about 1638, vol. 2, pls. 195, 197, vol. 3, pp. 63–64, no. 119, describes the composition, explains the

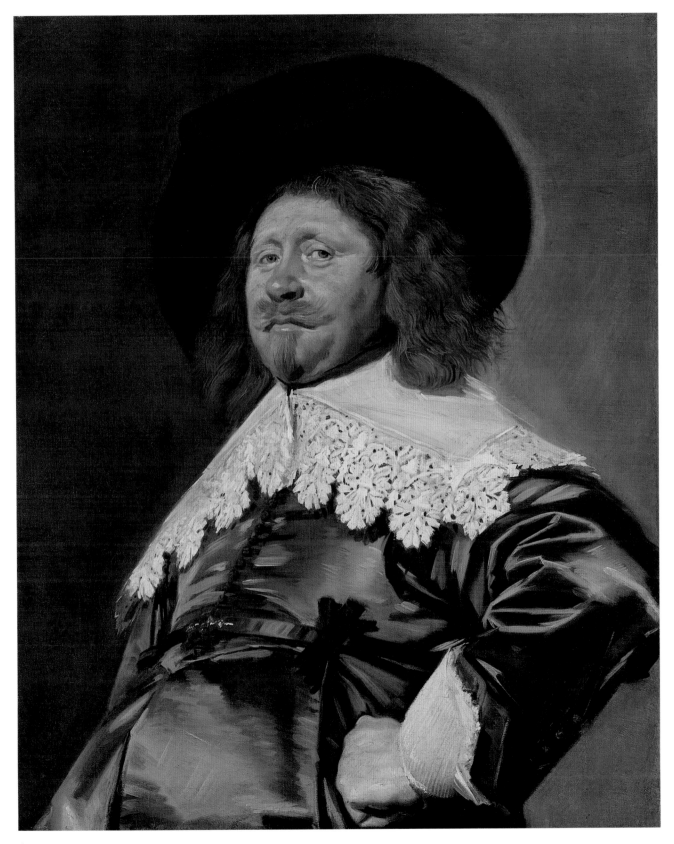

65

basis for the sitter's identification, and dates the painting to the mid- or late 1630s; Grimm 1972, pp. 93–94, 96, 128, 141, 155, 202, no. 73, figs. 95, 99, as from about 1635, compares various works by Hals; Grimm and Montagni 1974, pp. 99–100, no. 110, pl. XLI, explains the basis of the sitter's identification; Baard 1981, pp. 18, 122, pl. 30, suggests a date of about 1638; Pope-Hennessy in Bordeaux 1981, pp. 85, 88, no. 103 (ill.), dates the portrait to about 1630–35 and notes that the identification of the sitter is not certain; P. Sutton 1986, p. 185, fig. 261, concludes that "the identification of the lionine and not-a-little corpulent gentleman (his girth enhanced by the low point of view), who is supposed on the strength of an old inscription to depict [be?] Claes Duyst van Voorhout, is given added credence once we learn that Voorhout owned a brewery called 'in den Swaenshals'"; Grimm 1989, pp. 139, 184, 277, 284, no. 81, fig. 83, pl. 59 (a much too red and oversize detail of the face), dates the painting to about 1635–36, and describes the subject; Groen and Hendriks in Washington–London–Haarlem 1989–90, pp. 119, 123 n. 64, pp. 125–27, pl. VIII, fig. g (detail of paint cross section), report the color of the ground layer and the main pigments present in the paint layers; Slive in ibid., pp. xi (large detail of costume and hand), 170, 280–81, no. 52, as dating from about 1638, repeats the comments made in Slive 1970–74; Grimm 1990, pp. 138–39, 184, 282 (ill.), 291, no. 81, fig. 83, pl. 59 (detail of face), repeats Grimm 1989 in translation; Liedtke 1990, p. 52, mentions Bache's purchase of the picture in 1928; P. Sutton 1990b, p. 69, compares Waagen's reading of the sitter's character with Slive's slightly more restrained approach; Ingamells 1992a, p. 138 n. 12, lists the picture as one of the works in which the low viewpoint and pose of Hals's *Laughing Cavalier* are repeated; Baetjer 1995, p. 301; Wheelock 1995a, p. 74, fig. 1, dates the picture to about 1638, and finds the same pose in reverse in Hals's *Portrait of a Member of the Haarlem Civic Guard,* of about 1636–38 (National Gallery of Art, Washington, D.C.); Atkins 2004, pp. 297, 306 n. 80, mentions the picture as a portrait of "Nicolaes Duijst van Voorhout," from about 1638, and notes that numerous paintings of "extremely high quality" are listed in his estate inventory of 1650; Secrest 2004, p. 447, mentioned as sold by Duveen; Liedtke in Martigny 2006, pp. 70–74, no. 11, dates the picture to about 1636–38, discusses the identification of the sitter, and compares the com-

position of the portrait of Peeter Stevens in the Iconography series of engravings after Van Dyck; Liedtke in Barcelona 2006–7, pp. 42–45, no. 8, repeats the entry in Martiguy 2006.

EXHIBITED: London, Royal Academy of Arts, "Exhibition of Dutch Art, 1450–1900," 1929, no. 367 (lent by Jules S. Bache); Detroit, Mich., The Detroit Institute of Arts, "Fifty Paintings by Frans Hals," 1935, no. 33 (lent by Jules S. Bache, New York); Haarlem, Frans Halsmuseum, "Frans Hals," 1937, no. 66 (lent by Jules S. Bache, New York); New York, New York World's Fair, "Masterpieces of Art," 1939, no. 174 (lent by the Jules S. Bache collection, New York); New York, Duveen Galleries, "Paintings by the Great Dutch Masters of the Seventeenth Century," 1942, no. 18 (lent from the Bache collection, New York); New York, MMA, "The Bache Collection," 1943, no. 33; Los Angeles, Calif., Los Angeles County Museum, "Loan Exhibition of Paintings by Frans Hals, Rembrandt," 1947, no. 12 (lent by the MMA); Bordeaux, Galerie des Beaux-Arts, "Profil du Metropolitan Museum of Art de New York: De Ramsès à Picasso," 1981, no. 103; Washington, D.C., National Gallery of Art, "Frans Hals," 1989, no. 52; Martigny, Switzerland, Fondation Pierre Gianadda, "The Metropolitan Museum of Art, New York: Chefs-d'oeuvre de la peinture européenne," 2006, no. 11; Barcelona, Museu Nacional d'Art de Catalunya, "Grandes maestros de la pintura europea de The Metropolitan Museum of Art, Nueva York: De El Greco a Cézanne," 2006–7, no. 8.

EX COLL.: ?The Earls of Egremont;[1] probably George O'Brien Wyndham 3rd Earl of Egremont; his adopted heir, Colonel George Wyndham, later 1st Baron Leconfield, Petworth House, Sussex (by 1835–d. 1869); Henry Wyndham, 2nd Baron Leconfield, Petworth House (1869–d. 1901); Charles Henry Wyndham, 3rd Baron Leconfield, Petworth House (1901–27); [Duveen Brothers, London and New York, 1927–28; sold to Bache on January 9, 1928, for $350,000]; Jules S. Bache, New York (1928–d. 1944; his estate, 1944–49); The Jules Bache Collection, 1949 49.7.33

1. Information given to Bache by Duveen Bros., New York.

66. *Paulus Verschuur*

Oil on canvas, 46¾ x 37 in. (118.7 x 94 cm)
Signed, dated, and inscribed (right center): ÆTAT SVÆ 37/ AN° 1643/FH· [FH in monogram]

The painting is well preserved, but the impasto has been slightly flattened during past lining. The deep black passages in the hat and costume are abraded, and the freely brushed cast shadow of the figure in the lower right corner is damaged.

Gift of Archer M. Huntington, in memory of his father, Collis Potter Huntington, 1926 26.101.11

In this dignified portrait of 1643, Paulus Verschuur (1606–1667), a wealthy merchant of Rotterdam, is seen at the age of thirty-seven. His father, Joost Verschueren, moved from Antwerp to Rotterdam and established a textile firm. Paulus married Maria van Berckel (d. 1654) in 1631, and three years later combined his family business with the textile manufactory of his father-in-law, Gerard van Berckel.[1] Verschuur was also very active in civic affairs, serving as a member of the Rotterdam City Council in 1642; as a burgomaster in 1649–50, 1653–54, 1660–61, and 1667;

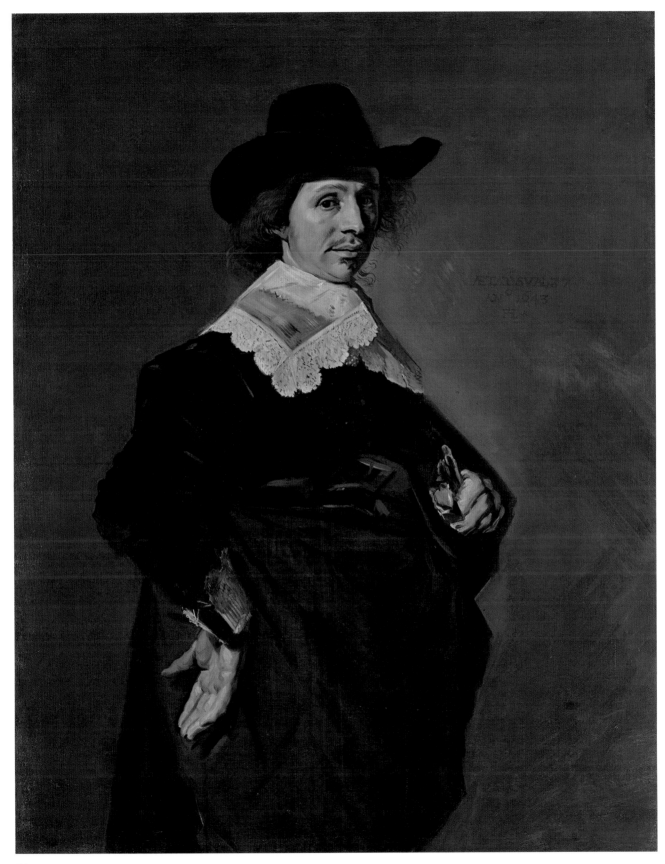

66

and as council deputy to the States of Holland in 1646, 1648–49, and on several later occasions. His other offices included church-warden (1646–48), commissioner of the East India Company (1651), commissioner for water rights (1656), and surveyor of manufactories (1658–59 and 1662–65).

About 1700, when the Rotterdam artist Pieter van der Werff (1661/65–1722) contributed a likeness of Verschuur to a large series of portraits of past and present directors of the Rotterdam chamber of the East India Company, he evidently based his oval, half-length portrait (fig. 76) on Hals's picture. Thirty-eight of at least forty-seven known portraits from the series survive in their original frames, which bear inscriptions identifying the directors and the dates of their appointments. It was on this basis that Gudlaugsson, in 1954, identified the subject of the present portrait.[2]

Verschuur's sister Margarieta was married to a Mennonite textile merchant, Pieter Jacobsz Wynants, and lived with her husband in Haarlem. In 1638, when the couple drew up their will (leaving one hundred Flemish pounds to a Mennonite orphanage in Haarlem), Paulus Verschuur was named as one of the four executors.[3] It is possible that Wynants or someone

in his circle referred Verschuur to Hals, who almost certainly would have recorded the Rotterdamer's features in Haarlem.[4]

In keeping with upper-middle-class preferences in the Reformed community, the costume is strictly black, apart from the lace collar and cuffs, and the beige gloves on and in the sitter's left hand.[5] The background, as often, is a dark olive tone. Even by Hals's standards, the execution of this large portrait is remarkable for its abbreviated definitions of form and effects of light and shadow. The voluminous cloak wrapped across the lower half of the figure is broken into broad, angular planes by black slashes indicating folds. Crisscrossing brush-strokes suggest the man's shadow on the wall to the right, and similar gestures on a small scale dispense with such necessities as describing the mustache and eyebrows. The simplicity with which Hals creates the impression of sheer fabric in the collar is extraordinary. At a normal viewing distance, however, one perceives only slight animation, rather than lessons in brush-work that would inspire painters until the end of the nine-teenth century.

Valentiner (see Refs.) believed that the figure's turn to the right implied a pendant portrait. This is entirely plausible, to judge from the compositions of other pair portraits by Hals.[6] Grimm (see Refs.) suggests that a companion might be found in *Portrait of a Woman* (fig. 78), which measures 31½ x 25¼ inches (80 x 64.1 cm) but "appears to have been cut on all four sides."[7] The painting would be quite consistent in design with *Paulus Verschuur* if it were the same size. Slive dates the female portrait to the first half of the 1630s, but in style and even cos-tume (which is quite conservative) the portrait could date from as late as 1643.[8] However, in the absence of technical evidence or a portrait known to be of Maria van Berckel, it is impossible to support or dismiss Grimm's hypothesis.[9]

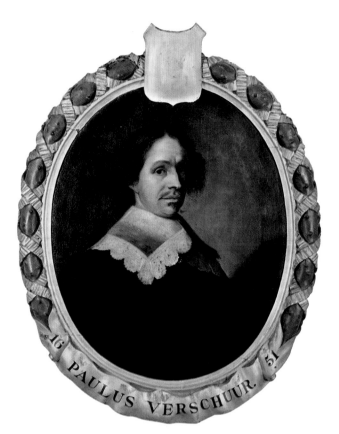

Figure 76. Pieter van der Werff, *Paulus Verschuur*, ca. 1700. Oil on canvas, 32¼ x 26¾ in. (82 x 68 cm). Rijksmuseum, Amsterdam, on loan to the Historisch Museum, Rotterdam

1. The couple married in a Reformed ceremony on April 22, 1631. The baptisms of four children are known: Maria, on February 10, 1632; Geret (Gerrit), on September 26, 1633; Elijsabet, on March 23, 1636; and Anna, on July 29, 1639. (Jeroen Giltaij kindly checked these details in the records of the Gemeentearchief, Rotterdam). Maria van Berckel's burial was recorded in Rotterdam on June 21, 1654; Paulus Verschuur's death on December 15, 1667, and burial on December 18, are noted in Engelbrecht 1973, pp. 139, 181–82, respectively (kindly brought to my attention by Friso Lammertse).

2. See Gudlaugsson 1954, pp. 235–36; Slive in Washington–London–Haarlem 1989–90, p. 292 (under no. 56); and, on the series (Rijksmuseum, Amsterdam, on loan to the Historisch Museum, Rotterdam), Van Thiel et al. 1976, p. 706.

3. This information is adopted from Biesboer's essay "The Burghers of Haarlem and Their Portrait Painters" in Washington–London–Haarlem 1989–90, pp. 37, 44 nn. 146–49, where Gudlaugsson

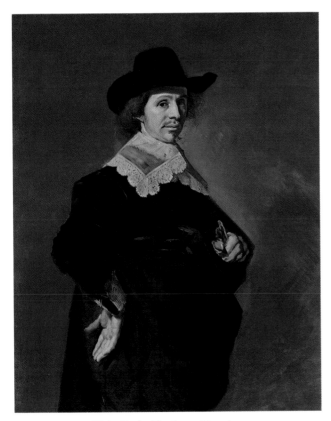

Figure 77. Frans Hals, *Paulus Verschuur* (Pl. 66)

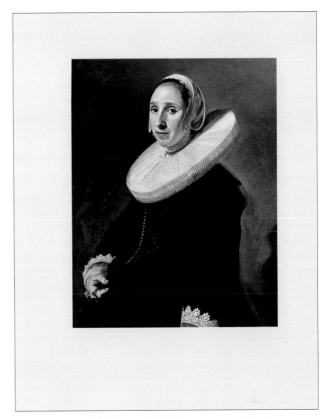

Figure 78. Frans Hals, *Portrait of a Woman*, ca. 1643? Oil on canvas, 31½ x 25¼ in. (80 x 64.1 cm). Private collection

1954 and several previously unpublished documents are cited.

4. Slive (1958, and in later publications; see Refs.) suggests that members of the Coymans family may have put Verschuur in touch with Hals, but they are not known to have been the artist's patrons before 1644, and there is no clear connection between the families. On the Coymans family as patrons of Hals, see Biesboer in Washington–London–Haarlem 1989–90, pp. 36–37.

5. Wheelock 1995a, p. 80, suggests that the removal of the right-hand glove may have been perceived as a welcoming gesture.

6. For example, Slive 1970–74, vol. 2, pls. 25, 26 (portraits of an anonymous couple), of about 1618–20, in the Gemäldegalerie Alte Meister, Staatliche Museen, Kassel.

7. The quote is from ibid., vol. 3, p. 55 (under no. 97). The painting was sold at Sotheby's, New York, May 19, 1995, no. 26, to a private collector.

8. Compare ibid., vol. 3, pls. 217, 230, 232; also Neumeister 2005, figs. 473, 475. An almost identical costume is seen in Gerbrand van den Eeckhout's portrait of his stepmother, dated 1644 (Sumowski 1983–[94], vol. 2, no. 521; Leiden 2005–6, fig. 70).

9. Attempts were made to locate the putative pendant, with a view to determining, through radiography, whether it and the Museum's picture might have been painted on supports cut from the same bolt of canvas. Perhaps this will prove possible at some future date.

REFERENCES: "A Frans Hals Masterpiece," *The Collector* 2, no. 5 (January 1, 1891), p. 54, celebrates the painting's appearance at the Durand-Ruel Gallery, New York; Moes 1909, p. 106, no. 136, listed, as in the Bösch sale (erroneously as in Vienna in 1884); Valentiner in New York 1909, p. 36, no. 35 (ill. opp. p. 36), describes the subject; Cox 1909–10, p. 245, mentioned as in the Hudson-Fulton exhibition; Hofstede de Groot 1907–27, vol. 3 (1910), p. 105, no. 360, describes the subject and gives provenance; Waldmann 1910 (ill. p. 78); Von Frimmel 1913–14, vol. 1, p. 198, listed as in the Bösch sale of 1885; Bode and Binder 1914b, vol. 2, p. 22, no. 273, pl. 179, listed as in Mrs. C. P. Huntington's collection; Valentiner 1921a, pp. 192 (ill.), 318, believes that the figure's presentation suggests that the portrait originally had a pendant; Valentiner 1923, pp. 208 (ill.), 319, repeats Valentiner 1921a; Valentiner in Detroit 1935, unpaged, no. 38 (ill.), listed (with "1632" incorrectly given under "Inscribed"); Valentiner 1936, unpaged, no. 74 (ill.), and (under no. 79), considers the portrait's large size and the figure's elegant clothing to indicate someone from "a well-to-do, aristocratic family"; Trivas 1941, p. 52, no. 85, pl. 115, lists the work, with provenance, and describes the palette; Gudlaugsson 1954, pp. 235–36, fig. 1, identifies the sitter as Paulus Verschuur based on a partial copy of the painting in the Rijksmuseum, Amsterdam, and provides biographical information; *MMA Bulletin* 14, no. 7 (March 1956), cover ill., text inside front cover summarizes Gudlaugsson's discovery; Slive 1958, pp. 13–14, suggests (following Gudlaugsson 1954) that the Rotterdam sitter may have been introduced to the Haarlem artist by a member of the Coymans family, which was also in the textile business; J. Rosenberg,

Slive, and Ter Kuile 1966, p. 44, mistakenly gives the date as 1642; Descargues 1968, p. 111, mentioned; Slive 1970–74, vol. 1, pp. 153, 174, fig. 187 (detail), repeats the idea of a Coymans connection (see Slive 1958) and compares the work with a portrait in Raleigh, N.C., which the author attributes to Hals's son Jan, vol. 2, pl. 247, vol. 3, p. 75, no. 144, summarizes the findings and suggestions presented in Gudlaugsson 1954; Colle 1972, p. IV (ill. as frontis.), calls the collar a "falling band," and draws attention to an "under-ruff with pleated edges barely visible" beneath the sheer collar; Grimm 1972, pp. 105, 107, 204, no. 120, suggests that the painting may have a pendant in a portrait of a woman in an English private collection (Grimm no. 121, pl. 129); Grimm and Montagni 1974, pp. 98 (under no. 94), 103–4, no. 159 (ill.), proposes that Hals's *Portrait of a Woman*, of 1643 (private collection, London), may be the picture's pendant; Van Thiel et al. 1976, p. 708 (under no. A4501), describes Pieter van der Werff's oval half-length portrait of Paulus Verschuur as a "free copy" after the Museum's picture; P. Sutton 1986, p. 185, describes the figure as "[looking] every inch the confident image of a wealthy Rotterdam cloth merchant and burgomaster"; Grimm 1989, pp. 193, 242, 281, 285, no. 118, pl. 44, as by Hals, calls the figure energetic; Biesboer in Washington–London–Haarlem 1989–90, p. 37, maintains that the picture must have been painted in Haarlem, and offers more information about the sitter's family; Groen and Hendriks in ibid., pp. 115, 117, 125–27, pl. VIII, fig. f (detail of paint cross section), report the color of the ground layer and the main pigments present in the paint layers; Slive in ibid., pp. 282, 292–94, no. 56 (ill.), again acknowledges Gudlaugsson's identification of the sitter, illustrates the portrait of Verschuur by Pieter van der Werff, and remarks on the fragility of the chalk ground used for the Museum's picture; Grimm 1990, pp. 193, 242, 286, 291, no. 118, pl. 44, repeats Grimm 1989 in translation; Liedtke 1990, p. 37, notes that the painting was given to the Museum by Archer Huntington; Krohn in Athens 1992– 93, pp. 36, 37, 306, no. 12 (ill.), describes the subject; Baetjer 1995, p. 301; Wheelock 1995a, pp. 80, 82 n. 10, fig. 3, compares the presentation of the figure to that found in Hals's portrait of Adriaen van Ostade, of about 1646–48 (National Gallery of Art, Washington, D.C.).

EXHIBITED: New York, MMA, "The Hudson-Fulton Celebration," 1909, no. 35, as "Portrait of a Man" (lent by Mrs. Collis P. Huntington, New York); Detroit, Mich., The Detroit Institute of Arts, "Fifty Paintings by Frans Hals," 1935, no. 38, as "Portrait of a Gentleman"; Los Angeles, Calif., Los Angeles County Museum, "Loan Exhibition of Paintings by Frans Hals, Rembrandt," 1947, no. 15, as "Portrait of a Gentleman"; Wilmington, Del., Delaware Art Center Building, "Paintings by Dutch Masters of the Seventeenth Century," 1951, no. 14, as "Portrait of a Man"; Raleigh, N.C., North Carolina Museum of Art, "Masterpieces of Art," 1959, no. 63, as "Paulus Verschuur"; Portland, Ore., Portland Art Museum, 1967–68; Berkeley, Calif., University of California at Berkeley, University Art Museum, and Houston, Tex., Rice University, Institute for the Arts, "Dutch Masters from The Metropolitan Museum of Art," 1969–70, checklist no. 5; Haarlem, Frans Halsmuseum, "Frans Hals," 1990, no. 56; Athens, National Gallery and Alexandros Soutzos Museum, "From El Greco to Cézanne: Masterpieces of European Painting from the National Gallery of Art, Washington, D.C., and The Metropolitan Museum of Art, New York," 1992–93, no. 12.

EX COLL.: Adolf Josef Bösch, Döbling, near Vienna (until d. 1884; his estate sale, Kaeser, Plach, and Kohlbacher, Döbling, April 28, 1885, no. 20, as "Männliches Portrait," for Fl 14,010 to Kaiser); [Durand-Ruel, New York, in 1891]; Mrs. Collis P. Huntington, New York (by 1909–d. 1924); her son, Archer Milton Huntington, New York (1924–26); Gift of Archer M. Huntington, in memory of his father, Collis Potter Huntington, 1926 26.101.11

67. *Portrait of a Man*

Oil on canvas, 43½ x 34 in. (110.5 x 86.4 cm)

The condition of the portrait is good, although the impasto has been slightly flattened during past lining and the whole paint surface is slightly abraded. Contributing to the diminishment of the image, particularly in the deep blacks, is the extensive network of very fine age cracks. A later canvas extending the composition along the left side is covered by the frame.

Marquand Collection, Gift of Henry G. Marquand, 1890 91.26.9

The finest of three pictures by Hals from the Marquand Collection, this large portrait of a fashionably attired but seemingly sober gentleman is generally agreed to date from the early 1650s.

Versions of the figure's pose are found in male portraits by Hals dating from about 1620 onward. The earliest examples show the figure at a greater angle to the picture plane, but equally frontal presentations are found in portraits by Hals (and by Rembrandt; see Pl. 143) dating from the early to mid-1630s.[1] As is obvious from comparisons with works such as *Portrait of a Man*, of about 1632–34 (Taft Museum, Cincinnati), and *Tieleman*

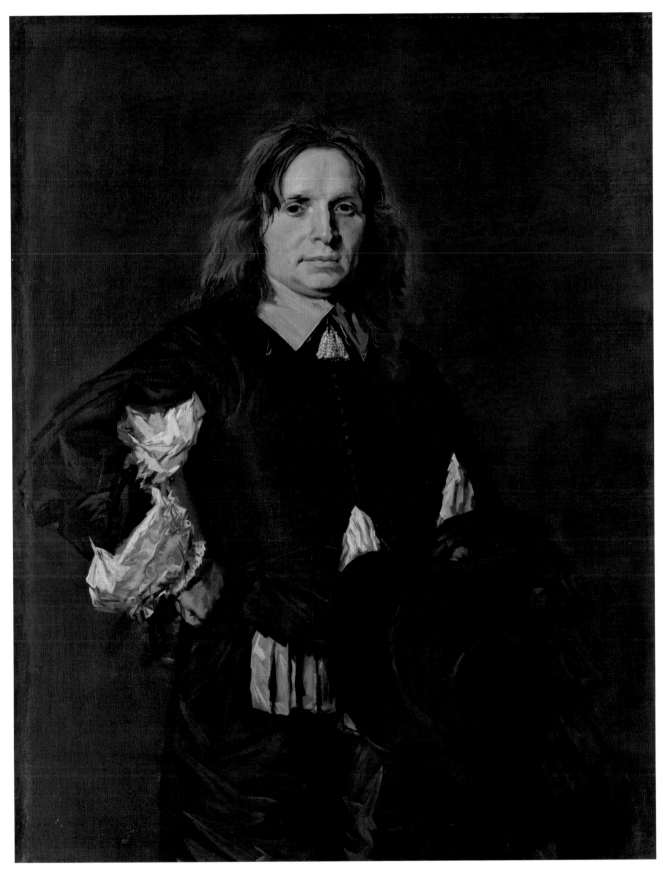

67

Roosterman, dated 1634 (Cleveland Museum of Art), Hals could very effectively convey character not only through facial expression but also by means of turning and tilting the head, shifting shoulders and arms, and other manipulations of posture.[2] In a number of earlier portraits, the viewpoint is lower, creating a commanding or somewhat aloof impression (compare Pl. 66). Here, the level gaze and slightly lower placement of the head in the picture field suggest an approachable personality, despite the sitter's serious expression and air of having little time to spare.

The latter effect is achieved through the direct glance, the cocked arm, the busy patterns in the costume, and, of course, by the presence of hat, cloak, and gloves. The hat is quite tall (its shape supports a dating to the 1650s) and is decorated with a large black ribbon. The man's gloved left hand is partially visible above the hat, and a cloak is draped over his forearm. A second glove, its form now somewhat ambiguous, is held in the left hand. The colorful loops of ribbon tied around the waist (called a *tablier de galants*) and the flouncing of the sleeve above a tight cuff were fashions imported from France.[3] These motifs, and the generous amounts of shirting that erupt from the slit sleeves and unbuttoned doublet, are exploited by Hals for dazzling displays of brushwork. The gray slashes defining folds in the breeches and other black garments are no less virtuoso, but serve as baselines to the brilliant treble of whites. In the face, the undulating strokes in the nose and mouth and in the contour on the shadowed side of the head hint at movement and maturity. As always in autograph works by Hals, a strong sense of three-dimensional form remains even in the most daring passages of brushwork. The hat's contribution to the spatial effect of the whole must have been stronger originally, and is more discernible in good photographs than in normal gallery light.

It is clear from the design of other portraits by Hals that this picture could have stood alone, and equally well might have had a pendant.[4] However, none has ever been identified or proposed.

A small copy on panel, arbitrarily attributed to Hals's son Harmen, was on the art market in the early 1950s.[5]

1. See Slive 1970–74, vol. 2, pls. 25, 58, 131, 154, 171, 203, 239, 250.
2. Ibid., vol. 2, pls. 131, 154. On the Taft picture, see also Liedtke in E. Sullivan et al. 1995, pp. 140–42. *Tieleman Roosterman,* formerly in the Kunsthistorisches Museum, Vienna, was restored to the Rothschild family in 1998, and in 1999 was acquired at auction by the Cleveland Museum of Art.
3. As discussed by Du Mortier in Washington–London–Haarlem 1989–90, p. 56.
4. Compare, for example, Slive 1970–74, vol. 2, pls. 239, 240 and 284, 285.

5. Parke-Bernet, New York, March 14, 1951, no. 9, and March 5, 1952, no. 31, as by "Harman" Hals.

REFERENCES: MMA 1905, p. 66, no. 264; Moes 1909, p. 108, no. 184, listed; Valentiner in New York 1909, p. 42, no. 41 (ill. opp. p. 42), dates the portrait to about 1650, and states that it is signed with the artist's monogram;[1] Cox 1909–10, p. 245, praises the work as one of the finest Halses known, describes the use of paint (blacks especially), and compares works by Whistler; Breck 1910, p. 50, mistakenly calls the picture a pendant of the Marquand *Portrait of a Woman* (Pl. 68); Hofstede de Groot 1907–27, vol. 3 (1910), p. 85, no. 297, describes the subject, and follows Valentiner in New York 1909 in referring to a monogram; Péladan 1912 (ill. opp. p. 98), no comment; Bode and Binder 1914b, vol. 2, p. 21, no. 260, pl. 169, listed; Valentiner 1921a, pp. 251 (ill.), 321, compares the *Portrait of a Man* of about 1660 (Frick Collection, New York); Valentiner 1923, pp. 266 (ill.), 322, dates the painting to about 1652–54; Dülberg 1930, p. 202, fig. 88, describes the figure, which in its pose foreshadows Napoleon; B. Burroughs 1931a, p. 149, no. H16-2; Valentiner 1936, no. 102 (ill.), "one of the artist's masterpieces of the 'fifties'"; Plietzsch 1940, pp. 4, 16 (ill. p. 34), suggests a date of about 1652; Rousseau 1954, p. 3 (ill. p. 32), "an ancestor of the Impressionists"; Slive in Haarlem 1962, pp. 69–70, no. 61, fig. 6, describes the execution and suggests a date of about 1650–52; J. Rosenberg, Slive, and Ter Kuile 1966, p. 45, pl. 25A, observes that the frontal pose is typical of Hals portraits painted after 1650, and that there are "incredibly subtle distinctions between the blacks of the man's suit, hat, and mantle"; G. Agnew 1967, unpaged (ill.), as sold to Marquand in 1890; Descargues 1968, pp. 111, 115 (ill.), mentioned; Boston 1970, p. 41 (ill.), considers the pose "striking, though natural"; Slive 1970–74, vol. 1, p. 194 (ill. opp. p. 136 [detail]), describes the execution, which Manet would have admired, and considers the colorful ribbons unusual in Hals, vol. 2, pls. 298, 301, vol. 3, p. 99, no. 190, dates the painting to about 1650–52, detects a monogram in the lower right corner, and admires the figure as "one of Hals' most penetrating characterizations"; Grimm 1972, pp. 23, 109, 205, no. 143, figs. 162, 166, dates the work to about 1649–50; Grimm and Montagni 1974, p. 106, no. 181 (ill.), as from about 1650; Zafran in Washington, and other cities 1975–76 p. 80 (under no. 21), compares the pose in *Portrait of a Man,* of about 1651 (Hermitage, Saint Petersburg); Wiesner 1976, pl. 67; Fuchs 1978, p. 85, fig. 59, as from about 1650; Baard 1981, frontis. (text), pl. 1 (detail), fig. 53, as from about 1650–52; Guratzsch 1981, pp. 139–40, pl. 113, considers the painting typical and masterly; Hofrichter in New Brunswick 1983, pp. 42, 97, no. 68 (ill. p. 96), fig. 20, considers the pose "thunderously brazen," although the picture is seen as "a prime example of the dignity and grandeur Hals expresses in his late works"; Grimm 1989, pp. 195–96, 283, 285, no. 136 (ill. p. 282), fig. 110, pl. 70 (detail), dates the picture to about 1654; Groen and Hendriks in Washington–London–Haarlem 1989–90, pp. 112, 113, 117, 122 nn. 29, 33, fig. 4 (X-radiograph), p. 125 (S no. 190), note that at some point a narrow strip of canvas was added to the left side, and describe the color of the ground layer and the main pigments present in the paint layers; Du Mortier in ibid., p. 56, describes the *tablier de galants* ("an apron-like skirt made of loops of ribbon" worn at the waist) and the flounces above the cuff of the shirt sleeves, both of which were French fashions; Slive in ibid.,

pp. 326–27, no. 70 (ill.), repeats the information in Slive 1970–74; Chapman 1990, p. 87, compares the pose with those found in approximately contemporary portraits by Rembrandt; Grimm 1990, pp. 195–96, 289, 292, no. 136 (ill.. p. 289), fig. 110, pl. 70 (detail), repeats Grimm 1989 in translation; Baetjer 1995, p. 302; Slive 1995a, pp. 51–52, fig. 56, repeats the remarks in J. Rosenberg, Slive, and Ter Kuile 1966; Wheelock 1995a, pp. 89, 91 n. 5, considers *Portrait of a Gentleman,* of about 1650–52 (National Gallery of Art, Washington, D.C.), as quite similar in its modeling of the features, "with broad, bold strokes that have great strength and surety"; Kuretsky in Poughkeepsie–Sarasota–Louisville 2005–6, p. 17, fig. 1, observes that the fleeting moment captured by Hals suggests not only character and "aliveness" but also mortality.

EXHIBITED: New York, MMA, "Exhibition of 1888–89" [Marquand Collection], 1888–89; New York, MMA, "The Hudson-Fulton Celebration," 1909, no. 41; Haarlem, Frans Halsmuseum, "Frans Hals tentoonstelling," 1937, no. 105; Haarlem, Frans Halsmuseum, "Frans Hals," 1962, no. 61; Boston, Mass., Museum of Fine Arts, "Masterpieces of Painting in The Metropolitan Museum of Art," 1970, p. 41; New York, MMA, "Masterpieces of Fifty Centuries," 1970–71, hors cat.; Leningrad, State Hermitage Museum, and Moscow, Pushkin State Museum, "100 Paintings from the Metropolitan Museum," 1975, no. 20; New Brunswick, N.J., Rutgers University, Jane Voorhees Zimmerli Art Museum, "Haarlem: The Seventeenth Century," 1983, no. 68; London, Royal Academy of Arts, "Frans Hals," 1990, no. 70.

EX COLL.: Augustus Edward Hobart-Hampden, 6th Earl of Buckinghamshire, Hampden House, Great Missenden, Buckinghamshire (until d. 1885; posthumous sale, Christie's, London, March 17, 1890, no. 131, for £1,995 to Agnew); [Agnew, London, 1890; sold to Marquand]; Henry G. Marquand, New York (1890); Marquand Collection, Gift of Henry G. Marquand, 1890 91.26.9

1. Microscopic examination of the canvas in 1977 found no evidence of a monogram.

68. *Portrait of a Woman*

Oil on canvas, 39⅜ x 32¼ in. (100 x 81.9 cm)

Passages of the portrait are abraded, particularly the deep blacks in the drapery, details in the lace collar and cuffs, and the coiffure. The canvas weave has been emphasized and the impasto slightly flattened during past lining. The entire background is a later construction painted over what was originally a monochrome gray green. Analysis of paint samples mounted in cross section confirms that the column in the background at left and the cityscape at right contain the pigment Naples yellow (lead antimony oxide). This pigment was generally unavailable to artists working in Holland in the seventeenth century and was not used by Hals. Naples yellow is found only rarely in paintings by Dutch artists of the late seventeenth or early eighteenth century (see Groen, De Keijzer, and Baadsgaard 1996).

Marquand Collection, Gift of Henry G. Marquand, 1890 91.26.10

The composition, manner of execution, and the sitter's costume suggest that this colorful portrait by Hals dates from about 1650. The background, originally rendered in a neutral tone, was completely painted over at a later date, most likely during the eighteenth century.[1] Except for the hair and cap, which are abraded, most areas of the figure reveal impressive brushwork, especially in the folded hands and upper portion of the skirt (the lower left part has been repainted).

Much of the scholarly literature has focused on the question of whether the *Portrait of a Painter* (fig. 79) is a pendant to the present picture. In earlier decades, the sitter in the Frick portrait was thought by some writers to be Hals himself, which may be dismissed on the grounds of appearance (see Pl. 70) and age (Hals was nearly seventy in 1650). No other plausible suggestion for the identity of either sitter has ever been made, which is not surprising, since the subjects of more than half of Hals's surviving portraits remain anonymous.

That the Frick and Metropolitan Museum portraits may have been intended as a pair is more likely than it might at first appear.[2] Slive observes that only two other female portraits by Hals, which also date from about 1650, show similarly informal poses, with the woman seated almost sideways and her right arm hooked over the back of the chair.[3] Although the poses found in the New York pictures have parallels in independent portraits by Hals, they complement each other remarkably well. This is more evident when one eliminates all background details and reduces the size of the painter's hat (which was enlarged at a later date, when the column was also added). The canvases are now almost identical in size; both have been slightly trimmed. The fact that at some later date, both pictures were provided with architectural backgrounds, and that the monumental columns balance each other, suggests that the pictures were together at the time. The earliest trace of the Museum's picture is in England during the 1790s, when it was evidently not accompanied by a pendant. The first record of the Frick picture is in England, in 1876.[4]

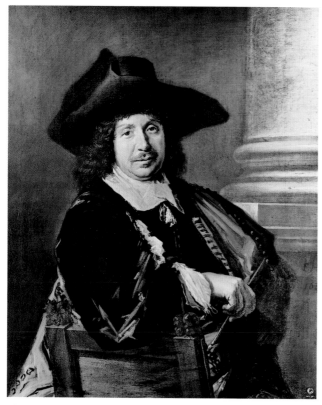

Figure 79. Frans Hals, *Portrait of a Painter*, ca. 1650. Oil on canvas, 39½ x 32⅛ in. (100.3 x 82.9 cm). The Frick Collection, New York

Figure 80. Frans Hals, *Portrait of a Woman* (Pl. 68)

1. See the condition note on the use of Naples yellow in the background. The cityscape bears a vague resemblance to architectural views in Dutch portraits of the 1650s and 1660s, but the ensemble of five spires, a castle, and two rooftops seems unlikely to have been imagined by a Netherlandish artist at any date.

2. The Museum's painting was taken to the Frick Collection for comparison on December 19, 1966. On that occasion, the Metropolitan Museum was represented by Theodore Rousseau, Elizabeth Gardner, Claus Virch, Hubert von Sonnenburg, and Philippe de Montebello, and the Frick Collection by director Harry Grier, Bernice Davidson, Edgar Munhall, Francis Richardson, and John Walsh. Later the same week, Julius Held and Seymour Slive examined the paintings together. In a memo from Virch to Rousseau summarizing the experience, the idea that the pictures were pendants was vigorously opposed. "The pose of the man is aggressive and closer to the viewer, that of the woman reserved and placed more [that is, deeper] in the picture space." (See also Frick Collection 1968, vol. 1, p. 216). These points may actually be taken as arguments in favor of the hypothesis that Hals designed the pictures as pendants: compare Slive 1970–74, vol. 3, pls. 123, 124, 143, 144, 150, 151, 169, 170. Virch also noted that "when placed close together, the columns do not match." Dutch pair portraits generally were not hung close together, and in any case Hals did not paint the background elements in either picture. Virch also maintains that the paintings differ in palette and execution. The present writer (and Slive, evidently) disagrees.

3. Slive in Washington–London–Haarlem 1989–90, p. 309, with reference to ibid., nos. 63, 64, the pendant portraits in the Taft Museum, Cincinnati (on which see also the present writer's discussion in E. Sullivan et al. 1995, pp. 142–44), and *Portrait of a Seated Woman, presumably Maria Vernatti* (Aurora Art Fund).

4. See Frick Collection 1968, vol. 1, pp. 215–16, on the condition and provenance of *Portrait of a Painter*. X-radiographs of the two paintings were examined side by side on June 13, 2006, by the present writer, Museum conservator Charlotte Hale, and Frick Collection curator Susan Galassi. It was concluded that the execution of the figures and drapery is consistent throughout the two works. The canvas supports are very similar, but were not cut from the same bolt of cloth. The Frick canvas has a slightly finer weave, about 12 x 14.5 threads per square centimeter. The weave of the Museum's canvas is about 12 x 12 threads per square centimeter.

REFERENCES: Caffin 1902, pp. 274, 275 (ill.), describes the picture as "the wonderful portrait of his wife by Frans Hals," and praises the figure, "an epitome of the Dutch bourgeoisie at its best"; MMA 1905, p. 66, no. 269, as "The Wife of Frans Hals," describes the subject and gives provenance; Moes 1909, p. 109, no. 205, listed, as "Portrait de femme"; Valentiner in New York 1909, p. 41, no. 40 (ill. opp. p. 41), describes the composition and states that the identification of the sitter as the artist's wife is erroneous; Cox 1909–10, p. 245, dates the painting to before 1650, and observes that

68

Hals's characteristic handling is "so thoroughly subordinated to an entire realization of natural appearance as almost to escape the attention"; Breck 1910, p. 50, mistakenly calls the picture a pendant of *Portrait of a Man* (Pl. 67; also a Marquand gift); Hofstede de Groot 1907–27, vol. 3 (1910), p. 112, no. 387, as "Portrait of a Woman," describes the subject and gives provenance; Waldmann 1910, p. 78, pens generous praise; Péladan 1912 (ill. opp. p. 68), titles the work "Inconnue (Peut-être Lisbeth Reyniers)" (Hals's wife); Bode and Binder 1914b, vol. 2, p. 9, no. 175, pl. 107, listed, as "Portrait of a Woman"; Valentiner 1921a, pp. VIII–IX, 120 (ill.), 314, considers the picture to be the pendant to the supposed self-portrait by Hals in the Frick Collection; Valentiner 1923, pp. XII–XIII, 127 (ill.), 314–15, repeats Valentiner 1921a; Valentiner 1925, pp. 153–54, defends the hypothesis (based partly on the conjecture that the "Massa" double portrait in the Rijksmuseum, Amsterdam, might depict the artist and his wife) that this picture represents Hals's wife, and that the *Portrait of a Painter* in the Frick Collection is a pendant self-portrait, probably of 1645 not 1635; Dülberg 1930, p. 117, pl. 45, considers the work a pendant to the Frick picture, tentatively identifies the sitter as the artist's wife, and dates the portrait to about 1635; B. Burroughs 1931a, p. 149, no. H16-3 (pl. opp. p. 152), "erroneously called 'Wife of the Artist'"; Valentiner 1935, p. 95, describes the painting as "the companion piece to the self portrait in the Frick collection"; Valentiner 1936, unpaged (under nos. 43 and 83), and as no. 84 (ill.), as "Lisbeth Reyniers, the Wife of the Artist," of about 1645, now maintains that there is "no question that [the Frick and the Metropolitan Museum picture] belong together as companion pieces," and that the identification of Hals himself in the male portrait "can not well be doubted"; Trivas 1941, pp. 56 (under no. 97), 57, no. 98, pl. 129, as "Portrait of a Woman (the Artist's Wife, Lisbeth Reyniers?)," considers the painting a pendant to the Frick picture, of about 1650; Vis 1965, pp. 9, 11, 82–91, 107–10, pl. 3, dates the portrait to 1643, and maintains at length that it represents Rembrandt's onetime companion, Geertje Dircks, and that the Frick picture is nothing less than Hals's portrait of Rembrandt;[1] Scheller 1966, pp. 117–18, submits the entire argument of Vis 1965 to detailed condemnation; Davidson in Frick Collection 1968, pp. 215–16, rejects the identification of the sitter as Hals's wife or Rembrandt's companion, and suggests that the Museum's picture and the Frick canvas were not intended as pendant portraits, but may have been altered at a later date to appear as such; Slive 1970–74, vol. 1, pp. 159, 184–85, considers the painting a pendant to the Frick *Portrait of a Painter*, and the architectural backgrounds in both pictures to be incongruous additions of a later period, probably "by two different hands," vol. 2, pls. 289, 296 (whole, and detail of the hands), vol. 3, p. 97, no. 187, considers the sitter unidentified, dates the painting to about 1650–52, acknowledges reasons to reject the Frick portrait as a pendant, but finds it hard "to reject categorically the notion that [the two canvases] were painted as companion pictures"; Grimm 1972, pp. 26–27, 28, 109, 205, no. 141, fig. 154, dates the picture to about 1648–50, describes the background as completely overpainted, and considers it possible that the Frick canvas is a pendant; D. Sutton in Fry 1972, vol. 1, p. 255 n. 1 to letter no. 177 of March 2, 1906, lists the painting among works in the 1906 exhibition; Grimm and Montagni 1974, pp. 105 (ill.), 106, no. 179, dates the painting to

about 1650, and reviews earlier opinions; D. Smith 1982a, pp. 111, 190 n. 46, argues that the present picture and the Frick canvas are pendants, mainly on formal grounds; Grimm 1989, p. 285, no. 187, calls the picture a product of Hals's workshop, "stylistically close to the anonymous Master of the Fisherboy";[2] Slive in Washington–London–Haarlem 1989–90, p. 309, compares the Taft Museum *Portrait of a Seated Woman Holding a Fan*, of about 1648–50, and a small female portrait of the same period as the only other female portraits by Hals in which a woman sits sideways on a chair with one arm hooked over the back, and also states flatly that the present picture "is the pendant to a *Painter Holding a Brush* at the Frick Collection"; Grimm 1990, p. 292 (under no. 187), repeats Grimm 1989 in translation; Baetjer 1995, p. 301; Dudok van Heel in Edinburgh–London 2001, p. 246 n. 47, mentions the hypothesis of Vis 1965, in connection with a brief account of Geertje Dircks's relationship with Rembrandt.

EXHIBITED: New York, MMA, "Exhibition of 1888–89" [Marquand Collection], 1888–89; New York, MMA, "Temporary Exhibition," 1906, no. 13; New York, MMA, "The Hudson-Fulton Celebration," 1909, no. 40; Toronto, Art Gallery of Toronto, Detroit, Mich., The Detroit Institute of Arts, Seattle, Wash., Seattle Art Museum, and Saint Louis, Mo., City Art Museum of Saint Louis, "Thirty-Eight Great Paintings from The Metropolitan Museum of Art," 1951–52, no cat.; Austin, Tex., City Coliseum, "Texas Fine Arts Festival: Metropolitan Museum $1,000,000 Collection of Old Masters," 1953, unnumbered checklist; Milwaukee, Wis., Milwaukee Auditorium, "Metropolitan Art Museum $1,000,000 Masterpiece Exhibition," 1953, p. 10; Little Rock, Ark., Arkansas Arts Center, "Five Centuries of European Painting," 1963, p. 26.

EX COLL.: ?William Ponsonby, 2nd Earl of Bessborough, London, and Bessborough House, Roehampton (until d. 1793; his estate sale, Christie's, London, February 5–7, 1801, no. 50, as "A Lady's Portrait," for £12 1s. 6d., bought in?); ?the Earls of Bessborough, Bessborough House (until 1847); John George Brabazon Ponsonby, 5th Earl of Bessborough, Bessborough House (until 1848; sold to Jarvis); Sir Lewis Jarvis, Middleton Towers, King's Lynn, Norfolk (1848–90; posthumous sale, Christie's, London, June 21, 1890, no. 35, as "Portrait of the Artist's Wife," for £1,837 10s. to Colnaghi); [Martin Colnaghi, London, 1890; sold to Marquand for £2,800]; Henry G. Marquand, New York (1890); Marquand Collection, Gift of Henry G. Marquand, 1890 91.26.10

1. Vis's idea concerning the Frick picture was reported in an anonymous article, "Did Frans Hals Paint Rembrandt," *The Knickerbocker* 21, no. 8 (August 1959), pp. 32–33. It describes Vis as "a Netherlands jurist turned painter," who had been "struck by artistic lightning" when looking at a photograph of the Frick canvas. After "diligent research," he went to New York with funding from The Netherlands Organization for Pure Scientific Research.

2. On a visit to the Museum in October 1983, Grimm accepted Hals's authorship of the painting, as he had in Grimm 1972 and Grimm and Montagni 1974.

69. *Malle Babbe*

Oil on canvas, 29½ x 24 in. (74.9 x 61 cm)
Inscribed (falsely, right center): FH [in monogram]

The painting is in good condition. In the black passages
and in the background, the priming is exposed by abrasion.

Purchase, 1871 71.76

Although this picture was one of the proudest trophies in the
Museum's 1871 Purchase, it was doubted as a work by Hals as
early as 1883, when Wilhelm von Bode described it as a free
repetition by Frans Hals the Younger after one of his father's
paintings (meaning the autograph picture, *Malle Babbe,* of
about 1633–35, in the Gemäldegalerie, Berlin).[1] Slive (see Refs.)
has repeatedly dismissed Frans Hals the Younger from consid-
eration, and considers it possible that the New York canvas is
"a copy of a lost original."[2] The present writer has compared
works ascribed to Hals's sons Harmen (1611–1669) and Jan
(ca. 1620–1654), and to other artists in Hals's circle, and like
Slive is unable to offer a plausible attribution. The picture is
superficially impressive for its bold execution, but it lacks
Hals's sense of form and interest in actual observation. The
work would appear to date from not long after Hals intro-
duced the subject into the art world of Haarlem, that is, from
the second half of the 1630s or the 1640s.

The name "Malle Babbe van Haerlem," which could be
translated as Silly Betty or Mad Meg of Haarlem,[3] is inscribed
on an old piece of stretcher let into the modern one supporting
the Berlin canvas. The misreading, "Hille Bobbe" (see Refs.), goes
back to an 1867 sale catalogue.[4] In 1653, the Haarlem burgo-
masters allowed the local "Workhouse" (which was both a house
of correction and a charitable institution) 65 guilders to care for
Malle Babbe. The document also refers to Frans Hals's mentally
impaired son, Pieter, who had been confined in the same place
since 1642.[5] Thus a real person served as the model for Hals's
painting in Berlin and for a number of related works.

The owl (rendered much more convincingly in the Berlin
picture) was a common symbol of folly in the Netherlands,
despite its classical association with Minerva, goddess of wis-
dom.[6] It is hard to say which owl sat on Valentiner's shoulder
when he reported that Malle Babbe was "a well-known street
figure in Haarlem, who went about among the beer shops and
on account of her droll nature enjoyed special popularity."[7]

1. Bode 1883, p. 103. For a discussion of the Berlin painting and
some of the works that it inspired, see Slive in Washington–
London–Haarlem 1989–90, pp. 236–41, no. 37.

2. The quote is from Slive in Washington–London–Haarlem 1989–
90, p. 238. Ibid., p. 218, notes the reference to "various copies after
Frans Hals" in an auction held by a Haarlem innkeeper in 1631.

3. The former is suggested in Westermann 1997, p. 268. *Babbelen,*
in modern Dutch, means "to babble," but "Babbe" was probably
just a nickname for Barbara or a similar name.

4. These details are noted by Slive in Washington–London–Haarlem
1989–90, p. 236.

5. See Van Thiel-Stroman in Washington–London–Haarlem 1989–
90, pp. 21 (under 1653), 395 (under doc. 94).

6. On the owl as a symbol of folly, see Slive 1963.

7. Valentiner 1936, unpaged, no. 57, basing himself on the evidence
of the beer mug in the Berlin picture.

REFERENCES: Possibly P. Mantz, "François Hals," in Blanc et al.
1864, pp. 6–7, refers to a painting by Hals of an old woman with an
owl which was etched by Coclers, and which anticipates Goya;[1] Thoré
1868a, p. 443, quotes Mantz (see preceding reference) and identifies
the figure as "old Hille Bobbe, a sort of popular sorceress" who lived
in Haarlem; Thoré 1869, p. 163, compares the painting in the
Suermondt collection (now Gemäldegalerie, Berlin) with the version
engraved by Coclers; Von Lützow 1870, pp. 78–79, explores the mean-
ing of the figure represented to Coclers's print, calling her "a kind of
female Falstaff"; MMA 1871, pl. [1], as by Hals; Decamps 1872, p. 476,
finds this version superior to that in the Suermondt collection;
Havard 1872, p. 221, compares the version in Dresden (on which see
Slive 1970–74, vol. 3, p. 141 [under no. D34]); James (1872) 1956,
pp. 55–56, as "Hille Bobbe of Haarlem," by Franz Hals, "a masterpiece
of inelegant vigour"; MMA 1872, pp. 54–55, no. 144, as "Hille Bobbe
Von Haarlem," discusses the recent provenance, and maintains that
"this capital chef d'oeuvre of science, color, spirit, life, and boldness
would do honor to any museum"; Bode 1883, p. 103, describes the
picture as a free repetition by Frans Hals the Younger after his father's
work; Kegel 1884, p. 461, mentions the work as Hals's "Hille Bobbe";
Moes 1897–1905, vol. 1 (1897), p. 88, no. 748-2, listed, under portraits
of "Hille Bobbe, fishwife of Haarlem," as one of three examples by
Frans Hals; Caffin 1902, p. 274, describes the work as Hals's "sketchy
portrait of the wicked-eyed, laughing old woman, 'Hille van Bobbe,'
[in which] one may study the impetuosity and yet faultless precision"
of the artist's technique; G. Davies 1902, p. 144, lists the work as
"Hille Bobbe (?), probably by Frans Hals, the son"; Moes 1909, pp.
64–65, III, no. 261, as "Hille Babbe," a person apparently on close
terms with Hals, who seems to have had the "intention to make a
very exact portrait of his friend"; Hofstede de Groot 1907–27, vol. 3
(1910), p. 30, no. 109, as "Hille Bobbe" by Hals, and as the version
etched by Coclers; Altman Collection 1914, pp. 29 (under no. 19), 34

(under no. 23), calls the work "a subject or character-picture," and describes the figure as "Hille Babbe, the old fishwife whose jolly and dissipated personality is preserved in several famous canvases"; Bode and Binder 1914b, vol. 1, p. 34, no. 69, pl. 32A, as "Malle Babbe"; Chase 1917, p. 437, considers this one of Hals's finest pictures; Valentiner 1921a, pp. 130 (ill.), 315, dates the picture to about 1635–40 and considers it a possible pendant of the *Merry Drinker* in the Staatliche Kunstsammlungen, Kassel; Monod 1923, p. 302, as "une *Hille Babbe* de Frans Hals le Jeune (?)"; Valentiner 1923, pp. 141 (ill.), 316, repeats Valentiner 1921a; Altman Collection 1928, pp. 62 (under no. 28), 63 (under no. 29), repeats Altman Collection 1914, but now refers to the painting as "attributed to Frans Hals the Younger"; Dülberg 1930, pp. 132, 134, as by Hals, and perhaps more true to reality than the version in Berlin; B. Burroughs 1931a, p. 152, no. H161-1, attributes the picture to Frans Hals the Younger, noting that "most authorities, including Bode and De Groot, consider the Museum's picture the work of someone close to Hals, probably Frans Hals the Younger"; Valentiner 1936, unpaged, no. 57 (ill.), as "Malle Babbe, the Witch of Haarlem," painted about 1635–40 by Frans Hals (as the writer has stated for twenty years), reports that "the woman represented was apparently a well-known street figure in Haarlem, who went about among the beer shops and on account of her droll nature enjoyed special popularity"; Van Dantzig 1937, p. 103, no. 97, calls the work a later imitation; Gratama 1937, pp. 6, 7 (ill.), 15, cites the work as one of the foremost pictures lent to the Haarlem exhibition of 1937; Siple 1937, p. 90, cites the painting as in "an especially fine lot of robust peasant folk painted about 1635 in Hals's freest manner," on view in the Haarlem exhibition of 1937; Trivas 1941, p. 36, no. 33b, describes the canvas as a copy by a contemporary of Hals after the painting in Berlin; Taubes 1958, p. 60 (ill.), as by Frans Hals, "an alla-prima painting which shows the use of highly polymerized (long) paint"; Slive in Haarlem 1962, p. 49, no. 31, fig. 5, as "painted *c.* 1630–33," considers this picture the closest of known versions to the painting in Berlin, but adds that "whether it is by the master himself or a brilliant follower is debatable," and rejects the attribution to Frans Hals the Younger; Slive 1963, p. 435, calls the picture a "problematic version" of the painting in Berlin, and reviews evidence indicating that the owl was understood in Hals's day as a symbol of folly; Von Saldern in New York–Richmond–San Francisco 1967, pp. 36, 73 (under no. 44), catalogues a copy by Frank Duveneck (ca. 1873–75) after this picture; Descargues 1968, p. 64, mentioned; Herzog 1969, p. 85 (under no. 44), suggests that the painting may be one seen together with the Kassel picture by Hals in the backgrounds of two works by Jan Steen; Slive 1970–74, vol. 1, pp. 146, 151, figs. 146, 156 (detail of head), compares the Berlin version of this subject, describes how the Museum's picture is inferior in execution, and considers it "the invention of a gifted follower or a copy after a lost original," vol. 3, pp. 140 (under no. D32), 141, no. D34, fig. 155, suggests that the painter may be the same anonymous artist responsible for the pictures of "fishergirls" in Cologne and Cincinnati, and rejects previous attributions to Frans Hals the Younger; D. Sutton in Fry 1972, vol. 1, p. 255 n. 1 to letter no. 177 of March 2, 1906, lists the picture among works included in the 1906 exhibition; Grimm and Montagni 1974, pp. 95 (under no. 71), 119, no. 339 (ill.), places the picture among problematic works assigned to Hals in the past, and cites previous opinions; Moiso-Diekamp 1987, pp. 332–34 (under no. B1), reviews earlier suggestions that this painting and the Kassel canvas (here called *Peeckelhaering als*

Trinker) might be pendants; M. Scott 1987, p. 64 (under no. 22), records Slive's suggestion that the anonymous painter of this work may also have been responsible for the *Fisher Girl* in the Cincinnati Art Museum; Slive in Washington–London–Haarlem 1989–90, pp. 216 (under no. 31), 238–39 (under no. 37), fig. 37c, compares the Berlin version by Hals, considers this a good painting by a lesser artist, and states that "the possibility that it is a copy of a lost original cannot be ruled out"; Liedtke 1990, p. 33, fig. 19, as by a contemporary follower of Frans Hals, quotes Henry James's appreciation of the picture, and considers it as a reflection of nineteenth-century American taste; N. Hall 1992, pp. 20–21, fig. 20, quotes Henry James and cites Courbet's copy of the Berlin version as "a testament to the new vogue for Hals"; Stukenbrock 1993, pp. 158, 159, 161, 162, 163, 167, 209, 225, 250, fig. 59, observes that the beer mug seen in the Berlin painting is absent here, but that the owl alone can refer to drunkenness, discusses other versions of the subject, illustrates Duveneck's copy of the Museum's picture, and describes both works as examples of the American taste for Hals, "which would reach a first high point in the 1890s"; Baetjer 1995, p. 303, as "Style of Frans Hals . . . second quarter 17th century"; Wheelock in Washington–Amsterdam 1996–97, p. 153 n. 9 (under no. 16), notes the inclusion of this picture, or a version of it, in the background of Jan Steen's *Baptismal Party* (Gemäldegalerie, Berlin); Baetjer 2004, pp. 173, 178–79, 182, 193 n. 67, 197, 217–18, 244–45, appendix 1A, no. 144 (ill. p. 217), figs. 30, 31 (floor plan), 34 (1946 gallery view), discusses the painting as part of the 1871 Purchase, and as a work that, "in the absence of a Rembrandt, was presented [when the MMA opened in February 1872] as one of the most important works in the collection," quotes James's description, and mentions the earlier owner, Lord Palmerston, "the Tory statesman and prime minister who died in 1865."

EXHIBITED: New York, MMA, "Temporary Exhibition," 1906, no. 12, as "Hillebobbe van Haarlem," by Frans Hals; Haarlem, Frans Halsmuseum, "Frans Hals tentoonstelling," 1937, no. 62, as "Malle Babbe," by Frans Hals; Dallas, Tex., Dallas Museum of Fine Arts, "30 Masterpieces: An Exhibition of Paintings from the Collection of The Metropolitan Museum of Art," 1947, unnumbered cat., as "Malle Babbe (The Witch)," by Frans Hals; Iowa City, Iowa, University of Iowa Gallery of Art, and Bloomington, Ind., Indiana University, "30 Masterpieces: An Exhibition of Paintings from the Collection of The Metropolitan Museum of Art," 1948, no cat.; Louisville, Ky., J. B. Speed Art Museum, "Old Masters from the Metropolitan," 1948–49, no cat.; Madison, Wis., University of Wisconsin, Memorial Union Gallery, "Old Masters from the Metropolitan," 1949, unnumbered cat.; Colorado Springs, Colo., Colorado Springs Fine Arts Center, "Old Masters from the Metropolitan," 1949, no cat.; Hempstead, N.Y., Hofstra College, "Metropolitan Museum Masterpieces," 1952, checklist no. 17; Haarlem, Frans Halsmuseum, "Frans Hals," 1962, no. 31, as "Malle Babbe"; Caracas, Museo de Bellas Artes de Caracas, "Grandes Maestros," 1967, no. 9, as "Malle Babbe," by Frans Hals.

EX COLL.: Henry John Temple, 3rd Viscount Palmerston, Broadlands, Romsey, Hampshire (by about 1805–d. 1865);[2] [Léon Gauchez, Brussels, 1870]; [Léon Gauchez, Paris, and Alexis Febvre, Paris, 1870; sold to Blodgett]; William T. Blodgett, Paris and New York (1870–71; sold half share to Johnston); William T. Blodgett, New York, and John Taylor Johnston, New York (1871; sold to MMA); Purchase, 1871 71.76

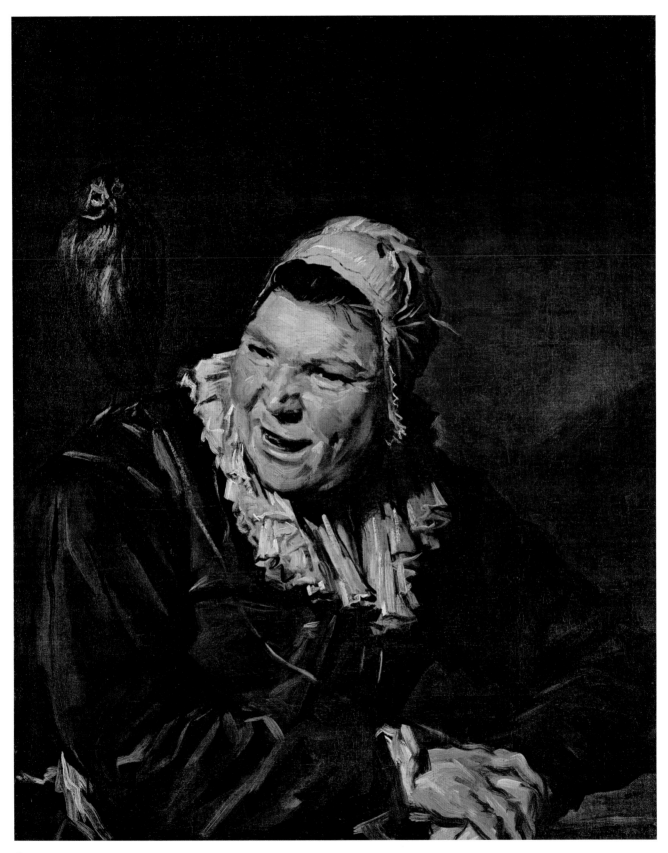

69

1. In Slive 1970–74, vol. 3, p. 141 (under no. D34), it is observed (following earlier authors) that the Museum's picture or a version of it was etched in reverse by Louis Bernhard Coclers (1740–1817), with the inscription: "Babel van Harlem/uw uil schijne u een valk, O Babel! 'k ben te vreen/Speel met een valsche pop, gij zijt het nit alleen" (Babel of Haarlem, to you, your owl seems a falcon; O Babel!, I'm content. Play with an illusion, you are not alone).

2. In about 1805, George Alexander Cooke listed in his *Itinerary* an "Old Woman, a sketch by Fr. Hals," in the dressing room at Broadlands. See Baetjer 2004, pp. 178, 193 n. 61, 218 (note under no. 144). As noted by Baetjer (ibid., p. 178), Palmerston probably inherited the picture from his parents. His father, Henry Temple, 2nd Viscount Palmerston, died in 1802, and his mother, Mary, died on January 20, 1805 (when Palmerston was twenty).

COPY AFTER FRANS HALS

70. *Frans Hals*

Oil on wood, 12⅞ x 11 in. (32.7 x 27.9 cm)
The painting is in good condition.
The Friedsam Collection, Bequest of Michael Friedsam, 1931
32.100.8

Until 1935, this small panel from the Friedsam collection was generally considered to be a self-portrait by Hals, of about 1650. Cleaning of the version formerly in the Clowes collection and now in the Indianapolis Museum of Art (fig. 82) led Valentiner (see Refs.) and others to regard that panel as the same size as the original. The Indianapolis picture is now viewed by Slive and other scholars as the best of the known copies of a lost self-portrait by Hals.[1] Its superiority is obvious from photographs, although it is clearly not by Hals himself. In the New York version and one in a German private collection,[2] the sitter's lips are slightly parted, which is not the case in the Indianapolis portrait. The Museum's painting in particular seems less somber in expression, but it is not possible to judge from the available evidence whether this reflects Hals's intention or that of one of his copyists.

There seems no reason to doubt that the Friedsam panel dates from the period, probably the 1650s. One might compare the considerable number of "self-portraits" that depict Rembrandt but appear to be by workshop assistants using actual self-portraits by the master as models.[3] The desire of collectors to own images of famous artists evidently led to the production of more "self-portraits" than the sitter cared to paint himself.

1. Slive 1970–74, vol. 3, pp. 123–24, no. L15-1, fig. 94; Slive in Washington–London–Haarlem 1989–90, p. 9, fig. 6; Grimm 1990, p. 67, fig. 61a.
2. Slive 1970–74, vol. 3, p. 124, no. 15-2, fig. 95.
3. See Van de Wetering, "'Self-portraits' Produced by Others in Rembrandt's Workshop," in *Corpus* 2005, pp. 117–32.

REFERENCES: Bode 1883, pp. 85, 87 n. 1, 93, no. 77, as "Kleines Brustbild eines jungen Mannes," by Hals, about 1650 (Warneck collection, Paris, in 1878), identifies a work in Dresden as a good copy after this picture; Hofstede de Groot in The Hague 1903, pp. 13–14, no. 34, pl. 21, questions whether this is a self-portrait, considering that the style indicates a date of about 1650, when Hals would have appeared older, and cites an old copy in the Kirchheim collection, Paris, and a version in the Frans Halsmuseum, Haarlem; Moes 1909, pp. 28, 101, no. 38 (ill. [frontis.]), considers the picture a self-portrait by Hals; Hofstede de Groot 1907–27, vol. 3 (1910), p. 46, no. 148, as by Hals, lists three supposed copies; Péladan 1912, pp. 111–12 (ill. opp. p. 110), considers this version the most authentic; Binder in Bode and Binder 1914b, vol. 1, p. 19, vol. 2, p. 15, no. 217, pl. 139B, rejects the identification of the subject as Hals; Valentiner 1921a (ill. [frontis.]), p. 305, as a self-portrait by Hals, about 1650, of which many contemporary copies are known; Valentiner 1923 (ill. [frontis.]), p. 305, repeats Valentiner 1921a; Valentiner 1925, p. 154, suggests that the work is a self-portrait by Hals, which would appear to be supported by its many copies, "but how far back this tradition goes, it is difficult to judge"; Valentiner 1928a, p. 5, dates the painting to about 1650, is inclined to consider it a self-portrait by Hals, and lists five copies; Dülberg 1930, pl. 1, as Hals's self-portrait of about 1650, and as still owned by Jules Porgès, Paris; B. Burroughs 1932, p. 13, as "in all probability" a self-portrait; B. Burroughs and Wehle 1932,

70

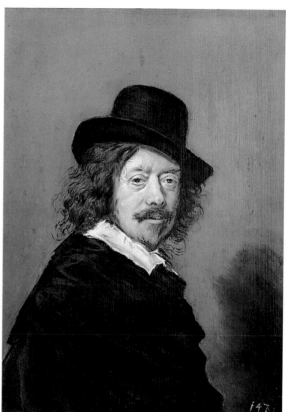

Figure 81. Copy after Frans Hals, *Frans Hals* (Pl. 70)

Figure 82. Copy after Frans Hals, *Self-Portrait*, ca. 1650. Oil on wood, 13½ x 10 in. (34.3 x 25.4 cm). Indianapolis Museum of Art, The Clowes Fund Collection

pp. 48–49, no. 85, questions the identification as a self-portrait; W. Martin 1935, pp. 342, 448 n. 461, as the best of all versions; Valentiner 1935, pp. 89–90, fig. 5, reverses the author's earlier position, now calling this picture a copy of the original in the Clowes collection (formerly in Dresden; now in the Indianapolis Museum of Art); Valentiner in Detroit 1935, unpaged (under no. 49), calls this one of the "considerable number of old copies" of the original in the Clowes collection; anon., "Neuentdeckungen zum Werke des Frans Hals," *Weltkunst* 9, no. 33–34 (August 25, 1935), p. 5 (ill.), summarizes the opinion given in Valentiner 1935; Valentiner 1936, unpaged (under no. 88), cites the painting as a copy of the *Self-Portrait* in the Clowes collection; Van Hall 1963, p. 126, no. 9a (under Frans Hals), lists the work as a copy after the Indianapolis version; Slive 1970–74, vol. 1, pp. 14, 163, considers the Indianapolis picture the best of

"a number of versions after a lost original" of about 1649, which would have been a self-portrait, vol. 3, p. 124, no. L15-3, fig. 96, considers this one of eight copies and variants of a lost original; Grimm and Montagni 1974, p. 107 (under no. 184), reviews earlier opinions; Baetjer 1995, p. 303, as Copy after Frans Hals.

EXHIBITED: The Hague, Haagsche Kunstkring, "Tentoonstelling van oude portretten," 1903, no. 34, as "Portrait of the Painter (?)," by Frans Hals (lent by Jules Porgès, Paris).

EX COLL.: [Édouard Warneck, Paris, in 1878]; Leopold Goldschmidt, Paris; Jules Porgès, Paris (by 1903–at least 1914); Michael Friedsam, New York (by 1923–d. 1931); The Friedsam Collection, Bequest of Michael Friedsam, 1931 32.100.8

ADRIAEN HANNEMAN

The Hague 1603/4–1671 The Hague

Hanneman was a highly successful portraitist in The Hague, where his Dutch version of Van Dyck's manner was ideally suited to the court city's cosmopolitan patrons. He depicted members of the national government and of the House of Orange, but from the late 1640s onward he found a large part of his clientele among English residents and visitors, in particular Royalist exiles.[1]

The artist came from a Catholic family that filled various government posts.[2] In 1619, he was apprenticed to Anthony van Ravesteyn the Younger (ca. 1580–1669), who, like his better-known brother Jan van Ravesteyn (q.v.), was a conservative portraitist in the manner of Michiel van Miereveld (q.v.). Hanneman laboriously followed this tradition in his earliest known work, a formal portrait of a woman dated 1625.[3]

In 1626, Hanneman moved to London, where he remained until about 1638. He married Elizabeth Wilson in 1630; evidently she died before Hanneman moved back to Holland.[4] Little is known of his work in England. He may have served as an assistant to Van Dyck once the latter settled in London in 1632.[5] In any event, the few known pictures from Hanneman's English period and most of his later portraits show how profoundly Van Dyck influenced his style.[6] The sophisticated *Henry, Duke of Gloucester,* of about 1653 (National Gallery of Art, Washington, D.C.), is one of a number of paintings by the Dutch artist that were long regarded as works by his Flemish contemporary.[7]

Hanneman joined the painters' guild of The Hague in 1640 and the same year married Jan van Ravesteyn's daughter Maria. The son-in-law served as *hoofdman* (headman) of the guild in 1643 and as dean from 1645 to 1647. He bought a fine house on the Nobelstraat in 1641 and appears to have enjoyed good fortune until the late 1660s.

A large portrait by Hanneman of Constantijn Huygens and his five children, each presented half-length in a medallion (Mauritshuis, The Hague), is dated 1640 but was completed slightly earlier. As secretary and artistic adviser to the Stadholder, Prince Frederick Hendrick, Huygens must have introduced Hanneman to many clients over the next thirty years. The prince was the most important patron of art and architecture that Holland had seen in some time. Van Dyck painted portraits of him and his wife, Amalia van Solms, in 1631–32, and by 1638 not only Hanneman but also Gerrit van Honthorst (1592–1656), Jan Mijtens (ca. 1614–1670), and Pieter Nason (ca. 1612–1688/90) were established at The Hague as fashionable portraitists.[8] Hanneman was working for the princely couple by 1645, and in the following year depicted their daughter-in-law Princess Mary (1631–1660; daughter of King Charles I), who in the 1650s was one of the painter's principal supporters (as in the portrait of her son, *Prince Willem III at the Age of Four,* 1654; Rijksmuseum, Amsterdam).[9] In addition to portraits, Hanneman painted a large *Allegory of Justice* in 1644 (Oud Stadhuis, The Hague) and a monumental *Allegory of Peace* about 1664 (Eerste Kamer, Binnenhof, The Hague).[10]

"A child of Mr. Hanneman in the Nobelstraat" was buried in March 1654; his second wife may have died by that time.[11] In November 1669, the artist married Alida Besemer, whom he evidently survived. In his last years, Hanneman declined in prosperity and health. He was buried in the Kloosterkerk on July 11, 1671.[12]

Hanneman was instrumental in the founding of the painters' confraternity Pictura in 1656, and was elected its first dean. He was one of the organization's principal officers throughout the 1660s, and between 1658 and 1669 had six pupils of whom Reinier de la Haye (ca. 1640–after 1695) is perhaps the best known.[13] Hanneman's known self-portraits include a canvas dated 1656 in the Rijksmuseum, Amsterdam, and a panel dated 1669 in the Kremer collection.[14]

1. As noted by Rudolf Ekkart in *Dictionary of Art* 1996, vol. 14, p. 139.
2. See Ter Kuile 1976, pp. 10, 29 n. 30, 52–53. Hanneman's father, Jan, served as clerk at the Court of Holland and in regional administrations.
3. Ibid., no. 1, pl. 1 (art market, 1970s).
4. Ter Kuile (ibid., p. 11) suggests that Hanneman left London because his wife died.
5. Ibid. 1976, pp. 10–11, 13, 17; Ekkart in *Dictionary of Art* 1996, vol. 14, p. 139.
6. See Ter Kuile 1976, nos. 2–5, pls. 2, 4, 22, 24; also Millar 1963, no. 214, pl. 93, for Hanneman's portrait of the miniaturist Peter Oliver, of about 1632–35 (Hampton Court).
7. See Wheelock 1995a, pp. 92–95.

8. See Haak 1984, pp. 332–35; The Hague 1998–99, pp. 155–61, 174–79, 207–17; and the present writer's review of portraiture in Delft and The Hague in New York–London 2001, pp. 46–53.

9. Ter Kuile 1976, no. 25, pl. 8. On Hanneman's English sitters, see also Toynbee 1950, Toynbee 1958, and Millar 1963, pp. 115–16.

10. Ter Kuile 1976, nos. 7, 79, pls. 20, 21.

11. Ibid., p. 30 n. 45.

12. See ibid., p. 11, for these and other biographical details.

13. See The Hague 1998–99, pp. 313–14, and p. 312, under Hanneman, for a list of his pupils.

14. See Van der Ploeg, Runia, and Van Suchtelen 2002, no. 14, on these two self-portraits and for references to two of the 1640s.

71. *Portrait of a Woman*

Oil on canvas, 31½ x 25 in. (80 x 63.5 cm)

The portrait is well preserved, although the impasto is somewhat flattened. The areas of the face, hair, hands, and lace collar and cuffs are in good condition. Although there are numerous minute losses distributed throughout the background and clothing, these do not substantially detract from the painting's appearance. X-radiography reveals cusping along the lower edge, confirming that the closely cropped composition is original.

Marquand Collection, Gift of Henry G. Marquand, 1889
89.15.27

This unsigned portrait of an attractive young woman is certainly by Hanneman and has been dated convincingly to about 1653.[1] The work is one of several portraits of upper-middle-class women in which the painter slightly varied a standard compositional scheme. His *Portrait of a Woman,* dated 1653, in the Pushkin Museum, Moscow, is very similar in design and even in the sitter's appearance, costume, and jewelry, although she is clearly not the same person.[2]

Ter Kuile conjectured that the Museum's picture might have had a male pendant, and he proposed the *Portrait of a Man,* signed and dated 1655, in the Dulwich Picture Gallery, London.[3] That canvas is about the same size and has a similar tan background. The fact that the man appears closer and higher in the composition than the woman in the New York painting would seem to speak against a pendant relationship were it not for the fact that the same disparity occurs in several approximately contemporary pair portraits by Hanneman.[4] However, the relevant examples feature a complementary play of male and female hands, whereas no hands are included in the Dulwich picture. Furthermore, a number of male portraits by Hanneman must now be unknown or unidentified.

As in similar portraits by the artist, the graceful proportions of the figure, with oval head, long neck, sloping shoulders, and tapered hands, recall Van Dyck's manner of flattering female subjects. The soft brown curls and the contours of the face also remind one of the Flemish master's images, but the modeling of the nose, the mouth, and especially the hand (which, unlike Van Dyck's version, has veins and some sort of skeletal structure) is more consistent with precedents in Hanneman's native city. The rather flat and mechanical description of lace likewise brings to mind passages in portraits from the workshop of Michiel van Miereveld (q.v.) and may indicate the use of an assistant for costume details (which were usually of considerable importance to the patron). In her costume, elegant hairstyle (with its cascade of curls), and above all extravagant display of pearls, the sitter is presented not only at her best but also as an exemplar of contemporary femininity.

1. Ter Kuile 1976, no. 24. A dating to 1654 or 1655 is also possible, to judge from the costume and coiffure, but a date earlier than 1653 is unlikely. The painting was considered to be by Cornelis Jonson van Ceulen the Elder (q.v.) until 1934, when curator Harry Wehle reassigned it to Hanneman. Notes in the curatorial files record the supporting opinions of F. Schmidt-Degener (1935) and L. van Puyvelde (1939).

2. Ter Kuile 1976, no. 20, pl. 42. The cropping of the hand and cuffs in the Museum's picture may seem unusual but is typical of Hanneman's female portraits: compare ibid., pls. 42, 44, 45, 49, 59, 61.

3. Ibid., p. 81 (under no. 24), n. 1, referring to his no. 32, pl. 9 (Murray 1980, no. 572). A signed pendant would account for the lack of a signature here, since Hanneman and other artists frequently signed only one of the portraits that formed a pair: for example, Ter Kuile 1976, nos. 27 (man's portrait), 30 (woman's).

4. See Ter Kuile 1976, pls. 46–49, 58, 59, 62, 63, 66, 67.

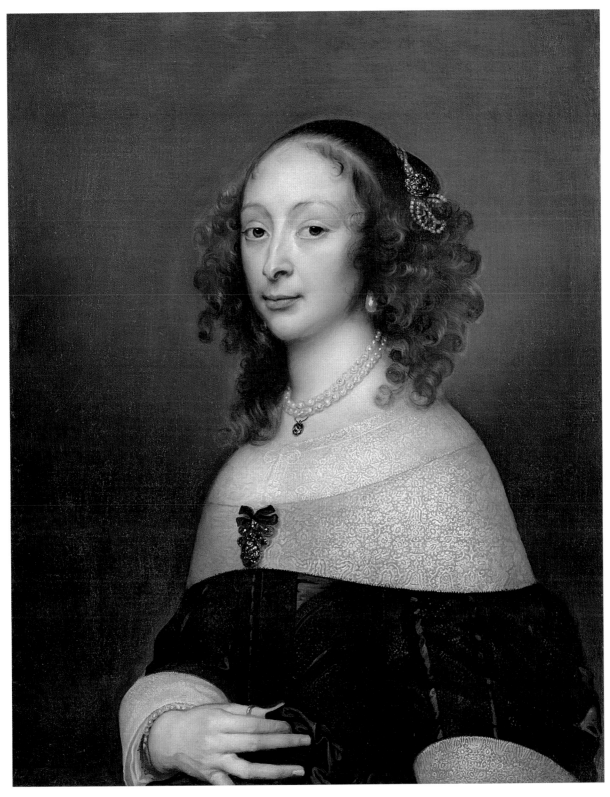

71

REFERENCES: B. Burroughs 1922, p. 154, cites the painting as by "Janssens van Ceulen"; Ter Kuile 1976, pp. 15, 79 (under no. 20), 81, 86 (under no. 32), no. 24, pl. 10, describes the type of composition, dates the painting to about 1653, and suggests that the *Portrait of a Man,* of 1655, in the Dulwich Picture Gallery might be its pendant; P. Sutton 1986, p. 183; Liedtke 1990, p. 36, as a Marquand picture; Baetjer 1995, p. 308.

EX COLL.: Henry G. Marquand, New York; Marquand Collection, Gift of Henry G. Marquand, 1889 89.15.27

MARGARETA HAVERMAN

Breda; active ca. 1715–in or after 1723 Paris?

The artist's dates of birth and death are unknown.[1] According to Johan van Gool (1751), who did not know Haverman, she was the daughter of a schoolmaster who moved from Breda to Amsterdam.[2] Her father evidently persuaded Jan van Huysum (1682–1749) to take her on as a pupil, despite the famous flower painter's secretive nature. Haverman's impressive approximation of Van Huysum's style, as seen in the Museum's painting (Pl. 72), suggests that she must have studied with him for some time.[3] Van Gool reports that the pupil weathered her teacher's ill temper with exceptional patience, but the relationship eventually dissolved.

By January 21, 1722, when Haverman became a member of the Académie Royale de Peinture in Paris, she was living there as the wife of Jacques de Mondoteguy.[4] Her acceptance into the Académie was based upon a previously completed flower and fruit piece, but she was requested to produce a similar painting as her reception piece. A legend later developed that Haverman was accused of submitting a picture by Van Huysum as her own, but it may be that she simply failed to submit the required painting. In any event, she was excluded from membership in 1723. Nothing further is known of her life.

In addition to being Van Huysum's only certain pupil and one of his first followers, Haverman may be counted among the earliest Dutch flower painters who pursued careers outside the Netherlands. Another was Rachel Ruysch (1664–1750), who lived mostly in Amsterdam, and was court painter to the Elector Palatine, Johann Wilhelm, from 1708 to 1716. In Paris, Haverman was followed (at some distance) by the brothers Gerard (1746–1822) and Cornelis (1756–1840) van Spaendonck, and by Willem van Leen (q.v.), among other specialists. While several works by Haverman are recorded in early inventories, only two signed paintings are presently known, the undated *Flowers in a Glass Vase,* in Fredensborg Castle (near Copenhagen), and the picture discussed below.

1. In Berardi 1997, p. 649, Haverman is said to have been born in 1693, without supporting evidence.
2. Van Gool 1750–51, vol. 2, pp. 31–33.
3. Most modern accounts, for example Van der Willigen and Meijer 2003, p. 101, report that Haverman was dismissed by Van Huysum after a short period. The maturity of Haverman's work in Van Huysum's style suggests otherwise, as noted in Berardi 1997, p. 651.
4. De Mondoteguy is usually said to have been an architect. He is presumably identical with the author of the same name who wrote *Traité de la banque d'Amsterdam,* which was published with Jean-Pierre Ricard's *Le négoce d'Amsterdam* (Rouen, 1723).

72. *A Vase of Flowers*

Oil on wood, 31¼ x 23¾ in. (79.4 x 60.3 cm)
Signed and dated (lower right): Margareta. Haverman fecit./A 1716

The condition overall is good, although the grapes at lower right now appear flat because only fragments of the green modeling glazes remain. Throughout, the very blue appearance of the green leaves and stems suggests the use of a now faded yellow lake pigment.

Purchase, 1871 71.6

This panel is one of only two indisputable works by Haverman known to survive, and the only one to bear a date. The other picture, *Flowers in a Glass Vase* (Fredensborg Castle, Denmark), appears to have been painted a little earlier, to judge from comparisons with works by Haverman's teacher, Jan van Huysum.[1]

In the New York painting, a tall bouquet of flowers fills a gray stone niche. The footed pot, evidently of terracotta, is cast in high relief, with the back of a putto seen in the center, and the leonine head of a man (crowned by a bumblebee) extending to the right. A peach and bunches of green and purple

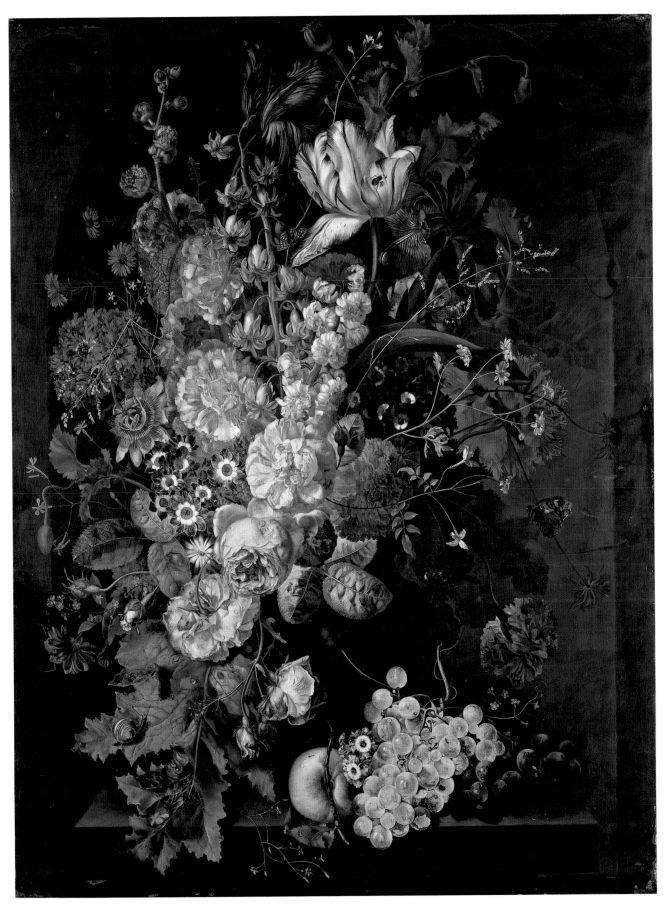

grapes rest on the stone ledge or pedestal, their surfaces covered with moisture and explored by a couple of ants. Flowers of many kinds are gathered around the slightly curved ascent of pink and white blooms in the center of the composition. They include roses, carnations, hollyhocks, irises, marigolds, passionflowers, primulas, poppies, and tulips (the striped one at top center features waterdrops, a moth, and a fly). A butterfly is perched on a leaf to the right, and a snail makes its way up the large leaf to the lower, which is a showpiece of fragile topography, with waterdrops and small areas of discoloration adding to the visual interest. On the whole, the still life is masterful in design and description, but a bit stale and uniform in execution when compared with similar works by Van Huysum. His suggestions of volume, light, and atmosphere are not quite equaled here, although Haverman (who was probably in her twenties at the time) comes impressively close. Similarly, her handling of precise detail is extraordinary rather than astonishing, and somewhat dry. The bluish color of some leaves, which makes an artificial impression, was probably toned down originally by yellow lake (see condition note above).

In sales of 1869 and earlier, the Museum's painting was accompanied by an unsigned pendant of similar design, but with a bird's nest.[2]

1. See Berardi 1997, p. 651, on the painting at "Fredenborg."
2. Berardi (ibid., p. 652) is reminded by the pendant's description of two works thought to be by Van Huysum, one in the Statens Museum for Kunst, Copenhagen (no. 341), the other in the Dulwich Picture Gallery, London (no. 120). She observes that they are both on panel and the same size as the Museum's Haverman, but the significance of this information is not made clear (both "Van Huysums" were acquired in the first half of the nineteenth century). Segal in Delft–Houston 2006–7 (see Refs.) quotes the description of the pendant picture in the Amsterdam sale of April 14, 1777 (if the present painting and its pendant were indeed nos. 62 and 63 in that sale), which stresses that the flower arrangements and settings are quite similar, and that the bird's nest contains five eggs. A painting consistent with the pendant's description, on a panel measuring 31¼ x 23⅞ in. (79.5 x 60.5 cm), was sold as by Van Huysum at the Galerie Georges Petit, Paris, May 22, 1919, no. 108 (evidently not in the catalogue raisonné, M. Grant 1954, where numerous works with nearly the same dimensions are listed). To judge from the poor photograph in the sale catalogue, there are three eggs in the bird's nest. Fred Meijer considers the panel sold in 1919 to be a good copy of the Van Huysum in Copenhagen (personal communication, October 31, 2005).

REFERENCES: Decamps 1872, p. 43, describes the painting as "superb"; James (1872) 1956, p. 65, as demonstrating "a magnificent elaboration of detail, an almost masculine grasp of the resources of high finish"; MMA 1872, p. 45, no. 112, "from the collection of M. Louis Fould," reproduces a facsimile of the inscription; anon. in Thieme and Becker 1907–50, vol. 16 (1923), p. 162, mentioned as one of three known works; Warner 1928, p. 88, pl. 39a, suggests that the date might be 1756; B. Burroughs 1931a, p. 156, gives basic information; Salinger 1950, pp. 259–60 (ill. p. 256), names the flowers depicted, and finds the "bluish unifying tone" to be "artificial though very handsome"; Mitchell 1973, p. 129, fig. 174, as "the best-known example by this rare artist"; Petersen and Wilson 1976, pp. 56, 58, fig. IV.24, repeats the "jealous" Van Huysum topos as a fact, and imagines that the artist was "much maligned"; Harris in Los Angeles and other cities 1976–77, pp. 34, 36, fig. 11, considers the work to demonstrate that Haverman had by 1716 mastered Van Huysum's technique and did not need to deceive the French academy by submitting one of his works as one of her own; Bergström et al. 1977, p. 192 (ill.), with short description; P. Sutton 1986, p. 190, listed; Grimm 1988, pp. 199, 243, pl. XXXI; Baetjer 1995, p. 343; Berardi 1997, pp. 650 (ill.), 651–52, describes the composition, names the flowers, suggests loss of glazes toning down the "metallic" blues, and discusses evidence for a pendant (see Ex Coll. below); E. Kloek, Sengers, and Tobé 1998, p. 144, listed; Van der Willigen and Meijer 2003, p. 101, listed; Baetjer 2004, pp. 182, 210, 244, no. 112 (ill.), notes that the work was valued at FFr 3,000 by Gauchez (see Ex Coll.), and clarifies its provenance; Segal in Delft–Houston 2006–7, pp. 313–16, no. C6, describes the subject, identifies all the flowers and insects, suggests possible provenance to 1777, and discusses eighteenth-century evidence of a possible pendant.

EXHIBITED: Wilmington, Del., Delaware Art Center, "Paintings by Dutch Masters of the Seventeenth Century," 1951, no cat. no.; Palm Beach, Fla., Society of Four Arts, 1952; Hempstead, N.Y., Hofstra College, "Metropolitan Museum Masterpieces," 1952, no. 18; New York, Union League Club, 1969–70; New York, MMA, "The Eighteenth-Century Woman," 1981–82, p. 51; Delft, Stedelijk Museum Het Prinsenhof, and Houston, Tex., The Museum of Fine Arts, "The Temptations of Flora: Jan van Huysum (1682–1749)," 2006–7, no. C6.

EX COLL.: Possibly François Ignace de Dufresne (his sale, De Winter, Amsterdam, August 22, 1770, no. 229, with a pendant, no. 230); (probably Nicolaas Nieuhoff sale, Amsterdam, Philippus van der Schley, Hendrik de Winter, and Jan Yver, April 14, 1777, no. 62, with a pendant, no. 63; sold for Fl 751 to Cornelis Ploos van Amstel);[1] Louis Fould (until 1860; his estate sale, Pillet and Laneuville, Paris, June 4, 1860, no. 5 with no. 6 for FFr 2,600); Édouard Fould (1860–69); his sale, Hôtel Drouot, Paris, April 5, 1869, no. 7, for FFr 2,100, with a pendant sold for FFr 2,050); [Léon Gauchez, Paris, with Alexis Febvre, Paris, until 1870; sold to Blodgett]; William T. Blodgett, Paris and New York (1870–71; sold half share to Johnston); William T. Blodgett, New York, and John Taylor Johnston, New York (1871; sold to MMA); Purchase, 1871 71.6

1. The provenance to 1777 was first proposed by Segal in Delft–Houston 2006–7, p. 313 (under no. C6).

WILLEM CLAESZ HEDA

Haarlem? 1594–1680 Haarlem

Heda's date of birth is estimated on the basis of a portrait of him dated 1678 (location unknown) by the Haarlem painter Jan de Bray (ca. 1627–1697), who inscribed the likeness "aetate 84"; and a document of 1627 in which Heda's age is given as about thirty-one.[1] Van Gelder reviewed a few possible ancestors in Haarlem, Utrecht, and elsewhere, but the family line has yet to be traced.[2] The family of his wife, Cornelia van Rijck (d. 1668), is better known from documents.[3]

The couple, who were Catholic, had at least five daughters (Elisabeth, Maria, Aefje, Claesje, and Anna), and two sons, Cornelis (who became a priest) and the still-life painter Gerrit Willemsz Heda (ca. 1620–1649). All but Gerrit are named in a will that Heda and his wife made on August 11, 1661.[4] Until recently, it was known only that Gerrit died before 1702, although some scholars assumed that the "zoon van Willem Claesz Heda" buried in Saint Bavo's on July 31, 1649, was probably Gerrit. This must indeed be the case. Dated works by him (very much in his father's manner) span a mere ten years, from 1637 to 1647.[5]

The family appears to have lived a comfortable middle-class life, to judge from the house in the Groote Houtstraat that Heda owned and rented out (according to a document of 1648) and another house in Haarlem that he substantially remodeled in 1649. Although he painted a triptych with a central Crucifixion in 1626,[6] and several still lifes date from the late 1620s, Heda joined the Haarlem painters' guild only in 1631.[7] He served as *hoofdman* (headman) in 1637, 1643, and 1651, and as dean in 1641 and 1662. Dated paintings range from 1625 or 1628 to 1665 or 1667.[8] In addition to his son Gerrit, Heda had a few other pupils, the most important of whom was Maerten Boelema (ca. 1620–?after 1664).[9]

With Pieter Claesz (q.v.), Heda was a leading still-life painter in Haarlem, specializing in the "monochrome banquet piece" (*banketje*). His early works have been associated with the more additive still lifes of Floris van Dijck (1574/75–1651) and Floris van Schooten (1585/88–1656),[10] but these comparisons are even less appropriate than they are for the slightly younger Claesz, with whom Heda (not unlike the pioneering Haarlem landscapists of the same period) explored a tonal and naturalistic manner of describing familiar motifs.[11] Heda was especially fond of describing reflections, which may account for the virtual triumph of metalwork and glassware over foodstuffs in his pictures and his preference for glistening hams, mince pies, and oysters (which is not to say that Claesz neglected the same). Heda's mature manner was emulated by several artists in Haarlem and elsewhere, including the Amsterdam masters Jan den Uyl (ca. 1595–1640) and Willem Kalf (q.v.).[12]

1. See Van der Willigen and Meijer 2003, p. 103.
2. For these and other biographical details, see H. van Gelder [1941], pp. 10–12, citing documents in the Haarlem archives.
3. Heda's mother-in-law, Annetje Pietersdr, widow of Jacob Philipsz van Rijck, was buried in Saint Bavo's (the Grote Kerk of Haarlem) on July 31, 1649. On September 6 of that year, Heda gave the executor of his mother-in-law's estate power of attorney to have a probate inventory made in her house, and to represent his own legal rights (as the husband of one of the heirs, who were Annetje's four children; Oud Notarieel Archief Haarlem, 161, fol. 249r, dated September 6, 1649). The writer owes this reference and a full discussion of Heda's immediate family to Pieter Biesboer, curator, Frans Halsmuseum, Haarlem (personal communication, August 16, 2005).
4. Oud Notarieel Archief Haarlem, 317, notary J. van Gellinkhuysen, fol. 102r, dated August 11, 1661 (brought to my attention by Pieter Biesboer).
5. See Vroom 1980, vol. 2, pp. 56–65.
6. Sotheby's, Amsterdam, May 8, 2001, no. 44; mentioned in Van der Willigen and Meijer 2003, p. 103.
7. See Blankert 1991, p. 103, on the *Vanitas Still Life* (Museum Bredius, The Hague), dated 1628, which was earlier thought to be dated 1621. A panel sold in 1907 and since untraced is said to be dated 1625 (Vroom 1980, vol. 2, p. 65, no. 324), which is plausible, considering that the artist was already about thirty at the time. A drawing of John the Baptist by Heda is dated 1626 (H. van Gelder [1941], pp. 10 [ill.], 12).
8. See Vroom 1980, vol. 2, pp. 65–80. The alternative dates of Heda's earliest and latest known works depend on old readings of inscriptions and the uncertainty of attributions. The date on an early panel in the Museum Bredius, The Hague, is given as 1625 in Gemar-Koeltzsch 1995, vol. 2, p. 419, but by the museum itself as 1628 (Blankert 1991, p. 103, no. 67).
9. See Vroom 1980, vol. 1, pp. 127–30, vol. 2, pp. 11–29.
10. Wheelock 1995a, p. 99.
11. See Bergström 1956, p. 122. The long discussion of Heda's style in Vroom 1980, vol. 1, chap. 3, is marred by the author's inability

to write concisely or coherently, but a few insights may be gleaned, and there are numerous illustrations. See also H. G. Dijk-Koekoek in *Dictionary of Art* 1996, vol. 14, pp. 286–87, and Amsterdam–Cleveland 1999–2000, pp. 152–55.

12. On Den Uyl, see Bergström 1956, pp. 144–51, and, for one of his finest works, Amsterdam–Cleveland 1999–2000, pp. 150–52, no. 20 (1633). The question of Kalf's connection with Heda requires further consideration, but see ibid., pp. 154–55, no. 22.

73. *Still Life with Oysters, a Silver Tazza, and Glassware*

Oil on wood, 19⅝ x 31¾ in. (49.8 x 80.6 cm)
Signed and dated (lower right): HEDA ·1635·

The painting is well preserved. Small paint losses are distributed throughout, and the area of the broken glass in the center is abraded. The panel, made of two boards joined in the middle, retains its original thickness but has been slightly trimmed on all sides. The absence of a bevel suggests the reduction is greater along the top edge.

From the Collection of Rita and Frits Markus, Bequest of Rita Markus, 2005 2005.331.4

This impressive picture from the Markus collection is typical of Heda's work in the mid-1630s. On the left, empty oyster shells rest in front of a plate of oysters yet to be consumed. The ebony and ivory handle of a knife extends over the edge of the table, and a gleaming spoon artfully leads the eye to a shard of glass and other curving forms. A cut lemon, a single pit, and a paper cone of spice (probably pepper) rest on another pewter plate in the foreground. In Heda's day, the printed paper would have been recognized as a page torn from an almanac, and perhaps as a reminder that one's days on earth are numbered. A more obvious sign that worldly pleasures quickly pass is the wineglass that has tipped over and broken.

The pewter plates are balanced visually by the silver tazza lying on its side, which reveals the untarnished interior of the base. The way the base touches the plate and lemon peel is characteristic of Heda, as is the constellation of highlights playing over the elaborately worked surface of the tazza. Behind the tazza to the left is a glass of beer, and to the right a pewter plate and a fancy glass pitcher. An open, leather-covered knife case to the right mirrors the position of the knife to the left, and draws attention to the artist's signature. Walnuts are scattered to the far right, and hazelnuts below the

stem of the tazza and at the foot of the large *roemer*. In this centerpiece of the composition, Heda displays his virtuosity in describing reflections and transparency. A tall window is reflected three times in the bowl of the glass, and the beaded molding on the glass (at the top of the prunted stem) is echoed more than once in the wine. Indeed the variety of reflected light throughout the picture—while somewhat open to question on optical grounds—is extraordinary. But that has little to do with what the artist has achieved in this so-called monochrome banquet piece, or *banketje*—actually an essay in silvers, greens, browns, whites, and yellows.

Heda had painted similar designs (if not motifs) by 1630, and closely related groups of objects by 1632. A panel dated 1632 in the Museo del Prado, Madrid, includes a *roemer* with comparable reflections (they are virtually the same in other works), a similar tazza tipped in the other direction, the same glass pitcher in the right background (but facing the other way), a plate with oysters, and a plate with a lemon shifted somewhat to the right.[1] The same or a similar tazza, in nearly the same position, is found in a still life by Heda dated 1632 (private collection).[2] Similar compositions and motifs were painted by Pieter Claesz (q.v.) at about the same time.[3]

A copy of the present picture is catalogued by Vroom (see Refs.).

1. Vroom 1980, vol. 1, pp. 54, 72, figs. 66, 88, for the *roemer* with similar reflections in a painting of 1630, and vol. 2, p. 66, no. 328 (ill.), for an analogous composition of 1630.
2. Ibid., vol. 1, p. 57, fig. 71. For the tazza and *roemer*, see also the Heda of 1634 in the Rijksmuseum, Amsterdam (Gemar-Koeltzsch 1995, vol. 2, p. 423, no. 157/8; and no. 157/9 [ill.], for the *roemer* with very similar reflections in a painting dated 1634).
3. Compare, for example, Vroom 1980, vol. 1, p. 36, fig. 40, a panel dated 16[??] in the Staatliche Kunsthalle, Karlsruhe.

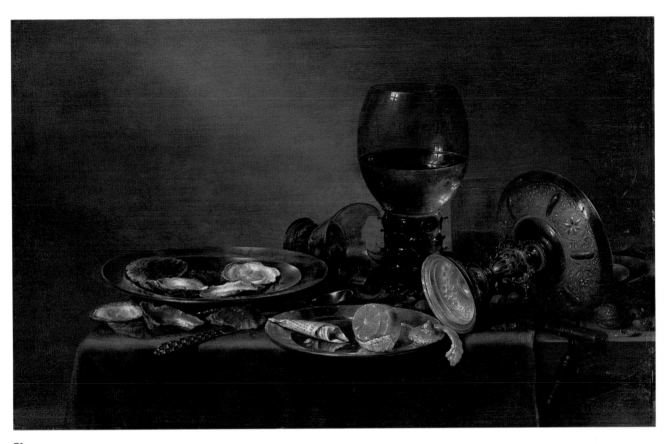

73

REFERENCES: Vroom 1945, pp. 193, 211, no. 186, fig. 179, cites the painting as dated 1633; Vroom 1980, vol. 2, pp. 67–68, no. 339a (ill.), and p. 68 (under no. 339b), repeats the information in Vroom 1945, and describes no. 339b (ill.; art market, Amsterdam, 1969) as a "later replica" of the Museum's painting.

EX COLL.: C. Freiherr Grote, Schloss Wedesbüttel (his estate sale, Heberle & Lempertz, Cologne, June 7 and 8, 1886, part 2, no. 93, to Galerie Oldenbourg for 2,000 marks); [Galerie Oldenbourg (sale, F. Muller & Co., Amsterdam, June 26, 1923, no. 18, probably bought in for Fl 3,300; sale, Amsterdam, F. Muller & Co., June 25, 1924, no. 131)]; Frits and Rita Markus, New York (until his d. 1996); Rita Markus, New York (1996–d. 2005); From the Collection of Rita and Frits Markus, Bequest of Rita Markus, 2005 2005.331.4

JAN DAVIDSZ DE HEEM

Utrecht 1606–1683/84 Antwerp

The artist was born in Utrecht during the month of April 1606. His parents were David Jansz van Antwerpen, a native of Utrecht whose father had come from Antwerp, and Hillegont Teunisdr, from Leiden. They married in 1603, after each of them had lost a spouse. David Jansz appears to have prospered (he was apparently a professional musician), but he died at an unknown age in 1612, leaving the future painter, then known as Johannes van Antwerpen, and two daughters, Margaretha and Heijltgen. In 1613, the artist's mother was married for the third time, to Johan Jacob Coornhert, a bookseller and binder from Worms. By 1623, he was in financial difficulties and, having sold two houses, moved the family to Leiden in 1625. In the same year, Johannes (who never signed himself Jan on paintings or in documents) expressed his intention of going to Italy in order to broaden his artistic education, but the plan fell through for lack of funds.[1]

On November 12, 1626, the twenty-year-old painter and Aletta van Weede, from Utrecht, posted their marriage banns in Leiden. This is the first known document in which the artist signs himself De Heem.[2] Five children were born to the couple; the first died in infancy, and the second (David) at the age of fifteen. Their third child, Cornelis de Heem (1631–1695), became Jan de Heem's student and, like him, an exceptional painter of still lifes. A girl and a boy were born in Antwerp, in about 1635 and in 1638. The children born in Leiden were baptized in Reformed churches, but the last child, with the telling name Thomas Maria, was baptized in the Sint Joriskerk, suggesting that De Heem and his wife had converted to Catholicism. Perhaps the strict Calvinist sentiments of De Heem's middle-class milieu in Leiden encouraged him to move to the Spanish Netherlands, though there may have been some other reason.[3]

The year in which De Heem and his family moved to Antwerp is not known. It has been suggested that they left Leiden as early as the winter of 1631–32,[4] but this is inconsistent with the fact that De Heem did not join the Antwerp painters' guild until 1635–36,[5] and did not become a citizen of Antwerp until August 28, 1637. On March 1, 1636, De Heem and Adriaen Brouwer (1605/6–1638) served as witnesses for Jan Lievens (1607–1674), who was signing a pupil's contract. De

Heem and his pal Brouwer play the principal parts in the latter's celebrated painting *The Smokers,* of about 1636–37 (Metropolitan Museum of Art, New York).[6]

De Heem's first wife died in March 1643. Shortly afterward, his house and possessions were valued at more than 4,000 guilders. The artist's work brought high prices, and he also had income from teaching. His several pupils included Andries Benedetti (1615/20–after 1660) and Alexander Coosermans (1627–1689). On March 6, 1644, in Antwerp Cathedral, De Heem married Anna Ruckers, a daughter of the famous manufacturer of virginals, Andries Ruckers. The artist's second wife bore him four girls and two boys between 1645 and 1654. The fourth child (and first son) became the rather obscure still-life painter Jan Jansz de Heem (1650–after 1695).

Various documents reveal that De Heem maintained close contacts with people in the northern Netherlands, including a patron in Amsterdam. He made a number of trips to his native Utrecht, and from late 1658 until 1667 he was registered there as a nonresident citizen. In the summer of 1667, he moved with his family to Utrecht, where he remained until the French invasion of 1672. De Heem's wife died in 1672, and from that year until his death in late 1683 or early 1684, he again lived in Antwerp.

De Heem's earliest works were inspired by Balthasar van der Ast (1593/94–1657), the accomplished fruit and flower painter who lived in Utrecht during the 1620s, and, from about 1628, by the Haarlem specialist Pieter Claesz (q.v.).[7] About 1632, De Heem started painting still lifes that were more distinctive, to a degree that one scholar has described them as demonstrating "complete independence" from any other master's "composition and conception."[8] What De Heem actually did in these pictures of the early 1630s was to adapt sections of compositions by Claesz and especially by Willem Claesz Heda (q.v.) to a vertical format, and to use contrasts of light and shadow, and lush reflections, in a manner reminiscent of his Leiden colleagues Jan Lievens and Gerrit Dou (q.v.).[9] The influence of the Amsterdam still-life painter Jan den Uyl (ca. 1595–1640) is obvious in a canvas by De Heem dated 1635 (private collection), and also likely in pictures with pewter vessels dating from 1632–34.[10] This tends to support the notion that De Heem continued to draw upon the Haarlem and Amsterdam

painters of monochrome banquet pieces until 1635, and that he remained in Leiden until about that year.

In Antwerp, De Heem soon adjusted to the local taste for opulence, producing *pronkstillevens* (still lifes of luxurious objects and delicacies) on an often larger scale, and with a brighter palette, than he had employed previously. His most important model was Frans Snyders (1579–1657), who, in addition to larders groaning with game and pictures often occupied by human figures, painted more exquisite arrangements of fruit and fancy tableware from the mid-teens onward.[11] In such pictures as De Heem's *Sumptuous Still Life with a Ham, Oysters, Fruits, and a Parrot,* of about 1640–45 (Gemäldegalerie der Akademie der Bildenden Künste, Vienna),[12] Snyders's influence is clear in the sheer abundance of motifs on the large table, the Baroque structure of the busy composition, and the rich coloring, of a variety and warmth very different from the restrained tones De Heem had favored in Leiden. De Heem's Antwerp pictures, however, even when closest to Snyders and his followers (Adriaen van Utrecht [1599–1652] was also important for De Heem), are recognizably Dutch in their finer description of physical qualities and their sense of order. From brushstrokes to broad patterns the Flemish predilection for rhythms flowing over the surface was tempered by De Heem, so that his most lavish displays reveal and invite contemplation.

In addition to *pronkstillevens,* De Heem painted fruit pieces, flower pictures, flower wreaths and garlands (of the type depicted by Daniel Seghers [1590–1661] in Antwerp), and vanitas still lifes. These last include paintings of secular books piled on a tabletop, a Leiden specialty to which the artist turned as early as 1628.[13] De Heem's innovations and technical virtuosity made a great impression on many Dutch and Flemish still-life painters, including Joris van Son (1623–1667) and lesser artists in Antwerp, Pieter de Ring (ca. 1615–1660 or later) and others in Leiden, and, in Utrecht, Jacob Marrell (1613/14–1681) and Abraham Mignon (1640–1679).[14]

1. These details are mostly adopted from the chapter devoted to the biography of Jan Davidsz de Heem and his artistic descendants by Liesbeth Helmus and Sam Segal in Utrecht–Braunschweig 1991, pp. 55–68. Important clarifications are found in Bok 1990. The artist is so well known in the literature as Jan de Heem (as he is named in Houbraken 1718–21, vol. 1, pp. 209–12) that even archivists see no point in arguing for the use of Johannes.

2. As noted by Helmus and Segal in Utrecht–Braunschweig 1991, pp. 57, 67 n. 7, the name De Heem (indeed, a deceased Jan de Heem) is mentioned earlier in Antwerp, but there is no known connection with the artist's family. A "heem" is a farmyard or homestead. At least one of Jan de Heem's sisters also adopted the name. It is not known why the surname Van Antwerpen was dropped in favor of De Heem, but this amounted to changing a name with an immigrant ring for something generic.

3. See ibid., pp. 60–61.

4. Ibid., pp. 61, 67 n. 20. No documents record the family in Leiden after 1631, but this hardly assures us of their absence from 1632 onward.

5. Rombouts and Van Lerius 1864–72, vol. 2, p. 71.

6. See Liedtke 1984a, pp. 5–10, pl. 1.

7. See Meijer 1988 and Bergström 1988 on De Heem's work in the 1620s.

8. Bergström 1988, p. 45.

9. See ibid., figs. 6–9.

10. Ibid., pp. 48–49, fig. 15 (1635); see also figs. 11, 12. On Den Uyl's influence, see also Segal in Utrecht–Braunschweig 1991, pp. 23–24, 134–35.

11. See Koslow 1995, chap. 3.

12. Utrecht–Braunschweig 1991, no. 9; Trnek 1992, pp. 171–76.

13. See Amsterdam–Cleveland 1999–2000, nos. 27, 28, and the discussions in Utrecht–Braunschweig 1991, pp. 20–21, 24, and in Meijer 2003, p. 217 (under no. 36).

14. For a broader survey of artists influenced by De Heem, see Segal 1989, pp. 156–64; Utrecht–Braunschweig 1991, pp. 43–49; and S. Segal in *Dictionary of Art* 1996, vol. 14, pp. 289–90.

74. *Still Life with a Glass and Oysters*

Oil on wood, 9⅞ x 7½ in. (25.1 x 19.1 cm)
Signed (upper right): J.De heem

The finishing glazes that contributed to the subtle color, texture, and modeling of the lemon, oysters, and grapes are damaged.

Purchase, 1871 71.78

A collector's item, this small panel was painted by De Heem early in his Antwerp years, probably during the late 1630s or about 1640. Visiting scholars have occasionally proposed other attributions, for example to Pieter de Ring (ca. 1615–1660 or later), which is understandable in view of De Heem's pervasive influence. There is no reason to doubt the typical signature in the upper right corner, and the picture, in motifs and particular passages of execution (especially the glass, the spiraling lemon peel, and the leaves), is completely characteristic of De Heem's work before the 1650s. The three leading specialists of recent decades, Ingvar Bergström, Fred Meijer, and Sam Segal, have each examined the painting on several occasions and agree that it is by De Heem.[1]

The aesthetic appeal of this picture is wonderfully concentrated in the glass, with its white and yellow reflections suggesting bright light from a window. Graceful leaves and tendrils fairly float above the rim and descend to green grapes, which with the wine form a simple paean to Bacchic pleasures. The latter traditionally included erotic pursuits, as seen in the Museum's painting by Abraham van Cuylenborch (Pl. 30), and as hinted here by the oysters, which had a reputation in the Netherlands (as in antiquity) for stimulating sexual appetites (Jacob Cats called them "love herbs"). Artists such as Frans van Mieris and Jacob Ochtervelt (q.q.v.) painted "oyster meals," with smiling couples tempting each other with plates of oysters and jugs of wine.[2] Oysters, grapes, and even lemons were delicacies in De Heem's day, so that his subject suggests a certain level of society, one in which idle hours and beautiful pictures were counted among life's rewards.[3]

1. Bergström, in 1983 and 1986, considered the painting a "very fine example" of De Heem's work early in the Antwerp years. F. Meijer entertained doubts in 1995, but did not "fully exclude

De Heem himself having executed it entirely or in part" (letter dated February 13, 1995). Meijer set aside reservations after seeing the painting in better light during 1997 (as recalled in a letter dated August 4, 1998). Nancy Minty, as a research assistant at the Museum in 1988, noted a good number of comparable motifs, painted in quite the same manner, in other works by De Heem. A very similar picture, with the same motifs differently arranged, was with Brian Koetser, London, in 1963.
2. See P. Sutton 1992, pp. 134–36, for examples, and for a very good discussion of the oyster in Dutch art (the precise source in Jacob Cats's *Houwelick* is not given).
3. Lemon trees were among the rare trees cultivated in the gardens of the princely palace at Honselaarsdijk, near The Hague (Sellers 2001, p. 58).

REFERENCES: Decamps 1872, p. 437, mentions the painting; MMA 1872, no. 125; B. Burroughs 1931a, p. 157, no. H36-1; Greindl 1956, pp. 105, 173, mentioned and listed; Greindl 1983, pp. 127, 361, no. 98, mentioned and listed; Baetjer 1995, p. 310; Luttikhuizen in Grand Rapids 1999, pp. 64–65, 103, no. 11, takes pains to make the picture's subject suit the theme of the exhibition, suggesting that "the wine likely suggests lust," and that the painting invites observers to choose between temporal pleasures and eternal gratification; Barnes in Albany 2002, p. 76, no. 24, repeats a few thoughts put forward by Luttikhuizen but concludes that the painting may be simply "a beautiful invocation of a modest number of gustatory delights that stimulate the eye and the palate . . . and perhaps the mind," and suggests the influence of Pieter Claesz; Minty in ibid., p. 7, notes the acquisition in 1871; Rose in ibid., p. 76, no. 24, observes that pictures such as this one create the impression that oysters were readily available in the Netherlands; Baetjer 2004, p. 214, no. 125, clarifies the painting's provenance.

EXHIBITED: Dallas, Tex., Dallas Museum of Fine Arts, "30 Masterpieces: An Exhibition of Paintings from the Collection of the Metropolitan Museum of Art," 1947, no cat. no.; Grand Rapids, Mich., Grand Rapids Art Museum, "A Moral Compass: Seventeenth and Eighteenth Century Painting in the Netherlands," 1999, no. 11; Albany, N.Y., Albany Institute of History and Art, "Matters of Taste: Food and Drink in Seventeenth-Century Dutch Art and Life," 2002, no. 24.

EX COLL.: [Léon Gauchez, Paris, with Alexis Febvre, Paris, until 1870; sold to Blodgett]; William T. Blodgett, Paris and New York (1870–71; sold half share to Johnston); William T. Blodgett, New York, and John Taylor Johnston, New York (1871; sold to MMA); Purchase, 1871 71.78

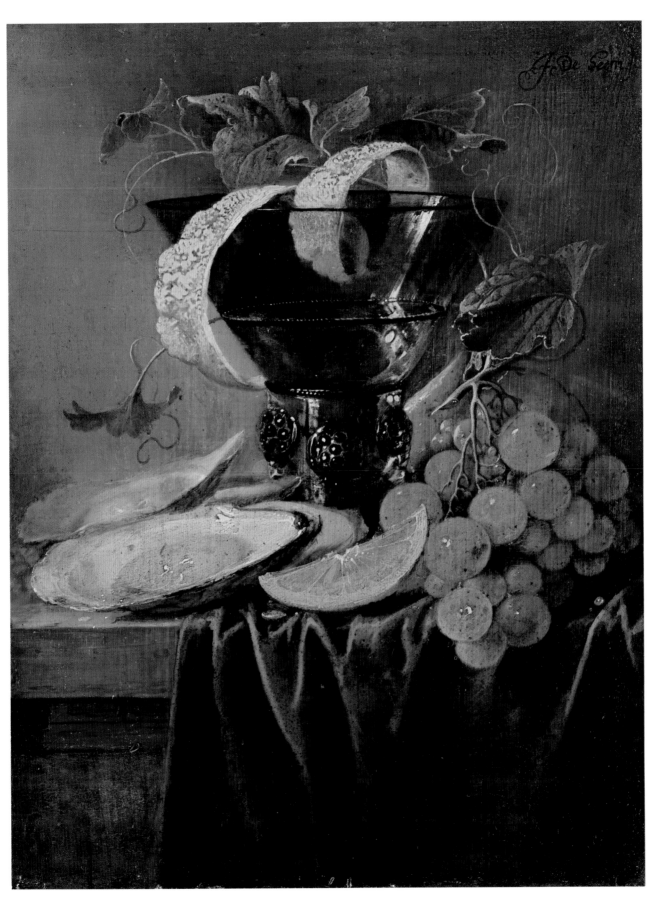

75. *Still Life: A Banqueting Scene*

Oil on canvas, 53¼ x 73 in. (135.3 x 185.4 cm)
Signed (?): (lower left, on napkin) JDH [in monogram];
inscribed (lower left): DeHeem fc

The painting is in good condition, with minor losses at the edges and in the curtain in the left background. Infrared reflectography reveals minor modifications that were made during the course of execution, for example, to the height and alignment of the chair and the shape of the column's pedestal. Isolated passages, such as the cut lemon and the neck of the lute, have become transparent with age and reveal completed forms below. The latter appear to reflect the painter's usual working procedure rather than revision in the composition.

Purchase, Charles B. Curtis Fund, 1912 12.195

The attribution of this large painting has presented particular difficulties. Some scholars have suggested orally that the picture was actually painted by one of De Heem's many pupils or followers. Horst Gerson, visiting at an unknown date (1960s?), doubted the "DeHeem" signature and suggested the possibility of Pieter de Ring's authorship (see De Heem's biography above, where De Ring and some other followers are mentioned). In 1983, Claus Grimm suggested an attribution to Jan van der Hecke (1620–1684), while Ingvar Bergström considered De Heem's son Jan Jansz de Heem (1650–after 1695) a possible candidate.[1] The case for Jan Jansz was strengthened by Sam Segal, who, in connection with his exhibition "Jan Davidsz de Heem and His Circle" (Utrecht and Braunschweig, 1991), gathered a group of works under that unfamiliar name.[2] Fresh from the exhibition (which was mostly an essay in connoisseurship) and from discussions with Segal, the present writer in 1992 (see Refs.) published the Museum's picture for the first time as a work by Jan Jansz de Heem. In 1995, another still-life

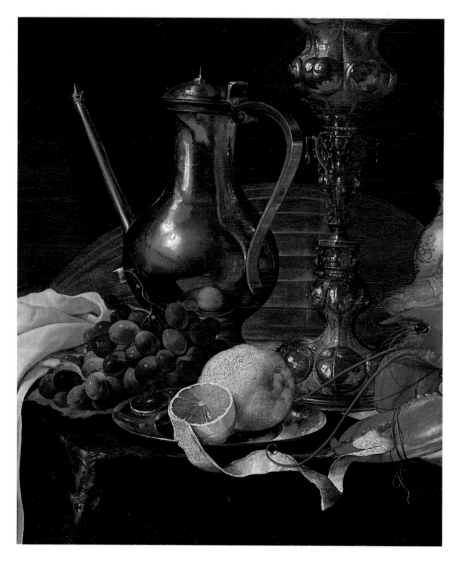

Figure 83. Detail of De Heem's *Still Life: A Banqueting Scene* (Pl. 75)

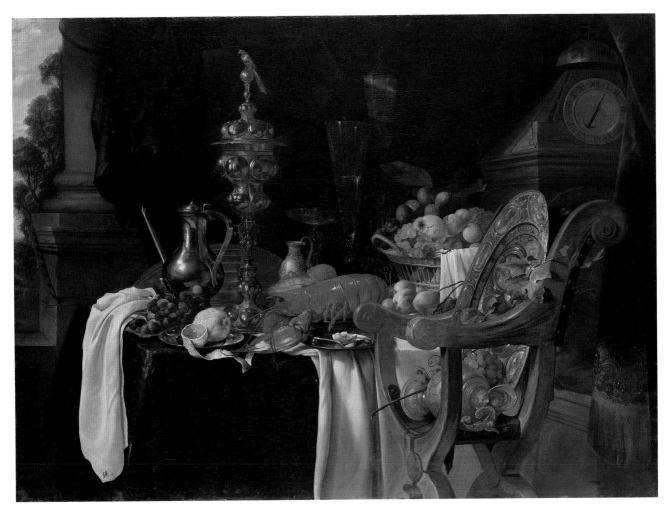

75

specialist, Fred Meijer, firmly rejected that hypothesis, maintaining orally and in correspondence that the painting is typical of Jan Davidsz de Heem in the early 1640s, and that "the oeuvre attributed to Jan Jansz in recent literature is a confusing amalgam," consisting usually of compositions "of a 1640s type, which would have been rather out of vogue in the son's lifetime."[3] A key work in the debate about Jan Jansz is a large banquet still life with a globe, musical instruments, and a servant (Museum van het Broodhuis, Brussels), which bears the signature "Johannes de Heem Fecit" and a date that has been read (by Meijer and others) as 1641, and, alternatively (by De Mirimonde and Segal), as 1691.[4] Meijer also considers the only canvas catalogued in the 1991 exhibition as a work by Jan Jansz de Heem to be by his father in about 1646.[5]

Meijer's letter of 1995 sets out several arguments defending the traditional attribution of the New York painting to Jan Davidsz de Heem. First, he regards the monogram "JDH" to be authentic, and similar to the monograms, or to the conjoined initials found in "JDHeem" signatures, on works of the 1630s. He has not found the same monogram on pictures by Jan Davidsz de Heem dating from after 1640. The inscription, "DeHeem fc," is considered by Meijer to have been added later, perhaps by copying the signature on a painting by Cornelis de Heem. Second, Meijer finds the composition typical of works dating from the early 1640s. In particular, the amount of space surrounding the main motifs is something the artist soon abandoned, in effect by cropping his previous designs on all sides, but especially at the bottom. Third, in execution and coloring Meijer considers the Museum's painting to be very similar to the large canvas *Un dessert,* dated 1640 (Louvre, Paris; fig. 84), and to the painting of 1641 (?) in Brussels, which "stands securely" between the Louvre picture and the magnificent *Pronk Still Life with Shells and Musical Instruments,* of 1642 (private collection).[6] He adds that the rendering of the

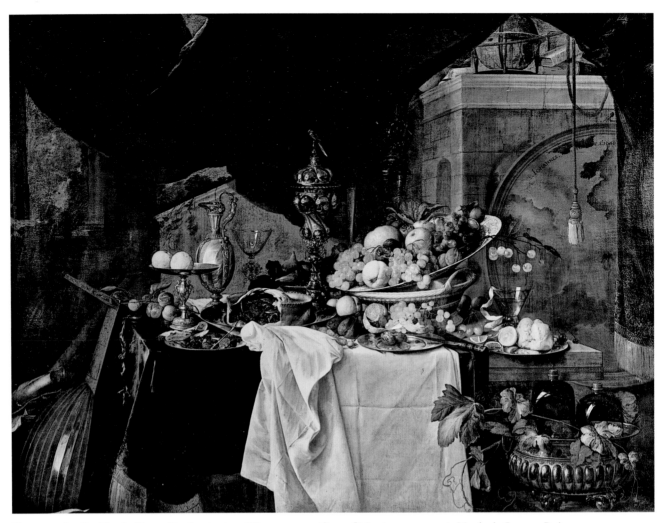

Figure 84. Jan Davidsz de Heem, *Un dessert*, 1640. Oil on canvas, 58⅛ x 79⅞ in. (149 x 203 cm). Musée du Louvre, Paris

white napkin and tablecloth (which in 1992 the present writer found rather "flat and dull") comes close to that in De Heem's works of the 1630s, citing an example dated 1635.[7] Meijer concludes that "the New York still life precedes the Paris one [of 1640], although probably not by more than a year." In a letter of 1998, Meijer expanded upon this remark, describing the Museum's picture as "without a shadow of a doubt a work by Jan Davidsz de Heem of 1639 or 1640. It is in fact a rather important painting as it must be one of the earliest of this type."[8]

A final point made by Meijer deserves closer examination, namely, his claim that "the objects depicted, all except one, can be dated securely to the first half of the seventeenth century." Obviously, if any of the manufactured objects in the picture were first made in the 1670s or later, this would favor Segal's thesis that the painting may be by Jan Jansz de Heem rather than Meijer's that it is by his father, dating from about 1639–40. In the following discussion, the question of dating

receives attention as required, within a survey of all the motifs in the painting, proceeding from left to right.

The column on the left and landscape view imply that the setting is the terrace of a grand country house. A green silk curtain hangs behind the still life; its crinkly folds and shiny surface are well described. The tablecloth is also green, but of a seemingly heavier fabric. A lute lies facedown on the table, the loose ends of its strings curling like calligraphy. A similar effect is found in the grape tendrils to the left of the large fruit basket, and also in the strings of the similar lute in De Heem's painting in the Louvre.[9]

On the near corner of the table, a bunch of purple grapes and a pewter plate with lemons (sliced, peeled, and whole) are shown in front of a pewter spouted flagon, of a Dutch type common in the first half of the seventeenth century. The plate of lemons, the silver-gilt covered goblet, and vague impressions of a room with bright windows are skillfully reflected in the tankard (fig. 83). The tall goblet itself, with its complexly

worked stem, knobby body (giving the cup its German name, *Buckelpokal*), and a cover that mirrors the goblet's design on a smaller scale, is typical of southern Germany and certainly dates from the first quarter of the 1600s.[10] The play of blurred reflections of windows (suggested by bright yellow impasto strokes) and hints of the tabletop provide arresting details on the goblet's smooth and chased surfaces. The parakeet finial is evidently a rarity, but it also occurs on the somewhat different covered goblet in the Louvre's De Heem, and in a painting said to be signed "J. van Hecke fecit 1643."[11]

In front of the huge lobster, a piece of bread, a spoon, and a single lemon pit sit on a pewter plate. Behind the lobster, a smaller one, upside down, lies in front of a white pitcher with a twisted handle and curvilinear floral decoration in blue. This object and the big clock present the only problems of dating in the picture. One scholar has suggested that the pitcher is probably German stoneware, with the handle modeled on that of a glass vessel, and proposes a date before 1600.[12] That the model might be a glass pitcher is easy to imagine when one compares the one in *Still Life with a Gilt Goblet,* of 1635, by Willem Claesz Heda (q.v.), in the Rijksmuseum, Amsterdam.[13] Behind the pitcher is a glass tazza (probably Venetian, about 1600), containing red wine, and two very tall glass flutes, the shorter one with white wine, the other apparently empty (the curtain's folds show through) and crowned by a fancy silver cover. The design of the flutes is typical of the first half of the century, but like the silver-gilt covered cup their scale is greatly exaggerated.

Peaches are found inside and in front of the fruit basket, which also contains green and purple grapes, a quince (?), and some very green walnuts, two with their skins partly peeled off. The chair is a Dutch *Vrouwstoel* ("lady's chair") from the first half of the seventeenth century, with a leather seat and back attached with big brass tacks. On the chair, some artfully placed grapes with leafy tendrils embellish the richly decorated forms of an enormous silver-gilt basin and a recumbent ewer made in the manner of Adam van Vianen (1569–1627), which would probably date from the 1620s or early 1630s. (However, the details appear to be De Heem's own invention.) These objects were used for rinsing hands at the table in the most ostentatious households.

The large clock is a curiosity, although not in the sense employed in collector's cabinets. One specialist considers the case "unusually primitive in its design and construction, which suggests that it is a provincial clock." Consequently, it could date from the mid-1600s or later.[14] Another specialist makes the same observations, noting that the bell on top, being undecorated and exposed, is somewhat unusual. This, together with "the odd case . . . the peculiar dial and chapter ring," and other qualities, suggest "someone who knew the various components of a clock, but had no model on which to base his depiction. The general feel of the clock, however, is of one made before c. 1650."[15] Both authorities stress that the clock is plain and provincial, and one of them notes how out of place it looks in its grand surroundings. The effect is rather like that of a country preacher (or Benjamin Franklin) sitting down to dinner at Versailles. Of course the clock is meant to be intrusive as a vanitas motif, and is so on a much larger scale than the watches that are commonly found in banquet scenes (compare the Museum's painting by Abraham Van Beyeren; Pl. 7). Some viewers of the period would have known that this older (weight-driven) type of clock struck the bell only on the hour, and they might have noted that the hour is nigh.

To the lower right, a red velvet pillow fills an empty space behind a green curtain with, at the bottom, elaborate brocade and fringe. A very similar curtain is found on the right of the Louvre picture, but more important, the two compositions are organized in quite the same way. The artist builds space with big forms emerging from the right background and leading into objects that fill the immediate foreground on the same side. The placement of the fruit baskets, tall flutes, covered goblet, small plates at the edge of the table, and so on, suggest the same sensibility, which does not permit spatial logic to spoil its flair for design. For example, just where the clock stands in the Museum's picture, and how (or from what) the curtains are hung, are questions not meant to be asked. Similarly, what appears to be a giant globe in the right background of the Louvre painting is actually a circular map, framed and hung from a nail driven into what looks like a masonry gatehouse playing the role of a cabinet. In both pictures, everything not on the table, in the chair, or in the Jordaens-style wine cooler (in the Louvre canvas) has the impromptu quality of window dressing serving to foil and frame the objects on display.

The similarities of the New York painting to the Louvre picture do not strike the patient viewer as derivations, but as the somewhat less mature and less ambitious efforts of the same artist. Thus, the present writer is inclined to support Meijer's argument that the Museum's picture is by Jan Davidsz de Heem about 1639. Some workshop collaboration is possible, but there are no clear differences in quality suggesting a second hand in specific areas (some "weaknesses," like the somewhat wooden handling of the white drapery, could be considered typical of De Heem at the time). Rather than later emulation,

the slightly awkward moments in design, and occasionally in execution, appear to reflect the formative stage in which this canvas was painted during De Heem's Antwerp career. Visiting connoisseurs have rightly noticed inconsistencies with the finest paintings by De Heem of this type, but have wrongly searched for solutions in his populous sphere of influence.

1. The oral opinions of these visiting scholars are recorded in the curatorial files. Many opinions of Gerson are recorded, few of them with a date. Grimm visited in October 1983, and Bergström on December 5, 1983, and at later dates.

2. See Utrecht–Braunschweig 1991, pp. 194–98. A printed addendum to the catalogue (no. 34A) added another work attributed to Jan Jansz de Heem (previously always published and sold as by J. D. de Heem). See Liedtke 1992a, p. 115 n. 9, for further details on this privately owned picture.

3. Fred Meijer, letter to the present writer dated February 13, 1995, following a visit to the Museum on January 10, 1995. Like Segal, Meijer has examined the Museum's picture on a number of occasions, both in the galleries and in storage.

4. De Mirimonde 1970, p. 290, fig. 47; Segal in Utrecht–Braunschweig 1991, pp. 195, 196 n. 2, fig. 33b. The Museum van het Broodhuis, or "Musée municipal," is the City Museum of Brussels, located on the Grand Place.

5. Letter of 1995 (see note 3 above), referring to Utrecht–Braunschweig 1991, no. 34 (private collection). The work is signed "J.De.heem. f" but not dated. The painting exhibited hors cat., no. 34A (see note 2 above), is considered by Meijer to be either from the studio of Jan Davidsz de Heem in the second half of the 1640s or a contemporary copy.

6. Utrecht–Braunschweig 1991, no. 7. This painting made an enormous impression in the sale at Christie's, New York, January 15, 1988, no. 107, which may have influenced viewers of the Museum's picture.

7. Bergström 1988, fig. 15 (private collection).

8. Letters from F. Meijer dated February 13, 1995, and September 2, 1998, in the curatorial files.

9. This similarity was noted by Nancy Minty (research assistant, in 1988), to whom the writer is indebted for her careful review of all the motifs in the Museum's picture.

10. The tankard and covered goblet were studied by Clare Le Corbeiller, curator of European Sculpture and Decorative Arts, who observed that she had never seen one with a parrot (parakeet?) on top (memo to the Department of European Paintings, 1971).

11. Warner 1928, p. 89, pl. 39b. See also the large still life (of somewhat similar design) by Andries Benedetti, in the Szépművészeti Múzeum, Budapest (De Maere and Wabbes 1994, vol. 2, p. 70).

12. Susan Miller, memo to the present writer, dated April 1, 2002. Jessie McNab, curator of European Sculpture and Decorative

Arts, compared works from Nuremberg, but suggested that the vase was either invented or is now unknown (personal communication, August 2005). There is some resemblance in the decoration to Medici faience of the later sixteenth century, surviving examples of which are extremely rare.

13. Illustrated in *Dictionary of Art* 1996, vol. 14, p. 286.

14. Personal communication to the writer from William Andrewes, January 22, 2002.

15. Jonathan Snellenburg, Christie's, London, in a letter to the writer, dated September 15, 1988.

REFERENCES: B. Burroughs 1912, p. 229, notes the acquisition of the painting, which represents a type of work in which De Heem and similar masters assembled "all manner of glittering and gorgeous articles . . . for the purpose of showing their scorn of difficulties and their skill in overcoming them"; B. Burroughs 1931a, p. 157, no. H36-3, with basic description; Vorenkamp 1933, p. 45, compares other works by De Heem; Greindl 1956, pp. 103, 173, mentioned and listed; De Mirimonde 1970, pp. 283, 285, fig. 40, as by J. D. de Heem, a *belle* example," associated with a group of works dating from the 1640s; Leppert 1977, vol. 2, col. 64, no. 268, listed as by Jan Davidsz de Heem; Baetjer 1980, vol. 1, p. 84, as by Jan Davidsz de Heem; Greindl 1983, p. 124, describes this picture and others as typical compositions by Jan Davidsz de Heem; Larsen 1985, pp. 309–10, fig. 240, as by Jan Davidsz de Heem, "a good example of the sumptuousness of his style"; P. Sutton 1986, p. 190, as a "banquet piece by Jan Davidsz de Heem"; Liedtke 1992a, pp. 112–15, fig. 10, attributes the painting to Jan Jansz de Heem (1650–after 1695), following the advice of Ingvar Bergström and Sam Segal, and suggests a date in the 1670s; Baetjer 1995, p. 342, as by Jan Jansz de Heem; Meijer 2003, p. 221 n. 2, as by Jan Davidsz de Heem, an important early work of about 1639; Giltaij and Meijer in Rotterdam–Aachen 2006–7, p. 72, fig. 4, as by Jan de Heem about 1639; see motifs in paintings such as this one that influenced Kalf in Paris.

EXHIBITED: Corning, N.Y., Corning Museum of Glass, "Glass Vessels in Dutch Painting of the 17th Century," 1952, no. 2; Little Rock, Ark., Arkansas Art Center, "Five Centuries of European Painting," 1963; New Orleans, La., Isaac Delgado Museum of Art, "Fêtes de la palette," 1963, no. 34; New York, Bronx County Courthouse, "Paintings from the Metropolitan," 1971, no. 25.

EX COLL.: [Horace Buttery, London, sold for £750 to MMA];[1] Purchase, Charles B. Curtis Fund, 1912 12.195

1. The purchase papers of September 23, 1912, note that the picture was recommended by John G. Johnson, the Philadelphia collector, who was (Museum president) J. P. Morgan's lawyer, and from 1910 until 1917 a trustee of the Museum. My thanks to Barbara File, archivist, for this reference.

BARTHOLOMEUS VAN DER HELST

Haarlem ca. 1612/15–1670 Amsterdam

One of the leading portraitists of Amsterdam's golden age, Van der Helst was born in Haarlem, the son of a merchant and innkeeper, Lodewijk van der Helst, and his second wife, Aeltgen Bartels. Bartholomeus's approximate date of birth is known only from the record that he was twenty-four years old on the occasion of his betrothal, on April 16, 1636, in the register of the Nieuwe Kerk, Amsterdam.[1] About three weeks later, on May 4, he married Anna du Pire, an eighteen-year-old Haarlem girl who lived in Amsterdam, and who had already lost her parents. The couple had at least five children, of whom one, Lodewyck van der Helst (1642–ca. 1684), became a portraitist in his father's manner.[2]

Bartholomeus rapidly became a prominent artist in Amsterdam. His teacher is unknown, but Nicolaes Eliasz Pickenoy (q.v.) is considered a likely candidate, given his clear influence in early works, such as *The Regents of the Walloon Orphanage in Amsterdam,* of 1637 (Maison Descartes, Amsterdam), and his animated portrait of a seated man with an open Bible on a lectern, probably a Protestant minister (Museum Boijmans Van Beuningen, Rotterdam), which is dated 1638.[3] In the following year, the artist was awarded the commission for *The Civic Guard Company of Captain Roelof Bicker and Lieutenant Jan Michielsz Blaeuw* (Rijksmuseum, Amsterdam), a monumental canvas (7 ft. 8 in. x 24 ft. 6 in. [2.35 x 7.5 m]) on which Van der Helst proves himself as capable as Frans Hals (q.v.) in creating interest throughout what amounts to a large wall filled with full-length portraits.[4] The painting (finished in 1642 or 1643) was installed over a wide fireplace in the assembly hall of the Kloveniersdoelen (Musketeers' Civic Guard Headquarters) in Amsterdam, for which Joachim von Sandrart (1606–1688) — a key figure for bringing an international style of portraiture to Amsterdam — painted a tall canvas, *The Company of Captain Cornelis Bicker,* in 1638 and Rembrandt painted *The Night Watch,* which was completed in 1642 (both in the Rijksmuseum, Amsterdam).[5] The success of Van der Helst's composition, which is as remarkable for the confident poses of the individual figures as for the staging of the whole, led to numerous commissions for single and double portraits,[6] such as those of the burgomaster Andries Bicker and his wife, in 1642 (Rijksmuseum, Amsterdam,

and Gemäldegalerie Alte Meister, Dresden). In 1648, Van der Helst painted another very large civic guard portrait, *The Celebration of the Peace of Münster at the Crossbowmen's Headquarters in Amsterdam* (Rijksmuseum, Amsterdam), which wonderfully combines naturalistic description of individual figures and motifs with a fluid and fashionable style.[7]

Exceptionally, Van der Helst secured prestigious commissions not only from members of Amsterdam society but also from important people in Rotterdam and elsewhere, including one in 1652 for a portrait of Princess Henrietta Maria Stuart, the widow of Willem II of Orange (Rijksmuseum, Amsterdam).[8] In the 1650s, the painter also produced four more large group portraits, and such impressive portraits of Amsterdam aristocrats as *Abraham del Court and His Wife, Maria de Kaersgieter,* of 1654 (Museum Boijmans Van Beuningen, Rotterdam).[9] The much admired *Portrait of Paulus Potter* (Mauritshuis, The Hague) dates from the same year.[10]

Unlike many of his contemporaries, Van der Helst remained at the top of his profession throughout his career. Late examples of the artist still setting the trend in his genre include a painting of the shipowner Daniel Bernard, dated 1669 (Museum Boijmans Van Beuningen, Rotterdam),[11] and the portraits of Admiral Aert van der Nes and his wife, and of Vice Admiral Johan de Liefde, each dated 1668 and with backgrounds by Ludolf Bakhuyzen (1631–1708; all three in the Rijksmuseum, Amsterdam). Apart from his son, Van der Helst had no significant pupils, but he strongly influenced a good number of portraitists, including Abraham van den Tempel (1622/23–1672).

Despite Van der Helst's high prices, he appears to have had some financial difficulties, perhaps as a result of living somewhat beyond his means. (Like Rembrandt, with whom he must have been well acquainted, Van der Helst owned a large house and a collection of paintings.) After the artist's death in December 1670, his widow was left with very little financial reserves and with various claims from creditors.[12]

Van der Helst's appearance is known from a fair number of self-portraits, such as the canvas dated 1662 in the Kunsthalle, Hamburg, and that of 1667 in the Galleria degli Uffizi, Florence.[13]

1. See De Gelder 1921, p. 138. Van der Helst's age was recorded as thirty-nine in 1653, and as about forty-three in 1658 (ibid., pp. 142, 143).

2. For examples of his work, see Van Thiel et al. 1976, p. 270; P. Sutton 1990a, pp. 116–19; and Amsterdam 1997b, no. 11.

3. On the latter, see the discussion in Ekkart 1995, pp. 100–101, and, for the 1637 group portrait, Slive 1995a, p. 254, fig. 346.

4. In Haarlem 1988, p. 42, fig. 17, the painting is set within the tradition of group portraits of civic guard companies. See also Slive 1995a, pp. 254–55, fig. 347.

5. For these and the other paintings in the room (Jacob Backer, Govert Flinck, and Nicolaes Eliasz Pickenoy also participated), see Haverkamp-Begemann 1982 (fig. 35 for a plan of the room and its decorations). Von Sandrart's influence on portraiture in Amsterdam is discussed in Klemm 1986, and reiterated in Dickey 2004, pp. 102–3 (see p. 193 n. 107 on the Kloveniersdoelen).

6. As observed in Rudolf Ekkart's article on Van der Helst in *Dictionary of Art* 1996, vol. 14, p. 373.

7. Van Thiel et al. 1976, p. 268; Haarlem 1988, pp. 38–39, no. 15, for a large color photograph (cropped at the sides); Slive 1995a, pp. 255–56, fig. 348.

8. The rarity of Amsterdam portraitists working elsewhere is slightly exaggerated by Ekkart in *Dictionary of Art* 1996, vol. 14, pp. 373–74. Rembrandt, for example, painted portraits of Maurits Huygens (1632), Jacques de Gheyn III (1632), Princess Amalia van Solms (1632), and the minister Johannes Wtenbogaert (1633), all of whom lived in The Hague (see *Corpus* 1982–89, vol. 2, nos. A56–57, A61, A80).

9. See Ekkart in *Dictionary of Art* 1996, vol. 14, p. 374, on these works, and Ekkart 1995, pp. 106–8, on the double portrait. Two of Van der Helst's group portraits of the 1650s are in the Rijksmuseum, Amsterdam, and the other two are in the Amsterdams Historisch Museum (see Van Thiel et al. 1976, pp. 268–69, and Blankert 1979, pp. 132–36). Another impressive portrait of 1654 is *A Family Group* (Wallace Collection, London), which is identified as Jochem van Aras and his wife and daughter, in Van Gent 2004.

10. Broos and Van Suchtelen 2004, no. 27.

11. Ekkart 1995, pp. 109–11.

12. See De Gelder 1921, pp. 28–30.

13. Published in Braunschweig 1980, no. 5, and in Chiarini 1989, pp. 179–81, respectively. The Florence picture is also discussed in Braunschweig and other cities 1988–90, pp. 150–52 (under no. 43). See also The Hague–San Francisco 1990–91, no. 29, where it is maintained that a portrait of a man dated 1655 (Toledo Museum of Art) is also a self-portrait.

76. *Portrait of a Man*

Oil on wood (oval), 26¼ x 21⅝ in. (66.7 x 54.9 cm)
Signed, dated, and inscribed (lower right): Æta. 62/
B. vanderhelst / 1647

The painting is well preserved, with only slight abrasion along the wood grain in the deepest black shadows on the right side of the man's coat.

Purchase, 1871 71.73

"The perfect prose of portraiture," observed Henry James of this panel, when he surveyed the most noteworthy paintings in the Museum's 1871 Purchase. The budding master of backhanded praise was inspired by the picture to opine:

> It seems almost hyperbolical to talk of Van der Helst
> as an *artist*; genuine painter as he was, his process is
> not so much the common, leisurely, critical return upon
> reality and truth as a bonded and indissoluble union
> with it; so that in all his unmitigated verity you detect
> no faintest throb of invention blossoming into style
> and straggling across the line which separates a fine
> likeness from a fine portrait."[1]

Had James written his essay two years later, after the Museum had purchased *The Musician* (Pl. 77) by Van der Helst, he might have tempered his delightfully opinionated remarks. With regard to style, it seems likely that no American critic of the 1870s had the experience or historical perspective to see that this portrait of a sixty-two-year-old man, like others by Van der Helst dating from the mid- to late 1640s, was influenced by Rembrandt's most straightforward examples of the 1630s and early 1640s, such as the Ellsworth *Portrait of a Man* and the *Herman Doomer* (Pls. 141, 148). The decade was something of a watershed for the artist, when his powers of description and expression came to surpass those of his first source of inspiration, Nicolaes Eliasz Pickenoy (see Pl. 136), and he had not yet followed Joachim von Sandrart (1606–1688) and former Rembrandt pupils such as Ferdinand Bol and Govert Flinck (q.q.v.) in adopting more fashionable and flattering modes of portraiture. Other paintings by Van der Helst that illustrate his comparatively sober approach in the 1640s include the half-length portraits of the Remonstrant minister Samuel van Lansbergen and his wife, in the Rijksmuseum,

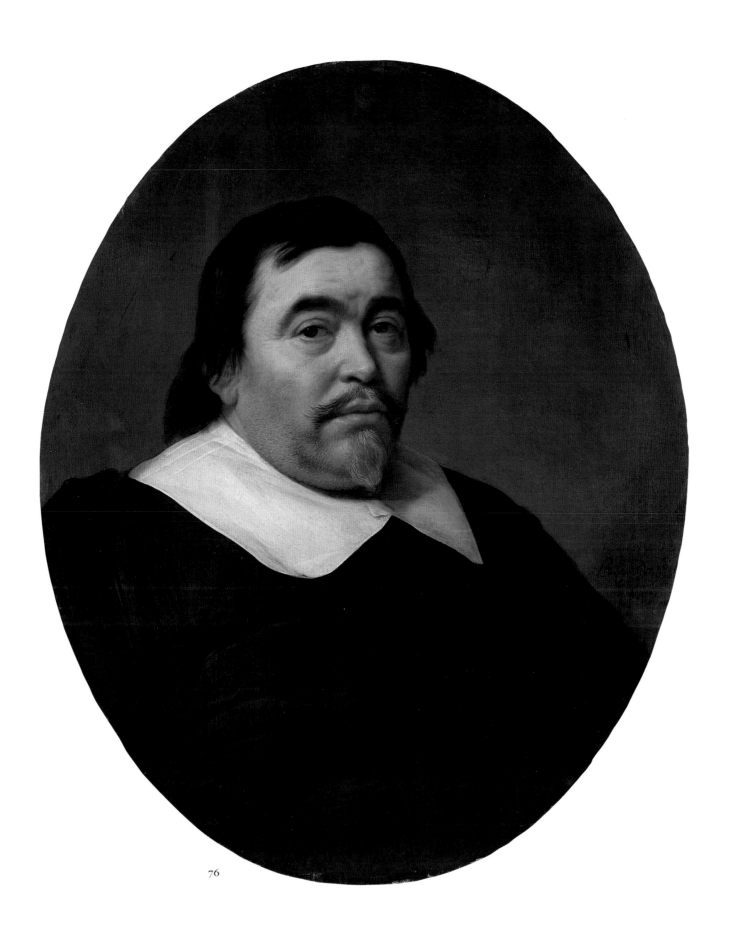

76

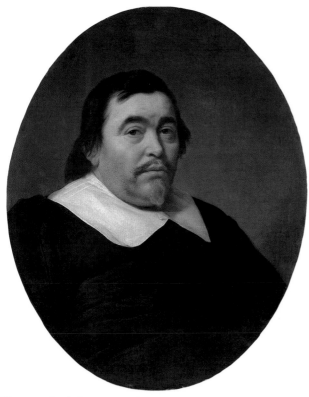

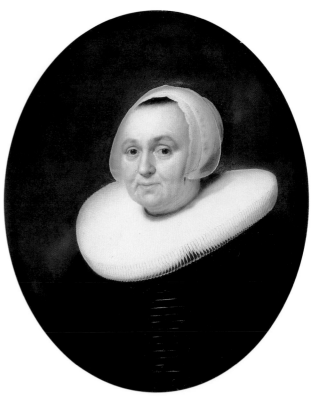

Figure 85. Bartholomeus van der Helst, *Portrait of a Man* (Pl. 76)

Figure 86. Bartholomeus van der Helst, *Portrait of a Lady Aged Fifty-four*, 1647. Oil on wood, 28 x 23¼ in. (71.2 x 59.1 cm). National Gallery of Ireland, Dublin

Amsterdam, and the similar half-length pendant portraits of 1646 in the Museum Boijmans Van Beuningen, Rotterdam, all of which date from 1646.[2]

The placement of the sitter to the left of center, and his slight turn toward the viewer's right, suggests that the portrait was originally provided with a pendant. In 1991, Hans Buijs, who at the time was researching the Dutch and Flemish pictures in the Musée des Beaux-Arts, Lyons, considered the possibility that Van der Helst's oval portrait of a fifty-two-year-old woman in that collection might be a candidate.[3] However, the dimensions of the undated panel (26⅜ x 15¾ in. [67 x 40 cm]) and the placement of the figure in the picture field discouraged that hypothesis. Buijs instead suggested that Van der Helst's *Portrait of a Lady Aged Fifty-four*, dated 1647 (fig. 86), would be a more fitting pendant to the New York painting of the same year. The woman is placed off-center to the right, and turns slightly toward the viewer's left (her right, the traditional place of honor for husbands in Netherlandish portraiture). The Dublin painting was acquired in 1866 from a British collector, and its earlier provenance is unknown.[4] The two portraits are entirely consistent in their careful execution, and

both are signed, dated, and inscribed in the same way, in complementary locations (the lowest area of the visible background).[5] The only difficulty is that the male portrait, although having the same proportions, is slightly smaller, 26¼ x 21⅝ inches (66.7 x 54.9 cm), as opposed to 28 x 23¼ inches (71.2 x 59.1 cm) for the Dublin panel. However, notwithstanding the fact that the Museum's panel was cradled in 1871, it is still possible to see that it has been cut down, probably to fit a frame.[6] It appears probable that these portraits of a man aged sixty-two and a woman aged fifty-four were painted as pendants.

The man bears a strong resemblance to the younger sitter in an oval portrait by Daniël Mijtens (q.v.), dated 1635 (location unknown; formerly Ruzicka Stiftung, Zürich). Ter Kuile, following an earlier writer,[7] suggested that Mijtens's subject was the Leiden grain mechant Willem Burchgraeff, based on a perceived (but imperceptible) resemblance to a Rembrandt sitter who was himself incorrectly identified as Burchgraeff.[8] The Mijtens portrait is signed and dated "D. Mytens ft. 1635," and is inscribed "Aetatus [*sic*] Suae ao 50,"[9] which matches the age of the man in Van der Helst's portrait (sixty-two in 1647), and indicates a birth date of about 1585 (Burchgraeff was born about 1604).

1. James (1872) 1956, p. 56. James continues with, among other remarks, the suggestion that "if Nature were to give her voice, and appoint once for all her painter-in-ordinary, she would lay a kindly hand on the sturdy shoulder of Van der Helst, and say, 'One must choose for the long run: this man I can *trust*.'" Although quite of its period, James's opinion echoes that of Constantijn Huygens, in his description (ca. 1630) of portraits by Michiel van Miereveld (q.v.): "Most [painters] who, as it were, attempt to force the truth through a disproportionate display of their own limited talent, fall into affectation. . . . With Van Miereveld, the whole of art lies with nature, and the whole of nature in his art." The quote is from Huygens 1971, p. 76, as translated by the present writer in New York–London 2001, p. 46.

2. See Van Thiel et al. 1976, p. 267, and Ekkart 1995, nos. 25, 26.

3. The painting was ultimately not included in the relevant exhibition (Paris–Lyon 1991), but in Lyon–Bourg-en-Bresse–Roanne 1992, no. 54.

4. See Potterton 1986, pp. 60–61. It is noted there that "the date [on the Dublin portrait] has always been misread as 1641, but it is clearly 1647. De Gelder [1921, p. 63] in fact thought that 1641 was probably false and on the basis of style he placed the picture [in] 1647."

5. See Potterton 1986, fig. 247, for a detail of the inscription on the Dublin portrait.

6. Conservator Dorothy Mahon (September 2006) confirms that the panel has been somewhat trimmed all around, as is normal when a cradle is attached. Brushstrokes on the surface and crowding of the artist's signature indicate that the panel was originally oval.

7. Ter Kuile 1969, p. 53, no. 18, fig. 3, trusting Ruzicka in Zürich 1949–50, p. 17 (under no. 20).

8. See *Corpus* 1982–89, vol. 2, no. C77, where on p. 804 Mijtens's portrait is used to dismiss the identification of Rembrandt's sitter as Burchgraeff! Compounding the methodological fiasco, the authors of the *Corpus* also propose that Mijtens's so-called *Portrait of Willem Burchgraeff,* of 1635, was painted as a pendant to Rembrandt's *Portrait of Maertgen van Bilderbeecq,* dated 1635 (ibid., pp. 410–12, fig. 6). Giltaij in Frankfurt 2003, p. 92 (under no. 16), uncritically restates the hypothesis.

9. Zürich 1949–50, p. 17. Ter Kuile 1969, p. 53 (under no. 18), accidently kept a comedy of errors going by omitting "50" from his record of the inscription on the Mijtens portrait.

REFERENCES: MMA 1871, pl. 9; Decamps 1872, p. 479, notes, "Nous avons ici van der Helst dans sa manière la plus robuste"; James (1872) 1956, p. 56, praises the painting ("a 'Burgomaster'") at some length for its lack of style and revelation of Van der Helst's "richly literal genius"; Kegel 1884, p. 461, cited as "das Porträt eines heimischen Bürgemeisters"; Harck 1888, p. 75, no. 111, mentioned as in the MMA ("das sehr schöne Porträt eines Bürgermeisters"); Wurzbach 1906–11, vol. 1 (1906), p. 672, listed as "Portrait eines Bürgermeisters"; Valentiner in New York 1909, p. 43, no. 42, with incorrect dimensions (8 x 10 in.); Waldmann 1910, p. 84, noted as in the Hudson-Fulton exhibition; De Gelder 1921, pp. 62, 184, 197, nos. 225, 393, gives basic catalogue information, adding the Vis Blokhuyzen provenance under no. 393; P. Sutton 1986, p. 183, listed; Liedtke 1990, p. 33, briefly quotes Henry James's description of the painting; Baetjer 1995, p. 322; Baetjer 2004, pp. 170–71, 216, no. 138, clarifies the picture's provenance.

EXHIBITED: New York, MMA, "The Hudson-Fulton Celebration," 1909, no. 42.

EX COLL.: D. Vis Blokhuyzen, Rotterdam (until 1870; his estate sale, Hôtel Drouot, Paris, April 1–2, 1870, no. 25 [date of painting transcribed incorrectly], for FFr 4,105 to Gauchez); [Léon Gauchez, Brussels, 1870; offered in April 1870 to the Musées Royaux de Belgique for BFr 6,000; offer declined]; [Léon Gauchez, Paris, with Alexis Febvre, Paris, 1870; sold to Blodgett]; William T. Blodgett, Paris and New York (1870–71; sold half share to Johnston); William T. Blodgett, New York, and John Taylor Johnston, New York (1871; sold to MMA); Purchase, 1871 71.73

77. The Musician

Oil on canvas, 54½ x 43¾ in. (138.4 x 111.1 cm)
Signed, dated, and inscribed (lower left): B. vanderhelst/
1662; (on sheet of music): iris; (on cover of book):
Supe[r]ius

The paint surface is extensively abraded, and the texture
was damaged during transfer to a new fabric support.

Purchase, 1873 73.2

In style and execution the painting is a typical work of Van
der Helst's mature years, and it is reliably signed and dated
1662.[1] The woman tunes a theorbo-lute, and a viola da gamba
rests in front of her. Some scholars have considered the picture
to be an allegory or personification of music, and it has been
suggested occasionally that the work may be a portrait (and
thus, a *portrait historié*).[2] The question of portraiture is compli-
cated, as discussed below.

Curator John Walsh, in 1973, and most later writers (see
Refs.) have treated the painting as a genre scene, comparing
works by Gerrit Dou, Johannes Vermeer (q.q.v.), and other con-
temporary artists. The picture is very close in date and in its
main motifs to Vermeer's *Woman with a Lute* (Pl. 204), despite
the obvious differences in scale and setting. In the Vermeer, a
young woman in fashionable attire, with an enormous pearl ear-
ring (perhaps hinting of Venus), tunes a lute and eagerly looks
out the window, as if expecting company. In the foreground, a
chair and (on the floor) a viola da gamba await a man's arrival,
to be followed by the playing of a duet (or, using the song-
books, a trio) and the pursuit of love.[3]

As in other works by Vermeer, the viewer is not acknowl-
edged; the most romantic interpretation would identify a male
viewer as a voyeur, imagining himself in the role of the
woman's suitor. No such options are offered by Van der
Helst's lute player, who appears to address any male viewer in
the room. The woman spills out of her dress (which justifies
her characterization by Sluijter as a "scantily clad courtesan"),[4]
and the manly viola tilts precipitously toward the viewer's
space. If the viewer dares enter the picture, a comfortable
stool and a red velvet pillow will be provided, along with
printed music in tenor and soprano parts.[5]

It is not immediately clear that the music rests on a carpet-
covered table, not a balustrade. In any case, the setting, as indi-
cated by the large urn at left with playful putti and (at the top)
reclining river gods, is the terrace of a grand country house,
with a view to landscape safely distant from the critical eyes of
Amsterdam society. For their sake, it might be maintained, Van

der Helst shows the woman tuning her instrument, a routine
task that in some pictures probably suggests (despite appear-
ances to the contrary) temperance or moderation.

In its scale and in the type of figure, the composition
recalls many genre paintings of the Utrecht school, such as
Gerrit van Honthorst's *Woman Tuning a Lute* and *Woman
Playing a Guitar* (both in the Louvre, Paris), which date from
1624, and by 1632 were hanging in the Stadholder's Quarters
in The Hague.[6] Large pictures of this type were more com-
mon in the first half of the century, but they were painted
later as well, as in the case of Ferdinand Bol's *Woman Playing
a Lute,* of 1654 (fig. 87).[7]

It seems highly unlikely that a patron would have asked an
Amsterdam portraitist to have herself (or, in the case of a male
client, his wife) depicted as a musical seductress, rather than as
a mythological, religious, or allegorical figure. However, artists
did portray themselves and their wives as romantic couples, as
in Hans von Aachen's portrait of himself with his wife as a
lute-playing courtesan (private collection), and, evidently, as in
Cornelis Bisschop's large canvas *A Young Woman and a Cavalier*
(Pl. 8), which like Van der Helst's painting dates from the early
1660s.[8] Thus one might ask whether the artist's wife, Anna du
Pire, might have served as a model for *The Musician,* and whether
it could have been painted together with a pendant portrait of
the artist, perhaps in the guise of a courting gentleman.

Unfortunately, no certain portrait of Van der Helst's wife is
known. A pair of portraits by Van der Helst, signed and dated
1660 (Národní Galerie, Prague), appear to represent the artist
and his wife as the shepherd Daifilo and his beloved Persian
princess, Granida, the protagonists of Pieter Cornelisz Hooft's
pastoral play *Granida* (Amsterdam, 1615).[9] Van Gent rejects the
identification, partly because Anna du Pire and the artist (as
seen in his *Self-Portrait* of 1667, in the Uffizi, Florence) must
have looked older in 1660, when they were about forty-two
and forty-eight years old, respectively. She also rejects the so-
called *Self-Portrait,* of 1662 (Kunsthalle, Hamburg), in part
because of the figure's youthful appearance compared with the
Self-Portrait dating from only five years later.[10] Van den Brink
maintains that in the Prague portraits Van der Helst presents
himself and his wife (reflecting their roles as idealized lovers)
as they appeared in earlier years.[11] Perhaps Van der Helst's
"musician" has been bathed in the same fountain of youth,
one formed by artistic license and a husband's adoring eyes.
But this is mere speculation, in the absence of an unquestion-
able portrait of Anna du Pire. And even if she does prove to

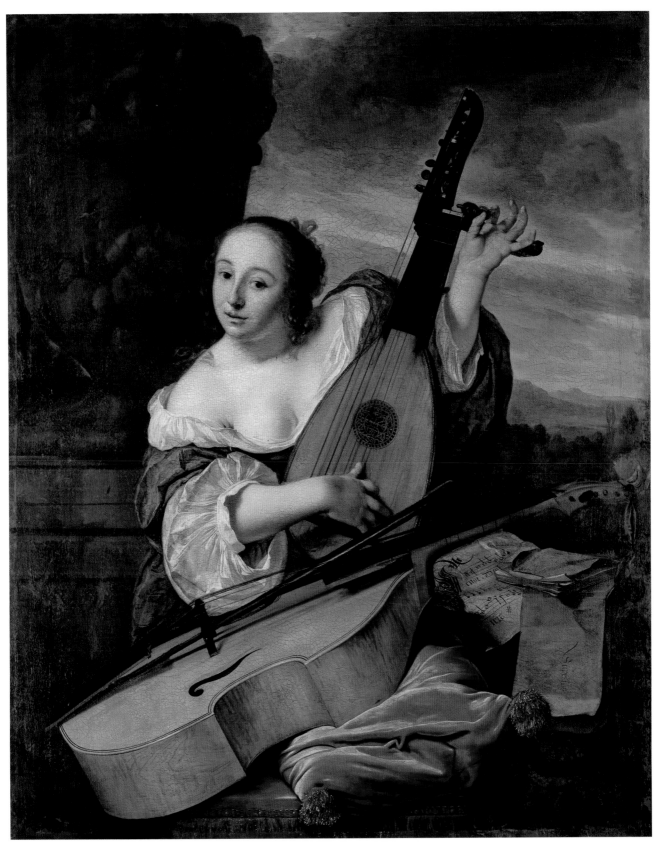

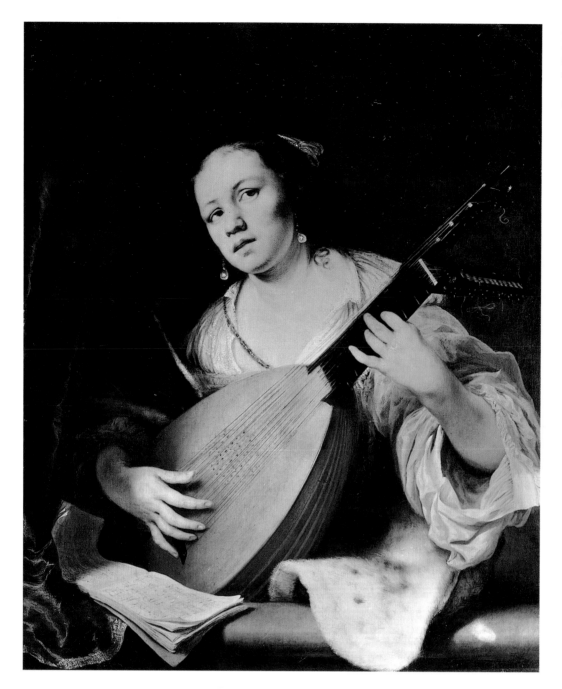

Figure 87. Ferdinand Bol, *Woman Playing a Lute*, 1654. Oil on canvas, 39⅜ x 32¼ in. (100 x 82 cm). National-museum, Stockholm

resemble the woman depicted here, it would mean no more than that the artist (like Rubens and Rembrandt before him) turned to a model close to his heart.

1. Two scholars, on visits to the Museum, voiced doubts about the attribution: Wilhelm Martin, in April 1938, and Otto Benesch, in December 1940, the latter suggesting that Abraham van den Tempel might be responsible. The Van der Helst specialist Judith van Gent examined the painting in May 2002 and accepts it as autograph, as did De Gelder in his monograph (1921; see Refs.).

2. See Refs., under Fischer 1972a and P. Sutton 1986. Van Gent (see note 1 above), in a personal communication dated July 12, 2005, writes that she is not absolutely sure whether the painting was intended as a portrait or not, but that it is "in any case an allegorical figure with portrait-like features" (that is, Van der Helst's use of a live model appears probable).

3. In addition to the discussion of Vermeer's picture below, see also that of Gerard ter Borch, *A Woman Playing the Theorbo-Lute and a Cavalier* (Pl. 15).

4. Sluijter 2000b, p. 292.

5. See Refs., under Fischer 1972a, regarding the tenor and soprano

(*superius*) parts. Kenneth Moore, curator in charge, Department of Musical Instruments, observes that *superius* (also called *medius*) is the second part in descending order of pitch, with *cantus* being higher.

6. Judson and Ekkart 1999, nos. 220, 222, pls. 117–18, pls. XVII, XVIII. See Liedtke in New York–London 2001, p. 383, for other examples.

7. See Blankert 1982, p. 140, no. 132, pl. 141, and p. 41, where the author discusses the Utrecht connection. The painting is also published in Stockholm 1992–93, no. 70. One of the Utrecht Caravaggesques, Jan van Bronchorst (ca. 1603–1661), worked in Amsterdam from about 1650 onward. Flemish painters also painted lute players of this type: see, for example, *Young Woman with a Lute,* by Thomas Willeboirts Bosschaert (Galerie Fischer, Lucerne, June 30, 1962, no. 2148 [ill.]), and the canvas incorrectly attributed to Nicolaes Berchem, at Sotheby's, Amsterdam, November 4, 2003, no. 37, and November 2, 2004, no. 53.

8. For references to Von Aachen's picture, Rembrandt's *The Prodigal Son in the Tavern,* and other relevant works, see the discussion of Bisschop's painting above.

9. See Utrecht–Frankfurt–Luxemburg 1993–94, pp. 163–67, no. 25. At the time, the female portrait had not yet been reunited with its pendant in Prague.

10. Personal communication, July 12, 2005. For the Hamburg canvas, see Ketelsen 2001, pp. 119–20, no. 297.

11. Utrecht–Frankfurt–Luxembourg 1993–94, p. 163, citing the evidence of the Uffizi portrait. Anna du Pire was born in 1617, so in 1660 she was forty-three and Van der Helst about forty-seven.

REFERENCES: Decamps 1872, pp. 478, 479 (ill.), describes the painting as a personification of music and contrasts the Museum's *Portrait of a Man*; Menard 1875, pp. 94, 96 (engraved ill. opp. p. 94) (French ed., pp. 95, 97), considers the picture "one of the jewels in the New-York museum . . . very real, very well painted, very pretty"; Kegel 1884, p. 461, considers this picture Van der Helst's "Hauptbild," an allegory but also a flattering portrait of someone; Harck 1888, p. 75, as "Lute Player," dated 1663 or 1665; Wurzbach 1906–11, vol. 1 (1906), p. 672, "Portrait einer Lautenspielerin," of 1663 or 1665; De Gelder 1921, pp. 22, 120, 123, 160, no. 17, properly identifies the instruments, sees the picture as an allegory of music, and considers the landscape to reflect the style of J. B. Weenix; J. J. de Gelder in Thieme and Becker 1907–50, vol. 16 (1923), p. 355, again notes the Weenix-style landscape; Fischer 1972a, pp. 110–12 (ill. p. 109), is uncertain whether the painting is a portrait or an allegory but favors the latter, sees "the dark clouds and sinister vase with river-gods" as threats to "euphonious harmony," notes the inscription "Iris" (goddess of the rainbow, who "arouses virile desires") and the "Superius" (soprano) part-book, and considers the viola to be waiting for a man, who will play "the tenor part which is shown"; Walsh 1973, unpaged, discussion of figs. 46–49, compares Vermeer's *Woman with a Lute* (Pl. 204), observing that "Van der Helst's voluptuous creature . . . gives us an overt invitation to play a duet with her, not only by her look but by the viola da gamba that lies waiting for us. Music serves as a metaphor for love, as it had since antiquity"; A. Hollander 1976, p. 661, fig. 9, cites the painting as an example of larger and more exposed breasts in late seventeenth-century art than in earlier images; Hedinger 1986, p. 100, fig. 99, discusses the "erotic connotation of playing music," which is emphasized here by the woman's glance and décolleté, by the putti on the vase, and by the proffered viola da gamba; P. Sutton 1986, p. 190, compares the subject with that of Vermeer's *Woman with a Lute,* and observes that Van der Helst's figure, which "may be a portrait, seems to address the viewer directly"; Foucart 1987, p. 82, compares the picture with Van der Helst's painting of a nude woman emerging from drapery, dated 1658 (Louvre, Paris); Liedtke 1990, p. 36, in a survey of Dutch pictures acquired by the Museum, notes that this was the only work purchased or given after 1871 and before 1889; Baetjer 1995, p. 322; Netta 1996, p. 133, fig. 32 compares the painting with Vermeer's *Woman with a Lute* (Pl. 204); Sluijter 2000b, chap. 7 ("On *Fijnschilders* and Meaning"), pp. 292, 294, fig. 240, compares the work with a painting by Dou and other genre scenes in which a duet between the viewer and the woman depicted is implied, referring to Van der Helst's subject as a "scantily clad courtesan tuning her lute, a scene in which a viola da gamba lying ready for use and a tenor score almost appear to emerge from the painting and are there for the taking, as it were"; Netta 1996, p. 133, fig. 32, compares the painting with Vermeer's *Woman with a Lute* (Pl. 204).

EXHIBITED: Berkeley, Calif., University of California at Berkeley, University Art Museum, and Houston, Tex., Rice University, Institute for the Arts, "Dutch Masters from The Metropolitan Museum of Art," 1969–70, checklist no. 6.

EX COLL.: [Probably Léon Gauchez, Paris, in 1872; sold to MMA]; Purchase, 1873[1] 73.2

1. The painting has been published previously as purchased in 1873, but it is clear from the minutes of meetings of the Board of Trustees that the work was acquired before it was placed on public view on November 18, 1872. Furthermore, a two-page Supplement in some copies (second printing?) of the Museum's 1872 catalogue (MMA 1872), p. 67, no. 176, lists a painting titled *The Guitarist* by Van der Helst. The purchases of this painting and the next in the catalogue, no. 177, a double portrait attributed to Karel de Moor (Carel van Moor; see Baetjer 1980, vol. 1, p. 131, "Purchase, 1872," acc. no. 73.1; deaccessioned in 1988), were approved simultaneously by the board's executive committee, at the recommendation of its chairman (and Museum vice president), William T. Blodgett. In the same catalogue, nos. 175 and 178–80 are paintings "presented to the Museum by M. Leon Gauchez," and two pictures given by him were also placed in the galleries (with the Van der Helst and the Van Moor) on November 18, 1872. The dealer Léon Gauchez, in Paris, directly or indirectly sold every one of the 174 paintings acquired by Blodgett on behalf of the Museum in the 1871 Purchase (see Baetjer 2004, pp. 161–68). It appears certain, then, that the Van der Helst also came from him.

JAN VAN DER HEYDEN

Gorinchem 1637–1712 Amsterdam

Van der Heyden is best known for his views of city streets and squares and of country houses, but he also painted landscapes (about forty are known) and a number of still lifes.[1] However, it has been said (by an art historian) that he is recognized above all as the inventor of the fire hose pump.[2] He also designed streetlights and supervised their installation in Amsterdam, where they cast a picturesque glow over the canals and quays from 1669 until 1840.[3] These inventions brought Van der Heyden a large income and two lucrative municipal offices, one responsible for street lighting, the other for the neighborhood fire brigades of Amsterdam (from 1670 and 1673, respectively).[4] After these appointments, the artist appears to have painted mainly for his own pleasure, and for that of a few prominent acquaintances. At his death on March 28, 1712, Van der Heyden had at least seventy-three of his own pictures in his house, along with works by Jan Lievens (1607–1674), Govert Flinck, Anthonie van Borssom, Jacob van Ruisdael, Gerard ter Borch, Willem van de Velde the Younger (q.q.v.), and others.[5] When his widow died on April 16 of the same year the couple's estate was valued at the remarkably high figure of 84,000 guilders.

Van der Heyden was baptized in Gorinchem on March 5, 1637, as the third child of Jan Goris Claesz (1607–1651), who owned an oil mill, and Neeltje Jansdr Munster (d. 1667).[6] The couple married on September 3, 1631, in Utrecht, where their first two children, Goris and Cornelis, were born. In 1650, the Mennonite family moved from Gorinchem to Amsterdam, where Jan Goris had registered as a grain merchant four years earlier. He died, much diminished in means, in November 1651, leaving behind his wife and eight children. The future painter's oldest brother, Goris, became the family's main provider by making and selling mirrors. In 1656, the Van der Heydens rented a house near the Town Hall on the Dam (main square), which is evidently where Goris had his shop and where Jan began his career as a painter.

On June 26, 1661, Van der Heyden, then twenty-four, married the thirty-year-old Sara ter Hiel. At the time, he lived on the Herengracht with his mother, and described himself as a painter.[7] Houbraken records that the young man "learned the rudiments of art from a glass engraver" (glasschryver), which

might have some connection with his brother's mirror business in Amsterdam.[8] Modern writers have reported that Van der Heyden studied with a "glass painter,"[9] or have conjectured that he trained with a maker of fine cabinets (i.e., his maternal grandfather, Jan Cornelisz Munster),[10] with the minor landscapist Jan Looten (ca. 1618–1681),[11] or with the Gorinchem painter and draftsman of town views Jacob van der Ulft (1627–1689; see fig. 232).[12] Curiously, Van der Ulft came from a family of glassmakers; he is described by Houbraken as "the leading glass painter of the century: so that many church windows around Gorinchem and Gelderland are embellished by his brushwork."[13] In 1653–54, Van der Ulft made drawings of the Dam with Jacob van Campen's new Town Hall and the proposed tower of the neighboring Nieuwe Kerk as they would appear when finished, presumably on the basis of the architect's wooden models.[14] It has been supposed that this work, which resulted in a popular engraving, influenced Van der Heyden's turn to the subject of the Town Hall and the Dam in the 1660s.[15] However, the subject of the Dam had also been treated by artists in earlier decades and attracted a number of painters in the 1650s and 1660s.[16]

The pictorial evidence indicates that between about 1655 and 1665, Van der Heyden essentially trained himself as a landscape painter, using an eclectic survey of readily available models. His early works bring to mind pictures by Cornelis Decker (ca. 1615–1678), Jan Looten (mentioned above), Emanuel Murant (q.v.), Paulus Potter (1625–1654), Jacob van Ruisdael (q.v.), Adriaen van de Velde (1636–1672), Jan Wijnants (1632–1684), and others.[17] Among the early landscapes are village views similar to those by Murant, who to some extent probably inspired Van der Heyden's detailed description of brickwork. In the mid- to late 1660s, Van der Heyden expanded his repertoire to include still lifes comparable to those painted a little earlier by Gerrit Dou (q.v.),[18] views of castles and country houses,[19] imaginary townscapes featuring motifs found in Cologne, Düsseldorf, and Emmerich, and views of the Dam and other locations in Amsterdam.[20] Architectural subjects (invariably exterior views) predominate in the 1670s and 1680s; no pictures are known to date from between 1684 and 1711.[21] In the last two years of his life, Van der Heyden painted a few fancy still lifes set in

domestic interiors, which evoke the private world of a gentleman scholar.[22]

The artist's first views of Amsterdam buildings, streets, and squares coincide with a great expansion of the city, which included an unprecedented investment in public buildings and other projects, and a similar boom in the construction of fine town houses along the canals.[23] In the same years, views of foreign cities, seaports, palaces, and so on became popular with cosmopolitan collectors in the Netherlands, especially in the great commercial center of Amsterdam. While Van der Heyden's townscapes depicting or evoking German cities along the Rhine may have appealed to patrons who had traveled there,[24] the fact that he kept a large part of his oeuvre suggests that his choice of subjects should not be linked too closely to market demand.[25] Especially in his architectural fantasies—*capricci* in which he often modified or relocated actual buildings—the painter favored picturesque motifs (compare Van Goyen; Pls. 51–53) and attractive pictorial effects. Houbraken, in praising Van der Heyden's style, observed that although one could count the bricks and see the mortar between them in his architectural views, no hardness resulted if the paintings were examined from a normal distance. Similarly, Sir Joshua Reynolds wrote of a work by Van der Heyden, "Notwithstanding this picture is finished as usual very minutely, he has not forgotten to preserve at the same time a great breadth of light. His pictures have very much the effect of nature, seen in a camera obscura."[26]

Houbraken wondered if Van der Heyden might have employed a "special device or means" in the execution of his detailed pictures, and modern writers have made claims such as "the precision and specialized visual effects in his cityscapes suggest the use of lenses, mirrors, and very possibly the camera obscura."[27] On the contrary, Van der Heyden's precision and his perspective constructions indicate quite the opposite, unless "the use of lenses" refers solely to a magnifying glass.[28] However, the artist often used counterproofs from copperplates engraved with minute brickwork and other patterns in order to describe masonry in extraordinary detail.[29]

Van der Heyden's work was much admired in the eighteenth century, and influenced Dutch painters of architectural views such as Isaac Ouwater (1750–1793). No students are recorded. However, stylistic anomalies in some of the later pictures that have been catalogued as by Van der Heyden raise the question of whether an immediate follower such as the artist's son Jan may have been responsible for their execution. The artist collaborated both with his son and with the printmaker Jan van Vianen (1660–after 1726) on his book about

"the newly discovered and patented hose fire engine," published in 1690.[30] Van der Heyden was a capable draftsman and painter of figures,[31] though on occasion he employed other painters, such as Johannes Lingelbach (q.v.) and Adriaen van de Velde, to supply staffage.[32]

1. Van der Heyden's paintings are catalogued in Wagner 1971, and are discussed broadly in L. de Vries 1984a, pp. 13–58. The best introduction to Van der Heyden's work is now that of Peter Sutton and his collaborators in Greenwich–Amsterdam 2006–7.

2. Schatborn 1995, p. 225, in an article that is mostly concerned with Van der Heyden's drawings for his illustrated book on the fire hose pump (earlier literature on this invention is cited in ibid., p. 234 nn. 2, 4). See also L. de Vries 1984a, pp. 74–103. Van der Heyden worked with his brother Nicolaes on the pump, which was actually not a new invention but a more effective version of an earlier design. He also arranged for its efficient manufacture and devised a well-organized system of firefighting.

3. See L. de Vries 1984a, pp. 7, 68–73, fig. 1, and L. de Vries in *Dictionary of Art* 1996, vol. 14, p. 503. Van der Heyden's introduction of streetlights with four glass panes may have benefited not only from his persistent experimentation but also from his older brother Goris's business of manufacturing mirrors (see text below).

4. G. Schwartz 1983, pp. 212–15, suggests plausibly that Van der Heyden's appointment to municipal positions also resulted from personal connections with the burgomasters Joan Huydecoper I and II and Johannes Hudde.

5. See Wagner 1971, p. 16. The inventory of Van der Heyden's paintings, drawings, and books was published in Bredius 1912a, pp. 133–37.

6. The main source for Van der Heyden's biography is the archival material published in Breen 1913a, and in Van Eeghen 1973. P. Sutton 1992, pp. 80–81, lists other important publications. The biographical chapter in Wagner 1971, pp. 9–16, is useful but includes errors such as the nonsensical patronymic given to the artist's mother, "Munsterdochter" (p. 9). L. de Vries 1984a, pp. 108–12, lists key events in Van der Heyden's life and reprints the biography from Houbraken 1718–21, vol. 3, pp. 80–82, and the mostly borrowed one in Weyerman 1729–69, vol. 2, pp. 391–92.

7. The artist's brother Cornelis had recently married one of Sara's sisters, as did his brother Nicolaes three years later. The Ter Hiels were Mennonites from Utrecht. It has been suggested that Van der Heyden's interest in architectural subjects recorded in the area of Utrecht and in near parts of Germany may go back to pleasure trips with the Ter Hiels in the early 1660s (Wagner 1971, pp. 10, 13; L. de Vries 1984a, p. 108). However, Van der Heyden had other reasons to be in the area of Utrecht (see G. Schwartz 1983), and there is really no reason to connect his recording of motifs in Emmerich, Düsseldorf, and Cologne (to say nothing of Brussels, or Veere in Zeeland) with early courtship excursions. Jan van Goyen (q.v.), Lambert Doomer (1624–1700), Herman Saftleven (1609–1685), and numerous other artists had earlier traveled on sketching trips up the Rhine Valley, where the Dutch had strong commercial ties (as is stressed in Schulz 1974, p. 22, in connection with Doomer) and family connections. Van

der Heyden himself had relatives in Wesel (Wagner 1971, p. 10).

8. Houbraken 1718–21, vol. 3, p. 80; reprinted in L. de Vries 1984a, p. 110.

9. For example, Wagner 1971, pp. 15, 55. In P. Sutton 1992, p. 80, it is stated that "Jan first studied with a glass painter in Gorinchem," but there is no documentary evidence that Van der Heyden trained as a painter or anything else before moving to Amsterdam at the age of thirteen. Many writers have rendered Houbraken's *glasschryver* as "glass painter," perhaps encouraged by the evidence of the one or two early landscapes that the artist is known to have painted on the back of sheets of glass (the more securely attributed example is in the Rijksmuseum, Amsterdam; see Bredius 1913b; Wagner 1971, pp. 47, 55–56, 109, nos. 192, 195; Sluijter 1973, pp. 245–47, which casts doubt on Wagner's no. 195; and L. de Vries 1984a, pp. 45–48). These pictures appear to be copies or pastiches of works by older artists, and suggest not professional training but a "mehr dilettantisch" approach (Wagner 1971, p. 56). In Sluijter 1973, pp. 244–45, Wagner is strongly criticized for quoting Houbraken as describing Van der Heyden as a *glasschilder*.

10. L. de Vries 1984a, pp. 45–46.

11. Looten was proposed as Van der Heyden's teacher in Sluijter 1973, p. 248, on the basis of comparison between his landscapes of about 1640–55 and Van der Heyden's early landscape on glass in the Rijksmuseum (see note 9 above).

12. 't Hooft 1912, p. 8; Bredius 1913b, p. 26; G. Schwartz 1983, p. 212. Van der Ulft's importance for Van der Heyden is emphasized by P. Sutton in Greenwich–Amsterdam 2006–7, pp. 28–29, 32–34.

13. Houbraken 1718–21, vol. 2, pp. 197–98. See Tissink and De Wit 1987, p. 33. Houbraken's description of Van der Ulft as a prominent glass painter is related to Van der Heyden's possible training in Bredius 1913b, p. 26. The point was missed in Wagner 1971, p. 15.

14. See Tissink and De Wit 1987, pp. 52–53.

15. G. Schwartz 1983, pp. 212–13.

16. Middelkoop 2001. In 1656, Johannes Lingelbach (q.v.), who later placed figures in townscapes by Van der Heyden, painted a view of the Dam with the new Town Hall under construction (Amsterdams Historisch Museum; see ibid., pp. 163–67, fig. 13, and Blankert 1979, p. 191, no. 246). One of Van der Heyden's first known views of the Dam (or any Amsterdam subject), the canvas dated 1667 in the Uffizi, Florence (Wagner 1971, no. 1), takes the same oblique approach to the Town Hall as is found in Lingelbach's picture. However, Van der Heyden's immediate model for the Uffizi composition appears to have been a painting dated 1665 by the Haarlem artist Gerrit Berckheyde (1638–1698; Staatliches Museum Schwerin, no. 3205). The three works

are compared in Stapel 2000, pp. 30–35, figs. 22, 24, 26.

17. On the chronology of Van der Heyden's early work, see Wagner 1971, pp. 47–49, 51, 54–59; Sluijter 1973, p. 248; and P. Sutton in Greenwich–Amsterdam 2006–7, pp. 34–36.

18. Wagner 1971, pp. 51–53, 113, nos. 211–15. Compare Dou's niche still life in the Gemäldegalerie Alte Meister, Dresden (Sumowski 1983–[94], vol. 1, no. 308, as dating from about 1660). Dou's importance for Van der Heyden's still lifes is discussed by P. Sutton in Greenwich–Amsterdam 2006–7, p. 183.

19. See Wagner 1971, pp. 44–46; L. de Vries 1984a, pp. 33–36; Wheelock 1995a, pp. 107–8; and P. Sutton in Greenwich–Amsterdam 2006–7, pp. 51–55.

20. See Wagner 1971, pp. 59–61; Sluijter 1973, p. 248; and P. Sutton in Greenwich–Amsterdam 2006–7, pp. 40–51. On the Cologne views, see also Trnek 1992, pp. 185–88.

21. See Wagner 1971, p. 115, for a list of dated works.

22. See ibid., p. 114, nos. 217–19; the discussion of Van der Heyden's still lifes in Trnek 1992, pp. 191–95; and P. Sutton in Greenwich–Amsterdam 2006–7, pp. 39–40, 206–8 (no. 38, a still life signed "JvdHeyden oud 74 ja[ar]").

23. See Lawrence 1991, pp. 51–52, and 't Hart 2001, pp. 144–49.

24. As suggested in L. de Vries 1984a, pp. 25–27.

25. This is also clear from Bikker's essay on Van der Heyden's known patrons, in Greenwich–Amsterdam 2006–7, pp. 83–89.

26. These remarks by Houbraken and by Reynolds are quoted (without giving the precise sources) in C. Brown 1979, pp. 10, 16, within a good review of Van der Heyden's various architectural subjects.

27. P. Sutton 1992, p. 80. For Houbraken's remark and the version of it ("art secret") found in Weyerman 1729–69, vol. 2, p. 391, see L. de Vries 1984a, pp. 110–11.

28. See L. de Vries 1984a, pp. 59–62, on this point. Houbraken appears to refer specifically to a means of execution other than "the usual way of painting," and not a recording device. P. Sutton in Greenwich–Amsterdam 2006–7, pp. 67–70, speculates about Van der Heyden's possible interest in the camera obscura.

29. See P. Sutton in Greenwich–Amsterdam 2006–7, pp. 36–37, and especially Wallert's essay in ibid., pp. 91–101.

30. As noted by L. de Vries in *Dictionary of Art* 1996, vol. 14, p. 504. On the book, see L. de Vries 1984a, pp. 74–93; P. Sutton in Greenwich–Amsterdam 2006–7, pp. 74–80; and Schapelhouman in ibid., pp. 210–35 (catalogue entries for nos. 39–54, drawings by Van der Heyden).

31. See Wagner 1970, and L. de Vries 1984a, pp. 95–103.

32. Van de Velde is frequently cited, convincingly, as the figure painter in works catalogued in Greenwich–Amsterdam 2006–7. See P. Sutton in ibid., pp. 56–57, on Van der Heyden's collaborators.

78. *The Huis ten Bosch at The Hague and Its Formal Garden (View from the South)*

Oil on wood, 15⅜ x 21¾ in. (39.1 x 55.2 cm)
Signed (lower left): IVD Heÿde[n]
The painting is well preserved.
Anonymous Gift, 1964 64.65.2

This panel and its pendant, no. 64.65.3 (Pl. 79), were painted by Van der Heyden about 1668–70. At present, six autograph pictures by Van der Heyden are known to represent the Huis ten Bosch (House in the Wood) and its property; another painting, dated 1665 or 1668, depicts part of the parterre garden and one of the ivy-covered pavilions, or Groene Kabinetten (Green Cabinets), without a view of the house.[1] The Museum's pair of paintings offers the most comprehensive views of the house and the formal garden behind it. They are also the most beautiful pictures of the subject, especially the view from the south, with its brilliant daylight slicing into the tan and gray house, and creating dense filigree patterns in the hedges and parterres. A number of figures, several barely discernible, lend scale to the scene and convey the sense of pleasure found in being outdoors under a blue sky. There are two workers and two courtly figures in the foreground, six people in the nearest garden to the left, a couple on the walkway in the right middle ground, and three figures on the pathway between the statues and the house. In the view of the garden from the east (Pl. 79), two courtiers in blue costume encounter a couple with a servant. Both pictures feature in the foreground a hedgerow cut to form a scrolling silhouette and architectural fragments on a strip of ground. The rhythm and recessions of the two compositions and the placement of the signatures make it clear that the view from the south was meant to hang on the left.

A smaller panel in the National Gallery, London (fig. 88), appears to bring the view in closer to the garden façade of the house not by actually recording it from a closer vantage point but by cropping the present composition or a version of it.[2] A similar relationship exists between the Museum's painting of the house from the side (Pl. 79) and a small panel in the Hamburger Kunsthalle (fig. 91).[3] Thus, these four paintings are probably based on a single pair of drawings made at the site. Van der Heyden's two other views of the Huis ten Bosch are entirely different. A panel in the Cannon Hall Museum, Barnsley, South Yorkshire (National Loan Collection Trust), shows the front (north side) of the house receding obliquely from a vantage point close to the northwestern corner of the

building.[4] Finally, *Park by the Huis ten Bosch,* in the Museum Wuyts–Van Campen in Lier, Belgium, may be described as a landscape painting that includes in the distance one of the garden pavilions of the Huis ten Bosch and a house that bears some resemblance to the princely dwelling as seen from the side.[5]

The Haarlem painter turned architect Pieter Post (1608–1669) designed the Huis ten Bosch about 1645 as a summer residence for Amalia van Solms, wife of the Stadholder, Prince Frederick Hendrick. The house was conceived as a *villa suburbana* at the eastern end of the Haagse Bos (Hague Wood), about a mile and a half east of the center of The Hague. At the prince's death in March 1647, Amalia resolved to make the country house into a memorial of his life and career. The large central hall, which is shaped like a Greek cross (+) and is crowned by a domed cupola with windows, was decorated with an elaborate program of historical, allegorical, and mythological paintings on the walls and vaults. The subjects were conceived by the Stadholder's secretary and artistic adviser, Constantijn Huygens, in consultation with the princess dowager. Huygens and Post referred to the entire structure as the Sael van Oranje, or Oranjezaal (Hall of Orange), in honor of the House of Orange-Nassau, but the name was later applied to the central hall alone. The painter and architect Jacob van Campen (1595–1657), whom Post had assisted in building the Mauritshuis and other projects, was appointed designer of the pictorial compositions and supervisor of a team of Dutch and Flemish painters, including himself and Jacob Jordaens (1593–1678). The project was completed in 1651.[6]

Post also designed the gardens, in collaboration with the land surveyor Pieter Florisz van der Sallem and the Stadholder's head gardener, Borchgaert Federic.[7] As seen in Post's bird's-eye view of 1655 (fig. 90; see also fig. 89), the property as a whole was divided geometrically in a manner typical of classical gardens dating from the first half of the seventeenth century.[8] Behind the house, each of the four *parterres de broderie* (one of which is shown behind the shaped hedgerow in the left foreground of the present picture) had at its center a monogram combining the initials of Frederick Hendrick and Amalia. At the crossing of the walkways, four lead statues, painted to resemble stone, were placed on tall pedestals. One of the female figures holds a cornucopia, and another an urn, which suggests that the Four Seasons were represented.[9] The walkways were divided into broad and narrow paths by low hedgerows and lines of planting pots on

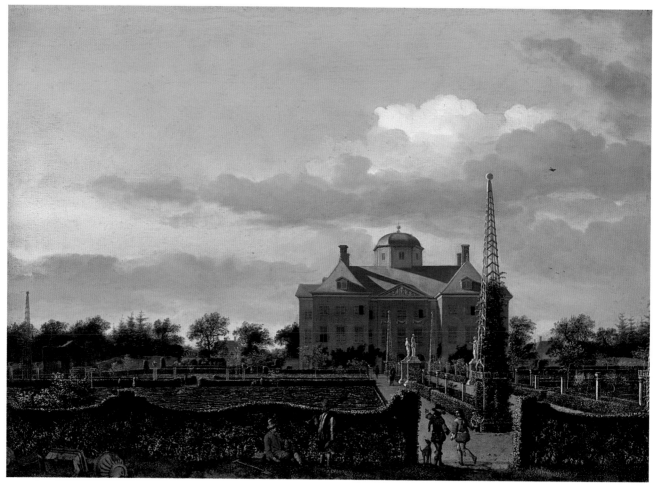

78

Figure 88. Jan van der Heyden, *The Huis ten Bosch at The Hague*, ca. 1670. Oil on wood, 8½ x 11¼ in. (21.6 x 28.6 cm). The National Gallery, London, Bequeathed by Sir James Morse Carmichael, Bt., 1902

Figure 89. Jan Mathijs after Pieter Post, "Plan of the Huis ten Bosch and Its Gardens," from Jan van der Groen, *Le jardinier hollandais* (Amsterdam, 1669). Engraving. Library of the Archiepiscopal Castle Kroměříž, Archbishopric Olomouc, Czech Republic

't PRINCELYK HUYS en HOF in 't BOSCH.

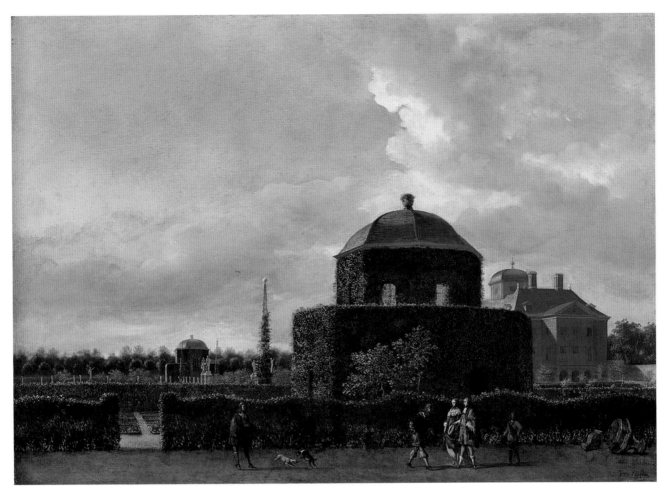

79

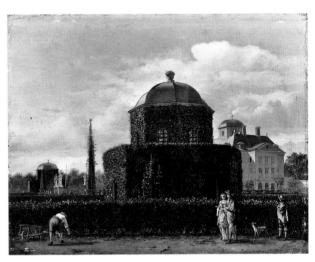

Figure 91. Jan van der Heyden, *A Pavilion in the Garden of the Huis ten Bosch*, ca. 1670. Oil on wood, 8¾ x 11⅝ in. (22.1 x 29.5 cm). Hamburger Kunsthalle, Hamburg

Figure 90. Jan Mathijs after Pieter Post, title page of *De Sael van Orange* (Amsterdam, 1655), showing the Huis ten Bosch and its property from the north. Etching. Gemeentearchief, The Hague

pedestals. Each end of the two major walkways was marked by a pair of latticework obelisks topped with reflecting balls.[10]

The two garden pavilions (see Pl. 79), in rectangular sections of seedbeds, were constructed of timber frameworks and probably had latticework panels behind their ivy walls. A lower chamber with doors supported the octagonal belvedere and surrounding deck, which was reached by a broad staircase facing the center of the garden. As is obvious in Van der Heyden's view from the east (Pl. 79), the Groene Kabinetten echoed the shape of the Huis ten Bosch's cupola. From their vantage points, one could appreciate the design of the parterres and glimpse the surrounding countryside.[11] A somewhat less elevated prospect of the garden could also be obtained from the Bezuidenhoutseweg (Southern Wood Way) at the end of the garden, where the artist, like a passerby, found this view of the most famous country house in Holland.

Beyond the trees to either side of the house, Van der Heyden shows the roofs and chimneys of the outbuildings that flank the main entranceway. The western building was occupied by the chamberlain, and the eastern one included the kitchen (see fig. 90, where these structures are shown with the horse and cow barns behind them).[12] Post's plan of the entire property shows that the distant outbuildings would appear as they do in the Museum's picture from the artist's off-center vantage point.[13] The outbuildings, the main house, and various motifs in the garden are less meticulously observed in the London version of this composition, where the somewhat different recession of statues and obelisks would have resulted from casting the same on-site drawing into another perspective scheme.[14] (It is revealing that the western sun casts nearly the same pattern of shadows on the house in both pictures.) In general, there is a shift in emphasis from an overview of the site to a closer look at the building, but less for its own sake than for its minute brickwork and as the setting for the princely party coming down the path.

Today, the Huis ten Bosch remains a royal residence and the decorations of the Oranjezaal are intact. But the exterior of the house and the gardens were altered at early dates. The parterres were redesigned in 1686, and again in the 1730s, when the architect Daniel Marot added two long wings to the front corners of the house.[15]

One can well imagine Van der Heyden turning to the subject of the Huis ten Bosch without being asked to by a patron. Views of various existing country houses were in the artist's collection at his death,[16] and he also painted imaginary estates, including

a superb picture of a Dutch Palladian villa reminiscent of buildings by Van Campen and Post (*An Architectural Fantasy*, ca. 1668–70, National Gallery of Art, Washington, D.C.).[17] Scholars have cited genre scenes set in formal gardens and other painted parallels to Van der Heyden's views of country estates,[18] but these comparisons are not very helpful in the case of an artist who was unresponsive to market demand. However, the general interest of polite society in country homes and gardens, poems about them, and views of fine examples (whether real or imaginary) is certainly relevant to Van der Heyden's work. The Huis ten Bosch and its gardens were considered models of modern taste, and Post's publication of a portfolio of prints, *De Sael van Orange*, in 1655 (see fig. 90), did nothing to discourage that view.[19]

1. For the latter picture, see Wagner 1971, no. 137 (ill.), and Dumas 1991, pp. 325–26, fig. 9.

2. On the National Gallery picture, see Wagner 1971, no. 133 (ill.); Dumas 1991, pp. 325–26, fig. 6; and MacLaren/Brown 1991, pp. 173–74, no. 1914, pl. 155.

3. Wagner 1971, no. 136 (ill.); Dumas 1991, p. 29, fig. 26; Ketelsen 2001, pp. 121–22, no. 77. In sales dating from 1764 to 1810 the painting in the National Gallery, London (see the preceding note), was offered together with a picture said to be its pendant (see MacLaren/Brown 1991, p. 173 [under "Provenance"]). The London and Hamburg panels are identical in size, but the latter appears to have a different provenance going back to 1760 (Ketelsen 2001, p. 121).

4. Wagner 1971, no. 138 (ill.); Dumas 1991, p. 29, fig. 25.

5. Wagner 1971, no. 139 (ill.), where it is noted that the house in the right background is really more similar to country houses on the river Vecht near Utrecht. Compared with side elevations of the Huis ten Bosch, the central section of the house in the Lier picture has been made taller by inserting a row of three windows below the pediment, and there are other significant differences. Jacob van Campen's Huis ten Bosch in Maarssen (1628) is somewhat similar, but it is only two stories high (see Huisken, Ottenheym, and Schwartz 1995, pp. 161–63, fig. 134). In MacLaren/Brown 1991, p. 173 n. 2, yet another painting by Van der Heyden is said to be a view of the Huis ten Bosch and its garden, but it is catalogued in Wagner 1971, no. 152 (not ill.), under "Unbekannte Landhäuser."

6. The essential literature on the Huis ten Bosch and the Oranjezaal includes Slothouwer 1945, pp. 179–211; Brenninkmeyer-de Rooij 1982; Terwen and Ottenheym 1993, pp. 56–70; and Huisken, Ottenheym, and Schwartz 1995, pp. 132–41.

7. See Sellers 2001, pp. 112–20, for a full discussion of the garden, with references to earlier literature and documents.

8. As noted in Dumas 1991, p. 323.

9. Sellers 2001, p. 118. The other statues visible in the present pair of paintings are apparently two of the four life-size portraits of

Princes of Orange that were ordered in 1646 by Amalia from François Dieussart (ibid., pp. 118, 288 n. 68).

10. The latter are said to have frightened birds (Dumas 1991, p. 323).

11. A print of about 1690 (Slothouwer 1945, fig. 72) shows a view of the then-altered garden from the deck of the eastern pavilion, and reveals the design of the waist-high railing around the deck (which is completely covered by ivy on the outside).

12. See Terwen and Ottenheym 1993, p. 71.

13. Reproduced in Slothouwer 1945, fig. 71; in Terwen and Ottenheym 1993, fig. 73b; and in Sellers 2001, fig. 95. In 1979 the present writer received a large photocopy of Post's plan from the late Beatrijs Brenninkmeyer-de Rooij, a leading historian of the Huis ten Bosch.

14. The realignment of obelisks and statues (all Four Seasons fall into the London view) is almost negligible compared with Pieter Saenredam's redrafting of colonnades first drawn in Dutch churches, and with Van der Heyden's perspective manipulations of other known sites. Architectural motifs like the cupola windows are less carefully drawn in the London picture, and some details (shutter hinges, for example) are simply omitted. Van der Heyden may have referred to engravings after Post's elevations of the house for specific details (for example, the hinges again), but those architectural renderings (see Slothouwer 1945, figs. 64–67) were clearly not employed to depict the building without making firsthand drawings of it.

15. See Sellers 2001, pp. 119–20. The eighteenth-century changes are also discussed in Slothouwer 1945, pp. 211–24.

16. As is emphasized in G. Schwartz 1983, pp. 215–16.

17. See the valuable discussion in Wheelock 1995a, pp. 107–12, and also P. Sutton in Greenwich–Amsterdam 2006–7, pp. 164–67, no. 24.

18. See, for example, Wagner 1971, p. 44. In the early 1660s, Jacob van der Croos (ca. 1630–after 1683) painted a small, rather mediocre view of the Huis ten Bosch from the south as part of a *View of The Hague* surrounded by twenty panels depicting locations in the general area (see Dumas 1991, nos. 18, 18q). As early as 1647 and in the 1650s, his father, Anthony van der Croos, painted some views of the Huis ten Bosch set amid trees (ibid., pp. 324, 326, fig. 5, and pp. 363–64, illustrating four pictures by Anthony, and one by Jacob dated 1656). None of these paintings anticipates any known composition by Van der Heyden, and it is doubtful that he knew them.

19. This point is made in a discussion of *buitenplaatsen* (country retreats) in Frijhoff and Spies 1999, p. 489. On Post's series of prints, see Terwen and Ottenheym 1993, p. 245, under sec. III, 1655. See G. Schwartz 1983 on Van Campen, Van der Heyden, and the Huydecopers of Maarsseveen, whose house, Goudestein, "was the first true *buitenplaats* (country estate) on the Vecht," and "a symbol for a gracious style of life" (ibid., p. 205). Van der Heyden painted a view of another country house in the neighborhood of the Huis ten Bosch, Huis Pasgeld on the Vliet between The Hague and Delft (Niemeijer 1960; Wagner 1971, no. 147; White 1982, pp. 49–50, no. 66, where the proposed date of about 1660 is about a decade too early; Dumas 1991, pp. 29,

54 n. 94). About the same period, 1665–70, the wealthy lawyer Jan de Bisschop (1628–1671), a close associate of Constantijn Huygens, drew views of Frederick Hendrick's palace just south of The Hague, the Huis ter Nieuburch at Rijswijk. The sheets were copied by Jacob van der Ulft, who is mentioned in Van der Heyden's biography, above. On De Bisschop's drawings and Van der Ulft's copies, see Plomp in New York–London 2001, nos. 101, 102. De Bisschop's drawings of the grounds of Frederick Hendrick's other country palace, Honselaarsdijk, are also relevant (see Amsterdam 1992a, no. 8).

REFERENCES: Ozinga 1938, p. 41, pl. 50A, describes the work as by Van der Heyden or his studio, compares the London version (in n. 1), and uses the painting to compare the design of the garden in the 1660s and its appearance about 1700; H. van Gelder 1959, p. 17, fig. 100; MacLaren 1960, p. 162, describes the present picture as "another, larger, version of the same view, seen from a little farther away," as compared with the panel in the National Gallery, London (fig. 88 here); Virch 1970, pp. 9–10, describes the subject and mentions the London version; Wagner 1971, pp. 45, 97, no. 134 (ill.); P. Sutton 1986, p. 191, mentioned; Dumas 1991, pp. 325–26, 328 nn. 23, 24, fig. 7 on p. 325, describes the subject; MacLaren/Brown 1991, p. 173, repeats the remark made in MacLaren 1960; Baetjer 1995, p. 340; Ketelsen 2001, p. 122, in a discussion of the Hamburg version of no. 64.65.3, calls it and no. 64.65.2 autograph "repetitions" of the Hamburg and London pictures; Sellers 2001, pp. 114–15, 229, 288 n. 62, 318 n. 48, fig. 96, pl. XIV (opp. p. 209), employs the painting as evidence for the appearance of the main parterre garden behind the Huis ten Bosch during the 1660s; P. Sutton in Greenwich–Amsterdam 2006–7, pp. 51–52, 158–59 no. 22, 162 (under no. 23), discusses the subject, reproduces Post's design for the front (north façade) of the house and his plan of the formal gardens, suggests that the figures might be by Johannes Lingelbach (q.v.), and compares Van der Heyden's other known views of the Huis ten Bosch.

EXHIBITED: Haarlem, Frans Halsmuseum, "Tentoonstelling van schilderijen van Oud-Hollandsche meesters uit de Collectie Katz te Dieren," 1934, no. 37; Brussels, Exposition universelle et internationale de Bruxelles, "Cinq siècles d'art," 1935, no. 733; Amsterdam, Amsterdamsch Historisch Museum Sint Anthonies Waag, "Jan van der Heyden," 1937, no. 13; Greenwich, Conn., Bruce Museum, and Amsterdam, Rijksmuseum, "Jan van der Heyden (1637–1712)," 2006–7, no. 22.

EX COLL.: Joshua Charles Vanneck, 4th Baron Huntingfield, Heveningham Hall, Yoxford, Suffolk (d. 1915); [Asscher and Welker, London, in 1933]; [D. Katz, Dieren, the Netherlands, in 1934]; [W. E. Duits, Amsterdam, in 1935]; [Galerie Sanct Lucas, Vienna, before 1937; sold to a private collection, Vienna, with 64.65.3]; private collection, Vienna, and later Greenwich, Conn. (by 1937–64; seized in Paris by the Nazis, held at Alt Aussee, Austria [1167/3], and at Munich collecting point [1368], returned to France October 30, 1946; restituted; given by owner to MMA; life interest, 1964–d. 1984); Anonymous Gift, 1964 64.65.2

79. The Huis ten Bosch at The Hague and Its Formal Garden (View from the East)

Oil on wood, 15⅜ x 21⅝ in. (39.1 x 54.9 cm)
Signed (lower right): I.V.D. Heyden
The painting is well preserved.
Anonymous Gift, 1964 64.65.3

The main motif in the picture is one of the two ivy-covered pavilions, or Groene Kabinetten (Green Cabinets), in the formal garden behind the Huis ten Bosch just outside The Hague. See the discussion of this painting and its pendant (Pl. 78) in the preceding entry.

REFERENCES: Virch 1970, p. 10, mentions the Hamburg version, which is considered to have been "painted from a position closer to the pavilion"; Wagner 1971, pp. 45, 97, no. 135 (ill. p. 157); L. de Vries 1984a, pp. 35–36, fig. 21, offers an appreciation of the pavilion and other features of the garden; P. Sutton 1986, p. 191, mentioned; Dumas 1991, pp. 29, 54 n. 96, 325–26, 328 n. 24, fig. 8 on p. 325, cites the picture and a painting of the Huis Pasgeld near Delft as among Van der Heyden's few views near The Hague, and describes the Hamburg "variant" as recorded from a closer vantage point; Baetjer 1995, p. 340; Ketelsen 2001, p. 122, in a discussion of the Hamburg version of no. 64.65.3, calls it and no. 64.65.2 autograph "repetitions" of the Hamburg and London pictures; P. Sutton in Greenwich–Amsterdam 2006–7, pp. 51–52, 159 (under no. 22), 162–63, no. 23, describes the subject and the artfulness of the composition.

EXHIBITED: Haarlem, Frans Halsmuseum, "Tentoonstelling van Schilderijen van Oud-Hollandsche meesters uit de Collectie Katz te Dieren," 1934, no. 36; Brussels, Exposition universelle et internationale de Bruxelles, "Cinq siècles d'art," 1935, no. 734; Amsterdam, Amsterdamsch Historisch Museum Sint Anthonies Waag, "Jan van der Heyden," 1937, no. 14; Greenwich, Conn., Bruce Museum, and Amsterdam, Rijksmuseum, "Jan van der Heyden (1637–1712)," 2006–7, no. 23.

EX COLL.: This painting has the same history of ownership as its pendant. See Ex Coll. for *The Huis ten Bosch at The Hague and Its Formal Garden (View from the South)* (Pl. 78); Anonymous Gift, 1964 64.65.3

MEYNDERT HOBBEMA

Amsterdam 1638–1709 Amsterdam

Meyndert Lubbertsz Hobbema, son of the carpenter Lubbert Meyndertsz, was baptized in Amsterdam on October 31, 1638, and rarely left the city until his death on December 7, 1709. Hobbema and his younger brother and sister entered an Amsterdam orphanage in 1653. Jacob van Ruisdael (q.v.), who was only a few years older than Hobbema, was his teacher during the second half of the 1650s.[1] Early works by Hobbema show the influence of Van Ruisdael's uncle, Salomon van Ruysdael (q.v.),[2] and perhaps of Cornelis Vroom (1590/91–1661),[3] but Van Ruisdael was Hobbema's main source of inspiration, and in some paintings of the early 1660s he adopted his master's compositional ideas.[4] In 1663–64, Hobbema's manner became calmer and more luminous; the space in his wooded landscapes is generally more open, and the touch more fluid, than in Van Ruisdael's comparable works.[5] Picturesque motifs such as waterfalls and cottages convey a sense of well-being in the countryside, which was a view favored in Amsterdam town houses.

Van Ruisdael was a witness at Hobbema's marriage to a burgomaster's kitchen maid, Eeltje Vinck, in 1668. In the same year, Hobbema was awarded a well-paid civic post as a wine gauger. From then on, he painted infrequently and mostly for his own pleasure, or so it seems in the famous *Avenue at Middelharnis*, of 1689 (National Gallery, London).[6]

Two close associates of Van Ruisdael, Jan van Kessel (1641–1680) and Isaac Koene (ca. 1637–1713), were influenced by Hobbema, and some of their works have been confused with his.[7]

Most of Hobbema's work is based on art not nature, although it reveals close observation and a distinctive disposition. His landscapes are those one might encounter on walks out of town,[8] which links him to a tradition in Amsterdam and Haarlem dating back to the first decades of the century (as seen, for example, in prints by Willem Buytewech, Jan van de Velde the Younger, and Claes Jansz Visscher).[9] There are always houses and other signs of life, and, in an oeuvre with countless clouds and trees, never an ominous shadow.

This view accorded well with the tastes of the eighteenth and nineteenth centuries, especially the period from about 1790 onward. In the Netherlands, Hobbema inspired the sunny woodlands of Egbert van Drielst (1745–1818),[10] while in England the

"highly appreciated landscape painter,"[11] whose pictures were in numerous collections by 1835 (the date of John Smith's oeuvre list of Hobbema), was one of the principal sources of inspiration for artists of the Norwich school.[12] At least two dozen paintings by Hobbema entered important American collections between the last years of the nineteenth century and about 1910.[13] Indeed, the demand for the artist's pictures in American, English, and Continental collections was such that very few works by him remain in the Netherlands.[14]

1. Bredius 1915, p. 194. Van Ruisdael was a resident of Amsterdam by June 1657, but probably earlier, and he testified in July 1660 that Hobbema had "served and learned" with him for some years.

2. For example, Hobbema's earliest dated work, the *River Scene,* of 1658, in the Detroit Institute of Arts (Broulhiet 1938, no. 286 [ill.]; Keyes et al. 2004, pp. 108–9, no. 42).

3. See Keyes 1975, p. 111.

4. See Walford 1991, pp. 9, 121, 123, 125–27, on the trip that Van Ruisdael and Hobbema evidently took together to the area of the German border, and ibid., p. 48, on Hobbema's possible use of drawings by Van Ruisdael; Slive 1995b, p. 457, shows that Hobbema's *River Landscape with Fishermen,* of about 1659–60 (City Art Gallery and Museum, Glasgow), closely depends upon a painting by Van Ruisdael.

5. This has often been observed, as in Walford 1991, p. 128, and by John Loughman in *Dictionary of Art* 1996, vol. 14, pp. 600–601.

6. See MacLaren/Brown 1991, pp. 176–79, regarding the picture's late date and topographical accuracy.

7. For example, Van Kessel's *Wooded Landscape,* in the Shizuoka Prefectural Museum of Art (A. Davies 1992, no. 87, fig. 87), which was acquired as a work by Hobbema. On Koene, see ibid., pp. 98–99.

8. This was precisely the observation of Robert Gilmor Jr., the pioneering Baltimore collector, who wrote from Amsterdam on July 17, 1800, "The road was lined with beautiful cottages, all enclosed in trees, and provided in actions and instances the originals of those sweet pictures of Hobbema whose charming works were ten times more pleasing to me since I have taken this ride." Quoted in H. Clark 1982, pp. 29, 172.

9. See Freedberg 1980, Leeflang 1998, W. S. Gibson 2000, and Liedtke 2003.

10. Assen 1968.

11. J. Smith 1829–42, vol. 6, p. 109, introducing his Hobbema catalogue of 1835.

12. As noted in Norwich 1988, pp. 114–15.

13. See Hofstede de Groot 1907–27, vol. 4, pp. 356–438, where it is

observed that "Hobbema's works, for their greater rarity, fetch much higher prices than those of Ruisdael" (p. 352).

14. See Van Thiel et al. 1976, p. 277, and Van der Ploeg 1995, pp. 19–20.

80. *Entrance to a Village*

Oil on wood, 29½ x 43⅜ in. (74.9 x 110.2 cm)
Signed (lower right): m [Ho]bb[ema]

The tonal contrast between the sky and the landscape has increased over time. The vegetation has darkened, and the figures, particularly the three in the near foreground, have lost definition as a result of natural aging and thinning of the paint film from abrasion during past cleaning. Abrasion in the area of the sky has revealed the dark horizontal grain of the oak panel and paint loss along the horizontal wood join.

Bequest of Benjamin Altman, 1913 14.40.614

This confidently painted panel in the Altman Collection probably dates from about 1665 and depicts Hobbema's quintessential theme of quiet village life.

The small church in the right background would have been about two hundred years old in the artist's lifetime and indicates that the modest houses, although placed according to no particular plan, form the center of a rural village. The structure with a thatched roof to the left is nearing the end of its usefulness, while the brick cottage with a tiled roof to the right, its small yard protected by a rough board fence, was probably imagined by the artist as the newest house nestled among the trees. In the distance, a walled churchyard and sun-filled meadows brighten the scene. The pen and shelter in the right foreground are probably meant for pigs.

The rather crude rendering of the staffage is typical of Hobbema, as is the suggestion of midmorning or another pleasant hour of a sunny day. In the foreground, a man walks with a sack and stick, the usual signs of a traveler (compare the man walking in Jacob van Ruisdael's *Wheatfields*; Pl. 182), while a seated woman converses with two standing men (the paint in this group of figures is now very thin). A couple approaches on the pathway leading to the church, as does a woman on the road branching to the left.

In composition and execution, this panel is closely related to a group of pictures by Hobbema, a few of which are dated

1665. Two paintings bearing this date, a smaller panel (23⅞ x 33¼ in. [60.5 x 84.5 cm]) in the Ruzicka Foundation, Zürich, and a canvas (38 x 48 in. [96.5 x 122 cm]) formerly in the Percy B. Meyer collection, London, were compared by Gerson with the Museum's picture and with the undated *Woody Landscape with a Road by a Cottage,* in the National Gallery, London.[1] MacLaren places the London panel before the very similar Zürich picture and then the Meyer painting, and concurs with Gerson that the Altman panel represents "a later development" within a brief period.[2] Another panel dated 1665 that is close to the present picture in composition and execution is the *Village among Trees,* in the Frick Collection, New York (fig. 92); the Frick *Village with Water Mill among Trees* and the *View on a High Road* (1665), in the National Gallery of Art, Washington, D.C., further reveal how Hobbema varied motifs and shifted the emphasis within the same compositional scheme.[3] Indeed, the design dated back to 1662 (as is seen in the *Wooded Road with Cottages,* in the Philadelphia Museum of Art, and in *The Farm,* in the Louvre, Paris),[4] and was repeated in a looser, more spacious manner in two landscapes dated 1667, one in the Fitzwilliam Museum, Cambridge, and the other (reversing the pattern) in the Indianapolis Museum of Art.[5]

Of all these compositions, the paintings of 1665 reveal comparatively less emphasis on a long diagonal recession from left to right. The eye tends to rest at the main group of trees, and to wander about the middle ground as one might explore such a village, at least in the imagination. The viewer has a stronger sense of participation in Hobbema's paintings of the mid-1660s than in later works, where scenes tend to become scenery (see Pl. 81). In this regard, the Altman picture is one of Hobbema's more memorable works.

1. Gerson 1947, p. 45; all four paintings are reproduced. See also Broulhiet 1938, no. 199 (ill.), for the Meyer canvas (formerly in the collection of Lady Cunliffe-Lister), which was sold at Sotheby's, London, December 3, 1969, no. 9.

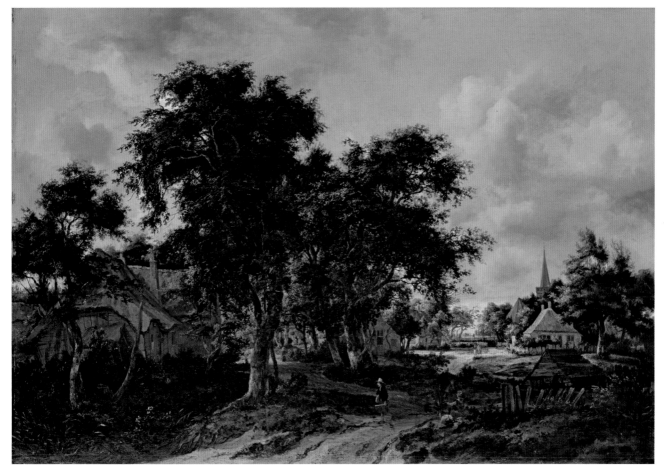

80

Figure 92. Meyndert Hobbema,
Village among Trees, 1665. Oil on
wood, 30 x 43½ in. (76.2 x 110.5 cm).
The Frick Collection, New York

2. MacLaren 1960, p. 164 (under no. 685); repeated in MacLaren/ Brown 1991, pp. 175–76, pl. 157.

3. Frick Collection 1968, vol. 1, pp. 222–27; Broulhiet 1938, nos. 193, 196 (ill.). Of the paintings discussed here the Frick *Village among Trees* (fig. 92) is the most similar in technique. For the Washington picture, see Broulhiet 1938, no. 189 (ill.), and Wheelock 1995a, pp. 123–26.

4. See P. Sutton in Amsterdam–Boston–Philadelphia 1987–88, no. 44, for a discussion and illustrations of the Philadelphia and Paris pictures (Broulhiet 1938, nos. 197, 192), and P. Sutton 1990a, pp. 121–23. These designs are anticipated by Hercules Segers's etching *A Country Road with Trees and Buildings,* of which a unique impression is in the British Museum (Rowlands 1979, no. 67; Freedberg 1980, fig. 64).

5. See Gerson in Gerson, Goodison, and Sutton 1960, p. 62, no. 49, pl. 32 (Broulhiet 1938, no. 208 [ill.]), and Indianapolis Museum of Art 1970, pp. 108–9, no. 43.108 (ill.), which is Broulhiet's no. 101 (collection of J. Pierpont Morgan). The seemingly uniform esteem of Hobbema during America's Gilded Age found expression in the very similar designs of the landscapes by him in the collections of Morgan, Frick, Mellon, Elkins (Philadelphia; see note 4 above), and Widener (Broulhiet 1938, no. 100).

REFERENCES: J. Smith 1829–42, vol. 4 (1833), pp. 118–19, no. 14, mentions the painting as in the collection of John Lucy ("Few pictures possess more pre-eminently the various beauties for which the master is esteemed"); Sedelmeyer Gallery 1898, p. 74, no. 60 (ill.), as in the collection of Rodolphe Kann; Bode 1900, p. XVII, pl. 41, as one of Hobbema's most important pictures; É. Michel 1901, pp. 395–96, praises the composition; Wurzbach 1906–11, vol. 1 (1906) p. 691, listed; Bode 1907, pp. xi–xii, 47, no. 46 (ill.); Nicolle 1908, pp. 198–99 (ill.), as "de toute beauté"; Hofstede de Groot 1907–27, vol. 4 (1912), pp. 366–67, no. 44, as with Duveen in Paris; Monod 1923,

p. 311, "Hobbema n'a mieux peint que dans cette *Entrée de village*"; Altman Collection 1928, pp. 72–73, no. 36, as "an example of his usual plan" and as signed "M. Hobbema"; Broulhiet 1938, pp. 289 (ill.), 428, no. 374, with provenance; Gerson 1947, p. 45, fig. 3 (see text above); Rousseau 1954, p. 3; MacLaren 1960, pp. 164–65 n. 4; Liedtke 1990, p. 48; MacLaren/Brown 1991, pp. 175–76 n. 4; A. Davies 1992, pp. 41, 185, fig. 24, compares a picture by Jan van Kessel; Baetjer 1995, p. 340; L. Miller, "Benjamin Altman," in *Dictionary of Art* 1996, vol. 1, p. 731, mentioned.

EXHIBITED: London, Royal Academy, "Winter Exhibition," 1878, no. 286 (lent by Baron Lionel de Rothschild); Paris, Galerie Georges Petit, "Cent chefs-d'oeuvre des écoles françaises et étrangères' (deuxième exposition)," 1892, no. 18 (lent by Rodolphe Kann); New York, MMA, "Art Treasures of the Metropolitan," 1952–53, no. 116.

EX COLL.: [Thomas Emmerson, before 1835, who according to Smith (see Refs.) "imported" the painting and sold it to John Lucy]; John Lucy, Charlecote Park, Warwickshire (in 1835); Baron Lionel de Rothschild, London (in 1878); [Sedelmeyer Gallery, Paris]; Rodolphe Kann, Paris (by 1892–d. 1905; his estate, 1905–7; sold to Duveen); [Duveen Brothers, Paris and New York, in 1907; sold to Altman on February 1, 1908, for $163,145];[1] Benjamin Altman, New York (1908–13); Bequest of Benjamin Altman, 1913 14.40.614

1. A letter dated January 13, 1908, from Altman to Wilhelm Bode in Berlin politely declines to cede the Kann Hobbema to the Kaiser-Friedrich-Museum, which Bode had requested "as a favor to the Emperor" (Altman's letter in the Zentralarchiv, Staatliche Museen, Berlin, was kindly brought to our attention by MMA curator Julien Chapuis in August 2006). Bode had published the picture in 1900 (see Refs.).

81. *Woodland Road*

Oil on canvas, 37¼ x 51 in. (94.6 x 129.5 cm)
Signed (lower right): m. Hobbema

The painting is damaged from past lining and cleaning, as a result of which many passages of the landscape have darkened. The blue sky is marred throughout where the dark underlayer has become visible as the paint has thinned over time and from abrasion.

Bequest of Mary Stillman Harkness, 1950 50.145.22

In this canvas of about 1670, a country road curves around the marsh to the left.[1] Farmhouses are visible among the trees straight ahead and to the right, where a woman at a Dutch door appears to be looking at the travelers.[2]

Dating the painting requires close consideration of its style. In many earlier works by Hobbema, the diversity of pathways and buildings invites the eye to wander, so that the viewer momentarily forgets the artful arrangement of the whole. The effect in the present picture is rather different. The breadth and depth of the foreground keep the viewer at a certain distance, from which the main impressions are made by the graceful massing of trees and the delicate variety of leaves. The tighter and generally more naturalistic description of trees in Hobbema's landscapes of about 1665 is here nearly abandoned in favor of a painterly screen of foliage notable for its many different textures and colors, including bright, soft touches of blues and yellows. Cloud formations fill the remarkably blue

81

sky, their billowing shapes conspicuously sympathetic to the ascending branches. The tallest tree and the cumulus cloud to the left (where two birds focus attention) are the two most prominent—almost paired—motifs; while Hobbema's descriptive qualities have diminished, his pictorial interests have become more sophisticated. This is true for many Dutch landscapists of the period—the painting looks back to Jacob van Ruisdael (q.v.) and forward to Frederick de Moucheron (1633–1686)[3]—but few other painters so successfully modified their style according to fashion as Hobbema does here.

Smith and Broulhiet dated the Museum's painting to the mid-1660s,[4] but Stechow placed it in a group of Hobbema's landscapes dating from the early 1670s.[5] Broulhiet's dating

depended partly upon his close association of the picture with a composition attributed to Van Ruisdael, but Slive sees the connection as "rather remote" and the attribution to Van Ruisdael as dubious.[6]

A panel (24 x 33 in. [61 x 83.8 cm]) formerly in the Yerkes collection employs a very similar composition in reverse.[7] The painting may be by Hobbema, but it is almost certainly later than the present work.[8]

For more than a century, the Museum's picture was in the Feversham collection at Duncombe Park, Yorkshire, where, according to Waagen, nearly all the paintings were Italian or French.[9]

1. It is not clear in reproductions that the three figures in the left background are on the same road as the three figures in the center of the picture.

2. The motif of a figure watching from a Dutch door was familiar enough from everyday experience but also went back more than a century in Netherlandish art, for example to landscape prints by Hans Bol (see Franz 1965, fig. 19, etc.).

3. For a typical work by the contemporary Amsterdam landscapist Frederick de Moucheron, see Amsterdam–Boston–Philadelphia 1987–88, pp. 378–80.

4. J. Smith 1829–42, vol. 6, p. 121; Broulhiet 1938, p. 394. In an unpublished monograph on the artist, Christopher Wright calls the picture "a masterpiece of Hobbema's maturity in the mid-1660s."

5. Stechow 1966, p. 79.

6. Letter to the writer dated October 29, 1984 (curatorial files).

7. Hofstede de Groot 1907–27, vol. 4, no. 134, as "only ascribed to Hobbema but . . . not bad"; Broulhiet 1938, no. 131, as "suite du no. 129" (the Museum's picture).

8. The reproduction in Broulhiet 1938, p. 167, is quite misleading; see Yerkes collection 1910, no. 48.

9. Waagen 1857, pp. 491–94, where landscapes by Jan Both and by Philips Wouwermans are also listed.

REFERENCES: J. Smith 1829–42, vol. 6 (1835), p. 121, no. 21, cites the painting as sold from the collection of Edward Coxe (see note 10 above), and vol. 9 (1842), p. 728, no. 26, as in the collection of Lord Feversham; Waagen 1857, p. 492, as in Lord Feversham's dining room at Duncombe Park; Hofstede de Groot 1907–27, vol. 4 (1912) p. 394, no. 119, as in the Feversham collection, and p. 419, no. 196, recording the 1807 Coxe sale; Broulhiet 1938, pp. 166 (ill.), 394, no. 129, as "directly inspired" by a Van Ruisdael (ill. p. 166); Rousseau 1954, pp. 3, 35 (ill.); Stechow 1966, p. 79, places the picture among works of about 1670, referring to its "very cursory treatment of the foliage and its blue distance"; New York 1970–71, p. 262, no. 284; Hibbard 1980, pp. 349–50, fig. 627, as "before 1668"; Baetjer 1995, p. 340.

EXHIBITED: London, British Institution, 1840, no. 20, as *A Forest Scene* (lent by Lord Feversham); London, British Institution, 1856, no. 47, as *Hobbima's* [sic] *Village*; York, 1879 (according to Broulhiet 1938); London, Royal Academy of Arts, "Exhibition of Dutch Art, 1450–1900," 1929, no. 179, as *Landscape with a Broad Road and a Sportsman*; Manchester, Art Gallery, "Dutch Old Masters," 1929, no. 19; New York, MMA, "Landscape Paintings," 1934, no. 24, as *Landscape* (lent by Edward S. Harkness); Boston, Mass., Museum of Fine Arts, "Masterpieces of Painting in the Metropolitan Museum of Art," 1970, p. 49; New York, MMA, "Masterpieces of Fifty Centuries," 1970–71, no. 284; Leningrad, State Hermitage Museum, and Moscow, Pushkin State Museum, "100 Paintings from the Metropolitan Museum," 1975, no. 26; Athens, National Gallery and Alexandros Soutzos Museum, "From El Greco to Cézanne: Masterpieces of European Painting from the National Gallery of Art, Washington, and The Metropolitan Museum of Art, New York," 1992–93, no. 21.

EX COLL.: Edward Coxe (sale, London, April 25, 1807, no. 64, to Charles Duncombe, for £588); Charles Duncombe, later 1st Baron Feversham, Duncombe Park, Yorkshire (d. 1841); William Duncombe, 2nd Baron Feversham (d. 1867); William Duncombe, 3rd Baron Feversham, later Viscount Helmsley and Earl of Feversham (d. 1915); his grandson Charles William Reginald Duncombe, 2nd Earl of Feversham (d. 1916); his son Charles William Slingsby Duncombe, 3rd Earl of Feversham (his sale, Christie's, London, July 18, 1930, no. 89, to Knoedler and Colnaghi, for £16,800); [M. Knoedler and Co., New York, in 1930 (invoice to Edward Harkness dated December 26, 1930)]; Mr. and Mrs. Edward S. Harkness, New York (1930–40); Mrs. Edward S. Harkness, New York (1940–50); Bequest of Mary Stillman Harkness, 1950 50.145.22

MELCHIOR D'HONDECOETER
Utrecht 1636–1695 Amsterdam

Hondecoeter represents the fourth generation of a family of painters that originally came from Flanders. His paternal grandfather, Gillis d'Hondecoeter (ca. 1580–1638), trained with his own father, Claes, and painted landscapes filled with birds and animals, similar to the Paradise pictures of Roelant Savery (1576–1639). Gillis's son, Gijsbert d'Hondecoeter (1604–1653), painted landscapes and pictures of waterfowl and barnyard birds. Melchior studied with his father in the early 1650s, and then with his uncle (the husband of his father's sister), Jan Baptist Weenix (1621–1660/61). This would have been about 1653–59, when Weenix's son Jan (q.v.) was a teenager and presumably training in the same studio. To some extent, the younger Weenix and his talented pupil Dirk Valkenburg (1675–1721) could be said to have extended the Hondecoeter family tradition of painting still lifes and landscapes featuring birds and animals into the first two decades of the eighteenth century.[1]

Between 1659 and 1663, Hondecoeter was a member of Pictura, the painters' confraternity in The Hague.[2] On February 9, 1663, the artist married Susanna Tradel in Amsterdam.[3] He spent the rest of his life in that city. It has been claimed that there are pictures by Hondecoeter dated 1661 and 1663,[4] but the first indisputable date on works by him is 1668, which is found on canvases in Karlsruhe, Kassel, London, Schwerin, and elsewhere.[5] Only about twenty paintings by Hondecoeter are dated, and his chronology is further complicated by the repetition of motifs years or decades after they were first introduced. The early pictures, however, reveal clear debts to Gijsbert d'Hondecoeter and to Jan Baptist Weenix, and in some cases to Willem van Aelst (1627–in or after 1683) or Otto Marseus van Schrieck (q.v.).[6] In his game-pieces, Hondecoeter was influenced not only by Weenix but also by Flemish examples, in particular trophy pictures by Frans Snyders (1579–1657). The inventory of works in Hondecoeter's possession, made after his death on April 3, 1695, lists several paintings by Snyders.[7] The Flemish connection probably explains in part how Hondecoeter arrived at one of his most distinctive qualities, namely, the dramatization of relationships between fine feathered friends and foes, ranging from minor squabbles to outright cockfights. By comparison, Gijsbert

d'Hondecoeter's chickens and ducks appear to have roosted quietly while their portraits were taken. The most relevant comparisons for Melchior's paintings include hunting scenes by the Antwerp specialist Paul de Vos (1596–1678), and especially pictures of nearly audible avian concerts by Snyders and his disciple Jan Fyt (1611–1661).[8] Concerts of birds were also part of Hondecoeter's repertoire.[9]

The artist painted exotic birds in parklike landscapes from the late 1660s until the end of his life. Peacocks, swans, and the imported pelican were often depicted by Hondecoeter, whose use of these motifs may be considered analogous to Marseus van Schrieck's representations of curious snakes, toads, and lizards, and the study of tulips, fritillaries, and so on, in seventeenth-century flower painting. Many of Hondecoeter's large canvases were not only commissioned but also made to order, that is, designed to decorate wall panels in Amsterdam town houses and palaces owned by Willem III (canvases by Hondecoeter, dating from 1674 onward, were made for the princely palaces at Soestdijk, Het Loo, and Honselaarsdijk).[10] One of the artist's most enthusiastic patrons was the merchant Adolf Visscher, who in the 1670s ordered three large canvases for Driemond, his country house at Weesperkarspel, and at his death in 1702 owned ceiling pictures, a painted room, and easel paintings made by him. None of these ensembles survives in the Netherlands, but a good impression of their effect is found in the Hondecoeter Room of Belton House, Lincolnshire, where the Jan Weenix hunting trophy over the mantel is a sympathetic touch.[11]

Hondecoeter must have worked with studio assistants on his larger paintings. Willem van Royen (1672–1742) was his pupil and one of his eighteenth-century followers, among whom were also significant figures such as Aart Schouman (1710–1792).[12] Numerous copies after Hondecoeter were made by Adriaen van Oolen (d. 1694), who often signed them with his own name. Hondecoeter's least expected emulator was the Middelburg still-life painter Adriaen Coorte (1660?–after 1707), who painted a version (1683; Ashmolean Museum, Oxford) of Hondecoeter's *The Menagerie,* from Soestdijk Palace (Rijksmuseum, Amsterdam).

The inventory of Hondecoeter's studio made after his death

mentions fourteen canvases on which he had painted studies of birds and animals.[13] Only one of these *modelli* is known today, a painting of seventeen birds and a squirrel in the Musée des Beaux-Arts, Lille. Hondecoeter copied oil sketches of this type in finished pictures dating from about 1668 onward; he also repeated entire passages, or repeated compositions with minor variations.[14] The studies themselves appear to have been painted mostly from life. However, rare birds, such as pelicans and cranes, are repeated without variation, suggesting that Hondecoeter had only one opportunity to study a live specimen, or another artist's record of one.[15]

Houbraken learned from Jan Weenix that in Hondecoeter's early years in Utrecht he was very religious, and prayed earnestly in his room every night. According to the biographer, the artist's disposition changed from being constantly subjected to his wife's carping criticism, so that he would routinely flee to a tavern and drink.[16] Houbraken is well known for his tales of drunken artists, but the story is told in greater detail than usual, and it may help to explain why the painter, although well paid for his pictures, left his daughter Isabella with substantial debts.[17]

Hondecoeter's portrait is seen in one of Houbraken's engraved plates.[18]

1. A general impression of the three Hondecoeters (Gillis, Gijsbert, and Melchior) may be gained from Bernt 1970, vol. 2, nos. 569–73; Van Thiel et al. 1976, pp. 281–84 (two works each by Gillis and by Gijsbert, and fifteen quite diverse pictures by Melchior, in the Rijksmuseum, Amsterdam); and Helmus 1999, vol. B, pp. 959–65.
2. Terwesten 1776, p. 24. Here and elsewhere in this biography, the writer has benefited from consulting Vlieger 1992, a copy of which was kindly given to the Department of European Paintings by the author.
3. Bredius 1915–22, part 4, p. 1214.
4. A fish still life in the Herzog Anton Ulrich-Museum, Braunschweig, is said to be dated 1661 (Klessmann 1983, p. 97, no. 392, defends the date). Richard C. Mühlberger in *Dictionary of Art* 1996, vol. 14, p. 706, refers to a picture of ducks and poultry dated 1663, without giving its location. Mühlberger (ibid., p. 707 [ill.]) dates a canvas in Caen to about 1657, with no explanation. It resembles paintings of a decade later, for example, the *Poultry Yard*, in the Detroit Institute of Arts (see Kuretsky in Keyes et al. 2004, pp. 114–15, no. 45).
5. See MacLaren/Brown 1991, p. 188 (under no. 1222, which was once attributed to Marseus van Schrieck).
6. See the previous note, and with regard to Van Aelst, S. Sullivan 1984, pp. 54–55.
7. Bredius 1915–22, part 4, pp. 1211–12.
8. See the present writer's discussion of Fyt's *Concert of Birds,* dated 1658 (Collections of the Princes of Liechtenstein, Vaduz), in New York 1985–86, pp. 294–95, no. 186.
9. Examples are in the Museum Smidt van Gelder, Antwerp; the Gemäldegalerie Alte Meister, Dresden; and the Gemäldegalerie Alte Meister, Kassel. Others are in private collections.
10. Vlieger 1995, p. 19. For canvases by Hondecoeter from Soestdijk, see Van Thiel et al. 1976, pp. 282–83, nos. A170–71, A173, A175.
11. Vlieger 1995, p. 18, figs. 17, 18, and p. 19 on Visscher. The inventory of Visscher's paintings is preserved in the Gemeentearchief, Amsterdam (NA5335), and is reprinted in Vlieger 1992, appendix 3.
12. On Schouman, see Bol 1991. Although one is warned in The Hague 1998–99, p. 342, not to confuse Willem Frederiksz van Royen (ca. 1645–1723) with the Willem van Royen who studied with Hondecoeter (according to Houbraken), Mühlberger does so in *Dictionary of Art* 1996, vol. 14, p. 706.
13. Bredius 1915–22, part 4, p. 1211, no. 18: "14 modellen, eenige *gedootverft*" (14 *modelli*, one with a painted ground).
14. As noted by Mühlberger in *Dictionary of Art* 1996, vol. 14, p. 707.
15. As noted in Vlieger 1995, p. 20.
16. Houbraken 1718–21, vol. 3, p. 73.
17. Bredius 1915–22, part 4, p. 1210.
18. Houbraken 1718–21, vol. 3, pl. C, fig. 10 (opp. p. 64).

82. *Peacocks*

Oil on canvas, 74⅞ x 53 in. (190.2 x 134.6 cm)
Signed and dated (center right): MDHondecoeter./AN 1683
[AN in monogram]

The condition of the painting is good, although the impasto was slightly flattened during past lining and the loss of finishing glazes has caused the fruit to appear flat. The background foliage has darkened with age.

Gift of Samuel H. Kress, 1927 27.250.1

This large and splendid picture, dated 1683, is one of about twenty works that allow a tentative outline of the artist's chronology.

The peacock's tail, cascading like a gown in one of Van Dyck's Genoese portraits, concentrates the colors used throughout the painting, which are dominated by greens and golden browns, with red, yellow, and blue accents. Next to the crowing peacock is his female companion, a peahen, which squawks at the

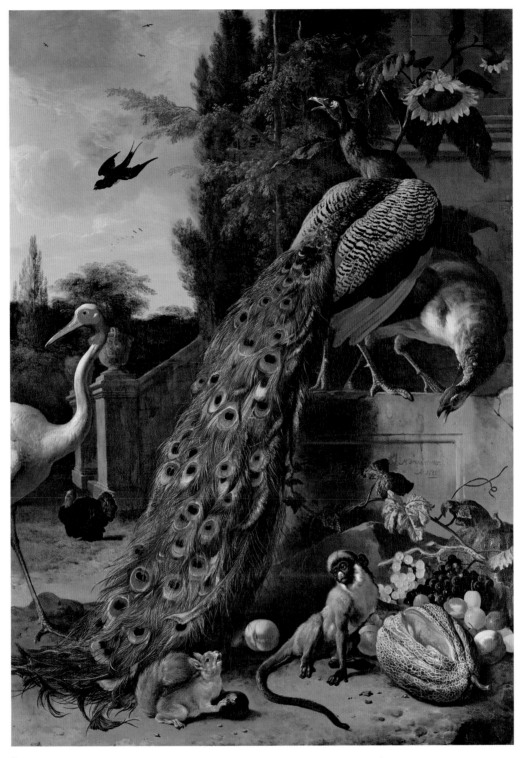

82

chattering squirrel and wide-eyed monkey. A crane approaches from the left, framing a view of the exotic (for this time and place) American turkey. The pile of fruit (melons, peaches, and grapes), the sunflowers, and the oversize swallow in the sky extend the rhythms of the carefully structured design, which is delineated by trees and architecture that (although the building's motifs are up-to-date) suggest a grand old country estate.

It was in such settings that aristocratic Europeans assembled rare birds and animals, quite as they cultivated unusual plants and collected shells and other naturalia. Like earlier still-life painters, in particular Otto Marseus van Schrieck (q.v.), Hondecoeter turned curiosities of nature into curiosities of art, and—on the scale seen in this painting—into elements of interior decoration. However, contemporary interest in and

knowledge of the variety of nature should not be underestimated. Even the peacock, which served as a symbol of pride in much earlier Netherlandish pictures, would have been recognized immediately as a creature from another continent, in this case southeastern Asia and the East Indies. In the confines of a room hung with paintings by Hondecoeter, it was easy to imagine not only the great outdoors of the Dutch countryside but also the entire world of Dutch overseas trade.

The crane was painted out at an unknown date and revealed by cleaning in 1956. The cropping of birds and animals at the sides of the composition is common in the artist's oeuvre.[1] The crane is present in an eighteenth-century copy of the Museum's painting by an anonymous Dutch watercolorist. In 1971, the drawing appeared in a sale together with a watercolor of the same size that records a Hondecoeter composition depicting ducks and a pelican in a foreign landscape.[2] This suggests at least the possibility that the New York canvas originally had a pendant. On the other hand, the watercolors could have come from a larger set or have been arbitrarily paired.

Other paintings by Hondecoeter (including canvases dated 1677 and 1682) show the peafowl in the same poses seen here.[3] The crane, the monkey, the squirrel, and the swallow are also repeated in other compositions.[4] In Hondecoeter's work as a whole, however, one finds peacocks, peahens, and turkeys (to say nothing of ducks and hens) studied in various poses and from different angles. An exception in his avian repertoire is the painter's pelican, which is always seen from the same vantage point and was obviously borrowed from a pictorial source.

1. As noted in Haak 1984, p. 405, and by Ishikawa in Raleigh and other cities 1994–95, p. 180 n. 4.
2. "Fine Old Master Drawings," Sotheby's, London, November 25, 1971, nos. 7, 8 (ill. pp. 56, 57); Raleigh and other cities 1994–95, p. 180, figs. 1, 2. The painting with a pelican is not recorded.
3. As noted in Ingamells 1992a, p. 160, with regard to the same motif in the undated *Peacocks and Ducks* (Wallace Collection, London), where the sunflowers also reappear. See also the paintings by Hondecoeter sold at Christie's, New York, June 3, 1987, no. 122 (Property of Countess Schönborn), and at Sotheby's, London, July 4, 1990, no. 26.
4. The crane occurs, similarly truncated (by another bird, not the frame), in the undated *Peacock and Rooster Fight* (Szépművészeti Múzeum, Budapest; see Wausau and other cities 1989–90, no. 2). The same monkey is found in *Birds on a Balustrade*, dated 1685 (private collection, England).

REFERENCES: J. M. L., "Accessions and Notes," *MMA Bulletin* 23, no. 3 (March 1928), pp. 91–92, describes the work as one of three paintings given to the Museum by Kress; B. Burroughs 1931a, p. 167, listed; C. Eisler 1977, p. 156, fig. 142, concludes that the formerly overpainted crane was hidden lest the canvas be regarded as a fragment, suggests that the picture may have belonged to a series of wall paintings, and compares the composition of Hondecoeter's *Peacocks and Ducks* in the Wallace Collection, London; P. Sutton 1986, p. 190, listed; P. Sutton 1990a, p. 128 n. 3, compares motifs in *The Poultry Yard* (Philadelphia Museum of Art); N. Hall 1992, p. 131, listed among paintings sold by Colnaghi; Ingamells 1992a, p. 160, notes the repetition of "the fine group of the peacock and peahen" in a few paintings by Hondecoeter, including the Museum's and that in the Wallace Collection, London; Ishikawa in Raleigh and other cities 1994–95, pp. 178–80, no. 27, describes the subject, noting that there is "nothing natural about their presentation," and follows P. Sutton in observing "a certain anthropomorphic quality to the postures and expressions" of the animals in the foreground; Perry in ibid., p. 19, mentioned as coming "from Contini's inexhaustible supply"; Baetjer 1995, p. 340; Vlieger 1995, pp. 21–22, fig. 23, notes the similarity of the main motif to the peacock in Hondecoeter's *Birds on a Balustrade*, of 1670 (Amsterdams Historisch Museum, Amsterdam).

EXHIBITED: New York, M. Knoedler & Co., "The Artist and the Animal: A Loan Exhibition for the Benefit of The Animal Medical Center," 1968, no. 41; Portland, Ore., Portland Art Museum, "Primates in Art," 1972; Raleigh, N.C., North Carolina Museum of Art, Houston, Tex., The Museum of Fine Arts, Seattle, Wash., Seattle Art Museum, and San Francisco, Calif., The Fine Arts Museums of San Francisco, "A Gift to America: Masterpieces of European Painting from the Samuel H. Kress Collection," 1994–95, no. 27.

EX COLL.: Possibly Cornelis Sebille Roos, Amsterdam (his sale, Amsterdam, August 28, 1820, no. 47, to C. F. Roos for Fl 206);[1] possibly Cornelis François Roos, Amsterdam (in 1820); [H. M. Clark, London, until 1926; sold to Colnaghi, London, on November 3, 1926, and resold to Contini-Bonacossi on the same day]; [Conte Alessandro Contini-Bonacossi, Rome, 1926–27; sold to Kress]; Samuel H. Kress, New York (1927); Gift of Samuel H. Kress, 1927 27.250.1

1. This sale was brought to the writer's attention by Els Vlieger, in 1993. C. F. Roos was one of the four organizers of the sale. The measurements of the canvas, 73 x 51 *duimen* (73⅞ x 51⅛ in. [187.6 x 131 cm]), are close to those of the Museum's picture. The composition is described in Dutch as follows: "On a stone balustrade are a peacock and a peahen, in the foreground a squirrel and monkey which are busy eating fruit." That the crane is not mentioned would suggest that, if this is indeed the Museum's picture, the bird (revealed during cleaning in 1956) was already painted out by 1820.

ABRAHAM HONDIUS

Rotterdam ca. 1631–1691 London

Hondius, as the artist signed himself, is the Latinized form of the artist's Dutch surname, De Hont. The family may be traced back in Rotterdam to the painter's grandfather Abraham Daniëlsz de Hont, a mason originally from Zierikzee. He married in 1603, and his second son, Daniël Abrahamsz, also became a mason. The latter married Crijntgen Alewijnsdr late in 1630. It has been suggested plausibly that Abraham Daniëlsz was the couple's first son, who by custom would have been given his paternal grandfather's name. Furthermore, the artist's earliest dated works, of 1651, are so accomplished that he could not have been much less than twenty years old when they were painted.[1]

On April 27, 1653, Hondius married a woman from Rotterdam, Geertruyd Willemsdr van der Eijck (d. 1681). The fact that the wedding was a civil ceremony, and that the couple later lived (from May 1665 through April 1671) in a house which incorporated a hidden Catholic church, indicates that the painter and his wife were Catholics.[2] Their daughter, Geertruyd (ca. 1655?–1678), married in a civil ceremony in 1675. Hondius also had a son, Abraham, who became an artist.[3]

It has been said that Hondius resided in Rotterdam until 1659,[4] when he is described as present in Amsterdam. There is no trace of Hondius as a resident of Amsterdam, and, as noted above, he rented living quarters in Rotterdam from 1665 to 1671. Hondius was evidently still in Rotterdam when his property was sold in December 1672.[5] By January 1674, when Robert Hooke mentions the artist in his diary, Hondius was established in London, where he had probably settled a year earlier.[6] According to Weyerman, Hondius went to England with another man's wife, and when she died, he married for the second time.[7] Shortly before his death (he was buried in the Parish of Saint Bride, Fleet Street, on September 17, 1691), Hondius made out a will naming his wife, Sarah, and his son, Abraham.[8]

About 113 paintings by Hondius are known.[9] The majority are hunting scenes, or fights between animals in nature, which follow the examples of Frans Snyders (1579–1657), Paul de Vos (1596–1678), Jan Fyt (1611–1661), and other Antwerp artists. How Hondius knew this tradition has been the subject of needless speculation, since Flemish art was well known in South Holland, and Antwerp was not far away.[10] It is possible,

as has been suggested, that Hondius was a pupil of Cornelis Saftleven (1607–1681), and it is clear that he was influenced by Ludolf de Jongh (q.v.), especially in pictures with men and women resting during or after a hunt.[11] These works, and Hondius's more naturalistic pictures in general, date from the 1650s. In the next decade, Hondius developed a more decorative and theatrical manner, perhaps in response to Flemish history painting, and Dutch artists working in a parallel vein (for example, Abraham Bloemaert [q.v.] and Christiaen van Couwenbergh [1604–1667] in Delft). The hot nocturnal lighting that Hondius employs in his pendant panels *Annunciation of the Shepherds* and *Adoration of the Shepherds,* dated 1663 (both in the Rijksmuseum, Amsterdam), recalls Rotterdam night scenes by Adam Colonia (1634–1685) and Egbert van der Poel (1621–1664).[12] Colonia left Rotterdam for London shortly after 1670, but it is not known if this had anything to do with Hondius's move to England.

The earliest dated religious paintings by Hondius are from 1662. Together with his mythological pictures, such as *The Rape of Europa,* of 1668 (formerly Semenov collection, Saint Petersburg), they remained a minor part of his work.[13] Some subjects, like the Annunciation and Christ Appearing to Mary Magdalene, must have been intended for Catholic patrons, and the very large *Adoration of the Shepherds,* dated 1664 (Museum Catharijneconvent, Utrecht), may have been painted for a "hidden church" in Rotterdam, perhaps the one next to which Hondius lived from 1665 onward.[14]

In London, Hondius painted a view of the frozen Thames, dated 1677 (London Museum), and his dramatic picture of a ship stranded in ice (Fitzwilliam Museum, Cambridge) probably dates from about the same time.[15] The last dated works are from 1689 and 1690.[16]

1. As observed in Peyser-Verhaar 1998, pp. 151–52, with particular reference to *Sportsman Outside an Italian Inn* (ibid., fig. 1; sold at Sotheby's, New York, May 16, 1996, no. 86; subsequently at the Richard Green Gallery, London). Four other pictures dated 1651 are listed in Hentzen 1963, p. 48, nos. 1–4. One of them is also discussed in Rotterdam 1994–95, no. 19.
2. Peyser-Verhaar 1998, pp. 151, 152–53.
3. In ibid., p. 151, Geertruyd is described as the only child of Abraham and Geertruyd Hondius, but Abraham (see ibid.,

pp. 152, 156 n. 15) must also have been a child of this marriage. The woman Hondius married late in life (according to Weyerman 1729–69, vol. 3, p. 157) could not have had a son who was old enough to be named as an artist at her husband's death.

4. For example, by Christiaan Shuckman in *Dictionary of Art* 1996, vol. 14, p. 709, following earlier publications.

5. Peyser-Verhaar 1998, p. 152.

6. See the slightly inconsistent remarks in ibid., p. 154. Payments to Hondius dating from 1674 and 1675 indicate that he painted pictures intended for rooms in the Royal College of Physicians.

7. See note 3 above. Presumably this was after Hondius's first wife had died, in 1681. Hondius is not mentioned in her will (Peyser-Verhaar 1998, pp. 151, 156 n. 12).

8. Peyser-Verhaar 1998, pp. 152, 156 n. 15.

9. Ibid., p. 156 n. 23, referring to Peyser-Verhaar's own doctoral dissertation on the artist (University of Utrecht, 1997).

10. Shuckman (see note 4 above) replaces implausible explanations of the past with one of his own. Compare Fleischer 1989, pp. 45, 49.

11. See Fleischer 1989, pp. 55–57, figs. 55–57, where a connection with the Utrecht painter Dirck Stoop (1610–1686) is also noted.

12. The Rijksmuseum paintings are discussed by Meyerman in Rotterdam 1994–95, p. 184 (under no. 20; pls. on pp. 210–11). In 1685, they were owned by the Dordrecht apothecary and collector Abraham Heijblom (see Loughman and Montias 2000, pp. 93–94, figs. 37, 38). Compare Colonia's *Annunciation to the Shepherds,* of 1662 (Museum Boijmans Van Beuningen, Rotterdam; ibid., no. 11).

13. See Hentzen 1963, pp. 49–55, nos. 14–18, 32, 35, 40, 50, 64, 65, 90.

14. On this painting and the church in question, see Peyser-Verhaar 1998, p. 153, and Van Eck in Van Schooten and Wüstefeld 2003, pp. 228–30, no. 79. Van Eck discusses sources of the composition in prints after Rubens and Taddeo Zuccaro.

15. Hentzen 1963, nos. 66, 89, figs. 18, 19.

16. Ibid., nos. 72, 73.

83. *Christ among the Doctors*

Oil on wood, 15 x 19½ in. (38.1 x 49.5 cm)
Signed and dated (lower left): Abraham Hondius/1668

The painting is well preserved. The green robe of the child holding the book is abraded, and there are several minor losses in the architecture at upper left. The panel, which retains its original thickness, is made from one piece of radially cut oak. The original bevel is present. Underdrawing is visible in passages where the paint film is transparent, and examination by infrared reflectography reveals more underdrawing in the figure of Christ and the figures of Mary and Joseph.

Gift of Dr. and Mrs. Carl F. Culicchia, 1974 1974.368

The panel, dated 1668, was painted in the artist's native Rotterdam during the period in which he lived in immediate proximity to a Catholic "hidden church" (see the biography above). Hondius treated a number of New Testament themes in the 1660s and later, some about this scale and others much larger. On the whole, such works were obviously intended for Catholic patrons. Although the subject of the present picture would have had broad appeal in the Netherlands, where religious disputes were common, the nimbus around Christ's head, the halo over his mother's head, and the emphasis given to Mary and Joseph may be described as Catholic iconography.

Luke (2:41–51) relates that the twelve-year-old Jesus entered the Temple of Jerusalem and engaged its learned elders in the-ological debate. After three days of searching, Mary and Joseph discovered their precocious son. Like other Dutch artists, Hondius treats the doctors as fools, a sure sign of which is hilarious headgear. The large volumes hauled down from the bookcase in the right background will be to no avail.

The monumental architecture is conceived in a contemporary classical style like that often depicted by Bartholomeus van Bassen (ca. 1590–1652).[1] Dogs routinely appear in the foregrounds of religious pictures by Hondius, for reasons that even Christ and the doctors together would not have been able to explain.[2]

1. Compare, for example, Van Bassen's *Imaginary Church with Renaissance Arcades,* of 1645 (Museum and Art Galleries, Glasgow; Jantzen 1979, fig. 23).

2. For example, two dogs nearly upstage Christ and the woman taken in adultery in a panel by Hondius dated 1667, which may also be compared with the Museum's picture for its architecture and its high priest. See "Old Master Pictures," Christie's, Amsterdam, May 8, 1995, no. 79.

REFERENCE: Baetjer 1995, p. 329.

EX COLL.: Sale, Christie's, London, May 3, 1974, no. 173, for Gn 400 to Holland [Feigen]; [Richard L. Feigen, New York, 1974; sold to Culicchia]; Dr. and Mrs. Carl F. Culicchia, New Orleans (1974); Gift of Dr. and Mrs. Carl F. Culicchia, 1974 1974.368

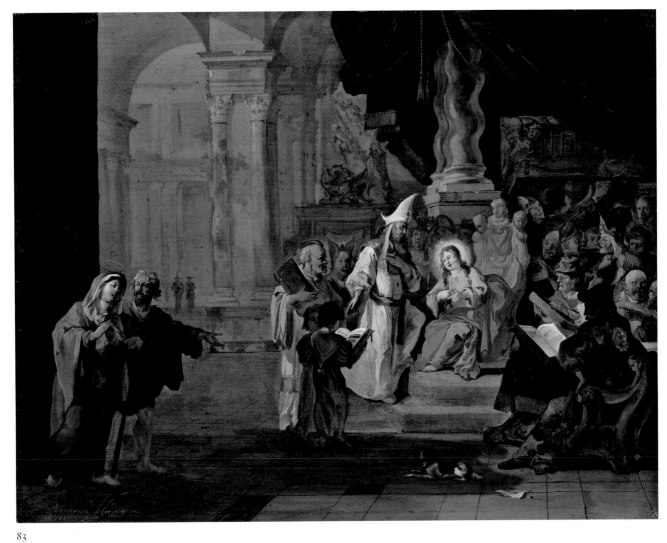

83

PIETER DE HOOCH
Rotterdam 1629–1684 Amsterdam

The artist is usually considered the second most important representative of the Delft school, after Johannes Vermeer (q.v.), although the slightly older De Hooch lived in Delft only from about 1654 or 1655 until about 1660. He was born in Rotterdam on November 20, 1629. His father, Hendrick, was a mason, his mother a midwife, occupations that might be said to find reflection in De Hooch's genre scenes.

Houbraken records that the painter was "for some time" a pupil, along with his fellow Rotterdammer Jacob Ochtervelt, of Nicolaes Berchem (q.q.v.) in Haarlem.[1] In the same passage, the biographer observes that De Hooch, "who was excellent in the painting of interior views," followed the older Rotterdam artist Ludolf de Jongh (q.v.).[2] De Hooch was also closely linked with another specialist in genre scenes, Hendrick van der Burch (1627–1665 or later), who was most probably the brother of Jannetje van der Burch, the woman De Hooch married on May 3, 1654. The Van der Burchs lived in Delft, while De Hooch was said to be a resident of Rotterdam at the time.[3] However, both De Hooch and Hendrick van der Burch were recorded as residents of Delft when they witnessed a will on August 5, 1652, and they both had contacts in Leiden.[4] In May 1653, "de Hooch, schilder [painter]," was described as in the service of Justus de la Grange (also called Justinius de la Oranje), a linen merchant who lived in Delft and Leiden, and who in 1655 owned eleven pictures by the artist.[5]

Children born to De Hooch and his wife were baptized in Delft in February 1655 and in November 1656. He joined the painters' guild on September 20, 1655, and paid dues to the guild in the following two years. Although paintings by De Hooch have been dated as early as about 1650 and a fair number have been placed in the mid-1650s, the earliest known works to bear dates are of 1658.[6] Several pictures by De Hooch of about 1658–60 feature details of domestic and other architecture that derive from buildings in Delft.[7]

Like other Delft and Leiden painters in the 1650s, De Hooch moved to the flourishing art center of Amsterdam (probably in 1660, and before April 1661, when one of his daughters was baptized in the Westerkerk).[8] Burial records of two children dating from 1663 and 1665 cite modest addresses for De Hooch

and his family, but by May 1668 they were living on the more respectable Konijnenstraat. Nothing is known of their lives after the birth of their seventh child in May 1672, except that the painter was buried on March 24, 1684, and that he had died in the *dolhuis* (madhouse).

The pictures painted after the French invasion of 1672 are on the whole inferior to those of the previous decade but include works as accomplished as *A Musical Party in a Courtyard*, of 1677 (National Gallery, London). The paintings of the early 1680s are almost uniformly mediocre in execution and formulaic in design.

De Hooch is routinely credited with influencing Vermeer,[9] which he did to some extent, but both artists benefited from earlier pictures of domestic life painted in the South Holland area and elsewhere.[10] The two artists shared a predilection, if not the same talent, for describing effects of light and space. To a remarkable degree, these interests compensate for De Hooch's modest abilities as a figure painter. His warm colors and restful compositions create a sense of well-being about the homey and usually innocent situations in which his inarticulate protagonists find themselves. De Hooch was quickly responsive to recent trends, like the guardroom scenes of De Jongh, Gerbrand van den Eeckhout (q.v.), and Jacob van Loo (1614–1670); the use of linear perspective by architectural painters like Hendrick van Vliet (q.v.); and the fashionable themes of such masters as Vermeer, Gerard ter Borch, and Gabriël Metsu (q.q.v.). Nonetheless, De Hooch's reputation rests on what he accomplished intuitively. A passage of sunlight, an intimate corner of space, or the quiet communion of a mother and child will reveal in De Hooch's work a sympathy for everyday existence that justifies his fame as the quintessential painter of domestic life.[11]

1. Houbraken 1718–21, vol. 2, pp. 34–35.
2. On this point, see Fleischer 1978 and Kuretsky 1979, p. 4.
3. P. Sutton 1980a, pp. 9, 145–46 (docs. 18, 19, 21). On Van der Burch as a painter, see P. Sutton 1980b.
4. See P. Sutton 1980a, p. 145 (docs. 14, 17). De Hooch and his future wife attended a baptism in her family on November 30, 1653, in Leiden.
5. P. Sutton 1980a, pp. 9, 145–46 (docs. 15, 16, 23). The term *dienaer* in the document does not imply that De Hooch was a "servant"

in the usual sense, as supposed in Franits 1989. See De Jongh 1980, p. 182.

6. P. Sutton 1980a, nos. 26–28, 30, 33, 34.

7. Ibid., nos. 20–22, 33–36, and New York–London 2001, nos. 27, 30, 31, 33.

8. See MacLaren/Brown 1991, p. 196, on this point. Delft motifs in paintings of the Amsterdam period are virtually irrelevant to the question, as the oeuvre of Emanuel de Witte (q.v.) demonstrates.

9. Above all in Blankert 1978b, pp. 29–31.

10. As discussed in Liedtke 2000a, chap. 4.

11. This biography depends primarily upon P. Sutton 1980a, pp. 9–10; P. Sutton in London–Hartford 1998–99, pp. 14–15; and P. Sutton in *Dictionary of Art* 1996, vol. 14, pp. 732–34. See also Liedtke 2000a, chap. 4, and New York–London 2001, pp. 132–45.

84. *The Visit*

Oil on wood, 26¾ x 23 in. (67.9 x 58.4 cm)
Inscribed (above cityscape in background): POTLN[]MA/ CAP['] . . . URBIUM . . . []MPIURIUM . . . DOMINA[]X

The painting is in good condition despite some abrasions in the wood ceiling, in the portrait hanging at far right, and in the bed and hat at lower right. The figural group and window are well preserved, although the still life on the table is damaged. The inscription and the harbor scene on the wall hanging are very difficult to read. This is due partly to abrasion and partly to the pentimento of a portrait turned upside down, over which the present composition was painted. X-radiography reveals that the head of that portrait was tried out in two different positions. In the present painting, there are changes in the position of the hat worn by the standing man, the hat on the floor at lower right, and the knees and back leg of the seated man.

H. O. Havemeyer Collection, Bequest of Mrs. H. O. Havemeyer, 1929 29.100.7

The Havemeyer De Hooch dates from about 1657, when the artist was on the threshold of his mature style. In 1864 (see Refs.) and 1866, Thoré paid this "superbe tableau" the compliment of attributing it to Vermeer,[1] although Smith in 1833 (see Refs.) had considered it "a good example" of De Hooch's manner. The price paid by the Havemeyers at the Secrétan sale of 1889 was one of the highest for a Dutch painting during the nineteenth century.[2]

Modern critics have mostly praised the picture, often crediting some of its quality to the influence of Vermeer. Cleaning and conservation in 1995–96 and the painting's inclusion in exhibitions since then have increased understanding of its key position in De Hooch's development.

Compared with almost any earlier painting by the artist, this one is more successful in its suggestion of an interior space that is established primarily by the architecture rather than by figure groups and furniture. The ceiling beams, the window, and an arbitrary seam in the floor establish main lines of recession, which are assisted by the bench and the raised shutter to the left, the nearest chair (which is aligned orthogonally), and to some extent the covered table. However, the underscaled bed and the rather sudden shift of scale within the figure group reveal that De Hooch adopted devices he had yet to master. Similarly, the watercolor view of a Mediterranean port and the conservative portrait of a man would not quite manage to define the wall plane even if the bed were hauled away. The progress in depth from the hat on the floor through the dark shadow (laid down like a rug) to the man's coat thrown over a chair seems like a naïve response to schemes Hendrick van Vliet and Emanuel de Witte (q.q.v.) had employed (compare the steps into space on the right in Pl. 222). Still clearly recognizable is the composition's development from De Hooch's inn scenes of a few years before, not only in the outline of space but in the interplay of light and shadow.[3]

Vermeer made similar but bolder progress in constructing interior space at about the same time: the additive filling of voids found in *A Maid Asleep* (Pl. 202) is replaced by an illusionistic corner of space in *The Letter Reader (Young Woman Reading a Letter)*, of about 1657 (Gemäldegalerie Alte Meister, Dresden), where the intersection of walls is handled somewhat as in the present painting. A strong recession is more precisely defined in Vermeer's *Cavalier and Young Woman* (Frick Collection, New York), of about the same date. Hints that Vermeer influenced De Hooch in *The Visit* may be detected in

the reflection of the woman's head and red jacket in the window glass to the left (which recalls the window in the Dresden picture) and in the highlighted red jacket itself (fig. 93), which together with the woman in a yellow jacket and white scarf unexpectedly remind one of the two figures diagonally juxtaposed in the Frick canvas. The subject of the latter painting, with its intimate encounter between a man and a woman at the corner of a table, passages like the sunlight on the tabletop, and motifs such as the map on the wall and the design on the backs of the chairs (gold diamonds on black leather, with lion's head finials) suggest that De Hooch was absorbing various impressions, some of them perhaps unconsciously, from his slightly younger colleague.

As the present writer has stressed elsewhere, the contemporaneous efforts of De Hooch and Vermeer to define the space of a typical domestic interior (which, however plausible, is always invented) represent the local culmination of a development that was already well under way in the South Holland area (which includes Delft, The Hague, Leiden, Rotterdam, and Dordrecht).[4] The Museum's domestic scene by Hendrick Sorgh (Pl. 194), for example, painted about 1645–50 in De Hooch's native Rotterdam (where he lived as late as 1654), is one of many genre interiors of the 1640s and early 1650s that anticipate the overall design and some of the specific devices that De Hooch used to construct the interior spaces of this and similar pictures. The grouping of figures and perhaps the shadowy and atmospheric space also recall paintings of courting couples by Gerard ter Borch (q.v.) that date from the early to mid-1650s, a few of which were evidently known in Delft.[5] What remains distinctive of De Hooch himself in this picture is the importance of daylight and shadows for the sense of space, atmosphere, and mood, and also the reticent figures, which, compared with those making theatrical gestures in some of his earlier works, appear more consistent with a style based on observation.

The subject of the Havemeyer painting is as conventional as its composition. Two young women, one of whom wears a revealing bodice and a knowing smile, entertain two gentlemen whose mood is suggested by discarded items of outerwear and by their hands, which grip a clay pipe, the back of a chair, and a woman's wrist. The Delftware bowl on the table contains oysters or another delicacy; what appears to be a silver fork and a slice of lemon invite the visitors to help themselves. The harbor scene on the wall must be meant to suggest worldly sophistication, since the city resembles Venice, which had a reputation for courtesans and luxury goods.[6] Like other pictures of the late 1650s by De Hooch, Ludolf de Jongh

(q.v.), Gabriël Metsu (see Pl. 116), and other genre painters, *The Visit* represents the domestication of a social theme that had earlier been set mostly in taverns and bordellos.[7] In slightly later works (for example, *Leisure Time in an Elegant Setting*; Pl. 87), De Hooch would depict more luxurious rooms—and superficially more polite behavior—than appear in paintings such as this important transitional work.

1. Thoré 1866, p. 316 ("je crois, sans pouvoir jusqu'ici le prouver").
2. According to Reitlinger 1961, vol. 1, p. 140, this De Hooch "achieved the record for any Dutch picture in the last century at £11,040." Esmée Quodbach kindly brought this reference to my attention, and pointed out that the Havemeyers paid more for Rembrandt's *Herman Doomer* (Pl. 148) at about the same time (see Quodbach 2004, p. 107).
3. Compare, for example, New York–London 2001, nos. 23, 24. In this entry, the present writer repeats several lines from ibid., no. 25.
4. See Liedtke 2000a, chap. 4, and my discussion of De Hooch's development in New York–London 2001, pp. 132–45.
5. See Liedtke 1979, P. Sutton 1980a, pp. 13–14, and my remarks in New York–London 2001, pp. 17, 140, 152.
6. See De Roever 1991, especially pp. 16–17 for Willem Jansz Blaeu's engraved profile view of Venice, 1614. Compare the engraved view of Amsterdam on the wall in De Hooch's *A Woman Drinking with Two Soldiers*, of 1658 (Louvre, Paris; P. Sutton 1980a, no. 26, pl. 23, and London–Hartford 1998–99, no. 12). The inscription above the cityscape in the present picture was probably never meant to be decipherable, apart from generally appropriate words such as "city" and "[year] of our lord."
7. This process is well described in the titles of Scholten 1994 and of Salomon 1998a, as well as on perceptive pages in those publications.

REFERENCES: J. Smith 1829–42, vol. 4 (1833), p. 229, no. 34, calls it "a good example of the master," in the collection of Baron Delassert [*sic*]; Delessert Collection 1844, p. 24, no. 58, as by De Hooch, described; Thoré 1864, p. 313, overrules the De Hooch attribution in favor of Vermeer; Thoré 1866, pp. 316–17, 551, no. 14, acknowledges J. Smith's attribution to De Hooch but regards many of the painting's characteristics as "bien vermeeresque"; Blanc 1869, pp. 202–4 (ill. opp. p. 202, engraving by Ch. Courtry), offers a long description and consideration of the attribution to Vermeer, which the writer rejects; Havard 1879–81, vol. 3, pp. 104–5, as *La collation* by De Hooch; Havard 1888, p. 36, no. 15, lists the picture as the *Conversation* by Vermeer; Bredius 1889, p. 161 n. 2, considers this one of De Hooch's finest works, and notes the price obtained in the sale of the same year, 1889; Hofstede de Groot 1892, pp. 188 no. 87e, 189 no. 34, as "the famous interior" by De Hooch, now in America; Bode 1895, pp. 17 (ill.), 72, as a superior work by De Hooch in the Havemeyer collection; Wurzbach 1906–11, vol. 1 (1906), pp. 716–17, as an example of one of the high prices paid for a De Hooch, and calls the picture *La consultation*, a "Hauptwerk"; Hofstede de Groot 1907–27, vol. 1 (1907), pp. 529–30, no. 192, as by De Hooch, "a

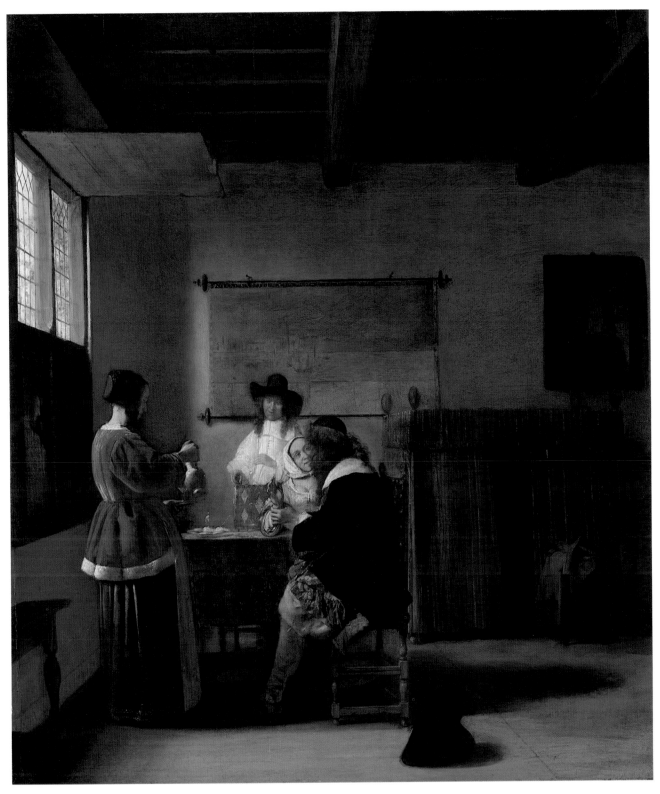

84

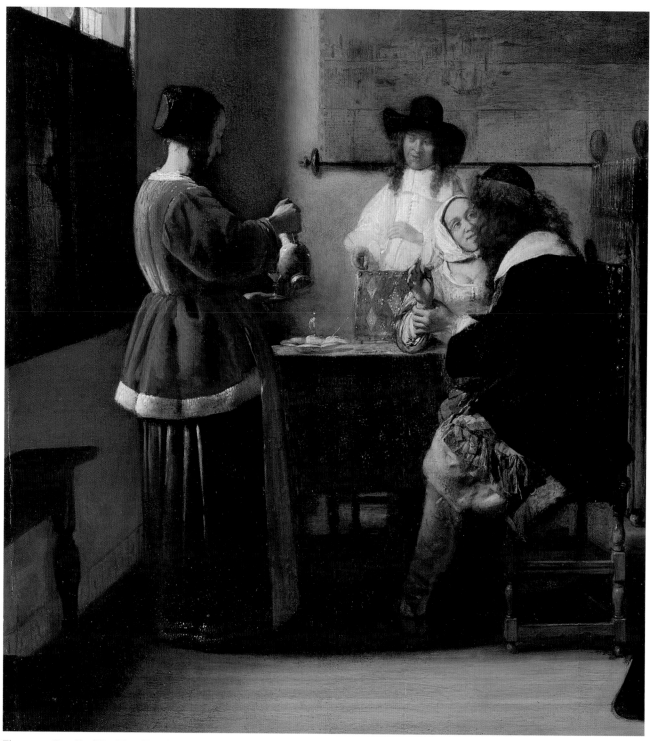

Figure 93. Detail of De Hooch's *The Visit* (Pl. 84)

good picture, powerful and luminous in the rendering of light and colour"; Cortissoz 1909, pp. 166–67, as Mrs. Havemeyer's "brilliant picture of 'The Visit'"; Valentiner in New York 1909, p. 54, no. 53 (ill.), as *The Visit* (first use of this title), "about 1658"; Cox 1909–10, p. 305, describes the work as "an altogether exceptional picture," and compares it with Vermeer; Breck 1910, p. 57, as from De Hooch's best period, 1655–65; Valentiner 1910, p. 9, as the finest of six De Hoochs in the 1909 exhibition; Waldmann 1910, p. 82, as the best De Hooch in the 1909 exhibition, dating from about 1660; Jantzen 1912, p. 24, notes the "strict division of the picture plane" as characteristic of all Dutch interior views dating from this period; De Rudder 1914, p. 105, listed; Valentiner 1926, pp. 47, 61, fig. 2, dates the painting to about 1663 and analyzes the composition, which possesses "a serenity and dignity originating in Italy and France"; Brière-Misme 1927, pp. 57 (ill.), 60, as *La collation,* sometimes called *La courtisane,* compares other works by De Hooch, and draws attention to the high prices paid for the painting in 1869, 1883, and 1889; Valentiner 1927, pp. 74, 76, no. 7, as reminiscent of Vermeer's *Cavalier and Young Woman* in the Frick Collection; Bredius 1928, p. 65, as *Das Frühstück,* a famous work; Mather 1930, pp. 474 (ill.), 462, mistakes the work for an example of De Hooch's "later and courtly" manner; New York 1930, p. 12, no. 71 (ill.); Valentiner 1930a, pp. x–xi, xv–xvi, 62 (ill.), 275, dates the work about 1661, and describes it as "one of the artist's masterpieces" and one of the most important Dutch pictures to have entered a private collection in America; Wehle 1930, p. 60, "a beautiful work from Pieter de Hooch's best period," in the exhibition of the Havemeyer collection; B. Burroughs 1931a, p. 168, as *The Visit*; Valentiner 1932, p. 317, detects the influence of Vermeer; Würtenberger 1937, p. 82, dates the work to about 1655–60; Havemeyer 1961, p. 19, recalls the purchase of 1889, and her husband's favoring the painting over a Courbet as "the sort of thing to buy"; Reitlinger 1961, vol. 1, p. 140, notes the very high price at which the picture sold in the Secrétan sale of 1889; P. Sutton 1980a, p. 79, no. 19, pl. 18, dates it to about 1657, compares other works, and offers a more complete reading of the (partly restored) inscription above the "harbor scene"; Weitzenhoffer 1982, pp. 109, 119 n. 24, 127, 131–32, 138, 144–45 n. 37, 149, 166 n. 7; Weitzenhoffer 1986, pp. 58, 66, 77 (ill. p. 224; installation photograph of the 1915 exhibition; see Exh. below), 254, recalls the picture's history in the Havemeyer collection; Liedtke 1990, p. 46, as "De Hooch's prototypical picture" of about 1657 in the Havemeyer bequest; Havemeyer 1993, pp. 19, 191, 310 n. 37, 329 n. 268, repeats Havemeyer 1961; Liedtke in New York 1993, p. 65; Rabinow in ibid., pp. 90 (installation photograph of the 1915 exhibition; see Exh. below), 91, 95 (no. 5); Stein in ibid., pp. 209 pl. 187, 214, 252, 283; Wold in ibid., pp. 349–50, no. 326 (ill.), reviews the painting's history in the Havemeyer collection; Baetjer 1995, p. 332; Jowell 1995, pp. 126–27 n. 29, fig. 7, quotes Thoré's excited remark about the high

price fetched in the Delessert sale; Jowell 1996, pp. 123–24, fig. 69, notes Thoré's delight at the high price fetched by the "Delessert de Hooch," which in his view was by Vermeer; Kersten in Delft 1996, pp. 143–45, 224, fig. 134 (photograph taken before conservation in 1995–96), describes the painting as a pioneering example of De Hooch's "new type of interior"; Paris 1997–98, pp. 17, 34, 35 (ill.), 104, no. 6, notes the Havemeyer purchase; P. Sutton in London–Hartford 1998–99, pp. 13, 26, 28, 31, 102–3, no. 8 (ill.), suggests a date of about 1657–58, observes that the work's "painterly technique" suited late-nineteenth-century taste, and notes that it was "handled by the famous dealer to the Impressionists, Durand-Ruel, who sold it to the Havemeyers, whose depths in Impressionism are legendary"; Liedtke 2000a, pp. 128, 144, 148, 161, 175–79, 232, 282–83 n. 156, fig. 242, pl. XII, places the work within De Hooch's development and compares works by Ludolf de Jongh; Liedtke in New York–London 2001, pp. 16, 113, 135, 140, 156, 270, 270–72, 280, 351, 376, no. 25 (ill.); Rüger 2001, pp. 47–48, fig. 40.

<small>EXHIBITED:</small> ?New York, American Fine Arts Society, "Loan Exhibition," 1893, no. 16; New York, MMA, "The Hudson-Fulton Celebration," 1909, no. 53; New York, Knoedler and Co., "Masterpieces by Old and Modern Painters," 1915, no. 5; New York, MMA, "The H. O. Havemeyer Collection," 1930, no. 71; Little Rock, Ark., Arkansas Art Center, "Five Centuries of European Painting," 1963; Berkeley, Calif., University of California at Berkeley, University Art Museum, and Houston, Tex., Rice University, Institute for the Arts, "Dutch Masters from the Metropolitan Museum of Art," 1969–70, no. 7; New York, MMA, "Splendid Legacy: The Havemeyer Collection," 1993, no. A326; Delft, Stedelijk Museum Het Prinsenhof, "Delft Masters, Vermeer's Contemporaries," 1996; Paris, Musée d'Orsay, "Le Collection Havemeyer: Quand l'Amérique découvrait l'Impressionisme . . . ," 1997–98, no. 6; London, Dulwich Picture Gallery, and Hartford, Conn., Wadsworth Atheneum, "Pieter de Hooch, 1629–1684," 1998–99, no. 8; New York, MMA, and London, The National Gallery, "Vermeer and the Delft School," 2001, no. 25.

<small>EX COLL.:</small> Possibly Jacob Odon, Amsterdam (his sale, Arnoldus Dankmeyer en Zoon, Amsterdam, September 6ff., 1784, no. 10; bought by Braams Pelsdinge for Fl 300); Baron François Delessert, Paris (by 1833; his sale, at his hôtel, Paris, March 15–18, 1869, no. 36, for FFr 150,000 to Narischkine); B. Narischkine (in 1869; his sale, Galerie Georges Petit, Paris, April 5, 1883, no. 16, for FFr 160,000 to Cedron); E. Secrétan, Paris (his sale, Galerie Charles Sedelmeyer, Paris, July 1–7, 1889, no. 128, for FFr 276,000 to Durand-Ruel for the Havemeyers); Mr. and Mrs. H. O. Havemeyer, New York (1889–1907); Mrs. H. O. Havemeyer, New York (1907–d. 1929); H. O. Havemeyer Collection, Bequest of Mrs. H. O. Havemeyer, 1929 29.100.7

85. *A Woman and Two Men in an Arbor*

Oil on wood, overall 17⅜ x 14¾ in. (44.1 x 37.5 cm);
painted surface 17 x 14⅜ in. (43.2 x 36.5 cm)
Signed (lower left, largely illegible): P. [de hoogh?]

The painting has suffered severe abrasion and was restored
before entering the collection. Although extensive, the restor-
ation faithfully follows the original figures and features. X-
radiography reveals that for this painting De Hooch reused
a panel cut from a portrait of a woman by another hand.

Bequest of Harry G. Sperling, 1971 1976.100.25

While not in good condition and a minor work by De Hooch,
this panel from the Sperling bequest is interesting for its place
in the artist's development. It dates from about 1657–58 and,
like *The Visit* (Pl. 84), represents a transitional phase between
De Hooch's tavern scenes of the early 1650s and his domestic
interiors and courtyard views of about 1658 onward. The earlier
works recall Haarlem-style genre pictures in which figure groups
dominate and largely define the space, and strong contrasts of
light and shadow enrich a restricted palette (the Museum's
panel by Pieter Quast is a good example; see Pl. 139). In the
present work, by contrast, the illumination is fairly even
throughout (the paint has probably darkened with age in the
shadows of the arbor), and local colors create a rich effect. The
woman's wine-red jacket, set off by the deep green foliage, is
echoed by roses to the left. Other color accents include the
smoker's orange-red stockings, the woman's blue ribbons, and
the patch of blue sky.

The hostess holds a pitcher and a glass of wine. The young
man, his left arm jauntily akimbo, holds a clay pipe and
responds to the woman's smile. In front of him on the table
are an open packet of tobacco and a pot of coals for lighting
up. The older man behind him, who appears to be reading a
letter, may be serving as a chaperone for the young woman,
whose attire is modest and middle-class. The young man must
be stopping by briefly, since he has not removed his hat or
sword (the latter, and his leather jerkin, or *kolder,* suggest that
he is a soldier).[1] The chair and cushion have been brought from
inside to this cozy corner of a garden behind a private house.

De Hooch painted a similar subject in a canvas of about
1658–60 (National Gallery of Art, Washington, D.C.; auto-
graph replica in the Mauritshuis, The Hague), but there the
woman is a maid.[2] The artist's *Woman and Child in a
Courtyard,* also dating from about 1658–60 (National Gallery
of Art, Washington, D.C.), includes two men and a woman
seated at a table under a more imposing arbor, but the principal
figures are a maid and child.[3] In a canvas of about 1663–65 in
the Rijksmuseum, Amsterdam, De Hooch depicts a more
assertive young man with a pipe and a young woman with a
glass of lemonade at a table in a courtyard behind a fine brick
house.[4] A smiling maid stands close by with a glass of beer
and seems (to judge from her cautious conviviality) to play the
role of chaperone.

The subject of the Museum's picture may be described as
innocent courtship, and in this the work differs from many of
De Hooch's amorous scenes of about the same date (Pl. 84)
and earlier, and from the purely domestic pictures that he
painted from about 1657 onward. Like Jacob van Loo (1614–
1670) and Gerbrand van den Eeckhout (q.v.) in Amsterdam,
who in the early 1650s depicted socializing couples on garden
terraces (see Pl. 43),[5] De Hooch in this painting modernizes
the tradition of Merry Companies set in gardens in a way that
is personal but also consistent with current trends.[6] The osten-
tatious garden parties painted in the first quarter of the century
by David Vinckboons (q.v.), Willem Buytewech (1591/92–1624),
Esaias van de Velde (1587–1630), and Dirck Hals (q.v.) are
recalled by the arbor, but in other respects De Hooch has
brought the romantic theme of the Garden of Love down to
earth in Delft.[7]

1. On the jerkin, see Albany 2002, p. 98.
2. P. Sutton 1980a, nos. 35A and 35B. See Wheelock 1995a, pp. 139–
 42, and New York–London 2001, no. 33.
3. Wheelock 1995a, pp. 136–39.
4. P. Sutton 1980a, no. 59; London–Hartford 1998–99, no. 30.
5. See Philadelphia–Berlin–London 1984, nos. 43, 64.
6. See my discussion in New York–London 2001, pp. 141–42,
 figs. 157, 158.
7. On the earlier Dutch examples, see especially Kolfin 2005, and
 also Philadelphia–Berlin–London 1984, nos. 26, 112, 113, 121,
 and the present writer's discussion of a panel by Dirck Hals, in
 New York 1985–86, pp. 265–66.

REFERENCES: Hofstede de Groot 1907–27, vol. 1 (1907), p. 562,
no. 306, cites the painting as in the Sellar sale (see below); Wilhelm
von Bode, in a letter dated March 3, 1912 (curatorial files), dates it
to about 1657–59, and considers De Hooch's wife to have modeled
for the woman; Valentiner 1930a, pp. 37 (ill.), 270, as an excellent
work of about 1656, signed "P. d. Hoogh"; P. Sutton 1980a, p. 80,
no. 23, pl. 20, as "surely genuine," from about 1657–60; Baetjer 1995,
p. 332; Lokin in Delft 1996, p. 109, fig. 93, as conveying an "impres-
sion of order and peace."

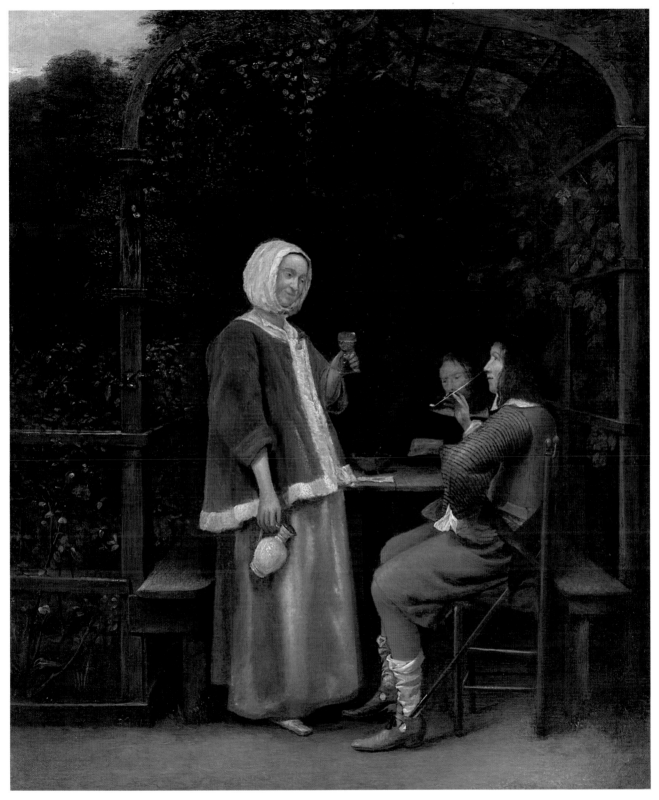

85

EX COLL.: [Christie's, London, July 25, 1822, no. 41];[1] David P. Sellar, London (sale, Christie's, London, March 17, 1894, no. 111, as by De Hooch, to A. Smith for £105); [A. Smith]; [M. van Slochem, New York (by 1912)]; [M. van Gelder, Uccle, near Brussels (by 1929)]; John Ringling, Sarasota, Fla. (until 1930; sold to Böhler); [Julius Böhler, Munich, 1930; sold to Neuerburg]; Hermann Neuerburg, Hamburg (from 1930); Gottfried Neuerburg, Cologne (until 1961; sold to Böhler); [Julius Böhler, Munich, 1961–67; sold to Kleinberger]; [F. Kleinberger, New York, 1967–75; bequeathed by Harry G. Sperling, last surviving partner of the firm, to MMA]; Bequest of Harry G. Sperling, 1971 1976.100.25

1. This sale was kindly brought to my attention by Burton Fredericksen, in a letter dated August 23, 2005. The sale was of pictures from anonymous owners and said to have come recently from the Netherlands. The De Hooch was "passed," evidently meaning withdrawn from the sale. It is described as "P. de Hooghe. A Female with a Jug and Glass of Liquor, in Conversation with a Cavalier smoking under an Arbour, and a Friend reading a Letter near him."

86. *Interior with a Young Couple*

Oil on canvas, 21⅛ x 24¾ in. (54.9 x 62.9 cm)

The painting has suffered extensive abrasion and has gradually darkened overall as the thinly applied paint layers have become more transparent. Despite its compromised condition, many passages retain the sensitive fall of light characteristic of the artist's serenely quiet interiors.

Bequest of Benjamin Altman, 1913 14.40.613

The Altman painting by De Hooch dates from the early or mid-1660s, when the artist worked in Amsterdam. The same compositional type, with an open doorway, an interior window with a curtain, an enclosed bed, and a receding wall with a window to one side, was employed by De Hooch in several paintings dating from about 1658–60, among them *The Bedroom*, in the National Gallery of Art, Washington, D.C., and *A Mother and Child (Maternal Duty)*, in the Rijksmuseum, Amsterdam.[1] However, the marble floor, the gilt-leather wall covering in the background, and the awkwardly intimate figures look forward to works of a few years later, such as *An Officer and a Woman Conversing, and a Soldier at a Window*, of about 1663–65, in the Germanisches Nationalmuseum, Nuremberg, and the morning-after scene of 1665 in Raby Castle, County Durham (fig. 94).[2] De Hooch placed an impasto parallelogram of sunlight in several interior views of about 1665–68 (see Pl. 88), an effect that is anticipated here. The passages of light and a few cast shadows (for example, that of the chair to the right) are among the best-preserved passages of the painting (see the condition note above). Cleaning and conservation carried out in 2005 substantially improved the picture's appearance.

The idea that the couple is married and "prêts à sortir pour la promenade" may be dismissed by comparing other interior scenes with a bed, a mirror, and a dog placed in close proximity to the figures (see the discussion of *The Maidservant*; Pl. 88).[3] Rather, the woman's attention to her visitor probably depends, like the dog's, on the prospect of compensation.

De Hooch often used paintings within paintings to comment upon scenes similar to this one (see Pl. 87), whereas in other pictures they serve simply as decoration. In the Altman canvas, the painting over the doorway (a still life?) seems to have been included for formal reasons alone; indeed, it contributes to one of the artist's most insistently rectilinear designs, in which even the figures and the dog appear to have been assigned specific places. The result in some pictures, and perhaps here, is a certain tension between social order and the natural inclinations of humanity.

1. For the Washington painting, see Wheelock 1995a, pp. 133–36. The Amsterdam canvas is discussed in New York–London 2001, no. 34. Both pictures are catalogued by P. Sutton in London–Hartford 1998–99, nos. 21, 22, where the Altman painting is compared.

2. P. Sutton 1980a, no. 55, pl. 58, and no. 69, pl. 72.

3. The quote is from Monod 1923, p. 310.

REFERENCES: Hofstede de Groot 1892, p. 186, no. 71; Bode 1900, no. 14, pl. X, compares the light with Vermeer's; Wurzbach 1906–11, vol. 1 (1906), p. 717, listed as in the Kann collection; Bode 1907, vol. 1, pp. vi, 53, no. 52 (ill.); Hofstede de Groot 1907–27, vol. 1 (1907), pp. 496–97, no. 74, dates the painting about 1665; Nicolle 1908, p. 197, as *Jeune couple se préparant à sortir*; Altman Collection 1914, no. 14; Monod 1923, p. 310, follows Hofstede de Groot's dating and Nicolle's interpretation; Lilienfeld 1924, p. 454, listed; Collins Baker

86

Figure 94. Pieter de Hooch, *A Man with a Glass of Wine and a Woman Lacing Her Bodice*, 1665. Oil on canvas, 21 x 25¼ in. (53.5 x 64 cm). The Lord Barnard Collection, Raby Castle, County Durham, England

1925, p. 8, detects the influence of Metsu; Brière-Misme 1927, p. 267, as *Préparatifs de sortie,* dating from about 1670 or slightly earlier; Valentiner 1927, p. 76, no. 8, as a work of the middle period, about 1658–68; Altman Collection 1928, no. 49; Mather 1930, p. 462, mentioned; Valentiner 1930a, pp. xv–xvi, 61 (ill.), 275, as dating from about 1660–62, and revealing Rembrandt's influence; B. Burroughs 1931a, p. 167; Hochfield 1976, p. 29, considers the picture a "ghostly ruin"; P. Sutton 1980a, p. 89, no. 43, pl. 47, dates it to about 1660–65 and compares other "versions of the Bedroom theme"; Todorov 1993, pp. 166–67, fig. 101, wonders what the figures might be thinking; Baetjer 1995, p. 332; L. Miller, "Benjamin Altman," in *Dictionary of Art* 1996, vol. 1, p. 731, mentioned; P. Sutton in London–Hartford 1998–99, pp. 30, 130, 132, 134, fig. 1 (under no. 21), compares the composition with that of *The Bedroom,* in the National Gallery of Art, Washington, D.C.; Salomon 2004, p. 98, fig. 82, suggests that the open door hints at the woman's availability.

EX COLL.: Rodolphe Kann, Paris (by 1892–d. 1905; his estate, 1905–7); [Duveen Brothers, London, 1907–8; sold to Altman for $77,920]; Benjamin Altman, New York (1908–13); Bequest of Benjamin Altman, 1913 14.40.613

87. *Leisure Time in an Elegant Setting*

Oil on canvas, 23 x 27⅜ in. (58.3 x 69.4 cm)
Signed (lower left, on crosspiece of chair): P. D. Hooch
Robert Lehman Collection, 1975 1975.1.144

Dutch paintings in the Robert Lehman Collection are catalogued by Egbert Haverkamp-Begemann in *The Robert Lehman Collection, II* (Sterling et al. 1998).

The picture is generally dated to about 1663–65. In his catalogue entry, Haverkamp-Begemann gives special attention to the gilt-leather wall covering, which De Hooch used in three other interior scenes of about the same date.[1]

1. Haverkamp-Begemann in Sterling et al. 1998, p. 162. "Gilt" leather was actually silvered and then toned with varnish, as described by H. van Soest in The Hague–Groningen 1989, pp. 13–17, and as noted in Koldeweij 1996, p. 136. The Amsterdam conservator Elizabet Nijhoff Asser first brought this fact to our attention, and reports that tests indicate that silver was used invariably (personal communication, 2003).

REFERENCES (additional to those given by Haverkamp-Begemann in Sterling et al. 1998, pp. 160–63, no. 35 [ill.]): P. Sutton in London–Hartford 1998–99, pp. 45, 64, 146, 148–49, no. 28, notes that a sample of gilt leather with the same pattern is preserved in the Rijksmuseum, Amsterdam, compares other works by De Hooch, and discusses the subject's significance; Liedtke in New York–London 2001, pp. 135, 144–45, 270, fig. 160, cites the painting as a precedent for Hendrick van der Burch's interior scene of about 1665 in the Philadelphia Museum of Art, and considers the Lehman picture an example of De Hooch's increasing interest in themes of wealth and fashion during the 1660s in Amsterdam; Saunders 2002, pp. 121–22, pl. 106, discusses the gilt-leather wall hanging, and notes that the design is known from a contemporary Dutch engraving, "one of a series of published prints which seem to have been produced as advertisements for popular patterns."

EXHIBITED (after 1998): London, Dulwich Picture Gallery, and Hartford, Conn., Wadsworth Atheneum, "Pieter de Hooch, 1629–1684," 1998–99, no. 28.

EX COLL.: See Sterling et al. 1998, p. 160.

87

88. *Woman with a Water Pitcher, and a Man by a Bed ("The Maidservant")*

Oil on canvas, 24¼ x 20½ in. (61.6 x 52.1 cm)

The paint surface is abraded throughout, and the surface texture has been flattened by lining in the past. Along the lower edge, there are losses in the area below the maidservant and the dog. Judging from the depth of cusping visible along all edges in the X-radiograph, it is possible that the original support was made from a strip of fabric one ell, or 27½ in. (70 cm), wide, a standard width for fabrics in the seventeenth century. The painting has been extended at the top by a 1 in. (2.5 cm) canvas strip and further enlarged by a stretcher that increased its height by 1¼ in. (3.2 cm) and its width by 1 in.

The Friedsam Collection, Bequest of Michael Friedsam, 1931
32.100.15

The Friedsam de Hooch is a fragment of a broader canvas that has been dated convincingly to about 1667–70.[1] The original state of the picture was described in the catalogue of an Amsterdam auction (the De Pinto sale) in 1785:

> Height 22 breadth 27 *duim* [inches], on Canvas. [lot] 2 This attractive Composition [*Ordonnantie*] depicts a furnished room, on the right side a young woman [*Juffrouw*] lies in bed and appears to speak to her husband, who is in his housecoat [*Japon*] sitting on a chair, occupied with pulling on his stockings. Next to him on a table covered with a carpet is a coat with fur trim and a hat, [and] in the foreground a graceful woman servant with a washbasin and pitcher, which she carries firmly with two hands. One sees another room further back through an open doorway. Everything is wonderfully natural in handling and the reflection of sunlight against the wall is rendered cleverly, with a pleasing palette and detailed execution.[2]

The size of the canvas as recorded in 1785 was approximately 22 x 27 inches (the *duim* is only .03 cm larger than an inch), which would mean that the picture has lost about 6½ inches (16.5 cm) on the right, but has gained about 2¼ inches (5.7 cm) in height. The female figure is about seven inches from the left frame; if a similar strip were added to the canvas on the right, the entire bed would probably fit within the composition and the woman would be more strongly balanced by the two figures on the right. Nevertheless, the figure was always prominent, framed in the brilliant yellow pattern of dappled sunlight and with the receding ceiling beams and dog drawing

attention in her direction. De Hooch has given the woman a certain gravity of expression and pose, which is enhanced by the fall of the towel draped over her arm and the flutelike folds of her voluminous skirt.

The subject has been misunderstood from at least 1785 until fairly recently, when the visible figures were described as existential lovers who "turn away from each other and from the light and from us,"[3] and the former couple to the right were considered "quite possibly married."[4] The so-called maidservant is actually another kind of "working girl," as her elegant attire makes clear.[5] A purple skirt, similar to the blue one worn by the young woman, has been tossed onto the table, followed by a woman's fur-trimmed jacket and a man's hat. The motif of pulling on a stocking and that of a dog nosing about were both recognized in De Hooch's day as sexual innuendos when the context supported such readings.[6] The two mirrors, placed over tables in each of the rooms, reflect marble floor tiles and the wisdom that all worldly pleasure is vanity. In this case, the basin and pitcher are ironic reminders of purity (compare their use in paintings by Ter Borch and Vermeer; Pls. 13 and 203).

In an earlier painting (of about 1657?), in the Pushkin Museum of Fine Arts, Moscow, De Hooch depicted an apparently tired cavalier pulling on his boots, while a woman makes up the bed. As in the Museum's picture, the fall of sunlight suggests a morning hour and the disconnected demeanor of the figures implies that they do not know each other well.[7] A canvas by De Hooch dated 1665 in Raby Castle, County Durham (see fig. 94), shows a more convivial morning-after scene, with a woman threading her bodice and a man in a nightshirt offering her a glass of wine. A dog and a partly covered painting of a female nude underscore the situation.[8] The New York painting, in its stillness and illumination, also recalls Emanuel de Witte's well-known *Interior with a Woman Playing a Virginal,* of about 1665–67 (Museum Boijmans Van Beuningen, Rotterdam), where a maid sweeps in the background, a large mirror reflects a musician, and an all-but-forgotten man (whose street clothes are on a chair in the foreground) looks with surprise at the viewer from the shadows of a covered bed.[9]

De Hooch's variations on an amorous theme must have been appreciated in his time as cosmopolitan entertainments. If they are rarely as understated as Vermeer's scenes of courtship, they are never as obvious as those by Steen (see Pl. 195). Nonetheless, the present picture's subject was evidently too flagrant for an early-nineteenth-century owner. In a certificate

88

dated February 17, 1851, "the undersigned Henry Héris, expert of the Musée Royal in Brussels," describes the picture ("now in the possession of Mr. Arnold of New York") as measuring 24⅜ x 20¼ "English inches" (its present size) and as depicting a young woman, a table with some clothing on it, and a dog. No man or bed is mentioned.[10] In a note to Kleinberger Galleries dated March 12, 1916, the conservator H. A. Hammond Smith reported that in cleaning the picture, "to my surprise the figure of the man seated in the chair and the bed appeared, both having been entirely covered with repainting. This repainting, I take it, must have antedated 1839 when M. Héris sold the picture to Col. Brié."[11]

1. P. Sutton 1980a, no. 79, revising Valentiner 1930a (see Refs.).
2. See Ex Coll. below. The canvas in the De Pinto sale was identified with the Friedsam picture for the first time by Brière-Misme 1927 (see Refs.).
3. F. Robinson in Saint Petersburg–Atlanta 1975, p. 44.
4. P. Sutton 1980a, p. 50.
5. Compare the costumes of the mistress of the house (who holds linen) and the maid in De Hooch's *The Linen Chest*, of 1663 (Rijksmuseum, Amsterdam), which are described in Franits 1993a, p. 104, fig. 88.
6. On the stocking, see Amsterdam 1976, no. 68 (cited in reference to this painting by P. Sutton 1980a, p. 71 n. 97), and no. 64. *Kous* (stocking or sock) was a slang term for vagina, and feet were considered phallic. See also De Jongh's discussion in Washington–Amsterdam 1996–97, pp. 47–49, and p. 111, where Wheelock cites the Dutch proverb "Kaart, kous en kan maakt menig arm man" (Card, stocking, and jug [meaning cardplaying, womanizing, and drinking] makes many a man poor); also pp. 160, 162 nn. 1, 8. Dogs occur suggestively in too many paintings to cite, but see Amsterdam 1976, no. 51 (especially fig. 51b), and the discussion of Steen's *The Lovesick Maiden* (Pl. 195).
7. P. Sutton 1980a, no. 15, pl. 13, proposes a date of about 1655–57. The composition may be inspired by an illustration in a racy songbook, *Incogniti scriptoris nova poemata* (Leiden, 1624); see De Jongh in Amsterdam 1976, p. 259, fig. 68b.
8. Which, *pace* P. Sutton 1980a, p. 98 (under no. 69 [pl. 72]), has nothing to do with "lovers [in the modern sense] or a married couple."
9. Manke 1963, no. 241, pl. 45. The painting is implausibly interpreted by P. Sutton in Philadelphia–Berlin–London 1984, pp. 361–62, and is compared with Vermeer's *Music Lesson* in Liedtke 2000a, pp. 229–30, figs. 283, 284.
10. Original certificate in curatorial files. For Héris, see Ex Coll.
11. Original letter in curatorial files.

REFERENCES: Catalogue of the Aron de Joseph de Pinto sale, Amsterdam, Oude Zyds Heeren Logement, April 11, 1785, no. 2 (quoted in full above); Blanc 1857–58, vol. 2, p. 441, records the Paris sale of 1841; Hofstede de Groot 1907–27, vol. 1 (1907), pp. 498–99, no. 80, cites the painting both as *Gentleman and Lady in a Bedroom*, with a description based on that in the 1785 sale catalogue, and pp. 501–2, no. 95, as *The Maid-Servant*, with a description based on that in the 1841 sale catalogue; Pène du Bois 1917, p. 399 (ill.); Brière-Misme 1927, pp. 268–70 (ill.), identifies the painting as both nos. 80 and 95 in Hofstede de Groot; Valentiner 1927, p. 77, listed; Valentiner 1928a, unpaged, describes the composition, and records a signature on the border of the table carpet, "P.D.H.," of which no trace remains today; Valentiner 1930a, pp. 127 (ill.), 284, dates the painting to about 1670–75, and misdates the De Pinto sale to 1875; B. Burroughs and Wehle 1932, pp. 48–49, no. 84, refers to the eighteenth-century sale catalogue and concludes that the picture was cut down; Barnouw 1944, pl. 20; F. Robinson in Saint Petersburg–Atlanta 1975, pp. 43–45, no. 30, misinterprets the subject and dates the painting to the early 1670s; P. Sutton 1980a, pp. 50, 100, no. 79, pl. 82, suggests a date of about 1667–70; Baetjer 1995, p. 333; Haverkamp-Begemann in Sterling et al. 1998, p. 167 n. 14.

EXHIBITED: Montreal, Art Association of Montreal, "Loan Exhibition of Great Paintings: Five Centuries of Dutch Art," 1944, no. 75; Hartford, Conn., Wadsworth Atheneum, "Life in Seventeenth Century Holland," 1950–51, no. 51; Milwaukee, Wis., Milwaukee Auditorium, "Metropolitan Museum of Art $1,000,000 Masterpiece Exhibition," 1953, no. 14; New York, MMA, "The Painter's Light," 1971, no. 14; Huntington, N.Y., Heckscher Museum, "Windows and Doors," 1972, no. 15; Tokyo, National Museum, and Kyōto, Municipal Museum, "Treasured Masterpieces of the Metropolitan Museum of Art," 1972, no. 82; Saint Petersburg, Fla., and Atlanta, Ga., High Museum of Art, "Dutch Life in the Golden Century," 1975, no. 30.

EX COLL.: Aron de Joseph de Pinto (his sale, Amsterdam, April 11, 1785, no. 2, sold [bought in?] for Fl 45 to Philippus van der Schley, one of the sale's organizers); "Van Helsleuter" collection [probably Van Eyl Sluyter, Amsterdam], according to the 1841 sale catalogue; [Henry Héris, Brussels, sold in 1839 to Col. Brié for FFr 6,000]; Colonel Brié [not Biré, as occasionally recorded], Brussels (1839–41; his anonymous sale, organized by Héris, Hôtel Rue des Jeuneurs, 16, rue des Jeuneurs, Paris, March 25, 1841, no. 12, for FFr 5,950); Mawson (until 1850, his anonymous sale, 42, rue des Jeuneurs, Paris, February 22–23, 1850, no. 31, sold for FFr 1980); Mr. Arnold, New York, in 1851 (according to Héris's certificate dated Feb. 17, 1851); H. A. Hammond Smith, New York (until 1916, according to Kleinberger bill of sale); [Kleinberger Gallery, New York; bought from Smith on March 9, 1916, and sold to Friedsam on February 22, 1917, for $22,000]; Michael Friedsam, New York (1917–31); The Friedsam Collection, Bequest of Michael Friedsam, 1931 32.100.15

89. *Paying the Hostess*

Oil on canvas, 37¼ x 43¾ in. (94.6 x 111.1 cm)
Signed (upper right, on beam): P d·Hoogh·

The condition of the work is good, although the paint
surface has been flattened by lining.

Gift of Stuart Borchard and Evelyn B. Metzger, 1958 58.144

Of the various human comedies that De Hooch set in city tav-
erns and country inns, the theme of settling accounts with the
establishment is not the most familiar. The subject of the pres-
ent picture, however, is anticipated in a painting of about 1650–
55 by De Hooch's Rotterdam colleague Ludolf de Jongh (q.v.)
and in De Hooch's own *Paying the Hostess,* of 1658 (private
collection, London).[1] The Museum's painting, which dates

from about 1670,[2] does not closely resemble either earlier
work, although the De Jongh features strongly receding horse
stalls with a large doorway to the left, and the De Hooch
includes a table with figures in a sunlit corner of the back-
ground. A few other Dutch artists depicted the motif of a dis-
puted reckoning; the sour mood and arrangement of the
figures in De Hooch's painting of 1658 are anticipated in
Adriaen van Ostade's etching of about 1646, *The Peasant
Settling His Debt.*[3] The subject must have struck a chord with
travelers along Holland's busy roads and waterways, as well as
travelers abroad. In 1668, Samuel Pepys (who had visited Delft
in 1660) recorded a similar incident after an outing to
Stonehenge: "So home to dinner [at his inn in Salisbury];

and, that being done, paid the reckoning, which was so exorbitant, and particularly in rate of my horses, and 7s. 6d. for bread and beer, that I was mad, and resolve to trouble the mistress about it."[4]

De Hooch enlivens the same theme in the present picture by transforming the customer (normally a more humble character) into a dandified gentleman and the proprietress into a pretty young woman with a flair for settling accounts. The figures' expressions and comparatively relaxed poses suggest that they are flirting as well as bargaining. Inn scenes often feature canine commentary (see Pl. 59), but here the dog is probably just a dog, and an effective spatial device.

Like many interiors by De Hooch this one is remarkable for its rendering of light, which may be that of late afternoon. Sunlight falls at a low angle through the doorway and through the window in the background. Various highlights draw attention to the hay, to the man's red coat with its gold lining and accents, and to otherwise mundane details like the broom in the left foreground. Silhouetted motifs, such as the wagon wheel, the woman with a baby, and the old smoker in a fur hat by the fireplace, have been handled with an eye to artistic effect. The illumination of shadowy areas—the horse stalls and hayloft, the rafters in the background—is also described with skill, enhancing the nearly symmetrical recession of the interior; the diagonal alignment of figures and objects also suggests depth. In the best works of his later career, De Hooch brought something of Delft to Amsterdam, where few painters of modern life (for example, Metsu; see Pl. 118) were as successful in creating the illusion of direct observation.

1. For the De Hooch of 1658, see New York–London 2001, no. 32, where the panel by De Jongh (art market, New York) is reproduced as fig. 256. De Jongh's painting is discussed in Fleischer 1978, pp. 60–65; P. Sutton 1980a, no. D20, pl. 182; Fleischer 1989, p. 69, pl. 80; and Fleischer and Reiss 1993, p. 668, fig. 1.
2. The painting is usually dated to the first half of the 1670s (see Refs.), but it seems strongly related to works of the 1660s in its naturalistic effects.
3. Hollstein 1949– , vol. 15, pp. 52–53 (B.42). See also the discussion of Salomon van Ruysdael's *Ferry near Gorinchem* (Pl. 185). A painting by F. Jansen (active ca. 1635–40 in Amsterdam?) in the Rijksmuseum, Amsterdam, includes similar motifs but not that of the payment of a bill. See also Jacob Duck's *Soldiers in a Stable,* in the same collection (Salomon 1998a, no. 90).
4. Pepys 1985, p. 923; entry for June 11, 1668.

REFERENCES: Kramm 1857–64, vol. 3 (1859), p. 734, possibly refers to this picture; Lagrange 1863, pp. 297–99, with an engraved reproduction, mistakes the man for "le propriétaire sans doute"; Havard 1879–81, vol. 3, p. 132, titles the painting *La sortie du cabaret* and interprets the subject correctly; Hofstede de Groot 1907–27, vol. 1 (1907), p. 553, no. 276, lists it as *Officer Buying Straw from a Peasant,* in the Cramer sale of 1769, and p. 554, no. 281, as *Setting Out from the Inn* ("the hostess is apparently wishing a gentleman a prosperous journey") in the De Morny sale of 1865; Valentiner 1926, p. 58; Brière-Misme 1927, pp. 259–61 (ill.), dates the picture to the 1670s and clears up Hofstede de Groot's confusion; Valentiner 1927, p. 76, no. 6, as *Paying the Hostess*; Valentiner 1930a, pp. xiv, 281 (ill. p. 105), suggests a date of about 1671–74; Fleischer 1978, pp. 58 n. 10, 64 n. 17, compares works by Ludolf de Jongh; P. Sutton 1980a, pp. 81 (under no. 27), 108, no. 111, concludes that "the scale and execution link the work to the musical company series of c. 1674"; Baetjer 1995, p. 333; Haverkamp-Begemann in Sterling et al. 1998, p. 167 n. 14; P. Sutton in London–Hartford 1998–99, pp. 17, 61, 114, describes the theme as one of the artist's favorites; Liedtke in New York–London 2001, p. 287, compares earlier treatments of the subject by De Hooch and De Jongh; Quodbach 2004, p. 97, notes the disastrous price brought by the picture in the de Morny sale.

EXHIBITED: New York, Duveen Galleries, "Paintings by the Great Dutch Masters of the Seventeenth Century," 1942, no. 31; Wichita, Kans., Wichita Art Museum, 1971–72; Bordeaux, Galerie des Beaux-Arts, "Profil du Metropolitan Museum of Art de New York: De Ramsès à Picasso," 1981, no. 104.

EX COLL.: J. G. Cramer, Amsterdam (until 1769; his sale, Amsterdam, November 13ff. or 15ff., 1769); sale, Amsterdam, November 30, 1772, no. 15; Charles-Auguste-Louis-Joseph de Morny, duc de Morny, Paris (possibly bought for FFr 100,000 in Saint Petersburg in 1857; definitely in his collection by 1863; d. 1865; his estate sale, Palais de la Présidence du Corps Législatif, Paris, May 31ff., 1865, no. 53, as "La sortie du cabaret," sold for FFr 10,000 to Demidoff); Paul Demidoff, Prince of San Donato, Florence and Saint Petersburg (from 1865); [Satinover, New York, 1922–23; ?sold to Borchard]; Samuel Borchard, New York (from 1923); his children, Stuart Borchard and Evelyn Borchard Metzger, New York (until 1958); Gift of Stuart Borchard and Evelyn B. Metzger, 1958 58.144

90. *A Couple Playing Cards, with a Serving Woman*

Oil on canvas, 27 x 23 in. (68.6 x 58.4 cm)
Inscribed by a later hand (on wall above tiles): PDH
Robert Lehman Collection, 1975 1975.1.143

Dutch paintings in the Robert Lehman Collection are
catalogued by Egbert Haverkamp-Begemann in *The Robert
Lehman Collection, II* (Sterling et al. 1998).

REFERENCES: Cited by Haverkamp-Begemann in Sterling et al.
1998, pp. 163–67, no. 36 (ill.).

EX COLL.: See Sterling et al. 1998, p. 163.

SAMUEL VAN HOOGSTRATEN

Dordrecht 1627–1678 Dordrecht

The painter, draftsman, and engraver Samuel Dircksz van Hoogstraten was born in Dordrecht on August 2, 1627. His father, Dirck van Hoogstraten (1596–1640), was a gold- and silversmith who took up painting in the 1620s. Samuel's mother, Maeiken de Coninck (1598–1645), was a silversmith's daughter who was distantly related to the landscapist Philips Koninck (q.v.). Both parents were Mennonites, a reserved sect to which the young Van Hoogstraten seems to have been temperamentally unsuited. In the 1650s, he adopted the attributes of a worldly, indeed courtly gentleman, for example wearing a sword in public (the Mennonites were pacifists). Van Hoogstraten married a patrician young woman, Sara Balen, in June 1656, and joined the Dutch Reformed Church in January 1657.[1]

According to Van Hoogstraten's own account in his well-known *Inleyding tot de Hooge Schoole der Schilder-konst* (Rotterdam, 1678), he trained with his father for several years before setting off at about the age of fifteen, in 1642, to study with Rembrandt in Amsterdam. He remained in the great teacher's studio until at least 1646 and perhaps until 1648.[2] At the time of Van Hoogstraten's arrival, the Dordrecht painter Ferdinand Bol (q.v.) had been working with Rembrandt for several years and had just become an independent master. Carel Fabritius (1622–1654) and Philips Koninck's brother-in-law, Abraham Furnerius (ca. 1628–1654), were also Rembrandt pupils in the early 1640s; Fabritius is discussed in Van Hoogstraten's *Inleyding* for his expertise, shared by the author, in painting illusionistic pictures and murals. Van Hoogstraten's earliest known paintings and drawings date from about 1644–48 and strongly reflect Rembrandt's influence; they also reveal close affinities with works by Bol and two other Rembrandt disciples of the 1630s, Govert Flinck and Jan Victors (q.q.v.). The formative phase of Van Hoogstraten's oeuvre still requires convincing definition, in part by placing within it a few works long ascribed to Rembrandt himself.[3]

Between 1648 and May 1651, Van Hoogstraten worked in Dordrecht, where he probably painted some of his most Rembrandtesque works, but also more fluid and fashionable pictures such as the *Self-Portrait as a Draftsman in a Window,* of about 1649 (Hermitage, Saint Petersburg).[4] At about the same time, Van Hoogstraten began to indulge in what has been described as "self-making and self-representation," for example by associating with local literati, publishing his first book (*Schoone Rosalin,* 1650), writing poems friendly to the House of Orange, and putting on airs inconsistent with his recent acceptance into the Mennonite community.[5]

In the spring of 1651, the artist auctioned off whatever paintings he had on hand and left Holland for a four-year sojourn abroad. The biographer and painter Arnold Houbraken (1660–1719), who was one of Van Hoogstraten's pupils, records that on August 6, 1651, his fellow townsman in Dordrecht presented three pictures to Emperor Ferdinand III in Vienna, and that one of them, an illusionistic still life, earned him an imperial medallion and a gold chain.[6] In addition to several other illusionistic pictures, including "letter rack" still lifes and the *Bearded Man at a Window,* of 1653 (Kunsthistorisches Museum, Vienna), Van Hoogstraten also painted some stylish portraits of courtiers.[7]

In 1652, he visited Rome, where he joined the fraternity of Netherlandish artists called the Bentveughels (Birds of a Feather) and stayed in the house of the successful still-life painter Otto Marseus van Schrieck (q.v.). During 1653 and 1654, Van Hoogstraten worked for clerical and noble patrons in Regensburg, and then went back to Vienna where evidently he remained until early 1656. He returned to Dordrecht a famous painter and poet, in good part because of the letters and verses he had sent home.

In May 1656, Van Hoogstraten secured a hereditary post on the board of the Mint of Holland and Zeeland in Dordrecht. This position, together with his marriage and entry into the Dutch Reformed Church, placed the painter advantageously in local society. He also joined the Dordrecht organization of Romanists (who dabbled in classical literature) and published *Den Eerlyken Jongeling* (Dordrecht, 1657), a loose translation of Nicolas Faret's *L'honnête homme, ou l'art de plaire à la cour* (Paris, 1630). A *Christ Crowned with Thorns* (Bayerische Staatsgemäldesammlungen, Munich), a number of portraits, and the *Perspective Box with Views of a Dutch Interior* (National Gallery, London) date from the second Dordrecht period of 1656–62.[8] In those years, Van Hoogstraten also established

himself as a teacher; Arent de Gelder (1645–1727) and Godfried Schalcken (q.v.) were his pupils about 1660.[9]

Apparently in search of aristocratic patrons, Van Hoogstraten and his wife left for London in the spring of 1662, and remained in England until 1667.[10] He became acquainted with members of the Royal Society, one of whom, Thomas Povey, installed two large illusionistic canvases by Van Hoogstraten in his London house (both now at Dyrham Park, Gloucester). These architectural views were admired by the diarists John Evelyn and Samuel Pepys,[11] and were followed by at least three illusionistic views of palace colonnades now in British private collections. Other works produced in England include a number of three-quarter-length and full-length formal portraits.[12]

Between 1668 and 1671, Van Hoogstraten was mostly active in The Hague, where he painted portraits of patrician figures, a large *Allegory of Truth and Justice* (Finspång Castle, Sweden) for the wealthy merchant Louis de Geer, and other works that embody the elegant taste of the court city. He also joined the painters' confraternity Pictura, and published *Haegaenveld* (Amsterdam, 1669), a pastoral hodgepodge dedicated to two princesses of the House of Orange. However, Van Hoogstraten appears never to have regained princely favor comparable to his coup in Vienna.[13]

In 1671 the painter purchased a furnished house from his widowed sister-in-law in Dordrecht and lived there until his death on October 19, 1678. He served as provost of the Mint from 1673 to 1676, kept company with prominent citizens, and wrote the *Inleyding,* which remains indispensable to the study of Dutch art.[14] In the early 1670s, Van Hoogstraten painted mostly portraits and small genre scenes, such as *Two Women Admiring a Baby in a Cradle* (Museum of Fine Arts, Springfield, Mass.) and *The Doctor's Visit* (Rijksmuseum, Amsterdam).[15] A number of smaller literary efforts reveal Van Hoogstraten's ongoing concern with recognition of his own stature and that of his profession, his family, and his hometown. In the last three years of his life, the artist was reportedly ill and devoted most of his time to completing projects already in progress, especially the *Inleyding,* which was published shortly before his death at the age of fifty-one.[16]

1. The most useful source for biographical details on Van Hoogstraten is Brusati 1995, chaps. 2, 3; see, for example, pp. 16 (birth and family), 19–24 (his father as teacher and artist), 79 (marriage and break with Mennonites). See also C. Brusati in *Dictionary of Art* 1996, vol. 14, pp. 737–42. Further information about Van Hoogstraten's life and family is found in Roscam Abbing 1987, Roscam Abbing 1993, and Thissen 1994. See also Brusati's essay and catalogue entries (nos. 43–49) in Dordrecht 1992–93.

2. See Brusati 1995, pp. 25, 273 n. 28, and p. 46 on Van Hoogstraten's return to Dordrecht (where he received adult baptism in 1648).

3. See Sumowski 1983–[94], vol. 2, nos. 823, 843–58; Liedtke 1989a, pp. 157–60; and Liedtke 1995b, pp. 4, 28.

4. Sumowski 1983–[94], vol. 5, no. 2095, and New York–Chicago 1988, no. 13. On the date, see Liedtke 1995b, p. 38 n. 124.

5. Brusati 1995, pp. 46–51, and chap. 3 (the title of which is quoted here).

6. Houbraken 1718–21, vol. 2, pp. 157–58. See Brusati 1995, pp. 54–55. Van Hoogstraten wrote a letter home to spread news of the honor in Holland, which is perhaps of interest for Rembrandt's representation of an imperial medallion and gold chain in *Aristotle with a Bust of Homer* (Pl. 151).

7. See Brusati 1995, figs. 36–38, 40–43; Dordrecht 1992–93, no. 44 (the *Bearded Man*); Wheelock in Washington 2002–3, p. 85, fig. 8; Russell in ibid., nos. 37, 49.

8. On the perspective box in London, see C. Brown et al. 1987, and Liedtke 2000a, pp. 46–50.

9. See Brusati 1995, pp. 78–91, especially p. 87 on Van Hoogstraten as a teacher. On De Gelder, see Dordrecht 1992–93, pp. 162–87; Von Moltke 1994; and Dordrecht–Cologne 1998–99.

10. Brusati 1995, pp. 91–109, 291 n. 90, 295 n. 115.

11. See ibid., p. 97, and Liedtke 1991, pp. 229–30, fig. 7, pl. III, on the illusionistic pictures in Povey's house.

12. Brusati 1995, figs. 55, 57, 60–63, 66, 67, 141, pls. XIV, XV, for works mentioned in this paragraph.

13. Ibid., pp. 109–27, on Van Hoogstraten in The Hague (pp. 110–11 on *Haegaenveld*).

14. In addition to citing many artists and discussing Rembrandt as a teacher, the book is essential for an understanding of seventeenth-century Dutch ideas on art (see Brusati 1995, chap. 6 and Czech 2000, chaps. 5–7).

15. See A. Davies 1993, pp. 49–53, on the Springfield canvas.

16. See Brusati 1995, pp. 127–37, 299 n. 169 on the last years in Dordrecht.

91. *The Annunciation of the Death of the Virgin*

Oil on canvas, 26 x 20¾ in. (66 x 52.7 cm)
Signed (lower left): S.v.H.

The painting is well preserved. A pentimento reveals that the artist slightly shifted the position of the angel's right forefinger and thumb.

Purchase, Rogers Fund and Joseph Pulitzer Bequest, 1992
1992.133

In this canvas of about 1670, Van Hoogstraten depicts the comparatively rare subject of an angel's visit to the Virgin shortly before her death. The artist's referent was probably Jacobus de Voragine's *Golden Legend*, which recounts that

> an angel stood by her in the midst of a great light, and greeted her with reverence as the mother of his Lord. "Hail, blessed Mary," he said, "receive the blessing of Him Who sent His salvation to Jacob! Behold I have brought unto thee, my Lady, a branch of the palm of Paradise! This thou must cause to be carried before thy bier; for three days hence thou shalt be called forth from the body, because thy Son awaits thee, His venerable mother!"[1]

The subject has occasionally been described as the Annunciation or the Virgin of the Immaculate Conception. Adams, in dismissing the former in favor of the latter identification, correctly observes that the angel holds a palm branch not a lily. However, her discussion does not account for the gesture, expression, and very presence of the angel, or for the somber mood of the scene.[2]

The intimacy of the conversation is enhanced by the boyish angel's costume (which resembles a nightdress) and natural pose, with his forearms supported comfortably on clouds. Houbraken recalls how Van Hoogstraten transformed his house into a theater where his students would stage plays and also enact subjects they had been assigned as weekly exercises in composition.[3]

The uncommon subject and comparatively small scale of the painting suggest that it was painted for a private Catholic patron rather than for an institution such as a "hidden church."[4] It is even possible that the picture was painted in memory of a Catholic woman named Maria.[5] Van Hoogstraten had worked for foreign Catholics in the early 1650s and like other Protestant painters in the Netherlands, for example

Hendrick ter Brugghen (q.v.), he also had Dutch Catholic clients and was capable of meeting their demands sympathetically.[6] The importance of Catholic patrons for seventeenth-century Dutch art has been underestimated until recently, and relevant pictures are scarce in American museums and most public collections elsewhere.[7]

The painting certainly dates within the chronological range proposed by Sumowski: 1665–75.[8] In its manner of execution and somewhat idealized figures, the work seems sufficiently close to two pictures dated 1670, *Allegory of Truth and Justice* (Finspång Castle, Sweden) and *Two Women Admiring a Baby in a Cradle* (Museum of Fine Arts, Springfield, Mass.),[9] and to other paintings of about the same time to suggest a dating close to 1670 — in any event, after Van Hoogstraten returned to the Netherlands from England in 1667 and before the Dordrecht portraits of the mid-1670s. None of the later religious pictures by Van Hoogstraten, such as *The Education of the Virgin* (location unknown), *The Repentant Magdalene* (location unknown), *Christ Carrying the Cross* (Hunterian Art Gallery, Glasgow), and the *Ascension of Christ* (Art Institute of Chicago), can be dated convincingly to later than 1671, when Van Hoogstraten moved back to Dordrecht from The Hague.[10]

Like the four works just cited, which were all probably painted for Catholic patrons, the present picture may be placed generally within the tradition of "Dutch classicism,"[11] which although traceable throughout the century was very much in the ascendant about 1670 (Gerard de Lairesse being a key representative; see Pl. 104). Many of the earlier exponents, such as Abraham Bloemaert (q.v.), Gerrit van Honthorst, Frans and Pieter de Grebber, Salomon and Jan de Bray, and Caesar van Everdingen, worked at some time for the court at The Hague or for Catholic clients. This tradition, more than any direct connection, most likely accounts for the strong similarities between the present composition and that of, for example, Van Honthorst's *Agony in the Garden*, of about 1617 (Hermitage, Saint Petersburg),[12] and Pieter de Grebber's *King David in Prayer*, of about 1635–40 (Museum Het Catherijneconvent, Utrecht).[13] However, the design of Godfried Schalcken's elegant *Annunciation* (J. Paul Getty Museum, Los Angeles), which was painted in the early 1670s, appears to have been influenced by this or a similar work by Van Hoogstraten, who had been Schalcken's teacher about ten years earlier.[14]

91

1. Voragine 1969, pp. 449–50.

2. A. Adams in New York 1988, p. 75, where the Virgin is incorrectly said to wear "contemporary dress." Compare Paulus Bor's large painting of *The Annunciation,* of about 1635–40 (National Gallery of Canada, Ottawa; see Dolphin 2007 in Refs.), where lilies and roses but no palms appear. The Annunciation of the Death of the Virgin is known mostly from earlier Italian art: for example, Duccio's panel in the *Maestà* (Museo dell'Opera del Duomo, Siena); Orcagna's relief in Or San Michele, Florence; and the predella panel of Filippo Lippi's Barbadori Altarpiece (Louvre, Paris; see Ruda 1993, pp. 394–96). Jean Fouquet also illustrated the subject in the *Livre d'heures d'Étienne Chevalier* (Musée Condé, Chantilly). Francisco Pacheco describes the story in his *Arte de la pintura* of 1638 (Pacheco 1956, vol. 1, p. 297). The palm occurs in some examples of the (first) Annunciation, but other symbols and the poses of the figures usually clarify the subject (see Held 1980, vol. 1, p. 441). These examples were gathered with the kind assistance of Dulce María Roman.

3. See Brusati 1995, pp. 87, 290 n. 85, quoting Houbraken 1718–21, vol. 2, pp. 162–63.

4. On clandestine Catholic churches and their paintings, see Schillemans 1992, Van Eck 1993–94, and Van Eck 1999. The proliferation of "hidden churches" or "house churches" in seventeenth-century Amsterdam is discussed by Dudok van Heel in Amsterdam–Weert 1995–96, pp. 35–43.

5. In Newark–Denver 2001–2, p. 110, Sluijter conjectures similarly that a painting of Mary Magdalene by Gerrit Dou in the collection of Franciscus de le Boe Sylvius, a Calvinist physician, "may have been particularly appealing" to him because his wife's name was Magdalena.

6. The question is discussed with regard to Ter Brugghen by Bok and Kobayashi 1985, pp. 13–14. Montias 1991, pp. 339, 356, offers statistical evidence that paintings of the Virgin "with or without the Christ child" and of the Annunciation were usually, though not exclusively, found in Catholic homes.

7. The purchase of this painting in 1992 was made with this point uppermost in mind. On Catholic patronage in the Netherlands during the seventeenth century, see Van Thiel 1990–91, esp. pp. 49–60.

8. See Sumowski 1983–[94], vol. 2, no. 828.

9. Ibid., nos. 830, 836.

10. Ibid., nos. 829, 831, 833, 835.

11. See Rotterdam–Frankfurt 1999–2000.

12. See New York–Chicago 1988, no. 12, or Judson and Ekkart 1999, no. 50.

13. Rotterdam–Frankfurt 1999–2000, no. 17; compare also no. 64, Adriaen van de Velde's *Annunciation* of 1667 (Rijksmuseum, Amsterdam).

14. Beherman 1988, no. 2, considers the Getty picture similar in technique to Van Hoogstraten's paintings of about 1670–75.

REFERENCES: Wegner 1967–68, pp. 52–53, 56 n. 29, compares a drawing in the Albertina, Vienna; Schaar 1968, p. 12 (under no. M12, *Heraclitus,* by Van Hoogstraten), as a work of the "middle period"; Sumowski 1983–[94], vol. 2, pp. 1292–93, no. 828 (ill. p. 1311), as dating from about 1665–75; New York 1988, p. 75 no. 26, as representing the Virgin of the Immaculate Conception, with plate on p. 59 reversed; Roscam Abbing 1993, p. 90 (under doc. 12), no. 41 (ill. p. 140), finds it possible that "Een Marijen-beelt van Hooghstraeten" (A picture of the Virgin by Hoogstraten) in the estate inventory of Myken Willems Bidloo, widow of Marcelis Adriaensz Bacx (Dordrecht, January 19, 1671), could refer to this painting; Baetjer 1995, p. 331; Brusati 1995, pp. 21, 355, no. 51, fig. 14, considers the figure of Mary to recall a figure in Dirck van Hoogstraten's *Virgin and Child with Saint Anne,* of 1630 (Rijksmuseum, Amsterdam); Ember 1999, pp. 109, 111, fig. 80, cites the Virgin's facial type in support of a new attribution to Van Hoogstraten; Dolphin 2007, p. 92, fig. 27, compares Paulus Bor's large painting of the same subject (acquired by the National Gallery of Canada, Ottawa, in 2003).

EXHIBITED: New York, National Academy of Design, "Dutch and Flemish Paintings from New York Private Collections," 1988, no. 26.

EX COLL.: G. L. Hevesi, London (before 1952); sale, Christie's, London, April 25, 1952, no. 138, to Appleby, for Gn 21; [Appleby, from 1952]; Walter Chrysler, Norfolk, Va. (until ca. 1960–65); [Stanley Moss, New York, purchased from Chrysler ca. 1960–65]; Ian Woodner, New York (purchased from Moss; d. 1990); Ian Woodner Family Collection, New York (1990–92; sale, Christie's, New York, January 16, 1992, no. 8, to Naumann); [Otto Naumann, New York, 1992]; Purchase, Rogers Fund and Joseph Pulitzer Bequest, 1992 1992.133

LUDOLF DE JONGH

Overschie 1616–1679 Hillegersberg

The artist was probably born in Overschie, near Rotterdam, in 1616.[1] His father, Leendert Leendertsz, was a Rotterdam tanner, shoemaker, and innkeeper of some means. According to Houbraken, De Jongh studied with Cornelis Saftleven (1607–1681) in Rotterdam, with Anthonie Palamedesz (1601–1673) in Delft, and with Jan van Bijlert (1597/98–1671) in Utrecht.[2] The biographer specifies that Saftleven taught De Jongh drawing (a small group of figure drawings is known);[3] this would have been about 1629–30. Palamedesz supposedly paid his pupil little attention, but the Delft master's influence is obvious in De Jongh's genre scenes of the 1630s and 1640s, and in his portraits of the 1650s. De Jongh reportedly made rapid progress under Van Bijlert (in about 1632–34?), whose work is occasionally recalled by De Jongh's Merry Company pictures of the 1640s.[4]

At some time shortly after October 11, 1635, when De Jongh was recorded in Rotterdam, he left for France with "a certain Frans Bacon," and stayed there for seven years.[5] He was called home to Rotterdam when his mother fell seriously ill, probably arriving there in the first months of 1643. By that time, Houbraken claims, the painter was so unpracticed in his native language that his parents called in an interpreter. On February 4, 1646, De Jongh married Adriana Pieters Montagne of Schoonhoven, whose father was well connected with patrician figures in both the bride's and groom's hometowns. This relationship, Houbraken implies, led to De Jongh's appointment as a major in the civic guard, in which he served from 1652 until 1664. In 1652 the artist borrowed a total of 5,600 guilders from three prominent citizens and purchased a house on the Hoogstraat.[6]

As an officer of the civic guard (of which he painted a group portrait, now lost), De Jongh was paid by the city and had various duties to perform. From 1659 until 1661, he was also a governor of a home for the aged, and in 1665 he was appointed *schout* ("sheriff," or public prosecutor) in nearby Hillegersberg, where he soon moved, and where he died in 1679.

De Jongh painted some conventional and some innovative portraits; perhaps the most remarkable of the latter is the *Boy with a Dog*, of 1661, in the Virginia Museum of Fine Arts, Richmond. The genre scenes are eclectic, but those of the 1650s are closely related to the work of Pieter de Hooch (q.v.). De Jongh, who was thirteen years De Hooch's senior, strongly influenced the Delft painter in the early to mid-1650s, but by about 1658–60 was responding to the younger artist's ideas.[7] From about 1665 onward, De Jongh painted elegant figures in the gardens and courtyards of country houses.[8] The aristocratic theme was also treated by Jan van der Heyden (Pls. 78, 79) and other Dutch painters but seems consistent with De Jongh's rise among Rotterdammers, who would embellish their conversation with phrases in French.

He painted a fair number of landscapes with figures and animals, most often hunting scenes with elegant riders and hounds, although mythological subjects are also known. The hunting scenes recall the work of numerous earlier and contemporary painters, including Nicolaes Berchem, Philips Wouwermans (q.q.v.), and Dirck Stoop (1610–1686), and De Jongh's younger colleague in Rotterdam Abraham Hondius (q.v.).

The artist occasionally collaborated with his brother-in-law Dirck Wijntrack (before 1625–1678), who painted animals in landscapes, and with the landscapist Joris van der Haagen (ca. 1615–1669) of The Hague.

1. On the evidence, see Fleischer 1989, p. 13 n. 1.
2. Houbraken 1718–21, vol. 2, p. 33.
3. Schatborn 1975.
4. See the chapters on portraiture and genre painting in Fleischer 1989. Scholten 1992, p. 51, reasonably suggests that some of De Jongh's Palamedesz-like genre pictures could date from the 1630s, and rightly dismisses Fleischer's conjecture (p. 14) that De Jongh might actually have studied with Van Bijlert in the 1640s.
5. Houbraken 1718–21, vol. 2, pp. 33–34. Fleischer 1989, p. 14, misreading Houbraken, refers to Bacon rather than De Jongh as nineteen years old at the time. Could Bacon have been a young English artist, perhaps related to the amateur painter Sir Nathaniel Bacon (1585–1627)?
6. Fleischer 1989, pp. 15–16, for the details in this paragraph.
7. See ibid 1989, p. 73, and Liedtke 2000a, pp. 159–62. Scholten 1992, p. 52, tries to make De Jongh into De Hooch's teacher in Rotterdam. The connection hardly requires that we dismiss Houbraken's account.
8. See Scholten 1994.

92. *Scene in a Courtyard*

Oil on canvas, 26½ x 32⅜ in. (67.3 x 82.2 cm)
The paint surface is slightly abraded throughout.
Bequest of William K. Vanderbilt, 1920 20.155.5

Although the picture was attributed in the past to Pieter de Hooch (q.v.) and to his brother-in-law Hendrick van der Burch (1627–1665 or later), it is entirely typical of the Rotterdam artist Ludolf de Jongh and may be dated on the basis of comparisons with other works by him to the early 1660s.[1] The composition and the subject itself, with a mistress and maid in the rear courtyard of an attractive town house,[2] are clearly indebted to paintings by De Hooch such as *A Woman and Her Maid in a Courtyard*, of about 1660–61, in the National Gallery, London.[3]

The lady of the house holds the hand of her well-dressed daughter and instructs the maid, who seems wary of the greyhound's proximity to the kitchen. A cook attends to fowl roasting on a spit in the hearth seen through the doorway to the right. A young man, presumably the mistress's son, looks on from a window to the left. In the background, a man enters from the street or alleyway carrying what appears to be a basket of mussels. The doorway frames a view through the roofed gateway of another enclosure (which must belong to the house in the background); the sunlit area in the distance may be part of the same property or another passageway between walled courtyards and gardens.

The composition, with its planes of contrasting bricks, is so obviously derived from De Hooch's courtyard views of about 1660 as to make the painting's long confusion with works of the Delft school understandable. De Jongh deserves recognition for his adaptation of a particular refinement in De Hooch's work, which is the way the young maid is caught in the sunlight, thereby focusing the viewer's attention at the center of activity and also suggesting a moment in time. It seems to be late afternoon on a spring or summer day, when sunlight falls eastward and bathes the rear side of this row of houses. The play of brown, red, and green tones throughout the shadowy spaces is balanced beautifully on the right, where the leafy vine curves gracefully against the sun-drenched brick wall. In this rectilinear environment certain curves catch the eye, for example the pump handle's apparent counterpoint to the vine, the maid's silhouette, and the sinuous contours of the dog. De Jongh's appeal often consists of his discovery of elegance in a comparatively ordinary world.

1. See Refs. for earlier attributions and suggested datings. Valentiner's attribution of the picture to Van der Burch (1929) was supported by F. Schmidt-Degener in 1935 but doubted by W. Martin in 1938 (oral opinions recorded in the curatorial files; on Van der Burch, see P. Sutton 1980b and Delft 1996, pp. 170–77). The earliest attribution to De Jongh appears to be J. G. van Gelder's undated annotation on a photograph at the Rijksbureau voor Kunsthistorische Documentatie, The Hague, which was supported by S. J. Gudlaugsson (1950s?). The Museum changed the attribution from De Hooch to Van der Burch in 1949, and from the latter to De Jongh in 1955. John Walsh, the Museum's curator, reviewed the relevant material at the Rijksbureau voor Kunsthistorische Documentatie, The Hague, in 1971 and concluded that the attribution to De Jongh was certainly correct.

2. The artist suggests a freestanding kitchen annex, which was an occasional feature of fine town houses. They were used especially in summer, when the heat of the hearth in the house itself (an important resource in colder months) was unwanted. On actual kitchens in seventeenth-century Dutch houses and the sometimes idealized depictions of them, see Corbeau 1993 (pp. 357, 372, on separate kitchens).

3. As noted in Scholten 1994, p. 147. On the De Hooch in London, see P. Sutton 1980a, no. 44, fig. 48, pl. x, and MacLaren/Brown 1991, pp. 197–98, pl. 171.

REFERENCES: J. Smith 1829–42, vol. 9 (1842), p. 568, no. 16, cites the painting as by De Hooch, in the collection of Rev. J. Clowes, Manchester; Havard 1879–81, vol. 3, p. 101, repeats J. Smith; Hofstede de Groot 1907–27, vol. 1 (1907), p. 561, no. 304, repeats J. Smith; Vanderbilt Bequest 1920, p. 268, suggests a date of about 1670; Brière-Misme 1927, pp. 260–62 (ill.), as by De Hooch; Valentiner 1927, p. 76, listed as by De Hooch, about 1658–68; Valentiner 1929, pp. 114, 107 (ill.), attributes the picture to Hendrick van der Burch; Valentiner 1930a, pp. 252 (ill.), 296, considers "the exaggerated perspective of the house walls on both sides" and the figures to be typical of Van der Burch, and dates the work to about 1655–60; P. Sutton 1980a, p. 164, listed as by De Jongh; Fleischer 1989, pp. 72–73, fig. 86, as by De Jongh about 1660, compares the De Hooch in London (see text above); Scholten 1992, p. 52, compares De Hooch; Fleischer and Reiss 1993, pp. 676–77, fig. 15, considers the painting to demonstrate De Jongh's "complete mastery of the Delft style by at least the start of the 1660s"; Scholten 1994, p. 147, fig. 10, compares the De Hooch in London; Baetjer 1995, p. 323; London–Hartford 1998–99, pp. 83–84 n. 70, records the private communication of conservator J. Wadum, who notes a pinhole in the canvas coincident with the vanishing point.

EXHIBITED: Hartford, Conn., Wadsworth Atheneum, "Life in Seventeenth Century Holland," 1950–51, no. 25, as by Van der Burch; Nashville, Tenn., Fisk University, Atlanta, Ga., Atlanta University, and New Orleans, La., Dillard University, 1951–52, no cat.; Hempstead, N.Y., Hofstra College, "Metropolitan Museum Masterpieces," 1952, no. 12; American Federation of Arts, "Little Masters in 17th Century

92

Holland and Flanders" (circulating exhibition), 1954–57; Berkeley, Calif., University of California at Berkeley, University Art Museum, and Houston, Tex., Rice University, Institute for the Arts, "Dutch Masters from The Metropolitan Museum of Art," 1969–70, checklist no. 8; Saint Petersburg, Fla., Museum of Fine Arts, and Atlanta, Ga., High Museum of Art, "Dutch Life in the Golden Century," 1975, no. 18, as by De Jongh; Delft, Stedelijk Museum het Prinsenhof, "Delft Masters, Vermeer's Contemporaries," 1996.

Ex Coll.: Rev. John Clowes, Manchester and Broughton, Lancashire (by 1842–until 1846); his nephew Rev. Samuel Bradshaw (in 1846); Mrs. Samuel Bradshaw; William K. Vanderbilt, New York (by 1920); Bequest of William K. Vanderbilt, 1920 20.155.5

CORNELIS JONSON VAN CEULEN THE ELDER

London 1593–1661 Utrecht

A leading portrait painter in London, Jonson worked there between about 1617 and October 1643, and in the Netherlands from 1644 onward. He was baptized in the Dutch Church at Austin Friars, London, on October 14, 1593. His Flemish parents, Cornelis Jonson and Jane Le Grand, moved from Antwerp to London (about 1568?) in order to live freely as Protestants. The painter's grandfather was Peter Jansen, originally from Cologne (Ceulen or Keulen in Dutch), so that the family also used the name Jonson van Ceulen. The artist signed his works Jonson or Janson (as well as "CJ"), sometimes adding "van Ceulen" on portraits dating from the Dutch period. The name "Janssens," evidently introduced by De Bie (1661), is a Dutch translation that the artist appears never to have employed.

Where Jonson trained is unknown. One specialist considers it probable that he studied in the northern Netherlands, "returning to London about 1618."[1] Supporting evidence cited by another scholar, namely, that a portrait said to be by Jonson and dated 1617 "looks like a Dutch work and a Dutch sitter," is rather thin compared with the visual testimony of portraits dating from 1619 until 1630.[2] When judged against Dutch portraits of the same period, for example by Michiel van Miereveld (q.v.), Jonson's style of the 1620s looks distinctly English, especially in its flatter handling of costume details.[3] Given predecessors in London such as Marcus Gheeraerts the Younger (1561–1635), Paul van Somer (1576–1621), and Daniël Mijtens (q.v.), there seems little need to send Jonson elsewhere for instruction. His practice of producing not only original portraits but also copies after other artists—for example, his monogrammed replica, dated 1631 (Chatsworth, Derbyshire), after Mijtens's *Charles I, King of England*, of 1629, in the Metropolitan Museum (Pl. 124)—underscores his close acquaintance with the leading portraitists in England, who were themselves either Dutch (Mijtens) or, in Van Somer's case, Flemish with a decade of work in Holland behind him.[4]

Jonson's manner evolved gradually in the direction of Van Dyck with that artist's arrival in London in 1632 (by April 1).[5] This is more evident in the individual figures than in the composition of Jonson's large and ambitious *Family of Arthur, Lord Capel*, of about 1639 (National Portrait Gallery, London). In single, half-length portraits by Jonson, livelier fabrics, softer modeling, and a new elegance reveal Van Dyck's influence, if not so much as in contemporary portraits by Adriaen Hanneman (q.v.), who was also in London between 1626 and about 1638. Jonson's main strengths were capturing a convincing likeness and suggesting character. Van Dyck's rhetorical flourishes are toned down to suit the less public sphere of Jonson's patrons, who were distinguished but not generally from the first circle of English society.

Jonson and his family left England for the Netherlands in 1643, at the beginning of the Civil War. In 1622, he had married Elizabeth Beck, of Colchester, whose family was Dutch. The couple had two sons, one of whom, Cornelis Jonson van Ceulen the Younger (q.v.), later followed in his father's footsteps. The family went first to Middelburg, but by 1649 they were evidently living in Amsterdam. Paintings such as *Magistrates of The Hague*, dated 1647 (Oud Stadhuis, The Hague), and many individual and pair portraits indicate continued success. In 1652, the Jonsons moved to Utrecht, where Cornelis the Elder died in August 1661.

1. Rudolf Ekkart in *Dictionary of Art* 1996, vol. 17, p. 644, in one of the most useful biographies of Jonson.
2. The quote is from Waterhouse 1962, p. 36.
3. A good, late example of this manner is the *Portrait of a Lady, called Mary Campion*, signed and dated "C.J. fecit 1630," sold at Sotheby's, London, March 14, 1984, no. 18 (ill.). A few typical portraits by Jonson dating from the 1620s and early 1630s are illustrated in Maison 1939 (pl. IA actually represents Henry, 18th Earl of Oxford, not the king of Bohemia).
4. See Waterhouse 1962, chap. 4, on these "precursors of Van Dyck." The essential article on Jonson in England is Hearn 2003 (pp. 116–18, on the question of where the artist might have trained).
5. See Hearn 2003, pp. 120–21.

93. *Portrait of a Man*

Oil on canvas, 40¾ x 31½ in. (103.5 x 80 cm); painted surface 40¾ x 31⅛ in. (103.5 x 79.1 cm)
Signed and dated (lower left): Cor. Jonson/fecit 1648

The painting is extensively abraded, and the surface texture was flattened during a past cleaning.

Gift of Mrs. J. E. Spingarn, 1957 57.30.1

This portrait of a man and its pendant (discussed below; Pl. 94) were probably painted by Jonson in Amsterdam (see the biography above). The gentleman wears a fine black suit and cape with a linen collar and cuffs, and holds tan leather gloves. His pose, with his right elbow resting on a slightly chipped stone plinth and the left arm akimbo, ultimately goes back to English portraits by Anthony van Dyck, about which Jonson was better informed than most Dutch artists.[1] Unfortunately, there are no clues to the subject's identity.

1. See, for example, Van Dyck's *Sir John Borlase,* of about 1638 (Bankes Collection, The National Trust, Kingston Lacy, Dorset); Barnes et al. 2004, p. 449, no. IV.29.

REFERENCES: Baetjer 1980, vol. 1, p. 99, cites the painting as by Cornelis Jonson van Ceulen the Younger; Baetjer 1995, p. 305, as by Cornelis Jonson van Ceulen the Elder.

EX COLL.: Amy E. (Mrs. Joel E.) Spingarn, New York (until 1957); Gift of Mrs. J. E. Spingarn, 1957 57.30.1

94. *Portrait of a Woman*

Oil on canvas, 40¾ x 31½ in. (103.5 x 80 cm); painted surface 40¾ x 30⅞ in. (103.5 x 78.4 cm)
Signed and dated (lower right): Cor. Jonson/Fecit 1648 —

The painting is extensively abraded, and the surface texture was flattened during a past lining.

Gift of Mrs. J. E. Spingarn, 1957 57.30.2

This portrait of an anonymous woman is a pendant to the picture discussed above (Pl. 93). Both figures are presented before a deep olive background and wear black, in this case apparently velvet. A gold-colored cap with two dark jewels crowns the woman's fashionable coiffure. She wears an abundance of pearls, although the effect is not ostentatious. Her earrings each have three large dangling pearls, she has a pearl necklace of one strand, and a string of pearls circles each wrist three times. Her sheer white blouse and cuffs are bordered with fine bands of lace, and a brooch and a white feather fan with a gilded handle complete the impression of quiet wealth. The pose and the elegant hands are familiar from English portraits by Van Dyck, including *Princess Mary,* of about 1636–37 (Museum of Fine Arts, Boston).[1] A very similar portrait by Jonson, dated 1650, is in the Centraal Museum, Utrecht, but the sitter appears to be a different woman.[2]

1. Barnes et al. 2004, pp. 554–55, no. IV.161.
2. Helmus 1999, vol. 2, pp. 1016–17, no. 321.

REFERENCES: Baetjer 1980, vol. 1, p. 99, cites the painting as by Cornelis Jonson van Ceulen the Younger; Baetjer 1995, p. 305, as by Cornelis Jonson van Ceulen the Elder.

EX COLL.: The painting has the same history of ownership as its pendant. See Ex Coll. for the *Portrait of a Man* (Pl. 93); Gift of Mrs. J. E. Spingarn, 1957 57.30.2

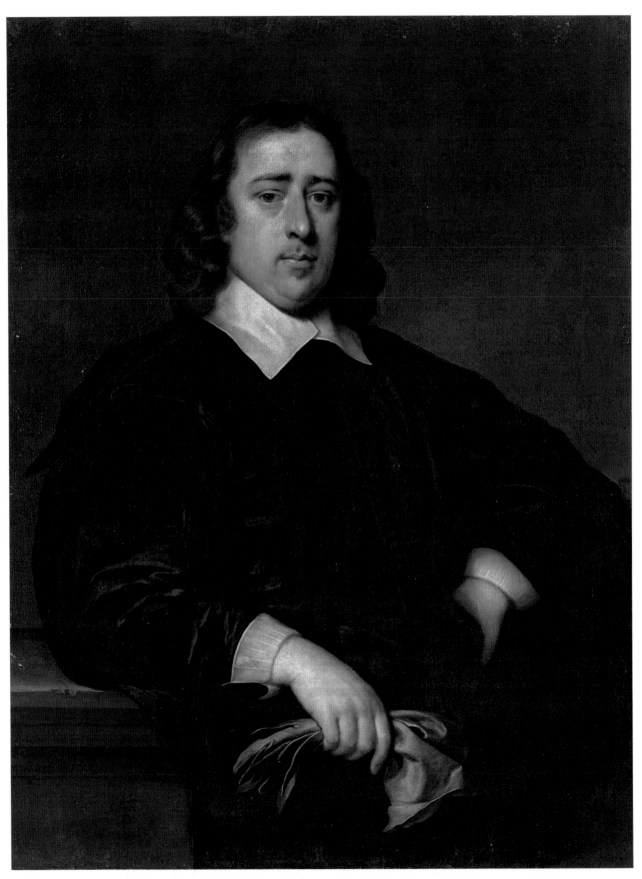

93

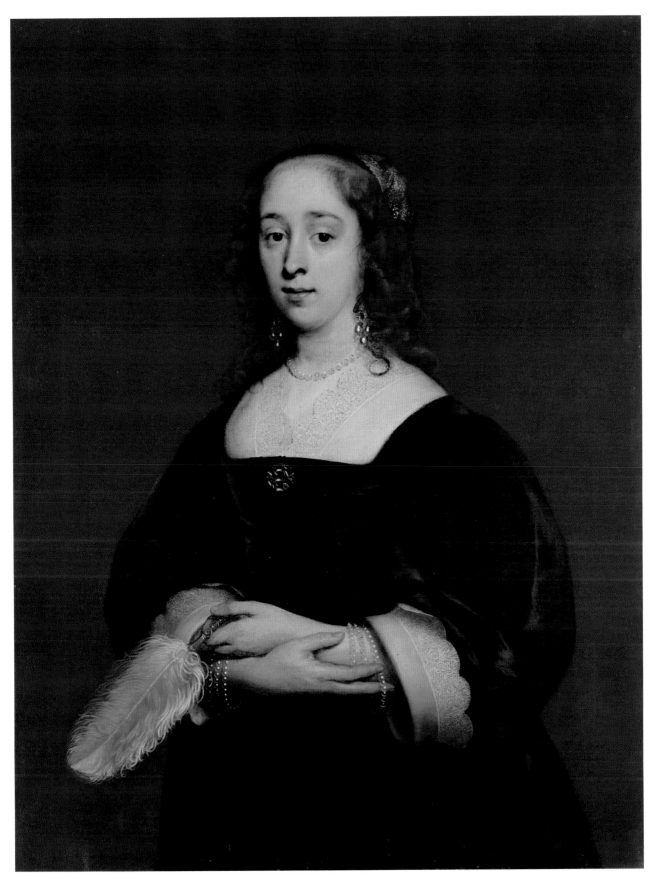

CORNELIS JONSON VAN CEULEN THE YOUNGER

London 1634–1715 Utrecht

Much less is known about Cornelis II than about his father, Cornelis Jonson van Ceulen the Elder (q.v.). He was baptized in London on August 15, 1634.[1] His family moved to the Netherlands in 1643, and Jonson (or Jansen, as he became known) presumably trained there with his father. In 1664, he was living with his mother in Utrecht, where he was also cited in 1670 and 1678. The notice of his marriage on November 16, 1681, describes him as a widower.[2] On April 5, 1698, the painter, "living in Utrecht, presently here" (in Amsterdam), declared himself in debt to Hendrick Uylenbroeck, and offered a variety of minor paintings as collateral.[3] Paintings by Cornelis II are often signed in full with the addition of "Junior" (as on the painting discussed below) or "Filius."[4] The mediocre quality of the artist's later work is well illustrated by his three portraits of the Martens brothers, of 1697, in the Centraal Museum, Utrecht.[5] Cornelis II was buried in the Jacobskerk, Utrecht, on December 20, 1715.[6]

1. Edmond 1978–80, p. 89.
2. H. Schneider in Thieme and Becker 1907–50, vol. 19, p. 144, summarizing earlier publications.
3. Bredius 1915–22, part 4, pp. 1302–3. The transcription is correct: this is not Uylenburgh, the art dealer. I am grateful to Jaap van der Veen, at the Rembrandthuis, Amsterdam, for checking this detail in April 2005.
4. The latter occurs, for example, on a portrait of a man, dated 1664, sold at Sotheby's, Amsterdam, May 10, 2005, no. 93.
5. Helmus 1999, vol. 2, pp. 1027–29, nos. 327–29.
6. Briels 1997, p. 343. Rieke van Leeuwen, of the Rijksbureau voor Kunsthistorische Documentatie, The Hague, kindly checked the evidence for the artist's dates of birth and death, which are often given incorrectly.

95. *Portrait of a Man with a Watch*

Oil on canvas, 33 x 27¾ in. (83.8 x 70.5 cm)
Signed and dated (lower left): Cornelius Jonson/ van Ceulen/Junior/1657

The portrait is well preserved. Illegible fragments of an inscription remain above the signature and date. The indigo blue in the background and tablecloth has faded a little, as is evidenced by a passage along the lower left edge where the original color is preserved.

Given in memory of Felix M. Warburg by his wife and children, 1941 41.116.3

The portrait is reliably signed by Jonson "Junior," which is a Dutch as well as an English word and is used in signatures. Ekkart considers the painting a routine example of the younger Jonson's manner, and proposes that it may be a replica of a portrait by his father.[1] Cleaning in 2005 revealed that the picture has considerable quality, suggesting that it is an entirely original work. In any case, it was probably painted in Utrecht.

The anonymous sitter is dressed in black and wears a black cap. A steel-blue curtain hangs behind him. In his hand he holds an open watch with a winding key on a blue ribbon. This is a conventional symbol of transience in portraiture, but in this presentation probably suggests temperance.[2]

1. Rudolf Ekkart, letter to the Museum dated October 8, 1990.
2. See the discussion under Ter Borch's *The Van Moerkerken Family* (Pl. 14), and note 8 in that entry.

REFERENCES: Baetjer 1980, vol. 1, p. 99; Baetjer 1995, p. 329.

EX COLL.: Felix M. Warburg, New York (until d. 1937; his estate, 1937–41); Given in memory of Felix M. Warburg by his wife and children, 1941 41.116.3

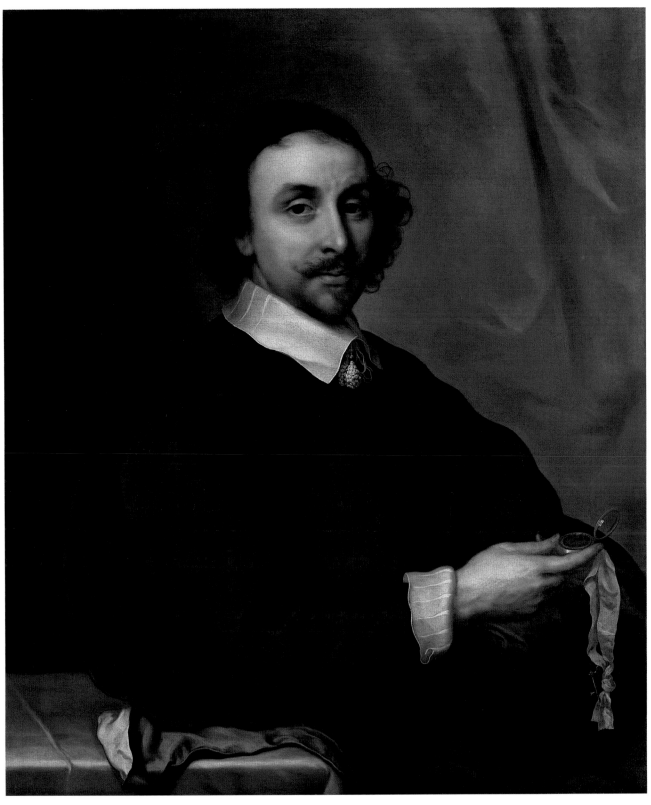

95

WILLEM KALF

Rotterdam 1619–1693 Amsterdam

Willem Jansz Kalf was baptized in Rotterdam on November 3, 1619, in a Protestant ceremony. His father was Jan Jansz Kalf (d. 1625), a prosperous cloth merchant who also held offices in the city government.[1] The artist's mother, Machtelt Gerrits (or Geerts; ca. 1578–1638), gave birth to at least seven children. At her death, Willem, aged eighteen, and his younger brother Govert were assigned guardians. When Govert died in March 1642, on a VOC ship headed for the East Indies, Willem had already been in Paris for some time, perhaps from about 1639. He remained there, living in a circle of mostly Flemish artists in the neighborhood of Saint Germain-des-Prés, until 1646. He was cited in Rotterdam during October of that year, but no documents are known for the years 1647–50, and no works are known to bear dates from 1647 through 1652. On October 22, 1651, "Willem Jansz Calff bachelor of Rotterdam, and Cornelia Pluvier [ca. 1626–1711] of Vollenhove bachelorette both living within this city Hoorn" were married in that port on the IJsselmeer in West Friesland, not far north of Amsterdam. Kalf's bride was an accomplished young woman, known for her poetry, calligraphy, and glass engraving, and for composing music and playing the virginal. Her aunt Margarita Pluvier was married to an important merchant of Amsterdam, Johan Le Thor, and the inventory of his estate, made in July 1653, was witnessed by, among others, "Willem Calff, cousin of the house."[2] This is the first mention of the painter in Amsterdam, but it is likely that he and his wife moved there shortly after their marriage. Kalf is cited again in Amsterdam on September 16, 1653, when he, Bartholomeus Breenbergh, Bartholomeus van der Helst, Philips Koninck (q.q.v.), and the local still-life painter Simon Luttichuys (1610–1661) authenticated a landscape painting by Paul Bril (ca. 1554–1626) on behalf of the Delft art dealer Abraham de Cooge.[3]

Kalf must have joined the Amsterdam painters' guild in the early 1650s, but the records for that period are lost. He is cited with Rembrandt, Flinck, Bol, Koninck, Van der Helst (q.q.v.), and other artists who spread the city's fame, in Jan Vos's poem "Zeege der Schilderkunst" (Triumph of Painting), of 1654.[4] In later years, as in 1653, Kalf passed judgment on the authorship of pictures. In 1661, he joined Jacob van Ruisdael, Meyndert Hobbema (q.q.v.), and Allart van Everdingen (1621–1675) in rejecting an attribution to Jan Porcellis (before 1584–1632). He was part of the impressive group of artists who in May 1672 questioned the authenticity of thirteen Italian paintings owned by the art dealer Gerrit Uylenburgh. Among the others present were the still-life specialists Willem van Aelst (1627–in or after 1683), Otto Marseus van Schrieck, and Melchior d'Hondecoeter (q.q.v.), as well as Gerard de Lairesse (q.v.) and a few landscapists. In 1686, Kalf dismissed a "Titian" as a copy.[5]

In a Rotterdam document dated November 14, 1690, "Wilm Kalff, artful painter in Amsterdam," gave up his part of the family grave in the Grote Kerk of his hometown in favor of a nephew. Kalf was buried in the Zuiderkerk, Amsterdam, on August 3, 1693. Later that year, Cornelia Kalf (b. 1662), "youngest daughter" of the artist, and in 1711 Cornelia, his widow, were buried in the same church. Three other children are known from baptismal records, Sophia (b. 1657), Johannes (b. 1660), and Samuel (b. 1664).[6]

In his early years, Kalf painted rustic interiors with still-life motifs, such as the picture discussed below (Pl. 96). These compositions derive in part from works by the Rotterdam artists Pieter de Bloot (1601–1658), Cornelis Saftleven (1607–1681), Herman Saftleven (1609–1685), and Hendrick Sorgh (q.v.), and also by François Rijckhals (shortly after 1600–1647), a Middelburg painter of peasant interiors and still lifes who has been proposed as a possible teacher of Kalf.[7] About sixty works of this type and similar exterior scenes dating from the first half of the 1640s in Paris are known.[8] Also dating from the Paris years are *pronkstillevens* (still lifes of luxurious objects) that depict silver-gilt basins and ewers, silver pilgrim's flasks and candlesticks, fancy glassware, Chinese porcelain, nautilus shells, and so on. In their dark spaces, dramatic illumination, and rich surfaces, these upright compositions could be described as the most Rembrandtesque still lifes ever painted.[9]

A painting dated 1653 (Alte Pinakothek, Munich) shows the Paris type of luxury still life evolved into another phase.[10] The design is now simpler, more classical than Baroque, the palette cooler, and the objects described with greater attention to their own qualities rather than as essays in glitter and reflection. The objects are different as well, with Chinese porcelain,

Dutch and German glassware, silver trays and Oriental carpets playing principal roles, and with lemons, oranges, other fruits, and occasionally a pocket watch as grace notes. The second picture discussed below (Pl. 97) is typical of Kalf's mature work, but other examples are much finer (for instance, *Still Life with Nautilus Cup and Other Objects,* 1662, in the Museo Thyssen-Bornemisza, Madrid),[11] and a few are spectacular (*Still Life with the Drinking Horn of the Saint Sebastian Archers' Guild, Lobster, and Glasses,* of the early 1650s, in the National Gallery, London).[12] Because of Kalf's exquisite handling of light, superficial comparisons of his Amsterdam still lifes with works by Johannes Vermeer (q.v.) have been made. Works by Gerard ter Borch (q.v.) are more analogous in style and content, the latter being a luxurious level of living suggested by gleaming forms in velvety environments. With Van Aelst, Kalf was one of the most successful still-life painters to evoke the world of wealth and taste that thrived in Amsterdam beginning in the 1650s.[13]

1. Grisebach 1974, p. 13, where some shady dealings with the Admiralty of Rotterdam are also mentioned. The entry by L. Grisebach in *Dictionary of Art* 1996, vol. 17, pp. 736–37, is disappointing, and heedlessly edited. For example, it lacks the date of Kalf's baptism, giving only his year of birth, and omits page numbers in the bibliographical entries. However, it greatly improves upon Houbraken 1718–21, vol. 2, p. 171, which has Kalf born in Amsterdam and, implausibly, as taught by the Haarlem artist Hendrick Pot (1580–1657). Although the report that Kalf studied with Pot is dismissed as "highly doubtful" in Grisebach 1974, p. 12 (see also pp. 16, 34–35), it is repeated in J. E. P.

Leistra's entry on Pot in *Dictionary of Art* 1996, vol. 25, p. 363. Giltaijin Rotterdam–Aachen 2006–7, pp. 37–38, suggests reasonably that Houbraken (or his source) mistakenly mentioned Pot but meant Hendrick Sorgh (q.v.) in Kalf's own city.

2. Grisebach 1974, p. 18. The term "cousin" (*cosijn*) means nephew as well as cousin. See ibid., pp. 14–19 for other details in this paragraph, 189–90 for documents, and 199–206 on Kalf's wife and her connection with Constantijn Huygens.

3. Ibid., pp. 20, 190–91, doc. 13. On Luttichuys and Kalf, see Meijer 2003, p. 245.

4. On Kalf's inclusion, see G. Weber 1991, pp. 36–38.

5. See Grisebach 1974, p. 23, on these three occasions of connoisseurship, and London–Amsterdam 2006, pp. 79–101, on the Uylenburgh affair. In 1686, Gerrit and Job Berckheyde were also present.

6. Grisebach 1974, pp. 192–95, for documents dating from 1657 to 1711.

7. This hypothesis was first advanced, at some length, in Bergström 1956, pp. 273–78, and is considered a possibility in Grisebach 1974, pp. 34–36. Grisebach in *Dictionary of Art* 1996, vol. 17, p. 737, inexplicably omits any allusion to Kalf's South Holland associates in favor of a vague reference to French and Flemish sources.

8. See Grisebach 1974, nos. 1–58, figs. 1–62. Several examples have come to light since this monograph appeared.

9. Except, of course, for a few by Rembrandt himself, and by one or two of his pupils. For this type of painting by Kalf, see ibid., nos. 59–70A, figs. 63–78, and Bergström 1956, figs. 218–26.

10. Bergström 1956, pp. 280–82, fig. 227, with outdated location; Grisebach 1974, no. 72, fig. 83.

11. Gaskell 1990, no. 10.

12. MacLaren/Brown 1991, pp. 213–14, inv. no. 6444, pl. 183.

13. On Kalf's mature work, see Bergström 1956, pp. 278–85; Grisebach 1974, chap. 6; and Segal 1989, chap. 10.

96. *Interior of a Kitchen*

Oil on wood, 10½ x 12½ in. (26.7 x 31.8 cm)
Signed (on chest): KALF

The painting has darkened overall, and its visual impact has deteriorated. Horizontal strokes of a warm brown imprimatura applied over the white ground are now visible through the thinned paint film. Much of the background detail, in particular the man tending the cow at left, is barely visible as the thinly applied paint layers with few opaque pigments have become more transparent with age and abrasion. The old woman and the still life at lower right retain more strength of form because they are more thickly painted. The bluish cast of portions of the still life—for example, the cabbage and the leeks—suggests the loss of a yellow glaze from fading or abrasion.

Purchase, 1871 71.69

One of the more modest items obtained in the 1871 Purchase, Kalf's so-called kitchen interior dates from about 1642–44. Although pictures like this one were a specialty of artists in his native city of Rotterdam, Kalf appears to have painted peasant interiors only during the first half of the 1640s, when he was living in Paris.[1]

The interior is a country dwelling in which distinctions such as living and dining areas, and for that matter house and barn, would have been lost on the inhabitants. In the left background, a man is busy with some routine task next to a resting cow. The sky seen through the upper half of the doorway suggests that the day is nearly done. In the foreground a seated woman, looking as worn as the wooden chest beside her, scrapes out a large squash (an earthenware bowl is nearly full). At her feet are a large basket containing a cabbage and, on the ground, a pumpkin, a broken squash, a bunch of chard (or a similar vegetable) bound with a vine, and a few onions and cucumbers. An iron pot hangs over a low flame in the fireplace. On the mantel, a copper-lined cooking pot gleams in what remains of daylight, which must enter from a window or doorway out of view to the left. Two candles hang on the masonry wall next to a niche containing a glass bottle, perhaps of *vin ordinaire*.

The layout of the interior, with its L-shape plan, and such space-defining elements as the sturdy post and beams, the leaning broom, and, as a repoussoir to the left, a washtub and a busted basket conform to a pattern employed during the 1630s by Kalf's Rotterdam colleagues Pieter de Bloot (1601–1658), Cornelis Saftleven (1607–1681), Herman Saftleven (1609–1685),

and Hendrick Sorgh (q.v.); by François Rijckhals (shortly after 1600–1647) in Middelburg; and by David Teniers the Younger (1610–1690) in Antwerp.[2]

Little is known about the market for such inexpensive pictures in seventeenth-century Paris. Considerable speculation has been devoted to the question of who purchased the peasant scenes attributed to Louis Le Nain (ca. 1600–1648),[3] but those pictures (and the scenes of street life painted in Rome by another French artist, Sébastien Bourdon) are not comparable to Kalf's peasant interiors, where the figures are ancillary to the still-life motifs. It is likely that, as in Rotterdam and Antwerp, the main appeal of such works was the way they were painted, with broad but convincing descriptions of natural forms dashed off with no apparent effort in a day or two. Kalf probably sold his Parisian products through a local dealer, to mostly middle-class buyers. At least half the known works of this type are unsigned, and, curiously, there are a good number of contemporary copies.

1. Grisebach, in his lengthly chapter on Kalf's peasant interiors (1974, chap. 4), comes to this conclusion on the basis of a few dated pictures, various motifs (including produce found in France but not the Netherlands), and the absence in seventeenth-century Dutch inventories of paintings by Kalf of this type.
2. See Heppner 1946, Klinge-Gross 1976, and James in Rotterdam 1994–95, pp. 133–41. The last essay overdoes the question of "meaning" (pp. 139–40), with the pietistic printmaker Jan Luyken (1649–1712) dragged in as reinforcement.
3. See Blunt 1999, pp. 175–77.

REFERENCES: MMA 1871, pl. 7; MMA 1872, no. 152, as *Interior of a Dutch Cottage*; MMA 1905, p. 90, no. 5, describes the subject somewhat inaccurately; Bode 1906a, mentioned in Kalf chap.; H. Schneider in Thieme and Becker 1907–50, vol. 19 (1926), p. 465, mentioned; B. Burroughs 1931a, p. 195, spots the cow; Bode 1951, p. 384, mentioned; Grisebach 1974, pp. 43, 71, 81, 228–29, no. 46, pl. 38, mistakenly identifies the comestibles, places the work in a group of pictures dating from about 1643–44, and surprisingly finds similarities in an early Kalf in the State Hermitage Museum, Saint Petersburg; Baetjer 1995, p. 326; Baetjer 2004, p. 220, no. 152, gives provenance.

EXHIBITED: New York, MMA, "The Taste of the Seventies," 1946, no. 29.

EX COLL.: [Léon Gauchez, Paris, with Alexis Febvre, Paris, until 1870; sold to Blodgett]; William T. Blodgett, Paris and New York (1870–71; sold half share to Johnston); William T. Blodgett, New York, and John Taylor Johnston, New York (1871; sold to MMA); Purchase, 1871 71.69

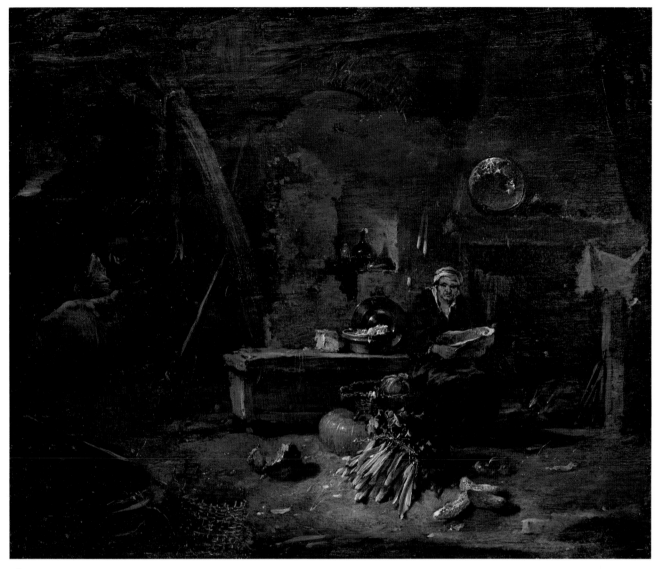

96

97. *Still Life with Fruit, Glassware, and a Wanli Bowl*

Oil on canvas, 23 x 20 in. (58.4 x 50.8 cm)
Signed and dated (lower right): W.KALF 1659.

With age, the entire painting has darkened, the fruits have lost local color, and the tall glass has become more transparent and lost definition.

Maria DeWitt Jesup Fund, 1953 53.111

Of the approximately one hundred fifty paintings by Kalf that are known, about thirty are dated and half of those bear dates falling within a six-year period, 1658–63. Dated works of the Amsterdam years (ca. 1652 onward) include one canvas of 1653, one of 1656, two of 1658, four of 1659 (including the Museum's picture), three for each of the years 1661, 1662, and 1663, and only single examples from the later dates of 1669, 1678, and 16(79?). Thus the present painting comes from the most thoroughly documented period of Kalf's production, when his career was flourishing in the artistic capital of the Netherlands.[1]

The composition, in its clarity, fine balance, and comparative simplicity, is typical of Kalf's style during the second half of the 1650s. The wooden tabletop, below which a baluster leg is visible, recedes to a stone wall, where an arched niche frames the off-center ensemble. As in other works by Kalf, the practical gesture of pushing back the Turkish carpet has purely aesthetic consequences, such as leading the eye into the picture with a soft cascade of folds, which, in their warm tones, furlike texture, and blurred contours, wonderfully foil the crisp edges and cool colors of the Chinese porcelain bowl. The bowl has been set at an artful angle on a superb Dutch silver tray by propping it on a piece of bread. This surprising expedient tends to support the claim made by Kalf's acquaintance Gerard de Lairesse (q.v.), who sympathetically observed that the painter would place precious objects in whatever way he wanted, without considering the logic of their encounter, or the "particular meaning" of the whole.[2]

Between the bread and the slice of lemon, a dark passage leads diagonally from the spiraling lemon peel to the rear corner of the table, where a gleam of golden light has been cast by rays falling through the white wine in the glass. From foot to rim, the *roemer* is a brilliant study in reflections, including an image of the fruit in the foreground, floating near the surface of the wine. A Seville orange, assisted by the distinctive proturberance in its skin, sits on peaches in the bowl, and lifts two brass-colored leaves upward where they fill a void and turn attention to the tall glass. This flute, a *façon de Venise* import or imitation (graceful brackets flare below the cone of red wine), was often used by Kalf, as here, as a centerpost for round forms arranged within a defined compass, and for circular highlights turning in horizontal and tilting planes. Countering this sense of movement, a knife with an agate handle points toward the near corner of the table, where a lemon pit and drops sparkle on the wet surface. A few drops have spilled over the edge, toward the artist's signature.[3]

Kalf had a predilection for depicting Chinese porcelain, and was obviously familiar with a variety of types and individual examples. The Wanli bowl represented in the New York canvas is also found in other paintings by Kalf,[4] and at least four different Wanli bowls, with known designs inside and out, occur in approximately contemporary pictures by the artist.[5] In other works, such as two paintings in the Museo Thyssen-Bornemisza, Madrid, Kalf shows less common pieces, in these cases a Wanli covered bowl with Taoist figures in high relief on the exterior and a tall ewer made for the Persian market.[6] More remarkably, the painter had an extraordinary gift for suggesting the translucent whites and blues of late Ming porcelain, which lend these hard, sharp-edged pieces their mirrorlike depth and evanescence. It has been claimed that Chinese porcelain can be impossible to distinguish from Delftware in Dutch pictures,[7] but mistaking one of Kalf's blue-and-white vessels for earthenware from Delft would be like mistaking a mature painting by Vermeer (Pl. 205 provides the closest analogy within the Museum's collection) for a picture by Pieter de Hooch (q.v.).[8]

1. The observation in A. Davies 1993, p. 71 n. 2, that "fewer than twenty percent" of Kalf's paintings bear dates, with half of those falling between 1658 and 1663, inspired this slightly closer look at the oeuvre catalogue in Grisebach 1974. According to that monograph, the Amsterdam pictures are dated as follows: 1653 (no. 72); 1656 (no. 85); 1658 (nos. 91, 93); 1659 (nos. 94–97); 1661 (nos. 106, 107, 109); 1662 (nos. 115–17); 1663 (nos. 122, 125, 126); 1669 (no. 135); 1678 (no. 138); and 1679? (no. 141).
2. De Lairesse 1740, p. 268. The passage is quoted in Wheelock 1995a, p. 148 n. 10, in a fine discussion of a contemporary still life by Kalf. An eighteenth-century English translation of the same lines is quoted in P. Sutton 1992, p. 103.
3. A facsimile of the signature and date is reproduced in Grisebach 1974, p. 208.
4. As noted in ibid., p. 254 (under no. 94), referring to nos. 81, 82, 88, 89 (figs. 87, 90, 96, 98).

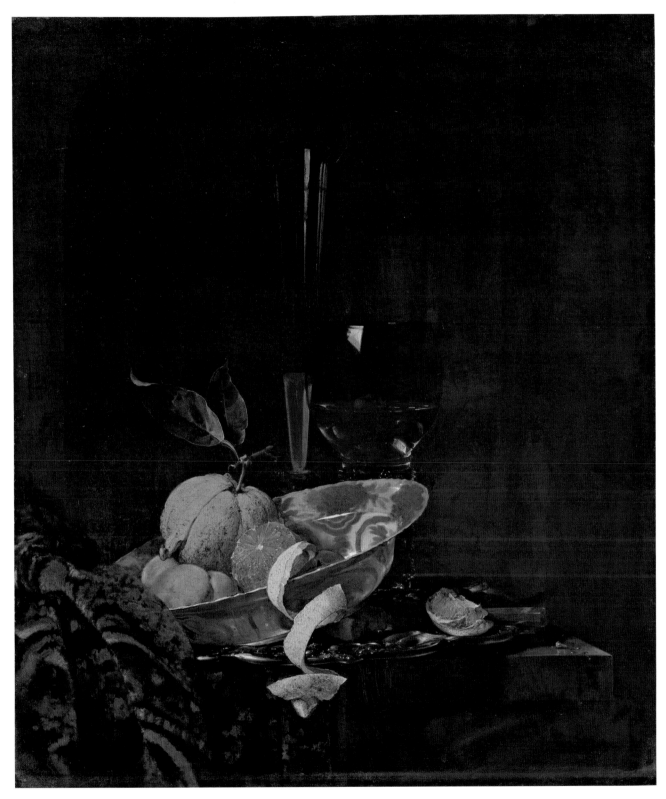

97

5. See, for example, ibid., figs. 88, 89, 102, 120. See the section "Classification of Klapmutsen," in Rinaldi 1989, pp. 118–37. This type of shallow bowl, made for the European market, is named for a woolen cap (*muts*) that one would "clap" on the head.

6. See Gaskell 1990, nos. 10, 11, where the types of porcelain are described on pp. 76 and 80.

7. A. Davies 1993, pp. 68–70. The point is probably taken from the literature of Oriental porcelain. However, in New York 1976–78 (under no. 16, the Museum's Kalf), Lerner observes that "while it is sometimes difficult to distinguish between Chinese, Delft, German, and Japanese blue and white ceramics in seventeenth-century European paintings, here the identification is almost certain."

8. Kalf is often compared with Vermeer, for the most part as a form of praise. A few stylistic comparisons are made in Liedtke 2000a, pp. 191, 207, 209, where the discussion of Vermeer's dark backgrounds in paintings of about 1665–67 (p. 241) might have added Kalf to the artists who are suggested as possible influences.

REFERENCES: Walsh in New York 1971, p. 11 (under no. 22), praises the description of natural objects; Walsh 1973, caption to fig. 26, compares a still-life passage in Vermeer; Grisebach 1974, pp. 114, 115, 122, 130, 147, 156, 158, 254, no. 94, fig. 103, begins discussion of still-lifes painted by Kalf in Amsterdam with this picture, which is compared with other examples that have similar motifs or analogously strict designs (said to be typical of works dating from 1656–59); Lerner in New York 1976–78, no. 16 (and under no. 9), compares a Wanli bowl in the Museum's collection; Hibbard 1980, pp. 349–50, fig. 628, shows "opulence, with some of Vermeer's sensitivity to color and texture"; P. Sutton 1986, p. 190, mentioned; Gaskell 1990, p. 70, notes

that several motifs found in the Museum's picture and a still life of 1660 by Kalf in the Museo Thyssen-Bornemisza, Madrid, appear regularly in his work; Baetjer 1995, p. 326; Meijer 2003, p. 227, finds similar motifs in a still life by Kalf in the Ashmolean Museum, Oxford, including (erroneously) "the same bowl"; Meijer in Rotterdam–Aachen 2006–7, p. 96, fig. 9, suggests the indirect influence on this painting of a composition by Simon Luttichuys, of 1651.

EXHIBITED: Corning, N.Y., The Corning Museum of Glass, "Glass Vessels in Dutch Painting of the 17th Century," 1952, no. 7, as *Nature Morte* (lent by M. Knoedler & Co.); Fort Worth, Tex., Fort Worth Art Center, "An Exhibition of Old Masters," 1953, no. 9 (lent by M. Knoedler & Co.); Indianapolis, Ind., Indianapolis Museum of Art, "Treasures from The Metropolitan Museum of Art," 1970–71, no. 71; New York, MMA, "The Painter's Light," 1971, no. 22; New York, MMA, "Blue & White: Early Japanese Export Ware," 1976–78, no. 16.

EX COLL.: Gräfin von Althann, Austria (?about 1725); by family descent through the eldest daughter in each generation to Martha Freifrau von Schönau-Wehr, née Freiin von und zu Menzingen, Untermünstertal, near Freiburg im Breisgau, Baden (1917–d. 1939);[1] her daughter Hildegard Freifrau von Kittlitz und Ottendorf, Untermünstertal (from 1939); her son Wilhelm Freiherr von Kittlitz und Ottendorf, Freiburg im Breisgau, Baden (until 1950; sale, Pfister, Freiburg im Breisgau, October 25–26, 1950, no. 517); [Otto Wertheimer, Paris, until 1951; sold to Knoedler]; [Knoedler, New York, 1951–53; sold to MMA]; Maria DeWitt Jesup Fund, 1953 53.111

1. The eldest daughters of the family are listed in Grisebach 1974, p. 254 (under no. 94).

THOMAS DE KEYSER

?Amsterdam 1596/97–1667 Amsterdam

The distinguished Amsterdam portraitist Thomas Hendricksz de Keyser was a son of the great Dutch architect and sculptor Hendrick de Keyser (1565–1621). In 1591, Hendrick moved from Utrecht to Amsterdam, where Thomas must have been born. His brothers, Pieter (1591–1676), Willem (1603–1674), and Hendrick II (1613–1665), and his cousin Huybrecht Keyser (1592–1678) were all sculptors, and his sister Maria married the English sculptor and architect Nicholas Stone (1586/87–1647). When the painter married, on July 5, 1626, he was said to be twenty-nine years old.[1]

De Keyser studied architecture with his father for two years, beginning in January 1616. It is not known with whom he apprenticed as a painter, but the most likely candidate is the prominent Amsterdam portraitist Cornelis van der Voort (ca. 1576–1624). The young artist was certainly well aware of his main competitors in the city, especially Werner van den Valckert (ca. 1580/85–ca. 1627) and Nicolaes Pickenoy (q.v.). De Keyser was the most inventive portraitist and the best painter in the group, with the result that many of the finest works by these and other portrait painters active in or near Amsterdam during the 1620s and 1630s (for example, Pl. 136) have been optimistically attributed to him in the past. However, portraits by De Keyser have never been confused with those by Rembrandt, who from 1632 onward became Amsterdam's leading portraitist.[2]

De Keyser is best known for small-scale full-length portraits like the one discussed below (see Pl. 100) and his much admired *Constantijn Huygens and His Clerk,* dated 1627 (National Gallery, London). (The commission to depict the Stadholder's secretary, who lived in The Hague, may have come through the portraitist's brother Pieter, who had projects in the neighboring city of Delft.) In 1632, De Keyser completed a large civic guard picture, *The Company of Captain Allaert Cloeck and Lieutenant Lucas Jacobsz Rotgans,* and, the following year, *The Company of Captain Jacob Symonsz de Vries and Lieutenant Dirck de Graeff* (both in the Rijksmuseum, Amsterdam). Also dating from the 1630s are conventional half-length portraits and a few religious pictures.

In the 1640s, De Keyser was less active as a portraitist and, like his brother Pieter and his brother-in-law in London,

became a dealer in marble and other building stone. It has been noted that many of De Keyser's portraits from this period represent colleagues rather than patrician figures in Amsterdam. Nonetheless, De Keyser was chosen to paint a large history picture, *Ulysses Beseeching Nausicaa,* dated 1652, for the new Town Hall (now Royal Palace) of Amsterdam. Another somewhat unexpected development was De Keyser's late production of equestrian portraits, possibly beginning with that of Pieter Schout, dated 1660 (Rijksmuseum, Amsterdam; a rare case in the genre of a painting on copper), and continuing with *Two Unknown Riders,* dated 1661 (Gemäldegalerie Alte Meister, Dresden), and other examples. In these small versions of an art form that had earlier been reserved for aristocratic clients, the artist reveals a very good understanding of equine anatomy and horsemanship.[3]

A number of De Keyser's portraits, including that of Huygens and a family portrait dated 1652 (Nasjonalgalleriet, Oslo), are remarkable for their genrelike interiors.[4] This approach was hardly unique to the artist, but he was perhaps the most skillful practitioner, especially in the 1620s. With regard to his manner of execution, *A Musician and His Daughter* (Pl. 100) is typical of his work in general, except, of course, for the large-scale group portraits and history pictures. De Keyser describes forms in considerable detail and with a fine eye for textures, color, and tonalities. His figures are often animated, if somewhat stiffly (their angular poses bring lay figures to mind). His enthusiasm for linear perspective is not unexpected for an architect's son, and partly explains the apparent absence of atmosphere in the interior settings.

De Keyser was buried in the Zuiderkerk, Amsterdam, on June 7, 1667.

1. Documents concerning De Keyser's life are printed in A. Adams 1985, vol. 2, pp. 490–528. For the most part, the present biographical sketch follows Ann Jensen Adams's entry in *Dictionary of Art* 1996, vol. 18, pp. 10–11, where Paul H. Rem (ibid., pp. 8, 10–11) briefly discusses the painter's brothers.
2. The best introduction to the city's portrait painters is Amsterdam 2002–3.
3. De Keyser's equestrian portraits are discussed in Oldenbourg 1911, pp. 61–65, and in Liedtke 1989b, pp. 82, 101 n. 27, 298, pl. 180. The known examples are listed in Leeuwarden–'s Hertogenbosch–

Assen 1979–80, p. 111 (no. 162, a canvas formerly in the Metropolitan Museum, was deaccessioned because of its condition; no. 159, said to date from the 1630s, is not by De Keyser).

4. On the portrait of Huygens and his (?) clerk, see MacLaren/

Brown 1991, pp. 215–17. The Oslo family portrait was originally painted by De Keyser in 1639, and revised by him in 1652. On the picture's two states, see Laarmann 2002, pp. 43–44, figs. 10, 11.

98. *Portrait of a Man with a Shell*

Oil on wood, 9½ x 6⅞ in. (24 x 17.5 cm)

There is some abrasion in the man's jacket and hat and in the upper left background, but overall the portrait is well preserved.

From the Collection of Rita and Frits Markus, Bequest of Rita Markus, 2005 2005.331.5

This picture and its pendant, *Portrait of a Woman with a Balance* (Pl. 99), which is catalogued below, were acquired separately by Mr. and Mrs. Frits Markus. The paintings are certainly by De Keyser and probably date from about 1625–26.

In a composition reminiscent of Italian Renaissance and Early Netherlandish portraits, the man holds a seashell in the foreground, where it appears to sit on the edge of the picture's frame. His fingers follow the curve of the shell and precisely fill the corner of space to the lower right. The patron has had himself presented by the artist as a collector of shells, which at the time was a common pastime of gentlemen who took an interest in rarities of nature.[1] The shell is a South African turban (*Turbo marmoratus*), an Indo-Pacific shell that is about three to five inches in diameter and becomes pearly white when polished.[2]

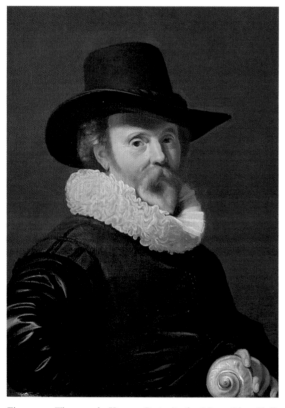

Figure 95. Thomas de Keyser, *Portrait of a Man with a Shell* (Pl. 98)

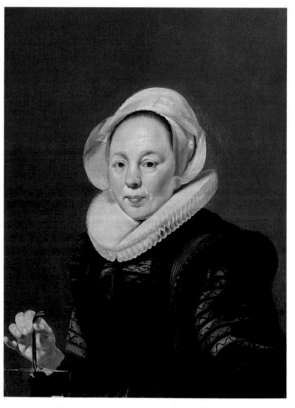

Figure 96. Thomas de Keyser, *Portrait of a Woman with a Balance* (Pl. 99)

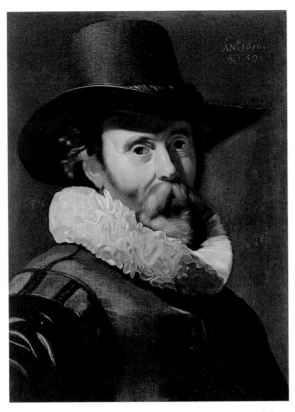

Figure 97. Thomas de Keyser, *Portrait of a Man*, 1626. Oil on wood, 9½ x 6⅞ in. (23.5 x 17.5 cm). Private collection, Switzerland

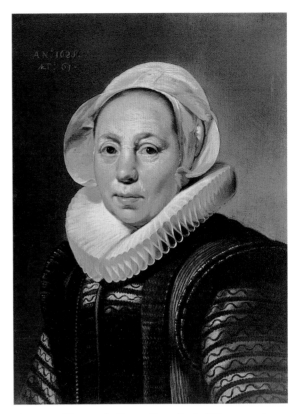

Figure 98. Thomas de Keyser, *Portrait of a Woman*, 1628. Oil on wood, 9½ x 6⅞ in. (23.5 x 17.5 cm). Private collection, Switzerland

Figure 99. Thomas de Keyser, *Portrait of a Man with a Ruff*, ca. 1626. Oil on copper (octagonal), 9⅞ x 7½ in. (25.1 x 19.1 cm). Allentown Art Museum, Allentown, Pennsylvania, Bequest of Mrs. Eugene L. Garbáty, 1993

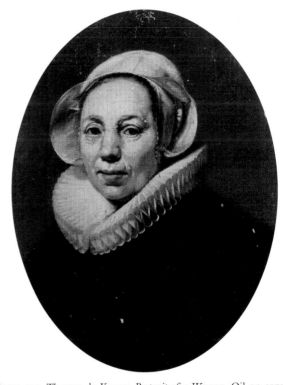

Figure 100. Thomas de Keyser, *Portrait of a Woman*. Oil on copper (oval or possibly octagonal), 9⅞ x 7¾ in. (25 x 19.5 cm). Formerly collection of Adolphe Schloss; seized by the Nazis in 1943

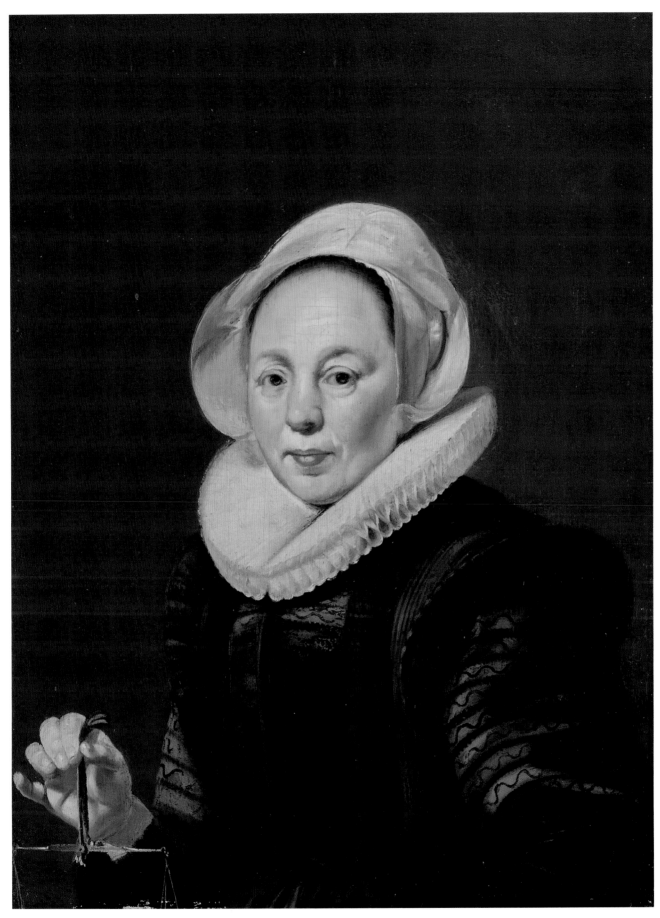

99

There are a few immediate precedents for portraits of Dutchmen as shell collectors. The best known is the *Portrait of Jan Govertsz van der Aar,* dated 1603 (P. and N. de Boer Foundation, Amsterdam, on loan to the Museum Boijmans Van Beuningen, Rotterdam), by Hendrick Goltzius (1558–1617).[3] Van der Aar (1544/45–1612) was a merchant who lived in Haarlem and invested in the East India Company (VOC), the likely source for his shells. Michiel van Miereveld (q.v.), in about 1606, painted a portrait of an old man with a shell (Royal Collection, Hampton Court), where the single specimen is an Indian volute.[4] *Neptune and Amphitrite* (P. and N. de Boer Foundation, Amsterdam), painted about 1616–17 by Cornelis Cornelisz van Haarlem (1562–1638), is said by at least one scholar to represent actual persons, and shows the sea god displaying a variety of shells like a collector in his cabinet.[5]

Two other versions of the present portrait are known, and two other versions of its pendant. In 1997, Otto Naumann, who earlier had the Markus pictures, brought to the Museum for direct comparison another pair of portraits of the same sitters (figs. 97, 98). Those paintings are on wood panels of the same size and present the sitters in the same way, but they appear about forty percent larger in the picture field, bust-length, without hands and attributes. The man's portrait is inscribed at the upper right, "An.° 1626/AET 59," and the woman's portrait is inscribed at the upper left, "An.° 1628./AET: 61."[6] Also brought in for examination on the same occasion was the third known version of the man's portrait (fig. 99), which was given to the Allentown Art Museum in 1993.[7] The Allentown painting, which is on an octagonal copper support,[8] is signed "TDK" in monogram.[9]

There was a general consensus among the two museum scholars and four art dealers present that all five paintings were probably by De Keyser himself.[10] The execution in the Markus pictures is smoother than in the Naumann versions, which have many short brushstrokes and more vivid coloring. This appears consistent with the difference in scale of the figures, which are similar in other respects, such as their sense of volume, tonalities, drawing of contours and details (in the facial features as well as in the costumes), and so on. The group hypothesized that the Markus portraits were painted first. There is no indication that they were derived from any of the other versions, which lack the attributes. Some pentimenti are visible in the Markus pictures (for example, in the woman's bonnet and proper right shoulder). The expression of the woman appears somewhat more serious in the Markus version, and in the same woman's portrait on copper (fig. 100; see the entry below). It also seemed to those present in 1997 that the

Allentown picture and its putative pendant (which was unknown from publications at the time) probably preceded the Naumann portraits, given the more impressive quality of the painting on copper and the choice of that support. However, Ann Adams is inclined to place the Allentown painting first, in view of its characteristic signature and its closeness in execution to indisputable works.[11] This view accords with that of Rudolf Oldenbourg in 1911 (see Refs.), who evidently knew the Allentown version firsthand (it was then in the collection of A. de Ridder, Schönberg, Cronberg, near Frankfurt am Main), and knew the Markus version (then in New York, and already separated from its pendant) only from a photograph. Of course, other versions of both portraits might be missing and preparatory drawings may have been employed. It was not unusual for Netherlandish portraitists to supply multiple versions of portraits to patrons, so that different members of their family might have them.

The dates and ages inscribed on the Naumann portraits indicate that both sitters were about fifty-nine years old in 1626. The present pair of portraits was probably painted in 1626 or slightly earlier.

1. On shell collecting in the Netherlands during the seventeenth and eighteenth centuries, see Coomans 1992. In the literature of art, shell collectors are often called conchologists, which incorrectly equates them with scholars specializing in that branch of zoology.
2. See Amsterdam 1992a, no. 64, and Coomans 1992, p. 201, fig. 172, for a *turbo* of this type, engraved in the seventeenth century with four rows of sea, air, and land creatures. The shell in this painting has been incorrectly described in earlier literature as a nautilus shell (see Refs.).
3. Amsterdam–New York–Toledo 2003–4, no. 104.
4. On the painting, see White 1982, p. 74, no. 105, pl. 89.
5. Nichols in Amsterdam–New York–Toledo 2003–4, p. 330 n. 115, where the portrait by Van Miereveld is also mentioned. *Neptune and Amphitrite* is catalogued in Van Thiel 1999, pp. 350–51, no. 147, pl. 227, where the question of portraiture is left in the air.
6. The Naumann portraits, as they are called here, were purchased at Sotheby's, London, July 5, 1995, no. 295, and sold in 1998 to Bert van Deun (d. 2004), who lived in Oberägeri, Switzerland.
7. Bequest of Mrs. Eugene L. (Marie Louise) Garbáty, 1993 (acc. no. 93.25.6). The painting was owned by the comte de Montbrison, Château Saint-Roch, according to the collection catalogue (Bode 1913, pl. 14) of its next owner, August de Ridder, Schönberg, near Cronberg in the Taunus (his sale, Paris, June 2, 1924, no. 35). It was later sold by Lange, Berlin, to Mr. and Mrs. Garbáty, of Berlin and later New York and East Norwalk, Connecticut. See Hartford 1957, no. 26.
8. At the time of comparison it was thought that the copper support, which is cut at the corners, might have originally been rectangular. But the same shape, a tall octagonal, was used for De Keyser's pendant portraits of a man and a woman, dated 1631

and 1634, respectively, in the collection of Stockholm University. See Karling 1978, pp. 146–49, nos. 53, 54 (ill.).

9. The painting is catalogued, with a facsimile of the monogram, in Oldenbourg 1911, p. 96, no. 50. The monogram is also reproduced in Bode 1913, opp. pl. 14.

10. The group included the present writer; Peter Blume, then director of the Allentown Art Museum; and art dealers Otto Naumann, Rachel Kaminsky, Larry Steigrad, and Peggy Stone.

11. Ann Adams, personal communication, May 2005.

REFERENCES: Oldenbourg 1911, pp. 21, 84, no. 98, pl. IV, describes the painting, then in New York, as "an apparently autograph replica" of the version on copper (now in the Allentown Art Museum, Allentown, Pa.), but in an expanded view ("in weiterem Ausschnitt"); A. Adams 1985, vol. 3, pp. 19–20, no. 5, describes the work as a copy; Nichols in Amsterdam–New York–Toledo 2003–4, p. 330 n. 115,

refers to this picture by "de Keyser" as *A Conchologist Holding a Nautilus Shell,* in connection with Goltzius's *Portrait of Jan Govertsz van der Aar* (see text above).

EX COLL.: Edward R. Bacon, New York (by 1911; d. 1915);[1] [J. Goudstikker, Amsterdam (by 1926)]; E. A. Veltman, Bloemendaal, the Netherlands; Frits Lugt, The Hague; [Alfred Brod, London (in 1955)]; private collection (sold, Christie's, London, December 10, 1993, no. 271, to Naumann); [Otto Naumann Ltd., New York, 1993–94 (sold to Markus)]; Frits and Rita Markus, New York (from 1994); From the Collection of Rita and Frits Markus, Bequest of Rita Markus, 2005 2005.331.5

1. The Museum owns a portrait of Edward R. Bacon (1846–1915), dated 1897, by Anders Zorn (1860–1920). See Baetjer 1995, p. 240.

99. *Portrait of a Woman with a Balance*

Oil on wood, 9⅛ x 6⅞ in. (23 x 17.4 cm)

The painting is well preserved, although the woman's face is slightly abraided.

From the Collection of Rita and Frits Markus, Bequest of Rita Markus, 2005 2005.331.6

This painting from the Markus collection and its pendant, *Portrait of a Man with a Shell* (Pl. 98), are discussed in the entry above. It is suggested there that the portraits date from about 1625–26. A second version of the present picture (fig. 98) is inscribed "An.º 1628./AET: 61," but its pendant (fig. 97) is dated 1626. The difference in date is not exceptional in pendants by De Keyser.[1]

A third version of the woman's portrait (fig. 100), on an oval (or possibly octagonal) copper support, became known in 1998 when it was published in a catalogue of paintings missing from a French collection that was seized in World War II.[2] That painting appears to be the lost mate to the *Portrait of a Man* in Allentown (fig. 99). The relationship between the three pairs of pendant portraits is discussed in the preceding entry.

When the De Keyser specialist Ann Adams published the Markus painting in 1988 (see Refs.), its pendant and the second (Naumann) versions of the two portraits were unknown.

Adams suggested a dating to the early 1630s, based on De Keyser's small pendant portraits in the collection of the University of Stockholm (dated 1631 and 1634), and on two larger portraits in the Musées Royaux des Beaux-Arts de Belgique, Brussels, one of which was previously said to be dated 1634. However, the women's costumes in the Stockholm and Brussels portraits are outdated, and the evidence favoring a mid-1620s date for the Markus paintings appears to be indisputable.

The object in the woman's hand is a balance or scale, of a type usually used for weighing gold and silver coins. That the object is only partially seen is sufficiently explained by the composition's formal relationship to the pendant portrait. As in genre paintings of the sixteenth and seventeenth centuries, such as Jan van Hemessen's *A Girl Weighing Gold,* of about 1530–35 (Gemäldegalerie, Berlin), and Vermeer's *Woman with a Balance,* of about 1663–64 (National Gallery of Art, Washington, D.C.), the balance symbolizes the virtue of temperance.[3] In Dutch pendant portraits of the period, it is not uncommon for an attribute in a portrait of a man to refer to his profession or intellectual interests, while a motif in the female portrait refers to a virtue especially expected of wives.

1. See the preceding entry, note 8, on De Keyser's pendant portraits in Stockholm, which are dated 1631 and 1634.

2. Schloss Collection 1998, p. 96. It is stated there that the portrait was attributed to the Haarlem school in the 1943 inventory of the Schloss collection (no. 313), but was ascribed to De Keyser in the will of Schloss's widow, Lucie. The identification of the sitter as "Mme Gracht née Broetmans" is based on a comparison with a portrait once thought to be by De Keyser (Oldenbourg 1911, no. 76, pl. XXI), and is certainly wrong. Like several other paintings seized from the Schloss collection, the De Keyser portrait was sold to a certain "Buittenweg" after 1943. It has been conjectured that the pseudonym refers either to the art historian Vitale Bloch (see discussion for Pl. 207) or, less plausibly, to J.-F. Lefranc, a French dealer and collaborator in the Nazi seizure of the Schloss collection. Bloch served as an assistant to Erhard Göpel, who was an official of Hitler's museum in Linz and his buying agent in the Netherlands (Schloss Collection 1998, p. 5 n. 5). It may be significant that Bloch left one of the Schloss pictures, Dirck van Delen's *Tulip in a Chinese Vase,* dated 1637, to the Museum Boijmans Van Beuningen, Rotterdam (Gemar-Koeltzsch 1995, vol. 2, p. 279).

3. Both paintings are discussed by the present writer in New York–London 2001, pp. 383–86 (under no. 73). P. Sutton (see Refs.) supports this interpretation, citing different precedents.

REFERENCES: A. Adams in New York 1988, pp. 61 (ill.), 77, no. 28, dates the picture to the early 1630s and suggests that the balance "may allude to the ideals of restraint by which the young [?] woman leads — or would like the viewer to believe she leads — her life"; P. Sutton in Boston 1992, p. 76, no. 76, pl. 25, describes the costume, and supports the interpretation of the balance as an attribute of temperance.

EXHIBITED: New York, National Academy of Design, "Dutch and Flemish Paintings from New York Private Collections," 1988, no. 28; Boston, Mass., Museum of Fine Arts, "Prized Possessions: European Paintings from Private Collections of Friends of the Museum of Fine Arts, Boston," 1992, no. 76.

EX COLL.: Private collection, the Netherlands; [K. W. Bachstitz, The Hague (1926–at least 1940)]; Von Pannwitz collection, Heemstede, the Netherlands; [Otto Naumann Ltd., New York (in 1988; sold to Markus)]; Frits and Rita Markus, New York (from 1988); From the Collection of Rita and Frits Markus, Bequest of Rita Markus, 2005 2005.331.6

100. *A Musician and His Daughter*

Oil on wood, 29½ x 20¾ in. (74.9 x 52.7 cm)
Signed and dated (upper right, on lintel): TDK [in monogram] 1629

The painting is well preserved. Slight abrasion has occurred in the deep black passages of the musician's costume, and there is paint loss along a vertical split in the panel extending from between the figure's legs to the floor.

Anonymous Gift, 1964 64.65.4

This picture, dated 1629, is one of several small-scale full-length portraits that De Keyser painted in Amsterdam during the late 1620s and early 1630s. In each case, the figures are set in a contemporary interior. At least four of them show a man with a child, and in two instances it is obvious that he is the child's father. The Museum's painting has been variously interpreted (see Refs.), but it is concluded here that the man is indeed the girl's father and moreover that he is an amateur musician not a professional music teacher.

The two figures are richly dressed in what might be described as the latest conservative fashion. Especially stylish are the man's shoes and white gloves, one of which is on the table. To the modern viewer it might appear that a man wearing a hat, a mantle over one shoulder, and a glove must have just come indoors, but many contemporary pictures, including De Keyser's *Constantijn Huygens and His Clerk,* dated 1627 (National Gallery, London), show that this is not the case. The young lady, who is perhaps ten or eleven years old, is dressed in a manner that is entirely consistent with what a wealthy woman twenty years older might wear. She is dressed in a black bodice and skirt over a green blouse and underskirt, all beautifully embroidered. Her lace collar and cuffs, and the white-feathered fan, are the equal, for the late 1620s, of what one finds in Rembrandt's *Portrait of a Young Woman with a Fan,* dated 1633 (Pl. 146), except that the gold chain securing the fan to the girl's waist rather exceeds expectations. She wears a considerable amount of jewelry, including pearl pendants attached to her cap, a gold chain gathered below the collar, and a gold bracelet on each wrist. Her hands are oddly mature.

The interior, although spare, makes a similarly grand impression. The high room is paneled and framed in a classicist style which recalls that of the artist's father (see the biography above) but is actually more up-to-date, like Salomon de Bray's

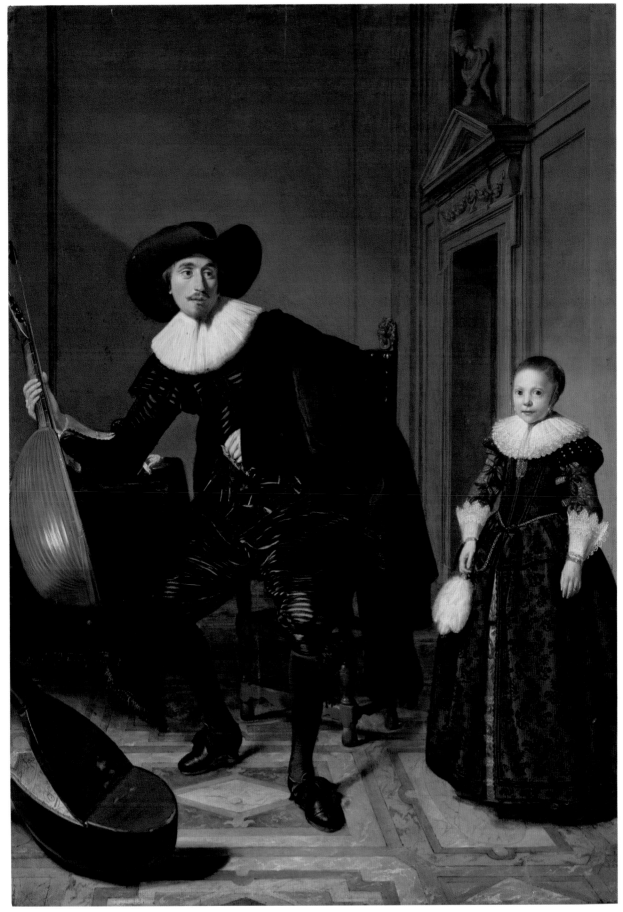

palace designs of the same year, 1629.[1] The faux-marble floor is extravagantly patterned and, like the more tamely "tiled" (painted) or bare wooden floors that he depicted in other portraits of the period, illustrates De Keyser's usual exaggeration of receding space. This design idea, which probably reflects the painter's early exposure to architectural drafting, complements the angular poses and arbitrary proportions (long limbs and short torsos) that he assigned to portrait patrons. The drawing of the lute (technically, a theorbo) and especially of the open lute case is also a demonstration of skill in the use of linear perspective.[2] For historians of musical instruments the lute case is something of a curiosity, at least with regard to its lining with paper decorated with drawn or printed images.[3] De Keyser deftly describes the case's construction and worn leather covering. His handling of fabrics, wood surfaces, and so on suggest that he could have pursued a career as a still-life painter.

Other artists of the day, including De Keyser's Amsterdam predecessor Cornelis van der Voort (ca. 1576–1624), set full-length portraits in contemporary interiors, a trend partly indebted to English court portraiture.[4] However, this approach and another comparatively new concept in Northern European portraiture, that of presenting figures in transitional poses, were employed more consistently by De Keyser than by any other Dutch portraitist of the 1620s.[5] The most striking examples include the portrait of Huygens, dated 1627 (mentioned above); the Museum's picture and *Portrait of a Gentleman Seated at a Table* (art market, 2005), both dated 1629;[6] *Portrait of a Silversmith,* dated 1630 (art market, 2002);[7] and *Portrait of a Gentleman and His Son,* dated 1631 (Norton Simon Museum of Art, Pasadena), where both figures stand by a table.

The man in the last work was repeated by De Keyser in *Portrait of a Gentleman and His Daughter* (art market, New York, 1997).[8] The room is different and the child is perched on a table, but the man and his costume are the same. The two paintings are certainly not pendants: the Pasadena picture is on canvas (25 x 19¼ in. [63.5 x 48.9 cm]), and the undated (slightly later?) portrait is on a smaller sheet of copper (19¾ x 16½ in. [50 x 42 cm]). Nothing suggests that the man is a widower (his flashy costume speaks against it), and the two works together reveal that he had more than one child. Other portraits of children with their father alone were painted in the northern Netherlands. For example, a "North Holland" portrait, dated 1624, by an unknown Dutch painter (the panel is signed "M.D.W.") shows a father walking with three children on a country road.[9] Jan van Ravesteyn's *Portrait of Pieter van Veen and His Son and Clerk,* of about 1615 (Musée d'Art et

d'Histoire, Geneva), is a more important antecedent of De Keyser's work.[10]

In her dissertation, Adams (see Refs.) proposed a narrative that might explain the man's action in the Museum's picture, which she then considered De Keyser's "strangest work." But comparisons with approximately contemporary portraits by the artist suggest that the man's pose is not so exceptional, and that reading any narrative into the picture may be inappropriate.[11] As in other portraits of seated men by De Keyser, the combination of a tall chair and an accelerated perspective recession results in what looks like a nearly standing pose, but the man here is firmly seated with his right elbow resting on the table. The lute is his attribute as an amateur musician, and as a gentleman who could afford a costly instrument.[12] The girl is probably too young to play it (smaller ones were available), and if De Keyser's idea was a music lesson, her pose is, by his own standards, an opportunity missed. The father could be described as setting an example rather than providing instruction, through his interest in one of the liberal arts. A similar image of a father as role model rather than pedagogue is found in Jan Steen's *A Burgher of Delft and His Daughter,* of 1655 (Rijksmuseum, Amsterdam).[13] The bust over the doorway, if it represents Minerva, would support this interpretation. The goddess was often depicted as a patroness of learning and of the arts.[14]

1. That is, De Bray's designs for the Huis te Warmond, which were drawn in 1629 and copied by Pieter Saenredam in 1632. See G. Schwartz and Bok 1990, pp. 103, 287, no. 176, fig. 113. Also illustrated in J. W. von Moltke's entry on De Bray (1597–1664) in *Dictionary of Art* 1996, vol. 4, pp. 701–2, where the Saenredam drawing is incorrectly captioned as by De Bray himself, and absurdly said to be for "the rebuilding of the Stadhuis, Haarlem."

2. See the discussion of foreshortened lutes as a standard perspective problem in Liedtke 2000a, pp. 57–58.

3. A fair number of lute cases from the period survive, and are usually lined with fabric. The cheaper lining here, and the battered exterior, may indicate that De Keyser used an actual model. The theorbo is in the lute family; compare the theorbo-lute in the painting by Ter Borch in the Altman Collection (Pl. 15). Kenneth Moore, curator in charge, Department of Musical Instruments, kindly discussed the De Keyser portrait with the present writer in May 2005.

4. As in the pendant portraits of Lord and Lady Arundel (1618) by Daniël Mijtens (q.v.). See also Van der Voort's portraits of Laurens Reael and his wife (Rijksmuseum, Amsterdam); *Portrait of a Girl,* 1623, by Paulus Moreelse (q.v.; National Gallery of Ireland, Dublin; Haarlem–Antwerp 2000–2001, no. 21); *Eva Wtewael,* 1628, by Joachim Wtewael (q.v.; Centraal Museum, Utrecht; Haarlem–Antwerp 2000–2001, no. 4); and the remarkable Merry Company with a young couple's portrait, painted in

1620 by the otherwise unknown Isack Elyas (Rijksmuseum, Amsterdam; Haarlem 1986a, no. 1). There is, of course, a connection with contemporary genre painting, such as the Merry Companies that Dirck Hals (q.v.) painted in collaboration with the architectural painter Dirck van Delen (1604/5–1671) during the late 1620s in Haarlem.

5. On Rembrandt's use of "fleeting posture" in the early 1630s, see the discussion of his *Portrait of a Man at a Writing Desk*, 1631 (Hermitage, Saint Petersburg), in *Corpus* 1982–89, vol. 2, p. 127 (under no. A44), where the Museum's *Portrait of a Young Woman with a Fan*, dated 1633 (Pl. 146), and its pendant (fig. 141 here) are also cited. The authors downplay the assumption of Flemish influence, made by earlier scholars "on the evidence of Rubens' *Portrait of Gevartzius* [Gevartius] in Antwerp," but the key figure to consider is Anthony van Dyck, as seen in the Museum's *Portrait of Lucas van Uffel*, which dates from the early 1620s (Liedtke 1984a, pp. 56–64, pl. 26; Barnes et al. 2004, pp. 209–10, no. II.70). On this question, see also Dickey 2004, pp. 24–27.

6. Sotheby's, New York, January 27, 2005, no. 173. The man, evidently a cloth merchant, responds to the viewer as he stamps a letter or document.

7. Christie's, London, June 14, 2002, no. 593.

8. With Newhouse Galleries, New York, in 1997, and later with Otto Naumann Ltd.

9. Laarmann 2002, pp. 71, 73, fig. 28 (private collection).

10. For this work and De Keyser's full-length *Portrait of a Man*, dated 1634, in the same collection, see Oberlin and other cities 1989–90, pp. 8, 10, fig. 7, and pp. 66–67, no. 19. The originality of the composition by Van Ravesteyn is discussed in Haak 1984, pp. 217–18, fig. 456.

11. On a visit to the Museum in March 1971, Julius Held remarked that the man "probably is *not* giving a lesson" (to quote from John Walsh's note in the curatorial files). Ann Adams now considers the figures to be father and daughter (personal communication in May 2005). The man appears to reach with his right hand into a small bag or purse, which the present writer is unable to explain.

12. See the remarks about Huygens and his musical instruments in Liedtke 2000a, p. 66.

13. See New York–London 2001, no. 58. The sitters are now identified as Adolf Croeser and his daughter Catharina; see Grijzenhout and Van Sas 2006. As a portrait type, the canvas by Steen more closely resembles yet another De Keyser depicting a father and one child, his *Frederick van Velthuysen and His Son, Dirck*, dated 1660 (Amir Pakzad collection, Hannover; Devapriam 1990, p. 713, fig. 40). In that painting, education is indeed an issue, since the father hands the boy a book.

14. Compare Rubens's *Education of Maria de' Medici* (Louvre, Paris), where Minerva teaches the princess to write and Apollo plays a viol. If the girl in De Keyser's portrait appeared to be learning something, then Minerva could be construed as her guide. But the bust over the doorway seems more of a household saint, and the sort of decoration an amateur musician might have.

REFERENCES: Oldenbourg 1911, p. 73, no. 32, knows the painting ("owner not known") from its inclusion in a Berlin exhibition of 1890; Huyghe 1964, p. 255, no. 620 (ill.); Virch 1970, p. 12, gives basic information about provenance and literature; Bénézit 1976, p. 206, lists the work as in the 1935 sale (see Ex Coll.); A. Adams 1985, vol. 1, pp. 149–51, considers the picture De Keyser's "strangest work," discusses the "odd hunched over pose" at some length, concludes that it conforms to "seventeenth-century ideals of grace in deportment," and that the man with the "cittern" is not the girl's father but an amateur musician, perhaps a family friend who gave the young lady lessons in playing the instrument, vol. 3, p. 53, no. 24, gives information on provenance, exhibition history, and references in literature; P. Sutton 1986, p. 184, maintains that the painting is "presumptuously titled *The Musician and His Daughter*"; P. Sutton in The Hague–San Francisco 1990–91, p. 105, mentions the work as part of an anonymous gift made to the Museum in 1964; Trnek 1992, pp. 198, 200, fig. 66a, considers the anonymous painter of a Merry Company in Vienna to have based his interior on the type of composition represented by the Museum's picture; Liedtke in New York 1992–93, p. 102 n. 5, cites the work as "a composition that sets the Lille picture [attributed to Pieter Codde] in a broader context," with respect to the description of interior space; Baetjer 1995, p. 307; Liedtke in New York–London 2001, p. 345, compares the portrait with Jan Steen's *A Burgher of Delft and His Daughter* (now in the Rijksmuseum, Amsterdam) as an image of "a commendable parent, setting an example for his child"; Van der Waals in Rotterdam 2006, p. 19, fig. 16, and frontis. (detail), notes how prints have been used to line the lute case.

EXHIBITED: Berlin, 1890 (according to Oldenbourg 1911; see Refs.).

EX COLL.: [Nikolaus Steinmeyer, Cologne, until 1911; sold to Kleinberger]; [Kleinberger, Paris, 1911–12; sold to Knoedler for FFr 55,000]; [Knoedler, New York and London, 1912–20; sold to Antik]; [A. B. Antik, Stockholm, from 1920]; Osborn Kling, Stockholm (by 1928–35; his sale, Christie's, London, June 28, 1935, for £483 to Cumming); [Galerie Sanct Lucas, Vienna, in 1935/36; sold to private collection, Vienna]; private collection, Vienna, and later Greenwich, Conn. (1935/36–64; seized in Paris by the Nazis, held at Munich collecting point and restituted; given by owner to MMA); Anonymous Gift, 1964 64.65.4

PHILIPS KONINCK

Amsterdam 1619–1688 Amsterdam

Philips Aertsz Koninck was born on November 5, 1619, in Amsterdam,[1] where his father, Aert de Koninck, was an affluent goldsmith. Of the artist's five older brothers, Jacob (ca. 1614/15–after 1690) was also a painter; Philips studied with him in Rotterdam between 1637 and the end of 1639.[2] "Heads" (*tronies*) by both Jacob and Philips were listed in the inventory of their father's estate (April 1639).[3] History pictures, portraits, and genre scenes by Philips date from 1642—a Rembrandtesque *Bathsheba Receiving David's Letter* is inscribed "Amstellendam/A° 1642"[4]—until 1674, when he painted two of his several portraits of the aged poet Joost van den Vondel.[5] Most of Koninck's known figure paintings are rather awkward and inexpressive, although the *Self-Portrait with an Antique Bust,* of 1661 (Uffizi, Florence), is an appealing work.[6] Today only specialists are familiar with pictures by Koninck that represent subjects other than landscape, but Vondel, in a few poems,[7] and Arnold Houbraken, in his brief remarks on the painter, mention only portraits and mythological and allegorical pictures.[8]

On January 1, 1641, Koninck was married in Rotterdam to Cornelia Furnerius,[9] sister of the young Rembrandt pupil Abraham Furnerius (ca. 1628–1654). In April of the following year the artist, already a widower, was recorded as living on the Keizersgracht in Amsterdam.[10] Houbraken calls Koninck a pupil of Rembrandt's, but it is doubtful that this was a formal relationship.[11] The figure paintings dating from the 1640s are less reminiscent of Rembrandt than of minor Rembrandt followers such as Salomon Koninck (1609–1656), who was apparently Philips's cousin or otherwise related to him.[12]

The earliest known dated landscape painting by Philips Koninck is the *Landscape with Travelers,* of 1647 (Victoria and Albert Museum, London).[13] The Metropolitan Museum's small canvas *Wide River Landscape* (Pl. 101) probably dates from the late 1640s, and the large *Panoramic Landscape with a Country Estate* (Pl. 102) is dated 164[9?]. These and other early landscape paintings by Koninck reveal the influence of Rembrandt's landscapes dating from about a decade earlier, and also that of the moody panoramas painted by Hercules Segers (1589/90–1633/38) about 1625–35. The same painters of imaginary landscapes influenced Roelant Roghman (1627–bur. Jan. 3, 1692)

and Johannes Ruischer (ca. 1625–after 1675), and it seems likely that the latter artists and Koninck came to appreciate Segers's work largely through the eight examples in Rembrandt's collection and through Rembrandt's eyes.[14]

Koninck must also have been aware of Jan van Goyen's views of extensive lowlands that date from about 1644–47 (see Pl. 50). Van Goyen's nearly contemporary pictures remind one that Koninck's sweeping landscapes, however innovative, date from a period in which Dutch landscape paintings in general became more spacious, more colorful, and often more monumental, with high skies and magnificent clouds conveying the impression that the new nation's distinctive topography had its own kind of majesty.

Koninck is not recorded in Amsterdam between 1642 and 1653,[15] but in these years he obviously was in contact with Rembrandt and a number of his pupils, such as Heyman Dullaert (1636–1684; Koninck's portrait of Dullaert is in the Saint Louis Art Museum) and Furnerius, whose family was cited several times in connection with Koninck in the 1650s and 1660s.[16] On May 15, 1657, in Rotterdam, Koninck married a widow, Margaretha van Rijn, who was not related to Rembrandt.[17] However, in 1667, Koninck and Gerrit Uylenburgh (the son of Rembrandt's former agent) were recorded together as judging a work attributed to Adriaen Brouwer (1605/6–1638),[18] and there are other documents indicating that Koninck was well known in Rembrandt's circle of artists, dealers, and patrons.

Koninck had one son from his first marriage, and at least five children from his second marriage survived beyond infancy. The family lived successively in various houses on Amsterdam's main canals and evidently prospered, probably for the most part because of the artist's and his wife's investments in canal boats operating between Amsterdam and other cities.[19] It is not clear whether this business helps to explain Koninck's apparent inactivity in later years; no painting by him is known to date from after 1676 (see fig. 103).[20] Koninck was buried in the Nieuwe Kerk, Amsterdam, on October 6, 1688, leaving his wife (d. 1703) with many fine household possessions, including several of his landscapes and two portraits of Vondel.[21] About two hundred and fifty paintings, nearly three hundred drawings,[22] and seven or eight etchings are known.[23]

1. According to Houbraken 1718–21, vol. 2, p. 53; Gerson 1980, p. 82, doc. 2.

2. Jacob Koninck was paid on January 2, 1640, for instructing Philips for a half year, which Gerson considers to have been the end of his tuition (Gerson 1980, pp. 8, 84, doc. 7d; see also A. D. de Vries 1883c, p. 306). On Jacob Koninck, see Sumowski 1983–[94], vol. 3, pp. 1516–17. After spending some time in Dordrecht, Jacob lived in Rotterdam (1637–45), The Hague (cited there in 1647 and 1648), Amsterdam (recorded 1652 and 1659), and Copenhagen (ca. 1676–1690 or later). Today only some landscape paintings and landscape drawings are known (see Sumowski 1983–[94], nos. 992–1001, and Sumowski 1979–95, vol. 6, pp. 2883–2943).

3. Gerson 1980, p. 83, doc. 5.

4. Ibid., p. 117, no. 140, as *Vertumnus and Pomona (?)*; Sumowski 1983–[94], vol. 3, no. 1002, correctly as *Bathsheba Receiving David's Letter* (location unknown).

5. Gerson 1980, pp. 125–26, nos. 222, 226; see also nos. 220, 221 (1665), 223–25, 227–30, and Sumowski 1983–[94], vol. 3, nos. 1033, 1036. On Koninck's figure paintings and drawings, see Gerson 1980, pp. 44–54, 67–81.

6. Both Chiarini (1989, pp. 212–14) and Langedijk (1992, pp. 55–57, no. 10) discuss the self-portrait's composition and iconography, and emphasize that the date must be read as 1661 (this was clarified by cleaning in 1992). Previously the date was usually read as 1667, for example in Gerson 1980, p. 124, no. 207, and in Sumowski 1983–[94], vol. 3, p. 1542, no. 1034 (on p. 1532, Sumowski arbitrarily describes the painting as "astonishingly weak"). P. Sutton in Amsterdam–Boston–Philadelphia 1987–88, p. 366, concludes, "the fact that his portrait was sought by the Grand Duke of Tuscany for the latter's gallery of artists' self-portraits is proof of his international reputation" (see Gerson 1980, p. 11, for a more temperate version of this claim). Cosimo III de' Medici visited Rembrandt on December 29, 1667, when the publisher Pieter Blaeu also took the grand duke to the studios of Willem van de Velde the Elder and of "Scamus who does seascapes" (Strauss and Van der Meulen 1979, pp. 569–70). There is no evidence that Cosimo requested Koninck's portrait at any date, and no reason to think that its presence in Florence (by 1707; mentioned in Houbraken 1718–21, vol. 1, p. 270), among many other artists' self-portraits, constitutes proof of an international reputation. On the Uffizi's encyclopedic but haphazard collection of self-portraits (which includes those of Job Berckheyde, Willem Drost, Jan Miel, etc.), see Prinz 1979.

7. See Gerson 1980, pp. 92–93, doc. 58.

8. Houbraken 1718–21, vol. 1, p. 269, vol. 2, pp. 53–54, 131, vol. 3, p. 79.

9. Gerson 1980, p. 84, doc. 10.

10. Ibid., p. 85, doc. 16.

11. Gerson (ibid., p. 9) rejects the idea that Koninck was Rembrandt's pupil either prior to 1637 or after 1640. Houbraken's remark (1718–21, vol. 2, p. 54) seems to rhetorically anticipate his observation that Koninck rejected "his teacher" Rembrandt's dark backgrounds in favor of a more fashionable "clarity" (here Houbraken follows the criticism of his teacher Van Hoogstraten; see Franits 1995).

12. Sumowski 1983–[94], vol. 3, p. 1531, sees Rembrandt and some Rotterdam painters as the principal influences on Koninck's historical and genre scenes. Salomon Koninck was the son of the Amsterdam goldsmith Pieter de Koninck and was cited among other relatives in a document of 1646 concerning Philips's stepmother (Gerson 1980, p. 86, doc. 17).

13. See Gerson 1980, pp. 15, 21, 107, no. 34, pl. 2.

14. As noted in ibid., p. 21. Compare Chong in Amsterdam–Boston–Philadelphia 1987–88, p. 487, and see p. 485, where most of the literature on Segers is cited. A fair number of works by Segers are cited in the 1640 inventory of the Amsterdam art dealer Johannes de Renialme (see Montias 2002a, pp. 141–42), and in the 1657 inventory of his estate, pictures by Segers and by Philips Koninck (landscapes and figure paintings) are cited a few times (see Bredius 1915–22, part 1, pp. 228–39).

15. Gerson 1980, p. 86, doc. 18 (Koninck, "age 33 years," along with other Amsterdam artists, judges the authenticity of a painting by Paul Bril).

16. See ibid., pp. 87–89, docs. 23, 25, 26, 41.

17. Ibid., pp. 12, 87, doc. 26. Margaretha van Rijn was from Rotterdam, not Rembrandt's native Leiden. In the previous year, 1656, Vondel wrote a poem praising Koninck's portrait of her (ibid., p. 87, doc. 21; p. 11 on Koninck's patrons in general).

18. Ibid., p. 89, doc. 38.

19. See ibid., pp. 11–12, and Trudy van Zadelhoff's remarks in *Dictionary of Art* 1996, vol. 18, p. 228.

20. Gerson 1980, pp. 35, 102, no. 2.

21. See ibid., pp. 14, 94, 96, docs. 64, 72, on the artist's burial and on the estate of Margaretha van Rijn; the entire estate (which included a large amount of furniture, pictures, linen, and especially Chinese and European porcelain) is published in Bredius 1915–22, part 1, pp. 153–55.

22. See Gerson 1980, pp. 55–81, 136–66, and Sumowski 1979–95, vol. 6, pp. 2945–3403.

23. For the etchings, see Gerson 1980, pp. 63–64, 179–80, pls. 36, 37.

101. *Wide River Landscape*

Oil on canvas, 16¼ x 22⅞ in. (41.3 x 58.1 cm)

The painting is well preserved, although there is some abrasion in the figures and animals in the foreground.

Anonymous Gift, 1963 63.43.2

This small, early canvas by Koninck, who probably painted it about 1648–49, is one of his most Rembrandtesque landscapes and at the same time one of the first works in which he reveals an individual style.

In the foreground, a roadway meanders past a farmhouse in shadow, a river shimmering in sunlight, another farmhouse and a barn huddled behind a tentative fence line, and a few houses partly hidden by trees. A man in the cottage by the riverbank looks out at a little field, where a woman milks a cow; to the right are two sheep, a resting cow, and a standing calf. This area of the paint surface is somewhat abraded, and the underscaled figures and animals are no longer clearly visible. The figure seated at some distance from the milkmaid has been described in the past as a man.[1]

As in Koninck's later panoramic landscapes, the view recedes through zones of space that are approximately parallel to the picture plane. Beyond the sailboats on the river, a tilled field is bordered by a farmhouse and a broad line of trees. Further back, a typical Dutch river town stretches out in the sun. Another tributary, or another part of the one in the fore-ground, opens into a larger body of water in the left background. The fall of sunlight suggests an hour late in the day and in its rosy tones seems to dismiss the rival claim of rain clouds. On the whole, the organization of the picture into areas of light and shadow is even more arbitrary than in the landscapes by Rembrandt that must have inspired Koninck, and recalls the alternating patterns employed by Hercules Segers (1589/90–1633/38) in such works as *Landscape with a Lake*, of the 1620s (Museum Boijmans Van Beuningen, Rotterdam).[2]

Wide River Landscape was virtually unknown before it was given to the Museum in 1963. In 1936, Gerson catalogued four versions of the composition (see fig. 101), none of which he considered autograph.[3] One of these pictures appears to be identical with a painting (support unknown, 17 x 20 in. [42.3 x 50.8 cm]) thought to be by Rembrandt when it was engraved by J. B. C. Chatelaine in 1744.[4] Gerson saw the Museum's painting in 1976 and was undecided about its authorship (the animals especially troubled him).[5] No scholar other than Gerson has ever expressed doubt about the picture's authenticity, either in print or in person at the Museum.

The painting is closely related in style to Koninck's *Panoramic Landscape with a Village* (Collection of Mr. and Mrs. Edward William Carter, Los Angeles), which has been dated convincingly to about 1648 on the basis of comparisons with the less accomplished landscapes in the Museo Thyssen-Bornemisza, Madrid (ca. 1645–46) and in the Victoria and

Figure 101. Copy after Philips Koninck, *Wide River Landscape*. Oil on canvas, 17⅛ x 23¼ in. (43.5 x 59 cm). Formerly Buchenau collection, Lübeck-Niendorf

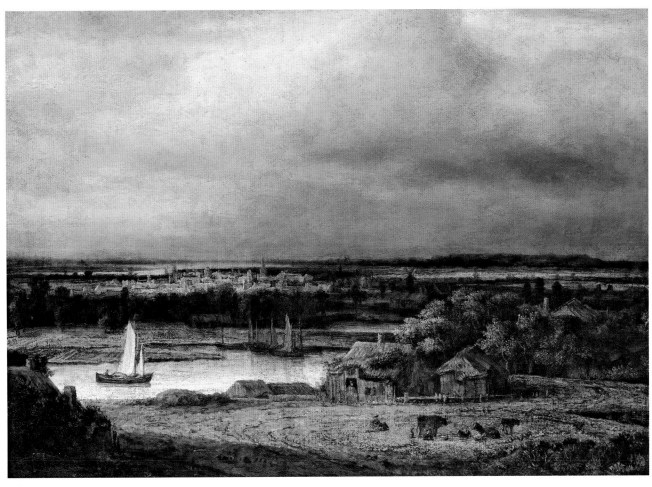

101

Albert Museum, London (dated 1647), and with a small panel dated 1648 (?) in the City Art Gallery, Manchester.[6] The smaller Carter painting has a somewhat less textured appearance than the Museum's picture, in part because of its smoother support (wood, 11⅜ x 14⅛ in. [29 x 36 cm]) and emptier foreground. However, the two works are conceived and executed in a very similar manner, which (as Walsh and Schneider observe) is more coherent and successful than Koninck's contemporary landscapes made on an imposing scale (for example, the Museum's *Panoramic Landscape with a Country Estate*; Pl. 102).[7] Sumowski evidently overlooked the greater challenges posed by Koninck's early large-scale panoramas when he dated the present picture to about 1651, which is when he believes the artist first fully developed his individual style, namely, in the canvas (24⅜ x 33⅞ in. [62 x 86 cm]), dated 1651, in the Sammlung Oskar Reinhart "Am Römerholz," Winterthur.[8] However, the small landscapes that Koninck painted about 1648–49, and a few of his panoramic landscape drawings dating from the second half

of the 1640s,[9] demonstrate that while he had created his own approach to composition before 1650, he needed another one or two years' experience to transform his vision of nature into something grand.

1. J. Smith 1829–42, vol. 7, p. 188 (under no. 597), describes the figures and animals in Chatelaine's engraving of 1744 after another version of this painting (see text below and note 3) as "two cows, a goat [the calf], and two sheep; a woman appears to be milking one of the cows, and a man sits on the ground next to her." In the Buchenau and Perman versions of this composition (see note 3 below and fig. 1), the seated figure to the left is clearly a man wearing a hat and the animal to the far right is a calf.

2. Amsterdam–Boston–Philadelphia 1987–88, no. 100. Rembrandt's influence on Koninck's early landscapes and the latter's different goals are cogently described in C. Schneider 1990, pp. 161–62.

3. See Gerson (1936) 1980, p. 130, nos. XII, XIIA-C. Gerson's no. XII (canvas, 17⅛ x 23¼ in. [43.5 x 59 cm]), which came from the famous collection of Charles Crews in London (sold, 1915) and was later in the collection of S. Buchenau in Lübeck-Niendorf,

was owned in 1967 by Buchenau's daughter, Mrs. Margarete Zantop, in Barcelona (Rijksbureau voor Kunsthistorische Documentatie, The Hague, RKD neg. L32625; fig. 101 here). Gerson's no. XIIA (canvas, 17⅜ x 23¼ in. [44 x 59 cm]), from the collection of A. Charles Kiefer, Schloss Dreilinden, Lucerne, is known from a photograph in the Rijksbureau voor Kunsthistorische Documentatie (RKD neg. L32626). Gerson's no. XIIB (canvas, 16⅛ x 23⅝ in. [41 x 60 cm]), which was left to the Metropolitan Museum by Theodore M. Davis (no. 30.95.295), was given by the Museum to Halloran Hospital, Staten Island, New York, in 1943. W. R. Valentiner saw the Davis version in 1931 and considered it to be a later copy, probably from the eighteenth century. Gerson lists his no. XIIC (canvas, 16¾ x 20⅛ in. [42.5 x 51 cm]) as in the J. Perman collection, Stockholm, but a note in the Rijksbureau voor Kunsthistorische Documentatie records that Perman himself refuted the information. Virch 1970, p. 13, lists a fifth version, "probably nineteenth century copy," as owned by F. B. Anthon, Beverly Hills, in 1967, and Virch observes that all five versions and the Chatelaine engraving differ from the Museum's picture in that they include two men fishing on the riverbank near the sailboat.

4. Recorded in J. Smith 1829–42, vol. 7, p. 188, no. 597.

5. Horst Gerson, oral opinion, April 7, 1976. Gerson said essentially the same thing in a letter to Claus Virch, dated April 19, 1967 ("does not look so bad, but there are very weak parts in it, for instance the foreground").

6. Close examination of the inscription on the Manchester picture indicates that it is dated 1645 or 1648 (kind communication of Melva Croal, November 2003). On the Carter picture, see Los Angeles–Boston–New York 1981–82, pp. 67–69, no. 16, where the Manchester, New York, and Thyssen paintings are also illustrated. On the Thyssen panel, see also Sumowski 1983–[94], vol. 3, no. 1041; Gaskell 1990, no. 84, as attributed to Koninck; and C. Schneider 1990, pp. 161–62, 213–15, no. R7, fig. 127, as by Koninck about 1645–46.

7. Los Angeles–Boston–New York 1981–82, pp. 68–69.

8. Sumowski 1983–[94], vol. 3, pp. 1545–46, nos. 1049 (Winterthur), 1050 (MMA).

9. See Duparc in Cambridge–Montreal 1988, no. 47, one of two early panoramic landscape drawings by Koninck in the Teylers Museum, Haarlem.

REFERENCES: Virch 1970, p. 13, concludes that the painting "was considered highly in the past for it exists in at least five other versions," none of them autograph; Walsh in New York 1971, pp. 10–11, comments on the use of light "for drama as well as for coherence"; Walsh 1974a, pp. 344, 348–49 n. 18, pl. v, as "the original [which] came to light in Vienna in 1934"; Hibbard 1980, pp. 330–31, fig. 595; Los Angeles–Boston–New York 1981–82, pp. 68–69 n. 5, fig. 2 (under no. 16) as "especially close in structure and spirit to the Carter painting" (see text above); Sumowski 1983–[94], vol. 3, pp. 1533, 1546, 1600, no. 1050 (ill.), dates the painting to about 1651, and cites other versions; P. Sutton 1986, p. 191, listed; Chong in Amsterdam–Boston–Philadelphia 1987–88, pp. 486–87, fig. 2 (under no. 100), as "closer to Segers's work" than to Rembrandt's; Baetjer 1995, p. 325; Liedtke in New York 1995–96, vol. 2, p. 149, no. 51 (ill.), as dating from about 1648–49 and as "one of Koninck's most Rembrandtesque works."

EXHIBITED: New York, MMA, "The Painter's Light," 1971, no. 21; New York, MMA, "Patterns of Collecting: Selected Acquisitions, 1965–1975," 1975–76, unnumbered cat.; New York, Wildenstein, "Romance and Reality: Aspects of Landscape Painting," 1978, no. 40; New York, MMA, "Rembrandt/Not Rembrandt in The Metropolitan Museum of Art," 1995–96, no. 51.

EX COLL.: ?Sale, London, early 1930s, to Galerie Sanct Lucas; [Galerie Sanct Lucas, Vienna, until 1934/38; sold to a private collection, Vienna]; private collection, Vienna, and later Greenwich, Conn. (1934/38–63; seized in Paris by the Nazis, held at Alt Aussee, Austria [1081], and at Munich collecting point [1282], returned to France October 30, 1946; restituted; given by owner to MMA); Anonymous Gift, 1963 63.43.2

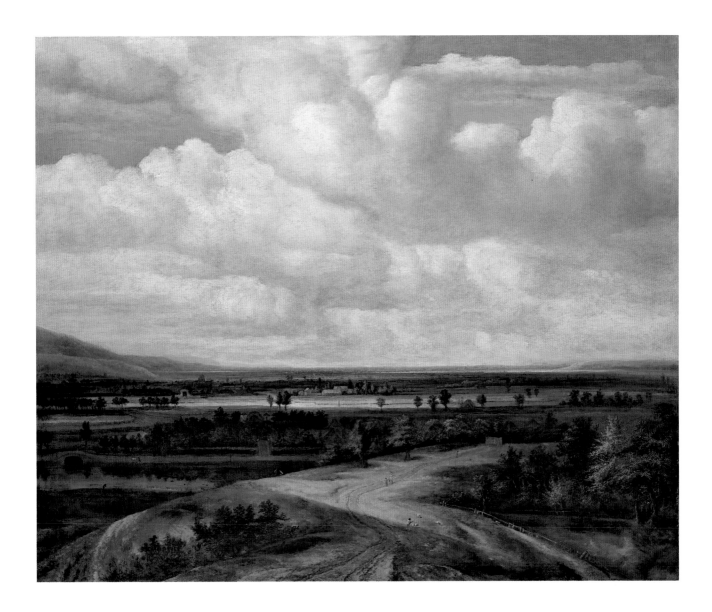

102. *A Panoramic Landscape with a Country Estate*

Oil on canvas, 56⅜ x 68¼ in. (143.2 x 173.4 cm)
Signed and dated (lower right): P koninck/164[9?]

Abrasion of the paint surface throughout the composition has exposed the dark underlayer, producing many dark spots that disfigure the cloud-filled sky. The effect of this damage is less disruptive in the landscape.

John Stewart Kennedy Fund, 1911 11.144

In this comparatively early work, one of Koninck's first large-scale landscapes, the arbitrarily high vantage point allows the viewer to survey not only extensive farmland but also three or more different rivers and four cities or towns. The highlands to the left and the hills to the right embrace a broad valley reminiscent of those in the eastern Netherlands. However, the topography and placement of motifs clearly depend more on Koninck's knowledge of earlier panoramic pictures (compare Pl. 50) than on his presumed experience of Gelderland or some other sparsely settled and wide-open place.

The complicated foreground, with its intersecting curves of shadow and terrain, is to some extent clarified by rutted wagon tracks descending past the tiny goatherd to more distant figures and a rustic wooden gate. The impressionistic triangle of water to the lower right is bordered by wooden railings and a stand of trees. There is no apparent connection

(which would justify Gerson's title, *Landschaft mit grossem Dammweg*) between the stream or pond to the lower right and the river or canal to the left. The land drops suddenly to either side in the foreground, dividing it into angular and arching areas. Perhaps the most obvious instance of Koninck's search for structure is the line of shadow that cuts across the road and seems continued by the nearest bank of the waterway on the left.

A small canal boat (*trekschuit*) on the same body of water is pulled by a horse on the towpath along the opposite bank. The boat passes by the tall wooden gate of an estate, surrounded by hedgerows and shaded by trees, on which stand farmhouses and a small manor house. A grainfield and grasslands extend to the light blue river in the sunny middle ground. With historical hindsight, it might be said that Koninck's mature style of landscape painting begins in this area, although the narrow tapestry of nature just below the horizon lacks the weavelike texture found in the artist's classic works.

In the central area of the view, a sailboat floats by a large group of farm buildings nestled among trees. To the left, a stone gateway guards a sizable town, which features an old church tower, two windmills, and red-tiled roofs. A stream winds past the town toward yet another sunlit plain, where windmills, isolated buildings, and a distant city appear. And a blanket of cottony clouds billows across the canvas, receding to the deep blue hills of the horizon.

Two aspects of this early work make it stand out in a survey of Koninck's career. First, despite its naïve qualities, the composition as a whole brings the traditional Netherlandish "world landscape" down to earth; the impression of a map shown in perspective, which lingers even in Jan van Goyen's *View of Haarlem and the Haarlemmer Meer* (Pl. 50), is here replaced by an environment into which one is invited to wander, and to explore beyond the limits of view.[1] Second, Koninck's kind of extensive landscape—called a *verschiet,* or vista, in a contemporary inventory[2]—includes something rarely seen in earlier works, a rich visual texture of light falling on various surfaces. From the velvety grass in the foreground and the myriad sun-tipped leaves to the white threads of sunlight drawn through distant fields, motifs and surfaces draw the eye, which comes to rest in sheer pleasure with the way things have been rendered.

The leading authority on Koninck, Horst Gerson, paid this picture the apparent compliment of puzzling over its date: 1649 seemed too early to him when he saw the painting in 1976.[3] However, the third digit of the date is unquestionably a 4, and Gerson's study of 1936 convincingly places the picture

among other paintings of about 1647–50.[4] It also includes the observation that the canvas is very close in coloring to the masterworks of the 1650s. In Koninck's confident use of a road leading through the foreground, an approach he more timidly attempted in compositions dated 1647 and 164[8?],[5] Gerson saw a response to the young Jacob van Ruisdael (q.v.), who indeed used rutted roads as boldly in a few prints and paintings dating from 1646–48.[6] However, the hills to either side, the flat plain between them, and the small vertical accents spaced across the composition seem more reminiscent of paintings by Hercules Segers (1589/90–1633/38), in this case with little sign of Rembrandt's having intervened.[7]

While the painting is in fairly good condition, some areas have darkened with age and the sky has suffered from abrasion. A dusky undertone helps to establish the Rembrandtesque mood, as in the early *Wide River Landscape* (Pl. 101). In mature works, Koninck made more conspicuous use of the textures of paint and canvas (which in this case is finely woven) and of a lighter ground. To judge the painting by the standard of works executed a decade later would seem an appropriate tribute, even if this was not always the intention.

The picture has not yet been traced in England before its appearance in the Heywood sale of 1893 (see Ex Coll.). One writer observes that "Koninck's large panoramas were much admired by British collectors during the second half of the eighteenth century and into the mid-nineteenth century."[8] In 1911, the English dealer Robert Langton Douglas, then a freelance agent for the Metropolitan Museum, assured the curator of paintings, Bryson Burroughs, that the Museum should buy the painting: "I follow Dr. Bode and Dr. de Groot in having the highest opinion of de Koninck as artist; and this is one of his best works."[9] Be that as it may, the painting holds an important place within the development of panoramic landscape views, and within the most comprehensive collection of Dutch landscape painting in America.

Formerly titled by the Museum *Landscape.*

1. On the "world landscape," see W. S. Gibson 1989. For Dutch plans and profiles in bird's-eye perspective, see Amsterdam–Toronto 1977, nos. 19–33, and Nuti 1994, p. 126, figs. 34, 35.
2. The 1657 inventory of the art dealer Johannes de Renialme's estate includes *Een verschiet van Philips Koninck,* valued at Fl 130 (Bredius 1915–22, part 1, p. 238).
3. Oral opinion, April 7, 1976.
4. Gerson (1936) 1980, pp. 16–17, rejecting an earlier reading of the date as 1645.
5. Ibid., no. 34, pl. 2, the panel dated 1647 in the Victoria and Albert Museum, London, and no. 13, from the collection of

Lord Mount Temple. The latter was sold at Sotheby's, London, December 9, 1992, no. 20.

6. Gerson 1980, p. 19. See, for example, Walford 1991, figs. 33, 47, 53 (Slive 2001, nos. E2, 78, 352).

7. As noted by Egbert Haverkamp-Begemann, in conversation (1994). Compare Segers's canvas in Rotterdam (Amsterdam–Boston–Philadelphia 1987–88, no. 100).

8. Moore in Norwich 1988, p. 65.

9. Letter of September 12, 1911, quoted in D. Sutton 1979, p. 423.

REFERENCES: Anon. in *Connoisseur* 15 (May–August 1906), p. 136, reports the Quilter sale, and mentions the Heywood sale of 1893; *MMA Bulletin* 7, no. 1 (January 1912), pp. 11 (ill.), 13, notes the acquisition; Hofstede de Groot 1927, p. 274, lists the picture; Gerson (1936) 1980, pp. 15–17, 19–20, 109, no. 46, pl. 18, lists it as in the "Desemeth" sale in Paris, 1811 (see Ex Coll.), as a "powerful" early work, reads the date as 1649 not 1645, and suggests Jacob van Ruisdael's influence; Stechow 1966, pp. 44–45, fig. 76, as anticipating Rembrandt; Van Thiel 1967, p. 111, as already demonstrating Koninck's mastery; Brussels and other cities 1968–69, p. 91 (under no. 89), compares the composition of a contemporary drawing by Koninck; C. Kauffmann 1973, p. 164 (under no. 202), compares the panel of 1647 in the Victoria and Albert Museum; Kahr 1978, p. 211, fig. 161, discusses the painting as a typical work; D. Sutton 1979, pp. 421, 423, fig. 20, as recommended by the dealer Langton Douglas to the Museum; Los Angeles–Boston–New York 1981–82,

p. 69 (under no. 16), compares the Carter picture; Sumowski 1979–95, vol. 6 (1982), p. 3280 (under no. 1479), compares a drawing by Koninck in the Teylers Museum, Haarlem; Sumowski 1983–[94], vol. 1, p. 428 (under no. 191), compares a work by Van Borssom, vol. 3, pp. 1533, 1545, no. 1046 (ill. p. 1596), considers this the first painting by Koninck to create the impression of enormous distance; New York–Chicago 1989, p. 115, compares a drawing by Koninck in the Teylers Museum, Haarlem; Venice 1991, p. 99, compares the Koninck painting of 1655 in Bucharest; Baetjer 1995, p. 325; Hochstrasser 1998, p. 220 n. 84, inappropriately compares a seventeenth-century religious song about protection from floods.

EXHIBITED: Athens, National Gallery and Alexandros Soutzos Museum, "From El Greco to Cézanne: Masterpieces of European Painting from the National Gallery of Art, Washington, and The Metropolitan Museum of Art," 1992–93, no. 20.

EX COLL.: Sale, Pieter de Smeth van Alphen et al., Le Brun, Paris, April 15ff., 1811, no. 82, for FFr 430 to Henri; John Pemberton Heywood, Norris Green, Lancashire, and Cloverly Hall, Shropshire (until 1893; posthumous sale, Christie's, London, June 10, 1893, no. 54, for Gns 900 [£945] to Quilter); Harry Quilter, London (until 1906; his sale, Christie's, London, April 7, 1906, no. 128, bought in, sold for £787 10s. to Weatherley); [R. Langton Douglas and another dealer, London, until 1911; sold to MMA]; John Stewart Kennedy Fund, 1911 11.144

103. *An Extensive Wooded Landscape*

Oil on canvas, 32¾ x 44⅝ in. (83.2 x 113.3 cm)
Signed (lower left): P. koninck

The painting is well preserved. There are minor paint losses throughout the sky and a larger area of loss associated with a tear in the support at the top, to right of center.

Purchase, Mr. and Mrs. David T. Schiff and George T. Delacorte Jr. Gifts, special funds, and Bequest of Mary Cushing Fosburgh and other gifts and bequests, by exchange, 1980
1980.4

In this colorful late work of the 1670s, the artist's emphasis is on elegant leisure and the picturesque. An estate with a new or remodeled house stands among the bushy trees on the far side of the river and provides an approximate center for pleasant country life. The staffage, which as usual is by Koninck himself, skillfully leads the viewer into the composition from

both sides. To the lower right, a small hunting boat, or *jacht* (yacht), is occupied by a few figures—apparently two couples, a servant, and an oarsman.[1] Ahead of them, a man poles a raft and a fisherman cools his feet at the water's edge. Other male figures, a horse, and dogs make their way along the riverbank. On the high road to the left, a stylish cavalier on horseback offers a coin to a begging woman and boy. The two sides of the river are linked by a bridge, which is crossed by a horse and rider. A variety of buildings can be seen in the plain that extends to a tranquil waterway and misty brown hills.

In the hills and other parts of the picture, Koninck seems almost to conjure the image out of the warm ground layer of paint. The edge of the sky is stroked over the landscape's contour, and rows of trees are dabbed directly on top of the brick-colored undertone.

No other work in the Museum's extensive collection of

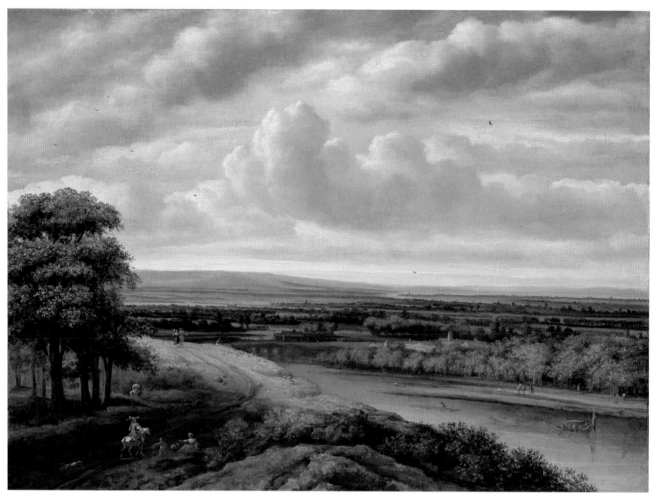

103

Dutch landscape paintings so clearly illustrates the decorative tendency of the genre during the 1670s and 1680s, when for many artists the embellishment of fine interiors became more important than verisimilitude. Koninck never rivaled Jacob van Ruisdael (q.v.) in the study of clouds and trees, but the primary importance of painterly effects in this picture is remarkable nonetheless.

The composition would seem more arbitrarily conceived than those of Koninck's panoramic views of the 1660s, and it finds an apparent counterpart in a canvas of the same dimensions (fig. 102) that was separated from the Museum's picture between 1900 and 1908.[2] It is possible that the two paintings were designed as pendants, presumably with the Museum's picture meant to hang on the left. (In the case of landscapes there is rarely much formal interdependence between paired pictures, apart from broad outlines and mood.)[3] The New York canvas is also very close in composition and execution to Koninck's last dated painting, the *River Landscape,* of 1676, in

Amsterdam (fig. 103).[4] Motifs such as the hunting boat, the country house, and the figures on the road reoccur with minor differences. Unlike the present picture and its possible pendant, the composition of the Amsterdam painting, with its horizon uninterrupted by trees, is reminiscent of Koninck's panoramic landscapes dating from the 1660s. It is possible that the design of *An Extensive Wooded Landscape* evolved from that of the picture dated 1676 or from a very similar design. Other paintings by Koninck with trees placed prominently to one side also date from the last years of his activity.[5]

1. The motif had been popular for some time. Compare the pleasure boats seen in Cornelis Vroom's *River Landscape,* a drawing of about 1622–23, and in Adriaen van de Venne's drawing *Spring,* of 1622, both of which are illustrated and discussed in London–Paris–Cambridge 2002–3, pp. 50–51 (under no. 13). Koninck had depicted pleasure boats for about twenty years, as in a drawing of about 1655 (Gerson 1980, no. z44, pl. 29; Cambridge–Montreal 1988, no. 49). See also the princely yacht on the canal in front of the residence of Baron Belmonte, Amsterdam, in an etching by

Figure 102. Philips Koninck, *Extensive River Landscape*, 1670s. Oil on canvas, 33⅛ x 44¼ in. (84 x 112.5 cm). Private collection

Figure 103. Philips Koninck, *River Landscape*, 1676. Oil on canvas, 36⅜ x 44⅛ in. (92.5 x 112 cm). Rijksmuseum, Amsterdam

Romeyn de Hooghe (Landwehr 1973, p. 297 [ill.]; Schama 1987a, p. 594, fig. 308). On the Dutch *jacht,* see Loeff in Laren 1972.

2. The related picture was sold from the Linda and Gerald Guterman collection at Sotheby's, New York, January 14, 1988, no. 23. An earlier sale recorded there, that of Martin Colnaghi in 1908, actually refers to the Museum's picture; the Guterman Koninck was not in that sale. Both pictures were sold from the Whatman collection at Christie's, London, June 16, 1900, nos. 59 (MMA) and 60, when they were purchased by Martin Colnaghi.

3. Moiso-Diekamp 1987 has little to say about pendant landscapes (see pp. 147–53), and the question is not addressed in Loughman and Montias 2000 (but see pp. 125–34 on patterns of hanging pictures and on standardized sizes).

4. Gerson 1980, no. 2, pl. 15, discussed pp. 35, 38, 40; Sumowski 1983–[94], vol. 3, no. 1072 (ill.).

5. See Gerson 1980, pls. 14, 17, 19, and Sumowski 1983–[94], vol. 3, nos. 1075–76.

REFERENCES: Gerson (1936) 1980, p. 113, no. 89, records the sale of 1900; Sumowski 1983–[94], vol. 3, pp. 1534, 1551, no. 1073 (ill. p. 1623), suggests a date of about 1676; P. Sutton 1986, p. 191, considers this "the finest of the three panoramas" by Koninck in the Museum; Baetjer 1995, p. 325; W. S. Gibson 2000, pp. xxvii, 120, fig. 85, "offers us a veritable catalogue of country pleasures."

EXHIBITED: Bordeaux, Galerie des Beaux-Arts, "Profil du Metropolitan Museum of Art de New York: De Ramsès à Picasso," 1981, no. 105; London, Colnaghi, "Art, Commerce, Scholarship: A Window onto the Art World—Colnaghi 1760 to 1984," 1984, no. 45.

EX COLL.: Mrs. Whatman, Vinters, Maidstone (by 1890–until 1900; sale, Christie's, London, June 16, 1900, no. 59, for £315 to Martin Colnaghi [no. 60 by Koninck, described as its "companion," went to the same buyer]); [Martin Colnaghi, London, 1900–d. 1908; sale, Robinson and Fisher, London, Nov. 19, 1908, no. 58, for £252, without pendant]; J. Friedlander (until 1943; sale, Sotheby's, London, October 27, 1943, no. 98, for Gns 660 to Minken); [Minken, in 1943]; Mrs. Mendelsohn-Bartholdy, London (until 1946; sold to Speelman); [Edward Speelman, London, 1946–47; sold to Silcock]; R. P. Silcock, Preston, Lancashire (1947–68; sold to Speelman); [Edward Speelman, London, 1968; sold to Samuel]; Harold Samuel, Baron Samuel of Wych Cross, London and Wych Cross Place, Forest Row, Sussex (1968–77; sale, Christie's, London, July 8, 1977, no. 65, £120,000 to Colnaghi); [Colnaghi, London, 1977–80; sold to MMA]; Purchase, Mr. and Mrs. David T. Schiff and George T. Delacorte Jr. Gifts, special funds, and Bequest of Mary Cushing Fosburgh and other gifts and bequests, by exchange, 1980 1980.4

GERARD DE LAIRESSE

Liège 1641–1711 Amsterdam

A native of Liège, De Lairesse was probably a pupil of his father, Renier de Lairesse (ca. 1597–1667), and, between about 1655 and 1660, of Bertholet Flémal (1614–1675).[1] The latter, whom Sandrart described as the "Netherlandish Raphael," had by about 1640 worked for a few years in Rome, and was active in and around Paris about 1645. He was highly successful in Liège as a portraitist, history painter, and architect. The influence of Poussin, Charles Le Brun, and other French classicists was passed on from Flémal to De Lairesse, who first found independent work at the court of Maximilian Hendrick of Bavaria in Cologne, and at a church in Aachen. Between 1662 and 1664, De Lairesse worked in the manner of Flémal for important patrons in Liège. His prospects there were ruined in April 1664 when two women, one of whom he had allegedly promised to marry, attacked him violently. The painter fatally wounded one of them and then fled to Maastricht with a distant cousin, Marie Salme, whom he married en route.[2] The couple soon settled in Utrecht, where their son was baptized in April 1665. The same year they moved to Amsterdam, where De Lairesse first found employment through the art dealer Gerrit Uylenburgh, the son of Rembrandt's former dealer, Hendrick Uylenburgh.[3] The portrait of De Lairesse by Rembrandt in the Robert Lehman Collection (Pl. 160) was probably painted in 1665 or shortly thereafter.[4]

With like-minded authors, De Lairesse founded a literary society, Nil Volentibus Arduum (Nothing Worthwhile Without Effort). French literature and theater and a classicist style of decoration had been favored at the court of the Stadholder Frederick Hendrick (1584–1647), and in the 1650s and 1660s became fashionable among the wealthy merchants and regents of Amsterdam.[5] The Fleming Erasmus Quellinus the Younger (1607–1678), who was himself influenced by Flémal, executed two large ceiling paintings for the Amsterdam Town Hall in 1656, and Dutch artists such as Jan van Bronchorst (ca. 1603–1661) from Utrecht and Cornelis Holsteyn (1618–1658) from Haarlem painted chimneypieces in the Town Hall and other decorative pictures for Amsterdam houses. De Lairesse brought to this trend a new level of sophistication in terms of design, execution, and marketing. He etched illustrations for plays of 1668 by Andries Pels, who was Amsterdam's answer to Corneille

and a critic of Rembrandt, and a book of 110 plates after the antique sculptures assembled by the famous collector Gerrit Reynst (1599–1658), *Signorum veterum icones* (Amsterdam, 1671).[6]

About 1670, De Lairesse painted a series of eight canvases in grisaille depicting the relief-like triumphal procession of a Roman army, The Triumph of Aemilius Paullus Macedonicus (Musée de l'Art Wallon, Liège; see fig. 106), for the burgomaster Nicolaes Pancras (see the catalogue entry below), and in 1672 he completed the three-part ceiling painting *Allegory of the Peace of Münster* (now in the Vredespaleis, The Hague), for the home of the celebrated burgomaster Andries de Graeff.[7] Many important commissions for decorative canvases followed, including an ensemble of ceiling paintings for the Lepers' Asylum in Amsterdam in 1675 (on loan to the Rijksmuseum, Amsterdam);[8] a number of ceiling paintings, chimneypieces, and other works for patrician homes; and (1676–82) various works for the palace of Willem III at Soestdijk.[9] The artist's success continued in the 1680s, when he painted a set of five large grisailles representing allegorical sculptures in high relief (ca. 1680; Rijksmuseum, Amsterdam) for the foyer of Filips de Flines's house on the Herengracht; organ shutters for the Westerkerk in Amsterdam (1686; still in situ); the illusionistic decoration of a large wooden ceiling in Paleis Het Loo, Apeldoorn (ca. 1687, with Johannes Glauber [1646–1726], his frequent collaborator in these years); and a large altarpiece, *The Assumption,* for the Cathedral of Saint Lambert in Liège (1687; now in the Cathedral of Saint Paul, Liège).[10] While De Lairesse remained a resident of Amsterdam, in 1684 he joined the painters' confraternity of The Hague, and in 1688 painted six large scenes of classical history and an *Allegory of Justice* for the council chamber of the Court of Justice in the Binnenhof.[11]

Apparently the victim of congenital syphilis, De Lairesse went blind in 1690.[12] He turned to writing and lecturing on art, and with the help of his sons published a treatise on drawing (*Grondlegginge ter Teekenkonst*) in 1701, and the well-known artists' manual *Het Groot Schilderboek*, in 1707.[13] Both books stress the importance of drawing classes and academic art theory. De Lairesse's deeply held belief in "the infallible rules of art" led him to condemn genre painters such as Adriaen van Ostade (q.v.),[14] as well as Rembrandt's late style.[15]

1. On Flémal, see Hendrick 1987, pp. 127–46, and Boston–Toledo 1993–94, pp. 593–98. Since De Lairesse came from the Bishopric of Liège, he is often considered "Flemish" or southern Netherlandish, but like that of Hendrick Goltzius and many other immigrants to the northern Netherlands his career was made almost entirely in Holland and was supported by Dutch patrons. This point was lost on the ardent apologist for the arts in Liège, Jacques Hendrick (see Hendrick 1987, pp. 165–201 on De Lairesse), and to a lesser extent was missed by Alain Roy (A. Roy 1992, on which see L. de Vries 1995). Houbraken 1718–21, vol. 3, p. 106, records that "many believe" De Lairesse to have been "a pupil of the famous Bartolet," but the author stresses the importance for De Lairesse of his father, "who like Bartolet was a good painter in the service of the Prince-Bishop of Liège."

2. On this incident, see A. Roy 1992, p. 46, quoting the biography of De Lairesse written about 1715 by his friend Louis Abry (1643–1720).

3. Houbraken 1718–21, vol. 3, pp. 109–11, records that De Lairesse had sent some pictures from Utrecht to Uylenburgh, and that after his arrival in Amsterdam he painted various works for the dealer in the course of eight weeks (on their business together, see also London–Amsterdam 2006, pp. 216–21). Once Uylenburgh had shown the young painter's work to art lovers, De Lairesse's career was made, according to Houbraken's enthusiastic account (on which see Chapman 1993, p. 137). Houbraken himself had much less success in Amsterdam between 1709 and his death in 1719 (see the biography in Dordrecht 1992–93, p. 210).

4. See Haverkamp-Begemann in Sterling et al. 1998, pp. 139–47, no. 31, and New York 1995–96, vol. 2, no. 19.

5. Some sense of this development is gained from Albert Blankert's essay "Classicism in Dutch Painting, 1614–1670," in Washington–Detroit–Amsterdam 1980–81, pp. 183–90, and from the exhibition catalogue Rotterdam–Frankfurt 1999–2000 (on the latter, see M. Westermann's review in Burlington Magazine 142 [2000], pp. 186–89). See also Snoep 1970 on De Lairesse's murals and ceiling paintings.

6. On the latter, see A.-M. Logan 1979, pp. 45–54, and A. Roy 1992, pp. 449–50 no. G.66, pp. 534–35 nos. G.R.14–123.

7. A. Roy 1992, pp. 246–49, no. P.68; see Van Eeghen et al. 1976, pp. 551–53, on the house (Herengracht 446).

8. A. Roy 1992, nos. P.75–82; Van Thiel et al. 1976, p. 335.

9. A. Roy 1992, nos. P.77, P.93, P.126, P.135–36, and P.138–39. See also Van Thiel et al. 1976, p. 336, no. A1233 (five-part ceiling decoration), and Broos 1993, pp. 180–86.

10. See A. Roy 1992, nos. P.143–47, P.174, P.187, and P.175, respectively, and Van Thiel et al. 1976, p. 334, for De Flines's ensemble.

11. A. Roy 1992, nos. P.197–203. The Binnenhof is the complex of government buildings next to the Mauritshuis.

12. On De Lairesse's medical condition, see Johnson 2004.

13. On the latter, see Bolten 1985, pp. 226–28, and A. Roy 1992, pp. 51–55.

14. As noted by A. Roy in Dictionary of Art 1996, vol. 18, p. 653.

15. De Lairesse 1707, book V, chap. 22, p. 325.

104. *Apollo and Aurora*

Oil on canvas, 80½ x 76⅛ in. (204.5 x 193.4 cm)
Signed and dated (lower left): G. Lairesse f/1671

The painting is well preserved. There is paint loss in six places where the support is torn: in the background between Apollo and the brown horse, from the proper right knee of Aurora into the salmon-colored drapery, in the clouds below Aurora, in the chest of the brown horse, in the foreleg of the white horse, and along a vertical tear that divides the last letters of the word *fecit* from the date.

Gift of Manuel E. and Ellen G. Rionda, 1943 43.118

This large and beautiful canvas, dated 1671, is one of the earliest known examples of De Lairesse's work as a history and decorative painter in Amsterdam. As discussed below, the picture was probably commissioned by the burgomaster Nicolaes Pancras

for his monumental new town house at Herengracht 539, which was completed in 1670. The figures of Apollo, the sun god, and Aurora, goddess of the dawn, are possibly portraits of two of the patron's children.

Apollo appears in the most brilliant part of the painting, his fiery nature suggested by bright yellow clouds, a fluttering red cape, and the molten gold convolutions of his classical armor, brocaded skirt, and windswept hair. Unobtrusive rays of light circle his head. Aurora wears a white dress embellished with gold stars,[1] and is "saffron-robed," as ancient authors specified, referring to the color of an early morning sky. Her coppery curls descend from a diadem, above which an eight-pointed "morning star" floats obeisantly.[2] Aurora's pearl necklace and crown recall the dewdrops that distill from her eyes

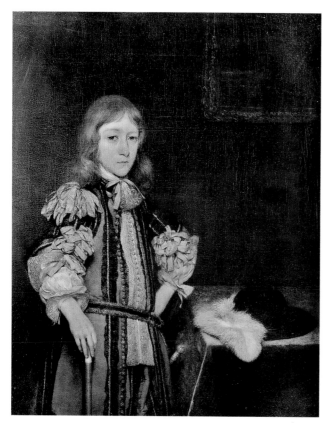

Figure 104. Gerard ter Borch, *Portrait of Gerbrand Pancras*, 1670. Oil on canvas, 13 x 11 in. (33 x 27.9 cm). Manchester City Art Gallery, Manchester, England, Assheton Bennett Bequest

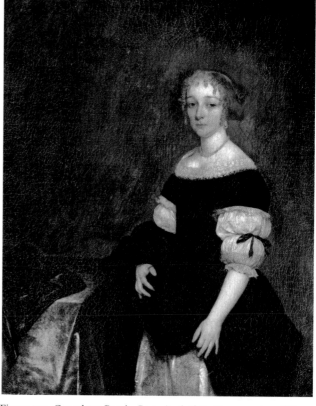

Figure 105. Gerard ter Borch, *Portrait of Aletta Pancras*, 1670. Oil on canvas, 15⅛ x 12¼ in. (38.5 x 31 cm). Rijksmuseum, Amsterdam

"comme des perles liquides," according to Baudouin's version of Ripa, published in 1644.[3] The basket of flowers is mentioned by Ripa and his translators; Baudouin explains that the earth's flowers awaken at dawn.[4]

The sun god drives a quadriga, the chariot with four horses abreast that is familiar from Roman monuments. Only the winged Pegasus is cited by Ripa in connection with Apollo, who usually appears with that creature in quite different contexts.[5] Most Baroque painters assigned two or four horses to Apollo (or two to Aurora, in Guercino's case; Casino Ludovisi, Rome). De Lairesse may have known Guido Reni's and Simon Vouet's quadrigas from engravings of the 1630s.[6] Some echo of Reni's *Aurora* is sensed in the bobbing horses' heads, their overlapping legs, and the artificial clouds, but the pose of the nearest horse and even that of Apollo (from the waist up) bring to mind many Flemish and a few Dutch equestrian portraits of about 1625–50, including Jacob Jordaens's Willem II on a bay horse in *The Triumph of Frederick Hendrick* and Jacob van Campen's *Frederick Hendrick as a Warrior*, both of which are canvas murals of about 1650 in the Oranjezaal of the Huis ten Bosch at The Hague (where Van Campen's *Apollo and Aurora* is painted on one of the wooden

vaults).[7] Contemporary taste is also reflected in the black leather halters and the reins and harnesses decorated with gold medallions, and in the purple velvet saddle blanket with gold silk fringe. Another sign of real rather than mythological life is the horseshoe on the nearest hoof.

The sun's course is suggested by the faintly painted band (the "elliptic") bearing zodiacal signs in the upper right corner of the composition. The visible signs are, from top to bottom, Virgo, Libra, and Scorpio. These signs are shown in their usual order and have no apparent connection with De Lairesse's models or patron.[8]

Roy considered the figure of Apollo to be a "portrait allégorique" of Prince Willem III (1650–1702), who married his cousin Mary II (1662–1694) in 1677, and in 1689 became William III, king of England.[9] Comparison with portraits of the prince, consideration of his political position in 1671, and of who Aurora might be (not the nine-year-old Mary) reveal the hypothesis to be completely implausible.[10]

It is almost certain that the present painting is identical with the picture sold as lot no. 2 in the sale of paintings from the estate of the burgomaster Gerbrand Pancras held in Amsterdam on April 7, 1716: "Apollo en Aurora, zynde een

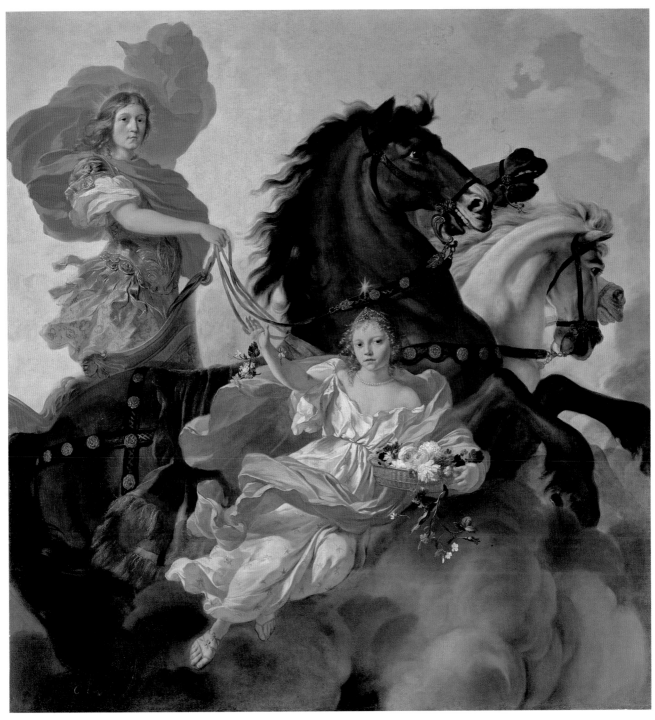

104

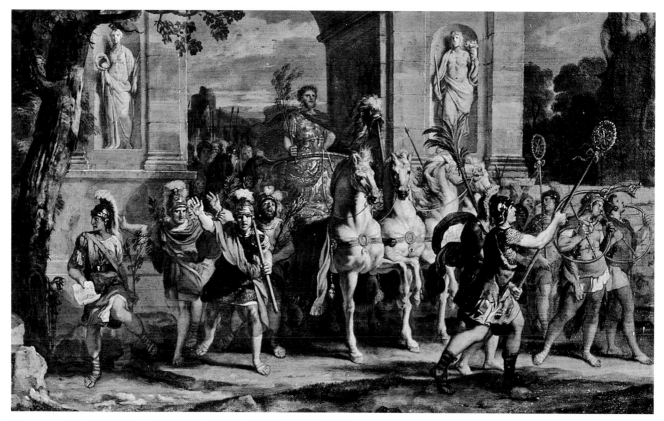

Figure 106. Gerard de Lairesse, *Aemilius Paullus Entering Rome*, one of eight paintings in The Triumph of Aemilius Paullus Macedonicus, ca. 1670. Oil on canvas, 19¼ x 31⅛ in. (49 x 79 cm). Musée de l'Art Wallon, Liège

Schoorsteen-stuk, van dezelve" (Apollo and Aurora, being a chimneypiece, by the same [artist]).[11] The preceding lot, no. 1, was "Eight pieces, comprising a Roman Triumph or Victory, by Gerard Larisse, extraordinarily artfully painted," which have been identified with the artist's eight relief-like canvases in grisaille, The Triumph of Aemilius Paullus Macedonicus, of about 1670 (fig. 106).[12] The series was also mentioned as belonging to "councillor Pancratius" in the 1683 Latin edition of Joachim von Sandrart's *Teutsche Academie* (1675), to which a biography of De Lairesse was added.[13]

Gerbrand Pancras (1658–1716) inherited Herengracht 539 and its contents upon his mother's death in 1709, and occupied the house until his own death seven years later. His children sold the residence to another frequent burgomaster, Gerrit Corver, who substantially modified the façade and the main rooms before moving in. Sandrart's remark indicates that the eight paintings now in Liège were in the Pancras residence as early as 1683, that is, at least twenty-six years before Gerbrand Pancras became its owner. Furthermore, "councillor Pancratius" must refer to the recently deceased Nicolaes Pancras (1622–1678), not his twenty-five-year-old son, who in 1683 could not have been described as a "councillor." There seems little doubt

that the *Apollo and Aurora,* of 1671, and the eight-part Triumph, which is dated about 1670 on stylistic grounds, were made to decorate Nicolaes Pancras's classicist town house of 1670.

Furthermore, it appears that Apollo and Aurora may be portraits of Nicolaes Pancras's son, the twelve- or thirteen-year-old Gerbrand, and one of his two sisters. In the same year, Gerbrand Pancras's portrait was painted by Gerard ter Borch (q.v.; fig. 104).[14] The sitter in that picture may be said to strongly resemble the Apollo in the present work, if one allows for the very different styles of the two artists and the transformation of the slight youth into a heroic deity. The figure of Aurora bears a family resemblance to Gerbrand's older sister, Aletta (1649–1707), whose features were also recorded by Ter Borch in 1670 (fig. 105).[15] But Aurora looks much too young to be a portrait of Aletta, who was moreover no longer living at home in 1671 (she married in 1667). Her sister Maria (1662–1740), however, was only nine years old in 1671. Perhaps De Lairesse lent Gerbrand and Maria a few more years, in accordance with their roles as god and goddess, and with a view to the impression that the paintings would make on viewers a few years hence.

While no independent portrait of Maria Pancras has been identified to date,[16] support for the identification of Aurora

with Maria comes from the newly discovered fact that she and her husband owned the painting after it appeared in the 1716 sale of her brother Gerbrand's estate. It was previously known that The Triumph of Aemilius Paullus Macedonicus was sold from the Amsterdam estate of Jacob van der Dussen on April 12, 1752, as lot no. 1.[17] But it is evidently noted here for the first time that no. 19 in the same sale was "Een capitaal stuk, ver-beeldende Aurora, door G. de Laires, h. 9 v., br. 7 v." (A capital piece, depicting Aurora, by G. de Lairesse, height 9 Amsterdam feet, width 7 Amsterdam feet),[18] and that Jacob van der Dussen (1683–1750) was the distinguished son (he served as secretary of Amsterdam from 1709 to 1750) of Maria Pancras and her husband, Bruno van der Dussen (1660–1742), burgomaster of Gouda and councillor at the Court of Holland.[19] Maria Pancras and her spouse may have acquired *Apollo and Aurora* (as well as the Triumph and a few other paintings) at her brother's estate sale; it was then inherited by their son Jacob after their deaths, in 1740 and 1742, respectively.[20]

Whether or not *Apollo and Aurora* portrays the children of Nicolaes Pancras, the painting probably refers to the burgomaster's public and private life. Apollo, dressed here as a Roman general, was associated with codes of law, cultural pursuits (he is the central figure in Jacob de Wit's *Allegory of the Arts*; Pl. 219), and other interests that parallel not only those of Aemilius Paullus, but those of Nicolaes Pancras as well (if not the former's rule over Hispania, which would have struck a patriotic chord for Pancras). The victorious consul, or "councillor," drives a quadriga into Republican Rome (see fig. 106, where two of his soldiers gesture like Aurora). The chimneypiece and the painted frieze form a parallel, not a program; they may well have been installed in different rooms (such as a salon and an entrance hall). However, the parallel recalls that drawn between the triumphal entry of Prince Frederick Hendrick, as painted by Jordaens in the Oranjezaal of the Huis ten Bosch (mentioned above), and Van Campen's *Apollo and Aurora* in the same room's vaults, which symbolizes the arrival of a Golden Age with the Princes of Orange.[21] Van Campen also intended to paint Apollo and Aurora on the lunette at the eastern end of the Burgerzaal in the Town Hall of Amsterdam.[22] In the Burgomaster's Chamber, a marble mantelpiece was carved with the Triumph of Fabius Maximus, Burgomaster of Rome, above which was a chimneypiece by Jan Lievens (1607–1674) depicting another Roman consul, Suessa, who in honor of his own office instructs his father, Fabius Maximus, to dismount his horse.[23] Pancras probably knew, either from reading Plutarch or from someone's explanation, that Fabius Maximus (like Scipio Africanus) was Aemilius Paullus's son.

Apollo and Aurora clearly demonstrates why De Lairesse was so successful in Amsterdam. Combining classical subjects, contemporary relevance, idealized portraiture, and the latest pictorial style, he gave sophisticated patrons pictures that are masterfully composed and painted, and—despite their show of learning—more accessible than the great majority of works in this vein.[24]

Formerly titled by the Museum *Apotheosis of the House of Nassau* (until 1979).

1. In Ripa 1603, p. 34, and in later editions, Aurora's dress is described as yellow, but artists took great liberties. In one of the closest Dutch precedents for De Lairesse's picture, Jacob van Campen's painted vault of about 1650–51 in the Oranjezaal of the Huis ten Bosch at The Hague, Apollo and Aurora are nude and the goddess holds an enormous wreath of flowers (see Huisken, Ottenheym, and Schwartz 1995, p. 78, pl. VII; also Peter-Raupp 1980, p. 58).

2. The star is not mentioned in Ripa 1603, p. 34, on Aurora, or in the Dutch edition (Ripa 1644a), p. 331 (*Morgenstand*). However, the latter does describe a star above the *amorino* representing Dawn (*Crepusculo della Matina*), calling it "Lucifer, the light-bearer," and quoting Petrarch on the Eastern Star: "Gelijck dees lieve sterre staet,/ In 't Oosten eer de Son opgaet" (p. 18; So this beloved star stands, in the East ere the Sun ascends).

3. Ripa 1644b, p. 26 (under Aurora); on p. 25, Baudouin says that the earth and its plants are aroused by Aurora's tears. In the edition of 1677 (pp. 234–35), Baudouin writes more explicitly, "changer en perles ses pleurs."

4. Ripa 1644b, p. 26 (see also note 3 above). Ripa 1603, p. 34, and Ripa 1644a, p. 331, specify that the basket is held in the left hand and flowers are scattered by the right. Baudouin (Ripa 1644b, p. 25) refers to "one hand" and "the other."

5. See, for example, the etching (of ca. 1560?) by Angelo Falconetto after Giulio Romano, *Apollo, Pegasus, and the Hippocrene Spring,* which is illustrated and explained in Thompson 2004, p. 13.

6. See Pepper 1984, no. 40, and Crelly 1962, no. 243, fig. 117.

7. See note 1 above; Huisken, Ottenheym, and Schwartz 1995, pp. 78–81, pls. VII, IX, XVI; and Liedtke 1989b, pp. 272–73, pl. 144.

8. By contrast, Van Campen himself noted that the zodiacal signs in his *Apollo and Aurora* (see note 1 above) referred to the planets under which Prince Frederick Hendrick was born (see Huisken, Ottenheym, and Schwartz 1995, p. 79).

9. A. Roy 1992, pp. 245–46, citing the half-hidden Scorpio as Willem's sign. See Refs. for earlier suggestions along these lines.

10. As is stressed in L. de Vries 1995, p. 114.

11. Hoet 1752–70, vol. 1, p. 186. No other painting of Apollo and Aurora by De Lairesse is known or recorded in known documents.

12. A. Roy 1992, pp. 49, 236–42, nos. P.55–62. In another context, Roy (ibid., p. 283) states that the series was painted "pour le bourgmestre d'Amsterdam Gerbrand Pancras" about 1670. The alleged patron was twelve years old at the time. Roy also suggests that the eight canvases now in Liège (each of which measures

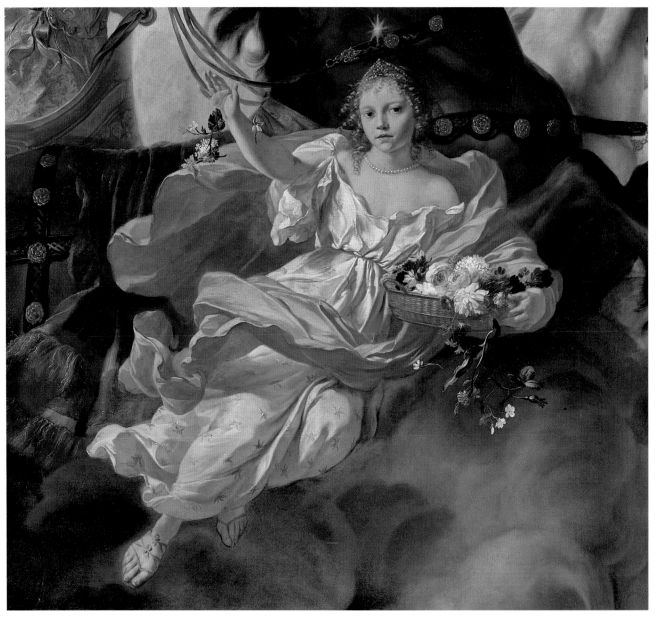

Figure 107. Detail of Lairesse's *Apollo and Aurora* (Pl. 104)

49 x 79 cm [19¼ x 31⅛ in.]) are actually not the Pancras paint-
ings but oil sketches for them, since the sale catalogue of 1716
indicates that the entire series was about 13 meters (42 ft. 8 in.)
in length, not 6.32 meters (21 ft.) like the Liège canvases. It is
almost certain, however, that the cataloguer paced off the pic-
tures in situ, or in any case included their frames (if the framing
elements were not part of the wall surface itself). The idea of
modelli on the scale and finished to the extent of the Liège paint-
ings is inconsistent with seventeenth-century practice, to say
nothing of De Lairesse's own. Contradicting his own hypothesis,
Roy gives the provenance of the Liège series as the Pancras sale
of 1716 and then (unwittingly compounding the error) as the
sale of Jacob van der Dussen, Amsterdam, April 12, 1752, no. 1.
As discussed below, Jacob van der Dussen was the son of Maria
Pancras, Gerbrand's sister.

13. Peltzer 1925, p. 365.

14. See Washington–Detroit 2004–5, pp. 177–79, 212, no. 49. In a
peculiar parallel to Roy's proposal (see Refs.), the painting by
Ter Borch was previously identified as a portrait of Willem III's
cousin Hendrick Casimir II, Prince of Nassau-Dietz (see Gud-
laugsson 1959–60, no. 239). The proper identification was first
proposed in Dudok van Heel 1983, pp. 66–67. Gerbrand Pancras
turned thirteen on September 8, 1671. On his public offices, see
Elias 1903–5, vol. 2, pp. 686–87.

15. Gudlaugsson 1959–60, no. 241.

16. Vanessa Schmid, Institute of Fine Arts, New York University, first
pointed out the resemblance of Apollo and Aurora to Gerbrand
and Aletta Pancras (2003). On Maria Pancras (who turned nine on
February 24, 1671), see Elias 1903–5, vol. 1, p. 468.

17. Hoet 1752–70, vol. 2, p. 309; A. Roy 1992, p. 236 (under nos. P.55–
62).

18. Hoet 1752–70, vol. 2, p. 310. Nine by seven Amsterdam feet

equals 8 feet 6¼ inches x 6 feet 6 inches (2.59 x 1.98 m). The measurements given in the 1752 sale are surely approximate. It is also possible that the height of the painting, if it was hung high on a wall or over a mantel, was merely guessed on the basis of its width. There is no clear evidence that the canvas was cut down at a later date.

19. See Elias 1903–5, vol. 1, pp. 468–69, on Bruno van der Dussen, his wife Maria Pancras (they married at Sloten on December 22, 1682), and their son Jacob. On Bruno van der Dussen, who was an important statesman, see also Van der Aa 1852–76, vol. 4, pp. 128–29.

20. Comparing the thirty entries in the Pancras sale of 1716 (Hoet 1752–70, vol. 1, pp. 186–88) and the seventy-eight entries in the Van der Dussen sale of 1752 (ibid., vol. 2, pp. 309–13), it would appear that Maria Pancras and Bruno van der Dussen acquired comparatively little in the first sale apart from the paintings by De Lairesse: a pair of Italianate landscapes by Frederick de Moucheron, possibly a marine by Ludolf Bakhuyzen and a landscape with horses by Philips Wouwermans, and perhaps a peasant scene by Adriaen van Ostade and a Merry Company by "Gerards."

21. See Huisken, Ottenheym, and Schwartz 1995, p. 140, on the "Aetas Aurea," and pls. XIII, XVI.

22. Ibid., pp. 142–43, figs. 112–113b.

23. See Fremantle 1959, pp. 67–68.

24. As noted by the present writer in New York–London 2001, p. 400 n. 4, direct comparison of the figure of Aurora with the figure in Vermeer's approximately contemporary *Allegory of the Catholic Faith* (Pl. 206) upsets preconceptions about both painters, since the classicist's woman is considerably more naturalistic than the realist's.

REFERENCES: Hoet 1752–70, vol. 1 (1752), p. 186, records the painting in the estate sale of burgomaster Gerbrand Pancras, Amsterdam, April 7, 1716, no. 2, sold for Fl. 60, vol. 2 (1752), p. 310, records the painting in the estate sale of Pancras's nephew, Jacob van der Dussen, Amsterdam, April 12, 1752, no. 19, sold for Fl 20; Timmers 1959, p. 137, pl. 428, as De Lairesse's *Apotheosis of the House of Orange-Nassau*, which has "a certain naive pathos"; Snoep 1970, p. 214 n. 4, rejects the Museum's title (see end of text above) and suggests that the figures of Apollo and Aurora may be portraits; Brenninkmeyer-de Rooij in Paris 1986, pp. 66–67, fig. 41, offers a general comparison with Jacob van Campen's *Apollo and Aurora* in the Huis ten Bosch; P. Sutton 1986, pp. 182–83, fig. 259, cites the work as an example of the new classicism in Dutch art ca. 1670; Hendrick 1987, pp. 178–79, fig. 159, employs the Museum's old title, but adds, "ou, Apollon et Flore," in the caption; A. Roy 1992, pp. 71,

245–46, no. P.67, pl. 10, as an "Apotheosis of William of Orange"; J. Reid 1993, vol. 2, p. 174, listed under works depicting Apollo; Baetjer 1995, p. 341; Franits 1995, p. 407, fig. 8, and p. 415 n. 64, suggests that the painting may be "a *portrait historié* of an unknown husband and wife in the guise of Apollo and Aurora"; Huet in Roberts-Jones 1995, pp. 171, 195 (ill.), describes De Lairesse's "distant idealization"; Huisken, Ottenheym, and Schwartz 1995, pp. 78–79, fig. 64, repeats Brenninkmeyer-de Rooij's remarks in Paris 1986; L. de Vries 1995, p. 114, rejects A. Roy's identification of Apollo with Willem III, seeing no resemblance, and noting that "the political situation of that year [1671] makes such a 'painted pamphlet' all but impossible"; Haverkamp-Begemann in Sterling et al. 1998, pp. 145, 147 n. 32, as *Apollo and Aurora (Apotheosis of William of Orange)*, calls the painting "the antithesis of Rembrandt's later works, as exemplified by the Lehman painting" (*Portrait of Gerard de Lairesse*); Krempel 2000, pp. 98, 131 n. 183, fig. 462, compares a painting by Nicolaes Maes, *Three Children as Ceres, Ganymede and Diana* (1673); Enklaar in Athens–Dordrecht 2000–2001, pp. 61, 186, 244, 278, 367, no. 44 (ill. pp. 13 [detail of Aurora] and 245 [plate of whole]), as *Helios and Eos*, suggests that the figures represent a man and wife of the Amsterdam patriciate; Liedtke in New York–London 2001, p. 400 n. 4, compares the style of this picture to that of Vermeer's *Allegory of the Catholic Faith* (Pl. 206); Johnson 2004, p. 302, fig. 2; Liedtke 2005a, pp. 193–95, fig. 2, suggests that the picture was painted for Nicolaes Pancras's town house at Herengracht 539 in Amsterdam, and that Apollo and Aurora are portraits of the patron's children, Gerbrand and Maria.

EXHIBITED: New York, MMA, "Rembrandt/Not Rembrandt in The Metropolitan Museum of Art," 1995–96, hors cat.; Amsterdam, Rijksmuseum, "The Glory of the Golden Age," 2000, no. 200; Dordrecht, Dordrechts Museum, "Greek Gods and Heroes in the Age of Rubens and Rembrandt," 2001, no. 44.

EX COLL.: Probably commissioned by Nicolaes Pancras, Amsterdam (from 1671; d. 1678); probably his wife, Petronella de Waert (from 1678; d. 1709); their son, Gerbrand Nicolaesz Pancras, Amsterdam (probably from 1709; d. 1716; his estate sale, Amsterdam, April 7, 1716, no. 2, sold for Fl 60); probably his sister, Maria Pancras (probably from 1716–d. 1740), and her husband, Bruno van der Dussen (probably from 1716–d. 1742); their son Jacob van der Dussen (1742–d. 1750; his sale, Amsterdam, April 12, 1752, no. 19, sold for Fl 20); evidently purchased before 1903 by the mother (Mrs. James D. Goin, New York) or grandmother (Mrs. S. M. Pike, New York) of one of the donors, Mrs. Rionda (as reported by her in 1945 and 1946); Manuel E. and Ellen G. Rionda, Alpine, N.J. (until 1943); Gift of Manuel E. and Ellen G. Rionda, 1943 43.118

WILLEM VAN LEEN

Dordrecht 1753–1825 Delfshaven

Van Leen was one of the late-eighteenth-century flower painters who flourished in the wake of Jan van Huysum (1682–1749) and his immediate followers (who included Margareta Haverman; q.v.). He was baptized in Dordrecht on February 19, 1753, and studied there with the popular Joris Ponse (1723–1783), a flower painter and tapestry designer; Dirk Kuipers (1733–1796); and Ponse's pupil Jan Arends (1738–1805).[1]

At the age of twenty Van Leen went to Paris, where he was closely associated with the highly successful Dutch flower painter Gerard van Spaendonck (1746–1822). He was mostly in Paris until 1789, when the French Revolution drove him back to the Netherlands. He settled in Delfshaven, by Rotterdam, and worked as an art dealer and auctioneer, as well as an artist. In addition to wall decorations, such as the one belonging to the Museum's Department of European Sculpture and Decorative Arts (Pl. 105), Van Leen painted flower and fruit still lifes, many of high finish and fine quality. He was also an accomplished draftsman, watercolorist, etcher, and painter of miniatures on snuffboxes. Van Leen had a number of minor pupils.[2]

1. Ponse was himself a pupil of Aart Schouman (1710–1792), an important figure in Dordrecht. On Arends, see *Saur AKL*, vol. 5 (1992), p. 20.
2. See Scheen 1969–70, vol. 1, p. 690.

105. *Flowers in a Blue Vase*

Oil on canvas, arched top, 55 x 29⅛ in. (139.7 x 74 cm)
Signed (bottom right): van Leen F

The painting is in good condition, although the paint surface is slightly abraded throughout. A tear at the top extends from the red tulip to the leaves below.

Gift of J. Pierpont Morgan, 1906 07.225.470

The canvas was almost certainly intended to decorate a section of wall, such as a space between windows or beside a door. A spiraling arrangement of flowers ascends from a large vase, which is set on a plinth in a shallow niche; shadows fall on the curving wall to the left. Grapes and peaches, strewn about the base of the vase, spill forward, to slightly illusionistic effect. The heavy vessel, of blue-glazed stoneware, has gilt bronze moldings at the top and center, with a decorative mask. The foreshortening of the vase implies a vantage point at the level of the plinth. The overall tonality is warm, which sets off the striking color of the vase.

The form of the vase and, to some extent, the flower arrangement were inspired by an engraving after Jean-Baptiste Monnoyer (1635–1699; fig. 108), which appeared in his portfolio of prints *Le livre de toutes sortes de fleurs d'après nature*, of about

Figure 108. Engraving by Nicolas de Poilly after Jean-Baptiste Monnoyer, *A Vase of Flowers,* from Monnoyer's *Le livre de toutes sortes de fleurs d'après nature* (Paris, ca. 1680). The Morgan Library & Museum, New York, Gift of Junius S. Morgan and Henry S. Morgan, 1957

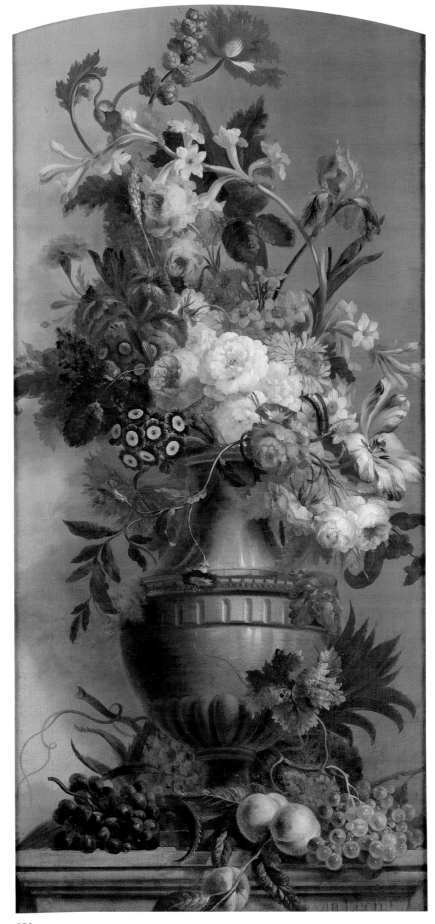

1680 (Nicolas de Poilly, Paris; 1635–99). The lighter, twisting, more asymmetrical design by Van Leen could be described as a post–Van Huysum approach.

For the most part, Van Leen's chronology is a matter of pure speculation. The present writer's intuition is that the canvas is a Parisian product, probably dating from the 1780s. Supporting this view would be the comparatively loose execution, the warm palette, and the style of the vase, which would have better suited French taste than Dutch. Van Leen is known to have drawn designs in Paris for floral wall decorations in the palace of Pavlovsk near Saint Petersburg, built in the 1780s. However, the present painting was surely intended for a more intimate interior.

Flowers in a Blue Vase is one of many eighteenth-century decorative works given to the Museum by J. Pierpont Morgan. They include a set of six tall canvases by Hubert Robert (1733–1808), a grisaille *Venus and Cupid* by Van Leen's acquaintance in Paris Piat Joseph Sauvage (1744–1818), a great variety of other French examples, and the Museum's four canvases by or in the manner of Jacob de Wit (q.v.).[1]

1. See Baetjer 1995, pp. 342, 383–84, 385–86, 390–97.

REFERENCES: Salinger 1950, pp. 258, 259 (ill.), "quite probably meant to be inserted in a wall . . . full of facile grace"; Baetjer 1995, p. 343, with an inaccurate reading of the signature.

EX COLL.: Georges Hoentschel, Paris (before 1906); J. Pierpont Morgan, New York (by 1906); Gift of J. Pierpont Morgan, 1906 07.225.470

DEPARTMENT OF EUROPEAN SCULPTURE AND DECORATIVE ARTS

JOHANNES LINGELBACH

Frankfurt am Main 1622–1674 Amsterdam

The artist was baptized in Frankfurt am Main on October 10, 1622. His father, David Lingelbach (d. 1653), was reportedly a tailor. By the time Johannes was twelve years old, in 1634, the family had moved to Amsterdam, where his father ran the Nieuwe Doolhof (New Labyrinth), a pleasure garden with automated diversions. Johannes must have trained in Amsterdam, although no record of his teacher is known. According to Houbraken, the young painter left for France in 1642 and arrived two years later in Rome, where he remained until his departure "May 8, 1650, on Sunday." He traveled through Germany, "and in June arrived back in Amsterdam in good health."[1] Apart from this account, the first document referring to Lingelbach in Amsterdam is that recording his marriage on April 26, 1653, to Tietje Hendrix Boussi, of Amsterdam. The couple had nine children; the first was baptized on December 9, 1653.[2] Lingelbach appears to have remained in Amsterdam until his death in November 1674. He was buried in a Lutheran church.

The earliest known works that are certainly by Lingelbach are *The Blacksmith* (private collection, Rome) and *Self-Portrait with Violin* (Kunsthaus, Zürich), both of which are dated 1650.[3] Signed and dated works from nearly every year thereafter are known. Lingelbach was a gifted figure painter, whose settings—Italianate landscapes, cityscapes, and harbor scenes—may be described as rather generalized compared with views by contemporary landscape specialists such as Jan Both (ca. 1615/18–1652). Even his drawings of specific sites have the look of stage scenery, artfully constructed with repoussoirs, layers of architecture, hills, and clouds, and strong contrasts of light and shadow. Landscape and cityscape drawings by Jan Worst (active ca. 1645–in or after 1686), whom Houbraken describes as Lingelbach's "especially good friend" and contemporary in Rome, are distinctly more naturalistic.[4]

In his early years, Lingelbach was influenced by the style of Pieter van Laer (1599–?1642) and by emulators of Van Laer such as Michelangelo Cerquozzi (1602–1660) and the Fleming Jan Miel (1599–1664). In the Netherlands, the strongest impression on Lingelbach's work was made by Philips Wouwermans (q.v.),[5] and in the case of Italianate harbor

scenes by Jan Baptist Weenix (1621–1660/61). Lingelbach often served as a staffageur, placing figures in landscapes by Philips Koninck, Jacob van Ruisdael (q.q.v.), Jan Hackaert (1628–in or after 1685), Jan Wijnants (1632–1684), and Frederick de Moucheron (1633–1686), among others.

The artist is most admired for his depictions of colorful street life in Italy, with scores of peasants and other types gathered in squares or on quays, and with classical porticos, tavern fronts, Baroque statues, ship masts, piles of still-life motifs, and animals spread out like props on an opera stage. The most animated scenes by David Teniers the Younger (1610–1690) are quiet and orderly by comparison. Lingelbach intensified the bustle of crowds with flickering light and local colors. For northerners who remembered or envisioned Rome as a confrontation of lofty monuments and low humanity, Lingelbach must have been regarded as the artist who brought it all to life.

1. Houbraken 1718–21, vol. 2, pp. 145–46. Despite his specific details, Houbraken supplies the wrong birth date (1625) and admits to having no information about what brought Lingelbach to Holland or about his training. Lingelbach is documented as a resident of Rome in 1647, 1648, and 1649 (Hoogewerff 1942, pp. 118–19, 121).
2. A. D. de Vries 1885, p. 159.
3. As noted by Laura Laureati in *Dictionary of Art* 1996, vol. 19, pp. 420–21, where a hypothetical group of earlier works (published in Kren 1982) is discussed. *The Blacksmith* is discussed and illustrated in Briganti, Trezzani, and Laureati 1983, pp. 260–63, fig. 10.1; for the self-portrait, see Cologne–Utrecht 1991–92, no. 21.12. At least two comparatively recent publications have repeated the misinformation that a painting by Lingelbach dated 1643 is in the Städelsches Kunstinstitut, Frankfurt (Cologne–Utrecht 1991–92, p. 212, and Amsterdam 2001, p. 124). The painting in question, inv. no. 2072, is signed by Abraham van Cuylenborch (q.v.; Sander and Brinkmann 1995, p. 26, fig. 26).
4. Houbraken 1718–21, vol. 2, p. 147. Compare the drawings by Lingelbach and by Worst in Amsterdam 2001, pp. 124–31.
5. This is most obvious in equestrian subjects, but also evident in such refined landscapes by Lingelbach as *A Shepherd and Shepherdess with a Flock*, of the 1660s (private collection; Montreal 1990, no. 42). The same work is compared with paintings by Karel du Jardin (1626–1678) in Kilian 2005, p. 74 n. 5.

106. *Peasants Dancing*

Oil on canvas, 26½ x 29½ in. (67.3 x 74.9 cm)
Signed and dated (lower center, on bench): J:lingelbach
165[1?]

The painting has suffered abrasion throughout, most severely in the figures.

Purchase, 1871 71.123

The last digit of the date on this canvas is very faint, but may be a 1, and the painting resembles others by Lingelbach dating from the early 1650s, such as *Marketplace in an Italian Town, with an Itinerant Toothpuller,* dated 1651 (Rijksmuseum, Amsterdam).[1] The Museum's picture must be one of the first painted by the artist after he settled in Amsterdam, where he is said to have arrived in June 1650, after six years in Rome.

The scene creates the impression of a Flemish festival moved to the Roman Campagna. The action centers on three couples dancing around a tree. The nearest dancer, with a hat in his hand, leads a woman with keys dangling from her belt, indicating that she is a maid or innkeeper. Music is provided by a bagpiper perched on a table to the left, and behind him a man who manages to tap a small drum and blow a flute at the same time. Two men in the center foreground urge the dancers on, one with a beer glass, the other with his hands held high. To the left of them, a couple nuzzles on the ground, their wine jug, overlapping legs, and the woman's expression promising more private pleasures to come. Another cozy couple sits on a bench near the musicians. To the left, a man snoozes, and a pair of peasant couples, one with an infant, bob their heads and smile.

To the far right, two boys, watched by another boy leaning on a saddle, play a lively game of morra.[2] A man relaxes on a small bay horse as it drinks water from a trough. A donkey and an oxcart with two oxen (one resting on the ground) complete the ensemble, which is arranged across the foreground like a rustic opera company on a stage (Verdi's *Anvil Chorus* comes to mind). For scenery, a house with a thatched roof, an inn with children coming down the steps, and two suffering trees are silhouetted against a background that includes a farm and distant mountains. All the near forms are rendered in shades of brown, with a blue sky descending to pink in the hills and green in the valley.

As one of Lingelbach's earliest dated works, the painting is important for an outline of his development, and for an appreciation of how he introduced himself into the flourishing art market of Amsterdam during the early 1650s. The artist's debts to

other painters who had been active in Rome, in particular Pieter van Laer, Jan Miel, and Michelangelo Cerquozzi (see Lingelbach's biography above), are also well illustrated here. The most comparable pictures by Lingelbach are the Amsterdam canvas mentioned above, *The Fiddler* (formerly art market, London), and other works of the 1650s.[3] Somewhat more mature compositions in the same vein include his *Peasant Dance,* in the Kunsthistorisches Museum, Vienna,[4] and the *Village Festival,* in the Castle Museum and Gallery, Nottingham.[5]

1. The Rijksmuseum picture is discussed in Kren 1982, passim, fig. 16; in Briganti, Trezzani, and Laureati 1983, p. 263, fig. 10.3; and in Cologne–Utrecht 1991–92, pp. 212–15, no. 21.
2. In the Amsterdam picture (see text above), two prominent figures play the same game, one that Pieter van Laer (1599–?1642) is said to have introduced into Roman painting during the 1630s (L. Trezzani in Cologne–Utrecht 1991–92, p. 166 [under no. 12.2]). However, the game is the main subject of an Italian-period genre scene by Johann Liss (ca. 1595/1600–1631) dating from about 1621 (*The Morra Game,* in the Staatliche Kunstsammlungen, Kassel; Klessmann 1999, no. 33, pl. 7). The saddle on the ground in the New York painting is of a type used on pack animals.
3. For *The Fiddler,* see Burger-Wegener 1976, no. 108; Kren 1982, p. 55, fig. 19; Briganti, Trezzani, and Laureati 1983, p. 276, fig. 10.8. In the last-named publication, compare scenes of peasants dancing by Miel and by Cerquozzi, e.g., figs. 4.16 and 5.19.
4. Salzburg–Vienna 1986, no. 44, and Cologne–Utrecht 1991–92, no. 21.10.
5. London 2002, no. 47.

REFERENCES: MMA 1872, p. 47, no. 117, incorrectly as "from the Broadlands collection of Lord Palmerston"; Harck 1888, p. 76, mentioned; Thieme and Becker 1907–50, vol. 23 (1929), p. 252, listed; B. Burroughs 1931a, p. 214, listed, with incorrect provenance; F. Robinson in Saint Petersburg–Atlanta 1975, p. 37, no. 24, considers "the strong, almost crude touch" of the early Lingelbach to be evident here, and compares the Amsterdam canvas (see text above); Burger-Wegener 1976, pp. 72, 279, no. 111, compares paintings by Miel and Cerquozzi, and notes the Italian (meaning stagelike) approach to composition; Dickey in Hamilton–Rochester–Amarillo 1983, pp. 16–17, no. 2, describes the picture as a work of the early 1650s, revealing close affinities with Van Laer; Baetjer 1995, p. 328; Baetjer 2004, p. 211, no. 117 (ill.), gives full provenance.

EXHIBITED: East Hampton, N.Y., Guild Hall, "Design for Living," 1959; New York, Union League Club, 1969–70; Saint Petersburg, Fla., Museum of Fine Arts, and Atlanta, Ga., High Museum of Art, "Dutch Life in the Golden Century," 1975, no. 24; Wichita, Kan., Wichita Art Museum, "5000 Years of Art from The Metropolitan Museum of Art," 1977–78, no. 45; Memphis, Tenn., Brooks Memorial

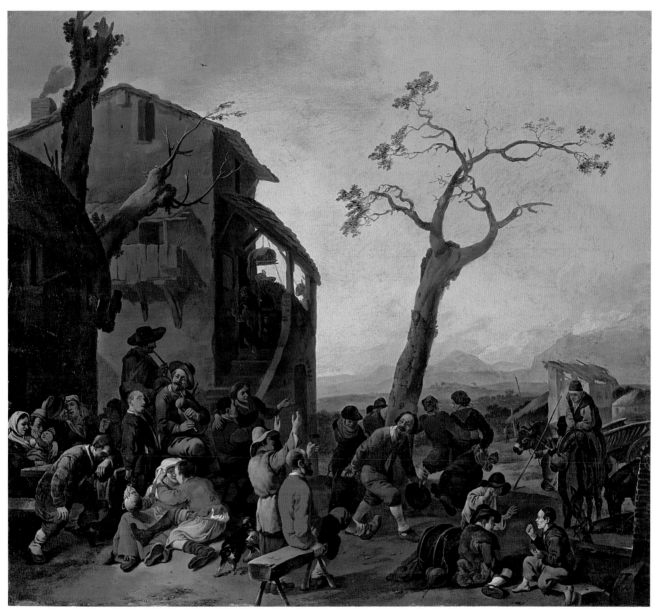

106

Art Gallery, and Columbus, Ohio, Columbus Museum of Art, "Seventeenth-Century Dutch Paintings from The Metropolitan Museum of Art," 1982, no cat.; Hamilton, N.Y., Colgate University, Picker Art Gallery, Rochester, N.Y., The Memorial Art Gallery of the University of Rochester, and Amarillo, Tex., Amarillo Art Center, "Dutch Painting in the Age of Rembrandt from The Metropolitan Museum of Art," 1983, no. 2.

EX COLL.: Abraham Delfos (until 1807; his sale, Bosboom, The Hague, June 10, 1807, no. 87); widow H. F. V. Usselino, née Tollens (until 1866; her estate sale, Roos and Engelberts, Amsterdam, January 30–31, 1866, no. 69, for Fl 69,353 to Enthouse); [Léon Gauchez, Paris, with Alexis Febvre, Paris, until 1870; sold to Blodgett]; William T. Blodgett, Paris and New York (1870–71; sold half share to Johnston); William T. Blodgett, New York, and John Taylor Johnston, New York (1871; sold to MMA); Purchase, 1871 71.123

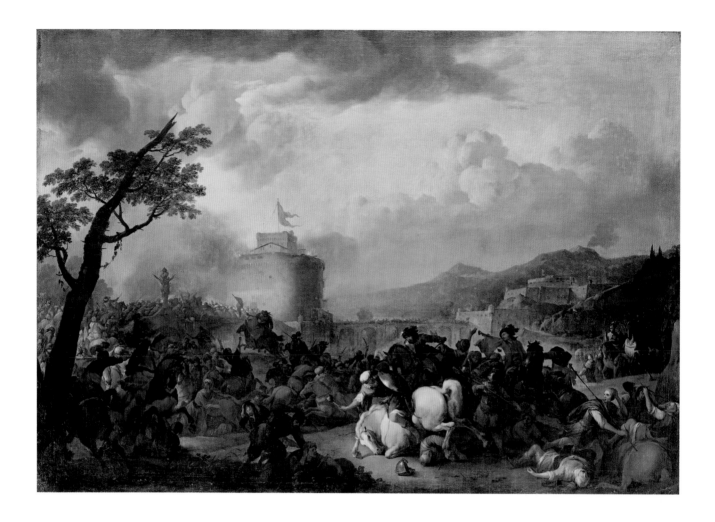

107. *Battle Scene*

Oil on canvas, 44⅜ x 63¼ in. (112.7 x 160.7 cm)
Signed and dated (lower center, on tree trunk): I/
LIN[G]ELBACH/fe/1671

Abrasion to the paint surface is most serious in the middle
distance at right, in the shadowed side of the building at
center left, and throughout the foreground battle scene.

Purchase, 1871 71.23

This late work by Lingelbach, like the early *Peasants Dancing*
(Pl. 106), is one of three paintings by the artist that were
acquired in the 1871 Purchase.[1]

The subject is a pitched battle between armies from Europe
and the Middle East. Both sides have many horsemen, but the
European cavalry is greater in number and carrying the day. The
viewer is placed close to the action in the foreground, where
unpleasant vignettes interrupt the sweep of action from right to
left. European cavalry charges up the hill on the right, and will
presumably reinforce the soldiers who are fighting their way
across the bridge in the left background. The Turks—to judge
from the mass of turbaned figures—are resisting the onslaught.
The fort, its red flag flying aloft, is based upon the Castel
Sant'Angelo in Rome, but for the moment assumes the guise of
a Muslim stronghold; cannons fire from the highest ramparts.
The bridge in the center background, swarming with figures,
leads to a fort on the far bank of the river, which appears to be
in European hands.

The costumes are contemporary but generalized. Pistols and
muskets, swords, scimitars, spears, bows and arrows, and a
conspicuous mace are brandished and employed to frightful
effect (the last weapon is held by the Turk on the stumbling
white horse). While dead and wounded are depicted, the overall
impression is of a rhythmic ebb and flow, with intricate chore-
ography in isolated groups, especially at center right, where a
heroic swordsman and a trumpeter hold forth on symmetrically

advancing horses. By this date, the compositional lineage of groups such as this one, a well as that of the two riders to the left, is so complex that it would be pointless to seek models in prints after Rubens, or by such artists as Antonio Tempesta, Jacques Callot, or Stefano della Bella. Lingelbach's more immediate sources of inspiration, in his comparatively few battle scenes, were paintings by Pieter van Laer (1599–?1642) and by Philips Wouwermans (q.v.). One of the most impressive examples is Wouwermans's large canvas *Cavalry Making a Sortie from a Fort on a Hill,* of 1646 (National Gallery, London).[2]

Many Dutch, Flemish, French, and Italian artists of the seventeenth century painted pictures of battles on land, often with cavalry. Lingelbach's subject, a generic battle of Turks and Christians, is found at least as early as the canvas of 1621 (Louvre, Paris) by the Neapolitan Anielle Falcone (1607–1656), the artist who invented the so-called battle without a hero, and was dubbed the "oracle" of the genre in his own day. Falcone had a good number of Italian followers, including Salvator Rosa (1615–1673), and he painted genre scenes that influenced Van Laer and Michelangelo Cerquozzi (1602–1660), two of Lingelbach's direct predecessors in Rome (see the biography above and the preceding entry).[3] Another key figure in Florence and Rome was Giacomo Cortese (Jacques Courtois; 1621–1675), called il Borgognone, who was friendly with Van Laer and Cerquozzi, and who painted battle pictures for noble patrons in Rome during the 1640s, when Lingelbach was there. Of course the specialty, like that of Dutch guardroom scenes, reflects the prevalence of military campaigns throughout much of Europe during the period. Here, however, the Italianate landscape and the standard "crusader" subject make it clear that the interest of the picture was essentially romantic rather than topical. A year after the canvas was painted, France invaded the Netherlands—and the image probably lost some of its appeal.

1. A late, weak work by the artist, *A Hawking Party,* was deaccessioned in 1989 (Baetjer 2004, pp. 240–41, no. 169).
2. MacLaren/Brown 1991, pp. 499–500, no. 6263, pl. 425. For a battle scene by Van Laer, see Briganti, Trezzani, and Laureati 1983, no. 1.42 (*Assault on a Fortress,* in a private collection).
3. On Falcone, see Arnauld Brejon de Lavergnée in *Dictionary of Art* 1996, vol. 10, pp. 762–63, and Simon Pepper, "Battle Pictures and Military Scenes," in ibid., vol. 3, p. 388. Rosa's major battle scenes, which feature motifs similar to Lingelbach's (stumbling white horses, for example), date from the 1640s onward (see Salerno 1963, pls. 19, 24a–25, 50).

REFERENCES: Kegel 1884, pp. 461–62, describes the picture as too conventionally composed; Harck 1888, p. 76, mentioned; MMA 1904, pp. 106–7, no. 52, as *Sobieski Defeating the Turks Before Vienna,* explains that the battle took place in 1683, and overlooks the difficulty that Lingelbach died in 1674 (as noted in the same entry); Thieme and Becker 1907–50, vol. 23 (1929), p. 252, listed; Burger-Wegener 1976, pp. 149–50, 338, no. 224, describes the work at length, observing that the imaginary battle is between Turks and Europeans, and compares compositions by Salvator Rosa; Baetjer 1995, p. 328; Baetjer 2004, p. 202, no. 49 (ill.), gives full provenance.

EXHIBITED: New York, American Federation of Arts, "Little Masters in 17th Century Holland and Flanders" (circulating exhibition), 1954–57, no cat.

EX COLL.: ?Fürst Alois Wenzel Kaunitz, Vienna (not in his sale, Artaria, Vienna, March 13, 1820); ?by descent to Martin, Comte Cornet de Ways Ruart, Brussels (until d. 1870); [Étienne Le Roy, Brussels, through Léon Gauchez, Paris, until 1870; sold to Blodgett]; William T. Blodgett, Paris and New York (1870–71; sold half share to Johnston); William T. Blodgett, New York, and John Taylor Johnston, New York (1871; sold to MMA); Purchase, 1871 71.23

NICOLAES MAES

Dordrecht 1634–1693 Amsterdam

Like Ferdinand Bol and Samuel van Hoogstraten (q.q.v.) before him, Maes was one of several artists who went from the South Holland city of Dordrecht to study with Rembrandt in Amsterdam, in his case between about 1649–50 and 1652–53. The second son of Gerrit Maes, a prosperous silk merchant and soap manufacturer in Dordrecht, and his wife Ida Claesdr, Maes was baptized in January 1634. According to Houbraken, the teenager learned drawing with "an ordinary master" in his hometown, and then studied painting with Rembrandt.[1] It is not known when Maes returned to Dordrecht, but on December 28, 1653, his forthcoming marriage was announced. The bride was Adriana Brouwers (1624–1690),[2] ten years Maes's senior, and the widow of a preacher, Arnoldus de Gelder (d. August 1652). The ceremony took place in the Reformed Church of Dordrecht on January 13, 1654. Adriana had a son, Justus (b. 1650), from her first marriage. Her son with Maes, Conraedus, baptized in September 1654, lived only two years. He died about two weeks after the couple's first daughter, Johanna, was baptized, which took place on April 24, 1656.[3] Maes was hardly the only Dutch artist who depicted mothers caring for infants and young children (see Pl. 110), but the fact that the theme became common in his oeuvre from about 1654 onward (when he was in his early twenties) strikes a personal note. Two more daughters, Arnoldina and Ida Margriet, were born in 1660 and 1664, respectively.

In March 1658, Maes signed a contract to buy a house on the Steegoversloot in Dordrecht from a sea captain and merchant, Job Jansz Cuyter, for 2,650 guilders together with a group portrait of the seller's family. This painting of Cuyter, his wife, and six children (with a few lost ones in the clouds), set on a quay by the Dordrecht harbor, is dated 1659 (North Carolina Museum of Art, Raleigh).[4] A good number of single and pendant portraits, as well as a few other family portraits, date from 1655 until the mid-1660s, most of them rather conservative. About 1664–65, Maes's portrait style became much more fashionable, in the Flemish manner, although one could also say in the style of The Hague, where Caspar Netscher (q.v.) turned in the same direction at about the same time.[5]

In a notation dated December 10, 1673, the Reformed Community of Dordrecht recorded that Maes, his wife, two of their children, and their maid had moved to Amsterdam. The artist retained two houses in Dordrecht, one of which he rented out in 1675. A will made by Maes and his wife in 1685 names their three daughters and Maes's stepson as beneficiaries. The painter was buried in the Oude Kerk, Amsterdam, on December 24, 1693.[6]

The earliest dated work by Maes is the Museum's *Abraham Dismissing Hagar and Ishmael,* of 1653 (Pl. 108). Here and in other works of about the same time, such as *Christ Blessing the Children* (National Gallery, London) and *The Sacrifice of Isaac* (private collection), the artist reveals his own personality when he was still close to Rembrandt, a temperament that was tender and domestic even in subjects where the Lord's will seems harsh. Between 1654 and the late 1650s, this sentiment found its ideal métier in images of homemakers, female servants, and mothers with children, set mostly in interiors that are typical of South Holland in their orderly compositions, but Rembrandtesque in their softening shadows and gentle light.[7] The painter's characteristic palette of warm reds, browns, yellows, whites, and blacks draws upon Rembrandt's but also appears to have been suited to Dordrecht taste. Maes's conversion to a Flemish style and the nearly exclusive practice of portraiture from the 1660s onward was not as extreme as many authors have suggested, and certainly not unexpected for the time.[8] Houbraken reports that Maes (probably in the 1660s) made a trip to Antwerp "to see the exquisite brushwork of Rubens, Van Dyck, and other high-flyers, and also to visit artists," in particular Jacob Jordaens (1593–1678).[9] The most Jordaens-like pictures Maes ever painted, although they are hardly similar in coloring or touch, are his portraits of infants in the guise of Ganymede, a hunter, or a shepherd—hugging their eagles, dogs, deer, and sheep while they themselves are swathed in enough silk, satin, and feathers to make a bed when playtime is done.

Houbraken names a few of Maes's forgotten Dordrecht pupils. The painter strongly influenced Cornelis Bisschop (q.v.), Reinier Covijn (ca. 1636–1681), Abraham van Dyck (1635–1672), and, in at least two early works, Johannes Vermeer (q.v.; see Pl. 202).[10]

1. Houbraken 1718–21, vol. 2, pp. 273–74. As in other cases (for example, Govert Flinck; q.v.), Houbraken is well off the mark in regard to the artist's birth date, giving it as 1632.

2. Adriana Brouwers's dates of birth and death are deduced in Ghandour 1999.

3. For these documents, see Krempel 2000, pp. 373–74.

4. See the chatty entry in Sarasota 1980–81, no. 42, and Krempel 2000, p. 290, no. A39, fig. 106, and p. 374, doc. 15.

5. For Maes as a portraitist, see the many illustrations in Krempel 2000, figs. 60ff.

6. See ibid., pp. 377, 279–80, docs. 50, 53, 83, 92.

7. See Liedtke 2000a, pp. 162–63, and Franits 2004, p. 152.

8. See Franits 1995.

9. Houbraken 1718–21, vol. 2, p. 275.

10. On Covijn, see Dordrecht 1992–93, pp. 114–15, and p. 227 for the names of Maes's actual pupils. Abraham van Dyck is tentatively reconstructed in Sumowski 1983–[94], vol. 1, pp. 666–711.

108. *Abraham Dismissing Hagar and Ishmael*

Oil on canvas, 34½ x 27½ in. (87.6 x 69.9 cm)
Signed and dated (lower center, on step): ИMAES.A 1653
[first four letters in ligature]

Most of the paint surface has suffered severe abrasion, although Ishmael's costume and Abraham's red robe are well preserved.

Gift of Mrs. Edward Brayton, 1971 1971.73

The date inscribed on this canvas, 1653, is the earliest known in Maes's oeuvre, and marks a moment when he was just beginning to work independently after studying with Rembrandt for two or three years. The work could have been painted in Amsterdam or in the artist's native Dordrecht. In conception, the picture depends upon examples by Rembrandt, while the manner of execution is similar to that of other Rembrandt pupils of the late 1640s and early 1650s, such as Willem Drost (q.v.).

With the exception of one reproduction published in 1936 (see Refs.), the painting was completely unknown to scholars until it was given to the Museum in 1971. The donor was a direct descendant of the man who brought the picture to America in about 1811.

The subject, from Genesis 21:14, occurs frequently in Dutch art, especially in Rembrandt's circle. Abraham, founder of the Hebrew nation, and his wife, Sarah, lived in the land of Canaan, having returned there from Egypt. Abraham was ninety-nine, and Sarah ninety years old. They were childless except for Ishmael, a son whom, at Sarah's suggestion, Abraham had by her Eqyptian maid, Hagar. The Lord appeared to Abraham, declaring that he would be the father of many nations, and that Sarah would give birth to a son, Isaac. Abraham doubted this extraordinary news, and made an appeal on behalf of Ishmael, who was then only thirteen. And God responded, promising to make Ishmael fruitful: "Twelve princes shall he beget, and a great nation," but adding, "My covenant will I establish with Isaac, which Sarah shall bear unto thee at this set time in the next year" (Gen. 17:20–21). And so it came to pass, after Isaac was weaned, Sarah saw Ishmael mocking, much as Hagar, when she first conceived, had looked down upon Sarah (Gen. 16:4). Sarah then demanded that Abraham cast Hagar and Ishmael from their house, "for the son of this bondwoman shall not be heir with my son" (Gen. 21:10). Abraham grieved at the prospect of losing Ishmael. But God told Abraham to accede to Sarah's wishes, saying that Ishmael too would found a nation. The next morning, Abraham turned Hagar and Ishmael out of his house, giving them bread and water. And so they departed, and wandered in the wilderness of Beersheba, where God protected them. "And God was with the lad; and he grew, and dwelt in the wilderness, and became an archer" (Gen. 21:20).

As Walsh and others have explained, Maes made a preparatory drawing for this picture (fig. 109) that recalls Rembrandt's etching of 1637 (fig. 110) in its upright composition and diagonal view of the doorway and steps, in aspects of Abraham's pose, and in the placement of Ishmael if not Hagar. (Hagar's headgear is also changed, to suggest her Egyptian origin.)[1] Maes evidently followed Rembrandt in showing Ishmael's head from the back, but then made a revision, turning the boy's head to reveal his sad expression and perhaps to imply a

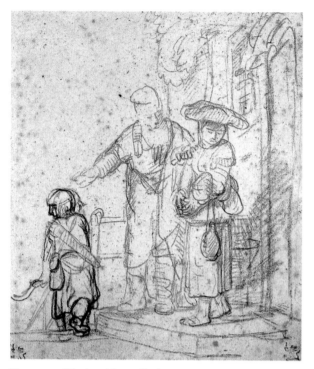

Figure 109. Nicolaes Maes, *Abraham Dismissing Hagar and Ishmael*, ca. 1653. Red chalk, 7 x 6⅛ in. (17.7 x 15.4 cm). Kupferstichkabinett, Staatliche Museen zu Berlin

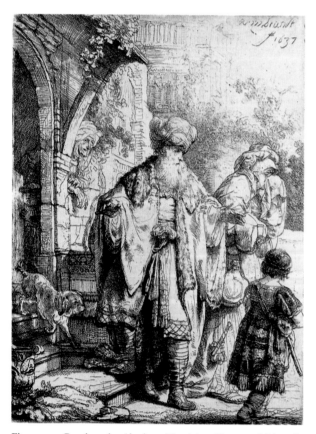

Figure 110. Rembrandt, *Abraham Dismissing Hagar and Ishmael*, 1637. Etching and drypoint, only state, 5 x 3¾ in. (12.6 x 9.6 cm). Rijksprentenkabinet, Rijksmuseum, Amsterdam

parting glance at the dog. There is general agreement that Maes himself modified the figure of Ishmael, as opposed to Rembrandt's suggesting an alternative to his nineteen-year-old disciple.

Walsh and other scholars have also compared two drawings of the subject that have traditionally been accepted as by Rembrandt, one in the British Museum, London (fig. 111), and the other in the Rijksprentenkabinet, Amsterdam. The latter, however, has been doubted recently, and associated with a "Drost group," which raises the possibility that Drost or another Rembrandt pupil was responding to the master's example about the same time as Maes, or perhaps slightly earlier.[2] In the London drawing, the arrangement of the three figures more closely anticipates Maes, who at the same time recalls Rembrandt's etching in that Abraham's hand is stretched toward Ishmael without touching him. Perhaps Maes combined these or similar precedents to create the impression of an intended blessing that falls short. Hagar steps forward in the drawings by Rembrandt and Maes (figs. 109, 110); in the painting, Maes has her stand still and turn her face away from Abraham. The result is a figure of great dignity, reminiscent of Early Renaissance painting and sculpture. Hagar's pose and expression, and those of Ishmael as well, strike one as heartfelt responses to Abraham's ineffectual words. His expression has been considered as one of "doting anxiety,"[3] but for some viewers it might seem suggestive of something less sympathetic, such as an attempt to explain that the matter is out of his hands. Hagar would have had no idea of how true this was.

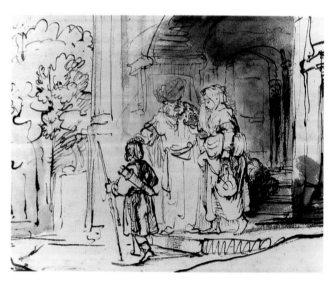

Figure 111. Attributed to Rembrandt, *Abraham Dismissing Hagar and Ishmael*, ca. 1642–46. Pen and brown ink with brown wash heightened with white, 7⅜ x 9⅜ in. (18.8 x 23.7 cm). The British Museum, London

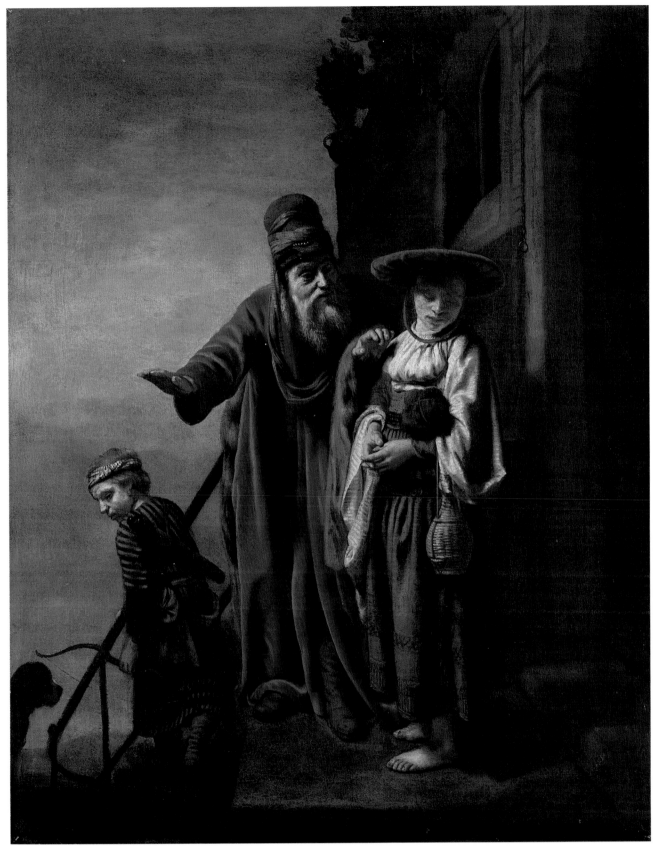

108

It has often been said that Rembrandt assigned subjects like this one to his students, expecting them to imagine the figures' behavior for themselves.[4] In any event, Maes has arrived at his own solution, and in terms of expression achieved something more affecting and profound than Rembrandt did in his etching (fig. 110). There, Hagar weeps as if following stage directions, and Ishmael's feelings are conveyed (if at all) by body language alone.[5] The key figure in the print is the patriarch, caught between the outcasts and the smug figures of Sarah in the window and Isaac at the door of the house. Maes shifts the emphasis to Hagar, whose earlier pride is symbolized by the peacock on the balustrade above her. She is barefoot, suggesting humility. In this handling, the dog may be meant as a reminder of fidelity, a trait more consistently found in his species than in humankind.

In a broad view, Maes's painting is related not only to Rembrandt's oeuvre but also to a Netherlandish tradition of depicting this subject and other Old Testament themes. In the conception of his etching, Rembrandt had in mind Lucas van Leyden's engraving of 1516,[6] and his teacher Pieter Lastman's painting of 1612 (Kunsthalle, Hamburg).[7] In some instances, Rembrandt's followers responded to Lastman's example as well as to that of Rembrandt, as in paintings by Jan Victors (q.v.) dating from 1642 (Richard L. Feigen, New York) and later,[8] and in a canvas of the early 1650s by Barent Fabritius (q.v.; Fine Arts Museums of San Francisco).[9] Other artists in Rembrandt's circle who treated the subject include Gerbrand van den Eeckhout and Govert Flinck (q.q.v.), in paintings of the early 1640s;[10] Ferdinand Bol (q.v.), in a picture perhaps of the early 1650s;[11] and Karel van der Pluym (1625–1672), in a panel probably dating from the mid-1650s.[12] Of course, the story was also depicted outside Rembrandt's sphere, for example by Gabriël Metsu (q.v.), who shows Abraham evicting Hagar as if she were a tenant behind on the rent.[13]

The story of Hagar and other episodes in the life of Abraham are among the Old Testament subjects that are cited fairly frequently in seventeenth-century inventories of paintings owned by Reformed collectors in the Netherlands.[14] The Protestant emphasis on individual study of the Bible, and on applying its message to everyday experience, is strongly borne out in Rembrandt's approach and in his teaching, insofar as it concerned the interpretation of religious themes. It has been suggested that Abraham's expulsion of Hagar and Ishmael and his later willingness to sacrifice Isaac are subjects that absorbed Rembrandt both because of their currency in Protestant theology and because of his "recurrent interest in problematic relationships between fathers and sons."[15] The complexity of human relationships in the story of Hagar's dismissal is reflected in the diversity of conceptions found in Rembrandt's circle. Maes's early painting is one of the simplest and most poignant interpretations, in good part because Hagar is given such a dominant role, comparable to that of Susanna and Bathsheba in other pictures by Rembrandt and his followers. Here, however, the emotions involve not desire but rejection, a more hurtful thing to bear.

1. See Walsh 1972, pp. 111–12 on Hagar's Gypsy *bern* and n. 17 on the supposed Egyptian origin of Gypsies, and rival legends in the seventeenth century. The Berlin drawing is discussed in Sumowski 1979–95, vol. 8, p. 3964, no. 1764.

2. In a personal communication dated March 18, 2005, Martin Royalton-Kisch described the drawing in the British Museum (Benesch no. 524; fig. 111 here) as probably but not unquestionably by Rembrandt. His entry in London 1992, p. 106 (under no. 41), concludes that the sheet should be "retained under Rembrandt's name only with misgivings," and "if by Rembrandt, should be dated to around 1642–6." In the same communication, Royalton-Kisch doubts that the Amsterdam drawing (Benesch no. 916; Walsh 1972, pp. 108–9, fig. 5; Amsterdam 1984–85, no. 70) is by Rembrandt, and is "not so sure that it doesn't belong to what is best termed the 'Drost group.' This would be close in time to the Maes, and in fact the figure of Abraham is not so far away in pose." Peter Schatborn, by contrast, considers the Amsterdam drawing to be by Rembrandt, and doubts the London drawing (personal communication, April 14, 2005). Both drawings are discussed as by Rembrandt in D. Smith 1985, p. 298, figs. 29, 30.

3. Walsh 1972, p. 110.

4. See, for example, Hamann 1936, p. 537; Walsh 1972, p. 108; Amsterdam 1984–85, pp. 12–13, 84–91; and Liedtke 1995b, p. 19.

5. On the print, see Ackley in Boston–Chicago 2003–4, pp. 19–20, 132–34 no. 66, 214. Ackley (ibid., p. 135 n. 3) notes that Rembrandt was supposed to turn over to a patron the copperplate and all but two or three impressions of the etching, but that he evidently retained more impressions than those to which he was entitled. This tends to support the notion of the print's use in Rembrandt's studio.

6. See Luijten in Amsterdam–London 2000–2001, pp. 15–16, figs. 6, 7.

7. See Manuth in Berlin–Amsterdam–London 1991–92a, pp. 380–83, figs. 81a, 81b, and 81d; A. Tümpel in Amsterdam 1991–92, p. 23, fig. 10; C. Tümpel in ibid., pp. 67–68, figs. 13, 14; and Stefes in Hamburg 2006, no. 15. A. Tümpel in Amsterdam 1991–92, p. 24, fig. 11, and p. 30, fig. 17, illustrates paintings of the subject by two other artists in Lastman's circle, Claes Moeyaert ("before 1624") and Jan Pynas (1613), respectively. See also Salomon de Bray's painting dated 1633 (location unknown; Sumowski 1983–[94], vol. 6, p. 3522 [ill. p. 3543]).

8. Sumowski 1983–[94], vol. 4, nos. 1731 (1642), 1741 (late 1640s), 1784 (1670s); Manuth in Berlin–Amsterdam–London 1991–92a, no. 69 (Victors's large canvas, dated 1650, in the Israel Museum, Jerusalem).

9. Berlin–Amsterdam–London 1991–92a, no. 81, as dating from

"about 1650" (p. 382). As late as 1666, Gerbrand van den Eeckhout (q.v.) looked back to Lastman, in his painting in the North Carolina Museum of Art, Raleigh (see Sumowski 1983–[94], vol. 2, pp. 739, 821, no. 458). See also Plomp 1997, no. 125.

10. For Van den Eeckhout's canvas dated 1642, see Sumowski 1983–[94], vol. 2, no. 393. For Flinck, see Von Moltke 1965, p. 65, nos. 1, 2, pl. 8, and also Manuth in Berlin–Amsterdam–London 1991–92a, p. 342, fig. 69b.

11. Blankert 1982, p. 90, no. 3, pl. 19 (Hermitage, Saint Petersburg), as dating from about 1652–56.

12. Sumowski 1983–[94], vol. 4, no. 1591. See also ibid., vol. 5, p. 3399, "Die Verstossung der Hagar," in the register of works by Rembrandt pupils and followers.

13. F. Robinson 1974, p. 17, fig. 5; Amsterdam–Jerusalem 1991–92, no. 7.

14. As noted in Montias 1991, p. 340. See also North 1992, p. 137. No Old Testament subject occurs regularly in inventories of contemporary Catholic collections.

15. D. Smith 1985, p. 293. The subject is also discussed in Sitt 2002, and in Sellin 2003.

REFERENCES: Hamann 1936, pp. 536–37, fig. 94, as in a private collection in New York, compares the painting and Maes's preparatory drawing to earlier drawings by Rembrandt and by one of his pupils; Sumowski 1957–58, p. 237, no. 6, listed; Walsh 1972, reviews the known provenance of the painting (based on the donor's family records), describes its rediscovery and the importance of the date, compares Maes's drawing and Rembrandt's etching (figs. 109, 110 here) and drawings of the subject, and relates other works by or attributed to Maes; Walsh 1974a, pp. 347–48, 349 n. 20, pl. VI, as Maes's earliest dated work, describes the picture's stylistic and expressive qualities; Bader in Milwaukee 1976, pp. 26–27, no. 8, as "of great art historical importance"; B[enedict] N[icolson] in a review of current exhibitions, *Burlington Magazine* 118 (1976), pp. 530, 539, fig. 103, remarks upon the picture's inclusion in the Milwaukee exhibition and claims that it solves some problems of connoisseurship; Naumann 1981, vol. 1, p. 51 n. 12, compares the artist's later concerns with space and geometry; Paris 1983, p. 79 (under no. 47), mentions the work in the context of a speculative attribution to Maes; Sumowski 1983–[94], vol. 3, pp. 1951, 1952, 2006 no. 1315 (and under no. 1314), 2007 (under no. 1316; ill. p. 2041), discusses the picture as Maes's earliest dated work, painted in Dordrecht, and compares his *Sacrifice of Isaac* (private collection) and other early paintings; Haak 1984, p. 420, fig. 917, considers Rembrandt's influence evident, and Maes's own direction as well; McTavish in Kingston 1984, p. 48, compares the painting with Maes's *Sacrifice of Isaac* (then in the Bader collection) and suggests a somewhat later date for the latter; W. Robinson 1984, pp. 540, 544, fig. 7, compares the newly discovered *Sacrifice of Isaac* by Maes (private collection) with the Museum's picture, noting similarities in color, execution, and costume; Sumowski 1979–95, vol. 8 (1984), pp. 3964–65 (under no. 1764), catalogues the sketch by Maes in Berlin as a preparatory drawing for the Museum's picture; P. Sutton in Philadelphia–Berlin–London 1984, p. LII, mentioned as Maes's earliest dated work; Amsterdam 1984–85, pp. 87–88 (under nos. 71, 72), describes Maes's drawing in Berlin (fig. 109 here) as a preliminary study for the present painting;

P. Sutton 1986, p. 183, "lovely"; Bruyn 1988b, p. 328, considers the work to reveal Maes as a fully developed artist; Giltaij 1988, p. 220 (under no. 111), considers a drawing of the same subject in Rotterdam to be by Maes and to predate the Museum's picture; MacLaren/Brown 1991, pp. 242–43, maintains convincingly that *Christ Blessing the Children* (National Gallery, London) is by Maes ca. 1652–53, based partly on comparison with the present picture; Huys Janssen in The Hague 1992a, pp. 236, 238, fig. 30a, considers the painting to support a similar date for Maes's *Young Woman with Three Children* (private collection), where the same female model appears to have been employed; Ingamells 1992a, p. 189, cited in the biography of Maes as his earliest dated work and as "Rembrandt-esque"; Chong and Wieseman in Dordrecht 1992–93, pp. 25–26, fig. 23, cited as Maes's earliest dated work; Wieseman in ibid., p. 228, compares Maes's *Christ Blessing the Children* (National Gallery, London), and suggests a date of about 1652–53 for that picture, and p. 232, compares Maes's *Sacrifice of Isaac* and (following W. Robinson 1984) suggests a somewhat later date for that work; Sumowski 1983–[94], vol. 6 [1994], p. 3627 (under no. 1315), adds literature dating from 1988–92; Baetjer 1995, p. 337; Wheelock 1995a, p. 163 n. 11, notes the use of a "striped headdress" (?) in this picture and in other works by Maes; Liedtke in New York 1995–96, vol. 2, pp. 6, 19, 30, 126, 146, 149–50, no. 52, describes Rembrandt's influence and Maes's distinctive qualities as seen in this work, mentions other treatments of the subject by Rembrandt pupils, and suggests that in expressive terms the painting is superior to Rembrandt's etching of 1637; William W. Robinson in *Dictionary of Art* 1996, vol. 20, p. 78, cites the work as an example of Maes's "precocious originality in the interpretation of the sacred text and iconographic tradition," and refers to the figure of Ishmael as "a prematurely embittered outcast"; Plomp 1997, p. 233 (under no. 250), relates a sheet of studies probably by Maes, which are "presumably related to Maes' painting of the subject of 1653 . . . even though all three figures are posed differently"; Krempel 2000, pp. 28, 42–43, 45, 46, 61, 110, 115 n. 14, 117 n. 27, 123 nn. 13, 14, 125 n. 54, 279, no. A2 (and under no. A1), fig. 1, pl. 1, catalogues the painting as Maes's earliest dated work, notes the type of signature (used 1653–56), considers it quite possible that Maes painted the picture while still in Amsterdam, describes the arrangement of the figures and the expressive effects, discusses the painting's style in comparison with that of Rembrandt and with other early works by Maes, and notes that the work may be identical with a picture in an anonymous sale in Dordrecht of 1810; Dickey 2002, p. 216 n. 79, compares the flat hat worn by Hagar to one seen in Rembrandt's etching, *Studies of Saskia and Other Women* of 1636; Sellin 2003, pp. 200–201, fig. 4, describes how Hagar and Ishmael are treated in an original manner; Heilmann in Copenhagen 2006, p. 326, cites the picture as a document revealing how early Maes was working independently.

EXHIBITED: New York, MMA, "Patterns of Collecting, Selected Acquisitions, 1965–1975," 1975–76; Milwaukee, Wis., Milwaukee Art Center, "The Bible through Dutch Eyes," 1976, no. 8; New York, MMA, "Rembrandt/Not Rembrandt in The Metropolitan Museum of Art," 1995–96, no. 52.

EX COLL.: Presumably the picture in a sale of works from anonymous owners, organized by Pieter van Braam, Dordrecht, December 3,

1810, no. 54, "Maas, De wegsending van Hagar. hoog 35, breed 26 duim";[1] purchased about 1810–11 in Europe and imported to America by John Hare Powel (1786–1856), secretary of the American legation in London;[2] John Hare Powel, Rhode Island (1811–55); his son John Hare Powel Jr. (by deed, from 1855); his son Pemberton Hare Powel; his daughter Annie Hare Powel Brayton (Mrs. Edward Brayton), Fall River, Mass. (until 1971); Gift of Mrs. Edward Brayton, 1971 1971.73

1. According to the Getty Provenance Index, and a memo sent by Burton Fredericksen at the Getty Information Institute to John Walsh, dated December 16, 1996. Also reported in Krempel 2000, pp. 123 n. 13, 279 (under no. A2). The only known copy of the sale catalogue (in the Bibliotheek van de Vereeniging ter Bevordering van de Belangen des Boekhandels, Amsterdam) is not annotated with the names of buyers or other information.

2. On the descent of the Museum's painting in the Powel family, see Walsh 1972, p. 105 n. 2.

109. Young Woman Peeling Apples

Oil on wood, 21½ x 18 in. (54.6 x 45.7 cm)

The painting is in good condition although there is slight abrasion overall, most apparent in the figure and the wall behind her. Still-life elements — the basket of apples, table-cloth, and bucket — are better preserved. A small amount of paint loss has occurred along the central vertical panel join.

Bequest of Benjamin Altman, 1913 14.40.612

The Altman picture by Maes was painted about 1655, in Dordrecht. A date of about 1657 has also been proposed,[1] but in its soft effects of light and shadow, warm, blended coloring, and simplicity of space, the painting is still strongly evocative of Maes's study under Rembrandt, which continued until 1652 or 1653. Dated pictures of similar subjects by Maes, such as *A Woman Scraping Parsnips, with a Child Standing by Her* (National Gallery, London), of 1655, support the earlier dating.[2] During the mid-1650s, Maes adopted the regional stylistic tendency (found in Delft, The Hague, and Rotterdam as well as in Dordrecht) to clearly articulate interior space by means of tiled floors, receding walls and windows, and a variety of rectilinear elements.[3] Accompanying this development in Maes's work was an inclination toward descriptive detail and more localized coloring. While not the most obvious example, the Museum's other genre painting by Maes, *The Lacemaker* (Pl. 110), shows this direction in his approach to domestic settings. Maes did not abandon altogether his preference for velvety shadows, but in works dating from after 1655 he tends to sweep them toward the corners of his interiors.[4] Here, by contrast, the shadows surround the young woman in a comforting, intimate manner, and the warm sunlight that falls on her

seems almost a metaphor for the satisfaction she finds in her work. This expressive quality was evidently a product of Maes's own personality, as well as a reflection of his admiration for the domestic religious scenes that Rembrandt painted during the 1640s, such as *The Holy Family with Angels,* of 1645 (Hermitage, Saint Petersburg).

The concentration of the figure (probably a maid) is conveyed by that of the composition, and of course by Maes's affectionate description of her face. A basket of apples sits on the carpet-covered table, and one by one they make their way to the girl's apron, to her hands, and to the bucket of water at her feet. The oil lamp hanging on the wall provides a sense of balance to the composition and further enhances the mood of the painting, which is entirely positive. Sumowski's remark (see Refs.) about apples and worldly temptation has more to do with academic fashions of the 1970s and 1980s than with the seventeenth-century Dutch appreciation of home life and honest work.

Paintings of women peeling apples, scraping parsnips, and otherwise preparing simple foods were one of several ways — the writings of Jacobs Cats were another — in which the Dutch endorsed an ideal of womanhood in middle-class society. The image of a homemaker, content with her modest and diligent life, had moral and religious overtones, but it is only in Maes's pictures of old women bent over work, praying, or dozing over a Bible that a didactic impression is made.[5] Gerrit Dou (q.v.) painted a picture of an old woman peeling apples in about 1630 (Gemäldegalerie, Berlin), but it was not until the 1650s that the motif and similar domestic subjects became fairly commonplace. Examples by Maes (*Old Woman Peeling Apples,*

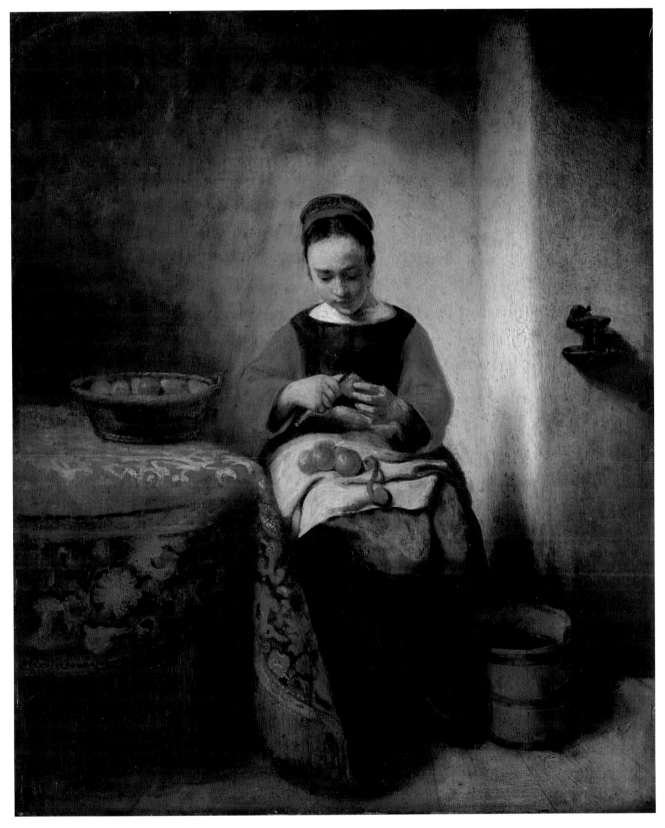

109

also in Berlin), Gabriël Metsu (see the discussion of *A Woman Seated at a Window*, Pl. 117, below), Pieter de Hooch, and Cornelis Bisschop (q.q.v.) are well known.[6]

The Altman panel appears prominently next to a tondo by Raphael in a painting by Pieter Christoffel Wonder (1780–1852), dated 1826, which shows three connoisseurs and the artist in an imaginary picture gallery.[7] Wonder included the painting again in the very center of his most ambitious gallery view, *Sir John Murray's Art Gallery*, dated 1830 (private collection, England).[8] The Dutch artist went to London in 1823 and probably saw the Maes at the Christie's sale of the following year (see Ex Coll.). His friendship with the Dordrecht painters Abraham van Strij (1753–1826) and his brother Jacob (q.v.) may have encouraged him to place a painting by Maes in exalted company.[9] This pictorial fiction became fact when the work entered the collections of the Duke of Sutherland, Rodolphe Kann, and Benjamin Altman (see Ex Coll.).[10]

1. Krempel 2000, p. 360 (under no. D28).

2. MacLaren/Brown 1991, pp. 240–41, no. 159, pl. 201; Krempel 2000, p. 281, no. A8, fig. 14.

3. On this development in the South Holland region, see Liedtke 2000a, chap. 4 (pp. 162–63).

4. The undated *Old Woman Spinning* (Rijksmuseum, Amsterdam) is no exception, although it appears to be in Krempel 2000, fig. 48 (reproduced next to the present picture), since the caption reads simply "1657." But in the catalogue entry for that work (ibid., p. 355, no. D5), one finds a tortuous argument for proximity to a work dated 1658 (*Old Woman Reading by a Spinning Wheel*, location unknown; ibid., no. A32, fig. 49), on the grounds of subject matter and a dismissal of the "older signature type" on the canvas as the sort of exception one encounters occasionally (no examples are cited).

5. Themes of domestic virtue in Dutch genre painting, and in the publications of "Father Cats," are very well described in Franits 1993a (see especially pp. 19, 89–92, 181–83, for the Altman painting's subject).

6. See Franits 1993a, figs. 70 (Metsu, in the Louvre, Paris), 161 and 162 (Dou and Maes in Berlin). The meaning of De Hooch's *A Woman Peeling Apples, with a Small Child*, of about 1663 (Wallace Collection, London), is sensibly described in P. Sutton 1980a, pp. 49, 95, no. 61, pl. 65. On Bisschop's *Apple-Peeler*, of 1667 (Rijksmuseum, Amsterdam), see Dordrecht 1992–93, no. 5.

7. See Herrmann 1972, fig. 28. On Wonder's relationship with General Sir John Murray, his patron and one of the men in the painting, see Frans Grijzenhout's article in *Dictionary of Art* 1996, vol. 33, pp. 322–23.

8. See "Display of Art," in *Dictionary of Art* 1996, vol. 9, p. 17, fig. 5 (the four figures from the painting of 1826 reappear here on the left).

9. See Dordrecht–Enschede 2000, pp. 21–22 on Wonder and the Van Strijs, and pp. 119–34 on Abraham van Strij's emulation of seventeenth-century Dutch genre painters.

10. For articles on these three collectors, and further literature, see *Dictionary of Art* 1996, vol. 1, pp. 730–31 (Altman), vol. 17, p. 777 (Kann), and vol. 19, pp. 270–71 (George Granville Leveson-Gower, 1st Duke of Sutherland).

REFERENCES: J. Smith 1829–42, vol. 4 (1833), p. 246, no. 11, records the sales of 1824 and 1828; Waagen 1854, vol. 2, p. 70, lists the painting as in Stafford House; Bode 1900, pp. III, IX–X, XIII (ill.), no. 12, catalogues the work in the Kann collection; Friedländer 1901, pp. 153 (ill.), 154; Marguillier 1903, part 2, p. 24; Bode 1907, vol. 1, no. 54, with provenance; *Connoisseur* 19 (September–December 1907), p. 68 (ill.), as from the Kann collection and with Duveen; Nicolle 1908, p. 197, "une petite toile [*sic*] d'effet très rembrantesque"; Wurzbach 1906–11, vol. 3 (1911), p. 112, as formerly in the Kann collection; Altman Collection 1914, pp. 24 (ill.), 25–26, no. 16, vapidly advises the reader of the picture's "contentment" and charm; Altman Collection 1915, pp. 85 (ill.), 86, mentioned; Hofstede de Groot 1907–27, vol. 6 (1916), pp. 485–86, no. 33, gives details of provenance from 1814 onward; A. Burroughs 1923, p. 270, cites the work in order to demonstrate that the Rembrandt-style *Old Woman Cutting Her Nails* (Pl. 169) is not by Maes; Valentiner 1924, pp. 11, 28 (ill.); Altman Collection 1928, pp. 92–93 (ill. opp. p. 92), no. 51, repeats Altman Collection 1914; A. Burroughs 1938, p. 105 n. 6, observes that the picture's subject is not closely related to Rembrandt's work, but in technique the painting resembles Rembrandt's *Supper at Emmaus* of 1648; J. Rosenberg 1948, p. 196, fig. 262, compares this painting with the Museum's *Old Woman Cutting Her Nails* (Pl. 169) to show Rembrandt's technical superiority; Haskell 1970, p. 279, offers brief praise; Keith Roberts, "Current and Forthcoming Exhibitions," *Burlington Magazine* 119 (December 1977), p. 874, compares "an early Nicolaes Maes" exhibited by Ronald Cook, London; Sumowski 1979–95, vol. 8 (1984), p. 4186 (under no. 1871), relates a drawing by Maes in the Museum's collection to this picture; Sumowski 1983–[94], vol. 3, pp. 2014, 2066 (ill.), no. 1340, dates the works about 1655, and sees the apple as a reminder of Original Sin; P. Sutton 1986, p. 188, mentioned; Edinburgh 1992, p. 176, listed among Dutch pictures formerly in Scotland; Jäkel-Scheglmann 1994, p. 74, fig. 68, mentioned; Baetjer 1995, p. 338; Liedtke in New York 1995–96, vol. 2, pp. 6, 151, no. 53, describes the work as an example of Maes adopting Rembrandt's style of the 1640s and also his sympathetic approach to domestic life; L. Miller, "Benjamin Altman," *Dictionary of Art* 1996, vol. 1, p. 731, mentioned; Krempel 2000, pp. 66, 359–60, no. D28, fig. 47, suggests a date of about 1657.

EXHIBITED: London, British Institution, 1838, no. 132 (lent by the Duke of Sutherland); London, Royal Academy, "Winter Exhibition," 1882, no. 103 (lent by J. Walter); New York, MMA, "Rembrandt/Not Rembrandt in The Metropolitan Museum of Art," 1995–96, no. 53.

EX COLL.: Possibly Mrs. Thomas Gordon, Bully Hill, Rochester (her sale, Christie's, London, April 2, 1808, no. 46, as by Dirk Maes, for £13 13s. to Michael Bryan); D. van Dijl, Amsterdam (sale, Vinkeles, Amsterdam, January 10, 1814, no. 102, sold for Fl 160 to Willem Gruyter Sr.); Ralph Bernal, London (his sale, Christie's, London, May 8, 1824, no. 11, for £63 to Zachary or Farley); Michael Zachary, London (his sale, Phillips, London, May 31, 1828, no. 37, for £147,

to the Duke of Sutherland); Duke of Sutherland, Stafford House, London (1828–d. 1833); Duchess of Sutherland, London (1833–46); [George Morant, London, in 1846];[1] [Emery, Rutley & Co., London]; [John Smith, London; sold to Morland for £130]; G. H. Morland, London (his sale, Christie's, London, May 9, 1863, no. 101, for £173 5s. to Woodin for John Walter); John Walter, Bearwood, Berkshire (1863–d. 1894); Rodolphe Kann, Paris (by 1900–d. 1905;

his estate, 1905–7; cat., 1907, vol. 1, no. 54; sold to Duveen); [Duveen, Paris, sold to Altman for $80,355]; Benjamin Altman, New York (1908–d. 1913); Bequest of Benjamin Altman, 1913 14.40.612

1. George Morant (1770–1846), a framemaker in London, was presumably acting as an agent.

110. *The Lacemaker*

Oil on canvas, 17¼ x 20¾ in. (45.1 x 52.7 cm)
Signed (on base of child's chair): N.MAES.

The paint surface is slightly worn throughout from past cleaning.

The Friedsam Collection, Bequest of Michael Friedsam, 1931
32.100.5

A fine genre picture by Maes is one of the many things Michael Friedsam had in common with his friend and business partner, Benjamin Altman. The present work, which Friedsam purchased in 1917, is a slightly later painting than the Altman *Young Woman Peeling Apples* (Pl. 109), and may be dated about 1656–57.[1] The rectilinear arrangement of the composition is typical of Maes's domestic scenes dating from this period.

The painting represents a young mother seated next to her child, who wears a *valhoedje* (fall hat, with a protective bumper) and sits in a substantial high chair. The baby holds an object in each hand, perhaps a pacifier and a ball. A ceramic porringer and spoon have been set down on the floor, while the silver beaker and rattle appear to have arrived there spontaneously. (Silver objects like these were often given as presents on the occasion of an infant's baptism.)[2] A white jug with a pewter lid sits on the table. A portrait engraving, perhaps of some public figure, has been neatly hung on the wall. The woman makes lace, working on top of a sewing cushion (*naijcussen*), which was a padded box with drawers or compartments.[3] A small scissors hangs on a string, casting a shadow on the apron. The warm palette of red, green, and browns, the bright sunlight, and the balance of simple shapes lend the scene a tranquillity suited to its subject. The painter also provides the viewer with the pleasure of dwelling on the specific qualities of things (silver, wood, glazed faience, wool, and so on), and on momentary effects like the shadow cast by the window onto the wall.

Sewing, spinning, and the more meticulous craft of lacemaking were appreciated at the time as examples of diligence, and of feminine virtue. Joachim Wtewael (q.v.) celebrated the skill and character of his daughter Eva in a sober portrait dated 1628 (Centraal Museum, Utrecht), which shows her working on an intricate piece of lace.[4] The theme of lacemaking flourished in genre paintings of the 1650s and 1660s, together with other images of conscientious homemaking.[5] A comparatively straightforward survey of "Women at Domestic Chores" was engraved in five prints by Geertruydt Roghman (1625–1651/57) about 1650, and included scenes of sewing and spinning.[6] A fair number of lacemakers were depicted by Leiden artists, such as Quirijn van Brekelenkam, Gabriël Metsu, Pieter van Slingelandt (q.q.v.), and Adriaen van Gaesbeeck (1621–1650).[7] But no Dutch artist returned to the subject of lacemaking as frequently as did Maes during the 1650s, both in paintings and in drawings.[8] The popular theme appears to have struck a personal chord.

1. Krempel 2000, p. 360 (under no. D29), favors a date of about 1656, and notes that the type of signature suggests a date "probably after 1655." In the early 1970s, Willem van de Watering told curator John Walsh that paintings by Maes signed with "AE" in ligature date from 1655, and those signed "N.MAES," as here, begin in 1656 (undated note in curatorial files).

2. A similar beaker of 1629 is in the Museum's collection; see Newark–Denver 2001–2, pp. 170–71, no. 33. Compare the objects on the floor in front of the high chair in Hendrick Sorgh's *The Family of Eeuwout Prins,* 1661 (Historisch Museum, Rotterdam; ibid., p. 139, fig. 185).

3. On sewing cushions and baskets, see Schipper van Lottum 1975.

4. See Franits 1993a, pp. 21–22, and the literature cited on p. 204 n. 21.

5. For numerous examples and insights, see ibid., pp. 21–29, 46–48, 76–80 on Caspar Netscher's *Lacemaker,* of 1662, in the Wallace Collection, London, pp. 83, 136–38 on teaching needlework, and

p. 181. Other images, and instances of excessive interpretation, are found in Gaskell 1990, no. 53, and in Haarlem–Worcester 1993, no. 8.

6. Newark–Denver 2001–2, pp. 192–93, no. 78.

7. On the two less familiar artists, Van Gaesbeeck and Van Slingelandt, see the discussion of the latter's *Young Mother with Two Children* in Leiden 1988, no. 66.

8. See Sumowski 1979–95, vol. 8, nos. 1776, 1807, 1896; P. Sutton 1992, pp. 117–18, no. 38; and Krempel 2000, figs. 9, 17, 20, 24, 25, 41, 46.

REFERENCES: J. Smith 1829–42, vol. 9 (1842), p. 579, no. 13, records the canvas in the Labouchère collection; Waagen 1854, vol. 2, p. 421, no. 2, in the Labouchère collection, reveals "a masterly hand and an astonishing power of colour"; Thoré 1857, pp. 255–56, as in the Manchester exhibition of 1857, anticipates "le bonheur de Chardin"; Thoré 1866, p. 315, cites among other works by Maes of a type that influenced Vermeer; G. Veth 1890, p. 141, notes Thoré's reference to the painting; Wurzbach 1906–11, vol. 2 (1910), p. 90, listed; Hofstede de Groot 1907–27, vol. 6 (1916), p. 496, no. 75, repeats information from J. Smith 1842 and Waagen 1854; M'Cormick 1924, p. 117, mentioned; Valentiner 1928a, p. 10, as from "the master's best period, when he was under Rembrandt's influence, about 1655"; Hibbard 1980, pp. 338, 344, fig. 611, "early 1650s?," offers a few derivative remarks; Sumowski 1983–[94], vol. 3, pp. 1954, 1956, 1957, 2016, 2073, no. 1347, as dating from about 1655, compares other works by Maes, and records a copy;[1] Burn 1984, p. 22 (ill.); P. Sutton 1986, p. 188, mentioned; Liedtke 1990, p. 52, mentioned as part of the Friedsam bequest; Baetjer 1995, p. 338; Franits 1995, pp. 395–96, fig. 1, uses the work as an example of the style Maes left behind in the 1660s; Liedtke in New York 1995–96, vol. 2, p. 151, mentioned; Krempel 2000, pp. 33, 34, 61, 360, no. D29, fig. 41, as datable to about 1656, and showing a lower viewpoint than in earlier works; Newark–Denver 2001–2, pp. 66–67, 178, no. 49, fig. 97, as dating from about 1656, and featuring a high chair, ceramic porringer, a small silver beaker, and a "white jug with pewter lid, whose broad neck identifies it as a beer pitcher"; Salomon 2004, p. 97, fig. 81, compares this type of genre picture with the somewhat different domestic scenes of Adriaen van Ostade.

EXHIBITED: Manchester, Museum of Ornamental Art, "Art Treasures of the United Kingdom," 1857, no. 1050 (lent by Rt. Hon. H. Labouchère; incorrect measurements given); New York, Lotos Club, "Loan Exhibition of XVIIth Century Paintings," 1919, no. 13 (lent by Michael Friedsam); New York, MMA, "The Michael Friedsam Collection," 1932–33, no cat.; Nantucket, Mass., Kenneth Taylor Galleries, "Realism," 1949; Honolulu, Hawaii, Honolulu Academy of Arts, "Four Centuries of European Painting," 1949–50, no. 4; Toronto, The Art Gallery of Toronto, "Fifty Paintings by Old Masters," 1950, no. 21; Hartford, Conn., Wadsworth Atheneum, "Life in Seventeenth Century Holland," 1950–51, no. 41; Nashville, Tenn., Fisk University, 1951; Atlanta, Ga., Atlanta University, 1951–52; New Orleans, La., Dillard University, 1952; New York, Hunter College, "Dutch Celebration," 1953; Southampton, N.Y., Parrish Art Museum, and Scottsdale, Ariz., Arizona Art Association, "Paintings from the Collection of The Metropolitan Museum of Art," 1954; New Paltz, N.Y., State University of New York, 1954; Vancouver, Vancouver Art Gallery, "Rembrandt to Van Gogh," 1957; Newark, N.J., The Newark Museum, and Denver, Colo., Denver Art Museum, "Art and Home: Dutch Interiors in the Age of Rembrandt," 2001–2, no. 49.

EX COLL.: Hon. Henry Labouchère, later 1st Baron Taunton, Taunton, Somerset, and Stoke, near Windsor (by 1842, ?until d. 1869); ?his eldest daughter, Hon. Mary Dorothy Labouchère, later Mrs. Edward James Stanley, Cross Hall, Lancashire (from 1869); [Scott & Fowles, New York, until 1916; sold for $25,000 to Kleinberger]; [Kleinberger, New York, 1916–17; sold to Friedsam for $27,500]; Michael Friedsam, New York (1917–d. 1931); The Friedsam Collection, Bequest of Michael Friedsam, 1931 32.100.5

1. The copy reappeared as a work by Reinier Covijn at Christie's East, New York, November 8, 1984, no. 60. Curator John Walsh noted photographs in the Rijksbureau voor Kunsthistorische Documentatie, The Hague, recording "another version, in upright format, minus the table," sold at Christie's, London, June 20, 1913, no. 127, later with Douwes, Amsterdam (panel, 22 x 17⅜ in. [56 x 44 cm]), and a copy on canvas (19⅛ x 24¼ in. [48.6 x 61.5 cm]), with Rothmann, Berlin, in 1929.

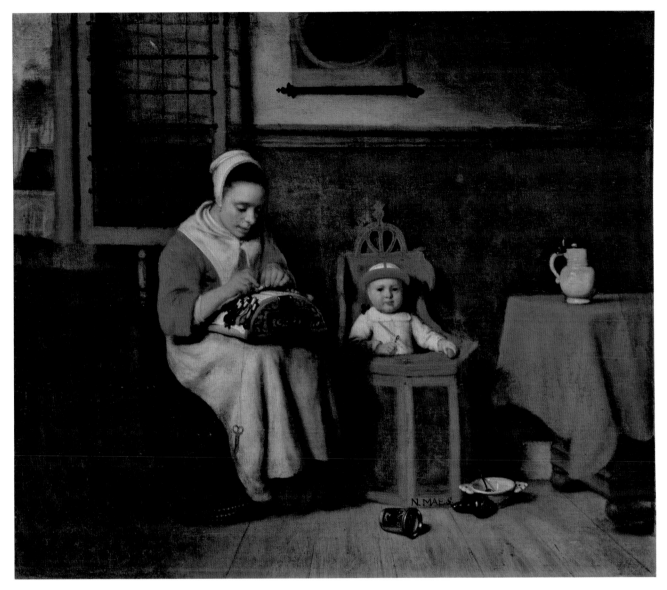

110

III. *Portrait of a Woman*

Oil on copper (oval), 4⅝ x 3⅜ in. (11.7 x 8.6 cm)
Signed and dated (at right, above ruff): .И.MAEƧ./1657

The painting is well preserved.

Gift of Lila and Herman Shickman, 2004 2004.392

This small, bust-length portrait on copper is a very rare instance of Maes's working as a miniaturist.[1] There is no doubt about his responsibility for the painting: the execution is quite consistent with that of figures in his portraits and genre scenes dating from the 1650s, and the signature on the brown background is intact and typical. The reversal of the N in the inscription is also found on three pictures by Maes dating from 1653–55, including the Museum's *Abraham Dismissing Hagar and Ishmael* (Pl. 108), and the S is reversed, as here, on a genre painting dated 1657.[2]

The sitter, who appears to be a woman in her fifties, has light brown hair and blue eyes, and wears quite conservative attire, with a millstone ruff dating from the 1630s. The costume, as well as a superficial resemblance, may have encouraged Wilson's identification of the subject with Margaretha de Geer (1583–1672), wife of the wealthy Dordrecht merchant Jacob Trip (see Refs.). Her much older appearance is known from portraits by Jacob Gerritsz Cuyp (1651; Rijksmuseum, Amsterdam);[3] by Rembrandt (ca. 1661; National Gallery, London);[4] and by Maes himself at a later date (1669; Dordrechts Museum, Dordrecht).[5]

1. Krempel 2000, p. 288, refers to four other examples in Hofstede de Groot 1907–27, vol. 6, pp. 550, 563, 571, nos. 287c, 287d, 362, 409. The first two are untraced miniatures of William III and Mary, last seen in an 1892 sale. The last is a bust-length portrait

9½ inches (24.1 cm) high, and thus not a miniature at all. The evidence for Maes's authorship is unknown in these three cases. Hofstede de Groot's no. 362 is a miniature portrait of a man in the John G. Johnson Collection, Philadelphia Museum of Art, which is not accepted in the modern literature as a work by Maes. Krempel (2000, p. 375, doc. 31) cites a document of 1665 in which Maes gives a receipt for payment for copies of two portraits painted by him on small silver supports.

2. Krempel 2000, nos. A2, A3, A6, and A25, kindly brought to my attention by the author. He saw the painting on February 18, 2005, and considered it entirely typical of Maes's early portrait style.

3. See Dordrecht 2002, no. 38, and also p. 156, fig. 37a, for the same artist's portrait of the same sitter in 1649.

4. MacLaren/Brown 1991, pp. 352–53, no. 1675, pl. 292.

5. Krempel 2000, no. A93, fig. 154.

REFERENCES: Wilson in Sarasota 1980–81, unpaged, no. 44, discusses the painting as a portrait of Margaretha de Geer in her mid-seventies; Sumowski 1983–[94], vol. 3, pp. 1957–58, 2027, 2117, no. 1391, as a portrait of an elderly woman, rejecting Wilson's identification of the sitter with Margaretha de Geer; W. Robinson 1993, p. 104, cites the painting as one of six portraits by Maes that are dated 1657, and as "Maes's only early portrait on the scale of a miniature"; Krempel 2000, pp. 287–88, no. A28, fig. 91, as a portrait of an elderly woman, noted as one of the few miniatures by Maes that are known or recorded.

EXHIBITED: Sarasota, Fla., The John and Mable Ringling Museum of Art, "Dutch Seventeenth Century Portraiture: The Golden Age," 1980–81, no. 44, as *Portrait of Margaretha de Geer.*

EX COLL.: Private collection (sale, Christie's, London, April 11, 1968, no. 122, under "various properties," as *Portrait of a Lady,* for Gns 700 to Koetser); [Brian Koetser, London, in 1968–ca. 1970, sold to Shickman]; Lila and Herman Shickman, New York (ca. 1970–2004); Gift of Lila and Herman Shickman, 2004 2004.392

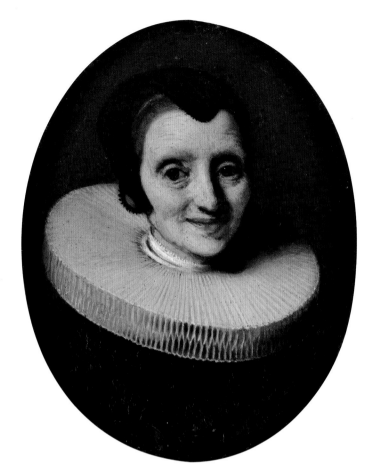

III. Shown actual size

112. *Portrait of a Woman*

Oil on canvas, 44 x 35¼ in. (111.8 x 89.5 cm)

The condition of the painting is good, although there is slight abrasion in the hair and eyes and in the deep blacks of the headdress and dress. A large paint loss has occurred where the hands cross. The red lake glazes applied to the background curtain, upholstered chair, and tablecloth have faded to such an extent that these fabrics now appear almost completely gray.

Rogers Fund, 1906 06.1325

The reputation of this picture has slipped somewhat since curator Roger Fry, in 1906, wrote to his wife of the "superb Maes portrait of an old woman which I found here," and since the *Evening Post* applauded the purchase, together with Goya's *Don Sebastián Martínez y Pérez* (06.289) and a kitchen scene said to be by Jan Steen (actually, by Peter Wtewael; Pl. 225).[1] A date in the second half of the 1660s is likely, considering the style of the woman's collar and sleeves, and the use of this kind of background in dated portraits by Maes.[2] W. R. Valentiner and A. Burroughs (see Refs.) suggest that the painting reveals the influence of Jacob Jordaens (1593–1678), who, according to Arnold Houbraken, was visited by Maes on a trip to Antwerp in the 1660s (see the biography above). While it is true that Jordaens painted generally similar portraits (seated, three-quarters-length, similarly posed, with agitated drapery and a glimpse of landscape in the background), so did many other Flemings and, by the 1660s, quite a few Dutch artists active in Amsterdam, The Hague, and elsewhere. The oeuvres of Bartholomeus van der Helst (q.v.) and Abraham van den Tempel (1622/23–1672) offer too many examples to cite.

The attribution of the Museum's painting has never been doubted. A pendant portrait has never been proposed, and probably never existed. The great majority of male pendants were placed to the viewer's left, that is, to the right of the female sitter, who would be turned in that direction or otherwise acknowledge the presence of her mate.

1. See Refs. (Fry 1972).
2. See Krempel 2000, figs. 137, 138, 150, etc.

REFERENCES: *American Art News* 4, no. 23 (March 17, 1906), [p. 6], applauds the purchase from the Ehrich Galleries, and reports that Mr. Ehrich "obtained the canvas when abroad last summer"; ibid., no. 35 (September 15, 1906), [p. 1 (ill.)], suggests that the work reveals Rembrandt's influence but gives a foretaste of Maes's later manner; *MMA Bulletin* 1, no. 5 (April 1906), pp. 73–74, reveals the "sinister influence" of the artist's wealthy patrons in his departure from Rembrandt's influence in favor of "the peculiar cold and polished tones of Maes's later style"; Fry 1906, pp. 136–37 (ill.), illustrates the transition between Maes's two styles of painting; Cary 1909, pp. lix–lx (ill. p. lix), praises the composition; Wurzbach 1906–11, vol. 3 (1911), p. 112, listed as in MMA; Hofstede de Groot 1907–27, vol. 6 (1916), p. 580, no. 463; Valentiner 1924, p. 66, pl. 66, as dating from the 1660s and influenced by Jordaens; A. Burroughs 1938, p. 104, considers the portrait "Jordaens-like"; Fry 1972, p. 251, letter of R. Fry to his wife dated February 18, 1906, refers to his purchase of "a superb Maes portrait of an old woman which I found here"; D. Sutton in ibid., p. 26, quotes an editorial in the *Evening Post* of April 25, 1906, applauding Roger Fry's demonstration of "standard museum values" by purchasing this picture, a Goya, and other "masterpieces," and p. 255 n. 1, included in a list of pictures shown in the "Temporary Exhibition in Gallery 24" of the MMA during April 1906; Spalding 1980, p. 91, listed among masterpieces acquired during Roger Fry's first year at the Museum; Baetjer 1995, p. 339; Liedtke in New York 1995–96, vol. 2, p. 151, as "ca. 1660?"

EXHIBITED: New York, MMA, "Temporary Exhibition," 1906, no. 19.

EX COLL.: [Ehrich Galleries, New York, 1905–6, bought abroad; sold to MMA]; Rogers Fund, 1906 06.1325

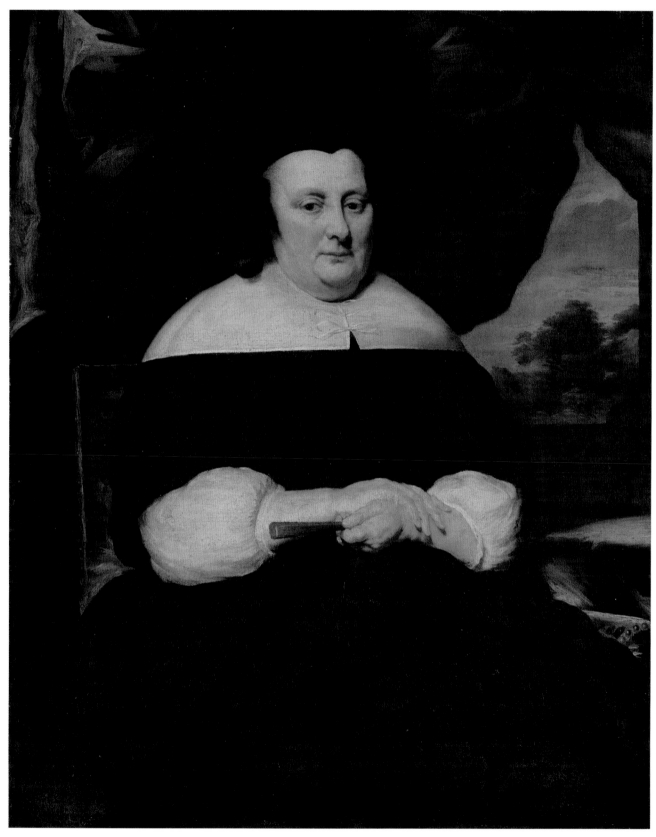

112

113. *Admiral Jacob Binkes*

Oil on canvas, 17¼ x 12⅞ in. (43.8 x 32.7 cm)
Signed (lower right): MAAS
The painting is well preserved.
Gift of J. Pierpont Morgan, 1911 11.149.2

This portrait of Jacob Binkes (or Binckes; ca. 1640–1677) and the pendant portrait of his fiancée, Ingena Rotterdam (see below and Pl. 114), were painted in 1676 by Maes in Amsterdam, where the artist frequently made portraits on this smaller scale. The identification of the sitters, which is given in the 1908 sale catalogue (see Ex Coll.) and in Hofstede de Groot's catalogue (see Refs.), depends upon labels stuck on the canvases' stretchers and inscribed in what appears to be an eighteenth-century hand. The label on the back of the present picture states: "Jacob Binkes/Commandeur van den Vloot/Bruidegom van Ingena Rotterdam" (Jacob Binkes/Commander of the Fleet/Bridegroom of Ingena Rotterdam). The label on the back of the pendant picture states: "Ingena Rotterdam/[Bru]idt van Jacob Binkes, dewelke voor de/voltre[kking] van dit huwelijk overleden sijnde, is/zij naderhand getrowt met Pieter D'Orville./ Obiit tot Amsterdam den 20. Januari 1704." (Ingena Rotterdam/ Bride of Jacob Binkes, who died before the performance of this marriage/She later married with Pieter D'Orville./Died in Amsterdam, January 20, 1704).

No other portraits of the sitters are known, but the information on the labels is completely in accord with their known biographies, and with the fact that the portraits conform to the convention for portraits of betrothed couples: the fiancée is on the man's right (the viewer's left), rather than the arrangement commonly observed for married couples (where the husband is placed to the wife's right). The portraits commemorate the couple's engagement in 1676. It was not unusual for marriages to be formally announced as much as a year in advance, and in Binkes's case a long engagement was only to be expected.

Binkes was one of the most capable and courageous naval officers of the 1660s and 1670s. His date of birth is unknown, but he reportedly came from the village of Koudum, near the port of Stavoren on the west coast of Friesland. His father was Nincke Binckes, burgomaster of Stavoren. Binkes began his career early in the Admiralty of Amsterdam; in 1666, when he was probably about twenty-six years old, he was in command of the *United Provinces,* a forty-eight-gun warship in the squadron of the celebrated admiral Maarten Harpertsz Tromp. He took part in the Saint James's Day Fight of August 4, 1666, when the English navy inflicted heavy losses on the Dutch.

Under Admiral Michiel de Ruyter, Binkes was captain of the *Essen,* with fifty guns, when the Dutch fleet sailed up the Thames in June 1667, burning five ships of the Royal Navy and towing away their flagship, the *Royal Charles.* The gold chain and medallion worn by Binkes in the present portrait (valued at 500 florins at the time) was presented to him in 1670 for his destruction or capture of three privateers.

After service in the Mediterranean and elsewhere in Europe, Binkes sailed with four ships to the West Indies, departing Holland in April 1673. For years the English, the French, and the Dutch had contested colonies in the Caribbean, and Binkes provided some of the more dramatic moments. He attacked ships in Martinique, Guadeloupe, and elsewhere, took Saint Eustatius, and then sailed for Virginia. On the James River, he encountered about thirty English ships, seven of which he left in flames. Provoked by an agreement between England and France to destroy Dutch trade routes, the States General dispatched Binkes's small fleet to New York, which he captured in September 1673. He then installed a new government and left a garrison to protect "New Orange," which survived as such until the winter of 1674. After a highly eventful trip, Binkes arrived in Amsterdam during the summer of 1674. In the following year, he was sent to strengthen the fleet of the king of Denmark.

On March 16, 1676 — shortly after his engagement, presumably (the date is unrecorded) — Binkes set off again for the West Indies, this time with eleven ships and hundreds of troops. In early May, he seized the island of Cayenne (French Guiana) and, after other engagements, sent part of his fleet under Jan Bont to protect the Dutch colony of Tobago ("New Walcheren"). Binkes's ships attacked the French in Santo Domingo and then sailed to Tobago, which Bont had abandoned. The island had been in Zeelander hands between 1628 and 1637, and since 1654. Binkes rebuilt the fortifications in Rockly Bay and prepared for the arrival of a large French fleet commanded by Vice Admiral Jean d'Estrées. The French attack on March 3, 1677, resulted in horrific losses of men and ships on both sides. With no French vessel left undamaged (the flagship *Glorieux* exploded with 445 crew on board), D'Estrées withdrew, and returned with a new fleet in early December. He landed fifteen hundred men and exchanged cannon fire with the fort. On December 12, a French fireball hit the fort's powder magazine, above which Binkes and his staff were having lunch. Half the garrison was killed in the explosion, and the fort was overrun.[1]

In Maes's portrait, the admiral appears in full armor, his hand resting on a plumed helmet, with a pistol cocked and his

finger on the trigger. A frigate sails in the background. The original carved and gilded frame was probably inspired by grander examples, such as that on Ferdinand Bol's large portrait of Admiral De Ruyter of 1667 (Mauritshuis, The Hague).[2] At the top, between winged putti, Neptune rides a horse with webbed hooves. Similar steeds occupy the bottom corners. The trophylike arrangement to the left consists of a drum and arms and armor, including spears and ramrods. To the right, spears, cannon equipment, and a cross-staff are clustered around a globe. At the bottom, the now rather worn decoration is completed by anchors, a basket of cannonballs, and a mortar (the type of cannon that cost Binkes his life).

1. This biography is adopted from that in Van der Aa 1852–76, vol. 1, pp. 171–72, with historical details checked against recent accounts.
2. See Broos and Van Suchtelen 2004, pp. 42–46, no. 5. Binkes must have known this version of Bol's portrait of De Ruyter, since it was made for the Admiralty of Amsterdam.

REFERENCES: Anon., "London Letter," *American Art News* 6, no. 33 (August 15, 1908), p. 2, as at Sabin's Gallery; Hofstede de Groot 1907–27, vol. 6 (1916), p. 517, no. 162, describes the composition and gives provenance; Dickey in Hamilton–Rochester–Amarillo 1983, pp. 18–19, no. 4, describes the subject and offers a few biographical details; Baetjer 1995, p. 339; Van Thiel and De Bruyn Kops 1995, p. 179, fig. c, describes the frame as a late example of its type; Liedtke in New York 1995–96, vol. 2, p. 151, mentioned; Krempel 2000, pp. 102, 316, no. A173a, fig. 259.

EXHIBITED: New York, MMA, "Dutch Couples: Rembrandt and His Contemporaries," 1973, checklist no. 12; Cincinnati, Ohio, Taft Museum, "Dutch Couples: Rembrandt and His Contemporaries," 1973–74; Memphis, Tenn., Brooks Museum of Art, 1982; Columbus, Ohio, Columbus Museum of Art, 1982; Hamilton, N.Y., Colgate University, Picker Art Gallery, Rochester, N.Y., The Memorial Art Gallery of the University of Rochester, and Amarillo, Tex., Amarillo Art Center, "Dutch Painting in the Age of Rembrandt from The Metropolitan Museum of Art," 1983, no. 4.

EX COLL.: Mrs. F. Lemker (née Muller), Kampen and Oldenbroek (her sale, organized by F. Muller & Co. of Amsterdam, Kampen, July 7, 1908, no. 26; [Frank T. Sabin, London, 1908]; J. Pierpont Morgan, New York; Gift of J. Pierpont Morgan, 1911 11.149.2

114. *Ingena Rotterdam, Betrothed of Admiral Jacob Binkes*

Oil on canvas, 17¼ x 13 in. (43.8 x 33 cm)
Signed (lower right): Maes/1676
The painting is well preserved.
Gift of J. Pierpont Morgan, 1911 11.149.3

As discussed in the entry above, the subject of this portrait is identified by an old sticker on the back of the stretcher. The pendant pictures celebrate Ingena Rotterdam's engagement to Jacob Binkes, which presumably was announced in the winter of 1675–76. Binkes sailed for the West Indies in March 1676, never to see the Netherlands or his fiancée again. Nine years later, in 1685, she married Pieter d'Orville in Amsterdam.[1] She died there on January 20, 1704.

The blonde sitter wears impressive pearls and a mauve wrap over her white dress. Dark trees and a sky at sunset fill the background. The original frame, made to match that on the pendant portrait in its general design, is crowned by the worn figure of a goddess. She wears a wreath of flowers and appears to hold another, so that she is probably Flora, not Venus or Neptune's spouse, Amphitrite. Roses and other flowers and tendrils embellish the frame, which also features putti to the right and left, and two doves on each of the four sides. The larger doves on the bottom of the frame kiss above a bunch of flowers.

1. Their wedding was celebrated in a poem by the Dutch poetess Katharina Lescailje: Grabowsky 2000, pp. 72–73.

114

REFERENCES: Anon., "London Letter," *American Art News* 6, no. 33 (August 15, 1908), p. 2, as at Sabin's Gallery; Dickey in Hamilton–Rochester–Amarillo 1983, pp. 18–19, no. 3, describes the subject and offers a few biographical details; Baetjer 1995, p. 339; Van Thiel and De Bruyn Kops 1995, p. 179, fig. c, describes the frame as a late example of its type; Liedtke in New York 1995–96, vol. 2, p. 151, mentioned; Krempel 2000, p. 316, no. A173, fig. 258, remarks that the commission must have been given on the occasion of the couple's engagement, as the man died before their marriage, and that placing the male sitter to the viewer's right also indicates betrothal not marriage.

EXHIBITED: New York, MMA, "Dutch Couples: Rembrandt and His Contemporaries," 1973, checklist no. 12; Cincinnati, Ohio, Taft Museum, "Dutch Couples: Rembrandt and His Contemporaries,"

113

1973–74; Memphis, Tenn., Brooks Museum of Art, 1982; Columbus, Ohio, Columbus Museum of Art, 1982; Hamilton, N.Y., Colgate University, Picker Art Gallery, Rochester, N.Y., The Memorial Art Gallery of the University of Rochester, and Amarillo, Tex., Amarillo Art Center, "Dutch Painting in the Age of Rembrandt from The Metropolitan Museum of Art," 1983, no. 3.

EX COLL.: The painting has the same history of ownership as its pendant. See Ex Coll. for *Admiral Jacob Binkes* (Pl. 113); Gift of J. Pierpont Morgan, 1911 11.149.3

OTTO MARSEUS VAN SCHRIECK

Nijmegen 1619/20–1678 Amsterdam

The artist was born in Nijmegen in 1619 or 1620.[1] The first known use of the double surname Marseus van Schrieck or Marseus de Schrieck occurs on a still life dated 1655, when the painter was in Italy.[2] He was known there as Ottone Marcellis (or "Ottavio Marsaus, *pittore,*" in a census of 1652); the addition of the Netherlandish surname Van Schrieck probably dates from an earlier period, or was intended for a Northern European customer.[3] When his brother's forthcoming marriage was registered at the Town Hall of Amsterdam in 1661, he gave his name as Evert Marseus, and his landscape paintings (usually signed "E.M.") are listed as by Evert Marseus in contemporary inventories.[4] In the inventory of Otto Marseus's estate (compiled in June and July of 1678), his unmarried sister is identified as Johanna Marseus, and his brother as Evert Marseus van Schrieck, but the latter signed the document "E. Marseus," and a landscape by Evert Marseus is listed in the inventory.[5] In 1669, "Otto Marseus, *Constschilder,*" and his wife, "Margaretha Gysels," made a will, and when the artist sold a parcel of land in 1674 the notary recorded his name as Otto Marseus. He is described as the late "Uncle Otto Marseus" (with reference to Evert's children) in a document dated August 6, 1678.[6] The mention of "A Maria with the baby Jesus by Otto Marseus" in a Dordrecht inventory dated 1674 is unexpected only for the picture's subject.[7] On the basis of these and other documents, it may be considered certain that the artist's name was Otto Marseus, and that references to him in scholarly literature as "van Schrieck" (or worse, "Schrieck") are ill-informed.[8]

Nothing is known of Otto Marseus's career before he went to Italy (ca. 1650?), except for Houbraken's report that "Otto Marcelis" worked in England and for the "Queen Mother" in France.[9] The information was obtained directly from Marseus's widow, "who after him outlived another two husbands [and is] now [1718] still alive" (at about the age of seventy-four). The royal patron must have been Anne of Austria, wife of Louis XIII, who reigned on behalf of her son Louis XIV between her husband's death in 1643 and 1651. Perhaps it was in Paris that Marseus first met the Delft-born still-life painter Willem van Aelst (1627–in or after 1683), who lived in France between 1645 and 1649, when he went to Florence and entered

the service of Ferdinando II de' Medici. It is occasionally claimed that Marseus and Van Aelst traveled to Italy together,[10] and that "according to Houbraken" Marseus went to Rome in 1648. What Houbraken actually reports, in his biography of Matthijs Withoos (1627–1703), is that Withoos and another pupil of Jacob van Campen (1595–1657), Hendrick Grauw (ca. 1627–1693), went with Marseus and three other, unnamed artists to Rome, and that one of them died on the way, "some" remained in Italy, and "Otto and Matthias came back after they were there two years, in the year 1650."[11] However, the usual inference that Marseus and Withoos traveled to Italy in 1648 would appear doubtful, considering that in 1652 both artists were still in Rome (Withoos was back in the Netherlands by February 1653), and that Marseus did not return to the Netherlands until sometime in 1656 at the earliest (he is first recorded there in 1663).[12]

Marseus and Withoos joined the fellowship of Netherlandish artists in Rome, the Schildersbent, in which Marseus was called "The Ferreter," in reference to his forest floor still lifes (see Pl. 115). When Samuel van Hoogstraten (q.v.) passed through Rome in 1652, he was Marseus's houseguest. In 1678, the writer observed, "But surely our Otho Marseus (alias Snuffelaer [Ferreter]) has made his particular aptitude in art, and the part [thereof] to which he is inclined, clear enough, for when in the year 1652 I was with him in Rome I was amazed at the number of monsters he kept and fed, and how he understood their nature quite as wonderfully as he vividly depicted their forms."[13]

Marseus evidently enjoyed the support of at least one great patron in Italy, Cardinal Leopoldo de' Medici (1613–1675).[14] According to Houbraken, Marseus was also "long in service to the Grand Duke of Florence," namely, Leopoldo's brother, Ferdinando II de' Medici.[15] His successor, Cosimo III de' Medici, visited Marseus in Amsterdam during the winter of 1667–68, and purchased three paintings by him for 500 guilders.[16]

Houbraken writes that Van Aelst was a "disciple" of Marseus in Italy, and "returned with him" to the Netherlands, but in another passage Van Aelst (with no mention of Marseus) is said to have "come back to his fatherland in the year 1656" (he is recorded in Amsterdam in 1657).[17] Perhaps Van Aelst, who was in his early twenties at the time, studied Marseus's work in Rome,

but he would not have been the older artist's pupil.[18] That Houbraken, on an earlier page, has Marseus and Withoos returning to the Netherlands in 1650 suggests that he mixed up scraps of information (and missed Van Hoogstraten's remarks). It appears possible that Marseus did not arrive in Holland until the early 1660s,[19] which would be consistent with the fact that he did not marry until 1664 (a number of Netherlandish artists married shortly after they returned from years abroad).

The French diplomat and connoisseur Balthasar de Monconys (1611–1665), who in 1663 visited Cornelis Bisschop, Johannes Vermeer (q.q.v.), and the Middelburg artist and naturalist Johannes Goedaert (1617–1668), went to see "'Otho' et ses tableaux" on August 20 of the same year. The artist's house, Waterrijk, was outside Amsterdam to the southeast, near the village of Diemen. De Monconys admired Marseus's butterflies, and also a "Calm" painted by Willem van de Velde the Younger (q.v.). On the same day, Marseus, De Monconys, and his son visited a "Mr. Hudde," who made "small microscopes with single lenses," and a "Mr. Rentre Heent" (Dr. Roetert Ernst?), who had a cabinet of curiosities with splendid shells, "des ouvrages du Japon," and many other things. On August 25, De Monconys again went to Marseus and "accepted a second Marine by 'Vandrevell'" and "another [painting] by M. Otho." He also met a "Mr. Borry," who had operated successfully on Marseus's eye. Two days later, De Monconys was again "chez Otho," where he saw "admirable pieces that he had made as studies [*pour son estude*] in Rome."[20] The scores of paintings by other Dutch artists (and dozens of his own) that are listed in the inventory of Marseus's estate—mostly landscapes, seascapes, still lifes (a few by Van Aelst), and genre scenes—indicate that he dealt in works of art.[21]

The house that De Monconys visited, "Oüater reik" (Waterrijk), had at least six rooms on two floors, with enough space to show or store about two hundred paintings. (A cittern, a lute, "real and false diamonds," many coins, gold pieces, a large chest containing mounted insects, other rarities of nature and art, and lots of clothing are also listed in the inventory of 1678.) Marseus also owned a little garden house (one of two under a single roof) on a plot of lowland outside the Muiderpoort of Amsterdam, where he kept a small boat, some fishing nets, and a bed.[22] The artist's widow told Houbraken that he went there daily to care for his creatures, and that he also kept some of them in "a pen behind his house."[23] The latter must refer to Marseus's proper residence, where he had his studio.

In his early years, Marseus painted flower pieces, evidently turning to his *sottobosco* nature studies when he moved to Rome. In the past, his work has been regarded as a surrealistic subcategory of "still life" painting,[24] but he is now seen as a prominent figure among European artists who took a serious interest in the study of plants, animals, and other forms of natural life. Marseus owned a copy of Rembert Dodoens's herbarium (*Cruydt-boeck van Rembertus Dodonaeus*) and surely consulted other books, but his actual collecting and study from life of some of the less familiar fauna and flora amounted to field biology. He was an important influence on a few Italian artists (especially Paolo Porpora; 1617–1679/80) and numerous northerners, including Van Aelst, Withoos, Rachel Ruysch (1664–1750), Elias van den Broeck (1657–1708), Abraham Mignon (1640–1679), Nicolaes Lachtropius (active 1656–in or after 1700), and Frans, James, and Karl Wilhelm de Hamilton.[25] His patrons, ranging from Medici dukes to Dutch amateurs such as Agnes Block, were scholars of nature as well as patrons of the arts.[26]

Marseus was buried on June 22, 1678, in the Nieuwezijds Kapel, a Protestant church in Amsterdam. His address is given as the Nieuwe Prinsengracht. His portrait appears in one of Houbraken's plates, accompanied by a snake curled up under a plant.[27]

1. A. D. de Vries 1883b, p. 167, first published the document that provides the only known evidence for the artist's place and approximate date of birth. When his marriage banns were announced in Amsterdam on April 25, 1664, he was described as "Otto Mercelis of Nimwegen [Nijmegen], painter, 44 years old . . . living near Diemen." His twenty-year-old bride, Margrita (Margaretha) Gijsels, from Amsterdam, appeared with her father, Cornelis Gijsels, who was a stonecutter specialized in carving crests (*wapens*).

2. According to Steensma 1999, pp. 11, 15, referring to the author's catalogue, no. B1.21. The still life (Uffizi, Florence; no. 5258) is signed "OTTO MARSEVS/DE SCHRIECK Fecyt in Roma/1655 Ly 10 aug . . ."

3. The former is more likely. According to Steensma 1999, p. 102, no. A1.2, fig. 2, *Flower Still Life* (location unknown) is signed and dated "Otto Marseus de S. 1647," and is conspicuously inscribed with a vanitas inscription in Dutch. This would appear to confirm that Marseus was already known as Marseus de Schrieck in 1647, and that he spent at least part of that year in the Netherlands rather than France.

4. Bredius 1916, pp. 710–11, where we learn that the mother of Evert and Otto was named Maria van Til, and that Evert was from Gennep, slightly to the south of Nijmegen. Testaments of 1637, 1660, 1668, and 1681 (deathbed), and inventories of paintings dating from 1646, 1671, 1680, 1682 (2), and 1718, give the landscapist's name as Evert Marseus. In an Amsterdam inventory of 1649, a "Landscape with waterfall" is listed as by E. Marcelis. In 1661, Evert Marseus gave his age as forty-four, and in 1668 as

fifty-one, indicating that he was born about 1617 (earlier testaments giving his age as "about twenty-five" and "about forty-six" appear less reliable). He died in December 1681. For all these documents, see Bredius 1916, pp. 710–12.

5. Ibid., pp. 697, 710.

6. Ibid., p. 709.

7. Ibid., p. 708.

8. The perpetrators are never Dutch. In Steensma 1999, a printed dissertation on "Schrieck" comprising a monograph and catalogue raisonné, the author speculates (p. 11) that the name may reflect the reaction of viewers to the painter's pictures ("Shriek!"). She also counters Riegl's suggestion that the name may refer originally to a village by observing that the artist was from Nijmegen not "from Schrieck" (p. 10). The inventory of the estate of an Otto van Schrieck in Amsterdam is dated December 30, 1646, and includes numerous paintings (none attributed), one of which is a portrait of the owner, his wife, "and children" (Bredius 1916, p. 708). Whether he is related to Evert and Otto Marseus is unknown. One of several possible explanations for Otto Marseus's adoption of "van Schrieck" would be that he wanted to clearly distinguish himself from his brother, whose name was known on the Amsterdam art market from the 1640s onward.

9. Houbraken 1718–21, vol. 1, pp. 357–58.

10. For example, in E. G. Dijk-Koekoek's entry on Withoos in *Dictionary of Art* 1996, vol. 33, p. 264.

11. Houbraken 1718–21, vol. 2, p. 187. To make matters worse, the line is mistranslated as "after a ten-year stay" in Hofstede de Groot 1893, p. 230.

12. See Steensma 1999, p. 15 n. 82 (on Withoos), and pp. 16–17.

13. Van Hoogstraten 1678, p. 169. The passage is quoted in Dutch (incorrectly citing p. 69) and provided with a somewhat different translation in Brusati 1995, pp. 287–88 n. 57.

14. The artist's Florentine patrons are discussed in Franchini Guelfi 1977.

15. Houbraken 1718–21, vol. 1, p. 358. The statement has been questioned on the grounds that no works by Marseus can be traced back to Ferdinando's collection (Steensma 1999, p. 16). But the author's claim that Houbraken meant Cosimo III (see text following) is unconvincing, since Marseus was never at his service for more than three meetings in Amsterdam. Presumably, Leopoldo was Marseus's patron in Italy, while Ferdinando shared the artist's interest in natural science.

16. Steensma 1999, pp. 19, 86.

17. Houbraken 1718–21, vol. 1, pp. 228, 358.

18. Van Aelst was an apprentice of his uncle Evert van Aelst and became a master in the Delft painters' guild on November 9, 1643.

19. Known provenances and signatures do not resolve the question, although it is curious that a still life in Braunschweig (Steensma 1999, no. B1.33) is signed OTTO/MARSEO. and dated 1662.

20. On De Monconys's visits with Marseus, see ibid., pp. 18–19.

21. See Bredius 1916, pp. 698–707.

22. Bredius (ibid., p. 707 n. 1) and some later writers must be mistaken to identify this structure with "the house 'in 't Waterrijk' . . . in which Monconys visited the artist in 1663." Had Bredius actually read De Monconys's journal entries, he would have realized that the camping shack was no place to keep paintings and serve lunch to a diplomat and his entourage.

23. Houbraken 1718–21, vol. 1, p. 358.

24. The most egregious example is found in Habicht 1923–24.

25. See Berardi 1987–88, p. 13 n. 11, for a more complete list. Marseus is the main figure discussed in Bol 1982a, where some of the artists he influenced are also reviewed (pp. 378–81).

26. According to Douglas Hildebrecht, who wrote a dissertation on Marseus at the University of Michigan (2004), the artist's watercolors representing rare plants cultivated by Agnes Block at her country estate "Vijverhof" (on the river Vecht near Utrecht) are preserved in Braunschweig but have not been studied or published.

27. Houbraken 1718–21, vol. 1, pl. R, opp. p. 358.

115. *Still Life with Poppy, Insects, and Reptiles*

Oil on canvas, 26⅞ x 20¾ in. (68.3 x 52.7 cm)
Signed (lower left, in red): otho Marseus/van Schrieck fecit

The painting is in good condition, although it has darkened with age. There is some abrasion in the deep green shadows of the poppy leaves and in the stone wall behind. Abrasions in the sky at the upper right have revealed the dark underlayer of paint.

Rogers Fund, 1953 53.155

This *sottobosco*, or "forest floor," picture must have been painted about 1670, to judge from dated works by the artist that are similar in composition, manner of execution, and some details of subject matter.[1] The main motif is a flourishing poppy plant, with large leaves and buds (the one on the right has begun to open), and at the top a red flower in full bloom. Small groups of mushrooms share the moss-covered ground with a lizard, a

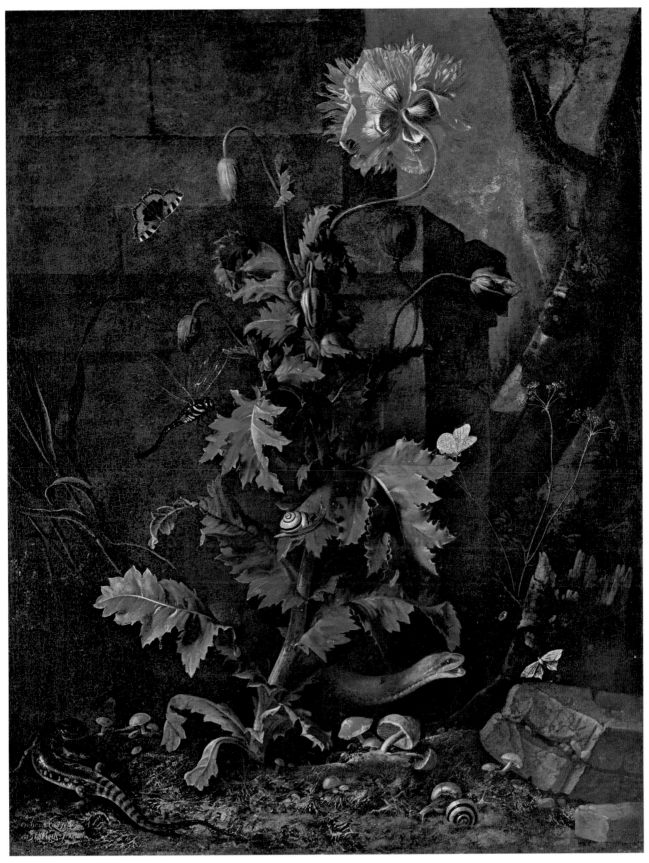

115

snake, and a pair of snails. As often in Marseus's work, the snake's attention is keenly focused on a moth. Another snail and a butterfly are perched on leaves, and an overscaled dragonfly hovers at the left. Higher up, a colorfully patterned butterfly is shown in flight, though it resembles a specimen in a display case. The base of a ruined monument or building sets off the teeming life in the foreground and suggests civilization overcome by nature. A few large trees and a cloudy sky in the right background offer slight relief from the deliberately claustrophobic atmosphere of the composition. Despite the acrobatic ascent of the poppy plant, attention is drawn downward to the lacelike tendrils of moss, the reptiles and snails, and the crumbling block of stone, which lies next to a broken tree stump. Contemporary viewers would have noticed contrasting signs of growth and decay, and may have recalled that the butterfly is a symbol of the soul. But vanitas themes in Marseus's work, if intended at all, are quite secondary to his interest in specific kinds of flora and fauna. Several authors have noted that the term "still life" is inappropriate for such a picture, which might be called a "nature study" or "nature piece."[2]

While not a fine example of Marseus's work, the authorship of the Museum's picture has not been doubted by any specialist. Ingvar Bergström in particular admired the painting.[3]

1. For example, Steensma 1999, no. BI.66, fig. 89, dated 1670, and nos. BI.67, BI.68, BI.72, figs. 90, 91, 96, dated 1671.

2. This point is stressed in Douglas Hildebrecht's doctoral dissertation, "Otto Marseus van Schrieck (1619/20–1678) and the Nature Piece: Art, Science, Religion, and the Seventeenth-Century Pursuit of Natural Knowledge," University of Michigan, 2004.
3. Bergström's oral opinion was recorded on visits of December 5, 1983 ("fine example"), and of November 17, 1986. On the second occasion, the present writer pressed the question of authorship.

REFERENCES: Linke 1970, p. 12, no. 16, identifies the reptiles as a lizard and a snake; Bergström 1974, p. 29, describes some of the motifs; Fahy 1982, pp. 59, 109, describes the "opium poppy" (which is seen from behind) as the principal subject of this "sinister painting"; Dickey in Hamilton–Rochester–Amarillo 1983, p. 20, no. 5, notes the accuracy with which each creature and plant is depicted, and suggests that some motifs may be symbolic; P. Sutton 1986, p. 190, mentioned; Baetjer 1995, p. 325; Steensma 1999, pp. 143–44, no. BI.69, fig. 93, and p. 150 (under no. BI.86), identifies the plants and insects, notes that a few motifs occur in other paintings by the artist, and mentions two pictures as "variants."

EXHIBITED: North Salem, N.Y., Hammond Museum, 1971; Hamilton, N.Y., Colgate University, Picker Art Gallery, Rochester, N.Y., The Memorial Art Gallery of the University of Rochester, and Amarillo, Tex., Amarillo Art Center, "Dutch Painting in the Age of Rembrandt from The Metropolitan Museum of Art," 1983, no. 5.

EX COLL.: ?Graaf van Limburg-Stirum, Rijksdorp, the Netherlands; Herr Schäfer, Düsseldorf (until 1953; sale, Lempertz, Cologne, May 6, 1953, no. 95, to Kleinberger); [Kleinberger, New York, 1953; sold to MMA]; Rogers Fund, 1953 53.155

GABRIËL METSU

Leiden 1629–1667 Amsterdam

In his survey of Dutch painters (1718–21), Houbraken regrets knowing so little about Metsu's life, apart from the (erroneous) information that he was born in Leiden in 1615. The biographer reports in other passages that Metsu died in 1658 and that Michiel van Musscher (1645–1705) had "seven lessons" with the master in 1665. Houbraken was on firmer ground when he praised the "famous" artist's rendering of fine materials, and of female faces and hands. The latter "could not be better if they had been painted by van Dyck."[1]

Almost certainly a native of Leiden, Metsu (also spelled Metzu and Metsue in documents) was the son of a Flemish immigrant painter, Jacques Metsue (ca. 1588–1629), and a midwife, Jacquemijntje Garniers (1589/93–1651).[2] If the archival records may be trusted, the artist was probably born in the second half of October or in November 1629 (not January 1629, the previously accepted date).[3] In a notarial record dated October 16, 1657, Metsu gave his age as twenty-seven.[4] When Metsu's betrothal to Isabella de Wolff was announced on April 12, 1658, in Amsterdam, he claimed to be twenty-eight.[5] The two documents together indicate that Metsu was born between October 16, 1629, and April 12, 1630. However, Jacques Metsue was buried on March 6, 1629,[6] so that his posthumous son presumably would have been born before December of the same year.

In March 1648, the eighteen-year-old Metsu became one of the founding members of the painters' guild in Leiden. He was probably trained there between about 1643 and 1648. Some authors have assumed that he studied with Gerrit Dou (q.v.), but there is no such indication in the early sources.[7] Metsu's juvenilia do not reveal the influence of any Leiden artist.[8] Scholars have considered two Utrecht painters, Nicolaes Knupfer (1603 or ca. 1609–1655) and Jan Baptist Weenix (1621–1660/61), to have been important for Metsu's early development.[9] It seems likely that Metsu worked with Knupfer in Utrecht, probably in 1651.[10] However, he was evidently living in Leiden in January 1654 and may have been there two years earlier.[11] In July 1657, neighbors of Metsu offered testimony at his request, and mentioned that he was currently living on the Prinsengracht in Amsterdam.[12] He appears to have remained in Amsterdam until October 1667, when he was buried in the Nieuwe Kerk.[13]

Metsu was an exceptionally talented, if eclectic, painter of genre scenes and, in much smaller numbers, of history pictures, portraits, and still lifes. His genre paintings, which treat themes that were popular in Leiden and Amsterdam, are executed in manners variously reminiscent of Gerard ter Borch, Pieter de Hooch, Nicolaes Maes, Jan Steen, and Johannes Vermeer (q.q.v.). About 13 of the approximately 140 known paintings by Metsu are dated.[14] This fact and a brisk exchange of ideas among genre painters of the 1650s and 1660s make it difficult to date many of Metsu's pictures. His most distinctive characteristics include demonstrative gestures (see Pl. 116) and, in his less theatrical pictures, tenderness (for example, in *The Sick Child*; Rijksmuseum, Amsterdam).

Paintings by the artist were highly prized in the eighteenth and nineteenth centuries, especially in France and England. The high prices paid for works by Metsu encouraged attributions to him of pictures by other Dutch genre painters, including the (at the time) less well-known Vermeer.

1. Houbraken 1718–21, vol. 1, p. 370, vol. 3, pp. 32 (lacks information), 40–42 (main text, with incorrect dates), 211 (on Van Musscher).
2. On Metsu's mother, who was widowed four times, and on aspects of Metsu's youth, see Stone-Ferrier 2000, pp. 230, 249–53, and Waiboer 2005, p. 80.
3. MacLaren 1960, p. 241, deduced the date of January 1629 (which is repeated in F. Robinson 1974, p. 12, MacLaren/Brown 1991, p. 253, and many other places) from the documents of 1657 and 1658 (see text following), and a document dated January 11, 1654 (see Bredius 1907a, p. 201). On that date, Metsu was described as a *voljaerde jongman*, meaning that he was at least twenty-five years old. The declaration released Metsu (an orphan since 1651) from the supervision of his legal guardians. It seems possible that the age requirement was waived, or that Metsu added a year to his age. If he really was twenty-five in January 1654, it would mean that he subtracted a year from his age in the declarations of 1657 and 1658. In Waiboer 2005, p. 80 n. 2, it is deduced that Metsu was born between November 1629 and about December 14, 1629.
4. Bredius 1907a, p. 202.
5. Kramm 1857–64, vol. 4, p. 1106. The twenty-six-year-old bride was accompanied by her mother, Maria de Grebber (ca. 1602–1680), who was also an artist (see Houbraken 1718–21, vol. 2, pp. 122–23). Her father was the Haarlem painter Frans Pietersz

de Grebber (1573–1649). Metsu and his fiancée married in her native Enkhuizen on May 19, 1658.

6. Bredius 1907a, p. 198.

7. MacLaren/Brown 1991, p. 253, states that "according to Houbraken, he was a pupil of Gerrit Dou," but this information cannot be found in Houbraken 1718–21 (nor in MacLaren 1960, p. 241). The error goes back to Hofstede de Groot 1907–27, vol. 1, p. 253 (kindly pointed out to the writer by Adriaan Waiboer). In Waiboer 2005, pp. 89–90, it is suggested that Dou's influence on Metsu is evident for the first time in a panel of about 1654–55, *Public Notary* (private collection).

8. Compare F. Robinson 1974, p. 15, where it is claimed that Metsu began his career as a follower of Dou.

9. See Gudlaugsson 1968, pp. 15–23; F. Robinson 1974, pp. 12, 18–19; Marijke van der Meij-Tolsma in *Dictionary of Art* 1996, vol. 21, p. 350; and (on Knupfer and Metsu), Saxton 2005, pp. 40–41.

10. The death of Metsu's mother in September 1651 may be relevant. In Waiboer 2005, p. 86, the period in which Metsu could have been with Knupfer is said to fall between October 1650 and the end of 1651. See ibid., pp. 83–87, on Metsu's relationship with Knupfer. In a personal communication dated November 29, 2002, Waiboer explains that the annotation in the Leiden guild records, to the effect that Metsu left town after 1650 (as reported by Bredius in Obreen 1877–90, vol. 5, p. 206, and in Bredius 1907a, pp. 197–98), was only added about 1659.

11. See Bredius 1907a, pp. 201–2. As noted in Waiboer 2005, p. 86, Metsu paid dues to the painters' guild of Leiden on January 2, 1652, and claimed to be living in the city at that time.

12. See Bredius 1907a, p. 202, and F. Robinson 1974, p. 12, where the document is misinterpreted. Adriaan Waiboer (see note 10 above) kindly clarified the matter in 2003.

13. A. D. de Vries 1883a. See Leiden 1966, pp. 17–19, for this and other documents.

14. According to Adriaan Waiboer (see note 10 above). C. Brown in MacLaren/Brown 1991, p. 253, counts nineteen dated works, while Wheelock (1995a, p. 164) knows of a "sizeable number."

116. *A Musical Party*

Oil on canvas, 24½ x 21⅜ in. (62.2 x 54.3 cm)
Signed and dated (lower left, on sheet of music): GMetsu./ 1659 [GM in monogram]; inscribed (upper right, on top of map): NOVISSISIMA HOL . . .

The painting is in fairly good condition, with slight abrasion throughout that is most apparent in the thinly painted background. Examination of the surface with a binocular microscope reveals that gold leaf underlies portions of the composition in the top left corner below the green curtain and extending to the right, as well as in passages along the center right edge behind the seated male figure.

Marquand Collection, Gift of Henry G. Marquand, 1890
91.26.11

This canvas in the Marquand Collection was painted by Metsu in 1659, when he was living in Amsterdam (on the much discussed date, see below). The painting represents the front rooms of a fine, if not palatial, town house (compare Pl. 118). A lady dressed in orange satin entertains two male visitors. She casually holds a large lute and hands a songbook to the moustached man by the window. Other songbooks spill from the chest on the floor, and two more threaten to fall off the table. The three main figures are fashionably dressed, especially the man to the left, whose lavish ensemble is completed by a walking stick and a red-feathered beret. The gentleman at the right, who tunes a viola da gamba, sits on his coat and has set down his sword and bandolier on a tapestry-covered cushion. A maid approaches from the other room with a wine jug and tray. Three flowers, probably carnations, are visible just above the tilted tray, suggesting that it supports a decorated pie. The map, on which the mouth of the Maas River and the southern part of the Province of Holland are seen (with the west at top), is based on the 1651 or 1656 revised edition of Balthasar Florisz van Berckenrode's map of Holland and West Friesland (first published by Blaeu in 1620).[1]

The date of 1659 on the sheet of music to the lower left was questioned by Gudlaugsson, who detected a difference in color between the signature and the date. Taking up Plietzsch's idea that the picture seems closely connected with works by Metsu of a few years earlier, Gudlaugsson claimed that the costumes and the manner of execution supported a slightly earlier date, and suggested that the painting was finished or inscribed by the artist a couple of years after it was begun.[2] Other scholars have come out for or against this hypothesis,[3] not realizing that the inscription was simply reinforced in a

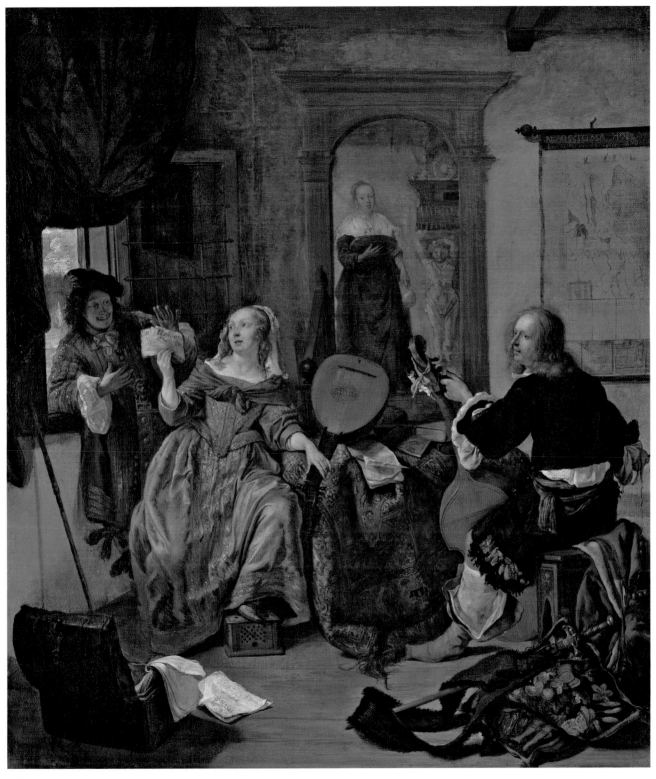

116

slightly different color at a later date.[4] Costumes like those seen here cannot be used to argue for a close dating within a period of two or three years.[5] Similarly, a dating based on the picture's style assumes a linear development, for which there is little evidence in Metsu's oeuvre.

The animation of the figures, especially the unstably seated woman, have reminded some viewers of figures by Nicolaes Knupfer (1603 or ca. 1609–1655), for example the bare-breasted beauty in his *Brothel Scene,* of about 1650 (Rijksmuseum, Amsterdam).[6] A more obvious response to that or another painting by Knupfer is found in Metsu's own *Brothel Scene* (Hermitage, Saint Petersburg), which probably dates from about 1653–54.[7] The figures in the New York painting (where the setting is not a brothel or an inn) are more restrained than in the earlier picture by Metsu and recall slightly earlier works by Frans van Mieris the Elder (q.v.), such as *The Doctor's Visit,* of 1657 (Kunsthistorisches Museum, Vienna), *The Duet,* of 1658 (Staatliches Museum, Schwerin), and the *Inn Scene,* of 1658 (Mauritshuis, The Hague). Naumann suggests plausibly that the figure of the seated man is derived from the one in the foreground of Van Mieris's *Inn Scene,* and that the setting was influenced by that of *The Doctor's Visit.* The two figures on the left are similarly reminiscent of types found in Van Mieris's work of about 1657–59. The arrangement of the curtain, the window, and objects in the left foreground recalls motifs in Van Mieris's *The Artist's Studio,* of about 1655–57 (formerly Gemäldegalerie Alte Meister, Dresden), and in contemporary works by Gerrit Dou (q.v.).[8] It should be noted, however, that Nicolaes Maes (q.v.) and other genre painters of the 1650s were also introducing spatial devices such as the curtain, the open window, and stairs leading to other rooms.[9]

The subject of elegant musical gatherings flourished during the decade of the 1650s, for example in the work of the Amsterdam painters Gerbrand van den Eeckhout (q.v.) and Jacob van Loo (1614–1670).[10] A lute, a viola da gamba, and songbooks are often combined (see Pl. 204, where a viol on the floor awaits a male visitor). Entries in Samuel Pepys's diary, written in England and Holland during the 1660s, reflect the contemporary enthusiasm for singing and playing stringed instruments as a form of socializing among members of polite society.[11] New songs, many of them amorous, were eagerly circulated among amateurs.

That the senses or heartstrings might turn into fetters is hinted at by the atlantes figure in the fireplace of the second room.[12] Metsu used the same sculpture in *A Woman Seated at a Table and a Man Tuning a Violin,* of about 1658 (National Gallery, London),[13] whereas Vermeer, with his usual obliquity, placed the back and bound arms of a nude male figure (Cimon, in a mostly invisible painting of Roman Charity) next to the man in *A Lady at the Virginal with a Gentleman* (Royal Collection, London).[14] As a moral buttress, the sculpture in *A Musical Party* does not seem intended to carry much weight.

1. Welu 1977, p. 64 n. 24, as noted by P. Sutton in Philadelphia–Berlin–London 1984, p. 253.
2. Gudlaugsson 1968, p. 14.
3. See Refs. under Wheelock 1976, Naumann 1981, and Philadelphia–Berlin–London 1984.
4. Dorothy Mahon, technical examination, March 1993. The musical notes on the page appear to be in the same color as the date. F. Robinson (1974) never raised the question of the date, probably because curator John Walsh, with whom he had many contacts, told him it presented no problem. A note to this effect was written by Walsh on a student's paper of 1976.
5. As noted by P. Sutton in Philadelphia–Berlin–London 1984, p. 253.
6. San Francisco–Baltimore–London 1997–98, no. 45.
7. See F. Robinson 1974, p. 22, figs. 16, 17.
8. For the Van Mieris, see Naumann 1981, vol. 2, no. 19.
9. See Liedtke 2000a, chap. 4. For Maes, see Naumann 1981, vol. 1, pp. 50–51; Sumowski 1983–[94], vol. 3, nos. 1347–57; and Krempel 2000.
10. As noted by P. Sutton in Philadelphia–Berlin–London 1984, p. 253, with references to no. 43 (Van den Eeckhout) and no. 64 (Van Loo) in the same catalogue.
11. Liedtke 1991, pp. 234–37. See also Moens 1986, The Hague–Antwerp 1994, and Buijsen's essay in The Hague 1996b.
12. The sculpture is not a caryatid, as is often claimed. Compare the herms supporting a mantel in Claes Jansz Visscher's engraving *Saying Grace,* of 1609 (Liedtke 2000a, fig. 192). Foot warmers often serve as sexual symbols (see Amsterdam 1976, pp. 96–97, and Chapman 1993, p. 143), but the woman here is probably using hers (without a pot of coals) simply to raise one knee, as is usual when playing a lute.
13. As noted by P. Sutton in Philadelphia–Berlin–London 1984, p. 253 n. 9, citing also Metsu's *Woman with a Glass and Tankard* (Louvre, Paris). For the London painting, see MacLaren/Brown 1991, pp. 254–55, pl. 216. On the Paris picture and its "classical caryatid," see Franits 1993a, pp. 90–92, fig. 71.
14. See White 1982, pp. 144–45 (under no. 230), and Washington–The Hague 1995–96, no. 8, with an implausible interpretation of Cimon and Pero in this context (p. 132).

REFERENCES: Descamps 1753–54, vol. 2, p. 243, mentions this picture (?) as "un Concert" in the collection of the marquis de Voyer; Buchanan 1824, vol. 2, pp. 53–54, no. 69, as coming from one of the finest collections in Holland, "where it was always considered to represent the portraits of the painter himself, his wife, and Jan Stein [*sic*]," and as in the Robit sale and "now again in Paris"; J. Smith 1829–42, vol. 4 (1833), p. 90, no. 53, describes the composition, compares the execution to that of Van Dyck, and records Smith's own sale of the painting to Zachary (see Ex Coll.); Bode 1895, p. 18, as from the Perkins collection, "ein etwas liebloses, noch an [Jacob] Duck

erinnerndes Werk"; Hofstede de Groot 1907–27, vol. 1 (1907), p. 303, no. 164, notes that Jan Steen, Metsu, and his wife were once thought to have served as models; Valentiner in New York 1909, no. 63, as signed and dated 1659; Cox 1909–10, p. 305, mentioned as in the MMA "Hudson-Fulton Celebration," a picture with many admirable qualities; Breck 1910, p. 57, as "presque trop fougueux"; Errera 1920–21, vol. 1, p. 294, listed under works dated 1659; Gerson 1930, p. 440, listed among dated works; Plietzsch 1936, pp. 5, 9, as still related to the youthful works, but already resembling pictures of 1661 in its painterly manner; Gowing 1952, p. 155 n. 142, compares the pose of the woman to that of the figure in Vermeer's *Allegory of the Catholic Faith* (Pl. 206); New York 1952–53, p. 229, no. 118; De Mirimonde 1966–67, p. 281, fig. 32, notes "la cariatide enchaînée" as symbolic; Gudlaugsson 1968, pp. 13–15, 24–25, fig. 5, suggests that the date of 1659 was added one or two years after the picture was painted, and sees the influence of both Leiden and Amsterdam artists; Schneede 1968, p. 47, places the picture in the first of three chronological groups, which are defined according to the form of signature; F. Robinson 1974, pp. 37, 49, 54, 59–60, 64, fig. 68, compares the styles of Dou, De Hooch, and Vermeer, and distinguishes the work from paintings by Metsu of the early 1660s; Wheelock 1976, p. 458, states that the picture "may indeed date ca. 1657," given the color of the date on the painting and elements that are "stylistically reminiscent of Knüpfer"; Welu 1977, p. 64 n. 24, identifies the map (see text above); Naumann 1981, vol. 1, pp. 51–52, 55–56, fig. 44, describes the influence of Van Mieris, and dismisses Gudlaugsson's and Wheelock's comments on the date; C. Brown 1984, pp. 119 (ill.), 137, describes the subject; P. Sutton in Philadelphia–Berlin–London 1984, no. 72, pl. 66, describes the composition and its sources, and finds "no reason to doubt" the date of 1659; Hedinger 1986, p. 158 n. 329, fig. 81, regards the map as an unusual motif in this kind of scene; P. Sutton 1986, pp. 184, 187–88, fig. 267, considers the portrayal of Metsu, his wife, and Steen "unconfirmed"; Broos in The Hague–San Francisco 1990–91, p. 337, observes that "the formal language of his later works is much more sober" than here; Ingamells 1992a, pp. 198, 201, attempts to date works by Metsu in the Wallace Collection by comparing the present picture as a work of about 1657; Jäkel-Scheglmann 1994, pp. 98, 100, fig. 100, describes the subject; Baetjer 1995, p. 331; Düchting 1996, p. 57 (ill.), compares the painting with Vermeer's approach; Edwards 1996, pp. 155, 156 (ill.), 302 (under no. 69), records the picture in the Robit sale of 1801; Marijke van der Meij-Tolsma in *Dictionary of Art* 1996, vol. 21, p. 351, mentioned; Luttikhuizen in Grand Rapids 1999, pp. 30 (detail ill.), 37, 72, 73 (ill.), 104, no. 15, discerns "numerous allusions to the excesses of love and romance throughout" the work; Vergara in Madrid 2003, no. 20, compares De Hooch's palette and organization of space.

EXHIBITED: London, British Institution, 1832, no. 103 (lent by Frederick Perkins); New York, MMA, "Exhibition, 1888–89" [Marquand Collection], 1888–89; New York, MMA, "The Hudson-Fulton Celebration," 1909, no. 63; New York, MMA, "Art Treasures of the Metropolitan," 1952–53, no. 118; Leiden, Stedelijk Museum De Lakenhal, "Gabriel Metsu," 1966, no. 42; Kansas City, Mo., The Nelson Gallery of Art and Atkins Museum, "Paintings of 17th Century Dutch Interiors," 1967–68, no. 12; Boston, Mass., Museum of Fine Arts, "Masterpieces of Painting in The Metropolitan Museum of Art," 1970; Philadelphia, Pa., Philadelphia Museum of Art, Berlin, Gemäldegalerie, Staatliche Museen Preussischer Kulturbesitz, and London, Royal Academy of Arts, "Masters of Seventeenth-Century Dutch Genre Painting," 1984, no. 72; Grand Rapids, Mich., Grand Rapids Art Museum, "A Moral Compass: Seventeenth and Eighteenth Century Painting in the Netherlands," 1999, no. 15; Madrid, Museo del Prado, "Vermeer y el interior holandés," 2003, no. 20.

EX COLL.: Possibly the marquis de Voyer, Paris (in 1754; see Refs. under Descamps 1753–54); Elizabeth Valckenier-Hooft, Amsterdam (until 1796; sale, Amsterdam, August 31, 1796, no. 25, to Fouquet for Fl 1,005); Pierre Fouquet, Amsterdam, in 1796; "Coquilery" to [Dulac] for FFr 7,200; [Dulac; sold to Robit for FFr 10,000];[1] Robit, Paris (until 1801; sale, Paris, May 11–18, 1801, no. 69, sold to Hypolite Delaroche [not on behalf of Michael Bryan, London, as previously assumed] for FFr 4,500); [Hypolite Delaroche and Alexandre Paillet, organizers of the Robit sale, 1801–3 (sale organized by Delaroche and Paillet, Paris, April 18–25, 1803, no. 368, as "Un sujet de Concert: par G. Metzu," bought in)]; anon. sale, Paris (Delaroche and Paillet), June 26ff., 1809, no. 29;[2] anon. sale (Paillet), Paris, March 14, 1810, no. 8; [John Smith, London (until 1825; sold to Zachary for Gns 400)]; M. M. Zachary, London (1825–28; his sale, Phillips, London, May 31, 1828, no. 45, bought in for Gns 500); Frederick Perkins, Chipstead Place, Seven Oaks, Kent, England (by 1832; his estate sale, Christie's, London, June 14, 1890, no. 9, to Colnaghi for £609); [Martin Colnaghi, London, in 1890]; Henry G. Marquand, New York (1890); Marquand Collection, Gift of Henry G. Marquand, 1890 91.26.11

1. According to J. B. P. Le Brun's annotation "Coquilery [?] le vendy a dulac—7200 qui le vendi a robie—10000 le tableau est mediocre," in a copy of the Robit sale catalogue in Geneva (this information and other corrections were kindly supplied by Burton Fredericksen, the Getty Art History Information Program, in a letter dated December 15, 1995).

2. Fredericksen and Peronnet 1998, vol. 1, p. 687.

117. *A Woman Seated at a Window*

Oil on wood, 10⅞ x 8⅞ in. (27.6 x 22.5 cm)
Signed (bottom center): G. Metsu

The painting is well preserved, although the flesh tones, particularly in the face, have been overcleaned in the past. The blue leaves on the vine at upper left suggest the use of a yellow lake pigment, now faded.

The Jack and Belle Linsky Collection, 1982 1982.60.32

The Linsky Metsu depicts a woman about to peel apples while seated at an arched stone window. This kind of framing device, called a *nisstuk* or *vensternis* (niche-piece or window-niche) in the seventeenth century, was popularized in Leiden by Gerrit Dou (see Pl. 37). He and his followers often rendered their signatures or the date as if they were carved in the stone, as Metsu does here.[1]

It has been maintained that this painting and Metsu's panel *A Huntsman,* dated 1661 (fig. 112), were probably painted as pendants.[2] The pictures are virtually identical in size and appear to be complementary in composition and subject matter. *A Huntsman* was one of the forty-one paintings in the collection of Govert van Slingelandt (chief tax collector at The Hague) that were bought en bloc by Willem V in 1768.[3] The Linsky picture cannot be traced before 1842, when Smith (see Refs.) recorded that it had been brought into England from Copenhagen. Van Slingelandt is known to have methodically restricted the size of his collection and to have steadily improved its quality. It is possible that he sold the present painting, or that it was separated from its supposed pendant at an earlier date.

Similar figures—a successful hunter just returned from the field and a woman occupied with some domestic task—occasionally encounter each other in single Dutch paintings of about the same time. Some of them obviously illustrate the belief, expressed by ancient authorities such as Aristotle and Xenophon or by contemporary moralists like Johan van Beverwijck (1639), Jan van Marconville (1647), and Petrus Wittewrongel (1655; 1661), that a man's work took him out of doors, while a woman's place was in the home.[4] He is the good provider, while she guards and feathers the nest.[5]

In some Dutch pictures, a hunter who brings a dead bird or hare to a woman has sex in mind: "birding" and "hunting hares" were slang expressions for making love to women in one sense or another.[6] As in *The Hunter's Gift* by Metsu (Rijksmuseum, Amsterdam), the figures usually interact in a way that makes the man's desire and the woman's caution clear.[7] The Linsky and

Mauritshuis pictures also have been interpreted along these lines.[8] However, the figures do not interact with each other, but gesture to the viewer in cordial acknowledgment. In her dress and demeanor, the woman seems a model of middle-class respectability, while the man, to judge from his fancy hunting horn and good manners, might be interpreted as a gentleman hunter who "brings home the bacon" as a gallant gesture and is rewarded with a glass of wine.[9]

A stronger objection to an amorous reading of the panels is Waiboer's argument that they are not pendants at all. He notes that at least eight other genre paintings by Metsu have dimensions nearly identical to those of the Linsky picture, suggesting that he may have purchased panels of a standard size. Furthermore, the compositions of the two paintings are not as complementary as they might at first seem. The man is presented in a significantly smaller scale; nor does his deeper placement in space seem to fully account for the different impressions that the figures make. Finally, the stone windows are not as consistent in shape, coloring, cropping, and the point of view from which they are seen (compare the receding right sides of the

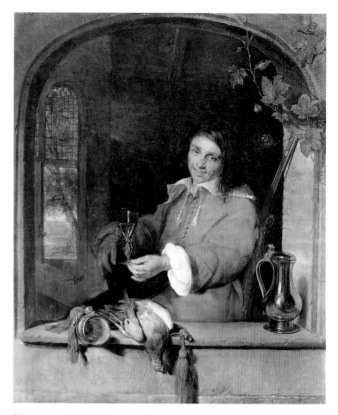

Figure 112. Gabriël Metsu, *A Huntsman*, 1661. Oil on wood, 11 x 9 in. (28 x 22.8 cm). Mauritshuis, The Hague

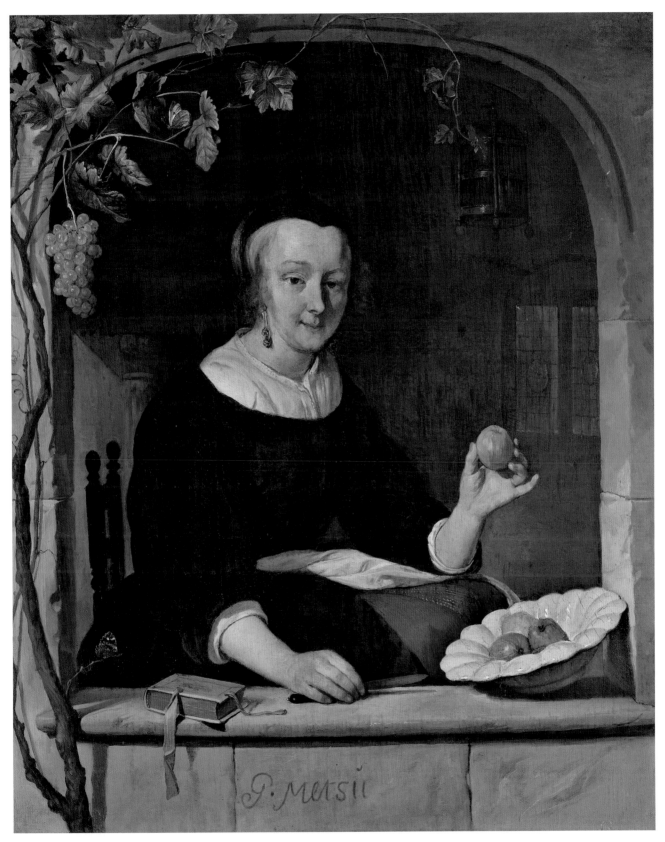

117

windows) as one would expect in pictures meant to be recognized as a pair.[10]

Considered on its own, *A Woman Seated at a Window* may be appreciated as a tribute to distaff virtue. The closed birdcage, the hearth, and perhaps the sense of confinement in the interior convey the notion of contented domesticity.[11] Metsu's contemporaries would have recognized the grapevine as a symbol of fidelity and marriage, best known from the description of a man's spouse in Psalm 128 as "as a fruitful vine by the sides of thine house."[12] Peeling apples is a sign of domestic virtue, familiar from works by Dutch artists such as Dou and Nicolaes Maes (see Pl. 109), and is found in another picture by Metsu, *Woman Peeling an Apple,* in the Musée du Louvre, Paris.[13] Given the biblical metaphor of the vine, it seems possible that the apples in the Museum's picture refer to chastity (they recall the Virgin as the New Eve) as well as to wifely duty, and that the colorful butterfly to the lower left and the muted one among the vine leaves are reminders of the soul.[14] The book on the windowsill may be religious or secular but must, in this context, speak well of the woman's character.[15] These iconographic embellishments would have increased the painting's appeal in Metsu's day, for the Dutch liked to recognize in books and pictures beliefs to which they already subscribed.

1. See Franits 1993a, pp. 80, 218 n. 77.
2. In F. Robinson 1974, pp. 28–29, and by the present writer in Linsky Collection 1984, p. 93.
3. See Hoetink et al. 1985, pp. 22, 398, no. 93.
4. See Franits 1993a, pp. 68–69, 215 n. 36, on these writers, and pp. 87–89, fig. 67, on Hendrick Sorgh's *Portrait of Jacob Bierens and His Family,* of 1663 (Instituut Collectie Nederland), where the husband and wife play roles comparable with those of Metsu's figures. On Van Beverwijck, see also Van Gemert 1994.
5. Franits 1993a, p. 90, on hunting equipment that alludes to the "husbandly role of providing for the family."
6. The classic article on the erotic meaning of birds and "birding" is De Jongh 1968–69; see De Jongh 2000, pp. 32–36, for the most relevant pages in English translation. See also Amsterdam 1976, no. 13; Braunschweig 1978, no. 25; Leiden 1988, nos. 41, 91; and Amsterdam 1989–90, nos. 48–50.
7. On the Amsterdam canvas, see F. Robinson 1974, pp. 27–30, 75–76 n. 45; Franits 1993b, pp. 303–4; and De Jongh 2000, pp. 33–35.
8. F. Robinson 1974, p. 29, describes details in the paintings as "laden with erotic allusions that have been discussed by De Jongh." E. J. Sluijter (orally, in 1984) supported this view, in response to the discussion in Linsky Collection 1984, p. 93.
9. On hunting in the Netherlands, see S. Sullivan 1984; and for the man's gesture, Braunschweig 1978, p. 168. On husbands as providers, see Franits 1993a, pp. 87–89, 220–21 n. 102.

10. Most of these points were made by Adriaan Waiboer in an undated letter to the present writer (Fall 2003), and are also presented in his dissertation (see the biography above, note 10).
11. On the birdcage as a symbol of domesticity, see Franits 1993a, pp. 80–82.
12. Ibid., pp. 82, 218–19 nn. 83–85. See also the discussion of Pieter de Hooch's *Portrait of a Family in a Courtyard in Delft* (Gemäldegalerie der Akademie der Bildenden Künste, Vienna) in New York–London 2001, pp. 274, 277 n. 3.
13. Franits 1993a, pp. 90–92, 181–83, figs. 70, 161–62.
14. For a conspicuous use of butterflies as symbols of the soul, see Joris Hoefnagel's *Allegory of Life's Brevity (Diptych with Flowers and Insects),* in the Musée des Beaux-Arts, Lille (New York 1992–93, no. 8). Compare Godfried Schalcken's placement of a butterfly on the edge of a stone window in *An Old Woman at a Window Scouring a Pot* (National Gallery, London), which is discussed as a vanitas symbol in Franits 1993a, pp. 172, 242 n. 32, fig. 149.
15. See Franits 1993a, pp. 19–20, and the discussion of Eglon van der Neer's painting *The Reader* (Pl. 132), below.

REFERENCES: J. Smith 1829–42, vol. 9 (1842), p. 528, no. 41, describes the picture as in the collection of Edmund Higginson, having been previously "imported by Mr. Chaplin, from Copenhagen"; Hofstede de Groot 1907–27, vol. 1 (1907), p. 324, no. 213, records the sales of 1846 and 1904, and the owner (in 1907) as M. Kappel, Berlin; Bode 1914, p. 16, no. 16 (ill.), considers the composition typical of Metsu's "mature period"; F. Robinson 1974, pp. 28–29, 78 n. 48, fig. 30, discusses the meaning of the picture, and tentatively suggests that *A Huntsman* (Mauritshuis, The Hague) might be its pendant; Liedtke in Linsky Collection 1984, pp. 92–94, no. 32, maintains that the Mauritshuis picture must be a pendant and discusses the iconography of both pictures; Baetjer 1995, p. 331; Sluijter in Dordrecht–Enschede 2000, p. 122, fig. 179, as "present location unknown," compares the woman's display of an apple to a similar motif in a painting of 1818 by Abraham van Strij; Franits 2004, pp. 182–83, fig. 168, discusses the picture's meaning, and considers *A Huntsman* its pendant.

EXHIBITED: Berlin, Kaiser-Friedrich-Museum, "Ausstellung von Werken Alter Kunst aus dem Privatbesitz der Mitglieder des Kaiser Friedrich Museums-Vereins," 1906, no. 83 (lent by Marcus Kappel).

EX COLL.: Mr. Chaplin, Copenhagen, later England (according to Smith in 1842); Edmund Higginson, Saltmarsh Castle, Herefordshire (by 1842–46; his sale, Christie's, London, June 4, 1846, no. 95, for £46); Mme Duval (until 1904; her estate sale, Hôtel Drouot, Paris, November 28, 1904, no. 9, for FFr 27,000 to Kleinberger); [Kleinberger, Paris, from 1904]; Marcus Kappel, Berlin (by 1906–30; his sale, Cassirer & Helbing, Berlin, November 25, 1930, no. 11); Mr. and Mrs. Jack Linsky (until 1980); The Jack and Belle Linsky Foundation, New York (1980–82); The Jack and Belle Linsky Collection, 1982 1982.60.32

118. *The Visit to the Nursery*

Oil on canvas, 30½ x 32 in. (77.5 x 81.3 cm)
Signed and dated (at left, above door): G.Metsu 1661

The painting was transferred from its original canvas support to another canvas before it entered the Museum's collection. The image of the original support is visible in the X-radiographs. The surface has been badly abraded throughout.

Gift of J. Pierpont Morgan, 1917 17.190.20

Celebrated in its own day, this picture was almost certainly painted by Metsu expressly for its first known owner, the Amsterdam alderman Jan Jacobsz Hinlopen (see below). Jan Vos (1610–1667), who served as a "house poet" to the Hinlopen family, included a poem about the painting in the 1662 edition of his collected works.[1] The title of the poem—"Op de Schildery van een Kraamvrouw, in de zaal den E. Heer Scheepen Jan Jakobsen Hinloopen, door G. Moetsu geschildert" (On the Painting of a Lying-in Woman in the Salon of the H[onorable] Alderman Mr. Jan Jakobsen Hinloopen, Painted by G. Metsu")— identifies its distinctively Dutch subject as a *kraambezoek*, or "lying-in visit," a social ritual also depicted in the Museum's painting by Matthijs Naiveu (Pl. 128). A *kraamvrouw* is a woman in confinement, either shortly before or shortly after giving birth.[2]

In Metsu's painting, the gesturing woman with a closed fan and fashionable attire is an invited guest. She is greeted by the new mother and her hat-doffing husband.[3] The maid to the left brings a side chair and a foot warmer, the latter for use as a footrest while holding the baby (compare the painting by Naiveu; Pl. 128). The old woman seated beside the luxuriously draped wicker cradle must be a *baker*, or dry nurse. The fur-lined robe that she wears would probably have been provided by the parents, with a view to the infant's comfort as well as the woman's own.[4]

The scene is set in an imaginary *zaal* or *voorkamer* (front or reception room) of a magnificent town house, like those built on the Bend of the Herengracht in Amsterdam from about 1660 onward.[5] The extraordinary size of the room, which is suggested by the marble fireplace and the seascape above it, exceeds what would have been found in almost any private house in a Dutch city during the period, with the possible exception of a very few new houses in Amsterdam, such as the Ioan Poppen House by Philips Vingboons, built in 1642 on the Kloveniersburgwal, and the Trip House (Trippenhuis) by Justus Vingboons, erected on the same canal in 1660–62.[6] In fact, Metsu employed an even grander model for the room's main features: the fireplace with red marble columns and a frieze with putti, the black-and-white marble floor, and even the doorway revealed by drapery are derived from the burgomasters' council chamber in the new Town Hall (now the Royal Palace) of Amsterdam, designed by Jacob van Campen (the room was in use from 1655; the fabric on the walls was purchased in 1658).[7] Pieter de Hooch (q.v.) shows the same chamber in a painting in the Museo Thyssen-Bornemisza, Madrid, where the fireplace is more precisely described, although the view through the doorway in the background is as fictitious as Metsu's is here. It is unlikely that Metsu was influenced by De Hooch's canvas, considering that it is usually dated somewhat later than 1661, and that Metsu's patron was directly connected with the council chamber of the Town Hall.[8]

Metsu's interior has been described as unrealistic not only in its architecture but also in its inclusion of such a stately bed, chairs placed in the middle of the room, and a Persian carpet on the floor.[9] However, the painting does not represent a grand living or reception room of about 1660 but the artist's idea of an extremely luxurious *kraamkamer*, or lying-in room, which in the finest homes might well feature an extravagant bed, a cradle, an armchair, and other items intended for display on this special occasion (compare Naiveu's later pictures, Pl. 128 and fig. 117).[10] One might compare Metsu's imaginary room, in its distance from everyday custom, to the silver layette basket that was created in 1666–67 by Adriaen van der Hoecke for the new parents Willem Adriaen van Nassau and his wife, Elizabeth van der Nisse (Museum of Fine Arts, Boston).[11] Silver brandy bowls, porridge bowls, and rattles were among the objects given as gifts or purchased to celebrate the birth of a child.[12]

The impressive silver bowl on the table probably contains some confection, but exactly what kind is unclear. The silver pitcher and the covered glass goblet must contain *kandeel*, a drink usually consisting of wine, lemon juice, sugar, and a spice such as cinnamon.[13] Two silver trays are partially visible to either side of the bowl.

The refinement of customs and objects pertaining to childbirth may be considered a reflection, in part, of the fact that mothers and especially infants often did not survive the experience. At the same time, the theme of childbirth in the Netherlands is only one aspect of a much larger subject, that of the family and the various roles—especially those of women— played within it.[14] Dutch authors, in particular Jacob Cats,

and Dutch artists such as Nicolaes Maes (see Pl. 110) devoted close attention to the virtues and responsibilities of motherhood.[15]

The area of the painting over the fireplace is now very worn but shows plainly enough a small ship (to the lower left) tossed in a stormy sea. Scholars have mentioned Ludolf Bakhuyzen (1631–1708) and Allart van Everdingen (1621–1675) as the authors of similar works, but the canvas is most reminiscent of marines by Jacob van Ruisdael (q.v.) that date from about the early 1660s.[16] The image of a boat or ship on a stormy sea has various meanings in Dutch art but certainly refers here to the journey of life that has just begun for the infant, and to the role that fate will play.[17] The same sort of image occurs in the Museum's painting by Naiveu (Pl. 128, in the right background).

In the present picture and others of the 1660s, Metsu was influenced by Gerard ter Borch (q.v.) in his handling of fine materials and furnishings, and in his observation of gestures, expressions, and poses (compare the two figures on the left to those in Pl. 13). Houbraken, in 1721, recalled the Museum's painting as the largest and finest work by Metsu he had ever seen. He describes the subject from memory as "a lying-in visit of ladies and gentlemen" ("een Kraambezoek van Juffrouwen en Heeren"); praises the execution, especially of the costumes; and admires "the particular placements and movements of the figures, so that it is easy to see what each one is saying in their encounter."[18] Similarly, in Vos's poem of 1661–62, the picture is praised for its lifelike description of different sub-stances ("flesh and blood; yea, silver, wool and silk") and for its dramatic effect (Vos was director of the Amsterdam Theater). The elegant visitor "seems to express herself respectfully with face and lips."[19]

Metsu's superb family portrait in Berlin (fig. 113) is now known to depict the original owner of *The Visit to the Nursery*, Jan Jacobsz Hinlopen (1626–1666), his wife Leonora Huyde-coper van Maarsseveen (1631–1663), their four children, and a maid. The sitters were identified only in 1998, partly on the basis of the portrait's description in the will made by the Hinlopens on October 16, 1663.[20] In 1995, the costume historian Irene Groeneweg dismissed an earlier identification of the sitters as members of the Valckenier family by dating elements of their clothing to about 1662 and by noting the resemblance between the couple in the family portrait and the proud parents in the Museum's picture. She concluded that the Berlin picture is not a portrait but a genre scene in which Metsu depicted types familiar from his contemporary scenes of everyday life.[21] This implausible interpretation of the Berlin painting is rejected by Van Thiel, who adds that "the one in New York is not a straightforward genre scene" but "may well turn out to be a genre-like portrait."[22] Westermann also suggests that the New York canvas may be "a genrelike portrait of the Hinlopens themselves, who had been married in 1657 and may have had a new birth to celebrate with a family portrait."[23] Indeed, the Hinlopens produced a son and three daughters between 1658 and 1662.[24]

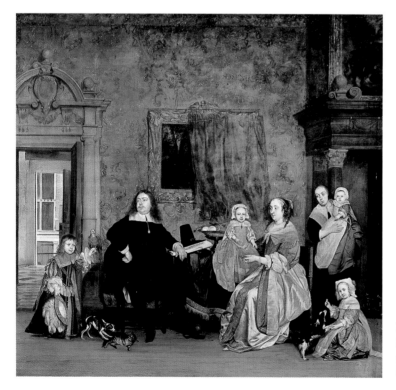

Figure 113. Gabriël Metsu, *Portrait of Jan Jacobsz Hinlopen and His Family*, ca. 1662. Oil on canvas, 28 x 31⅛ in. (71 x 79 cm). Gemäldegalerie, Staatliche Museen zu Berlin

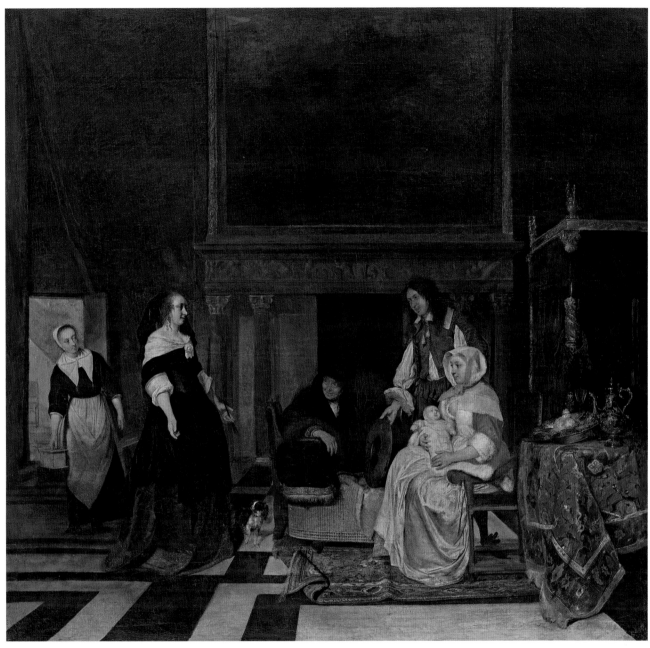

118

While there is a general resemblance between the parents in the family portrait and those in *The Visit to the Nursery,* it is not strong enough to qualify the painting as a "genrelike portrait" of the Hinlopens. The couple's third child was born in 1660; older children would not necessarily have been present during a lying-in visit, but they might well have been (as in Pl. 128). The Museum's picture must have been regarded by the Hinlopens as a "conversation piece" that came close to home, a work that evoked their world but did not portray it literally.[25]

Part of that world was the Town Hall of Amsterdam, which Hinlopen's father-in-law, the wealthy burgomaster Joan Huydecoper van Maarsseveen, considered to a great degree his own creation.[26] Both Huydecoper and before him his father-in-law, the Flemish banker Balthasar Coymans, built Amsterdam mansions in the classicist style: the Coymans house (1625) on the Keizersgracht is Jacob van Campen's first known commission, and Huydecoper's house (1639–42) on the Singel was an influential early work by Philips Vingboons.[27] The house on the Nieuwe Doelenstraat that Hinlopen rented from 1656 onward was built about 1633 in the Dutch Renaissance manner of Hendrick de Keyser (1565–1621).[28] The interior's appearance is unrecorded, but it is worth noting that the doorframe and fireplace in the Hinlopen family portrait (fig. 113) recall De Keyser's style.[29]

As for Jan Vos, he rarely missed an opportunity to celebrate the Huydecopers and the Hinlopens. The first edition of his collected works is dedicated in its entirety to Joan Huydecoper and includes seventy-six poems for or concerning Huydecoper himself and about ten members of his immediate family. Vos treated such subjects as "their [new] houses in Amsterdam and Maarsseveen, their marriages and deaths, their gifts from foreign dignitaries, and the attentions they bestowed upon the poet."[30] As Schwartz notes, it was with Huydecoper's help during the 1640s that Vos advanced from his activities as a humble glazier and amateur poet and playwright to municipal posts in both fields. Thus the poet who commemorated the inauguration of the Town Hall in 1655 also saw to it that the windows were finished on time.[31]

Occasionally, doubt has been expressed about whether the Museum's painting is identical with the *kraamkamer* by Metsu that was in the famous collection of Gerret Braamcamp (1699–1771) in Amsterdam.[32] In the incomplete and celebratory catalogue compiled in 1766 by Jean François de Bastide, the picture is said to be on wood (the dimensions are given with the abbreviation "B." for *bois*).[33] This information was repeated in the Braamcamp sale catalogue of 1771.[34] No record of the support is given in the sale catalogues of 1706 and 1749.[35] Smith (1833) describes the composition carefully, mentions two of its colors, and identifies the support as canvas.[36] Examination of the painting and of the X-radiograph indicates clearly that the paint film and ground were transferred from their original support at some unknown date (which could be much later than Smith's description) and that the original support was canvas not wood.[37] Since many paintings by Metsu are on panel, and because even his canvases usually have a smooth surface (the present picture's comparatively thick ground layer contributes to that effect), it would not be surprising if de Bastide mistakenly made the notation "B." when looking at the painting on the wall during his room-to-room survey of pictures in Braamcamp's house.[38]

When Houbraken saw the painting it was owned by "the art-lover Jan de Wolf," who is said to have since parted with it (by 1721). Jan de Wolff (1681–1735) was the grandson of the better-known Hans de Wolff (1613–1670), an Amsterdam silk merchant whose uncle was the famous poet Joost van den Vondel, and whose second wife was the amateur of art and botany Agnes Block (1629–1704).[39] It is not clear how the picture was transferred from the Hinlopens to De Wolff, but the families were related and often involved with each other.[40]

Hofstede de Groot lists a few copies after the Museum's painting, and another was mentioned by Lagrange.[41] A picture listed in an Amsterdam sale of May 18, 1706, as an exceptionally fine work by Metsu depicting a woman with a child on her lap and other figures in a room may have been the present painting, an autograph replica, or a copy.[42]

1. Vos 1662, p. 654; Vos 1726, vol. 1, p. 388. The poem is quoted in full and translated into German in G. Weber 1991, pp. 173–74. The Dutch text is also given in Van Gent 1998, p. 134 n. 20. In a letter to the present writer dated September 4, 2001, Gregor Weber helpfully emphasized that the poem was included in Vos's collected works at "the last moment shortly before printing in 1662, thus shortly after the date 1661 on the painting itself." Franits 1993a, p. 227 n. 16, mistakenly claims that the poem is not in the 1662 edition of Vos's works, and inexplicably adds that therefore the picture may have been painted after that date.

2. Two other paintings of this theme, a panel attributed to Quirijn van Brekelenkam (q.v.) in the Staatliche Kunstsammlungen, Dresden (Lasius 1992, no. 149, pl. 42), and a canvas of 1664 by Eglon van der Neer (q.v.) in the Koninklijk Museum voor Schone Kunsten, Antwerp, are connected with the Museum's picture in Gudlaugsson 1968, p. 30 n. 55. Neither work is similar to Metsu's in composition, although in each case the couple with a baby are on the right and receive a standing female visitor. The subject was also treated by Anthonie Palamedesz (1601–1673): Wijsenbeek-Olthuis 1996, pp. 156–57, 161 n. 37, notes five examples by him recorded in the photograph files of the Rijksbureau voor Kunsthistorische Documentatie, The Hague, one of which is dated 1650 (art market; ibid., fig. VI on p. 157).

3. On the man's form of greeting, see Roodenburg 1991, pp. 164–71.

4. Esmée Quodbach kindly brought our attention to the term *baker* and convincingly suggested that the old woman in the painting must be such a servant rather than a family member.

5. See Van Eeghen et al. 1976, pp. 120–28, 633–34. The principal architect of such houses was Philips Vingboons, about whom see Kuyper 1980, chap. 12. P. Sutton in Amsterdam 1997b, p. 28, mistakenly states that Jan Vos's poem "identifies the scene as taking place in the chambers of alderman Jan Jakobsen Hinlopen," thereby taking the word *zaal* to mean Hinlopen's office (presumably in the Town Hall). However, the term occurs frequently on the original plans of contemporary town houses; see, for example, Fock et al. 2001, pp. 26, 31, 90, for rooms inscribed *zaal* or *sael* (on p. 31, Fock illustrates Joan Huydecoper's sketch for the arrangement of chairs in "de sael" of his house on the occasion of his daughter Leonora's marriage to Jan Jacobsz Hinlopen).

6. On the Poppen House, see Kuyper 1980, pp. 112–13, fig. 19A. The State Room measured 24 x 40 feet (7.3 x 12.2 m) and had a large central fireplace. On the Trip House, see Meischke and Reeser 1983. Curiously, the famous collector Gerret Braamcamp bought the Trip House (where he lived from 1750 to about 1758) and the present painting at about the same time (see Ex Coll.).

7. Fremantle 1959, pp. 70 n. 1, 71 n. 6; see also Gaskell 1990, pp. 286, 288.

8. P. Sutton 1980a, pp. 31–32, 97, no. 66, pl. 71, dates the Thyssen painting to about 1664–66; Gaskell 1990, no. 62, suggests a date of about 1661–70. Metsu also used the fireplace in *A Young*

Woman Composing Music (Mauritshuis, The Hague; see Rotterdam–Frankfurt 2004–5, pp. 219–20, no. 61). For a plan of the council chamber, see Gaskell 1990, p. 289. Detail photographs of the friezes over the chamber's two fireplaces are published in Fremantle 1959, figs. 75, 76 (see pp. 69–71 on the room). Of course, the cavorting putti suit the subject of a newborn child.

9. Fock et al. 2001, p. 134. See also Fock in Newark–Denver 2001–2, p. 91, where the author dismisses the impression given by the Metsu canvas, to the effect that "Turkish carpets were customary floor coverings," on the basis of a few inventories. However, she also cites an inventory of 1685 (that of "an extremely wealthy banker of Amsterdam, Joseph Deutz, who lived on the most prestigious canal, the Herengracht") as listing a Turkish carpet on the floor rather than on a table. Like Fock, E. Goossens (in Amsterdam 1997b, p. 79) fails to consider that Metsu had good reason to evoke the grandeur of the new Town Hall on behalf of Hinlopen and his wife, a Huydecoper (see below).

10. See Lunsingh Scheurleer 1971–72, p. 302. As noted in Wijsenbeek-Olthuis 1987, pp. 156–57, and in Loughman and Montias 2000, p. 85, "lying-in rooms" are not identified as such in inventories, probably because other rooms temporarily served the purpose. Loughman and Montias (ibid., fig. 32) illustrate the rather grand example in Petronella Oortman's dollhouse (begun 1686–90) in the Rijksmuseum, Amsterdam.

11. Newark–Denver 2001–2, no. 75, fig. 95.

12. Ibid., p. 65, nos. 72–74.

13. See the discussion under Naiveu (q.v.). The food historian Peter Rose helped identify these special refreshments in 1993. I am also grateful to my former research assistant, Els Vlieger, for exploring the subject of the *kraambezoek*. One English equivalent of *kandeel* is negus, named for Francis Negus (d. 1732). The goblet in the present picture is crowned by a figure too indistinct (partly because of wear) to be described. And each of the finials above the Solomonic bedposts is surmounted by what appears to be a pair of naked figures, although these were probably never meant to be identified.

14. On the definition of roles within the Dutch family, see Haks 1985. See also Durantini 1983 on the child in Dutch art, although her appendix on the subject of the newborn child is not helpful for pictures such as the Museum's Metsu and Naiveu. Dutch child-rearing practices are discussed in B. Roberts 1998, where on p. 146 visits to see newborn children in (as it happens) the Huydecoper family are described.

15. See Franits 1993a, chap. 3 on "Moeder," and, more generally, Westermann 1996, pp. 120–22.

16. See The Hague–Cambridge 1981–82, nos. 11, 27, 32, and Slive 2001, nos. 637–61. In the Braamcamp sale catalogue of 1771 (see Bille 1961, vol. 2, p. 30 [under no. 124]), the seascape over Metsu's fireplace is said to be "in the taste of *Percelles*," meaning the pioneering seascape painter Jan Porcellis (before 1584–1632).

17. See Goedde 1989, p. 156. In another work of the early 1660s by Metsu, the *Musical Party,* in the Mauritshuis, The Hague, a different stormy seascape (over a version of Van Campen's fireplace) suggests the turbulent emotions that threaten in affairs of the heart (see Hoetink et al. 1985, no. 56, and Goedde 1989, p. 156).

18. Houbraken 1718–21, vol. 3, p. 41.

19. Vos 1726, vol. 1, p. 388.

20. Van Gent 1998, pp. 127–28, 134 n. 8, 136. On Hinlopen and his brother, see also Dudok van Heel 1998.

21. Groeneweg 1995, pp. 201–3.

22. Van Thiel 1997, p. 243.

23. Westermann in Newark–Denver 2001–2, p. 182, where neither Van Thiel 1997 nor Van Gent 1998 is cited.

24. Dudok van Heel 1996, p. 166 n. 13, and Van Gent 1998, pp. 128, 134 n. 10, list the Hinlopen children as Jacob (1658–1663), Joanna (1659–1706), Sara (1660–1749), and Geertruyt (1662–1663). See Amsterdam 1988, p. 30, for an incomplete family tree of the Hinloopen (or Hinlopen) family, where Jan Jacobsz and his older brother Jacob (1621–1679) may be written in beneath Jacob Hinloopen (1582–1629) and his wife Sara de Wale (1591–1652). The Hinlopens were related by marriage to many distinguished figures in Dutch society, including members of the Pauw and Six families, as well as the Huydecopers, the authors Jacob Cats, Pieter C. Hooft, and Joost van de Vondel, and the celebrated collectors Gerard and Jan Reynst (on the latter, see A.-M. Logan 1979). G. Schwartz 1985, pp. 136–37, offers a chart of "One Hundred Related Dutchmen" that suggests how many of Rembrandt's patrons (such as Jan Jacobsz Hinlopen and his father-in-law, Joan Huydecoper) were closely interconnected. On the two families, see also Elias 1903–5, pp. 309–16, 384–91, 507, 518–20, and Kooijmans 1997, pp. 112–95 (cited in Van Gent 1998, p. 134 n. 9); and on Hinlopen's collection, see Dudok van Heel 1969, pp. 233–37. As noted in Van Gent 1998, pp. 130, 134 n. 19, Jan Vos also wrote poems about other paintings in Hinlopen's collection (including works by Rembrandt and Jan Lievens, and a "Venus in a Cloud Filled with Cupids," said to be by Rubens) and in that of Joan Huydecoper (1599–1661). The latter married Maria Coymans (1603–1647) in 1624. For their portraits by Bartholomeus van der Helst (q.v.), see E. Goossens 1996, p. 33, pls. I and II.

25. Van Gent 1998, pp. 131, 134–35 n. 21, suggests that the family portrait in Berlin (fig. 113 here), which is similar in composition and dimensions to the Museum's picture, may have been made as "a kind of pendant" to it. However, the author considers "an iconographic concept for the combination of the two pictures [to be] problematic."

26. As noted by Gary Schwartz in *Dictionary of Art* 1996, vol. 15, p. 40.

27. See Huisken, Ottenheym, and Schwartz 1995, pp. 158–60, fig. 132, on the Coymans House at Keizersgracht 177, and Querido 2000 on the Huydecoper House (destroyed in 1943) at Singel 548.

28. See Dudok van Heel 1998, pp. 37–38, on the house that Hinlopen rented from Pieter Carpentier, governor-general of the East India Company (kindly brought to my attention by Judith van Gent). The house is visible in an anonymous drawing of about 1636 (Gemeentearchief, Amsterdam; see Dudok van Heel in Berlin–Amsterdam–London 1991–92a, p. 55, fig. 70; the drawing is attributed to A. Beerstraten in Dudok van Heel 1998, fig. 2); it stands just to the right of the large house with two chimneys.

29. Compare, for example, the central elements of the façade on De Keyser's Town Hall in Delft (New York–London 2001, p. 4, fig. 2).

30. G. Schwartz 1983, p. 210.

31. See ibid., on Vos's career, and Fremantle 1959, p. 203, on his "Inwyding van het Stadthuis t' Amsterdam."

32. On the collection itself, see Bille 1961.

33. See Bille 1961, vol. 2, p. 29, correctly reporting the information in Bastide 1766, p. 99. However, on the same page Bille records "P." for panel under Hoet 1752 (see Refs.), which gives no indication of the support.

34. Bille 1961, vol. 2, p. 29, no. 124, "Verbeeldende een Kraamkamer," with the support given as *H. 29, br. 33 d. Pnl.* (height 29, breadth 33 *duim* on panel). The Amsterdam inch, or *duim,* was equal to about 2.57 centimeters, whereas the English inch is approximately 2.54 centimeters.

35. See Ex Coll. below. The painting had previously been assumed to have been in the 1791 Amsterdam sale of the dealer Pieter Oets, who bought the picture at the 1771 Braamcamp sale. Wouter Kloek kindly checked the copy of the rare Oets sale catalogue at the Rijksmuseum, Amsterdam, and found no Metsu listed (letter of October 1, 1996).

36. J. Smith 1829–42, vol. 4, p. 80, no. 19, with dimensions and "C."

37. Conservator Dorothy Mahon and the present writer, in September 1996. The same conclusion was reached, with reference to the X-radiograph, by F. du Pont Cornelius in his conservation report dated June 17, 1946.

38. Bastide 1766, p. 99, locates the picture as on the first floor, first room to the right, in Braamcamp's house at 462 Heerengracht. Like the Trip House (see text above and note 6), the next house owned by Braamcamp (which was built for Guilliam Sweedenryck between 1665 and 1671) was an Amsterdam mansion from the same decade as Metsu's picture. See Bille 1961, vol. 1, p. 222, and Van Eeghen et al. 1976, p. 560.

39. See Amsterdam 1988, p. 31, and Amsterdam 1992a, pp. 134–35.

40. For example, Jan Jacobsz Hinlopen's wealthy cousin Catharina ("Catalina") Hinlopen (1614–1681), who with her sister Anna was the subject of a Vondel poem dating from 1646, remembered Agnes Block in her will (see Amsterdam 1988, pp. 31, 35).

41. Hofstede de Groot 1907–27, vol. 1, p. 285 (under no. 110); Lagrange 1863, p. 294, citing a copy in the Hermitage, Saint Petersburg. Hofstede de Groot's nos. 110a and 110d may record a single *Visit to the Nursury* (panel, ca. 25 x 30 in. [63.5 x 76.2 cm]), while his no. 110b, *The Young Mother* (8 x 7 in. [20.3 x 17.8 cm]), must be another composition. Apparently none of the copies is known today, including the one formerly in the Hermitage.

42. Recorded in Hoet 1752–70, vol. 1, p. 94, no. 2 (sold for Fl 435).

REFERENCES: Jan Vos, "Op de Schildery van een Kraamvrouw, in de zaal van den E. Heer Scheepen Jan Jakobsen Hinloopen, door G. Moetsu geschildert," in Vos 1662, p. 654, praises the painting's descriptive and expressive qualities; Houbraken 1718–21, vol. 3, p. 41, describes the subject, praises the composition and execution, and notes that the painting was formerly owned by "the art-lover Jan de Wolf" (see text and Ex Coll.); Vos 1726, vol. 1, p. 388, repeats the verse published in 1662; possibly Hoet 1752–70, vol. 1 (1752), p. 94, no. 2, as in an anonymous Amsterdam sale of May 18, 1706, vol. 2 (1752), p. 240, no. 24, as in the sale of the art dealer David Ietswaart, in Amsterdam, April 22, 1749; Descamps 1753–54, vol. 2, p. 245, mentions the "très-beau Tableau" as in Braamcamp's collection;

Bastide 1766, p. 99, catalogues the picture in Braamcamp's collection, recording the support as wood (see text above); J. Smith 1829–42, vol. 4 (1833), p. 80, no. 19, describes the composition, records the support as canvas, and notes the sales of 1742 and 1771; Nieuwenhuys 1834, pp. 296–97, quotes Houbraken, records the eighteenth-century provenance (following "memorandums . . . written by Peter Fouquet, who bought a great number of the paintings of the Braamcamp collection"), and speculates about the picture's state of preservation; Blanc 1863, vol. 1, p. 470, quotes the entry from the Braamcamp sale catalogue of 1771; Lagrange 1863, pp. 293–94, with engraved reproduction opp. p. 292, interprets the subject novelistically, praises the picture as "une des oeuvres les plus exquises de Metsu," and mentions a copy in the Hermitage which was considered the original; Lagrange 1864, p. 532, compares a painting by Florent Willems (1823–1905); *Chronique des arts,* no. 105 (June 18, 1865), p. 217, notes that the duchesse de Morny acquired the picture at the duc de Morny's sale; Hofstede de Groot 1893, pp. 144, 469 (note to p. 144), mentions Vos's poem, cites eighteenth-century owners, and locates the picture in the collection of the duchesse de Sesto (see Ex Coll.); Sedelmeyer Gallery 1895, p. 30, no. 25 (ill.); Bode 1900, p. III, no. 15 (ill.); Glück 1900, p. 91, mentioned; É. Michel 1901, pp. 392–93 (ill.), describes the subject and setting; Marguillier 1903, no. 14, pp. 20 (ill.), 24, mentioned; Bode 1907, vol. 1, pp. VI, 56, no. 55 (ill. opp. p. 56); Hofstede de Groot 1907–27, vol. 1 (1907), pp. 284–85, no. 110, gives description, early references, and provenance (with Duveen, London, in August 1907); Nicolle 1908, p. 197 (ill. opp. p. 196), as a "tableau bien connu"; Kronig 1909, pp. 93, 94, 217 n. 1, as from the Kann collection, and as acquired by Morgan; Valentiner in New York 1909, p. 65, no. 64 (ill. opp. p. 65), lent by Morgan, the seascape in Van Everdingen's style; Cox 1909–10, p. 305, offers a long description and comparison with Vermeer; Breck 1910, p. 58; Waldmann 1910, pp. 82–83 (ill.), criticizes the colors; Gowans 1912, p. 22 (ill.); Morgan Gift 1918, pp. 16–17 (ill.), listed; Errera 1920–21, vol. 1, p. 301, listed; Gerson 1930, p. 440, mentioned as a masterpiece of the 1660s; W. Martin 1936, pp. 224–25, fig. 111, as an example of Metsu's *fijnschilder* style after about 1660; Plietzsch 1936, p. 9 (ill.), as a famous work; *Duveen Pictures* 1941, no. 212; *MMA Bulletin,* n.s., 2, no. 9 (May 1944), text inside cover (ill. and cover ill. [detail]); Gerson 1952, p. 35, fig. 99, as Metsu's masterwork; Gudlaugsson 1959–60, vol. 2, p. 148 (under no. 139), sees the influence of Ter Borch; Bille 1961, vol. 1 (ill. after p. 252), vol. 2, pp. 29–30, no. 124, and p. 104, records the picture in the Braamcamp collection and sale, and lists earlier owners; Gudlaugsson 1968, pp. 14, 30, as a major work poorly preserved, and notes the fireplace's source; Schneede 1968, pp. 47, 50, figs. 1, 3 (detail of signature), discusses the form of signature and considers Ter Borch's influence possible; F. Robinson 1974, pp. 52, 53–54, 55, 56, 59, 65, 79 n. 59, 83 nn. 92–94, fig. 130, broadly reviews the picture's subject and style; Walsh 1974b, p. 657 n. 21, relates the painting over the mantelpiece to the "familiar *topos* in literature and art" of life as a fragile vessel; Buitendijk 1975, p. 27, discusses Vos's poem about the picture; Wheelock 1976, p. 458, sees the influence of Ter Borch and Pieter de Hooch; Hibbard 1980, p. 344, fig. 619, mentioned; P. Sutton 1980a, pp. 30, 31, fig. 27, as possibly influencing De Hooch's Amsterdam interiors; Thornton 1984, p. 46, fig. 50, appears to consider the picture as a reliable representation of "a grand Dutch bedchamber"; F. Robinson 1985, fig. 8, mentioned; Spicer 1988, pp. 577–79, fig. 6,

employs the Museum's picture to date the family portrait by Metsu in Berlin (fig. 113 here); Goedde 1989, pp. 156, 238 n. 97, fig. 114, describes the seascape as "a symbol of the tribulations of the voyage of life"; Gaskell 1990, pp. 288–89, follows Gudlaugsson in noting the fireplace's derivation from one in the Town Hall of Amsterdam; Liedtke 1990, p. 40, mentions the painting as in J. P. Morgan's collection; Welu in Minneapolis–Toledo–Los Angeles 1990–91, p. 54, fig. 41, supports Walsh's suggestion (in MMA curatorial files) that the marine painting over the mantelpiece "probably serves as a reminder of the fragility of human life"; G. Weber 1991, pp. 12 n. 10, 173–74, 210, fig. 21, discusses Vos's poem about the painting; Lasius 1992, p. 51, compares a painting of the same subject by Van Brekelenkam; Franits 1993a, p. 227 n. 16, states incorrectly that Vos's poem was not included in the 1662 edition of his collected works; Jäkel-Scheglmann 1994, p. 52, fig. 27, describes the subject; Baetjer 1995, p. 331; Groeneweg 1995, p. 203, fig. 5, mistakenly interprets Metsu's family portrait in Berlin (fig. 113) as a genre scene, in part by comparing figures in the present picture; Dudok van Heel 1996, p. 165, cites the work among important pictures in Hinlopen's collection; L. de Vries in Washington–Amsterdam 1996–97, p. 73, compares the composition with that of Steen's family portrait in Kansas City; E. Goossens in Amsterdam 1997b, pp. 77–79, no. 20 (ill.), inappropriately criticizes Metsu's use of a room in the Town Hall of Amsterdam as a model for "such a simple, domestic scene"; P. Sutton in ibid., pp. 27–29, discusses the subject and setting, and (n. 19) repeats the error found in Franits 1993a; Van Thiel 1997, pp. 242–43, rejects the argument in Groeneweg 1995, and suggests that the Museum's painting "may well turn out to be a genre-like portrait"; Westermann 1997, pp. 117, 168–69, fig. 68, compares Steen's approach in pictures such as his *Childbirth Celebration* of 1664; Fock 1998, p. 209, fig. 22, describes the use of a "Turkish" carpet on the floor as exceptional for the period; Van Gent 1998, pp. 127, 129, 130–31, 134–35 nn. 20–21, fig. 2, considers the painting as "a sort of pendant" to the family portrait in Berlin (fig. 113), which the author identifies for the first time as depicting the Hinlopens; P. Sutton in London–Hartford 1998–99, pp. 142, 144, fig. 1 (under no. 26), maintains that the Museum's painting "may depict the family of Jan Jacobsz Hinloopen," although the Berlin portrait (fig. 113) is considered to represent the Valkeniers; Strouse 1999, p. 568, as *A Visit to the Baby*, owned by Morgan; Lokin in Osaka 2000, p. 38, discusses the interior decoration; Wheelock in ibid., pp. 18, 21 n. 11, 152–55, no. 26, fig. 11, interprets the painting as a family portrait and a "public statement," detects "Christian allusions" in the mother and child, and mistakenly assumes that "archival research has not yet been undertaken to confirm that Hinlopen and his wife had a newborn child in 1661" (see note 24 above); Strouse 2000, p. 31, fig. 34, notes the lavish setting; Fock et al. 2001, p. 134, fig. 88, considers the bed and floor carpet unrealistic but notes that side chairs would indeed have to be brought out from the wall; Fock in Newark–Denver 2001–2, p. 91, considers the use of a Turkish carpet on the floor to be misleading as evidence of contemporary practice; Westermann in ibid., pp. 64–65, 182, no. 57, fig. 93, speculates that the painting might have been "a particularly expensive example of the fine birth gifts made for these occasions" (lying-in visits) and that it might be "a genrelike portrait of the Hinlopens themselves"; Vergara in Madrid 2003, no. 21, as *Retrato de grupo*, concludes that the painting "is a family portrait" of the Hinlopens; Franits 2004, pp. 183–85, 209, 233, 290 nn. 46, 50, fig. 170, fully discusses the subject, Hinlopen's ownership, Vos's poem, and other details (partly on the basis of an early draft of the present catalogue entry), and compares the treatments of the subject by Steen and Naiveu; Quodbach 2004, p. 96, describes the circumstances under which the duchesse de Morny purchased the picture in her husband's estate sale; Liedtke 2005a, p. 192, mentions the picture in a review of Dutch paintings made for specific patrons or locations; Zandvliet 2006, p. 345 (ill.), describes the work as perhaps identical with the painting described in Vos 1662 as in Hinlopen's collection.

EXHIBITED: New York, MMA, "The Hudson-Fulton Celebration," 1909, no. 64; Amsterdam, Royal Palace, "The Royal Palace of Amsterdam in Paintings of the Golden Age," 1997, no. 20; Osaka, Osaka Municipal Museum of Art, "The Public and the Private in the Age of Vermeer," 2000, no. 26; Newark, N.J., The Newark Museum, and Denver, Colo., Denver Art Museum, "Art & Home: Dutch Interiors in the Age of Rembrandt," 2001–2, no. 57; Madrid, Museo Nacional del Prado, "Vermeer y el Interior Holandés," 2003, no. 21.

EX COLL.: Jan Jacobsz Hinlopen, Amsterdam (by 1662, according to Jan Vos's contemporary poem [see Refs.]); probably Jan de Wolff (1681–1735; according to Houbraken in 1721, "the art-lover Jan de Wolf" owned but had parted with the picture); [David Ietswaart, Amsterdam (until 1749; his sale, Amsterdam, April 22ff., 1749, no. 24, for Fl 850 to Daalens for Braamcamp)]; Gerret Braamcamp, Amsterdam (1749–d. 1771; his estate sale, Amsterdam, July 31, 1771, no. 124, for Fl 1,200 to Oets); [Pieter Oets, Amsterdam, from 1771]; Charles-Auguste-Louis-Joseph de Morny, duc de Morny, Paris (until d. 1865; his estate sale, Palais de la Présidence du Corps Législatif, Paris, May 31–June 12, 1865, no. 58, bought in for FFr 50,000 by the duchesse de Morny); Princess Sophie Troubetzkoi, duchesse de Morny, later duquesa de Sexto, Madrid (1865–at least ca. 1883); [Sedelmeyer, Paris, in 1895]; Rodolphe Kann, Paris (by 1900–d. 1905; his estate, 1905–7; sold to Duveen); [Duveen, London and New York, 1907; sold for £31,000 to Morgan]; J. Pierpont Morgan (1907–d. 1913; his estate, 1913–17; Gift of J. Pierpont Morgan, 1917 17.190.20

119. *Tavern Scene*

Oil on wood, 14⅜ x 12⅝ in. (36.5 x 32.1 cm)
Inscribed (on table leg): GMetsu. [initials in monogram]
The painting is in good condition.
Bequest of William H. Herriman, 1920 21.134.5

The picture appears to be a good copy after a lost painting by Metsu. The panel support and the execution suggest a late-seventeenth-century date.[1] Another version of the composition, on a panel of about the same size, is known from a color reproduction published in 1947.[2] The two works differ slightly in details, and the drawing of the architecture and the furniture in the other version is somewhat more rectilinear overall. In a few passages—for example, the man's collar, his hair, and perhaps the faces of both figures—the present painting appears to be superior, insofar as the other version may be judged from an old color illustration. The open cupboard door in the left background of the New York picture does not occur in the latter, where the back of the chair is also slightly different; chalk marks appear on the slate tablet; and a man's portrait in an octagonal frame hangs from the mantelpiece (here, the frame is round and the image is indecipherable). While one would prefer to base a judgment upon direct confrontation, it seems likely that both versions are old copies of an otherwise unknown painting. The original probably was painted in the mid-1650s, when Metsu was still in his native Leiden. His pupil in Amsterdam, Michiel van Musscher (1645–1705), is not a plausible candidate as copyist.

The subject is too familiar from other Dutch paintings of the period to require discussion here.[3] A few motifs, however, might be explained. The man is a customer, the woman a servant in a tavern. Dutch inns had a reputation for offering personal services of the kind that seems implied here. Other vices are catalogued for the viewer: the man lights a clay pipe in a pot of hot coals (a used pipe lies on the floor); three cards, including a queen of hearts, have fallen from the table; the pewter pitcher and the slate with a lump of chalk in front of it suggest that more than one drink will be tallied. The large box with a clasp and, at the corner, a ring for hanging is the tavern's backgammon board (for another example, see Pl. 196).[4] The fiddle on the wall falls into another category of standard diversions available in such an establishment.[5] The other objects are functional or decorative (the triangular form to the right of the pitcher is the corner of a pillow on the chair).

The suggestion that Metsu and his wife served as the models for the man and woman goes back at least to Smith (1833) and is unconvincing, although there is a slight resemblance to the unidealized self-portrait and its pendant in the Speed Art Museum, Louisville.[6]

Formerly catalogued by the Museum as by Gabriël Metsu.

1. According to Hubert von Sonnenburg, who considers the work to be a late-seventeenth-century copy with a false signature (orally, June 1994). Both Von Sonnenburg and Otto Naumann (orally, 1994) have noted that the execution is very like Metsu's own in parts, for example in the hands and in the pewter can.
2. Anon., "Gabriel Metsu," *Apollo* 45 (1947), pp. 138–39 (ill.); sold at Christie's, London, November 24, 1961, no. 77. Recorded in Hofstede de Groot 1907–27, vol. 1, p. 320, no. 203d, as on wood, 14½ x 12 in. (36.8 x 30.5 cm), exhibited at the Royal Academy Winter Exhibition, 1879, no. 110 (lent by S. Sanders).
3. Compare Metsu's own *Tavern Scene* and *Smokers at the Fireside,* both in the Gemäldegalerie Alte Meister, Dresden (F. Robinson 1974, pp. 29, 38, figs. 34, 71, and Dresden–Leiden 2000–2001, pp. 55–57, 66–67); Pieter de Hooch's *A Soldier with an Empty Glass and a Serving Woman,* of about 1650–55, in the Museum Boijmans Van Beuningen, Rotterdam (P. Sutton 1980a, no. 5, pl. 4); Frans van Mieris the Elder's *Inn Scene,* in the Stedelijk Museum De Lakenhal, Leiden (Naumann 1981, no. 15; Leiden 1988, no. 22); and the same artist's *Inn Scene,* in the Mauritshuis, The Hague (Naumann 1981, no. 23; Amsterdam 1989–90, no. 13).
4. A number of these items were listed (along with about sixty paintings) as contents of the large inn owned by the father (Isack, d. 1629) of Rembrandt's pupil Isaack Jouderville (1612/13–1645/48): see Bredius 1915–22, part 6, p. 1947 ("verschiedene Tricktrackspiele").
5. See Liedtke 2000a, pp. 67–68, on musical instruments in Dutch taverns.
6. F. Robinson 1974, figs. 43, 44. On portraits of Metsu and his wife, see Renckens and Duyvetter 1959.

REFERENCES: J. Smith 1829–42, vol. 4 (1833), p. 102, no. 93, as a picture of the artist and his wife in a room, owned by Mr. Oppenheim; Waagen 1854, p. 329, as a Metsu "of his best time, warm and transparent," in the Oppenheim collection; Blanc 1857–58, vol. 1, p. 226, records the sale of 1773 and correctly describes the subject; Sedelmeyer Gallery 1898, pp. 108, 109 (ill.), no. 91; Moes 1897–1905, vol. 2 (1905), pp. 94–95, listed as nos. 2 and 8 (under no. 5005); Hofstede de Groot 1907–27, vol. 1 (1907), pp. 308–9, no. 178, records the provenance, and ignores J. Smith's identification of Metsu and his wife as models; H. B. Wehle in *MMA Bulletin* 16, no. 12 (December 1921), p. 263, notes the bequest, and considers the work

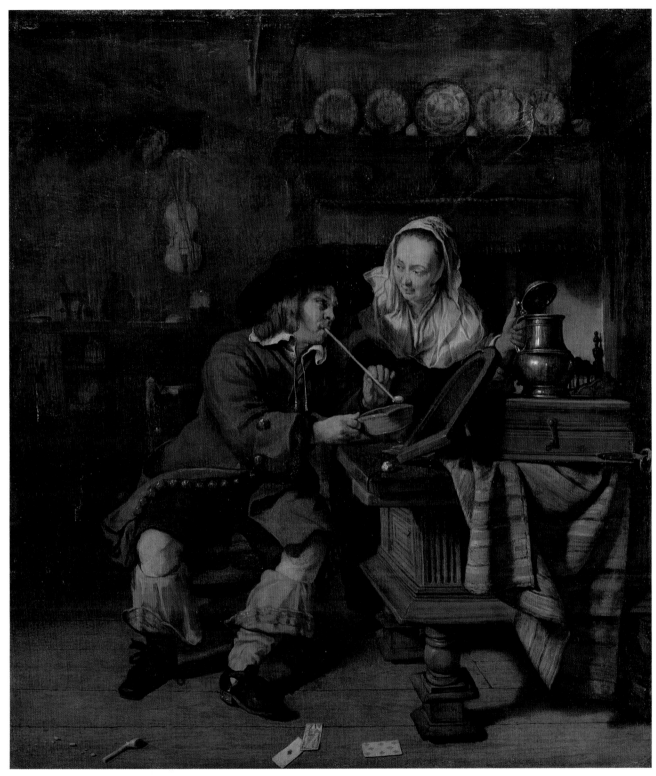

119

to be "painted with less vivacity than the two pictures by Metsu which the Museum already owned"; Gerson 1930, p. 440, listed as "Young Man and Young Woman"; B. Burroughs 1931a, p. 243, as "The Artist and his Wife"; Anon., "Gabriel Metsu," *Apollo* 45 (1947), p. 138, considers the Museum's picture to be one of two autograph versions; Gudlaugsson 1968, p. 26, as from the beginning of Metsu's Amsterdam period, and influenced by Ter Borch; Schneede 1968, p. 47, as probably dating from the second half of the 1650s; Eckardt 1971, pl. 24, as depicting Metsu and his wife; F. Robinson 1974, pp. 69–70, 204, fig. 173, as possibly an inferior work by Metsu himself, but probably not by him, and (p. 73 n. 15) as "at best a copy of an original composition by Metsu"; Baetjer 1980, vol. 1, p. 125, as by Metsu; Baetjer 1995, p. 330, as by Metsu; Marijke van der Meij-Tolsma in *Dictionary of Art* 1996, vol. 21, p. 352, as by Metsu, including a table he depicted elsewhere.

EXHIBITED: San Francisco, Calif., Palace of Fine Arts, "Golden Gate International Exposition," 1940, no. 192; Dallas, Tex., Dallas Museum of Fine Arts, "30 Masterpieces: An Exhibition of Paintings from the Collection of The Metropolitan Museum of Art," 1947, as *The Artist and His Wife*; Iowa City, Iowa, University of Iowa, "30 Masterpieces: An Exhibition of Paintings from the Collection of The Metropolitan Museum of Art," 1948; Dayton, Ohio, The Dayton Arts Institute, "The Artist and His Family," 1950, no cat.

EX COLL.: Possibly Johan Aegidiusz van der Marck, Leiden (until 1773; sale, Winter & Yver, Amsterdam, August 25, 1773, no. 176, to Fouquet for Fl 800); [Pierre Fouquet, Amsterdam (in 1773)]; J. M. Oppenheim, London (by 1833–64; sale, London, June 4, 1864, for £78 15s., to Smith, according to Hofstede de Groot 1907–27, vol. 1, p. 309); [Smith, London, in 1864]; the baron de Beurnonville, Paris (until 1881; sale, Pillet, Paris, May 9–16, 1881, no. 368, for FFr 16,200); Rodolphe Kann, Paris (according to Sedelmeyer); Édouard Pierre Rombaut Kums, Antwerp (until d. 1891; his estate, 1891–98; sale, Hôtel Kums, Antwerp, May 17–18, 1898, no. 115); ?[Charles Sedelmeyer, Paris]; William H. Herriman, Rome (d. 1920); Bequest of William H. Herriman, 1921 21.134.5

MICHIEL VAN MIEREVELD

Delft 1567–1641 Delft

Karel van Mander (correcting his own account) reports that Michiel Jansz van Miereveld (or Mierevelt) was born in a house on the marketsquare of Delft on May 1, 1567.[1] His father was a prominent goldsmith, Jan Michielsz van Miereveld (1528–1612), and his mother was the daughter of a glass painter. The biographer cites two early teachers of Van Miereveld in his native city, the obscure Willem Willemsz and "a pupil of [Anthonie] Blocklandt, Augustijn, in Delft, whose spirit greatly overflowed with invention."[2] At about the age of fourteen (presumably in 1581), the artist, who already excelled in writing, drawing, and engraving, went to study "for two years and three months" in Utrecht with Anthonie Blocklandt (1533/34–1583), who had been a highly regarded history painter in Delft during the 1550s and 1560s.[3] Four designs constituting a *Judgment of Paris,* engraved in 1609 but inscribed "M. Mierevelt invent. 1588," recall nudes of the 1580s by Blocklandt, Bartholomeus Spranger (1546–1611) and Hendrick Goltzius (1558–1617).[4] Van Mander records that Van Miereveld also painted "kitchens with all sorts of things from life" and that "his preference very much inclines towards compositions and figures" (i.e., history pictures). But it was for his portraits that he was preeminently in demand.[5] As the most prominent portraitist in Delft, Van Miereveld succeeded Jacob Willemsz Delff (ca. 1550–1601), whose son Willem Jacobsz Delff (1580–1638) made many fine engravings after Van Miereveld, and married his daughter in 1618.[6]

In 1587, Van Miereveld joined the painters' guild in Delft; he served as *hoofdman* (headman) in 1589–90, and again in 1611–12. In 1607, he became court painter to Prince Maurits, and effectively began his career as the leading portraitist of aristocratic figures in The Hague, Delft, and other cities. It must have been in order to continue in this capacity that the artist joined the painters' guild of The Hague in 1625, but his membership became unnecessary when he was named court painter in the same year by Maurits's successor, Frederick Hendrick.[7] Numerous Dutch courtiers, foreign diplomats (such as Sir Dudley Carleton), and patrician patrons sat for Van Miereveld, who met the enormous demand with the help of several assistants.[8] The latter generally painted subordinate motifs, such as costume details, and also workshop replicas (often in modified format, for example copying a bust-length portrait from a three-quarter-length model).

Success made Van Miereveld a wealthy man. At his death, on June 27, 1641, he owned two houses (one valued at more than 2,000 guilders), ten parcels of land that were rented to farmers, various bonds and other interest-bearing assets, and 5,829 guilders in cash on hand (at the time, a skilled laborer might earn 500 guilders per year). In his will, he left several thousand guilders to a wide range of Protestant charities.[9]

Van Miereveld married twice, in 1589 and in 1633. His sons Pieter (1596–1623) and Jan (1604–1633) were among his many pupils, but they predeceased their father, and after his death the studio was inherited by his grandson Jacob Willemsz Delff the Younger (1619–1661). Van Miereveld's most important pupils were Paulus Moreelse (q.v.), Willem van Vliet (ca. 1584–1642), and Anthonie Palamedesz (1601–1673). He also influenced Jan van Ravesteyn and Daniël Mijtens (q.q.v.). With the rise of the court portraitist and history painter Gerrit van Honthorst (1592–1656) in the 1630s, Van Miereveld fell out of fashion, but not out of favor with distinguished figures in Delft—such as Jacob van Dalen, discussed below.

1. Van Mander/Miedema 1994–99, vol. 1, pp. 380 (note to line 30), 462 (Van Mander's appendix, fol. 301r), vol. 5, p. 167.
2. On Willem Willemsz, who is evidently identical with Willem Willem Luitsz, see Montias 1982, pp. 35, 47, 137–38, 154, 254, 334, and Van Mander/Miedema 1994–99, vol. 5, p. 168. He was dean of the Delft guild in 1557, 1582–83, and 1587–88. Miedema (ibid.) casts doubt on earlier attempts to identify "Augustijn."
3. On Blocklandt, see W. Th. Kloek in *Dictionary of Art* 1996, vol. 4, pp. 148–49, and the literature cited there. On Blocklandt's role in Delft, see Liedtke in New York–London 2001, p. 37.
4. See New York–London 2001, pp. 37–38, figs. 39 (Willem van Swanenburg's engravings after Van Miereveld) and 40 (Blocklandt's *Venus and Cupid,* in the Národní Galerie, Prague). On a related painting of the Judgment of Paris (Nationalmuseum, Stockholm), see Cavalli-Björkman 1986, no. 40, and Van Mander/Miedema 1994–99, vol. 5, p. 169, fig. 88.
5. Van Mander/Miedema 1994–99, vol. 1, p. 385, vol. 5, p. 172. See also my remarks in New York–London 2001, p. 571 n. 9.
6. See Amsterdam 1993–94a, p. 304, for biographies of both Delffs, and on W. J. Delff, Rudolf Ekkart in *Dictionary of Art* 1996, vol. 8, pp. 664–65. The Delffs are also discussed in New York–London 2001, pp. 44, 48, 178–80, 466.

7. For Van Miereveld's portraits of the princes dating from 1607 and about 1610 (Stedelijk Museum Het Prinsenhof, Delft), see New York–London 2001, nos. 43, 44.
8. Joachim von Sandrart claimed that Van Miereveld painted ten thousand portraits (Peltzer 1925, p. 171), but Ekkart more reasonably estimates that he turned out "at least a thousand portraits with the help of his assistants, of which several hundred are extant" (*Dictionary of Art* 1996, vol. 21, p. 486).
9. On Van Miereveld's estate, see Montias 1982, p. 129; pp. 121, 126 for similar information, and p. 154 on his will.

120. *Portrait of a Woman with a Lace Collar*

Oil on wood, 29⅜ x 23¾ in. (74.6 x 60.3 cm)

The paint surface has suffered slight abrasion along the vertical grain of the oak panel.

Bequest of Theodore M. Davis, 1915 30.95.257

The portrait has been described by Rudolf Ekkart as a "characteristic work by the painter," which does not imply that it is entirely by his hand.[1] Van Miereveld is probably responsible for the face alone, which is remarkable for its suggestion of both friendliness and reserve.[2] The execution of the collar, dress, and even the jewelry appears routine, by comparison, when examined firsthand.

The hairstyle and dress, in particular the layered lace collar, suggest a date of about 1632–35. Lace collars varied considerably within certain patterns, and were prized possessions (they are often listed in inventories of estates).[3] The one depicted here was probably the sitter's own.[4]

1. Rudolf Ekkart, in his report to the Department of European Paintings, dated November 3, 1988. See Ekkart's remarks on studio assistance in most of Van Miereveld's portraits, in *Dictionary of Art* 1996, vol. 21, p. 486.
2. Van Miereveld's ability to suggest character as well as to record physiognomy is frequently underestimated, and quite extraordinary remarks have been offered in explanation of his and his sitters' reserve (see, for example, Wheelock 1995a, p. 170, on Neo-Stoicism). With regard to the history of taste, it is interesting to compare conservative portraits, both painted and photographic, from the 1890s, when this picture was acquired by Theodore Davis. Two years earlier, Harry Havemeyer purchased Rembrandt's *Herman Doomer* (Pl. 148), and also the pair of less emotive Van Beresteyn portraits by Rembrandt (Pls. 143, 144). The present writer considers Havemeyer's taste and temperament in New York 1993, pp. 62–65.
3. See Kinderen-Besier 1950, pp. 260–62, for the inventory of Anna of Nassau (d. 1588).
4. On August 6, 1641, a former maid to the Leiden painter Isaack Jouderville (1612/13–1645/48) testified that a shoemaker had lent his lace collar to the artist so that it could be depicted in a portrait. (Bredius 1915–22, part 6, p. 1963; mentioned by Van de Wetering in Amsterdam–Groningen 1983, p. 60.)

REFERENCES: Anon., "Pictures in the Fourth Gallery," *Boston Museum of Fine Arts Bulletin* 1 (1903), pp. 30–31, suggests that the painting may be by the younger (i.e., Pieter) Van Miereveld; B. Burroughs 1931b, p. 16, listed; Baetjer 1995, p. 297.

EXHIBITED: Boston, Mass., Museum of Fine Arts, 1903–4.

EX COLL.: Count Potocki, London; M. Barres, Paris; [Durand-Ruel, New York, sold in March 1891 to Davis]; Theodore M. Davis, Newport, R.I. (1891–1915); Theodore M. Davis Collection, Bequest of Theodore M. Davis, 1915 30.95.257

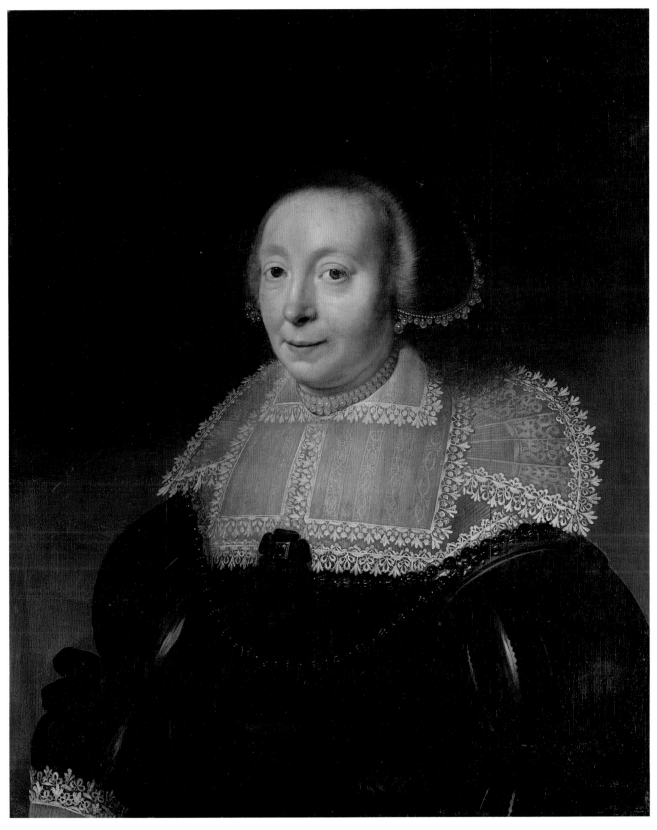

120

121. *Jacob van Dalen, called Vallensis*

Oil on wood, 27½ x 23 in. (69.9 x 58.4 cm)
Signed, dated, and inscribed (left): Ætatis.69./A.º 1640./
M. Miereveld. Arms (upper left) of the Van Dalen family

The painting is well preserved. With age, the thinly painted
beard has become more transparent and the vertical grain of
the oak panel more prominent.

Bequest of Collis P. Huntington, 1900 25.110.13

This portrait and its pendant (Pl. 122) are late works by Van
Miereveld, dated 1640 and 1639, respectively. The difference in
dates is not unusual in Dutch pair portraits, and probably indi-
cates that the commission was executed in the winter months.

The family crests allowed Moes (1897) to identify the sitters
as Jacob van Dael (or Dalen; 1570–1644) and his wife,
Margaretha van Clootwijk (ca. 1580/81–1662); Van Dael was
the personal physician of the Dutch Stadholders Prince
Maurits (1567–1625) and Prince Frederick Hendrick (1584–
1647).[1] The same eminent doctor appears in a group portrait
painted twenty-three years earlier, *The Anatomy Lesson of Dr.
Willem van der Meer* (Oude- en Nieuwe Gasthuis, Delft),
which is dated 1617 and bears a Latin inscription to the effect
that Van Miereveld drew the composition and his son Pieter
carried out the painting.[2]

Jacob van Dael, professionally known by the Latinized
form of his name, Vallensis, was born in Speyer, Germany, on
November 21, 1570. His father was a preacher, Theodorus van
Dale, and his mother was Maria van Wassenaer Hanecops. Val-
lensis studied medicine at the University of Leiden from 1589
to 1593. He moved to Delft and soon became the personal physi-
cian of the Stadholder in the neighboring city of The Hague.
The doctor died in Delft on February 14, 1644, and was buried
in the Oude Kerk. The gravestone of Vallensis and his wife bears
the same crests as the paintings in the Metropolitan Museum.[3]

The 1641 inventory of Van Miereveld's estate records that
"Dr. Valentius" was to receive the "four large and two small
portraits of him and his wife" that remained in the artist's
house. The other versions of the present pictures are now
unknown, and it is difficult to say whether the Museum's pan-
els are the small pendants or one of the larger pairs. The doc-
ument also suggests that Van Miereveld's grandson and heir to
his studio, Jacob Willemsz Delff the Younger (1619–1661),
painted the costumes in the present pictures.[4]

The provenance below was reconstructed by Rudolf Ekkart.
The sitter's son and heir, Dr. Theodoor Vallensis (1612–1673),
graduated from the University of Leiden as doctor of medicine

in 1634. His marriage to the burgomaster's daughter Agatha
van Beresteyn (1625–1702) brought him into the regent class
of Delft, where he held several civic offices. He is certainly
"the art-loving late Dr. Valentius" in whose house Carel
Fabritius (1622–1654) painted an illusionistic mural, as record-
ed by Samuel van Hoogstraten (q.v.).[5]

1. Moes 1897–1905, vol. 1, pp. 181 no. 1587, 217 no. 1886.
2. New York–London 2001, no. 45; all nineteen figures are iden-
 tified in Delft 1981, fig. 125.
3. The information in this paragraph was kindly provided by
 Rudolf Ekkart in a letter dated August 28, 1997. Van Beresteyn
 1938, p. 49, records Van Dalen's gravestone as no. 54, fig. 24.
4. For this item in the painter's estate, see Bredius 1908, p. 8. The
 inventory was compiled by Van Miereveld's son-in-law, the
 notary Johan van Beest. It mentions the group of Valentius
 portraits "and one of his mother, in which Jacob Delff also
 painted." It is not clear from the Dutch whether Delff's collabo-
 ration is specified for all the Valentius portraits or just that of
 the doctor's mother. Elsewhere in the inventory Delff is indicat-
 ed as the painter of costumes in recent portraits by Van
 Miereveld (for example, "De conterfeitsels van den Pensionaris
 BERCHOUT ende syn huysvrouwe, daervan by JACOB DELFF de
 klederen syn gemaect"; see Bredius 1908, p. 11). Delff was Van
 Miereveld's principal assistant after his sons died (see the biog-
 raphy above). Given Van Miereveld's age and Delff's importance
 in his studio when these late portraits were painted, it would
 be reasonable to assume that Delff did execute the costumes.
5. Van Hoogstraten 1678, p. 274; see C. Brown 1981, p. 160, and
 Liedtke 2000a, p. 64.

REFERENCES: Moes 1897–1905, vol. 1 (1897), p. 217, no. 1886
(Van Dalen), item no. 2 (the present portrait), as in the collection
of J. Oyens in Baarn; Montias 1982, p. 55, fig. 3; Liedtke in Linsky
Collection 1984, p. 85, compares the style of the Museum's portrait
by David Bailly (Pl. 3); P. Sutton 1986, p. 183, mentioned; F.
Schwartz 1989, p. 91, fig. 1, as a typical example of Van Miereveld's
work; Baetjer 1995, p. 297; Liedtke 2000a, pp. 64, 104, mentioned
as an example of a Dutch artist working from an original painting
(prime version) when producing replicas, not from a drawing;
Liedtke in New York–London 2001, pp. 43, 47–48, 55, 316, fig. 45a,
on the sitter at court and at an auction, and on the picture as possi-
bly one of the portraits of Van Dalen in Van Miereveld's estate.

EXHIBITED: New York, MMA, "Dutch Couples: Pair Portraits by
Rembrandt and His Contemporaries," 1973, no. 7 (with pendant);
New York, MMA, "Vermeer and the Delft School," 2001, hors cat.

EX COLL.: Jacob van Dalen (in 1641–d. 1644); his wife, Margar-
etha van Clootwijk (d. 1662)?; their son Dr. Theodoor Vallensis,
Delft (by 1662; d. 1673); his son, Jacob Vallensis (1673–d. 1725); his
daughter Catharina Maria Vallensis (1725–d. 1745), wife of Ewoud

van der Dussen (d. 1729); their son Nicolaes van der Dussen (1745–d. 1770); his son Jhr. Jacob van der Dussen, lord of Zouteveen (1770–d. 1839); [sold by his heirs through the dealer A. Praetorius in the sale of C. Kruseman, J. van der Dussen van Zouteveen, and others, Amsterdam, February 16, 1858, no. 129; bought back by Praetorius];

J. Oyens, Baarn (before 1897); Collis P. Huntington, New York (until d. 1900); life interest of Mrs. Collis P. (Arabella D.) Huntington, later (from 1913) Mrs. Henry E. Huntington (d. 1924); life interest of her son, Archer Milton Huntington, New York (1924–terminated in 1925); Bequest of Collis P. Huntington, 1900 25.110.13

122. *Margaretha van Clootwijk, Wife of Jacob van Dalen*

Oil on wood, 27¾ x 22⅞ in. (70.5 x 58.1 cm)
Signed, dated, and inscribed (right): Ætatis.56./A.° 1639/ M. Miereveld. Arms (upper right) of the Van Dalen and Van Clootwijk families

The painting is well preserved.

Bequest of Collis P. Huntington, 1900 25.110.12

The painting is discussed above, with the pendant portrait. Margaretha van Clootwijk (ca. 1580/81–1662), Jacob Van Dalen's second wife, was the daughter of Matthijs van Clootwijk, a burgomaster of Geertruidenberg (North Brabant), and Henrica van Drimmelen. She died on July 30, 1662, and was buried in the Oude Kerk, Delft.

REFERENCES: Moes 1897–1905, vol. 1 (1897), p. 181, no. 1587, as in the collection of J. Oyens in Baarn; Montias 1982, p. 55, fig. 3; P. Sutton 1986, p. 183, mentioned; Baetjer 1995, p. 297; Liedtke 2000a, pp. 64, 104, cited as an example of a Dutch artist working from an original painting (prime version) when producing replicas, not from a drawing; Liedtke in New York–London 2001, pp. 47–48, 316, fig. 45b, as possibly one of the portraits of the sitter in Van Miereveld's estate.

EXHIBITED: New York, MMA, "Dutch Couples: Pair Portraits by Rembrandt and His Contemporaries," 1973, no. 7 (with pendant); New York, MMA, "Vermeer and the Delft School," 2001, hors cat.

EX COLL.: The painting has the same history of ownership as its pendant. See Ex Coll. for *Jacob van Dalen, called Vallenis* (Pl. 121); Bequest of Collis P. Huntington, 1900 25.110.12

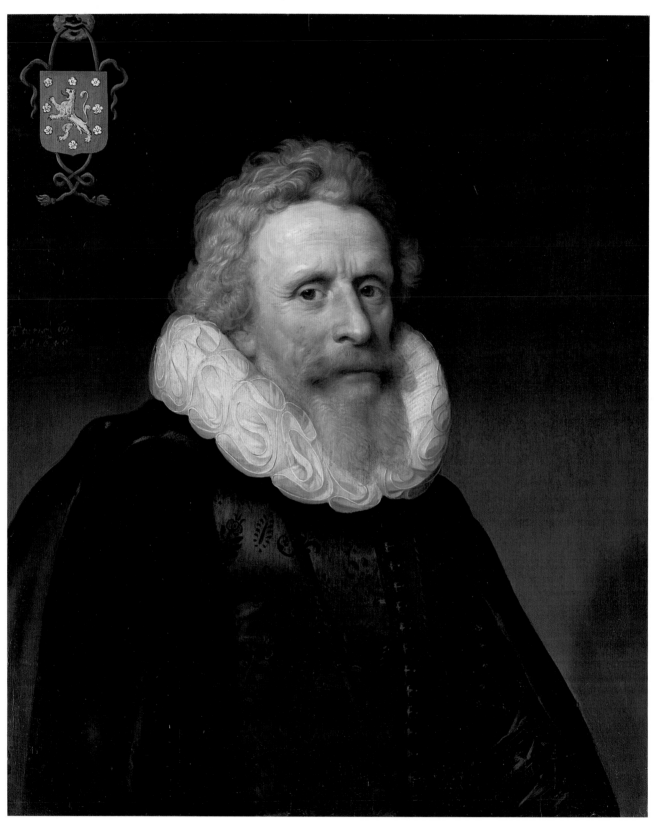

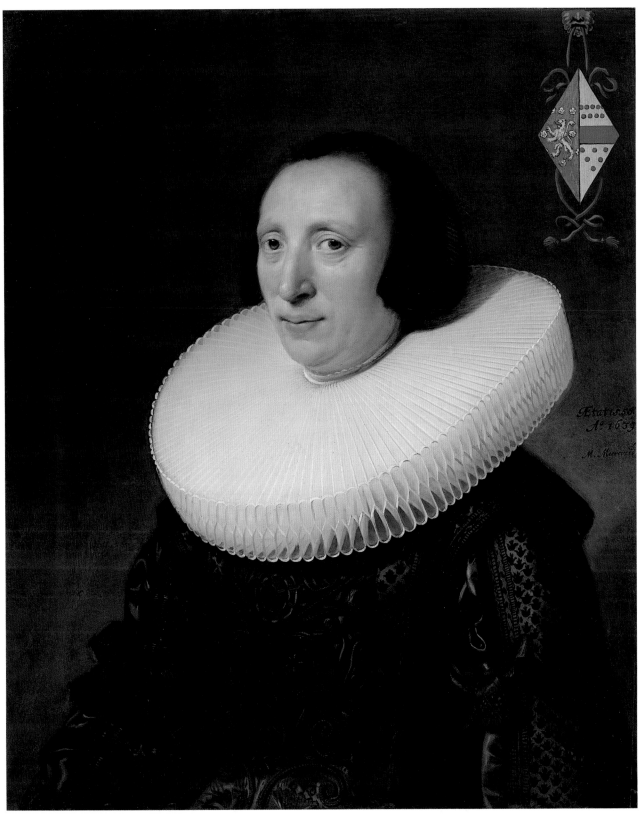

122

FRANS VAN MIERIS THE ELDER

Leiden 1635–1681 Leiden

The artist was presumably born in Leiden in April 1635, as reported in Weyerman's *Levens-beschrijvingen* (1729) and in the second edition of Houbraken's *Groote Schouburgh* (1753).[1] His father, Jan Bastiaensz (d. 1650), and his two uncles were goldsmiths. Van Mieris trained in the same profession under his cousin, Willem Fransz, from about 1645–46 onward.[2] According to Houbraken, his father then sent him to study with the glass painter and drawing master Abraham van Toorenvliet (ca. 1620–1692); this must have been about 1649–50.[3] He soon went on to the studio of Gerrit Dou (q.v.), probably about 1650–51, and then to Leiden's most successful portraitist, Abraham van den Tempel (1622/23–1672). Finally, Van Mieris returned to Dou, who deemed him "the Prince of his pupils."[4] This often quoted remark seems justified by comparisons of autograph works by the artist, including those dating from as early as about 1655–57, with even the finest efforts of Godfried Schalcken and Matthijs Naiveu (q.q.v.). In such paintings as the *Inn Scene,* of 1658 (Mauritshuis, The Hague), and *The Oyster Meal,* of 1659 (Hermitage, Saint Petersburg), Van Mieris might be considered to have surpassed his famous master in ways that recall contemporary works by Gerard ter Borch and Johannes Vermeer (q.q.v.).

In March 1657, Van Mieris married a somewhat older woman, Cunera van der Cock (ca. 1630–1700).[5] He joined the painters' guild in Leiden on May 14, 1658, although he had already placed his signature ("F v Mieris" or "F van Mieris") on a number of pictures.[6] The artist remained in Leiden throughout his comparatively short life (he died at the age of about forty-six). He served as *hoofdman,* or headman, of the guild in 1663 and 1664, and as dean in 1665. Van Mieris was paid nearly unprecedented sums for his paintings by some of Leiden's leading citizens and by such distinguished connoisseurs as Duke Cosimo III de' Medici and Archduke Leopold Wilhelm.[7] Nonetheless, notarial records reveal that the artist was persistently in debt during the 1660s and 1670s; they also confirm Houbraken's claim that the artist had a drinking problem.[8] He died on March 12, 1681, and was buried in the Pieterskerk. The family belonged to the Remonstrant community.

Van Mieris is mostly known for elegant genre scenes and for small portraits, including a number of self-portraits, although he also painted historical subjects (which are occasionally obscure).[9] He employed an eccentric cast of characters, with strong and sometimes grimacing expressions, and demonstrative gestures suggestive of the stage. His most distinctive works seem self-consciously sophisticated and introduce a note of courtly decadence into familiar domestic environments. Among the painter's most remarkable qualities are his descriptions of light effects (including nocturnal illumination), reflections, and the changing colors of shiny satins and silks. His manner was imitated but never equaled by his sons Jan (1660–1690) and the more gifted Willem (1662–1747), and by Willem's son, Frans van Mieris the Younger (1689–1763).[10]

1. It is commonly reported that Van Mieris was born in Leiden on April 16, 1635, and that the source of this information is Houbraken 1718–21, vol. 3, p. 2 (see, for example, Naumann 1981, vol. 1, pp. 21 n. 8, 195). However, Van Mieris's date of birth is not found in the (already posthumous) third volume of Houbraken's *Groote Schouburgh* but is the subject of a new sentence added to the revised second edition of 1753 (vol. 3, p. 2): "Deze [Van Mieris] is geboren tot Leiden in den jare 1635 op den 16 van Grasmaand." The author of this line, presumably the biographer Johan van Gool, was certainly aware that in Weyerman 1729–69 (vol. 2 [1729], p. 341) Van Mieris is said to have been born "op den tiende van de Grasmaand, des jaars duyzent seshondert vyfendertig" (on April 10, 1635; see Horn 2000, p. 79, on Van Gool's relationship to Houbraken and to Weyerman). The change in date from April 10 to April 16 may be a correction based on another source of information or a misreading of handwritten notes.

 The question is not immediately resolved by the inscription on Van Mieris's *Self-Portrait* in the National Gallery, London, which reads: "ÆTAT 38$\frac{4}{13}$"; and, on a second line, "A⁰ D^{OM} 1674." In MacLaren 1960, p. 253, it is noted that "the date of the present portrait, 13 April 1674, is three days before van Mieris's thirty-ninth birthday"; this statement is repeated in MacLaren/Brown 1991, p. 266, where the inscription is reproduced in fig. 62. But does the date "4/13" refer to the completion of the painting and not to the sitter's date of birth (or baptism)? If Van Mieris turned thirty-eight on April 10 or April 13, 1674, then he was born in 1636.

 There are two other pieces of documentary evidence for the year of Van Mieris's birth. He was said to be "aged about twelve" when he formally became his cousin's apprentice on December 2, 1647 (Naumann 1981, vol. 1, p. 160). At the time

Van Mieris was about four months short of his twelfth or thirteenth birthday, depending on whether he was born in 1635 or 1636. However, the first edition of Houbraken (1718–21, vol. 3, p. 9) claims that the artist "died on the 12 of March 1681, barely 46 years old" ("naaulyks 46 jaren out"). It is not clear whether "naaulyks 46" should be taken to mean that Van Mieris was "only 46" or "nearly 46" when he died. But if he was already forty-six years old in March 1681 (that is, since April 1680), then he was born in 1634. This conflicts with the document giving his age as "about twelve" in December 1647; he would have been thirteen years and eight months old if he were born in April 1634. Van Mieris must have been born in 1635, and probably on April 16, as stated in Houbraken 1753.

2. See Naumann 1981, vol. 1, pp. 20, 22, 160–61.

3. Houbraken 1718–21, vol. 3, p. 2; see Naumann 1981, vol. 1, pp. 20, 22–23, 35–36.

4. According to Houbraken 1718–21, vol. 3, p. 2. See Naumann 1981, vol. 1, chap. 2, on Van Mieris's training and early work.

5. See Naumann 1981, vol. 1, pp. 23, 164. The documents cited by Naumann indicate that the couple had their first child, Christina, shortly before they married.

6. See ibid., vol. 2, nos. 1–20 (the two versions of no. 20 are dated 1657). As Sluijter explains in Leiden 1988, p. 127, the guild's normal activities of collecting dues and taking in new masters appear to have been interrupted in the mid-1650s.

7. See Naumann 1981, vol. 1, p. 24, on Leopold Wilhelm, whose offer to Van Mieris of a large income and a post in Vienna was refused, pp. 24–37 on his Leiden patrons, and pp. 27–30 on Cosimo.

8. See ibid., pp. 30–33, and Hecht 1996, p. 162.

9. See New York 1992–93, pp. 106–9, on *The Wife of Jeroboam with the Prophet Ahijah*, of 1671 (Musée des Beaux-Arts, Lille).

10. For biographies of and works by all four Van Mierises, see Leiden 1988, pp. 127–68. See also Amsterdam 1989–90, pp. 66–128, for works by Frans the Elder and by Willem.

123. *The Serenade*

Oil on wood, arched top, 5¾ x 4⅜ in. (14.6 x 11.1 cm)

The painting is in good condition, although there is slight abrasion along a network of fine cracks in the deep shadows of the background at left, in the masked figure, in the child holding a torch, and on the building between the two central figures. The modeling of the woman's iridescent silk skirt is disrupted.

Bequest of Lillian S. Timken, 1959 60.71.3

This small panel was little known before its publication in the early 1980s and its frequent display from that period onward. The picture was evidently taken to America by the celebrity Lola Montez (1821–1861), whose lover King Ludwig I of Bavaria (1786–1868) is said to have owned it before her.[1] This would have made the painting unknown to the leading connoisseurs of Dutch art who flourished in the late nineteenth and early twentieth centuries, until one of them, Cornelis Hofstede de Groot, was consulted somewhat before or in connection with the New York sale of 1927. His certificate endorsing the picture's attribution to Gerrit Dou (q.v.) was not overruled until Naumann included the work in his catalogue raisonné of paintings by Dou's most accomplished pupil, Frans van Mieris.[2] The picture's style and figure types (especially the woman) are entirely consistent with Van Mieris's later work. Naumann convincingly dates the painting to about 1678–80.[3]

The night scene is illuminated mainly by the large torch carried by a boy in fancy dress. He leads the way for three figures, an elegant woman playing a lute and two men in theatrical costumes (at least one of whom is masked). As in Van Mieris's *The Old Lover*, of 1674 (Uffizi, Florence), light from a full moon allows the sky, the murky silhouette of a landscape, and the outline of a building to be barely discerned. The low placement of the torch results in strange shadows on the figures, enhancing their bizarre appearance. Candlelight cast from below similarly adds a sense of mystery or menace in other night scenes by Van Mieris.[4] Another function of the torchlight in the present picture is to create the flaring reflections on the nearest figure's red garment, a passage that may be said to serve as a kind of signature for the artist in this unsigned work.

Naumann suggests plausibly that *The Serenade* is identical with a painting by Van Mieris listed in the inventory of the Diego Duarte collection, compiled in Antwerp and dated July 12, 1682.[5] The Duarte picture is described as "Een nacht met vier figuren, een keerslicht en lanternelicht, maenschyn, seer curieus" (A night [scene] with four figures, a candle torch and a lantern light, moonlight, very curious).[6] Hofstede de Groot cited this document in 1928 (see Refs.) but evidently missed its connection with the "Dou" he had seen somewhat earlier.

Naumann compares the work with Jan Steen's *Serenade,* of

about 1675–78 (Národní Galerie, Prague), noting compositional as well as thematic similarities in the two torchlit scenes.[7] The painting by Van Mieris's close associate in Leiden shows costumed figures (including one wearing a turban and another a mask) ringing the doorbell of a stately town house and serenading the secluded occupants. The subject, with specific commedia dell'arte players, is known from earlier French prints.[8] The figures in Van Mieris's painting must also be actors making nocturnal rounds from house to house. The change from loud revelers on a Dutch sidewalk in Steen's picture to the rather disturbing personages in the Museum's shadowy scene is typical of Van Mieris. A source in Molière has rightly been discounted.[9]

A contemporary copy was on the art market in 1995.[10]

Formerly attributed by the Museum to Gerrit Dou.

1. See Ex Coll. An excellent sketch of Lola Montez's life is found in Fiona MacCarthy, "Star" (review of Bruce Seymour, *Lola Montez: A Life*), *New York Review of Books* 43, no. 8 (June 20, 1996), pp. 7–9. Montez was the king's mistress in Munich from 1846 until his abdication in 1848.

2. See Refs. The connoisseur Daan Cevat, on a visit to the Museum in 1966, considered the picture a "good Dou, very Elsheimeresque." The present writer recatalogued the painting in 1986, after consultation with Otto Naumann.

3. Among the most similar works by Van Mieris are *A Sleeping Courtesan*, of 1669(?), and *The Old Lover*, of 1674 (both in the Uffizi, Florence), and *A Woman Tuning a Lute*, of about 1680 (Rijksmuseum, Amsterdam). See Naumann 1981, vol. 2, nos. 75, 98, and 119 respectively.

4. For example, in *A Young Man with an Owl*, of 1675 (copy in the Akademie der Bildenden Künste, Vienna; see ibid., no. 104), and in *The Old Lover*, mentioned above (see note 3).

5. Ibid., vol. 1, pp. 83–84, 188, vol. 2, p. 123. Naumann and Hofstede de Groot (see Refs.) repeat the error of F. Muller 1870, placing the great Antwerp art collector and dealer Diego Duarte (before 1616–1691) in Amsterdam (on this point see Dogaer 1971, p. 198 n. 11). On Duarte, see Frans Baudouin's entry in *Dictionary of Art* 1996, vol. 9, pp. 311–12, and Samuel 1976, pp. 305–9. Duarte was famous for his interest in musical instruments and owned paintings depicting various examples, including "a work with a young woman playing on the virginal with other motifs by Vermeer" (see my remarks in New York–London 2001, pp. 9, 403).

6. Dogaer 1971, p. 212, no. 98, valued at Fl 400 (not no. 89, and not Fl 403 as stated in other publications). The entry is misquoted in F. Muller 1870, p. 400, no. 89, and therefore also in Naumann 1981, vol. 1, p. 188. The original manuscript is in the Bibliothèque Royale Albert Ier, Brussels. The reference to "lantern light" is probably an understandable misreading of the reflection on the cuirass worn by the figure to the right, and perhaps of the sword hilt in the same area.

7. Naumann 1981, vol. 1, p. 84, fig. 126, vol. 2, p. 123. As Naumann reports, the Steen has been dated between 1674 and 1678. A dating to 1668–72 is suggested in K. Braun 1980, p. 133, no. 321. On the Prague picture's subject, see Westermann 1997, pp. 148–49, 179 n. 45.

8. See Gudlaugsson 1975, pp. 52–54, fig. 56.

9. See ibid., pp. 53–54, and Naumann 1981, vol. 2, p. 123.

10. Sotheby's, London, October 18, 1995, no. 67, as Studio of Frans van Mieris the Elder. Also at Sotheby's, New York, May 20, 1993, no. 234, as Attributed to Willem van Mieris, with erroneous provenance.

REFERENCES: Probably F. Muller 1870, p. 400, no. 89, as in the 1682 inventory of Diego Duarte's collection (see text above and notes 5 and 6); probably Hofstede de Groot 1907–28, vol. 10 (1928), p. 63, no. 235, where the preceding reference is cited; probably Dogaer 1971, p. 212, no. 98, where the entry in the inventory of Duarte's collection is transcribed; probably Samuel 1976, pp. 314, 319, where a "Lus de Laterna" by "Mirins" is listed as one of the unsold works in Diego Duarte's house in early 1693, and as being offered for sale by his heir, Manuel Levy Duarte, for Fl 600; Baetjer 1980, vol. 1, p. 48, as by Dou; Naumann 1981, vol. 1, pp. 83–84, vol. 2, pp. 122–23, no. 117, pl. 117, as by Van Mieris about 1678–80, possibly the picture in the inventory of Duarte's collection; P. Sutton 1986, p. 187, supports Naumann's attribution; Beherman 1988, p. 367, no. 353, rejects an old attribution to Schalcken (photograph files of the Rijksbureau voor Kunsthistorische Documentatie, The Hague); Hecht in Amsterdam 1989–90, p. 215 n. 4, notes the display of various light effects in the picture, for which it was considered "very curious" in the 1682 inventory of Duarte's collection; Baetjer 1995, p. 339, as by Van Mieris; The Hague–Washington 2005–6, p. 238, no. 117, included in a complete list of known works by Frans van Mieris.

EX COLL.: Probably Diego Duarte, Antwerp (d. 1691; inventory of his collection, July 12, 1682, no. 98 [see text and notes 5 and 6 above]; his executor and heir, Manuel Levy Duarte, Amsterdam and Antwerp, 1691–early 1693 or later);[1] King Ludwig I of Bavaria, Munich (according to 1927 sale catalogue); Lola Montez (also Eliza Gilbert, Maria Dolores de Porris y Montez), presumably in Munich about 1846–48, in New York (where she died), and elsewhere (according to 1927 sale catalogue); Mrs. Dana, Boston, Mass. (according to 1927 sale catalogue); Dr. Reuling, Baltimore, Md. (according to 1927 sale catalogue); Dr. John Edwin Stillwell, New York (until 1927; sale, Anderson Galleries, New York, December 1–3, 1927, no. 236, as by Gerrit Dou); Mr. and Mrs. William R. Timken, New York (1927–49); Mrs. William R. Timken, New York (1949–59); Bequest of Lillian S. Timken, 1959 60.71.3

1. See Samuel 1976, pp. 306–9, on Manuel Levy Duarte and his role in disposing of Diego Duarte's stock. M. L. Duarte moved to The Hague in 1696. According to Samuel (ibid., p. 306 n. 13), M. L. Duarte "was the husband of Constantia Duarte who seems to have been the daughter of Diego's deceased brother Gaspar Duarte."

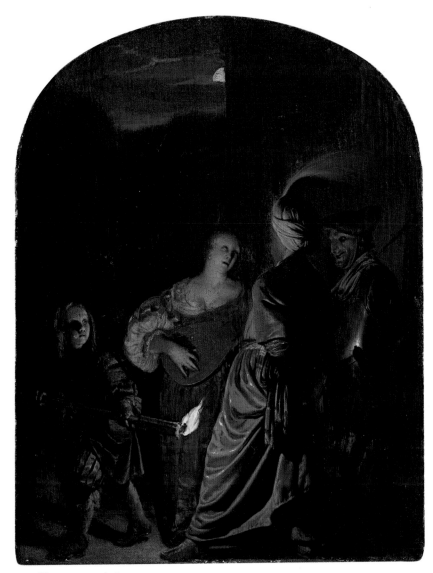

123. Shown actual size

DANIËL MIJTENS

Delft ca. 1590–1647/48 The Hague

A native of Delft, Mijtens was the son of a saddle-
and coachmaker to the Prince of Orange, Maerten
Mijtens (1551–1628), who came from Brussels.
Maerten's brother, Aert Mijtens (1541–1602), was active as a
portrait and history painter in Italy, where he died.[1] Daniël
probably studied under one of the two most important por-
traitists in the South Holland region, Jan van Ravesteyn (q.v.)
in The Hague or Michiel van Miereveld (q.v.) in Delft. In
1610, he joined the painters' guild in The Hague. Gratia
Cletcher, of The Hague, became Mijtens's wife in 1612.[2] No
paintings from this early Dutch period are known.[3]

By 1618, Mijtens was in London, writing to Sir Dudley
Carleton in excellent English,[4] and painting life-size portraits
of the great collector Thomas Howard, Earl of Arundel, and
his wife Alathea, Countess Arundel, who are shown seated in
front of idealized views of the sculpture and portrait galleries
in Arundel House, London (National Portrait Gallery, London;
on loan to Arundel Castle, Sussex).[5] In these stately pictures,
as Ekkart remarks, "Mijtens can already be seen combining sty-
listic elements from his Delft–Hague background with certain
formal aspects of the Elizabethan and Jacobean tradition of
English court portraiture," one of which is a predilection for
large full-length portraits.[6]

Mijtens evidently was presented to James I about 1619, and
by May 1620 was receiving payments for portraits ordered by
the Crown. Upon the death of Paul van Somer (1576–1621),
Mijtens succeeded as court painter and was soon producing
portraits of James I and Prince Charles (payments for which
date from 1623). It has been observed that the pension of fifty
pounds per annum awarded Mijtens by James I on July 19,
1624, "on condition that he do not depart from the realm
without a warrant from the King or the Council," reflects the
memory of Anthony van Dyck's failure to return after his brief
stay in London in the winter of 1620–21.[7] In fact, Mijtens
remained until 1634, by which time Van Dyck's presence in
London (since at least April 1632) had cost the Dutch painter
his position as the preeminent portraitist in England.

The portrait of Charles I that is catalogued below (Pl. 124)
is typical of Mijtens's achievement from about 1627 to 1633.
The majority of his paintings were large full-length portraits of
the king or of distinguished noblemen and combine stateliness

with naturalistic description and a certain ease of pose and
expression. The latter quality was hardly the equal of Van
Dyck's approach, but must have made the Fleming all the
more welcome in England.

A widower, Mijtens remarried in 1628. His second wife,
Susanna Droeshout (dates unknown), was a painter of minia-
tures. The couple moved to The Hague in 1634, where Mijtens
worked as an art dealer as well as a portraitist. He remained
active as one of Arundel's collecting agents. Ekkart reports that
only four portraits are known to date from this second Dutch
period of Mijtens's career, all of them bust length.[8] No pupils
are identified, but the artist's nephew and later son-in-law, Jan
Mijtens (ca. 1614–1670), may have been his apprentice in the
mid-1630s, after initial training elsewhere.[9]

Ter Kuile catalogues three self-portraits by Mijtens, the best
of which is the panel of about 1630 at Hampton Court.[10] In
addition, Anthony van Dyck included a portrait of Mijtens
(engraved by Paul Pontius) in his *Iconography*.[11]

1. See Ter Kuile 1969, pp. 18–19, for a family tree. Mijtens's mother,
 Anneke Tijckmakers, died before November 1611, when his
 father remarried.
2. Gratia Cletcher is called the "sister of the goldsmith Thomas
 Cletcher the elder" by Rudolf Ekkart in *Dictionary of Art* 1996,
 vol. 21, p. 508, but Thomas was a wine merchant. His son,
 Thomas Cletcher the Younger, was jeweler to Prince Frederick
 Hendrick (as correctly recorded in The Hague 1998–99, p. 294,
 in the biography of the painter Daniël Cletcher, who like
 Thomas II was Gratia's nephew).
3. See Ter Kuile 1969, pp. 40–42, for an overview of signed and
 dated works by Mijtens, and of works attributed to him or by
 his workshop; ibid., pp. 43–99, for a catalogue of paintings.
4. According to Waterhouse 1962, p. 33, citing sources.
5. Ter Kuile 1969, nos. 1, 2, figs. 11, 12. See also Howarth 1985,
 pp. 57–59, pls. 2, 3; Malibu 1995, p. 9, pls. II, III; and London
 1995–96, pp. 208–12, nos. 140, 141.
6. Ekkart in *Dictionary of Art* 1996, vol. 21, p. 509.
7. Waterhouse 1962, p. 33, following Stopes 1910, p. 161, and others.
8. Ekkart in *Dictionary of Art* 1996, vol. 21, p. 509.
9. On the various painters named Mijtens active in The Hague,
 including Jan's son Daniël Mijtens II, see The Hague 1998–99,
 pp. 329–30.
10. Ter Kuile 1969, pp. 82–83, nos. 70–72, figs. 1, 55.
11. See Dickey 2004, pp. 27, 173 n. 26, fig. 32.

124. *Charles I, King of England*

Oil on canvas, 78⅞ x 55⅜ in. (200.3 x 140.7 cm)
Signed, dated, and inscribed: (lower right) Pinxit Daniel
Mytens; (right, on column base) CAROLVS D[EI] G[RATIA]
MAG[NI]/BRITANNIÆ FRANCIÆ/ET HIBERNIÆ REX/FIDEI
DEFENSOR./ÆTAT. 29/ANNO 1629 (Charles, by the grace of
almighty God, king of Britain, France, and Ireland. Defender
of the Faith. Aged 29. In the year 1629)

The painting is not well preserved. The support has suffered
damage in many places, and there is paint loss throughout.
Tears in the background to the right of the figure extend from
his collar to the floor and between the legs. Abrasion along
the edges of the extensive crack pattern and along the crowns
of the weave is most significant in the face, background,
and floor. The green glazes in the tablecloth and background
curtain are severely abraded. The top of the composition
was altered in the past to an arched shape and then returned
to its original rectangular format. There is an added strip
3½ in. (8.9 cm) wide along the bottom.

Gift of George A. Hearn, 1906 06.1289

The New York portrait of Charles I (1600–1649; r. 1625–49) by
Mijtens is generally agreed to be the prime version of one of the
standard types of royal portraits that the artist painted in London
between the king's accession to the throne in 1625 and Mijtens's
departure from England in 1634. The canvas is signed and dated
1629, and despite condition problems is clearly consistent in exe-
cution with autograph works of the period, such as the impres-
sive full-length portrait *James, Duke of Hamilton,* also of 1629
(Duke of Hamilton, on loan to the National Gallery of Scotland,
Edinburgh).[1] The modeling of the figure, the sense of space
around it, the suggestion of textures, the delicate handling of
costume details, and a few pentimenti (for example, in the con-
tours of the lace collar) leave little room for doubt about
Mijtens's authorship (fig. 114).[2]

Mijtens painted full-length portraits of Charles as Prince of
Wales in the early 1620s. Ter Kuile considers the example at
Parham Park, Sussex, to date from as early as 1621, and the
one at Hampton Court is dated 1623. In these images and in
the portrait of a more mature-looking prince dated 1624
(National Gallery of Canada, Ottawa), Charles is turned in a
three-quarters view to the right (in the direction opposite to
that seen here).[3] The very large canvas dated 1626 and 1627 in
the Galleria Sabauda, Turin, which has an elaborate architec-
tural setting by Hendrick van Steenwyck the Younger (ca. 1580–
?1649), shows the king from the same angle but in a more
authoritative pose, with his right hand extended straight to a
cane and his left arm akimbo.[4] In 1628, Mijtens repeated the

Turin-type figure of the king in a full-length portrait at
Windsor Castle, where the setting is reduced to a tiled floor
and a pillar and curtain flanking a balustrade (suggesting a bal-
cony or terrace) with a view of landscape.[5] Autograph replicas
of the Windsor version are in Milton House, Northampton-
shire, and in Hatfield House, Hertfordshire.[6]

A new series of royal portraits begins with the Museum's
picture of 1629, where the king is turned in a three-quarters
view to the left. Again his right arm extends to the top of a
cane, but it is not cocked in the commanding manner found
in the Turin and similar portraits. The left arm also has been
relaxed, and rests lightly on the hilt of a rapier. The king no
longer seems to insist on his majesty, but simply stands next
to its symbols on the table: the orb, scepter, and crown. He is
dressed in red with silver embroidery and wears tan gloves and
boots, and gold spurs. The blue sash and blue ribbon (the lat-
ter falling from behind the left knee) represent the Order of
the Garter.

A workshop replica, unsigned but dated 1629, was formerly
in the Spencer-Churchill collection at Northwick Park.[7]
Another unsigned version, dated 1631, is in the National
Maritime Museum, Greenwich.[8] The copy of the Museum's
painting in the Devonshire Collection at Chatsworth,
Derbyshire, is monogrammed by Cornelis Jonson van Ceulen
the Elder (q.v.) and dated 1631, which suggests that either the
artist worked in Mijtens's studio (with other assistants, to be
sure) or that about 1631 he was specially engaged to help satisfy
demand.[9] In addition, an unsigned version of the present com-
position, but with the figure in a dark gray costume with differ-
ent details and no embroidery, is dated 1631 (National Portrait
Gallery, London).[10]

A third type of full-length portrait of Charles I by Mijtens
presents the king in the ceremonial robes of the Order of the
Garter. The prime version, dated 1633, is in Milton House,
Northamptonshire.[11] Much as this (most likely) last image of
the king by Mijtens was adopted and improved by Van Dyck
in his *Charles I in Robes of State,* dated 1636 (Windsor Castle),
the same artist's *Charles I at the Hunt ("Le roi à la ciasse"),* of
about 1636 (Louvre, Paris), draws upon both earlier types of
Charles I with a cane, and yet gives the impression that the
king himself created the dashing pose.[12]

Stopes, in 1910, published two references in royal account
books of the period, one of which probably is to the Museum's
painting. The more promising of the two entries is the first,
dated April 2, 1630: "bill for Daniell Mittens . . . viz., £60 for
his Majesty's picture at large with a prospect, and the Crown
and the Sceptre, in a scarlet embroidered suit." On June 29,

Figure 114. Detail
of Mijtens's *Charles I,
King of England* (Pl. 124)

1631, the artist was credited "£50 for his Majesty's picture at large, with a prospect and the Crown and Sceptre, in a scarlet embroidered suit, delivered by special command unto the Lord Bishop of London in April, 1631."[13]

A biography of Charles I is not required here. However, it should be noted that the reference to France in the inscription on this canvas was earned through the king's marriage, in 1625, to Henrietta Maria (1609–1669), youngest child of Henry IV of France and Marie de Médicis.

1. Ter Kuile 1969, no. 53, fig. 32; Waterhouse 1962, p. 35, pl. 31.
2. In his report to the Museum dated November 3, 1988, Rudolf Ekkart described the Museum's picture by Mijtens as "a very good work of the English period of the painter. Nothing to add to Ter Kuile's article of 1969" (see Refs.).
3. Ter Kuile 1969, nos. 19, 20, 22, figs. 17–19.
4. Ibid., no. 24, fig. 20. Both artists signed the work, Van Steenwyck with the date 1626 and Mijtens with the inscription, "Ad Vivum dep. D. Mytens p. Regius A. 1627."
5. Ibid., no. 25, fig. 21; Millar 1963, no. 118, pl. 48.
6. Ter Kuile 1969, nos. 26, 27, fig. 22 (Hatfield; the photograph is mistakenly reproduced over the caption of fig. 23, for the Museum's picture, which is reproduced above the caption for the Hatfield canvas).
7. Ibid., no. 29. Sold at Christie's, London, June 25, 1965, no. 68, and November 10, 1995, no. 7, as "circle of Daniel Mijtens."
8. Ter Kuile 1969, no. 30. For reasons that remain unclear, Ter Kuile (ibid., p. 59) specifies that the Greenwich canvas is a copy

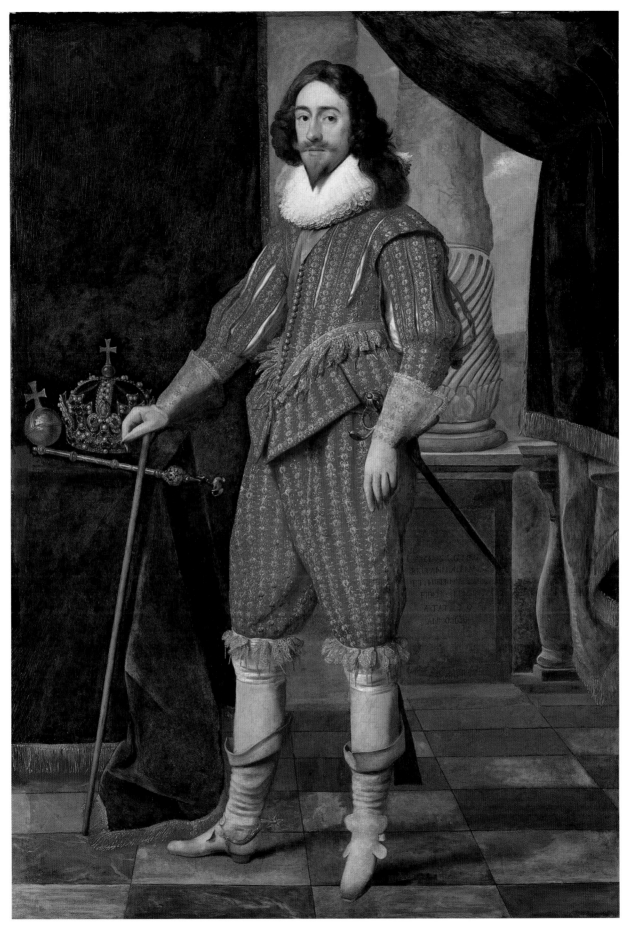

of the Spencer-Churchill version, as opposed to being a studio replica of the New York painting. In some aspects, for example the subtler highlights in the curtain and table cover, the Greenwich picture is closer to the Museum's painting than is the Spencer-Churchill canvas.

9. See ibid., pp. 59–60, no. 31, "fig. 24," but reproduced above the caption for fig. 25. (Jonson's version of the Museum's picture includes a view of Windsor Castle in the left background, and a dog in the right foreground.) Ter Kuile (ibid., pp. 59, 89, no. 86, fig. 41) mentions one other copy by Jonson after Mijtens, namely *William Herbert, Third Earl of Pembroke,* signed "C. Johnson/ pinxit" (Penshurst Place, Kent). The latter is not "dated 1630," as Ter Kuile records, but is inscribed with the information that the sitter died on April 10, 1630. On Jonson's copy of the New York canvas, see also Refs. in this entry.

10. Ibid., no. 32, fig. 24; see also p. 58 (under no. 28). A version of the latter, with no signature or date, was formerly owned by the Marquess of Waterford (ibid., no. 33). Other workshop replicas or old copies, with the king in red or gray costume, are known to exist.

11. Ibid., pp. 61–62, no. 34, recording various copies (one ill. as fig. 26); Waterhouse 1962, p. 35, pl. 32.

12. See Waterhouse 1962, p. 35, pls. 32, 33, for the first comparison, and for both Van Dycks, see Barnes et al. 2004, nos. IV.50, IV.53.

13. Stopes 1910, p. 162. See also Ter Kuile 1969, pp. 58–59 (under no. 28), for slightly different and evidently more accurate quotations.

REFERENCES: Probably Stopes 1910, p. 162, which publishes a document from the royal accounts, dated April 2, 1630, which may refer to this picture (see text above); probably Collins Baker 1912, vol. 1, pp. 42–43, which refers to three versions of Mijtens's portrait of Charles I, each "in a scarlet embroidered suit," with a crown and scepter, and "with a prospect" (view), one paid for on April 2, 1630, and two paid for on June 29, 1631; Kelly 1920, pp. 84, 89, and pl. IID, on p. 87, considers this portrait as possibly the one paid for on April 2, 1630, and finds it "rather the more sympathetic, despite the gaudy dress," when compared with the version in gray costume, dated 1631 (National Portrait Gallery, London); Kelly 1930 (ill. opp. p. 214); Thieme and Becker 1907–50, vol. 25 (1931), p. 316, listed; Millar 1948, p. 322, notes that only the Museum's picture, of ver-

sions dated 1629 or 1631, is signed by Mijtens, and observes that the version at Chatsworth is signed and dated *C.J: fect.*/1631, and is by Cornelis Jonson (van Ceulen the Elder; q.v.); Bénézit (1948–55) 1976, vol. 7, p. 633, listed; Waterhouse (1953) 1962, p. 35, describes the New York version, which represents one of the "types" of portraits of the king by Mijtens, as "a signed and dated original of 1629"; Held 1958, p. 148, observes the king's early adoption of the fashion of carrying a cane, as depicted in the Museum's painting, where royal attributes and riding boots are also seen; Piper 1963, p. 61 (under no. 1246), mentions the picture as "a signed and dated version, 1629, in red with a falling ruff," and as representing a type of royal portrait by Mijtens that "was popular between 1629 and 1631," of which the canvas dated 1631 in the National Portrait Gallery, London, is "a version, probably from Mytens's studio"; Ter Kuile 1969, pp. 11, 14, 58–59, no. 28, fig. 23 (image switched with that of fig. 22), and pp. 59–60 (under nos. 29, 31, and 32), refers to the copy by Cornelis Jonson van Ceulen, considers the pose more confident than in earlier paintings of Charles I by Mijtens, and describes the picture as the "prototype" (prime version) of a series of portraits of Charles I, listing a few workshop replicas, two copies, and two variants; Chapman 1990, p. 143 n. 53, discerns the "wearing [of] a 'lovelock' over one shoulder" in this portrait; Baetjer 1995, p. 181; Rudolf Ekkart in *Dictionary of Art* 1996, vol. 17, p. 645, refers to the copy of this painting by Cornelis Jonson; Rudolf Ekkart in ibid., vol. 21, p. 509, describes the Museum's picture as "the original portrait painted and signed by Mijtens himself," and mentions the copy by Cornelis Jonson; Gordenker 2001, p. 102 n. 70, mistakenly refers to the New York painting as a copy of the picture by Mijtens in the National Portrait Gallery, London;[1] Hearn 2003, p. 119, refers to the version of this painting by Cornelis Jonson van Ceulen the Elder (q.v.).

EXHIBITED: Tokyo, National Museum, and Kyōto, Municipal Museum, "Treasured Masterpieces of The Metropolitan Museum of Art," 1972, no. 76.

EX COLL.: George A. Hearn, New York (until 1906); Gift of George A. Hearn, 1906 06.1289

1. In a personal communication dated May 2, 2005, Emilie Gordenker describes the word "copy" as an error. She meant to say "version."

PIETER DE MOLIJN

London 1595–1661 Haarlem

Pieter de Molijn (or De Molyn) was baptized in London on April 6, 1595. His father, also named Pieter (profession unknown), came from Ghent, and his mother, Catalijnke van der Bossche, was from Brussels. The first record of De Molijn in Holland dates from 1616, when he was enrolled as a master in the Guild of Saint Luke in Haarlem. In 1624, he joined a civic guard company and the Dutch Reformed Church in Haarlem, and in the same year he married a local woman, Mayken Gerards. The couple had at least seven children between 1625 and 1639.[1]

De Molijn's earliest known dated paintings are from 1625: the *Nocturnal Street Scene,* in the Musées Royaux des Beaux-Arts de Belgique, Brussels; a wooded landscape in Raby Castle, County Durham; and a panel in the National Gallery of Ireland, Dublin, depicting the Dutch princes riding out to hunt.[2] The last painting especially is indebted to Esaias van de Velde (1587–1630), who influenced De Molijn's colleague Jan van Goyen (q.v.) at about the same time.[3] De Molijn himself, in the *Dune Landscape* of 1626 (Herzog Anton Ulrich-Museum, Braunschweig), was an innovator in the tonal manner of landscape painting that is especially associated with artists in Haarlem, in particular Van Goyen and Salomon van Ruysdael (q.v.).[4] Although the importance of individual artists and specific pictures can at times be exaggerated, it is clear that as a painter, draftsman, and etcher, De Molijn was a leading figure in the development of naturalistic landscape in the Netherlands between 1625 and 1631.[5]

In the 1630s, when De Molijn painted comparatively few pictures, and during the more prolific decade that followed, his landscapes depended mostly on the examples of Van Goyen, Van Ruysdael, and the young Jacob van Ruisdael (q.v.).[6] In this period, De Molijn was very busy on behalf of the painters' guild: he was *vinder,* or foreman, in 1631, 1637–38, 1645, and 1649, and dean in 1632–33, 1638, and 1646.[7] Gerard ter Borch (q.v.) studied with him in 1634–35, and, according to Houbraken, Allart van Everdingen (1621–1675) was also his pupil.[8]

De Molijn was more active as a painter and a draftsman in the late 1640s and 1650s. His late landscapes (which are much better known from the art market than from currently available literature) recall contemporary compositions by Van Goyen and Van Ruisdael, but also the distinctive qualities of his own early work. In general, he favored richer colors, closer description, and more structured designs than did Van Goyen, and he imparted a strong sense of rhythmic flow from one form to the next. De Molijn's masterful drawings, of which about five hundred are known, combine detailed observation with energetic technique.[9]

The artist was buried in Saint Bavo's, Haarlem, on March 23, 1661. When his widow sold the house that the couple had lived in for at least thirty years, it brought a substantial sum.[10]

1. For biographical documents, see E. Allen 1987, chap. 3; and Van Thiel-Stromon in Biesboer et al. 2006, pp. 246–49.
2. For these pictures see, respectively, Stechow 1966, p. 175, fig. 349; Amsterdam–Boston–Philadelphia 1987–88, p. 375, fig. 1; London 1986a, no. 51; and Potterton 1986, pp. 96–97, fig. 108.
3. See Stechow 1966, p. 23. Keyes 1984, p. 73, stresses the importance of Van de Velde's first chalk sketchbook of about 1618–20 for the fluid landscape drawings that were made by De Molijn, Van Goyen, and other Haarlem landscapists.
4. See Amsterdam–Boston–Philadelphia 1987–88, no. 56, and Beck 1991, pl. XL (pp. 273–91 for a biography of De Molijn and a selective catalogue of his Van Goyen–like works).
5. For a critical view of individual contributions, see Liedtke 2003 and the extensive literature cited there.
6. See Stechow 1966, p. 26, and Eva Allen's discussion in *Dictionary of Art* 1996, vol. 21, pp. 826–27.
7. See Miedema 1980, p. 1166 (index), for references to these and other records of De Molijn's activity in the guild. On the artist's role in the organization, see Taverne 1972–73; and G. Schwartz and Bok 1990, pp. 102, 172–73. That De Molijn was a prominent member of the guild tempers Taverne's hypothesis that more academic artists and Catholics were in control (see also Montias 1990, p. 370).
8. Houbraken 1718–21, vol. 2, p. 95; supported in A. Davies 2001, pp. 24–25.
9. De Molijn's known drawings are catalogued in Beck 1998.
10. See E. Allen 1987, p. 35, for the document of February 13, 1662.

125. *Landscape with a Cottage*

Oil on wood, 14¾ x 21¾ in. (37.5 x 55.2 cm)
Signed and dated (lower left): P MoLyn/1629 [PM in monogram]

The painting is well preserved. Concentrated in the upper sky at center are small flake losses along the horizontal wood grain.

Gift of Henry G. Marquand, 1895 95.7

This panel, dated 1629, is one of the most accomplished pictures of De Molijn's early period (1625–31). As in the celebrated *Dune Landscape,* of 1626 (Herzog Anton Ulrich-Museum, Braunschweig), and paintings of 1627–28,[1] the artist's subject is a rugged road through countryside near the Dutch coast. The route recedes from the lower left to a sunny area behind the shadowy rise on the right, and then winds past farm buildings and over a hill, where three travelers make their way. The figures (one with a walking stick) lead the eye into the distance, toward the mastlike beacon on the horizon to the right (compare the beacon in the left background of Jacob van Ruisdael's *Wheatfields*; Pl. 182). Another man works on the side of the barn, next to a stack of poles probably intended to hold down roof thatching (compare Pl. 49). The very low roof to the right is the top of a hayrick, which protects hay from rain and can be raised or lowered on corner posts.[2]

De Molijn's contemporaries would have recognized at a glance the rolling dune landscape west of Haarlem, where trees and bushes stubbornly survive in the sandy soil. Turning the distinctive terrain to artistic advantage, De Molijn compares the dense vegetation to the left with the smooth, swirling patches of grass and barren earth in the middle ground. The contrasts

of textures and of green and tan tones are skillfully rendered, and the whole surges to a crest like a wave at sea.

While inspired by the environs of Haarlem, celebrated by writers and printmakers of the time,[3] the picture conveys less topographical fact than poetic evocation. Comparison with De Molijn's etchings dating from 1626 and slightly later,[4] with Van Goyen's *Sandy Road with a Farmhouse,* of 1627 (Pl. 49), and with other compositions of about 1627–29 by De Molijn, Van Goyen, and Salomon van Ruysdael (q.v.) reveals that the pattern employed here is an example of an early Baroque scheme repeatedly imposed upon the local landscape during a brief period of three or four years. Although these Haarlem colleagues found inspiration in woodcuts by Hendrick Goltzius (1558–1617), drawings by Esaias van de Velde (1587–1630), and engravings after artists such as Abraham Bloemaert (q.v.) and Claes Jansz Visscher (1587–1652), they may be credited with defining some of the most durable conventions of landscape painting in the 1620s and 1630s.[5]

As discussed in the entry for Van Goyen's *Sandy Road,* pictures of peasant cottages flourished in the Netherlands during the early seventeenth century, especially in Haarlem, Amsterdam, and Utrecht.[6] Of the values that have been cited in connection with this development — local and national pride, esteem of God's Creation, admiration of life on the land — the last sentiment, which ultimately derives from classical poetry, seems among the most relevant to images of this kind. In 1597, a Dutch translation of Virgil's *Bucolics* and *Georgics* by the Haarlem artist and author Karel van Mander (1548–1606) was published with the folksy subtitle *Ossen-stal en Landt-werck* (Ox Stall and Land Work).[7] De Molijn's idea of "land work" falls

Figure 115. Infrared reflectogram mosaic (detail) of De Molijns's *Landscape with a Cottage* (Pl. 125)

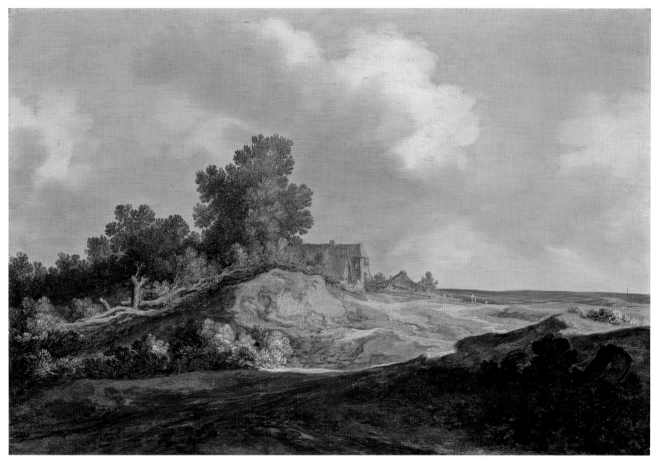

125

within the same tradition of depicting agrarian occupations from a distant, indeed urban, point of view.[8]

Infrared reflectography (fig. 115) reveals careful underdrawing throughout the composition, except in the sky. All the main lines of the landscape are indicated, while the buildings are merely outlined. The trees and bushes are most completely described. No departures from the sketched composition are evident.[9]

1. See the biography above, note 4.
2. This structure appears frequently in Dutch landscapes; see Beck 1991, pls. XLVIII and LI for examples raised to different heights.
3. See Leeflang 1998, which refers to further literature.
4. On the set of four etchings dated 1626, see Freedberg 1980, pp. 38–39, figs. 37–39; London 1986a, no. 53; and Amsterdam 1993, no. 29. The composition of De Molijn's panel is very similar to that found in his etching of the late 1620s *A Peasant on Horseback, Followed by Two Horses, Riding over a Hill* (Hollstein 1949– , vol. 14, p. 71, no. 6).
5. The essential literature includes Stechow 1966, chap. 1, and London 1986a.
6. The literature on this subject is reviewed in Liedtke 2003.
7. Karel van Mander, *Bucolica en Georgica, Dat is Ossen-stal en Landt-werck P. Virgillis Maronis, Prince der Poeten, Nu eerst in Rijmdicht vertaelt* (Amsterdam and Haarlem, 1597). On the Dutch response to Virgil (and Horace), see Spickernagel 1979, p. 135; Leeflang 1998, pp. 66–69; and W. S. Gibson 2000, chap. 6, esp. pp. 128–32 (p. 131 on Van Mander's titles). Each of the fourteen poems in Van Mander's volume begins with a woodcut by Goltzius illustrating one of its main themes (see Amsterdam–Cleveland 1992–93b, pp. 156–72, nos. 35–48).
8. See Liedtke 2003, pp. 24–29, on this tradition and its literature.
9. See ibid., p. 24, fig. 6, comparing underdrawing in paintings by Esaias van de Velde, Van Goyen, and Van Ruysdael. Similar underdrawing is found in De Molijn's *Landscape with an Open Gate,* of about 1630 (National Gallery of Art, Washington, D.C.), except that there is some outlining of clouds, and the trees are less fully described (see Wheelock 1995a, pp. 178–80, fig. 2).

REFERENCES: T. H. Fokker in Thieme and Becker 1907–50, vol. 25 (1931), p. 49, lists the painting; J. Rosenberg, Slive, and Ter Kuile 1966, p. 149, describes the work as "equally original" as the artist's compositions of 1626; Stechow 1966, p. 26, fig. 25, considers the painting rare for its minimal staffage, and as "distinguished by a much more unified sweep than the Berlin picture" of 1628; P. Sutton 1986, p. 190, as "beautifully understated"; E. Allen 1987, pp. 110, 118, 134, fig. 79, suggests that Roelant Savery (1576–1639) may have influenced De Molijn, with regard to the palette employed here; P. Sutton in Amsterdam–Boston–Philadelphia 1987–88, p. 376, fig. 3, as "somewhat tighter and more controlled" than the Braunschweig painting of 1626; New York 1988, p. 97 n. 3, compares a later landscape by Jacob van Moscher (active ca. 1635–55); Liedtke 1990, p. 36, mentions the picture in the context of Marquand's collection; Baetjer 1995, p. 308; Van der Ree-Scholtens et al. 1995, p. 290, fig. 12.24, cites the work as typical of naturalistic landscape painting in Haarlem; Goedde 1997, pp. 134–35, fig. 84, cites the work in connection with a thesis relating the rise of monochrome landscape painting to land reclamation projects of the period; M. Hollander 2002, pp. 36–37, fig. 16, describes the work as an example of a new approach to composition and pictorial space, as compared with Mannerist landscape paintings; Liedtke 2003, pp. 23, 30 n. 25, fig. 3, compares the painting to contemporary works by Van Goyen and Van Ruysdael with regard to conventions of style and meaning, and methods of underdrawing.

EXHIBITED: New York, MMA, "Landscape Paintings," 1934, no. 20; Indianapolis, Ind., John Herron Art Museum, and San Diego, Calif., The Fine Arts Gallery, "The Young Rembrandt and His Times," 1958, no. 53.

EX COLL.: F. T. Robinson, Boston, Mass.; Henry G. Marquand, New York (until 1895); Gift of Henry G. Marquand, 1895 95.7

PAULUS MOREELSE

Utrecht 1571–1638 Utrecht

With Abraham Bloemaert and Joachim Wtewael (q.q.v.), Moreelse was one of the leading masters of the Utrecht school during the first decades of the seventeenth century. His father, Jan Jansz Moreelse (ca. 1544–ca. 1593), a cooper from Louvain, moved to Utrecht by 1568, when he married Jannichen Mertensdr in the local Jacobskerk.[1] According to Van Mander in 1604, Moreelse "trained with Michiel van Miereveld [q.v.] for two years and is an excellent portrait painter."[2] This must have been in Delft during the late 1580s. Moreelse then went to Italy, where he painted portraits and probably gained some knowledge of Italian architecture. He designed the Catherijnepoort (Saint Catherine's Gate; 1621–25), the first classicist structure in Utrecht.[3]

Moreelse returned to Utrecht about 1593 and in 1596 joined the saddlers' guild, to which painters belonged. In 1602, he married Antonia van Wyntershoven, the daughter of a bailiff in the provincial court. From 1605 until his death in 1638, Moreelse and his wife lived in De Hoorn, a house on the Boterstraat in the center of Utrecht.[4] The artist became dean of the saddlers' guild in the spring of 1611, and in September of the same year he became the first dean of the newly established Guild of Saint Luke. This organization of professional painters and sculptors must have been in good part Moreelse's idea; he served again as dean in 1612, 1615, and 1619. Moreelse was also a key figure in the founding of an "academie" for the study of drawing in Utrecht, which probably opened in 1612.[5] Bloemaert and Moreelse appear to have been the principal teachers, and together they had dozens of pupils.[6] Moreelse's most important student was Dirck van Baburen (ca. 1594/95–1624), who was in his studio from 1611 to about 1614.

To judge from Van Mander's account, Moreelse soon established himself as the leading portraitist of Utrecht society. He also painted a commanding portrait of the Amsterdam Archers' Civic Guard Company in 1616 (Rijksmuseum, Amsterdam). He was a good friend of the influential humanist scholar Arnold Buchelius (Aernout van Buchell; 1565–1641) and shared his Calvinist ideas. However, it would appear to have been political opportunism rather than religious conviction that led Moreelse, along with Wtewael and other citizens, to successfully request that the Stadholder, Prince Maurits, dismiss the Utrecht city council in 1618. Moreelse became a member of the new government and remained on the city council for the rest of his life. He appears to have played prominent, if not universally appreciated, parts in many aspects of civic life, including the founding of a university in Utrecht (1636) and a plan to enlarge the city (implemented in 1663 by his son Hendrick, who was a burgomaster and law professor).[7]

Moreelse's public life must have served him well in his already successful career. He painted portraits of fellow city councillors and their wives, such as those of Philips Ram and Anna Ram-Strick, dated 1625 (Centraal Museum, Utrecht). In April 1627, the States of Utrecht presented the new Stadholder, Prince Frederick Hendrick, and his wife, Amalia van Solms, with pastoral genre pictures by Moreelse, *A Shepherd* (Staatliches Museum, Schwerin) and *A Shepherdess* (location unknown), and by the early 1630s the prince also owned three other paintings by the artist.[8] These were not the first works by Moreelse to enter princely collections. In 1611, he was commissioned to paint portraits of Count Ernst Casimir of Nassau, the new lieutenant governor of the Province of Utrecht, and his spouse, Sophia Hedwig, and in 1619 her brother, Duke Christian of Brunswick, was depicted by Moreelse in a portrait that enlivens the Van Miereveld model.[9] In 1621, the painter, with remarkable flair and gravity, portrayed Sophia Hedwig as Charity, with her three sons (Rijksmuseum Paleis Het Loo, Apeldoorn).[10]

In addition to his many portraits in various formats, the more modest of which include images of himself (Niedersächsisches Landesmuseum, Hannover; Mauritshuis, The Hague),[11] as well as of Bloemaert and of Buchelius (both in the Centraal Museum, Utrecht), Moreelse painted mythological scenes and a few religious subjects, including the *Allegory of the Protestant Faith,* of 1619 (Museo de Arte de Ponce).[12] Worldly temptations, which are trampled in the *Allegory,* accompany one of the artist's erotic beauties in the *Allegory of Vanity,* dated 1627 (Fitzwilliam Museum, Cambridge).[13]

Moreelse was buried in Utrecht's Buurkerk (where he had been a churchwarden) on March 6, 1638. He and his wife (who died in 1645) had at least ten children, including the short-lived painter Benjamin Moreelse (ca. 1625–1649). Another

son, Johannes, a painter of great promise, died in the plague of 1634.[14]

1. According to Domela Nieuwenhuis in Braunschweig 2000, p. 46. Between 1577 and 1582, Jan Moreelse bought three houses in the center of Utrecht. He remarried in 1588.
2. Van Mander/Miedema 1994–99, vol. 1, p. 385 (fol. 281v); see also pp. 457–58 on portraits that Van Mander knew.
3. See Kuyper 1994, pp. 265–66, pls. 505, 506.
4. See no. 29 on the plan of Utrecht in San Francisco–Baltimore–London 1997–98, pp. 88–89, and p. 386 for M. J. Bok's biography of Moreelse. A more comprehensive biography by the same Utrecht archivist and art historian is in Amsterdam 1993–94a, pp. 311–12, from which many details are adopted here.
5. See Bok in San Francisco–Baltimore–London 1997–98, pp. 91–94, on the new guild and the academy.
6. As noted by Domela Nieuwenhuis in Braunschweig 2000, p. 48, twenty-eight pupils registered with Moreelse between 1611 and 1624. Most of them did not become professional artists, but were interested in learning to draw.
7. As noted by J. A. L. de Meyere in Dictionary of Art 1996, vol. 22, p. 94. On Moreelse's political maneuvering, see especially Bok in

San Francisco–Baltimore–London 1997–98, p. 311, and Domela Niuewenhuis in Braunschweig 2000, pp. 51–52.
8. De Meyere in Dictionary of Art 1996, vol. 22, p. 94. See Spicer in San Francisco–Baltimore–London 1997–98, pp. 34–35, fig. 13, for the Schwerin Shepherd, and pp. 323–26 (under no. 64), for Moreelse's paintings of sexy shepherdesses dating from 1617 and about 1627.
9. See Beekman in Amsterdam 1993–94a, p. 264 (under no. 264), where the 1611 portraits are also discussed. On the portrait of Christian of Brunswick, see also Braunschweig 2000, pp. 9–13, 69, no. 1.
10. Haarlem 1986a, no. 78.
11. See Braunschweig 2000, pp. 76–77 (under no. 3), and especially Broos and Van Suchtelen 2004, pp. 180–83 (under no. 41), on the known self-portraits.
12. See De Meyere in Dictionary of Art 1996, vol. 22, p. 94, for some examples, and, for the Ponce painting, San Francisco–Baltimore–London 1997–98, p. 188, fig. 1. The standard monograph on Moreelse, De Jonge 1938, should be superseded by that of Eric Domela Nieuwenhuis.
13. See San Francisco–Baltimore–London 1997–98, pp. 193–96 (under no. 21).
14. Ibid., pp. 326–29 (under no. 65), 385–86 (biography).

STYLE OF PAULUS MOREELSE

126. *Portrait of a Young Boy*

Oil on wood, oval, 23 x 19⅝ in. (58.4 x 49.8 cm)

This portrait is thinly painted and, although rigorously cleaned, remains in fair condition. There are minor losses, scratches, and abrasions distributed across the surface. The originally rectangular oak panel was refashioned in the past into its present oval shape and cradled. Microscopic examination reveals remnants of a red lake glaze in the slits of the sleeves, suggesting that these touches and the decorative bows at the waistline that now appear a dull brown were originally more colorful. The decoration on the doublet was created by painting the black pattern on top of an even application of golden yellow. Examination with infrared reflectography reveals underdrawing beneath the eyes, along the side of the child's proper right cheek, at the corners of the mouth, and marking the top of the shoulders. The eyes were not painted over the underdrawing but placed a bit higher.

Bequest of Alexandrine Sinsheimer, 1958 59.23.17

This charming portrait certainly represents a young boy, to judge from his attire. The collar follows adult male fashion of about 1637, a date consistent with the style of lace on the collar and cuffs (the lace on the cap is old-fashioned, suggesting that it was made about 1630). The doublet is decorated with gold passementerie; brownish gold bows and silver aglets surround the waist. The aglets were used to lace breeches to the doublet, or were merely symbolic of boyhood, when the child had not yet graduated from skirts to pants.[1]

The painting was listed as an attribution to Moreelse in De Jonge's 1938 monograph (see Refs.). Rudolf Ekkart considered the picture to be by Moreelse himself when he studied the work at the Museum in 1988. However, Eric Domela Nieuwenhuis, in his dissertation on the artist, considers the painting to be neither by Moreelse nor from his workshop, and not even from the artist's city of Utrecht.[2] In the present writer's opinion,

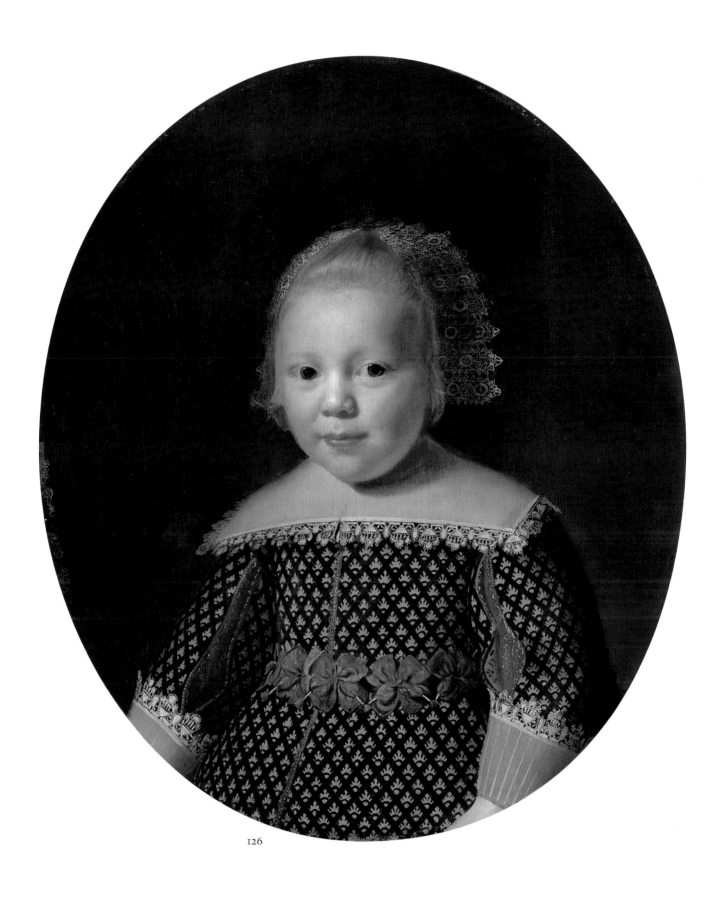

126

which is shared by Ekkart,[3] the picture was probably painted in Utrecht and may be from Moreelse's studio.[4]

The panel is unusually broad for an oval support of the 1630s. This impression, examination of the edges, and the uncomfortable truncation of the figure suggest that the work was originally rectagular.

Previously catalogued by the Museum as by Paulus Moreelse and titled *Portrait of a Child*.

1. The Dutch costume scholar Marieke de Winkel kindly identified all the elements of costume, in a personal communication sent under the heading, "It's a boy!" on December 21, 2006.
2. Personal communication, July 6, 2004, referring to no. SZP41 in his doctoral dissertation, "Paulus Moreelse (1571–1638)," Leiden University, 2001. Domela Nieuwenhuis saw the picture in 1995.
3. Oral communication, December 2, 2004.
4. The condition of the paint layer hinders judgment of quality, but the execution of the head appears to be by a better hand than the one responsible for the flat and rather mechanical execution of the doublet, lace collar, and cuffs. See Domela Nieuwenhuis in Braunschweig 2000, p. 48, on the known members of Moreelse's workshop. The artist is especially admired for his portraits of children. Perhaps the finest is the *Portrait of Two Young Girls in Pastoral Dress,* of 1622 (Instituut Collectie Nederland, on loan to the Centraal Museum, Utrecht; see Helmus 1999, vol. 1, pp. 147–49, and Haarlem–Antwerp 2000–2001, no. 20). A full-length portrait of a four-year-old boy with a *colf* stick is in the Michaelis Collection, Cape Town (Fransen 1997, no. 42). Other portraits of children by Moreelse are catalogued and illus- trated in De Jonge 1938. See also Haarlem–Antwerp 2000–2001, on Dutch and Flemish portraits of children, where Moreelse's impressive *Young Girl ("The Princess"),* of about 1620 (Rijksmuseum, Amsterdam), is discussed on pp. 127–29 (under no. 18).

REFERENCES: "Der Kunstmarkt," *Der Cicerone* 10 (1918), p. 260, records the painting's sale in Amsterdam (see Ex Coll.); Hirschmann 1923, p. 130 (ill. p. 131), describes the picture, "of charming naïvity," as one of the Dutch portraits in the Preyer collection; Comstock 1927, p. 42 (ill. p. 43), erroneously reports that "the portrait remained in the family of the sitter until 1918 when it was purchased by A. Preyer of The Hague";[1] De Jonge 1938, pp. 112–13, no. 224, fig. 146, as attributed to Moreelse, datable about 1630–35, "from Castle Biljoen"; Burn 1984, p. 28 (ill.), notes the fine details and sweet expression; P. Sutton 1986, p. 184, mentioned; Baetjer 1995, p. 298, as by Moreelse.

EX COLL.: Biljoen Castle, Velp, Gelderland (until 1918; sale, Frederik Muller, Amsterdam, May 28, 1918, no. 174, for Fl. 12,100 to Preyer); A. Preyer, The Hague (1918–at least 1926); [Knoedler, New York, ?1926–at least 1927]; Alexandrine (Mrs. A. L.) Sinsheimer, New York (until 1958); Bequest of Alexandrine Sinsheimer, 1958 59.23.17

1. This assumption appears to be based on the fact that in the Amsterdam sale catalogue of May 28, 1918 (see Ex Coll.), the work is listed in section I, "L'ancienne collection du Chateau de Biljoen." But this castle is not even in the Province of Utrecht, and has changed hands a number of times since 1661. Members of the Lüps family have owned the castle since 1872.

EMANUEL MURANT

Amsterdam 1622–1700 Leeuwarden

Until recently, the main source of information on Murant's life was the account in Houbraken's *Groote Schonburgh* (Great Theater) of Netherlandish painters, published in 1718–21. The details appear to have come from the artist's brother, David, and are largely consistent with newly published documentation. A literal translation reads:

> Herewith Emanuel Murant, born at Amsterdam in the same Year [1622], on the 22nd of December, takes the Stage. His disposition led him to the depiction of Dutch Village and Landscape views, and in particular to the depiction of dilapidated peasant sheds and cottages, which he depicted in such a detailed way that one could count the bricks in the masonry; from which it certainly may be estimated that he did not bring a large number of Paintings into the world; considering that such a manner of painting takes a lot of time. His Brother David Murant, in Amsterdam, owns the greater part of his artworks that are in the country, for he [the painter] travelled for many Years in France and elsewhere. His art is desired especially in Friesland; where he took himself to live. He died at Leeuwarden in the Year 1700. He was a pupil of *Philip Wouwerman*.[1]

The date of Emanuel's birth must be correct, since he was baptized in the Oude Kerk, Amsterdam, three days later, on December 25, 1622.[2] He is documented as in Leeuwarden between July 1670 and 1680, and was still a resident there, "aged 74 years," in 1696.[3] Murant's burial is not recorded, but Houbraken's reference to the very day of his birth suggests that the report of his death in 1700 is probably reliable.

The artist's parents were Esaias Davidsz Meurant (1588–1664), of Amsterdam, and Margaritha Meulemans (ca. 1593–1665 or later), of Antwerp. They married in Amsterdam on March 7, 1622. From November 1, 1628, until January 18, 1630, the couple rented a house on the Koestraat (a short street east of the Dam), which they then purchased for 2,660 guilders. The house was one of four built about 1600 by the city of Amsterdam next to the Old Side Latin School, where Esaias Meurant (as he spelled his surname) started teaching in 1622.[4] He was also the author of several poetry collections, one of which (*De verzen van Morandt*, now lost) was condemned

about 1626 by Joost van den Vondel for its sympathy with the orthodox Calvinist Franciscus Gomarus.[5] This prepossession is not surprising, considering that Meurant attended the University of Geneva (Calvin's city), where he enrolled on September 9, 1614.

The artist probably attended the New Side Latin School, to which his father was transferred in 1634. Houbraken's statement that Murant studied with Philips Wouwermans (q.v.) is plausible; this must have been in the early 1640s, shortly after the slightly older Haarlem artist joined that city's guild. Murant's "many years in France and elsewhere" may tentatively be dated between about 1642 and 1648, when he is completely undocumented. On October 8, 1649, he acted as a witness for his father in Amsterdam.

The earliest known painting by Murant appears to date from 1652.[6] About that year he was also employed by the Amsterdam Admiralty, evidently as secretary of a fleet commanded by Sipke Fockes (who was killed early in 1653). Murant refers to his experience as "onetime writer for the fleet" in the *album amicorum* of Jacob Heyblocq (1623–1690), a poet in Latin and Dutch and teaching colleague of Esaias Meurant.[7] Emanuel contributed two drawings and four amusing lines of Latin verse to the album.

On September 4, 1654, "Emaniwel Meurant of Amsterdam, age 32 years, Painter, asst. by his Father Esaias Meurant, [who] lives in the Koestraat," married Elisabeth Aswerus [also Assuerus; ca. 1623–before 1670], age 31 years, no parents, also Koestraat." The couple had at least two children, Esaias (b. 1656) and Catharina (b. 1658), one of whom (probably the newborn) died in 1658. Murant's wife evidently died between 1665 and 1670.

Emanuel was the oldest of six children. His brothers Vincent and David became merchants, his sisters Beatrix and Elisabeth married during the 1650s, and his sister Catharine apparently never married. Several documents suggest that Emanuel was not the most successful or responsible member of the family. This probably accounts for his leaving Amsterdam by 1665, when the inventory of his father's estate describes him as living in Naarden. His move there must be connected with the fact that his aunt Anna (Esaias Meurant's sister) lived in Naarden with her husband, Jan Marcus. However,

from no later than 1670 onward Murant lived in Leeuwarden. He married there, for a second time, on October 16, 1670, three months after he and Berberke Willems (b. 1629?) posted their marriage banns. Daughters were born to the couple in 1671, 1673, and 1676.

Emanuel may have been drawn to Leeuwarden by family connections. His brother Vincent's aunt by marriage, Catrina Valckenier, had a brother Daniel who was mintmaster of the States of Friesland, in Leeuwarden. It is also possible that Emanuel's move to Leeuwarden had something to do with the innkeeper, art dealer, and painter Casparus Hoomis (1630–1677), who grew up on the Koestraat in Amsterdam but is recorded in Leeuwarden from 1665 until his death. When Casparus was nine, his mother married the accomplished landscape painter, topographical draftsman, and etcher Anthonie Waterloo (1609–1690). Murant would have taken an interest in Waterloo, who made large, detailed topographical views of Amsterdam sites between 1650 and 1653.

Murant's early paintings of cottages and barns in rural landscapes are reminiscent of Wouwermans, Paulus Potter (1625–1654), and the Haarlem artists Cornelis Decker (ca. 1615–1678) and Roelof van Vries (q.v.).[8] Works of the 1650s already reveal detailed passages of brickwork, which anticipate the more minute descriptions found in paintings such as the one discussed below and pictures by Jan van der Heyden (q.v.). The latter artist also lived on the Koestraat, but only from 1680 to 1681.[9] Nonetheless, the painters must have been aware of each other through the Amsterdam painters' guild and other art-world connections. It has been suggested that Murant influenced Van der Heyden's work, which is plausible, but Van der Heyden may also have returned the favor, and other artists, for example Daniël Vosmaer (1622–1669/70) and Pieter de Hooch (q.v.), shared their interest in picturesque passages of masonry.[10]

1. Houbraken 1718–21, vol. 2, p. 102.
2. Gemeentearchief Amsterdam, Oude Kerk, 6/36. All the details in the present biography come from the more comprehensive account of Murant's life published in Liedtke and Bakker 2006. That article supersedes and occasionally corrects the information published in Bredius 1937a. Piet Bakker combed the archives of Amsterdam on the writer's behalf and checked details recorded in Leeuwarden.
3. Bakker transcribed the document, which is preserved in the Historisch Centrum Leeuwarden, Informatieboeken, c6, fol. 16/17, March 11, 1696. It records "Emanuel Murant, art-painter [living] on the Grachtswal outside this city, age 74 years," as discovering the suicide of an acquaintance. Klaas Zandberg of the HCL kindly brought this document to my attention.
4. Breen 1913b, p. 110.
5. Sterck 1916–17, pp. 14–20.
6. See Liedtke and Bakker 2006, fig. 1 (location unknown). The article concludes with a list of paintings by Murant in public collections. A reliable list of dated paintings is provided in Krempel 2005, p. 196 n. 2.
7. For the contributions of both Murants to Heyblocq's *album amicorum,* see Thomassen and Gruys 1998, pp. 30, 117–19, 122–24.
8. See Bol 1982c, pp. 220–24.
9. Breen 1913b, pp. 109–18.
10. For Vosmaer, see New York–London 2001, pp. 421–25. Bol 1982c, p. 224, and Keyes in Keyes et al. 2004, p. 138, are particularly insistent on Murant's precedence over Van der Heyden.

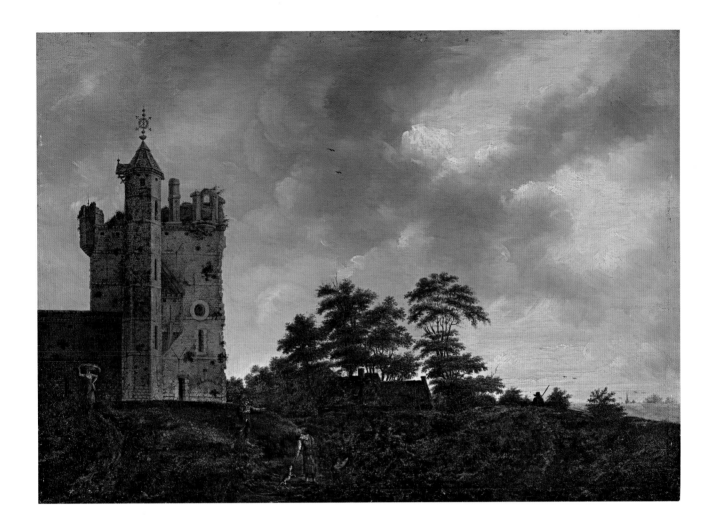

127. *The Old Castle*

Oil on wood, 15⅝ x 21⅞ in. (39.7 x 55.6 cm)

The painting is in good condition, although the foreground has darkened over time, making details less distinct. Portions of the hexagonal tower are worn, and a network of fine cracks in the castle developed as the paint dried. The sky is very well preserved.

Theodore M. Davis Collection, Bequest of Theodore M. Davis, 1915 30.95.260

Although not signed, the painting is entirely consistent in execution with works by Murant that bear his usual inscription, "E.M." Few of his pictures are dated, and his small known oeuvre allows little more than chronological conjecture. The subject, composition, and comparisons with works by other Dutch artists, especially Jan van der Heyden (q.v.), suggest a tentative dating between about 1665 and 1680.

The painting depicts part of a ruined Late Medieval castle of a type common in the Netherlands. The stair tower is crowned by a weather vane, but there are no signs of recent habitation. (Many Dutch castles were ruined in the late sixteenth century, during the war with Spain.) A farmhouse nestles near a stand of trees in the center of the composition. To the left, a woman with a large basket of washing on her head comes down a pathway. A man on the grass points in the direction of the traveler over the hill to the right. In the center foreground, a woman plays with a dog, and a boy behind her also points in the approximate direction of the wayfarer. Each male figure carries a stick. The tower of a church and a glimpse of a few other buildings appear beyond the sunlit field in the right background.

The artist has achieved a balanced composition by arranging motifs parallel to the picture plane and by using the left side of the panel like a buttress. Each section of the painting is

Figure 116. Detail of Murant's *The Old Castle* (Pl. 127)

Van der Heyden, for example, the undated *Houses at the Edge of a Town* (formerly Los Angeles County Museum of Art), and *A Pavilion near Goudestein on the Vecht,* dated 1666 (art market, 1938).[2] As discussed in the biography above, Murant painted impressive passages of brickwork before Van der Heyden did the same, but the meticulous degree to which he defined the masonry in the Museum's picture strikes one as a response to Van der Heyden's seemingly obsessive standard.

In more general terms, the subject does not recall works by Van der Heyden but of artists who painted picturesque fragments of medieval architecture in country settings. Jan van Goyen's *Pelkus Gate near Utrecht* (Pl. 51) and Roelof van Vries's *Pigeon House* (Pl. 215) are good examples; in the discussion of the latter painting, works by Claes Molenaer (1628/29–1676) and by Cornelis Decker (ca. 1615–1678) are also mentioned. The subject of ruins in Dutch art has recently been explored.[3] In Murant's picture, a contemporary viewer might have discovered evidence that while man's most durable monuments pass away in time, life goes on. But the same viewer would have come to these conclusions on a walk in the country, and that common pleasure, both here and in his work overall, is Murant's essential subject.

1. Julius Böhler, Munich. The undated panel measures 16⅝ x 19⅜ inches (42.2 x 49.3 cm). A color image, clipped from an unidentified German art magazine, is in the Sperling photograph files, Department of European Paintings.
2. Wagner 1971, nos. 115, 129. The Los Angeles panel was sold at Christie's, New York, January 14, 1993, no. 46.
3. See Poughkeepsie–Sarasota–Louisville 2005–6.

REFERENCES: H. Gerson in Thieme and Becker 1907–50, vol. 25 (1931), p. 281, listed; Baetjer 1995, p. 328; Liedtke and Bakker 2006, p. 241, figs. 3, 4 (detail), briefly discusses the painting in a biographical essay on Murant.

EX COLL.: [Durand-Ruel, Paris and New York; sold to Davis on May 6, 1892, for $600]; Theodore M. Davis, Newport, R.I. (1892–d. 1915); Theodore M. Davis Collection, Bequest of Theodore M. Davis, 1915 30.95.260

executed in a carefully routine manner. The clouds in the blue sky are evoked by a patchwork of impasto touches, the grass by scumbling green and brown blotches on the warm ground layer (an area crudely reminiscent of the young Jacob van Ruisdael; see Pl. 179), and the trees reveal a systematic pattern of strokes and dabs. Most remarkable—and meant to be recognized as such—is the minute description of brickwork on the castle, relieved here and there by metal braces, isolated outbreaks of foliage, and various apertures (fig. 116). Examination with a microscope reveals that all the masonry was painted freehand with a tiny brush, probably with the help of a magnifying glass. The irregular horizontal bands are hatched by vertical ticks, many of them white or white and dark gray together, which creates the impression of daylight catching the edges of bricks.

A similar painting by Murant is a view of a village bordered by a stream and pastureland, with a narrow brick house at the left. The panel, close in size to this one, was on the art market in 1968.[1] There are a few broadly comparable compositions by

MATTHIJS NAIVEU

Leiden 1647–1726 Amsterdam

The son of a wine merchant from Rotterdam and a woman from Leiden, Naiveu was baptized in the Hooglandse Church in Leiden on April 16, 1647.[1] Two brothers (baptized in 1649 and 1651) and evidently a daughter were also born there.

Houbraken records that Naiveu studied drawing with Abraham van Toorenvliet (ca. 1620–1692) and then painting with Gerrit Dou (q.v.).[2] Receipts for tuition confirm that Naiveu was instructed by Dou between 1667 and 1669.[3] In 1671, he became a member of the Guild of Saint Luke in Leiden, to which he paid dues through 1677. He was *hoofdman* (headman) of the guild between 1677 and 1679.

Naiveu married a widow, Agatha van Strichtenhuyse, on January 4, 1675. A son, Matheus, was baptized on October 6 of the same year, and a daughter, Susanna, on December 1, 1677. The family moved to Amsterdam in the second half of 1678 or in 1679. When Naiveu and his wife made out their will in December 1691, they were said to be living on the Prinsengracht near the Spiegelgracht.

In 1696, Naiveu was appointed inspector of hops in Amsterdam. Houbraken, writing about 1720, notes that despite this position and his advanced years, Naiveu still painted with pleasure every day. Naiveu's wife died in 1722, and the artist died at the age of seventy-nine on June 4, 1726.[4]

Naiveu is known for portraits and genre scenes. He also painted allegorical and religious pictures; Houbraken describes a painting of The Seven Acts of Mercy as the artist's most important work.[5] Naiveu's style recalls that of Willem van Mieris (1662–1747) in its decorative details, but the dryness of his descriptive manner is generally more reminiscent of followers of Dou such as Quirijn van Brekelenkam, Pieter van Slingelandt (q.q.v.), and Dominicus van Tol (after 1630–1676).

A painting that is almost certainly an early self-portrait, signed and dated 1670, was recently on the market.[6] The composition derives from the Museum's *Self-Portrait* by Dou (Pl. 37) or from some closely related picture.

1. See Leiden 1988, p. 186, for a reliable biography in Dutch that cites a number of original documents. The Hooglandse Church was Dutch Reformed.
2. Houbraken 1718–21, vol. 3, p. 228.
3. W. Martin 1902, p. 64, cited in Leiden 1988, p. 186.
4. This date and other details, which correct earlier accounts (for example, the biography in Philadelphia–Berlin–London 1984, p. 267), are published with documentation in Leiden 1988, p. 186.
5. Houbraken 1718–21, vol. 3, p. 228. This must be the large panel, signed and dated 1705, that was sold at Sotheby's, London, April 10, 1986, no. 13. The tower of the Westerkerk in Amsterdam appears in the background. A few still lifes are also known (see Gemar-Koeltzsch 1995, vol. 3, p. 727).
6. Sotheby's, New York, January 11, 1996, no. 68. Hoet 1752–70, vol. 1, p. 558, no. 52, lists "The Portrait, of M. Neveu in a Niche, painted by himself," in an Amsterdam sale of October 1, 1738. This and another work are listed (mistakenly as three works) in Moes 1897–1905, vol. 2, p. 131. The other self-portrait is a knee-length composition dated 1675, as recorded in Van Hall 1963, p. 225.

128. *The Newborn Baby*

Oil on canvas, 25¼ x 31½ in. (64.1 x 80 cm)
Signed and dated (lower left): M: Naiveú F./1675

The painting is in good condition, although there is slight abrasion in the torsos and heads of the mother and the nurse-midwife.

Purchase, 1871 71.160

The picture celebrates the arrival of a newborn baby and was painted in 1675, the year in which the artist himself married and became a father for the first time. However, the subject was traditional and popular in the 1660s, to judge from paintings by Gabriël Metsu (Pl. 118), Jan Steen, Eglon van der Neer (q.q.v.), and others.[1] In slightly later years, the theme flourished in art and literature, for example with paintings by Naiveu of about 1700 such as *The Lying-in Room,* in Leiden (fig. 117), and plays such as Thomas Asselijn's *Kraem-bedt* (Birthbed), of 1683.[2] The Amsterdam genre painter Cornelis Troost (1696–1750) followed Naiveu in presenting the scene as if it were set on a stage. The present picture's composition, the more theatrical look of the painting in Leiden, and Naiveu's other representations of theatrical subjects underscore the connection with popular plays.[3]

Compared with Metsu's description of the same social ritual — a *kraambezoek,* or "lying-in visit" — Naiveu characteristically takes a more literal approach. The convalescent mistress of the house is attended by an old nurse-midwife, who serves a bowl of porridge; it may be flavored with anise, which was thought to encourage the flow of mother's milk or to relieve cramps.[4] A visiting lady, elegantly turned out, holds the tightly swaddled infant on her lap.[5] A pot of hot coals has been placed in the foot warmer. The luxurious fabrics covering the wicker cradle, the table, the bed, and the mother herself were special features of a *kraamkamer,* or birthing room, which was usually set up temporarily in a town house.[6]

The covered glass goblet on the table contains *kandeel,* a drink usually made with wine, sugar, cinnamon, and other spices. A cinnamon stick, lemon slices, and probably egg white (on the bottom) complete the concoction, which was intended for guests. On the plate is a little bowl of bread or pastry filled with *muisjes* (little mice), sugar-coated caraway seeds or cinnamon sticks made as treats for children. Another bowl of *muisjes* delights the little girl.[7]

The Steen-like vignette in the background shows the new father smoking a pipe and celebrating with four male companions. A maid hands around another goblet of *kandeel* while the father is toasted with a glass of wine.[8] As in Metsu's picture (Pl. 118), a large stormy seascape reminds one of life's

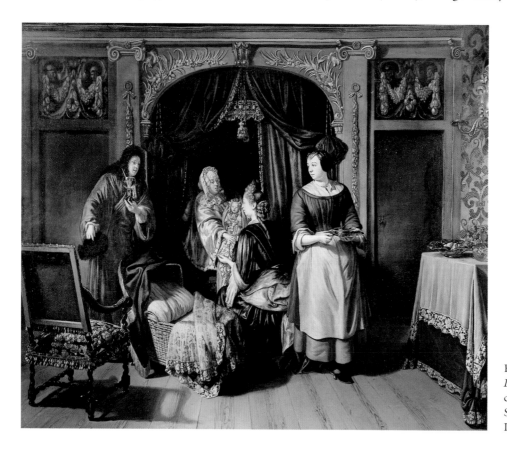

Figure 117. Matthijs Naiveu, *The Lying-in Room,* ca. 1700. Oil on canvas, 27¾ x 34¼ in. (70.5 x 87 cm). Stedelijk Museum De Lakenhal, Leiden

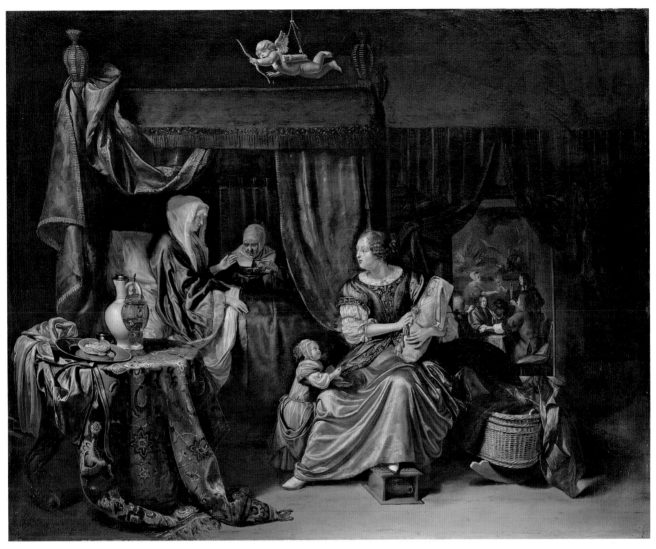

128

uncertainty.[9] The sculpted cupid that swings aloft at top center is an uncommon motif in this context but probably refers to the newborn.[10]

1. On Steen's *Celebrating the Birth*, 1664, in the Wallace Collection, London, see Ingamells 1992a, pp. 350–53; Westermann 1996, pp. 120–22, compares the Naiveu in Leiden (fig. 117 here). Van der Neer's *Visit to the Nursery*, also of 1664, is in the Koninklijk Museum voor Schone Kunsten, Antwerp. A painting of the subject by Hieronymus Janssens (1624–1693) is known from an Amsterdam sale of 1893; see Lunsingh Scheurleer 1971–72, p. 302, fig. 4b (incorrectly attributed to Gonzales Coques), and Worcester 1983–84, pp. 70, 75 n. 7, fig. 18d. Case studies of child-rearing practices in the Netherlands are considered in B. Roberts 1998.

2. See Leiden 1988, no. 58, on Naiveu's canvas in Leiden, and p. 190 n. 6 on Asselijn's play. Another painting of the subject by Naiveu, from shortly after 1700, was at Christie's, New York, January 11, 1989 (no. 31), and May 31, 1990 (no. 47).

3. On this point, see Sluijter in Leiden 1988, p. 190, which cites Niemeijer 1973, nos. 591–601 (paintings by Troost). The Flemish artists Jan Josef Horemans the Elder (1682–1759) and especially Jan Josef Horemans the Younger (1714–after 1790) also referred to seventeenth-century precedents when painting the subject (see Worcester 1983–84, no. 18).

4. As noted by the Dutch food historian Peter Rose in Albany 2002, p. 94.

5. Lunsingh Scheurleer 1971–72, pp. 315, 318, fig. 14, discusses the swaddling clothes of the time and illustrates an anonymous painting of 1621 depicting quadruplets, three of whom survived and are bundled up in the same way.

6. On the arrangement of a *kraamkamer*, see Wijsenbeek-Olthuis 1987, pp. 156–57; Loughman and Montias 2000, p. 85; and Fock et al. 2001, p. 174.

7. Peter Rose first described these details in a visit to the Museum in 1992, and treats them more fully in Albany 2002 (under nos. 33 and 40). On the rusklike bowl of bread, which is variously known as a *kindermaandstik*, *kindermaanstuk*, or *zottinnekoecken*, see Schotel 1868, pp. 29–30, and Albany 2002, p. 94.

8. See Schotel 1868, p. 27, on the customary drinks.

9. See Goedde 1989, p. 156.

10. Barnes in Albany 2002, p. 94, states that the Cupid signifies "that this child was conceived in love." The sentiment is modern and finds little support in seventeenth-century sources. The figure recalls Hansje in de Kelder (Little Hans in the Cellar), who occasionally took the form of a little Cupid (see Lunsingh Scheurleer 1971–72, pp. 298–302, figs. 1–3). Silver and porcelain cups that are known by this name have a miniature figure inside a central stem or mound, the "cellar." When the cup is filled with wine the figure pops up, which in the proper context stands for the birth of a child. Cupids also occur as helmsmen on little ships, a motif that was engraved on glass goblets meant to celebrate childbirth (ibid., p. 301). Some examples are inscribed with the saying, "Het wel afloopen van het Scheepje," meaning "[Here's to] a good start for the little ship." The term *scheepje* relates to the seascape as a symbol for the course of life.

REFERENCES: MMA 1872, no. 102, as *The Invalid*, P. Sutton 1986, p. 188, mentioned; Leiden 1988, pp. 72, 190, fig. 64, compares the Museum's picture with an illustration in an instruction book for midwives published in 1591; Baetjer 1995, p. 342; Gaskell 2000, p. 242 n. 51, compares the Cupid motif with its use by Vermeer; Barnes and Rose in Albany 2002, p. 94, describe the subject and various motifs; Baetjer 2004, p. 208, no. 102, gives provenance; Franits 2004, pp. 233, 298 n. 60, fig. 215, observes that the picture dates from 1675, "the year of the artist's own marriage and of the birth of his first child."

EXHIBITED: Nashville, Tenn., Fisk University, 1951; Atlanta, Ga., Atlanta University, 1951–52; New Orleans, La., Dillard University, 1952; The Elms, Newport, R.I., extended loan between 1962 and 1974; Albany, N.Y., Albany Institute of History and Art, "Matters of Taste: Food and Drink in Seventeenth-Century Dutch Art and Life," 2002, no. 33.

EX COLL.: [Léon Gauchez, Paris, with Alexis Febvre, Paris, until 1870; sold to Blodgett]; William T. Blodgett, Paris and New York (1870–71; sold half share to Johnston); William T. Blodgett, New York, and John Taylor Johnston, New York (1871; sold to MMA); Purchase, 1871 71.160

AERT VAN DER NEER

Gorinchem 1603/4–1677 Amsterdam

The landscape painter Aert (Aernout) van der Neer was probably born in or near Gorinchem in 1603 or 1604.[1] He was the son of Egerom (or Igrom) Aertsz van der Neer, a *majoor* (steward or estate manager) at Fort Suikerberg in Klundert (North Brabant), and his wife, Aeltje Jansdr (they married on December 29, 1602). According to Arnold Houbraken, the artist also served as a *majoor* in his youth, for the lords of Arkel, who had an estate in the village of Arkel just north of Gorinchem.[2] The city (also called Gorcum or Gorkum; see Pl. 185) is on the river Waal, to the east of Rotterdam and south of Utrecht.

It is not known where or when Van der Neer trained as an artist. However, his certificate of marriage, issued on March 16, 1629, in Amsterdam, describes him as a "painter, 25 years old." Two weeks later, he married the twenty-year-old Lijsbeth Govaertsdr, of Bergen op Zoom.[3] The ceremony took place in the Nieuwe Kerk, where the Reformed couple's sons Pieter (1640–before 1648) and Pieter II (1648–before 1683) and daughters Cornelia (1642–1683) and Lijsbeth (1645–before 1675) would later be baptized.[4] The birth dates of two other sons, Eglon (q.v.) and Johannes (1637/38–1665), are not recorded. Johannes is known as his father's assistant and imitator. Eglon van der Neer (q.v.) enjoyed great success as a genre painter.

Van der Neer was strongly influenced by the work of two landscapists from Gorinchem, the brothers Rafael Govertsz Camphuysen (1598 or 1606–1657) and Jochem Govertsz Camphuysen (1601–1659).[5] Jochem moved to Amsterdam around 1621 and Rafael about a year later.[6] Van der Neer and Jochem collaborated on a landscape painting dated 1633.[7]

As one might expect of an artist who moved from a small city to Amsterdam, Van der Neer gleaned ideas from a variety of sources. The influence of the Flemish immigrant Alexander Keirincx (1600–1652) is evident in his work of about 1635, while Gillis van Coninxloo (1544–bur. Jan. 4, 1607), Roelant Savery (1576–1639), and Gillis d'Hondecoeter (ca. 1580–1638) have also been cited in connection with the painter's early style.[8] His trees, often shaped like broccoli *en branche,* and his tunnel-like recessions derive from the Flemish tradition of these artists, all of whom worked at some time in Amsterdam,[9] inspiring Van der Neer's eclecticism and turning his eye to the picturesque.[10]

Van der Neer's more empirical interests, by contrast, depended upon the pioneering efforts of Dutch painters and printmakers such as Willem Buytewech (1591/92–1624) and Esaias van de Velde (1587–1630; see the discussion under *The Farrier;* Pl. 129), and upon his own considerable powers of observation. Haarlem painters such as Van de Velde, Jan van Goyen, and Pieter de Molijn (q.q.v.) provided examples of compositional schemes and subjects such as river, winter, and nocturnal views.[11] Van der Neer himself must be credited with the naturalistic qualities of light, color, and atmosphere, and with the panoramic sweeps of space (enhanced by curved horizons), that lend his paintings their distinctive and sometimes experimental appearance.

In the painter's later years, poverty went hand in hand with low prices, high volume, repetition, and diminished quality. Van der Neer was cited as a taverner on the Kalverstraat in 1659 and in 1662. Late in 1662, he went bankrupt and became a widower. From then on he lived and worked in a state of considerable hardship, until his death on November 9, 1677.

1. See Bredius 1900, p. 71. The most reliable biography is found in Schulz 2002, pp. 9–15, where it is said that "later documents allow us to establish with some certainty" that the artist was born in 1604 (p. 9). However, a birth date in the last quarter of 1603 would also be consistent with those documents (he was twenty-five in March 1629, and forty-three in July 1647; ibid., pp. 10, 11), and with the marriage of Van der Neer's parents at the very end of 1602.
2. Houbraken 1718–21, vol. 3, p. 172.
3. See Schulz 2002, pp. 10, 21, which corrects the present writer's suggestion (in New York 1985–86, p. 255) that she was probably the sister of the Gorinchem landscapists Rafael Govertsz and Jochem Govertsz Camphuysen.
4. Schulz 2002, pp. 11, 117.
5. Bachmann 1982, chaps. 1, 2. See also Bachmann's articles of 1968, 1970, and 1975; and Tissink and De Wit 1987, pp. 73–75, on the Camphuysens in Gorinchem. The Camphuysens are also discussed at some length in Schulz 2002, pp. 20–38, on the artistic development of Van der Neer's early years.
6. Bachmann 1980, p. 9 (this 79-page booklet on Rafael Camphuysen illustrates fourteen of his paintings and a few comparative pictures). See also Schulz 2002, pp. 20–22.

7. Bachmann 1975, p. 215, fig. 1 (n. 8 on the signatures); Bachmann 1982, p. 20, pl. 2; Schulz 2002, p. 395, no. 1065, pls. 23, 75. The picture was at the P. de Boer Gallery, Amsterdam, in 1972. The only earlier known dated painting by Van der Neer is, unexpectedly, a genre scene of 1632 (Oblastní Galerie, Liberec) reminiscent of the Gorinchem artist Jan Olis (ca. 1610–1676) or of Pieter Quast (q.v.): see Seifertová-Korecká 1962; Bachmann 1982, p. 18, pl. 1; Schulz 2002, p. 478, no. 1447, pl. 70.

8. For example, in Bachmann 1975. See also Schulz 2002, pp. 27–30.

9. See Briels 1987, pp. 297–355. The Flemish tradition of landscape painting was particularly influential in the southern part of the Province of Holland, where Gorinchem is located. Compare landscape painting in the South Holland city of Delft, which is discussed in New York–London 2001, pp. 83–86, 264–65.

10. These qualities are undervalued in Bachmann 1982; see John Walford's review in *Burlington Magazine* 125 (1983), pp. 759–60.

11. See Schulz 2002, pp. 39–46, on moonlit landscapes, and pp. 66–88, on winter scenes.

129. *The Farrier*

Oil on wood, 19 x 24⅛ in. (48.3 x 61.3 cm)
Signed (lower left): AV DN [AV and DN in monogram]
The painting has suffered slight abrasion overall.
Purchase, 1871 71.60

This dark painting represents a blacksmith's shop at the edge of a river, with a wooded area at the opposite side. The moon is low in the sky, which is brighter above; it must be late in the day. The smithy hammers at an anvil next to a flaming forge. A horse stands in an exterior stall, where a man, presumably the horse's owner, seems to huddle in the cool evening air. To the right, a man and two boys warm themselves by a blazing fire. Logs lie side by side in the foreground; the large basket nearby may have been used to gather kindling.

Nocturnal landscapes were a popular subject of Dutch painters and printmakers from about 1620 onward, and were inspired in part by the well-known engravings of Hendrick Goudt (1583–1648) after Adam Elsheimer (1578–1610).[1] *The Flight into Egypt,* Goudt's print dated 1613, anticipates this and similar paintings by Van der Neer in its virtuoso study of various light sources, including the moon and a campfire.[2]

Nocturnes were depicted only occasionally between 1620 and about 1645, by painters such as Esaias van de Velde (1587–1630) and Pieter de Molijn (q.v.).[3] The works of these and other Haarlem artists, which include the influential engraving *Ignis (Fire),* by Jan van de Velde (1593–1641) after Willem Buytewech (1591/92–1624),[4] are often remarkable for their observation of unusual light effects, and seem free of obvious schematization (unlike nocturnal compositions by Caravaggesque contemporaries). In the 1640s, night scenes in both interior and exterior settings flourished in such different fields as reli-

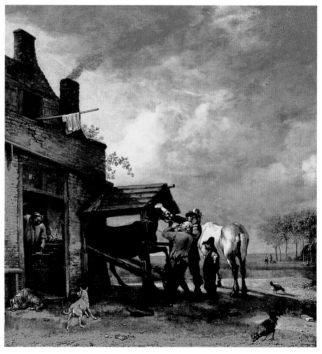

Figure 118. Paulus Potter, *The Farrier's Shop*, 1648. Oil on wood, 19 x 18 in. (48.3 x 45.7 cm). National Gallery of Art, Washington, D.C., The Widener Collection

gious paintings, architectural views, and landscapes.[5] Among the most familiar examples in Van der Neer's field are works by Jan Asselijn (ca. or after 1610–1652), Nicolaes Berchem, Jan van Goyen, and Rembrandt (q.q.v.).[6]

Most Dutch nocturnes were painted in the area of Haarlem and Amsterdam, and it was in the latter city that Van der Neer and Rafael Govertsz Camphuysen (1598 or 1606–1657) each produced a series of moonlit landscapes during the second half of the 1640s and later.[7] There is evidence that Camphuysen

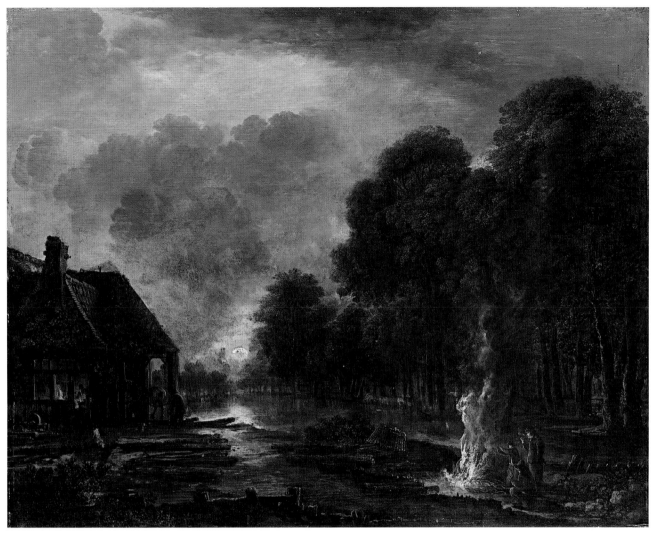

129

painted this kind of picture some years earlier than Van der Neer,[8] but the two artists appear to have had a reciprocal relationship around midcentury, with Van der Neer devoting far more time to night scenes. His nocturnes are also much subtler in their observation of light effects and in the use of light and shade to create an expansive sense of space. In this regard, Van der Neer seems very much a painter of the 1650s and a contemporary of Pieter de Hooch, Emanuel de Witte, and Aelbert Cuyp (q.q.v.).

Van der Neer painted more than a hundred night scenes, about two dozen of them with burning buildings or villages.[9] The motifs vary greatly, and none of the other known pictures closely resembles the present one. In both subject and scale, the smithy is exceptional in Van der Neer's oeuvre, and pentimenti reveal that the structure was considerably modified in the course of work. Other Dutch artists painted farrier's shops at about the same time (for example, Paulus Potter's panel of 1648; fig. 118), but few of them reveal a comparable interest in effects of light.[10]

Schulz (see Refs.) dates the Museum's painting to the early 1650s. The work is clearly mature; the comparatively broad handling of the trees and sky differs from the more conventionalized description found in most works of the 1640s.[11] At the same time, the quality of execution and structured design of the picture would dissuade one from placing it about 1660 or later. The work probably dates from the early to mid-1650s.

1. See Boston–Saint Louis 1980–81, pp. 72–77; Amsterdam 1993, nos. 22, 23; and Schulz 2002, pp. 39–41, on the development of the "moonlit landscape" in Dutch art.
2. Boston–Saint Louis 1980–81, no. 44; Stechow 1966, chap. 10 on "Nocturnes," and fig. 345 for Goudt's print. The composition is similar to that of *The Farrier* in the area of the river and trees.
3. Stechow 1966, figs. 347–49; Keyes 1984, nos. 31, 33, 46.
4. Stechow 1966, pp. 174–75, fig. 346; Haverkamp-Begemann 1959, pp. 199–200, no. CP39, fig. 137; Rotterdam–Paris 1974–75, no. 179.
5. See Milwaukee 1992–93 for examples by Leonaert Bramer and others. Liedtke 1982a, figs. 109 and 110, for nocturnal church interiors by Anthonie de Lorme (ca. 1610–1673) and Daniël de Blieck (ca. 1630–1673).
6. See Stechow 1966, figs. 350–53, and Rembrandt's *Landscape with the Rest on the Flight into Egypt,* 1647, in the National Gallery of Ireland, Dublin (Amsterdam–Boston–Philadelphia 1987–88, no. 78).
7. Stechow 1966, pp. 177–81; Bachmann 1980, pp. 38–58; Bachmann 1982, pp. 28–29, 82–85, passim.
8. See Bachmann 1980, p. 34, and Bachmann 1982, p. 82.
9. For the latter, see Schulz 2002, pp. 455–61, nos. 1354–78.
10. On Potter's painting, see Wheelock 1995a, pp. 198–200.
11. Compare Amsterdam–Boston–Philadelphia 1987–88, no. 59, the *Moonlit View on a River,* of 1647 (private collection); Bachmann 1968; and works of the 1640s catalogued and illustrated in Schulz 2002.

REFERENCES: MMA 1872, no. 156, as "from the collection of the Marquis Maison"; Harck 1888, p. 76, as a good, signed example; Valentiner in New York 1909, no. 67 (ill.), describes the subject; Hofstede de Groot 1907–27, vol. 7 (1923), p. 385, no. 244, as *Moonlit Landscape with a Smithy,* describes the scene in some detail; New York 1934, p. 16, no. 21, comments on the muted tonality; New York 1971, p. 11, no. 24, as datable to about 1660; Baetjer 1995, p. 310; Schulz 2002, pp. 52, 242, no. 446, pl. 169, as *Forge on a Forest Edge by Moonlight,* dating from about 1650 or the early 1650s; Baetjer 2004, p. 220, no. 156, gives provenance.

EXHIBITED: New York, MMA, "The Hudson-Fulton Celebration," 1909, no. 67; New York, MMA, "Landscape Paintings," 1934, no. 21; New York, MMA, "The Painter's Light," 1971, no. 24.

EX COLL.: ?Marquis Maison (not in his estate sale, Hôtel Drouot, Paris, June 10–12, 1869); [Léon Gauchez, Paris, with Alexis Febvre, Paris, until 1870; sold to Blodgett]; William T. Blodgett, Paris and New York (1870–71; sold half share to Johnston); William T. Blodgett, New York, and John Taylor Johnston, New York (1871; sold to MMA); Purchase, 1871 71.60

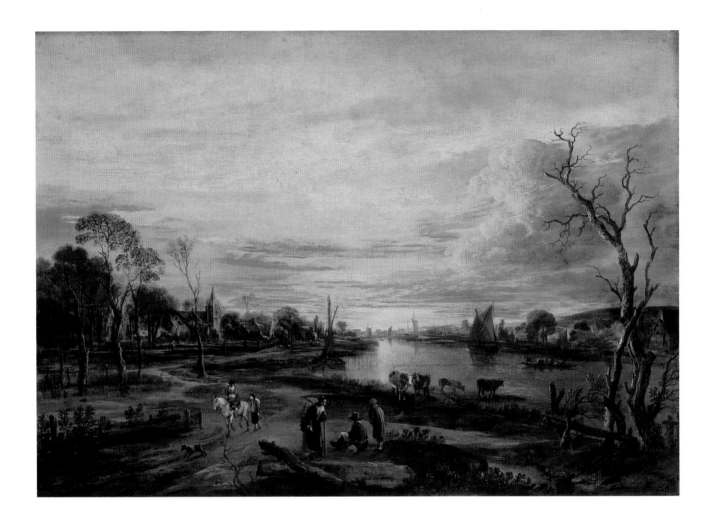

130. *Landscape at Sunset*

Oil on canvas, 20 x 28⅛ in. (50.8 x 71.4 cm)
Signed (lower center): AV DN [AV and DN in monogram]

Slight abrasion throughout the paint surface is most apparent in the deep brown passages of the foreground and the trees in the middle ground at left.

Gift of J. Pierpont Morgan, 1917 17.190.11

This colorful canvas from the collection of J. Pierpont Morgan represents a river at sunset, with boats, cows, and travelers enlivening the landscape. A village with a church appears on the left, while farmhouses and a tower are visible in the right background. A sailboat full of people and a barge full of cows move over the still surface of the water. The dead tree on the right frames the view and carries the eye up to the brilliantly colored clouds. In this wide panorama, the river seems not only to recede but also to flow forward and out of the composition to the right. As in similar works by the artist, the picture

includes motifs that bring the eye back to the center, to the gently curved horizon, and to the frequent discovery of picturesque or painterly effects.

Van der Neer's optical interests are strikingly evident in the sky and less assertively so in the water. The dark vertical strokes next to the boat by the shoreline, the reflections by the boats on the right, and the transition from a shadowy to a shiny surface in the river are instances of Van der Neer's understated sensitivity to observed and aesthetic effects.

As Schulz maintains, these qualities support a later dating than that suggested in earlier literature (see Refs.). Van der Neer's sunset scenes and other landscapes of the 1640s are by comparison almost naïve in their treatment of light, space, and certain motifs, such as trees. The standardized foliage of the trees to the left in the Museum's picture also occurs in paintings by the artist dating from midcentury, but these works already reveal the special interest in light effects that comes to fruition here. River views of approximately this composition

are common in the early 1650s and often feature beautiful skies.[1] A variety of stylistic considerations incline the present writer to favor a dating in the 1650s rather than the early 1660s, as Schulz tentatively suggests.

It has been observed that a drawing in the Albertina, Vienna, corresponds closely in design if not motifs to the left three-quarters of the present composition.[2] The sheet may be regarded as another invention of the 1650s that demonstrates Van der Neer's gift for recycling ideas.

Formerly titled by the Museum *Landscape*.

1. Compare Bachmann 1982, figs. 60 (dated 1647), 65–69, 70, 71 (1653), 72–76. The remark in Schulz 2002, p. 241 (under no. 445), to the effect that the present writer "recently dated the work around 1650/53," refers to an earlier draft of this entry.
2. Stephanie Dickey, note in the curatorial files dated March 1982; Schulz 2002, p. 241 ("compare the drawing in Vienna"; ibid., no. DII, pl. 349).

REFERENCES: Hofstede de Groot 1907–27, vol. 7 (1923), p. 345, no. 62, as from the Morgan collection and on loan to the MMA since 1911; Dickey in Hamilton–Rochester–Amarillo 1983, pp. 10, 22–23, no. 6 (ill.), as probably dating from the 1640s; New York 1985, no. 8 (ill.), as probably from the 1640s; Baetjer 1995, p. 310; Schulz 2002, pp. 241–42, no. 445, pl. 215, pl. 61, as "possibly created in the early sixties," and as in a "mediocre state of preservation" (compare the condition report above).

EXHIBITED: Binghamton, N.Y., Robertson Center, 1976; Memphis, Tenn., Brooks Memorial Art Gallery, and Columbus, Ohio, Columbus Museum of Art, 1982; Hamilton, N.Y., Colgate University, Picker Art Gallery, Rochester, N.Y., The Memorial Art Gallery of the University of Rochester, and Amarillo, Tex., Amarillo Art Center, "Dutch Painting in the Age of Rembrandt from The Metropolitan Museum of Art," 1983, no. 6; Poughkeepsie, N.Y., Vassar College Art Gallery, 1984; New York, Minskoff Cultural Center, "The Golden Ambiance: Dutch Landscape Painting in the Seventeenth Century," 1985, no. 8; Shizuoka, The Shizuoka Prefectural Museum of Art, and Kōbe, Kōbe City Museum, "Landscape Painting in the East and West," 1986, no. 2.

EX COLL.: [Duveen, Paris, London, and New York, until 1907; sold for £9,500 to Morgan]; J. Pierpont Morgan, New York (1907–d. 1913; his estate, 1913–17); Gift of J. Pierpont Morgan, 1917 17.190.11

131. *Sports on a Frozen River*

Oil on wood, 9⅛ x 13¾ in. (23.2 x 34.9 cm)
Signed (lower left): AV[D]N [AV and DN in monogram]
The painting has suffered extensive abrasion.
The Friedsam Collection, Bequest of Michael Friedsam, 1931
32.100.11

The small, delicately painted panel in the Friedsam Collection is a mature example of Van der Neer's ice-skating scenes, and probably dates from about 1660.

In this lumionus picture, the sun sets over one of Holland's inland waterways. The icy landscape is described mostly in tones of rose and gray. Houses crowd the shoreline at either side. The towers of two village churches mark the recession on the left, which terminates at an overscaled windmill. A small sailboat is moored by the simple, snow-traced crane at the left edge of the composition. A few of the scattered skaters practice their game of *colf*.[1]

The great majority of Van der Neer's *wintertjes* (little winter scenes), which number more than two hundred, depict figures on a frozen river or canal.[2] These mostly panoramic compositions are structured by receding riverbanks and vertical accents, and in general recall the designs of Hendrick Avercamp (1585–1634) rather than those of the younger painters who were active in the area of Haarlem and Amsterdam.[3] This conservatism is a legacy of Van der Neer's training in Gorinchem (see the biography above), which did not, however, discourage his describing optical effects such as the sun's reflection, shadows cast by boats, and the sense of light and space infusing cloudy skies. Especially impressive in this picture is the way in which the brillance of the sunset is diffused throughout the landscape. These qualities may be considered the artist's main concern, whereas predecessors such as Avercamp usually concentrated on the figures. For Van der Neer, humanity seems to represent not so much society as another aspect of nature.

Some of the painter's winter scenes of the 1640s are dated, but very few later examples are inscribed with a year.[4] The undated examples are difficult to place chronologically; they reveal a remarkable lack of repetition, and pentimenti suggesting much invention *ad libitum*. The present picture, however, is consistent in style with a group of small skating scenes that date from the late 1650s and early 1660s.[5]

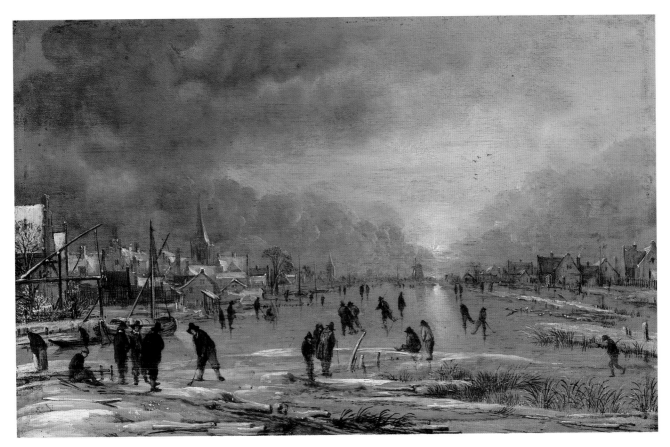

131

1. The game is not *kolf,* as is often said in connection with similar scenes (e.g., in Los Angeles–Boston–New York 1981–82, p. 70, in regard to Van der Neer's painting of about the same date in the Carter collection). *Colf* resembled golf, not ice hockey, in that the goal was to hit a ball at a small target. The game was played on land (mowed greens and holes were used as early as 1500) and, in winter, on the ice. For a history of the game, the *colf–kolf* distinction, and a variety of examples in Dutch art, see Bergen op Zoom and other cities 1982.

2. On winter scenes in Dutch art, see Stechow 1966, chap. 11, figs. 162–96; Van Straaten 1977b; Schulz 2002, pp. 66–81; and various entries in Amsterdam–Boston–Philadelphia 1987–88, e.g., nos. 5–7 (Hendrick Avercamp), 18 (Jan van de Cappelle), 60, 61 (Van der Neer), 77 (Rembrandt), 95 (Salomon van Ruysdael), 104 (Adriaen van de Velde), 107 (Esaias van de Velde), 109 (Adriaen van de Venne), and 111 (David Vinckboons). A good survey of skating in Dutch art is sketched by Laurinda Dixon in Cincinnati 1987.

3. On this point, see De Bruyn Kops in Amsterdam–Boston–Philadelphia 1987–88, p. 385. On Avercamp, see C. Welcker 1979, where the ice scene that seems to look forward to Van der Neer more than any other (no. s65, pl. IV A, a canvas in the New-York Historical Society) is not by Avercamp.

4. See Schulz 2002, pls. 1, 3, 5, 7, 8, winter scenes bearing dates in the 1640s, and pl. 50 (1662), passim.

5. Compare Bachmann 1982, figs. 83, 85, 91, 93, 108, 112, and p. 132 in the note to fig. 101 (ill. on p. 92); and see Schulz 2002, pp. 83–88.

REFERENCES: Pène du Bois 1917, p. 402, as in the Friedsam Collection; Hofstede de Groot 1907–27, vol. 7 (1923), p. 453, no. 543, as *Winter Sports on a Broad Frozen River: Sunset,* a panel in the P. Calkoen sale, Amsterdam, September 10, 1781, no. 99, sold for Fl 61 to J. D. Nijman; Valentiner 1928a, p. 18, as *Winter Scene in Haarlem,* signed AVDN, from the collection of Sir A. Robertson, Chatham, England; P. Sutton 1986, p. 191, as dating from about 1660; Baetjer 1995, p. 310; Schulz 2002, p. 138, no. 43, pl. 46, as "Authentic. Created around 1660."

EXHIBITED: Los Angeles, Calif., University of California at Los Angeles, 1954; Colorado Springs, Colo., Colorado Springs Fine Arts Center, 1955.

EX COLL.: Possibly P. Calkoen sale, Amsterdam, September 10, 1781, no. 99, for Fl 61 (see Refs.); possibly Jan Danser Nijman (see Refs.); Sir A. Robertson, Chatham, England (see Refs.); [Kleinberger Galleries, New York (according to a note in the curatorial files)]; Michael Friedsam, New York (by 1917–1931); The Friedsam Collection, Bequest of Michael Friedsam, 1931 32.100.11

EGLON VAN DER NEER

Amsterdam 1635/36–1703 Düsseldorf

This polished painter of genre scenes, who is also known for portraits and for classical landscapes with biblical or mythological figures, was the son of the landscapist Aert van der Neer (q.v.). According to Houbraken, Eglon Hendrick van der Neer was born in Amsterdam in 1643 and died in May 1703, having painted until his seventieth year. From this inconsistency (if Houbraken's dates were correct, the artist would have died in his sixtieth year) and other evidence (on January 7, 1662, the artist gave his age as twenty-six), it has been concluded that Van der Neer was born in 1634 or 1635/36, not about nine years later.[1]

Because he wanted to paint figures, Houbraken explains, Van der Neer turned from his father's tutelage to that of Jacob van Loo (1614–1670), who at the time (ca. 1651–53?) was a successful portraitist and genre painter in Amsterdam. Van der Neer then went to southern France and was supported by Count Friedrich van Dohna, the Dutch governor of the principality of Orange from about 1655 to 1658. He returned to the Netherlands before his marriage in Rotterdam on February 20, 1659, to Maria Wagensvelt, daughter of a secretary at the judicial court of Schieland in Schiedam. Houbraken says that this union brought the artist lots of money and sixteen children (the first of whom was baptized in Amsterdam on February 15, 1660), but that he lost much of his wealth in lawsuits.[2]

Van der Neer is recorded in Rotterdam between 1663 and 1678, although he also did business in Amsterdam and The Hague. He joined Pictura, the painters' confraternity of The Hague, in 1670. In December 1677, his wife died in childbirth. Van der Neer moved to Brussels by January 1679, and in 1681 he married the miniaturist Marie Du Chastel (1652–?1692), daughter of the portrait and genre painter François Du Chastel (1625–1694).[3] Houbraken mentions nine children from this marriage, of whom six are recorded in documents. The biographer also states that Van der Neer's second wife died in Brussels, where, sick in bed, she made out a will in July 1692.[4] In 1697, Van der Neer married for a third time, in Düsseldorf, where he remained until his death on March 3, 1703. His last bride was the forty-one-year-old portraitist Adriana Spilberg (1656–after 1721), daughter of the painter Johannes Spilberg (1619–1690).[5] It is not known when Van der Neer settled in

Düsseldorf; he appears to have remained in Brussels for some time after his second wife's death. His appointment as court painter to Charles II of Spain, in July 1687, evidently did not necessitate his leaving Brussels.[6]

Van der Neer's patrons and the time-consuming refinements of his most impressive pictures (for example, the Liechtenstein panel of 1665; fig. 120) are among the many indications of his considerable success. His self-portrait of 1696 (Uffizi, Florence), which was sent to Cosimo III de' Medici, shows the artist in a fashionable wig and costume, with the gold chain and medallion of the grand duke's son-in-law Johann Wilhelm, and with one of his own classical landscapes.[7]

Dated works by Van der Neer are known from most years between 1662 and 1702. As a genre painter, he was strongly influenced by Gerard ter Borch (q.v.), and he obviously admired the work of Gabriël Metsu and Frans van Mieris (q.q.v.).[8] Houbraken reports that a painting by Van Mieris was borrowed by Van der Neer so that his pupil, Adriaen van der Werff (1659–1722), could copy it (this he did well enough to deceive several Leiden connoisseurs).[9] Van der Werff is the only pupil mentioned by Houbraken. He is thought to have studied with Van der Neer in Rotterdam about 1671–76.[10]

1. See Prins 2000, p. 205. Eddy Schavemaker, the author of a *doctoraalscriptie* on Eglon van der Neer (Utrecht, 1999), kindly sent me a copy of Prins's article, and offered a number of helpful comments.
2. Houbraken 1718–21, vol. 3, pp. 172–73. See Prins 2000, p. 206, where it is noted that only eleven children can be traced in known documents. Van der Neer's family was Reformed, and his wife's Lutheran, but their children were baptized as Remonstrant (Prins 2000, p. 207).
3. For a miniature portrait by Marie Du Chastel, of about 1690, of Amalia van Anhalt-Dessau (1666–1726), wife of Hendrik Casimir II, prince of Nassau-Dietz, see Van Thiel et al. 1976, p. 754. The Du Chastels were Catholic, and Van der Neer converted to their religion (see Prins 2000, p. 207).
4. Houbraken 1718–21, vol. 3, p. 173. See Prins 2000, p. 207, and Schulz 2002, pp. 16, 118 (where the family tree is incomplete).
5. Houbraken 1718–21, vol. 3, p. 46, records that Adriana Spilberg was previously married to the painter Willem Breekvelt (1658–1687). The year of her birth is often given as 1652, but Prins 2000, p. 212, corrects the date to 1656. On Spilberg, a Düsseldorf native who studied with Govert Flinck (q.v.) in Amster-

dam, see The Hague 1992a, pp. 287–92. Further literature on Van der Neer's contact with the Elector is cited by Schavemaker in Rotterdam–Frankfurt 2004–5, p. 267 nn. 11, 13.

6. See Prins 2000, pp. 206–7.

7. Langedijk 1992, no. 23. Houbraken 1718–21, vol. 1, p. 270, mentions the picture in passing, and in vol. 3, p. 353, cites the artist as "the excellent painter of small landscapes." See his *Tobias and the Angel*, 1690, in the Rijksmuseum, Amsterdam.

8. See F. Robinson 1974, p. 67, and Naumann 1981, vol. 1, pp. 58, 64–65, 67–68.

9. Houbraken 1718–21, vol. 3, pp. 389–90.

10. Gaehtgens 1987, pp. 42–45.

132. *The Reader*

Oil on canvas, 15 x 11 in. (38.1 x 27.9 cm)
Inscribed (lower right): GTB [in monogram]
The painting is well preserved.
The Friedsam Collection, Bequest of Michael Friedsam, 1931
32.100.9

From its first known appearance in a Rotterdam sale of 1730 until its bequest to the Museum in the Friedsam Collection (1931), this painting was considered to be by Gerard ter Borch (q.v.) and the awkward monogram was not questioned. F. Schmidt-Degener, on a visit to the Museum in 1935, suggested an attribution to Eglon van der Neer, but later in the same year curator Harry Wehle catalogued the canvas as by an "Imitator of Terborch, 17th century." Another curator, Elizabeth Gardner, accepted the attribution to Van der Neer in 1949. His authorship has been challenged occasionally, for example by A. B. de Vries, who in 1952 considered the picture to be a copy or "compilation" after Ter Borch, possibly of a later date.[1] However, the present writer and other scholars concur with Gudlaugsson's conclusion that "the execution points decisively to Eglon van der Neer," and that the work, while clearly inspired by Ter Borch, does not necessarily record a lost composition by him.[2]

Gudlaugsson observed that motifs in the present picture, such as the inkwell, the table, and the door in the background, differ from the precise forms that Ter Borch usually employed. Naumann describes the "tight, boxy" arrangement of the composition as typical of Van der Neer.[3] Ter Borch's genre scenes of the 1650s reveal nothing quite like the architectonic design of this composition; his slightly angled furniture and more atmospheric spaces, relaxed postures, textured materials, and convincingly thoughtful expressions all contribute to a sense of naturalism that is quite distinct in style from Van der Neer's work in the same vein.[4]

Whatever the connection with Ter Borch, his former pupil Caspar Netscher (q.v.) may have served as an intermediary. The most comparable pictures by Ter Borch were painted when Netscher was in his Deventer studio. Van der Neer may have known a few of Netscher's versions of Ter Borch compositions, or some similar inventions by Netscher dating from the early 1660s.[5]

In 1665, Van der Neer painted two pictures that are closely related to this one. Execution in the mid- rather than early 1660s is consistent with their more elaborate motifs (including costlier costumes), more refined technique, and greater distance from Ter Borch. One of the paintings, signed and dated 1665 (fig. 119), on a canvas of about the same size as the Museum's picture but with rounded corners at the top, depicts a very similar woman in slightly more fashionable attire.[6] She gestures to the open book in front of her. The writing set and candlestick on the table in the New York painting have been replaced by a silver box and brush, a fancy knife or letter opener, and a mirror in a gold frame. A tapestry in the background represents an apparently wounded man, perhaps Adonis. In the other painting dated 1665 (fig. 120), evidently the same woman as the one in the Friedsam canvas appears with her head uncovered, an exceedingly stylish dress, and a pearl necklace and bracelet as well as earrings.[7] She holds not a book but a plate of oysters, and the objects on the table (a wineglass and pitcher on a silver tray) similarly suggest elegant entertainment rather than reading, writing, or vanity. The covering pushed to the back of the table has evolved from the brown material (velvet?) in the Museum's painting and the

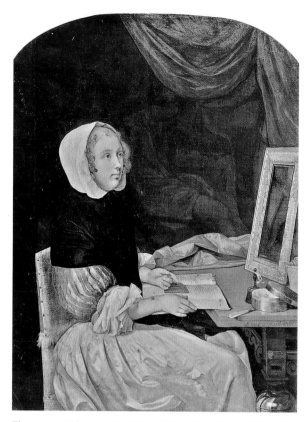

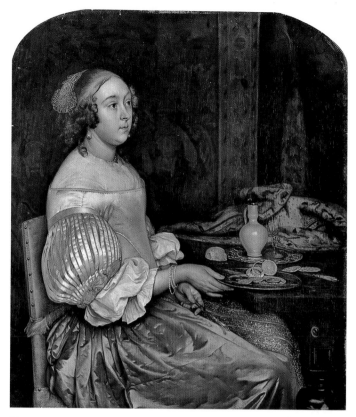

Figure 119. Eglon van der Neer, *Woman Seated at a Table with a Book and a Mirror*, 1665. Oil on canvas, 14⅝ x 11 in. (37 x 28 cm). Formerly Richard Green Galleries, London

Figure 120. Eglon van der Neer, *A Young Woman with a Plate of Oysters*, 1665. Oil on wood, 12⅛ x 10½ in. (30.8 x 26.8 cm). Collections of the Princes of Liechtenstein, Vaduz

satin or silk in the second picture to a Persian carpet. The woman's eyes seem more focused now that her thoughts have turned from literature to an offstage or imaginary companion.

Whether the woman in the Museum's picture pauses in her reading in order to reflect or because of some distraction is difficult to say. The theme of interrupted reading was already well established; the main point is usually that the figure is absorbed in thought, which suggests a degree of cultivation. In contrast to the books in Titian's *Empress Isabella* (Prado, Madrid) and Anthony van Dyck's *Portrait of a Woman, called the Marchesa Durazzo* (MMA), those in the present painting and the version dated 1665 (fig. 119) are obviously secular.[8] The silver writing set (with a piece of sealing wax) is another sign of literacy raised to the level of social grace. The extinguished candle may be regarded as a conventional vanitas symbol, as is the mirror in the other painting with a book. It seems likely that virtue is implied by the act of reading, especially if the illustrated volumes are meant as emblem books or as one of the edifying treatises by Jacob Cats.[9] In the paintings dated 1665, however, virtue seems suggested in the one for form's sake and in the other not at all.

1. A. B. de Vries, oral opinion, February 1952. The note in the curatorial files makes it clear that De Vries was focused on the question of whether or not the painting is by Ter Borch. J. G. van Gelder, oral opinion, February 1954, suggested calling the picture a copy after Ter Borch rather than a work by Van der Neer; and Daan Cevat, on a visit to the Museum in January 1966, pronounced the picture a copy after Ter Borch of the mid-eighteenth century.

2. Gudlaugsson 1959–60, vol. 2, p. 161 (under no. 147b). Otto Naumann, who had been preparing a book on Eglon van der Neer, discussed the painting with the writer in 1996. He believes emphatically that it is an early work by the artist, probably of about 1662–64. H. Gerson, oral opinion (n.d.; 1960s?) also accepted the Museum's attribution to Van der Neer.

3. See the preceding note. In addition to the works by Van der Neer discussed below, compare also *A Lady Drawing*, of about 1664/65, in the Wallace Collection, London (Ingamells 1992a, pp. 236–38).

4. Compare Gudlaugsson 1959–60, vol. 1, pls. 114, 188, and esp. pl. 125 (Ter Borch's *Woman Drinking Wine*, of about 1656–57, in the Städelsches Kunstinstitut, Frankfurt).

5. See Wieseman 2002, pp. 53–58.

6. The painting was with Richard Green, London, in the late 1970s. It appears to be identical with the picture cited by Gudlaugsson 1959–60, vol. 2, p. 161 (under no. 147; pl. XVI, fig. 3),

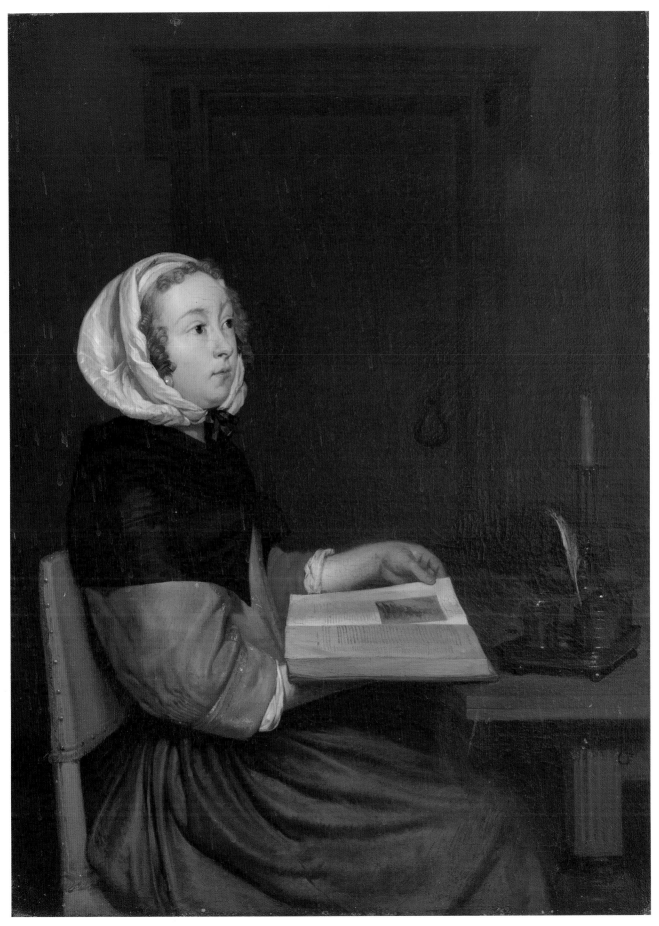

as in the N. M. Matthews sale in New York (American Art Association), February 17–18, 1914, no. 90; as later with Knoedler, New York; and as not in Hofstede de Groot. However, it is cited as Hofstede de Groot 1907–27, vol. 5, p. 488, no. 47; the nineteenth-century English provenance given there was correctly combined by Green with references to Nicholas M. Matthews of Baltimore and the estate of Mrs. Charles Henschel (sale, Sotheby Parke Bernet, New York, January 22–23, 1976, no. 22). See also P. Sutton in Philadelphia–Berlin–London 1984, pp. LVIII, LXVI n. 127, fig. 110.

7. See New York 1985–86, no. 174.

8. On the Titian and the Van Dyck, see Liedtke 1984a, pp. 54–56, pl. 25, fig. 10.

9. Werche in Frankfurt 1993–94, p. 256, suggests that the book in the Museum's picture is perhaps an emblem book. Franits 1993a, pp. 19–20, discusses books in a portrait of a young woman by Gerrit Dou (private collection) as "attributes of docility."

REFERENCES: Hoet 1752–70, vol. 1 (1752), p. 358, no. 83, and p. 459, no. 10, as by Ter Borch, in the 1730 Van Belle and 1736 de Neufville sales; Bode 1913, unpaged, pl. 20, as by Ter Borch; Hofstede de Groot 1907–27, vol. 5 (1913), p. 40, no. 103, as by Ter Borch, with extensive provenance; Valentiner 1928a, p. 15, as by Ter Borch; B. Burroughs and Wehle 1932, p. 48, no. 83, as by Ter Borch, signed G T B; Gudlaugsson 1959–60, vol. 1, p. 304, fig. 147b, vol. 2, p. 161, no. 147b, rejects the monogram, considers the execution typical of Eglon van der Neer, and dismisses the idea that the painting could come from Ter Borch's studio on the basis of motifs; Liedtke in New York 1985–86, p. 272 (under no. 174; fig. 120 here), defends the attribution to Van der Neer, but considers the picture a copy of a lost painting by Ter Borch; D. Smith 1987, p. 418 n. 45, suggests that the painting, even "though not a portrait, seems entirely innocent in meaning"; Hecht in Amsterdam 1989–90, p. 130, fig. 25c (under no. 25), relates the picture, which he considers "anonymous," to the Liechtenstein panel; Schenkeveld 1991, dust jacket and p. iv (ill.); Ingamells 1992a, p. 237 (under no. P243), compares *A Lady Drawing* by Eglon van der Neer in the Wallace Collection to the Museum's picture, which is mistakenly said to be dated 1665; Werche in Frankfurt 1993–94, pp. 256–57, no. 60 (ill.), suggests that the book may be an emblem book, compares works by Ter Borch, and suggests a date of about 1665; Baetjer 1995, p. 339; Luijten in Amsterdam 1997a, pp. 304–5, fig. 6, as an "anonymous canvas" attributed to Eglon van der Neer, cites the work as a rare example of a Dutch painting depicting someone reading for pleasure; Franits 2004, p. 300 n. 39, calls the picture "a possible copy by van der Neer after a ter Borch painting."

EXHIBITED: Amsterdam, "Exposition rétrospective," 1867, no. 195 (lent by Messchert van Vollenhoven?); The Hague, "Exposition rétrospective," 1890, no. 14 (lent by Messchert van Vollenhoven?); Palm Beach, Fla., Society of the Four Arts, "Portraits, Figures, and Landscapes," 1951, no. 30; Frankfurt am Main, Schirn Kunsthalle, "Leselust: Niederländische Malerei von Rembrandt bis Vermeer," 1993–94, no. 60.

EX COLL.: Josua van Belle (until 1730; his sale, Rotterdam, September 6, 1730, no. 83, for Fl 32); Robbert de Neufville (until 1736; his sale, Leiden, March 15, 1736, no. 10, for Fl 38); [possibly J. Wijsman et al. sale, Amsterdam, November 24, 1828, no. 172]; ?[J. Bleuland, Utrecht; sale, Utrecht, May 6, 1839, no. 342, for Fl 2,000 to Engelberts]; Messchert van Vollenhoven (until 1892; sale, Amsterdam, March 29, 1892, no. 4, for Fl 4,300); [Sedelmeyer, Paris, in 1898; cat., 1898, no. 217 (ill.), as "Lecture interrompue," by Ter Borch]; Max Wassermann, Paris (in 1898); [Kleinberger, Paris, in 1910]; August de Ridder, Schönberg, near Kronberg im Taunus (until d. 1911; on loan to the Städelsches Kunstinstitut, Frankfurt am Main, in 1913; sale of his sequestered property, Galerie Georges Petit, Paris, June 2, 1924, no. 82, for FFr 128,000); Michael Friedsam, New York; The Friedsam Collection, Bequest of Michael Friedsam, 1931 32.100.9

CASPAR NETSCHER

Heidelberg 1639?–1684 The Hague

Although famous in his day, this painter of sophisticated genre scenes and fashionable portraits can barely be traced before 1662, when he joined the confraternity Pictura in The Hague. Houbraken gives his birthplace as "Heydelberg, in 't jaar 1639," and records that the artist's parents were Johannes Netscher, a stone sculptor originally from Stuttgart, and Elizabeth Vetter, daughter of a Heidelberg burgomaster.[1] Widowed, the mother, three sons, and a daughter were driven by the Thirty Years' War to a besieged castle (where the two older sons died of starvation), and then to Arnhem, when Caspar was about two years old. A wealthy member of the Tulleken family (which filled many civic offices in Arnhem) later sent the boy to Latin school, where, in Houbraken's words, he "covered every piece of paper he could come by with figures and animals."[2] Caspar was then placed with "the painter *Koster*," namely Hendrick Coster (act. in Arnhem 1642–59), who is known for Caravaggesque genre subjects, still lifes, and portraits such as the *Portrait of a Woman*, signed "H Coster, fec./In Arnhem/Ao. 1642" in the Museum Bredius, The Hague.[3] "After that [Netscher was sent to study] with *Gerard Terburgh*, painter and burgomaster of Deventer, through the [connection made by] Mr. *Wynant* [Willem?] *Everwyn*, who was a cousin of *Terburg*."[4] Houbraken's detailed description of Netscher's earliest years has recently been disputed, and an obscure "Johannes Nescher, painter," proposed as the artist's father, but no concrete evidence conflicts with the biographer's account.[5]

Netscher most likely worked with Gerard Ter Borch (q.v.) in Deventer from about 1654 until 1658 or 1659. He produced copies of paintings by his master, some of which are signed and even dated (for example, the copy signed "C. Netscher fecit 1655," in Schloss Friedenstein, Gotha, after Ter Borch's *Parental Admonition,* in the Gemäldegalerie, Berlin).[6] Small pendant portraits of a man and woman, signed and dated 1656 (private collection, The Hague), are independent works by Netscher, but derive from Ter Borch's Everwijn portraits of about 1653 (private collection, New York).[7] The fact that Netscher signed these appealing portraits and some copies after Ter Borch suggests that the master allowed the pupil an unusual degree of independence. Ter Borch also employed Netscher as a

model, most notably as the suitor in *The Suitor's Visit,* of about 1658 (National Gallery of Art, Washington, D.C.).[8]

In 1658 or 1659, Netscher (probably encouraged by the well-traveled Ter Borch) sailed for Italy, but disembarked at Bordeaux and married there on November 25, 1659. His wife, Margaretha Godijn, was the daughter of an engineer from Liège. A son, Theodoor (1661–1728), was born in Bordeaux and later became his father's collaborator and then an independent painter.[9] In 1662, the family moved to The Hague, where Netscher was recorded nearly every year until his death on January 15, 1684. He became a citizen of the city and joined one of the civic guard companies in 1668. The Netschers had eleven more children between 1663 and 1679, nine of whom lived to adulthood. Constantijn (1668–1723) succeeded his father as a portraitist in The Hague.[10]

Houbraken reports that Netscher, who died in his early forties, suffered from gout and other illnesses. Nonetheless, he was a prolific painter and draftsman, and also an art dealer. He was visited by collectors such as Pieter Teding van Berckhout and Cosimo III de' Medici. In 1668, Cosimo III bought four paintings, one of which is the portrait of the artist with his wife and two sons, dated 1664, in the Uffizi, Florence.[11]

From 1662 to about 1664, Netscher painted genre scenes that are both original and impressively reminiscent of Ter Borch, such as the *Chaff Cutter with a Woman Spinning and a Young Boy* (John G. Johnson Collection, Philadelphia Museum of Art),[12] and the celebrated *Lace Maker,* of 1662 (not 1664; Wallace Collection, London).[13] About 1665, Netscher turned to scenes of stylish social life, such as the *Musical Company,* dated 1665 (Alte Pinakothek, Munich), and the painting discussed below.[14] At the same time, his technique and palette became more arbitrarily refined, with an emphasis on fancy fabrics that recalls works by Frans van Mieris (q.v.). Netscher's oeuvre dating from about 1667 onward is composed mostly of elegant portraits in a manner reminiscent of Adriaen Hanneman (q.v.) and Jan Mijtens (ca. 1614–1670), and of contemporary works by Nicolaes Maes (see Pls. 113, 114). In routine examples, Netscher's participation was often limited to the heads, with the rest left to his sons or other members of his studio.[15] All of his paintings, which include some history pictures, are com-

paratively modest in size. Netscher is considered a key figure in bringing an international style (often described as French, but in good part Flemish) to the northern Netherlands, which was elaborated by younger artists such as Adriaen van der Werff (1659–1722).[16]

1. Houbraken 1718–21, vol. 3, p. 92. In vol. 1 (1718), p. 6, Houbraken, following De Piles 1699, p. 452, gives Netscher's birthplace as Prague. De Piles's information is favored over Houbraken's self-correction in MacLaren/Brown 1991, p. 282, in my view mistakenly.
2. Houbraken 1718–21, vol. 3, p. 93.
3. Blankert 1991, no. 37.
4. Houbraken 1718–21, vol. 3, p. 94. Gudlaugsson 1959–60, vol. 2, p. 113 (under no. 113), Ter Borch's *Portrait of Willem Everwijn* (1617–1673), formerly in the Hartog collection, New York, suggests that Houbraken confused Willem with his nephew Wynand (b. 1648). See also Wieseman 2002, pp. 24–25 n. 12.
5. Wieseman (2002, pp. 23–24) tentatively advances the figure of Johannes Nescher, a painter who was betrothed in Amsterdam and married in Rotterdam in 1632. As Wieseman notes, Houbraken's account cannot be supported by known documents, but the records of the Reformed Church in Heidelberg were destroyed in 1693, and students of the Latin school in Arnhem are listed only from 1655 onward (ibid., p. 24 nn. 7, 11). Bredius (1887, p. 264) considered Houbraken "very well informed" about Netscher, partly on the basis of corresponding documents, such as "een boeckje daerin C. NETSCHER heeft geteijckent tot Aernhem sijnde," which was in his widow's estate (ibid., p. 273; Wieseman 2002, pp. 24 n. 9, 143 [under doc. 99, item O]). The surname "Netscher," which the painter used on his earliest pictures, and versions of the name are common in northern Germany (Wieseman 2002, p. 23 n. 3, mentions a "Philipp Netscher, steinhauer," who married in Heidelberg in 1650). It seems highly unlikely that "Johannes Nescher, painter," had he actually been Caspar Netscher's father, would have escaped the attention of Houbraken and Van Gool. The latter (Van Gool 1750–51, vol. 1, pp. 367–70) claims to have received his information from Netscher's son Theodoor, who, with his brother Constantijn, was Van Gool's main concern. On this author's reliability and art criticism, see L. de Vries 1983. I am grateful to Dr. Wieseman for critically reviewing this biography and this note in particular. She is certainly correct in drawing attention to Johannes Nescher in the absence of conclusive documentary evidence.
6. Wieseman 2002, no. 1; Gudlaugsson 1959–60, vol. 2, p. 117, no. 110, version II, copy a. G. Jansen in *Dictionary of Art* 1996, vol. 22, p. 915, erroneously identifies the original as Ter Borch's painting of the same subject in the Rijksmuseum, Amsterdam.
7. Wieseman 2002, pp. 167–68, nos. 2, 3; Gudlaugsson 1959–60, nos. 103, 104.
8. See Wheelock 1995a, p. 28. "Netscher's signed copy" of the Ter Borch in Washington, D.C. (ibid., p. 28 n. 9; Gudlaugsson 1959–60, vol. 2, p. 148, no. 139, copy a, pl. XVI, fig. 2) is rejected as his work in Wieseman 2002, no. B2. Paintings by Ter Borch in which Netscher appears are listed in ibid., p. 25 n. 14.
9. See Simons 1990.
10. See Wieseman 2002, pp. 119–20, on Netscher's artistic sons.
11. See ibid., pp. 31–33, and Langedijk 1992, pp. 128–32.
12. Philadelphia–Berlin–London 1984, no. 83.
13. Ingamells 1992a, pp. 245–47; Wieseman 2002, pp. 176–77, no. 16.
14. For the Munich painting, see Philadelphia–Berlin–London 1984, no. 84, and Madrid 2003, no. 28.
15. See Blankert 1966.
16. See Gaehtgens 1987, pp. 102–4, on Netscher's role.

133. *The Card Party*

Oil on canvas, 19¾ x 17¾ in. (50.2 x 45.1 cm)
Signed and dated (on stretcher of stool): CNetsch[er]/[1]66[]

There is abrasion throughout. The surface of the paint that defines the yellow skirt of the woman at left has suffered to an extreme degree. The little dog and the red silk skirt of the woman holding the cards are well preserved.

Marquand Collection, Gift of Henry G. Marquand, 1889
89.15.6

Netscher's scenes of fashionable figures in luxurious interiors date mostly from the mid-1660s. This one has been placed convincingly about 1665.[1] The subject of courting couples, the figure types, the attention to fine fabrics, the arrangement of the furniture (especially the matching stool and chair), and the dog are all indebted in some degree to the artist's teacher, Gerard ter Borch (compare Pls. 13, 17). As in *The Suitor's Visit*, of about 1658, by Ter Borch (National Gallery of Art, Washington, D.C.),[2] Netscher himself appears to have served as a model for one of the suitors here, the seated man.

Although not involved in the card game, the tall beauty to the left may be described as the center of attention. She is addressed by a male companion but concentrates on the fluffy lapdog. The love triangle of mistress, suitor, and spaniel recalls that in Frans van Mieris's *Teasing the Pet*, of 1660 (Mauritshuis, The Hague), which influenced a number of contemporary painters.[3] In the present picture, the color of the dog's coat, his

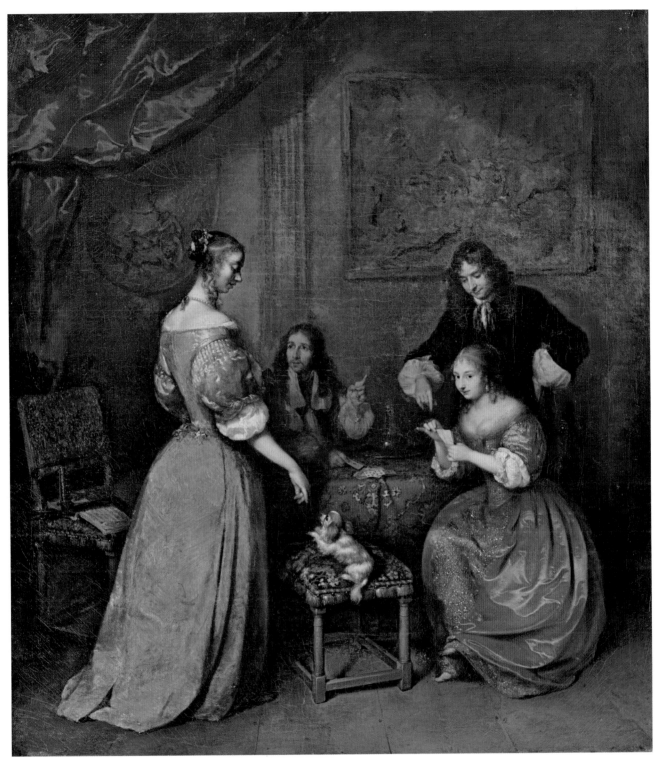

133

earnest eyes, and perhaps the pointing nose and floppy ears underscore a comparison with the young lady's other plaything. Some comment on the male visitors also may be detected in the seated woman's smile at the viewer.

Netherlandish images comparing courtship with cardplaying and other games of chance date back to the first half of the sixteenth century.[4] In older examples, various transgressions are symbolized, but here the cards, like the theorbo and songbook on the chair to the left (the instrument's case, now nearly invisible, is behind the couple to the right), and the wine decanter and glass on a tray on the table, are mere props in a scene that is understood almost entirely in terms of gestures, expressions, and poses. No one surpassed Ter Borch in observing social behavior, but Netscher was sometimes a worthy follower.

The subjects of the simulated reliefs on the back wall, which in the Netherlands would likely have been grisaille on canvas (compare Pl. 221), have not been identified previously. The oval composition depicts a victorious rider with a fallen figure beneath a rearing horse. This motif descended from Roman coins and Renaissance designs for equestrian monuments to seventeenth-century sculptures and prints.[5] The other relief is nearly indecipherable, but appears to represent a scene of sea gods, perhaps the Triumph of Venus.[6] It is likely that both images suggest the subjugation of men.

1. For example, by Wieseman 2002, pp. 113, 202–3, no. 50. Compare Netscher's *Company Making Music* (Mauritshuis, The Hague) and *Musical Company* (Alte Pinakothek, Munich), both of which are dated 1665 (see Philadelphia–Berlin–London 1984, no. 84).

2. See Wheelock 1995a, p. 28.

3. See Naumann 1981, vol. 1, pp. 58, 68, citing works by Gabriël Metsu, Eglon van der Neer, and Jacob Ochtervelt (q.q.v.), and vol. 2, pp. 40–43, no. 35, pl. 35, for Van Mieris's picture.

4. See the discussion of the approximately contemporaneous *Cardplayers* by Cornelis de Man (1621–1706), at Polesden Lacey, Surrey, in Amsterdam 1976, no. 35.

5. See Liedtke 1989b, pls. 26, 28, 32, 35 (Pollaiuolo and Leonardo), 69 (Giambologna), 93 (A. Sadeler), 138 (C. Schut), 159 (Coysevox's marble relief of Louis XIV in the Salon de la Guerre at Versailles).

6. In the Mauritshuis painting cited in note 1 above, Netscher placed a relief of a classical abduction scene (with Helen?) behind the figures.

REFERENCES: Hoet 1752–70, vol. 1 (1752), p. 450, no. 56, lists the work as in the Van Schuylenburg sale of 1735, a "kapitaal Cabinet Stuk . . . zoo goed en fraay als van hem bekent is"; J. Smith 1829–42, vol. 4 (1833), p. 149, no. 10, as in the collection of Col. Hugh Baillie; Blanc 1857–58, vol. 1, p. 140, mistakenly identifies the work as the picture engraved by Lépicié with the title "Le jeu de piquet" (Ter Borch's *Two Woman and a Man Playing Cards*, of about 1659, in the Los Angeles County Museum of Art); Hofstede de Groot 1907–27, vol. 5 (1913), p. 191, no. 126, as "The Card Party" in the MMA, with some incorrect information (see Wieseman 2002, p. 202 [under Literature]); Gudlaugsson 1959–60, vol. 2, p. 158 (under no. 146), notes that J. Smith and Hofstede de Groot confused the painting with the Ter Borch engraved by Lépicié; F. Robinson in Saint Petersburg–Atlanta 1975, no. 35, wrongly as dated "__66," notes the influence of Ter Borch, and "amorous overtones"; Perez 1980, p. 48 (ill.), incorrectly places the picture in the Montribloud collection until 1784; Liedtke 1990, p. 36, listed as part of Marquand's gift to the MMA; Ydema 1991, p. 148, identifies the table carpet as from Transylvania; Baetjer 1995, p. 340; Wieseman 2002, pp. 113, 202–3, no. 50, and p. 341 (under no. C22) records a "hasty compositional sketch" in the Prentenkabinet der Rijksuniversiteit, Leiden, and a more developed drawing for the composition in the Musée du Louvre, Paris.[1] Wieseman 2004, pp. 250–51, more carefully compares the Leiden and Paris preparatory drawings.

EXHIBITED: London, British Institution, 1829, no. 187 (lent by Col. Hugh Baillie); New York, MMA, "Collection of Dutch and Flemish Paintings by Old Masters, Owned by Mr. Charles Sedelmeyer," 1886–87, no. 9, as "La partie de Piquet" (lent by Henry G. Marquand); New York, MMA, "Exhibition of 1888–89" [Marquand Collection], 1888–89, no. 31, as "A Game of Piquet"; Nashville, Tenn., Fisk University, 1951, no cat.; Atlanta, Ga., Atlanta University, 1951–52, no cat.; New Orleans, La., Dillard University, 1952, no cat.; New York, American Federation of Arts, "Little Masters in 17th Century Holland and Flanders" (circulating exhibition), 1954–57, no cat.; Saint Petersburg, Fla., Museum of Fine Arts, and Atlanta, Ga., High Museum of Art, "Dutch Life in the Golden Century," 1975, no. 35.

EX COLL.: Johan van Schuylenburg, Haarlem (until 1735; his sale, The Hague, September 20, 1735, no. 56, for Fl 400); ?Pierre-Louis-Paul Randon de Boisset, Paris (until 1777; his estate sale, Rémy & Julliot, Paris, February 27ff., 1777, no. 141, for FFr 2,800]; Philip Hill (in 1811; his sale, Christie's, London, January 26, 1811, no. 36, bought in for £84); Colonel Hugh Baillie, Tarradale, Jedburgh, Roxburgh, Scotland (by 1829–58; his sale, Christie's, London, May 15, 1858, no. 10, as by Eglon van der Neer, for £161 14s. to Nieuwenhuys); [C. J. Nieuwenhuys, London (until d. 1883; his estate sale, Christie's, London, July 17, 1886, no. 80, as by Netscher, for £278 5s. to Colnaghi)]; [Colnaghi's, London, 1886]; [Sedelmeyer Gallery, Paris, 1886; sold to Marquand]; Henry G. Marquand, New York (by 1886–89); Marquand Collection, Gift of Henry G. Marquand, 1889 89.15.6

1. Wieseman 2002, figs. 53, 54 (on p. 113, Wieseman's fig. 52 is said to reproduce the verso of the Paris sheet, but it is the more important recto that is illustrated, as fig. 53).

JACOB OCHTERVELT

Rotterdam 1634–1682 Amsterdam

A Rotterdam painter of fashionable genre scenes, Ochtervelt was baptized in the city's Reformed Church on February 1 (?), 1634.[1] His father, Lucas Hendricksz, was a bridgeman of very modest means. The artist's two brothers died as sailors, one in the East Indies and the other returning from that part of the world. He also had three sisters, one of whom married a sailor. Houbraken reports that Ochtervelt and Pieter de Hooch (q.v.), who was also a native of Rotterdam, studied with Nicolaes Berchem (q.v.) in Haarlem at the same time. Reasonably enough, the biographer describes De Hooch as a painter of *kamergezigten* (views of rooms) with figures, and Ochtervelt as an artist who depicted figures "without using much perspective in his backgrounds."[2]

Ochtervelt was more than four years younger than De Hooch, and probably began his training under Berchem somewhat earlier, perhaps about 1649–50. His earliest known dated work, *Hunters and Shepherds in a Landscape,* of 1652 (Städtische Kunstsammlungen, Chemnitz), has been compared with paintings by Berchem, Jan Baptist Weenix (1621–1660/61), and Ochtervelt's predecessor in Rotterdam, Ludolf de Jongh (q.v.).[3] Presumably, the eighteen-year-old painter returned to Rotterdam about the time he painted this picture, or slightly later, but the earliest record of his being back in the city is the posting of his marriage banns on November 28, 1655. Ochtervelt and Dirckjen Meesters, also of Rotterdam, were married on December 14 of the same year. Apparently the couple had no children, but the artist served as guardian for the orphaned children of his brother Jan (d. 1666).

It is not known when Ochtervelt joined the painters' guild in Rotterdam. However, he stood (unsuccessfully) as a candidate for office in the organization during October 1667. From May 1 of that year, he leased a house on the Hoogstraat in Rotterdam, for the comparatively modest rent of 190 guilders a year. Ochtervelt and his wife witnessed a baptism in Rotterdam on July 10, 1672, but by 1674 they had moved to Amsterdam (his group portrait *Four Regents of the Lepers' Asylum in Amsterdam* [Rijksmuseum, Amsterdam] is dated 1674). They lived at a few different addresses in Amsterdam until Ochtervelt's death in the spring of 1682 (he was buried on May 1). His widow returned to Rotterdam and died there in 1710.

In the 1650s, Ochtervelt's Merry Companies were set in ambiguous tavern interiors or on garden terraces. The figures, strongly lighted from the side, nearly fill the compositions. During the 1660s, Ochtervelt placed his enthusiastic young women and their suitors in more fully described interiors, based on compositions adopted mainly from Frans van Mieris (q.v.), but also from De Hooch, De Jongh, and other genre painters in the South Holland area. With his tendency to employ exaggerated gestures in triangular figure groups, Ochtervelt might have depicted martyrdoms, but the mood is almost invariably light-headed in his courtship scenes. The drama subsides somewhat during the Amsterdam period, in works recalling contemporary pictures by De Hooch, Gerard ter Borch, and, more broadly, Gerard de Lairesse (q.q.v.). From the mid-1660s onward, Ochtervelt also painted scenes set in the foyers or entrance halls of fine town houses, with a view to the street and with visiting merchants or entertainers at the threshold. His arrangements have parallels in the oeuvres of De Hooch, De Jongh, and others, but Ochtervelt's type of composition (usually focused on a frontal and fairly close doorway) is distinctive, and allows for attractive contrasts of light and shadow. *Street Musicians at the Door,* dated 1665 (Saint Louis Art Museum), is one of the most impressive examples, with its marble-tiled floor, satin-clad mistress, excited child and maid, and receding row of houses outside. Some market scenes, family portraits, and other subjects (including the very late *Last Testament,* in Jagdschloss Grünewald, Berlin) also date from the artist's late years. The uneven quality and eclectic style of Ochtervelt's work reflect the realities of the art market at the time, which encouraged the conflicting demands of conformity and innovation. About one hundred paintings by Ochtervelt are known.

1. The specific day is not clear in the church records. See Kuretsky 1979, pp. 4, 8 n. 7, 220.
2. Houbraken 1718–21, vol. 2, pp. 34–35.
3. Kuretsky 1979, pp. 11, 53–54, no. 3, fig. 8, and S. D. Kuretsky in *Dictionary of Art* 1996, vol. 23, p. 344.

Oil on canvas, 36 x 25 in. (91.4 x 63.5 cm)

The surface is abraded throughout. Loss of the finish is particularly severe in the figures and background. The carpet on the table is better preserved.

Gift of Mr. and Mrs. Walter Mendelsohn, 1980 1980.203.5

This unsigned canvas first came to light in 1980. Susan Donahue Kuretsky, whose monograph on Ochtervelt was published the year before, examined the work prior to its accession by the Museum and confirmed its authorship. Peter Sutton (see Refs.) reasonably suggests a date in the early 1670s.

The subject is a pretty woman at her toilet, wearing a white satin housecoat over a coral-colored skirt. She gestures with enthusiasm as she reads a letter that must be from a suitor. A maid (whose head has been simplified by abrasion) threads a string of pearls through her mistress's hair. A second servant leaves the room (a doorway is dimly indicated in the center background) carrying a silver basin and pitcher. A canopied bed stands in the right background. To the near right is a table covered with an Oriental carpet and a chair upholstered in a silver fabric, apparently silk. A fine silver box is on the seat, and a lapdog lies near the lady's delicate foot.

In style and subject, the picture responds to works by Gerard ter Borch (q.v.), the Museum's *Curiosity* (Pl. 17), for example, and *The Letter* (Royal Collection, Buckingham Palace, London), both dating from the early 1660s. Although the present composition is original, the shadowy interior, with a bed and table forming a corner, figures grouped closely together, and a young woman whose satin garment glistens in the light are all features typical of Ter Borch, whose work was admired by other artists active in South Holland, such as Caspar Netscher in The Hague and Johannes Vermeer in Delft (q.q.v.), as well as by Ochtervelt in Rotterdam.[1] Both a seated woman reading a letter and a maid dressing a young woman's hair are motifs found in paintings of the early 1660s by Ter Borch.[2]

The pitcher and basin perhaps refer here to purity, as is suggested also for Ter Borch's *A Young Woman at Her Toilet with a Maid* (Pl. 13). In this instance, however, the motif is less conspicuous; Ochtervelt was not one to dwell on didactic ideas.[3] The most important motif in the picture could be described, literally, as material, namely, the satin garment, one of the finest examples in the artist's oeuvre.

1. On Ochtervelt's interest in Ter Borch, especially about 1670–72, see Kuretsky 1979, pp. 19–20, 23–24. Given its suggested dating, the Museum's picture could also have been painted in Amsterdam (see Ochtervelt's biography above). However, the style it represents was employed by the artist long before he moved.
2. See Gudlaugsson 1959–60, nos. 168, 188, 234.
3. P. Sutton (see Refs.) finds the "same ewer and basin" in five other paintings by Ochtervelt (Kuretsky 1979, figs. 87–91), and discusses the notion of purity at some length.

REFERENCES: W. Liedtke in MMA, *Notable Acquisitions, 1980–1981* (New York, 1981), p. 44 (ill.), publishes the picture for the first time, dates it to about 1670, and notes Ter Borch's influence; Baetjer 1995, p. 339; P. Sutton in Dublin–Greenwich 2003–4, pp. 194–95, no. 41, titles the painting *A Woman Reading a Letter with Two Maidservants*, dates it to the early 1670s, and compares a few other works by Ochtervelt.

EXHIBITED: Dublin, National Gallery of Ireland, and Greenwich, Conn., Bruce Museum of Arts and Science, "Love Letters: Dutch Genre Paintings in the Age of Vermeer," 2003–4, no. 41.

EX COLL.: Mr. and Mrs. Walter Mendelsohn, New York (by the 1960s–until 1980);[1] Gift of Mr. and Mrs. Walter Mendelsohn, 1980 1980.203.5

1. The Mendelsohn children recall the painting in their parents' home at least as early as the 1960s. No family member was able to say when or where the picture was acquired. According to a *New York Times* obituary published on October 16, 1995, Mr. Mendelsohn died four days earlier at the age of ninety-eight. A graduate of Yale, in 1921 he joined the law firm of Proskauer Rose Goetz & Mendelsohn in his native New York, and was the last surviving name partner of the firm. His wife predeceased him.

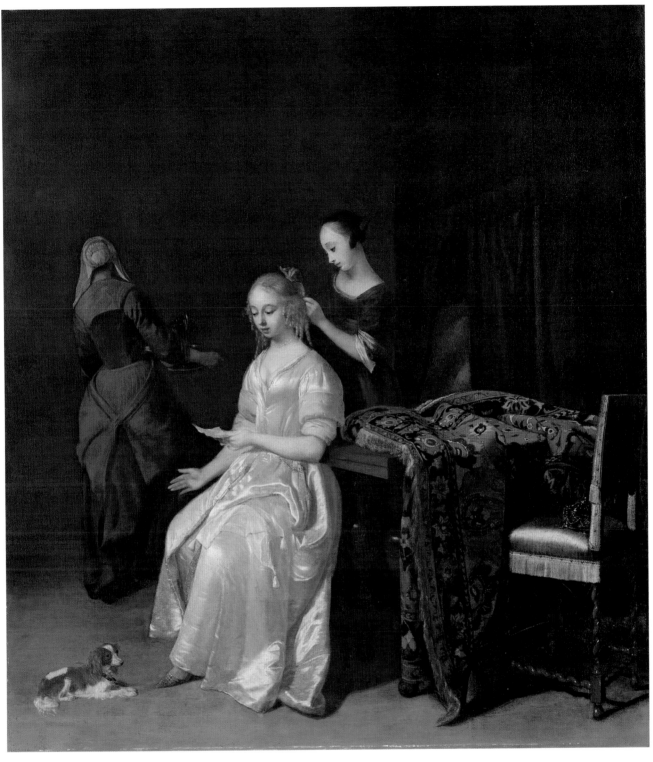

134

ADRIAEN VAN OSTADE

Haarlem 1610–1685 Haarlem

Van Ostade was the son of a weaver, Jan Hendricx van Eyndhoven, and Janneke Hendricksdr. Baptized on December 19, 1610, he was the third of eight children, who included the short-lived genre painter and landscapist Isack van Ostade (1621–1649). Houbraken reports that Adriaen van Ostade and Adriaen Brouwer (1605/6–1638) were contemporary pupils of Frans Hals (q.v.), which would have been in the second half of the 1620s.[1] However, Brouwer's influence on Van Ostade's early style and subjects is much easier to discern than Hals's influence on either artist.[2] Van Ostade's prolific career as a painter, draftsman, and etcher was pursued entirely in Haarlem, where he married a local woman, Machteltje Pietersdr, on July 25, 1638. She died in 1642, and on May 26, 1657, Van Ostade married a well-to-do Catholic woman, Anna Ingels, of Amsterdam. He probably assumed her religion, and certainly shared in her prosperity until she died in 1666. The widower was left with a substantial inheritance, which helped support the couple's daughter and his sister Maeyeken's five children and, from 1668, the children of his brother Jan. The artist's industrious output also contributed to his material comfort, which is suggested by his several changes of address (in Haarlem, although he moved temporarily to Amsterdam during the French invasion of 1672–73). Van Ostade was also active in the painters' guild, which he joined by 1634 at the latest. He was buried in Saint Bavo's, Haarlem, on May 2, 1685. On July 3 and 4 of that year, the contents of his studio were auctioned off. His daughter's announcement in the Haarlem *Courant* of June 23 and 28, 1685, mentions "over two hundred works from his hand and a great number by various masters, all his engraved plates as well as a great number of etchings, drawings, etc., by him and other masters."[3]

A fuller discussion of this familiar figure's oeuvre would be inappropriate here, since the Museum does not have any work by him in the collection, and Schnackenburg's review in the *Dictionary of Art* is especially complete.[4] The several hundred paintings by Van Ostade that survive have yet to be properly catalogued. About fifty etchings and some four hundred drawings and watercolors are also considered autograph. He had many imitators, in addition to at least three gifted pupils: his brother Isack, Cornelis Bega (1631/32–1664), and, very late in the master's life, Cornelis Dusart (1660–1704).[5]

It has been maintained convincingly that a superb portrait by Hals in the National Gallery of Art, Washington, D.C., represents Van Ostade and dates from the late 1640s.[6]

1. Houbraken 1718–21, vol. 1, pp. 320, 347.
2. On Van Ostade's early work, see Schnackenburg 1970.
3. See Van Thiel-Stroman in Biesboer et al. 2006, p. 259.
4. B. Schnackenburg in *Dictionary of Art* 1996, vol. 23, pp. 609–12, with a substantial bibliography.
5. Jan Steen (q.v.) and Michiel van Musscher (1645–1705) have also been said to have studied briefly with Van Ostade.
6. Wheelock 1995a, pp. 79–82.

STYLE OF ADRIAEN VAN OSTADE

135. *Man with a Tankard*

Oil on wood, 10⅛ x 8½ in. (25.7 x 21.6 cm)
The paint surface is badly abraded.
H. O. Havemeyer Collection, Bequest of Mrs. H. O. Havemeyer, 1929 29.100.198

The execution of this painting, being looser than expected for Adriaen van Ostade, reminded A. B. de Vries and Horst Gerson of Isack van Ostade (see biography above).[1] However, the work's quality is entirely inconsistent with that of either brother's work. Adriaen van Ostade painted this type of small picture in the

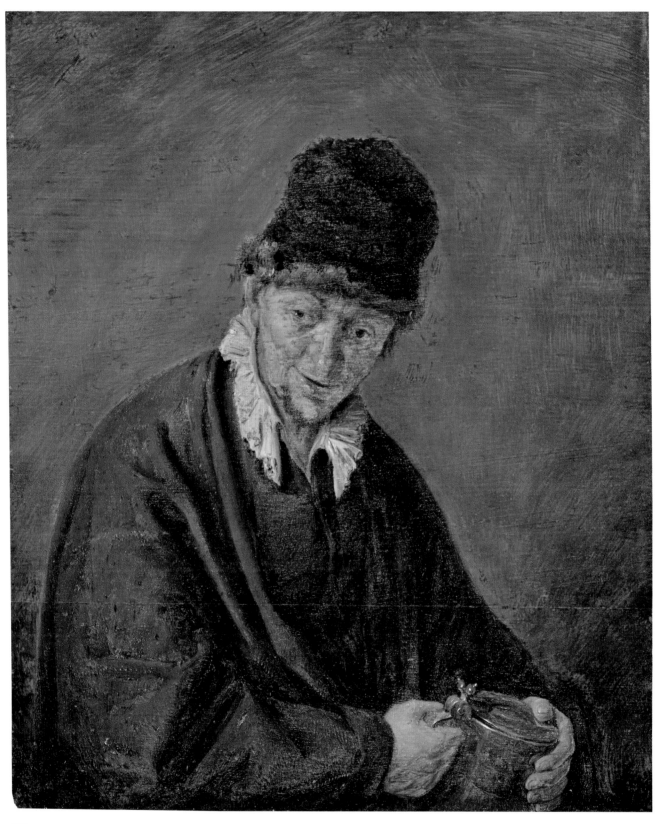

1650s and 1660s, when he was at the height of his abilities and a master of close observation.[2] The Havemeyer panel is a seventeenth-century imitation of a work by Van Ostade or, quite possibly, a copy of an unknown work.[3]

1. Oral opinions, 1952, and an unknown but later date, respectively.
2. For an autograph work of this type, and on this subject, see the present writer's discussion in E. Sullivan et al. 1995, vol. 1, pp. 149–50. Curator John Walsh gave the Museum's picture its present title in 1972.
3. The present writer changed the attribution to Style of Adriaen van Ostade in 1988. Various scholars, including the Van Ostade specialist Hiltraut Doll, have examined the work in storage and concurred with the present attribution. For signed and autograph works of this type, see Sotheby's, New York, January 14, 1988, no. 28, and Christie's, London, December 11, 1992, no. 95.

REFERENCES: New York 1930, p. 15, no. 89, as by Adriaen van Ostade, and entitled *Portrait of a Man*; B. Burroughs 1931a, p. 267, no. Os71-4, as by Adriaen van Ostade; Havemeyer Collection 1958, p. 6, no. 16, as by Isack van Ostade, and entitled *Portrait of a Man*; Baetjer 1980, vol. 1, p. 137, as by Adriaen van Ostade, *Man with a Tankard*; Weitzenhoffer 1982, p. 127 (?); Weitzenhoffer 1986, p. 64 (?); Stein in New York 1993, pp. 209, 285; Wold in ibid., 368, no. A423 (ill.), as Style of Adriaen van Ostade; Baetjer 1995, p. 321, as Style of Adriaen van Ostade.

EXHIBITED: New York, MMA, "The H. O. Havemeyer Collection," 1930, no. 89, as by Adriaen van Ostade, and entitled *Portrait of a Man*; Nashville, Tenn., Fisk University, 1961.

EX COLL.: Possibly Édouard Warneck, Paris (until 1889); [possibly Durand-Ruel, Paris, in 1889]; Mr. and Mrs. H. O. Havemeyer, New York (possibly by February 1892–until 1907); Mrs. H. O. Havemeyer, New York (1907–29); H. O. Havemeyer Collection, Bequest of Mrs. H. O. Havemeyer, 1929 29.100.198

NICOLAES ELIASZ PICKENOY

Amsterdam 1588–1650/56 Amsterdam

Nicolaes Eliasz Pickenoy was the son of Elias Claesz Pickenoy, an armorial stonecutter from Antwerp. The painter was baptized in Amsterdam on January 10, 1588. He was probably trained by the formal portraitist Cornelis van der Voort (ca. 1576–1624), whose parents had also emigrated from the Spanish Netherlands. Pickenoy and another possible pupil of Van der Voort's, Thomas de Keyser (q.v.), were the main portraitists of Amsterdam society until Rembrandt established himself there. Until fairly recently, an important group portrait, *The Anatomy Lesson of Dr. Sebastiaen Egbertsz de Vrij,* of 1619 (Amsterdams Historisch Museum, Amsterdam), was thought to be by De Keyser, but is now generally agreed to be by Pickenoy.[1]

In 1621, Pickenoy married a woman named Levina Bouwens. They had ten children, only one of whom lived to adulthood. The artist flourished in the 1620s and 1630s, painting large civic-guard pictures as well as single and pendant portraits of prominent citizens.[2] Among these are nearly life-size full-length portraits, a type previously common at European courts but not in the circle of patrician figures such as Cornelis de Graeff and his wife, Catharina Hooft, whose portraits of 1636 by Pickenoy are in the Gemäldegalerie, Berlin.[3] Attempts at animation are found in civic-guard portraits of 1639, 1642, and 1645 (all in the Rijksmuseum, Amsterdam), but compared with pictures of this type by Frans Hals and Rembrandt (q.q.v.) they look a generation out-of-date. No single or pair portraits by Pickenoy are known from after 1640.[4] The comparatively rare religious paintings by this artist are, not surprisingly, conservative and dignified.[5]

Between 1637 and 1645, Pickenoy owned the corner house on the Saint Anthonisbreestraat, next to the house that Rembrandt bought in 1639.[6] It is not known when he died, but his wife was described as a widow in October 1656. Bartholomeus van der Helst (q.v.) may have been his pupil. The portrait discussed below is entirely typical of Pickenoy in style, and rather typical of him in that it has been attributed to De Keyser and to Werner van den Valckert (ca. 1580/85–ca. 1627). The latter was from The Hague, but by 1614 he had abandoned the realm of Michiel van Miereveld and Jan van Ravesteyn (q.q.v.) for Amsterdam, another quite competitive place.[7]

1. See Ekkart in Amsterdam 1993–94a, pp. 595–96, no. 268, and Middelkoop in Amsterdam 2002–3, pp. 172–73, no. 54. Ekkart's argument is supported by the De Keyser specialist Ann Jensen Adams in *Dictionary of Art* 1996, vol. 18, p. 10.
2. See Van Thiel et al. 1976, pp. 217–18, erroneously under Eliasz, "called Pickenoy." As explained in Dudok van Heel 1985, the family name is Pickenoy.
3. On this point and for these pendant portraits, see Dudok van Heel in Amsterdam 2002–3, pp. 46–47, 50, 118–19, nos. 21a, 21b.
4. According to Rudolf E. O. Ekkart in *Dictionary of Art* 1996, vol. 24, p. 735.
5. See Van Schooten and Wüstefeld 2003, no. 53.
6. Dudok van Heel 2001, p. 13, and Amsterdam 2002–3, pp. 51–52. In Schama 1999a, pp. 459–60, Pickenoy's house is mistakenly placed on the other side. The studio with northern light had previously been occupied by Cornelis van der Voort (until his death in 1624) and then by Rembrandt's dealer Hendrick Uylenburgh (ca. 1584/89–1661).
7. On Van den Valckert, see Van Thiel 1983.

136. *Man with a Celestial Globe*

Oil on wood, 41¼ x 30 in. (104.8 x 76.2 cm)
Dated and inscribed (upper right): Ætatis·Sua·/·47·/Anº·1624·

The painting is well preserved. The original oak panel is composed of three joined wooden boards with vertical grain. It has been thinned to 1 mm and laminated to a custom-made composite panel, cradled. There is a small amount of paint loss extending the entire length of the left panel join and along the upper and lower 10 in. (25.4 cm) of the right panel join. Infrared reflectography reveals adjustments to the placement of the hand on the globe and a few lines of the preliminary sketch that define the white ruff.

Bequest of Harry G. Sperling, 1971 1976.100.22

The opinions that have been expressed about the authorship of this dignified Amsterdam portrait are more consistent than they might at first appear. In 1911, Oldenbourg (see Refs.), following the advice of Hofstede de Groot, catalogued the painting as by Thomas de Keyser (q.v.). As noted in Pickenoy's biography above, an important *Anatomy Lesson*, dated 1619, has only recently been recognized as a work by Pickenoy rather than the much better known De Keyser. Van Thiel's suggestion, in 1983, that the Museum's portrait was probably painted by Werner van den Valckert (ca. 1580/85–ca. 1627) places the work directly in the Amsterdam milieu of De Keyser, Pickenoy, and their predecessor Cornelis van der Voort (ca. 1576–1624), although no one has seconded Van Thiel's particular candidate.[1] At least two scholars, Bruyn and De Bruyn Kops, immediately rejected the attribution to Van den Valckert, and Bruyn maintained firmly that the painting is by Pickenoy, "one of his earliest known works."[2] After firsthand examination in 1988, the Dutch portrait specialist Rudolf Ekkart concluded, "There is no doubt that this excellent painting is a work by Nicolaes Eliasz Pickenoy."[3]

The more conservative Dutch portraitists of the seventeenth century have received closer attention in recent decades than ever before, a trend that reflects greater concern with iconography, social context, and the art market.[4] The Museum's picture has become known only during this period, although it is in storage more often than not. In contrast to visiting scholars, or those who know the work only from photographs, the present writer has had the advantage of viewing the painting frequently, and of having it clearly in mind whenever similar pictures are encountered. For example, the *Portrait of a Man with a Lay Figure*, which is also dated 1624 (Speed Art Museum, Louisville), is convincingly ascribed by Van Thiel to Van den Valckert, but

reveals differences of quality and style in comparison with the New York portrait that go well beyond the few that Van Thiel acknowledges (he describes the latter painting as being "much better worked out" in the head and in the hand resting on the globe).[5] Indeed, the smooth, masklike modeling of the woodcarver's face in the Louisville portrait, as well as his puppetlike movement, suggests a distinctly different sensibility than that found in *Man with a Celestial Globe,* where the description of passages such as the figure's blond hair, facial features, ruff, elegant black costume, and globe reveal a genuine interest in observation rather than clever artistic conceits. Comparison with signed works by Van den Valckert, such as the male portraits dated 1616, 1617, 1620, and 1622 (a group portrait) in Boston, Amsterdam, Châteauroux, and Berlin, respectively, leads to the same conclusion.[6]

Unfortunately, Pickenoy rarely signed his paintings. Nonetheless, male portraits considered typical of the artist strongly support his authorship of the present picture. These works include the *Portrait of a Man*, dated 1632, inscribed in the very same manner as here (art market, 1994);[7] the portraits of Maerten Rey and of Jochem Hendricksz Swartenhont, both dated 1627 (both Rijksmuseum, Amsterdam); and the *Portrait of a Man Aged Twenty-seven,* dated 1629, and the presumed *Self-Portrait,* dated 1627, again with the same style of inscription (both Louvre, Paris).[8] It is worth noting that despite the generally similar hands depicted in portraits by Van der Voort, Van Miereveld, and other Dutch artists, the precise form of the proper right hand in *Man with a Celestial Globe,* with its swelling back, tightly bent fingers, and shape recalling a lobster claw, is characteristic of Pickenoy.

The hand-colored engravings of the celestial globe were published in 1603 by Willem Jansz Blaeu (1571–1638).[9] In 1990, the Museum purchased a globe by the same publisher.[10] The globe may refer to the man's profession, or to an amateur interest in astronomy. It was presumably this attribute that, about a century ago, led to the identification of the sitter with the 9th Earl of Northumberland (see Ex Coll.), that is, Henry Percy (1564–1632), who was known for his knowledge of astronomy and navigation.

1. See Van Thiel 1983, pp. 165–66. Significantly, Van Thiel suggests that *The Anatomy Lesson of Dr. Sebastiaen Egbertsz de Vrij,* of 1619, might be by Van den Valckert and not De Keyser (ibid., p. 171, fig. 48).

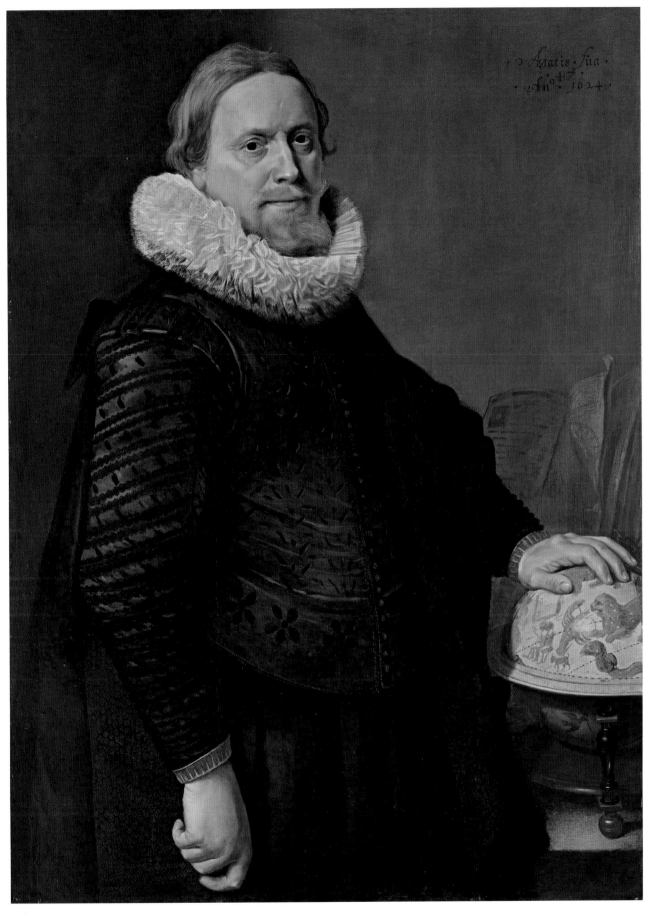

136

2. J. Bruyn, letter to the present writer, dated November 9, 1983. C. J. de Bruyn Kops, of the Rijksmuseum, Amsterdam, studied the portrait in New York on January 10, 1984. He had doubts about an attribution to Pickenoy, but said that Van den Valckert was certainly not responsible. Albert Blankert, on a visit to the Museum in 1988, considered the portrait undoubtedly by Pickenoy. The Museum's attribution was changed from Dutch Painter, Unknown, to Pickenoy in 1990.

3. Memo to the Museum, dated November 3, 1988.

4. See, for example, Haarlem 1986a; Blasse-Hegeman et al. 1990; and Amsterdam 2002–3.

5. Van Thiel 1983, p. 165, figs. 42, 43. The Louisville portrait, acquired in 1963, was previously on the art market as a De Keyser.

6. For the portraits in the Museum of Fine Arts, Boston; the Rijksmuseum, Amsterdam; the Musée-Hôtel Bertrand, Châteauroux; and the Gemäldegalerie, Berlin, see ibid., figs. 33, 34, 38, 40.

7. Sotheby's, New York, January 14, 1994, no. 23; previously at Sotheby's, London, April 20, 1988, no. 46. The pendant female portrait is in the J. Paul Getty Museum, Los Angeles.

8. Inventory numbers R.F. 2134 and R.F. 1213, respectively. The Louvre's *Portrait of a Man,* which bears no inscription (inv. no. R.F. 1575), is also similar in execution to the Museum's painting.

9. See Van der Krogt 1993, p. 159, fig. 4.20. The book has not been identified.

10. See Clare Vincent in *MMA Bulletin* 48, no. 2 Autumn (1990), p. 25.

REFERENCES: Oldenbourg 1911, p. 83, no. 93, as by De Keyser, *Portrait of a Man,* probably the 9th Earl of Northumberland, crediting Hofstede de Groot with the attribution to De Keyser; Graves 1913–15, vol. 3, p. 1170, listed as a Rubens in the 1907 Royal Academy exhibition; Baetjer 1980, vol. 1, p. 51, as by a Dutch Painter, Unknown, in 1624; Van Thiel 1983, pp. 165–66, 180, no. 14, fig. 43, attributes the work to Werner van den Valckert and compares works by that artist; Ekkart in Amsterdam 1993–94a, p. 596 n. 5 (under no. 268), cites the work, "which Van Thiel . . . wrongly attributes to Van den Valckert," in support of another attribution to Pickenoy; Baetjer 1995, p. 305, as by Pickenoy.

EXHIBITED: London, Royal Academy, "Winter Exhibition," 1907, no. 105, as *Portrait of the Earl of Northumberland,* by Rubens (lent by the Hon. Mrs. Trollope).

EX COLL.: Hon. Mrs. Ethel Mary Trollope, Crowcombe Court, near Taunton, Somerset (by 1907–d. 1934; as "The Earl of Northumberland" by Rubens, later as by Thomas de Keyser); her grandson Maj. Thomas Fleming Trollope-Bellew, Crowcombe, Taunton (from 1934); [Martin Asscher, London, until 1967]; [Kleinberger, New York, 1967–75; bequeathed by Harry G. Sperling, last surviving partner of the firm, to MMA]; Bequest of Harry G. Sperling, 1971 1976.100.22

FRANS POST

Haarlem 1612–1680 Haarlem

The artist's father, Jan Jansz Post (ca. 1575–1614), was a stained-glass painter from Leiden. Although he is praised in Samuel Ampzing's 1628 "Description" of Haarlem,[1] only one drawing by him, dated 1612, is known today. In 1604, he moved to Haarlem and married Francijntje Pieters Verbraak (1581–1656). Their first child, Pieter Post (1608–1669), trained as a painter, but is better known as one of the most important Dutch architects of the century.[2] The next child, Anthoni (1610–after 1657), pursued a legal career. Frans was the couple's third child, baptized on November 17, 1612. His sister, Johanna (1614–1672), married a Haarlem merchant in 1645. Following the death of Jan Jansz in 1614, Frans's mother remarried in 1620, and later divorced.[3]

Pieter Post became a member of the Haarlem painters' guild in 1623, and by the late 1620s was an independent master. In the early 1630s, he painted cavalry engagements similar to those by Esaias van de Velde (1587–1630), and a few views of local landscape that are generally consistent with developments in Haarlem as represented by Van de Velde, Pieter de Molijn (q.v.), and Cornelis Vroom (1590/91–1661), but are also distinctive in a manner that anticipates paintings by his brother Frans.[4] Presumably, Frans studied with his older brother in the late 1620s and early 1630s.[5]

By the mid-1630s, Pieter had turned his attention to architecture and was working with Jacob van Campen (1595–1657) for Constantijn Huygens, secretary to the Prince of Orange. It must have been through this connection that Frans was made known to the prince's cousin Johan Maurits, Count of Nassau-Siegen (1604–1679), who in 1633 commissioned Van Campen to design his house, the Mauritshuis, in The Hague (Pieter Post supervised the construction). In 1636, the West India Company named Johan Maurits governor of the Dutch colony in northeast Brazil, where between 1637 and 1643 he built towns and fortifications, and devoted great attention to studying the land's native people, flora, and fauna. A small team of specialists accompanied the count at his own expense, and included the geographer, cartographer, and natural scientist Georg Marcgraf (1610–1643/44); the court physician and scholar of tropical diseases Willem Pies (Piso; 1611–1678); and the artists Frans Post and Albert Eckhout (ca. 1610–1665/66).[6] Eckhout is best known for his large paintings of Brazilian "Indians,"[7] and he also made hundreds of drawings of fish, reptiles, plants, and whatever curious living creature he saw in South America. Post, too, was active as a draftsman, mainly of landscape views. Only seven landscape paintings, dating from 1637 to 1640, are known from his Brazilian period (four are in the Louvre, Paris; Johan Maurits presented over thirty paintings by Post to Louis XIV in 1679).[8] The earliest, *The Island of Itamaracá* (Rijksmuseum, Amsterdam, on loan to the Mauritshuis, The Hague), is dated 1637 1/3.[9]

Post returned to the Netherlands in 1644 and settled in Haarlem, where he is first mentioned in September of that year. He joined the painters' guild there in 1646 and, in 1650, married Jannetje (or Janneke) Bogaert, a granddaughter of the architect Lieven de Key (ca. 1560–1627), in nearby Zandvoort. The couple apparently had nine children, seven of whom died at a young age.[10] When she died in 1664, Jannetje left the artist with three children, born 1655, 1656, and 1660.[11] In 1645, Post made drawings for the thirty-three etched views of Brazil (and ships off the coast) in Caspar van Baerle's *Rerum per octennium in Brasilia gestarum historia* (Amsterdam, 1647).[12] Until at least the end of the 1660s, he painted views of Brazil based on drawings and from memory. His pictures follow Haarlem landscape conventions but feature plausible topography and many exotic details, as seen in the figures, plants, and animals found in the painting discussed below. It has been observed that works dating from after the mid-1650s are more stylized, which is hardly surprising, considering the artist's increasing distance from the extraordinary experience he had in his late twenties and early thirties. About one hundred fifty paintings are known today.

Post was buried in Saint Bavo's, Haarlem, on February 17, 1680. A small portrait of him was painted by Frans Hals (Worcester Art Museum).[13]

1. Ampzing 1628, p. 366.
2. See Terwen and Ottenheym 1993, from which some of the details about Post's family are taken (p. 9).
3. For the most reliable biographies of Frans and Pieter Post, see Van Thiel-Stroman in Biesboer et al. 2006, pp. 268–73.
4. See Duparc 1980, pp. 78–80, nos. 765, 766, and 970, for two

cavalry scenes of 1631 and a dune landscape of 1633 (all in the Mauritshuis, The Hague), and Terwen and Ottenheym 1993, pp. 12–14, 246, for a description and list of paintings also by or attributed to Pieter Post. The topographical flavor of Pieter Post's *Landscape with Bleaching Fields,* of 1631 (Fondation Custodia, Institut Néerlandais, Paris; see Paris 1983, pp. 104–5, no. 63, pl. 15), is especially interesting for his brother's early work.

5. According to F. J. Duparc in *Dictionary of Art* 1996, vol. 25, p. 325, Frans "probably received his early training from his father," although the latter died when the boy was about two years old.

6. On Johan Maurits, see B. Brenninkmeyer de Rooij in ibid., vol. 22, p. 536, and the literature listed there (and also that cited in note 1 of the entry below). He and his scientific team are concisely described in the now standard work on Eckhout, The Hague 2004 (pp. 131–33, 134–35, on the colony in Brazil).

7. As they are quaintly called, by B. J. P. Broos in *Dictionary of Art* 1996, vol. 9, p. 703. The term is still commonly employed in the Netherlands when referring to native North and South Americans.

8. See Sousa-Leão 1973, nos. 1–6; Duparc in *Dictionary of Art* 1996, vol. 25, p. 326; and Paris 2005–6. Duparc's tally of "only six known paintings made in the New World by Post" was true at the time of writing. As he observes, a sketchbook with nineteen views made by Post on the voyage to Brazil (the ship sailed on October 25, 1636) and upon arrival in January 1637 is in the Nederlands Scheepvaartmuseum, Amsterdam (see Sousa-Leão 1973, pp. 143–48).

9. Sousa-Leão 1973, p. 55, no. 1, pl. opp. p. 16; Duparc 1980, pp. 73–76, no. 915 (ill. p. 205); Paris 2005–6, no. 1.

10. Drijfhout van Hooff 1959, pp. 123–24.

11. Larsen 1962, p. 247, doc. 24.

12. Opinions appear to differ on whether these drawings were all made in Holland or in Brazil. Compare Sousa-Leão 1973, p. 37 (pp. 153–56 for illustrations of all the drawings), and Duparc in *Dictionary of Art* 1996, vol. 25, p. 327.

13. Slive 1970–74, no. 206, pl. 318.

137. *A Brazilian Landscape*

Oil on wood, 24 x 36 in. (61 x 91.4 cm)
Signed and dated (right, on papaya tree): F POST/1650

The painting is well preserved. There is a small amount of paint loss in the sky along the horizontal panel join.

Purchase, Rogers Fund, special funds, James S. Deely Gift, and Gift of Edna H. Sachs and other gifts and bequests, by exchange, 1981 1981.318

This large painting by Post is remarkable for its excellent state of preservation and for its exceptional quality. It was painted in the artist's native Haarlem in 1650, about six years after he returned from his long stay in northeast Brazil, where he was employed by the governor of the Dutch colony, Johan Maurits (see the biography above).

The picture's effect overall and its many diverting details are difficult to appreciate in reproductions. The sky is filled with a subtle and complex cover of clouds, and the gradual undulation of terrain from the foreground to the horizon is wonderfully naturalistic. Perhaps most impressive is the middle ground, where scattered bushes, stands of trees, and shifting colors in the grasses convey a highly convincing impression of actual countryside closely observed. The overgrown islands in the river and the hills and plains in the distance delight the searching eye with their remarkable detail, despite the entirely successful suggestion of atmospheric perspective. A small village can be made out among the dozen palm trees on the far distant hill, seen in the hazy light of the central background. Immediately below, in the river, two native sailboats are visible; a third can be seen by the spit of land to the right (in the area of water above the cactus in the foreground). The roofs of three houses emerge from low trees beyond the hill to the right.

At least a dozen different plants are carefully described in the repoussoir of vegetation that fills the right foreground, providing refuge for an iguana. A naturalist would be required to identify all the varieties, apart from the cactus, the bird of paradise (with orange flowers), and the papaya tree (on which the artist's signature and date appear as if carved). Such a specialist, Georg Marcgraf (1610–1643/44), was the painter's companion on expeditions, and their mutual interests are recorded in many pictures by Post. (The inclusion of an iguana, anteater, or armadillo in the foreground is common in his oeuvre.) Marcgraf collected numerous plants and animals in

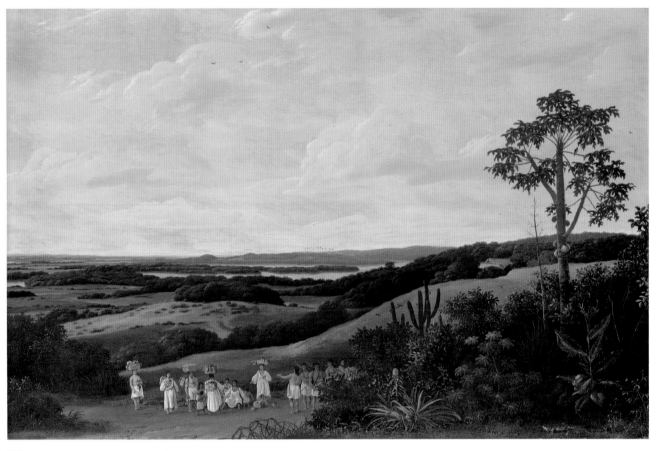

137

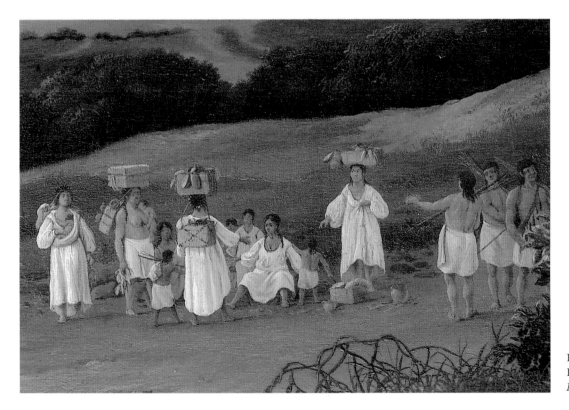

Figure 121. Detail of
Post's *A Brazilian
Landscape* (Pl. 137)

FRANS POST 533

Brazil, and these were described for the first time in a posthumous publication (he died on his return journey to Europe) coauthored by Willem Piso, *Historia naturalis Brasiliae* (Amsterdam, 1648). Marcgraf also made a superb map of the coastal area controlled by the Dutch, with detailed renderings of the rivers leading into the interior. The river valley in the Museum's painting probably corresponds with a view that Post recorded in a drawing, but it would be difficult to identify the location today.[1]

A good number of Post's pictures show native Brazilians traveling on foot, occasionally in the company of Europeans. In this painting, there are seven women, six children, and six men, all natives (fig. 121). The women bear rectangular baskets on their heads and backs, the latter supported by straps slung from the forehead. At least two of the women have dead birds in their hands. The second and third women from the left carry infants. The young woman sitting on the ground has evidently lost control of her basket, to the irritation of the woman on the right. Four of the men carry bows and long arrows, while two of them shoulder muskets and wear cartridge belts. Similar details are included in paintings of Brazilian natives by Albert Eckhout (ca. 1610–1665/66), in woodcuts published in the *Historia naturalis Brasiliae,* in the illustrated journal of the German soldier Caspar Schmalkalden (who was in Brazil and Chile between 1642 and 1645), and in other contemporary sources.[2]

For Post, a painter of sweeping vistas, the timing of his return to Holland could hardly have been better. As discussed above in the entries for panoramic landscapes by Jan van Goyen and Philips Koninck (see Pls. 50, 101, 102), the second half of the 1640s was the beginning of a golden age for this kind of view. Post must have had some knowledge of works by these artists, but his descriptive style and coloring are more reminiscent of a much admired master from Haarlem, Cornelis Vroom (1590/91–1661). In the late 1630s and early 1640s, Vroom painted compositions similar to this one, with panoramic views extending from a gentle rise and with a few trees to the side. A parallel between Vroom's drawings of the early 1630s and Pieter Post's landscape paintings of the same period has also been observed.[3]

1. There is extensive literature on Marcgraf and Piso, and on their work for Johan Maurits. Among the most relevant publications are Van den Boogaart, Hoetink, and Whitehead 1979 (see especially Whitehead's essay, "Georg Markgraf and Brazilian Zoology," pp. 424–71); Whitehead and Boeseman 1989 (see pp. 178–93 on Post, and pl. 80 for Marcgraf's map of Brazil); and Siegen 2004.
2. See Whitehead and Boeseman 1989, pp. 58–89 (on Schmalkalden and Eckhout), pls. 4, 36–46. For Eckhout's oeuvre, see The Hague 2004.
3. See Chong and P. Sutton in Amsterdam–Boston–Philadelphia 1987–88, p. 519 (under no. 115), Vroom's beautiful *Estuary Viewed through a Screen of Trees,* of about 1638 (private collection). See also Keyes 1975, vol. 2, pp. 185–87, no. P25, fig. 49, the *Panorama with Dunes,* of about 1640–42 (Stichting Hannema-de Steurs, Kasteel "het Nijenhuis," Heino).

REFERENCES: Sousa-Leão 1948, pp. 46 (ill.), 99, no. 11, lists the work as in the Marcondes Ferreira collection; Guimarães 1957, p. 258, no. 69, as in the Marcondes Ferreira collection; Larsen 1962, p. 187, no. 15; Sousa-Leão 1973, p. 65, no. 14 (ill.), sees the landscape as "an unusual setting for Post"; W. Liedtke in MMA, *Notable Acquisitions, 1981–1982* (New York, 1981), pp. 41–42 (ill.), describes the subject and Post's work in Brazil; Liedtke 1982b, pp. 350–51 (ill.), describes the picture's subject, style, and condition ("superb"); P. Sutton 1986, p. 191, mentions the "new acquisition" as a "major work"; Baetjer 1995, p. 322; F. J. Duparc in *Dictionary of Art* 1996, vol. 25, p. 326, considers the picture one of the most successful compositions of the period shortly after Post returned from Brazil; Corrêa do Lago in Paris 2005–6, pp. 23, 25, fig. 10 (incorrectly as on canvas), mentions the work in a brief survey of Post's oeuvre; Krempel in Munich 2006, pp. 78–79, no. 8, describes the composition and identifies the natives as Tupi, who were allies of the Dutch; Corrêa do Lago and Corrêa do Lago 2007, pp. 128 (ill.), 129 (detail), no. 13, catalogues the picture as one of "the most successful and original pictures of Post's second phase."

EXHIBITED: Rio de Janeiro, Museu de Arte Moderna, "Os Pintores de Maurício de Nassau," 1968, no. 17; Munich, Haus der Kunst, "Frans Post (1612–1680), Maler des Verlorenen Paradieses," 2006, no. 8.

EX COLL.: Popper, Prague (in 1946); E. Kellner, Rio de Janeiro (in 1947); E. Rais, Rio de Janeiro (1948); Octales Marcondes Ferreira, São Paulo (to at least 1973); [Noortman & Brod, New York, until 1981; sold to MMA]; Purchase, Rogers Fund, special funds, James S. Deely Gift, and Gift of Edna H. Sachs and other gifts and bequests, by exchange, 1981 1981.318

JACOB PYNAS

Amsterdam 1592/93–after 1650 Amsterdam?

Jacob Symonsz Pynas and his older brother, Jan (1583/84–1631), were from a patrician Catholic family in Alkmaar. In 1590, their father, Symon Jansz Brouwer (1555/60–1624), became a citizen of Amsterdam, the hometown of their mother, Oude Neel (Old Nellie) Jacobsdr van Harencarspel. The name Pynas (*pinas,* meaning "pinnace," a light sailing ship often used as a tender) was adopted from a property that Symon Brouwer bought in 1594, At the Sign of the Pinnace, on the Nieuwendijk in the center of Amsterdam.[1]

Jan Pynas was reportedly in Italy with Pieter Lastman (1583–1633) from about 1605 until 1607, when they both returned to Amsterdam. It has been supposed that Jacob trained under his brother and that he also went to Italy, but at a later date. Jan himself evidently went again to Rome in 1616–17,[2] but it is very doubtful that Jacob ever made the trip.[3] Among the earliest known dated paintings by Jacob are *Nebuchadnezzar Restored to His Kingdom,* of 1616 (Alte Pinakothek, Munich), and *The Adoration of the Magi,* which appears to be dated 1617 (Wadsworth Atheneum, Hartford).[4]

The Pynas brothers belonged to a group of Amsterdam history painters that are now known as the Pre-Rembrandtists. They include Lastman, Claes Moeyaert (1591–1655), François Venant (1591/92–1636), and the Pynas's brother-in-law Jan Tengnagel (1584–1635).[5] The anachronistic name of the group, which would be better described as the Lastman circle, pays tribute to the considerable influence they had on Rembrandt in the 1620s, and on a number of his pupils in later decades. Rembrandt's high regard for the Early Baroque history pictures of Adam Elsheimer (1578–1610), the German artist who worked in Rome from 1600 onward, was adopted from Lastman and his Amsterdam associates. Especially in his landscapes with small figures, Jacob Pynas was inspired by Elsheimer, in part through engravings by Hendrick Goudt (1583–1648).[6]

After Jan Pynas died in December 1631, Jacob moved to Delft, where he joined the painters' guild on November 12, 1632. He appears to have worked in Delft until about 1640 and then returned to Amsterdam.[7] Patrons in Delft and in the neighboring court city of The Hague were interested in cabinet-size history pictures, for example, by the Delft painters Hans Jordaens the Elder (1555/60–1630) and Leonaert Bramer (q.v.), and by Utrecht artists such as Cornelis van Poelenburch (1594/95–1667).[8] It is not known whether the art market or personal circumstances motivated Pynas to move to Delft. He appears to have had at least one enthusiastic supporter in Amsterdam, Aris Hendricksz Halewat, whose inventory of 1645 included seven paintings by Pynas.[9]

1. See Dudok van Heel and Giskes 1984, p. 14, and Dudok van Heel 2006, pp. 125–26 (chap. 3 for an archival study of Jan and Jacob Pynas, their parents, and other relatives).

2. See Amsterdam 1993–94a, pp. 314, 579 (under no. 252).

3. On this point, see Dudok van Heel 2006, pp. 135–36.

4. A. Tümpel in *Dictionary of Art* 1996, vol. 25, p. 758 (and in Sacramento 1974–75, p. 68), reports that the Hartford picture is dated 1613 or 1617, and adds—with some exaggeration—that "the style is already so mature that it seems reasonable to suppose that there were earlier works." In Haverkamp-Begemann 1978, p. 175, and other sources, the painting is said to be dated 1617, with no suggestion of uncertainty. A *Stoning of Saint Stephen,* dated 1617 (formerly private collection, Budapest), is illustrated in K. Bauch 1935–37, p. 79, fig. 1.

5. An excellent biography of Tengnagel is that by M. J. Bok in Amsterdam 1993–94a, pp. 318–19. On Moeyaert, see A. Tümpel 1974, and A. Tümpel in *Dictionary of Art* 1996, vol. 21, pp. 789–91, vol. 25, pp. 556–57 on the Pre-Rembrandtists, 757–59 on the Pynases. Still useful, though poorly organized, is Sacramento 1974–75 (reviewed by S. D. Kuretsky in *Art Bulletin* 58 [1976], pp. 622–24). On Lastman, see Amsterdam 1991–92.

6. On Elsheimer and the Pynas brothers, see Oehler 1967. The notion that Jacob Pynas was a key figure for spreading Elsheimer's landscape style in the Netherlands is dismissed in Dudok van Heel 2006, pp. 134–35.

7. See Dudok van Heel 2006, p. 137.

8. See Liedtke in New York–London 2001, pp. 54–56.

9. Bredius 1937b, p. 257; Dudok van Heel 2006, pp. 137–38.

138. *Paul and Barnabas at Lystra*

Oil on wood, 19 x 28⅞ in. (48.3 x 73.3 cm)
Inscribed (bottom center, on step) : PL [in monogram, over traces of an original monogram, apparently reading JACP f]

The paint surface is abraded throughout. Concentrated in the right half of the composition are numerous small blisters and losses that seem to be the result of exposure to heat. Extensive underdrawing is visible in many passages beneath the thin paint layers.

Gift of Emile E. Wolf, 1971 1971.255

This painting, which unfortunately has suffered considerably (see condition note above), is certainly by Jacob Pynas and may be dated to the late 1620s, partly on the basis of comparison with the artist's different rendering of the subject, dated 1628 (fig. 122). At some late date, the monogram PL was painted on top of Pynas's own, in order to pass the picture off as a work by the more important Amsterdam artist who strongly influenced Pynas, Pieter Lastman (1583–1633).[1]

The subject is taken from Acts 14:6–18. Paul and Barnabas, having been driven out of Iconium by both the Gentiles and the Jews, flee to Lystra, in Lycaonia (Asia Minor), where they preach the Gospel. When Paul heals a cripple by commanding him to walk, the locals "[lift] up their voices," declaring that Jupiter and Mercury "are come down to us in the likeness of men." A statue of Jupiter stands before the city (Pynas shows the statue to the upper right), and the high priest of the temple has the people bring garlands and sacrificial oxen (in the

painting, the procession, with two garlanded oxen, approaches from the left background). In frustration, the apostles tear at their clothes, crying, "We are also men of like passions with you, and preach unto you that ye should turn from these vanities unto the living God" (who, as Paul, pointing upward, indicates in the painting, is in heaven, not present as a graven image). Pynas depicts the priest in a white robe and surrounded by excited celebrants, some with torches and one with a tambourine. Behind him, the bearded man with bare feet must be the former cripple; a worshipful woman lifts his tunic and gestures at his healed legs. On the steps, Barnabus twists around and rends his garment, attracting curious spectators.[2]

Lastman had treated the subject at least twice in the previous decade, in a painting of 1614 (location unknown) and in a canvas dated 1617 (Amsterdams Historisch Museum, Amsterdam).[3] Except for the gesturing Paul in the earlier picture, the later work is closer to the Pynas, both in composition and in the placement of key figures such as the apostles and the priest. The idea of adding a rooster to the sacrifice may also come from Lastman's panel of 1617. Pynas's picture of 1628 (fig. 122) presents the action more clearly, in a less crowded arrangement, than does the present work or either painting by Lastman.[4] This might be taken to suggest that the present picture was painted slightly earlier than the version in Amsterdam, but other evidence may now be lost, and a survey of known works by Pynas does not suggest a linear development.

Figure 122. Jacob Pynas, *Paul and Barnabas at Lystra*, 1628. Oil on wood, 25¼ x 41⅜ in. (64 x 105 cm). Rijksmuseum, Amsterdam

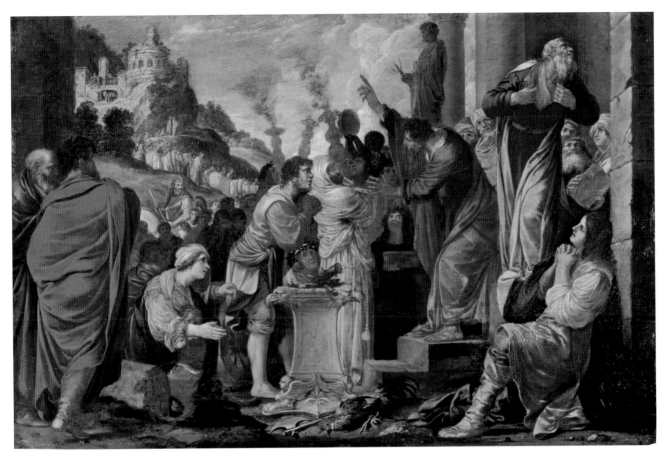

138

1. The modification of the monogram is described by Walsh (see Refs.), who credits a seminar paper by John Mortensen. In a letter to the owner, Emile Wolf, dated January 10, 1961, the scholar Otto Benesch wrote that the picture was not by Lastman (Wolf had mentioned that painter's signature and the date 1607) but by Pynas, adding, "I suspect that the signature was originally that of Jacob Pynas and may have been later changed to that of Lastman." Wolf gave the picture to the Museum as a work by Pynas.

2. On the interpretation of this subject in seventeenth-century Dutch art and literature (the poet Joost van den Vondel wrote a poem about one of Lastman's pictures), see C. Tümpel in Sacramento 1974–75, pp. 127–28; Golahny 1996; and Westermann 1996, p. 44, where it is observed that "the story of Paul and Barnabas could serve as a potent example of early Christian resistance to idolatry, the worship of more than one god or of images of God. This issue was central to Reformed theologians who attacked Catholic rituals involving images, relics, and incense as idolatrous."

3. See Amsterdam 1991–92, pp. 72, 106–7, no. 11, fig. 20. On the panel of 1617, see Reinhardt in Hamburg 2006, no. 11. In Blankert 1979, p. 171, the "preoccupation" of Lastman, Pynas, and others with this subject is credited to the influence of a painting by Elsheimer in the Städelsches Kunstinstitut, Frankfurt, but that work is by the Antwerp master Adriaen van Stalbemt (Sander and Brinkmann 1995, p. 53, pl. 132).

4. For the Pynas in Amsterdam, see Van Thiel et al. 1976, p. 459, citing earlier literature.

REFERENCES: C. Cunningham 1959, p. 11 n. 8, fig. 7, as "extremely close" to Jacob Pynas, but attributed to Lastman on the basis of the monogram, which "appears genuine"; Walsh 1974a, pp. 342–44, 349 n. 6, figs. 5, 6, shows in a drawing how Pynas's monogram was modified to "PL" for Lastman, dates the work to the 1620s, and describes it as "typical of Pynas's classicizing stagecraft, the expressive stretchings and twistings of his actors and the broad, thin technique of painting"; A. Tümpel in Sacramento 1974–75, pp. 29, 70–71, no. 10, discusses the manner of execution, reproduces a facsimile of Pynas's monogram, dates the work to the 1620s, compares Lastman's painting of the subject dated 1614 (location unknown), and notes Pynas's different treatment of the subject dated 1628 (Rijksmuseum, Amsterdam); C. Tümpel in ibid., pp. 127, 149 n. 74, considers the iconography; MMA 1975, p. 92 (ill.); Blankert 1979, p. 171, in a discussion of Lastman's painting of the subject in the Amsterdams Historisch Museum, Amsterdam, notes that the New York picture was previously considered to be by the same artist but was rightly reattributed by Walsh; Haak 1984, p. 193, fig. 395, reveals an affinity to Lastman in composition and subject matter; P. Sutton 1986, p. 180, cited; A. Tümpel in Amsterdam 1991–92, p. 20, fig. 6, incorrectly as dated 1617, notes the influence of Lastman's painting in the Amsterdams Historisch Museum, Amsterdam; Baetjer 1995, p. 303, mentions only the monogram PL.

EXHIBITED: Sacramento, Calif., E. B. Crocker Art Gallery, "The Pre-Rembrandtists," 1974–75, no. 10; New York, MMA, "Patterns of Collecting, Selected Acquisitions, 1965–1975," 1975–76.

EX COLL.: [Leslie Hand, London, ca. 1953, as by Lastman; sold to Wolf]; Emile E. Wolf, New York (by 1959–71); Gift of Emile E. Wolf, 1971 1971.255

PIETER QUAST

Amsterdam? 1605/6–1647 Amsterdam

Pieter Jansz Quast gave his age as twenty-six when his marriage banns were published on June 29, 1632.[1] At the time, he lived on the Molensteeg in Amsterdam, where he was most likely born. Nothing is known of his parents or of his life before his marriage, which took place on December 19, 1632, in Sloten, a village near Amsterdam (see Pl. 4). His bride was Annetje Splinter (dates unknown), who at least in the 1640s was active as a flower painter.[2] Annetje was from The Hague, and the couple settled there before Quast joined the painters' guild in 1634. A daughter, Constantia, was baptized in the Kloosterkerk on July 1, 1639, with the local landscapist François van Knibbergen (1596/97?–?after 1664) attending as a witness.[3] Another child (name unknown) was baptized on August 2, 1641. From the beginning of 1640 until sometime in the first half of 1643, the family lived in a house on the Groene Burchwal, in the neighborhood on the southeast side of The Hague where Jan van Goyen (q.v.) and other artists resided.[4]

Quast failed to flourish in The Hague, which was an expensive place to live. His debts to a shopkeeper in 1640, to an innkeeper in 1641, and to a carpenter in 1642 were the subject of court cases. Of the 1,700 guilders Quast owed for the house on the Groene Burchwal, it would appear that he never gave a down payment of more than 100 guilders. In January 1644, he transferred ownership of the house to his wife, who paid 1,000 guilders toward the old debt in May 1648. Later that year, she filed a claim against a Colonel Brant (presumably of The Hague) for 60 guilders he was said to have owed her late husband (Quast had died the year before) for two paintings acquired in 1640.

Quast fared no better in Amsterdam, where he and his family were living by June 1, 1643. On that date, Annetje was entertaining a clergyman from Utrecht in the kitchen of the house the family was living in on the Kalverstraat. The subject turned to prostitutes, many of whom, according to the hostess, the visitor had patronized. The offended guest slashed her face with a glass *roemer*—at which her husband rushed in and held the pastor at knifepoint. Other documents suggest that the Quasts did not move in the upper circles of Amsterdam society. In February 1644, two men, whom Annetje knew by name, entered the house and damaged a portrait by smearing it with paint and scratching it with knives. Rent was another nuisance. Quast owed 235 guilders in April 1644, and two years later at another address (the Nes, in a bad neighborhood) he refused to pay rent until certain repairs were made. Quast's last resting place was the Nieuwe Kerk, where he was buried on May 29, 1647, having lived for forty-one or forty-two years. His widow and two children withdrew to The Hague, where in May 1649 Annetje gave two paintings to her landlord in lieu of 23 guilders in rent. She is last recorded on May 8, 1650, when she married Jacob van Spreeuwen (b. 1611), a Rembrandt-esque genre painter from Leiden.

Quast is best known as a painter of peasant scenes and Merry Companies, such as the one discussed below, although he also painted portraits, religious and historical pictures, and other subjects.[5] During his years in The Hague, at least two living artists made an impression on his work, Adriaen van de Venne (1589–1662), the prolific painter, print designer, and from 1639 to 1641 dean of the painters' guild, and Anthonie Palamedesz (1601–1673), who lived in the neighboring city of Delft.[6] The former influenced Quast's pictures of low life and the comic stage, the latter his scenes of nominally polite society. Also important for Quast's wittier imagery were actual stage performances in The Hague and theatrical characters etched by Jacques Callot (1592–1635), in particular the *Balli di Sfessania*, of 1621, and *Varie figure di Gobbi*, of 1622.[7] This interest continued in Amsterdam, with paintings of comic actors on stages very like that of the Amsterdam Schouburg (Playhouse), and with numerous drawings.[8] Quast was a prolific draftsman and made many sheets as finished works of art. He also copied "naer het leven" drawings by Roelant Savery (1576–1639), perhaps for that artist's nephew Salomon Savery, a printmaker and publisher in Amsterdam. The latter published prints after other drawings by Roelant Savery in 1638, and had earlier published engravings after two series of drawings by Quast (*The Five Senses* and *The Life of Peasants*; the first is dated 1633).[9] The strongest influence on Quast's paintings of Merry Companies and some similar pictures was the Amsterdam artist Pieter Codde (1599–1678), to whom the Museum's picture was previously attributed.[10]

1. This announcement followed Quast's breach of promise and legal proceedings lasting two months. The best biography of Quast to date, especially with respect to the accurate citation of documents, is the "archival study on Quast" published as an addendum to Stanton-Hirst 1982, pp. 234–37. The author corrects mistranscribed dates given in Bredius 1902, and cites previously unpublished documents. Despite this effort, some recent publications give the artist's date of birth simply as 1606, report that he was married in June 1632 (for example, MacLaren/Brown 1991, p. 317), or repeat other morsels of misinformation.

2. See The Hague 1998–99, p. 348.

3. Ibid., p. 339, and p. 321 on the artist. Unless otherwise stated, documents are cited in Stanton-Hirst 1982, pp. 234–35, and notes.

4. See the map in The Hague 1998–99, pp. 46–47.

5. See Bredius 1915–22, part 1, pp. 273–74, on pictures owned by Quast in 1632; his *Christ on the Cross*, dated 1633 (ill. opp. p. 274); and an inventory of 1673 citing paintings by Quast of the Raising of Lazarus and the Holy Women at the Sepulcher. A *Descent from the Cross* is in a private collection in Germany (Grevenbroich 1993, no. 25). Quast also made terracotta reliefs of genre subjects. One, dated 1629, is in the Rijksmuseum, Amsterdam (see Leeuwenberg 1966), and another is in a private collection, New York.

6. The importance of these two painters for Quast is mentioned by J. E. P. Leistra in *Dictionary of Art* 1996, vol. 25, p. 797. For a very Palamedesz-like *Elegant Company* by Quast, dated 1639, see Worcester 1979, no. 28 (and no. 27 for his goatish *Peasants in an Interior*), or Boston 1992, no. 117. The painting was offered at Sotheby's, New York, May 20, 1993, no. 32, and at Christie's, London, December 3, 1997, no. 146.

7. Both subjects are discussed in Stanton-Hirst 1982.

8. Ibid., pp. 216–22.

9. Kuznetsov 1973. Salomon Savery is also known for his engraving of the Amsterdam Schouburg, as mentioned in Stanton-Hirst 1982, pp. 217, 232 n. 20.

10. On Codde, see Philadelphia–Berlin–London 1984, pp. 174–79; Franits 2004, pp. 57–64; Rotterdam–Frankfurt 2004–5, pp. 69–81; and the brief entry by Netty van de Kamp in *Dictionary of Art* 1996, vol. 7, pp. 510–11, where the bibliography might have included Torresan 1975.

139. *A Party of Merrymakers*

Oil on wood, 14¾ x 19½ in. (37.5 x 49.5 cm)
Signed (right, on man's shirt): PQ [in monogram]

The painting is well preserved. There are minor paint losses and abrasions throughout. Past cleaning exposed part of an earlier composition behind the male figure at left, which was repainted by the restorer to vaguely resemble a cloak gathered in the man's proper left arm. During conservation treatment at the Museum in 1995, the damaged passage was retouched and the intended composition restored.

Bequest of Josephine Bieber, in memory of her husband, Siegfried Bieber, 1970 1973.155.1

This colorful Merry Company by Quast was painted in the mid- to late 1630s, to judge from broad qualities of pictorial style, such as the arrangement of space and lighting, and from the more fashionable articles of clothing. At the time, the artist lived in The Hague. His previous knowledge of Pieter Codde's work in Amsterdam (see the biography of Quast above) is obvious in this picture, which was attributed to Codde from 1929 (see Exh.; on that occasion, the monogram was read as PC), and perhaps much earlier; the Museum recatalogued the work in 1990. Even after the painting's bequest to the Museum in 1970, it was little known, and was rarely exhibited before conservation treatment in 1995–96. In 1986, Sutton (see Refs.) suggested that Quast was probably responsible for the picture, and, in response to the present writer's inquiry in 1989, Justus Müller Hofstede (who has studied Codde's circle in Amsterdam) agreed with the attribution to Quast and proposed a date in the later 1630s.[1] Quast's usual PQ monogram, painted in red on the shirt (just below the closed buttons) of the singing young man, became legible with cleaning in 1995. The X-radiograph made at that time reveals that the painting underwent many transformations.

The subject hardly requires explanation. Three young women entertain three men who may be described as out on the town. That they are just visiting, for as long as they feel entertained, is indicated by the hat and cloak thrown casually aside, or carried and worn in the case of the man with the fancy sword belt. One of the women has unfastened her lace collar; her scruples were loosened sometime before. Her shiny yellow dress with its big slashed sleeves seems in harmony with the

139

silk doublet worn by her impromptu companion—perhaps more so than the tune that they sing. A man seated behind the carpet-covered table accompanies the couple on a lute. The woman on the left, in a blue dress and a cape lined in red, places her hand on the arm of a man who raises his glass, looking into his face as though to focus his attention on some proposition. Another woman walks out through an open door, perhaps on her way to the kitchen, although her actual purpose is to create a clear recession on the left side of the composition. The same function is served by the fireplace on the right, where the satyrlike atlantes figure (compare the fireplace in Gabriël Metsu's *Musical Party*; Pl. 116) provides the only commentary in the picture on the company's character. But that, in Quast's day, would have been understood at a glance, from the frizzy hairstyles and showy shoes of the women to the central figure's wanton position on the table, facilitating glances at her leg and décolletage. This is hardly furniture for comfort—though such surely beckons in other rooms.[2]

Two copies of this picture are known from old photographs.[3]

Formerly attributed by the Museum to Pieter Codde.

1. Letter dated April 22, 1989, in the curatorial files.
2. For earlier pictures with similar subjects by Pieter Codde and Dirck Hals, see Rotterdam–Frankfurt 2004–5, nos. 4, 12.
3. Photocopies in the curatorial files record images at the Rijksbureau voor Kunsthistorische Documentatie, The Hague. One copy, attributed for no particular reason to Herman Doncker, was in the collection of K. M. von Wolf about 1900, and appears to be from the seventeenth century. The other copy, with the art dealer D. Katz, Dieren, about 1933, introduces a landscape view in the left background, and must date from after 1700. The notice "A. Palamedesz?" is an inappropriate compliment.

REFERENCES: P. Sutton 1986, p. 187, suggests that the painting is probably by Quast; Jean L. Druesedow in "Recent Acquisitions," *MMA Bulletin* 48, no. 2 (Fall 1990), p. 56, on the purchase of a silk doublet dating from about 1625, compares the similar garment worn by the figure on the right in the Museum's picture (then still attributed to Pieter Codde); Baetjer 1995, p. 310, as by Quast.

EXHIBITED: Berlin, Galerie Dr. Schäffer, "Die Meister des holländischen Interieurs," 1929, no. 20, as by Pieter Codde; Lucerne, Kunstmuseum Luzern (date unknown).[1]

EX COLL.: Benjamin C. Smith, Paisley, Scotland (before 1925; as by Vermeer); [Art Collectors Association, London, ca. 1925];[2] [Galerie Dr. Schäffer, Berlin, in 1929?]; Siegfried Bieber, Berlin and New York (probably from about 1929–d. 1960); Josephine Bieber, New York (1960–70); Bequest of Josephine Bieber, in memory of her husband, Siegfried Bieber, 1970 1973.155.1

1. A stamped sticker on the back of the panel reads "Kunstmuseum Luzern KH 214." The Kunstmuseum was unable to identify the exhibition (letter from curator Cornelia Dietschi, dated December 12, 2000). However, a date in the early 1930s is likely, considering that the probable owner, Siegfried Bieber, emigrated to America in 1934.
2. This firm and Smith's previous ownership are mentioned on the mount of an old photograph at the Rijksbureau voor Kunsthistorische Documentatie, The Hague. Paintings and drawings owned by B. C. Smith of Whiteleigh, Paisley, were included in an auction at Christie's, London, July 11, 1924, nos. 87–103 (drawings), 104–42 (paintings). All these works date from the 1860s to 1923. Sarah Christie of the Paisley Museums and Art Galleries kindly confirmed that Smith's first name was Benjamin, that his house on Stanley Road in Paisley was called Whiteleigh, and that his business, Smith Brothers & Co., manufactured textiles (personal communication, May 2005).

JAN VAN RAVESTEYN

Culemborg? ca. 1572–1657 The Hague

In his brief review of "Netherlandish Painters Still Alive," Karel van Mander mentions "a very good painter and portraitist in The Hague called Ravesteyn who has a beautiful, good working manner."[1] The artist's father, Anthonie van Ravesteyn, was a glass painter "living in Culemborch" (Culemborg in Gelderland) in 1593, when he delivered three windows decorated with the arms of the Generality to a patron in The Hague. The family probably moved to the court city within the next few years.[2] In October 1597, Jan Anthonisz van Ravesteyn was cited as a witness by a notary in Delft, which together with a broad assessment of his later style has led some writers to report implausibly that he was a pupil of Michiel van Miereveld (q.v.).[3] Van Ravesteyn joined the painters' guild in The Hague on February 17, 1598; his younger brother Anthony (ca. 1580–1669) became an apprentice in the same year.

In January 1604, "Jan van Ravesteijn Antonisz. Schilder" and Anna Arents van Berendrecht were married. This notice, recorded in the Town Hall rather than a church, indicates that the artist was Catholic. He is also cited in later years as present at baptisms and marriages in the Catholic church in the Oude Molstraat, where he resided from 1608 until at least 1646. Van Ravesteyn's wife died in 1640. In 1654, the artist was living in the Nobelstraat next to his daughter Maria and her husband, the portraitist Adriaen Hanneman (q.v.), while his son Cornelis, a lawyer, remained at the earlier address. In 1641, another daughter, Agnes, married Willem van Culemborch, whose name may suggest that he came from the same town as his in-laws.[4]

Van Ravesteyn appears to have served as dean of the painters' guild in 1617 but to have held no office in later years.[5] About a dozen pupils are recorded, mostly between 1612 and 1624.[6] In 1656, the eighty-four-year-old artist broke with the guild to become a founding member of the rival confraternity, Pictura. He was buried on June 21, 1657.

Van Ravesteyn was exclusively a portrait painter.[7] The earliest known example of his work, an intimate portrait of the child prodigy Hugo Grotius (1583–1645), dated 1599 (Fondation Custodia, Institut Néerlandais, Paris),[8] is less reminiscent of pictures produced in the area of Delft and The Hague than of a pair of circular portraits by Pieter Pietersz (1539/41–1603) of a man and a woman, dated 1597 (Mauritshuis, The Hague). By 1585, Pietersz had moved from Haarlem to Amsterdam, where he painted portraits of prominent citizens. Van Ravesteyn's teacher has not been identified, but it seems possible that he studied with Pietersz or was at least influenced by him.[9] About 1630, Constantijn Huygens, secretary to Prince Frederick Hendrick, who must have been well acquainted with Van Ravesteyn, wrote in his diary that the portraitist's "splendid and fresh manner of painting" derived from his experience of Italy, but that later on "he faded a little," by adding to his art "something of his native land, *the old leaven* so to speak."[10]

Indeed, Van Ravesteyn's mature style is typical of South Holland and responds to Van Miereveld, as may be seen in the slightly younger artist's twenty-five portraits of military officers dating from 1611 onward (Mauritshuis, The Hague).[11] The commission for the series probably came from Prince Maurits, who was captain general of the Dutch army. Van Ravesteyn painted many distinguished figures during the 1610s, including Prince Frederick Hendrick (Dutch Royal Collection); officers of the Orange Company civic guard, and the city magistrates together with officers of the four civic guard companies of The Hague (both in the Haags Historisch Museum, The Hague); and, most memorably, the amateur Pieter van Veen with his son and clerk (Musée d'Art et d'Histoire, Geneva).[12]

Van Ravesteyn's approach to portraiture was more fluid and more flattering than Van Miereveld's, who nevertheless enjoyed greater favor from members of the Dutch court and an international reputation.[13] From about 1641 (when Van Miereveld died), Van Ravesteyn seems to have virtually ceased production. The immediate future of portraiture in The Hague was left to his son-in-law Hanneman, who, despite competition from Gerrit van Honthorst (1592–1656) and others, enjoyed a quarter century of success comparable to that of his father-in-law.

1. Van Mander/Miedema 1994–99, vol. 1, p. 458 (fol. 300r).
2. In 1602, Anthonie van Ravesteyn was recorded as making another sale in The Hague, with no mention of living elsewhere; see Bredius and Moes 1892, p. 41.
3. For example, in Haak 1984, p. 217, where it is also recorded that "Ravesteyn was a native of The Hague," although there is no

known connection between the artist's family and that city during the first two decades of his life.

4. For the details in this paragraph and their sources, see Bredius and Moes 1892, pp. 42–44.

5. See ibid., p. 43, noting that the Van Ravesteyn who was dean in 1617 could have been Jan's brother Anthonie.

6. Ibid., p. 44, lists their names, none of which is familiar. See also The Hague 1998–99, p. 340, where Hanneman is mistakenly added to the list.

7. However, see the artist's *Commemorative Portrait of Adriaen van Maeusyenbroeck and Anna Elant,* 1618 (Museum Het Catherijneconvent, Utrecht), in which the patron and his late wife, accompanied by their name saints, kneel in a chapel before a painting of Christ on the cross; see Van Schooten and Wüstefeld 2003, no. 40.

8. Paris 1983, no. 67, pl. 59; The Hague 2002, no. 26.

9. As suggested by Ariane van Suchtelen in Amsterdam 1993–94a, p. 400 (under no. 54). On the circular portraits by Pietersz, see Noble and Pottasch 1997.

10. Huygens 1971, p. 75; see Buijs in The Hague 2002, pp. 149, 216 n. 20, noting that Van Ravesteyn's trip to Italy is otherwise undocumented.

11. Hoetink et al. 1985, pp. 424–28; Ekkart 1991, pp. 10–11; Spruit 1997; Broos and Van Suchtelen 2004, pp. 194–99 (under no. 45), 303–7. Compare Van Miereveld's portraits of Prince Maurits and Prince Frederick Hendrick, of 1607 and about 1610, respectively (New York–London 2001, nos. 43, 44).

12. See Ekkart 1991, pp. 11, 15 n. 23; W. Kloek in Amsterdam 1993–94a, pp. 33–34, figs. 34, 36; and Van Suchtelen in ibid., nos. 269, 270.

13. See Rudolf Ekkart in *Dictionary of Art* 1996, vol. 26, p. 38, comparing the two artists.

140. *Portrait of a Woman*

Oil on wood, 26⅞ x 22⅞ in. (68.3 x 58.1 cm)
Signed and dated (upper right): Anno 1635/JVR F.
[JVR in monogram]

The painting is in good condition, although the face is slightly abraded, most noticeably in the lips and jaw. There are a few small losses in the face and collar.

Gift of Henry Goldman, 1912 12.202

The authorship of this comparatively late work by Van Ravesteyn has never been questioned. The effect of the woman's stern expression and somewhat outdated millstone ruff is softened by her small lace collar and delicate lace cap, and perhaps as well by the artist's brushwork. Van Ravesteyn was usually more attentive than Michiel van Miereveld or Paulus Moreelse (q.q.v.) to visual effects, seen here in the textures of costume, face, and hair, in the moistness of the sitter's eyes, and in the diaphanous plane of the cap. Details of dress in Dutch formal portraits are usually faithful reflections of the sitter's own clothing; an item such as the cap would have been lent to the artist if both parties found it convenient.

The portrait may have had a pendant (compare the composition of Pl. 122), but no trace of one is known.

REFERENCES: H. Gerson in Thieme and Becker 1907–50, vol. 28 (1934), p. 53, mentions the picture; Baetjer 1995, p. 297.

EX COLL.: Henry Goldman, New York; Gift of Henry Goldman, 1912 12.202

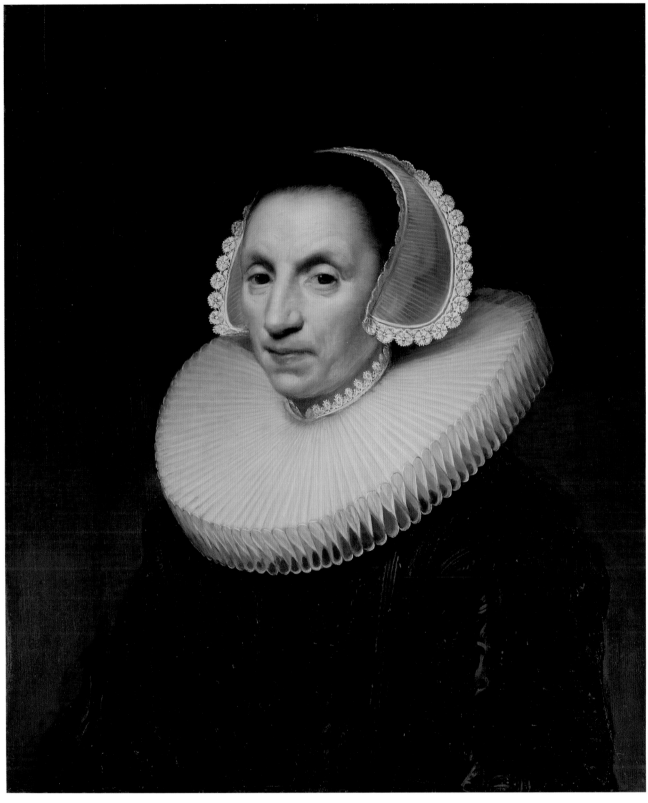

140